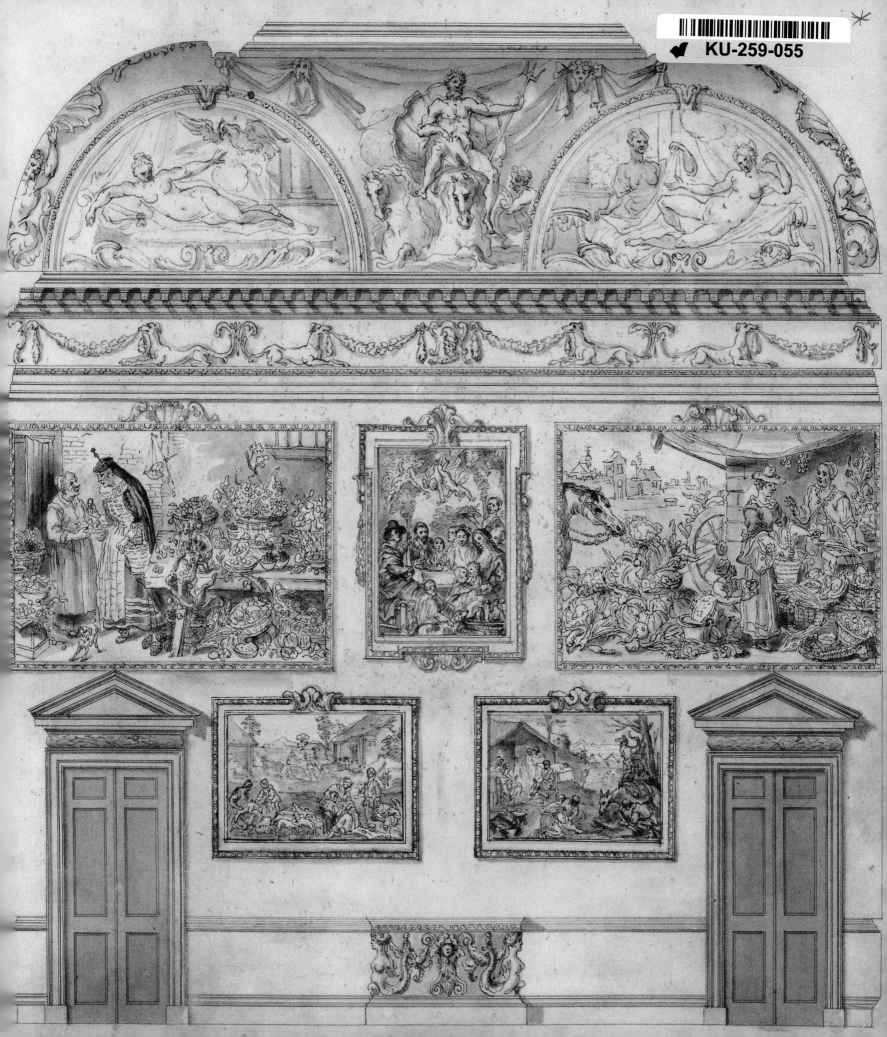

A CAPITAL COLLECTION

A CAPITAL COLLECTION

HOUGHTON HALL AND THE HERMITAGE

Edited by
Larissa Dukelskaya and Andrew Moore

with a modern edition of
AEDES WALPOLIANAE
Horace Walpole's Catalogue of Sir Robert Walpole's Collection

Published for the State Hermitage Museum
and the Paul Mellon Centre for Studies in British Art by
Yale University Press
New Haven and London
2002

Edited and designed by Guilland Sutherland.
Translated by Catherine Phillips.
Printed by CS Graphics, Singapore.

Library of Congress Card Number: 2002111057.
A catalogue record for this book is available from the British Library.
ISBN No. 0-300-09758-1.

Photographic Credits

© State Hermitage Museum (Photographers Leonid Heifitz, Yury Molodkovets, Sergey Pokrovskiy, Inessa Regentova, Konstantin Sinyavskiy, Svetlana Suyetova, Vladimir Terebenin)

Catalogue numbers: 1, 2, 4, 5, 6, 7, 8, 11,13, 15, 17, 18, 19, 21, 25, 29, 30, 33, 34, 35, 36, 38, 39, 40, 41, 43, 44, 46, 47, 48, 54, 57, 58, 59, 60, 62, 63, 65, 66, 67, 70, 72, 73, 75, 76, 77, 79, 81, 83, 85, 94, 95, 97, 98, 99, 100, 101, 102, 103, 104, 105, 107, 109, 110, 111, 115, 116, 118, 119, 120, 121, 122, 123, 124, 127, 128, 129, 130, 132, 133, 134, 135, 136, 137, 138, 139, 140, 142, 143, 144, 146, 150, 151, 153, 156, 158, 159, 160, 161, 162, 164, 165, 166, 167, 169, 170, 171, 172, 173, 176, 177, 179, 180, 181, 182, 183, 186, 188, 193, 194, 195, 199, 200, 201, 203, 204

Alupka State Palace and Park Museum Reserve, Alupka, Crimea (Ukraine)
Cat. nos.: 45, 49
Calouste Gulbenkian Museum, Lisbon
Cat. no.: 117
Far Eastern Art Museum, Khabarovsk
Cat. no.: 50
Gatchina State Museum Reserve, near St Petersburg
Cat. no: 112
M. P. Kroshitskiy Art Museum, Sevastopol
Cat. no.: 24
Kuban Art Museum, Krasnodar
Cat. no.: 93
National Gallery of Art, Washington
Cat. nos.: 108, 149, 187
Palekh Museum, Palekh
Cat. no.: 42
Pavlovsk State Museum Reserve, near St Petersburg
Cat. nos.: 64, 147, 148
State Art Gallery, Perm
Cat. no.: 22
Peterhof State Museum Reserve, near St Petersburg
Cat. no.: 113
Pushkin Museum of Fine Arts, Moscow
Cat. nos.: 10, 14, 31, 69, 86, 87, 95, 114, 125, 131, 154, 168, 178, 185, 191
Research Museum of the Academy of Arts, St Petersburg
Cat. nos.: 55, 56
Tsarskoye Selo State Museum Reserve, near St Petersburg
Cat. nos.: 9, 26, 51, 174, 175
William Morris Collection, Houston, Texas
Cat. no.: 126
Unless otherwise credited, photography of sculpture at Houghton: Andrew Perkins

Contents

Foreword

The acquisition of the Walpole collection from Houghton Hall in 1779 came at the height of Catherine II's activities as a collector of paintings and it made a very significant addition to her burgeoning holdings of Old Master painting. We do not know precisely when the idea of creating a picture gallery first occurred to the Empress, but there can be little doubt that it was suggested by the policy and practice of Peter the Great. His interest in collecting and the founding of the Kunstkammer museum and the Picture House at Peterhof, where Catherine previously resided as Grand Duchess, must have influenced the taste of the future Empress.

Catherine established her Hermitage picture gallery in 1764, a little over a year into her reign, with the acquisition of an important collection of 225 paintings from the Berlin merchant Johann Ernest Gotzkowski. To these were added the collections formed by Carl Cobentzl and Prince Charles de Ligne, acquired in 1768 at Brussels, and that of Count Heinrich Brühl, bought in 1769 at Dresden. This latter had been built up over several generations, as had that of François Tronchin of Geneva, purchased in 1770 with the aid of Prince Dimitry Golitsyn and Denis Diderot. The year 1770 also witnessed the death in Paris of Antoine Crozat, Baron de Thiers. He was the owner of a magnificent picture gallery, founded in the late seventeenth century by the banker Pierre Crozat (1665-1740) and after eighteen months of negotiation involving Prince Golitsyn, Baron Grimm and Diderot, the Empress purchased the entire collection for 460,000 livres. The result of this feverish collecting was to place the Hermitage gallery on a par with the richest European collections. The gallery was regarded as an important part in a series of measures designed to demonstrate to the world that Russia had every right to be considered a European country. By 1774 the Empress's picture gallery had grown at a staggering rate to contain 2,080 paintings and by the time of her death in 1796 she owned some 4,000 pictures.

The fascinating story of the addition of the 204 pictures from the Walpole collection to the Hermitage in 1779 is vividly brought to life in this book and we congratulate Larissa Dukelskaya, Curator of English Prints at the Hermitage and Andrew Moore, Keeper and Senior Curator at the Castle Museum and Art Gallery, Norwich for their painstaking research in charting both the formation of this remarkable collection by England's first 'Prime Minister', Sir Robert Walpole, and examining its subsequent history in Russia. Although the best-known and most admired pictures from Walpole's collection have always been prominently displayed in the Hermitage since their arrival in 1779, the fate of many of the lesser works was problematic, as their provenance had occasionally been forgotten thanks to changes in attribution and location. The many scholarly contributors to this book from the Hermitage and the Pushkin Museum of Fine Arts in Moscow should be thanked not only for cataloguing the collection but also for rediscovering in the course of their research 'lost' Walpole pictures. Within the covers of this book these works of art are now reunited with those that remained at Houghton Hall for the first time since they left the shores of England.

The State Hermitage Museum in St Petersburg and the Paul Mellon Centre for Studies in British Art in London are delighted to see this complex project so admirably completed. Our two institutions worked closely together some years ago on the organisation of the exhibition *British Art Treasures from Russian Imperial Collections in the Hermitage* that travelled to the Yale Center for British Art in New Haven, Connecticut, the Toledo Museum of Art and the Saint Louis Art Museum in 1996-97 before being shown at the Hermitage in 1998. That project, like the present one, is an excellent example of the kind of international scholarly relationships that we are both keen to encourage. The publication of this book will coincide with the opening of the exhibition *Painting, Passion and Politics: Masterpieces from the Walpole Collection*, containing thirty-four of the best pictures from Sir Robert Walpole's collection, at the Hermitage Rooms at Somerset House in London. Their brief sojourn there will give the British public an opportunity to glimpse some of the pictures that made the collection at Houghton Hall so famous in the eighteenth century.

Mikhail Piotrovski
Director, State Hermitage Museum

Brian Allen
Director of Studies, Paul Mellon Centre for Studies in British Art

Acknowledgments

This book introduces to a modern audience a detailed visual and scholarly record of Horace Walpole's catalogue of the collection of his father, Sir Robert Walpole, England's first 'Prime Minister'. The visual element that enhances this book was of course not possible when Horace Walpole published the first edition of his *Aedes Walpolianae* in 1747, although he did live to see some of the Old Master collection illustrated in conjunction with part of his text (the 'Description'), in the two volumes of prints published by John Boydell in 1788. By that date the Walpole collection was no longer intact; the family portraits and classical sculpture were still housed at Houghton Hall, Norfolk but the Old Master collection had been sold in 1779 by Sir Robert's grandson, the 3rd Earl of Orford, to Catherine II of Russia for her Hermitage in St Petersburg, where much of it remains to this day.

The task of reconstructing the Walpole collection has come to fruition as a result of the coincidence of two exhibitions held in 1996-97, both of which examined the significance of Sir Robert's patronage. Houghton Hall. The Prime Minister, the Empress and the Heritage (Norwich Castle Museum and Kenwood House, London) and its accompanying publication enabled a group of contributors to evaluate the integral history of the house and the collection, whilst British Art Treasures from Russian Imperial Collections in the Hermitage (Yale Center for British Art, Toledo Museum of Art, Saint Louis Art Museum and the State Hermitage) included a number of important British paintings from Walpole's collection.

Now that the curators of the Hermitage and the various other museums where the works are housed have been able to publish the collection with the apparatus of contemporary scholarship alongside the text of Horace Walpole's seminal work, the dispersal of the collection is no longer such an impediment to an appreciation of just how important Sir Robert Walpole's collection was to the collective consciousness of eighteenth-century society in Britain. An aspect of the collection that has been overlooked is its metropolitan origins in Downing Street and the other Walpole London residences. Our respective essays in this book explore this context and the significance of the *Aedes Walpolianae* as the model of country house collection catalogues, and it is hoped that they will enable the reader to appreciate the subsequent history of the collection unencumbered by lamentations echoing from either Horace Walpole or the British Parliament. In addition to a modern catalogue of the collection, appendices provide a directory of over fifty agents, buyers and collectors who influenced the formation of the collection, as well as publishing key documents and a Concordance to facilitate use of the material. With the aid of the early published catalogue, a critical assessment and a visual record, the modern reader is now equipped to assess the achievement of father and son in terms of the history of European collecting during the first half of the eighteenth century. Although the fate of thirty-six of the two hundred and four works acquired by Catherine II from Houghton Hall is still unknown, it is hoped that this publication will provide the means for further rediscoveries to be made.

The study of collections of necessity involves a wide range of expertise and we are pleased to have the opportunity to acknowledge the many institutions and individuals who have contributed in various ways towards our collective understanding of this subject. The staffs of the Research Museum of the Academy of Arts, St Petersburg; the British Library, London; Cambridge University Library; the Fitzwilliam Museum, Cambridge; the Fogg Art Museum, Harvard University; the Frick Art Reference Library, New York; the Getty Research Institute (Provenance Index); the State Hermitage Archives and Research Library; the Huntington Library, San Marino; the Lewis Walpole Library, Yale University; the Library of the Paul Mellon Centre for Studies in British Art, London; the Library and Print Room of the Metropolitan Museum of Art, New York; the National Art Library, Victoria & Albert Museum, London; the New York Public Library; the Pierpont Morgan Library, New York; the Rijksbureau voor Kunsthistorisches Documentatie, The Hague (RKD); the Russian State Archive of Ancient Acts, Moscow (RGADA); the Russian State Historical Archive, St Petersburg (RGIA); the Russian National Library, St Petersburg; the Russian State Library, Moscow; the Russian State Naval Archive, St Petersburg; the Sterling Library, Yale University, and the Witt Library of the Courtauld Institute of Art, University of London, have all been indispensable in providing access to original manuscripts, books, photographs and other materials in their collections. In addition, private owners of archives, notably the Marquess of Cholmondeley and the Lord Walpole, have been especially generous in their support.

We also thank colleagues in our respective institutions. At the Hermitage Elena Solomakha and Valentina Marishkina of the Department of Manuscripts and Documents (Hermitage Archives) have been especially helpful as have Ksenia Gryazeva and Nadezhda Serova, respectively heads of the Department of Rare Books and of the Library of the Western European Department. In the generation of images, Elena Livshits and her staff have been untiring in their patience. Andrew Moore particularly thanks his colleagues in the Norfolk Museums and Archaeology Service for their support throughout this project. We both thank the Board of the Lewis Walpole Library,

Yale University and the Librarian, Margaret Powell, for arranging Fellowships and a travel grant to research the indispensable collections of Walpoliana and related literature amassed by Wilmarth Sheldon Lewis. Grateful thanks are also due to the Annie Burr Lewis Fund for a generous grant towards the cost of publishing this volume.

A number of colleagues in Russia have contributed to our project with their own expertise. We acknowledge with gratitude their written contributions and their names are listed on page 92. We should, however, single out the size-able contributions made by Natalya Gritsay, Elizaveta Renne, Irina Sokolova and Svetlana Vsevolozhskaya from the Department of Western European Art at the Hermitage. The Directors and research staff of the former Imperial palaces around St Petersburg have also offered much assistance in providing photographs and information about paintings from Houghton Hall now in their collections. At Tsarskoye Selo State Museum Reserve we thank Direc-tor Ivan Sautov, Deputy Director for Research Iraida Bott and Senior Curator Larissa Bardovskaya. Thanks are also due to Vadim Znamenov, Director and Igor Maltsev, Curator at Peterhof State Museum Reserve. At Pavlovsk State Museum Reserve, Director Nikolay Tretyakov, and Senior Researcher and Keeper of Paintings Nina Stadnichuk were most helpful as were Nikolay Batenin and Valery Semyonov, respectively Director and Deputy Director of Gatchina State Museum Reserve. Beyond St Petersburg and its environs in Russia we would also like to thank the following for their support and assistance: Ludmila Rudneva, Researcher at the State History Museum in Moscow; Natalya Grigoryeva, Deputy Director for Research at the Kroshitskiy Art Museum in Sevastopol; Anna Galichenko, Chief Researcher of Alupka State Palace and Park Museum Reserve; Natalya Skomorovskaya, Keeper of Painting at Perm State Art Gallery. We would like to make particular mention here of Ksenia Yegorova of the Pushkin Museum of Fine Arts, Moscow, who died during production of this book but whose publications on works in Russ-ian collections have made a significant contribution over the years to the study of Dutch and Flemish art.

In England, Edward Bottoms has been an immensely helpful research assistant on the project and has compiled the directory of agents, buyers and collectors (Appendix I). We also wish to thank a number of individual scholars and friends who have shared ideas and information that has been influential to us including Irene Aghion; Elizabeth Angelicoussis; the late Ilaria Bignamini; Iain Brown; Susan Cleaver; John Cornforth; Charlotte Crawley; Burton Fredericksen; Joseph Friedman; Sir John Guinness, Clare Haynes; Ludmilla Jordanova; Alastair Laing; Anna Mal-icka; Frank Martin; Tom Mason; Suzanne Mathesen; Sir Oliver Millar; John Nicoll; Elizabeth Rutledge; Leo Schmidt; Joseph Spang; Sheila Stainton; Martin Stiles; Joan Sussler; Susan Walker; Geoffrey Waywell; Susie West; Annabel Westman; Richard Wilson and David Yaxley. Additional contributions are acknowledged in the footnotes.

We both wish particularly to express our appreciation of the support we have received from the Paul Mellon Centre for Studies in British Art, for travel and support grants awarded for the preparation of this work. As this highly complex book was assembled and typeset at the Paul Mellon Centre in London we incurred a significant debt to its staff for all their various efforts. Emma Lauze, with her customary efficiency and skill, assembled many of the illus-trations and Amanda Robinson and Kasha Jenkinson helped in numerous ways. The contribution of Guilland Sutherland as the designer of this elegant book has been immense. She has remained a model of patience whilst work-ing to tight deadlines with highly complex material and deserves our most profound gratitude.

A special mention must be made of Catherine Phillips. Catherine is nominally the translator of the Russian sec-tion of this book but, as those who have worked with her quickly recognise, she always becomes an absolutely indis-pensable figure. We gratefully acknowledge that without her diplomatic, linguistic and art-historical skills this proj-ect could simply never have been completed.

Finally, we both offer our individual thanks to Professor Mikhail Piotrovski, Director of the State Hermitage Museum and Professor Brian Allen, Director of Studies at the Paul Mellon Centre for Studies in British Art. Both not only supported the idea of this publication from the outset but actively followed its progress to completion. Brian Allen lent his own expertise to the project at all times and we are indebted to him for his various intercessions on our behalf. The idea for the exhibition *Painting, Passion and Politics: Masterpieces from the Walpole Collection* that coincides with the publication of this book at the Hermitage Rooms at Somerset House - the fourth in a series that celebrate the richness and diversity of the Hermitage collections - was their idea and it marks the completion of the project.

Larissa Dukelskaya
Andrew Moore

A CAPITAL COLLECTION

Aedes Walpolianae: The Collection as Edifice

Andrew Moore

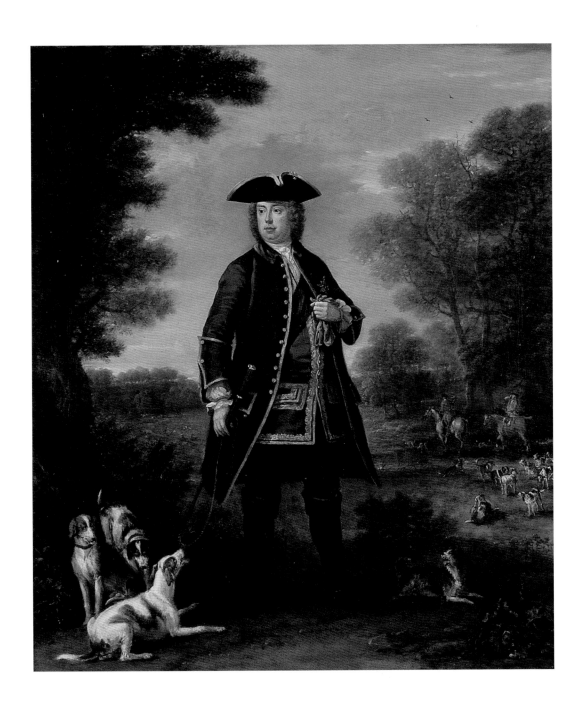

illustration overleaf:
John Wootton, *Sir Robert Walpole,* C.1725, oil on canvas, 86.3 x 76.2
The Marquess of Cholmondeley

Aedes Walpolianae: The Collection as Edifice

PERSONAL AND POLITICAL FORTUNES

Horace Walpole's creation of Strawberry Hill, together with his characteristically critical views expressed late in life about the affairs of Houghton under the stewardship of his nephew George Walpole, 3rd Earl of Orford, have combined to overshadow his real affection for his father's Norfolk home. Houghton, together with his father's London residences, housed a magnificent collection that was of seminal importance to Horace in the development of his early connoisseurship. The compilation and publication of his *Aedes Walpolianae* was the direct result of the experience gained on his Grand Tour of Europe (March 1739–September 1741), during which he acquired works of art both for himself and his father.

Sir Robert's collections were not exclusively those held at Houghton. An important manuscript inventory survives which details the extent of the collections Sir Robert had amassed by 1736, when Houghton Hall was all but complete.[1] While Houghton housed one hundred and twenty paintings, 10 Downing Street boasted one hundred and fifty-four. In addition, there were a further sixty-six paintings at 16 Grosvenor Street, Mayfair (at that time occupied by his eldest son Robert) and a further seventy-eight paintings at Orford House, in the grounds of the Royal Hospital, Chelsea. The process of amalgamating the collection at Houghton had taken place by the time Horace Walpole had compiled the manuscript for his first edition of his *Aedes Walpolianae*, 24 August 1743.[2]

Although this is a personal story in so much as Horace had undertaken to prepare and publish what amounted to a paean of praise in honour of his father, the collection was by this time already a symbol of Sir Robert's national, indeed European identity. Sir Robert was inevitably the butt of political satire in his role of 'prime' minister in Parliament and this extended to the perceived excesses of his building programme in Norfolk. He had conceived and built his own prime-ministerial palace — a temple of the arts — in a 'wilderness' in deepest Norfolk. Although he had not exactly parted the Red Sea, he had certainly moved an entire village and a line from his mother's edition of the poems of Abraham Cowley came readily to mind as Horace penned his sermon on painting to be delivered before his father: 'He struck the Rock, and strait the Waters flow'd'. If paternal excesses could inspire equally excessive filial admiration, they could certainly also provoke political opprobrium.

Wherever the Walpole family turned there were politically inspired criticism, gossip and satire in all media. Henry Fielding came up with *Pasquin A Dramatic Satire on the Times* (London, 1736), which was a satire upon Sir Robert and his ministry, while Probius Britannicus, better known as Samuel Johnson, produced a squib entitled *Marmor norfolciense; or, An essay on an ancient prophetical inscription, in monkish rhyme, lately discovered near Lynn, in Norfolk* (London, 1739). Sir Robert himself could be depicted in one moment by his favourite country sports painter and portraitist, John Wootton, in the attire and stance of Ranger of Richmond Park, only to find his assured pose turned against him. To be likened to 'the English Colossus' in an anonymous engraving of 1740 was a back-handed compliment, but that self-

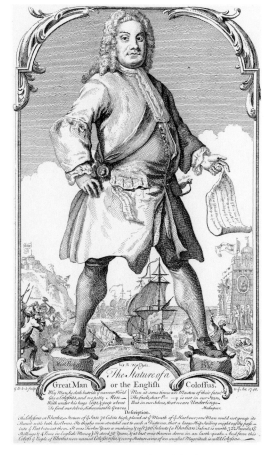

Anon., *The Stature of a Great Man, or The English Colossus*, 1740, engraving, 29.2 x 18.4
Copyright The British Museum

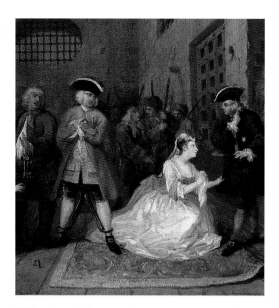

William Hogarth, *The Beggar's Opera, Act III, scene XI*, 1729, oil on canvas, 59 × 76
Yale Center for British Art, Paul Mellon Collection (detail)

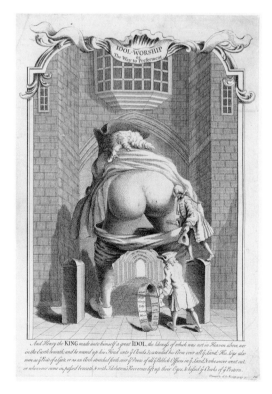

Anon, *Idol Worship, or The Way to Preferment*, 1740, engraving, 35 × 25
Copyright The British Museum

same pose was adopted by Hogarth in his depiction of Macheath in John Gay's *The Beggar's Opera*. The audiences to Gay's opera were only too well aware of the rumoured comparison of Macheath and his moll Polly Peachum with Robert Walpole and his mistress Maria Skerrett, all too publicly 'at home' at the newly rebuilt Ranger's Lodge in Richmond New Park. Far worse, Sir Robert found himself depicted in full rear view in an anonymous print of 1740, *Idol Worship, or The Way to Preferment*.

In this case Sir Robert Walpole was the butt of perhaps the most memorable lampoon of them all. It was advertised in *The Daily Post* in late July 1740[3] while Horace was still absent on his tour of Europe: on his return a few weeks later, it would surely have stung the son as much as the father. The engraving shows an entrance gateway barred by the naked rear view of the celebrated contemporary Colossus. Through his legs we see the long arcade that leads to those addresses over which Sir Robert held sway: 'Saint [James's] Place', 'The Treasury', 'The Exchequer' and 'The Admiralty'. Between the legs of the Colossus an MP drives a hoop inscribed 'Wealth Pride Vanity Folly Luxury Want Dependance Servility Venality Corruption Prostitution'. In case we should be left in any doubt as to the meaning of the image, another MP has clambered onto a post to kiss the proffered arse. The legitimizing text for this lampoon is engraved below: 'And Henry the KING made unto himself a great IDOL, the likeness of which was not in Heaven above, nor in the Earth beneath; and he reared up his Head unto ye Clouds, & extended his Arm over all ye Land; His Legs also were as ye Poste of a Gate, or as an Arch stretched forth over ye Doors of all ye Publick Offices in ye Land, & with Idolatrous Reverence lift up their Eyes, & kissed ye cheeks of ye Postern. Chronicle of the Kings, page 51.'

This is potent sarcasm and makes direct reference to Cardinal Wolsey whose 'reign' under Henry VIII was often likened to Walpole's power and influence.[4] This tabloid squib derived its impetus from the fact that relations with France and Spain at this time were seen as considerably worsened by Walpole's squandering pacificism. As an image, however, it stands not only as a critical summation of the way Walpole conducted his affairs, but also of the manner in which his contemporaries endorsed this *modus operandae*. This extended to the way in which Walpole developed his art collection: the Directory of Agents, Buyers and Collectors in this volume (Appendix I) identifies a steady flow of gifts made to prime the first minister with the artefacts he desired to consolidate his position as a man of taste as well as power, in exchange for preferment and the accoutrements of office. The Directory, meanwhile, provides an update on the information supplied by Horace Walpole himself in the text of the *Aedes*, clearly with a view to establishing the honour and provenance of the collection.[5]

The rump as a political motif had first made an appearance three years earlier in an engraving, *The Festival of The Golden Rump*, designed by the self-styled 'Author of Common Sense', published 7 May 1737. Sir Robert was not the only target of this print: on an altar is George II, in the form of a satyr; beside him is Queen Caroline, as a priestess, with those who attend in supplication. Sir Robert, Chief Magician with a belly as prominent as the satyr's rump, has his brother, Horace, Baron Walpole of Wolterton, in attendance, holding the scales in balance as befits his reputation at the time as the 'Balance Master of Europe'. Nearby a group of peers wear the badge of the 'Golden Rump'. Sir Robert at this time was going through perhaps the most difficult period of his long ministry. His opponents were attempting once more to cause his impeachment for high crimes and misdemeanours, and dramatists and polemicists were uniting in a series of lampoons, considerably damaging his reputation with the populace. On this occasion it seems Sir Robert himself had taken the initiative by causing a two-act play to be sent to one of his detractors, the theatre manager Gifford, in an attempt to encourage him to overstep the mark. When

he informed the King of this satire, which lampooned not only Walpole but also the King himself, it was only a very short time before a Bill for licensing plays was passed in Parliament. This is a typical example of Sir Robert's approach to damage limitation.

It is fruitful to pay attention to the squibs of political lampoonists at this time insofar as they provide a telling backdrop against which to appreciate the quality of young Horace Walpole's purpose when it came to his decision to publish a frankly adulatory volume in praise of his father. This is even more the case when one considers how much Sir Robert's youngest son was himself someone only too ready to vent his spleen in print, in prose or poetry. One more broadside will suffice to demonstrate the political background to Sir Robert's fall from office. The engraving entitled *The Night Visit, or The Relapse: With the Pranks of Bob Fox the Jugler, while Steward to Lady Brit, display'd on a Screen* (published 12 April 1742) captures precisely the charges against Walpole which lead to his resignation just a few months earlier on 3 February.

The engraving shows a screen, bearing a series of scenes, placed across a large room at night. The King, seated at a table in the foreground, asks simply 'What is to be done?'. Sir Robert, in his now familiar silhouette, replies 'Mix and divide them'. A supporter duly comments ''tis good advice'. The devil peeps from behind the screen to crow: 'Hah! I shall have business here again'. Through one window against the night sky we can see Sir Robert with two others flying through the air on a broomstick. Through the other window silhouetted figures share a telescope, and one observes 'It must be a Comet'. The second replies 'No! by Jove, its Robin Goodfellow from R-chm-d'. A third figure declares 'I wish the Telescope was a Gun'.

The designs on the screen detail a series of twenty-two charges laid at Sir Robert's door and the print is accompanied by a letterpress that makes those charges clear. It suffices here to list these: 'Forrage Contract', 'S. Sea Screens', 'H-se of Pl-m-n & Pensioners', 'Oppressions', 'Trade Neglected', 'Excise Scheme', 'Register Bill', 'Sinking Fund', 'Treasure embezzled', 'Standing Army', 'French Councils', 'Constitution', 'Haughton [*sic*] Hall', 'Treaty of Hanover and Seville', 'Spanish Depredations', 'Wool to France', 'Negotiations', 'Convention', 'War

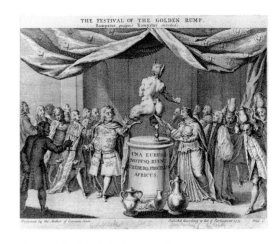

Anon., *The Festival of the Golden Rump*, 1737, engraving
Courtesy of The Lewis Walpole Library, Yale University

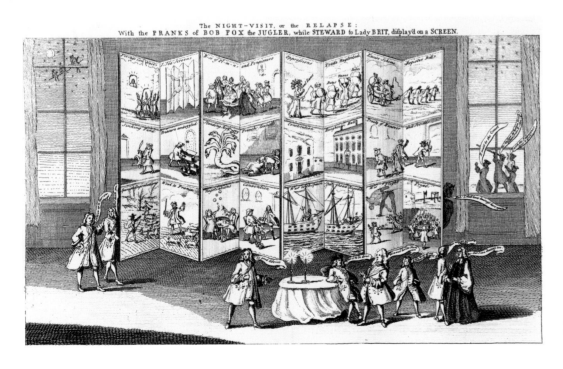

Anon., *The Night Visit, or The Relapse*, 1742, engraving
Courtesy of The Lewis Walpole Library, Yale University

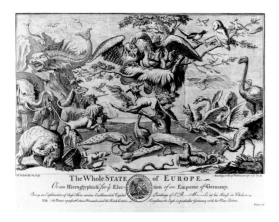

I. B. Vandrulle, *The Whole State of Europe*, 1741, engraving
Courtesy of The Lewis Walpole Library, Yale University

with Spain', 'Spithead Expedit.', 'His Flight', and 'Trial'. The image of Houghton is by no means accurate, but is of a solid and noble pile, pointedly set against the image of the Constitution as a crumbling ruin. The figure of Sir Robert flits through almost every scene. The inference with respect to the South Sea Company is that Sir Robert literally screened the principal perpetrators of the finance scam from any form of retribution. This has long been recognised as an unfair judgement on Walpole. He had opposed the South Sea Company's offer to manage the national debt, but had bought considerable South Sea Stock, selling out before the market peaked and then buying more shares, losing heavily. If there is any question in the public mind as to quite where the money for Houghton might have come from, the King's first minister is clearly seen delving deep into the Treasury Chest under the title 'Treasure embezzled'. 'French Councils', meanwhile, involves a scene that makes explicit the charge that Sir Robert had effectively got down on his hands and knees to kiss the rump, this time, of Cardinal Fleury. 'His Flight' shows Walpole fleeing from those massed against him in pursuit, with the unmistakable silhouette of a Colossus in the background, broken in half and falling to the ground.

In one image we have the stark reality of Walpole's downfall. This must have been as hard for his son Horace to stomach as for Sir Robert. The letterpress makes for insulting reading for the Walpole family as well as for Sir Robert himself. Although the metaphors should not be taken too literally, paragraphs 5 and 7 bear quoting:

> 5. He murdered his own child, whom he pretended a more than ordinary Fondness for, in order to get the Disposal of the Effects which had been left him by an Uncle.—Next He robs his Lady of vast sums of Money; and cheats her of more, by bringing in Bills, for Repairs, which never were made: for Necessaries of the House and Stock for the Land, which never were sent in; and for Expences in Law-suits, which never were carried on: Always adding a swinging Article, for Services which he never made known to her.

> 7. He lets the Mansion-House, then much decayed, run to ruin for want of Repair; pulls down some of the main Beams that supported it, with great Part of the Foundation Wall; takes away the partitions of the middle Floor, and throws the whole into one.—At the same time he builds a splendid House like a Palace for himself, with Part of the Spoils of his Lady's.

Sir Robert Walpole's public and private life was at the mercy of the media, but he remained one step ahead of the game. He announced his retirement on 3 February 1742, was created Earl of Orford on 9 February and resigned two days later with a promise of £4,000 annual pension. This blatant control of even his own fall from office no doubt added venom to the attacks he received. By the time of the publication of *The Night Visit, or The Relapse* he was out of office and an easy target. He had prepared well for his retirement in the country in that his 'palace' was established and only required the translation of his picture collection to Norfolk to make it complete.

Sir Robert Walpole's picture collection was a significant element in the creation of his image as first minister. As such it could work for as well as against him. An intriguing instance of just how much the collection was part of his public image may be seen in the publication of another political engraving, this time referencing his collection in a quite sophisticated sense. I. B. Vandrulle's engraving *THE WHOLE STATE OF EUROPE. Or an Hieroglyphick for ye Election of an Emperor of Germany* was based upon emblematic paintings by Melchior d'Hondecoeter which hung at Orford House, Sir Robert's fashionable residence at Chelsea. Two of these in particular had evidently gained some iconic status, as they were the basis of Vandrulle's print. They were not, however, destined for Houghton, instead being included in the first sale of paintings from Sir Robert's collection after his death, in 1748. By a strange quirk of history they were pur-

chased by Matthew Brettingham on behalf of Thomas Coke, Earl of Leicester, to hang in the Drawing Room at neighbouring Holkham Hall in Norfolk, where they remain today.[6] They are unusual works in Hondecoeter's oeuvre and depict the Goose as emblematic of England, the Cockatrice of France, the Eagle of Austria, the Stork of Holland, the Raven of Denmark, the Serpent of Turkey and the Brown Eagle of Russia. The paintings were in fact emblematical representations of the wars of William III and key paintings for Sir Robert, demonstrating the breadth of his European interests and, by implication, influence.

The implication was not lost on Vandrulle[7] and his print is a fascinating insight into the political effect of a picture collection in the ownership of a key political figure. The engraving shows an eagle offering a fox cub to her nine eaglets, as a fox takes revenge by firing the nest. Peacocks retrieve their plumes, which have been used by a jay to adopt borrowed glories. A bear scratches in desperation to avoid being stung by bees from the overturned hive, labelled EUROPE. Published on 17 November 1741, this was among the last of the pro-Walpole broadsheets: the accompanying letterpress deserves quoting in full as a reminder of the world stage that Sir Robert bestrode in true colossal style:

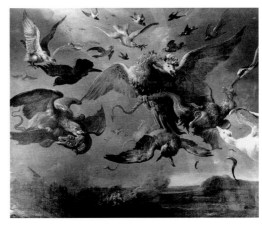

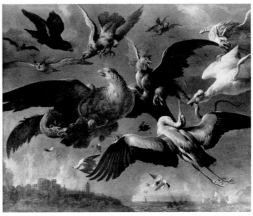

Melchior D'Hondecoeter, *Emblematic Representations of King William's Wars*, C.1690, oil on canvas, 150 x 185
By kind permission of the Earl of Leicester and the Trustees of the Holkham Estate
Photograph: Photographic Survey, Courtauld Institute of Art

> A Cub of France th'Imperial Eagle tears,
> The Gallic Fox avenging Fire prepares,
> The German Brood, th'Electors, catch th'Alarm,
> Some vain Complaints prefer, some wisely arm.
> The Prussian Jay exults with borrow'd Plumes,
> But after Feasting know the Reck'ning comes.
> Th' Hungarian Peacock soon returns th' Attack,
> The Tuscan too requires his Feather back,
> Nor will the wrong'd Bohemian lose her Snack.

Horace's disembarkation from his European tour at Dover on 12 September 1741 was closely followed by his father's resignation from office and the consequent upheaval of his retirement to the country. Horace evidently determined to embark upon a personal tribute to his father in a form that enabled him to exercise his new learning to the public endorsement of his father's achievements. It was also in some part a rejoinder to the public acrimony that was endangering the longevity of his father's future reputation. The *Aedes Walpolianae* was almost certainly conceived at this moment and was substantially completed—although not actually published—by 24 August 1743, the date Horace signs off the Dedication to his father.

Horace was aware of some precedents as he conceived his publication. He specifically refers to the *Aedes Barberinae* in his Introduction as one of his models. This was evidently an inspiration for his own catalogue and must relate to his direct experience of consulting the *Aedes Barberinae* quite probably while in Rome. This *Aedes* was an elaborate folio volume which bore a frontispiece, populated with a prominent Muse and putti in the foreground, with the Barberini Palace, home of the collection of Cardinal Antonio Barberini (1607-71), in the distance. Horace did own a copy of Hieronymous Tetius, *Aedes Barberinae ad Quirinalem ... descriptae* (Rome 1642), although it is not clear when he acquired it.[8] In addition a copy of Cardinal Francesco Barberino's two-volume Index *Bibliotheca qua Franciscus S.R.E. Cardinalis Magnificentissimis suae Familiae ad Quirinalem Aedes magnificentiores* (Rome 1686) remains in the Library at Houghton today.[9] Even more pertinent was the publication by Carlo Gambarini of the Pembroke collection at Wilton House and in London, *A Description of the Earl of Pembroke's Pictures* (Westminster, 1731). Horace owned two copies of this rare octavo volume compiled by the Luccese, Carlo Gambarini (1680-1725), later owning George Vertue's own copy.[10] Nevertheless it was only

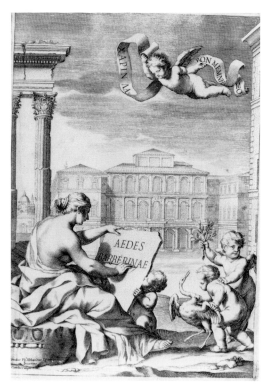

Frontispiece to Hieronymous Tetius, *Aedes Barberinae ad Quirinalem … descriptae*, Rome 1642. By permission of the British Library

subsequently that the Pembroke collection was republished, in 1774, this time styled as the *Aedes Pembrochianae*,[11] in direct emulation of Horace's original publication.[12]

Perhaps the most serendipitous inspiration came from an altogether more informal production, which nevertheless engendered a direct response from the young Horace. The poet and pamphleteer Rev. Joseph Trapp, D.D. (1679-1747) had penned what reads today as an excruciating paean of praise of his own in honour of the Duke and Duchess of Gloucester in 1701. Trapp entitled his unsigned piece 'Aedes Badmintonianae: A poem Most Humbly Presented To His Grace Henry Duke of Beaufort, &c. and To Her Grace Mary Dutchess Dowager of Beaufort, &c. Upon Their Magnificent and Delightful seat in Gloucester-shire 1701'. This proceeds at some length to praise the 'the lofty Fabrick', a 'stately Pile with Front Majestick', which proudly displays 'The unaffected Grandeur of the Place' and concludes with the flourish:

> So when for Heav'n This Grandeur You shall leave,
> More Grandeur in Exchange You shall receive;
> A happier Seat than This You there shall find,
> And wear more Glories than you left behind.

It is difficult to believe that Horace Walpole was unaware of this slight but typical production from an earlier era.[13] Trapp later became the first professor of Poetry at Oxford (1708-18) and in 1714 was incorporated MA of Cambridge. The most likely conduit for Trapp's example was his contemporary, the Rev. John Whaley, who must surely have been aware of the 'Aedes Badmintonianae' when embarking upon his own 'Journey to Houghton'.[14]

Horace's book is a quite remarkable achievement for a young man recently returned from the grand tour. Its separate parts combine to form a compendium of tributes to a father, a Prime Minister and a collection, which if not quite new in its concept is entirely original in its execution. The name of the publication is itself a tribute that calls upon classical allusions appropriate to Horace Walpole's purpose. An 'aedes' in its original meaning is a sanctuary or temple, where poems might be publicly recited. It also came to reference a collection of several apartments, or even, according to Suetonius, a catafalque on which the body of Caesar was laid out.[15] Walpole's *Aedes* is a true edifice, constructed in honour and tribute to a latter-day Caesar. The contents are a carefully arranged sequence of contributions that seem at first sight somewhat random or serendipitous in their inclusion. The 'Dedication' has an obvious place, the 'Introduction' takes the form of a young writer's first essay in art historical criticism and the 'Description' heralds material rather different from what it actually offers. The Description is in fact a careful catalogue of works of art that skates over a description in any real depth of the house itself that the reader might expect to find. Instead we find an exposition of provenance details and attributions that demonstrates an early appreciation by the writer of the value of such material in bestowing both historical and artistic merit to a collection and, by association, its owner. The 'Sermon on Painting' might seem out of place were it not for the fact that its adulatory principles are entirely in line with those of the rest of the compendium. The most unexpected contribution is that of the Rev. John Whaley, whose poem 'A Journey to Houghton' is frankly poor as a work of art but admirable in its virtues of poetic appreciation. The *Aedes Walpolianae* as published in its second edition of 1752 therefore succeeds triumphantly in its young author's purpose. Any implicit criticism of the first edition of 1747–48 echoes Horace Walpole's own horror at the large number of typographical corrections that had to be incorporated prior to the publication of the second edition. Nevertheless, the first edition, with its unmistakable binding of mottled leather and Horace's own attempts at correction and amendment in manuscript today remains a bibliophile collector's treasure.[16]

Throughout his lifetime Horace Walpole maintained a fond filial regard for his father. Even late in life he would note down small anecdotes in his letters and also in his private Commonplace Books, recording either the injustices Sir Robert had suffered or examples of his wit in trouncing his various political opponents. Here one anecdote concerning his father's political stature may suffice to demonstrate these fond attempts to set the record straight:

> The opposition to Sr Robert Walpole accused him of being duped & influenced by France. It appears by the authentic memoires of the Marshal de Villars published in four volumes in 1707, that the Marshal who was of the French Cabinet Council was concerned that Cardinal Fleury was governed, & as he says, duped by Sr Robert & his Brother Horace the Embassador in France. It appears from the same book that while the Marshal was endeavouring to unite France & Spain, & to prevent Spain from joining the Emperor, that Sr Robert & his Brother dexterously balanced the French policies, & sometimes supported Spain & sometimes the Emperor, kept England out of War, & till the death of Augustus 2nd K. of Poland prevented any Union amongst those three great powers, that would have been prejudicial to England. This Defence out of the mouth of an enemy so well informed, is the highest Panegyric on Sr Robert Walpole.[17]

Horace had other jibes to counteract. In his manuscript 'Commonplace Book' he noted that Alexander Pope 'made the following Epigram to Sr. R.W. in the year 1740 when the war with Spain had not had so great success as had been expected:

> Walpole, be wise, let each man play his Part,
>
> You mould the State, let others judge of Art.[18]

This could well have been a final straw for Horace and the rehabilitation of his father's reputation as a man of taste and judgement began in earnest.

Horace's earnestness is unmistakable from the moment the reader opens the volume. The typography is that of many publications of the period, but by Horace's account the style is established by the example of the *Aedes Barberinae* and Joseph Spence's *Polymetis*. Horace chooses to quote Matthew Prior's *Solomon on the Vanity of The World*, in which Solomon, renowned for his wisdom, when seeking Happiness asks whether Wealth and Greatness can secure it.[19] The tone is set for an excursus into the wisdom and taste of Sir Robert's vision for his seat and collection not only as the symbol of wealth and greatness, but also acumen and honour. A description of the collection will establish the credentials of provenance, the wisdom of purchase and the felicities of friendship through gifts from some of the most notable individuals in the land.

Facing the title page Horace placed George Vertue's frontispiece, which transformed the original private tribute designed by Zincke as a miniature into a solemn manifestation of the contents of the book as tribute.[20] The image of Houghton Hall is just visible in the right background, while the foreground displays the accoutrements of Sir Robert's active involvement in his collection and society, in this case that of Court and Country. The status of his position is emphasized: he wears the Garter Shield and the feathered Cap is placed nearby; the Privy Purse is also in evidence, as is the bust of his King, George. The more personal attributes of the Walpole Arms lie against the Kentian table, while the plans of Houghton are displayed with an architect's protractor and compass, suggesting an active involvement with the building of the newly completed Hall. A sealed envelope in close proximity to the protractor, coinage and wand of state suggest the dispensation of preferment and wisdom, in the manner of Solomon.

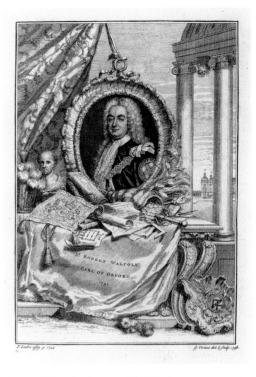

Sir Robert Walpole, frontispiece to *Aedes Walpolianae*, 1747, engraved by George Vertue
Photograph: Norwich Castle Museum and Art Gallery

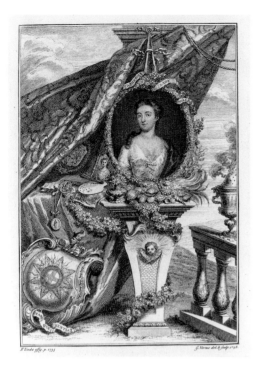

A caduceus suggests the attributes of Mercury: peace, justice, the arts, commerce and eloquence. Zincke had completed his miniature shortly before Sir Robert's death and Vertue's frontispiece is dated 1748, one of the last contributions to the volume to be completed.

Vertue's image of Sir Robert should not be seen in isolation from his pendant tribute to Horace's mother, Catherine Shorter who had died on 20 August 1737 at Chelsea.[21] Horace had been devastated by her death: 'If my loss consisted solely in being deprived of one that loved me so much, it would feel lighter to me than it now does, as I doated on her.'[22] Horace was actually—probably inevitably—disappointed with the two portraits when he first saw them: 'the two portraits [are] wretchedly unlike'.[23] In fact Catherine's portrait flatters her by association not simply with the attributes of Sir Robert but by reference to her own qualities, notably her love of the arts, her facility with the brush and as a portraitist and her own genealogical contribution to the family heraldry, the arms of the Shorter family. Her portrait is bedecked with flowers and to enhance the fragrance that surrounds her a burner visibly dispenses a scented vapour. Horace's filial devotion extended to finding a place in the *Aedes Walpolianae* for Catherine's portrait: although some editions can place it as a pendant to Sir Robert, the preferred position is as an independent frontispiece at the head of the final part of the volume, 'A Journey to Houghton'. Horace must have felt comfortable with this outcome because he subsequently commissioned from John Wootton and John Eccardt the double portrait based on Vertue's two images, which later hung over the chimney-piece of the Blue Bedchamber at Strawberry Hill.[24] In return, Wootton was to receive a gold-tooled copy of the second edition of the *Aedes* in 1754, bearing a manuscript dedication page.[25]

It is in the 'Dedication' to Sir Robert that Horace states his purpose most clearly. The reader is told that 'you will easily perceive how different this address is from other dedica-

Catherine Shorter, plate to *Aedes Walpolianae,* 1747, engraved by
George Vertue
Photograph: Norwich Castle Museum and Art Gallery

John Eccardt and John Wootton, *Sir Robert Walpole and Catherine
Shorter,* c.1750, oil on canvas, 50.5 x 102.4
Courtesy of The Lewis Walpole Library, Yale University

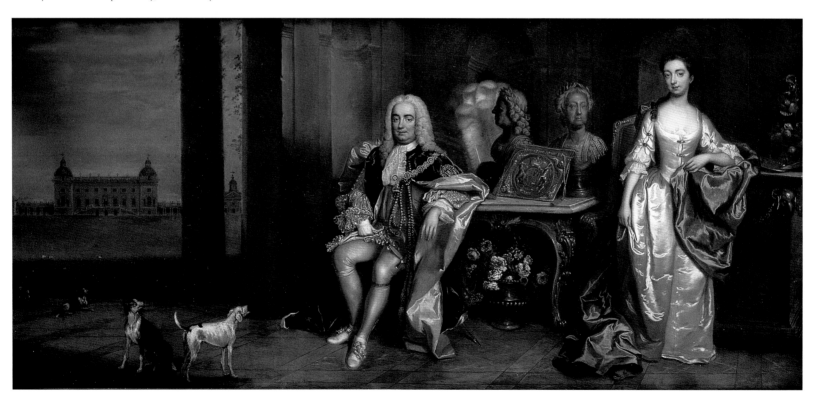

tions.' As is usual the dedicatee is the prime addressee, but every reader is included. Horace has no need to seek favour, he simply desires to give 'a plain description of the effects of your own taste'. Sir Robert's power and wealth 'speak themselves in the grandeur of the whole building'. His 'enjoying the latter after losing the former, is the brightest proof how honest were the foundations of both.' Horace's insistence on honesty here verges on losing all credibility to the modern reader, and presumably many of the readers of the new 'post-Robinocracy' ministry would have spluttered at this blatant piece of apparent whitewash. Nevertheless Horace is honest in his stated endeavour and it is the traditional format of a Dedication that it was entirely proper to praise the Dedicatee in fulsome terms. Horace was well able to apply the form to his purpose and he ends on a moralistic note, affirming that the family forbears would be well satisfied by the moving of the village of Houghton and the removal of the old Hall to achieve Sir Robert's great moral purpose. Horace here gives the reader more pause for thought at the grandiosity of Sir Robert's vision, yet uses the Dedication to address precisely these most delicate issues. The 'dutiful and affectionate son' makes clear that he intends no 'disgrace' to fall from him upon the father.

The twenty-eight-page Introduction is a further tribute to Sir Robert as the history of art therein is entirely illustrated by artists and works of art represented in Sir Robert's collection. It is also the first tangible published outcome of Horace's European tour, financed by Sir Robert as the completion of his youngest son's education. It also further explains Horace's purpose: 'The following account of Lord ORFORD's Collection of Pictures, is rather intended as a Catalogue than a Description of them. The mention of Cabinets in which they have formerly been, with the addition of the measures, will contribute to ascertain their originality, and be a kind of pedigree to them.'[26] As we have learned already in the Dedication, pedigree is an important issue for the Walpoles. The most concerted effort at placing the family within an historical continuum had been published by William Musgrave in 1732.[27] This publication certainly provided the panegyric that Sir Robert needed to combat any jibes about his lineage. The frontispiece reveals just how much this particular volume was an 'authorised version' of both the family's history and of Sir Robert's ministry: 'GENUINE MEMOIRS OF THE LIFE and CHARACTER of the RIGHT Honourable Sir Robert Walpole, And of the Family of the WALPOLES, From their first settling in England, before the CONQUEST, to the present Times: Containing several curious Facts, and Pieces of History hitherto unknown. Extracted from Original Papers, and Manuscripts, never yet printed …'(London 1732).[28] The life of Sir Robert extends to some fifty pages, the memoirs of the Walpole family to seventy-eight, ending with the clear contention that 'A good Prince can have no Enemy but Faction; and that Faction, which abuses the Sovereign and the Minister alike, gives the latter a noble Testimonial of his Fidelity and Merit.' Musgrave's life of Sir Robert was republished in 1738, the struggle to vindicate Sir Robert continuing to be an issue for the family. A second tribute to Sir Robert was printed on his death just prior to the publication of the *Aedes*, which was written anonymously by the Rev. Thomas Ashton (1715–75), who was chaplain to Sir Robert:[29] Horace was knowingly stepping into this quagmire.

Horace's 'Introduction' proceeds to underline the association between the collection of Sir Robert and those of the principle 'Princes and Noblemen' of Europe. He makes explicit the influence upon him of 'the most pompous works … Aedes Barbarinae and Giustinianae, the latter of which are now extremely scarce and dear'. It is clear that Horace was indeed inspired by Hieronymus Tetius's *Aedes Barberinae ad Quirinalem / a comite Hieronymo Tetio Pervsino descriptae*, published in Rome, 1762. The titlepage is illustrated with an engraving of the Barberini

Titlepage to William Musgrave, *Genuine Memoirs of … Sir Robert Walpole*, London 1732
Courtesy of The Lewis Walpole Library, Yale University

Titlepage to Hieronymous Tetius, *Aedes Barberinae ad Quirinalem …
descriptae*, Rome 1642. By permission of the British Library

arms, containing the words 'HIC DOMUS', and is a clear reference point for Vertue's frontispiece for the *Aedes*.[30] This magnificent volume pays tribute to the Barberini family and is as much a family encomium as a tribute to the Barberini Palace and the works of art decorating it. The frontispiece (see p. 8), inscribed AEDES BARBERINAE, shows the Barberini Palace in the background, while its Roman antecedents are referred to in the ruined columns in the foreground.

The entire volume, dedicated to 'EMINENTISS. PRINCIPI CARDINALI ANTONIO BARBERINO S.R.E.CAMERARIO. HIERONYMOUS TETIUS FEL', acts as a dedication to the Barberini family, including individual members, the palace and the sculpture collection. Small plates decorate the volume and the placing of the marginalia and choice of typesetting is exactly that replicated by the design of the *Aedes Walpolianae*. A second full page plate acts as another frontispiece. The figure of Hieronymus Tetius is seen bringing his book in tribute to the seated Cardinal who reaches out to take it in an interior showing watered silk on the walls, a garden in the distance and a sculpture in a niche. A further series of plates of ceiling designs is interspersed within the text. It is difficult to avoid the conclusion that this was a direct source for many of Horace's ideas for the *Aedes Walpolianae*. To some extent it also explains the brief comments Horace made to the printer Dodsley with respect to the planning of the contents of his publication.[31] Nevertheless his own encomium was to take a different format, becoming much more a catalogue in the modern sense, while Thomas Ripley's prints acted as the extra illustrations. These, after all, featured the decorative details of the house, albeit more prosaically.

In his 'Introduction' Horace acknowledges too the influence of 'commerce', in this case the art market: 'How many valuable Collections of Pictures are there established in England on the frequent ruins and dispersion of the finest Galleries in Rome and other Cities!' Compared to the panegyrics of Musgrave and Ashton this was a completely new means of drawing attention to his father's prowess, this time as a gentleman of taste as well as possessing a princely lineage, this time by association.

How glorious it must have seemed to Horace's purpose that he could pen the sentence: 'There are not a great many Collections left in Italy more worth seeing than this at Houghton: In the preservation of the Pictures, it certainly excells most of them.' This was no mere eulogy: he had been, for example, to the Borghese palace at Rome and could testify to the collection being at risk from 'the damps'. It was the case that 'Lord ORFORD has not been able to meet with a few very principal Hands: but there are enough here for any man who studies Painting, to form very true ideas of most of the chief Schools, and to acquaint himself with most of the chief Hands.' There was surely a comparable moral, too, to be drawn from the bombast associated with the historiography surrounding the understanding of painting and the cant surrounding Sir Robert himself: 'No Science has had so much jargon introduc'd into it as Painting: the bombast expression of the Italians, and the prejudice of the French, join'd to the vanity of the Professors, and the interested mysteriousness of Picture-merchants, have altogether compiled a new language. 'Tis almost easier to distinguish the hands of the Masters, than to decypher the Cant of the Virtuosi.' Horace reveals himself as conversant with the leading authors, notably Pliny and the classical texts as well as the recent contemporary Matthew Prior. He had set himself the task of negotiating a new language with which to interpret the character of Sir Robert as much as of the history of painting.

Thereon Horace displays his learning and credentials in embarking upon a catalogue of his father's collection and the second half of the Introduction also lays the foundation of his art criticism for the remainder of his career as an art historian and writer. His assertion that 'Knowledge of this sort is only to be learnt from Pictures themselves'[32] is somewhat disingenuous: he

may be acknowledging the value of connoisseurship but his own library — and indeed that of his father available to him at Houghton during the period he was compiling the *Aedes* — represented a prodigious collection of prevailing texts.[33] The library at Houghton survives today as one of the most perfectly preserved interiors to give a sense of the integrity of an early eighteenth-century book collection in the context of the room designed for it.[34] While it contains new accretions it is substantially still intact and contains the principal texts one might expect to see.[35] Sir Robert had built upon the book collection of his father who himself owned a significant collection of classical texts. Horace was able to consult at Houghton the full range of classical works to which he refers throughout the *Aedes*, and key volumes including the first English edition of Alberti (1726); Cardinal Pietro Bembo's *Historiae Venetae Libri XII* (Venice 1551); Antoine Degodetz, *Les Edifices Antiques de Rome dessinés et mesurés très exactement* (Paris 1682); a 1676 edition of André Felibien, *Des Principes de l'Architecture, de la Sculpture, de la Peinture, et des Autres Arts qui en dépendent …* (Paris 1676); William Kent's *The Designs of Inigo Jones …* (London 1727); a large paper copy of Ovid's *Metamorphoses*, with a dedication plate to his mother; and a complete set of Andrea Palladio's *The Architecture … in Four Books* (John Watts 1715).[36] Sir Robert took care of his Library and a good number of volumes were bound by the bookseller John Brindley, whose characteristic tool, a dolphin within a crowned circular wreath, is an unmistakable signature. A French publication no longer at Houghton but of significance in this context is J. C. Le Blon's *Coloritto; or the Harmony of Colouring in Painting* [1730], a copy of which was sold in the Earl of Orford's library sale of July 1751.[37] This contains a Dedication to Sir Robert that mentions his collection in glowing terms. This is of interest in that it confirms the international regard in which the collection was held at an early date.[38]

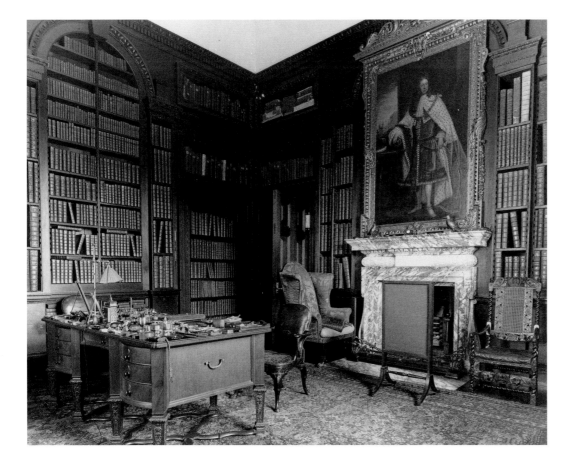

The Library, Houghton Hall
Photograph courtesy of The Country Life Picture Library

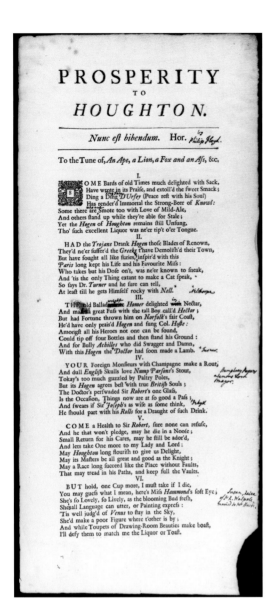

Philip Floyd, *Prosperity to Houghton*, broadsheet, C.1735
Courtesy of The Lewis Walpole Library, Yale University

Having established the context for the collection Horace embarked upon a careful catalogue of principal parts. His decision to call this section of his publication a 'Description' points up the fact that this is very much more than either a strict catalogue of the full contents of the house or simply an inventory of it. Horace takes care to describe the thinking behind the creation of the principal rooms, noting his own input on one occasion and the history of the development of the Picture Gallery. He is careful to describe the inscription above the South Door, which records in stone the creation of the AEDES of ROBERTUS WALPOLIANAE, from inception (1722) until completion (1735). He is not slavish in his articulation of the building: some rooms are described simply enough by their titles. The pear-tree carving by Grinling Gibbons in the Common Parlour, however, deserves a brief mention as does the 'painted Taffety' of Sir Robert's own bed. The mention of Sir Robert's portrait in the Blue Damask Bed Chamber is the place where Horace slips in the remark 'He built this House, and made all the Plantations and Waters here': this is the only place where he mentions the external works. The Drawing Room cannot be passed through without acknowledging the decoration of the ceiling: taken from 'the old house' it now additionally bears the 'Paternal Coat for the Star and Garter'. The Salon wall hangings are briefly referred to, as is the contribution of William Kent, 'who design'd all the Ornaments throughout the House.' The Carlo Marratt Room and the Velvet Bed Chamber are both hung with green velvet, as is the Cabinet. The Marble Parlour and the Hall are briefly described, but it is the Gallery that receives Horace's most extensive description. For Horace the history of the design of this space is important, as is his own contribution towards the design of the ceiling,[39] as well as the story of the removal of the paintings from Downing Street. The most important description however fell to the collection itself: the other embellishments all pale in comparison to Horace's record of the collection and its provenance details. Finally, prior to publication Horace realized that a valuable enhancement of the volume could be achieved by incorporating copies of Thomas Ripley's ground plans of Houghton and views of the East and West Fronts, originally published by Isaac Ware in 1735. Horace Mann had shown them to the Princesse de Craon 'and she said you had found means de l'interesser en tout ce que vous regarde'.[40] These were duly inserted on either side of the 'Description'.

The paean of praise was almost complete, but a devotional quality was arguably yet to be put in place. The idea for 'The Sermon on Painting' seems to have developed out of Horace's deep immersion in the task he had set himself.[41] On 14 July 1742 Horace sent Horace Mann in Florence the text of 'The Lesson for the Day', which is a scriptural parody satirizing those seeking preferment and office from the new ministry within days of Sir Robert's own fall from office.[42] It was a typically scurrilous piece and a relatively short step for Horace to turn his mind towards a rather more positive, less satirical piece. This took the form of a sermon, conceived in the traditional sense and even declaimed from the pulpit. The Sermon served as a eulogy to Sir Robert but Horace's mind was currently so caught up with the painting collection, he also wrote it as a further critique of the collection now rehung at Houghton.[43] The Rev. Thomas Deresley, or even Thomas Ashton, could have delivered the Sermon at Houghton Church. By including it in the *Aedes* Horace provides a suitably Christian and even Liturgical balance to the assembled paean of praise.

The inclusion of the poem, 'A Journey to Houghton', is perhaps the most surprising, as it is not by Horace himself and is close to repeating the idea of encomium by reference to the painting collection. Yet Whaley, a fellow poetaster, held a special place in Horace's affections. It was very likely through Whaley that Horace honed his ideas for the publication, and possibly Whaley

who drew his attention to the poem by Joseph Trapp, *Aedes Badmintonianae*. Horace was well aware of the poetical contributions of others, for example, Philip Floyd, who had penned the broadsheet ballad *Prosperity to Houghton*, which was written to be sung in the Hunting Hall, to the tune of *An Ape, a Lion, a Fox and an Ass*, one verse of which may suffice here:

> Come a Health to Sir Robert, sure none can refuse,
>
> And he that won't pledge, may he die in a Noose;
>
> Small Return for his Cares, may he still be ador'd,
>
> And lets take One more to my Lady and Lord:
>
> May Houghton long flourish to give us Delight,
>
> May its Masters be all great and good as the knight;
>
> May a Race long succeed like the Place without faults,
>
> That may tread in his Paths, and keep full the vaults.

Prosperity to Houghton was a celebration as much of the strong beer, 'Hogen of Houghton', as of Sir Robert and his hunting parties at Houghton.[44] Another ballad, *The Norfolk Garland or The Death of Reynard the Fox*, this time to be sung to the tune of *A Begging we will go*, was a further example of the praises that had been sung to Sir Robert in headier days. Although Horace kept broadsheet copies of both of these together with his manuscript version of the *Aedes Walpolianae*,[45] there was no question that these were of a suitable standard to include in his considerably more serious encomium.

Whaley, by contrast, had all the seriousness of purpose that his friend was seeking.[46] His poem 'ON THE STATUE of Laocoon, At the Right Honourable Sir ROBERT WALPOLE's Seat, at Houghton, in Norfolk' (1732) had been a remarkably early tribute to the collection and confirms that the statue was installed by that time. However, it was not actually appropriate to Horace's purpose as it was directly addressed to the priest Laocoon and in the context of the *Aedes Walpolianae* might be misconstrued as equating Sir Robert with the 'Wretch in Torments', his pain immortalized in statuary. Whaley's death in 1745 almost certainly encouraged Horace to think of republishing 'A Journey to Houghton' in tribute to his friend as well as his father. Horace's decision found favour with Horace Mann whose appreciative remarks on receipt of his copy of the 1747–48 edition in Florence also included the reaction of Dr. Antonio Cocchi, at that time Keeper of the Grand-Ducal Collections:

> Doctor Cocchi's [opinion] was very sincere, and as you know he is a judge, I can't help telling you that he thinks the observations extremely just, is pleased with the idea of the whole as being quite new, and thinks it the best compendium upon painting that has been wrote, and that the characters of the great masters are most judicious. He carried it home with him and entertained his conversazione with it that evening, except the poem of Mr. Whaley, which could not be read off in another language. Your permitting that to be placed in your book is a proof that you allow all the beauties of that poem which we find in it, which indeed are many; an elegance, and in proper places a force of expression, an agreeable variety adapted to the different subjects, and a conduct in the whole which, though it is owing to your description in the first part of the book, does not in the least diminish his merit, or the just claim he has to praise, as much as the justness of the last character shows him an admirer of true virtue and his friend. Doctor Cocchi is extremely flattered by the present, as well as I am by the mention of the mite[47] which you got me leave to place in a collection, which your book will render immortal (if you will allow the expression). May no accident ever cause it to be dispersed![48]

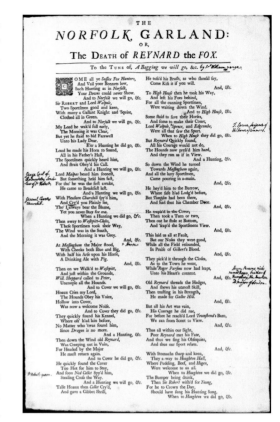

Sir William Yonge, 4th Bt, *A Norfolk Garland*, with handwritten notes by Horace Walpole, broadsheet, c.1735
Courtesy of The Lewis Walpole Library, Yale University

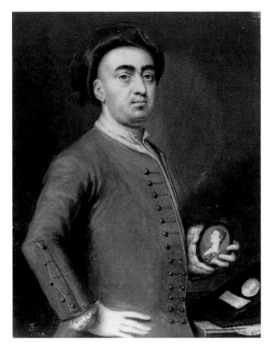

Bernard Lens, the Younger (1682–1740), *Self Portrait*, 1724,
miniature, 13 x 10
Ashmolean Museum, Oxford

Throughout his lifetime Horace Walpole displayed an extraordinary quality of mind that today leaves the reader breathless with the scope of the networks, contemporary and historical, amongst which he moved with such magpie ease. His Commonplace Books, Library and above all his letters articulate an approach to the world that is at once learned but also skittish. He is a man of letters in the literal sense, communicative and gossipy; he is also literate in his appreciation of contemporary writing and scholarly in his familiarity with classical texts. While his mind becomes most obviously antiquarian as he becomes older, there is a quality to his early thinking which is fresh in his appreciation of new experiences. The early influences upon him at Eton and Cambridge, as well as of his European tour, invest the writing of the *Aedes Walpolianae* with those qualities associated with classical accomplishment that was the aim of every young eighteenth-century gentleman's parent, if not always the son. In Horace Walpole's case he had the classical learning of his grandfather and of his father to emulate. The fact that his father was the most influential figure in government, and — for one period — outside government, meant that he was well able to move with ease in metropolitan and country circles, adding polish and anecdote to his vocabulary, in the best classical tradition.

In his 'Short Notes' Horace himself provided a succinct resumé of his early years, identifying his first tutor as Edward Weston (1703–70), second son of Bishop Stephen Weston (1665–1742) DD, who had himself been the master of Sir Robert Walpole at Eton.[49] Edward Weston's main claim to a footnote in the history of eighteenth-century studies is his authorship of improving works such as *The Country Gentleman's Advice to his Son on Coming of Age*. Horace records his tutor at Eton as Henry Bland (c.1703–68) DD, who became a prebendary of Durham in 1737. Bland's father, also called Henry, was an acquaintance of Sir Robert.[50] By Horace's account his father wanted him to go into law, but Horace had different ideas, 'not caring for the profession'. While at King's College, Cambridge, Horace's most formative influence was John Whaley, fellow at King's 1731–45.[51] It was Whaley who confirmed the poetical as well as the standard classical mien to Horace's mind. Horace's teachers were otherwise unexceptional, and notably unable to imbue him with mathematical skills despite extra tuition. He had learned French at Eton from a French teacher M. Francois Julien; Italian at Cambridge from Girolamo Bartolomeo Piazza and 'to draw of Bernard Lens'. Lens (1682–1740) was a miniature painter and water-colourist, who imparted a certain practical skill which, although not enabling Horace to claim much more than facility, did give him an entry into the world of connoisseurship.[52]

These were the talents that Horace took with him on his European tour, which he had eagerly awaited for a while. His intention to tour abroad had been announced in the *London Evening Post*, 4–7 October 1735, but he did not actually leave Dover for Calais until 29 March 1739. It could well have been during this frustrating period of waiting that he conceived his spoof tour of Europe, 'Some fragments of a Journey to Italy', which enthusiastically describe a fragmentary record of a series of places not visited, with a humour that echoes a similar piece by one 'Tim Shallow' that was published in the *Gentleman's Magazine*, February 1736.[53]

His friendships and circle established at Eton and Cambridge came into their own in Europe and he maintained a considered and open approach to his experiences, which enabled him to both gossip and learn. It is to these friendships that we may see some of the most guiding influences at the start of his career as an art historian, allied as they were to the direct experience of the cultural tourism of the period. Horace was accompanied on his tour in the first instance by Thomas Gray, poet and classical scholar, who had been his friend since their days at Eton as well as Cambridge.

Horace was not accompanied by a 'bear-leader', a tutor in whose company he could complete his education. Instead Sir Robert was presumably happy for his son to be accompanied by the sober presence of Gray. However, they did in fact clash before their tour was complete.

Horace was much impressed by the architecture of Paris: 'They beat us vastly in buildings, both in number and magnificence. The tombs of Richelieu and Mazarin at the Sorbonne and the Collège de Quatre Nations are wonderfully fine, especially the former'.[54] The sight in Paris that moved Horace the most was the small cloister of the Convent of Chartreux decorated with scenes of the history of St. Bruno, painted by Eustache Lesueur, known as the 'French Raphael'. Walpole wrote to his friend Richard West, describing the convent[55] and the cloister series in terms that reveal the origins of the lasting impression that Lesueur was to have on him. His assessment of the French School in the 'Introduction' to the *Aedes* in consequence includes Le Sueur and does not simply stop at Poussin and Claude as so many of his contemporaries were apt to do. Indeed he includes Bourdon and Le Brun in his frame of reference. Walpole was always to consider that Le Sueur had rivalled Raphael, even after his visit to Italy.

En route beyond Paris Gray and Horace were accompanied by Henry Conway (1719–95) and later George Montagu and George Selwyn. They found their way, through a landscape reminiscent of Salvator Rosa, to the Chartreuse monastery not far from Aix-les-Bains, and 'rode back through this charming picture, wished for a painter, wished to be poets!'[56] The idyll was broken by the loss of Horace's dog 'poor dear Tory' to a wolf, but Horace found comfort in Turin where they met up with Henry Fiennes-Clinton (1720–94), ninth Earl of Lincoln with his tutor the Rev. Joseph Spence (1699–1768). When Horace and Gray reached Genoa, they stayed a week before moving on to Bologna where they stopped for twelve days. Horace commented: 'Except pictures and statues, we are not very fond of sights; don't go a-staring after crooked towers and conundrum staircases.'[57] When they reached Florence Horace met his host and namesake, Horace Mann (c.1706–86), chargé d'affaires at the court of the Grand Duke of Tuscany, who was to be appointed British Minister at Florence in 1740. It was while at Mann's Casa Ambrogi that Horace met two more Englishmen who were to become lifelong friends, John Chute (1701–76) and Francis Whithed (1719–51). He also became Mann's firm friend and correspondent: Mann acted as his ears and eyes in Florence in the search for artefacts for both Sir Robert and Horace. It was while Horace was in Florence that he wrote his first significant poem,[58] a long and formal piece in the form of an epistle, owing much to the Augustan style of Pope, which also exemplified his taste for classical forms at this period.

It was once in Rome that Horace really had a sense of the disintegration of the great collections in their palaces: 'I am very glad that I see Rome while it yet exists … the palaces are so ill kept, that half the pictures are spoiled by damp.'[59] He wrote again in a similar vein: 'I am persuaded that in an hundred years Rome will not be worth seeing; 'tis less so now than one would believe. All the public pictures are decayed or decaying; the few ruins cannot last long; and the statues and private collections must be sold, from the great poverty of the families.'[60] His empathy with the classical world was complete when he witnessed first hand the excavations at Herculaneum, he and Gray having left to make the trip south to Naples on 12 June 1740. By the time they were back in Florence, around 8 July, Horace had acquired some artefacts of his own, notably 'some bronzes and medals, a few busts, and two or three pictures'.[61] These he could now add to the prints and coins he had acquired when in France. This is a story of a quite rapid turnaround in his sense of purpose, whereby he became increasingly acquisitive. He had originally set out as much upon his father's behalf as his own. He did not forget Sir Robert's needs, however, communicating with Mann concerning 'urns and figures'

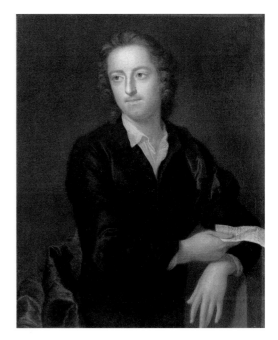

John Eccardt, *Thomas Gray*, 1747-48, oil on canvas, 40.3 x 32.7
By courtesy of the National Portrait Gallery, London

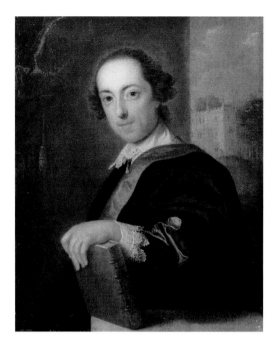

John Eccardt, *Horatio (Horace) Walpole, 4th Earl of Orford*, 1754, oil on canvas, 39.4 x 31.8
By courtesy of the National Portrait Gallery, London

while in Rome in spring 1740 and also once back home in England: 'I was mentioning some pictures in Italy which I wished him to buy; two particularly, if they can be got, would make him delight in you beyond measure. They are, a Madonna and Child by Dominichino, in the Palace Zambeccari at Bologna … Mr Chute knows the picture. The other is by Correggio, in a convent at Parma, and reckoned the second best of that hand in the world'.[62]

Horace Walpole's writings are so compendious that it is deceptively easy for the writer today to find and define the particular element of Horace for which he or she searches. For example, no writer today can ignore the culture of debate concerning Horace Walpole's sexuality.[63] Morris Brownell in 2001 identified in Horace something of a charlatan when in pursuit of his 'Domenichino' for Sir Robert and a connoisseurship articulated primarily by the interests of the antiquarian. It is important to register the milieu in which Horace moved in the period prior to the publication of the *Aedes* without exercising too much hindsight into how his penmanship was to develop alongside his antiquarian focus once his father was dead and his attention consumed by the many facets of his creation at Strawberry Hill. Horace began his European tour with a view to contributing to his father's collection in grand tour style and ended it with the beginnings of his own collection and networks for acquisition and 'Gothicizing'. Indeed, his portrait by Eccardt acts as a summary of this stage in his life, reflecting the turning point of his career as a connoisseur and art historian. In his hand he holds a copy of his recently published *Aedes Walpolianae* in celebration of his father's grand tour collection, while in the background can be seen the Gothic Strawberry Hill, developing as a symbol of a new order.

To study the *Aedes* in association with Horace Walpole's network of friendships and influences at this time reveals a quality of mind that is at once practical and engaging. He had a practical mission to fulfill whilst abroad in keeping a lookout for potential acquisitions for his father's now magnificent collection. This in itself was not so different from the ambitions of many of his fellow travellers who were also keen to acquire souvenirs of the Grand Tour that would establish their place in the pantheon of learned and usually landed 'milordi' back home. Horace, bearing a name that bespoke the classical world, was at ease with the Greek and Roman worlds he entered into in a physical sense whilst abroad. The arts of painting, sculpture and music acted as a portico through which to pass in the enhancement of his learning. He did not have the funds to acquire works of art in quantity in the manner of, for example, his father's Norfolk neighbour Thomas Coke, who had spent almost six years on his European tour. Instead the young Horace embarked upon his tour hungry to see works of art at first hand. He acquired the knowledge of specific collections that stayed with him for the rest of his life. By the time he was back at Dover just five months before his father resigned, he was equipped to write from an art historical perspective. The conception of the *Aedes* was based upon an understanding of that quality of provenance, whereby knowledge of the previous collection history of individual works could add lustre to the status of a collection, endowing an owner with a lineage that could encompass the noble families and even religious houses of Europe. In unsophisticated hands this power of provenance could result in pomposity, but Horace aimed for encomium and eulogy in direct opposition to pomposity.

Just how good was Horace Walpole's grasp of art history? Within the terms he set himself his grasp was good. The *Aedes* demonstrates some slips, perhaps the most notable being his belief that Rubens' *Hélène Fourment* was by Van Dyck.[64] With the benefit of hindsight we can see that the most obvious occasion when his eye let him down, or at least when he was at his most wishful in thinking, was over the manoeuvres to obtain the *Madonna and Child* attributed to 'Domenichino'. This is now recognised as by Giovanni Battista Salvi, called Sassoferrato.[65]

Today we can indulge, through reading Horace's correspondence, in the thrill of the chase as he and his friends discussed the acquisition of this celebrated painting, the quality of which was not in dispute.[66] However, issues of quality need to be shored up by those of attribution and when Horace discovered that the truth of authorship was determined by the evidence of the existing print by Francois de Poilly after Pierre Mignard, he chose to excise the identification on the print. He quite simply cut the inscribed name of Pierre Mignard out of the sheet with, it must be said, the utmost care and inscribed in ink 'Dominichin pinx'.[67] This is clear evidence of possible dishonesty in his record keeping, but there is a sense in which he was honestly convinced of his own connoisseurship: he could not be accused of, for example, producing a fake signature. It is debatable whether this displays dishonesty in scholarship: it was certainly an aberration that was out of tune with his established, almost finicky, practice. He remained committed to the attribution to Domenichino long after the death of his father. Given the then prevalent tendency to attribute paintings to a relatively small canon of 'known' masters, Horace may perhaps be forgiven the occasional mistake without too much special pleading. The practice of optimistic attribution in the face of alternative evidence survives to this day, even with the increased portfolio of choice in newly recognised painters formerly in the shadows of their more celebrated masters.[68]

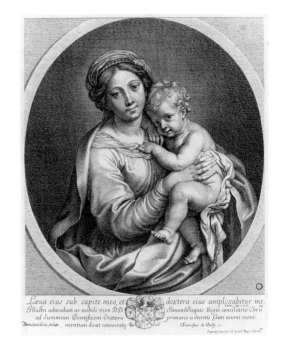

François de Poilly after Pierre Mignard, *Madonna and Child*, c.1656, line engraving.
The Metropolitan Museum of Art, New York

Horace came out of Europe with a barely disguised ignorance of British art, which consequently receives no attention in his 'Introduction'. Thereafter he made amends, publishing his *Anecdotes on Painting* (1762–71), which consisted of the fruits of George Vertue's researches as much as his own. The *Anecdotes* included 'A Catalogue of Engravers, who have been born, or resided in England; Digested by Mr. Horace Walpole from the MSS. of Mr. George Vertue'. It is characteristic of Horace that he should still be using the language of classical times in his title-page, here describing his relationship to Vertue's notes as that of 'digestion', the systematic compilation of texts in a digested, methodical arrangement. Vertue gave Horace his notebooks, recognizing in him the person who could see their contents through to publication. Throughout his career we see Horace in dialogue with the texts of others, notably Vertue, but we also see him continue to compile picture catalogues, publish collections such as that of Charles I and make notes on the paintings he saw at exhibitions and in country houses. This represents a real engagement beyond the purely antiquarian—an engagement we first witness in the *Aedes*.

There is another quality to Horace Walpole's engagement with scholarship that reflects as much on his tutelage as an art historian as on his approach to textual research. On 28 January 1754 Horace Walpole wrote to Horace Mann about how he had made a discovery in a book in his library. 'I must tell you a critical discovery of mine. . . . In an old book of Venetian arms,[69] there are two coats of Capello. . . . This discovery I made by a talisman, which Mr. Chute calls the Sortes Walpolianae, by which I find everything I want, à pointe nommée, wherever I dip for it. This discovery, indeed, is almost of that kind which I call Serendipity.'[70] Horace is here describing a process that informs his approach to his own scholarship and, by inference, explains much of the impetus behind his incessant note-taking, particularly when confronted by anecdote or object. It was an approach which mirrored that of George Vertue, making the task of publishing the latter's notebooks a sympathetic one for Horace. Indeed, Horace's art scholarship was relatively unexceptional. He had read the standard authors and his exegesis on painting in the 'Introduction' was informed by his reading of authors such as Roger De Piles (1706),[71] Felibien,[72] the Richardsons[73] and Sir William Sanderson.[74]

These were the influences upon the young Horace as an art historian. There is one final aspect of Horace's reputation in this field that should be acknowledged, namely the context of

the subsequent critical writing on Houghton and the *Aedes Walpolianae*. The fact of the later sale of the Houghton Collection to Catherine II of Russia and the story of Houghton thereafter has tended to obscure the achievement of Horace Walpole in creating the *Aedes* at such an early point in his career. In the second half of the twentieth century writers on Sir Robert have tended to concentrate upon the machinations of his political career. J. H. Plumb was unable to complete his universally praised and potentially monumental biography, giving only some pointers towards the complexity of Sir Robert's final achievement as a collector and builder of a 'Palace of the Arts'.[75] Critical writing has concentrated on the reconstruction of Houghton in the absence of the collection that it was built to house.[76] This process of reconstruction has concentrated of necessity upon the house and its furnishings, spurred on by the remarkable survival of so much of those furnishings. In conjunction with detailed inventories compiled in 1745 and 1792, the *Aedes* can be used to provide an unparalleled insight into the life of a country house and it is in the field of country house studies that the young Horace's work has been barely considered. Some of this work has focused upon the reconstitution of the house itself under the ownership of the Cholmondeley family, while a sale of mainly Sassoon family artefacts from Houghton generated further scholarship again around the furniture and furnishings.[77] Individual studies concerning the building of Houghton and the Walpole family, together with more discursive studies of the English Country House complete the recent historiography of Houghton.[78]

The purpose of this publication is to reintroduce Horace's early volume to a modern audience in the context of a visual and detailed record of the collection. The visual recreation of the collection was not achievable for Horace when he published the *Aedes* and it is interesting to see that he did not embark upon purely descriptive writing for his work, even in the 'Description'. Instead, throughout the rest of his long life he gathered prints with which to extra-illustrate his personal manuscript copy of the *Aedes* and he did live to see the collection illustrated in conjunction with his text in the volumes published by John Boydell.[79] Most recently, the task of reconstruction was taken a stage further by the exhibition and accompanying publication *Houghton Hall The Prime Minister, the Empress and the Heritage* (1996), in which a group of contributors evaluated the integral history of the house and collection.[80] Today, the separation of the collection from its original home is no longer such an impediment to an appreciation of just how important the Houghton Collection was to the collective consciousness of eighteenth-century society in Britain. This is especially so now that the present curators of Sir Robert's collection have been able to publish it with the apparatus of contemporary scholarship alongside that of Horace Walpole's seminal work. The essay by Larissa Dukelskaya, which follows this, enables the reader to appreciate the subsequent history of the collection unencumbered by lamentations echoing from the ghosts of either Horace Walpole or the British Parliament.[81] It is under these circumstances that the modern reader is best equipped to judge the achievement of father and son.

An aspect of the Walpole Collection, which has tended to be overlooked in the literature on the collection, is the nice point as to whether the collection was conceived for Houghton or whether Houghton was conceived for it. The process of twentieth-century reconstruction has led to Houghton being considered as bereft, as much the result of Horace's anguished response to its sale as to the reaction of George Walpole who had been responsible for selling it. As soon as the sale was secure, the third Earl of Orford commissioned Giovanni Baptista Cipriani (1727–85), who had himself been responsible for helping to value the collection in readiness for sale, to paint a series of three large canvases in an apparently desperate bid to cover the bare walls once more. Cipriani made a brave stab at the commission, producing three large classical narrative scenes which sought to edify the hapless Earl and his family and visiting friends. The third Earl hung the paintings, *Philoctetes on Lemnos* (1781), *Castor and Pollux* (1783) and *Oedipus on Colonnus* (undated) on the walls of the Salon.[82] Cipriani was abetted in his task by Philip Reinagle RA, another favourite artist of the third Earl, who produced some massive and uncontentious exotic bird paintings for the walls of Houghton.[83]

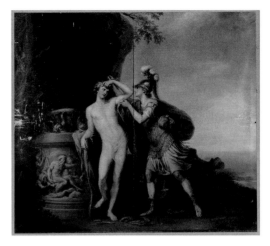

G. B. Cipriani, *Oedipus on Colonnus*, private collection
Photograph courtesy of Christie's Images Ltd.

This story obscures the fact that Downing Street too had been stripped of the Walpole Collection with the exit of Sir Robert in 1742. Sir Robert had gradually removed his collection to the country in the preceding months, effecting a series of picture rehangs at Houghton and at Downing Street before the removal was complete. An inventory of the collection was made in 1736 when Sir Robert's ambitions for it were complete. The new Hall at Houghton was finished, while Sir Robert's London residences were extensive. At this time Sir Robert was styled 'the Right Honourable Sir Robert Walpole, first Lord of the Treasury and Chancellor of the Exchequer.'[84] Sir Robert's paintings were to be seen in great splendour at 10 Downing Street and in Orford House, Chelsea, which had been enlarged by Vanbrugh about 1721–23. Orford House was Sir Robert's residence as Paymaster General of the Royal Hospital and was highly fashionable: Queen Caroline and the Knights of Bath had been entertained there in 1729. In addition there was the large five-bay terrace house at 16 Grosvenor Street, Mayfair: similarly to Downing Street, this sported a first floor Great Room in which prized paintings were hanging. Built by Thomas Ripley, c. 1724, this was occupied by Sir Robert's eldest son Robert, Lord Walpole 1725–38.[85]

There were other Walpole residences which were not included in the inventory of 1736, but which from the sales (in 1748 and 1751) of paintings that took place after the death of Sir Robert and his eldest son can be seen to have contained more works from the collection.[86] A further surviving sale catalogue, that of Catherine Walpole's house in Dover Street, Mayfair in 1740, details more paintings that were sold from the prime ministerial collection during Sir Robert's lifetime.[87] This was a significant collection of paintings in the Walpole Collection that has passed unnoticed mainly because Vertue did not itemize it and the catalogue is now rare. The catalogue lists some two hundred and fifty pictures, many of which were 'limnings'—probably by Catherine Walpole herself—and difficult to identify today. Lady Walpole preferred to hang paintings that pleased her and had no desire to use her apartments to identify her status in the metropolis. Nevertheless some items in the catalogue do stand out, those in the Dining Room being typical of the traditional mix of Italianate landscapes and classical narratives, with a single still life. In the Yellow Mohair Bedchamber was a series of 'Five pieces of fine historical tapestry-hangings, about 10 feet deep, at 3s. per ell Flemish'.

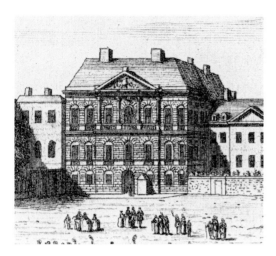

Number 10 Downing Street, c.1754, engraving by Maurer in Strype's 2nd edition of Stow's *Survey of London* (detail)

Later, the acquisitions of Horace were to mingle with those of Sir Robert in their home in Arlington Street off Piccadilly, which Sir Robert leased for himself and Horace on his resignation in 1742, where he was to die after just three years: Horace kept this house on until 1781.[88] As Auditor of the Exchequer, his son, Robert, created Baron Walpole of Walpole, kept offices in the Old Palace of Westminster from 1739-51. Here were displayed part of the Wharton Collection of paintings by Van Dyck, the prize acquisition made by Sir Robert in 1725.[89] While some of these paintings were finally removed to Houghton in time to be included in the *Aedes*, others were later sold in 1748 and 1751.[90] Lord Walpole provided Sir Robert with another venue in his position as Ranger of Richmond Park: Ranger's Lodge, Spanker's Hill. Sir Robert, as deputy, made most use of this hunting and banqueting lodge: it was here that he maintained his relationship with Maria Skerrett and also entertained George I.

The collection was essentially a metropolitan one at the time of its creation. It is its subsequent history that has defined it as a country house collection and the *Aedes* has played a significant role in that process. During the making of the collection Sir Robert was orchestrating his metropolitan career and position and Horace would later recall how the paintings were visited in Downing Street and Chelsea 'where queens and crowds admired them'.[91] He also commented that, as ever on a public occasion, the visitors did not necessarily see them: the paintings were fulfilling their function as a showpiece collection. The paintings were in fact newly installed in Downing Street in 1736: William Kent and Henry Flitcroft had recently remodelled the older house of 1677. Horace lived with his father at No. 10, which consisted of two houses made into one, until they left on Sir Robert's resignation.

The collection had already boasted some magnificent works in the 1720s when housed at Arlington Street. When James Brydges, 1st Duke of Chandos (1673–1744) was struggling with the problem of what should be done with his large Raphael cartoons, he suggested that Robert Walpole might be interested in them as he too was 'making a noble collection'.[92] George Vertue made partial records of it on a number of occasions at that time and the paintings were also described in glowing terms by a French connoisseur and collector in 1728. This is of interest in that it demonstrates a Continental appreciation of the quality of the collection at a relatively early moment in its development. This early assessment is contained in a manuscript account of a visit to England, Holland and Flanders by an anonymous writer who is believed to have been the French connoisseur and collector, Antoine-Joseph Dezallier d'Argenville (1680–1765):[93]

Monsieur Walpole Chevalier de la Jarretière et premier ministre du Roy sans en avoir le titre, dont le fils et le gendre sont tous deux Milords, â un des meilleurs cabinets de Londres. Il est composé de fort bons tableaux qui ornent un appartement de quatre pièces de plein pied en haut et autant en bas; On y voit entre autre une grande famille à table de Jaques Jordans[94] de son meilleur temps. Un grand tableau de vulcain de Ribera;[95] une Ste famille d'Andrea Sacchi; deux beaux Poussins dont un représente la Continence de Scipion.[96] L'ordonnance est de douze figures parfaitement belles, le mauvais riche à table de Paul Veronèse, le Bacanale de Rubens[97] gravé par Soutman très beau tableau, un grand paysage de Rubens[98] de la suitte de ceux qui sont gravez. Quatre petits Carlo Marrati dont le plus beau est une Ste famille[99] avec un très beau fond de paysage. Une grande Nativité de Guide,[100] l'original de celle que Poilly a gravé appellée la nativité aux Anges, Deux beaux paisages de Claude Lorain,[101] une petite Vierge de Baroche[102] qui est admirable, un Noli me tangere en petit de louis Carache, deux petits Giorgions représentant des femmes mòes d'un caractère surprenant, un grand Salvator Rosa[103] gravé dans son œuvre. Deux beaux paysages de Poussin,[104] Trois autres de Guaspar. Diane grande

'A Catalogue of the Rt Hon.ble Sir Robert Walpole's Collection of Pictures', 1736, bound into the author's copy of *Aedes Walpolianae*, 2nd edition, 1752.
The Pierpont Morgan Library, New York, PML 7586, pp. 11-12

A Catalogue of Sir Robert Walpole's Pictures in Downing street, Westminster.

In the Parlour.

A Young Christ, with God the Father, the Virgin & Angels —
Christ after His Resurrection, with the Virgin &c. —
A Cooks Shop with several figures; Teniers himself like a Falconer
A Cock as large as life with a Greyhound, Cats, & Dead Fowl &c. —
The Doge of Venice in His Barge, with Gondola's & Masqueradrs
A View of Venice —
Two Pictures of Boys with Fruit —
The Exposition of Cyrus —
Its Companion. a Man with Cattle —
A Landscape —

In the Great Middle Room below:

A Lioness & two Lions —
The Virgin, Child, & Joseph, with a Dance of Angels —
Christ at the House of Simon the Pharisee; Mary
Magdalen is anointing his feet; several figures as large as life —
The Child lying along, with the Virgins & two more Heads
The Holy Family in a round; the child stands in the Virgins lap, leaning forward
Apollo, half length in Crayons —
Diana with a Greyhound, Ditto —
A Landscape —
Its Companion —
Two Landscapes with several little figures —
Two Landscapes, over two of the Doors —
Two Sea Peices, over the other Doors —

Painter's names.	Dimensions. High. = Wide.	
Solimeni.	7 feet 1 Inch	5 : 5½ In.
Solimeni.	7 : 1½	5 : 5¼
Teniers.	5 : 7½	7 : 8½
Martin de Vos.	5 : 7½	7 : 10½
Canalletti.	2 : 9½	4 : 5¾
Canalletti.	2 : 9½	4 : 5¾
	2 : 4	3 : 2.
Castiglioni.	2 : 8¾	3 : 2¼
Castiglioni.	2 : 8¾	3 : 2¼
Ivanwelt		
Rubens	5 : 5¾	8 : 0¼
Vandyke	7 : 1	9 : 5
Rubens.	6 : 1	8 : 2.
Camillo Procacino.	1 : 9	2 : 3¾
Cantarini.	3 : 6½	3 : 6½
Rosalba.	2 : 2	1 : 8
Rosalba.	2 : 2	1 : 8.
Gaspar Poussin.	1 : 1¾	1 : 6.
Gaspar Poussin.	1 : 1¾	1 : 6.
Borgognone.	1 : 1¼	1 : 4¾
Wootton.	3 : 5	4 : 3¼
Scott.	3 : 5¾	4 : 1.

chasse de Rubens.[105] Une Assomption de la Vierge du Cigniani d'un grand caractère; deux grands Bourgignons des plus beaux qui se voient, dont un est Abraham en voyage avec sa troupe, deux grands morceaux de Rubens bacanales,[106] Deux femmes demy corps avec une teste d'homme dans un coin de la main du Titien. Deux demy figures d' hommes et de femmes avec un enfant de Rubens de ses plus belles choses. Un regard d'un homme tenant un livre,[107] l'autre d'une vielle femme tenant un eventail,[108] d' une vérité et d'un clair-obscur surprenant, de la main de Rembrant.

Horace was therefore very familiar with his father's collection as it grew. He may well have bid at auction on his behalf,[109] although Sir Robert himself is recorded as purchaser in some of the catalogues of the period.[110] He also made direct offers for pictures: Horace recorded in 1751 Sir Robert's offer to Lord Spencer of £700 for a painting attributed to Andrea Sacchi.[111] An analysis of the collection as it was dispersed around the Walpole London residences in 1736 is informative, nowhere more so than at Downing Street.[112]

The interior at Downing Street would still be just recognizable to Sir Robert and Horace today, despite some alterations and decorations undertaken by John Soane in 1825 and others since. The *Survey of London* describes the rooms generally as follows: 'the rooms are lofty, with the walls panelled, and finished with an entablature consisting of an enriched architrave, frieze and modillion cornice. The first floor rooms have a plain dado, and an entablature with a pulvinated frieze carved with oak leaves and crossed ribbons. The mantelpieces are carved in marble, and the door-cases have moulded overdoors, with carving to the pulvinated frieze representing oak or acanthus leaves.'[113] The original picture hanging plans still survive, stored away by Horace at the end of his extra-illustrated manuscript *Aedes Walpolianae*.[114] These, together with the 1736 inventory enable us to reconstruct the effect of these rooms in all their symbolic grandeur.[115]

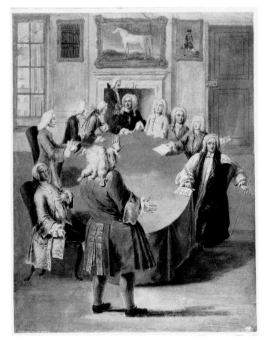

Joseph Goupy, *Sir Robert Walpole addressing the Cabinet*, c.1735
Copyright The British Museum

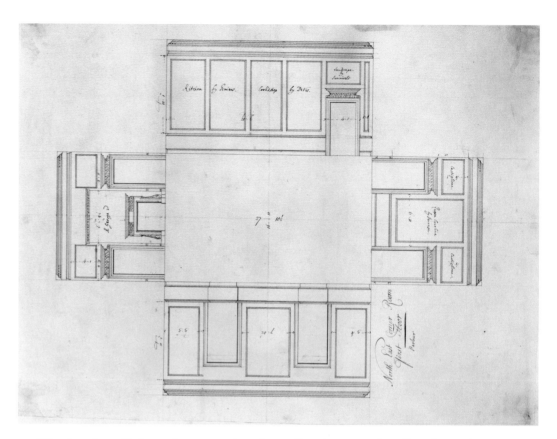

Isaac Ware, Plan of the First-floor Parlour ('Northeast Corner Room'), 10 Downing Street, 1736–42, in Horace Walpole's extra-illustrated manuscript of *Aedes Walpolianae*
The Metropolitan Museum of Art, Harry Brisbane Dick Fund, 1925 (23.26 fol. 67 recto)

The first floor Parlour[116] presented an immediate impact of quality about the paintings arranged on the walls. Throughout the house there was careful planning of the hang from a decorative but also an art historical viewpoint. Although some of the attributions have changed the quality of the selected works of course remains the same. The pictures were arranged in pairings; in the Parlour there were two oils by Francesco Solimena, two by Canaletto and two by Antonio Vassallo (cat. nos. 85, 86), while the splendid *Kitchen* by Teniers (cat. no. 138) took centre stage and was paired with the similar subject by Paul de Vos (cat. no. 144).[117] These relationships were fundamentally established in Downing Street and were to be reinstated when the paintings came to be shipped to their new locations at Houghton and elsewhere, although at Houghton often in the new arrangement of the Picture Gallery, rather than in individual room settings. The effect of these paintings in the rooms at Downing Street was quite stunning and it was here that the collection acquired its early reputation.

'The Great Middle Room Below' also had real impact. Here the pairings were of works by Rosalba Carriera (cat. nos. 18, 19), Gaspard Dughet (cat. nos. 167, 168), and two military subjects by Jacques Courtois (cat. nos. 160, 161). A pair of overdoors specially painted by John Wootton were matched by two overdoors by Samuel Scott. In this room the eye was ravished by Van Dyck's superb *Rest on the Flight into Egypt* (cat. no. 110), with Rubens's *Christ in the House of Simon the Pharisee* (cat. no. 127) as the 'pair', bringing master and pupil together with two Christian scenes. This was an eclectic mix of subject-matter and school, the prime purpose being to register splendour and quality — and thereby status — upon the awareness of the visitor. 'The End Room Below' similarly possessed a clutch of works that was gathered around the signal work, Poussin's *Moses striking the Rock* (cat. no. 176). Here were two Gaspard Dughets, two canvases by Agostino Carracci, two by Francesco Bassano. A painting by a follower of Leonardo (cat. no. 39) was here paired with one by Guido Reni (cat. no. 71), establishing a hierarchy that Horace was to articu-

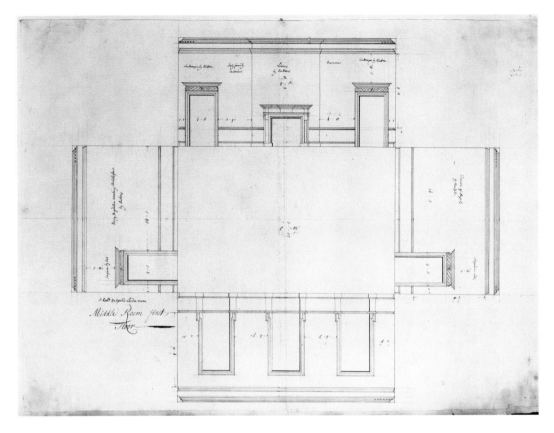

Isaac Ware, Plan of the Great Middle Room ('Middle Room, first floor'), 10 Downing Street, 1736–42, in Horace Walpole's extra-illustrated manuscript of *Aedes Walpolianae*
The Metropolitan Museum of Art, Harry Brisbane Dick Fund, 1925 (23.26 fol. 67 verso)

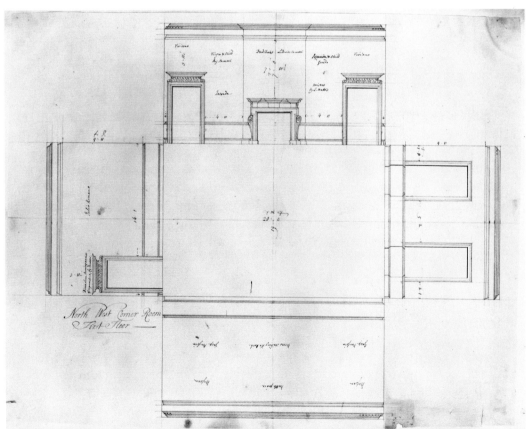

Isaac Ware, Plan of the End Room Below ('Northwest Corner Room'), 10 Downing Street, 1736–42, in Horace Walpole's extra-illustrated manuscript of *Aedes Walpolianae*
The Metropolitan Museum of Art, Harry Brisbane Dick Fund, 1925 (23.26 fol. 67 recto)

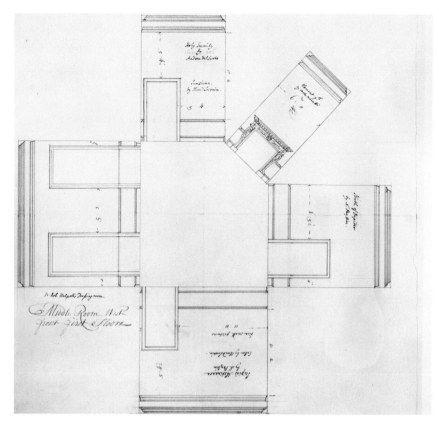

Isaac Ware, Plan of the Dressing Room ('Middle Room, West Front, First Floor'), 10 Downing Street, 1736-42, in Horace Walpole's extra-illustrated manuscript of *Aedes Walpolianae*
The Metropolitan Museum of Art, Harry Brisbane Dick Fund, 1925 (23.26 fol. 67 recto)

late in his 'Introduction' of some seven years later. Added to these were two architectural subjects by Viviano Codazzi (cat. nos. 27, 28) and the great *Augustus and the Sibyl* by Paris Bordone (cat. no. 10). Even the devastatingly appropriate *The Annuity Sellers* by Marinus van Reymerswaele (cat. no. 115) could claim a grandeur: 'This Picture is very near the same with one in the Gallery at Windsor'.[118] The appropriateness of this painting in the Prime Minister's End Room was only slightly less apposite with its then title, *An Usurer & his Wife*. Horace at the time the paintings were arranged at Downing Street had yet to embark upon his European tour and was as yet not in a position to articulate his views on the history of European art as evidenced by his father's collection: this was, however, his 'kindergarten' as an art historian.

As the visitor made their way to an audience with the 'sole' minister they embarked upon a psychological journey similar to that an ambassador had to take when visiting the Doge of Venice or the leading minister or even monarch of one of the Courts of Europe. Certainly the contemporary comparisons with Cardinal Wolsey make absolute sense; the public imagination could barely conceive the grandeur of the minister's palace recently completed in the country, on an even larger scale. Sir Robert's Dressing Room is the next on the 1736 itinerary, certainly as grand as any on the first floor. Here were two Claudes (cat. nos. 169, 170) and two Poussins (cat. nos. 176, 178), a lowering Salvator Rosa of impressive scale, *Democritus and Protagoras* (cat. no. 75), a *Bacchanalia* by Rubens (cat. no. 131) and two paintings attributed to Castiglione. A group of small Cabinet pictures completed the schema in this very public private room.

It was in the Great Room that Sir Robert's collection found its most splendid expression. The two vast canvases by Francesco Mola (cat. nos. 55, 56) hung here, with Jordaens's *Self-portrait with Parents, Brothers and Sisters* (cat. no. 111) also given prominence. The scale of Mola's canvases were such that there was little room for other paintings and they are likely to have been among the first paintings to be shipped up to Norfolk to be housed in the new Gallery at

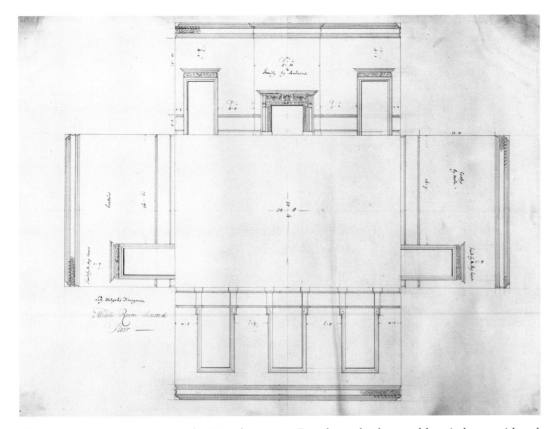

Houghton as soon as it was ready. Here hung two Dutch works that could again be considered a 'pair', both having arched tops but also coming from the same 'school': *An Old Woman with a Book* by Ferdinand Bol (cat. no. 146) and *An Old Man Writing* attributed to Gerard Douw. The Rubens workshop sketch for the ceiling of the nearby Banqueting House at Whitehall, *The Apotheosis of King James I* (cat. no. 119) was an eminently suitable subject given the location of Downing Street. It also conferred royal dynastic links and stature. Four fruitpieces by Michele Pace del Campidoglio for overdoors completed the ambience, as did a small devotional painting, *Holy Family*, attributed by Horace to Raphael Reggio (cat. no. 93).

Lady Walpole's Drawing Room at Downing Street possessed an altogether more private — or at least family — atmosphere. Here were the two Rosalba pastel drawings of her two eldest sons, Robert and Edward (cat. nos. 210, 211), to which was added a matching pastel of her daughter, Lady Malpas commissioned from Charles Jervas (cat. no. 218). Horace Walpole's portrait by George Knapton hung in the group. Horace was to complete the set for Houghton once in Venice by also sitting to the now venerable Rosalba Carriera (cat. no. 212). The usual mix of mythological and religious subjects was entirely satisfactory for Catherine Walpole and the selection of works included prize paintings, such as Rubens's *The Carters* (cat. no. 117) as well as a group of cabinet paintings, including six so small that Horace did not bother to measure them. Here hung too the now disputed Watteau, *A Dream of Watteau's. Himself Asleep by a Rock; Several Dancers & Grotesque figures in the Clouds*: this would surely have appealed to Lady Walpole, with its romantic image of the artist in a dream. Herself an artist, she would presumably have had a personal interest in the technical aspects of two paintings on marble, attributed to Stella (cat. no. 179) and Alexander Turchi (cat. no. 84), appreciating too the portrait of the artist Isaac Fuller, *Fuller the Painter in a Storm*, a self-portrait described by Vertue as 'in his shirt'.[119] In the Red Damask Bedchamber, meanwhile, were simply paintings of animals and

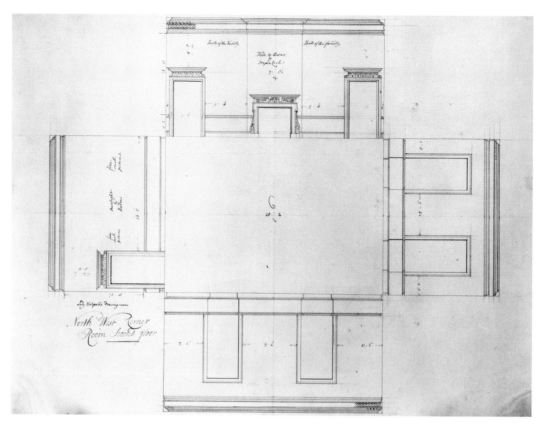

Isaac Ware, Plan of Lady Walpole's Drawing Room ('North West Corner Room, Second Floor'), 10 Downing Street, 1736–42, in Horace Walpole's extra-illustrated manuscript of *Aedes Walpolianae* The Metropolitan Museum of Art, Harry Brisbane Dick Fund, 1925 (23.26 fol. 69 verso)

birds, notably by Jakob Bogdani and Marmaduke Cradock, the eye being drawn to the one portrait in the room, Jonathan Richardson's *Sir Robert Walpole, in an Hunting Dress*.

Adjacent to the Bedchamber was the Closet: here again the selection was eclectic, this time featuring Horace's portrait by Richardson and commissioned overdoors of dogs by John Wootton. These were accompanied by a mix of paintings that were not destined to go to Houghton, and there is no doubt that the quality of these works were recognised as not so 'capital'. Those in the Closet that did reach Norfolk were Filippo Lauri's *The Appearance of Christ to Mary Magdalene* (cat. no. 38); Andrea Schiavone's so-called *Midas Judging between Pan and Apollo* (cat. no. 90) and *The Judgement of Paris*, now called sixteenth-century Venetian School (cat. no. 91); and a sixteenth-century copy of Raphael's *Last Supper* (cat. no. 67).

Orford House, in the grounds of the Royal Hospital, Chelsea was in the latest fashion and the collection on display was very much in the public eye.[120] One contemporary account was explicit in identifying Chelsea as the home of the cream of the collection; 'Sir Robert Walpole, the late Earl of Orford, had here for some time a house adorned with a noble collection of pictures, which was afterwards removed to Houghton-hall in Norfolk, and is now thought the finest collection in England.'[121] From around 1722 Sir Robert spent the summer months at Chelsea while Houghton was in construction. Although the house as it was is now almost obliterated, a large lead cistern survives emblazoned with two impressed Walpole arms, bearing the date 1721, the time of Vanbrugh's intervention. This is the surviving stamp of Walpole's identification with Chelsea as a significant home in which he first began to display his taste for emphatic embellishment.

In the Parlour at Chelsea in 1736 were again major 'pairs' of works of art to match the effect of those in the Parlour at Downing Street. The chimney overmantel displayed a family tribute, Charles Jervas's portrait of Charlotte Shorter, Lady Conway who had recently died (in 1734).

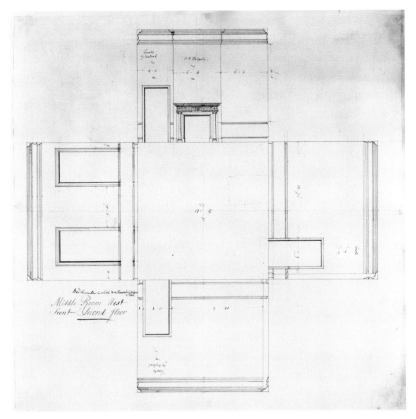

Isaac Ware, Plan of the Red Damask Bedchamber ('Middle Room, West Front, Second Floor'), 10 Downing Street, 1736-42, in Horace Walpole's extra-illustrated manuscript of *Aedes Walpolianae* The Metropolitan Museum of Art, Harry Brisbane Dick Fund, 1925 (23.26 fol. 70 recto)

The pairings were of paintings attributed to Castiglione, Angelist and Canaletto. The idea of the personification of Sir Robert as Moses was perhaps present in *The Egyptians drown'd in the Red Sea*. However, these were not paintings that would later be recorded in the *Aedes*. Paintings hanging in the adjacent 'Best Drawing Room' included a full-length Van Dyck portrait *The Countess of Carlisle*, Sir Robert's own portrait by Hyssing and a *Bear-Hunting* by Snyders, while by far the grandest work was described by Horace as 'St. Andrew leading to his crucifixion, with many figures. This Picture is a copy from Guido, in the Vatican.' The only painting from this Best Drawing Room to be catalogued in the *Aedes*, however, was the portrait *Sir John Gresham* by Antonis Mor (cat. no. 114). Two works in 'Sir Robert's Dressing Room' found favour: Frans Snyders' *A Concert of Birds* (cat. no. 132) and a sixteenth-century Italian painting attributed to Pordenone *The Return of the Prodigal Son* (cat. no. 92) were both shipped to Norfolk, quite possibly with two pictures of fruit and flowers which may equate with paintings still at Houghton today. For it was the case that a number of paintings were taken to Norfolk and never hung in Sir Robert's lifetime, while the *Aedes* does not identify the contents of all the bedrooms in the upper storey.

The Yellow Damask Bedchamber at Orford House featured over the chimney a family portrait by Richardson of General Charles Churchill, together with a full length by Kneller of Lady Walpole herself. One painting in this room seems to have been of some quality, a panel attributed to Jacopo Bellini, *Holy Family* that was duly moved to hang in the Cabinet at Houghton (cat. no. 88). The other paintings in this room—mainly still lives—were small pictures and should not be dismissed simply because they pass unrecognized today. The same should be emphasized for the remainder of the paintings at Chelsea. The Closet was not large in scale and the inventory begins to lose its momentum at this point, with a number of paintings passing unmeasured (simply recorded as 'small') or unattributed. A major painting in the Hall was Lesueur's *The Finding of*

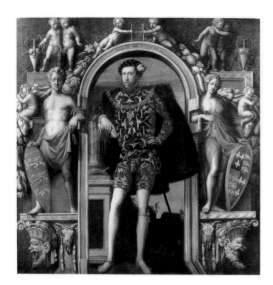

Unknown artist, *Henry Howard, Earl of Surrey*, c.1546, oil on canvas, 222.3 x219.7
Courtesy of The National Portrait Gallery, London

Moses, which was to hang in the Gallery at Houghton (cat. no. 173), while in Lady Walpole's Dressing Room at Chelsea was *A Portrait of a Young Man* by Frans Hals which at that time was believed to be a self-portrait (cat. no. 149). Also at Chelsea at this time was the full-scale portrait of *'Henry Howard, Earl of Surrey, beheaded ye last year of Henry 8th'*. This impressive portrait, painted by an unknown artist c.1546, had been in the Arundel Sale of 1720 at Stafford House, where Sir Robert bought it.[122] The portrait depicts allegorical figures holding shields that demonstrate the Earl's royal descent through his parents. The portrait, perhaps on account of its story of a dynastic fall from royal grace was felt not appropriate for Houghton and it remained in London until sold in 1751, when it was purchased by George Vertue.

The final London property to be inventoried in 1736 was 16 Grosvenor Street, Mayfair. Presumably through Sir Robert's patronage Thomas Ripley entered into the building lease of this property and it was Ripley who developed it into a solid five-bay frontage similar to that of the Admiralty. Sir Robert's 'ownership' of this building was completed by the installation of Robert, 1st Baron Walpole as tenant, 1725–38. The next occupant was to be Baron Conway, later 1st Earl and 1st Marquess of Hertford, Horace's cousin and correspondent. Here the Parlour was filled with an array of two dozen paintings attributed to a variety of Dutch, Flemish and Italian artists, with landscapes by Orizonte as overdoors. Just two of these were to go to Houghton: Raphael's *A Profile Head of a Man* (cat. no. 68) and *The Ascension* by Paolo Veronese and his workshop (cat. no. 87). The Back Parlour, by contrast, displayed just seven paintings, again two of which were to be transported to Houghton. These were the two splendid canvases by Sebastian Bourdon, *Jacob burying Laban's Images* (cat. no. 158), which hung over the mantel, and *The Massacre of the Innocents* (cat. no. 159). In Lord Walpole's Dressing Room none of the paintings made it to Houghton to be recorded in the *Aedes*. In 'The Great Room above' were hung some of the finest of Sir Robert's prize portraits by Van Dyck from the Wharton Collection, three of which were soon to join the Van Dycks already at Houghton (cat. nos. 98, 99, 108). Also in this room were four paintings by Wootton and Salvator Rosa's *Portrait of a Man* (cat. no. 76). One of the oils by Wootton, *A White Hound*, made it to Houghton, although not recorded as such in the *Aedes*, along with the Rosa. Just one of the paintings in the Drawing Room, Kneller's *Joseph Carreras* (described in the inventory as *A Man Writing*), was also to move to Houghton (cat. no. 198). To complete the picture, the sixteenth-century Venetian School painting in this room, *Boy with his Nurse*, was also destined for Houghton (cat. no. 57). It is the case, therefore, that despite the fact that Lord Walpole was to move out in 1738, relatively few of the paintings at Grosvenor Street reached Houghton.

This process of assessment is important for a full understanding of the magnitude of Sir Robert's collecting, as well as realizing the impact of the metropolitan collection upon visitors and, indeed, upon the larger story of collecting in England in the first half of the eighteenth century. Sir Robert's network was extensive, a model of process and procedure whereby a collector could aim to extend influence and exercise taste with the support of others. Narratives of power and patronage were articulated by the assemblage of the Prime Minister's collection and it was this process that the *Aedes* was to record. The value of the earlier inventory, meanwhile, lies in a different narrative: the record of a truly 'Capital' collection. I use the word 'Capital' here in the sense both of a collection for the metropolis, and in the sense used so extensively by auctioneers of the period to confer status upon articles that could otherwise be overlooked as simply marketable goods.[123] Vocabulary that in auctioneers' hands can be dismissed as simply 'puff', in the context of a Prime Minister's collection becomes a powerful instrument.

If the Prime Minister's collection could be a powerful instrument, Sir Robert Walpole wielded that instrument with remarkable efficacy. The provenance details so carefully and assiduously recorded by Horace Walpole in every facet of his writings, recognised and contributed towards this process. Horace himself exercised considerable skill. At the same time it would be mistake to consider that Sir Robert was himself an impotent bystander in a process of acquisition that was simply exercised by others. Family, friends, agents, buyers and seekers of preferment were all at work on his behalf, but it is important to remember that it was Walpole who was the all-seeing, all-powerful Wolsey figure, or Moses, depending upon your political orientation at the time.

In this respect it is instructive to witness just how extensive was Sir Robert's world of acquisition.[124] The closest family members could be relied upon, notably his two eldest sons, Robert, 1st Lord Walpole (1700–51) and Edward (1706–84), and later Horace, but also his younger brother Horatio (1678–1757), whose diplomatic career and own tastes were heavily influenced by Sir Robert. It is interesting that it was to the family that Sir Robert seems to have turned to help him acquire sculpture for Houghton, although not exclusively so. Among his closest friends to help in this respect was General Charles Churchill (c.1678–1745), who acquired busts from Cardinal Alessandro Albani (1692–1779), which he subsequently presented to Sir Robert and who also negotiated with Baron Philipp von Stosch (1691–1757) to acquire paintings. Churchill's affiliation with the family was to be cemented by his illegitimate son Charles who married Sir Robert's daughter Lady Mary Walpole in the year following the deaths of both Sir Robert and the General.

Among those abroad, one who relied upon Sir Robert's patronage was Sir Horace Mann (1706–86). He returned the compliment with a birthday present of an Italian Renaissance bronze *Rape of the Sabine Woman* (cat. no. 266). Mann would subsequently be of continuing help to Horace Walpole in his collecting. Sir Robert's friendship with James, 1st Earl Waldegrave led to a flourishing diplomatic career for the latter and opportunities to acquire works of art while on the Continent. Waldegrave both negotiated the purchase of a painting by Nicholas Poussin on Sir Robert's behalf[125] and presented him with a gift of a painting, *The Entombment* by the workshop of Jacopo Bassano (cat. no. 6), at about the time he was granted the Order of the Garter. Other friendships were more obviously self-serving. James O'Hara, Baron Kilmaine and 2nd Baron Tyrawley (1680–1773) presented Sir Robert with a version of Holbein's *Edward VI* (cat. no. 204) while presenting no other evidence of an interest in painting himself. Equally, Horace was not that impressed with Sir Joseph Danvers (1686–1753), but could not ignore his gift to Sir Robert of a striking portrait by Van Dyck of *Henry Danvers, Earl of Danby* (cat. no. 101). Robert Trevor, Viscount Hampden, by contrast, was closely involved in diplomacy with Horatio Walpole and took an active role in the arts, negotiating the purchase of a Ponzone *Holy Family* (cat. no. 64) on behalf of Sir Robert.

If diplomacy was, as ever, a means to an end for all concerned, friendship could be more generous. James Brydges, 1st Duke of Chandos (1673–1744) was an enthusiastic purchaser of works of art and his gift of Van der Werff's *Sarah leading Hagar to Abraham* (cat. no. 156) was clearly meant as an act of generosity between equals. The gift of Eustache Lesueur's *The Finding of Moses* (cat. no. 173) by John, 2nd Duke of Montagu (1690–1749) was as much a mark of friendship as of perspicacity. Thomas, 8th Earl of Pembroke (1656–1733) counted as a true member of a close network of friendships, which also included Sir Andrew Fountaine (1676–1753). It was Pembroke who

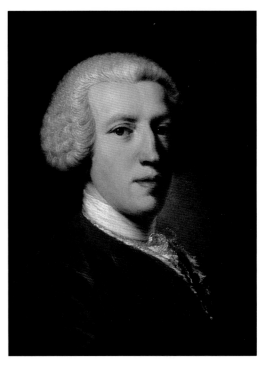

John Astley, *Horace Mann*, 1751, oil on canvas, 49.5 x 36.8
Courtesy of The Lewis Walpole Library, Yale University

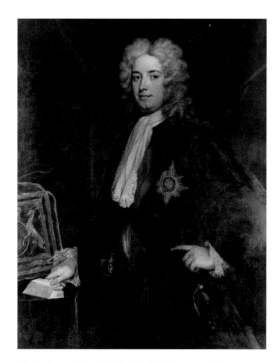

Charles Jervas, *Robert Walpole, Earl of Orford*, c.1725, oil on canvas, 125 x 100, formerly coll. The Lord de Saumerez
Photograph: Photographic Survey, Courtauld Institute of Art

gave Sir Robert his bronze of the *Borghese Gladiator* by Hubert Le Sueur (cat. no. 248), and his son who designed the Palladian Water House at Houghton. Other neighbourly networks were at work in Norfolk: Benjamin Keene (1697–1757) of King's Lynn was appointed to the South Sea Company and later a diplomatic post in Madrid: a Murillo *Virgin and Child* was a natural gift in such circumstances (cat. no. 184). Even Sir Henry Arundel Bedingfield (c.1685–1760), described by Horace as 'a most bigoted Papist in Norfolk', managed to present Sir Robert with an acceptable *St. Christopher* by Adam Elsheimer (cat. no. 188).

Sir Robert was especially well placed to employ agents on his behalf, both commercial and secret. At one end of the scale was the artist Charles Jervas whose personal charm gave him entrée to the literary circle of Swift, Addison and Pope, yet also the aristocratic circles of the Dukes of Marlborough and Newcastle, becoming in 1723 Principal Portrait Painter to the King. Sir Robert evidently regarded Jervas as a favourite choice from whom to commission portraits and 'presentation' pieces and it was also through Jervas that he acquired Pope Clement IX by his 'favourite' Carlo Marratti (cat. no. 41). From the world of the art trade Sir Robert engaged the framemaker John Howard (died 1746), who not only provided Kentian frames for the collection, but was also at the Duke of Portland sale of 1722 where he bought Ferdinand Bol's *An Old Woman with a Book* (cat. no. 146). Another key figure in the London art world during this period who both supplied Sir Robert with a portrait of Fulke Harold (cat. no. 214), the Gardener at Houghton, and was sent to Holland to make purchases on his behalf, was the painter John Ellys (c.1701–1757). Good connections here meant that Ellys held the posts of 'Tapestry Maker to the King' and 'Master Keeper of the Lyons in the Tower of London', as well as Principal Painter to Frederick, Prince of Wales. Sir Robert's network extended to representation at the right place at the right moment. Having helped to exonerate the well-known Scottish dealer Andrew Hay of Jacobitism in 1722, he successfully purchased Romanelli's *Hercules and Omphale* (cat. no. 73), Pietro da Cortona's *The Return of Hagar* (cat. no. 31) and a portrait head of Innocent X (circle of Velazquez, cat. no. 187)[126] at one of Hay's sales in 1725. Sir Robert made no more such purchases from Hay: in 1745 Hay was to retire to Scotland, which suggests that he was indeed a sympathiser of the Jacobite cause and that Sir Robert's network had long since decided that buying from Hay was no longer a good idea.

Another shadowy figure on the art scene at this time was Humphrey Edwin (1673–1747). The son of the Lord Mayor of London, relatively little is known of his activities, other than his extensive travelling and representation at picture sales, which suggest he was as much a dealer as a picture collector. Sir Robert at one point found himself in competition with the Prince of Wales when buying from Edwin, suggesting in this case that Edwin was in no-one's pocket.[127] Major pictures were bought direct from Edwin, notably two landscapes by Gaspar Dughet and Claude's *Landscape with Apollo and the Cumaean Sibyl* (cat. no. 170) and quite possibly Andrea del Sarto's *Holy Family* (cat. no. 80) from the collection of the Marchese di Mari. The dealer and auctioneer most actively involved in the making of Sir Robert's collection, and subsequently engaged by Robert, Lord Walpole at the start of its dispersal, was Christopher Cock (died 1748). A leading London auctioneer, he built his own auction rooms off the Piazza, Covent Garden in 1731. The most clandestine agent with whom Sir Robert dealt directly and extensively was John Macky (died Rotterdam 1726). In the guise of a Jacobite abroad, Macky was the leading protagonist in the acquisition of the four major *Market Scenes* by Snyders that were to take such a prominent place at Houghton (cat. nos. 133–136).

Sir Robert's collecting was not so entirely manipulative that he could not be represented in the public marketplace. The bulk of his collection was purchased from some of the most influ-

ential collections of the day. For this reason Horace Walpole had real purpose in setting down the provenance of so much of the collection, himself buying into the reflected glories of others. Among some of the most prestigious collection sales at which Sir Robert acquired significant works of art were those of Charles Montagu, Earl of Halifax (1661–1715); Grinling Gibbons (1648–1721); William van Huls (died c.1722); Philip, Duke of Wharton (1698–1731); John Law (1671–1729); William Cadogan, 1st Earl Cadogan (1675–1726) and Jonathan Richardson (1665–1745).[128] Sir Robert's first recorded purchase at auction was from the studio sale of Jan Griffier (c.1645–1718), his last in 1743 from Thomas Scawen (after 1695–1774). He also purchased singular works, important in their own right with no especially courtly provenance, but even these were often inevitably from known connoisseurs such as the London surgeon, Alexander Geekie (died 1721), from whose collection came Kneller's portrait of John Locke (cat. no. 200). Sir Robert's tentacles also extended abroad to some of the most important collection dispersals of the period, notably those of Marchese Nicolo Maria Pallavacini (1650–1714), Nicolaes Anthonis Flinck (1646–1723), Ferdinand Graaf van Plettenberg en Wittem (1690–1737), the Comte de Morville (1686–1732) and the Comtesse de Verrue (1670–1736). At some point he also bought directly from the celebrated Phelypeaux family, while it was through Horace that he purchased from Conte Zambeccari (c.1685–1749) his *Virgin and Child* (cat. no. 81) attributed to Domenichino and now recognized as by Sassoferrato.

This is a story of prodigious acquisition over a relatively short space of time. Yet it is not a tale of buying in bulk as, for example, Catherine II of Russia was later notoriously wont to do. Sir Robert Walpole effectively built a collection for the capital that was eminently appropriate to his ambitions. It is necessary to ask quite what those ambitions were and to what extent the Tory Opposition squibs and lampoons were justified. The answer must lie somewhere in between the Whig determinism of Horace Walpole and the excoriating abuse which came with political office. One means of assessing the collection as it stood in 1736 is to seek to compare it with those in other town houses in London at this period. This is not easily achieved through the few published records of the town house collections as they stood in the 1730s. This is in effect a further indication of the status of Horace's *Aedes* as a model of practice. He was too late to record the collection in published form as it stood in London, and so was born the model for country house catalogues in England in the second half of the eighteenth century.

The first publication to do any justice to London collections was published by Dodsley, who was following the example of his own practice in publishing the *Aedes*. Dodsley's six-volume work was first published in 1761 and its aim was very much more than the description of collections: *London and its Environs Described. Containing an Account of whatever is most remarkable for Grandeur, Elegance, Curiosity or Use, in the City and in the Country Twenty Miles round it. Comprehending also whatever is most material in the History and Antiquities of this great Metropolis.* The scope of this anonymous compendium was so large that it was feeling its way in the history of guides to London, but it managed to focus on a few of the great collections of the time. Dodsley had inevitably turned to discuss this with Horace Walpole who may well have supplied him with a copy of his own volume, *Catalogues of the Collections of Pictures of the Duke of Devonshire, General Guise and the Late Sir Paul Methuen* (1760), printed at Strawberry Hill.[129] The *Environs* describes Devonshire House in Piccadilly, 'the residence of his Grace the Duke of Devonshire when in London', an obvious choice for a description of its superlative collection of paintings: 'The collection of pictures, with which this house is adorned, is surpassed by very few either at home or abroad; of which the following is an exact list.'[130] While it is of interest to see that one of the Van Dyck full-lengths, Arthur Goodwin, formerly in the collection of Sir Robert, is here cited as still

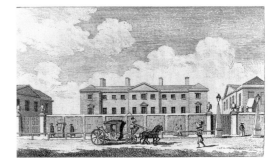

Devonshire House, line engraving from John Dodsley, *London and its Environs*, 1761
Courtesy of The Lewis Walpole Library, Yale University

Sir Anthony Van Dyck, *Arthur Goodwin, MP*, 1639, oil on canvas,
218.4 x 130.9
Devonshire Collection, Chatsworth. By permission of the Duke of
Devonshire and The Chatsworth House Trust

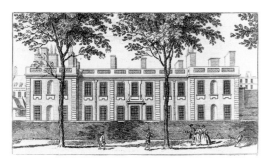

Marlborough House, line engraving from John Dodsley, *London and its
Environs*, 1761
Courtesy of The Lewis Walpole Library, Yale University

in London at that time, in fact the paintings are only listed and carry nothing of the apparatus modelled by the *Aedes*.[131] What is apparent from the list, however, is that the same eclecticism of taste in the way the paintings were arranged was still the norm. Classical and narrative subjects, 'Romish' as well as Roman, were hung together with portraits and northern European works with no attempts at classification other than representation of the established canon of admired names.

The other great house of the period was Marlborough House, which 'situated behind the houses on the west side of Pallmall, is a very large brick edifice, ornamented with stone, and built in a peculiar taste. ... The late Duchess of Marlborough, when this structure was finished, intended to have opened a way to it from Pallmall, directly in the front, as is evident from the manner in which the court yard is finished; but Sir Robert Walpole having purchased the house before it, and being upon no good terms with the Duchess, she was prevented in her design.'[132] Sarah, Duchess of Marlborough had underestimated the extent to which Sir Robert would go to make his view of the world stick. The Marlborough case for longevity and acclaim was reinforced in the entrance vestibule with a painting of the battle of Hochstet, in which 'the figures of the great Duke of Marlborough, of Prince Eugene of Savoy, and General Cadogan, are finely painted'. This, however, is as far as the *Environs* goes in describing the interior. The only other London town house interior to be described was that of Northumberland House, 'a building so complete and stately, as to be generally admired for its elegance and grandeur.' In this case the writer concentrates upon the impressive interior 'of several spacious rooms, fitted up in the most elegant manner'. The rooms are described in some detail, while the collection is described in glowing but general terms: 'They also contain a great variety of landscapes, history pieces, and portraits, painted by Titian and the most eminent masters.' The room singled out for especial mention was the 'state gallery or ball room, admirable in every respect, whether we consider the dimensions, the taste, and masterly manner in which it is finished, or the elegant magnificence of the furniture.' The gilded ceiling compartments were painted with 'fine imitations of some antique figures' while the walls were adorned with copies of 'five of the most admired paintings in Italy'. These were part of a schema developed with the help of Horace Mann and consisted of a copy by Mengs of Raphael's *School of Athens*; Batoni's copies of the *Feast and Council of the Gods* from the Farnesina; a copy of Carracci's *Bacchus and Ariadne* in the Farnese Palace; and a copy of Guido's *Aurora* in the Villa Rospigliosi: 'All these pictures are very large, being exactly of the same dimensions with the originals, and are copied in a very masterly manner. We heartily wish his Lordship's taste in procuring them may incite those, who can afford it, to follow the example, and purchase copies of such paintings as are universally admired; for by these means not only private curiosity would be gratified, but the public taste also greatly improved.' This is, however, a description of the house after its renovation undertaken after Sir Robert's death, which had begun in 1749. It remains the case that in the *Aedes* Horace was providing his father with a singular and original means by which to record the fact that his father had achieved a collection to match those of the most established and celebrated families.

The aspirations of Sir Robert should be seen in the context of a great tradition of town and country houses that stretched back into the seventeenth century and earlier. It was Sir Robert Walpole's power, position and presumably his access to Exchequer funds as well as his investments that enabled him to create an edifice that could stretch to maintaining a series of London residences as well as his building programme at Houghton. The principal façades of that edifice prior to 1735 were at Chelsea and Downing Street and it was only thereafter that Houghton became a visible emblem of his position. By that time the collection was substantially complete.

It is when comparing the collection with those established by, for example, the Devonshires and Pembrokes, that the extraordinary nature of Sir Robert's achievement is made clear. The accretions made over time by these aristocratic families were matched by the Walpole family in barely more than a quarter century. The Walpole collection also epitomizes the English Grand Tour taste, which is an irony when one considers that Sir Robert never actually managed to go abroad. Although political life kept Sir Robert himself at home, he clearly had ample opportunity to develop his taste as well as his collection. Again, it is relevant to address the view that the collection could hardly be said to represent the taste of a collector who had never been abroad. In fact Sir Robert's taste appears to have affected the collection in quite a profound sense. The Walpole collection did not consist of a notable preponderance of view paintings, or 'vedute', such as might be expected of a personal tour. Remarkably, it was not necessarily appropriate to present Sir Robert with a 'souvenir'; rather, a classic example from the established canon was what was required. While grand tourists might return home typically with a portrait by Rosalba, or later Batoni, other pressing acquisitions tended to be the work of the view painters such as perhaps Gaspar van Wittel (1653–1736), Giovanni Battista Busiri (1698–1757), or Pietro Bianchi (1694–1740). The most obviously successful producer of this genre was Canaletto and Sir Robert could indeed boast four examples of Canaletto's work by 1736. These, however, were judiciously dispersed between the Parlours at Chelsea and Downing Street, rather than presented as a group such as the Duke of Bedford arranged on a far larger scale at Woburn Abbey. These do not seem to have been that highly regarded by Sir Robert and none made it to Houghton.[133] This is not to say, either, that Sir Robert had no interest in travel. In 1743 Horace informed Horace Mann that his father had said that 'if he thought he [Sir Robert] had strength, he would see Florence, Bologna, and Rome, by way of Marseilles to Leghorn. You may imagine how I gave in to such a jaunt. I don't set my heart upon it, because I think he cannot do it; but if he does, I promise you, you shall be his cicerone.'[134] Horace was right and his father died without ever having been abroad himself, but surrounded by the emblems of journeys that others had travelled on his behalf.

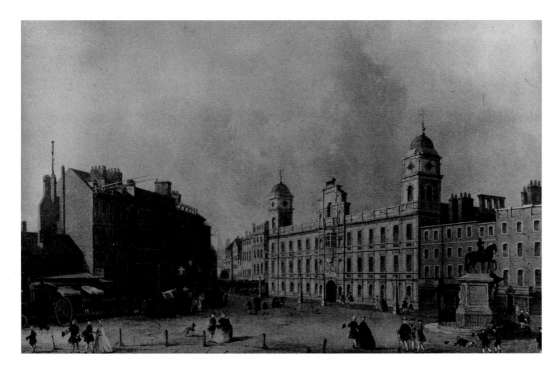

G. A. Canaletto, *Northumberland House*, 1752, oil on canvas, 84 x 137
Photograph courtesy of the Paul Mellon Centre for Studies in British Art

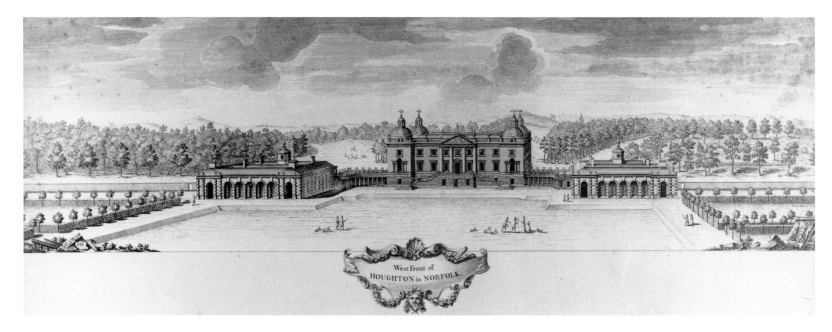

Pierre Fourdrinier after Isaac Ware, *Elevation of Houghton Hall*, 1735,
Boydell I, pl. II, line engraving , 39.3 x 66.7.
The Marquess of Cholmondeley

VISITING HOUGHTON HALL, PALACE OF THE ARTS

Today the *Aedes Walpolianae* is perhaps most obviously perceived as a catalogue of a country house collection, indeed the model by which such catalogues subsequently came to be written. Houghton was the ultimate destination of those elements of the collection that would stand the test of time. While the collection was made in the capital, Houghton was created to house it and this is where the most visitors were able to appreciate it as an entity in relation to the family estate in which it was finally set. A visit to Houghton was an experience for countless visitors who were eager to record their reactions as the house became one of the prime set down points for travellers on tours of the eastern region or more specifically the 'Norfolk Tour'. In this context Houghton as a destination became as much a focus for travellers as the European centres, which had originally been home to so many of the paintings. Once building at Houghton was complete, the country house joined the town residences in hosting a collection that necessitated a renewed appreciation of the joys of travel at home. In the process the Houghton Collection gathered its own mythology, kept alive by the *Aedes Walpolianae*, until such time as the announcement of its impending sale made its demise a subject for discussion in parliament. This section will focus on these accounts of the collection rather than rehearse material covered elsewhere in this volume or recently published.

An early visitor whose comments are often quoted is Lord Hervey who wrote a long account of Houghton to the Prince of Wales on 14 July 1731. His account is here worth reproducing in full in that he gives a personal and rounded picture of the house as it was still developing. He was evidently impressed and gave a fulsome description, at a time when the building was not yet complete nor fully furnished. The Prince of Wales had requested a full account and the resulting letter sets out the quality of the 'Houghton experience' that others in turn were to identify and which by no means rested upon the collection alone. We read of the life of a burgeoning estate through the voice of a courtier, who adopts a dispassionate tone of reportage:

> Your Royal Highness commanded me to give you a very particular account of this place, and as I have no pretence to the character of a connoisseur, I hope you will neither expect I should give it in proper terms, nor with any remarks of my own. As to the style of a vir-

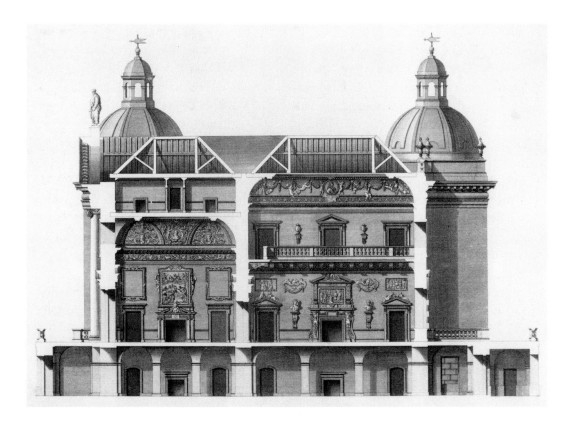

Pierre Fourdrinier after Isaac Ware, *Section of the Hall and Salone*, 1735, Boydell I, pl. VIII, line engraving
The Marquess of Cholmondeley

tuoso, I own I am not ambitious to learn it, for, by the technical jargon of a true follower of Palladio and Vertuvius [Vitruvius], one would imagine that a modern architect must have as great a contempt for his mother tongue as his grandfather's taste; but as I am learned enough to be proper in my dialect, I may have some chance to be ignorant enough to be intelligible.

In order to give your Royal Highness a notion of what is done here, I should first let you know what materials Sir Robert had to work upon. I believe he will forgive me, when I say the country and situation are not what he would have chosen, if chance had not chosen for him. The soil is not fruitful, there is little wood, and no water: absolutely none for ornament, and all that is necessary for use forced up by art. These are disadvantages he had to struggle with, when that natural leaning to the paternal field and the scene of his youth, a bias which everybody feels and nobody can account for, determined him to adorn and settle at Houghton.[135]

He has already, by the force of manuring and planting, so changed the face of the country, that his park is a pleasant, fertile island of his own creation in the middle of a naked sea of land. The manuring has given it verdure, and the plantations thrive so well, that it will very soon be far from wanting wood.

There is a garden of 23 acres to one side of the house; and to the other three, the park comes close up without any interruption. The house itself is 164 foot in front. There are two ranges of offices of 100 foot square, joined to the house by two colonnades of 68 foot each, which makes the front of the whole from out to out just 55 foot.

The building is all of stone, and its chief ornaments four cupellos at the four corners, where were obstinately raised by the master, and covered with stones in defiance of all the virtuosi who ever gave their opinions about it.[136] The base, or rustic story, is what is chiefly

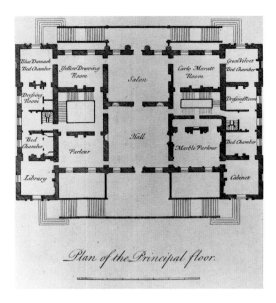

Pierre Fourdrinier after Isaac Ware, *Plan of the Principal Floor*, 1735, plate inserted in *Aedes Walpolianae*, 2nd edition 1752
The Marquess of Cholmondeley

inhabited at the Congress. There is a room for breakfast, another for supper, another for dinner, another for afternooning, and the great arcade with four chimneys for walking and quid-nuncing. The rest of this floor is merely for use, by which your Royal Highness must percieve that the whole is dedicated to fox-hunters, hospitality, noise, dirt and business.

The next is the floor of taste, expense, state and parade. The first room is a hall, a cube of 40 foot furnished entirely with stone, a gallery of stone round it and the ceiling of stucco, the best executed of anything I ever saw in stucco in any country. The ornaments over the chimney and doors are bas-reliefs of stone; round the side marble bustos, and over against the chimney the famous group of Laocoon and his two Sons. Behind the hall is the salon, finished in a different taste, hung, carved and gilt large glasses between the windows, and some of his finest pictures round the three other sides of the room (this room looks to the garden). On the left hand of the hall and salon, this floor is divided into a common eating room, a library, a dressing room, a bed-chamber, and withdrawing-room for ordinary use; and on the right hand (which is the only part yet unfinished) is to be the great dining room, and the State apartment. The furniture is to be green velvet and tapestry, Kent designs of chimneys, the marble gilded and modern ornaments. Titian and Guido supply those that are borrowed from antiquity.

The great staircase is the gayest, cheerfulest and prettiest thing I ever saw; some very beautiful heresies in the particulars, and the result of the whole more charming than any bigotry I ever saw.

The upper or attic story is divided all into lodging-rooms. There are twelve of them, of which ten have servants' rooms belonging to them: and by deviating from orthodoxy in the proportion of the windows on this floor, he has not only dared to let in light enough for the poor inhabitant to be able to read at noon day (which the Palladian Votaries would fain have prevented), but he has made the building much handsomer on the outside that without this successful transgression it could possibly have been. In short, I think his house has all the beauties of regularity without the inconveniences; and wherever he has deviated from the established religion of the architects, I believe Your Royal Highness would say he had found his account in being a libertine.[137]

Hervey wrote again on 21 July to continue his account:

Our company at Houghton swelled at last into so numerous a body that we used to sit down to dinner a little snug party of about thirty odd, up to the chin in beef, venison, geese, turkeys, etc.; and generally over the chin in claret, strong beer and punch. We had Lords spiritual and temporal, besides commoners, parsons and freeholders innumerable. In public we drank loyal healths, talked of the times and cultivated popularity; in private we drew plans and cultivated the country.[138]

Two more accounts will serve to give a contemporary aristocratic overview of life at Houghton at this time. The Earl of Carlisle was also curious to learn of the developments at Houghton. At this time hearsay needed to be countermanded by direct visits and reports: the image of Houghton otherwise was that promulgated in *The Craftsman* and other Opposition broadsheets. A print circulating from 1733 showed a vignette with a passing resemblance to Houghton in front of which are 'Nobles bowing to one who throws money in their hats'.[139]

It fell to Sir Thomas Robinson to report to Lord Carlisle on 9 December 1731:

I was a fortnight in my tour into the eastern parts of England, and was, during that time, a week at Houghton. We were generally between 20 and 30 at two tables, and as much cheerfulness and good nature as I ever saw where the company was so numerous.

Young Lady Walpole and Mrs. Hamond (Sir R[obert Walpole]'s sister) were the only two ladies. Sir Robert does the honours of his house extremely well, and so as to make it perfectly agreeable to everyone who lives with him. They hunted six days in the week, three times with Lord Walpole's fox-hounds, and thrice with Sir R[obert's] harriers and indeed 'tis a very fine open country for sport.

During the Duke of Lorrain's being there the consumption both from the larder and the cellar was prodigious. They dined in the hall, which was lighted by 130 wax candles, and saloon with 50; the whole expense in that article being computed at fifteen pounds a night.

The house is less than Mr. Duncomb's, but as they make use of the ground storey, and have cellars under that, I believe it is the best house in the world for its size, capable of the greatest reception for company, and the most convenient state apartments, very noble, especially the hall and saloon. The finishing of the inside is, I think, a pattern for all great houses and may hereafter be built; the vast quantity of mahogoni, all the doors, window-shutters, best staircase, &c. being entirely of that wood; the finest chimnies of statuary and other fine marbles; the ceilings in the modern taste by Italians, painted by Mr. Kent, and finely gilt; the furniture of the richest tapestry, &c.; the pictures hung on Genoa velvet and damask; this one article is the price of a good house, for in one drawing-room there are to the value of three thousand pounds; in short, the whole expense of this place must be a prodigious sum, and, I think, all done in a fine taste. There is only one dining room to be finished which is to be lined with marble, and will be a noble work. The offices are also built of Mr. Chomley's stone, and are well disposed and suitable to the house. In one wing are the kitchens and all necessary rooms belonging to a table, servants' halls, &c., and over head are several very good lodging rooms; in the other are the brew-house and wash-house, &c., and a very magnificent hall for a chapel, and a large room which looks on the parterre, designed for a gallery, there being the same in the opposite wing for a greenhouse.[140]

The enclosure of the Park contains seven hundred acres, very finely planted, and the ground laid out to the greatest advantage. The gardens are about 40 acres, which are only fenced from the Park by a fossé, and I think very prettily disposed. Sir Robert and Bridgeman showed me the large design for the plantations in the country, which is the present undertaking; they are to be plumps and avenues to go quite round the Park pale, and to make straight and oblique lines of a mile or two in length, as the situation of the country admits of. this design will be about 12 miles in circumference, and nature has disposed of the country so as these plantations will have a very noble and fine effect; and at every angle there are to be obelisks, or some other building. In short, the outworks at Houghton will be 200 years hence that those at Castle Howard are now, for he has very little full-grown timber, and not a drop of water for ornament; but take all together, it is a seat so perfectly magnificent and agreeable, that I think nothing but envy itself can find fault because there is no more of the one, and I scarce missed the entire want of the other.

The stables (which are very large and [have] been finished about 13 years ago) are to be pulled down next summer, not only as they are very ill built, but stand in the way of one of the most agreeable prospects you have from the house, and 'tis not yet quite determined whether they should be rebuilt as wings to the Park front of the house, and as part of the whole design, or only a separate building, only for use and not to appear. I own I argued strenuously for the former, but Sir Robert seems almost fixed upon having a plain structure, and to be placed out of the way and not to be seen in your approach to the house.

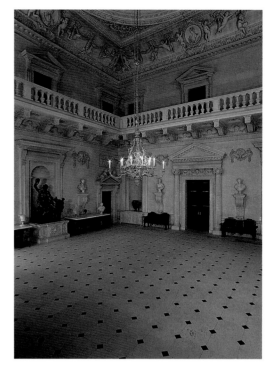

The Stone Hall, Houghton Hall
Photograph Neil Jinkerson 1996, courtesy of Jarrold Publishing

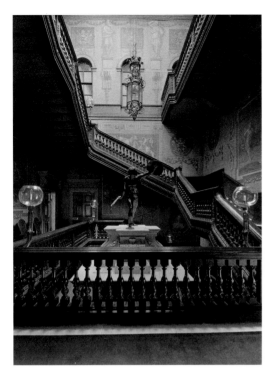

The Staircase, Houghton Hall
Photograph courtesy of The Country Life Picture Library

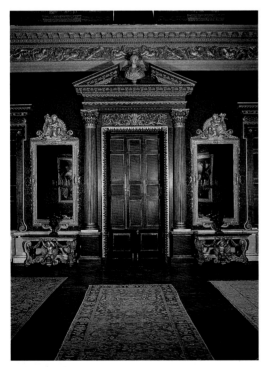

The Saloon, Houghton Hall, south wall
Photograph Neil Jinkerson 1996, courtesy of Jarrold Publishing

The other wings are thrown quite backwards into the garden, and make very little ornament to this front of the house, which, being without either a portico, three-quarter columns and a pediment, or any other break, appears to me to be too naked and exposed, and rather as an end front to a very large palace, than the principal one of a modern house; and wings to be built here would greatly obviate all objections of this nature.

I had forgot his fine La[o]coon in brass, done by the famous Gerrardon (who made my equestrian figure of Lewis 14th), which cost 1,000 guin[eas] at Paris; a fine gilt gladiator, given him by Lord Pembroke, and which is very prettily placed on four Doric columns with their proper entablature, which stand in the void of the great staircase; and the figure stands upon a level with the floor of the great apartment, and fronts the door which goes into the hall, and has a very fine effect, when you go out of that room. Upon the s[tair]case he has several other fine bronzes, and 12 noble busts in the hall. His statues for two niches are not yet bought; the La[o]coon stands before that which is opposite to the chimney.

A brief comment upon Houghton at this period is that of Laurence Charteris (died 1735), who late in life became Lord of the Manor at nearby Mannington Hall in Norfolk. In a letter of 16 August, 1732 he commented: 'Houghton, Sir Robert's house, is the grandest and most glorious place that ever my eyes beheld, and the finest furniture, the statues, vases, pictures, etc are immense, and the noblest house keeping in England for man and horse'.[141] By way of counterpoint, another (oft quoted) account is that drawn from the diary of 2nd Earl of Oxford published by the Historical Manuscripts Commission, which describes a journey undertaken through East Anglia in September 1732. Lord Oxford gave a refreshingly acid account of a number of the places he visited at this time, although he was much enamoured of the hospitality he received at Raynham Hall, home of Charles, 2nd Viscount Townshend. His party continued straight from Raynham to Houghton and on this occasion Houghton suffered in the comparison:

We parted from this fine place in the afternoon to go to Houghton, the seat of the great Sir Robert Walpole. It is about four very short miles from Rainham. This house at Houghton has made a great deal of noise, but I think it is not deserving of it. Some admire it because it belongs to the first Minister; others envy it because it is his, and consequently rail at it. These gentlemen's praise and blame are not worth anything, because they know nothing of the art of building, or anything about it. I think it is neither magnificent nor beautiful, there is a very great expense without either judgement or taste. The two best rooms are the hall and the saloon, which take up just the depth of the house. The measures of the hall, as well as the plan of the house, are exhibited in that ignorant rascal's book called "Vitruvius Britannicus," the editor Colin Campbell; there is some small alteration, as the roofs of the towers [*Note in MS: Which were altered by Mr Gibbs from the first design. The house as it is now is a composition of the greatest blockheads and most ignorant fellows in architecture that are. I think Gibbs was to blame to alter any of their designs or mend their blunders. Sir Robert Walpole was in the Treasury, and Gibbs is a Scotch man.*] else it is exact. In the saloon are a great many fine pictures, particularly the famous Markets of Snyder, but I think they are very oddly put up, one is above the other and joined in the middle with a thin piece of wood gilt. It is certainly wrong because as these pictures of the markets were painted to one point of view, and to be even with the eye, they certainly ought not to be put one above another, besides that narrow gold ledge that is between the two pictures takes the eye and has a very ill effect.[142]

In the hall there is a most noble cast of the Laocoon, which my Lord Walpole brought from Italy. There are the casts of two river gods the Tiber and the Nile, very fine ones. The

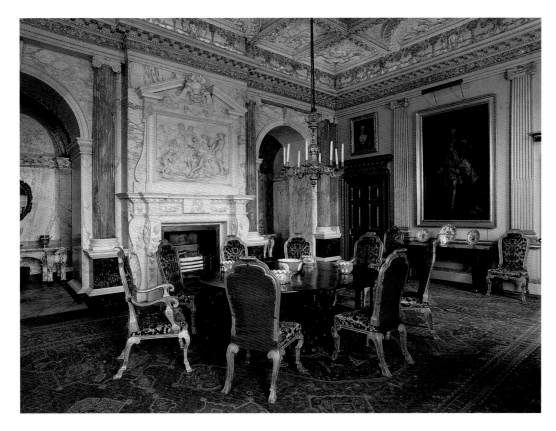

The Marble Parlour, Houghton Hall
Photograph Neil Jinkerson 1996, courtesy of Jarrold Publishing

room is much crowded with 'terms' and bustos, and besides the room is very dark, for the light which should come from the lower windows is intercepted by the gallery above; and the light that should come from the attic windows that also is intercepted by a large projecting cornice. In this hall hangs the much talked of lanthorn, which the "Craftsman" was so idle to take notice of. In the first place it is very ugly, and in the next it is not really big enough for the room it hangs in. It cost Sir Robert Walpole at an auction one hundred and seventy pounds. There are niches for statues, but there are no statues but terms are put in them and bustos put upon them, which I think have a very ill effect. There is in the well of the staircase the fine cast of the Gladiator, which was given Sir Robert Walpole by the Earl of Pembroke, upon a most clumsy pedestal, which is supported by four columns fluted. It fills the well of the staircase. It is very ill placed, for you cannot stand anywhere to have a good view of it, which is a great pity. No apartments in the whole house. There are twenty bedchambers but small; the rooms in the four towers have each a little room for a servant to lie in; the dining room or eating room is not finished; the buffet is lined with marble, Mr. Rysbrach is making a chimney piece for it of exquisite workmanship; the design is Kent's, which is no addition to it. I took notice of Sir Robert's own bedchamber; the bed is shut up in a box, a case made of mahogany with glass, as it if was a cabin, the room small, my lady's picture over the chimney. They showed us with ceremony, this is the room the Duke of Lorraine lay in, a very different room. I suppose it is always to go after his name.

There is a room where there are hangings done from the pictures of King James the First, his Queen with her little dogs and horse, the King of Denmark her father, and King Charles the First. What is called the hunting apartment, I like it not, though it is much commended, the rooms are low and being even with the ground one seems to be under ground, and it has a very ill look in my opinion. The kitchen is very fine, four large chim-

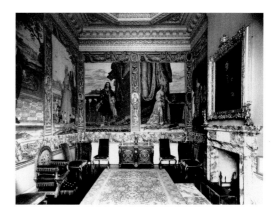

The Mortlake Tapestry Dressing Room, Houghton Hall
Photograph courtesy of Christie's Images Ltd

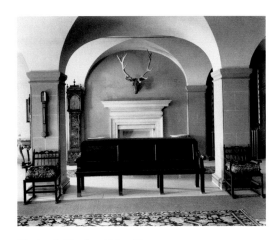

The Arcade, Houghton Hall, 1986
Photograph courtesy of The Country Life Picture Library

neys; the offices are very large and very convenient, over them are a great many lodging rooms. The stables are not yet built, the foundations not dug. The body of the house projects a great way before the wings, as you may see from the plan in the third volume of "Vitruvius Britannicus". There is a double colonnade, one open, the other shut up. [*Note in MS: In this house there are the greatest profusion and waste of mahogony wood that ever I saw. The doors which are all of that wood are near - inches thick, most monstrous!*] My Lord Hay [*Note in MS: If my good Lord Hay finds water, he, being a true Scot, I dare say will make Sir Robert Walpole pay well for employing such an engineer.*] was there seeking for water, but I believe he will find none; all that they have is drawn up out of a very deep well. I dare say had the money which has been laid out here, nay and much less, been put into the hands of a man of taste and understanding, there would have been a much finer house, and better rooms, and greater.[143]

However, it is the case that the acerbic Lord Oxford returned on a second trip to East Anglia in 1738. This time the house was complete, apart from the Picture Gallery and the London paintings. On this occasion Lord Oxford received the personal ministrations of Sir Robert himself and this seems to have softened his temper. His account is more appreciative this time and supports the general viewpoint of the contemporary visitor from amongst Sir Robert's network of landed friends and political associates.[144] On this occasion Lord Oxford's reactions were altogether less quarrelsome: 'The fine marble room is finished, and a most beautiful chimney piece made by Rysbrach as can be seen. . . . We then took another view of the pictures, and indeed they are very exquisite; the more one sees the more one admires and desires to see.'[145]

Not all Houghton's visitors were from the aristocratic class. It is instructive to read a couple of accounts by visitors who are virtually anonymous but for the fact that their travel diaries survive. The first of these documents is from the Journals of the Rev. Jeremiah Milles, of his travels in different parts of England and Wales between July 1735 and September 1742: 'An Account of the journey Mr. Hardiess y I took in July 1735'.[146] In common with other visitors Milles proceeds to describe the works of art, but his account reads as little more than a list of works viewed. One comment noted that Milles and Hardiess also made the trip to Houghton following on from Rainham: 'This magnificent house is situated pretty high in a Park yt is not unpleasant: it is all built of Portland stone. One Ripley was the architect . . . The inside of this house exceeds ye outside. Ye furniture is vastly magnificent.' The tourist noted the celebrated lantern in the Hall, 'in ye middle of it hangs by a gilt chain, a very noble lantern; wch is so famous for its size', while Sir Robert's study was dismissed as 'not a very large one'. In fact the overall impression is that for this visitor Houghton seems to have made very little lasting impression.

A second manuscript account of a visit to Houghton by an otherwise unknown traveller is that by a member of the Jenkinson or Cope families whose diary (now in the British Library) charts the itinerary of a journey from Cambridge through Suffolk, Norfolk, Lincolnshire and Yorkshire in the summer of 1741.[147] This party 'arrived safe at the Inn, which is a very good one, at Houghton Hall Gate. Next morning we walked up to the House, took a turn or two in the Arcade'. The opinion this time of the Arcade was that 'had it been a little lower it would have done for a Cellar, but the Use that is made of it at present is to walk and sit in, in Summer times'. The description of the paintings here is a more personal response than visitors were soon to provide for the simple reason that Horace's guide would become ubiquitous in its impact upon the observations of visitors. As it was, the present writer commented: 'The pictures are collected with very great taste, and all good: Catalogues are so common that we shall take notice only of those that struck us most.' The comment about catalogues demonstrates that there were pre-

sumably numerous manuscript lists in circulation. One survives in the Chester Record Office that has all the appearance of being Sir Robert's own handlist, dating from after his retirement from office.[148] However, the writer does indeed make his own judgements, commenting on the swarthiness of the Cyclops at Vulcan's forge and the method by which 'Michaelangelo' has 'hit upon the way' to show Ganymede being transported by the Eagle without being hurt: 'Ganymede folds his arms around the Eagle's wings, as near the body as possible. The Eagle locks his legs with Ganymede, so that the Eagle seems to fly with pleasure and the posture of Ganymede looks easy.' The four *Markets*, attributed then to both Rubens and Snyders 'were done by the two most masterly hands, that ever were in the World, and are such a composition of master piece that the United pencils of all the Painters in their present Degeneracy must despair of Imitating.' One last observation about one of the paintings in the Marratti Room serves to demonstrate this layman's response to the awe inspiring collection: 'Venus Naked, with Cupid pulling a thorn out of her foot, the tears running down her Cheeks & down her arms, her pouting Cheeks, a little redness upon the part affected; and the Industrious concern of Cupid, are all excellent.' No especial claims can be made for this visitor's art education or appreciation of contemporary English art beyond the fact that he was keen to record at length his responses, recognizing that he was in the presence of 'One of the compleatest buildings and most compeatly furnished of any house in England.' He was also impressed by the information that 'they can make up at an hour's notice 110 Beds'.

By 1743 a signal visitor to Houghton was the young Horace Walpole, who had some difficulty coming to terms with the isolation his attention to his increasingly ailing father required. He wrote to Horace Mann on 25 April 1743:

> I go in three weeks to Norfolk; the only place that could make me wish to live at St. James's. My Lord has pressed me so much, that I could not with decency refuse; he is going to furnish and hang his picture gallery, and wants me. I can't help wishing that I had never known a Guido from a Teniers — but who could ever suspect any connection between painting and the wilds of Norfolk?[149]

A visit for this purpose had been planned for some time. On 10 June Horace had written to Mann the previous summer: 'Sir R[obert] who begins to talk seriously of Houghton, has desired me to go with him thither, but that is not at all settled. Now I mention Houghton, you was in the right to miss a gallery there, but there is one actually fitting up, where the greenhouse was, and to be furnished with the spoils of Downing Street.'[150]

The completion of the Picture Gallery was crucial to the final coming together of the different elements at Houghton. The descriptions of Sir Thomas Robinson in 1731 and even the published plans of Ripley are to some extent more an indication of the layout of the Gallery than an accurate record. The completion of the Gallery was a long time in gestation. It provided a triumphant conclusion to the building programme and a very early example of clerestory toplighting in England for the display of paintings. Sir Robert's neighbour Sir Andrew Fountaine had created his own version of the top-lit gallery in imitation of the Tribuna at the Uffizi in Florence for the display of his maiolica collection. Sir Robert and his architects took this idea a stage further and created the most handsome new style Gallery in England. It was the creation of this Gallery that marked Sir Robert out from his contemporaries: even James Brydges, 1st Duke of Chandos, had not conceived a Gallery at Cannons on such a scale for his collection. It is difficult to appreciate this today as the gallery was burnt out in 1789 and replaced by a conventionally lit and somewhat plainer space. Nevertheless, hung with crimson Norwich wool damask the effect once the paintings from London were installed was magnificent.

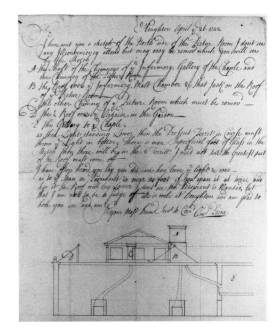

Ambrose Paine, letter to Sir Robert Walpole with a cross-section of the proposed alteration to the Gallery, 26 April 1742
Houghton Hall Archive

Most visitors appreciated the results of these labours and Horace Walpole records something of their comings and goings, including those of 'swarms of natives of the country'[151] that bring the house alive through the pages of his correspondence. We know that Horace won his father's appreciation from Sir Robert's brief letter to Horace of 14 July 1744. Writing from London Sir Robert wrote in ruminative vein of the pleasures of the country as against the 'busy world', 'The amusements arising from the inanimate world afford no relish to men of taste. The wild beasts of the woods, the flocks and herds, wear neither breeches nor petticoats, and are wholly inconversable'. Nevertheless Sir Robert found comfort in the country, and wrote fondly to Horace 'we all love to please ourselves, and may it always be in your power to make yourself as happy as I wish you'.[152]

Sir Robert's death did not bring an end to Houghton as a place of pilgrimage for travellers on the 'Norfolk Tour'. Sir Robert's will makes his intentions clear with respect to Houghton and his collection: 'And I do direct that all my pictures in my house at Chelsea be removed from thence as soon as conveniently can be done after my decease, to my house at Houghton, in the county of Norfolk. And I give and bequeath all such pictures to be removed and all my pictures, household goods, furniture and utensils in, and belonging to my said house at Houghton, and in the office and gardens thereto appertaining, unto my said sons Edward Walpole and Horace Walpole, in trust to permit the same to be used and enjoyed, (but not to be sold, or disposed of) by the respective persons to whom the freehold or inheritance of the said house at Houghton shall, for the time being, by virtue of the settlement made thereof on the marriage of my eldest son the said Lord Walpole, belong or appertain. To the intent the same pictures, household goods, furniture and utensils may as in the nature of heir-looms with the said house, as far as the rules of law and equity will permit.'[153] In the event Sir Robert had not managed to achieve longevity for the entire collection in the context of Houghton, but it was to take another thirty years before the dispersal of the paintings was inevitable.

The remarks of Philip Yorke in his travel journal of 1750 may here serve as a tribute to the continuum that Houghton achieved even as Sir Robert's eldest son determined how to make it survive:

> From hence we went to Houghton, and in the afternoon went up to see the house. The exact plans of this place, that are already in print, and the complete catalogue lately given of the pictures by Mr Horace Walpole junior make it needless to enter into a particular description of it. Those who would see a house fitted up in the most magnificent, convenient and substantial manner in all parts of it, or would study the manners of the different schools of painters to as great perfection as may be done almost anywhere on this side of the Alps must come here for entertainment and instruction. The making of this place must have cost a prodigious sum of money; the late Lord Orford owned to Lord Coke, as he informed us, above £200,000, and would not say how much more, declaring he had burnt the bills. We had an opportunity (which few strangers have) by Lord Orford's civility, who obliged us to lie there that night, of seeing the plantations and park. The former are of vast extent, not less in the whole circuit than 13 miles, with serpentine ridings cut through them, and form beautiful thick cover to that wild barren country. The park is regularly planted, with some fine old oaks near the house which Lord Orford used pleasantly to call his schoolmasters, because they taught him how trees would grow there; and indeed the trees of all kinds thrive extremely well in this soil. The deer park is 6 miles round, besides what is kept in farm.[154]

It is appropriate to consider the circumstances under which Horace Walpole created the *Aedes Walpolianae*, not only in order to witness his methodology when creating his encomium, but also to explain something of the myriad annotated copies that survive today.[155] While it is partial in its purpose, it is also true that the task he set himself was prodigious and did not involve simply listing the works. It was to be a guidebook to the collection for visitors and it was necessary to compile it while the paintings were in a certain state of flux. On 14 July 1742 Horace wrote to Mann in turmoil as they prepared to leave Downing Street:

> I am writing to you up to the ears in packing: Lord Wilmington has lent this house to Sandys,[156] and he has given us instant warning—We are moving as fast as possible to Siberia, Sir Robert has a house there within a few miles of the duke of Courland — In short, child, we are all going to Norfolk, till we can get a house ready in town: all the furniture is taken down, and lying about in confusion: I look like St. John in the Isle of Patmos writing revelations, and prophesying 'Woe! Woe! Woe! The kingdom of desolation is at hand!'[157]

Horace was tempting Providence by likening Sir Robert to Ernst Johann Biron (1690–1772), Duke of Courland, the favourite of Czarina Anne, after whose death he had been exiled to Siberia in 1741. Courland was to be finally restored to his duchy by Catherine II, whose Court was to be the ultimate destination of another set of packing cases containing the Walpole Collection.

Horace was soon happily back in London, living with the retired minister, whose health had begun to fail, yet who was not exactly leading the life of a recluse. They were involved in a hectic social life from their base in Arlington Street: 'By the crowds that come hither one should not know that Sir Robert is out of place, only that now he is scarce abused'.[158] Once the paintings were back in Houghton and the business of rehanging was finished, Horace once again passed time there with mixed feelings. He spent the best part of the summer of 1743 at Houghton, leaving for Norfolk on 15 August[159] and was on his way back to London on 3 October, when he wrote to Mann from Newmarket. It was probably over this period that he was most involved in writing his manuscript. At Houghton again the following summer, he wrote to Charles Hanbury Williams on 19 September 1744 to bemoan his isolation while looking after Sir Robert's needs. On one occasion he took a visitor to neighbouring Raynham Hall: 'I carried [Richard] Rigby to Rainham yesterday; we wanted my Lady excessively to do the honours! I showed the house to the housekeeper, who is a new one, and did not know one portrait; I suppose has never dared to ask my Lord.'[160] It was the purpose of his *Aedes* that this should not happen to visitors at Houghton. It must have been around this time that he presumably finished the fair copy of the manuscript, which he finally had ready for his printer, Robert Dodsley. Even then the volume was a long time in coming to fruition.

The first edition of the *Aedes* seems to have been finally printed in the summer of 1748. On finishing this first edition Horace voiced another concern that the *Aedes* answered: 'As my fears about Houghton are great, I am a little pleased to have finished a slight memorial of it, a description of the pictures, of which I have just printed an hundred, to give to particular people'.[161] His concern was over the debts that the family faced on the death of Sir Robert. Horace's brother, now 2nd Earl of Orford, was ill and he found it difficult to stand by and 'see the family torn to pieces, and falling into such ruin, as I foresee; for should my brother die too soon, leaving so great a debt, so small an estate to pay it off, two great places sinking, and a wild boy of nineteen to succeed, there would soon be an end of the glory of Houghton, which had my father proportioned more to his fortune, would probably have a longer duration.' This

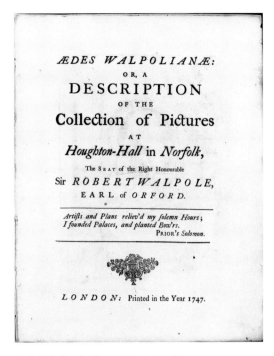

Aedes Walpolianae by Horace Walpole, 1st edition 1747
Courtesy of The Lewis Walpole Library, Yale University.
The 1st edition of the *Aedes* was actually printed in summer 1748
despite the date of 1747 on the title page..

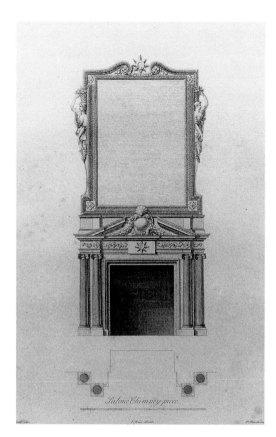

Pierre Fourdrinier after Isaac Ware, *Plan of the Salon Chimneypiece*,
1735, Boydell I, pl. XIV, line engraving
The Marquess of Cholmondeley

was to become a constant refrain for the rest of his long life.[162] At one point he even regretted publishing the *Aedes* at all: 'I am mortified now at having printed the catalogue'. Horace felt responsible for the fact that his catalogue somehow tempted providence, precipitating the first sale of paintings from the collection in 1751.[163] This might have been true if the sale had secured healthy prices: his work could have been accused of encouraging their prices to go beyond their values. This was not the case, however, as the pictures were sold at 'thrown away' prices, their recent provenance now having little apparent bearing on their values.

It might seem inconsistent for Horace to relate the *Aedes* — the record of the collection to be seen at Houghton — to the sale of paintings from Downing Street and Ranger's Lodge but both Sir Robert and his son evidently saw the collection as an entity. A manuscript survives which suggests that quite probably as Horace prepared to write the manuscript he wrote out a check-list of the artists with whom he was familiar: this refers to artists represented in the collection and is not exclusively of artists only represented at Houghton.[164] He carefully squirrelled this list away as with all his other writings. A rather more systematic record of Horace's process, however, is his fair copy manuscript prepared for Robert Dodsley (1703–64). Dodsley was the perfect publisher for Horace: he jokingly called himself the 'Muses Midwife' and published the work of Jonathan Swift, Samuel Johnson, Joseph Spence, Thomas Gray and Alexander Pope among many. He appears to have been a sympathetic interpreter of Horace's ideas for the presentation of the *Aedes*. A first layout for the title page survives in the British Library, which charts the early thinking about the nature of the publication.[165] The initial concept was to have featured Isaac Ware's section drawings, including ten chimney pieces and eight ceiling plans,[166] as well as to feature Dr. Henry Bland's inscription on the title page. The curious statement 'Table of Painters in Succession / eight or ten Printed Leaves / ornaments or Tail-peices' suggests a much more ornamented book than transpired, as well as plans for a 'Table' which was to set out in a chart the principal painters. The plan was to include all the outbuildings as drawn by Ware, while we also learn that 'First thoughts or considerations of M H. Walpole / To press the work in large sheets.' Horace evidently preferred in the end to opt for a more manageable scale, suitable as a guide for the visitor as well as for the record or for presentation to friends and family.

The extra-illustrated manuscript now in the collection of the Metropolitan Museum of Art, New York is a fascinating example of Horace Walpole's antiquarian method. Its interest lies not so much in it being a manuscript in preparation, as being a fair copy manuscript for the printer, which Horace subsequently retrieved and annotated in his usual style. The manuscript includes the Isaac Ware drawings as originally proposed, as well as a host of engravings and mezzotints of the paintings in the collection. Horace notes at the start of the folio: ' I have added the Prints of such of Them as I could get, and the Original Sections of the House as taken by Ware, from which he made his prints' (f.7). Both family portraits and the European masters are included in Horace's sweep, together with drawings of the room plans for Downing Street. Sometimes Horace has collected more than one printed version of a painting, usually a Continental version as well as early impressions of Boydell's mezzotints, presumably added as the individual portfolios were published. There is also Ware's original plan of the garden at Houghton (f. 16)[167] and prints after the designs from which some of Houghton's tapestries were woven. A loose-leaf folio in marbled boards, Horace listed this volume among the rare books in his library in the *Description of Strawberry Hill*, 1774. It also includes a family pedigree, compiled in 1776,[168] and the rejected 'Chronological Table of the Principal Painters and Schools', two printed sheets stuck down (f. 8). At the end of the 'Description' is a list of instructions to the printer in Horace's hand, referring to the handling and placement of the margin notes. The folio also incorporates

a pen and brown wash drawing inscribed 'Ceiling to the Gallery'. This is almost certainly Horace's drawing of the ceiling designed by Serlio in the Inner Library at San Marco, Venice to which Horace refers in the *Aedes*: 'brought from thence, by Mr. Horace Walpole Junior' (p. 76).[169] This magpie collection includes a rough print dedicated to Walter Robertson, merchant at King's Lynn after Rubens's *Lions* by one Henry Mackworth which Horace has helpfully annotated in pen: 'Blacksmith at Lynn' (f. 59). It also originally contained two broadsheets, *Houghton Hare Hunting* and *Prosperity to Houghton*.[170]

The entire collection is a fascinating compilation over many years, but one of the most important elements is the series of seven record drawings 'of the two principal apartments of the Treasury House in Downing Street as it was altered and fitted up by Sir Robert Walpole'. Horace typically wished to make a record of the apartments in their heyday. The plans do not match the inventory of 1736 and must postdate it, but they do predate 1742. To cite just one instance, the North East Corner Room featured by this time a portrait of George II by Kneller over the fireplace with a Jervas full-length portrait of Queen Caroline hanging opposite. Two Castigliones and a Swanevelt were hung as overdoors, while the two Kitchen Scenes by Teniers and De Vos remained in situ.[171] This fleshes out our appreciation of the room arrangement recorded in 1736, and incorporates the two recently purchased royal portraits, the Jervas presumably acquired prior to his death in 1739.[172] The royal family had at last been incorporated into the first room of the apartments.

In the Dyce Collection of the National Art Library, London there is another of those seemingly slight documents which nevertheless provides a startling insight into Horace Walpole's sphere of interest and influence at the time of publication of the first edition of the *Aedes*. In the absence of a published list of subscribers this document 'The List of Persons to whom I have given the Aedes Walpolianae' provides an even more personal view of Horace's main networks at the time.[173] A total of eighty-three people had received copies by the time of writing. The group consisted of a microcosm of Horace's principal connections, falling into four distinctive groups: family, Sir Robert's friends, Horace's friends and people of influence. That of family was the most obvious, as were the few surviving elderly friends and colleagues of Sir Robert and the far larger group of Horace's friends. Perhaps more instructive are the considerable number of people who held public office to whom Horace felt obliged to send a copy, yet who would on the face of it warrant a rather less handsome gift. Some names come as a surprise, perhaps none more so than the Norfolk painter to whom Horace had recently taken a shine but who was otherwise barely to feature in the history of even local art, John Davis (c.1696–1778). Davis, of Watlington, Norfolk, had made what Horace regarded as a good copy of Sir Robert's 'Domenichino' at Houghton, 'the third picture he ever copied in his life' and given it to Horace.[174] Horace regarded him as 'the most decent sensible man you ever saw' and one gift deserved another. The inclusion of the Prince of Wales dates the list to after Horace's audience with the Prince in July 1749 when they discussed the *Aedes*:

> In short he had seen my Aedes Walpolianae at Sir Luke Schaub's, and sent by him to desire one. I sent him one, bound quite in coronation robes, and went last Sunday to thank him for the honour. There were all the new Knights of the Garter. . . . he turned to me, and said such a crowd of civil things that I did not know what to answer: commended the style and the quotations, said I had sent him back to his Livy, in short that there were but two things he disliked, one that I had not given it of my own accord, and the other that I had abused his friend Andrea del Sarto; and that he insisted when I came to town again, I should come and see two very fine ones that he has lately bought of that master. This drew on a very long conversation on painting.[175]

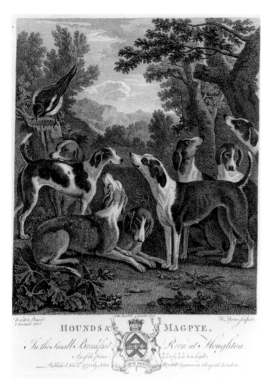

W. Byrne (from a drawing by Joseph Farington) after John Wootton,
Hounds and Magpye, Boydell I, pl. XIV, line engraving
Yale Center for British Art, Paul Mellon Collection

Horace was to spend the rest of his life, as with so many of his publishing projects, recording new information: extra-illustrating his original manuscript and annotating and up-dating his personal record copies at Strawberry Hill. It is thanks to this continuing process that we today know more of his father's collection than was compiled by 1743.

Once the *Aedes* was published Horace was immediately dissatisfied with it: he sent off two copies in October 1748 to Horace Mann and pronounced 'I am by no means satisfied with them; they are full of faults.'[176] The following decades saw a process of constant updating of his records, but only one significantly new edition, in 1752. While it was more than a further four years after he had signed off his 'Dedication' before the first edition was published, the 1752 edition was the outcome of that process of refinement that Horace was habitually undertaking. He became increasingly antiquarian in his method, and in his personal collecting, and it is evident that although his taste was not that of an absolute connoisseur, he was a judge of quality in painting with a good visual memory. He could also respond to paintings for their aesthetic and visceral impact upon him, appreciating far more than simply narrative content, despite his predilection for associative anecdote. The fact that the family and Exchequer purses were no longer there to support his interest beyond his own finances was instrumental in checking his expenditure on his collecting thereafter at Strawberry Hill.

The record keeping did not generate any changes to the content of the third edition of the *Aedes*, published in 1767. Horace's interest in the collection thereafter revolved around the publication of the collection of prints by the publisher and engraver John Boydell (1719–1804).[177] Although the collection was in the ownership of the 3rd Earl of Orford, Horace continued to perform his personally appointed role of Honorary Keeper of the Collection. Horace preserved in his extra-illustrated manuscript a letter from Boydell which provides a snapshot of his continued involvement. Writing over 5–7 November 1775, Boydell discusses the second folio of ten prints from the collection to be published. Boydell proposed a blue cover but asked that if anything 'strikes you for the better please to mention it'. He added: 'Enclosed is a proof of the Hounds which I w. willingly put in this Number as it is a subject that generally pleases, particularly County Gentlemen – desire your immediate opinion of it that Mr. Byrne[178] may finish it directly'. Horace seems to have been consulted at several stages through the genesis of this publication: 'J. Carreras and Inigo Jones are much better than the proves you saw. The Shepherds Offering is particularly much improved'. Boydell even seems to have hoped to change some of Horace's titles: 'The Larder I do not know what title you give it better, a Cook's shop is certainly very improper.' Boydell also shared with Horace some of the frustrations of dealing with recalcitrant engravers: 'The Europa has been with Bartolozzi some time, I cannot have it to publish with this number.' When Boydell's folios were finally published as a two-volume set, Horace's *Aedes* 'Description' accompanied them as the letterpress.

Horace had believed from the beginning of his *Aedes* enterprise that he was producing a volume that would have a signal impact upon the history of collections within Britain. A number of his own subsequent publications were modelled on the example of the *Aedes*. While he had been inspired by the example of Carlo Gambarini's catalogue of the Pembroke Collection, he effectively cited it as a negative influence. In 1757 he published a *Catalogue and Description of King Charles the First's Capital Collection of Pictures, Limnings, Statues, Bronzes, Medals, and other Curiosities; Now first published from an Original Manuscript in the Ashmolean Musaeum at Oxford. The whole transcribed and prepared for the Press, and a great part of it printed, by the late ingenious Mr. Vertue, and now finished from his Papers*. In the 'Advertisement' of this volume is his account of his purpose, which was to publish the work of the Keeper of the King's Cabinet, Abraham van der Doort, as

transcribed by Vertue. Once again Horace aimed to make reparation, this time for 'the stroke that laid Royalty so low', the demise of Charles I:

> Hitherto, this Vanderdoort, and one or two foreigners scarce better qualified, have been the chief illustrators of British Musaeums. One Gambarini began with Lord Pembroke's collection, and made pompous promises of proceeding with what he was incapable of executing well. There is another account of the pictures and statues at Wilton:[179] the coins and medals have been published in a fair edition. Many of the duke of Devonshire's and doctor Mead's appear in Haym's Tesoro Britannico.[180] These, and the Aedes Walpolianae, are, I think, the only descriptions of the riches of a country, which for some years has been assembling the arts and works of the politest nations and greatest masters.[181]

Horace here adds to our knowledge of his principal models in creating the *Aedes*, adding Haym to his list of main sources already acknowledged in the *Aedes* itself.[182] Nicolas Haym, a Roman domiciled in London, published his two volume bi-lingual catalogue of the coins and medals in Britain in 1719–20. Horace consciously applied Haym's cataloguing methods to his father's collection of paintings and sculpture, as well as adopting the more noble presentation methods of Hieronymus Tetius. Haym, in the preface to volume II, explains his purpose: he has detailed provenance, most of which came from the Devonshire Collection; he has indicated quality and borne in mind the need to be concise and has been typological in his approach. These were not precisely the methods used by Horace, who in addition adopted the further format of a practical and visual room by room guide, and it again becomes clear that Horace has been original in his enterprise.

Horace's ambitions for his publications were that they should contribute towards a greater appreciation of the arts in England, both by way of recording and celebrating the great collections.[183] He also believed he was contributing towards the debate for the establishment of a 'British academy of arts', a 'new aera of virtù', in which 'pictures and statues flow in to books and medals, and curiosities of every kind'.[184] When Horace visited Houghton in March 1761 he saw the collection again and felt that his work did not do them justice: 'The surprise the pictures gave me is again renewed—accustomed for many years to see nothing but wretched daubs and varnished copies at auctions, I look at these with enchantment. My own description of them [the *Aedes*] seems poor—but shall I tell you truly—the majesty of Italian ideas almost sinks before the warm nature of Flemish colouring! Alas! Don't I grow old? My young imagination was fired with Guido's ideas—must they be plump and prominent as Abishag to warm me now? Does great youth feel with poetic limbs, as well as see with poetic eyes?'[185] We see Horace changing his standpoint from that of his earlier writing. Horace was to continue to receive criticism for his treatment of the Dutch and Flemish Schools in particular. In 1780 he wrote to the Rev. William Cole: 'Some blamed me for undervaluing the Flemish and Dutch painters in my preface to the *Aedes Walpolianae*. [James] Barry the painter, because I laughed at his extravagances, says, in his rejection of that school, "But I leave them to be admired by the Honourable H. W. and such judges!"—Would not one think I had been their champion?'[186] Barry had misjudged Horace's reaction to the Dutch and Flemish painters, basing his diatribe upon Horace's reaction to one of his paintings on exhibition, rather than any real critique of his writings.

There was one more area in which Horace proceeded to redress the balance in his art critical writings subsequent to the *Aedes*. He was aware that his treatment of the English School was non-existent and the acquisition of Vertue's writings enabled him to embark upon his *Anecdotes of Painting*, a project which he described to the Rev. Henry Zouch in February 1760: 'From Henry VIII there will be a regular succession of painters, short lives of whom I am

enabled by Vertue's MSS to write, and I shall connect them historically. I by no means mean to touch on foreign artists, unless they came over hither; but they are essential, for we had scarce any painters tolerable.'[187] This opinion of English art was by no means unique to Horace Walpole and has had a lasting impact on the subsequent appreciation of British art and of Horace as an art critic in the critical literature. However it should not cloud the quality of our appreciation of his response to his father's collection.

The *Aedes Walpolianae* was conceived as a paean of praise for a truly 'capital' collection formed in the taste of the grand tour. It also published a collection created under unique circumstances for England's first and most powerful minister, whose example was to shape a nation's awareness of premiership. At the same moment it became the standard by which English country house collections were increasingly to be described and appreciated. Finally, it was compiled by one of the most influential writers of the eighteenth century, at a time when his opinions and connoisseurship had been freshly shaped by the experience of the grand tour. Horace Walpole was uniquely placed both to celebrate and perpetuate a collection whose subsequent history proved as auspicious as its origins.[188]

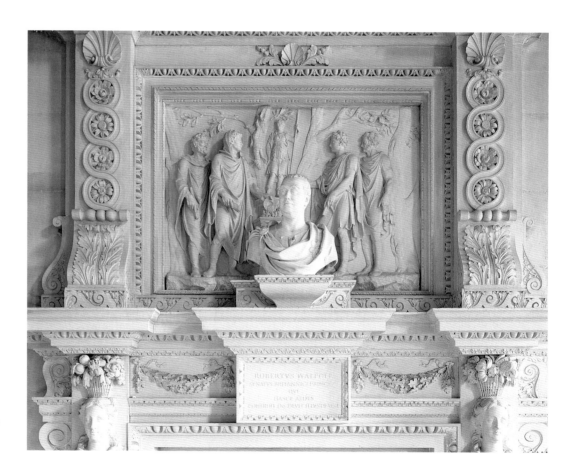

John Michael Rysbrack, Bust of Sir Robert Walpole, marble, height 63.5, c. 1726, The Stone Hall, Houghton Hall
The Marquess of Cholmondeley

1 'A Catalogue of the Right Hon.ble Sir Robert Walpole's Collection of Pictures, 1736', Autograph MS, thirty-six folios, 24.2 x 13.8 cm, bound into the author's copy of *Aedes Walpolianae*, 2nd edition, London 1752 (with extensive annotations), New York, The Pierpont Morgan Library, PML 7586 (see Appendix III).

2 'Aedes Walpolianae, or, a description of the collection of pictures at Houghton Hall'. Original MS by HW, extra illustrated with 120 drawings and prints, and Ripley's original drawings of buildings. Folio. Hazen 1969, 3546.

3 *The Daily Post*, 29 July 1740. p. 2, col. 3.

4 For example, in *The Craftsman Extraordinary*, 30 December 1726, p. 66, a critic had directly compared Walpole to Wolsey in the following terms: 'This saucy Minister, who, by the way, could never get rid of the scoundrel habits of a low Education, had some knowledge, more wit and much more impudence; the fortune he made was equally exorbitant and rapid. The use he made of this fortune was extravagant and ostentatious to the highest degree. He seem'd industrious to erect the trophies of his folly, and to furnish the truths of his rapine wherever he went. He adorned Villas, he built Palaces; and his train outshin'd his Master's so much, that when he retired into the Country, on a party of pleasure, the Court became desart. Even foreign Ministers attended on him and found their account in it, for he had ever found some interest separate from that of his Country. He was zealous for the Emperor, zealous for France; and zealous for the Court of Rome, in their turns; and notwithstanding his parts, he was the Bubble of them all.' Bindman 1997, pp. 72-73.

5 Horace himself was already a beneficiary of the system: 'My mother died Aug.20, 1737. Soon after, my father gave me the place of Inspector of the Imports and Exports in the Custom, worth £500 a year, which I resigned on his appointing me Usher of the Exchequer in the room of Colonel William Townshend Jan. 29, 1738; a place worth above £1500 a year. And as soon as I came of age I took possession of two other little patent places in the Exchequer, called Controller of the Pipe, and Clerk of the Estreats, worth united about £300 a year.' HW, Walpole's Short Notes, HWC vol. 13, pp. 7-8.

6 The invoice was paid on 1 April 1749 (Holkham accounts).

7 Vandrulle is presumably a *nom de plume* for the engraver of the broadsheet.

8 Hazen 1969, 3725. Strawberry Hill Sale, day 7, lot 69. This was probably kept in the Glass Closet at Strawberry Hill in 1763 and therefore escaped being catalogued. See also pp. 11, 12.

9 Houghton Library O 4a 4-5.

10 Hazen 1969, 297 (now Fellows Library, Eton) and Hazen 1969, 2378 (now LWL).

11 *Aedes Pembrochianae: or a critical account of the statues, bustos, relievos, paintings, medals, and other antiquities and curiosities at Wilton – House. Formed on the plan of Mr. Spence's Polymetis; The Ancient Poets and Artists being made mutually to explain and illustrate each other. To which is prefixed, an Extract of the Rules to judge of the Goodness of a Picture: and The Science of a Connoisseur in Painting. By Mr. Richardson. With a complete index; by which any particular statue, Busto, Painting, &. And the Places or Rooms where disposed, may be immediately turned to*, London: Printed for R. Baldwin, in Pater-Noster-Row, MDCCLXXIV.

12 HW later in life was to cast a critical eye over this parvenue publication and had to admit that it was infinitely better than Gambarini's account of the Wilton collection. His copy from Strawberry Hill bears a number of MS corrections and is inscribed on the title page 'This is the last & truest account, yet is not without some faults. Hor Walpole'. For another comment on Gambarini by HW, see p. 48.

13 HW's library at Strawberry Hill included a few works by Trapp, notably *Praelectiones Poeticae*, London 1722 (now British Museum) which bears the signature 'Hor. Walpole 1733'. Hazen 1969, 2135.

14 I am grateful to Clare Haynes for drawing my attention to this poem (from the English Poetry Full-text Database published by Chadwyck-Healey Ltd.). For John Whaley see 'A Journey to Houghton', below p. 407, note 1.

15 For full definitions see Oxford English Dictionary.

16 HW's 'List of [83] Persons to whom I have given the Aedes Walpolianae. N.B. There were but one hundred copies printed.' (Strawberry Hill Sale day 4, lot 155) is now in the Dyce Collection, Victoria & Albert Museum (Hazen 1969, 2483). See Appendix V.

17 HW, 'Book of Materials', I, 1759, p. 44 (LWL).

18 HW, MS Commonplace Book, p. 26 (LWL).

19 See *Aedes*, title page, p. 353.

20 See p. 355.

21 Zincke had designed the original miniature in 1735.

22 HW to Charles Lyttelton, 18 September 1737; HWC vol. 40, p. 23.

23 HW to Mann 24 October 1748; HWC vol. 19, p. 511.

24 Horace Walpole's copy, Hazen 1969, 2432. Now LWL.

25 'JOANNI WOOTTON / Pictorum saeculi sui non infimo, / ducu-lentam hanc aulae tabularumque Houghtoniarum descrip-tionem, / quibus pares vix ullibi terrarum inveneris, / meliores sane peregrinando frustra quaesiveris, / dono dedit, ipsissimus libri auctor, / HORATIUS, / filiorum ROBERTI WALPOLE, / COMITIS ORFORDIAE, / natu solummodo minimus. / MDCCLIV / Hunc, mi nate, librum vosque o servate nepotes, / Aeternum magnae pignus amicitiae.' LWL 24 4B copy 3.

26 *Aedes* 1752, p. vii.

27 Presumably William Musgrave (born c.1698), son of Philip Musgrave of Lincolnshire, matriculated Merton College, Oxford, 16 July 1715, proceeded to MA 24 January 1721/22. Foster 1888, iii, p. 1002.

28 LWL. The dedication to Walpole is here offered by 'Philalethes': 'In the midst of all his Cares for his Country, I will take the Freedom to offer up the following Memoirs at the Shrine of his Merit … The very best Men, have it not in their Power, so to conduct themselves in a censorious World, as to be safe from Envy and Calumny'. In this case Musgrave was taking a lead from 'Lord Lansdowne's Vindication of Sir Richard Granville. 4to.p. 557.'

29 Perhaps more significantly, Ashton had been living with HW in 1742, when HW sought a living for Ashton at Aldingham, Lancs.

30 The edition in the Beineke Library bears the bookplate of Cardinal Antonio Barberini (1608-71), and also that of the Earl of Galloway. Rare Book Room Jat78.R61.642T. Red morocco, gold tooled with the Barberini arms.

31 See p. 46 .

32 *Aedes* 1752, p. 10.

33 These included at Strawberry Hill a 1725 edition of Andre Felibien, *Entretiens …, 6* vols. (Hazen 1969, 1294) and a 1701 edition of Charles Le Brun, *Conference on Expression* (Hazen 1969, 361 (1)).

34 By his own account HW spent hours here with his dog Patapan: ' My love to Mr. Chute; tell him, as he looks on [the plans of] the east front of Houghton, to tap under the two windows in the left-hand wing, upstairs close to the colonnade – there are Patapan and I at this instant writing to you: there we are almost every morning, or in the library'. HW to Mann 28 August 1742. HWC vol. 18, p. 36.

35 See also footnote to *Aedes* 1752, 'The Library', p. 49.

36 I am indebted to Lord Cholmondeley and Hamish Bain for enabling me to consult his full catalogue of the Houghton Library. In addition it should be noted that Abraham Langford (1711-74) organised a sale of books which included works properly regarded as those of Sir Robert, rather than exclusively of his son Robert: 'A catalogue of the genuine and curious collection of books of the Right Honourable the Earl of Orford, deceas'd; (brought from his late lodge at Richmond-Park) … which will be sold by auction, by Mr. Langford … on Wednesday the 17th and Thursday the 18th of this instant July 1751.at his house in the Great Piazza, Covent-Garden' (London 1751).

37 *Ibid.*, day 1, lot 88.

38 I am grateful to Joseph Friedman for drawing my attention to the Dedication in a copy in the British Library. Le Blon also dedicated his translation of Lambert Ten Kate, *The Beau Ideal* (1732) to Lady Walpole (Hazen 1969, 3882).

39 HW preserved his drawing of the ceiling of the Inner Library of San Marco, Venice, inserting it in his MS. Aedes (Metropolitan Museum of Art, New York).

40 Mann to HW, 17 June 1742. HWC vol. 17, p. 443.

41 See summary note to the 'Sermon', in this volume, p. 399ff.

42 HWC vol. 17, pp. 491-93.

43 HW identified closely with the collection, as much as with the desire to support his father's reputation. When HW visited Houghton in 1773 and witnessed its deterioration, he wrote: 'The pictures alone have escaped the devastation. Methinks I could write another sermon on them; it would be crowded with texts from the lamentations of Jeremiah. What can I say to you but woe, woe, woe?' HW to Mason, 3 September 1773. HWC vol. 28, p. 103.

44 A bottle of Hogen is said to be buried under the foundation stone of Houghton; surely no finer tribute could be made for the hospitality intended to be bestowed at the inception of a Country House. *Gentleman's Magazine*, 1735, V, p. 216. HWC vol. 13, p. 112.

45 Three broadsheets were removed from HW's copy of the extra-illustrated MS. Aedes and sold to W. S. Lewis at the time that the Metropolitan Museum of Art, New York purchased the MS. They are now LWL. HW's MS notes identify the anonymous writers as Philip Floyd and Sir William Yonge respectively.

46 For Whaley's biography and poetry see 'A Journey to Houghton', footnote 1.

47 See *Aedes* 2002, no. 79, Florentine workshop after Giambologna, *Rape of the Sabine Woman*.

48 Mann to HW 20 June 1749. HWC vol. 20, p.69.

49 HW, 'Short notes of the life of Horatio Walpole, youngest son of Sir Robert Walpole, Earl of Orford, and of Catherine Shorter, his first wife.' HWC vol. 13, pp (1)-51 (see also for the following facts about HW's tutors).

50 See *Aedes* 2002, 'Description', p. 370 note iii.

51 See *Aedes* 2002, 'A Journey to Houghton', footnote 1.

52 *A Description of Strawberry Hill*, p. 85, notes a portrait of 'Rembrandt; by old Lens', to which HW added an MS note in his copy 'given by Lens to Mr H. Walpole when he left off learning to draw'. Hazen 1969, 2552a.

53 HW Commonplace Book, 49.2616. II, p. 40 (LWL). *Gentleman's Magazine*, VI, p. ii, February 1736 (*Universal Spectator*, 14 February, No. 184), see Moore 1985, pp. 13-14.

54 HW to Richard West 21 April 1739, HWC vol. 13-14, I, p. 165.

55 See 'Introduction', p. 365 note ci.

56 HW to Richard West, 28/30 September 1739. HWC vol. 13-14, I, p. 182.

57 HW to Richard West, 14 December 1739. HWC vol. 13-14, I, p. 192.

58 Epistle from Florence to Thomas Ashton, Esq., Tutor to the Earl of Plymouth.

59 HW to Richard West, 16 April 1740. HWC vol. 13-14, I, p.208.

60 *Ibid.*, 7 May 1740. HWC vol. 13-14, I, p.214.

61 *Ibid.*, 2 October 1740. HWC vol. 13-14, I, p. 232.

62 HW to H. Mann, 8 October 1741. HWC vol. 17, pp. 166-67.

63 See Mowl 1996; Brownell 2001; Haggerty 2001.

64 *Aedes* 2002, no. 139.

65 *Aedes* 2002, no.275.

66 See Brownell 2001, pp. 28-36 for an extended account of this chase.

67 HW's extra-illustrated MS. Folio 59 verso. Now Metropolitan Museum of Art, New York.

68 Some attributions continue to be open to new understanding. See individual catalogue entries.

69 Hazen 1969, 2051. LWL.

70 HWC vol. 20, p. 407.

71 *Cours de peintures par principes*, Paris 1708; *Abrege de la vie des peintres*, 2nd edition, Paris 1715. Hazen 1969, 351, 350.

72 *Entretiens sur les vies et sur les ouvrages des … peintres*, 6 vols. Trevoux 1725. Hazen 1969, 1294.

73 *An account of some of the statues, bas-reliefs, drawings, and pictures, in Italy*, London 1722 (Hazen 1969, 309); *Two discourses; I. An essay on the whole art of criticism as it relates to painting …. II. An argument in behalf of the science of a connoisseur*, London 1719 (Hazen 1969, 310).

74 Hazen 1969, 251.

75 Plumb 1956 and Plumb 1960. See also Ketton-Cremer 1940; Ketton-Cremer 1948; Sutton 1981; Hill 1989.

76 Notably Tipping 1921; Hussey 1955; Hussey 1963; Cornforth

77 Christie's 1994.

78 For Houghton archive studies see Bowden-Smith 1987; Davison et al. 1988; Yaxley 1984; Yaxley 1994; Yaxley 1996. For Houghton in the context of other studies see Beard 1975 and 1981; Girouard 1978, pp. 160-62; Moore 1985, pp. 22-24; Moore 1988a, pp. 13-15; Williamson 1995, pp. 51-55. For Houghton in the context of HW studies see Brownell 2001, pp. 37-68.

79 Boydell, 2 vols. 1788; See also Rubenstein 1991.

80 Moore ed. 1996: contributors, Chloe Archer, Geoffrey Beard, The 7th Marquess of Cholmondeley, John Cornforth, Sebastian Edwards, John Harris, Andrew Moore, Gregory Rubenstein, William Speck, Tom Williamson.

81 See pp. 63, 64, 70.

82 Sold Christie's 20 April 1990, lots 53-55; now Spencer House, St. James's.

83 Sold Christie's 20 April 1990, lots 57-59. Also Christie's 12 June 2002, lots 32–33.

84 Seymour 1734-35, II, p. 655. Prior to moving into Downing Street RW had tenanted in St. James's Square, November 1732-September 1735. Thanks to Joseph Friedman for this information.

85 'at Lord Walpoles many excellent picture.part of Sr. Roberts purchasing, a fine piece of dead fowl birds game. A swan & c. a rare & capital large piece – of Snyders. 2 large pieces of Rosa of Tivoli a Holy family Carlo Morat a head of Sr. G. Kneller – a print from it, by Becket – another head of of [sic] a Fryer a bold head of Kneller one of the most capital – several whole lenghts, by Vandyke that did belong to Ld. Wharton – King Charles first in armor. his Queen – Philip Ld. Wharton 1639. Sr. Thomas Wharton 1639. & 4 other Ladies. Over the Chimney Ruubens his wife & child one of Jordans of Naples. 2 fine Bordones Snyders a fox hunting – a Brower', Vertue, III, p. 44. See also Vertue, V, p. 85.

86 See 'Walpole Family Houses and Residences 1676-1745' in Moore ed.1996, pp. 164-65.

87 A catalogue of the late dwelling house, in Dover-Street, St James's late in the possession of the Right honourable The Lady Walpole, deceas'd … at the said House in Dover-Street, St James's, on Tuesday the 28th, and Wednesday the 28th of April, 1741 … Catalogues may be had Gratis at the place of sale, and at Mr. Cock's, in the Great Piazza, Covent Garden. Saffron Walden Museum, Essex. Other properties were involved in this sale and Mr. Cock may have been eliding collections together, with the finesse of the auctioneers of the period. The sale was advertised in the Daily Advertiser, no. 3192 (14 April 1741) Joseph Friedman.

88 RW had also occupied [17] Arlington Street 1715-32, where his early acquisitions were hung. See Vertue I, p. 122; Vertue III, p. 9; Vertue III, p. 18. Vertue refers to RW as 'Mr Walpole', indicating his notes date prior to RW's knighthood in 1725.

89 See Vertue, I, p. 109.

90 See Appendices.

91 HW to Montagu, 25-30 March 1761. HWC vol. 9, p. 348.

92 Baker and Baker 1949, pp. 83-84.

93 'Voiage D'Angleterre D'Hollande Et de Flandre fait en L'annee 1728'. National Art Library, MS 86 NN 2, ff. 82-83. I am grateful to Joseph Friedman for drawing my attention to this MS. Francis Russell has also suggested this author may be Pierre-Jacques Fougeroux, to whom Antoine-Joseph Dezallier d'Argenville was related.

94 Aedes 2002, no. 140.

95 Aedes 2002, no. 94.

96 Aedes 2002, no. 258 and ?no. 259.

97 Aedes 2002, no. 38.

98 Aedes 2002, no. 251.

99 Aedes 2002, no. 106.

100 Aedes 2002, no. 257.

101 Aedes 2002, nos 267, 268.

102 1736 MS, Downing Street, no. 178.

103 Aedes 2002, ?no. 256.

104 1736 MS, Grosvenor Street, nos. 298, 299.

105 1736 MS, Grosvenor Street, no. 306.

106 1736 MS, Downing Street, no. 169 and Grosvenor Street, ?no. 300.

107 Aedes 2002, no. 239?

108 Aedes 2002, no. 238?

109 HW to H. Mann, 30 June 1742 records one auction house visit, possibly that of 21-25 June, of 'the rich household furniture and valuable effects of the Right Hon. Lord Viscount St. John, at his Lordship's late dwelling house in Albemarle Street'. HWC vol. 17, p. 477.

110 See Moore 'Sir Robert Walpole: The Prime Minister as Collector' in Moore ed. 1996, pp. 48-55 for an account of the development of Sir Robert's collection.

111 Toynbee, 'HW's Journals of Visits to Country Seats &c', Walpole Society 1928, p. 14.

112 Architect, possibly Isaac Ware or Thomas Ripley. I would here like to acknowledge a valuable discussion with Joseph Friedman and in particular his generous sharing of his researches into London newspapers.

113 Survey of London, XIV, Part III, p. 123 ff.

114 See footnote 2 above. These plans in fact present a problem, as do most of the plans relating to Houghton as well. The Downing Street plans relate to a schema that is not that recorded in the inventory of 1736. HW securely identifies the drawings as 'of the two principal apartments of the Treasury House in Downing Street as it was altered and fitted up by Sir Robert Walpole' (f.67). They appear to represent a subsequent and more considered arrangement to 1736, but prior to the full house clearance of 1742. It should be remembered that Houghton was finished in stages, just as new acquisitions continued to flow in. Vide addendum to 1736 Inventory: 'Pictures bought since the catalogue was made'. This details acquisitions included in the HW picture hanging plans.

115 The following account, based on the 1736 inventory, is an amplification of that provided by Vertue's notes of a visit c. 1740: the paintings recorded by Vertue, while substantially less inclusive, are almost all those of 1736, with only a few differences. See Vertue V, pp. 125-26.

116 'North East Corner Room: First Floor'. HW Met. MS f. 67.

117 The paintings cited in the following description of the rooms in RW's London residences may all be found in the Aedes, unless cited otherwise. The modern attributions are given where confirmed. See Concordance and Catalogue.

118 1736 MS f. 13 (Aedes 2002, no. 242).

119 Vertue V, p. 14.

120 See the account of Vandrulle's print above, pp. 6–7.

121 Dodsley 1761, II, p. 101.Thanks to Joseph Friedman for this information.

122 Moore ed. 1996, p. 54.

123 See Cynthia Wall, 'The English Auction: Narratives of Dismantlings', Eighteenth-Century Studies, vol. 31, no. 1 (1997), pp. 1-25.

124 For full details of RW's agents, buyers and collectors see Appendix I. The following account concentrates upon RW's networks. For a more strictly chronological treatment of the development of the collection, see Moore ed. 1996, chapter 6.

125 See Moore ed.1996, pp. 53, 133.

126 Aedes 2002, no. 153.

127 Aedes, p. 94, nos.269, 270.

128 See Appendix I, Directory of Agents, Buyers and Collectors, for details.

129 Hazen 1969, 2507:4.

130 Dodsley 1761, II, pp. 224-32.

131 HW's 1760 catalogue was printed in the same year as his first printed catalogue of any part of his own collection, Catalogue of Pictures and Drawings in the Holbein Chamber. Dodsley and HW were here both working in advance of publication of T. Martyn's wider-ranging The English Connoisseur (1766).

132 Dodsley 1761, IV, p. 263.

133 Those at Downing Street were later sold to Sampson Gideon, 1751 (see Appendix VII).

134 HW to Horace Mann, 25 March 1743. HWC vol. 18, p. 202.

135 HW: 'Sr. RW had a great inclination, instead of building at Houghton, to have bought the old Cavendish House, built at Roehampton by the Cs of Shrewsbury, called Bess of Hardw. & have built there – but was afraid of the expence of living so near London – He saved nothing by not.' Book of Materials, I, 1759, p.41. LWL.

136 HW: '[RW] took the idea of the Towers of Houghton from Mr. Child's at Osterley, built by Sr. T. Gresham, who like the Duc de Feuillade, built the wall of a court in a night's time, while Q. Eliz was there, bec. She sd it wanted one.' Book of Materials, I, 1759, p. 41. LWL.

137 Ilchester, Lord Hervey and his friends, 1726-38, 1950, pp. 70-72.

138 Ilchester, ibid., pp. 73-74.

139 The Scheme Disappointed, A Fruitless Sacrifice, a print principally satirizing RW's Excise Scheme, published April 1733, Stroud et al., no. 1928.

140 See p. 43, concerning the Gallery.

141 National Archives of Scotland, Clerk Papers, GD18/5245/4/99, Charteris to John Clerk of Penicuik, 16 August 1732. At this time Charteris was overseeing work on the house and grounds at Wolterton. I am grateful to Iain Gordon Brown for sharing his research into the papers of Sir John Clerk of Penicuik (1676-1755).

142 This early arrangement for the four market scenes by Snyders was rectified as soon as the Gallery was finished.

143 'Report on the Mss. of His Grace The Duke Portland, preserved at Welbeck Abbey', vol. VI, pp. 160-61, HMC 29, 1901.

144 Another important documentary record which describes both Houghton and Wolterton at this period is the 1733 travel diary of Sir John Clerk, 2nd Bt of Penicuik (1693-1754). National Archives of Scotland MS GD18/2110/4.

145 HMC, Portland MSS, vol. vi, p. 171.

146 British Library Add. Mss. 15,776, ff. 61-66.

147 British Library Add. Ms. 38,488 (part of the Liverpool papers): Houghton Sunday 29 / Monday 30 July 1741ff. 17b-49. I am grateful to Richard Wilson for sight of his essay which will publish this journal in full in C. Rawcliffe, C. Harper-Bill and R.G. Wilson, eds., Studies in East Anglian History in Honour of Norman Scarfe (forthcoming). Other journals survive which record visits to Houghton, notably 'Diary of a travelling man', (entry c.1745) in the collection of the Sir John Soane Museum (A.L.46A). Grateful thanks to Edward Bottoms and Susie West.

148 MS, stamped Eaton Estate Office, Eccleston, Chester. Cover inscribed: 'Houghton Hall / begun 1722 / perfected 1735 / R. W.' Photostat copy in Houghton Archive. The inventory of the collection is substantially that of the Aedes.

149 HWC vol. 18, p. 218.

150 HWC vol. 17, p. 452.

151 HW to Lincoln 23 August 1742. HWC vol. 30, p. 33.

152 RW to HW 14 July 1744. HWC vol. 36, p. 9.

153 Hazen 1969, 2492 (1).

154 Joyce Godber, 'The Marchioness Grey of Wrest Park', Bedfordshire Historical Record Society, vol. XLVII, 1968, p. 144. Subsequent visitors to Houghton who recorded their visits in some detail include Lady Letitia Beauchamp Proctor, in 1764 and 1772, and William Gilpin (1724-1804).

155 See Appendix IV.

156 Samuel Sandys (1695-1770), cr. Baron Sandys (1743), RW's immediate successor as Chancellor of the Exchequer, who had been responsible for the motion to remove RW ('a very simple fellow' HW).

157 HW to Horace Mann, 14 July 1742. HWC vol. 17, p. 495. HW made the comparison again in HW to C H Williams, 17 July 1744. HWC vol. 30, p. 63.

158 HW to Horace Mann, 2 December 1742. HWC vol. 18 p. 119.

159 HW to Horace Mann, 4 August 1743. HWC vol. 18, p. 292.

160 HWC vol. 30, p. 80.

161 HW to Mann, c. August 1748. HWC vol. 19, p. 496. See also Appendix I, 'List of Persons …'.

162 For the story of the efforts to retrieve the family's debt see Moore ed. 1996, chapter 7 and Larissa Dukelskaya, in the essay following.

163 HW to Mann, 18 June 1751. HWC vol. 20, p. 261.

164 LWL.

165 British Library Add Mss 23090, f. 49. A curious document survives in the Norwich Record Office (NRO MS. DS 489 351 x 3) which has all the appearance of being HW's first draft of the *Aedes* while in front of the pictures in situ, compiled prior to the manuscript for Dodsley. This dates the manuscript to 1742–43, shortly after the Gallery was first hung. The arrangement of works is that recorded in the *Aedes*, but includes one additional painting at the end of the description of the Gallery that did not make the final hang as published in the *Aedes*: a *Holy Family, with Angels*, attributed to Valerio Castelli, 'who studied Vandyke'. The manuscript notes are closely written on a series of small folded sheets of paper and give HW's descriptions of the paintings which were subsequently edited for publication. In the process measurements were added, together with historical details presumably from printed sources, while a great number of more whimsical or repetitious observations were cut. Four of the five sheets are also inscribed with the name of Robert Marsham of Stratton Strawless, suggesting that HW was using the scrapped outer covers of documents or letters for his initial notes. One additional provenance is given which was not published in 1747/48: Andrea Sacchi's *Venus Bathing* is noted as coming from Lord Halifax'x collection, a mistake that crept into the 1752 edition.

166 Already published by Ripley, 1735.

167 'Geometrical Plan of the Garden, Park and Plantation of Houghton', 42.8 x 51.4 mm.

168 'A Pedigree of Walpole to explain the portraits and coats of arms at Strawberry Hill Anno. 1776'.

169 Pen and brown wash with added touches of monochrome wash on paper (24.8 x 32.7 cm), 19.7 x 28.2 cm. (folio 53).

170 These were removed and sold separately to W.S. Lewis at the time the collection was acquired by the Metropolitan Museum of Art. Now LWL. See also above p. 14.

171 See Appendix III, Nos 123,124,129-31.

172 Appendix III, Nos 449, 451. See also footnote 114 above. This analysis indicates a later dating than 1735 as given in the M. Cox and P. Norman, *Survey of London*, XIV, 1931, plates 149-54. Plate 148 is also of this series, and not 'circ. 1751'. See also figs on pp. 24-29.

173 See Appendix V. Hazen 1969, 2483.

174 HW to Horace Mann, 25 December 1746. The painting later hung in the Gallery at SH. Sold SH, xxi, lot 68.

175 HW to Montagu, 5 July 1749. HWC vol. 9, pp. 88-89.

176 HW to H. Mann, 24 October 1748. HWC vol. 19, p. 511.

177 An advertisement published by Boydell, dated 25 March 1775, includes a list of ten works, which were due to be released in the first issue: 'THE COLLECTION OF PICTURES AT HOUGHTON, THE SEAT OF THE Right Honourable the Earl of Orford, IS NOW ENGRAVING BY SUBSCRIPTION, AND PUBLISHING BY THE PROPRIETOR JOHN BOYDELL, ENGRAVER IN CHEAPSIDE, LONDON.' This bears the proposal: 'This collection is universally allowed to be the first in the Kingdom, and is esteemed, by the best Critics, to be equal to any in Europe. It consists of upwards of Two Hundred Pictures, after which Engravings are now executing; which will be published in Numbers, and printed in Two Volumes, of the same size as the Proprietor's former Undertakings.

The whole work will be included in about Eighteen Numbers, at Two Guineas each, to be paid on the Delivery; not less than Ten Prints will be published in each Number. The Proprietor exercises his utmost care to have the Work performed in a manner which shall render it an /Honour to our Country, a faithful imitation of the Originals from which it is taken, and a Credit to every Artist employed in it.

The Proprietor promises that the Subscribers shall have the first Impressions; that no more than Four Hundred complete Sets shall be printed; and that as soon as the above number shall have been subscribed for or sold, the Subscription shall be closed.' Insert in 1752 edition, now University Library, Cambridge (Rare Books VIII.2.42).

178 William Byrne (1743-1805), engraver.

179 HW: 'By Cowdrey'. Richard Cowdry, *A description of the pictures … at Wilton*, London 1751. Hazen 1969, 2387 (6(1)). This account was finally updated once more and published as *Aedes Pembrochianae: or a critical account of the … curiosities at Wilton House*, London 1774. Hazen 1969, 2387 (6).

180 Niccolo Francesco Haym, *Del tesoro Britannico parte prima*, 2 vols, London 1719-20. Hazen 1969, 269.

181 HW 1757, pp. iii-iv.

182 ie. Hieronymus Tetius, *Aedes Quirinalem … descriptae*, Rome 1642 and Joseph Spence, *Polymetis*, London 1747.

183 cf. T.F. Dibdin, *Aedes Althorpianae; or an account of the mansion, books, and pictures, at Althorp; the residence of George John Earl Spencer, K.G. to which is added a supplement to the Bibliotheca Spenceriana*, London 1822. If imitation is the sincerest form of flattery HW would have been pleased with the publication of this volume which included a direct quote from his own description of the Althorp Picture Gallery: '…the Gallery at Althorp, one of those enchanted scenes which is a thousand circumstances of history and art endear to a pensive spectator'. Walpole, *Anecdotes of Painting*, vol. III, p. 18 (1765 edn.)

184 *Ibid.*, p. iv.

185 HW to Montagu, 25-30 March 1761. HWC vol. 9, p. 348.

186 HW to Cole, 5 February 1780. HWC vol. 2, p. 189.

187 Zouch (c.1725-95), 4 February 1760. HWC vol. 16, p. 37.

188 Horace Walpole's links to Houghton continued after his death. He drew up the following list of paintings, also published in HWC 30, pp. 370-71, as part of his will. Many of the paintings, formerly at Strawberry Hill, may be identified as still at Houghton today. Where confirmed, these are indicated with an asterisk.

List of Pictures to be sent to Houghton if the lawsuit is decided in favour of Lord Cholmondeley: if not they are to go with the house in Berkeley Square
The Lions very large [a copy of cat. no. 137]★
Elector Palatine [now called *Prince Edward*]★ *and Prince Rupert half lengths* [Van Dyck studio]★
Two views of Florence by Patch★★ { *Heads*
Duchess of Gloucester by Ramsay★ { *Heads*
Lady Monkton [Morton], *governess of the children of Charles I. Vide Waller* { *Heads*
Lady Whitmore by Mrs Beal, was Miss [Frances]*Brook*[e]. *Vide Grammont*★ { *Heads*
Mrs [Jane] *Middleton*★ { *Heads*
Charles I in armour★ { *Heads*
Cromwell, ditto { *Heads*
Lord Essex or Sir Stephen Fox by Mrs Beale { *Heads*
A fine Andrea del Sarto, much damaged★
Still Life, by Roestraten
Two views of Venice by Marieski
Two ditto of Strawberry Hill by Muntz
Two views in Jersey, by ditto
Head of Nicholas Pasquier [?Etienne Pasquier (1529-1615)]
Wilmot, Earl of Rochester★
Head of a Magdalen from the Head of Niobe by Guido, finished by Sassa Ferrati
Sir Robert Walpole in morning dress of nightgown and cap★
Francis, Earl and then Marquis of Hertford, with a dog in the hunting livery of George II by Dandridge half length★
Henry Seymour Conway afterwards field Marshal, his brother by ditto★
John Dodd, Esquire, of Swallowfield by ditto
An old man's head with a double white beard, and ruff, in black, right hand on a book, left holding a glove, half length★
A view of Winchenton [Winchendon] *House, the seat of the Lords and Duke of Wharton, whence Sir Robert Walpole bought the fine collection of Vandycks and Lelys*
An old peasant kissing a woman, with still life, a good copy of Polemburgh
Catherine, eldest daughter of Sir Robert Walpole and Catherine Shorter, his first wife, in yellow, with a crook and a sheep half length★

The Houghton Sale and the Fate of a Great Collection

Larissa Dukelskaya

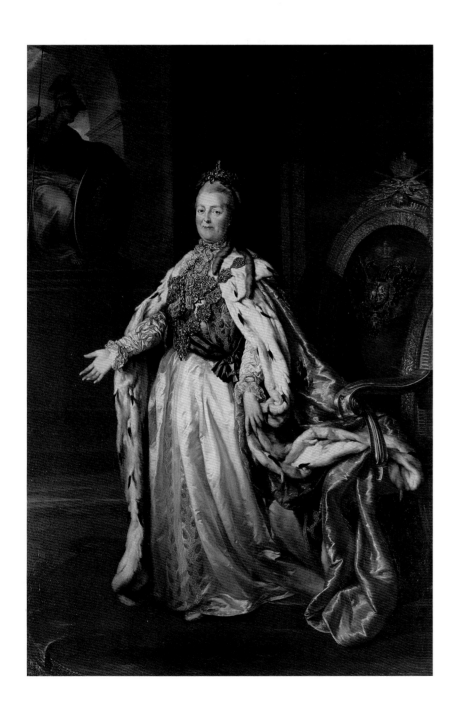

illustration overleaf:
After Alexander Roslin, *Catherine the Great*, before 1780, oil on
canvas, 239 x 142
The Marquess of Cholmondeley

The Houghton Sale and the Fate of a Great Collection

Larissa Dukelskaya

On 5 February 1779 the *Cambridge Chronicle* announced 'We are informed that, much to the dishonour of this country, the celebrated Houghton collection of pictures, the property of Lord Orford, and collected at vast expence by the late Sir Robert Walpole, is actually purchased by the Empress of Russia for 40 000 £.' The sale of the collection at Houghton Hall, amassed by England's first Prime Minister Sir Robert Walpole (1676-1745), aroused considerable consternation in England. From the outset, negotiations for the sale of the collection were veiled in secrecy and rumours abounded about its proposed fate. The initiator and executor of the sale was Sir Robert Walpole's grandson, George Walpole, 3rd Earl of Orford (1730-91). Lord Orford was an eccentric, unstable man who appears to have been utterly indifferent to the memory of his distinguished grandfather. When in October 1778 Lord Orford requested that James Christie value the paintings at Houghton his over-riding concern was 'that you will, in the first place, observe the most profound secrecy'[1].

The loss of the Walpole collection was perceived in England as an irreplaceable loss to the nation. In his invaluable notebooks George Vertue had remarked that the Walpole collection at Houghton Hall was 'fine and rare' and 'the most considerable of any in England'.[2] The uniqueness of the collection lay in its core of numerous excellent pictures by those great seventeenth-century masters who were so much admired in the following century.

The sense of loss was exacerbated not only by the change of ownership but because the collection was leaving England altogether for a most inaccessible setting. Paradoxically, the sale came at a time, in the wake of the establishment of the British Museum in 1753, when there was much discussion about how that fledgling collection might be enlarged. Long before the sale, Horace Walpole wrote in an 'Advertisement' for publication of a catalogue of the collection of Charles I, not only of the significance of such catalogues, but of the need to acquire such collections for the state: 'Hitherto, this Vanderdoort, and one or two foreigners scarce better qualified, have been the chief illustrators of British musæums. One Gambarini began with lord Pembroke's collections. ... Many of the duke of Devonshire's and doctor Mead's appear in Haym's Tresoro Britannico. These, and the Aedes Walpolianae, are, I think, the only descriptions of the riches of a country, which for some years has been assembling the arts and works of the politest nations and greatest masters. The establishment of the British musæum seems a character for incorporating the arts, a new æra of virtù. It is to be hoped that collections wont to straggle through auctions into obscurity, will there find a center! Who that should destine his collection to the British musæum, would not purchase curiosities with redoubled spirit and pleasure, whenever he reflected, that he was collecting for his country, and would have his name recorded as a benefactor to its arts and improvements? ... and our artists can study Greece and Rome, Praxiteles and Raphael, without stirring from their own metropolis.'[3]

The public only learnt of the sale of the Houghton Hall collection when it was already too late to prevent its departure from England. Even the usually well-informed press only

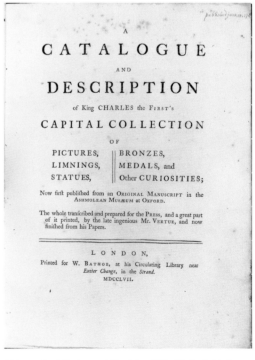

Titlepage for *A Catalogue and Description of King Charles the First's Capital Collection*, London, 1757

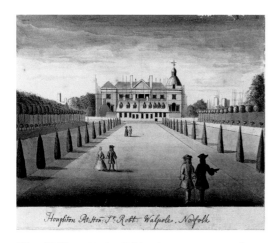

Edmund Prideaux, *Houghton Hall from the West*, c.1725, pen and wash, 26.7 x 40.6 (album size).
Courtesy of Mr Peter Prideaux-Brune Esq.

published their first notices and lamentations after the sale had been concluded. By that time they could only indulge in speculation about the price paid by the Empress of Russia. Public reaction was far from enthusiastic about the destination of the collection since Russia was still primarily regarded as an exotic land and Catherine II was not perceived as an enlightened monarch but as a despot with unlimited power. The sale, however, was an event not only of social and cultural significance but also profoundly personal, a drama in which the fate and ethical principles of three personalities were tightly bound up. This apparently prosaic tale of sale and purchase reflected very different understandings of the concepts of 'historical' memory and moral obligation.

In 1742, Sir Robert Walpole resigned all his government posts and quit his official residence in Downing Street. From then on he was to live mainly in his comparatively modest house on Arlington Street and on his beloved estate, Houghton, in Norfolk. He devoted much time and energy to the improvement of the latter, involving himself in all the details of construction, decoration and furnishing, and in the planning of the park.[4] After his retirement, the park was to become for him a venue for spiritual contemplation: 'The place affords no news, no subject of entertainment or amusement; for fine men of wit and pleasure about town understand not the language and taste, nor the pleasure of the inanimate world. My flatterers here are all mutes. The oaks, the beeches, the chesnuts, seem to contend which best shall please the Lord of the Manor. They cannot deceive—they will not lie. I in sincerity admire them.'[5]

By 1736, just a year after construction of Houghton Hall was completed, it already contained a collection of 113 paintings, including family portraits,[6] and Sir Robert continued to add to it, mainly at the expense of works which had formerly hung, up to 1742, at his London and Chelsea houses. George Vertue, who visited Houghton in the summer of 1739, during Sir Robert's lifetime, wrote: 'to Houghton-Hall—Sr Robt. Walpoles—the Magnificence and beauty of this structure being well known—and in print. on large sheet.[7] which is the best description the range of the State Rooms being all finely adornd and furnisht with great Variety rich furniture carving Gilding Marble & Stucco works—every room in a different manner but the great Collection of noble original pictures exceed all others in number and variety. . . . The Hall large and square. many Fine busts and stucco Ornaments the Laacon and his Sons in Bronze a fine Cast the Gladiator on the Stair Case in brass—as the Antique. So many rare pictures statues requires time to view well & review at several times to conceive their great merit & beauty.'[8] Vertue's enthusiasm was echoed years later by the Reverend William Gilpin who described Houghton's contents as 'the most celebrated collection in England.'[9]

It was this collection and a profound shared interest in painting which were to bring together Sir Robert Walpole and his younger son Horace (1717-97) who had previously seemed indifferently disposed towards each other. Horace Walpole returned from his Grand Tour in 1741 and was to spend much of his time between his father's retirement and death, particularly the summers of 1743-45, at Houghton. Although irritated and shocked at first by the coarse rural pastimes—hunting, horse racing, raucous dinner parties—he was occasionally amused by the sometimes ridiculous questions posed by the numerous guests who came to look over the house and its paintings. In 1761, recalling those years, he was to write 'I remember formerly being often diverted with this kind of seers—they come, ask what such a room is called, in which Sir Robert lay, write it down, admire a lobster or a cabbage in a market-piece [*Markets*, by Frans Snyders, cat. nos. 133-136], dispute whether the last room was green or purple, and then hurry to the inn for fear the fish should be over-dressed—how different my sensations!'[10]

But young Horace was won over by his father's unusual and striking personality and the

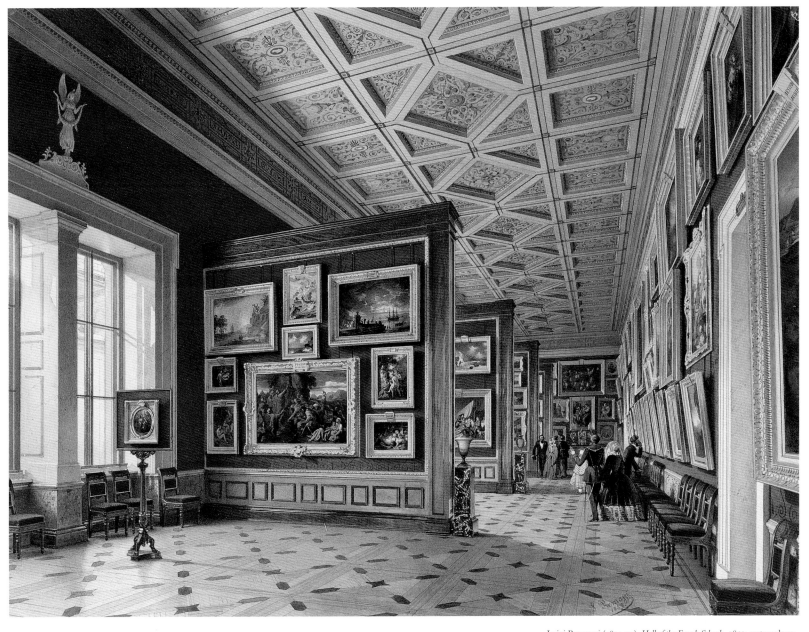

Luigi Premazzi (1814–91), *Hall of the French Schools*, 1859, watercolour
State Hermitage Museum
In the middle of the first stand is Poussin's *Moses Striking the Rock*.

sincerity of Sir Robert's letters from Houghton Hall in which he asks his son to 'sacrifice the Joys of the Beau-monde to ye amusements of dull rural life',[11] and these helped to dispel Horace's uneasy feelings about the place. Undoubtedly, one of the most powerful factors that influenced their increasing closeness was a mutual enjoyment of painting.

In 1742, Horace Walpole completed 'A Sermon on Painting', 'a really admirable pastiche of the apostrophic and exclamatory sermon of the day'.[12] Horace illustrated his thoughts and judgements on spiritual and moral values, on human merit and the postulates of Holy Writ, with reference to the paintings that hung at Houghton Hall, seeing direct analogies for his thoughts in these subjects and images. The Sermon draws to a close with thoughts on Moses: 'See the great Moses himself: the Lawgiver, the Defender, the Preserver of Israel?... how boldly in his youth he undertook the Cause of Liberty!' and in the margins Horace remarked 'The Allusion to Lord Orford's Life is carried on through this whole character.'[13] At the end

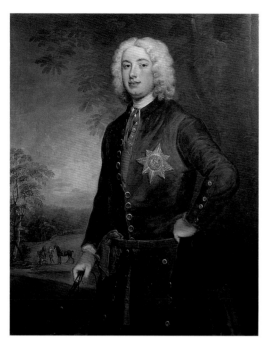

John Wootton, *Lord Robert Walpole* (son of Sir Robert Walpole)
Private collection / Bridgeman Art Library

of the section, he adds the marginal note 'Alludes to the Waters made at Houghton and to the picture of Moses striking the rock, by Poussin [cat. no. 176], in the Gallery'.[14]

In the following year, 1743, Horace completed his work of many years, his *Aedes Walpolianae*, a catalogue of the art collection at Houghton Hall that listed 276 items including paintings, sculpture and works of applied art.[15] The description and analysis of the most valuable part of the collection — the sixteenth and seventeenth-century pictures by the great European masters — occupies the greater part of the catalogue. 'Painting, in itself, is innocent; No Art, no Science can be criminal; 'tis the Misapplication that must constitute the Sin,' he wrote in his Sermon,[16] and these words serve as an epigraph not only to the *Aedes* but to all of his 'art historical' work.

Horace Walpole quoted the opinions of his father on the respective merits of a number of paintings and the interpretation of certain subjects in the *Aedes*. Dedicating his text to his father in terms which remind us just how frequently and with what mutual pleasure the two men must have looked at and discussed the contents of the picture gallery, young Horace wrote admiringly: 'This is not the case of what I offer you: it is a work of your own; a plain description of the effects of your own taste.'[17]

Although Sir Robert Walpole died before the *Aedes* was published, he almost certainly saw it in manuscript form since Horace finished it as early as 1743, judging from the dedication and the signature beneath it which reads: 'Houghton, Aug. 24, 1743'. Sir Robert Walpole, 1st Earl of Orford, died 18 March 1745, in London, in the small house on Arlington Street. The *Aedes Walpolianae* was first published two years later, in 1747/48. 'As my fears about Houghton are great,' wrote Horace Walpole to Horace Mann in August 1748, 'I am a little pleased to have finished a slight memorial of it, a description of the pictures, of which I have just printed an hundred, to give to particular people.'[18] Not only did the *Aedes* immortalise the collection Sir Robert had formed, but today it enables us to recreate the collection and identify the now dispersed pictures. It also contributes greatly to our understanding of this collection's historical significance.

With the death of Sir Robert Walpole, a new era in the history of the collection began, although it was merely a prelude to its eventual removal from Houghton Hall. A month after his father's death, Horace Walpole summarised his inheritance in gloomy tones in a letter to Horace Mann:[19] 'It is certain, he is dead very poor: his debts, with his legacies, which are trifling, amount to fifty thousand pounds. His estate, a nominal eight thousand a year, much mortgaged. In short, his fondness for Houghton, has endangered Houghton. If he had not so overdone it, he might have left such an estate to the family, as might have secured the glory of the place for many years: another such debt must expose it to sale! If he had lived, his unbounded generosity and contempt of money would have run him into vast difficulties.'[20]

Robert Walpole (1701-51), eldest son of Sir Robert and now 2nd Earl of Orford, was Houghton's new owner and heir to all his famous father's debts. Far from reducing those debts, the second Earl managed to add considerably to them. It was the 2nd Lord Orford who initiated the first sale of works from the collection, comprised of paintings from the family house at Chelsea.[21] The contents of the sale, organised by the auctioneer Christopher Cock in London, is known from a manuscript copy of the catalogue, dated 1748.[22] The money raised from the sale was very modest compared to the vast sums owed. On the death of Robert Walpole, 2nd Earl of Orford on 31 March 1751, Houghton Hall, the earldom and the accumulated debts of both father and grandfather were inherited by his only son, George (1730-91).[23]

Two months later, in June 1751, another auction took place, including paintings from the Walpole houses in London and at Richmond. Vertue described the auction and its success,

noting that it did not include the best paintings from the collection, which were all at Houghton: as the Collections of S^r. Rob. Walpole. late Earl of Orford made so much noise amongst the admirers of Art for so many years and so many purchases of pictures of great value. was made by him in all parts of Europe. after the death of son the Earl of Orford. those pictures that were in London or at his house at Richmond came to be sold by aucktion — which drew a great concourse of persons to see them sold — indeed those were but a lesser part of his Collections — for the greatest part & most valuable are at Houghton hall his fine noble house in Norfolk — but amongst these were many fine pictures that did not sell at one third part what they cost him — … in some part the occasion of lowering the price was the advanced season of the year — and persons of distinction — out of Town in June 13 14 — 1751 and the suddennes of the disposal — after the death of this last Lord Orford. by the want of money in this young present Lord. the grandson. Such a strange turn of fortune & Grandeur is hardly to be paralelled — in any family — to be sure these will not amount to any great summe-.[24]

The proceeds of the sale went nowhere near meeting the family debts although the new Earl seems not to have been unduly concerned. Not without a good deal of charm and wit, whatever talents he possessed were rarely made manifest and most of his time was spent with his horses. Hunting and breeding pedigree dogs were among the least surprising of his extravagant pastimes.[25] He might have been taken directly from the caricatures of Thomas Rowlandson, and he was indeed directly caricatured as a 'prodigal' by George Townshend.

At first charmed by his nephew, Horace Walpole foresaw the unpredictability of his behaviour, noting in a letter to Horace Mann on 15 June 1755, 'But to speak freely to you, my dear Sir, he is the most particular young man I ever saw… I flattered myself that he would restore some lustre to our house; at least, not let it totally sink; but I am forced to give him up, and all my Walpole-views… he promises, offers everything one can wish — but this is all; the instant he leaves you, you, all the world, are nothing to him … his whole pleasure is outrageous exercise… He is the most selfish man in the world, without being the least interested: he loves nobody but himself, yet neglects every view of fortune and ambition… In short, it is impossible not to love him when one sees him: impossible to esteem him when one thinks of him.'[26]

It was George's unpredictability and his indifference to the fate of Houghton Hall which prompted Horace Walpole to lament bitterly the loss of an opportunity to sell the collection most profitably in 1758 and thus resolve many of the financial problems. In May 1758 a collection of somewhat mediocre paintings belonging to Sir Luke Shaub[27] was sold in London for a fabulous sum. 'I want to paint my coat and sell it off my back — there never was such a season — I am mad to have the Houghton pictures sold now; what injury to the creditors to have them postponed, till half of these vast estates are spent, and the other half grown ten years older,' wrote Walpole to Mann on 10 May.[28]

For the better part of three years there seems to have been no mention of the Walpole collection until in March 1761, sixteen years after the death of his father, Horace Walpole paid a visit to Houghton. What he saw amazed and upset him.

Here I am, at Houghton! And alone! In this spot, where (except two hours last month) I have not been in sixteen years! Think, what a crowd of reflections! — No, Gray and forty churchyards could not furnish so many… Here I am, probably for the last time of my life, though not for the last time — every clock that strikes tells me I am an hour nearer to yonder church — that church, into which I have not yet had courage to enter, where lies that mother on whom I doted, and who doted on me!… The surprise the

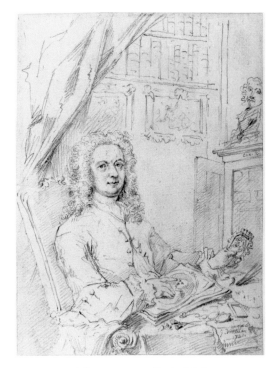

George Vertue, *Self portrait*, 1741, pencil and red chalk, 23.5 x 14
Courtesy of The National Portrait Gallery, London

George Townshend, 4th Viscount and 1st Marquess Townshend, *George Walpole, 3rd Earl of Orford after the Manner of Salvator Rosa's Prodigal Son*, 1751-58, pen and ink, 33 x 20.5
Courtesy of The National Portrait Gallery, London

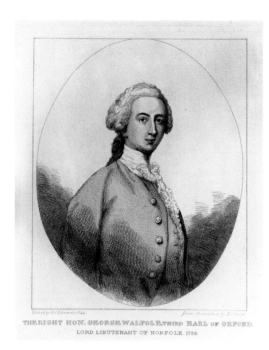

William Camden Edwards after Jean Etienne Liotard, *George Walpole, 3rd Earl of Orford*, 1844, etching
Archive Collection, The National Portrait Gallery, London

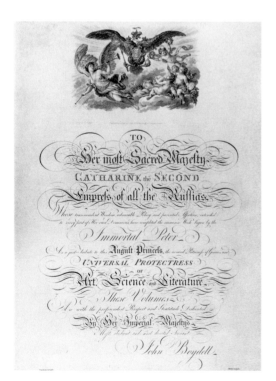

P. P. Choffard, engraved dedication page to vol. I of John Boydell's *A Set of Prints …* , London, 1788
Yale Center for British Art, Paul Mellon Collection

pictures gave me is again renewed—accustomed for many years to see nothing but wretched daubs and varnished copies at auctions… not a picture here, but recalls a history; not one, but I remember in Downing Street or Chelsea, where queens and crowds admired them, though seeing them as little as these travelers! In the days when all my soul was tuned to pleasure and vivacity… I hated Houghton and its solitude—yet I loved this garden; as now, with many regrets, I love Houghton—Houghton, I know not what to call it, a monument of grandeur or ruin! For what has he built Houghton? For his grandson to annihilate, or for his son to mourn over![29]

Although the collection remained intact throughout the 1760s and much of the 1770s the inevitability of its sale became increasingly obvious to its owner, his numerous creditors and to his uncle Horace Walpole and his friends. Lord Orford continued his profligate lifestyle while both his uncles, Edward[30] and Horace, remained uninvolved. This period of inertia was not to last.

In January 1773, Lord Orford was debilitated by the onset of mental illness that was characterised by fits of madness and even attempts at suicide. Horace Walpole informed the 3rd Earl's mother, who was then living in Italy, making only rare appearances in England. On 27 April, Horace Walpole wrote to his friend Horace Mann 'I doubt much of his recovery. I wish for some answer from his mother;[31] . . . I fear she will not come over herself. This will be a great distress to my brother and me, who are most unwilling to take the direction of his affairs.'[32] Lady Orford seemed to be indifferent to her son's illness and had no intention of leaving Italy. Edward Walpole also refused to share the burden. Only Horace, with a sense of compassion for his debt-ridden nephew, made some attempt to put the latter's affairs in order and to deal with his health problems. On 28 June, he wrote to the Reverend William Mason[33] from his home at Strawberry Hill: 'All Lord Orford's affairs are devolved upon me because nobody else will undertake the office. I am selling his horses, and buying off his matches. I live in town to hear of mortgages and annuities . . . Mr Manners,[34] who was the son of Beelzebub, deserves to be crucified. He was so obliging the other day to make me a visit, and tell me he should seize the pictures at Houghton—I have sent for a lawyer to exorcise him. My dear sir, what vicissitudes have I seen in my family! I seem to live upon a chessboard; every other step is black or white. A nephew mad and ruined, a niece, a princess;[35] Houghton, the envy of England—last week Mr Vernon, the jockey, offered to vouchsafe to live in it, if he might have the care of the game.'[36]

On 1 September 1773 Horace Walpole sent Lady Ossory[37] a long and detailed letter, reporting on his stay at Houghton 'You know, Madame, . . . how very fond I am of Houghton, as the object of my father's fondness. Judge then what I felt at finding it half a ruin, though the pictures, the glorious pictures, and furniture are in general admirably well preserved. All the rest is destruction and desolation!' To his great surprise, in one room of the run-down mansion, Horace saw a 'room full of painters, who… are making drawings from the whole collection, which Boydell[38] is going to engrave.'[39] Walpole could not have foreseen that for many years these engravings would not only remain the sole visual evidence in western Europe of the collection's existence at Houghton Hall but would effectively form an illustrated appendix to his own *Aedes*.

Horace Walpole was now devoting all his time not to the intellectual issues that usually preoccupied him but with more prosaic matters. He looked over kennels, sold pointers, hounds and exotic beasts, drew up pedigrees for horses, sold sheep and oxen, listened to the complaints of servants who were drunk from morning to night, mended the roof, sorted through papers with the lawyer and managed other household affairs. All these time-consuming and irritating tasks at least produced a positive effect since his nephew's finances were put

in order. In August 1773 alone savings of £1,189.2s. were made, and the inevitability of a sale receded.[40] But his mood remained gloomy: 'For my part,' he concludes his letter to Lady Ossory, 'I sat down by the waters of Babylon, and wept over our Jerusalem—I might almost say over my father's ashes, on whose gravestone the rain pours!'[41]

In the last days of December 1773, Lord Orford made a sudden recovery, but by the following spring his uncle Horace was under no illusions about the relative sanity of his nephew's behaviour. 'I have been with him at Houghton,' he wrote on 18 March 1774 to Rev. Mason, 'and return full of sorrow; . . . In one word, he observes no regimen, eats intemperately, and drinks a bottle a day.'[42] Everything that Horace Walpole had been able to put in order was once more thrown into chaos by his nephew, although there were as yet still no thoughts of a sale.

In April 1777, as suddenly as on the previous occasion, Lord Orford's illness returned. Horace Walpole wrote on 21 April 'my Lord was in bed, and is very mad'.[43] Once again, the burden of responsibility for arranging medical care fell on Horace. On 25 April he wrote to his brother Edward 'In truth I shall not believe my Lord is rational... I... determined never to meddle with his affairs more, though I would always be ready to take care of his person; which now that it is clear that his madness is constitutional and not accidental, I fear will often be my lot as long as I shall live, if my own health permits it. I forgive my nephew because I firmly believe he has not been in his senses for many years.'[44]

It was perhaps Lord Orford's madness and his utter incompetence that provoked a speech to parliament by John Wilkes on 28 April, in which he expressed concern about further acquisitions for the British Museum.[45] He saw a possible solution to the problem of the collection at Houghton Hall.

> The British Museum, Sir, possesses few valuable paintings, yet we are anxious to have an English school of painters. If we expect to rival the Italian, the Flemish, or even the French school, our artists must have before their eyes the finished works of the greatest masters. Such an opportunity, if I am rightly informed, will soon present itself. I understand that an application is intended to parliament, that one of the first collections in Europe, that at Houghton, made by Sir Robert Walpole, of acknowledged superiority to most in Italy, and scarcely inferior even to the duke of Orleans's in the Palais Royal at Paris, may be sold by the family. I hope it will not be dispersed but purchased by parliament, and added to the British Museum. Such an important acquisition as the

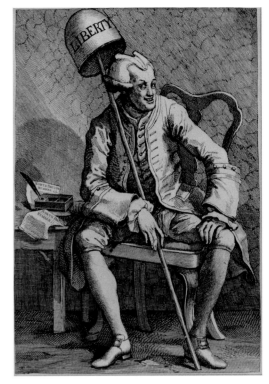

William Hogarth, *John Wilkes M.P.*,

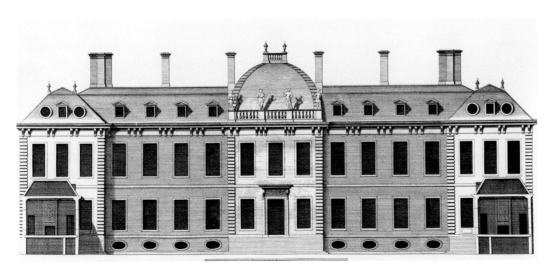

'Elevation of the second Montague House of 1686', plate from vol. I of *Vitruvius Britannicus* by Colin Campbell, 1715-25

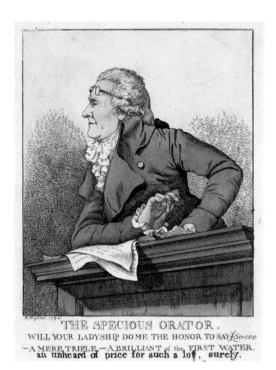

Robert Dighton, *The Specious Orator* [James Christie], 1794, engraving
Courtesy of Christies Images Ltd.

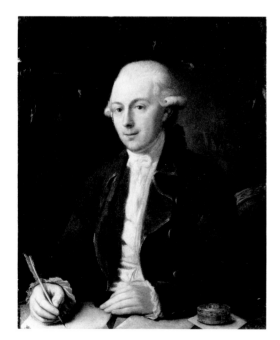

Anon. British Artist, *Count Alexey Musin-Pushkin*, 1770s, oil on canvas, 75 x 61.8
Courtesy of the State History Museum, Moscow

Houghton collection, would in some degree alleviate the concern, which every man of taste now feels at being deprived of viewing those prodigies of art, the Cartons of the divine Raphael.[46]

Wilkes's speech was made several weeks after the recurrence of Lord Orford's illness, and it is unlikely that the Earl himself lay behind it. The speech and its contents came as a total surprise to Horace Walpole. On 16 May he received a sympathetic letter from his friend Horace Mann who stated 'I most sincerely pity your distress and admire your humanity and tenderness for Lord Orford. . . . Both my nephew and I were much surprised to see in the last public papers a speech of Wilkes recommending to Parliament the purchase of the collection at Houghton. Was it a thought of his own, or suggested to him by anybody? I approve the proposal, but fear that the time is improper.'[47] Wilkes's suggestion seemed indeed to find public support, but it remained merely wishful thinking.

In late March 1778 Lord Orford once again unexpectedly recovered and immediately embarked on a period of frenetic activity with the aim of resolving his financial problems. Apparently he began to contemplate the sale of the Houghton pictures and the idea was encouraged by his solicitor, Carlos Cony,[48] one of those individuals surrounding Lord Orford whom Horace Walpole called 'harpies' and who were driven primarily by the prospect of personal gain. Walpole wrote on the subject of Lord Orford to Mann on 18 June 'He has put his affairs into the hands of a man of whom I think ill, and have been forced to say so, and have no power to remove. This man and the crew may, on the first interval, make my Lord call in question and dispute all I might do. I would serve my Lord with my pains, but I will not pay for serving him.'[49]

In May 1778, Cony set off for London on behalf of Lord Orford in order to establish contact with the auctioneer James Christie and for legal consultations regarding the possible sale of the collection. He reported back on his journey in his bill. '1778. 30th May. Journey to London . . . for the purpose of setting a plan with Mr Christie for sale of your pictures, and for that purpose, various attendances on him and also numberless attendances on Messrs Dunning Price[50] and Duane[51] your counsel for the purpose of settling a special letter of attorney, which they thought necessary, and after many consultations settled and approved, and withal endeavoring to raise £15000 agt first of next Jany, as the present time afforded a very unfavorable prospect of disposing of the pictures to advantage, all which took up going returning and staying in town 3 weeks — £22 1s'.[52]

It would seem that the idea soon arose of offering the collection to the Empress of Russia, Catherine II, who was already famous for her extravagant acquisition of many works of art, including entire collections. The intermediary in the execution of this plan was to be the Russian Ambassador at the Court of St James's, Count Alexey Musin-Pushkin.[53] On 27 July, Cony made a special trip to London specifically to establish contact with the Count, as we can deduce from his report on expenses to Lord Orford: '27th [July 1778] . . . to consult Christie on the Sale of your Pictures, take Mr Dunnings Opinion & attend Mr Pousschin the Russian Ambassador thereon, also attending Mr Peters a Russia merchant for an introduction to Mr Pousschin . . . & drawing cash for Mr Dunnings Opinion on practicability of selling pictures & attending him.'[54]

In preparation for the sale of the Houghton paintings, and apparently concerned that the valuation should not err on the low side, Cony set out to establish the prices paid at the previous auctions of Sir Robert Walpole's paintings that had taken place in 1748 and 1751. He would seem to have requested that James Christie send him catalogues (or indeed any information), a supposition supported by a letter from Christie to Cony of 26 September 1778:

Dear Sir

The Reason of my not answering your letter before this was that I have been waiting with utmost expectance and Impatiance the getting back the Valuation made some years ago of Ld O— —– Collection and am very unhappy to find it is not forthcoming. Therefore I have sent the Catalogue only of BraamKamps[55] Collection you will find all the prises mark'd in the Margin but please to [note?] that those sums are Florins and not pounds which you may Value at about two Shillings each.[56]

Lord Orford, meanwhile, gave no hint to Horace Walpole of his intended actions and the latter remained completely unaware of his nephew's secret plans. At the end of September Lord Orford asked both his uncles, Edward and Horace, to resign their right to inherit Houghton Hall and thus help him cover the debts of both father and grandfather. Having received their agreement,[57] on 1 October Lord Orford sent his uncle Horace Walpole a respectful letter 'to thank you for your ready concurrence in the measures I am now pursuing to settle the affairs of the family and to satisfy Sir Robert Walpole's creditors; and by leave to trouble you to make my compliments, and to return my thanks also to Sir Edward.'[58]

Horace Walpole replied on 5 October with a long and conciliatory letter from his home at Strawberry Hill: 'Your Lordship is very good in thanking me for what I could not claim any thanks, as in complying with your request and assisting you to settle your affairs, according to my father's will, was not only my duty; but to promote your service and benefit, to reestablish the affairs of my family, and to conform myself to the views of the excellent man, the glory of human nature, who made us all that we are, has been constantly one of the principal objects of my whole life. My honour is much dearer to me than fortune; and to contribute to your Lordship's enjoying your fortune with credit and satisfaction, is a point I would have purchased with far greater compliances. . . . We [Horace and Edward] are both old men now, and without sons to inspire us with future visions. We wish to leave your Lordship in as happy and respectable a situation as you was born to; and we have both given you all the proof in our power, by acquiescing in your proposal immediately.'[59]

Whilst expressing profound respect for his relatives, Lord Orford continued to play a duplicitous game, avoiding all reference to the fate of Houghton Hall. At this time, when there was no longer any acute need to sell the paintings, he was engaged on that very question. Just a few weeks later, on 30 October, Lord Orford wrote to James Christie:

You have already been apprised of my intention from Prader and Co.'s notices of disposing of the pictures of the Houghton collection, & that I have preferred selling them by private contract; at the same time 'tis my desire that you shall be employed in valuing them, & shall have any profit from this business that you shall own adequate to the trouble you will have. My desire is that you will, in the first place observe the most profound secrecy; that you will send immediately a proper person to examine and value all the pictures in the collection, family pictures excepted, which must be finished in a fortnight. In order to give you in some measure a key towards judging of the value of them you must know that, from the best intelligence I could ever get, I have reason to believe that the pictures cost Sr Robert Walpole upwards of thirty-five thousand pounds, reckoning the many indifferent pictures he was obliged to buy in whole collections, & disposed of again at great loss, in order to come at perhaps two or three capital ones. Sr Joshua Reynolds formerly offered me two thousand guineas for one picture only (the Doctors) [cat. no. 70], & asured me that if I would part with it to him he meant to keep it. The bronzes are not intended to be included in this sale, therefore need not to be valued. I

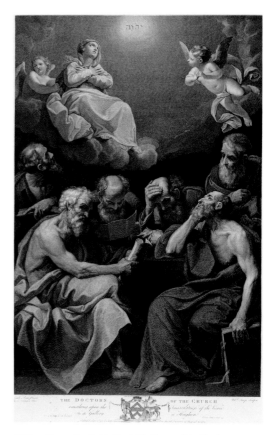

William Sharp after Guido Reni, *The Doctors of the Church*, engraving, plate from John Boydell's *Set of Prints … 1788*, vol. II, pl. LVIII
The Marquess of Cholmondeley

Red morocco binding of Catherine the Great's copy of the
Aedes Walpolianae
Library of the State Hermitage Museum

mention'd before that 'tis absolutely necessary that this valuation, &c., should be finished in a fortnight. I must desire also that you will buy two sets of catalogues of the Houghton collection, printed by Dodsley, & that you have them most richly bound in gilt, & in blue or red morocco, as these books are intended as presents;[60] these to be finished in a fortnight. N.B. — Please to direct to me as Enishall, near Mildenhall, Suffolk.[61]

Lord Orford was anxious not only to retain complete confidentiality but also for speed of action. That James Christie responded punctually to his request that the valuation 'be finished in a fortnight' (i.e. by 14-15 November 1778) is clear from his letter dated 23 November to Lord Orford's solicitor Carlos Cony:

Some time ago I received a letter from Lord Orford desiring I woud go to Houghton Hall and form a Valuation on the Collection 'saying it must be completed in a fortnight and also that I was to get two Catalogues elegantly Bound and that I was to write to his Lordship in Suffolk. Accordingly I set off on the Wednesday following, with a proper assistant and finish'd the business, wrote and directed my Letter agreeable to his Lordship's desire but not hearing from his Lordship I begin to fear my letter has not met with him. Supposing that shoud have been the case I beg to repeat the substance Matter of it. That I had with a competant viewed and valued the Collection and Marked against each picture or pr of Pictures our opinion in the Margin of a Catalogue[62] and that those several sums amounted to 40555£ exclusive of the family Pictures and some few Furniture Pictures also four or five Pictures my reason for which I would communicate when I had the honor of waiting on his Lordship.

I shoud have been happy to have paid my Respects to you at Lynn but was press'd for time having a Sale coming on which I was obliged to attend to

Shoud it so have happen'd that his Lordship has not red my letter which I hope is not the case you will best judge what part of this letter is proper to communicate to him. The two Catalogues are bound, and others marked with the prizes.

I am with great Respect / Sir / Your most Obliged and obedient / Servant James Christie[63]

Lord Orford's silence, so surprising to James Christie given the delicacy of the matter and the need for a speedy reply was yet another manifestation of his unreliability and gives credence to Horace Walpole's estimation of his fecklessness in his youth: 'letters he never answers, not of business, not even of his own business: engagements of no sort he ever keeps.'[64]

In the last week of November there followed a lively exchange of letters between Christie and Lord Orford's solicitor, with Lord Orford himself maintaining a consistently stony silence. On 26 November, immediately upon receiving Christie's letter of the 23rd instant, Cony sent him from Lynn a detailed reply, not omitting to reproach Christie for taking insufficient pains to bring about a meeting. More significantly, the first line of the letter makes it clear that a meeting had taken place between Lord Orford and the Russian Ambassador:[65]

I lately saw Lord Orford at Houghton, when he informed Me he had seen the Ambassador,[66] & wrote you to make a Valuation, that he expected you had been down & made it, but had not heard from you. I own I was not a little surprized at not hearing from you, at least, as you did not take Lynn in your Way, that I might have met you at Houghton. I shall see my Lord next Week, the beginning I believe, & if you will send Me by Post a Copy of the Valuation, I will then communicate it to him, as I know he expects to see it, & will endeavor to facilitate your future Proceedings. I this Month had a Letter from a particular friend of Mine, <u>a Man of the first Virtue in London</u>,[67] wherein he says — 'I met at Bath the Revd Dr Arnold King, who transacts business for 'the

Empress of Russia';[68] he assured me that the Empress has — 'expressly signified to him lately that she cannot buy any — 'Pictures Medals &c.'[69] Should this be the case, let me know if you will take them at your own Valuation, or should my Lord expect more, if you will give the 40,000 Gs, which you have told Me the Pictures were formerly valued at, & I will communicate your Answer to him. If the Empress is not, & you are, the purchaser, on proper security, the Payments will be made easy, to which I shall, with pleasure, contribute as far as in my power, consistent with my Lords Interests, being with real Regard, / Sir, / Your most obed.t S.t / Car. Cony.

P.S. You are to observe my Lord will not on any account part with his Cast of Laocoon, nor any of his Bronzes, Busts, Vases &c, but merely the Pictures.

Please to mention the pictures not valued, with your Reasons, & I will not fail acquainting his Lordship with them.[70]

Since Cony provides no details at all of Lord Orford's meeting with the Russian Ambassador Musin-Pushkin, we must presume that they discussed various questions linked with the sale of Sir Robert Walpole's collection. This is confirmed by the Ambassador's letter to the Empress Catherine of 15 December 1778 (OS 4 Decemer; see below, page 69). The information Cony received about the possibility that the Empress might decline the opportunity to acquire the collection was very far from the truth and probably resulted from a rather free interpretation of the undocumented conversation with Rev. King.

One can only deduce from Cony's suggestion at the end of his letter to Christie that the latter should purchase the Houghton collection in the event of the Russian Empress turning it down — a suggestion apparently made without consulting Lord Orford — that the solicitor had some personal interest in the speedy conclusion of a sale.[71] The same thought had clearly occurred to Horace Walpole, who wrote to Mann on 11 February 1779 (i.e. two months after Cony's letter to Christie): 'I am persuaded that the villainous crew about him [Lord Orford], knowing they could not make away clandestinely with the collection in case of his death, prefer money, which they can easily appropriate to themselves.'[72]

On 29 November, Christie replied to Cony:

I am favour with yours of the 26 Instant, and with respect to my Journey and what was done in consequence I beg to refer you to my last letter which I presume you have received before this. I send with this, the Catalogue on which I made the Valuation, the two Catalogues are bound agreeable to his Lordships direction[73] and beg to know if I shall send them to you. I am exceedingly at a loss to account for my two letters not reaching his Lordship. I am sorry to hear there is likely to be a negative put on the expected treaty with the Empress, the Collection is truly worthy of her. With respect to myself I consider it a matter of too much consequence to attempt, but I think if I had the pleasure of some conversation with you I coud form a plan that might facilitate the sale of them in one lot which I cannot communicate by letter. You will observe by the Catalogue that I have not Valued the Bronzes &c Those pictures that I omitted to Value of course have no figures against them, the Family Pictures omitted by Lord Orfords direction and some Pictures that are only Furniture Pictures. In the Drawing Room, Archbishop Laud notwithstanding the University of Oxford made so liberal an offer for it You may depend is undoubtedly a Copy, the two pictures of Poussin Le Mer, I also omitted to Value as he is a Master that is not esteemd, together with some of the Modern Artists. In Page 72 Sir Ths Wharton calld Vandyke/ undoubtedly a Copy.[74] If the Minister had a mind to Immortalize himself[75] I coud put him in the way to do it

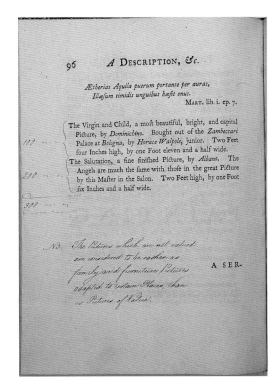

1767 edition of the *Aedes Walpolianae* with manuscript annotation possibly by James Christie
Library of the State Hermitage Museum

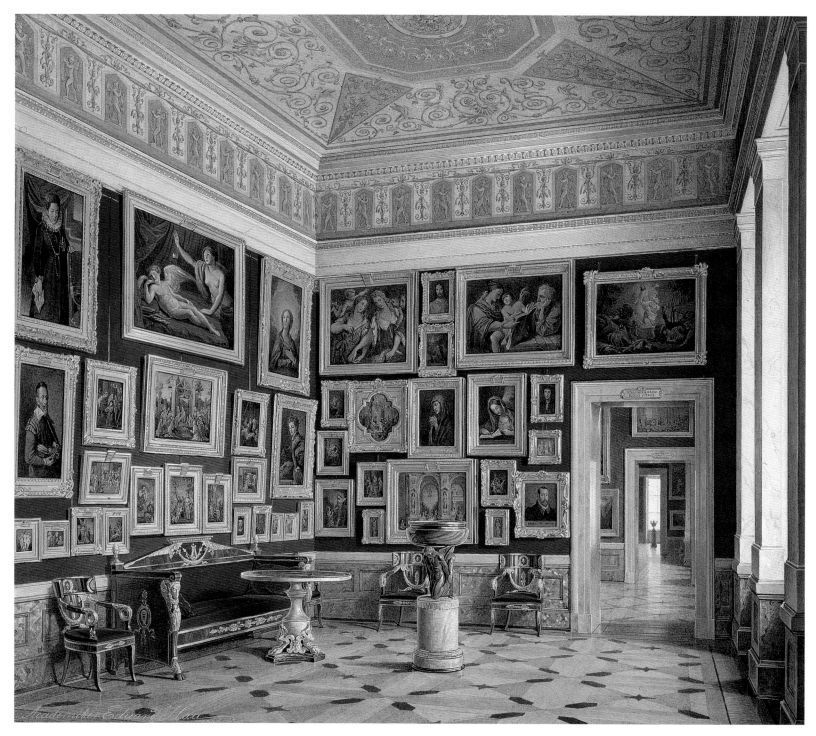

Anon., *The Cabinet of the Italian School,* mid-nineteenth century, watercolour, State Hermitage Museum. St Petersburg
Above the door is Veronese's *Resurrection* (now Pushkin Museum of Fine Art, Moscow); above the vase in the centre is Benedetto Caliari's *Dives and Lazarus* (provincial Russian Museum); in the top left corner of the same wall is Paris Bordone's *Allegory.*

effectually by causing this Collection to be purchased at the expence of the Publick and Building a Room at the British Museum for their reception. I woud undertake that it woud be the means of bringing all the Foreigners of Taste from distant Parts of the World to see them and it woud most undoubtedly correct the Taste, and Qualify the Judgements of our Modern Artists.

I am most Respectfully / Sir / Your Obliged Humble / Servant James Christie[76]

Lord Orford finally broke his silence on 2 December, writing to Christie:

I have been favoured with your letter mentioning therein the gross sum of your valuation of the pictures at Houghton. I am much obliged to you for the diligence and dispatch used in this business, & desire you will wait upon the Russian Embassador with the particulars of your valuation fairly written,[77] & deliver to him at the same time the two catalogues which you have got bound, and the inclosed letter, adding any particulars. If her Imperial Majesty should purchase this collection, I should recommend to the Embassador that for greater security a ship-of-war should be sent from Petersburg to Lynn, where the pictures, being each put into separate wooden cases with their frames, may be put on board, and as the Russians they will be respected by the powers now at variance, there will be no danger of any interruption being given to their vessel in its passage back to Russia. As you are perfectly acquainted with the best methods of packing pictures, the Embassador cannot employ any person so well qualified as yourself to execute that business.

The family pictures will, in course, be excepted out of the list. You mention a picture you have not valued, you will oblige at your leisure by sending a particular of your valuation by light coach to this place.[78]

The end result of this correspondence would seem to have been a letter from Musin-Pushkin (in his own handwriting) to the Empress Catherine II, sent to St Petersburg on 15 December (OS 4 December) 1778:

Madame.

Votre Majesté aura peut-être entendu parler de la collection des tableaux du célèbre Robert Walpole. Le ministre mit en oeuvre toutes les ressources de sa longue administration, pour la rendre aussie belle que complète.[79] Son petit fils lord Orford prend la liberté de la déposer toute, ou en partie, aux pieds de Votre Majesté Impériale. Elle est digne, de l'aveu de tous les connaisseurs, d'appartenir au plus grand des souverains. Votre Majesté en verra les prix dans ce catalogue,[80] des gens aussi véridiques que juges compétents ne les trouvent pas exorbitants: plusieurs d'entre eux leur paraissent au contraire être si modiques, que le propriétaire pourrait en retirer davantage en les vendant en détail: des chefs-d'oeuvre aussi parfaits ne sauraient qu'être recherchés. Mais la gloire de transmettre sa collection à Votre Majesté emporte sur toutes les considérations. Ce sentiment joint à la profonde vénération pour Votre Majesté engage lord Orford de Vous remettre, madame, entièrement tout le choix de ceux de ses tableaux qui mériteront le plus Votre attention, ainsi que la manière dont Votre Majesté voudra les faire payer.

S'il en reçoit une moitié dans le courant de l'été prochain, il ne s'attendra à l'autre qu'au terme que Votre Majesté daignera y mettre elle-même. Il s'agirait, Madame, de faire examiner de près sur les lieux mêmes l'état de conservation de ses tableaux. Les peintres Chipriani ou West[81] ne se refuseront, pas je me flatte, à m'assister dans cette opération de leurs lumières, ne fût-ce qu'en les récompensant de leurs peines.

Dans le cas que Votre Majesté se détermine à faire cette acquisition, les caisses ne seront faites que sous mes yeux; elles n'auront que 12 milles d'Angleterre de chemin pour arriver à Lery [Lynn], dans le Norfolk. Une frégate pourra y venir pour les prendre; et pour la conduire plus sûrement dans ce port là, j'enverrai à Copenhague ou à Elséneur deux pilotes anglais, aussitôt que j'en aurai les ordres.

Je suis avec le plus profond respect / Madame / de Votre Majesté Impériale / le plus dévoué et le plus soumis sujet.[82]

Thus the collection had been valued and a copy of the *Aedes* sent to St Petersburg with each page marked in the margins with a price for each, plus a separate list of the prices totalling a

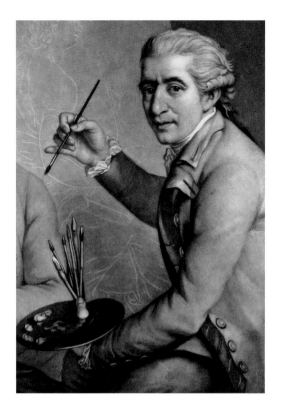

John Raphael Smith after F. Rigaud, *G.B.Cipriani*, mezzotint (detail)
Yale Center for British Art, Paul Mellon Collection

sum of £40,550.[83] The plan for despatching the pictures had also been outlined in general terms, although it was later to undergo some changes. Written over thirty years previously by Horace Walpole to honour his father and the collection he had formed, the *Aedes Walpolianae* thus found itself amongst those important documents figuring in this complex commercial deal. It was later to serve as the key source for the reconstruction of the collection.

By the middle of December, the sale of the Houghton paintings had ceased to be a secret. A letter from Horace Walpole to Horace Mann of 18 December bitterly summarises the situation: 'What I have long-apprehended is on the point of conclusion, the sale of the pictures at Houghton. The mad master has sent his final demand of forty-five thousand pounds for them to the Empress of Russia at the same time that he has been what he calls improving the outside of the house—basta!—thus end all my visions about Houghton.'[84] So, in December 1778, the first stage in the sale of the collection was complete.

At the beginning of 1779 nothing could be done to prevent the collection leaving Houghton for its new home in St Petersburg where the Russian Empress eagerly awaited its arrival. In England meanwhile the last formalities were being concluded and details of the despatch of the pictures finalised. By this point further details of the sale began to appear in the press and some commentators expressed their anger and indignation at the loss.

Writing to Horace Walpole on 16 January 1779, Mann speculated 'I wonder that the King does not purchase them. One should be tempted in some cases almost to wish there was authority lodged in some hands to prevent such mad owners from dissipaiting their patrimony and injuring their descendants.'[85]

Letters written by Horace Walpole in February refer to Houghton Hall in despairing terms and convey his sense of his utter helplessness in the face of a fait accompli. He wrote to Lady Ossory on 1 February: 'The pictures at Houghton, I hear, and I fear, are sold—what can I say? I do not like even to think on it. It is the most signal mortification to my idolatry for my father's memory, that it could receive. It is stripping the temple of his glory and his affection. A madman excited by rascals has burnt his Ephesus. I must never cast a thought towards Norfolk more—nor will hear my nephew's name, if I can avoid it.'[86]

On 11 February Horace Walpole penned a fulsome reply to Mann's letter of 16 January. During the intervening four weeks new information had reached Walpole: 'Last night I heard the bargain is not concluded. Cipriani was desired to value them, and has called in West. To be sure, I should wish they were rather sold to the Crown of England than to that of Russia, where they will be burnt in a wooden palace[87] on the first insurrection. Here they would be still Sir Robert Walpole's Collection.'[88] But what most angered Horace Walpole was that there was no longer any desperate need to sell the collection since the outstanding family debts amounted to far less than £40,000. Once again, Walpole attributed the manner and haste of the entire transaction, conducted so soon after Lord Orford's second illness, to the vested interests of those 'rascals' surrounding his nephew.

A few days later, on 16 February (OS 5 February), Catherine II wrote to Baron Grimm[89] in Paris: 'Savez-vous que je suis en marché avec le comte d'Orforth pour toutes les peintures qui ont appartenu à feu son père Robert Walpole? Voyez un peu comme les alouettes viennent donner dans mes filets.'[90] Grimm confirmed the excellence of the collection as the 'superbe cabinet Walpole, qui je me rappelle fort bien d'avoir admiré il y a sept ans en Norfolkshire.'[91]

Some weeks passed before the following note dated 6 April (OS 26 March) was added to a communiqué to St Petersburg from the Russian Ambassador: 'Received yesterday an answer from Lord Orford,[92] tomorrow I go with Cipriani to him for a detailed and careful look at his

paintings.'[93] As a result of his visit to Houghton, Musin-Pushkin wrote to the Empress of 23 April (OS 12 April):[94]

Having looked closely at Lord Orford's paintings together with Cipriani, I can now most faithfully inform Your Imperial Majesty that they are worthy to form part of the best gallery in Europe, not only ordinary collectors, but also the connoisseurs themselves have long come to this conclusion, because of its many rare, capital and the best compositions of the most glorious masters.

Since amongst them are to be found several spoiled, I have the honour to append here a detailed description. Two or three canvases are so worn as to require new support; which can easily be carried out here or in Russia, as Your Imperial Majesty pleases to command, the other paintings and that is those which are indicated in the special appendix are as fresh and in such perfect condition as if they were painted recently. All such information I took only from the truthful and equally knowledgeable Cipriani, who has diligently spent all the necessary time and effort on the precise study of this collection.

Count Orfort in a letter to me agrees: 1) to add to the paintings previously valued all those which I selected and which follow on in this register, 2) to receive here in payment 40000 pounds sterling, in November or December of this year 16 th. pounds sterling, dividing the payment of the remaining 24 th. pounds. Sterling, into three equal parts each of 8 th. pounds sterling that is in 1780—81—82, or according to any other system which Your Imperial Majesty should be pleased to suggest, 3) to permit meanwhile the release of the paintings for their despatch by water this summer. Their packing by people knowledgeable in such matters and by labourers of course requires, most gracious Sovereign! my presence there, if only during the initial organisation and the final despatch by sea from Lynn, no other than on a naval frigate, not only because of this time of war, but also because many of these paintings, by their size, cannot conveniently fit into merchant ships.

Your most obedient servant must inform Your Imperial Majesty that the greater part of the nobility here are displaying general dissatisfaction and regret that these paintings are being allowed out of this state, and are setting in train various projects to keep them here: in confounding all such vain ideas, no little assistance comes from Lord Orfort's zealous desire rather to unite it [the collection] to the gallery of Your Imperial Majesty than to sell it to parliament itself and least of all to divide it through sale to different individuals.

Indeed, appended to the text was a list or register[95] composed of three sections. The first section is a list of paintings requiring restoration (19 in all),[96] then the 'Register of paintings in fresh and perfect condition' (61 in all, with at the end the phrase 'and several others'), and lastly 'Additional paintings without increasing the previous price' (17 in all).[97]

The conditions of payment—in separate instalments over several years—provoked Horace Walpole to comment caustically 'as I hear it is to be discharged at three payments—a miserable bargain for a mighty Empress! Fresh lovers and fresh, will perhaps intercept the second and third payments.'[98] In a letter from London to Cole dated 23 April, Horace Walpole provided a depressing summary of nearly a year of negotiations: 'I have been told today that they are actually sold to the Czarina—sic transit!—mortifying enough, were not everything transitory.'[99]

In St Petersburg, meanwhile, the Empress was jubilantly anticipating the arrival of her latest acquisitions and on 27 April (OS 16 April) she wrote to Grimm: 'Pour les Walpole et les Udney,[100] ils ne sont plus à avoir, parce que votre très humble servante a déjà mis la patte dessus et qu'elle ne les lâchera pas plus qu'un chat une souris.'[101]

Unknown artist, *Baron Grimm*
Chantilly Collection

Simultaneously in London lists and prices of the paintings sold from Houghton Hall were beginning to circulate. Horace Walpole informed Cole in a letter of 27 April that one of these manuscript lists confirmed the price paid for the collection as £40,555 and was 'numbered according to the pages… of the Aedes Walpolianae'.[102] A similar list had been attached to the letter dated 15 December 1778 (OS 4 December) from the Russian Ambassador to the Empress. That same day the *London Chronicle* published the erroneous statement that 'We are credibly informed that the Empress of Russia has purchased 25 pictures from the collection of the late Lord Orford at Houghton at 40,000 L and that a man of war is to be sent to Yarmouth to convoy them from thence to Russia.'[103] On 31 May, *The Gentleman's Magazine* offered its readers yet another version of events 'The Empress of Russia has purchased the Houghton collection of pictures for 43,000 £. They were estimated at 40,000 £ but the Empress advanced 3,000 for the liberty of selecting such of them as are most suited to her purpose of establishing a school for painting in her capital. The rest will probably be disposed of by auction in England.—Such is the fate of this first collection in Great Britain; … if it survives the hazard of the sea or risques war, to assist the slow progress of the arts in the cold unripening regions of the North.'[104]

Numerous other rumours abounded in London, most of which bore little resemblance to the truth. However, the final price of £40,555 put on the collection is confirmed not only by Walpole's letter to Cole quoted above but also by a number of other sources.[105] Yet still no official announcement of the sale of the paintings was forthcoming. On 18 May (OS 7 May) Catherine II wrote to Baron Grimm: 'Le Cabinet Walpole n'est pas acheté encore',[106] and on 10 June (OS 30 May) 'Les Walpole, les Udney ne sont pas encore arrivés, voilà une terrible année d'emplettes.'[107] Apparently, this lack of precise information about events at Houghton led Horace Walpole to entertain false hopes of salvaging the situation. 'I know nothing more of Houghton . . . I conceive faint hopes, as the sale is not concluded—however I take care not to flatter myself' he wrote to Cole on 2 June.[108]

All doubts were finally resolved on 23 June (OS 12 June). This is the date on a letter from Musin-Pushkin to the Empress, in which he stated that the court banker, Baron Friedrichs, had 'transferred to my control the monies necessary for the paintings of Lord Orford', and also that he had given the order to commence packing.[109] He continues 'I sent the Consul General[110] to Gaton [Houghton] with a man well qualified in the packing of paintings, in order to prepare both the cases and everything necessary without loss of time. I follow on tomorrow, as much to oversee and perhaps to correct the first in the packing and despatch of the paintings of this kind, as to complete my previous agreement with Count Orfort.' (This latter probably refers to payment of the first instalment.)

Events now unfolded rapidly. The main question now concerning Musin-Pushkin, as he informed the Empress in his next letter of 22 July (OS 2 August), was how to safely deliver the paintings to St Petersburg:

> In my care of Your paintings from Lord Orfort, nothing, Most Gracious Sovereign, has been omitted which can ensure their absolute preservation and full safety. On receipt of the order they probably began yesterday to pack in order of size; some of them particularly, individually, others with up to 9 together; thus they will come to up to 50 cases, which for greater reliability shall, about two weeks from now, be sent on two of the best ships directly to the great name of Your Imperial Majesty, with all the necessary documents, but for greater precaution I requested of the Admiralty here that they command one frigate to take both the ships with the paintings[111] under its protection to Gambra,[112] to which I now await a reply, I hope in advance in accordance with my expectation.[113]

Horace Walpole meanwhile eagerly awaited information noting in a letter of 4 August to Horace Mann 'Private news we have none but what I have long been bidden to expect, the completion of the sale of the pictures at Houghton to the Czarina … Well adieu to Houghton!—about its mad master I shall never trouble myself more … and since he has stript Houghton of its glory, I do not care a straw what he does with the stone or the acres.'[114] According to *The Gentleman's Magazine* of 31 July, 'the pictures remain at Houghton'.[115] But exactly one month later, on 31 August, one of Horace Walpole's correspondents, Mr Lort, wrote that 'A friend of mine… went … to see the Houghton Collection, but was told the whole was very near packed up.'[116]

In St Petersburg, on 6 August (OS 26 July) 1779, Count Ivan Chernyshov,[117] vice-president of the Admiralty Collegium, received an enquiry from Prince Vyazemsky:[118] 'By the highest Imperial request I have the honour to address Your Grace for an answer as to whether we can with haste send to London a military frigate to carry from there the paintings purchased for Her Majesty.'[119] The frigate employed was the *Natalia*, which was prepared for its voyage by Vice Admiral Samuel Greig,[120] these preparations being completed on 17 August (OS 6 August). In charge of the frigate was 'captain of the second rank and cavalier' Khanykov. Special instructions issued to him stated that, by personal decree of Her Imperial Majesty, he was 'to send to England to the city of London … the frigate *Natalia* beneath a merchant flag and with a cargo from Baron Friedrichs.'[121] The same ship was to return to England the sister of Sir James Harris, British Ambassador to the Russian court, as Harris confirmed in a despatch to Viscount Weymouth: 'Petersburg, 7th, 18th [i.e. 7th OS, 18th NS] August, 1779, My Lord, - the Empress [has] permitted my sister to return home on board of Russian frigate Her Imperial Majesty sends to England to fetch Lord Orford's collection of pictures.'[122]

At the by now denuded Houghton Hall, Lord Orford, liberated from the burden of ownership his grandfather's great collection, began renovating the facade of the house and invited Cipriani to work on improving the interiors. The loss of the collection seems not to have disturbed his conscience in the least because, in his opinion, the house contained far too many paintings by one and the same master, an opinion which led Horace Walpole to exclaim in exasperation 'as if one could have to many Carlo Marattis, Rubens's and Vandykes! … His Cipriani would not have been worthy to paint the dog-kennel, when the house possessed its original collection; Cipriani is to Guido, as his Lordship is to his grand-father.'[123]

Lord Orford's gratitude to the Russian Empress was expressed, somewhat bizarrely, in his drawing up for her a 'code of the laws of coursing' and naming his favourite greyhound bitch 'Czarina'.[124] It must have been at the end of 1779 that he received from Catherine a gift of a portrait of the Empress herself (see p. 55) beneath which, as Cole informed Horace Walpole, 'he has caused an inscription to be written, importing that your father, Prime Minister to two kings and for so many years, had so little enriched himself, that his grandson was forced to sell his collection of pictures to pay his debts.'[125]

If we are to believe the newspaper reports, the paintings had by now been packed and were awaiting the Russian ship's arrival at Lynn.[126] But the elements unexpectedly interfered with these careful plans for the *Natalia*, sent from St Petersburg to convey the paintings, was wrecked off the coast of Holland. On 3 October 1779, the sister of the British Ambassador, Miss Harris, wrote to Sir James in St Petersburg from Schalen: 'Our frigate was wrecked this morning about a German mile from this village … I must do the captain the justice to say that nothing could be more manly, more calm, than his behaviour; much presence of mind, and seeming to possess himself entirely. Indeed we owe our lives to his firmness … I should be

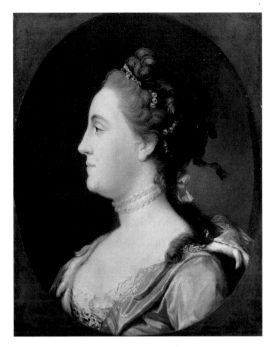

Vigilius Eriksson (1722–82), *Catherine II*, oil on canvas, 54 x 42.5 State Hermitage Museum. St Petersburg

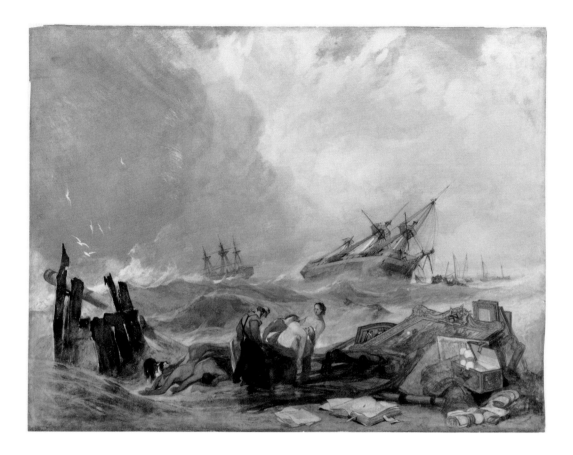

John Sell Cotman, *Lee Shore, with the Wreck of the Houghton Pictures, Books, &c., Sold to the Empress Catherine of Russia*, 1838, pencil and watercolour with bodycolour and gum arabic, 68 x 90.2 Fitzwilliam Museum, Cambridge

happy to have this testimony of his behaviour mentioned, as 'tis my real opinion, and not from any partiality or favour toward him. He remained there till the last, and saved many things, but not the cargo. Many of the cannons were thrown over to lighten the ship. Our rudder was carried away by the first stroke. In short, our danger was immediate and infinite. . . . I have lost many of my books; the others are spoilt. Your Chinese pictures are lost, and many more things which I cannot miss now. . . . Your Berlin china, and all that box is gone.'[127]

News of the shipwreck quickly reached England and rumours were soon circulating that the ship had been carrying the Houghton paintings, which had thus perished. Although on 30 October, the *Gentleman's Magazine* published a short note, that seems to have gone largely unnoticed, informing its readers that 'the Houghton collection of pictures, we hear, is safely arrived at St. Petersburg'[128] weeks later the *Whitehall Evening Post* for 14–16 December was still mistakenly assuming the worst as a result of 'the *Natalia*, the ship in which they [the pictures] were carrying to Russia, having foundered.'[129] On 30 December Cole wrote to Walpole: 'I hope and wish, that the news we had in all our papers, that the Houghton Collection of pictures are at the bottom of the sea is false. Good God! What a destruction! I am shocked when I think of it.'[130] By that date these disturbing rumours had in fact been finally scotched by the *Whitehall Evening Post* for 25–28 December that confirmed the pictures safe arrival: 'the master of the ship . . . saw them safely unpacked in the Empress's palace.'[131]

The paintings had indeed been safely delivered to St Petersburg. The Empress Catherine wrote to Baron Grimm on 12 March (OS 1 March) 1780: 'La Natalie est échouée, tandis qu'elle allait quérir ce qui était déjà embarqué, envoyé et arrivé; les Walpoles se portent au mieux et ont passé l'hiver, entassés dans ma galérie.'[132]

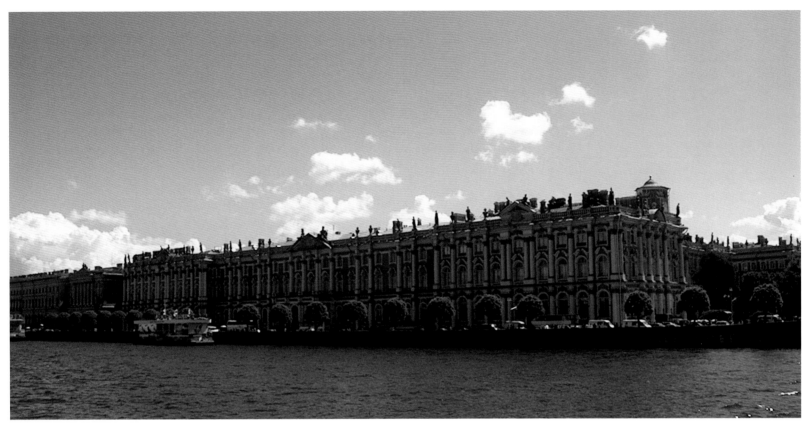

The Winter Palace, former residence of the Tsars and now part of the Hermitage Museum

The first Russian commentator to remark on the collection after its arrival in St. Petersburg in 1779 was Jacob Stählin[133] who noted that 'In the summer the Empress received from on board a Russian ship sent specially to England an incomparable collection of paintings from the Houghton family, which Her Majesty purchased for 62,000 roubles. Connoisseurs of art assess its true value at no less than least three times more since it was sold to Russia.'[134]

So it was that the year 1779 witnessed, as the distinguished Russian art-historian Vladimir Levinson-Lessing put it, 'one of the greatest events in the life of the Hermitage — the purchase in England of the famous gallery of Lord Walpole. It was of similar significance for the composition of the Hermitage collections as the Crozat collection, and its sale caused just such a sensation in England as the sale of the Crozat gallery in Paris had been seven years earlier.'[135] With their arrival in Russia a new chapter opened in the history of the pictures collected by Sir Robert Walpole. The collection now belonged to Russian Empress Catherine II and was to form an integral part of her own museum, her Hermitage.

In summer of 1780, the paintings were seen in St Petersburg by the French chargé d'affaires in Russia, chevallier de Corberon, and he noted in his diary for 24 August: 'Nous avons causé hier chez le comte Panin,[136] et comme il a fait le projet de voir ce matin l'Ermitage de l'Impératrice et la superbe collection de tableaux qu'elle a acheté en Angleterre je fait partie pour la voir ensemble. Cette galérie a couté à l'Impératrice qui l'a fait acheter par son ministre M. Pouchkine. . . . Elle est placée dans la galérie de tableaux aux palais, mais mal en ordre, n'ayant pas assez place.'[137]

During a visit to St Petersburg with her husband the renowned English physician Baron Dimsdale in the summer of 1781, Elizabeth Dimsdale also visited the Winter Palace, describing the event thus in her diary: 'I likewise saw the empress's Collection of Pictures, which are numerous

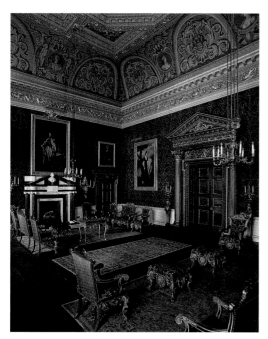

The Saloon, Houghton Hall
Photograph: Neil Jinkerson 1996, courtesy of Jarrold Publishing

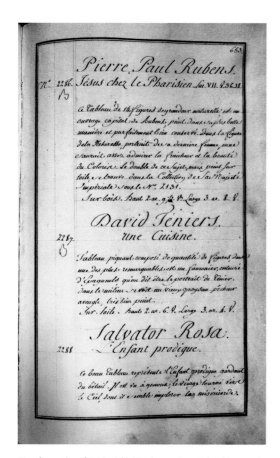

Page from vol. 2 of E. Munich's 'Catalogue raisonné des tableaux qui se trouvent dans les Galeries, Sallons et Cabinets du Palais Impériale de S. Petersbourg, commencé en 1773 et continué jusqu'en 1785', MS in 3 vols. State Hermitage Archives

and of the best Masters, among them were the whole of the Orford Collection, they are at present placed in a Gallery in the uppermost Story of the Palace, and in good Preservation.'[138]

That same summer, another Englishwoman, Mrs Phylip Lybbe Powis of Hardwick, visited Houghton Hall in Norfolk, also recording her contrasting impressions in her diary: 'At Houghton we proposed again seeing Lord Orford's, a seat once so famed for the most capital collection of pictures in England, lately purchased by the Empress of Russia. We had most fortunately seen them in the year 1756. . . . 'Tis really melancholy to see the hangings disrob'd of those beautiful ornaments, and only one picture now there, a portrait of the Empress herself, which she made my Lord a present of; but though 'tis said to be a striking likeness, and well painted, it rather gives one pain, to see the person who must deprive every one who now visits Houghton of the entertainment given to them by these pictures, and their going out of the kingdom makes it still worse.'[139]

In February 1782 the *European Magazine* published a full list of the paintings sold from Houghton Hall, preceded by a most indignant article signed simply 'C.D.' and addressed to the journal's publisher: 'The removal of the Houghton Collection of Pictures to Russia is, perhaps, one of the most striking instances that can be produced of the decline of the empire of Great Britain, and the advancement of that of our powerful ally in the north . . . But it is too late to lament; the disgrace has been sustained; and the capital of Russia now boasts what formerly drew crowds into the county of Norfolk to see and to admire . . . on this occasion [I] cannot but applaud the public spirit of Mr. Boydell,[140] by whose means, we are possessed of some memorials of what once existed at Houghton.'[141]

By this time, the Houghton paintings had become an integral part of the imperial collection. The first official recognition of this was their introduction into the manuscript catalogue of the painting collection, compiled in three volumes by Ernest Munich between 1773 and 1785.[142] The Houghton collection appears in the second volume, although listed in a somewhat arbitrary order. Although Munich used no particular classification system, the Walpole paintings form a compact group with their inventory numbers running between 2219 and 2421. It is perfectly clear that use was made of the *Aedes Walpolianae* in compiling these entries, although Munich frequently added his own comments.[143] He also measured all the paintings anew[144] giving an indication of support (canvas, panel, card etc) but, sadly, omitted all mention of provenance. Altogether, the catalogue records 203 works of the 204 that were acquired from the Walpole collection.[145]

Henceforth, the fate of the Walpole collection was to be inseparable from that of the Museum itself. Judging from numerous contemporary reports, the majority of the paintings were put on display in the Picture Gallery, which in these years filled the rooms and halls of the Small and Large Hermitages.[146]

Between November 1784 and April 1785, the Rev. William Coxe made his second visit to Russia, on this occasion as tutor to Samuel Whitbread II, who had recently graduated from Cambridge University.[147] While looking at the paintings in the Hermitage he paid particular attention, like most of his compatriots, to 'The Collection of Houghton-house, the loss of which all lovers of the arts must sincerely regret, and upon which I need not enlarge, as the pictures are well known, from the catalogue published by Horace Walpole and from the engravings by Boydell.'[148]

Despite these indignant protestations, one wonders what might have happened to the Walpole collection had it remained intact at Houghton for in 1789, ten years after the collection departed for Russia, Houghton Hall suffered a devastating fire. On 7 December 1789 the flames destroyed the north wing, the very part of the building where once the majority of the paintings hung. On 12 December, Horace wrote to Lady Ossory: 'Have you heard ... that one of the wings of

Houghton… is burnt down? I know not by what accident. … As the gallery is burnt, the glorious pictures have escaped.'[149]

Just two years after the fire, in 1791, the 3rd Earl of Orford died and Horace Walpole found himself both heir to the ruined estates and the Earldom of Orford. In a letter to Beloe[150] of 2 November 1792, he wrote: 'I have seen a noble seat built by a very wise man, who thought he had reason to expect it would remain to his posterity as long as human foundations do in the ordinary course of things—alas! Sir, I have lived to be the last of that posterity, and to see the glorious collection of pictures that were the principal ornaments of the house, gone to the North Pole; and to have the house remaining half a ruin on my hands!'[151]

Despite these comparatively numerous early references to the Houghton pictures from English sources, the first reference to the Walpole collection in Russian literature is found in Johann Georgi's *Description of the Russian Imperial Capital City of St Petersburg and the Sights in its Environs* of 1794, where a large section of chapter IV, 'On the Collection of Works of the Sciences and Arts' is devoted to the description of 'Her Imperial Majesty's Hermitage'.[152] Amongst the collections Catherine acquired, Georgi lists 'the collection of the Englishman Gougton'.[153] Georgi's book provides us with the first description of the display as it appeared in the early 1790s: 'The paintings hang in three galleries and partly in the rooms of the Hermitage and are placed not so much in the precise order of the schools, masters etc, as by the appearance they create. … Since there is not enough space to hang the paintings, some of them are not only stored separately, but according to circumstances those which are hung are removed and replaced with new, or more important ones. … The frames are highly varied, the greater part are gilded, but of simple design; a small number of paintings have elegantly worked frames, but many are totally without frames.'[154]

The main entrance to the New Hermitage, built on to the Winter Palace and Hermitage complex by Nicholas I as Russia's first public art museum. It opened its doors in 1852.

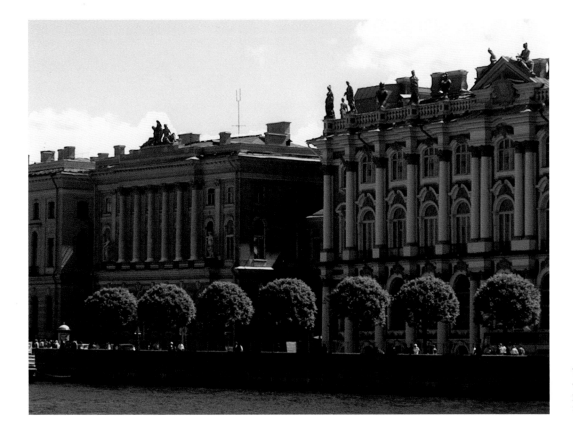

The north pavilion of the Small Hermitage, Catherine the Great's original 'hermitage' where she kept her art and entertained friends at private parties. As the collections grew she extended the Small Hermitage and added the Large Hermitage (visible to the left).

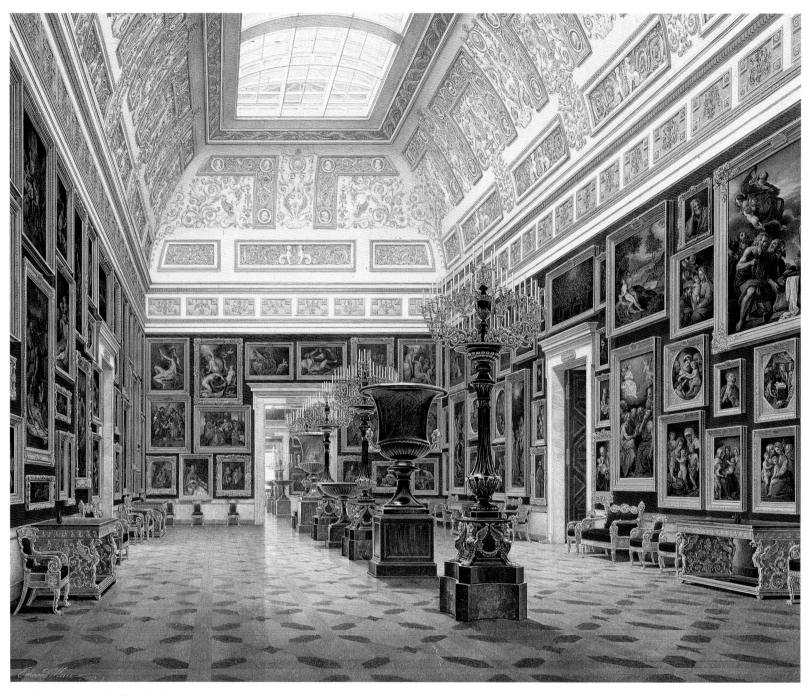

Edward Hau (1807–87), *Hall of the Italian Schools*, 1853, watercolour.
State Hermitage Museum
To the right of the door is Guido Reni's *The Doctors of the Church*; by
the right edge is Reni's octagonal *Adoration of the Shepherds* (now
Pushkin Museum of Fine Arts, Moscow); on the end wall is Carlo
Maratti's *Portrait of Clement IX*

The pictures are also mentioned in a later guidebook to St Petersburg published in 1821. In
the fourth volume of Paul Swignine's *Description des objets les plus remarquables de S-t. Petersbourg
et de ses environs*,[155] he refers the entire collections of paintings acquired by Catherine noting 'la
belle galerie du Lord Hougton, achetée au comte d'Oxford 35 mille livres sterling, (700, 000
roubles) dont les Anglais déplorent encore aujourd'hui la perte.'[156] Swignine singled out three
paintings from the Walpole collection: the *Portrait of Clement IX* by Maratti (cat. no. 41) —
'Tout les traits du Saint père sont animés; la douceur et la pénétration se confondent dans son
regard . . . il parle';[157] *The Fathers of the Church* by Guido Reni (cat. no. 70) — 'Il n'est pas

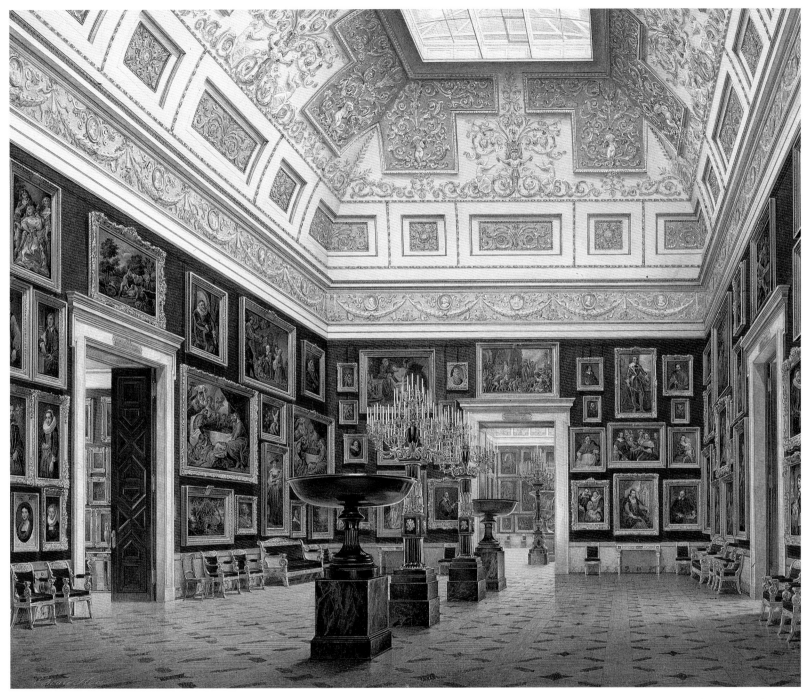

moins admirable pour la précision du dessin, que pour la beauté du coloris';[158] and Salvator Rosa's *Prodigal Son* (cat. no. 77) — 'Ce tableaux, un des plus beaux de Salvatore-Rosa, se distingue par la correction du dessin et la vivacité du coloris … appartenait à la collection de Haugton.'[159]

In 1826 the renowned physician, A. B. Granville, a member of many scientific societies, including the Imperial Academy of Sciences, visited St Petersburg and noted in his careful study of the Hermitage 'the celebrated Houghton collection', which was in the Small Hermitage. He particularly remarked on the works of Rubens and Van Dyck from Houghton

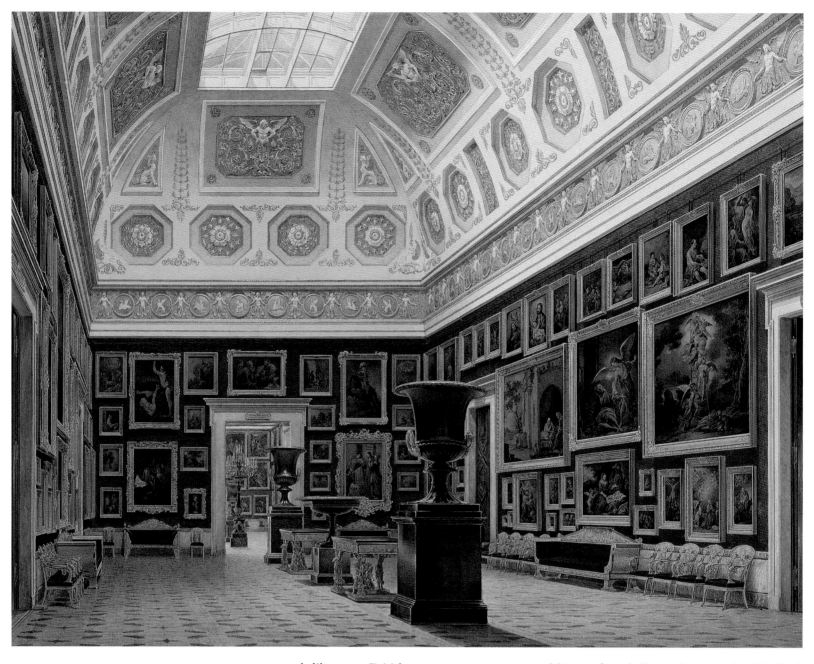

Edward Hau (1807-87), *Hall of Spanish Painting*, watercolour
State Hermitage Museum
On the end wall to left is Murillo's *Adoration of the Shepherds*

and, like most British commentators, expressed his profound disappointment that England had missed such a rare opportunity to acquire in one fell swoop 'chef-d'oeuvres of so many celebrated masters.'[160]

Apart from the continual rehanging of pictures that is not unusual in most great private picture galleries, the Walpole collection endured only minor disturbances throughout the nineteenth and early twentieth centuries. Works were regularly moved between the private apartments of members of the imperial family in the Winter Palace, the Marble and Anichkov Palaces or one of the imperial country residences.

In the 1840s, Emperor Nicholas I ordered the construction of a new museum building to provide public access to the Hermitage collections. Designed by Leo von Klenze, this was to be the New Hermitage.[161] When it opened in February 1852 the paintings were densely hung,

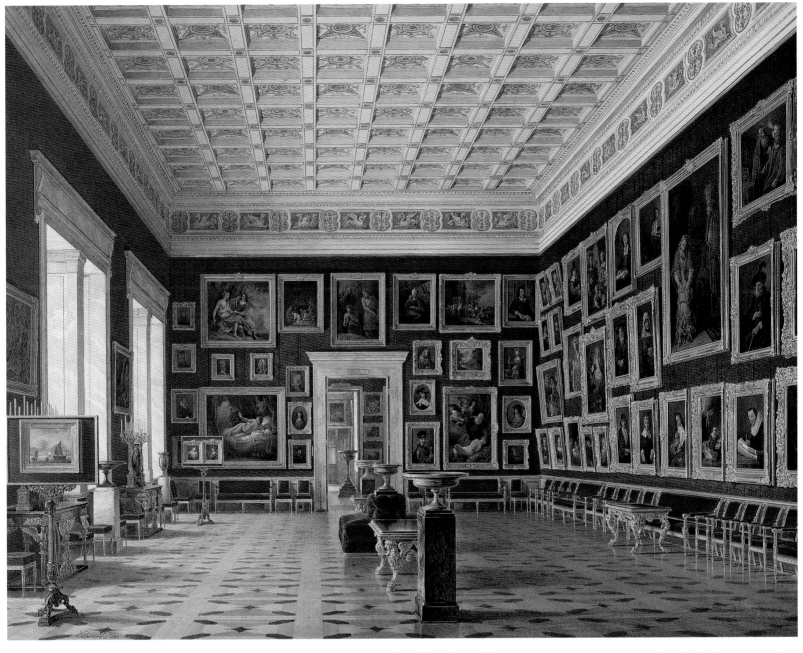

strictly observing the historical principle according to national schools and largely in chrono-
logical order. In the 1850s and early 1860s, the watercolourists Edward Hau (1807-87) and
Luigi Premazzi (1814-91) created a series of watercolours that capture the precise appearance of
rooms in the New Hermitage (see figs. on pp. 59, 68, 78–82, 84). A number of them illustrate
quite clearly how some of the best Houghton paintings occupied prominent places in the New
Hermitage displays. For example, Horace Walpole's beloved Poussin, *Moses Striking the Rock*
(cat. no. 176 and see p. 59), dominated the stand visible as one entered the room of French sev-
enteenth and eighteenth century painting (now the Rembrandt Room). Large canvases by Sal-
vator Rosa, Guido Reni and Maratti, as well as a number of Spanish paintings, were on show
in the Skylight Rooms. *Abraham's Sacrifice* by Rembrandt (cat. no. 153) hung in the lower row
in the Dutch painting room, near the door (on the other side of which hung the same artist's

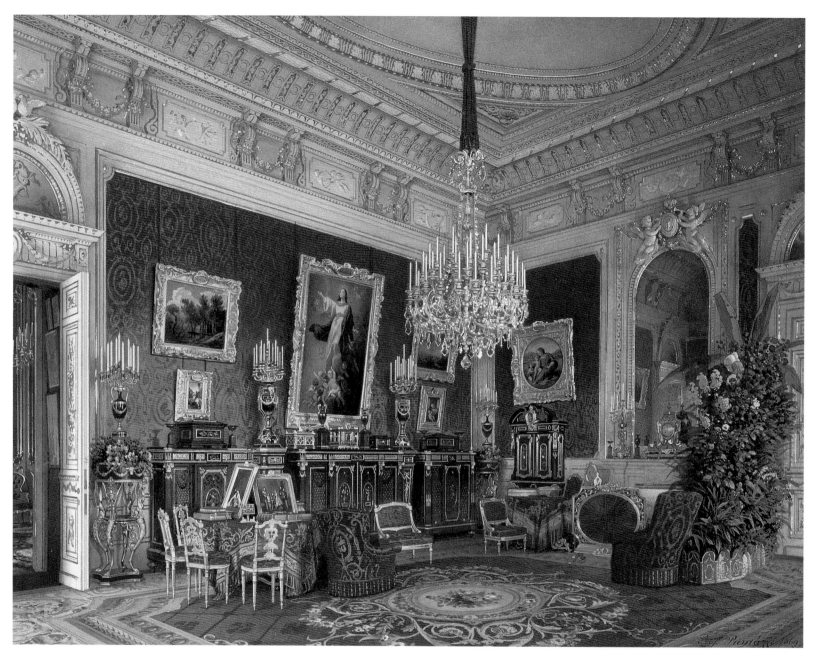

Luigi Premazzi (1814-91), *The Study of Empress Maria Fyodorovna in the Winter Palace*, 1869, watercolour
State Hermitage Museum
In the middle of the wall is Murillo's *Immaculate Conception*

Danaë from the Crozat collection). A small group of Walpole paintings was by now outside the museum itself. In Empress Maria Alexandrovna's study[162] in the Winter Palace hung Murillo's *Immaculate Conception* (cat. no. 182), while Wootton's *Hounds and Magpie* was initially in a room in the Winter Palace but was later moved to the palace at Gatchina, outside the city.[163]

The Emperor Nicholas I ordered a total reassessment of the Picture Gallery and the paintings in the imperial collection in the summer of 1853.[164] He dominated the selection process himself, dividing the paintings into groups, including the selection of a group that was to be put up for sale. Without consulting specialists, he decreed the sale of 1,219 paintings, amongst them several from the Walpole collection. Fortunately, only two were actually sold: Pordenone's *The Return of the Prodigal Son* (cat. no. 92; present location unknown) and Kneller's *Joseph Carreras* (cat. no. 198). The latter was to return to Houghton Hall as recently as 1975.

In 1860 and 1861, the Hermitage was visited by Dr Gustav Waagen, the renowned scholar and director of the picture gallery at the Berlin Museums.[165] It was Waagen who laid the basis for a thorough, scholarly study of the Hermitage collections and the compilation of full scholarly catalogues. He also presented a list of proposals for improving the hanging of the paintings suggesting, for instance, that Van Dyck's *The Rest on the Flight into Egypt* (cat. no. 110) was hung far too high and could not be viewed properly. Under his guidance, in 1861 the paintings were sorted and a selection made of those to send to the newly established Rumyantsev Public Museum in Moscow.[166] In May 1862, Waagen's selection was approved by Alexander II, as we learn from a report of 9 June (OS 29 May) 1862 to Ober-Hofmarshal Count A. P. Shuvalov from the head of the 2nd Department (Picture Gallery) of the Hermitage, Fyodor Bruni: 'I have the honour to inform Your Highness that His Sovereign Majesty the Emperor was so kind this 26th of May to look over the Hermitage paintings selected by Mr Waagen for the Moscow museum, and that His Majesty deigned to approve the selection Mr Waagen had made.'[167] In the autumn of 1862, 201 paintings from the Hermitage were transferred to Moscow, seven of them from the Walpole collection.[168]

Another art critic, J. Beavington Atkinson, visited St Petersburg in 1873, leaving us a detailed description of the Hermitage collection in which he particularly emphasised the role of the Walpole paintings.[169] Significantly, the Russian connoisseur A. Trubnikov, describing in the early twentieth century the works by English artists from the Walpole collection at Gatchina, saw fit to mention the significance of the collection as a whole: 'Just how much beauty was given to the Great Monarch through the purchase cannot be overstated. Suffice it to mention Van Dyck's elegant images of the English nobility, the fiery sketches of Rubens, from which his genius radiates in blinding sparks, the marvellous canvases of Salvator Rosa.'[170]

Visitors to the Hermitage, however, would have found it almost impossible to learn anything about the provenance of a particular painting. Catalogues of the picture gallery began to appear regularly from 1863, but only rarely did these indicate the previous ownership of works.[171] Such catalogues were, of course not intended for ordinary visitors and Horace Walpole's *Aedes Walpolianae* was known only to the narrowest circle of specialists. The Hermitage library in fact possessed two copies of the 1767 edition, one of them that presented to Catherine II (see p. 66), plus two manuscript copies, one in English and the second a Russian translation. These are preserved today in the Hermitage archive.

In 1910 the first detailed illustrated guide to the Hermitage Picture Gallery was published, the text written by Russia's renowned art critic, Alexandre Benois.[172] In his foreword, Benois mentioned those most celebrated collections that comprised the core of the Picture Gallery, including the 'superb collection of Lord Walpole'.

The tragic events of 1917 mercifully did not fulfil Horace Walpole's gloomy prediction that the Houghton Hall paintings would be 'burnt in a wooden palace on the first insurrection'.[173] Together with all the Hermitage treasures, they were evacuated to Moscow in September 1917 on the orders of the Provisional Government[174] because the war front was dangerously close to the city and the fear of disturbances, or worse, in Petrograd was dramatically increased.[175] When the collections were returned on 18 November 1920, however, it was not to the Imperial Hermitage that they had vacated, but to the re-named State Hermitage Museum.[176]

Between 1924 and 1930, after long and difficult negotiations, a number of paintings were transferred from the Hermitage to the Museum of Fine Arts (now the Pushkin Museum of Fine Arts) in Moscow. The Walpole collection, however, was affected considerably less than other parts of the Picture Gallery.[177]

Russian translation of *Aedes Walpolianae*, made in 1778-79?
State Hermitage Archives

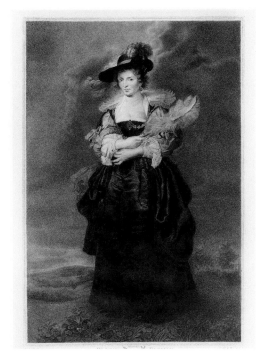

After Anthony Van Dyck, *Hélène Fourment*, 1783, stipple engraving in Boydell's *A Set of Prints ...*, vol. II, pl. XXXVI..
Yale Center for British Art, Paul Mellon Collection

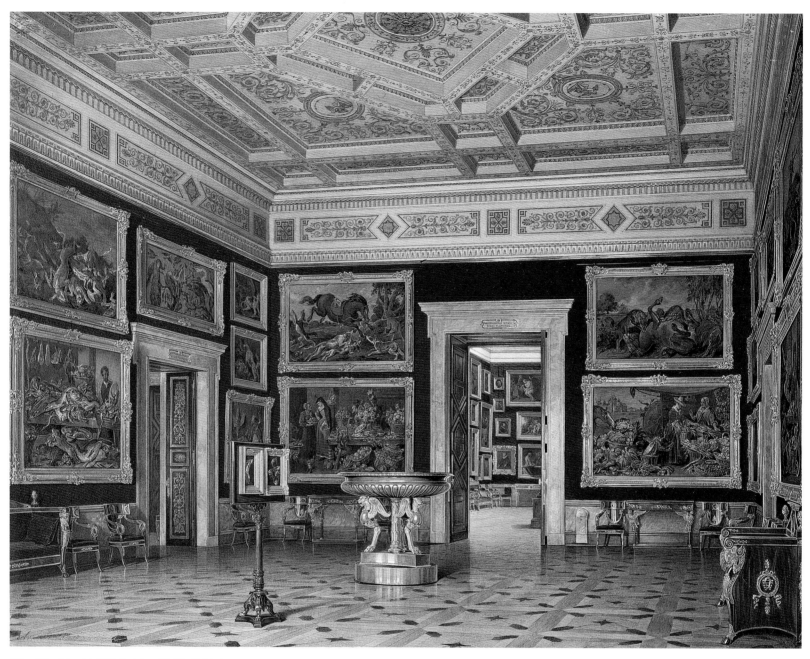

Edward Hau (1807-87), *Hall of Paintings of the Flemish Schools*, 1860, watercolour. In the lower row are Snyders' *Markets*
State Hermitage Museum

Between 1928 and 1933 terrible losses were borne by the Hermitage. During these years the government organised sales of many precious objects from the recently nationalised collections. By various government decrees, the Hermitage was obliged to transfer several thousand paintings for sale, many of them through Antikvariat.[176] The desperate battles by members of the Hermitage staff to preserve paintings, graphic works and pieces of applied art — among them numerous masterpieces — frequently ended in defeat.[177] From the Houghton pictures after numerous negotiations and lengthy correspondence,[178] this meant the loss of Rubens' portrait ?*Hélène Fourment* (cat. no. 117, Calouste Gulbenkian Museum, Lisbon), Van Dyck's portrait *Philip Wharton* (cat. no. 108, National Gallery of Art, Washington); the portrait *Innocent X* by ?Velasquez (cat. no. 187, National Gallery of Art, Washington); *Portrait of a Young Man* by Hals cat. no. 149,

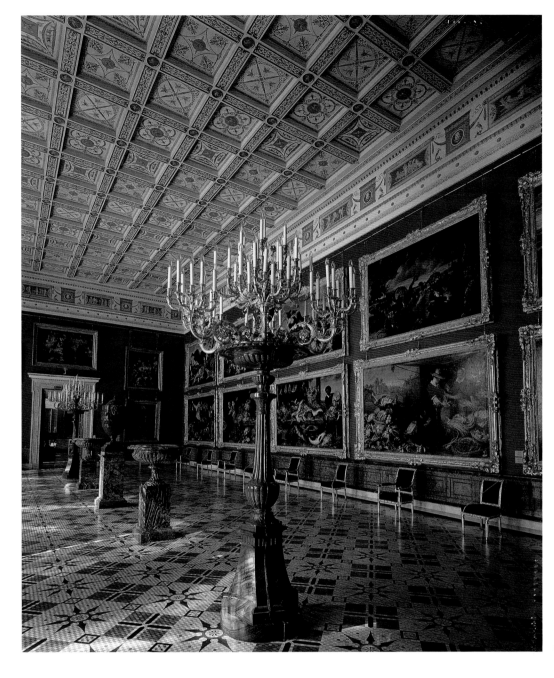

Snyders' *Markets* on display in the Hermitage in 2002

National Gallery of Art, Washington; sold from the Museum of Fine Arts in Moscow), and *A Horse's Head* by Rubens (cat. no. 127, William Morris Collection, Houston, USA).

The loss of the Velasquez was noted by visitors to the Museum[179] while the battle to retain Van Dyck's portrait of *Henry Danvers, Earl of Danby* (cat. no. 101), was particularly fierce. In the face of relentless demands from the government to hand over this masterpiece for sale the Hermitage curators once more refused. Legrand, the Director of the State Hermitage, expressed his and his fellow curators' objections as follows: 'Antikvariat has received from the Hermitage six portraits by Van Dyck, including such world masterpieces as the portrait of Isabella Brandt (from the Crozat collection; now National Gallery of Art, Washington) and the portrait of Philip Wharton. Thus the departure of yet another significat painting by the master will affect

extremely painfully the collection of his works. The sum offered, of 15,000 pounds sterling, is not high in comparison with the prices at European auctions, and with those received earlier by Antikvariat.'[180]

During the Second World War, the Hermitage was safely evacuated to Sverdlovsk (Yekaterinburg), the most arduous journey the paintings had made since their arrival in Russia.[181] On 10 October 1945 the exhibits returned to Leningrad and on 8 November the first display was opened in the restored rooms that had suffered some damage during three years of blockade and regular artillery fire across the city. Work on the display was completed in 1946 and over the following years the exhibition of Western European painting was to undergo few radical changes. Paintings came to be hung less densely than before, but the central principle continues to be arrangement by national schools and chronology. Until very recently, however, it was still extremely difficult for visitors to discover from which collections paintings had been acquired. Only at the very end of the twentieth century did it at last prove possible to produce new labels including an indication of provenance. Thus the 'secret' became accessible not only to readers of the Hermitage's two-volume catalogue of painting,[182] but to all interested visitors.

Of the two hundred and one paintings, two pastels and one drawing which arrived in 1779 from Houghton Hall we can today identify one hundred and twenty six works in the Hermitage and most of them are on display. A further fifteen are in Moscow, in the Pushkin Museum of Fine Arts; twenty more are in various museums around the Russian Federation and Ukraine. Six more are in museums and collections abroad. The fate of thirty-seven works is still unknown, seven of which are known to have disappeared during the Second World War.[183] It is hoped that this publication will help to identify some of those missing works.

Postscript

Even at this late stage the fate of the Walpole pictures remains in flux. As this book was about to go to press, Kneller and Wootton's portrait of King George I (cat. no. 197) was discovered in Germany. This was formerly at the Imperial Palace at Gatchina, which was occupied by German troops during the Second World War. This and many other pictures from Gatchina were thought to be lost or destroyed. In May 2002 this picture was returned to Russia as part of a continuing process of restitution of works of art from Germany. So the number of untraced pictures is now one fewer. Only thirty-six works are now missing.

DATES

Russia adopted the Gregorian calendar, used by the rest of Europe, only in 1918. Russian dates in the eighteenth century follow the Julian calendar and are therefore eleven days behind those in England (e.g. 4 December in Russia was 15 December in England). The Julian dates are abbreviated as OS or Old Style, as opposed to NS or New Style. Although correspondence between Russians cited in this publication uses OS dates, for the logic of chronology they have all been given here NS, with the OS equivalent, i.e. the date written on the document, in brackets.

1 Morrison 1887-97, vol. V. (N–R), p. 49.
2 Vertue, vol. I, 1929-30, p. 6.
3 Horace Walpole: 'Advertisement to a Catalogue and Description of King Charles the First's Capital Collection of Pictures, Statues, Bronzes, Medals, &s.', cited from HW Works 1798, vol. I, pp. 236-37.

4 Building of the house had been initiated in 1721, the foundations were laid in May 1722. The original design for the house was by Colen Campbell, but was considerably altered by Thomas Ripley. Robert Walpole followed all stages of the construction closely. In 1727 William Kent was entrusted with decoration of the interiors, bringing in Rysbrack and Venetian *stuccatori*, among them Giuseppe Artari. Construction and decoration were completed in 1735. Replanning of the park began in 1719 (gardener Fulke Harold) and completed in 1731. For greater detail on both house and park see 'Survey of the Houghton Hall Estate by Joseph Hill, 1800', *Norfolk Record Society*, vol. 1, 1984; Cornforth in Moore ed. 1996, pp. 20-47.

5 RW to General Churchill, 24 June 1743. Cited in Warburton 1851, vol. II, pp. 358-59.

6 Walpole MS 1736, pp. 1-10 (see Appendix III). It is possible that there were in fact more than 113 paintings, as several references are ambiguous about the quantity (e.g. 'Cattle over the doors' may

refer to one, two or even more paintings). Pears (1988, p. 263, note 70), for instance, gives the figure as 114. See Appendix III.

7 The engravings referred to by Vertue were first published by Isaac Ware and Thomas Ripley, *The Plans, Elevations and Sections, Chimney-Pieces and Ceilings of Houghton in Norfolk...* (London, 1735). They later appear in the first volume of *A Set of Prints Engraved After the Most Capital Paintings... at Houghton Hall in Norfolk*, published in 1788 by John Boydell (1719-1804). This includes 'Twenty-eight PLANS, ELEVATIONS, PERSPECTIVE VIEWS, CHIMNEY PIECES, CEILINGS, &c.' engraved by P. Foundreniere who, according to information provided by Vertue, 'came over into England in 1720.- his remarkable works are mostly of Architecture ruling work—many are very curious and neatly done. principally that book & the plates of Houghton House Sr Robert Walpoles, in Norfolk' (Vertue, vol. III, 1933-34, p. 136). On Paul Foudreniere (fl. 1720-58) see Clayton 1997, p. 113. For detailed information on Boydell see Bruntjen 1985; Rubenstein in Moore ed. 1996, pp. 65-73.

8 Vertue, vol. V, 1937-38, p. 121.

9 Gilpin 1809, p. 42.

10 HW to Montagu, 25-30 March 1761; HWC vol. 9, p. 348.

11 Cited in Ketton-Cremer 1940, p. 97.

12 *Ibid.*

13 *Aedes* 1752, p. 113.

14 *Ibid.*, p. 114.

15 *Aedes Walpolianae. A Description of Houghton-Hall* was published three times during the author's lifetime: the first edition in 1747; a second edition in 1752, with a number of corrections and additions by Horace himself; a third edition in 1767, identical to the second edition, including the page layout and numbers. After Walpole's death, the *Aedes* was included in the second volume of *The Works of Horatio Walpole, Earl of Orford*, 5 vols., London, 1798. It is important to note that the collection's composition did not alter after completion of the *Aedes*.

16 *Aedes* 1752, p. 101.

17 *Ibid.*, p. iv.

18 HWC vol. 19, pp. 496-97. See Appendix V.

19 Sir Horatio Mann (1706-86). British minister in Tuscany, from 1755 Baronet.

20 15 April 1745; HWC vol. 19, p. 32.

21 Pears 1988, p.248, note 155, records that the antiquarian William Stukeley attended a sale under the name of Robert Bragge and assumed that it was composed of Walpole paintings. There is, however, no evidence for such a supposition.

22 Houlditch MSS, see Appendix VI. Christopher Cock (d. 1748) was one of the most famous auctioneers in London during the first half of the 18th century. The sale of Lord Orford's paintings in 1748 was the most significant event of its kind to be held at his auction rooms. See Pears 1988, p. 248, n. 155; Lippincott 1983, pp. 113-14.

23 For a biography of George Walpole, see Ketton-Cremer 1948, pp. 162-87; Austin 1999, pp. 105-20.

24 Vertue, vol. V, 1937-38, pp. 85-86. See Appendix VII.

25 'in 1756 ... he and Lord Rockingham raced five turkeys and five geese from Norwich to London. ... Lord Orford was also renowned for driving around the Newmarket area in a phaeton drawn by four red deer' (Austin 1999, p. 109).

26 HWC vol. 20, pp. 481-82.

27 Sir Luke Schaub (d. 1758). Diplomat.

28 HWC vol. 21, p. 200.

29 HW to Montagu, 25-30 March, 1761; HWC vol. 9, pp. 347, 348, 349.

30 Edward Walpole (1706-84). Second son of Sir Robert Walpole, 1st Lord Orford. His interests were more towards music and literature than painting. See cat. no. 211.

31 Margaret Rolle (1719-1781). Countess of Orford, Viscountess Walpole, suo jure Baroness Clinton. Married Robert Walpole, eldest son and heir to Sir Robert, 1st Lord Orford, in 1724. For details of her life see: 'Margaret, Countess of Orford, Viscountess Walpole, suo jure Baroness Clinton', in Austin 1999, pp. 85-104. '... she told Mann of her regret that she was too old and infirm to travel so far and, in any case, she could not see what use she would be to George. In reality, Lady Orford was preoccupied with her plans to establish a home for herself and [her lover] Mozzi. In March 1773 she bought the Villa Medici, which was situated on the hill in Fiesole.... Immediately after notifying Mann of her inability to travel to England, Lady Orford set out for Naples to select and bring back furniture from her house there for her new residence.' (Austin 1999, p. 98).

32 HWC vol. 36, p. 332. Appendix 6 in vol. 36 (pp. 331-36) presents what is effectively a chronicle of the illnesses of George Walpole as reflected in the letters of Horace Walpole.

33 Rev. William Mason (1724-97). Poet.

34 John Manners (c. 1730-92). Illegitimate son of Lord Manners. Lord Orford owed him the sum of £9,000.

35 Maria Walpole (1736-1807). Daughter of Edward Walpole. By her first marriage Lady Waldegrave; Duchess of Gloucester by her second marriage.

36 HWC vol. 28, pp. 92-93.

37 The Hon. Anne Lidolel (c. 1738–1840). By her first marriage (1756) Duchess of Grafton; she married after her divorce John Fitzpatrick, 2nd Earl of Upper Ossory. Walpole's letters to Lady Ossory contain a mass of minor details, sketches of small events and features of everyday life. He wrote 450 letters to her, the last dated just one month before his death in 1797.

38 In June 1773 John Boydell sent to Houghton his nephew Josiah Boydell, Joseph and George Farington, and Richard Earlom, to produce drawings from the most famous paintings, from which engravings were later made. This work continued for four years. The first ten engravings were published in 1774. The whole publication was completed after the sale of the collection, in 1788. Bruntjen 1985; Rubinstein 1991.

39 HWC vol. 32, pp. 140, 142.

40 Austin 1999, p. 113.

41 HWC vol. 32, pp. 145.

42 HWC vol. 7, p. 560.

43 HWC vol. 36, p. 335.

44 HWC vol. 36, pp. 122, 123.

45 John Wilkes (1727-97). Journalist. MP 1757-64, 1768-69, 1774-90.

46 Quoted in William Cobbett, *The Parliamentary History of England from the Earliest Period to the Year 1803*, vol. XIX, London, 1814, '29th of January 1777 to the 4th of December 1778', pp. 188-90. The Raphael Cartoons had been removed from Hampton Court Palace in December 1763 to the Great Room at King George III's Buckingham House (see Shearman 1972, p.153).

47 HWC vol. 24, pp. 303, 304.

48 Carlos Cony, Lord Orford's solicitor c. 1774-91. See also HWC vol. 36, p. 164, note 1.

49 HWC vol. 24, pp. 310-11.

50 John Dunning (1731-83). Cr. (1782) 1st Baron Ashburton; barrister, Middle Temple (1756). Price was presumably a legal partner.

51 Matthew Duane (1707-85). Lawyer and eminent conveyancer; antiquarian and numismatist, Fellow of the Royal Society of Antiquaries, one of the Trustees of the British Museum. See *DNB*, vol. XVI, p. 76.

52 MS NRO (BL VIb (vi)); part of this is published in HWC vol. 26, p. 55.

53 Count Alexey Semyonovich Musin-Pushkin (1730-1817). Diplomat, senator, Privy Counsellor 1766-68 and Ambassador to the Court of St James 1769-79. For a detailed biography see Ferrand 1994, p. 92.

54 MS NRO (BL VIb (vi)).

55 The sale of the collection of M. G. Braamcamp took place in Amsterdam on 31 July 1771. A considerable proportion of the paintings were acquired for Catherine II through the Russian ambassador to the Hague, Dmitry Alexeevich Golitsyn. All perished, however, on the journey to Russia when the ship bearing them sank off the shore of Finland.

56 MS NRO (BL VIb (vi)).

57 For further information on their agreement to give up their right to inherit Houghton Hall, see the full commentary to Lord Orford's letter of 1 October 1778 in HWC vol. 36, p. 163, note 1.

58 HWC vol. 36, p. 163.

59 *Ibid.*, pp. 163, 164.

60 Those copies of the *Aedes* mentioned in Lord Orford's letter, 'intended as presents', were for the Empress and (perhaps) for her Ambassador. It seems likely that the copy of *Aedes* 1767 now in the Hermitage Library (Rare Books Department R.K.5.4.24), bound in red leather with gold stamping along the edge of the binding is one of these two copies (see fig. on p. 66). Placed in the margins against each picture are prices and at the bottom of the page is a sum total of the prices on that page, divided off by a double line. The value of the whole collection is not indicated. On the last page, p. 96, stands the inscription: 'NB the Pictures which are not valued are considered to be rather as family and furniture Pictures adapted to certain Places, than as Pictures of Value.'

61 Morrison, 1887-97, p. 49.

62 This is possibly a reference (for an alternative explanation see text to note 77) to a manuscript catalogue (i.e. not a full copy of the *Aedes* but only the 'Description') in the Hermitage Archive (Fund I, *Opis* VI A, *yed. khr.* 145). This manuscript is bound in greyish brown marbled paper. Against each painting intended for sale, as in the leather bound copy of *Aedes*, is the world 'Lot' and the price (see Concordance). On the last page is the word 'End' and no indication of the total price. The copy was made, as indicated on the title page, from the 1767 edition of the *Aedes*.

63 MS NRO (BL VIb (vi)). The letter was published, with edited omissions, by Andrew Moore in Moore ed. 1996, No. 73, p. 154.

64 Letter from HW to Horatio Mann, 15 June 1755; HWC vol. 20, p. 482.

65 Andrew Moore (Moore ed. 1996, p. 61) suggested that it was 'this meeting that caused him [Lord Orford] to appoint James Christie to value the pictures at Houghton'. It is clear from Cony's bill of late July (see p. 64, n. 54) and Lord Orford's letter to Christie of 30 October that contact had in fact been established with Christie considerably earlier.

66 Unfortunately we have no other information regarding this meeting.

67 The antiquarian and collector of medals, Matthew Duane (see note 51).

68 Rev. Dr Arnold King—probably a confusion for Rev. John Glen King (1732-87). In 1763 King arrived in St Petersburg, where he remained until 1774, performing the duties of chaplain at the English Church. Thanks to the patronage of the British Ambassador, Sir George Macartney, and then of Lord Cathcart, he gained access to the highest Petersburg society. Whilst in Russia he studied the Orthodox Church and left a number of compositions on the history of Russia. During a visit to London in 1771 he was elected a member of the Society of Antiquaries and then of the Royal Society. King visited Russia for the last time with Baron Dimsdale (see note 138) in 1781. For full details of his activities in Russia see Cross 1997, pp. 104-9. King was well acquainted with the sculptor Falconet and his name is mentioned repeatedly by Jacob Stählin (1709-85), author of notes on the fine arts in Russia, with whom he corresponded (Stählin1990).

69 Duane gave Cony this news in a letter of 12 November (MS NRO (BL VIb (vi)); Moore 1996, p. 51).

70 MS NRO (BL VIb (vi)). Moore mentions this letter to Cony, without citing the text (Moore ed. 1996, p. 61).

71 It is not clear why, in his letter to Christie, Cony indicates that the collection was valued at 40,000 guineas (i.e. £42,000) when Christie had valued it at £40,555 (see above, Christie's letter of 23 November, p. 66).

72 HWC vol. 24, p. 441.

73 A reference to the presentation copies of *Aedes* which Lord Orford requested Christie to have bound in leather (see above, Lord Orford's letter to James Christie of 30 October 1778, p. 66). As regards 'the Catalogue on which I made the Valuation', see notes 62 and 77.

74 Paintings listed by Christie here as not in need of valuation due to their poor quality were simply not marked on the pages of the *Aedes*. Nor did they appear in any of the various lists which include prices. In Christie's opinion, these works were not suitable for sale. But during later negotiations between Lord Orford and the Russian Ambassador in 1779 they were added to those being acquired without any increase in the agreed price (see p. 71 below, letter from Musin-Pushkin to Catherine II of 6 April (OS 26 March) 1779 and notes). In addition to the paintings mentioned in this letter from Christie, no valuation was put on a whole series of other works (see note 97).

75 Probably a reference to the speech by John Wilkes to Parliament on 28 April 1777 (see above p. 63).

76 MS NRO (BL VIb (vi)). Partly published by Moore (Moore ed. 1996, no. 73, p. 154).

77 See note 62. It is not clear precisely which of the versions mentioned in the various correspondence is that now in the Hermitage Archive.

78 Morrison 1887-97, p. 48.

79 This suggests that Musin-Pushkin was making his first approach to the Empress on the matter.

80 Presumably a reference to the annotated presentation copy of 'A Description of Houghton Hall' (see above, note 62).

81 Judging from the ambassador's later correspondence (letter from Musin-Pushkin to Catherine II of 6 April 1779; letter from Musin-Pushkin to Catherine II 23 April 1779; see p. 71), Cipriani was Musin-Pushkin's main adviser in this affair.

82 Archive of the Russian Federation Ministry of Foreign Affairs, Fund 35, *Opis'* 35/6, *delo* 287, ff. 19-20. This letter is in French, but it should be noted that all other letters from the Ambassador were written in Russian. Published in SbRIO 18, 1876, pp. 395-96, although with a significant error: in the middle of the text are the words (in Russian) '>From this material regarding the paintings for sale by Lord Orford a personal Imperial Decree was issued to the Plenipotentiary Minister Musin-Pushkin of 13 February 1779'. The original of the letter reveals clearly that this text is a later addition at the end of the first page, written in another hand. The decree has so far not been uncovered in Russian archives.

83 In the archive, attached to the letter of 15 December (OS 4 December) 1778, is a separate sheet of paper which provides a list of the page numbers in *Aedes* and the total value of the paintings on that page, without any commentaries: e.g Page 38.....50 £ 40....150 £, etc After page 96 is a line and below that the overall sum of 40,550 £. St. [pounds sterling]. This should probably be seen as a supplement or appendix to the *Aedes*. When published in SbRIO this page was given as an appendix to the letter of 23 April (OS 12 April) 1779, but in the archive itself it appears with the letter cited here.

84 HWC vol. 24, p. 427.

85 HWC vol. 24, p. 434.

86 HWC vol. 33, p. 86.

87 The early royal wooden palace had in fact already been replaced by today's famous Winter Palace (1745-62), designed by Bartolomeo Rastrelli.

88 HWC vol. 24, p. 441.

89 Friedrich Melchior Grimm (1723–1807). Writer, art critic and diplomat. From 1774 in regular correspondence with Catherine II, he acted as the Empress's official agent in the acquisition of works of art. His letters to Catherine II and Emperor Paul I are published in SbRIO 44, 1885, while Catherine's letters to him appear in full in SbRIO 23, 1878. A selection of the correspondence between Catherine and Grimm was published by L. Réau (1932).

90 SbRIO 23, 1878, p. 126.

91 27 March 1779; SbRIO 44, 1885, p. 45 (Réau 1932, p. 51).

92 Unfortunately, neither the letter from Musin-Pushkin nor the answer from Lord Orford have proved possible to find in Russian archives.

93 Archive of the Russian Federation Ministry of Foreign Affairs, Fund 35, *Opis'* 35/6 1735-1808, *delo* 296, f. 4.

94 *Ibid.*, ff. 7-9. Published in SbRIO 17, 1876, pp. 396-97. The publication omits the date of the letter and Musin-Pushkin's full signature below.

95 Archive of the Russian Federation Ministry of Foreign Affairs, Fund 35, *Opis'* 35/6 1735-1808, *delo* 296, ff. 10-11. Published in SbRIO 17, 1876, pp. 398-400. The orthography of the artists' names is most erratic, while the titles of the paintings are somewhat freely translated into Russian and are sometimes merely descriptive. Thus Maratt is written both Karl Muratis and Karla Marati, also Maratini; Velasquez is rendered as Velyasko; Van Dyck is Vandek, Vaydeik etc.

96 In the original (manuscript) in the archive the list of paintings in need of restoration is marked off from the paintings in good condition not by a heading but simply by a thin pen vignette.

97 See note 74.
'Additional paintings without increasing the previous price:
Birds' Concert, Marieyu Defori.
The Repentant Son, Porderpone.
Racing Dog, Old Wyck.
Field Hunt, Wooton.
Portrait of King William 3] Gotfrey-Neller.
' ' George 1]

Hispanic poet, Gotfrid-Kneller.
Archbishop Laub, main culprit of the unhappy fate of King I [i.e. Charles I], copy after Vandalk.★
The Judgment of Paris, Carl Maratini, he painted this picture in the 83rd year of his old age.
Alexander adorning the tomb of Achilles.★
Consulting the Sybilline oracles, Lemaire.★
Two paintings of cattle, Rosa Ditivolli.
Cavalier Wharton, Vaydeik.★ [i.e. Thomas Wharton]
Two pictures of vegetables, Michel Angelo Comkidani and portrait of Cavalier Robert Walpole.'
In fact, not 17 but 24 paintings were acquired 'without increasing the previous price'. In addition to those listed, there were Wootton's *Hounds and Magpie* (cat. no. 201), Kneller's portraits of *Grinling Gibbons* and *John Locke* (cat. nos. 199, 200); Old Griffier's *Sea-port and Landscape* (cat. nos. 147, 148)★; Jervas' *Dogs and Still-Life* and *Deer, Dog and Cat* (cat. nos. 194, 195). Paintings marked in this footnote with an asterisk (★) were not valued by Christie, who saw them as being of insignificant artistic interest (see above letter from Christie to Carlos Cony of 29 November 1778, p. 67). The portrait of Sir Robert Walpole by Vanloo was probably considered by Christie to be one of the 'family pictures' and it must therefore have been included at Catherine's particular request. As for the other paintings, the reason for their exclusion from the original sale list is unclear (we can only presume that Christie saw Wootton's *Field Hunt* as something in the nature of a 'family picture', and Wootton's *Hounds and a Magpie* and Old Wyck's *Greyhound* as 'furniture pictures'). Paintings added 'without increasing the previous price' were not indicated in any of the surviving lists of paintings sold, nor were they marked in those copies of the *Aedes* where prices were put in the margins. Thus, their further history after the sale remained unknown both to contemporaries and to many later scholars.
The list appended to the letter should in no way be seen as reflecting the full content of the collection as acquired by Catherine. Rather it is a draft working text, for it includes just 97 of the 204 paintings eventually purchased, with the afterthought 'and several others'.

98 HW to Horatio Mann, 4 August 1779; HWC vol. 24, p. 502.

99 HWC vol. 7, p. 158.

100 Probably a reference to Robert Udny (1722-1802), West Indian merchant, collector and art dealer. Udny made several visits to Italy, where his brother John Udny (1727-1800), also a merchant and collector, occupied the post of consul in Venice and then at Livorno. Robert Udny assembled a collection of paintings, mainly of the Italian school, in which he was aided considerably by his brother. It was probably part of such a collection which was acquired for the Russian Empress. Catherine mentions this acquisition in the same letters to Baron Grimm in which she writes of the purchase of the Walpole collection (letters to Grimm of 27 April (OS 16 April), 18 and 29 May and 10 June (OS 7, 18 and 30 May) 1779, published in SbRIO 23, 1878, pp. 135, 140, 143. Whitley (1915, p. 279) gives the sum paid for the collection as £25,000. Unfortunately no documents have been uncovered in the Hermitage regarding 'Udney's pictures'. For Robert and John Udny see Ingamells 1997, pp. 961-64.

101 SbRIO 23, 1878, p. 135 (Réau 1932, p. 53).

102 HWC vol. 7, p. 159.

103 *The London Chronicle* for 1779, Tuesday 27 April, p. 398.

104 *The Gentleman's Magazine*, 1779, vol. XLIX, pp. 270-71.

105 This sum of £40,555 figures on the last page (p. 96) of one of the copies of the *Aedes* (1767) in the Hermitage Library (RK 37.2.52), in the list published by William Gilpin (1809, pp. 68-75) and a number of others (Redford 1888, vol. II, pp. 356-57; Herrman 1999, pp. 80-82). Some of the price lists differ by the sum of £5 (i.e. £45,550). This may be explained in that Dobson's *Portrait of Van der Doort* was priced at £25 and since all the other prices ended in a zero this last figure was apparently not taken into account in the final summary. The majority of the known lists give the titles of the paintings with an indication of their price and a total at the end. Even three years after the sale had taken place the *European Magazine* (February 1782, pp. 96-99) pub-

lished an incomplete list under the title 'Authentic Catalogue of the Houghton Collection of Pictures lately sold, and transmitted to the Empress of Russia, with the price which was paid to Lord Orford for each Painting, as settled by the appraisement'.

106 SbRIO 23, 1878, p. 139 (Réau 1932, p. 58). Although Catherine wrote to Grimm just 11 days later, on 29 May (OS 18 May) with rather more satisfaction: 'il me suffit cette année d'avoir acheté toutes les inutilités possibles, savoir bibliothèque patriarcale, tableaux Walpole, tableaux Udney etc. et quantité des jouets d'enfants pour M. Alexandre [her grandson] et compagnie.'

107 *Ibid.*, p. 143.

108 HWC vol. 2, p. 165.

109 Archive of the Russian Federation Ministry of Foreign Affairs, Fund 35, 1720-1808, *Opis'* 35/6, *delo* 296, ff. 25-26. Published (undated) in SbRIO 17, 1876, pp. 400-1.

110 The Consul General in England at this time was Alexander Baxter, an 'English merchant of the First Guild'. He was appointed by a Russian government decree of January 1773.

111 The information provided by Musin-Pushkin regarding details of the transportation is contradictory: in his letter of 6 April (OS 26 March) 1779 the Ambassador speaks of the need to despatch them on 'a naval frigate', but here he already mentions two ships and an English frigate to accompany them.

112 Gambra: it has not proved possible to identify the place meant, although it could be Hamburg.

113 Archive of the Russian Federation Ministry of Foreign Affairs, Fund 35, 1720-1808, *Opis'* 35/6, *delo* 296, f. 22. Published in SbRIO 17, 1876, p. 401 (undated). The Admiralty's reply to Musin-Pushkin's request for a frigate is unknown.

114 HWC vol. 24, pp. 502, 503.

115 *The Gentleman's Magazine*, vol. XLIX, Saturday 31 July 1779, p. 375. 'The Houghton collection of paintings is not yet actually sold. They have been viewed by the Russian ambassador, who sent over a list of one hundred of them to the Empress, which are valued at 40, 525 £. But at present the pictures remain at Houghton.' This information probably resulted from Musin-Pushkin's visit to Houghton Hall in April 1779 (see pp. 70–71), but the number of paintings cited and the prices are imprecise.

116 HWC vol. 16, p. 189.

117 Count Ivan Grigoryevich Chernyshov (1726-97). Fieldmarshal-General of the Fleet, vice-president of the Admiralty Collegium 1769-90, and president from 1796. He carried out many diplomatic missions, being, for instance, Ambassador to London 1768-69.

118 Prince Alexander Alexeyevich Vyazemsky (1727-96). Procurator General.

119 Central State Naval Archive, Fund 172, *Opis'* 1, *delo* 239, f. 2.

120 Samuel Greig (1735/6-88). One of five Scottish naval officers, 'captain of the first rank', who arrived in St Petersburg in 1764. For his numerous achievements in the Russian fleet he was in 1775 made Vice Admiral and appointed Commandant of the naval port city, Kronstadt. For more detailed information see Cross 1997, chapter 5.

121 Central State Naval Archive, Fund 172, *Opis'* 1, *delo* 239, f. 11.

122 Harris 1844, vol. I, p. 436. James Harris (1746-1820). Diplomat. 1773-83 British Ambassador to St Petersburg; 1778 Knight of the Bath; 1788 created Baron of Malmesbury; 1800 created Earl of Malmesbury.

123 HW to Horatio Mann, 7 July 1783; HWC vol. 25, p. 418.

124 Ketton-Cremer 1940, p. 184.

125 12 February 1779; HWC vol. 2, p. 192. The portrait was hung in the Saloon at Houghton, where it remains today, but the plaque with the inscription has not survived. 'When he sold the collection of pictures at Houghton, he declared at St James's, that he was forced to it, to pay the fortunes of his uncles [Edward and Horace]—which amounted but to ten thousand pounds—and he sold the pictures for forty, grievously to our discontent, and without any application from us for our money—which he now retains, trusting that we will not press him, lest he should disinherit us, were we to outlive him. But we are not so silly as to have any such expectations at our ages; nor, as he has sold the pictures which we wished to have preserved in the family, do we care

what he does with the estate. Would you believe—yes, for he is a madman, that he is refurnishing Houghton—aye, and with pictures too—and by Cipriani—That flimsy scene-painter is to replace Guido, Claude Lorran, Rubens, Vandyck, Carlo Maratti, Albano, Le Suoeur, etc., etc…But enough!—it is madness to dwell on Bedlam actuated by attorneys.' (Letter from Horace Walpole to Mann, 8 September 1782; HWC vol. 25, p. 316.)

126 *The Morning Chronicle* for 17 September 1779 published the following communication: 'The Houghton collection is not only now certainly sold to the Empress of Russia, but actually shipped; the delay was occasioned by the empress insisting on having the noble collector's portrait into the bargain; which being once agreed to, there was hardly time allowed for packing the pictures; and they were sent by waggons to the port of Lynn the latter end of last month.' This information later appeared in the *Gentleman's Magazine*, vol. XLIX, 23 September 1779, pp. 469–70. The agreement to include the portrait of Sir Robert Walpole by Van Loo, without any increase in the previous price, was reached in April (see p. 71 and note 97).

127 Malmesbury Letters, vol. I, pp. 436, 437. Miss Harris also sent a letter of similar content to Vice Admiral Greig himself. Central State Naval Archive, Fund 172, *Opis'* 1, *delo* 239, ff.96-98.

128 *The Gentleman's Magazine*, vol. XLIX, Saturday 30 October 1779, p. 518.

129 Cited in HWC vol. 2, p. 184, note 22.

130 HWC vol. 2, p. 183.

131 HWC vol. 2, p, 184, note 22.

132 SbRIO 23, 1878, p. 175. Documents which might more precisely reveal the history behind transportation of the paintings from Lynn to St Petersburg after the *Natalia* was wrecked have so far not been uncovered. The theory that the paintings had perished remained in circulation in England right up to the mid-19th century, as is proved by a watercolour by John Sell Cotman, *Lee Shore, with the Wreck of the Houghton Pictures, Books &c., sold to the Empress Catherine of Russia, 1838* (Fitzwilliam Museum, Cambridge, see fig on p. 74).

133 Stählin 1990, vol. I, p. 384.

134 Stählin was in error, for the ship could not have arrived in the summer of 1779, and certainly no earlier than late autumn (see p. 74). As in the majority of 18th-century Russian sources, Houghton is treated as the owner's surname.

135 Levinson-Lessing 1986, p. 87. Vladimir Frantsevich Levinson-Lessing (1893-1972). Leading Russian museum specialist and scholar. Worked at the Hermitage from 1921 to his death. His history of the Hermitage Picture Gallery 1764-1917 remains to this day the most serious study of the subject and laid the foundations for all subsequent works.
Catherine II's most significant acquisitions of paintings in Europe prior to 1779 were as follows.
1764: 225 paintings belonging to the Berlin merchant Johann Gotzkowski, which laid the foundation for the picture gallery
1769: collection of Count Heinrich Brühl, Dresden
1770: collection of François Tronchin, Geneva
1772: collection of Pierre Crozat, Paris
1772: collection of the duc de Choiseul, Paris
For a good general summary of Catherine's collecting for the Hermitage, see also Waagen 1864; Descargues 1956.

136 Count Nikita Ivanovich Panin (1718-83). Statesman and diplomat, from 1760 tutor to the heir to the throne, Grand Duke Paul (future Paul I); 1763-81 attached to the Collegium of Foreign Affairs.

137 Corberon 1901, vol. II, pp. 296-97.

138 *An English Lady at the Court of Catherine the Great. The Journal of Baroness Elizabeth Dimsdale, 1781*, edited, with an introduction and notes by A. G. Cross, Cambridge, 1989, p. 42.

139 *Passages from the Diaries of Mrs. Lybbe Powis of Hardwick House, Oxon. A. D. 1756 to 1808*, London, New York and Bombay, 1896, pp. 212-13. Despite the evidence of these and other writers, we should note that a certain confusion surrounded the Walpole collection's status in Russia. Incorrect information was given in a book by Robert Kerr Porter (1777-1842), an English artist who worked in St Petersburg. After a visit to the Hermitage

in the first decade of the 19th century, he wrote: 'at a considerable expence, [Catherine] added the Houghton Gallery to her own. The pictures were not unpacked during her life; but were taken out and arranged under the auspices of her successor.' Robert Kerr Porter, *Travelling Sketches in Russia and Sweden, During the Years 1805, 1806, 1807, 1808*, 2 vols, London, 1809, vol. I, p. 41.

140 Although Boydell published his two volumes of engravings from the paintings at Houghton Hall (129 prints) in 1788, some of the engravings had already appeared in *A Collection of Prints Engraved after the Most Capital Paintings in England*, the first issue of which appeared in 1769. The Houghton Gallery was published in portfolios, 1774-88. The 1788 edition gave on the title page the name of the collection's new owner: *A Set of Prints Engraved after the most capital Paintings in the Collection of Her Imperial Majesty the Empress of Russia Lately in the Possession of the Earl of Orford, Houghton in Norfolk*. A copy of this was sent to the Empress, specially bound in red leather with gold stamping and including the Russian arms (sold in 1930 for 4,000 roubles during the sales of state property; now priv. coll. France), as a reward for which, Boydell received a present from Catherine of a snuffbox with her portrait. See Clayton 1997, p. 230.

141 *The European Magazine*, February 1782, pp. 95-99.

142 'Catalogue raisonné des tableaux qui se trouvent dans les Galéries, Sallons et Cabinets du Palais Impériale de S. Pétersbourg, commencé en 1773 et continué jusqu'en 1785', 3 vols, 1773-85, Hermitage Archives, Fund 1, *Opis'* VI-A, *delo* 85 = Cat. 1773-85. The first volume of this catalogue was printed, under the same title, in 1774. The other volumes remained in manuscript form. It is likely that the second volume was begun in 1775.

143 Since Munich did not know English, he probably used the Russian translation of the *Aedes* (Hermitage Archive, Fund I, *Opis'* VI A, *yed. khr.* 146). This manuscript translation (bound in red leather and decorated around the edges with fine gold stamping) was presumably made for the Empress, as she also was not familiar with English. The translation was taken not from the printed copy of the *Aedes* presented to Catherine II (see p. 66) but from the manuscript copy reproducing only the 'Description' from the Aedes (Hermitage Archive, Fund I, *Opis'* VI A, *yed. khr.* 145).

144 All the measurements are given in Russian units: the *arshin* (71.12 cm) and the *vershok* (4.45 cm).

145 In addition to paintings, these included two pastels by Rosalba Carriera and one drawing then attributed to Raphael. For some unknown reason, Munich did not include one painting in the catalogue: the portrait of Erasmus attributed to Holbein (cat. no. 192), while two paintings by Rosa da Tivoli, recorded in the *Aedes* as 'Two pieces of Cattle' (cat. nos. 189, 190) and published by Boydell as *The Goat's-Herd* (Boydell I, pl. XXVIII) and *The Shepherd* (Boydell I, pl. XXIX), were attributed to Dietrich (Cat. 1775-83, nos. 2332, 2333). Also, under no. 2312, in the midst of the Walpole paintings, Munich listed a work by Paolo Veronese, *The Conversion of the Apostle Paul*, which has no relation to the Houghton Hall collection at all (Hermitage Inv. No. 68; provenance unknown—although we might suggest that it came from the Udny collection, see note 100).

146 The Small Hermitage: building adjoining the Winter Palace, overlooking the River Neva. Built to a design by Jean-Baptiste Vallin de la Mothe (1729?-1800) in 1766-68. Later underwent numerous reworkings. The Large Hermitage: building adjoining the Small Hermitage, also overlooking the River Neva. Built to a design by Yury Velten (1730-1801) in 1771-84. See *Ermitazh. Istorya i arkhitektura zdaniy/L'Ermitage. L'histoire et l'architecture des bâtiments*, Leningrad, 1974; *Ermitazh. Istoriya stroitel'stva i arkhitektury zdaniy* [*The Hermitage. A History of the Construction and Architecture of the Buildings*], Leningrad, 1989.

147 William Coxe (1747-1828) first visited Russia in 1778 as tutor to George, Lord Herbert, elder son of Lord Pembroke. The result of this first journey was *Travels in Poland, Russia, Sweden and Denmark*, published in 1784 and dedicated to Lord Herbert. This went through several editions and served as a kind of guide book for many travellers visiting Russia. In 1803 a fuller edition was

produced. Coxe produced two more books on Russia: *Account of the Russian Discoveries between Asia and America* (1780) and *Account of the Prisons and Hospitals in Russia, Sweden and Denmark* (1781). Catherine II was well acquainted with Coxe's works and she granted him an audience on two occasions. On the reception of Coxe's book in Russia see Alekseyev 1982, pp. 132-33. For further information on Coxe himself, see Cross 1997, pp. 349-53.

148 Coxe 1803, vol. II, p. 53.

149 HWC vol. 34, pp. 87-88.

150 William Beloe (1756-1817). Divine and miscellaneous writer, author of various translations.

151 HWC vol. 15, p. 228.

152 Johann Gottlieb Georgi (1729-1802). Born in the Prussian province of Pomerania, he was a scientist and traveller. Author of numerous scholarly works and a lengthy ethnographical work on the peoples of the Russian lands; elected to the Russian Academy of Sciences. Georgi's book on St Petersburg, which provided the first encyclopaedic description of the city, was issued in German in 1791 and translated into French, but this did not include the description of the Hermitage, which appeared only in the Russian edition of 1794.

153 Not only Georgi but also early 19th-century Russian authors often turned the name of Houghton Hall into the surname of its owner. Some works from the Walpole collection are mentioned by Georgi in his description of the Picture Gallery (Georgi 1794 (1996 edition, pp. 346-79)) but without an indication of their provenance.

154 Georgi 1794 (1996 edition, pp. 343-44, 345). We know nothing of the fate of the Houghton frames, although Musin-Pushkin mentions the packing of the pictures together with their frames (see p. 69). It has proved possible to identify only two original frames by analogy with those still at Houghton Hall. Exhibited in these 'original' frames to this day are two paintings by Murillo, *The Adoration of the Shepherds* and *The Immaculate Conception*.

155 Swignine 1821. Peter P. Swignine (1787-1839), served from 1805 to 1824 in the Collegium of Foreign Affairs. Upon his retirement he took up writing, publishing and painting, and assembled a collection of Russian art.

156 Swignine 1821, p. 17 (Russian edition 1997, p. 240). In nineteeth-century Russia, another corruption of the name of Lord Orford was 'Lord Oxford'. In his footnotes, Swignine gives his version of where collections were acquired and the sum paid, without mentioning his sources of information.

157 Swignine 1821, p. 33 (Russian edition 1997, pp. 247-48).

158 Swignine 1821, p. 33 (Russian edition 1997, pp. 247-48).

159 Swignine 1821, p. 25 (Russian edition 1997, p. 244).

160 Granville 1828, vol. I, pp. 548-49.

161 The New Hermitage: building attached to the back of the Large Hermitage. Designed by Leo von Klenze (1784-1864). The last version of the design was approved in 1840 and construction completed in 1851. From 21 September 1850 the building was officially known as the New Hermitage. The new public museum was ceremonially opened on 5 February 1852. See *Ermitazh. Istoriya stroitel'stva i arkhitetury zdaniy* [*The Hermitage. A History of the Construction and Architecture of the Buildings*], Leningrad, 1989, pp. 407-28. On the organisation of the exhibition and the Hermitage's new existence as a public museum see Levinson-Lessing 1986, pp. 180-84. Watercolours and drawings showing the interiors of both museum rooms and private apartments in the Winter Palace are to be found in A. N. Voronikhina, *Vidy zalov Ermitazha i Zimnego dvortsa v akvarelyakh i risunkakh khudozhnikov serediny XIX veka* [*Views of the Hermitage and Winter Palace in Watercolours and Drawings by Artists of the Mid-19th Century*], Moscow, 1983; Emmanuel Decamp, ed., *The Winter Palace, St Petersburg*, Paris, 1995.

162 Empress Maria Alexandrovna, née Augusta-Sophia-Maria (1824-80), daughter of the Duke of Hesse, Ludwig II. From 1841 wife of Grand Duke Alexander, later Alexander II.

163 Also at Gatchina were two portraits by Kneller, Wootton's *Hunting-Piece*, as well as Van Loo's *Portrait of Sir Robert Walpole*. The latter was in the so-called Ministers' Corridor which formed a

164 sort of portrait gallery. Some paintings hung at Pavlovsk Palace and in the Catherine Palace at Tsarskoye Selo. It should be noted that paintings were frequently moved from one location to another.

164 Wrangell 1913, pp. 60, 62. 'By Highest order a commission was set up ... this commission was entrusted by the late Sovereign Emperor to look over the whole body of paintings scattered throughout various palaces and make from them a strict selection for the Hermitage. 4,000 canvases were collected, and all were carefully studied and from them three categories compiled: 1) a category of first class pictures, around 1,600, which were to hang on the walls of the new museum, 2) a category of secondary pictures which it was suggested should be hung in various palaces, and 3) a category of totally bad works, which should be sold. The late Sovereign was closely involved in the workings of the commission. It was a rare day on which he did not attend ... On 31 August 1853, "The Sovereign Emperor desired personally to set each painting's purpose". Unfortunately, this "purpose" was largely destructive and one thousand two hundred and nineteen pictures were set aside for sale "as worthless".' Those paintings which were not sold were returned to the Hermitage. See the essay by Svetlana Vsevolozhskaya in this publication.

165 In 1864, Waagen published his *Die Gemäldesammlung in der Kaiserlichen Ermitage zu St. Petersburg nebst Bemerkungen über andere dortige Kunstsammlungen* (2nd ed., St Petersburg, 1870). Here Waagen gave a short description of the Houghton Hall collection, although he introduced some incorrect information, for instance in the number of works from different schools of painting and the overall price paid for the collection. 'Diese auf £40,500 geschätze Sammlung wurde nach langen Verhandlungen in Jahre 1779 von dem ältesten Sohn des Grafen Sir Robert, George, Grafen von Orfort, für £36,080 erworten. Etwa 55 Bilder der seben sind Werke von ersten Rang, der Hauptgewinn für St. Petersburg bestand unter diesen weider einer ganzen Reihe den trefflichsten Portraite von van Dyck.' (Waagen 1864, p. 19).

166 The Rumyantsev Museum opened in Moscow in 1862, based around a varied and extensive collection formerly belonging to the State Chancellor, Count Nikolay Petrovich Rumyantsev (1754-1826), who bequeathed it to the state. This had initially been kept in his mansion on the English Quay in St Petersburg, where it was opened to the public as the Rumyantsev Museum after his death. In 1861, by order of Alexander II the 'Muzeum' collections were transferred to Moscow and housed in the Pashkov Mansion. Over the next half century the collection grew considerably, acquiring large numbers of paintings and works on paper. The Pashkov Mansion also housed, in addition to the Rumyantsev Museum, the Moscow Public Museum (based on the Moscow University collection). As a result of the proximity of both museums within a single building, catalogues and guides produced before 1924 bore the title 'Moscow Public and Rumyantsev Museums'. To follow the variations in title, see publications 'Rumyantsev Museum' in the Bibliography. In 1924 the Soviet government took the decision to close the Rumyantsev Museum. Most of its collections were transferred to the Museum of Fine Arts, now Pushkin Museum of Fine Arts.

167 Hermitage Archive, Fund I, *Opis* II, *yed. khr.* 4.

168 Hermitage Archive, Fund I, *Opis* II, 1862, *yed. khr.* 10 (MS Moscow Public Museum 1862). Since the closure of the Rumyantsev Museum, the fate of three of its seven Houghton paintings remains unknown: *The Virgin and Child with St John the Baptist* (*Aedes* p. 55, as 'Holy Family' by Titian'), Reni's *St Joseph Holding the Christ Child*, and Van Dyck's *Portrait of Lady Philadelphia Wharton* (cat. nos. 89, 71, 107).

169 J. Beavington Atkinson, *An Art Tour to Russia*, New York, 1986, pp. 34-113. First published in England in 1873 as *An Art Tour to the Northern Capitals of Europe*, Atkinson was the first English author to provide, in writing of the Hermitage, a detailed description not only of the paintings themselves but also of the catalogues.

170 Trubnikov 1914, p. 89.

171 The first catalogue of the Picture Gallery was compiled by B. de Koehne and appeared in 1863. This was re-issued several times in both Russian and French. It was followed by a whole series of catalogues compiled mainly by A. Somov (Somof, Somoff) devoted both to individual schools and to the Picture Gallery as a whole. In 1912 a catalogue of Italian painting by Ernst Liphart was published. The last pre-revolutionary brief catalogue appeared in 1916. The same numbering was retained throughout all these catalogues. For a full list of catalogues, see Bibliography. For details of the principles behind compilation of the catalogues see V. F. Levinson-Lessing: 'Ocherk istorii sobraniya' [Outline of the History of the Collection], in Cat. 1976, pp. 33-34, 37.

172 Benois [1910]. Alexandre [Alexander] Nikolayevich Benois [Benua] (1870 Paris). Renowned artist, theatrical designer, art critic and art historian. From 1918 to 1926 head of the Hermitage Picture Gallery. See *Aleksander Nikolayevich Benua i Ermitazh* [Alexandre Nikolayevich Benois and the Hermitage], exh. cat., Hermitage Museum, St Petersburg, 1994.

173 Letter from Horace Walpole to Mann, 11 February 1779; HWC vol. 24, p. 441.

174 Nicholas II abdicated in February 1917 and the country was then ruled by the Provisional Government until the Revolution of 7 November (OS 25 October) which eventually brought the Bolsheviks to power.

175 St Petersburg was renamed Petrograd in 1914, a reflection of the anti-German mood at the start of the First World War.

176 In Moscow, the boxes of exhibits were stored in the History Museum, the Armoury and the Great Kremlin Palace. After re-evacuation of the paintings to Petrograd in November 1920, the first 22 rooms of the Picture Gallery re-opened on 2 January 1922. See Piotrovski 1990, pp. 51-54; Piotrovski 2000, I, pp. 70-74, 270-302.

177 Amongst the works transferred to the Pushkin Museum were such outstanding paintings as Poussin's *Continence of Scipio* (cat. no. 178), Rubens's *Bacchanalia* (cat. no. 131), Rembrandt's *Portrait of an Old Woman* (cat. no. 154), and Hals's *Portrait of a Young Man* (cat. no. 149), which was soon sold through Antikvariat and is now in the National Gallery of Art, Washington.

178 Antikvariat: All Union Export Association, Antikvariat, a state body which carried out the sale of works of art both within the Soviet Union and abroad. For detailed information on the sales, see Robert C. Williams, *Russian Art and American Money, 1900-1940*, London, 1980; Larsons [M. Y. Lazerson], *An Expert in the Service of the Soviets*, London, 1929; 'Mr Mellon Admits he Owns Ex-Hermitage Treasures', *Newsweek*, 2 March 1935, p. 23; the lists of works sent to Antikvariat, the relevant government decrees as well as letters from Hermitage employees relating to the transfer, were first published in Piotrovski 2000, pp. 352-495; these documents are in the Hermitage Archives. Further documents have recently been made public in Lost Hermitage 2001.

179 It should be noted that many of the works handed over to Antikvariat for auction were in fact unsold and were returned to Russia. Not all, however, were returned to the museum from which they had derived, and in some cases it has not proved possible to trace their present whereabouts.

180 Documents relating to the period 1928–33 include numerous demands that the Hermitage hand over for sale a number of paintings from the Walpole collection, together with counter proposals put forward by the museum staff. The paintings demanded were Huysum's *Flowers*, Bordone's *Allegory (Venus, Flora, Mars and Cupid)*, Poussin's *Moses Striking the Rock*, Claude's *Bay at Baia*, and nearly all the portraits by Van Dyck (Lost Hermitage 2001, pp. 132, 134–36, 152, 336–37).

181 'When any painting is removed from the exhibition, a note is always left (in its place): where, what for, and why it is not there ... Now Velasquez's *Pope Innocent X* is not on show. Where is it and what has happened? We don't know (some other painting hangs in its place). The information officers won't answer the question. Some members of the public have been saying that it has been sold!', letter from worker B. Golovanov, 22 November 1931, which was posted in the suggestion box for visitors. The reaction was swift, and the Hermitage informed those in charge of the sales that 'the painting mentioned in the letter by the artist Velasquez, Portrait of Pope Innocent X, has been removed from exhibition and on the orders of the Government transferred to the Antikvariat State Organization.' Cited in Lost Hermitage 2001, pp. 177–78.

182 Lost Hermitage 2001, p. 337.

183 For more information on the evacuation see *Ermitazh spasyonnyy* [*The Hermitage Saved*], exh. cat., Sverdlovsk, 1995; Sergei Varshavsky, Boris Rest, *The Ordeal of the Hermitage*, Leningrad and New York, 1985.

184 Cat. 1958, 2 vols; Cat 1976 (Italy, Spain, France, Switzerland) and Cat. 1981 (Netherlands, Flanders, Belgium, Holland, Austria, England, Finland, Sweden, Hungary, Poland, Romania, Czechoslovakia). Both 2-volume publications give inventory numbers, not catalogue numbers as in Cats 1863-1916, and cite the provenance of works.

185 This figure also includes a number of paintings which were transferred from both the Hermitage and the Pushkin Museum in Moscow to Antikvariat (see note 176), the fate of which cannot be traced further, nor the attributions with any certainty established.

THE CATALOGUE

Catalogue Explanation

All measurements are given in cm, height x width
Some early sources, e.g. Munich (Cat. 1773-85), give measurements using the Russian *arshin* and *vershok*, usually abbreviated as *ar.* and *v.*:
One *arshin* = 71.12 cm
One *vershok* = 4.45 cm

After support and technique, catalogue headings list artist's signature or monogram, date or any other inscription present on the work.

Provenance:
Provenance is arranged chronologically, from earliest to present day.
The first date in the provenance beside Sir Robert Walpole's name indicates the first record of the painting in his collection.
'1736' indicates that the painting is included in the inventory of Sir Robert's paintings in his various houses which is dated to 1736 (Walpole MS 1736; Appendix III).
Where the location is given as 'Houghton', without a date, the painting was acquired after 1736 and reference is thus to *Aedes Walpolianae*, i.e. it fixes the painting's presence at Houghton no later than 1743, the date when Horace Walpole completed the manuscript copy of the text.
Where a painting was in one of the London houses and then moved to Houghton by 1743, the provenance uses the formula 1736 [location (room)], later Houghton ([room])';
 if a painting was at Houghton both in 1736 and 1743, in the same room, the formula is '1736 Houghton ([room])';
 if a painting was at Houghton both in 1736 and 1743 but is listed in different rooms, the formula used is '1736 Houghton ([room] then [room])'; where the same room had different names in the different sources, the room formula is '[room as per 1736 inventory] / [room as per *Aedes*]'.
1779 Hermitage – abbreviation for the purchase of the Houghton paintings from Sir Robert Walpole's grandson George, 3rd Lord Orford, by Catherine II, in 1778-79 and their arrival in St Petersburg.

Literature:
References to pages in the *Aedes Walpolianae* are all to the edition of 1752, which is identical to the edition of 1767; where the title or attribution have changed significantly since the *Aedes* was compiled, the title/author as in the *Aedes* is given in brackets. This is followed by the catalogue number according to the facsimile *Aedes* (ie. *Aedes* 2002) in this book, on pp. 351-418.

Where an engraving from the work was included in John Boydell's *Set of Prints Engraved after the most capital paintings In the Collection of Her Imperial Majesty the Empress of Russia. Lately in the Possession of the Earl of Orford at Houghton in* Norfolk, 2 vols., London, 1788, this is given in the heading as volume number then print number, e.g. Boydell I, pl. XIII. Where the title or attribution have changed significantly since publication of the engravings, the title/author as in Boydell is given in brackets.

Catalogue Authors

I. A.	Irina Artemieva
T. B.	Tatyana Bushmina
A. L.	Alexey Larionov
I. S.	Irina Sokolova
E. R.	Elizaveta Renne
N. G.	Natalya Gritsay
N. B.	Natalya Babina
K. Ye.	Ksenia Yegorova
N. S.	Natalya Serebriannaia
E. D.	Ekaterina Deryabina
Ye. Sh.	Yelena Sharnova
M. G.	Maria Garlova
T. K.	Tatyana Kustodieva
A. K.-G.	Asya Kantor-Gukovskaya
S. V.	Svetlana Vsevolozhskaya
I. G.	Irina Grigorieva
V. M.	Viktoria Markova
M. S.	Marina Sinenko
O. N.	Olga Nikitiuk
L. K.	Ludmila Kagane

The catalogue entries for the works of art remaining at Houghton (cat. nos. 205-274) were compiled by Andrew Moore.

The Seventeenth-Century Italian Paintings from the Walpole Collection

Svetlana Vsevolozhskaya

The acquisition of the Walpole collection for the Hermitage was as significant for the formation of the seventeenth-century Italian collection as that of the Crozat collection had been seven years earlier for the Renaissance section of Catherine II's burgeoning museum.

Before 1779, the acquisition of works by seventeenth-century masters for the Imperial gallery had been somewhat erratic and it was only with the purchase of the Walpole paintings that the nucleus of this section of the Hermitage collection was formed. Although new acquisitions were to augment it, the Walpole paintings were of such excellent quality that later additions could never detract from the importance of that original purchase. It was largely thanks to the Houghton collection that by the end of the eighteenth century the Hermitage Picture Gallery had a representative selection of works from Bologna, Rome, Naples and Genoa, the main Italian schools of the seventeenth century.

Although the Houghton collection contained relatively few Bolognese works (by Carracci, Albani, Cantarini, Sirani and Cignani) their significance is such that, when added to the Empress Catherine's acquisitions of the Brühl and Crozat collections in 1769 and 1772 respectively, they added enormous distinction to the status of her Hermitage. *The Pietà with Saints* (cat. no. 15) — although for much of its earlier history attributed to Ludovico Carracci — is a representative example of Agostino Carracci's somewhat archaic classical style. More famous as a scholar and engraver, we have so few pictures surviving by this artist that each one is of great interest.

Two pictures from Houghton by Francesco Albani, together with his *Rape of Europa* from the Brühl collection (Inv. No. 55), reveal the full range of this painter. From his vast altarpiece *The Baptism* (cat. no. 2) to the small, carefully executed, and fully signed *Annunciation* (cat. no. 1).

Two canvases by Guido Reni are discussed at length in the literature on the artist: *The Fathers of the Church Disputing the Christian Doctrine of the Immaculate Conception* (cat. no. 70) and *The Adoration of the Shepherds* (cat. no. 69). The first is especially notable for its subject matter, reflecting as it does on a central doctrinal concern for the Catholic Church in the seventeenth century, the question of the Virgin Birth. The re-affirmation of Mary's saintliness was of course in direct opposition to the Protestant principles of Luther and Calvin.

The second work by Reni, *The Adoration of the Shepherds* in an unusual octagonal format, is a more poetic image of the Virgin leaning over her radiant Child. The number of copies and engravings of the latter are a testament to the considerable popularity of the image.

Prior to the acquisition of the Walpole collection, the Roman school had only a meagre representation in the Hermitage but the Houghton acquisitions were of great significance. Two superb pictures by Pietro da Cortona, *The Return of Hagar* (cat. no. 31) and *The Appearance of Christ to Mary Magdalene* (cat. no. 30), enjoyed particular fame and reinforce Horace Walpole's assertion that 'No collection can be complete without one Picture of his hand.'[1] Another canvas, *Hercules and Omphale* (cat. no. 73) by Giovanni Francesco Romanelli, a pupil of Pietro da Cortona, also complements the master's own work.

Still relatively unknown to specialists, although most undeservedly so, are two huge compositions by Pier Francesco Mola, *Horatio Cocles Holding the Sublicius Bridge* and *Marcus Curtius Leaping into the Gulf* (cat. nos. 55, 56). Unique in the painter's oeuvre, they have been lent over the last decade to temporary exhibitions in the Museum of the St Petersburg Academy of Arts and reproduced in catalogues, but it is hoped that they will now attract the attention they undoubtedly merit.

Two splendid still lives by Michele Pace del Campidoglio (cat. nos. 58, 59), housed for many years at the former imperial residence at Gatchina, south of St Petersburg, were known from Boydell's engravings after them. When, comparatively recently, art historians began to seriously study Italian still-life painting these two Walpole pictures were seen as benchmarks for identifying works from the master's own hand.[2]

Amongst the most important acquisitions from the Walpole Collection was a group of works, outstanding both in number and quality, by Carlo Maratti and his pupils, which occupied a whole 'Carlo Maratt Room' at Houghton Hall. Before 1779 the Hermitage had only four good but small works by the master. The twelve paintings from Houghton that joined them, extremely varied in format and content, were mostly of high quality. Amongst these are the excellent *Portrait of Pope Clement IX* (cat. no. 41), several late religious pictures with subject matter found commonly in seventeenth-century Italian art (*The*

Vision of Joachim and Anna, St John the Evangelist, The Virgin Teaching Jesus to Read, The Mystic Marriage of St Catherine, cat. nos. 48, 49, 44, 52), and two vast mythological subjects, *The Judgement of Paris* (cat. no. 51) and *Acis and Galatea* (cat. no. 50). The former of these is signed by the artist 1708 and inscribed with his age, 83, as if to proudly confirm his undiminished powers. Even though these two monumental works were largely painted with the help of pupils, Maratti apparently wished for the last time to leave evidence of his health, uncannily predicting and refuting Giovanni Pietro Bellori's assertion that: 'nell' anno 1706 . . . , oltre la debolezza della vista, incominciò a vacillargli di sì fatta maniera la mano, che non potea più reggerla ferma al lavoro: con tuttociò volle continuare ad assistere a' suoi scolari.'[3]

Four of Maratti's pupils were also represented in the Walpole collection. Among these were his closest and most talented assistant Niccolò Berrettoni (cat. nos. 8, 9) and his faithful follower Giuseppe Chiari (cat. nos. 21–24). Pietro de' Pietris, chosen by the master to assist in the restoration of Raphael's Vatican frescoes, was also represented (cat. no. 61), as well as the almost unknown Michele Semini, whose name we have sought to resurrect here. His *Galatea* (cat. no. 82), which disappeared during the Second World War, would doubtless have shed some light on this artist's work. Had all these paintings remained in the Hermitage, no other museum outside Italy could boast a comparable selection of works by Maratti and his school. As Horace Walpole put it in the introduction to the *Aedes Walpolianae*, Maratti and his pupils 'formed a new Roman School, and added Grace, Beauty, and Lightness, to the Majesty, Dignity and Solemnity of their Predecessors. . . . The Carlo Marat Rooms, is a perfect School of the Works of him, Nicolo Berretoni, and Giosepe, his Disciples.'[4]

Other parts of the Imperial Picture Gallery were also significantly enhanced by the acquisition of the Walpole collection. At the centre of the museum's seventeenth-century Italian holdings today are three superb works by Salvator Rosa. *The Portrait of a Man* (cat. no. 76) is, as Filippo Baldinucci suggested, possibly the artist himself whilst Horace Walpole's description of *The Return of the Prodigal Son* (cat. no. 77) in the foreword to the *Aedes* as 'the extremity of Misery and low Nature; not foul and burlesque, like Michael Angelo Caravaggio; nor minute, circumstantial, and laborious, like the Dutch painters'[5] remains highly appropriate today. *Democritus and Protagorus* (cat. no. 75) is an example of a subject rarely tackled by other artists. Rosa was particularly taken with such unusual themes, which were often recommended to him by his friend Ricciardi.

Although the Hermitage already possessed canvases by Luca Giordano (acquired with the Gotzkowski, Brühl and Triebl collections), those works which came from the Walpole collection — *Vulcan's Forge* (cat. no. 33), *Sleeping Bacchus* (cat. no. 34) and *The Judgment of*

Paris (cat. no. 35) — were of far greater fame and significance. Superbly painted, they quite properly occupy a key place in the artist's considerable artistic legacy.

Just as important as Pace del Campidoglio's still lifes as benchmarks in the artist's career are Vassallo's *Bacchus/Orpheus* (cat. no. 86) and *The Exposition of King Cyrus* (cat. no. 85). Both were for many years attributed to Giovanni Benedetto Castiglione until, at the beginning of the twentieth century, the signature of the then little-known Genoese artist Antonio Maria Vassallo was discovered on the *Bacchus/Orpheus*. That exciting discovery facilitated the identification of a group of works by the artist.

The Marchese Niccolò Maria Pallavicini, a renowned collector and patron who commissioned numerous works from contemporary artists, built up a collection that was justly famous in its day. A good number of the works with a Pallavicini provenance were acquired by Sir Robert Walpole and thereby eventually came to the Hermitage (see Appendix I).

Pallavicini was of course an important patron of Carlo Maratti and his pupils. Stella Rudolph, the author of an important study of Pallavicini's activities as a collector, has suggested that many of the canvases by Maratti, Berrettoni, Chiari and other masters formerly at Houghton came from the Marchese's collection, even though this is not specifically documented in the *Aedes Walpolianae*.[6] In his introduction to the *Aedes*, Horace Walpole noted that 'most of the famous Pallavicini Collection have been brought over; many of them are actually at Houghton,'[7] but in the catalogue itself he indicated a Pallavicini provenance for only five works by Maratti: the *Portrait of Clement IX* (cat. no. 41), *The Judgment of Paris* (cat. no. 51), *Acis and Galatea* (cat. no. 50), *The Virgin Teaching Jesus to Read* (cat. no. 44) and *St Cecilia with Angels* (cat. no. 45). To these we should add three mentioned by Bellori: *The Vision of Joachim and Anna* (cat. no. 48), *St John the Evangelist* (cat. no. 49) and *The Mystic Marriage of St Catherine* (cat. no. 52). Stella Rudolph also lists a number of other works that may have belonged to the Marchese Pallavicini before they came to Houghton: *The Holy Family Beneath a Palm Tree* (cat. no. 42), *The Assumption of the Virgin* (cat. no. 46), *Venus and Cupid* (cat. no. 53) all by Carlo Maratti, both canvases by Niccolò Berrettoni (cat. nos. 8, 9), and all four works by Giuseppe Chiari (cat. nos. 21–24).[8]

Unfortunately, the inventory of the Pallavicini collection made in 1714 and published by Rudolph does not always include the artist's names.[9] Yet to Rudolph's list we might tentatively add several more works that were later to enter the Walpole collection. That listed as no. 325 in the Pallavicini inventory may well be the Walpole *Mystic Marriage of St Catherine* by Maratti (cat. no. 52) and no. 71 is possibly Salvator Rosa's *Three Soldiers* (cat. no. 78).

When they arrived at the Hermitage, the Houghton paintings were entered in the current manuscript catalogue (Cat. 1773-85). This French-language catalogue was compiled for Catherine II by Count Johann Ernst Münnich, usually known by the French version of his name, Munich (in Russian his name is always written Minikh). An erudite man, well-versed in the arts, Munich did not hesitate to consult other specialists and artists, particularly with regard to the attribution of paintings. In the foreword to the manuscript catalogue Munich described himself in the following terms: 'Honoré par Votre Majesté de la commision d'y Travailler j'en ai fait l'Object de tous mes soins, et ne rien avancer au hazard, quand il s'agissait de déterminer le vrai nom du Maître, le sens de l'allégorie et l'originalité de certains Tableaux, j'ai pinsé dans les auteurs iconographes, dans l'histoire de la fable, sans negliger de consulter les connaisseurs et les artists en état de m'aider de leurs lumières.'

Munich's chief assistant was the Venetian artist Giuseppe Antonio Martinelli, who was responsible for the Imperial Picture Gallery.[10] Martinelli undoubtedly played an active role in hanging the newly acquired paintings. The Picture Gallery was then housed in the Small Hermitage, in three galleries surrounding a hanging garden, and also in what is today called the Old Hermitage. It is clear that the Walpole paintings had been put on exhibition by the summer of 1780, as we learn from the journal of a French diplomat, the Baron de Corberon. On 24 August 1780 he wrote of his intention 'de voir ce matin l'Ermitage de l'Impératrice et la superbe collection de tableaux qu'elle a achetée en Angleterre'.[11]

Despite the dense hanging of paintings, lack of space meant that the Walpole collection could not be exhibited in its entirety; but in 1793 no less than half of the Italian paintings were accessible to visitors. This is clear from the description of St Petersburg by Johann Gottlieb Georgi, scientist, scholar, traveller and Professor at the St Petersburg Academy of Sciences. He provided the first detailed and systematic description of the Russian capital. First published in 1790 in German, then in 1793 in a French edition, it was not until the appearance of the Russian-language version in 1794 that the book came to include a description of the Hermitage.[12] Although Georgi's text is extremely well known to Russian art lovers it has remained essentially unstudied by foreign scholars.

Georgi was no specialist and he too turned for assistance to Martinelli, who indicated the most valuable works of art: 'Here am I able, thanks to the aid of M. Martinelli's diligence and benevolence, to portray all the masters whose works are now kept in the imperial gallery of the Hermitage. . . . The chief and most precious paintings are indicated on the basis of M. Martinelli's well-founded judgments.' Giuseppe Martinelli also seems to have provided the provenance of many of the pictures, including those from the Walpole collection, which became corrupted in Georgi's book as 'the collection of the Englishman Gougton'.

Which of the Italian paintings from Houghton were on show in the gallery?[13] Georgi dwells on the works of Maratti: 'The Virgin with a Book in her Hands' (*The Virgin Teaching Jesus to Read*, cat. no. 44) and 'An Image of Jesus Christ, the Virgin and Joseph' (probably *The Holy Family Beneath a Palm Tree*, cat. no. 42). He was particularly taken with 'two large marvellous paintings, of which one shows "The Judgment of Paris" and the other "Galatea" (cat. nos. 51, 50). Georgi specifically names only these four works although he does state that there were eighteen pictures by Maratti on display in the gallery. Since the Hermitage had six pictures by Maratti from sources other than Houghton, we might deduce that all twelve Marattis from the Walpole collection were exhibited.

The four paintings by Giuseppe Chiari and one by Niccolò Berrettoni that drew the author's attention were all undoubtedly from the Walpole collection. Georgi particularly noted *Christ Appearing to Mary Magdalene* by Filippo Lauri (cat. no. 38), *The Virgin and Child* by Sassoferrato (cat. no. 81), *The Return of Hagar* by Pietro da Cortona (cat. no. 31), *The Baptism* by Francesco Albani (cat. no. 2), Carracci's *Virgin and Child* (cat. no. 16) and *Bacchus/Orpheus* 'by Castiglione' (Vassallo, cat. no. 86). Of the four canvases by Viviano Codazzi that he mentioned, two were from the Walpole collection. His 'one painting' by Raffaello Motta can only be the Walpole *Holy Family* formerly attributed to Raphael da Reggio (cat. no. 93). He even names *The Prodigal Son* and 'Old Man with Children' (*Democritus and Protagorus*) by Salvator Rosa (cat. nos. 77, 75). At the end, Georgi mentions a *Virgin and Child*, 'a small, most elegant image', attributing it to Domenico Ricci, called Brusasorci. It is perfectly possible that this in fact refers to a work by Alessandro Turchi (cat. no. 84) from Houghton, since in the Hermitage there was a confusion between Brusasorci and Turchi.

One important feature of the Imperial collection was that paintings were used extensively in the decoration of Royal residences. In some instances this might mean a move from the Hermitage to the adjacent Winter Palace, and paintings were certainly hung in the Empress's private apartments there. In 1780 the inspector of the gallery was ordered by Catherine II 'To adorn my study with paintings and . . . for this order Martinelli to choose the pictures.'[14]

Martinelli selected several dozen works from amongst those acquired by the Empress, amongst them two Walpole pictures, 'Portrait of a Woman' (*Donna nuda*) (cat. no. 39), then attributed to Leonardo da Vinci, and 'Simeon with the Christ Child' (*St Joseph Holding the Christ Child*; cat. no. 71) by Guido Reni. Additional

paintings were distributed amongst the Imperial and Grand Ducal apartments and, as a result of their small size and calm, pleasing appearance, works by Carlo Maratti were particularly suitable for this purpose. During the first quarter of the nineteenth century *The Virgin Teaching Jesus to Read* and *St Cecilia with Angels* hung in the Winter Palace apartments of Empress Elizaveta Alexeevna, wife of Alexander I. *The Mystic Marriage of St Catherine* was given to the church of the Marble Palace; *St John the Evangelist* was transferred a little later to the church in the Tauride Palace.[15] The dispersal of paintings during the first half of the nineteenth century was, however, much less radical than it was to become in the 1850s and again after 1917.

Visiting St Petersburg in the 1820s, Ferdinand Hand saw many of the paintings still hanging in the Hermitage gallery. His close study of them resulted in a detailed and thorough book, published in 1827.[16] He felt obliged to take up his pen in order to correct the errors and inaccuracies in the works of his predecessors. Hand's book, now a rarity, provided the first full, critical description of Italian and Spanish painting in the Hermitage.[17] The author was well acquainted with the Walpole collection which he already knew from the Boydell engravings. He must have walked through the Hermitage with the *Aedes Walpolianae* in his hands since his observations show a detailed awareness of the work of both George Vertue and Horace Walpole.[18] One example of the extent of Hand's pedantry is his lamenting the absence of the two large canvases by Mola, and at not finding other works from Houghton such as Maratti's *The Virgin Teaching Jesus to Read* or *St Cecilia with Angels* — he could hardly have been aware that they were actually then hanging nearby in the Winter Palace.

Hand's book gives the first direct indication of the provenance of each painting. The author often provides more than mere listing of the pictures and does not hesitate to offer his own subjective remarks on quality and attribution. From Hand's description of the Hermitage it would certainly appear that the greater part of the Italian paintings from Houghton were still to be found there on public display.

Hand's work appears to have served as a the main source for a number of subsequent authors,[19] most important of whom was G. K. Nagler, who in the 1830s undertook the production of a twenty-volume Künstler-Lexicon.[20] In the foreword to the first volume, he lists Hand 'Unter den neueren Gelehrten' from whose writings he drew much essential information. This would certainly help to explain Nagler's well-informed comments on paintings in the Hermitage. He lists many Italian paintings from Houghton Hall, as well as the engravings made after them.

The descriptions of the Walpole pictures by Georgi and Hand were largely included in the first official catalogue of the imperial picture gallery, published in 1838.[21] Compiled by Auguste Planat, assistant to the keeper of the gallery Franz Labensky (Franciszek Xawery Labensky), it included a description of the paintings, medium, technique, size, the presence of signatures and dates, and brief information about provenance. Impressive by the standards of early nineteenth-century scholarship, this work (to which Planat devoted many years) reflected the old principle of arrangement for the exhibition (in the order of the rooms), and more or less completes the first stage in the formation and development of the Hermitage Picture Gallery.

The creation of the New Hermitage, erected between 1842 and 1851 to the designs of the Munich architect Leo von Klenze, heralded the beginning of a new era. The new building opened as the first truly publicly accessible museum in 1852. The superb watercolours executed in the second half of the nineteenth century by Luigi Premazzi and Eduard Hau depicting a number of the rooms in the New Hermitage provide much important information about the picture hang at this time and many of the Italian pictures from Houghton are clearly visible (reproduced in this volume, see pp. 59, 68, 78-82, 84).

The opening of the new building provided an opportunity to reorganise the entire museum and to significantly extend and enhance the display. It led however to a wider dispersal of the pictures. A commission was set up under the jurisdiction of the artist Fyodor Bruni, who had replaced Labensky as head of the Picture Gallery, the task being to select paintings for the New Hermitage and to re-order the remaining works. This new classification had to be approved personally by Nicholas I. Quality was the deciding factor and the best works were chosen to hang in the Picture Gallery, with the remainder either allocated to the numerous palaces and official organisations or placed in storage. However a large number of pictures (1,219 in total) were to be put up for sale at auction, and this was undertaken during the course of 1854.[22] Those works relegated to this last group were thought to be of little significance or in a poor state of preservation.

Of the Walpole paintings, both canvases by Pier Francesco Mola (cat. nos. 55, 56) were put up for auction, along with *The Rape of Europa* by Pietro de' Pietris (cat. no. 61), *Galatea* by Michele Semini (cat. no. 82) and *The Assumption of the Virgin* by Carlo Maratti (cat. no. 46, then attributed to Giovanni Lanfranco). As it transpired the Walpole pictures were not sold. The Molas were sent to the summer residence at Gatchina and were eventually despatched to the Academy of Arts, whilst Maratti's work returned to the Hermitage. On the orders of Emperor Alexander II two other Walpole paintings, Pietris' *The Rape of Europa* and Semini's *Galatea,* were incorporated in the 1860s by the architect Andrey Stakenschneider into the ceiling of the central staircase at the Catherine Palace, Tsarskoye Selo. The Catherine Palace also acquired Alessandro Turchi's *Virgin and Child* (cat. no. 84) and *The Virgin and Child with SS Elizabeth, John the Baptist and Joseph* by Niccolò Berrettoni (cat. no. 9).

It has also been discovered that in the 1850s the following works were distributed to various other locations: Maratti's *Vision of Joachim and Anna* (cat. no. 48) went to the Imperial Palace at Pavlovsk, his *St John the Evangelist* and *The Adoration of the Magi* (cat. nos. 49, 47) to the Tauride Palace in St Petersburg; the painting by Carlo Dolci (cat. no. 32) went to the Academy of Arts; both *Architectural Fantasies* by Vivano Codazzi (cat. nos. 27, 28) to the Kamennoostrovsky [Stone Island] Palace in St Petersburg. A significantly larger number found their way to Gatchina where they joined the two Molas. Both works by Vassallo (cat. nos. 85, 86), two by Pace del Campidoglio (cat. nos. 58, 59), Salvator Rosa's *Three Soldiers* (cat. no. 78), *Cupid Burning the Weapons of Mars* by Elisabetta Sirani (cat. no. 83) and the anonymous *The Archangel Gabriel*, then attributed to Guido Reni (cat. no. 94), all ended up at Gatchina.

As a result of such major reorganisation of the collections it was deemed necessary to compile an entirely new inventory, which remained in use from 1859 to the 1920s.[23] Pictures that had been allocated to the Imperial residences in and around St Petersburg were entered in this inventory but were excluded from the printed catalogues of the Hermitage that listed only those works exhibited in the Picture Gallery.[24] Thus many of these pictures remained largely unnoticed by foreign specialists, although some were published in the early twentieth century in articles published in Russian periodical publications such as *Staryye gody* [Days of Yore] and *Khudozhestvennyye sokrovishcha Rossii* [Russia's Artistic Treasures]. Amongst these essays and articles, one by E. Liphart concentrated on the seventeenth-century Italian paintings at Gatchina, including works by Maratti, Mola, Reni and Campidoglio.[25]

The foundation of a new museum in Moscow in 1862, the Public and Rumyantsev Museum, led to the transfer there of 201 paintings from the Hermitage.[26] Gustav Waagen, director of the Picture Gallery of the Berlin Museum, who had been invited to St Petersburg to edit a new catalogue of the Hermitage Picture Gallery,[27] was responsible for making the selection. Amongst the Italian paintings transferred to the Rumyantsev Museum were three from the Walpole collection: *St Cecilia with Angels* by Maratti (cat. no. 45), *St Joseph Holding the Christ Child* by Guido Reni (cat. no. 71) and *The Return of Hagar* by Pietro da Cortona (cat. no. 31).

As a result of the October Revolution of 1917 other changes were made to the location of pictures. Some were returned to the Hermitage from other palaces and country residences; some were transferred to the newly founded Picture Gallery of the State Museum of Fine Arts (since 1937 the Pushkin Museum of Fine Arts) in the new capital, Moscow. Others were distributed amongst museums established in the capitals of the new Union Republics and other provincial galleries. Lastly, paintings and other works were confiscated by the state and transferred to Antikvariat All-Union Export Association,

with the intention of selling them at auction abroad. Inevitably, the Walpole collection did not escape unscathed.

After 1916, no new catalogues of the Hermitage Picture Gallery were to be published for more than forty years. In the first publications after this interval, the two-volume catalogue of 1958[28] and the updated edition of the Italian volume in 1976,[29] there is reference to more than twenty seventeenth-century Italian works from the Walpole collection. Only three works in the Hermitage stores whose Houghton provenance was known were not mentioned: Carracci's *Venus Sleeping*, Cignani's *Shepherd and Shepherdess*, and *The Triumph of Job* (*Job Receiving the Homage of the People*), a copy after Guido Reni (cat. nos. 17, 25, 72).

Seven Italian pictures from Houghton were identified outside the Hermitage. Mola's two historical compositions (cat. nos. 55, 56), had been transferred to the Academy of Arts in 1927. Pietro da Cortona's *Return of Hagar* (cat. no. 31) passed from the reformed Rumyantsev Museum to the Pushkin Museum of Fine Arts, to which another four works were transferred directly from the Hermitage between 1924 and 1930: *Bacchus/Orpheus* by Vassallo (cat. no. 86), Reni's *Adoration of the Shepherds* (cat. no. 69), *The Holy Family with the Infant St John the Baptist and St Elisabeth* by Cantarini (cat. no. 14) and Maratti's *Holy Family Beneath a Palm Tree* (cat. no. 42).

When this present publication was first conceived, the whereabouts of approximately half the seventeenth-century Italian works from the Walpole collection was known. Some cause for optimism that further research might prove fruitful was confirmed by the successful identification in the 1970s of several works in store that proved to have come from the Gotzkowski and Crozat collections. Furthermore, the discovery of Maratti's *Judgment of Paris* (cat. no. 51), set into the staircase ceiling at the Catherine Palace at Tsarskoye Selo offered further encouragement. Then in the 1980s, whilst preparing the (as yet unpublished) catalogue raisonné of 17th-century Italian paintings, a copy of Giordano's large *Presentation of the Virgin in the Temple* (cat. no. 36) was discovered in the Hermitage stores. It was established that its pair, *The Birth of the Virgin* (cat. no. 37), had been transferred in 1929 to Antikvariat, and their provenance from the Walpole collection was thereby revealed. Thereafter the stores yielded *The Vision of Joachim and Anna* (cat. no. 48), soon after attributed to Carlo Maratti, and *St John the Evangelist* (cat. no. 49), thanks largely to the descriptions provided by Bellori, Boydell and Walpole. The Hermitage curators were unaware at this time that Stella Rudolph was preparing her study of the Pallavicini collection but she was eventually to state in her book that 'Il vero problema e posto dalle non poche opere di provenienza Walpole assegnate, subito o quasi, alle varie residenze imperiali come Gatschina o Pavlovsk, di cui venne persa la traccià

nelle catalogazioni. Mi auguro perciò che la presente indagine possa almeno incorraggiare una ricognizione di tutto quanto da parte degli studiosi in loco.'[30] This present publication has therefore in some respects proved to be a continuation of Stella Rudolph's research. In embarking on the present project the main task lay in further attempts to locate and identify the present whereabouts of further works. Considerable time and effort has brought success, but only about half the missing paintings have been traced.

Among the discoveries made in the Hermitage stores are the identification of Niccolò Berrettoni's *Assumption of the Virgin* (cat. no. 8), Maratti's *Adoration of the Magi* and *Assumption of the Virgin* (cat. nos. 47, 46) and the *Archangel Gabriel* formerly attributed to Reni (cat. no. 94). Despite having been transferred to Antikvariat, some of these had later been returned to the Hermitage.

Several works that had been sent to the Imperial country residences (now Museum Reserves) also had their former history revealed. Maratti's large *Acis and Galatea* (cat. no. 50), the pair to *The Judgment of Paris*, had been at Gatchina but in 1927 was given to the Museum of the Academy of Arts before being sent in 1931 to Khabarovsk in the Far East of Russia. Turchi's small picture (cat. no. 84) was transferred from Tsarskoye Selo in 1929 to Antikvariat, from whence it never returned. Amongst those works lost during German occupation of the Leningrad area during the Second World War were Pietro de' Pietris' *Rape of Europa* and Michele Semini's *Galatea* (cat. nos. 61, 82) from the Catherine Palace at Tsarskoye Selo, and Salvator Rosa's *Three Soldiers* (cat. no. 78) from Gatchina.[31]

Two Italian paintings that had been in the Rumyantsev Museum in 1862 remained a mystery but Maratti's *St Cecilia* (cat. no. 45) was finally located in the Vorontsov Palace at Alupka (Crimea, now Ukraine). There it was erroneously identified as 'The Virgin Surrounded by Angels', an understandable error since not only is St Cecilia very similar to Maratti's own images of the Virgin, but the saint's pose accords with that of Mary in the *Vierge au Missel* in the Musée de Digne. The other work, *St Joseph* (previously Simeon) *Holding the Christ Child* by Guido Reni, was probably removed from the Rumyantsev Museum and put on the art market. It may have left Russia or is perhaps still to be found in some private collection in Moscow (for more information see cat. no. 71). According to V. Markova at the Pushkin Museum, *The Holy Family Beneath a Palm Tree* by Maratti (cat. no. 42) was transferred in 1937 from there to a museum in the small town of Palekh, near Moscow, world renowned for its painted lacquer ware.

It also transpired that *The Virgin and Child with SS Elisabeth, John the Baptist and Joseph* by Niccolò Berrettoni (cat. no. 9) was still at Tsarskoye Selo, but according to Larisa Bardovskaya, Chief Curator of the Palace Museum, it was listed in all documents as the work of Maratti. Its great artistic merit would seem to have led to the upgrading of the attribution but the return to Berrettoni's oeuvre of the two Walpole paintings will contribute greatly to our understanding of the considerable talent of Maratti's leading pupil. It was also at Tsarskoye Selo that Carlo Cignani's very painterly *Adoration of the Shepherds* (cat. no. 26) was rediscovered.

Of four works by Giuseppe Chiari (cat. nos. 21–24), the location of only *The Pool of Bethesda* (cat. no. 23) remains unknown. *Christ's Sermon on the Mount* is now in the Sevastopol Art Museum (Crimea, Ukraine). Two others had been transferred to Antikvariat for sale but were returned to the Hermitage in 1933, although record of their authorship had by this time been lost and they were then given to Antoine Coypel. Their whereabouts was established as recently as 2001 by T. Bushmina. *The Bacchus and Ariadne* (cat. no. 21) is in the Hermitage reserve collection, while *Apollo and Daphne* (cat. no. 22) had been transferred to the State Picture Gallery in Perm.

Viviano Codazzi's two *Architectural Fantasies* (cat. nos. 27, 28) were apparently to be sent to the Russian Embassy in Rome in 1911. However, they were still listed in the Hermitage in 1915. It is not clear if they had actually left the museum or that they had simply been accidentally excluded from the inventory.

The whereabouts of four other paintings that disappeared in the nineteenth century remains a mystery. Maratti's *Mystic Marriage of St Catherine* (cat. no. 52) is last mentioned in the Church of the Marble Palace. His *Venus and Cupid* (cat. no. 53) disappears from the records after the 1830s. *The Virgin with the Christ Child Asleep in her Arms* (cat. no. 16) is last recorded in the Hermitage by Georgi as the work of Carracci. Hand made no mention of the picture, although Nagler referred to it as follows among the works of Agostino Carracci: 'Aus Houghtonhall kam eine Madonna mit dem schlafenden Kinde im Arme nach Russland. Dieses Bild ist aber nicht in der Eremitage.'[32] Confusion about Valerio Castello's *Holy Family* (cat. no. 20) began as early as Munich's catalogue, where the author was given as Giovanni Benedetto Castiglione. The attribution vacillates between the two artists in later sources until in the second half of the nineteenth century all trace of the work disappears. There is a mention that at one time it was in a private apartment and later in the Winter Palace.

It seems entirely probable that these works have not disappeared but are simply lurking today under other names. Some help in identifying them may come from Boydell's engravings, the descriptions given by Munich cited in this catalogue, or the inventory numbers that may appear on the canvas and stretcher. We must remain optimistic that further research will help identify those works that are still missing.

1 *Aedes* 1752, p. xxii.
2 Natura Morta 1989, vol. 2, p. 775.
3 Bellori 1732, p. 106.
4 *Aedes* 1752, p. xxii.
5 *Aedes* 1752, p. xxvii.
6 Rudolph 1995, p. 15.
7 Aedes 1752, p. viii.
8 Rudolph 1995, pp. 158-9.
9 Rudolph 1995, App. II.
10 Giuseppe Antonio Martinelli was in charge of the Hermitage Picture Gallery from 1775 to 1797. Catherine II had great respect for the Italian's knowledge and opinions, as we learn from her letters to Melchior Grimm, published in SbRIO 23, 1878 (a selection was published Réau 1932).
11 Corberon 1901, vol. 2, p. 296.
12 Georgi 1794. Georgi's description of the Hermitage was most timely, for the brief catalogue of the paintings published in 1774 appeared too soon to include such important subsequent acquisitions as the Walpole collection: *Catalogue des tableaux qui se trouvent dans les Galeries et dans les Cabinets du Palais Impérial de Saint-Pétersbourg*, St Petersburg, 1774. Published in only a limited edition, this catalogue has become a great rarity. It was reprinted in the journal Revue *Universelle des Arts* for 1861, vols XIII, XIV, and 1862, vol. XV, after which many had the mistaken idea, which survives today, that the French publication included the whole of Munich's manuscript catalogue of 1773-85.
13 We should note that it is highly likely that more of the Walpole Italian paintings were exhibited than we have counted here, but they are not always possible to identify from Georgi's description as he often merely names the number of works by a particular artist. We can hence only guess whether or not they included paintings from Houghton Hall.
14 Quoted in O. G. Dintser: 'O. G. Martinelli – pervyy khranitel' Ermitazha' [O. G. Martinelli – First Keeper of the Hermitage], *Nauka i kul'tura Rossii XVIII v. Sbornik statey* [Science and Culture in 18th-century Russia. Anthology of Essays], Leningrad, 1984, p. 183.

15 Notes on the location of paintings in the 19th century are found in the manuscript catalogue begun after the death of Catherine II, during the reign of Paul I, in 1797, under the guidance of Franz Labensky, head of the Picture Gallery. This catalogue remained in use until the mid-19th century. Cat. 1797. The numbers used in this catalogue were usually placed on the front of the canvas.
16 Hand 1827. Only the first volume, devoted to Italian and Spanish painting, was issued.
17 Of previous publications, we should note Labensky 1805-9, Reimers 1805 (Reimers was helped in compiling his description of the Hermitage by the English engraver John Saunders or Sanders, member of the St Petersburg Academy of Arts; Swignine), 1821.
18 Hand 1827, p. 41.
19 As in, for instance, the small publication Schnitzler 1828.
20 Nagler 1835-52.
21 Livret 1838.
22 The list of works set aside for auction was published in Wrangell 1913.
23 Inventory 1859 – begun in 1859. Numbers according to this catalogue were placed in black ink on the back of the canvas.
24 A full list of catalogues of Hermitage painting (Cats. 1863-1916) is provided in the Bibliography.
25 Liphart 1916.
26 MS Moscow Public Museum 1862.
27 Waagen 1864.
28 Cat. 1958, 2 vols.
29 Cat. 1976, Italian, French and Swiss painting.
30 Rudolph 1995, p. 209, note 462.
31 I would like to thank Rifat Gafifullin of Pavlovsk Palace Museum for his assistance in locating these works.
32 Nagler 1835-52, vol. 2, p. 391.

The Houghton Paintings Sold to Catherine II

Italian School

I

FRANCESCO ALBANI (1578–1660)

The Annunciation

Oil on copper, 62 x 47, signed in the bottom right corner: *Fran^{cus} Albanus Bononien*

Inv. No. 86

PROVENANCE: Sir Robert Walpole, 1736 Downing St (Sir Robert's Dressing Room), later Houghton (Gallery); 1779 Hermitage.

LITERATURE: *Aedes* 1752, p. 96 (as 'The Salutation'); 2002, no. 276; Ripley 1760, p. 10; Labensky 1805–9, vol. 1, bk. 1, pp. 15–16; Hand 1827, pp. 224–25; Schnitzler 1828, pp. 27, 128; Nagler 1835–52, vol. 1, p. 38; Livret 1838, p. 65, no. 15; Giordani, in Bolognini Amorini 1839, pp. 38–39; Giordani, in Malvasia 1678 [ed. 1841], vol. 2, p. 199; Cats. 1863–1916, no. 202; Waagen 1864, p. 80; Cat. 1958, vol. I, p. 51; Schaak 1970, p. 229, no. 94, 230; Cat. 1976, p. 67; Vsevolozhskaya 1981, no. 108; Musées de France 1988, p. 39; Puglisi 1991, pp. 299–300, no. 145; Puglisi 1999, pp. 60, 173, 190, cat. 108, pl. 220.

On the basis of the unusual form of the signature, Puglisi (1999) suggested 'that the commission held special importance and perhaps came from a foreign client.' Albani painted a number of similar versions of this subject (from Luke i: 26–38). Two such compositions (then in the royal collection in Paris) were recorded by Hand (1827), although he emphasised that the Hermitage painting is not identical with either of them. Much closer is the version in the Church of San Bartolomeo in Bologna, by comparison with which the Hermitage painting is usually dated to the early 1630s. Puglisi (1999) opts for a later date of c.1640.

There is another smaller horizontal version (18 x 24) in the Thomas Henry Museum in Cherbourg, where the figures of Mary and the angel are very similar to those in the Hermitage *Annunciation*.

It has been suggested (Musées de France 1988, p. 39) that in the seventeenth century the Walpole painting was in the collection of the Marquis de Ménars, where it was engraved by Jean Audran. This would seem to be an error, however, since the composition reproduced by Audran differs significantly in detail from the Walpole painting and must have been a different work.

S. V.

2

FRANCESCO ALBANI (1578-1660)
The Baptism of Christ
Oil on canvas, 268 x 195; inscribed on the ribbon around the cross in the hand of John the Baptist: *ECCE AGNUS DEI* (John i: 29, 36).
Inv. No. 29
PROVENANCE: coll. John Law, Paris; Sir Robert Walpole, 1736 Houghton (Saloon); 1779 Hermitage; 1800 Church of the Order of St John of Malta, St Petersburg; 1805 returned to the Hermitage.
LITERATURE: *Aedes* 1752, pp. 53-54; 2002, no. 82; Ripley 1760, p. 4; Georgi 1794, p. 460 (1996 edition, p. 350); Hand 1827, pp. 225-26; Schnitzler 1828, pp. 38, 128; Nagler 1835-52, p. 38; Livret 1838, p. 40, no. 18; Viardot 1844, p. 483; Viardot 1852, p. 304; Cats. 1863-1916, no. 203; Waagen 1864, p. 80; Vertue, vol. VI, 1948-50, p. 178; Cat. 1958, vol. I, p. 51; Schaak 1970, p. 230, no. 95; Cat. 1976, p. 67; Vsevolozhskaya 1981, no. 107; Puglisi 1991, p. 265, no. 109; Moore ed. 1996, p. 50; Puglisi 1999, pp. 60, 178, cat. 93, pl. 197.

Painted around 1640-44 (Puglisi 1999), the composition is known from a number of versions which vary in detail, the best known being that in the Pinacoteca Nazionale, Bologna.

There is reason to believe that the Hermitage picture originally had a rounded top, like the work in Bologna, but that this was removed before the compilation of the *Aedes*. The area removed undoubtedly included an image of God the Father, which would have been in keeping with the traditional iconography of the subject, and which is confirmed by the angels facing upwards.

In 1800, at the request of the architect Giacomo Quarenghi, the painting was placed in the Church of the Order of St John in St Petersburg when it was consecrated. A receipt in Quarenghi's own hand is now in the Hermitage Archives but the picture was returned to the Hermitage in 1805. Although Boydell did not include a separate engraving of the work in his publication it can nevertheless be seen hanging over the fireplace in the *Section of the Hall and Salon* (Boydell I, pl. VIII, engraved by P. Fourdreniere).

S. V.

3

FEDERICO BAROCCI (FEDERICO FIORI) (c.1535-1612)
The Virgin and Child
Panel, c.41.16 x 32.26
PROVENANCE: Sir Robert Walpole, 1728 Arlington St, 1736 Downing St (Sir Robert's Dressing Room), later Houghton (Cabinet); 1779 Hermitage; whereabouts unknown.
LITERATURE: *Aedes* 1752, p. 66; 2002, no. 149.

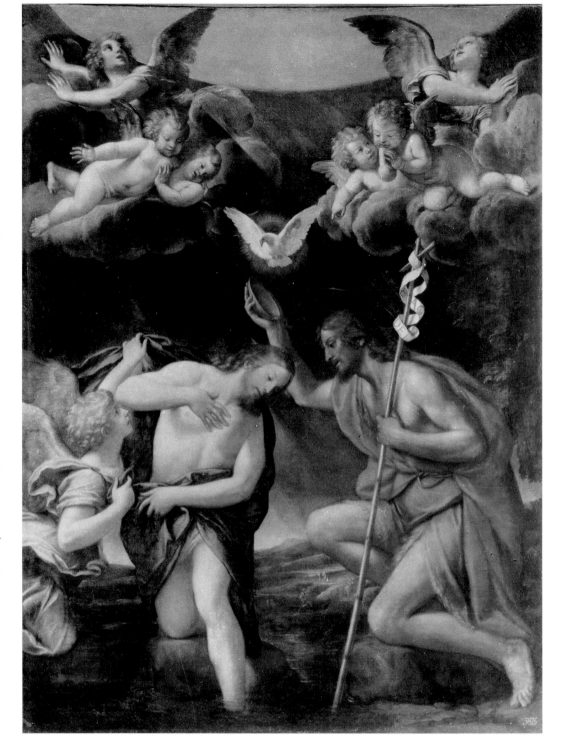

In the Catalogue of 1773-85, listed as no. 2236, is 'La Vierge et l'Enfant Jesus. Haut 9¼ v. L. 7¼ v. [41.16 x 32.26] Sur bois. Joli Tableaux mais incorrect de dessin.' This would seem to refer to the painting described in the *Aedes*, which also noted that 'the

Drawing is full of Faults'. The work is not mentioned in any later catalogues. It was valued at £50 when sold to Catherine.

T. K.

Not reproduced

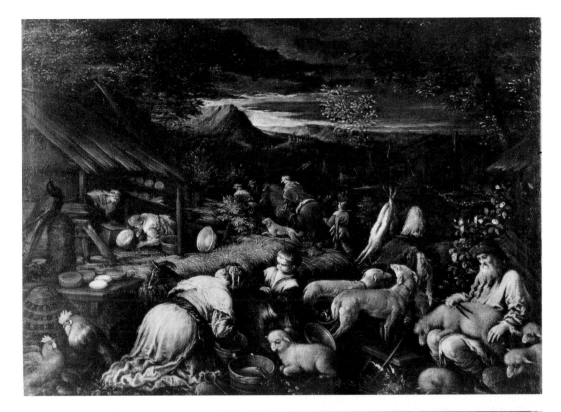

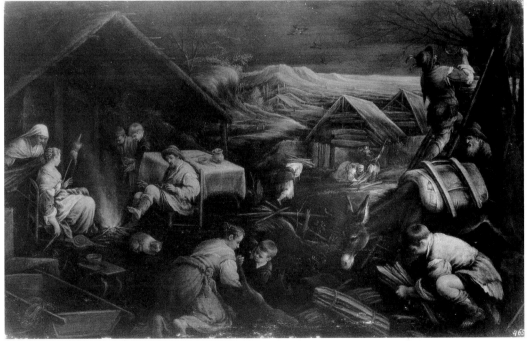

Both this and its companion, *Winter* (cat. no. 5), are part of a set of *Seasons*, which were the signature work of Bassano's workshop in the 1570s and 1580s. Jacopo himself and his sons Francesco, Leandro and Girolamo turned repeatedly to this theme. The authorship of numerous surviving compositions depicting the seasons remains controversial. Both the Walpole canvases are by the same hand, Francesco Bassano, although when they arrived in 1779 they were attributed to Jacopo and Leandro respectively. They derive from the first set of *The Seasons*, painted by Jacopo in the mid-1570s (Ballarin 1999, notes of a conversation between I.A. and Ballarin). *Summer* is close to several works of the same title from Bassano's workshop but it is not an exact replica of any of them. The most famous of them is a set (of which not all survive) by Francesco mentioned in the inventory produced in 1659 of the gallery of Leopold Wilhelm and depicted by David Teniers II in his *Teatrum Pictorum*. Waagen changed the attribution from Jacopo to Leandro Bassano in 1864, but later Hermitage catalogues and Fomiciova (1992) list the work as school of Bassano; Ballarin (1992 and 1998) continues to accept it as the work of Francesco.

I. A.

4

FRANCESCO BASSANO (1549-92)
Summer
Oil on canvas, 115 x 184
Inv. No. 232
PROVENANCE: coll. M. de la Vrillière, French Secretary of State, Paris; Sir Robert Walpole, 1736 Downing St (End Room Below, as by 'Leonardo Bassan'), later Houghton (Cabinet); 1779 Hermitage.
LITERATURE: *Aedes* 1752, p. 65 (as 'A Summer-piece, by Leonardo Bassan'); 2002, no. 142; Livret 1838, p. 324; Waagen 1864, p. 73; Fomiciova 1981; Fomiciova 1992, no. 33.
EXHIBITION: 2001 Bassano–Barcelona, no. 33.

5

FRANCESCO BASSANO (1549-92)
Winter
Oil on canvas, 115 x 184
Inv. No. 233
PROVENANCE: coll. M. de la Vrillière, French Secretary of State, Paris; Sir Robert Walpole, 1736 Downing St (End Room Below, as by 'Giacomo Bassan'), later Houghton (Cabinet); 1779 Hermitage.
LITERATURE: *Aedes* 1752, p. 65 (as 'A Winter-piece, by Giacomo Bassan'); 2002, no. 141; Livret 1838, p. 324; Waagen 1864, p. 73; Fomiciova 1981; Fomiciova 1992, no. 34.
EXHIBITION: 2001 Bassano–Barcelona, no. 34.

Like its companion *Summer* (cat. no. 4), *Winter* is one of the few surviving versions of the subject by Francesco Bassano. It is notable for several details such as the two boys standing by the flame in the background, and the girl and boy in the centre foreground not found in other replicas or copies of *Winter* produced in the Bassano workshop. Ballarin (1992 and 1998, and notes of conversations between I.A. and Ballarin) has suggested that the two Walpole paintings are precise replicas by Francesco dating from the late 1570s of a series by Jacopo Bassano, later changed in numerous versions and variations both by Francesco and in the workshop of the Bassano brothers.

I. A.

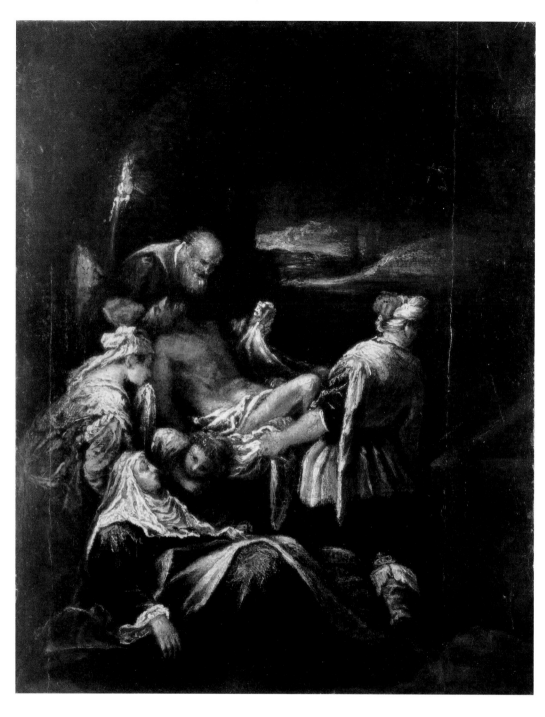

by *Giacomo Bassan;* a very particular Picture, the Lights are laid on so thick that it seems quite Basso Relievo. It is a fine Design for a great Altar-piece which he has painted at *Padua.* This Picture was a Present to Lord *Orford,* from *James* Earl of *Waldegrave,* Knight of the Garter, and Ambassador at *Paris.*' For many years the work was considered an autograph sketch for the altarpiece in the Church of Santa Maria in Vanzo, executed by Jacopo Bassano in 1574. The comparatively poor quality of the painting, however, rules out a definite attribution either to Jacopo or to any of his sons, despite Waagen's confidence in 1864 in specifically naming Leandro Bassano as its author. *The Entombment* was catalogued as school of Bassano by both Somov (1889) and Liphart (Cat. 1912). More recently Arslan (1960) described its author as 'un bas-sanesco modesto', an opinion shared by Fomiciova (Cat. 1976; Fomiciova 1992).

The painting repeats Jacopo's *modello* for the Paduan altar, now in the Kunsthistorisches Museum, Vienna. Other replicas of the composition produced in Bassano's workshop can be found in the Accademia, Venice; Chiesa dell'Ospedale, Bergamo; Civici Musei di Vicenza; Gemäldegalerie, Kassel; Alte Pinakothek, Munich; Ringling Museum, Sarasota, Florida, USA and the National Gallery, Prague.

I. A.

7

ALVISE BENFATTO DEL FRISO (1559-1611)
Pentecost
Oil on canvas, 96 x 138
Inv. No. 152
PROVENANCE: Sir Robert Walpole, 1736, Grosvenor St (as by 'Veronese'), later Houghton (Marble Parlour); 1779 Hermitage; 1838 transferred to the Catherine Palace, Tsarskoye Selo; 1920 returned to the Hermitage.
LITERATURE: *Aedes* 1752, p. 73 (as 'The Apostles After the Ascension, by Paolo Veronese'); 2002, no. 196; Livret 1838, p. 279, no. 30; Marini 1968, p. 111; Safarik 1968, p. 79; Fomiciova 1973, p. 44; Fomiciova 1974b, p. 128; Pignatti 1976, no. A 141; Fomiciova 1979, p.133; Fomiciova 1983, p. 121; Fomiciova 1992, no. 58.
EXHIBITION: 1978b Leningrad, no. 16.

In the 1773-85 catalogue, Munich described this work as follows: '*Les apôtres assemblés après l'ascension. Ce tableau, du même merite que le precédent, est composé de 14 figures y compris deux anges. Il représente la quatrième assemblée des apôtres après l'ascension de N.S.*' The work's title results from the misidentification in the Walpole collection of the supposed 'pair' to the work, an *Ascension* (in fact a *Resurrection,* now in the Pushkin Museum of Fine Arts, Moscow, cat. no. 87).

6

BASSANO, workshop
The Entombment
Last quarter of the 16th century, oil on canvas, 38 x 28
Inv. No. 1573
PROVENANCE: in or shortly after 1736 presented to Sir Robert Walpole by James, Earl Waldegrave; Sir Robert Walpole, Houghton (Cabinet); 1779 Hermitage.
LITERATURE: *Aedes* 1752, p. 68 (as 'Christ laid in the Sepulchre, by Giacomo Bassan'); 2002, no. 161; Livret 1838, p. 280, no. 33; Cats. 1863-1916, no. 166 (1863-1912 school of Bassano; 1916 Francesco Bassano); Waagen 1864, no. 160; Cat. 1958, vol. I, p. 63; Arslan 1960, vol. I, p. 347; Cat. 1976, p. 74; Fomiciova 1992, no. 31.

The Entombment is listed in the 1736 Walpole MS under 'Pictures bought since the catalogue was made' which suggests that Robert Walpole acquired it in that year or shortly after. Horace Walpole described it as follows in the *Aedes*: 'Christ laid in the Sepulchre,

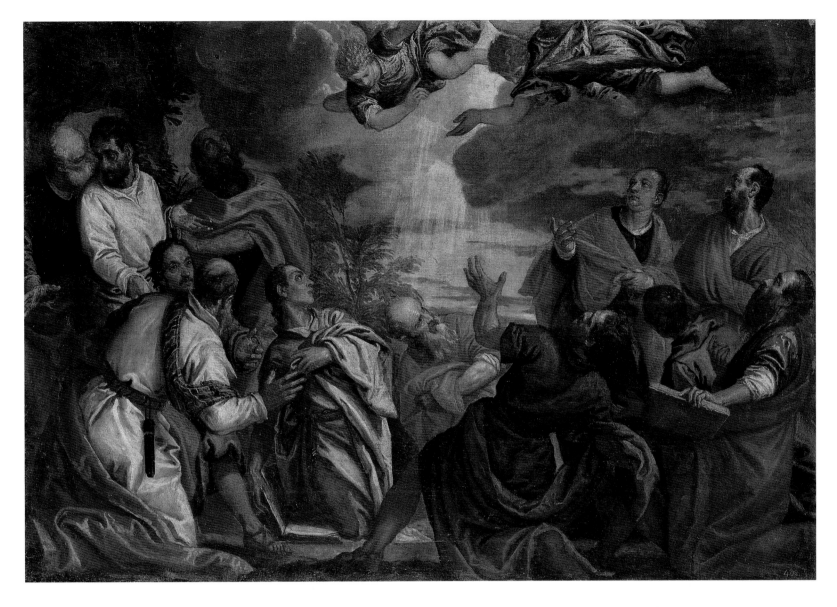

The pair was split when it entered the Hermitage. *The Apostles* was despatched as early as 1838 to the Imperial residence at Tsarskoye Selo, while *The Resurrection* (as we can see from a watercolour of 1859 by Eduard Hau, see p. 80) remained on display in the Italian rooms of the New Hermitage. When doubts about Veronese's authorship of these works was voiced later in the nineteenth century, *The Resurrection* was also moved to the Catherine Palace in Tsarskoye Selo as a copy.

The title of the picture has changed on several occasions. The 1958 catalogue described it as *The Apostles at the Tomb of Mary*, a title repeated by Marini (1968). After Safarik (1968) published Paolo Veronese's *Pentecost* from the National Gallery in Prague, Fomiciova (1973) re-instated the previous title to the Hermitage painting and this opinion is endorsed by Pignatti (1976).

As is clear from his correspondence, Horace Walpole was inclined to dismiss the attribution of both paintings to Paolo Veronese since he wrote in a letter to Cole on 12 July 1779 that the 'two supposed Paul Veronese are very indifferent copies, yet all roundly valued' (see HWC 2, pp. 168–69).

With its rhythmical, compact composition, harmonious colour range and expressive figures, it is perfectly possible to see why for many years this work was thought to be by Paolo Veronese, but the facial features are treated much too sharply and the surface of the painting is harsher and thicker than in genuine works by Veronese. The 1958 and 1976 catalogues listed the work as school of Veronese; Safarik (1968) regarded it as the work of a pupil or imitator; Palluccini (1968, an oral opinion) was inclined to view the work as by both master and pupils; Pignatti (1976) supported Fomiciova's opinion that it was a workshop picture.

Fomiciova (1983, 1992) subsequently arrived at the current attribution to Alvise Benfatto del Friso, Paolo's nephew and pupil. The drawing of the heads of some of the apostles is analogous to those in accepted works by Benfatto del Friso, including another Hermitage piece, *The Adoration of the Magi* (Inv. No. 1503). In this work, as in *Pentecost,* Benfatto can be seen not only as a talented imitator of his master's painting style, but as an artist who can successfully employ Veronese's compositional devices.

The *Pentecost* was probably painted after 1576, like other works created in Veronese's studio for the Scuola di San Fantin (Ateneo Veneto) (L. Larcher Crosato, 'Note per Alvise Benfatto del Friso', *Arte Veneta*, vol. XXX, 1976, p. 110).

I. A.

8

Niccolò Berrettoni (1637-82)
The Assumption of the Virgin
Oil on canvas, 67 x 52
Inv. No. 2654

PROVENANCE: ?coll. Marchese Niccolò Maria Pallavicini, Rome (Rudolph 1995); Sir Robert Walpole, 1736 Houghton (Green Velvet Drawing Room); 1779 Hermitage; in the 19th century and until 1923 housed in the church of the Tauride Palace, St Petersburg; 1929 transferred to Antikvariat for sale; unsold, 1933 returned to the Hermitage.
LITERATURE: *Aedes* 1752, p. 59; 2002, no. 112; Boydell II, pl. XLVI; Chambers 1829, vol. I, p. 527; Vertue, vol. VI, 1948-50, p. 179 ('Maratti'); Rudolph 1995, p. 159.

This is a variant of a picture of the same subject (derived from Jacopo da Voragine, *The Golden Legend*, CXVII, I) by Maratti (see cat. no. 46). Vertue (vol. VI, 1948-50 p. 179) apparently took it for a work by Maratti himself since he mentions two *Assumptions of the Virgin* by that artist, and refers only to the *Holy Family (The Virgin and Child with SS Elisabeth, John the Baptist and Joseph*, cat. no. 9) under the name of Berrettoni. Hand (1827, p. 270) did not see Berrettoni's *Assumption of the Virgin* in the Hermitage, as it was then in the church of the Tauride Palace. Although it was correctly attributed to Maratti's pupil Berettoni in the 1773-85 catalogue this painting was thereafter described as by Maratti himself and by the time the work re-entered the Hermitage in 1933 its authorship had been entirely forgotten. The painting was only identified during work on this catalogue. It is clearly not good enough to be by Maratti himself and is also inferior to known works by Berrettoni. This may possibly be the result of dry spot and the forthcoming restoration may prove to be revealing.

S. V.

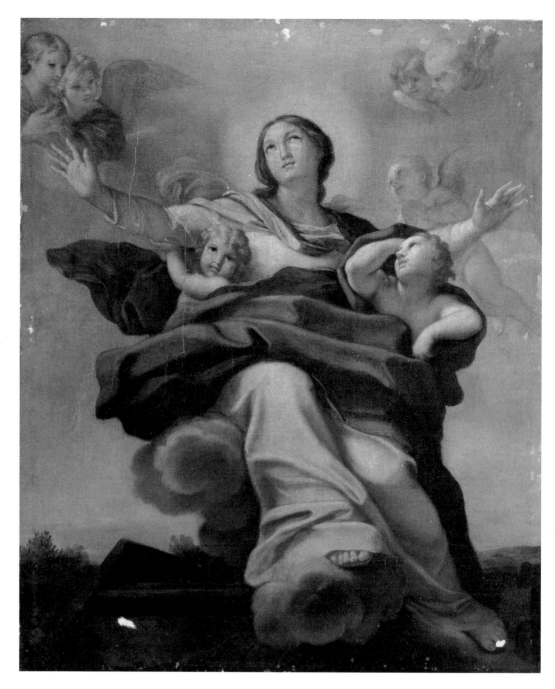

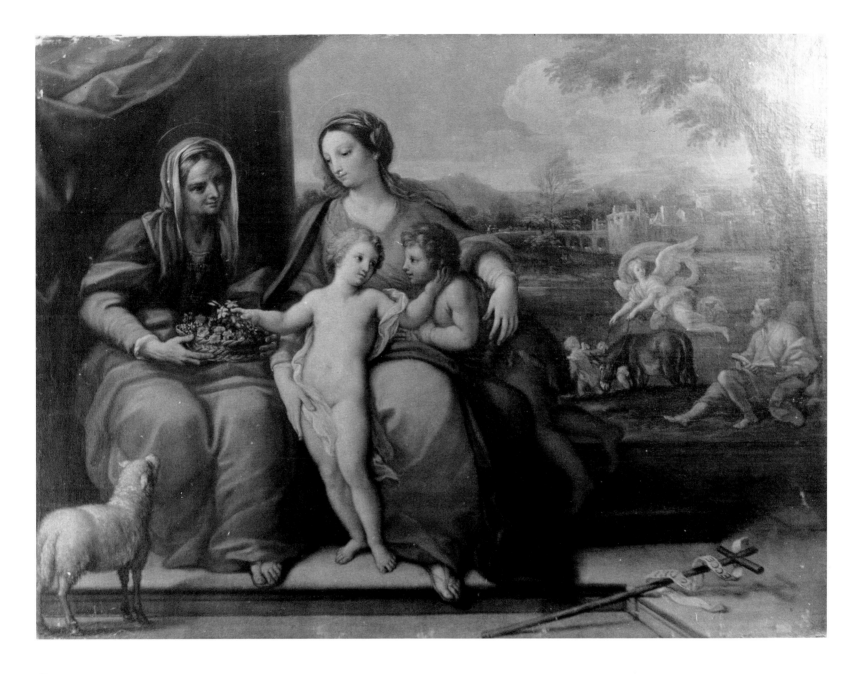

9

NICCOLÒ BERRETTONI (1637-82)
The Virgin and Child with SS Elisabeth, John the Baptist and Joseph
Oil on canvas, 96 x 132
Tsarskoye Selo State Museum Reserve, Inv. No. 155-X
PROVENANCE: ?coll. Marchese Niccolò Maria Pallavicini, Rome; Sir Robert Walpole, 1736 Houghton (Green Velvet Drawing Room/Carlo Maratt Room); 1779 Hermitage; since the mid-19th century in the Catherine Palace, Tsarskoye Selo (Pushkin).
LITERATURE: *Aedes* 1752, p. 59 (as 'The Holy Family'); 2002, no. 111; Boydell I, pl. XLIV; Georgi 1794, p. 455 (1996 edition, p. 347); Hand 1827, pp. 269-70; Schnitzler 1828, pp. 79, 131 (as 'La Visitation'); Chambers 1829, vol. I, p. 527; Livret 1838, pp. 274-75, no. 13; Vertue, vol. VI, 1948-50, p. 179; Rudolph 1995, p. 159.

Stella Rudolph (1995) has suggested that this picture may be among those that entered the Walpole collection from the Pallavicini gallery, although there is no firm documentary confirmation to prove this. While the painting is still described at the Catherine Palace at Tsarskoye Selo (where the picture has hung since the mid-nineteenth century) as the work of an unidentified seventeenth-century artist, the present cataloguer is convinced both by Rudolph's notion that the picture has a Pallavicini provenance and by the attribution in the Walpole 1736 MS catalogue where it is listed as the work of Berrettoni.

Berrettoni's picture was much praised by Horace Walpole in the *Aedes* as 'equal to any of his Master's. The Grace and Sweetness of the *Virgin*, and the Beauty and Drawing of the young *Jesus*, are incomparable' and was also singled out by Chambers (1829) and by Hand (1827) as 'eine höchst schätzbares Gemälde'. The latter also mistakenly attributed it to Berrettoni's teacher Maratti.

10

PARIS BORDONE (1500–71)
Augustus and the Sibyl
Oil on canvas, 165 x 230
Pushkin Museum of Fine Arts, Moscow, Inv. No. 4354
PROVENANCE: 1661 coll. Cardinal Mazarin; brought to England by the 1st Duke of Marlborough; from him passed to his brother, General Charles Churchill, who presented it to Sir Robert Walpole; Sir Robert Walpole, 1736 Downing St (End Room Below as 'Julio Romano'), later Houghton (Gallery); 1779 Hermitage; 19th century in the Tauride Palace, St Petersburg; later in stores of the Court Chancellery; removed from the Hermitage sometime between 1859 and 1915, probably at the turn of the century; by 1950s coll. S. Obraztsov, theatre director, Moscow (acquired in an antique shop, Moscow); 1983 acquired by Pushkin Museum of Fine Arts, Moscow.
LITERATURE: *Aedes* 1752, p. 84 (as 'Architecture … Julio Romano'); 2002, no. 237; Livret 1838, p. 467, no. 11; De Cosnac 1885, no. 1312; Fomiciova 1970, pp. 54–57; Fomiciova 1971, pp. 152–55; Pigler 1974, vol. I, p. 480; Canova 1985, pp. 140, 143, 154 (as coll. Obraztsov, Moscow); Béguin 1987, pp. 19–20 (as coll. Obraztsov, Moscow); Garas 1987, p. 74; Grabski 1987, p. 205; Markova 1992, pp. 146–47; Pushkin Museum Guide 1994, p. 100; Guidebook 1995, p. 99; Pushkin Museum 1995, pp. 84–85; Mandel 1996, p. 401; Ekserdjian 1999, pp. 51–52.
EXHIBITIONS: 1965 Moscow, no. 38 (dimensions incorrectly given as 218 x 173); 1982 Moscow, no. 9 (dimensions incorrectly given as 173 x 218); 1987 Moscow, no. 346.

The subject of this picture is taken from the *Golden Legend* of Jacopo da Voragine, in which the Emperor Augustus sought the advice of the Tiburtine Sibyl when the Roman Senate decreed the celebration of his apotheosis. She predicted the arrival of a child who would be more powerful than all the Roman gods. At this moment the heavens opened and the Emperor had a vision of the Virgin Mary standing on an altar with the Christ Child in her arms.

Augustus kneels in the centre alongside the Sibyl, who points to the skies where the Virgin and Child appear in the clouds. To the left of Augustus is a boy holding the Emperor's staff. The relief scenes on the socle of the building in the left part of the painting should apparently be interpreted as depicting the Emperor's military triumphs.

Bordone was cited as author of this picture in the 1661 description of Cardinal Mazarin's collection (De Cosnac 1885), but in the Walpole collection the painting was attributed to Giulio Romano and subsequently, in the Hermitage, to Giulio Romano and Baldassare Perruzzi. Paris Bordone was reinstated as the author by Fomiciova (1970, 1971).

Various interpretations of the subject have been proposed. The Mazarin inventory described it thus: 'Une perspective de Paris Bourdonne fait sur toile où soit representez plusieurs bastiments, Hérode au milieu à genoux auquel la Sybille montre le ciel d'où sort une Nostre Dame tenant le petit Jesus' (De Cosnac 1885). But less than a century later, after the painting's arrival in England, Horace Walpole wrote: 'About the Year 1525, Julio Roman made Designs for Aretine's Putana Errante, which were engraved by Marc Antonio, for which the latter was put in Prison, and Julio fled to Mantua. Two Years after Rome was sacked by Charles V. who made public processions and Prayers for the Delivery of the Pope [Clement VII] whom he kept in Prison; 'tis supposed the Figure kneeling in this Picture is Charles V. who is prompted by Religion to ask Pardon of the Virgin (above in the Clouds) for having so ill treated the Pope: The Figure sitting on the Steps is certainly Aretine, and the Man in Prison in the Corner Marc Antonio' (*Aedes* 1752, pp. 84–85).

However, no documents in the Hermitage allude to any such interpretation. The 1797 catalogue describes the painting simply as a 'Temple in perspective, adorned with columns (Giulio Romano)', while the 1859 Inventory lists it as a 'Perspective of a temple adorned with figures. Painted on canvas, the work of Giulio Romano'.

In support of the attribution to Paris Bordone, Fomiciova cited stylistic analogies with the *Presentation of a Ring to a Doge* (Accademia, Venice, Inv. No. 318). She was the first to identify the Walpole painting with that mentioned in the inventory of Cardinal Mazarin's collection in Paris, an opinion supported by Garas (1987). When the above-cited quotation was published by Béguin, she identified it with a canvas by Antoine Caron in the Louvre, *The Tiburtine Sibyl* (Béguin 1968, p. 202, n. 32). From the Mazarin inventory it is clear that the collection included other architectural perspectives by Paris Bordone, notably a picture of Marcus Curtius (present whereabouts unknown).

Compositions with detailed architectural backgrounds are common in Bordone's work. In addition to *Presentation of the Ring to the Doge*, we should note two versions of *Bathsheba* (Kunsthalle, Hamburg, Inv. No. 744; Wallraf-Richartz Museum, Cologne, Inv. No. 517; see Canova 1964, pp. 73, 76–77, figs. 70, 102); the latter includes buildings similar to the architectural motifs in the Walpole painting. In overall composition, the Moscow painting is particularly close to *Gladiators* in the Kunsthistorisches Museum, Vienna (Inv. No. 238; Canova 1964, pp. 116–17, fig. 142), where, due to the small scale of the figures, the architecture has a particularly expressive quality. The architecture in *Gladiators* was also previously attributed to Giulio Romano.

In comparison with other works of this type, the architecture in the Walpole painting has a certain independence that makes it the dominant visual motif. Both the spatial construction and the nature of individual buildings derive from Baldassare Peruzzi and his pupil Sebastiano Serlio. The latter worked in Venice between 1527 and 1541 and Bordone was in close contact with him, taking inspiration from his work. A well-known drawing by Peruzzi in the Biblioteca Reale, Turin (Inv. No. 15728, lt. 45; see Wurm 1984, p. 3), shows a perspective group of buildings similar to those in the left side of the Walpole painting. E. Tietze Conrat ('A Memento of a Pageant of the Past', *Gazette des Beaux-Arts*, vol. XXVIII, 1945, p. 55) suggested that such perspectives might depict theatrical scenes although this notion has found very little scholarly support (Béguin 1968, p. 195; Garas 1987).

It has been suggested that the painting is somehow linked with Augsburg, where the artist had contacts and which he is known to have visited in 1540. Those scholars who supported this theory cited Vasari's description of a painting by Paris Bordone in his *Life of Titian*: 'e nella medesima città fece per i Prineri, grand'uomini di quel luogo, un quadrone grande dove in prospettiva mise tutti i cinque ordini d'architettura, che fu opera molto bella; ed un altro quadro da camera, il quale è appresso il cardinale d'Augusta' (G. Vasari, *Le Vite de' più eccelenti pittori, scultori ed architetti …* [1550; 1568], ed. G. Milanesi, Florence, 9 vols, 1878–85, vol. VII, 1881, p. 464). For some scholars the Walpole painting is the 'quadrone grande' (Fomiciova 1970, 1971), while others suggest that the painting should be identified with the 'quadro da camera'. This is in keeping with the current interpretation of the subject , i.e. that the name of Augustus is associated with Augusta, the Latin name of the city of Augsburg, and that the Cardinal of Augsburg was the patron for the painting mentioned by Vasari (Ekserdjian 1999, p. 52).

Fomiciova dated the canvas to 1535 but Mariani Canova (1985) suggested 1539–40, when the artist returned to Venice for a short time before departing for Augsburg. Despite the lack of clarity in the chronology of the work of Paris Bordone, these proposed dates seem too early. The artist worked extensively outside Italy, in France in 1538 and 1559 and in Augsburg around 1540. Stylistically, the Walpole painting fits neatly into the circle of works from the 1550s, prior to Bordone's last trip to France in 1559, a view supported by Béguin (1987). Paris Bordone may have produced in Venice a commission received during his stay in Augsburg and we should note that he used Venetian canvas of *sarge* (diagonal) weave.

V. M.

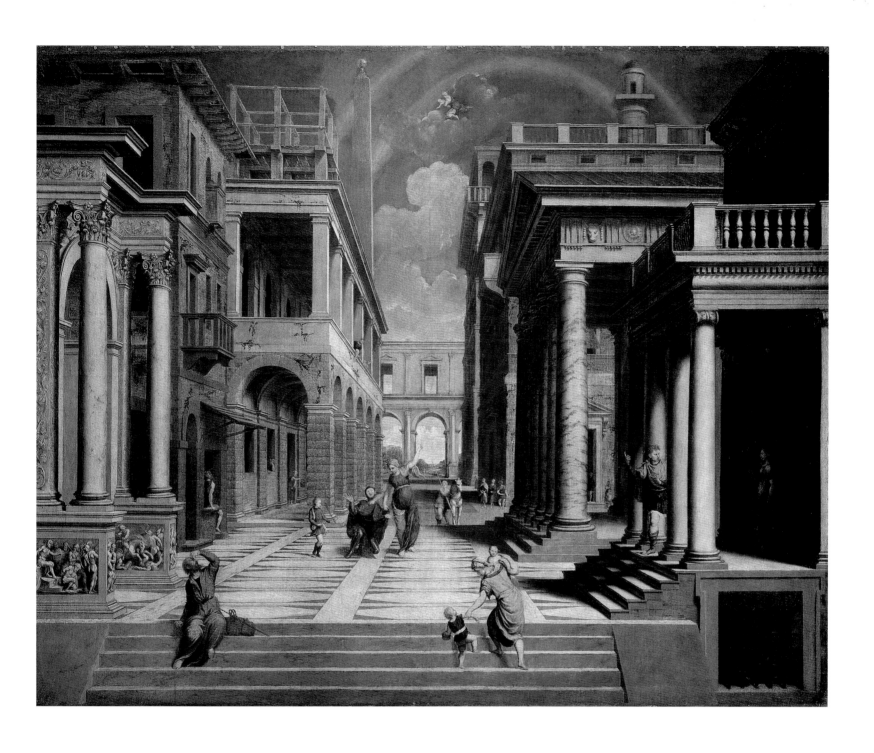

II

Paris Bordone (1500-71)
Venus, Flora, Mars and Cupid [Allegory]
Oil on canvas, 108 x 129, inscription bottom left:
PARIS bordon F.
Inv. No. 163

PROVENANCE: ?coll. Emperor Rudolf II; coll. Nicolaes Anthonis Flinck; Sir Robert Walpole, 1736 Houghton (Marble Parlour, then Gallery); 1779 Hermitage.

LITERATURE: *Aedes* 1752, p. 88 (as 'Two Women, an emblematical Picture'); 2002, no. 253; Cats. 1889-1916, no. 1846; Harck 1896, p. 426; Bailo, Biscaro 1900, p. 143, no. 61; Zimmermann 1904; Weiner 1923, p. 317; Venturi A. 1929, pl. 1052; Berenson 1957, vol. I, p. 74; vol. II, pl. 1134; Cat. 1958, vol. I, p. 70; Canova 1961, p. 88; Canova 1964, p. 80; Cat. 1976, p. 79; Vsevolozhskaya 1981, p. 274, pls. 62, 63; Pallucchini 1981, pp. 11, 21; Canova 1981, p. 121; Canova, in 1983 London, no. 21; Canova 1984, pp. 43-45; Pallucchini 1984a, p. 43; Limentani Virdis 1988, pp. 84-89, fig. 2; Canova 1988, p. 146, fig. 20; Grabski 1988, pp. 207-8, fig. 10; Wazbinski 1988, pp. 109-17; Fomiciova 1992, no. 67; Béguin 1993, p. 536.

EXHIBITIONS: 1968 Göteborg, no. 4; 1977 Milan, no. 4; 1983 London, no. 21; 1987-88 Begrade–Ljubljana–Zagreb, no. 2; 1996-97 Amsterdam, no. 85; 1998 Florence, no. 66.

The 1736 manuscript catalogue of the Walpole collection describes the subject as 'Two Women, a Cupid and a Soldier, over the Door in the Hall' (Walpole MS 1736, pp. 5-6) and a decade later the *Aedes* lists the picture as 'Two Women, an emblematical picture, by Paris Bourdon'. Munich's description in the 1773-85 catalogue particularly emphasised the symbolic nature of the image: 'Sujet allégorique. Ce tableau d'une belle execution est composé de trois figures ou Portraits de grandeur naturelle, demi longueur, et d'un petit amour. Il représent deux femmes, l'une prenant de la main de sa compagne des fleurs qu'un Amour, volligeant au dessus d'elles, verse d'une Corbeille. Derrière la première est un homme vu du profil, armée … et tenant une hâche d'arme à la main'. Despite this detailed description, which is entirely in accordance with the information provided in the *Aedes*, later Hermitage catalogues did not mention the Walpole provenance for this work.

Despite the allegorical subtext emphasised in eighteenth-century catalogues there is in fact no complex iconographical programme in the picture: Bordone's allegories, highly valued by his educated patrons, tend to be improvisations on the same theme.

Wazbinski (1988) has drawn attention to Bordone's very precise following of the iconographical precedent set by Vincenzo Cartari's *Le Imagini de i Dei de gli antichi...* (Venice, 1556), the first printed work of

its kind. Cupid holds in his hand a myrtle wreath, myrtle being traditionally linked with Venus and symbolic of marriage. As Cartari puts it, myrtle not only has the power 'di far nascere amore fra le persone, e di conservarlo' but is also a emblem of peace, 'perché con gli fogli di questo albero erano coronati tutti i vincitori che sono riusciti senza uccisione; pianti de Venere, perché ella ha in odio grandamente la violenza, le guerre e le discordie'. Cartari's text is entirely consistent with the Neoplatonic views of the Italian humanists, who perceived Venus not only as the ideal of Beauty, but more generally as signifying Peace and Humanity. The red roses in Flora's hand also owe their origin to Venus: the goddess's feet were pierced by thorns as she sought her beloved Adonis, and the blood from her wounds turned white roses to scarlet.

With its subject of the triumph of Beauty and Wisdom over Strength, and of high-minded Love, the painting may have been commissioned for a wedding. Ginzburg (1980, p. 127), however, considers that 'quadri da camera' depictions of the ancient gods were simply a part of Renaissance courtly culture, enabling artists to represent, under the guise of allegory, not only erotic subjects which might otherwise remain essentially forbidden but also portraits of famous courtesans. The ambiguous subtext and the use of allegory, both of which are particularly characteristic of northern European Mannerism, would appear to have significantly facilitated both the awareness of Bordone's works beyond Italy and his influence on German and Netherlandish artists. As has been convincingly demonstrated by Limentani Virdis (1988, pp. 84-89), the Hermitage canvas is directly linked with art at the court of Rudolf II. Notably, it served as prototype both for a number of compositions by Dirck de Quade Ravestijn (including *Allegory of the Reign of Rudolf II*, National Gallery, Prague) and for works by Vincent Sellaer and Martin de Vos. The wide fame of the Hermitage *Allegory* may be explained also by its possible provenance in Rudolf II's own collection: in the 1621 inventory (no. 1014) is a 'Venere e Flora con Amore e Marte' (Zimmermann 1904).

Allegories such as this mark the height of the evolution of Bordone's style; the closest analogies to this painting are a *Venus, Flora, Mars and Cupid* and *Lovers as Mars and Venus* (both Kunsthistorisches Museum, Vienna) and a *Vanitas* (National Gallery of Scotland, Edinburgh). Grabski (1988, pp. 207-9) has suggested that the symmetry of the Hermitage work and Bordone's related compositions are analogous to the rhythmical link in Renaissance poetry, particularly with the short *stanza* form so beloved of Pietro Bembo.

The dating of these works by Canova (1964) and Pallucchini (1981) was never seriously challenged until Canova (1988) proposed a new chronology of Bordone's work, in which this *Allegory* was dated

1543-45, an opinion not supported by Sylvie Béguin (1993, p. 536). Equally controversial is Béguin's attempt to differentiate stylistically between similar compositions by Bordone according to the complexity of the figures' spatial orientation. The most likely date of execution for the Hermitage painting remains the accepted one of 1553-55.

A preparatory drawing for the right hand of Flora (*Sheet of Studies of Hands*) is in the Victoria & Albert Museum, London (Rearick 1988, pp. 41, 42).

I. A.

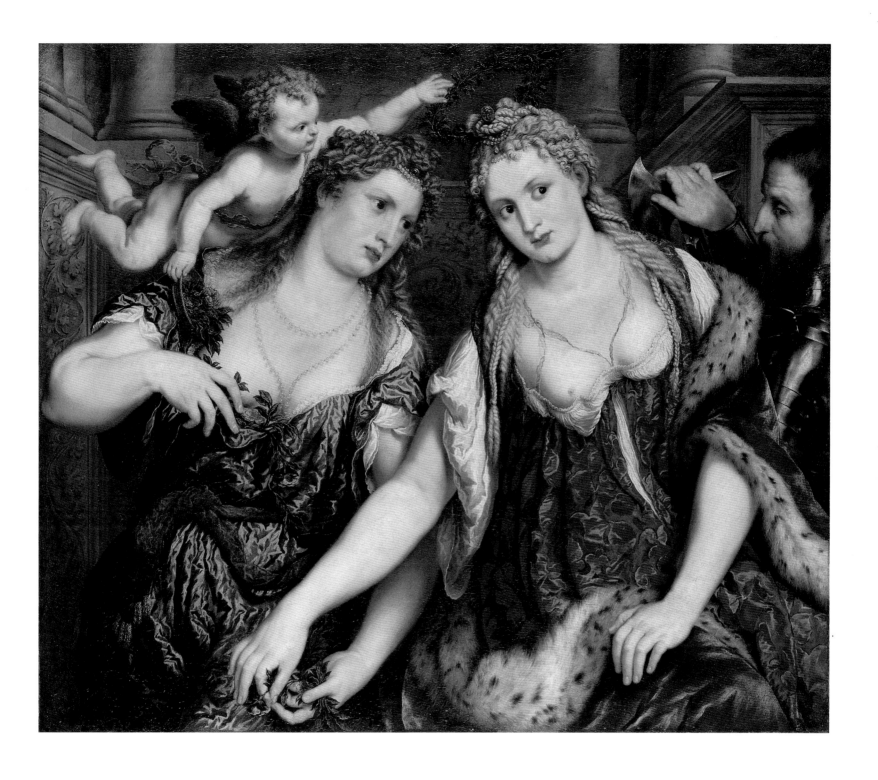

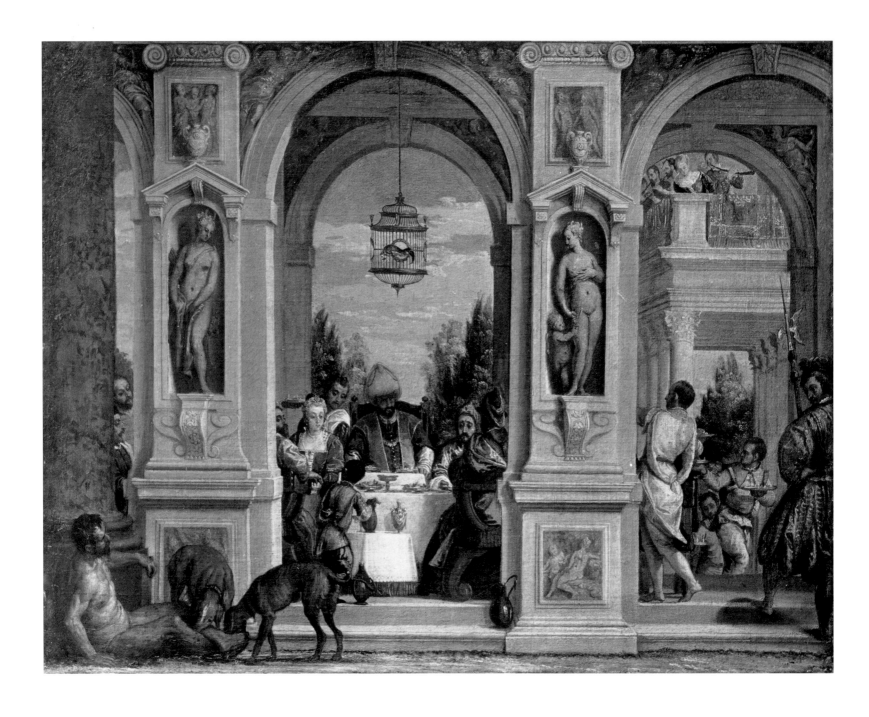

12

BENEDETTO CALIARI (1530-96)
Dives and Lazarus
Oil on canvas, 80 x 104.5
PROVENANCE: coll. Charles-Jean-Baptiste Fleuriau, Comte de Morville (1686-1732), French diplomat; Sir Robert Walpole, 1736 Downing St (Sir Robert's Dressing Room, as by 'Veronese'), later Houghton (Gallery); 1779 Hermitage; 1924 transferred to Museum of Fine Arts, Moscow (now Pushkin Museum of

Fine Arts), Moscow; from there transferred to a Russian provincial museum.
LITERATURE: *Aedes* 1752, p. 86 (as 'Dives and Lazarus, by Paul Veronese'); 2002, no. 246; Cats. 1863-1916, no. 143; Fiocco 1928, pp.151-52; Menegazzi 1957, p. 175.

It is possible that the Comte de Morville acquired this painting in Paris from the collection of M. de la Vrillière, French Secretary of State. A picture, listed as no. 34 and described in the posthumous inventory of the latter's collection, would seem to correspond with

the present work: 'un tableau en longeur peint sur toille avec sa bordure unie et dorée representant "le mauvais riche à table dans son pallais magnifique", original de Paul Veronese, prisé sept cent livres' (Cotté 1985).

Horace Walpole described the work in the *Aedes* as '*Dives and Lazarus*, by *Paul Veronese*. There are few of him better than this, the Building is particularly good . . . it belonged to Monsieur de *Morville*, Secretary of State in *France*'. Munich (Cat. 1773-85) shared this high opinion describing it in the following terms:

'Morceau de plus beaux de ce Maître et particulière-
ment pour ce qui est de l'Architecture dont il est
orné. On y voit le Riche à Table sous le portique
d'un grand Palais et le pauvre Lazare couché sur le
pavé avec un chien pres de lui.' The attribution to
Veronese was first questioned by Somov (Cat. 1889),
however, and later catalogues (1891-1916) relegate
the picture to school of Veronese.

This work contains numerous motifs derived from
various compositions by Paolo Veronese yet the archi-
tectural setting, while employing Veronese's traditional
method of separating the action into three parts, is
overloaded with ornament and distracting details in a
way uncharacteristic of works by the master himself.
Fiocco (1928) suggested that the author might be
Benedetto Caliari, Paolo's brother and regular assistant,
to whom he entrusted architectural backgrounds in
their joint works. Certainly the drawing of the figures is
entirely in accordance with what we know of
Benedetto's individual style. Benedetto often worked
independently and his paintings were in some demand.
Rare evidence of Benedetto Caliari's status on the
Venetian mainland can be found in the direct borrow-
ing of motifs from the Walpole picture in depictions of
the same subject by Ludovico Toeput, called il Poz-
zoserrato, especially in a painting in the Gemäldega-
lerie, Kassel, another in the Monte de Pietà collection,
Treviso, and also in a drawing in a private collection in
Zurich (see Menegazzi 1957, pp. 182-85).

The painting can be seen hanging in one of the
Italian rooms in the New Hermitage painted by
Eduard Hau in the early 1860s (see fig. on p. 68).

I. A.

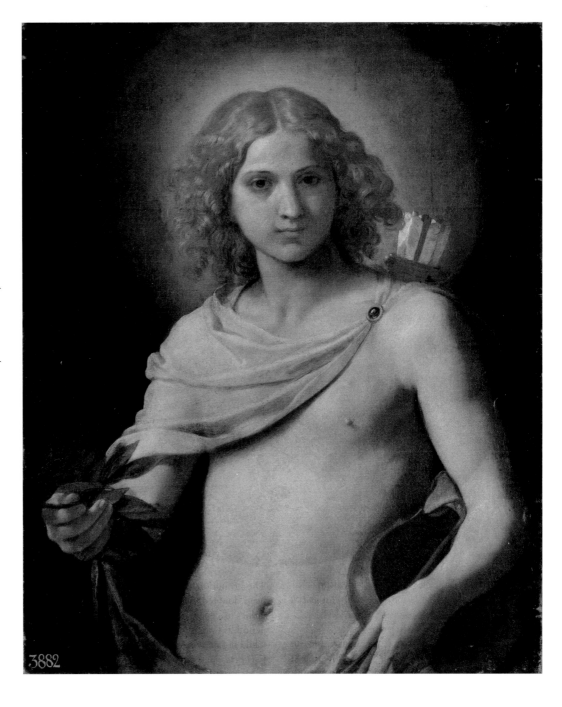

13

Simone Cantarini, called Pesarese (1612-48)
Apollo
Oil on canvas, 78.5 x 67.5
Inv. No. 2089

PROVENANCE: Sir Robert Walpole, 1736 Houghton
(Little Breakfast Room, then Gallery); 1779 Hermitage.
LITERATURE: *Aedes* 1752, p. 95; 2002, no. 272; Boy-
dell II, pl. LV; Livret 1838, p. 151, no. 4; Nagler
1835-52, vol. 11, p. 281, no. 5 (V. M. Picot).

This is an appropriate place to correct a number of mis-
understandings surrounding this painting. The first
derives from the engraving included in Boydell's publi-
cations. On the letter press beneath the image on the
engraving is the inscription 'Picot sculpsit', whilst the
explanatory text mistakenly gives the author of the paint-
ing from which the engraving is taken as J. B. Michel.

In the 1958 and 1976 catalogues the painting was for
some unknown reason listed amongst the works of Elis-
abetta Sirani, with the correct inventory number and

dimensions, but with a provenance said to be the Bar-
barigo collection (1850). In fact, this provenance relates
to another picture of *Apollo* in the Hermitage, by the
Venetian artist Giovanni Contarini (Inv. No. 7139).

S. V.

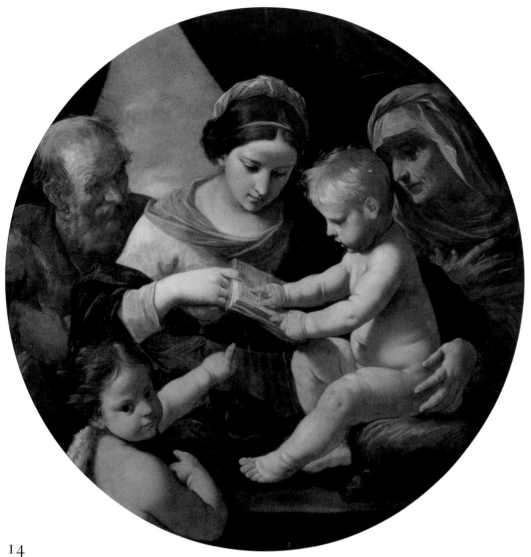

15

AGOSTINO CARRACCI (1557-1602)
Pietà with Saints
Oil on canvas, 191 x 156
Inv. No. 1489
PROVENANCE: Sir Robert Walpole, 1736 Downing St
(End Room Below, as by 'Annibal Caracci'), later
Houghton (Gallery); 1779 Hermitage.
LITERATURE: *Aedes*, 1752, p. 93 (as 'Placing Christ in
the Sepulchre ... by Ludovico Caracci'); 2002, no.
260; Boydell I, pl. VI; Hand 1827, p. 178; Livret
1838, p. 47, no. 44; Viardot 1844, p. 481; Cats. 1863-
1916, no. 166; Waagen 1864, p. 75; Penther 1883, p.
139; Voss 1924, p. 502; Vertue, vol. VI, 1948-50, p.
175; Longhi 1957, pp. 33-36; Cat. 1958, vol. I, p. 106;
Posner 1971, vol. 2, p. 13 (mistakenly described as a
'small version'); Cat. 1976, p. 99; Vsevolozhskaya
1981, no. 95; Bologna 1984, p. 176, no. 120 R; Her-
mitage 1989, no. 31.

Until early in the twentieth century this painting was
attributed to Ludovico Carracci. The attribution to
Agostino first appeared in the 1911 catalogue and this
was modified by Liphart (Cats. 1912, 1916) to Anni-
bale Carracci, under whose name the picture remained
until the mid-twentieth century. The picture is usually
thought to be a version of Annibale's *Pietà* in the Gal-
leria Nazionale, Parma, dating from 1585.

The attribution to Agostino Carracci, supported by
Longhi (1957) and Posner (1971), is the most con-
vincing although Posner points out that Ostrow has
cast doubt on this attribution in an unpublished dis-
sertation ('Agostino Carracci', New York University,
1966, vol. 3, pp. 407-9, no. 11/4).

The somewhat archaic balance of this composition,
typical of Agostino, can also be seen in his *Virgin and
Child with Saints* (Galleria Nazionale, Parma); both
pictures employ a very similar distribution of areas of
light and shade. The most likely date for the creation
of the work is 1586, the date of the Parma *Virgin and
Child with Saints*. It is possible that Agostino's compo-
sition was influenced not only by Annibale's Parma
Pietà, but also by Paolo Veronese's *Lamentation*, which
was engraved by Agostino in 1582 (Bartsch XVIII, p.
93, no. 102). A drawing by Agostino Carracci in the
Uffizi, Florence, is recorded by Posner (1971) as a
study for the figure of Christ in this work.

The source of the subject is John xix: 38-40.

S. V.

14

SIMONE CANTARINI, called PESARESE (1612-48)
*The Holy Family with the Infant John the Baptist and St
Elisabeth*
Oil on canvas, diameter 108 (tondo)
Pushkin Museum of Fine Arts, Moscow, Inv. No. 37
PROVENANCE: Sir Robert Walpole, 1736 Downing St
(Great Middle Room below), later Houghton (Salon);
1779 Hermitage; 1924 transferred to Museum of Fine
Arts (now Pushkin Museum of Fine Arts), Moscow.
LITERATURE: *Aedes* 1752, p. 55 (as 'The Holy Family in
a Round'); 2002, no. 86; Hand 1827, p. 293; Livret
1838, p. 280; Somov 1859, pp. 55, 56; Cats. 1863-1916,
no. 196; Waagen 1964, p. 79; Neustroyev 1898, p. 78;
Pushkin Museum 1961, p. 91; Mancigotti 1975, p. 159;
Pushkin Museum 1986, p. 88; Markova 1992, p. 205;
Colombi Ferretti 1992, fig. 123; Pushkin Museum
1995, pp. 164, 165; Cantarini 1997, p. 156, no. 1.44.

The attribution to Cantarini is traditional but has never
been doubted. The influence of Guido Reni, Can-
tarini's teacher, particularly of works from his Roman
period, is noticeable in this painting. The pose of the
Child also derives from Guido and a possible prototype
is *The Adoration of the Shepherds* (cat. no. 69).

Mancigotti (1975) thought the Walpole canvas to
be from Cantarini's last period, dating it between
1645 and 1648. Emiliani (in Cantarini 1997) proposed
an earlier date of c.1640-42.

A preparatory drawing in red chalk (Brera, Milan,
Inv. No. 501) has the composition set into an oval,
while the final painted version is a roundel. Emiliani
(Cantarini 1997) mentions another sheet in which the
composition is also an oval, but, unlike the first, is
elongated horizontally rather than vertically.

A copy of the work, for many years thought to be the
original, is in the Collezioni Comunali d'Arte, Palazzo
Comunale, Bologna (Zucchini 1938, p. 41, no. 11).

V. M.

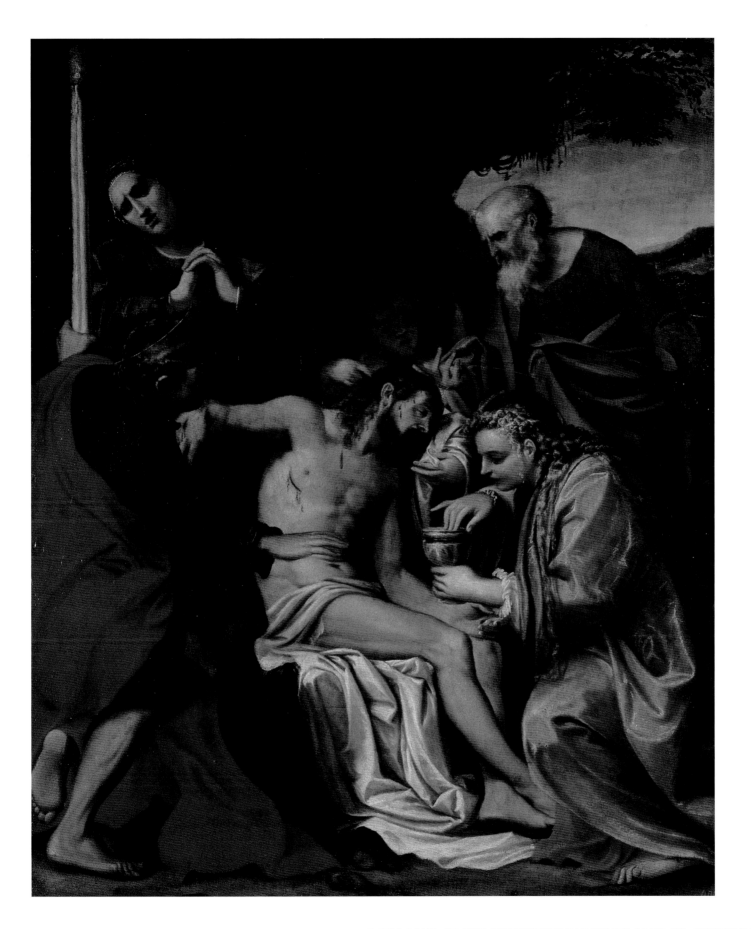

16

AGOSTINO CARRACCI (1557–1602)
The Virgin with the Christ Child Asleep in her Arms
Oil on canvas, 107 x 87
PROVENANCE: Sir Robert Walpole, 1736 Downing St
(End Room Below, as by 'Ludovico Carracci'), later
Houghton (Salon); 1779 Hermitage; whereabouts
unknown.
LITERATURE: *Aedes* 1752, p. 55; 2002, no. 89; Georgi
1794, p. 459 (1996 edition, p. 349); Hand 1827, p.
178; Vertue, vol. VI, 1948–50, p. 175.

In Walpole MS 1736 *The Virgin and Child Asleep in Her
Arms* is listed as by Ludovico Carracci, while in the
Aedes it is given to Agostino. This would also appear to
be the picture referred to by Vertue (vol. VI, 1948–50:
'A Madonna with a Child') as simply by 'Carracci'. A
slightly more detailed description is found in the 1773–
85 Hermitage catalogue (no. 2402): 'Ce beau morceau
représente la Vierge assise tenant dans ses bras l'Enfant
endormie. Elle est coiffée d'un Linge qui lui couvre en
même temps le Col et la poitrine'. The painting was not
listed in the 1797 catalogue nor in the 1859 inventory.
Hand (1827) seems to have been correct in noting:
'Von Agostino Carracci besaß die Houghtonhollische
Sammlung eine heilige Jungfrau mit dem schlafenden
Kinde im Arme; ich habe es hier vergeblich gesucht.
Wahrscheinlich hat man dessen Benennung geändert'.

S. V.

Not reproduced

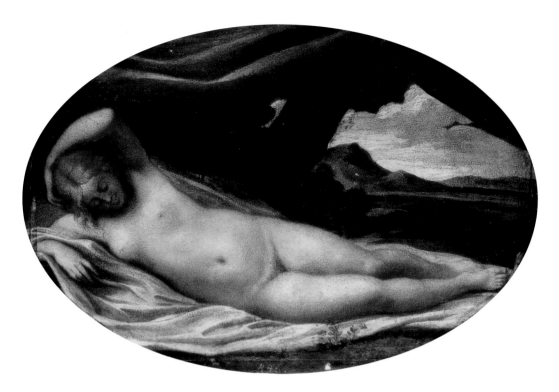

17

CIRCLE OF ANNIBALE CARRACCI (1560–1609)
Sleeping Venus
Oil on panel, 23 x 35.5 (oval: originally octagonal in
shape, with later additions to sides and bottom and
the top cut off to form the present oval).
Inv. No. 146
PROVENANCE: Sir Robert Walpole, ?1736 Downing
St (Sir Robert's Dressing Room, as by 'Corregio'),
later Houghton (Cabinet); 1779 Hermitage.
LITERATURE: *Aedes* 1752, p. 66 (as by 'Annibal Car-
racci'); 2002, no. 150; Boydell II, pl. LXV; Hand
1827, p. 184; Réveil 1828–31, vol. 12, no. 860; Cats.
1863–1916, no. 177; Waagen 1864, p. 76; Vertue, vol.
VI, 1948–50, p. 175; Bénézit 1976, vol. 2, p. 551;
Pigler 1974, vol. 2, p. 244; Annibale Carracci e i suoi
incisori 1986, p. 287.

It seems reasonable to associate this work with the
painting of identical dimensions listed in Walpole MS
of 1736 as 'A Naked Venus sleeping' by Correggio. In
the *Aedes* and in all Hermitage inventories and cata-
logues from the late eighteenth and early nineteenth
centuries, however, it is attributed to Annibale Car-
racci. Only Vertue (vol. VI, 1948–50) listed it as the
work of Ludovico Carracci. Some uncertainty about
its authorship was expressed by Hand (1827) but he
offered no alternative attribution.

The painting's merits were thus described in the
1773–85 catalogue (no. 2307): 'les contours et le col-
oris de cette figure sont de la plus grande beauté' and

Sleeping Venus was one of only a select group of Her-
mitage paintings to be included in the publication
undertaken by Réveil (1828–34), devoted to celebrat-
ed paintings and sculptures in European museums.
Waagen (1864) proclaimed the high quality of the
painting and was in no doubt about Annibale's
authorship.

The painting survived into the twentieth century
in a seriously damaged state and was not included in
either the 1958 or 1976 catalogues. Restoration work
undertaken in the early 1990s did not, alas, reveal any
of the qualities mentioned by connoisseurs of the past
and it must be supposed that the *Sleeping Venus* was
the work of a lesser artist, perhaps from the circle of
Annibale Carracci.

S. V.

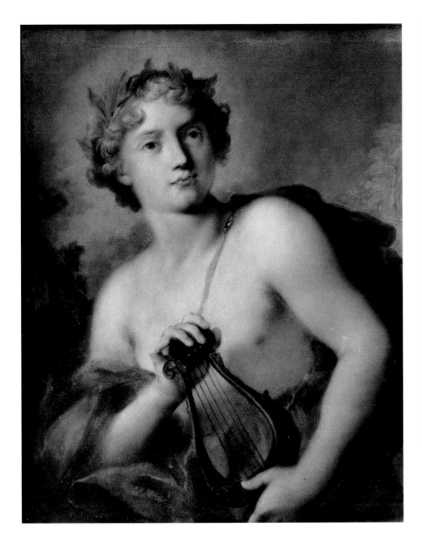

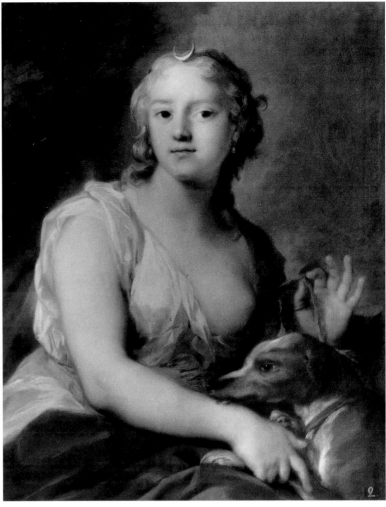

18

ROSALBA CARRIERA (1675-1757)
Apollo
Pastel on blue paper, attached to canvas along its
edges, 67 x 52.5
Inv. No. OR 17961
PROVENANCE: Sir Robert Walpole, 1736 Downing St
(Great Middle Room below), later Houghton (Carlo
Maratt Room); 1779 Hermitage; early 1800s Gatchi-
na Palace; 1925 returned to the Hermitage.
LITERATURE: *Aedes* 1752, p. 60; 2002, no. 117; Boy-
dell II, pl. XLIV; Weiner 1916, p. 137, pp. 141-43
notes 26 and 31; Kamenskaya 1960, pp. 37-38, no. 57;
Gatto 1971, p. 190, fig. 245.
EXHIBITION: 1972a Leningrad, no. 26.

With its companion *Diana* (cat. no. 19), this work was
moved to Gatchina Palace sometime after completion
of the complex in 1799. There, together with pastels
by other masters, they were later kept in the Recep-
tion Quarters of Alexander III, in which location they
were recorded in the Room Inventory of Gatchina

Palace, now in the Hermitage Archives (Hermitage
Archives, Fund 1, *Opis'* VII *zh*, no. 13). Under no. 26
this lists 'Apollo, drawing in pastel colours by an
unknown artist 14 x 11½ *vershki*'. In 1925, when the
work returned to the Hermitage, the authorship of
Rosalba Carriera was reinstated.

The Hermitage pastels can both be dated to 1740-
46, late in the artist's career (Gatto 1971, p. 190).
They are typical of Rosalba's works from this period,
being relatively large in format, with large-scale fig-
ures in calm poses, and predominantly pale in colour.
Both works are executed with light strokes in pallid
bluish-grey tones. To meet the taste of her sitters dur-
ing these years, Rosalba frequently employed mytho-
logical or allegorical motifs, often reworking and
modifying earlier compositions. Close in style to the
Apollo is a pastel *Allegory of Poetry* (also known as *Semi-
nude Woman Representing History,* or *Allegory of Histo-
ry,* Staatliche Kunsthalle, Karlsruhe).

A. K-G.

19

ROSALBA CARRIERA (1675-1757)
Diana
Pastel on blue paper, attached to canvas along its
edges, 67 x 52
Inv. No. OR 17960
PROVENANCE: see cat. no. 19.
LITERATURE: *Aedes* 1752, p. 60; 2002, no. 118; Boy-
dell II, pl. XLIII; Georgi 1794, p. 469 (1996 edition,
p. 355); Weiner 1916, p. 137, pp. 141-3 notes 26 &
31; Kamenskaya 1960, pp. 37, no. 56, tab. XXIV; Pal-
lucchini 1960, p. 46; Gatto 1971, p. 190.
EXHIBITIONS: 1972a Leningrad, no. 27.

By the time this work and its companion (cat. no. 18)
were recorded in the Room Inventory of Gatchina
Palace, both authorship and subject matter had been
forgotten. This work is listed as no. 262 and the pas-
tel is described simply as 'Female portrait with a dog.
Drawing in pastel colours by an unknown artist. 14¾
x 11⅜ *vershki*'.

A. K-G.

20

?Valerio Castello (1624–59) or
?Giovanni Benedetto Castiglione (c.1609–64)
The Holy Family with Angels
Oil on canvas, 76.5 x 58.5
PROVENANCE: Sir Robert Walpole, Houghton
(Gallery); 1779 Hermitage; whereabouts unknown.
LITERATURE: *Aedes* 1752, p. 95 (as by 'Valerio Castel-
lo'); 2002, no. 273; Hand 1827, pp. 193–94 (Castello);
Livret 1838, p. 51, no. 61 (Castello).

When accessioned in the 1773–85 catalogue (no.
2231) under the name of Giovanni Benedetto Cas-
tiglione, it was described as follows: 'Beau tableau que
représente S. Joseph donnant des Cerises à l'Enfant
Jésus. Il est orné de plusieurs figures d'Anges en dif-
férentes attitudes. Le catalogue du Lord Orford le
donne mal à propos à Valerio Castelli, qu'il nomme
Disciple de Van Dyck. Ce n'est pas Castelli, mais Cas-
tiglione, qui a etudié sous ce maître et d'ailleurs le
Nom du dernier se trouve écrit sur le Dos du tableau.'
The 1797 catalogue (no. 656) and 1859 inventory (no.
4472) both attribute the painting to Castiglione. The
1859 inventory also reveals that at one time it hung in
a study in the Winter Palace and then in the apart-
ment of General D— (name illegible, and location of
that apartment unknown). Thereafter its whereabouts
has not been recorded and it is not known if the work
was removed altogether from the Hermitage or if the
attribution was simply altered.

Hand (1827) mentions two works of a similar sub-
ject under the name of Castello. The first of these
('Maria hält das Kind auf dem Schoose und reicht ihm
Blumen. Zwei tiefer stehende Angel spielen auch mit
blumen. Zur seite stehen Joseph und ein Himmels-
bote') had a Walpole provenance while the second
('Die Mutter gottes sitzt seitwärts, ihr auf dem
Schooße das Kind. Joseph bringt ihm Zwei
Kirschen') had no provenance.

Mysteriously, Hand seems to have split into two
the canvas described by Munich in Cat. 1773–85.
According to him, one of them has the angels while
the other depicts St Joseph and the cherries. Neither
the 1773–85 or 1797 catalogues nor the 1859 invento-
ry include any reference to any other painting which
includes the Virgin, angels and flowers under the
name of either Castello or of Castiglione.

S. V.

Not reproduced

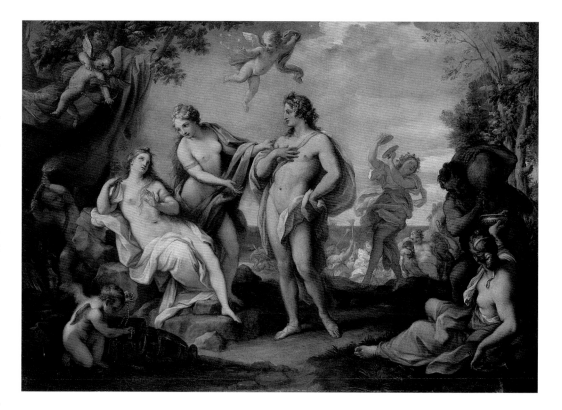

21

Giuseppe Bartolomeo Chiari (1654–1727)
Bacchus and Ariadne
Oil on canvas, 103.5 x 151
Inv. No. 7495
PROVENANCE: Sir Robert Walpole, 1736 Houghton
(Green Velvet Drawing Room/Carlo Maratt Room);
1779 Hermitage; 1923 transferred to the Catherine
Palace, Tsarskoye Selo; late 1920s transferred to the
State Museum Fund; 1933 returned to the Hermitage.
LITERATURE: *Aedes* 1752, p. 60; 2002, no. 116; Geor-
gi 1794, p. 455 (1996 edition, p. 347); Hand 1827, p.
390, no. 255; Schnitzler 1828, p. 93; Chambers 1829,
vol. I, p. 527; Livret 1838, p. 382, no. 36; Gille 1860,
no. 71; Vertue, vol. V, 1937–38, p. 121; Kerber 1968,
p. 85; Rudolph 1995, p. 159.

According to the *Aedes*, Sir Robert Walpole had four
paintings by Giuseppe Chiari, all measuring 3' 3" x 4' 5",
at Houghton Hall. Two of these were New Testament
subjects, *The Pool of Bethesda* (cat. no. 23) and *Christ's
Sermon on the Mount* (cat. no. 24), while the others illus-
trated subjects from Ovid's *Metamorphoses, Apollo and
Daphne* and *Bacchus and Ariadne* (cat. nos. 22, 21).

In the *Aedes* Horace Walpole specifically compares
the paintings with a series Chiari produced in 1708
for Cardinal Fabrizio Spada-Veralli: 'There are four
Pictures about the Size of these in the Spada Palace at
Rome, by the same Hand; two, just the same with

these two last, the other two are likewise Stories out
of the Metamorphosis.'

Stella Rudolph (1995) has suggested that all four
works may have been in the possession of Marchese
Niccolò Maria Pallavicini before being acquired by
Walpole, but cites no evidence in support of such a
hypothesis, and the Pallavicini inventories make no
mention of any such works by Chiari.

Although the four paintings are not united by a
common theme, they have always been perceived as a
set of four. The fact that they were recorded as hanging
together in the same room in descriptions of the Wal-
pole collection and when sold to Catherine II were
valued at £450 'for the four' supports this notion.

In the nineteenth century, the set was split into two
pairs, one biblical and one mythological, and exhibited
in separate rooms of the Hermitage Picture Gallery
(Livret 1838). Then in the early twentieth century all
four paintings by Chiari were divided between differ-
ent collections, their authorship and provenance for-
gotten. Until recently, all four were thought to be lost.

In 1911, on the orders of Tsar Nicholas II, *The Pool
of Bethesda* and *Christ's Sermon on the Mount* were
included in a group of thirteen Italian paintings sent
to the Livadia Palace, the new imperial summer resi-
dence in the Crimea, and were therefore removed
from the Hermitage inventory. Documents in the
Hermitage Archive relating to the transfer to Livadia

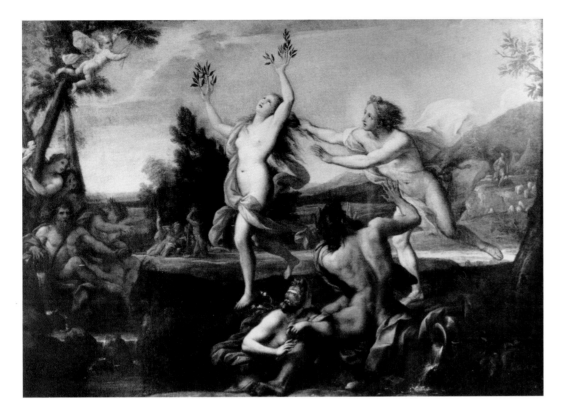

include a letter with a plan of the palace and a suggested layout by Hermitage staff for the hanging of Chiari's paintings in the Red Drawing Room.

The other two paintings in the series, *Apollo and Daphne* and *Bacchus and Ariadne,* were transferred in 1923 from the Hermitage to the Catherine Palace at Tsarskoye Selo, from where at the end of the 1920s they were allocated to the State Museum Fund. In 1933 they returned to the Hermitage, misattributed to Antoine Coypel (?) and thereby placed in the eighteenth-century French section. In 1940 the pair was divided when *Apollo and Daphne* was given to the State Art Gallery in the city of Perm.

Bacchus and Ariadne is the only one of the series to be described in detail in the *Aedes*: 'Bacchus and Ariadne, ditto, the best of the four; the Bacchus seems to be taken from the Apollo Belvedere, as the Ideas of the Ariadne and the Venus evidently are from the Figures of Liberality and Modesty in the famous Picture of Guido, in the Collection of Marquise del Monte at Bologna.'

The borrowings from the celebrated works noted by Walpole were typical of the eclectic nature of the work of Chiari, a pupil and the most consistent follower of Carlo Maratti. In the Spada *Bacchus and Ariadne* (see F. Zeri, *Galleria Spada*, Florence, 1954, no. 288) scholars have noted many analogies with the work of Guido Reni, Giovanni Battista Gaulli, Annibale Carracci and Romanelli, while in the figure of Apollo a direct borrowing from Andrea Sacchi's *Apollo Crowning Marcantonio Pasqualini* (Metropolitan Museum of Art, New York) can be seen. The same can also be said of the Hermitage painting. Horace Walpole noted in the *Aedes* the similarity of the two paintings in the Walpole series with works produced by Chiari for Cardinal Fabrizio Spada-Veralli.

Indeed, the compositions of the *Bacchus and Ariadne* in the Hermitage and in the Spada Gallery differ only in insignificant details. For instance, the cupid with the pearl necklace to the left in the Spada painting looks towards Bacchus, while in the Hermitage painting his head is lowered. The Hermitage painting also has a cupid floating above the central group, holding in his right hand a garland of small stars. A drawing in the collection of the Duke of Devonshire at Chatsworth, traditionally thought to be a preparatory work for the *Bacchus and Ariadne* in the Spada Gallery, is more likely to be a preliminary sketch for the Hermitage work, since the drawing also has a floating cupid, although he holds a torch.

The subject is from Ovid, *Metamorphoses*, VI, 176 and 599.

T. B.

22

GIUSEPPE BARTOLOMEO CHIARI (1654-1727)
Apollo and Daphne
Oil on canvas, 99.5 x 147.5
Perm State Art Gallery, Perm. Inv. No. 40
PROVENANCE: Sir Robert Walpole, 1736 Houghton (Green Velvet Drawing Room/Carlo Maratt Room); 1779 Hermitage; 1923 transferred to the Catherine Palace, Tsarskoye Selo; late 1920s transferred to the State Museum Fund; 1933 returned to the Hermitage; 1940 transferred to Perm State Art Gallery.
LITERATURE: *Aedes* 1752, p. 60; 2002, no. 115; Georgi 1794, p. 455 (1996 edition, p. 347); Schnitzler 1828, p. 93; Chambers 1829, vol. I, p. 527; Livret 1838, p. 377, no. 16; Gille 1860, no. 73; Vertue, vol. V, 1937-38, p. 121; Perm Catalogue 1963, p. 161; Kerber 1968, p. 85; Rudolph 1995, p. 159.

One of four paintings from a series by Chiari (see commentary to cat. no. 21). The subject is from Ovid, *Metamorphoses*, I, 452.

T. B.

23

GIUSEPPE BARTOLOMEO CHIARI (1654-1727)
The Pool of Bethesda (The Healing of the Paralytic)
Oil on canvas, c.96 x 130
PROVENANCE: Sir Robert Walpole, 1736 Houghton (Green Velvet Drawing Room/Carlo Maratt Room); 1779 Hermitage; 1911 transferred to New Livadia Palace, Yalta, Crimea; whereabouts unknown.
LITERATURE: *Aedes* 1752, p. 60; 2002, no. 113; Georgi 1794, p. 455 (1996 edition, p. 347); Hand 1827, p. 390, no. 270; Schnitzler 1828, p. 93; Chambers 1829, vol. I, p. 527; Livret 1838, p. 53, no. 75; Gille 1860, no. 67; Vertue, vol. V, 1937-38, p. 121; Kerber 1968, p. 85; Rudolph 1995, p. 159.

One of four paintings from a series by Chiari (see commentary to cat. no. 21).

The series opens with *The Pool of Bethesda*. Munich's catalogue (1773-85) provides us with only a short description of the painting – 'Il est bien de composition avec nombre de figures d'orné d'architecture' – but it may eventually be possible to identify this painting from the inventory numbers on the canvas: 2388 (Cat. 1773-85) in red on the front, or 2644 (Inventory 1859) in black on the back.

T. B.

Not reproduced

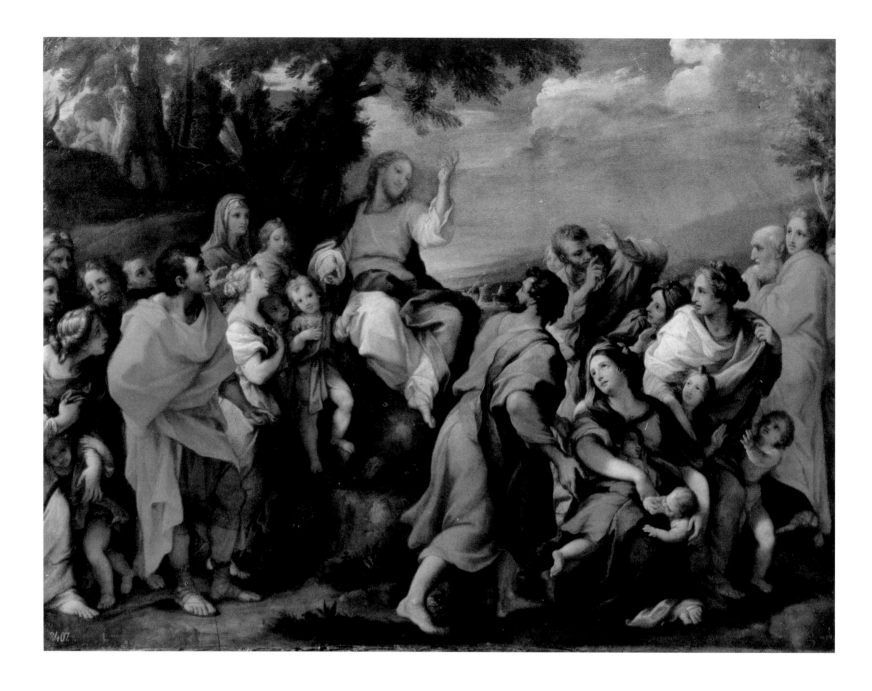

24

GIUSEPPE BARTOLOMEO CHIARI (1654-1727)
Christ's Sermon on the Mount
Oil on canvas, 100 x 137
M. P. Kroshitskiy Art Museum, Sevastopol. Inv. No. 227
PROVENANCE: Sir Robert Walpole, 1736 Houghton (Green Velvet Drawing Room/Carlo Maratt Room); 1779 Hermitage; 1911 transferred to New Livadia Palace, Yalta, Crimea; ?1922 transferred to Yalta Museum, Yalta; 1927 transferred to M. P. Kroshitskiy Art Museum, Sevastopol [Sebastopol], Crimea (now Ukraine).

LITERATURE: *Aedes* 1752, p. 60; 2002, no. 114; Georgi 1794, p. 455 (1996 edition, p. 347); Schnitzler 1828, p. 93; Chambers 1829, vol. I, p. 527; Livret 1838, p. 53, no. 71; Gille 1860, no. 70; Korenev 1931, no. 34; Vertue, vol. V, 1937-38, p. 121; Kerber 1968, p. 85; Markova 1986, p. 132, no. 47; Rudolph 1995, p. 159.

One of four paintings from a series by Chiari (see commentary to cat. no. 21). The 1773-85 catalogue provides only the following brief description: 'Bon tableau de beaucoup de figures où Jésus Christ est representé assis sur la terre au dessous d'un arbre.'

By the time the painting arrived in Sevastopol Art Museum, the artist's name had been forgotten and the museum catalogue (Korenev 1931) attributed it to Carlo Maratti. Markova (1986) published the work with the traditional attribution to Chiari on the basis of the 1797 Hermitage catalogue but she was unaware of the painting's Walpole provenance. On the front of the canvas, in the right bottom corner, is a white number, 1054, the origin of which is unknown.

T. B.

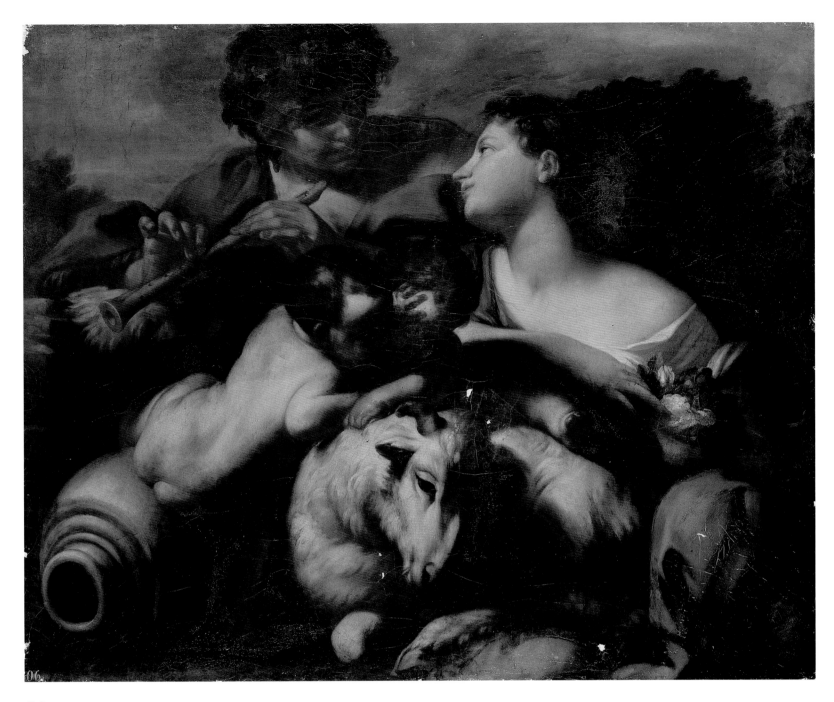

25

CARLO CIGNANI (1628–1719)
Shepherd and Shepherdess
Oil on canvas, 102.5 x 127.5
Inv. No. 7009
PROVENANCE: Sir Robert Walpole, 1736 Houghton
(Marble Parlour, then Gallery); 1779 Hermitage; from
the mid-19th century to 1919 in Pavlovsk Palace;
1919 returned to the Hermitage.
LITERATURE: *Aedes* 1752, p. 87; 2002, no. 252; Boydell
I, pl. XVIII; Gilpin 1809, p. 61; Chambers 1829, vol. I,
p. 537; Vertue, vol. VI, 1948–50, p. 180.

In the Walpole collection and the *Aedes* the painting
bore the title *Nymph and Shepherd* although Vertue (vol.
VI, 1948–50) called it 'A Shepherd, Shepherdess, two
Boys and a Sheep'.

This picture is close in style to works by Cignani such
as *Flora* (Galleria Estense, Modena) and *Spring* (Galleria
Spada, Rome) and it may thus be dated to the 1660s to
1670s. A somewhat altered version of the composition
(Schäferszene/Shepherd Scene, 111 x 145.5) was listed in E.
Henschel-Simon's catalogue of the Palace of Sansouci,
as coming from the collection of Cardinal Valenti Gon-

zaga (E. Henschel-Simon, *Die Gemälde und Skulpturen in
der Bildergalerie von Sansouci*, Berlin, 1930, No. 20).

Chambers (1829), noting that 'Mr. Charles Stan-
hope has another of the same design, but much dark-
er', also cited William Gilpin's 1809 description of the
Walpole painting: 'The nymph is a charming figure,
the composition is beautiful, and the light would have
been well thrown if the ram, a part of the boy's back,
and the bottle, had been in shade.'

S. V.

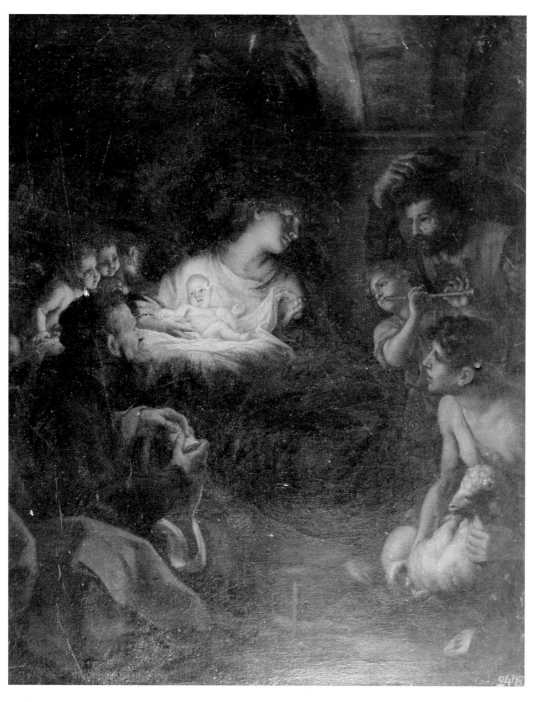

subject (dimensions 131 x 114, the figures three-quarter length). This entered the Hermitage at the end of the eighteenth century and is now attributed to Ignaz Stern, a pupil of Cignani (Inv. No. 1587). It was during work on this catalogue in early 2000 that the painting was identified in store at the Catherine Palace.

S. V

27

VIVIANO CODAZZI (1604-70)
Architectural Fantasy with a Scene of Christ Healing the Man Possessed of Devils
Oil on canvas, 74 x 102
PROVENANCE: Sir Robert Walpole, 1736 Downing St (End Room Below), then Houghton (Common Parlour); 1779 Hermitage; in the 19th century in Kamenniy Ostrov (Stone Island) Palace, St Petersburg; whereabouts unknown.
LITERATURE: *Aedes* 1752, p. 48 (as 'Two Pieces of Ruins' by 'Viviano'); 2002, no. 54; Georgi 1794, p. 461 (1996 edition, p. 351); Vertue, vol. III, 1933-34, p. 9; Vertue, vol. VI, 1948-50, p. 176.

Pair to *Architectural Fantasy with a Scene of Feasting* (cat. no. 28).

Vertue (vol. III, 1933-34) first saw Codazzi's canvases in the early 1720s 'at M. Walpole's ... of Vivian two peices of Architet.' He mentions them a second time in 1739 as in Sir Robert Walpole's house in Downing Street where they hung over the door (Vertue, vol. VI, 1948-50).

As Stella Rudolph has suggested, they may well have come from the Pallavicini collection (Rudolph 1995, App. II, nos. 225-26; App. III, nos. 12-13), although since Vertue saw them in 1720s, this presumes a very early purchase of works by Sir Robert Walpole from the Pallavicini heirs, the Arnaldi family. Munich (Cat. 1773-85, no. 2399) identified the scene amidst the ruins more precisely as 'Jesus Christ healing the man possessed of devils' but in the absence of the picture itself it is difficult to establish which version of the story (Mark v: 1-20; Luke viii: 26-39; or Matthew ix: 32-4; xii: 22-4; Mark ix: 16-26; Luke xi: 14-15) is being illustrated.

According to a note in the 1859 inventory, the paintings were given in 1911 to the Russian Embassy in Rome but other evidence suggests that the pictures were still in the Hermitage in 1915. This may simply be a misunderstanding since the Hermitage also had another similar but slightly smaller pair of pictures by Vivian Codazzi, the whereabouts of which is also unknown.

S. V.

Not reproduced

26

CARLO CIGNANI (1628-1719)
The Adoration of the Shepherds
Oil on canvas, 108 x 88
Tsarskoye Selo State Museum Reserve, Inv. No. 197-X
PROVENANCE: Sir Robert Walpole, 1736 Houghton (Common Parlour); 1779 Hermitage; from the mid-19th century in the Catherine Palace, Tsarskoye Selo (Pushkin).
LITERATURE: *Aedes* 1752, p. 46 (as 'The Nativity'); 2002, no. 39; Boydell II, pl. XVII; Hand 1827, pp.

318-19; Nagler 1835-52, vol. 2, p. 538; Yakovlev 1926, p. 56; Vertue, vol. VI, 1948-50, p. 178.

The Adoration of the Shepherds is described in the Hermitage 1773-85 catalogue (no. 2311) and again in the 1797 catalogue (no. 2447), but is not mentioned in the 1859 inventory. It was therefore assumed until recently that this work had been lost, particularly since the Walpole painting is sometimes confused with another canvas thought to be by Carlo Cignani of the same

28

VIVIANO CODAZZI (1604-70)
Architectural Fantasy with a Scene of Feasting
Oil on canvas, 74 x 102
PROVENANCE: see cat. no. 27.
LITERATURE: *Aedes* 1752, p. 48 (as 'Two Pieces of Ruins' by 'Viviano'); 2002, no. 55; Georgi 1794, p. 461 (1996 edition, p. 351); Vertue, vol. III, 1933-34, p. 9; Vertue, vol. VI, 1948-50, p. 176.

Pair to *Architectural Fantasy with a Scene of Christ Healing the Man Possessed of Devils* (cat. no. 27).
 Munich (Cat. 1773-85, no. 2398) did not specifically identify the subject but he described the scene as follows: 'Beau morceau où sous les ruines on voit un Cabaret et quelques personnes assises à table qui se font servir des rafraîchissemens'. It is possible that the subject matter was biblical, such as the Marriage at Cana (John ii: 1-11).

S. V.

Not reproduced

29

SEBASTIANO CONCA (1680-1764)
The Virgin with the Child in her Arms Asleep
Oil on canvas, 31.5 x 24.5
Inv. No. 2256
PROVENANCE: Sir Robert Walpole, 1736 Downing St (Lady Walpole's Drawing Room), later Houghton (Cabinet); 1779 Hermitage; from the late 18th century in the Tauride Palace, St Petersburg; 1863 transferred to Gatchina Palace; 1920s returned to the Hermitage.
LITERATURE: *Aedes* 1752, p. 69; 2002, no. 167; Boydell II, pl. XXXI.

This work is typical of Sebastiano Conca's works produced during the first years after his arrival in Rome in 1707. It clearly reflects the influence of paintings of the Virgin by Francesco Trevisani, in the period from 1710 to 1715 when Conca worked closely with Tre-

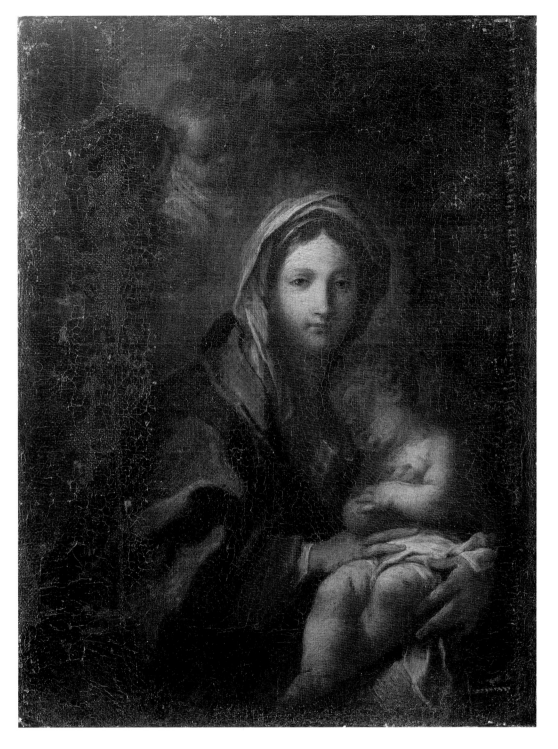

visani on such commissions for Cardinal Pietro Ottoboni as *The Madonna and the Sleeping Christ Child* (Burghley House) or *The Virgin Reading with the Sleeping Christ Child* (Galleria Nazionale d'Arte Antica, Palazzo Corsini, Rome). The Virgin's features are classically severe and lack that prettiness and roundness of form which characterise Conca's later works.

The painting has suffered large areas of loss and creasing of the paint surface, particularly on the left side, creating the impression that it has been scorched by fire. As a result of its poor state of preservation, this painting was not included in the Hermitage catalogues of 1958 or 1976.

T. B.

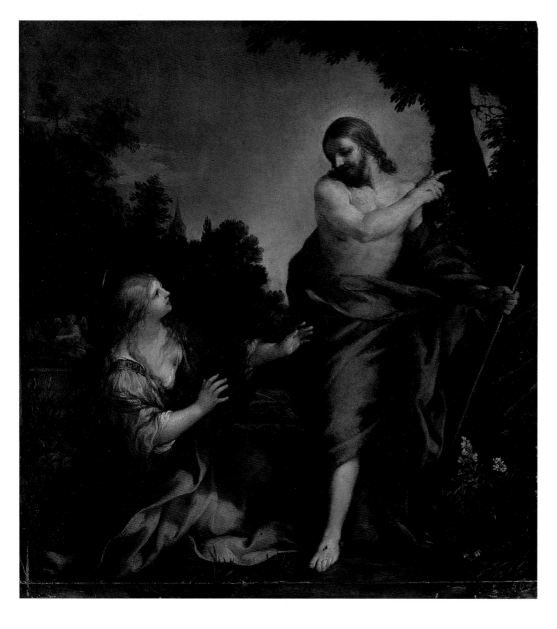

30

PIETRO DA CORTONA (PIETRO BERRETTINI) (1596-1669)
The Appearance of Christ to Mary Magdalene
Oil on panel, 55 x 50.5
Inv. No. 166
PROVENANCE: Sir Robert Walpole, 1736 Houghton (Green Velvet Drawing Room, then Cabinet); 1779 Hermitage.
LITERATURE: *Aedes* 1752, p. 65 (as 'Christ appearing to Mary in the Garden'); 2002, no. 144; Boydell II, pl. XXV; Hand 1827, p. 278; Schnitzler 1828, pp. 85, 129-30; Nagler 1835-52, vol. 1, p. 461; vol. 10, p. 55, no. 11 (Murphy); vol. 21, p. 99, no. 5 (W. Walker); Viardot 1844, p. 472; Viardot 1852, p. 299; Cats. 1863-1916, no. 280; Waagen 1864, p. 94; Penther 1883, p. 45; Fabbrini 1896, pp. 278-79; Thieme-Becker 1907-50, vol. 7, p. 489; Voss 1924, p. 546; Vertue, vol. VI, 1948-50, p. 179; Cat. 1958, vol. I, p. 156; Blunt, Cooke 1960, p. 80, no. 613; Briganti 1962, pp. 241-42, no. 102; Vsevolozhskaya 1981, no. 131; Briganti 1982, pp. 241-42, no. 102.

The subject is from John xx: 14-17.

A drawing by Pietro da Cortona in the Royal Collection at Windsor Castle has been loosely linked by Blunt and Cooke (Blunt, Cooke 1960) with two paintings by the artist. One of these is in the Hermitage, the other was formerly in the Hamilton Palace collection (Sale, 1882, lot 707). Blunt and Cooke suggest that the Windsor drawing is not a preparatory study for either of these two paintings since they are only similar in general outline. A third painting associated with the drawing was exhibited at Colnaghi's in London in 1958 as by Giuseppe Chiari.

A version of Pietro da Cortona's *The Appearance of Christ to Mary Magdalene*, in the collection of Cardinal Fesch, was twice as large as the Walpole canvas. This was described as 'une reproduction de celui gravé par A. Walker', i.e. a version of the Hermitage composition. The catalogue of the Fesch collection mistakenly names Antony Walker instead of William Walker as the engraver (see *Galerie de feu S. E. le Cardinal Fesch. Catalogue des tableaux des écoles italienne et espagnol par Georges, peintre*, Rome, 1845, part 4, p. 172, no. 832). As Briganti (1962, 1982) has suggested, the picture can be dated to 1640-50.

S. V.

31

PIETRO DA CORTONA (PIETRO BERRETTINI) (1596–1669)

The Return of Hagar

Oil on canvas, 206 x 150

Pushkin Museum of Fine Arts, Moscow, Inv. No. 135
PROVENANCE: 1725/26 acquired by Sir Robert Walpole at a sale of paintings by Andrew Hay (Lot 73, price £215; Pears 1988, p. 87); Sir Robert Walpole, 1736 Houghton (Yellow Drawing Room, then Gallery); 1779 Hermitage; 1862 transferred to Rumyantsev Museum, Moscow; 1924 transferred to Museum of Fine Arts (now Pushkin Museum of Fine Arts), Moscow.
LITERATURE: *Aedes* 1752, p. 88 (as 'Abraham, Sarah and Hagar'); 2002, no. 254; Boydell I, pl. XXVII; Georgi 1794, p. 458 (1996 edition, p. 348); Labensky 1805-9, vol. 2, bk. 5, pp. 35-37; Hand 1827, pp. 274, 276-77; Schnitzler 1828, pp. 48, 129; Livret 1838, p. 263; Viardot 1844, p. 477; Gille 1860, p. 130, no. 19; Rumyantsev Museum 1862, p. 15, no. 135; Rumyantsev Museum 1865, p. 15, no. 135; Guide dans la Galerie 1872, p. 45, no. 135; Andreyev 1853-83, vol. 2, p. 142; Novitsky 1889, pp. 182-83; Fabbrini 1896, p. 279, no. 97; Rumyantsev Museum 1901, p. 36, no. 429; Rumyantsev Museum 1909 and 1910, p. 81, no. 745; Rumyantsev Museum 1912, p. 91, no. 4; Rumyantsev Museum 1915, pp. 21, 212, no. 4; Voss 1924, pp. 261, 545; Von Below 1932, p. 50; Vertue, vol. VI, 1948-50, p. 178; Briganti 1962, p. 247, no. 113; Kunsthistorisches Museum 1965, p. 42, no. 503; Wipper 1966, p. 84; Turner 1980, p. 46, no. 14; Pushkin Museum 1986, p. 144; Pears 1988, p. 87; Markova 1992, pp. 252, 253; Pushkin Museum 1995, p. 170; Moore ed. 1996, pp. 51, 52; Brownell 2001, p. 53.
EXHIBITION: Moscow 1961, p. 39.

A smaller version of the composition (the subject from Genesis xvi: 8-16), executed c.1637, is in the Kunsthistorisches Museum, Vienna (Briganti 1962, p. 217, no. 72). It came from the collection of the Grand Dukes of Tuscany and was formerly in the Palazzo Pitti, Florence. The Vienna version has no figure of Sarah and the composition itself is reversed. Briganti (1962) suggests that it was painted earlier than the Moscow painting.

Von Below (1932) noted a connection with a drawing in the Louvre, on the back of which is an inscription: 'H. Dufour: Doms Petrus de Cortona fecit et dono dedit mihi Florentie in Julio 1647.' On the basis of this date, the Moscow painting can be placed around 1647, when the artist was working in Florence (1644-47) and in general this accords well with the style of the work. Fabbrini (1896) mistakenly suggested that it was the Moscow painting that formerly belonged to the Dukes of Tuscany.

In 1927 there was a copy of the work in the collection of Abbé Thuclin, Paris (Briganti 1962).

V. M.

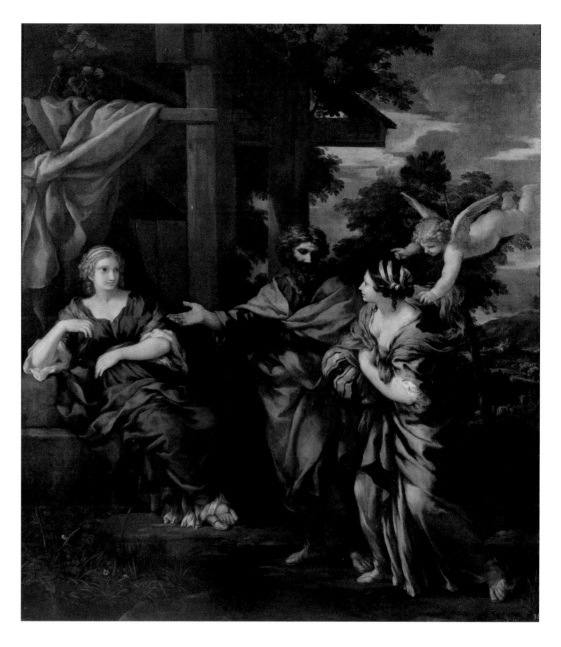

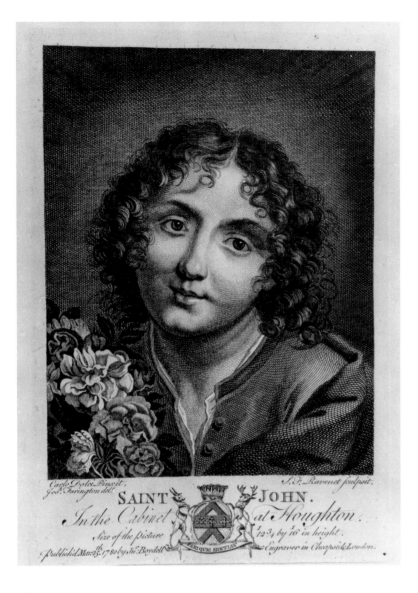

32

CARLO DOLCI (1616-86)
Head of a Young Man (Boy?)
Oil on canvas, 40.5 x 33.5
PROVENANCE: Sir Robert Walpole, 1736 Chelsea (Lady Walpole's Drawing Room), later Houghton (Cabinet); 1779 Hermitage; 1859 transferred to the Museum of the Academy of Arts, St Petersburg; whereabouts unknown.
LITERATURE: *Aedes* 1752, p. 67 (as 'St. John, a Head'); 2002, no. 152; Boydell II, pl. XIII ('St John'); Hand 1827, p. 289; Livret 1838, p. 49, no. 57; Wrangell 1913, p. 73.

Now known only from the Boydell print, engraved by S. F. Ravenet, published 25 March 1780.

Although described in the *Aedes* as the head of St John, Munich challenged this (Cat. 1773-85, no. 2379) in his description of the picture: 'Tête d'un jeune homme. Le Catalogue du lord d'Orford donne ce morceau pour la tête de S. Jean mais que ce soit celle de qui l'on voudra on y trouve toute l'Aménité du pinceau et tout le brilliant du colorit de Carlo Dolci. Le vêtement en est rouge avec une guirlande de fleurs en écharpe.'

In the 1797 catalogue (no. 526) the painting is listed simply as 'Head of a Young Man', and in Livret 1838 as 'Buste d'enfant ayant une guirlande de fleurs en écharpe'. When the painting was transferred to the Academy of Arts in 1859, however, it was described as 'Head of a Saint'. It had earlier been listed by Hand (1827) as 'Iohannes' and he noted that 'in der Hand hält ... eine Blume'. It is mystifying how these accounts of the same picture can be so at variance. How could a young man in secular dress, with a casually open collar and a single flower (or garland) in his hand be mistaken for a head of St John, especially since there is no hand visible in the engraving?

S. V.

33

LUCA GIORDANO (1634-1705)
Vulcan's Forge
Oil on canvas, transferred from old canvas in 1848, 192.5 x 151.5
Inv. No. 188
PROVENANCE: coll. Grinling Gibbons, London; November 1722 acquired by Sir Robert Walpole at the sale of the Gibbons coll.; Sir Robert Walpole, 1728 Arlington St, London, 1736 Houghton (Saloon); 1779 Hermitage.
LITERATURE: *Aedes* 1752, p. 56 (as 'The Cyclops at their Forge'); 2002, no. 94; Boydell II, pl. LXVI; Labensky 1805-9, vol. 1, bk. 3, pp. 123-26; Gilpin 1809, p. 48; Hand 1827, pp. 323-27; Schnitzler 1828, pp. 42-43, 132; Nagler 1835-52, vol. 5, p. 187; vol. 10, p. 54-55, no. 2 (engr. Murphy); Livret 1838, p. 260, no. 51; Cats. 1863-1916, no. 1638; Thieme-Becker 1907-50, vol. 14, p. 78; Vertue, vol. VI, 1948-50, p. 178; Cat. 1958, vol. I, p. 91; Italian Painting 1964, no. 166; Baroque and Rococo 1965, no. 13; Ferrari, Scavizzi 1966, vol. I, p. 63; vol. 2, pp. 273, 337; Pigler 1974, vol. 2, p. 271; Cat. 1976, p. 90; Vsevolozhskaya 1981, no. 190; Ferrari, Scavizzi 1992, p. 264, no. A 91; Moore ed. 1996, pp. 48, 50, 119-20 (engr. Murphy).

This work is close in style and composition to Giordano's *Venus, Mars and Vulcan's Forge* (coll. Denis Mahon, London) and *Vulcan's Forge* (Galleria di Palazzo Spinola, Genoa), which Ferrari and Scavizzi (1966) date to 1657-60. The Hermitage canvas was probably executed c.1660.

The picture was acquired by Walpole in November 1722 at the Grinling Gibbons sale (lot 87, see Moore ed. 1996). In 1728 it was described as 'un grand tableau de vulcain de Ribera' (MS Fougeroux 1728).

In the *Aedes* Horace Walpole mentions a copy of this picture made by Peter Walton, which was then in St James Palace, and later at Hampton Court (destr. 1924).

The subject is from Virgil, *Aeneid* VIII, 424-53.

S. V.

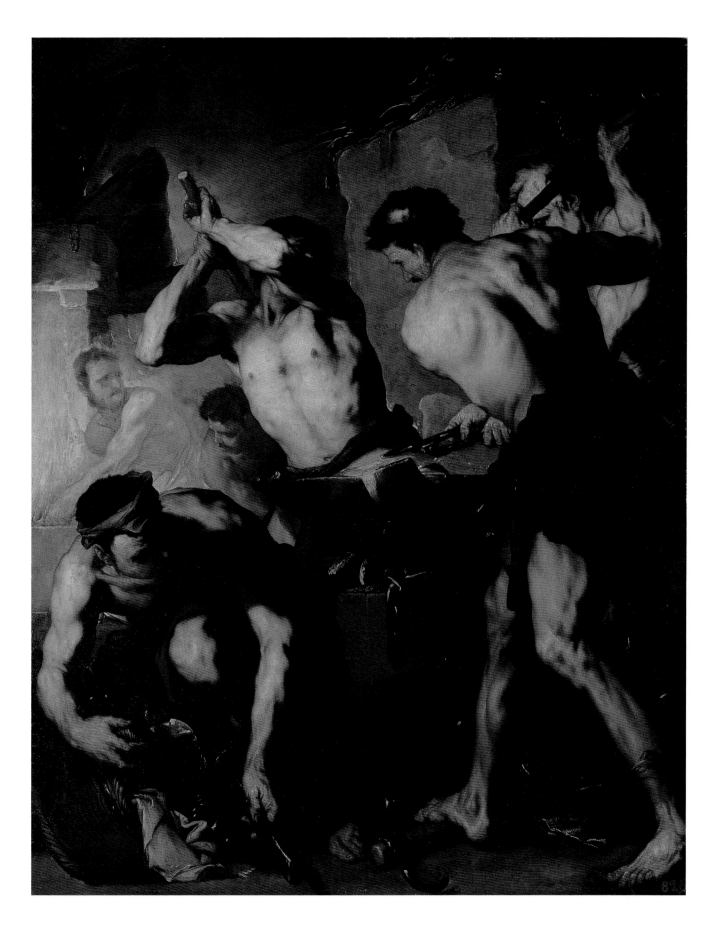

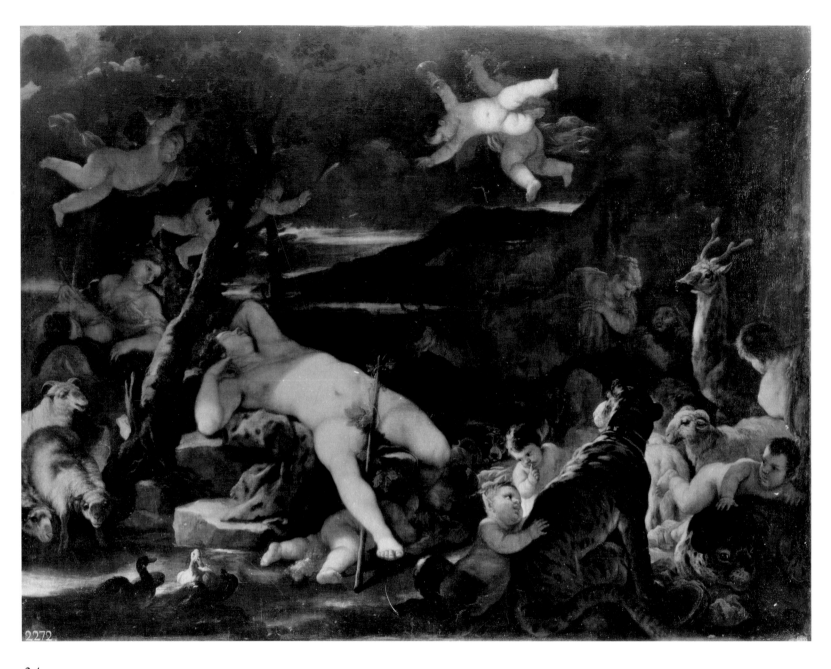

34

LUCA GIORDANO (1634–1705)
Sleeping Bacchus
Oil on canvas, 246.5 x 329, signed bottom centre:
Luca Giordano F.
Inv. No. 197
PROVENANCE: Sir Robert Walpole, 1736 Houghton
(Yellow Drawing Room, then Drawing-Room);
1779 Hermitage.
LITERATURE: *Aedes* 1752, p. 51; 2002, no. 64; Boydell
II, pl. II; Hand 1827, p. 322; Nagler 1835-52, vol. 5,
p. 187; Livret 1838, p. 271, no. 1; Viardot 1844, p.
486; Viardot 1852, p. 307; Cats. 1863-1908, no. 294;
Waagen 1864, p. 294; Thieme-Becker 1907-50, vol.

14, p. 78; Vertue, vol. VI, 1948-50, p. 178; Ferrari,
Scavizzi 1966, vol. 2, pp. 271, 337; Pigler 1974, vol.
2, p. 208; Cat. 1976, p. 90; Ferrari, Scavizzi 1992, pp.
299-300, no. A 291-b, 383.

The subject derives from Apollodorus, III, 4, 3.

In keeping with the opinion of Ferrari, Scavizzi
(1966, 1992), curators at the Hermitage have always
dated this work to the early 1680s, when the artist was
in Florence. Scavizzi was the first to suggest (Ferrari,
Scavizzi 1992, fig.1006) that a drawing of a sleeping
Bacchus (British Museum, London) was a preparato-
ry work for the Hermitage painting. The same
authors also identified the pair to this drawing as a
Drunken Silenus (Musée des Beaux-Arts, Dijon). The
painting based on this drawing, which would have
formed a pair with the Hermitage *Sleeping Bacchus*,
was not in Walpole's possession. It is now lost and is
known only from a copy in a private collection in
New York.

Ferrari, Scavizzi (1992) noted that the basis for the
figure of Bacchus was the celebrated antique sculp-
ture, the *Barberini Faun* (Glyptothek, Munich).

S. V.

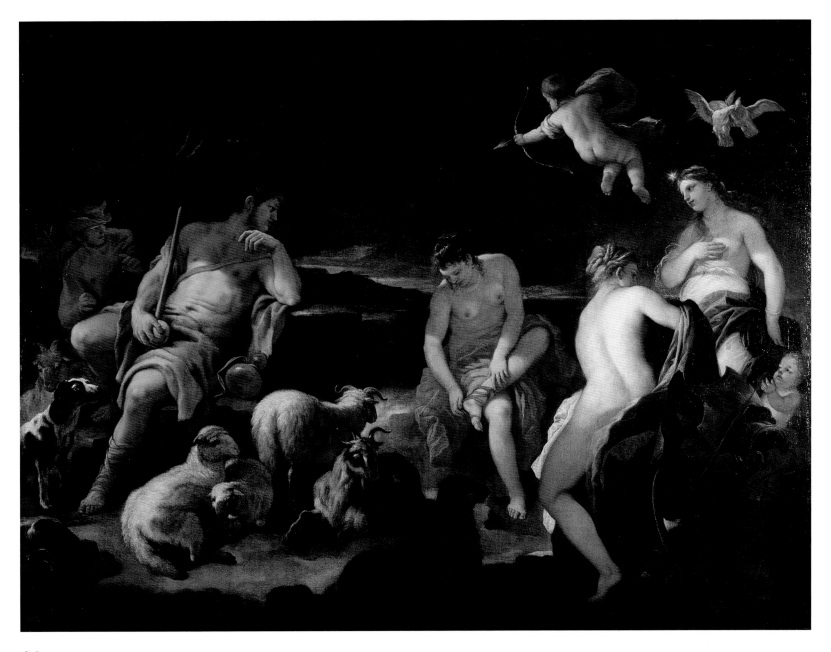

35

Luca Giordano (1634–1705)

The Judgment of Paris

Oil on canvas, 246 x 329, signed at the bottom, right of centre: *Luca Giordano F.*

Inv. No. 9965

PROVENANCE: Sir Robert Walpole, 1736 Houghton (Yellow Drawing Room, then Drawing-Room); 1779 Hermitage.

LITERATURE: *Aedes* 1752, p. 51; 2002, no. 63; Boydell II, pl. I; Hand 1827, p. 322; Nagler 1835–52, vol. 5, p. 187; Livret 1838, p. 271, no. 1; Viardot 1844, p. 486; Viardot 1852, p. 307; Cats. 1863–1908, no. 294; Waagen 1864, p. 294; Thieme-Becker 1907–50, vol. 14, p. 78; Vertue, vol. VI, 1948–50, p. 178; Ferrari, Scavizzi 1966, vol. 2, pp. 271, 337; Pigler 1974, vol. 2, p. 208; Cat. 1976, p. 90; Ferrari, Scavizzi 1992, pp. 299–300, no. A 291-b, 383.

There are numerous versions of this subject (from Homer, *The Iliad*, XXIV, 25–30; Lucian, *Dialogues of the Gods*, 20) by Luca Giordano (Museo Civico, Vicenza; coll. Borromeo, Isola Bella, Como; Academy of Arts, Vienna; Galleria Pallavicini, Rome and elsewhere). The Hermitage painting is particularly close to the *Judgment of Paris* formerly in the Kaiser Friedrich Museum, Berlin (destr. during the Second World War). Catalogues of the Berlin collection referred to the Hermitage picture as a replica of their painting, but it would be more correct to see it as a variant. The most recent scholarship suggests a date of execution c.1682.

Until recently this work was thought to be a pair to the *Sleeping Bacchus* (cat. no. 34), but it has now been shown that the pair to the latter was in fact a lost *Drunken Silenus*.

At the beginning of the twentieth century *The Judgment of Paris* and two other paintings by Giordano, *The Triumph of Galatea* (Inv. No. 9966) and *The Rape of Europa* (Inv. No. 9987) were set into the ceiling of the Hermitage theatre foyer and were therefore not included in catalogues of the collection published between 1909 and 1976. In the 1970s they were removed from that location and, after considerable conservation, were restored to the painting collection.

S. V.

36

LUCA GIORDANO (1634–1705), copy after
The Presentation of the Virgin in the Temple
Oil on canvas, glued onto panel, 66.5 x 36
Inv. No. 1609
PROVENANCE: 1722 acquired by Sir Robert Walpole
at the van Huls house sale; Sir Robert Walpole, 1736
Houghton (Green Velvet Drawing Room/Carlo
Maratt Room); 1779 Hermitage.
LITERATURE: *Aedes* 1752, pp. 60–61; 2002, no. 122;
Hand 1827, p. 326; Livret 1838, p. 281, no. 34;
Vertue, vol. VI, 1948–50, p. 179; Moore 1996a, p. 49.

Pair to *The Birth of the Virgin* (cat. no. 37), both sub-
jects derived from Jacopo da Voragine, *The Golden
Legend*, CXXIX, I.

Moore (ed. 1996) identified this work and its com-
panion (cat. no. 37) as the two small pictures by Gior-
dano in the van Huls sale, 6 August 1722. The pair
was then titled *The Birth of Elisabeth* and *Her [Elisa-
beth's] Confirmation*. In the Walpole collection the lat-
ter (this work) was initially called *Samuel presented to
Eli, on the steps of the Temple* (Walpole MS 1736) but
was finally correctly identified in the *Aedes*, where
Horace Walpole suggested that these small works
were sketches for Giordano's large canvases in the
Church of Santa Maria della Salute in Venice, which
are dated to between 1667 and 1674.

The Hermitage picture differs from the Venetian
canvas in some secondary details, but its much inferi-
or quality suggests that it is a copy. Other reduced-
scale copies of both compositions are certainly
known.

S. V.

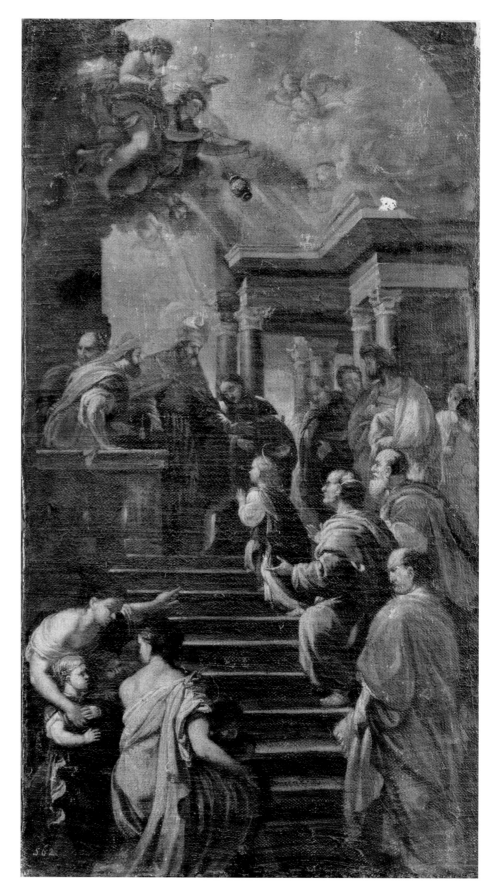

37

LUCA GIORDANO (1634-1705), copy after
The Birth of the Virgin
Oil on canvas, glued onto panel. 66.5 x 36.5
PROVENANCE: 1722 acquired by Sir Robert Walpole
at the van Huls house sale; Sir Robert Walpole, 1736
Houghton (Green Velvet Drawing Room/Carlo
Maratt Room); 1779 Hermitage; 1929 transferred to
Antikvariat for sale; whereabouts unknown.
LITERATURE: *Aedes* 1752, pp. 60 (as by 'Luca Jordano');
2002, no. 121; Hand 1827, p. 326; Livret 1838, p. 281,
no. 37; Vertue, vol. VI, 1948-50, p. 178; Moore ed.
1996, p. 49.

Pair to *The Presentation of the Virgin in the Temple* (cat.
no. 36).

This work was identified by Moore (ed. 1996) as
the picture wrongly entitled the *Birth of Elisabeth* in
the house sale of Mr van Huls, 6 August 1722. In the
manuscript catalogue of 1736 (Walpole MS 1736) it
was mis-identified as *The Nativity* but a decade later
the subject was correctly identified in the *Aedes*,
where it is also described as a 'finished design' for a
large picture painted by Giordano for the Church of
Santa Maria della Salute in Venice (1667-74).

In 1929 the painting was appropriated for sale by
Antikvariat and its whereabouts thereafter is
unknown. It may eventually prove possible to identi-
fy it by the inscription '561' on the front of the can-
vas (the number from the 1797 catalogue) and in
black ink on the back '2685' (from the 1859 Inven-
tory) and 1608 (Hermitage Inv. No.).

S. V.

Not reproduced

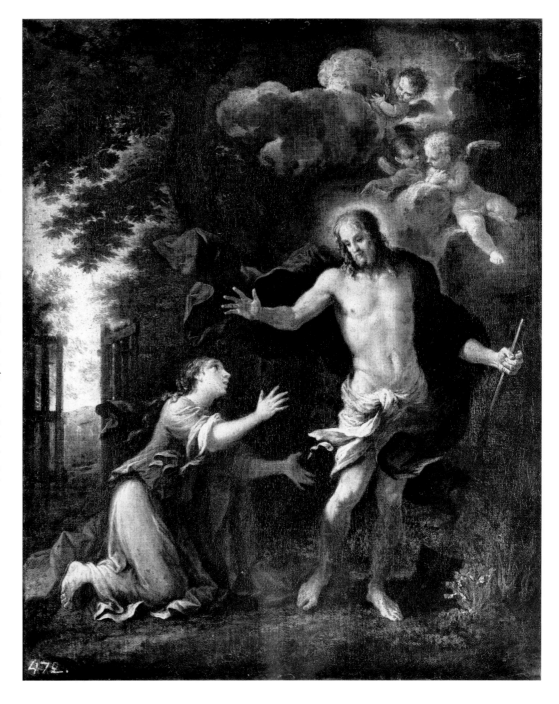

38

FILIPPO LAURI (1623-94)
The Appearance of Christ to Mary Magdalene
Oil on canvas, 43.5 x 36.5
Inv. No. 1514
PROVENANCE: Sir Robert Walpole, 1736 Downing St
(Closet), later Houghton (Cabinet); 1779 Hermitage.
LITERATURE: *Aedes* 1752, p. 70 (as 'Christ and Mary
in the Garden'); 2002, no. 180; Boydell II, pl. LIX
('Our Saviour in the Garden'); Georgi 1794, p. 455
(1996 edition, p. 347); Hand 1827, pp. 262-63; Livret

1838, p. 49, no. 55; Nagler 1835-52, vol. 7, p. 340;
vol. 16, p. 431, no. 2 (Simon); Cats. 1863-1916, no.
311; Waagen 1864, p. 96; Voss 1924, p. 575; Cat.
1958, vol. I, p. 116; Bénézit 1976, vol. 6, p. 485;
Pigler 1974, vol. 1, p. 349; Cat. 1976, p. 104.

Small paintings by Lauri were very popular and many
of them were engraved. *The Appearance of Christ to
Mary Magdalene* (the subject from John xx: 14-17)
owes much of its fame to a good engraving by Peter

Simon, which conveys excellently the individual fea-
tures of Lauri's style.

Writing of the Hermitage picture, Voss (1924)
noted that the anthology of letters on art compiled by
Gualandi mentions a painting by Lauri of this subject
(M. Gualandi, *Nuova raccolta di lettere... in aggiunta a
quella data in luce da Mons. Bottari e dal Ticozzi*,
Bologna, 1844-46, vol. 3, p. 218).

S. V.

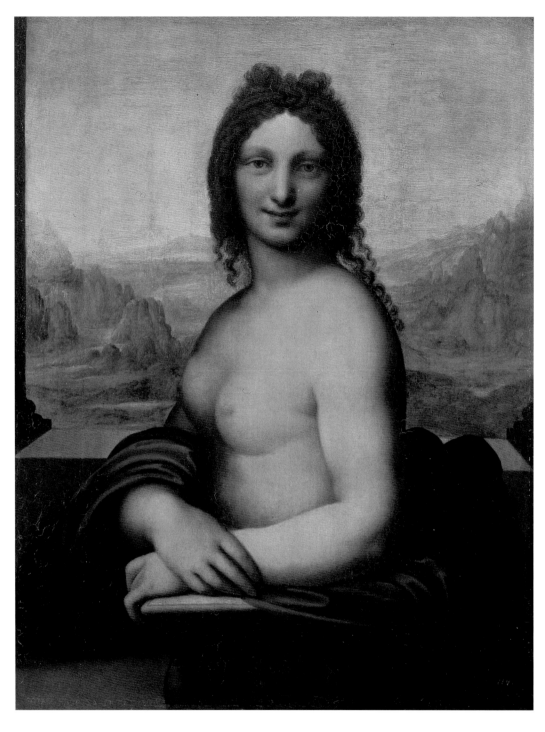

289; Berenson 1907, p. 261; Schmidt 1909b, pp. 699-701; Cook 1909, p. 108; Benois [1910], p. 34; Liphart 1910, pp. 15-16; Weiner 1910, p. 146; Peldan 1912, p. 9; Liphart 1912b, p. 217; Schulze 1912, p. 41; Venturi A. 1920, p. 184; Reinach 1922, vol. 5, p. 217; Liphart 1928, pp. 30-33; Suida 1929, pp. 239, 305; Berenson 1938, p. 290; Hevesy 1952, p. 16; Hommage à Léonard 1952, p. 28; Cat. 1958, vol. I, p. 172; Pedretti 1959, p. 178; Reu 1966, p. 43; Ottino Della Chiesa 1967, p. 104; Cat. 1976, p. 132; Leonardo e il leonardismo 1983, p. 205; Disegni e dipinti 1987, p. 101; Kustodieva 1991, pp. 62-63; Kustodieva 1994, no. 117; Kustodieva 1998-99, pp. 61-63.

EXHIBITIONS: 1954 Travelling, p. 37; 1977 Milan, no. 6; 1979 Sofia, no. 16; 1998-99 St Petersburg, no. 9.

Set against a mountainous landscape background, this nude young woman, a cloak tossed across her right arm and descending onto the arm of the chair, is in the same pose as Leonardo's *Giaconda* or *Mona Lisa*. From the late seventeenth to the early nineteenth century it was thought that this painting was a portrait of the mistress of either Lodovico Moro or François I, King of France. Horace Walpole preferred the latter hypothesis and noted in the *Aedes* that the sitter was 'reckoned the handsomest Woman of her Time'.

The work is known by a number of different names—*Monna Vanna*, *Donna nuda*, *Naked Giaconda* etc. The attribution to Leonardo was sustained in catalogues of the Hermitage up to and including that of 1888, after which a question mark was added. It was only in the 1911 Hermitage catalogue that the painting was demoted to school of Leonardo although as early as 1859 Somov had declared that the work was not an original by the artist. Gustav Waagen (1864) suggested that this work was a study painted by Leonardo for the Louvre portrait at some point between 1499 and 1506 but all later scholars (Bode (1882), Harck (1896), Benois ([1910]), Liphart (1910, 1912b), A. Venturi (1920) and Suida (1929) list the picture as school of Leonardo. Cook (1909) tentatively suggested the name of Cesare da Sesto. In the 1958 and 1976 catalogues the painting was attributed without any particular justification to Salaino (Salai). We know that Salaino was indeed a pupil of Leonardo but no unquestionably authentic work by him has been identified. Documentary evidence published in 1991 listing works (by either Salaino or Leonardo) remaining in his studio after Salaino's death in 1524 includes reference to a '*quadro cum una meza nuda*', no doubt some variant on the *Monna Vanna*. The relatively low value assigned to it (25 scudi) suggests that it was a *Flora* or *Columbine* executed by Salai, or, less probably, the 'Chantilly cartoon' (J. Shell, G. Sironi: 'Salai and Leonardo's Legacy', *Burlington Magazine*, vol. CXXXIII, 1991, p. 100).

Closest to the Hermitage version is a cartoon in the Musée Condé, Chantilly, formerly considered an

39

LEONARDO DA VINCI, follower of
Female Nude (Donna nuda)
Oil on canvas, transferred from panel, 86.5 x 66.5
Inv. No. 110
PROVENANCE: coll. Charles-Jean-Baptiste Fleuriau, Comte de Morville, French diplomat; Sir Robert Walpole, 1736 Downing St (End Room Below), later Houghton (Gallery); 1779 Hermitage.

LITERATURE: *Aedes* 1752, p. 95 (as 'The Joconda ... by Lionardo da Vinci'); 2002, no. 271; Boydell I, pl. VII; Hand 1827, p. 72; Schnitzler 1828, p. 44; Livret 1838, p. 457; Viardot 1844, p. 469; Andreyev 1857, p. 38; Somov 1859, p. 21; Cats. 1863-1916, no. 15; Waagen 1864, pp. 34-35; Clément de Ris 1879-80, pt II, p. 343; Bode 1882, Part 4, p. 6; Part 8, p. 7; Penther 1883, p. 19; Harck 1896, p. 421; Peinture en Europe 1905, p.

original by Leonardo. There are a number of variants on the *Donna nuda*, in which the figure appears beneath a canopy of leaves and fruits (priv. coll, Switzerland, formerly coll. Mackenzie, London), against a background of distant hills (coll. Kaupe, Palanza), or framed by flowers (Accademia Carrara, Bergamo, now attributed to the circle of Jan Brueghel I, see F. Rossi, *Accademia Carrara, Bergamo*, 4 vols., Milan, 1989, vol. 2, p. 37). The catalogue of the exhibition *Hommage à Léonard* (1952) listed twelve versions of the *Nude Giaconda* (pp. 27-29).

We do not know which member of Leonardo's circle first had the idea of reworking his famous *Giaconda*. Pedretti (1996, p. 127) suggests that the idea may have emerged in Rome, culminating in the creation of Giulio Romano's erotic portraits. A drawing of a woman's head in the Biblioteca Ambrosiana, Milan, appears to depict the same face as that in the Hermitage *Donna nuda*. Mariani (Disegni e dipinti 1987), however, suggests that this drawing is a copy from another drawing from Leonardo's workshop rather than a repetition of one of the surviving versions.

<div align="right">T. K.</div>

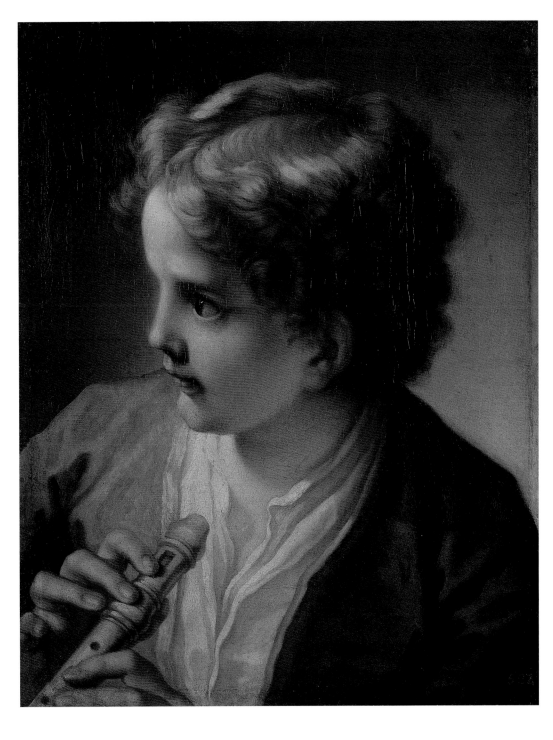

40

BENEDETTO LUTI (1666-1724)
Boy with a Flute
Oil on canvas, 42 x 33
Inv. No. 131
PROVENANCE: Sir Robert Walpole, 1736 Chelsea (Lady Walpole's Drawing Room), later Houghton (Cabinet); 1779 Hermitage.
LITERATURE: *Aedes* 1752, p. 67 (as 'Boy's Head with a Lute'); 2002, no. 154; Boydell II, pl. XV; Georgi 1794, p. 459 (1996 edition, p. 349); Chambers 1829, vol. I, p. 530; Livret 1838, p. 47, no. 47; Cats. 1863-1916, no. 289; Waagen 1864, p. 95; Bode 1882, Part 7, p. 5; Neustroyev 1898, p. 89; Moschini 1923, p. 113, no. 16; Voss 1924, p. 610; Cat. 1958, vol. I, p. 127; Italian Painting 1964, no. 193; Cat. 1976, p. 108; Bowron 1979, p. 265, no. 25; Vsevolozhskaya 1981, no. 210.

In the manuscript Cat. 1773-85, Munich provides a short but very precise description of the work: 'Ce joli petit morceau d'un pinceau frais et vigoureux représente un jeune garçon à mi corps tenant une flute à bec dans les mains.'

Luti had previously produced a drawing in black, red and green chalks, *Head of a Girl* (Holkham Hall, Norfolk, UK), in which, according to M. Brettingham (*The Plans, Elevations ... of Holkham*, London,

1773, p. 14), the artist depicted one of his daughters. Together with its pair (a drawing in pastel showing the artist's second daughter), *Head of a Girl* was presented by Luti to Thomas Coke, 1st Earl of Leicester, whilst the latter was on his Grand Tour in Italy at some time between 1712 and 1718. Heads such as these became extremely popular in the eighteenth century and were in great demand on the art market, and due to their small size were sought after by travelling collectors.

Luti used this composition, with the same turn of the child's head, repeatedly in his paintings. It not only served as a prototype for a female figure in *Rebecca and Eliezer at the Well* (Holkham Hall, Norfolk, UK; another version priv. coll., New York) but was also used in another composition, *Boy's Head* (Uffizi, Florence), where although the hair and clothing differ from those in the Holkham drawing the composition and the colour range remain the same. *Boy with a Flute* was the next stage in the development of this theme, and by adding the flute in the boy's hand Luti effectively transformed the image into a genre painting.

Two other versions of the composition with the boy are known in oil, in the Staatsgalerie, Augsburg, and in the Alte Pinakothek, Munich. The latter has no flute and is now attributed by some scholars to Rosalba Carriera.

From the time the painting first entered the Hermitage, its attribution to Luti remained largely unquestioned, although Moschini (1923) described it rather harshly as an indifferent school work ('scadente opera di scuola'). *Boy with a Flute* was often copied in a variety of media, providing further evidence of its popularity. At Burghley House there is a mosaic based on it, and a copy appears on a decorative vase (1830, Imperial Porcelain Manufactory) at the Great Palace at Peterhof State Museum Reserve, near St Petersburg.

The painting was also engraved in mezzotint by James Walker in 1785, in the album *A Collection of Prints, from the Most Celebrated Pictures in the Gallery of Her Imperial Majesty Catherine II* (London, 1792), where it was mistakenly described as the work of Greuze and attached to the same page as Greuze's *Young Woman*.

T. B.

41

CARLO MARATTI (1625-1713)
Pope Clement IX
Oil on canvas, 153 x 118.5, dedication and signature on the sheet of paper on the table: *Alla Santitià di N./ Sig.re.Clemente IX / Per Carlo Maratti.*
Inv. No 42

PROVENANCE: coll. Marchese Niccolò Maria Pallavicini, Rome; coll. Arnaldi, Florence; Charles Jervas; 1739 acquired by Sir Robert Walpole; Sir Robert Walpole 1739 Houghton (Carlo Maratt Room); 1779 Hermitage.
LITERATURE: *Aedes* 1752, p. 57; 2002, no. 99; Boydell II, pl. XXIV; Labensky 1805-9, vol. 1, bk. 2, pp. 69-70; Gilpin 1809, p. 49; Swignine 1821, p. 31 (Russian edition 1997, pp. 247-48); Hand 1827, p. 264; Schnitzler 1828, pp. 42, 126; Nagler 1835-52, vol. 8, p. 290; Livret 1838, p. 40, no. 21; Cats. 1863-1916, no. 307; Waagen 1864, pp. 95-96; Bode 1882, Part 7, p. 9; Penther 1883, p. 46; Voss 1924, p. 349; Ritratto italiano 1927, p. 26; Vertue, vol. III, 1933-34, pp. 96, 112, 114; Vertue, vol. V, p. 14; Malitskaya 1939, pp. 64-65; Mezzetti 1955, p. 328, no. 64; Cat. 1958, vol. I, p. 132; Anthal 1962, pp. 40, 46; Italian Painting 1964, no. 137; Bénézit 1976, vol. 7, p. 157; Wipper 1966, p. 128; Cat. 1976, p. 111; Vsevolozhskaya 1981, no. 137; Gemäldegalerie Berlin 1986, p. 47; Hermitage 1989, no. 40; Rudolph 1995, pp. 33, 154, 194 note 80; Brownell 2001, p. 41.
EXHIBITIONS: 1938 Leningrad, no. 97; 1972d Leningrad, no. 353; 1981 Vienna, p. 74; 1993-94 Tokyo-Mie-Ibaraki, no. 27; 1996-97 Norwich-London, no. 45.

Clement IX Rospigliosi (1600-69) was created a cardinal in 1657 by Alexander VII and was Pope from 27 June 1667 to 9 December 1669. He had previously been papal nuncio in Italy and state secretary under Alexander VII.

According to Bellori (G. P. Bellori, *Vite di Guido Reni, Andrea Sacchi e Carlo Maratti*, Rome, 1695, ed. 1942, pp. 88-89), Maratti painted a portrait of Clement IX in 1669 shortly before the Pope's death. Clement sat for the artist at the Palazzo di Santa Sabina on the Aventine in Rome despite his poor health and this is the picture now in the Vatican Gallery. Until recently the Vatican version was assumed to be the prime version but cleaning of the Hermitage canvas has revealed the inscription, which corresponds to that originally recorded by Bellori.

Marchese Niccolò Maria Pallavicini commissioned a version of the portrait from Maratti and after the former's death this work passed, with the rest of the collection, to the Arnaldi family. From there it was acquired by Charles Jervas, who brought it to England not long before his death in 1739. Vertue (vol. III, 1933-34) tells us that the latter sold the painting to Sir Robert Walpole for 100 guineas. Vertue (vol. V,

1937-38) also described the portrait at some length: 'a fine picture and in great preservation <a small fraction has happend in the face> the complexion rather pale then florid the cloke red velvet his cap red – the chair richly adorn'd. gold carv'd a book under his right hand'. Vertue (*ibid.*) provided detailed information about another version of the portrait by the artist in England: 'The R^t Hon^ble Lord Burlington has another such picture of this Pope, which he bought in England. – which was painted for Heneage Earl of Winchelsea by Carlo Morat, who in his return from Constantinople where he had been Embassador – 1668/9 causd that to be done' (now Chatsworth, collection of the Duke of Devonshire).

In addition to these two versions there are other surviving copies, the most famous of which is in the picture gallery of the Staatliche Museen Preussischer Kulturbesitz, Berlin (exhibited in the Staatliche Kunstsammlungen, Kassel). Vertue (vol. III, 1933-34, pp. 112, 114) also mentions a copy from the portrait belonging to Sir Robert Walpole made by Ranelagh Barwick (Barret).

A drawing by Carlo Maratti in the Kupferstichkabinett, Dresden, is thought to be a preparatory study for the portrait.

S. V.

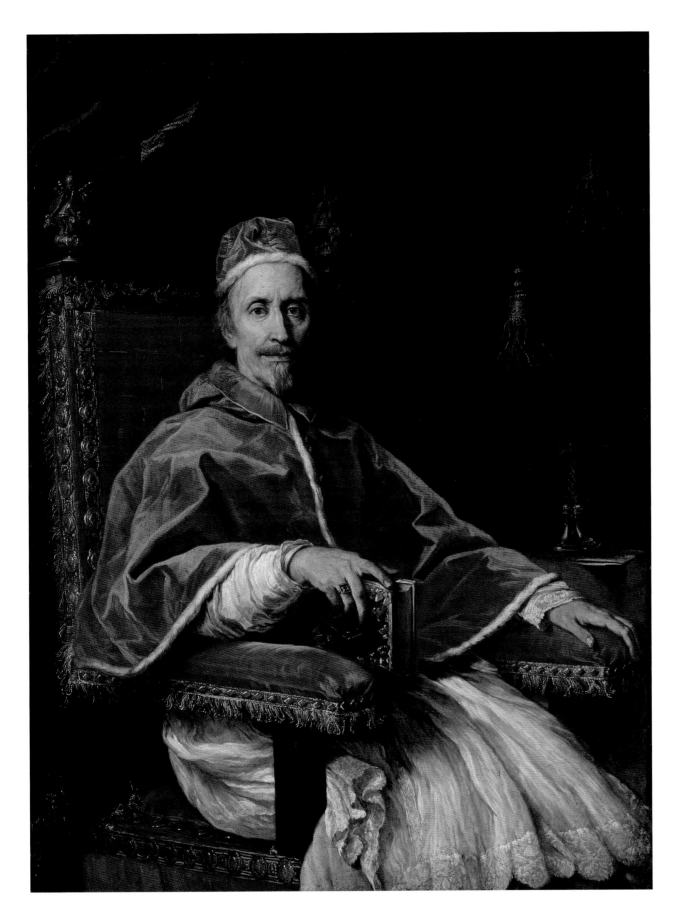

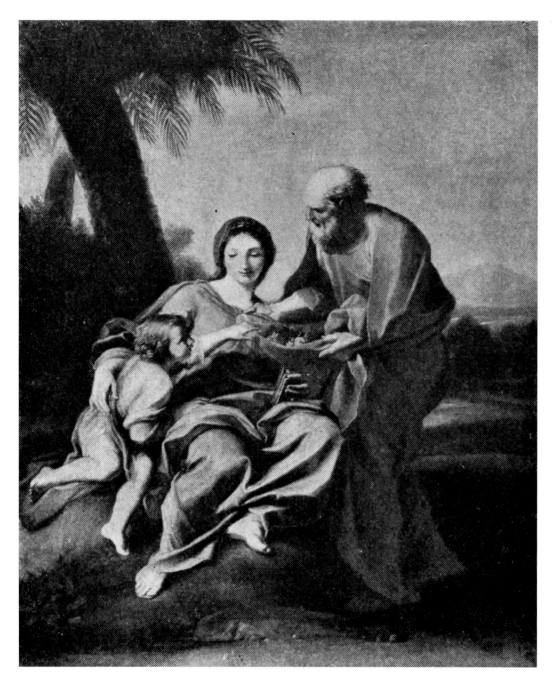

42

?CARLO MARATTI (1625-1713)
The Holy Family Beneath a Palm Tree
Oil on canvas, 76 x 63
Palekh Museum, Palekh. Inv. No. 68
PROVENANCE: ?coll. Marchese Niccolò Maria Pallavicini, Rome (Rudolph 1995); Sir Robert Walpole, 1736 Houghton (Green Velvet Drawing Room/Carlo Maratt Room); 1779 Hermitage; 1924 transferred to Museum of Fine Arts, Moscow; 1937 transferred to Palekh Museum, Palekh, Russia.
LITERATURE: *Aedes* 1752, p. 59 (as 'The Virgin and Joseph with a young Jesus'); 2002, no. 106; Boydell II, pl. XLVII; Georgi 1794, p. 455 (1996 edition, p. 346); Hand 1827, p. 266; Nagler 1835-52, vol. 4, p. 74 (Edelink); Livret 1838, p. 50, no. 59; Cats. 1863-1912, no. 300; Vertue, vol. VI, 1948-50, p. 179 (undoubtedly one of those described as 'Madonna with other figures'); Mezzetti 1955, p. 327, no. 60; Bénézit 1976, vol. 7, p. 157; Rudolph 1995, p. 158 (fig. 87 in fact reproduces another Hermitage picture, Inv. No. 1557, purchased in 1782 from the dealer Klostermann in St Petersburg), p. 203, note 276.

Several versions of this composition are known. One of these, painted in 1680 for the Marchese Pallavicini and described by Bellori, is now in the Palazzo Rosso, Genoa (for further details see Rudolph 1995, p. 38, 195 notes 90, 91). Rudolph suggests that Niccolò Berrettoni had a hand in its execution, a view with which the present author concurs. The picture in Genoa differs in a few details from the Walpole work and has more figures. The Hermitage owns another version, with the composition in reverse (Inv. No. 1557, 67 x 49), which is sometimes confused with the Walpole picture. The latter was thought—by Edmond de Bruiningk, author of the 1889 Hermitage catalogue and Somov, author of later catalogues (1901, 1909)—to be 'une copie d'un original de Maratti, dont on ignore le possesseur'. Liphart included the picture in the 1912 catalogue as an original by Maratti, but excluded it in later editions of the catalogue. Doubts about the authenticity of the Walpole canvas may result from the participation of one of Maratti's pupils.

In addition to an engraving by Robert Dunkarton (Boydell), there is another print by Gerhard Edelink, which (in reverse) is entirely consistent with the composition of the painting from the Walpole collection.
S. V.

43

Carlo Maratti (1625-1713)
The Virgin and Child with John the Baptist
Oil on canvas, transferred from old canvas in 1869,
100 x 84
Inv. No. 1560

PROVENANCE: ?coll. Marchese Niccolò Maria Pallavicini, Rome (Rudolph 1995); Sir Robert Walpole, 1736 Houghton (Green Velvet Drawing Room/Carlo Maratt Room); 1779 Hermitage.

LITERATURE: *Aedes* 1752, p. 58 (as 'The Holy Family'); 2002, no. 102; Hand 1827, pp. 266-67; Schnitzler 1828, pp. 29-30, 131; Livret 1838, p. 53, no. 72; Viardot 1844, p. 477; Viardot 1852, p. 299; Cats. 1863-1912, no. 302; Voss 1924, p. 601; Vertue, vol. VI, 1948-50, p. 179; Mezzetti 1955, p. 327, no. 57; Cat. 1958, vol. I, p. 130; Bénézit 1976, vol. 7, p. 157; Cat. 1976, p. 111; Rudolph 1995, pp. 128, 129 fig. 95, 158, 203-4 note 293.

It is possible, as with many of the other works by Maratti in the Walpole collection, that this picture came from Pallavicini, although it has not proved possible to identify it in the inventory made of the latter's collection in 1714 (published in Rudolph 1995, App. II).

In the *Aedes* it is described as 'an unfinished Picture, large as Life, by Carlo Maratti in his last Manner' and this is how it is described in all Hermitage catalogues and in the scholarly literature on the artist.

The picture is of high quality, painted in the broad manner and with the colouring consistent with that employed by the artist in his last years. The manner of painting the fabrics, particularly the transparent veil, is close to that in the *Virgin with Sleeping Child and Angels* (Louvre, Paris), executed in 1697.

S. V.

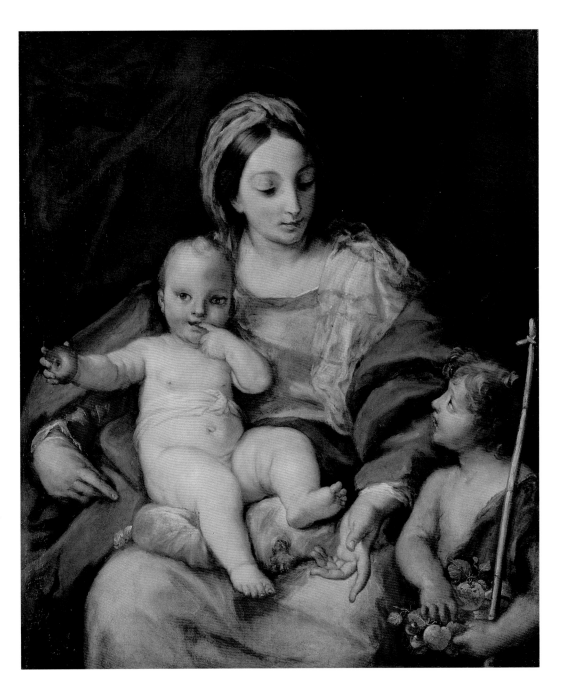

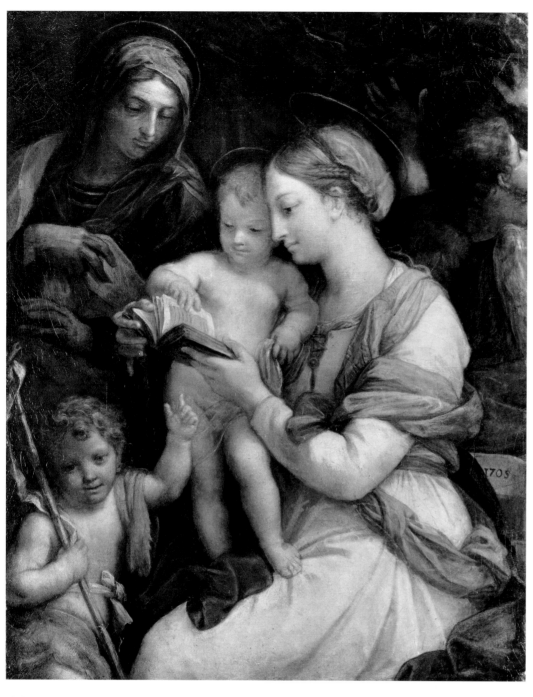

Pair to *St Cecilia with Angels* (Alupka, cat. no. 45).

In the *Aedes* and in all the Hermitage catalogues the female figure to the left was identified as St Elisabeth, but Mezzetti (1955) suggested that the figure is in fact St Anne. If this painting is that listed anonymously in the Pallavicini inventory of 1714 (Rudolph 1995, App. II, no. 378), we should note that the figure there is also thought to represent St Anne: 'di palmi tre incirca fuori di misura in piedi rappresenta la Madonna Santissima col Bambino in braccio, San Giovanni e Sant Anna'. The presence of the young John the Baptist would suggest, however, that this is Elisabeth rather than Anne.

Thanks to the superb quality of the painting, the work was to enjoy great success and was much copied. Horace Walpole records in the *Aedes* that a similar work, then in the Palazzo Barberini in Rome, had been painted by Giuseppe Chiari, where, in place of St Elisabeth and John the Baptist, the artist had depicted a Cardinal reading and the Madonna in white rather than the traditional red. Mezzetti also points to an anonymous engraving, dated 1705, in the Gabinetto Nazionale delle Stampe, Rome, which (in reverse) is very close to the composition of this picture but does not feature St Anne/Elisabeth. The inscription on the engraving gives the author of the original painting as Carlo Maratti.

In the Hermitage there is also a similar small painting on copper (24.5 x 19) possibly executed by one of Maratti's pupils, depicting only the Virgin and Christ. This painting entered the Hermitage in 1946 from a private collection, but in the nineteenth century it had passed through two St Petersburg collections, those of Count Tormazov and Academician V. Bunyakovskiy. A similar painting bearing the inscription *Porbus Sarto 1712*, appeared at auction at Christie's in London, 30 March 1989 (lot 180) and was then attributed to an unidentified Bolognese painter. A precise copy of the Hermitage painting is in the National Gallery of Ireland, Dublin (no. 1703).

It seems likely, as Rudolph has suggested (Rudolph 1995, App. III A, p. 231, no. 17), that the Walpole painting ('Carlo Maratti. *Sacra conversazione*') was included in the exhibition organised in 1729 and opened on St Luke's day in the Basilica di SS Annunziata in Florence. By that date the Pallavicini collection had passed to the Arnaldi family. It cannot, however, be associated with Maratti's 'Sacra famiglia con l'aggionta di Sta Elisabetta e S. Gio: Batta', offered by the Arnaldis amongst a number of other paintings for sale to Marchese Vincenzo Riccardi in 1749 (Rudolph 1995, App. IV, p. 236, no. 76): by this time the painting had already been in the collection of Sir Robert Walpole for at least thirteen years (it appears in the manuscript catalogue of his paintings, Walpole MS 1736). Since it was recorded in the *Aedes*, the picture has been seen as the pair to *St Cecilia* (cat. no. 45).

S. V.

44

CARLO MARATTI (1625–1713)
The Virgin Teaching Jesus to Read
Oil on canvas, transferred from panel in 1869, 69.5 x 55.5, dated to the right on the back of the chair: *1705*
Inv. No. 1500

PROVENANCE: coll. Marchese Niccolò Maria Pallavicini, Rome; Sir Robert Walpole, 1736 Houghton (Green Velvet Drawing Room/Carlo Maratt Room); 1779 Hermitage; in the 19th century hung in the Cabinet of Empress Yelizaveta Alexeyevna, wife of Alexander I, in the Winter Palace.

LITERATURE: *Aedes* 1752, p. 58; 2002, no. 103; Hand 1827, p. 267; Livret 1838, p. 24, no. 1; Cats. 1863–1916, no. 306; Waagen 1864, p. 96; Bode 1882, Part 10, p. 7; Thieme-Becker 1907–50, vol. 24, p. 52; Voss 1924, p. 601; Vertue, vol. VI, 1948–50, p. 179; Mezzetti 1955, p. 328, no. 65; Cat. 1958, vol. I, p. 132; Bénézit 1976, vol. 7, p. 157; Cat. 1976, p. 111; Rudolph 1995, pp. 128, 129 fig. 94, pp. 158, 203–4 note 293; App. II, p. 229, no. 378; App. III, p. 231, no. 17.

45

CARLO MARATTI (1625–1713)
St Cecilia with Angels
Oil on canvas, 69 x 56
Alupka State Palace and Park Museum Reserve,
Alupka, Crimea. Inv. No. 86
PROVENANCE: coll. Marchese Niccolò Maria
Pallavicini, Rome; Sir Robert Walpole, 1736
Houghton (Green Velvet Drawing Room/Carlo
Maratt Room); 1779 Hermitage; in the 19th century
in the Cabinet of Empress Yelizaveta Alexeyevna,
wife of Alexander I, in the Winter Palace; 1862 trans-
ferred to the Moscow Public and Rumyantsev Muse-
um; Pushkin Museum of Fine Arts, Moscow; 1956
Alupka State Palace and Park Museum Reserve,
Alupka, Crimea.
LITERATURE: *Aedes* 1752, p. 58 (as 'St. Caecilia with
four Angels playing on musical Instruments'); 2002,
no. 104; Chambers 1829, vol. I, p. 527; Livret 1838,
p. 34, no. 36; Nagler 1835–52, vol. 8, pp. 290, 292,
no. 62; vol. 17, p. 458, no. 24 (Strange); Le Blanc
1848, p. 16, no. 15; Rumyantsev Museum 1912, p.
96, no. 26; Rumyantsev Museum 1913, p. 104, no.
26; Rumyantsev Museum 1915, pp. 216, 222, no.
589; Alupka 1992, fig. 264; Rudolph 1995, p. 158.

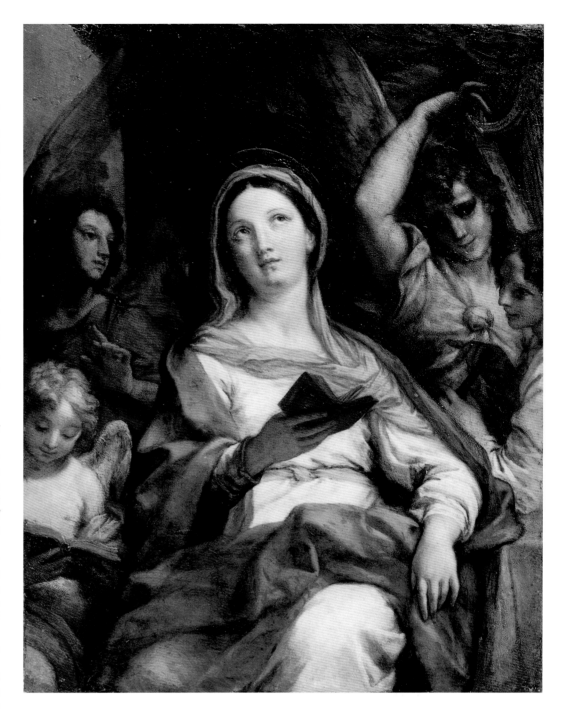

The source of the subject is Jacopo da Voragine, *The
Golden Legend*, CLXVI.

In the *Aedes* and in subsequent Hermitage cata-
logues this painting is listed as the pair to *The Virgin
Teaching Jesus to Read* (cat. no. 44), which bears the
date 1705. It is interesting to note the similarity
between these compositions and the *Vierge au missel*
(c.1690) in the Musée de Digne, particularly in the
figure of St Cecilia and the Digne Virgin.

The painting was much admired by Horace Wal-
pole, who in the *Aedes* quoted the following verses
from Alexander Pope's *Moral Essays* (Epistle II, 'To a
Lady'), as appropriately analogous to Maratti's paint-
ing: 'Or dress'd in Smiles of sweet Caecilia, shine /
With simp'ring Angels, Palms, and Harps divine.'

When he visited the Hermitage, Hand (1827, p.
269) failed to locate this painting and Nagler (1835–
52, vol. 8), listed it among the works by Maratti from
the Walpole collection which could not be found in
St Petersburg. It later transpired that in the nine-
teenth century it was mistakenly described as the *Vir-
gin Surrounded by Angels*, and it hung in the cabinet of
the wife of Alexander I, remaining in the Winter
Palace after her death. In 1862 it was part of a con-
signment of two hundred paintings from the Her-
mitage sent to the newly founded Moscow Public
and Rumyantsev Museum, where its original title
was restored. However, when the work was trans-
ferred to Alupka it was once again called *The Virgin
Surrounded by Angels*.

Charles Le Blanc (1848) drew attention to the print

after the picture by Robert Strange (*Te Deum lau-
damus*) which is sometimes known as *La sainte Vierge
chantant les louanges de Dieu*. Vertue (vol. VI, 1948–50,
p. 179) does not mention a St Cecilia, but it is possible
that this was the painting listed by him after the 'Mad.
Teaching X to read' as a 'Madonna with other figures'.

S. V.

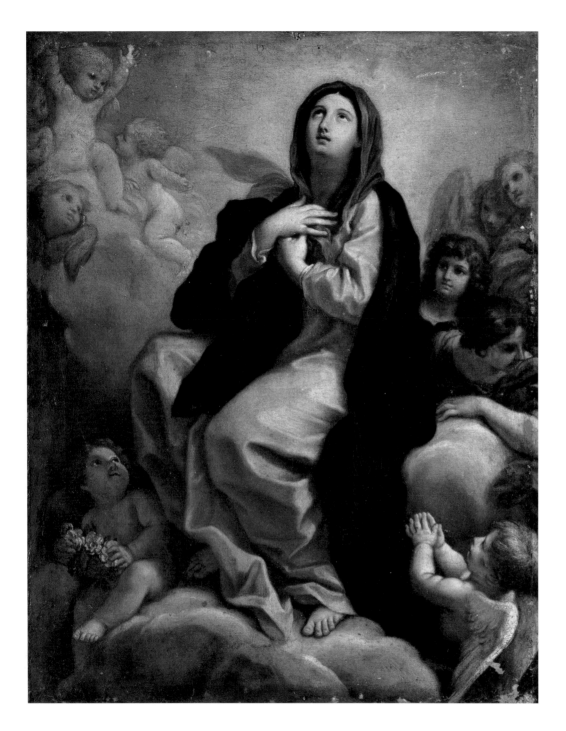

46

CARLO MARATTI (1625–1713)
The Assumption of the Virgin
Oil on canvas, 71 x 57
Inv. No. 1544
PROVENANCE: ?coll. Marchese Niccolò Maria Pallavicini, Rome; Sir Robert Walpole, 1736 Houghton (Green Velvet Drawing Room/Carlo Maratt Room); 1779 Hermitage.
LITERATURE: *Aedes* 1752, p. 59; 2002, no. 105; Hand 1827, p. 268; Nagler 1835-52, vol. 8, p. 290; Livret 1838, p. 50, no. 60; Wrangell 1913, p. 134, no. 756 (Giovanni Lanfranco, and with the Cat. 1797 number mistakenly given as 2452 in place of 2451); Vertue, vol. VI, 1948-50, p. 179; Rudolph 1995, p. 158.

The subject derives from Jacopo da Voragine, *The Golden Legend*, CXVII, I.

It was only during work on the present catalogue that this painting was uncovered in the Hermitage stores and identified as a work by Maratti from the Walpole collection. Although in a poor state of conservation (the paint surface is worn and has been retouched) the comparative dullness of the painting suggests that one of Maratti's pupils was involved in its execution. Its mediocre quality possibly accounts for the fact that its authorship was forgotten for so long in the Hermitage. Hand (1827) and Nagler (1835-52) mention it in passing amongst Maratti's works but thereafter this painting was neither exhibited nor included in museum catalogues.

It is difficult to determine whether this painting once belonged to Marchese Pallavicini, but the inventory of his collection made in 1714 (Rudolph 1995, App. II, no. 325) includes a Madonna 'con un coro d'Angeli', which might be this picture, although the description also states that the Virgin is shown 'con offizio in mano', not as seen in the Walpole canvas.

S. V.

47

CARLO MARATTI (1625-1713), copy after, or studio variant
The Adoration of the Magi
Oil on canvas, 210 x 134
Inv. No. 2657
PROVENANCE: Sir Robert Walpole, 1736 Houghton (Green Velvet Drawing Room, then Gallery); 1779 Hermitage; 19th and early 20th century in the Church of the Tauride Palace, St Petersburg; 1923 returned to the Hermitage; 1929 transferred to Gostorg for sale; unsold, 1931 returned to the Hermitage.
LITERATURE: *Aedes* 1752, p. 93 (as by 'Carlo Maratti'); 2002, no. 262; Gilpin 1809, p. 64; Chambers 1829, vol. I, p. 538; SbRIO 17, 1876, p. 398; HWC 2, pp. 168-69; Vertue, vol. VI, 1948-50, p. 179.

It was only during preparation of this catalogue that the provenance of this work from the Walpole collection was established. Vertue described the painting as 'Wise men offering to Christ'. In the *Aedes* it is described as an original work by Maratti, but in a letter to Cole of 12 July 1779, Horace Walpole describes it as a copy: 'Three, "The Magi offering" by Carlo Maratti, as it is called, and two Paule Veroneses are very indifferent copies, yet all are roundly valued, and the first ridiculously.'

In an appendix to a letter to Catherine II from Alexey Musin-Pushkin, listing works added to the Walpole sale 'without increasing the previous price' this picture is described as 'Adoration of the Magi, Carlo Murati, seems to be a copy, but a very good one' (SbRIO 17, 1876). William Gilpin, however, 'thought this the best of Maratt's I had ever seen. There is great simplicity in the whole and the figures are fine but it is a pity this master could paint nothing without a profusion of staring colours'.

In the *Aedes* Horace Walpole compares *The Adoration of the Magi* with Maratti's painting of the same title 'in the Church of the Venetian St. Mark at Rome', but although the composition is close it is not identical. It is possible that the work from the Walpole collection is a studio version.

The subject is from Matthew ii: 11.

S. V.

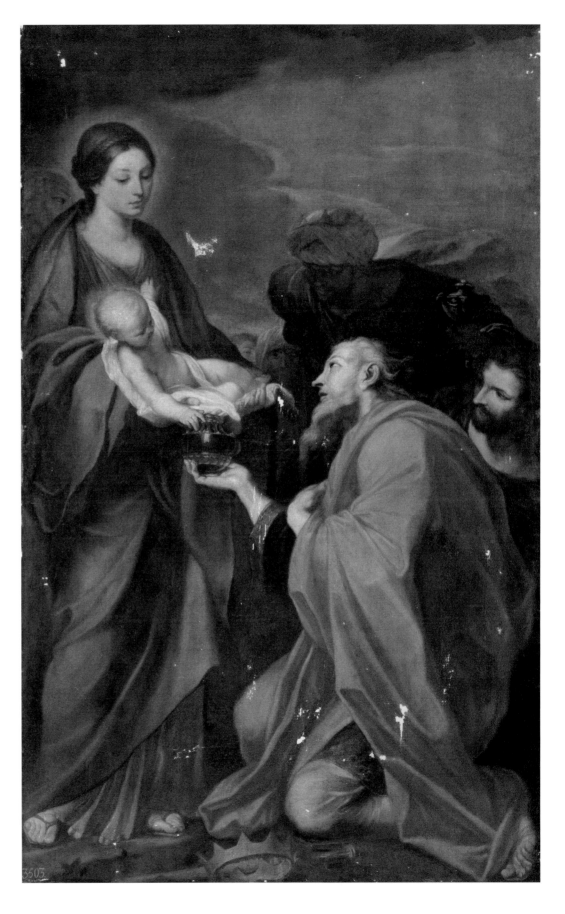

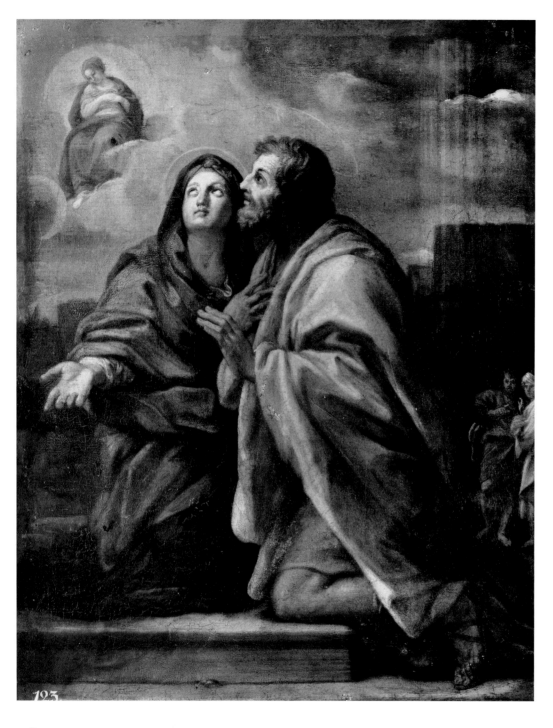

Boydell II, pl. LXII ('Two Saints Worshipping the Virgin in the Clouds'); Bellori 1672, p. 78; Nagler 1835-52, vol. 13, p. 203; Vertue, vol. VI, 1948-50, p. 179; Mezzetti 1955, p. 304 note 8; Rudolph 1995, pp. 48, 158, 195 note 107; App. II, p. 227, no. 321.

Pair to *St John the Evangelist* (Alupka, cat. no. 49). The source for the subject is Jacopo da Voragine, *The Golden Legend*, CXXIX, I.

In his biography of Carlo Maratti, Bellori (1672) tells us that in the 1680s Marchese Niccolò Maria Pallavicini commissioned from the artist versions of four pictures painted for the Cappella della Presentazione in St Peter's, Rome (*Jael and Sisera, Miriam's Dance, Judith with the Head of Holofernes*, and *Joshua*). The Marchese apparently wished to add these four paintings to two pictures he already owned of the Immaculate Conception. The first showed 'San Gioacchino, e Sant' Anna ginocchioni con le mani giunte in venerazione della Vergine, che lungi risplende sopra una nube', the second St John the Evangelist (see cat. no. 49). In the inventory of the Pallavicini collection, made in 1714 (Rudolph 1995, App. II, no. 321), the subject is also described as 'Sant' Anna con Gioacchino', but not long after this, in Vertue's Notebooks (vol. VI, 1948-50), it had become 'two figs praying'. In 1741 it was described as follows: 'In the Green Velvet Withdrawing Room, 19 pictures by Carlo Maratti ... Zachariah & Elizabeth worshipping' (Liverpool Papers 1741). In the *Aedes* it appears as 'Two saints worshipping the Virgin in the Clouds', while the manuscript inventories of the Hermitage describe it as 'Une apparition de la Vierge'. The correct title was only re-established when the painting returned to the Hermitage in 1931 (Inventory of the State Hermitage) after a short period with Antikvariat.

The Walpole provenance was only recovered in the late 1980s, for before this the painting had been neglected due to its poor condition. Bellori's evidence should be seen as guaranteeing the attribution to Maratti, although it seems quite likely that he employed his pupils in the execution of a number of works for Pallavicini and, in this instance, the participation of Pietro de Pietris can be suggested.

It should be noted that when engraved for Boydell, the letterpress said 'Riotte sculpsit', although the explanatory text gave the engraver's name as Victor Marie Picot.

S. V.

48

CARLO MARATTI (1625-1713)
The Vision of Joachim and Anna
Oil on canvas, transferred from old canvas, 72 x 57
In many places the paint layer is worn and there are numerous retouchings. In the right part there are columns, in Maratti's hand, coming through the upper layer of paint.
Inv. No. 8724

PROVENANCE: coll. Marchese Niccolò Maria Pallavicini, Rome; Sir Robert Walpole, 1736 Houghton (Green Velvet Drawing Room/Carlo Maratt Room); 1779 Hermitage; from the 19th century to 1919 in Pavlovsk Palace; presumably passed for sale to Antikvariat; unsold, 1931 returned to the Hermitage from Antikvariat.
LITERATURE: *Aedes* 1752, p. 59 (as 'Two Saints worshipping the Virgin in the Clouds'); 2002, no. 108;

49

CARLO MARATTI (1625-1713)
St John the Evangelist (St John's Vision on Patmos)
Oil on canvas, 72 x 57
Alupka State Palace and Park Museum Reserve, Alupka, Crimea, Inv. No. 527
PROVENANCE: coll. Marchese Niccolò Maria Pallavicini, Rome; Sir Robert Walpole, 1736 Houghton (Green Velvet Drawing Room/Carlo Maratt Room); 1779 Hermitage; in the mid-19th century hung in the Church of the Tauride Palace, St Petersburg; 1923 returned to the Hermitage; 1934 transferred to the Alupka State Palace and Park Museum Reserve, Alupka, Crimea; during the Second World War removed to Germany; 1945-70 Hermitage; 1970 returned to Alupka.
LITERATURE: *Aedes* 1752, p. 59; 2002, no. 109; Boydell II, pl. LXI; Bellori 1672, p. 78; Nagler 1835-52, vol. 8, p. 290; vol. 13, p. 209; Vertue, vol. VI, 1948-50, p. 179; Mezzetti 1955, p. 304, no. 8; Rudolph 1995, pp. 48, 158, 195, note 107; App. I, p. 211, no. 6; App. II, p. 227, no. 322.

Pair to *The Vision of Joachim and Anna* (cat. no. 48). The subject of *St John the Evangelist* derives from Revelation, xii: 1-2; Jacopo da Voragine, *The Golden Legend*, IX.

Vertue (vol. VI, 1948-50) records a 'Single figure' painting by Maratti immediately after 'two figs praying', *The Vision of Joachim and Anna* in the Walpole collection. The two works would seem to have hung together. In the *Aedes, The Vision of Joachim and Anna,* described as 'Two Saints worshipping the Virgin in the Clouds', is followed by 'St. John the Evangelist, its Companion'. Nowhere else are these paintings listed as a pair. While Munich listed them together in the 1773-85 catalogue (no. 2263) and praised this work as 'Tableaux d'un pinceau frais et de la plus belle expression', later Hermitage inventories split the paintings up.

Like its pair, *St John the Evangelist* was described by Bellori (1672): 'Vi è San Giovanni Evangelista con una mano sopra un libro appoggiato al seno; con l'altra sospende una penna, meditando il mistero della Concezione di Maria, che apparisce in lontananza'. Both pictures were painted for Marchese Pallavicini (see cat. no. 48) and Rudolph (1995, App. I, no. 6) identifies this work with the *St John the Evangelist* by Carlo Maratti lent by Marchese Pallavicini to an exhibition in 1691 organised by Giuseppe Ghezzi in San Salvatore in Lauro, Rome.

It should be noted that, as with cat. no. 48, when engraved for Boydell, the letterpress said 'Riotte sculpsit', although the explanatory text gave the engraver's name as Victor Marie Picot.

S. V.

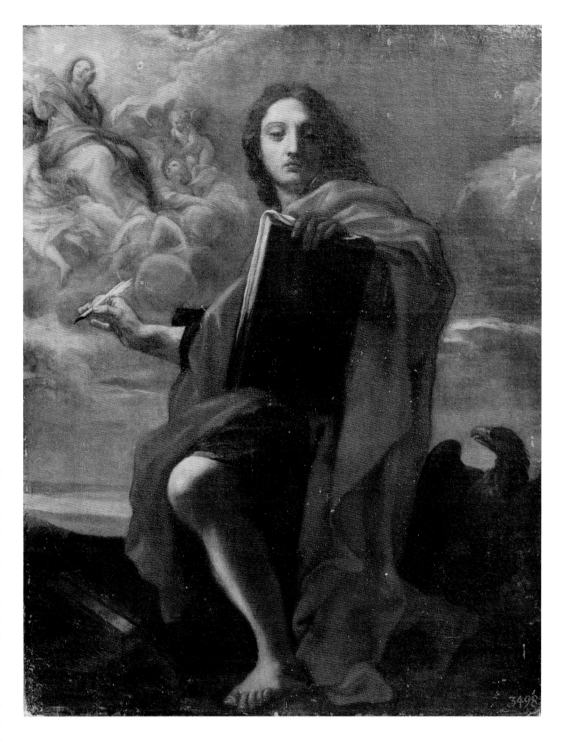

50

CARLO MARATTI (1625–1713)
Acis and Galatea
Oil on canvas, 182 x 232
Far Eastern Art Museum, Khabarovsk, Inv. No. 617
PROVENANCE: coll. Marchese Niccolò Maria Pallavicini, Rome; Sir Robert Walpole, 1736 Houghton (Green Velvet Drawing Room/Carlo Maratt Room); 1779 Hermitage; mid-19th century transferred to Gatchina Palace; 1927 Museum of the Academy of Arts, Leningrad; 1931 transferred to the Far Eastern Art Museum, Khabarovsk.
LITERATURE: *Aedes* 1752, p. 58 (as 'Galatea sitting with Acis, Tritons and Cupids'); 2002, no. 101; Georgi 1794, p. 455 (1996 edition, p. 347); Hand 1827, p. 269; Nagler 1835-52, vol. 8, p. 290; Livret 1838, p. 257, no. 41; Liphart 1916, p. 26, reproduced after p. 24; Vertue, vol. VI, 1948-50, p. 179; Mezzetti 1955, p. 237, no. 63; Bénézit 1976, vol. 7, p. 157; Starikova, Likhalo 1966, p. 18; Rudolph 1995, pp. 128-29, 158, 220, App. II, no. 166; Cornforth in Moore ed. 1996, p. 35; Moore ed. 1996, p. 124.

Pair to *The Judgment of Paris* (Tsarskoye Selo, cat. no. 51). The subject of *Acis and Galatea* comes from Ovid, *Metamorphoses*, XIII, 750-897.

Along with *The Judgment of Paris*, which is dated 1708, this work was executed late in the artist's life. Both paintings are mentioned together in the inventory of the property of Marchese Niccolò Maria Pallavicini at the Palazzo all'Orso, Rome, compiled in 1714 (Rudolph 1995, App. II, p. 220, nos. 165-66) and the 1773-85 catalogue also lists them as a pair. Not long after they were split up, the provenance of *Acis and Galatea* was lost. Liphart (1916) devoted only a few lines to a description of this painting in his article on the Italian pictures at Gatchina, failing to make the connection between it and either the *Judgment of Paris* or the Walpole collection.

It should be mentioned that the Walpole *Acis and Galatea* is sometimes confused with another slightly smaller painting (143 x 213) by Maratti of the same subject, purchased for the Hermitage in 1886 as part of the collection in the Golitsyn Museum and transferred in 1924 to the Pushkin Museum of Fine Arts in Moscow. The composition of the two paintings is different. With its pair, *The Judgment of Paris*, the painting was valued at £500 when sold to Catherine II.

S. V.

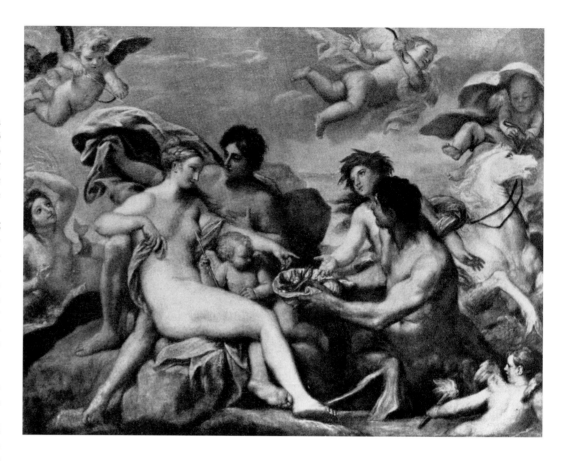

51

CARLO MARATTI (1625–1713)
The Judgment of Paris
Oil on canvas, 176 x 231, signed and dated bottom right: *Eqv: Carolus Maratti pingebat Anno MDCCVIII: AEtatis autem Sue LXXXIII*
Tsarskoye Selo State Museum Reserve, Inv. No. 820-X
PROVENANCE: coll. Marchese Niccolò Maria Pallavicini, Rome; Sir Robert Walpole, 1736 Houghton (Green Velvet Drawing Room/Carlo Maratt Room); 1779 Hermitage; 1960 transferred to the Catherine Palace, Tsarskoye Selo (Pushkin).
LITERATURE: *Aedes* 1752, p. 57; 2002, no. 100; Georgi 1794, p. 455 (1996 edition, p. 347); Hand 1827, p. 269; Nagler 1835-52, vol. 4, p. 494 (Frezza); vol. 8, p. 290, 292, no. 30; Livret 1838, p. 253, no. 19 (provenance given as Pallavicini collection, not Walpole); Vertue, vol. VI, 1948-50, p. 179; Mezzetti 1955, p. 327, no. 63; Rudolph 1995, pp.128, 158, 187, 204 note 295, 296, App. II, no. 165; Cornforth in Moore ed. 1996, p. 35; Moore ed. 1996, p. 124; Brownell 2001, p. 41.

Pair to *Acis and Galatea* (cat. no. 50). The subject of *The Judgment of Paris* comes from Homer, *The Iliad*, XXIV, 25-30; Lucian: *Dialogues of the Gods*, 20.

It is known that this picture hung briefly in the nineteenth century the Tauride Palace, St Petersburg. After its return to the Hermitage it was placed in

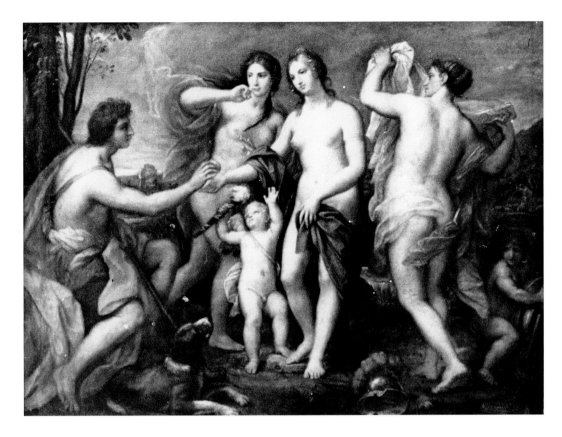

the 'Madonna Benois', now in the Hermitage). It is also tempting to associate this picture with the reference in the 1714 inventory of Pallavicini's collection (Rudolph 1995, App. II, no. 416) to an unattributed *Judgment of Paris* of appropriate dimensions ('da testa per traverso').

The Houghton *Judgment of Paris* is mentioned in the list of works appended to a letter from Alexey Musin-Pushkin, Russian ambassador in London, to the Empress Catherine, added to the Walpole sale 'without increasing the previous price' (SbRIO 17, 1876, p. 400). In fact, this work and its companion were valued at £500 (Christie's Sale List, 'Galatea and its Companion').

Brownell (2001) provides further information about the provenance of this work, citing marginalia by Jonathan Richardson Jr. in Richardson's annotated *Works* of 1728: 'Sir Robert's son, Edward [probably Robert, in Italy 1722-23] Walpole, brought back from his Grand Tour in 1722 Maratti's Judgement of Paris for his father's collection.' It is puzzling, however, that no mention is made here of the painting's pair, *Acis and Galatea*.

S. V.

store because of its poor state of preservation and it was therefore not included in the museum's catalogues. During the Second World War the greater part of the Hermitage collections were evacuated to Sverdlovsk (Yekaterinburg), but when they returned the painting remained stored on a roll and was thereby inaccessible to scholars. By this time, its authorship and provenance were already long forgotten. After the painting was transferred to the Catherine Palace in 1960 it was in conservation for many years but was eventually mounted into the ceiling of the staircase. Only then did the present author identify the painting, on the basis of its similarity to the engraving by Giovanni Girolamo Frezza, which bears a dedication to Marchese Niccolò Maria Pallavicini. When the canvas underwent further restoration in the 1980s it proved possible to read the inscription which provided the artist's age and the date the work was executed.

Since Nagler (1835-52, vol. 8) had noted that *The Judgment of Paris* and its pair, *Acis and Galatea*, 'finden sich nicht in St.Petersburg', it had been assumed that both works were lost, although the first of these works was mentioned in the catalogues of 1889-1909 and 1912, in relation to a small, slightly altered copy (Inv. No. 312; 24.5 x 35) which Waagen (1864) very tentatively attributed to Marcantonio Franceschini.

The Hermitage catalogues indicate that this also was once in the Pallavicini collection.

The Judgment of Paris and its pair are of particular interest as late works, dated by the artist himself. With the date 1708 established we can conclude, in the face of traditional opinion, that despite serious illness the artist remained fit enough to work during these later years of his life. Maratti may well have been assisted by pupils in the execution of these large canvases but the signature and extensive inscription are significant.

Maratti's pictorial source for the composition was an engraving by Marcantonio Raimondi after Raphael. According to Voss (1924, p. 658) Maratti's own *Judgment of Paris* in turn served as a model for the composition of the same subject by Mengs (Roettgen 1999, pp. 167-68, cat. 109). The work seems to have been popular judging from the number of copies and variants of the composition. In the *Aedes* Horace Walpole refers to a copy by Giuseppe Chiari, then in the collection of the Earl of Strafford. Rudolph (1995, fig. 96) has also published a copy produced in the artist's studio. In addition to the small copy in the Hermitage already mentioned, attributed to Franceschini, there is also another somewhat larger version of the composition in St Petersburg which formerly belonged to Mme Benois (famous as the previous owner of Leonardo da Vinci's *Madonna with a Flower*,

52

CARLO MARATTI (1625-1713)
The Mystic Marriage of St Catherine
Oil on canvas, c.69 x 55.6
PROVENANCE: coll. Marchese Niccolò Maria Pallavicini, Rome; Sir Robert Walpole, 1736 Houghton (Green Velvet Drawing Room/Carlo Maratt Room); 1779 Hermitage; in the early 19th century transferred to the Church of the Marble Palace, St Petersburg; whereabouts unknown.
LITERATURE: *Aedes* 1752, p. 59; 2002, no. 107; Bellori 1672, p. 79; Nagler 1835-52, vol. 8, p. 290; Rudolph 1995, p. 158.

When it entered the Hermitage, this painting was listed in the 1773-85 catalogue as no. 2267 (dimensions 15½ *vershki* x 12½ *vershki* or c.69 x 55.6) but thereafter there is no trace of it. It is not listed in the 1797 catalogue nor in the 1859 inventory, but no. 154 in the 1820 manuscript inventory of the Marble Palace in St Petersburg (RGIA, Fund 539, *Opis* 1, *ye. khr.* 240) records a painting by an unknown artist of *The Marriage of St Catherine*, its dimensions commensurate with this picture from the Walpole collection. Similarly, the description is in keeping with that given on page 1 of the manuscript catalogue of Walpole's pictures compiled in 1736 (Walpole MS 1736): 'The Marriage of Christ and St. Catherine; He sits on the

Virgin's lap and puts the Ring on St. Cath.ˢ finger. She is kneeling'. The inventory of the Marble Palace also records that the painting had the number 2267 in black, according with the number given to the Walpole painting when accessioned in the 1773–85 catalogue. A copy of the inventory of the Marble Palace now at Pavlovsk also contains a note suggesting Carlo Maratti as the possible author of this work (thanks to N. I. Stadnichuk for this information). According to information provided by V. M. Belkovskaya of the Marble Palace, *The Mystic Marriage of St Catherine* hung in the Church there in 1830. It is possible that it was among a number of works moved from there in 1832 to a regimental church at Strelna, near St Petersburg.

It is probably correct to identify the Walpole painting with that described by Bellori (1672) in his biography of Carlo Maratti: 'Per lo medesimo Signor Marchese [Pallavicini], Santa Caterina dalla Ruota inginocchiata avanti al Bambino, il quale stando in seno della Madre, porge l'anello alla Santa Sposa, con San Giuseppe in lontananza'. In the 1714 inventory of the Pallavicini collection (Rudolph 1995, App. II) no. 326 is listed, as with so many of the pictures in this document, without naming the artist, as 'la madonna SSᵐᵃ [---] col Bambino in braccio, che dà l'anello a Santa Caterina'. In the opinion of the present author this might be identified with the Walpole picture since the works listed directly above it are clearly by Maratti. For instance Nos. 321 and 322 accord with cat. nos. 48 and 49), and the context and similar dimensions (given as 2' 7" x 1' 10") suggest that the Pallavicini and Walpole pictures are one and the same.

The subject of the painting is from Jacopo da Voragine, *The Golden Legend*, CLXIX, 2.

S. V.

Not reproduced

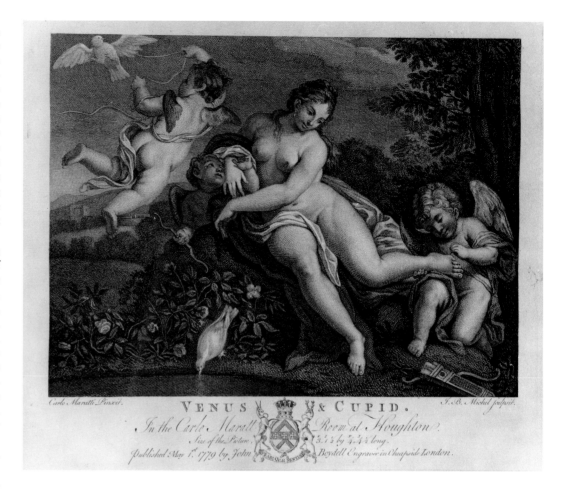

53

Carlo Maratti (1625–1713)
Venus and Cupid
Oil on canvas, 96 x 134
PROVENANCE: coll. Marchese Niccolò Maria Pallavicini, Rome; Sir Robert Walpole, 1736 Houghton (Green Velvet Drawing Room/Carlo Maratt Room); 1779 Hermitage; whereabouts unknown.
LITERATURE: *Aedes* 1752, p. 59 (as 'A naked Venus and Cupid'); 2002, no. 110; Boydell II, pl. VIII; Hand 1827, p. 269; Nagler 1835–52, vol. 8, p. 290; Livret 1838, p. 54, no. 79; Rudolph 1995, pp. 158, 207 note 380; Cornforth in Moore ed. 1996, p. 35.

It is difficult to understand what Horace Walpole meant when he described this work in the *Aedes* as being 'in a very particular style', and we cannot be sure if this referred to the style of painting or to some other characteristic of the artist.

To judge from the engraving, the composition was very close to a picture Maratti executed for Ferrante Capponi in 1679. From a detailed description by Bellori (1672, p. 80) it would appear that despite differing in some details both works shared a common concept.

We know where the *Venus and Cupid* was until the mid-nineteenth century. It was seen by Hand (1827) during his visit to the Hermitage, and mentioned by Nagler (1835–52), but there is no painting of this subject mentioned amongst the works by Maratti in the 1859 inventory. It is possible that the attribution was changed, making it difficult to identify the work. Rudolph (1995) has suggested that the painting came from the Pallavicini collection.

The source of the subject of the painting is Pausanias, VI, 24, 7. It is now known only from the Boydell print, engraved by J. B. Michel, published 1 May 1779.

S. V.

54

MICHELANGELO BUONAROTTI, 16th-century copy after
The Rape of Ganymede
Oil on canvas, transferred from panel, 88.9 x 58.5
Inv. No. 2064
PROVENANCE: Sir Robert Walpole, 1736 Houghton
(Common Parlour, then Gallery); 1779 Hermitage.
LITERATURE: *Aedes* 1752, p. 95 (as 'The Eagle and
Ganymede, by Michael Angelo Buonarotti)'; 2002,
no. 274; Georgi 1794, p. 457 (1996 edition, p. 348);
Schnitzler 1828, p. 60; Livret 1838, p. 461; Brownell
2001, p. 53.

There are many painted compositions deriving from
drawings by Michelangelo, among them a drawing in
the Royal Collection at Windsor of *The Rape of
Ganymede*. This was in turn a copy of a lost original by
Michelangelo (L. Dussler, *Die Zeichnungen des Michelan-
gelo. Kritischer Katalog*, Berlin, 1959, no. 722).

Michelangelo's composition, its source Ovid's
Metamorphoses, X, 155-162, had consisted of only two
figures, but here the unidentified painter has added a
landscape background and a dog in the foreground
watching the eagle carry away his master.

In his description of the Hermitage Picture Gallery
in 1794, Georgi wrote of this work: 'Michelangelo
Buonarotti. Rape of Ganymede. Marvellous picture,
having lost, however, some of its beauty through a
renewal of the colours.'

By the time it was listed in the 1797 catalogue it
was described as a copy. Both Schnitzler (1828) and
Livret 1838, however, restored Michelangelo's name
as the author.

Horace Walpole listed three versions of the picture
in the *Aedes*: one larger version belonging to the Eng-
lish royal collection, another in the Palazzo Altieri in
Rome, and a third belonging to the Queen of Hun-
gary. Of the latter, he noted that it was 'printed in
Teniers's Gallery', and Teniers's *Theatrum pictorum* (pl.
11) does indeed include an engraving by Peter Boel
from a composition similar to that in the Hermitage.
The painter's name on the engraving is given as
Michelangelo. The work is not mentioned in any
Hermitage catalogues after 1797.

T. K.

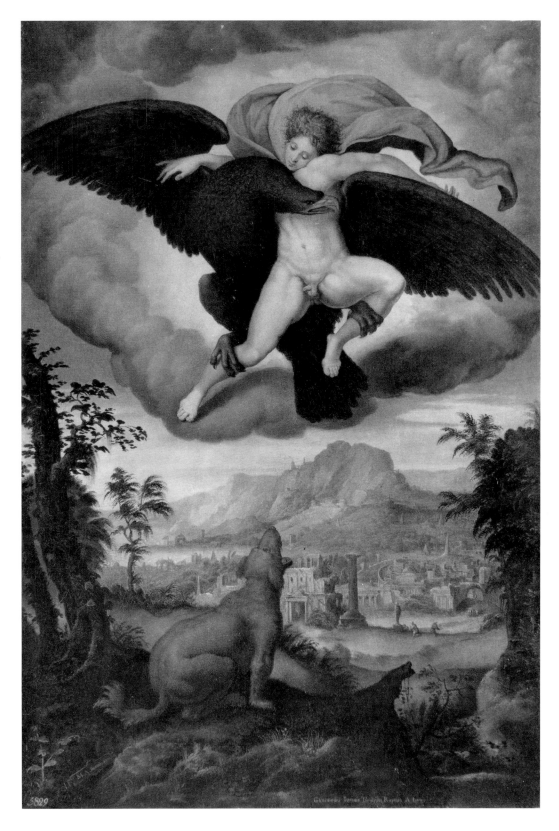

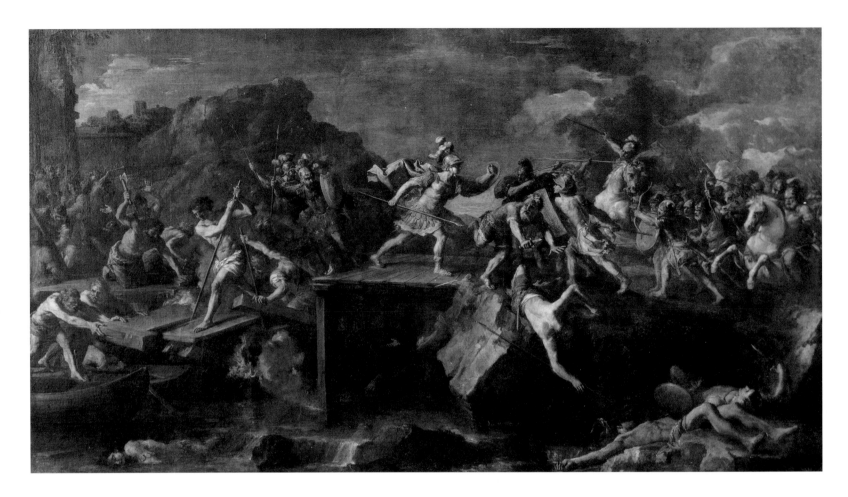

55

PIER FRANCESCO MOLA (1612-66)
Horatio Cocles Holding the Sublicius Bridge
Oil on canvas, 198 x 348
Research Museum of the Academy of Arts, St Petersburg, Inv. No. 63

PROVENANCE: coll. Grinling Gibbons, London; November 1722 acquired by Sir Robert Walpole at sale of the Gibbons coll.; Sir Robert Walpole, 1736 Downing St (Great Room above Stairs), later Houghton (Gallery); 1779 Hermitage; during the second half of the 19th and early 20th century moved to Tauride Palace and then Gatchina Palace; 1927 transferred to the Museum of the Academy of Arts, St Petersburg.

LITERATURE: *Aedes* 1752, pp. 82-84 (as 'Horatio Cocles defending the Bridge'); 2002, no. 235; Chambers 1829, vol. I, p. 535; Thieme-Becker 1907-50, vol. 25, p. 28; Wrangell 1913, p. 145, no. 915; Liphart 1916, pp. 19-20; Vertue, vol. V, 1937-38, p. 125; Vertue, vol. VI, 1948-50, p. 177; Moore ed. 1996, p. 99; Tselishcheva, in 1997 St Petersburg, p. 57.

EXHIBITIONS: 1993 St Petersburg, no. 118; 1996 St Petersburg, no. 14.

Pair to *Marcus Curtius Leaping into the Gulf* (Academy of Arts, cat. no. 56).

Vertue (vol. V, 1937-38; vol. VI, 1948-50) mentions the painting in 1739: 'at Sr.R.Walpoles – Dineing Room above stairs ... an other large picture [its pair *Marcus Curtius*] Horatius Chocles defending the Bridge, a multitude of figures – finely painted by Francisco Mola'. The attribution is traditional and there are few comparable works in Mola's established oeuvre. Liphart (1916) considered both this and *Marcus Curtius* to be early works by the artist whilst Voss (Thieme-Becker 1907-50) does not comment on them other than by reference to Liphart's essay. Unfortunately these large and interesting pictures were not known to Richard Cocke when he published his monograph on the artist (*Pier Francesco Mola*, Oxford, 1972).

We should note that, prior to Mola, the same subjects from Roman history were used (in 1613-15 or 1622-23) by Bernardo Strozzi in his frescoes in the vaults of the *salotti* of the Villa Centurione-Carpeneto in Genoa-Sampierdarena. The story of Horatio Cocles (from Livy, *History of Rome*, II, 10; Plutarch, *Lives*, VI, 16) is related by Valerius Maximus (*Facta et dicta memorabilia*, Venice, 1471, III, 2.1) in the paragraph entitled 'De Fortitudine Romana', while the heroic feat of Marcus Curtius appears under 'De Pietate Romanorum erga Patriam'.

S. V.

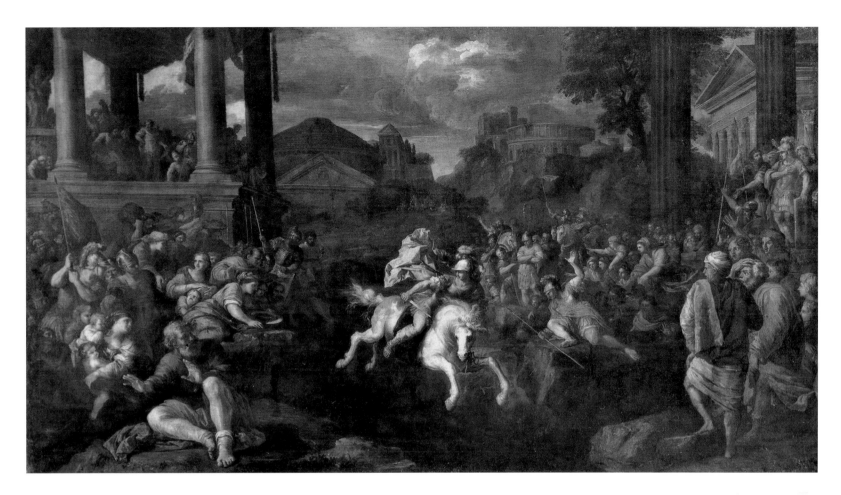

56

PIER FRANCESCO MOLA (1612-66)
Marcus Curtius Leaping into the Gulf
Oil on canvas, 196 x 350
Research Museum of the Academy of Arts, St Petersburg, Inv. No. 62.
PROVENANCE: coll. Grinling Gibbons, London; November 1722 acquired by Sir Robert Walpole at sale of the Gibbons coll.; Sir Robert Walpole, 1736 Downing St (Great Room above Stairs), later Houghton (Gallery); 1779 Hermitage; during the second half of the 19th and early 20th century moved to Tauride Palace and then Gatchina Palace; 1927 transferred to the Museum of the Academy of Arts, St Petersburg.
LITERATURE: *Aedes* 1752, pp. 82-84; 2002, no. 234; Chambers 1829, vol. I, p. 535; Thieme-Becker 1907-50, vol. 25, p. 28; Wrangell 1913, p. 145, no. 916; Liphart 1916, pp. 19-20; Vertue, vol. V, 1937-8, p. 125; Vertue, vol. VI, 1948-50, p. 176; Pigler 1974, vol. 2, p. 395; Moore ed. 1996, p. 99; Tselishcheva, in 1997 St Petersburg, p. 61.
EXHIBITION: 1997 St Petersburg, no. 86.

Pair to *Horatio Cocles Holding the Sublicius Bridge* (Academy of Arts, cat. no. 55).

Vertue (vol. V, 1937-38; vol. VI, 1948-50) described the picture as follows: 'at Sr.R.Walpoles – Dineing Room above stairs a large picture of many figures Curtius on Horsback leaping into the Gulph painted by Francisco Mola'. In the *Aedes* Horace Walpole described the subject in detail, giving the source correctly as Titus Livius (*History of Rome,* VII, 6; also Valerius Maximus, *Facta et dita memorabilia*, Venice, 1471, V, 6, 2). For some inexplicable reason, however, Voss (Thieme-Becker 1907-50) identified the subject as 'Opfertod des Decius Mus', which was repeated by Pigler (1974) with a reference to Voss.

S. V.

57

?ALESSANDRO BONVICINO, called IL MORETTO DA BRESCIA (c.1498-1554)

A Boy with his Nurse

Oil on canvas, 150 x 105, inscription on the back: *La vecchia serva ritratta dal famoso Titiano con il di lui figlio*

Inv. No. 182

PROVENANCE: coll. Marchese de Maria, Genoa; Sir Robert Walpole, 1736 Grosvenor St (Bedchamber, as by 'Titian'), later Houghton (Salon); 1779 Hermitage; in the 19th century at Gatchina Palace; probably during the 19th century returned to the Hermitage.

LITERATURE: *Aedes* 1752, p. 56 (as 'An old Woman giving a Boy Cherries, by Titian'); 2002, no. 90; Boydell I, pl. LVIII (as 'Titian's Son & Nurse, Titian'); ; Livret 1838, p. 286; Cats. 1863-1916, no. 1636 (1889-1909 school of Titian; 1912-16 Jacopo Bassano); Harck 1896, p. 426; Fiocco 1956, pp. 104-6; Cat. 1958, vol. I, p. 132; Kuhnel-Kunze 1962, 20, p. 93; Freedberg 1975, p. 550; Cat. 1976, p. 111; Fomiciova 1992, no. 162; Kusche 1992, p. 8; Kusche 1995, p. 52, Cat. 21.

EXHIBITIONS: 1938 Leningrad, no. 12 (Jacopo Bassano); 1995 Vienna, no. 21 (Sofonisba Anguissola); 2001 Bassano–Barcelona, no. 19.

In the *Aedes Walpolianae* Horace Walpole described this painting as 'by Titian. It is his own Son and Nurse' and he stated that both it and the work which follows it in the *Aedes* — *The Holy Family* by Andrea del Sarto (cat. no. 80) — 'were from the Collection of the Marquis Mari at Genoa'. The attribution was accepted in the Hermitage catalogues for over a century until, in the late nineteenth century, Somov (Cats. 1898-1909) demoted it — still somewhat over-optimistically — to 'school of Titian'. The painting's style and sober realism, however, suggested that it was probably not painted in Venice itself but on the mainland. Liphart (Cat. 1912) attributed it to Jacopo Bassano, following an earlier suggestion made in 1896 by Harck and at about the same date Frizzoni (orally) suggested that it might be by Moretto da Brescia.

Fiocco's article about the Hermitage painting, published in 1956 ('Un capolavoro di Pietro Mariscalchi') suggested that at last the painting 'troverà quiete dopo tanti incerti, seppure giovevoli battesimi' (p. 106). Fiocco considered it an outstanding example of a sixteenth-century group portrait that had quite reasonably always been linked with the names of the two important Venetian masters:

Ambiguità ragionevoli in un tempo in cui di Pietro de' Mariscalchi non si aveva sentore; utile in ogni modo per far comprendere che all'opera era stata sempre attribuito notevole pregio, tanto da farla oscillare fra i due grandi poli, di Tiziano e di Jacopo Bassano. Si sarebbe anche potuto rievocare Paolo Veronese, famoso per cotesti gruppi famigliari; ma come ingredienti di una espressione che aveva ben altre caratteristiche, come si è visto.

L'accento affettuoso del gruppo è, a ben guardare, di una umanità più cordiale, più alla mano di quello astratto e staccato caro a quei grandi. Forse Jacopo Bassano avrebbe fatto eccezione, se uso a dipingere gruppi di tal formato e di tale grandiosità. Particolare che da solo basterebbe a vietarci di fare il suo nome.

Da Tiziano mancano il cipiglio eroico e la pennellata calda e gioiosa. Facile è quindi a noi… ripiegare sul Mariscalchi, anche se un opera di questa fatta sia del pari eccezionale per lui.

Fiocco's attribution of the picture to Pietro Mariscalchi was thereafter accepted in subsequent Hermitage catalogues (Cat. 1958, Cat. 1976) and was supported by Fomiciova (1992), but not all scholars were convinced. In 1962, Kuhnel-Kunze suggested the name of the Cremona painter Sofonisba Anguisciola (or Anguissola) on the basis of a similarity between the nurse's costume and that of the serving woman in a group portrait of Anguisciola's sisters (National Museum, Poznan). This is not entirely convincing since similarities of this kind can be found in numerous other works. Anguisciola remained a possible candidate for authorship and M. Kusche (1992) included the painting in the exhibition devoted to Sofonisba Anguisciola (1995 Vienna). In this catalogue Kusche suggests that the portrait was painted c.1559 and that it may depict the son of the Duke de Sessa, the Spanish Governor of Milan, in whose house Anguisciola stayed before her departure for Spain.

The present author, however, accepts neither the attribution to Anguisciola nor Pietro Mariscalchi and suggests that the authorship of this painting must continue to remain uncertain. An exhibition of Mariscalchi's work at Feltre in 1994 (*Pietro de Marescalchi. Restauri, studi e proposte per il Cinquecento feltrino,* curated by Giuliana Ericani, Museo Civico, Feltre, Treviso, 1994) makes no mention of this painting. It seems likely that the author of the Hermitage picture was strongly influenced by painters of the Veneto region but probably worked in Bergamo or Brescia

Gustavo Frizzoni's idea that it was painted by Alessandro Bonvicino, called il Moretto, remains the most sustainable hypothesis. A number of formal features, including the use of similar architectural elements, can be found in Moretto's monumental compositions such as the *Adoration of the Shepherds* (Pinacoteca Civica Tosio e Martinengo, Brescia) and *Portrait of a Gentleman* (National Gallery, London), and these features were the origin of Frizzoni's hypothesis. Also characteristic is the placing of the figures in the manner often to be found in Moretto's work. The dynamic realism of the figure of the nurse, who must have been painted from life, may be the key element in supporting the attribution to Alessandro Bonvicino, whose late works have similar characteristics.

I. A.

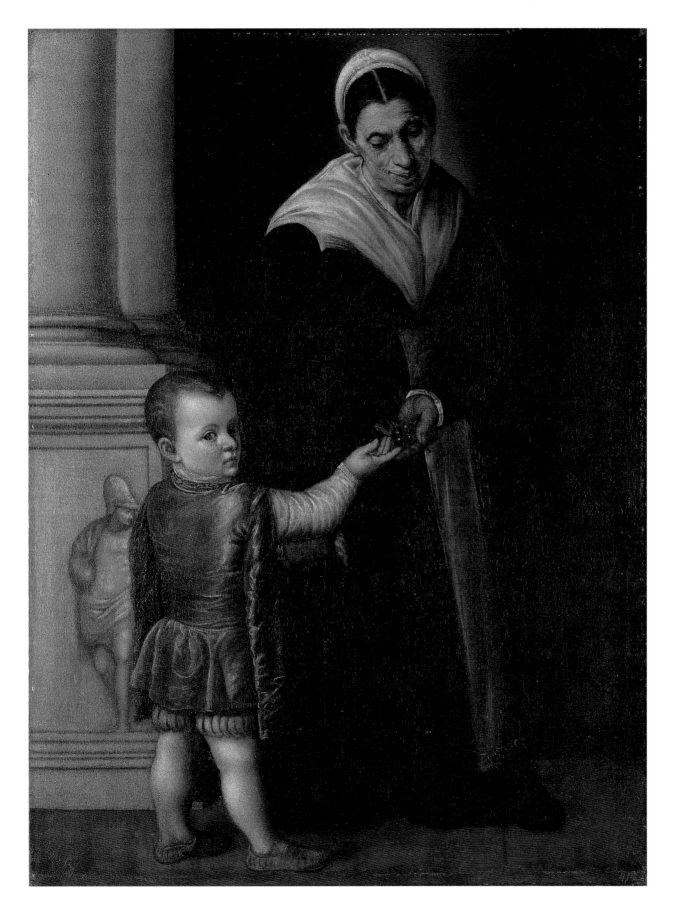

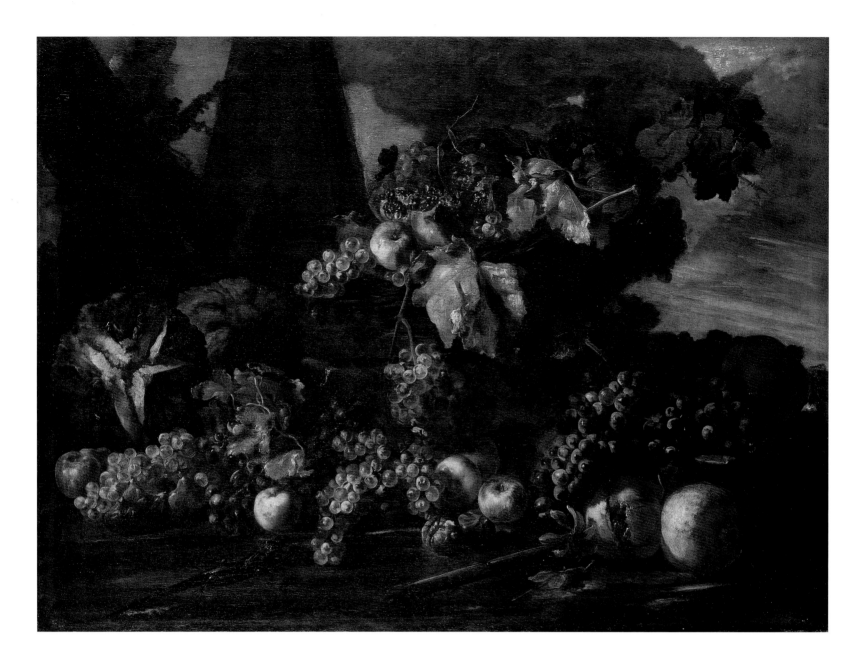

58

MICHELANGELO DEL CAMPIDOGLIO (MICHELE PACE)
(c.1610–70)
Still Life with Grapes
Oil on canvas, 98 x 134
Inv. No. 2486
PROVENANCE: coll. Scawen; Sir Robert Walpole,
1736 Downing St (Great Room above Stairs), later
Houghton (Marble Parlour); 1779 Hermitage; from
the mid-19th century Gatchina Palace; 1926 returned
to the Hermitage.
LITERATURE: *Aedes* 1752, p. 73 (as 'Two Fruit-pieces
over the Door'); 2002, no. 193; Boydell I, pl. XLI;
Gilpin 1809, p. 54; Nagler 1835–52, vol. 4, p. 54 (Ear-

lom); Liphart 1916, pp. 37, 41; Cat. 1958, vol. I, p.
99; Delogu 1962, pp. 113, 189; Natura morta italiana
1964, p. 68; Kuznetsov 1966, pp. 200-1; Faldi 1966,
p. 146; Cat. 1976, p. 95; Vsevolozhskaya 1981, no. 12;
Salerno 1984, pp. 178, 181; Hermitage 1989, no. 39;
Natura morta 1989, vol. 2, pp. 775, 776, pl. 910.
EXHIBITIONS: 1990 Milan, no. 30; 1997 Bonn, no. 23.

Pair to *Still Life with Melon* (cat. no. 59).

Since this pair was for many years at Gatchina, and
neither picture was thus included in Hermitage cata-
logues prior to 1958, these two works were for long
unknown outside Russia. As a result most references in

the literature on Campidoglio's still-life paintings mis-
takenly suggest that the present whereabouts of these
two works from the Walpole collection is unknown.

A variant of this composition, differing in some
details (particularly in the background) was published
in 1989 (Natura morta 1989, vol. 2, pl. 911) and was
attributed to Campidoglio or Abraham Brueghel. The
basket of fruit in the Hermitage work can also be found
in a painting in the Leicester Museum and Art Gallery
and in other works by Campidoglio. Ludovica Trez-
zani (Natura morta 1989) suggests a date of execution
for the Hermitage painting of c.1650 or later.

Both still life paintings by Campidoglio are men-

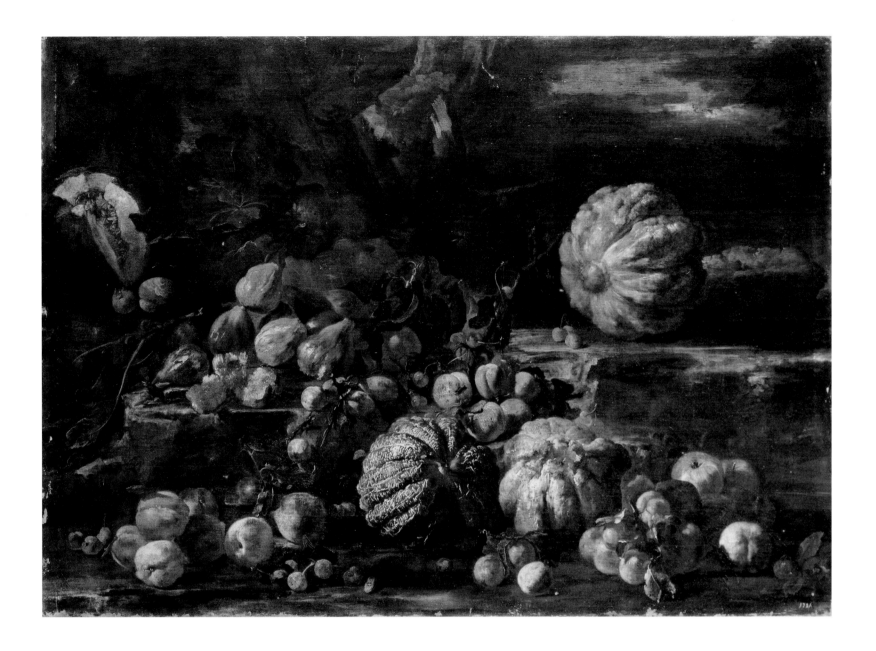

tioned in the list of works appended to a letter from Alexey Musin-Pushkin, Russian ambassador in London, to the Empress Catherine, added to those negotiated as part of the Walpole sale 'without increasing the previous price' (SbRIO 17, 1876, p. 400).

S. V.

59

MICHELANGELO DEL CAMPIDOGLIO (MICHELE PACE)
(c.1610-70)
Still Life with Melon
Oil on canvas, 98 x 134
Inv. No. 2485
PROVENANCE: see cat. no. 58.
LITERATURE: *Aedes* 1752, p. 73 (as 'Two Fruit-pieces over the Door'); 2002, no. 194; Boydell II, pl. XLV; Gilpin 1809, p. 54; Liphart 1916, pp. 37, 41; Cat. 1958, vol. I, p. 99; Kuznetsov 1966, pp. 200-1; Cat. 1976, p. 95; Vsevolozhskaya 1981, p. 287; Hermitage 1989, p. 338; Natura morta 1989, vol. 2, p. 775.

Pair to *Still Life with Grapes* (cat. no. 58)

A version of this painting was published by Ludovica Trezzani in Natura morta 1989 (vol. 2, pl. 916). For further details see cat. no. 58.

S. V.

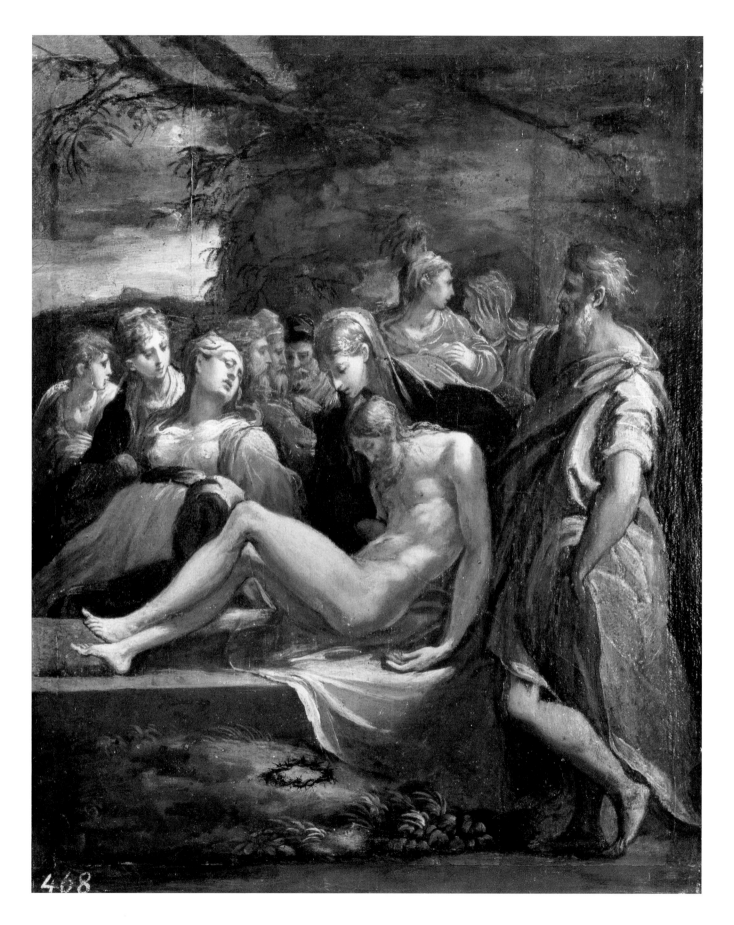

60

PARMIGIANINO (FRANCESCO MAZZOLA) (1503-40),
copy after
The Entombment
Oil on canvas, transferred from panel in 1815, 32 x
26.5, additions to the canvas on all four sides
Inv. No. 139
PROVENANCE: Sir Robert Walpole, 1736 Downing St
(Sir Robert's Dressing Room), Houghton (Cabinet)
by 1739 (Vertue); 1779 Hermitage.
LITERATURE: *Aedes* 1752, p. 66 (as 'Christ laid in the
Sepulchre ... Parmegiano'); 2002, no. 147; Boydell II,
pl. LIV; Labensky 1805-9, vol. 2, bk. 6, pp. 63-72;
Gilpin 1809, p. 51; Hand 1827, p. 144-46; Schnitzler
1828, pp. 46, 125; Chambers 1829, vol. I, p. 529;
Livret 1838, p. 42, no. 27; Cats. 1863-1916, no. 86;
Waagen 1864, p. 58; Penther 1883, p. 29; Bode 1882,
Part 10, p. 10; Benois [1910], p. 74; Frölich-Bum
1915, pp. 4-7; Frölich-Bum 1921, pp. 43-44, 72;
Copertini 1932, vol. 2, p. 104; Freedberg 1950, pp.
219-20; Cat. 1958, vol. I, p. 149; Italian Painting
1964, no. 95; Cat. 1976, p. 121; Rossi 1980, p. 108;
Vsevolozhskaya 1981, no. 91; Kustodieva 1994, no.
178.

Horace Walpole in the *Aedes* describes this picture as
'one of the finest Pictures that Parmegiano ever paint-
ed, and for which there is a Tradition, that he was
knighted by a Duke of Parma ... The Figure of
Joseph of Arimathea is Parmegiano's own Portrait.' It
is not insignificant that *The Entombment* was valued
fifty percent higher than the *Female Nude*, then attrib-
uted to Leonardo da Vinci (cat. no. 39).

This picture has always been accepted as an authen-
tic work by Parmigianino in all Hermitage documen-
tation up until 1976. It is certainly typical of the
artist's work in terms of composition and figures with
their exaggerated elongated proportions. However,
justifiable doubts regarding the attribution began to
be expressed early in the twentieth century. Frölich-
Bum (1915) initially accepted it as by Parmigianino
but in 1921 modified his views and suggested that it
was a copy from the artist's etching of the same sub-
ject. Copertini (1932) attributed the Hermitage paint-
ing to Schiavone, while Freedberg (1950) also
thought it a version (not autograph) painted from
Parmigianino's etching. Rossi (1980) also suggests a
relationship with works attributed to Parmigianino.

Two etchings by Parmigianino showing *The
Entombment*, as well as a number of preparatory draw-
ings for them, are known (see A. E. Popham, *Cata-
logue of the Drawings of Parmigianino*, 3 vols, New
Haven and London, 1971, vol. I, pp. 94-95). Bartsch
(XVIII, p. 300, no. 46) considered the etching corre-
sponding to the Walpole picture as a copy by Guido
Reni after Parmigianino, although Oberhuber con-

sidered it an autograph Parmigianino (K. Oberhuber,
'Parmigianino als Radierer', *Alte und Moderne Kunst*,
1963, vol. 8, p. 36).

It would seem however that the Walpole picture is
not the work of Parmigianino himself since it cer-
tainly differs in style from his accepted works. Coper-
tini's attribution to Schiavone may have some foun-
dation. The latter made frequent copies of Parmigian-
ino's *Entombment* as wood engravings (Bartsch XVI,
p. 8, no. 5) and there is a drawing by him of the same
subject in the Uffizi, Florence.

Another painted version of this work, in its time
attributed to Parmigianino himself (Musée des
Beaux-Arts, Dijon; 34.5 x 28.5) is now no longer
given to him. It derives from Parmigianino's second
engraving on the subject (Bartsch XVI, p. 8, no. 5). It
should be pointed out that the majority of engravings
usually linked with the Walpole version were in fact
not taken from this painting.

T. K.

61

PIETRO DE' PIETRIS (PIETRO ANTONIO DE PIETRI)
(1663-1716), copy after Guido Reni
The Rape of Europa
Oil on canvas, c.148 x 190
PROVENANCE: Sir Robert Walpole, 1736 Houghton
(Coffee Room); 1779 Hermitage; from the mid-19th
century in the Tauride Palace, St Petersburg; then
Catherine Palace, Tsarskoye Selo (Pushkin); disappeared
during the Second World War; whereabouts unknown.
LITERATURE: *Aedes* 1752, p. 43 (as 'Jupiter and
Europa'); 2002, no. 24; Hand 1827, p. 390;
Vilchkovsky 1911, p. 116; Wrangell 1913, p. 157, no.
1094; Lukomsky 1918, p. 78; Golerbakh 1922, p. 36;
Yakovlev 1926, p. 64; Vertue, vol. VI, 1948-50, p.
177; Catherine Palace 1940, p. 29; Lemus et al 1980,
pp. 26, 27; Combined Cat. 1999, p. 64.

It was probably this picture that Vertue (VI, 1948-50,
p. 177) had in mind when he wrote on 8 July 1739,
of his visit to Houghton Hall, ' "Europa carried on
the Bull" Guido, (fig as big as the life)' but in the
Aedes Horace Walpole describes the picture as 'after
Guido by Pietro de' Pietris'.

The lack of a description in the *Aedes* and the early
Hermitage catalogues prevents us from speculating
about which version by Guido Pietro de' Pietris
copied. The size of the canvas suggests that the basis
for the composition was *The Rape of Europa* (194 x
220 cm) now at Sansouci, Potsdam, which though
attributed to Guido Reni in the seventeenth century
is now seen as the copy by of one of his pupils, from
a lost original by Reni himself. It is of course possible
that Pietro de' Pietris made his copy not from the
Potsdam work but from the same lost original.

Pepper's monograph on Guido Reni (1988, p. 296)
mentions a studio version of *The Rape of Europa*, now
in the Hermitage (Inv. No. 4051, 114 x 89), copied
from the original in the collection of Denis Mahon,
mistakenly giving its provenance as Houghton Hall.
In fact this picture came from the collection of
Robert Udny.

In the Hermitage, Pietro de' Pietris' *Rape of Europa*
was considered the pair to the *Galatea* by Michele
Semini (cat. no. 82). Both were exhibited for sale in
1854, when Nicholas I rationalised the Hermitage
collection (see Wrangell 1913), but they remained
unsold and were deposited in the Tauride Palace.
There is a curious note in the 1859 Inventory (to no.
5837) which reads: 'On the verbal order of His
Majesty [Emperor Alexander II] moved to the middle
state staircase in the large Tsarskoye Selo Palace
[Catherine Palace] 4 July 1860 and turned into a pla-
fond.' Semini's *Galatea* was similarly adapted as a ceil-
ing decoration in the Catherine Palace. The identity
of both artists was subsequently forgotten and both
works were later simply described as copies after
Guido Reni.

These two paintings and another set into the ceil-
ing of the staircase (a copy of Vanloo's *Triumph of
Venus*) disappeared during the Second World War (see
Lemus et al 1980; Combined Cat. 1999). One of these
has now been replaced by Carlo Maratti's *Judgment of
Paris* from the Walpole collection (see cat. no. 51).

S. V.

Not reproduced

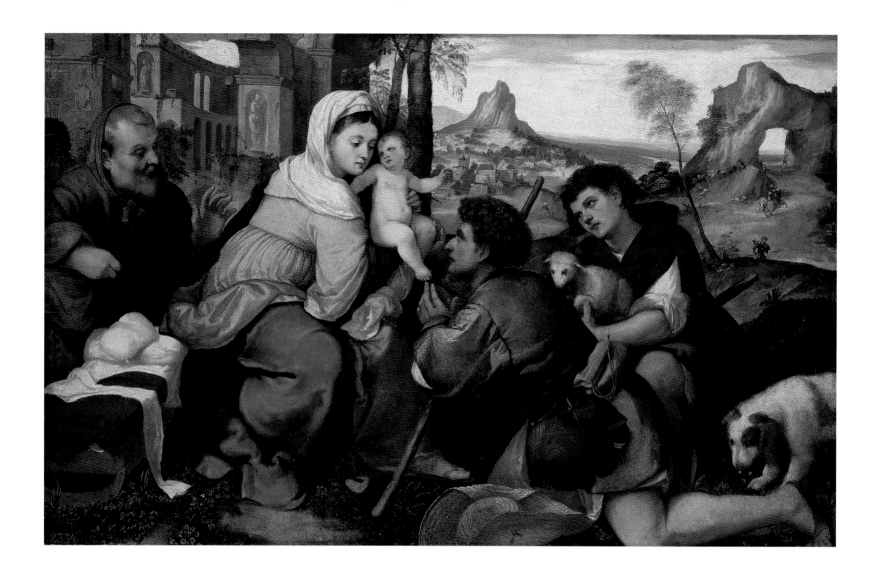

62

BONIFAZIO DE' PITATI (BONIFAZIO VERONESE) (1487-1553)
The Adoration of the Shepherds
Oil on panel. 76 x 119.5
Inv. No. 33

PROVENANCE: coll. Nicolaes Anthonis Flinck; Sir Robert Walpole, 1736 Houghton (Marble Parlour, as by 'Palma Vecchio', then Gallery); 1779 Hermitage.

LITERATURE: *Aedes* 1752, p. 87 (as by 'old Palma'); 2002, no. 249; Schnitzler 1828, p.36; Cats. 1863-1916, no. 90; Waagen 1864, p. 61; Penther 1883, p. 32; Bode 1882, p. 9; Harck 1896, p. 425; Wickhoff 1903, f. 3; Crowe, Cavalcaselle 1912, vol. 2, p. 487; Venturi L. 1912, p. 209; Westphal 1931, p. 129; Cat. 1958, vol. I, p. 68; Cat. 1976, p. 78; Simonetti 1986, A 76; Fomiciova 1992, no. 62.

EXHIBITION: 2001 Bassano–Barcelona, no. 12.

Hung at Houghton Hall 'over the … Door' with the *Sacra Conversazione* by Bonifacio Veronese (cat. no. 63), with which it was mistakenly thought to form a pair, both pictures at this time were attributed to Palma Vecchio, and had cost Walpole £300 (HRO MS 1744).

The *Aedes* mistakenly records that the painting came from 'the Collection of Monsieur de la Vrillière, Secretary of State in France'. In fact this reference is to the *Sacra Conversazione* (cat. no. 63) and *The Adoration of the Shepherds* was thus likely to have come from the Flinck collection (given in the *Aedes* as the source of the *Sacra Conversazione*).

The name of Bonifazio (Bonifacio) de' Pitati, known as Bonifazio Veronese, was first proposed by Penther (1883), who wrote '[er] scheint mir nicht, wie der Katalog behauptet, dem Palma, sondern seinem famosen Schüler Bonifazio Veronese anzugehören.' With a question mark after the the attribution it thus appeared

in the 1889 catalogue. Later publications raised doubts not so much about the attribution to Bonifazio himself as about the precise extent of his involvement in the execution. Wickhoff (1903) attributed the painting to Bonifazio's most talented pupil, Jacopo Bassano, while Westphal (1931) also saw the hand of a pupil but did not venture to suggest a particular name. All these opinions, like that of L. Venturi (1912) who took the view that it was a 'weak imitation' of Bonifazio's style, are in fact at odds with the high quality of the Walpole painting, which should surely be placed alongside the most characteristic and outstanding examples of Bonifazio's own work. Fomiciova (Cat. 1958, Cat. 1976, Fomiciova 1992) consistently defended the attribution to Bonifazio, citing by comparison *The Massacre of the Innocents* in the Accademia, Venice. The same author noted that some details in the Hermitage canvas derive from a composition of the same subject by Bonifazio's teacher,

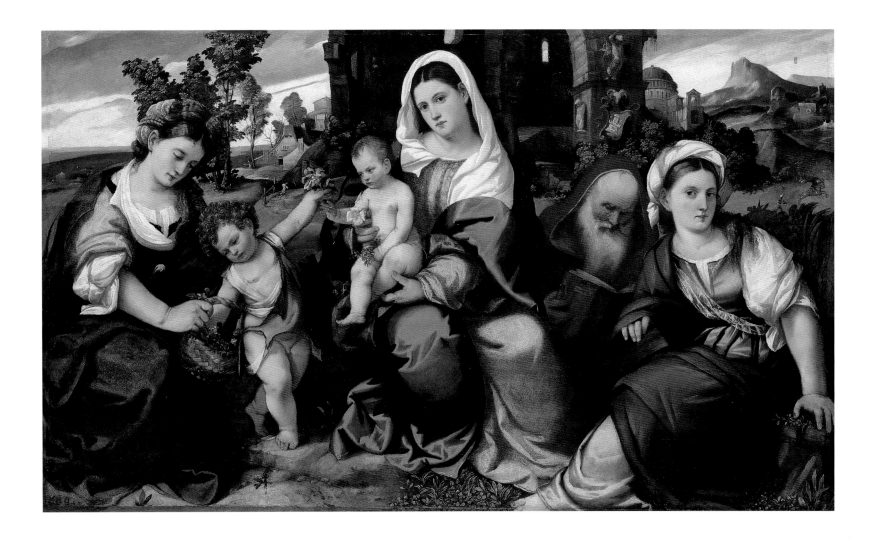

Palma Vecchio (Louvre, Paris). We should note that the same combination of Bonifazio's favourite motifs — architectural details and extensive landscape with figures of a similar type — can be found in another accepted version of the same subject, *The Adoration of the Shepherds* (City Art Gallery, Birmingham, UK). Close in style to the *Sacra Conversazione, The Adoration of the Shepherds* may also be dated to the same period, c.1525-28.

I. A.

63

Bonifazio de' Pitati (Bonifazio Veronese) (1487-1553)

Sacra Conversazione

Oil on canvas, transferred from panel in 1837, 80 x 135

Inv. No. 39

PROVENANCE: coll. M. de la Vrillière, French Secretary of State; Sir Robert Walpole, 1736 Houghton (Marble Parlour, as by 'Palma Vecchio', then Gallery); 1779 Hermitage.

LITERATURE: *Aedes* 1752, p. 87 (as 'The Holy Family, by old Palma'); 2002, no. 250; Cats. 1863-89, no. 92 (1863-88 Palma Vecchio, 1889-91 Bonifazio Veronese?); Waagen 1864, p. 61; Penther 1883, p. 29; Harck 1896, p. 425; Crowe, Cavalcaselle 1912, vol. 2, p. 487; Venturi L. 1912, p. 209; Westphal 1931, p. 28; Berenson 1932, p. 94; Cat. 1958, vol. I, p. 68; Cat. 1976, p. 78; Simonetti 1986, A 77; Fomiciova 1992, no. 61.

EXHIBITIONS: 1999 Tokyo, no. 29; 2001 Bassano–Barcelona, no. 19.

Listed as a 'Holy Family' by Palma Vecchio in both the Walpole MS of 1736 (pp. 5-6) and in the *Aedes*, this remained the accepted attribution when the painting was recorded in the 1773-85 catalogue when it entered the Hermitage. Although Penther (1883) correctly identified Bonifazio as the author of *The Adoration of the Shepherds* (cat. no. 62), the pendant to the Walpole painting when both hung at Houghton Hall, he remained convinced that *Sacra Conversazione* was one of Palma Vecchio's best works, describing it as 'ein wunderschönes Bild aus seiner besten Epoche'. This error, not unusual with regard to works by Bonifazio, was retained in catalogues of the Hermitage right up to 1889 when Somov first expressed doubts about Palma Vecchio's authorship and tentatively suggested the

name of Bonifazio as an alternative. In later publications all doubt seems to have disappeared and the attribution came to be accepted in the literature. There is now no doubt that the work is wholly by Bonifazio himself, although L. Venturi (1912) and Westphal (1931) both thought that the picture was completed with workshop assistance.

In the Hermitage painting the artist employed his favoured balanced and symmetrical compositional pattern with the Virgin and Child at the centre and saints Anthony Abbot and Catherine to the right and saints John the Baptist and Dorothy to the left. The subject of the picture was mistakenly identified in all previous publications as the Holy Family with St Catherine, St Elizabeth and John the Baptist. The subject is in fact not a 'Holy Family' but a sacra conversazione, a lyrically narrative interpretation of a theme that became the leitmotiv in Bonifazio's work. Unconnected with liturgical ritual, such paintings were usually intended for private patrons, and indeed on the pillar behind St Anthony's head can be seen the arms of the Castelli family, one of whose members must have commissioned the picture.

The painting can be dated to 1525-28, a period when Palma Vecchio's influence was particularly visible in Bonifazio's work.

In the *Aedes*, Horace Walpole suggested that the painting came from the Flinck collection. In fact, on the basis of a precise description provided in a 1681 inventory, the present author has established that it came from the de la Vrillière collection in France. With a somewhat optimistic attribution to Giorgione it is described thus: 'Dans le cabinet de tableaux attenant la d. Gallérie des peintures … [64] Item un autre tableau à longueur peint sur bois garni de sa bordure taillée et dorée representant une "Vierge, son fils Jesus et un petit sainct Jean qui luy presente des fleurs, un sainct Joseph qui lit dans un livre et deux femmes, dont l'une tient un petit pannier plein des fleurs", original de Georgeon prisé six cents livres.' (Cotté 1985, p. 94).

A version of the Hermitage composition described as a 'follower of Bonifazio' is in the National Gallery of Art, Washington (Inv. No. 1829).

I. A

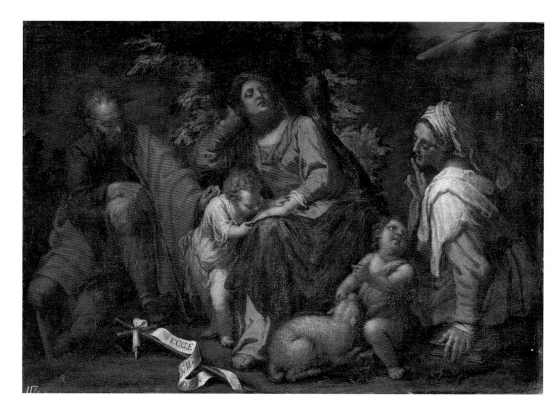

64

Matteo Ponzone (1583–after 1663)
The Holy Family
Oil on canvas, 109 x 160
Pavlovsk State Museum Reserve, Inv. No. 1791-III
PROVENANCE: coll. Ferdinand Graf van Plettenberg, Rome; in or shortly after 1736 acquired by Sir robert Walpole; Sir Robert Walpole, Houghton (Cabinet); 1779 Hermitage; since 1800 at Pavlovsk Palace.
LITERATURE: *Aedes* 1752, pp. 70-71; 2002, no. 186; Boydell I, pl. XXXII.

The Walpole MS 1736 lists this painting among those works acquired after the catalogue was compiled (i.e. in or shortly after 1736). Horace Walpole fortunately provides us with a detailed history of the provenance and acquisition of what he thought a very rare piece: 'the Holy Family, by Matteo Ponzoni, a most uncommon hand and a very fine Picture. … It belonged to Count Plattemberg, the Emperor's Minister at Rome, who had carried all his Pictures thither, and died there. They were sent to Amsterdam to be sold, where Mr. Trevor bought this for Sir Robert Walpole. Lord Burlington has a Head by the same Master, who was a Venetian; there are no others in England of the Hand.' The work hung 'Over the Door in the Bedchamber' at Houghton Hall.

Horace Walpole's high opinion of the painting's quality was shared by Munich (Cat. 1773-85) who described it as 'Excellent Tableau d'une main peu connue. Il représente la Vierge endormie et l'Enfant Jésus lui baisant la main. On y voit encore le petit St. Jean et St. Elizabethe faisant du doigt le signe du silence.'

The Walpole picture reveals the 'maniera grave veneziana' (Boschini) of Matteo Ponzone's mature work, freed from the influence of the exalted style of his teachers Palma Giovane and Sante Peranda. The closest stylistical analogy to this work is an *Adoration of the Magi* at Treviso (Museo Civico Luigi Bailo). Both works reveal Matteo Ponzone to be a significant independent master, one of the first exponents of the Baroque style in the Venetian school. By analogy with the Treviso work the painting can be dated c.1629-30.

I. A.

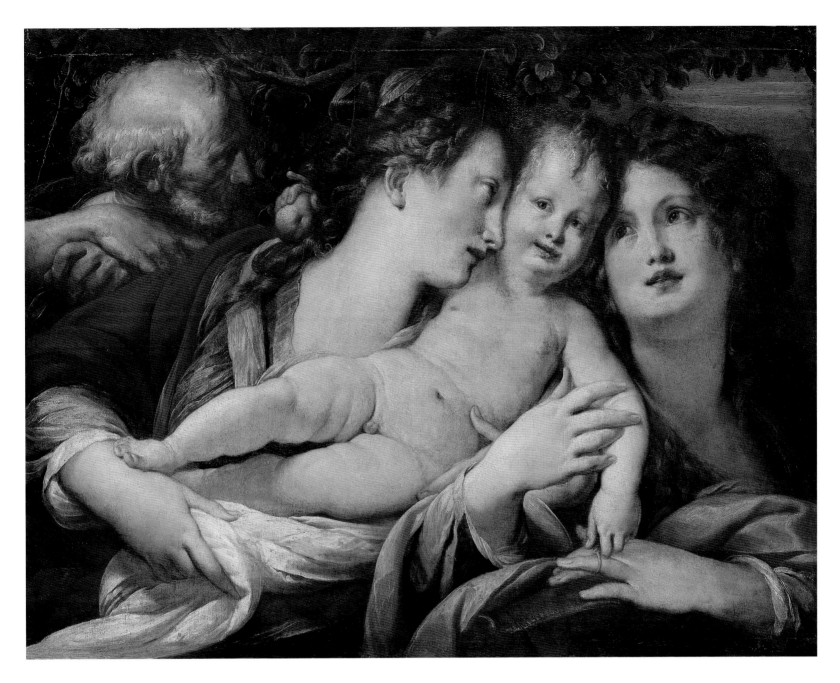

65

GIULIO CESARE PROCACCINI (1574-1625)
The Mystic Marriage of St Catherine
Oil on panel, 56 x 73
Inv. No. 94
PROVENANCE: Sir Robert Walpole, 1736 Downing St
(Great Middle Room below), later Houghton
(Gallery); 1779 Hermitage.
LITERATURE: *Aedes* 1752, p. 85 (as 'The Holy Family
... by Camillo Proccaccino'); 2002, no. 241; Boydell
I, pl. V; Gilpin 1809, p. 59; Hand 1827, p. 192; Nagler
1835-52, vol. 12, p. 85; Livret 1838, p. 70; Cats. 1863-
1916, no. 264; Waagen 1864, p. 90; Benois [1910], p.

74; Cleaned Pictures 1955, p. 48; Cat. 1958, vol. I, p.
155; Cat. 1976, p. 124; Vsevolozhskaya 1981, no. 94;
Kustodieva 1994, no. 195.

The subject derives from Jacopo da Voragine, *The
Golden Legend*, CLXXII.

In the Walpole collection, and then when it entered
the Hermitage, the picture was listed as the work of
Camillo Procaccini. Waagen (1864) however correctly
attributed it to Camillo's brother, Giulio Cesare, the
most talented of the Procaccini family of artists.

Here, as in nearly all his paintings, the artist repeated
his favourite female type – a buxom woman with luxu-

riant copper-tinted hair. Another characteristic feature
of the work of Giulio Cesare is the combination of
warm golden-brown and olive-green tones. The
rhythmic structure of the composition, especially the
figure of the Child lying in His mother's embrace, is
determined by the panel's elongated format.

A copy of the Hermitage work is in the Ciurlionis
Art Museum, Kaunas, Lithuania (Markova 1986, pp.
76-77) and similar works by Procaccini are to be
found in the Brera, Milan; the Walker Art Gallery,
Liverpool; the Staatsgalerie, Augsburg; the Pinacote-
ca Nazionale, Bologna and in the Duomo, Milan.

T. K.

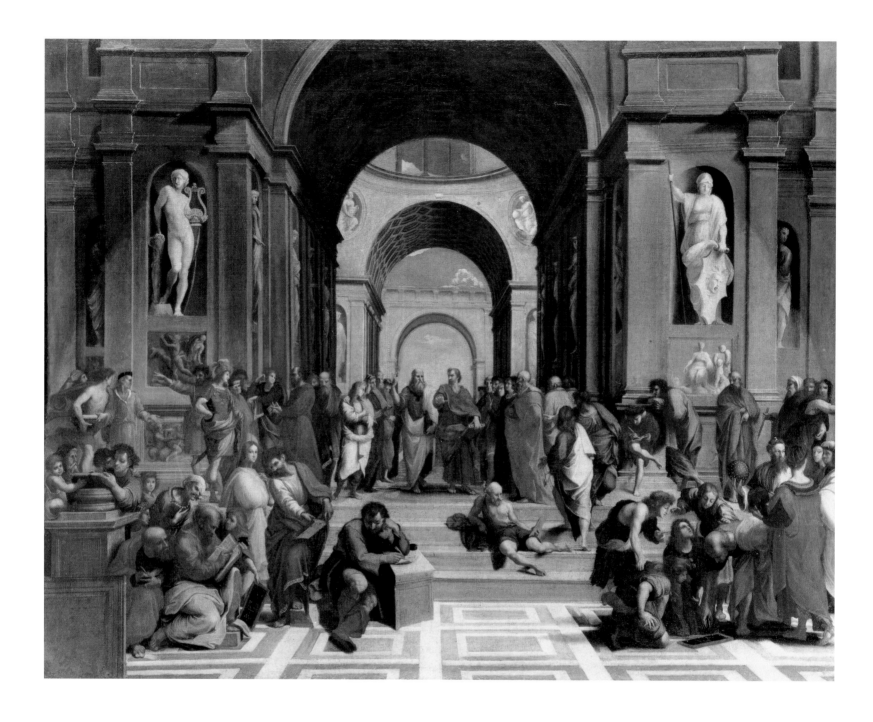

66

RAPHAEL (1483–1520), 17th-century Italian copy after
The School of Athens
Oil on canvas, 98 x 133
Inv. No. 1781
PROVENANCE: Sir Robert Walpole, Houghton (Common Parlour); 1779 Hermitage; 1929 transferred to Antikvariat for sale; unsold, 1931 returned to the Hermitage.
LITERATURE: *Aedes* 1752, p. 48 (as a copy by Le Brun); 2002, no. 45; Cats. 1863–1909, no. 46; Waagen 1864, p. 47; Neustroyev 1898, p. 28, no. 6; Kustodieva 1994, no. 213.
EXHIBITIONS: 1954 Travelling, p. 37; 1969 Travelling, p. 14.

This is a copy after Raphael's celebrated fresco painted between 1508 and 1512 in the Stanza della Segnatura in the Vatican. Waagen (1864) noted that, despite its small dimensions, it provides a reasonably good idea of the original. It was listed in Hermitage catalogues into the early twentieth century (Cat. 1773–85, Cat. 1797, Cats. 1863–1909) as a copy by Charles Lebrun, but later catalogues (Liphart's Cat. 1912 or the 1976 Cat.) excluded it. More recently, Kustodieva (1994) suggested that it is a seventeenth-century Italian copy. A full size copy from Raphael's original by leading Russian artist Karl Bryullov (1799–1852) can be found in the Research Museum of the Academy of Arts in St Petersburg.

T. K.

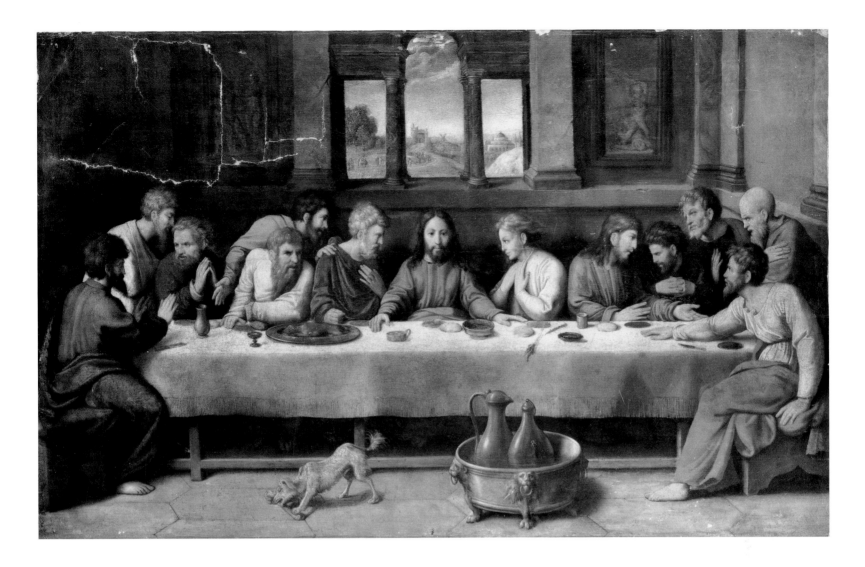

67

RAPHAEL (1483-1520), 16th-century Netherlandish copy after
The Last Supper
Oil on canvas, transferred from panel in 1829, 51 x 83
Inv. No. 1536
PROVENANCE: coll. Arundel; coll. Earl of Yarmouth; coll. Sir John Holland; Sir Robert Walpole, 1736 Downing St (Closet), later Houghton (Gallery); 1779 Hermitage; 1929 transferred to Antikvariat for sale; unsold, 1931 returned to Hermitage.
LITERATURE: *Aedes* 1752, p. 93 (as by Raphael); 2002, no. 265; Schnitzler 1828, p. 45; Livret 1838, p. 279; Cats. 1863-1907, no. 44; Waagen 1864, p. 47; Swignine 1821, p. 35 (Russian edition 1997, p. 249).

As late as 1838 Livret upheld the earlier attribution of this work to Raphael, but the 1863 catalogue listed it as a copy after Raphael's fresco by a Netherlandish artist. Waagen (1864) described it as 'a beautiful copy,

very famous, thanks to the engraving by Marcantonio [Raimondi], of *The Last Supper*, by a very gifted master of the Netherlandish school'.

The author of the 1901 catalogue also considered the work a copy from Raphael's work, offering the following justification: 'En le comparison avec les oeuvres incontestables de Michiel Coxie (1499-1592) on arrive à la conviction que c'est une copie de ce dernier, élève de Raphaël; il l'a fait d'après un dessin de son maître, en se livrant à sa propre inspiration. Ce dessin figure actuellement dans la collection du roi d'Angleterre. Il a été gravé par M.-A. Raimondi, avec d'autres tableaux de la collection du Lord Arundel, et a été copié à l'huile, de la même dimension; cette copie ce trouve au musée Sancta Trinidad, à Madrid.' The reference is to a drawing by Raphael at Windsor Castle, from which there is indeed an engraving by Marcantonio Raimondi (Bartsch XIV, p. 33, no. 26). Of no great artistic merit, this work undoubtedly belongs in stylistic terms to the Netherlandish school.

T. K.

68

?Raphael (1483–1520)
A Profile Head of a Man
Card. c.51.2 x 44.5
PROVENANCE: Sir Robert Walpole, 1736 Grosvenor
St (Parlour), later Houghton (Carlo Maratt Room);
1779 Hermitage; whereabouts unknown.
LITERATURE: *Aedes* 1752, p. 60; 2002, no. 119.

This drawing was accessioned along with the paint-
ings in Hermitage Cat. 1773–1785 (no. 2418).
Although the *Aedes* Walpolianae provides no infor-
mation about it apart from its title and an assessment
of its artistic merit as 'a Capital Drawing, in a great
Style', the manuscript catalogue does at least provide
some more precise information and endorses Horace
Walpole's lavish assessment of the work's quality with
the words 'Excellent morceau et dans le grand Style
de ce maître'. Although it is stated that the drawing is
on 'carton' and its dimensions are given as 11 *vershki*
by 10 *vershki* (c.51.2 x 44.5) there is no indication of
the medium employed.

This drawing is no longer recorded in any modern
catalogues of Raphael's work and it was probably re-
attributed at some point after it entered the Her-
mitage. In the absence of a more precise description
it has not proved possible to identify the drawing in
the extensive Old Master drawings collection in the
Hermitage.

I. G.

Not reproduced

69

Guido Reni (1575–1642)
The Adoration of the Shepherds
Oil on panel, 100 x 100 (octagonal)
Pushkin Museum of Fine Arts, Moscow, Inv. No. 1608
PROVENANCE: coll. M. de la Vrillière, French Secre-
tary of State, Paris; Sir Robert Walpole, 1728 Arling-
ton St, London; 1736 Houghton (Green Velvet
Drawing Room, then Gallery); 1779 Hermitage;
1928 transferred to Museum of Fine Arts (now
Pushkin Museum of Fine Arts), Moscow.
LITERATURE: *Aedes* 1752, pp. 88–89; 2002, no. 257;
[Boydell II, pl. XLVIII (after the painting in the col-
lection of the Rt Revd Dr Newton, Lord Bishop of
Bristol)]; Malvasia 1678 [ed. 1841], vol. 1, p. 95;
Labensky 1805-9, vol. I, bk. 3, pp. 121–22; Hand
1827, p. 205; Schnitzler 1828, pp. 47-48; Cats. 1863-
1916, no. 182; Waagen 1864, p. 78; Neustroyev 1898,
p. 72; Benois [1910], p. 89; Kurz 1937, p. 217; Vertue,
vol. VI, 1948-50, p. 179; Pushkin Museum 1957, p.
177; Pushkin Museum 1961, p. 157; Garboli, Bacch-
eschi 1971, no. 201c (ill. no. 201d); Pepper 1984, p.
287, no. 190; Pushkin Museum 1986, p. 149; Guido
Reni und Europa 1988, pp. 425–26; Pushkin Museum
Album 1989, no. 133; Markova 1992, p. 193; Pushkin
Museum 1995, p. 192.
EXHIBITIONS: Moscow 1961, p. 52.

The Walpole painting is among those works by Reni
that were already renowned during the artist's lifetime.
It was first mentioned by Cesare Malvasia (Malvasia
1678 [ed. 1841]), who described it as 'la famose Presepe
che si trova in Francia in forma ottagonale'. Guido
Reni turned to the subject on numerous occasions.

Individual motifs which occur in the painting are
to be seen in large-scale compositions in the Nation-
al Gallery, London (1640; Inv. No. NG 6270) and in
the Certosa di San Martino, Naples (Pepper 1984,
nos. 200, 201). In 1820 there was a picture of the same
subject, also octagonal, but smaller, in the Devonshire
collection at Chatsworth and this was engraved by J.
B. Michel.

Kurz (1937) tentatively dated this canvas to 1622.
This work is an example of the artist's late style and
was probably produced no earlier than 1639. There
are numerous copies of the Moscow composition.
Pepper (1984, p. 287) cites seven in all. One of these
is in the Museum of Fine Arts, Budapest (Inv. No.
505; Pigler 1967, p. 574), and would seem to have
been produced in Reni's studio.

V. M.

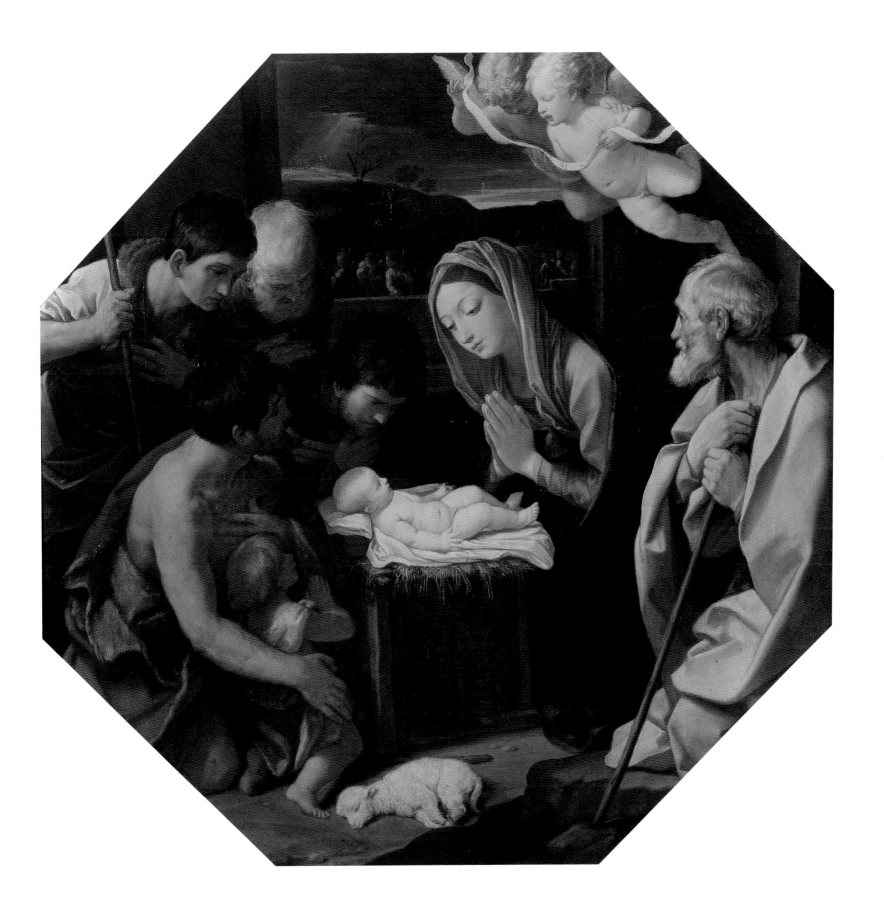

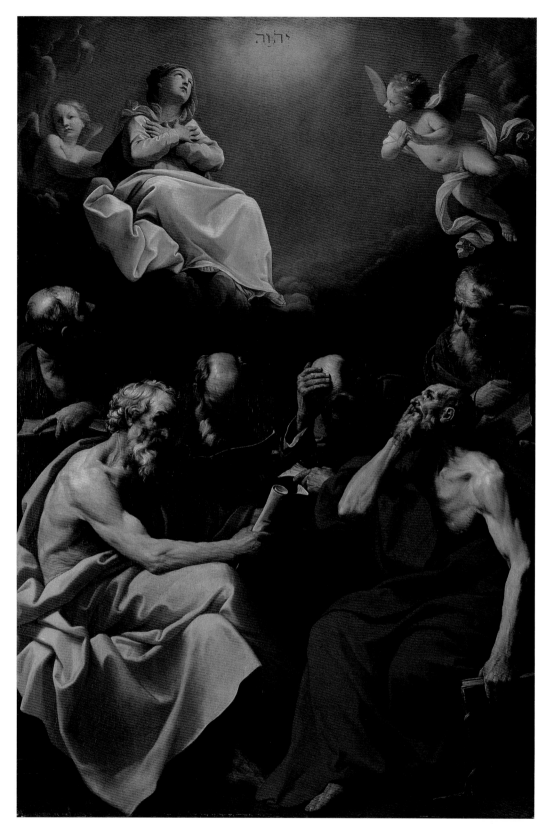

70

Guido Reni (1575-1642)
The Fathers of the Church Disputing the Christian Doctrine of the Immaculate Conception

Oil on canvas, 273.5 x 184, at the top, in the sky, a Hebrew inscription with the name Jahweh
Inv. No. 59

PROVENANCE: coll. Marchese Degli Angeli (De Angelis), Rome; Sir Robert Walpole, 1736 Houghton (Marble Parlour, then Gallery); 1779 Hermitage.

LITERATURE: *Aedes*, 1752, pp. 76-80 (as 'The Doctors of the Church'); 2002, no. 227; Boydell II, pl. LVIII; Labensky 1805-9, vol. 1, bk. 2, pp. 63-64; Gilpin 1809, pp. 55-57; Landon 1819, 2, no. 15; Swignine 1821, p. 33 (Russian edition 1997, pp. 247-48); Hand 1827, pp. 206-9; Schnitzler 1828, pp. 37-38, 126; Chambers 1829, vol. I, pp. 533, 534; Nagler 1835-52, vol. 4, p. 488 (Frey); vol. 13, p. 15; vol. 16, p. 329 (Scharp); Livret 1838, p. 45, no. 38; Viardot 1844, p. 482; Viardot 1852, p. 304; Cats. 1863-1916, no. 187; Waagen 1864, p. 78; Mémoires secrètes 1862, p. 145; Penther 1883, p. 39; Thieme-Becker 1907-50, vol. 28, p. 163; Boehn 1910, p. 41, figs. 37, 102; Vertue, vol. VI, 1948-50, p. 180; Kurz 1937, p. 219; Cat. 1958, vol. I, p. 163; Bénézit 1976, vol. 8, p. 688; Garboli, Baccheschi 1971, p.108, no. 162; Pigler 1974, vol. 1, p. 514; Cat. 1976, p. 127; Vsevolozhskaya 1981, no. 104; Pepper 1984, p. 250, no. 98; Pepper 1988, p. 255, no. 87; Guido Reni und Europa 1988, p. 470; Spear 1997, pp. 142-43, 150; Pears 1988, pp. 157, 159, 201-2, 259; Herrmann 1999, p. 81; Brownell 2001, p. 57.

A detailed explanation of the painting's subject is given by Horace Walpole in the *Aedes*. The theme of the Immaculate Conception first appeared in art in the sixteenth century but became especially widespread in the following century. The central debate concerned the question of the Virgin Birth and arose out of different readings of Gospel texts (e.g. Matthew i: 25). The Fathers of the Church were regarded as the first and most consistent defenders of the dogma of the Immaculate Conception. Artists usually depicted St Augustine (354-430), Gregory of Nazianzus (c.329-c.389), Basil the Great (330-79) and John Chrysostom (347-407). This picture, however, adds another two, Jerome (c.341-420) and Ambrose (339/40-397).

There are differing opinions about the date of the picture. Hermitage catalogues have dated it to the period after 1620 but Pepper (1984, 1988) suggests 1624-25. A date nearer 1635 is perhaps more accurate (Kurz 1937; Garboli, Baccheschi 1971).

A preparatory drawing is in the Kupferstichkabinett, Berlin, but its authenticity has been challenged by Pepper. *The Fathers of the Church* is sometimes compared with a canvas in the Chiesa Nuova in

Perugia, mentioned by G. B. Passeri (*Vite de' Pittori, Scultori ed Architetti che henno lavorato in Roma, morti al 1641 al 1673*, Rome, 1772, p.74), but Kurz has identified the painting mentioned by Passeri with a composition now in the Musée des Beaux-Arts, Lyon.

Horace Walpole provides some interesting details in the *Aedes* about his father's acquisition of the picture: 'After Sir Robert had bought this Picture, and it was gone to Cività Vecchia to be shipped for England, Innocent XIII, then Pope, demanded it back, as being too fine to be let go out of Rome; but on hearing who had bought it, he gave Permission for its being sent away again.' We know that Walpole paid £700 for it, an extremely high price at that date (Herrmann 1999).

This work was also referred to in the foreword to the *Aedes* (p. xxxiv) where Horace Walpole noted that 'The largeness and simplicity of the folds in Guido's Dispute of the Doctors, is a pattern and standard for that sort of Painting' and it is described in Liverpool Papers 1741 as 'a most beautiful Picture of the Doctos. ... You see reason & argument in their very faces.' It was similarly praised in 1797 by Stanislas Poniatowski as 'Le tableau, qui le prince Yousoupoff regarde comme le plus beau de toute la collection impériale est de Guido Reni, représente les quatre Docteurs de l'Eglise avec la Ste Vierge planant dans les airs' (Mémoires Secrètes 1862).

In addition to Sharp's engraving for Boydell's publication, there is another by Jacob Frey where the location of the picture is given on the letterpress as the house of 'Marchionis de Angelis'. Separate figures from the composition were engraved by Johann Christoph Steinberger (St Jerome) and Johann Christoph Winkler (St Ambrose).

S. V.

71

Guido Reni (1575-1642)
St Joseph Holding the Christ Child
Oil on canvas, 98 x 82

PROVENANCE: coll. Charles-Jean-Baptiste Fleuriau, Comte de Morville, French diplomat; Sir Robert Walpole, 1736 Downing St (End Room Below), later Houghton (Salon); 1779 Hermitage; 1862 transferred to Moscow Public and Rumyantsev Museum; whereabouts unknown.

LITERATURE: *Aedes* 1752, p. 55 (as 'Simeon and the Child'); 2002, no. 88; Boydell II, pl. IV ('Simeon & the Child'); Nagler 1835-52, vol. 4, p. 53 (Earlom); Livret 1838, p. 272, no. 4; Rumyantsev Museum 1912, p. 99, no. 46 (school of Guido Reni); Rumyantsev Museum 1913, p. 107, no. 46 (school of Guido Reni); Pepper 1988, p. 297.

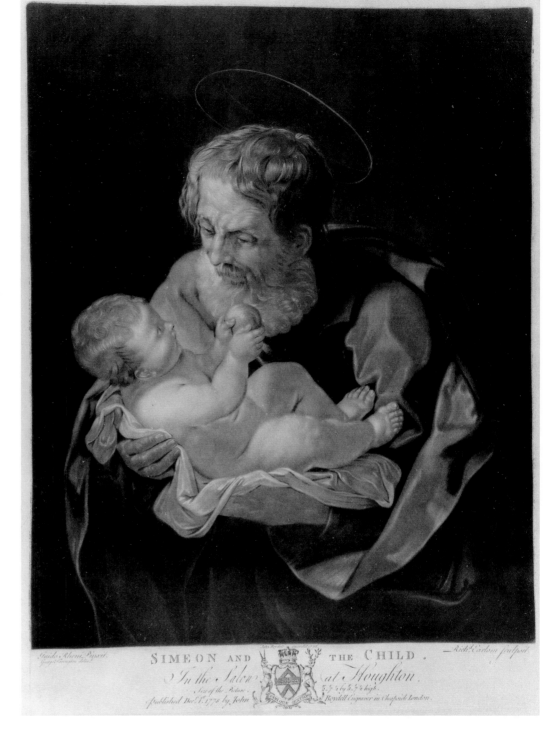

According to Horace Walpole 'The Design is taken from a statue of a Silenus with a young Bacchus, in the Villa Borghese at Rome' (*Aedes*). Several versions of Guido Reni's composition of St Joseph holding the Christ Child are known. Two of these are completely consistent with the picture from the Walpole collection, one of them in a private collection in Houston, Texas (Pepper 1988, pp. 296-97, no. 177, 86 x 71), which Pepper dates to 1638-40, and the other which passed through the New York art market (Pepper 1988, p. 343, no. 63, 91 x 76), dated 1640-42.

Pepper has suggested that the first of these came from the Gerini collection in Florence: as Horace Walpole noted in the *Aedes* there 'is another of these,

but much less finished, in the Palace of the Marquis Gerini in Florence.' The Gerini collection was eventually sold in Florence on 1 December 1825, and a *St Joseph with the Child* is listed as no. 281.

The provenance of the second picture is not known but the possibility that this was the Walpole picture cannot be dismissed. The Walpole picture should bear a black number '2239' (as in the 1859 Inventory). It should also be noted that another version of the same composition was in private hands in Moscow in the 1970s. Its owner insisted that he had the painting from the Walpole collection but it was difficult to judge the merits of this picture from a poor amateur photograph and it proved impossible to see the original.

The painting is now known from the Boydell print, engraved by Earlom, published 1 December 1778.

S. V.

72

GUIDO RENI (1575-1642), copy after
The Triumph of Job (Job Receiving the Homage of the People)
Oil on panel, 95.5 x 71, additions to right and left of 7 cm, bottom of 2.5 cm
Inv. No. 2714
PROVENANCE: Sir Robert Walpole, 1736 Houghton (Yellow Drawing Room, then Gallery); 1779 Hermitage.
LITERATURE: *Aedes* 1752, p. 86 (as 'Job's Friends bringing him Presents... by Guido'); 2002, no. 243; Hand 1827, pp. 209-10; Nagler 1835-52, vol. 13, p. 7; Livret 1838, p. 272, no. 3; Pepper 1984, pp. 272-73; Pepper 1988, p. 282.
EXHIBITIONS: 1944-45 Leningrad, p. 12.

Aedes and eighteenth-century catalogues of the Hermitage list the painting as an original work by Guido Reni, the subject from Book of Job xlii: 7-10. Hand (1827) described it as a copy of the famous altarpiece in the Chiesa dei Mendicanti in Bologna. Livret (1838) considered it a finished sketch for this altarpiece whilst Nagler (1835-52) thought it 'eine Copie oder vielleicht die Skizze'. A century passed before the picture surfaced again (curiously as by an 'Italian early eighteenth-century artist from the school of Francesco Solimena') when it was exhibited in 1944-45 at the Hermitage as part of an exhibition of works that remained in Leningrad during the Siege.

There is no doubt that *The Triumph of Job* is a reduced-scale seventeenth-century copy of a large (415 x 265) altarpiece completed by Guido Reni in

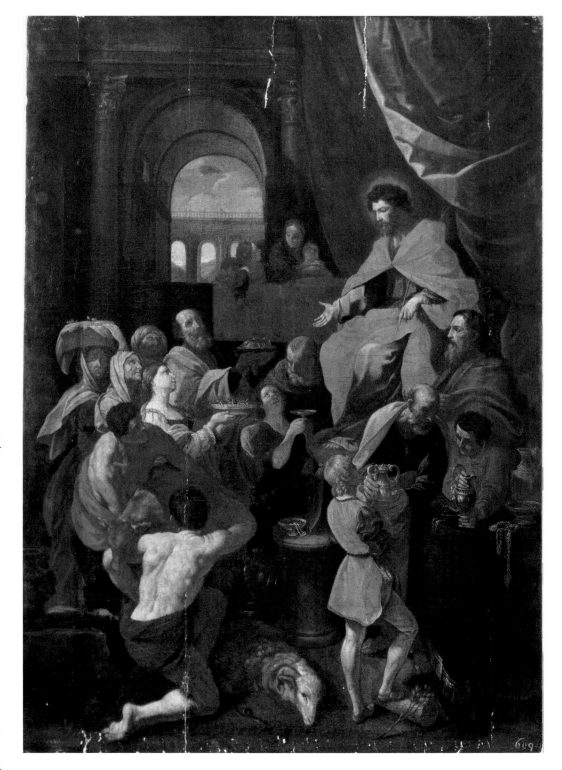

1635 for the Church of Santa Maria della Pietà (dei Mendicanti) in Bologna. The altarpiece was removed from Italy to France by Napoleon and placed in Notre Dame in Paris. With the passage of time the author's name was forgotten and the subject of the picture came to be known as *Christ Receiving Gifts*. It was eventually identified in Notre Dame by Denis Mahon as Guido Reni's altarpiece. Pepper listed two small copies, one at Houghton Hall and the other in the Hermitage, apparently unaware that they are one and the same (see Pepper 1988).

S. V.

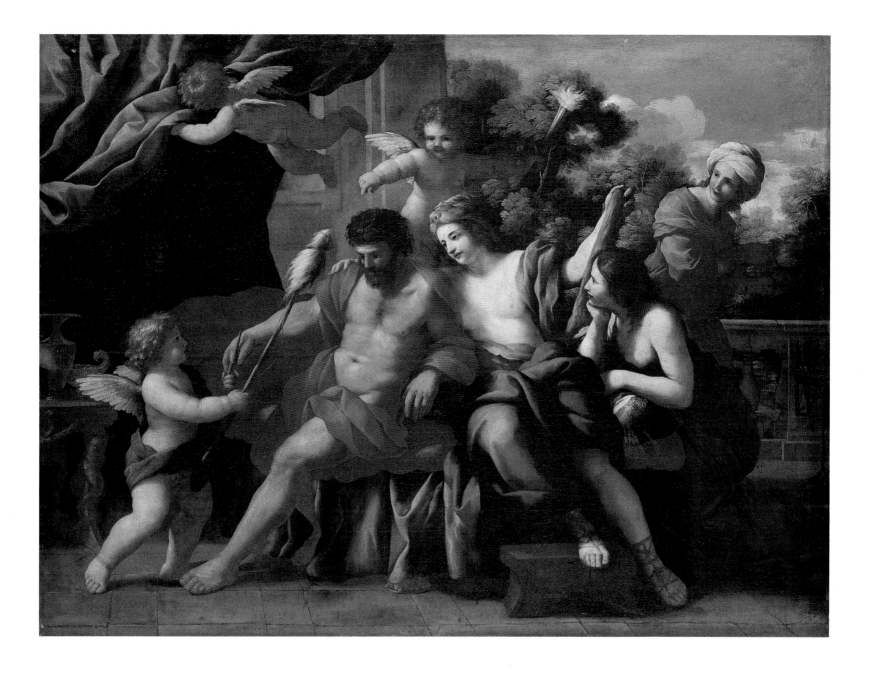

73

GIOVANNI FRANCESCO ROMANELLI (1611-62)
Hercules and Omphale
Oil on canvas, 100 x 133
Inv. No. 1601
PROVENANCE: 1725/26 acquired by Sir Robert Walpole at a sale of paintings by Andrew Hay for £44 2s (Pears 1988, p. 86); Sir Robert Walpole, 1736 Downing St (Lady Walpole's Drawing Room), later Houghton (Carlo Maratt Room); 1779 Hermitage (Cats. 1958 and 1976 both mistakenly give provenance as Crozat coll.).
LITERATURE: *Aedes* 1752, p. 61; 2002, no. 125; Boydell II, pl. VII; Hand 1827, pp. 291-92; Nagler 1835-52, vol. 13, p. 330; Livret 1838, p. 383, no. 42; Waagen 1864, p. 79; Vertue, vol. V, 1937-38, p. 126; Vertue, vol. VI, 1948-50, p. 177; Cat. 1958, vol. I, p. 168; Kerber 1973, pp. 138, 164-65; Pigler 1974, vol. 2, p. 120; Cat. 1976, p. 130; Kerber 1979, pp. 6, 14 note 48; Vsevolozhskaya 1981, no. 136; Pears 1988, p. 86; Moore ed. 1996, p. 51.
EXHIBITIONS: 1997 Bonn, no. 30.

One of the artist's best works, close in style and colour to pictures of the second half of the 1650s such as *The Daughters of Joseph* (Musée Magnin, Dijon). The picture was seen by Vertue in Sir Robert Walpole's house 'near the Treasury, Whitehall' (Vertue, vol. V, 1937-38; vol. VI, 1948-50). It has also been discovered (Kerber 1979) that in 1725 it was sold as part of 'A Collection of Pictures brought from Abroad by Mr. Andrew Hay ... sold by auction at Mr. Cocks New Auction Room in Poland Street on the 19th February 1725' ('6.62 Hercules and Omphale with Nymphs by Romanelli'). On that occasion Robert Walpole paid £44 2s for it (Pears 1988). A somewhat altered replica of poorer quality is in the Museo Civico, Viterbo.

The subject is from Apollodorus II, 6, 2-3.

S. V.

74

GIULIO ROMANO (c.1499-1546), copy after
The Battle Between Constantine and Maxentius
Oil on canvas, c.142.2 x 294.6
PROVENANCE: Sir Robert Walpole, 1736 Houghton
(Supping Parlour); 1779 Hermitage; 1853 transferred
to the Museum of the Academy of Arts; whereabouts
unknown.
LITERATURE: *Aedes* 1752, pp. 40-41; 2002, no. 10;
Wrangell 1913, p. 72; Brownell 2001, p. 51.

In 312 AD, Constantine I (274-337), Roman Emperor from 306 AD, defeated Maxentius, pretender to power in Rome, at a battle near the Milvian Bridge on the River Tiber. According to legend, on the eve of the battle, Constantine had a dream in which he saw an angel pointing at a cross bearing the inscription 'In hoc signo vinces'. Constantine thus went into battle with a cross in his hand. In the *Aedes* the subject, deriving from Jacopo da Voragine, *The Golden Legend,* LXVIII, is explained with the aid of a long Latin quotation from a work by the fifth-century Greek historian Zosimus (*Historiae Graece et Laine*...Lib. II, Cap. 15, 125-26.)

The painting was based on Giulio Romano's fresco of 1520-24 in the Hall of Constantine in the Vatican Palace, executed from a cartoon by Raphael.

The dimensions provided in the *Aedes* ('four Feet eight Inches and a half high, by nine Feet seven and a quarter wide') accord fully with the entry in the Hermitage Cat. 1773-85 (no. 2220: 'Sur toile, haut 2 ar. Large 4 ar. 2v.', i.e. c.142.2 x 294.6). The painting is then mentioned in the 1797 Cat. (no. 2926) accompanied by a pencilled marginal note stating 'in the stores'. In 1853 it was among 19 paintings transferred by personal order of Nicholas I to the Museum of the Academy of Arts, but thereafter its fate is unknown.

The Hermitage has another copy after Giulio Romano's Vatican fresco (Inv. No. 6929), but the dimensions (95.5 x 211) differ radically from that in the Walpole collection. This painting came to the museum from Antikvariat in 1931.

T. K.

Not reproduced

75

SALVATOR ROSA (1615-73)
Democritus and Protagoras
Oil on canvas, 185 x 128
Inv. No. 31
PROVENANCE: acquired from the author by Cardinal Chigi and presented by him to Louis XIV; Sir Robert Walpole, 1736 Downing St (Sir Robert's Dressing Room), later Houghton (Gallery); 1779 Hermitage.
LITERATURE: *Aedes* 1752, p. 88 (as 'The Old Man and his Sons with the Bundle of Sticks'); 2002, no. 256; Boydell I, pl. LV ('Democritus & Protagoras'; engraving signed W. Pether, although Nagler 1835-52 states that the engraving was produced for Boydell by John Taylor); Labensky 1805-9, vol. 1, bk. 1, pp. 35-36; Gilpin 1809, p. 63; Hand 1827, pp. 283-84; Schnitzler 1828, pp. 41, 131; Chambers 1829, vol. I, p. 537; Nagler 1835-52, vol. 13, p. 379; Livret 1838, p. 37, no. 5; Viardot 1844, p. 486; Viardot 1852, p. 307; Cats. 1863-1916, no. 222; Waagen 1864, p. 84; Penther 1883, pp. 41-42; Thieme-Becker 1907-50, vol. 29, p. 2; Voss 1924, p. 572; Pettorelli 1924, p. 43; Vertue, vol. VI, 1948-50, p. 175; Rinaldis 1939, pp. 168-69; Cat. 1958, vol. I, p. 168; Salerno 1963, pp. 57, 98, 143-44; Bénézit 1976, vol. 9, p. 85; Salerno 1975, no. 184; Cat. 1976, p. 129; Vsevolozhskaya 1981, no. 185; Hermitage 1989, no. 37.

The manuscript catalogue of 1736 (Walpole MS 1736, pp. 13-14) places the picture at Downing Street and describes the picture's subject as 'The Fable of the Old Man and his sons trying to break the Bundle of Sticks', a view supported by Vertue in his inventory of the collection of Houghton Hall in 1739 (Vertue, vol. VI, 1948-50), and later by Horace Walpole in the *Aedes*. The subject was first correctly identified in the letterpress beneath the Boydell engraving and in the explanatory text which states that it was formerly identified as 'Old man and his Sons' from the Lafontaine fable. Further research has shown that the picture illustrates the legend from Aulus Gellius (*Noctes Atticae*, V, 3; also Diogenes Laertes IX; Athenaeus VIII, 354). Salvator Rosa describes the painting as *Vocazione di Protagora alla Filosofia* in a letter dated 9 November 1664 to his friend, the man of letters Giovanni Battista Ricciardi (Rinaldis 1939). The same letter makes it clear that this painting, amongst other works commissioned by Cardinal Chigi as a gift to the French King, was met with gracious approval.

It would appear that the painting was executed not long before it was sent to France, in 1663 or early 1664. It bears clear stylistic similarity to other works of the early 1660s, when Rosa turned on several occasions to the image of Democritus. Salerno (1963) notes that in 1826 the auction of the collection of Lord Radstock included a copy of the *Democritus and*

Protagoras (as *The Fable of the Sticks*) which then entered the collection of the Marquess of Aylesbury.

It has long been thought in the Hermitage that this painting forms a pair with *Odysseus and Nausicaa* (Hermitage Inv. No. 35) and Hermitage publications also suggested that they both came from the Walpole collection. The erroneous notion resulted from two factors; the relative similarity in dimensions (the *Odysseus* measures 194.5 x 144, having been enlarged when it was transferred to a new canvas) and style, and because in the 1773-85 catalogue the entry relating to the *Odysseus* is close to those recording the acquisitions from the Walpole collection.

S. V.

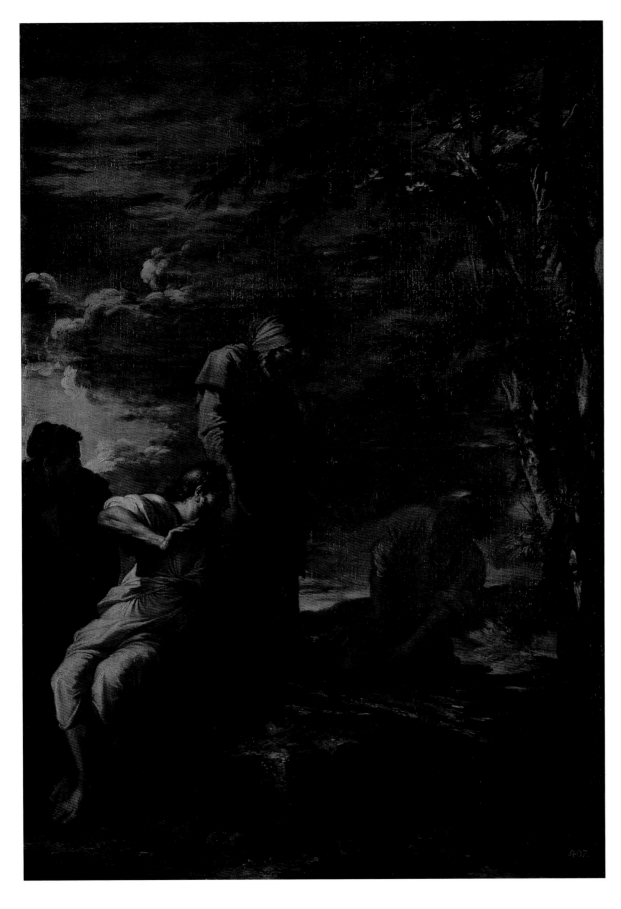

76

SALVATOR ROSA (1615-73)
Portrait of a Man
Oil on canvas, 78 x 64.5
Inv. No. 1483
PROVENANCE: Sir Robert Walpole, 1736 Grosvenor St (Drawing Room), later Houghton (Common Parlour); 1779 Hermitage.
LITERATURE: *Aedes* 1752, p. 48 (as 'A Man's Head'); 2002, no. 49; Boydell I, pl. XL ('A Captain of Banditti'); Hand 1827, p. 280; Schnitzler 1828, pp. 49, 131; Nagler 1835-52, vol. 13, p. 379; Livret 1838, p. 284, no. 48; Viardot 1852, p. 307; Cats. 1863-1916, no. 225; Waagen 1864, p. 84; Bode 1882, Part 10, p. 11; Thieme-Becker 1907-50, vol. 29, p. 2; Ozzola 1908, pp. 95-96; Ozzola 1909, p. 566; Voss 1924, p. 572; Salerno 1963, p. 120, no. 27; Italian Painting 1964, no. 156; Baroque and Rococo 1965, no. 12; Bénézit 1976, vol. 9, p. 85; Salerno 1975, p. 92, no. 98; Znamerovskaya 1978, p. 78; Vsevolozhskaya 1981, no. 183; Scott 1995, p. 59.
EXHIBITIONS: 1938 Leningrad, no. 166; 1968-69 Belgrade, no. 9; 1972d Leningrad, no. 381; 1973 Budapest, no. 6; 1979-80 Melbourne-Sydney, no. 10; 1987 New Delhi, no. 39; 1990 Milan, no. 27; 1993-94 Tokyo-Mie-Ibaraki, no. 25; 1996-97 Norwich-London, p. 95, no. 11.

In the eighteenth and early nineteenth centuries, this portrait was variously entitled *Italian Robber, Brigand Captain*, and *Portrait of a Bandit*, which can be explained by the sitter's exotic costume. This romantic interpretation of the subject derives from the annotation in Boydell's album, *A Captain of Banditti*. In the *Aedes* the work is simply called *A Man's Head,* and in the Hermitage 1773-85 catalogue *Portrait d'homme*.

Leandro Ozzola (1908) identified the picture as a self-portrait of the artist painted, according to Baldinucci, for the Florentine Girolamo Signoretti: 'A Girolamo Signoretti, nostro cittadino, fece ... e ancora donogli un ritratto di se stesso, vestito in abito di Pascariello, con guanti stracciati, quadro, che passò poi alle mani del serenissimo cardinale Leopoldo di Toscana' (Baldinucci 1681-1728). Voss (1924) supported Ozzola's opinion, and although it has subsequently not gone unchallenged it should not be dismissed. The stiff frontal pose of the sitter, gazing directly out at the viewer certainly suggests a self-portrait painted with the aid of a mirror. There is also a certain similarity in the facial features with known self-portraits of Salvator Rosa, one of which appeared on the art market in 1992 (Christie's, London, 15 April 1992, lot 45) as a self-portrait of Rosa dressed as Pascarello painted for Signoretti (Scott 1995). The present author has not seen that painting and cannot comment on its relevance to the Hermitage portrait.

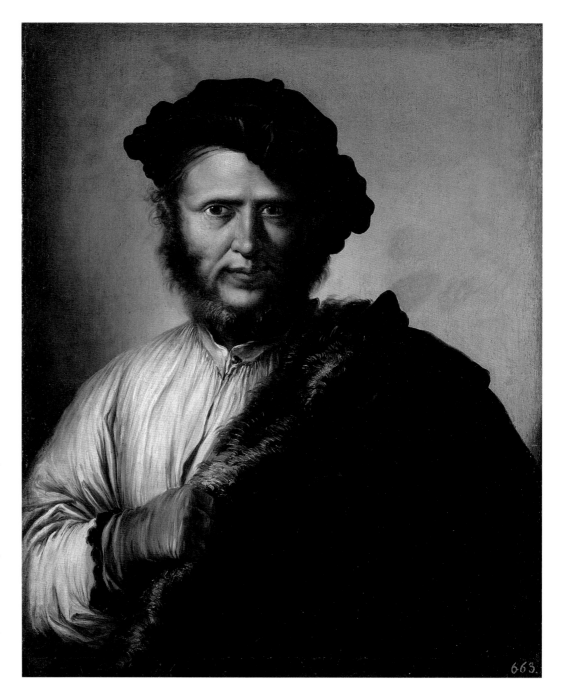

Salerno (1963), however, does not accept the Hermitage picture as a self-portrait. Attention should be drawn to the close likeness between the man in the Hermitage canvas and the sitter in a painting in the collection of K. Davies, London (reproduced in Salerno 1975, no. 119). In the London portrait the man is older, with grey hair, but he has the same beard and a very similar beret.

The work is thought to date from the Rosa's Florentine period c.1640.

S. V.

77

SALVATOR ROSA (1615-73)
The Prodigal Son
Oil on canvas, 253.5 x 201, monogram signature of intertwined letters in bottom right corner: *SR*
Inv. No. 34
PROVENANCE: coll. Robert Gear, Wilton; Sir Robert Walpole, 1736 Houghton (Marble Parlour, then Gallery); 1779 Hermitage.
LITERATURE: *Aedes* 1752, p. 80; 2002, no. 228; Boydell I, pl. VIII; II, pl. XXXII; Baldinucci 1681-1728, vol.

5, pp. 444-45; Georgi 1794, p. 464 (1996 edition, p. 352); Labensky 1805-9, vol. 2, bk. 4, pp. 23-24; Gilpin 1809, pp. 57-58; Swignine 1821, p. 25 (Russian edition 1997, p. 244); Hand 1827, p. 281; Schnitzler 1828, pp. 29, 131; Réveil 1828-31, vol. 10, no. 711; Nagler 1835-52, vol. 12, p. 316, no. 15 (Ravenet); vol. 13, p. 379; Livret 1838, p. 32, no. 29; Viardot 1844, p. 486; Viardot 1852, p. 307; Cats. 1863-1916, no. 220; Waagen 1864, pp. 83-84; Bode 1882, Part 12, p. 11; Penther 1883, p. 41; Thieme-Becker 1907-50, vol. 29, p. 2; Ozzola 1908, pp. 155-56; Ozzola 1909, p. 572; Réau 1912, p. 392; Stanghellini 1914, pp. 105-6; Voss 1924, p. 572; Vertue, vol. VI, 1948-50, p. 180; Cat. 1958, vol. I, p. 168; Salerno 1963, pp. 45, 78, 123, no. 37; Italian Painting 1964, no. 157; Bénézit 1976, vol. 9, p. 85; Stampfle, Bean 1967, p. 70; Pigler 1974, vol. 1, p. 369; Maratti 1975, p. 87, no. 54; Salerno 1975, p. 95, no. 127; Cat. 1976, p. 129; Mahoney 1977, pp. 103, 377, 378, 379, 380; Znamerovskaya 1978, p. 84; Vsevolozhskaya 1981, no. 184; Levinson-Lessing 1986, pp. 89, 280; Herrmann 1999, p. 81.

Salvator Rosa's *Prodigal Son* gained wide fame as early as the eighteenth century thanks to several engravings made of it (the first published in Boydell's *Most Capital Paintings...*, I, 41) and to Horace Walpole's comments in the introduction to the *Aedes* (p. xxvii): 'In Lord Orford's Prodigal is represented the extremity of Misery and low Nature; not foul and burlesque, like Michael Angelo Caravaggio; nor minute, circumstantial, and laborious, like the Dutch Painters.'

As Herrmann (1999) has noted, Sir Robert Walpole was prepared to go to great lengths to secure pictures and 'the prices he paid were often record ones of the period: £500 for Salvator Rosa's Prodigal Son.'

Many nineteenth-century commentators described the painting as one of Rosa's most famous works which makes Leandro Ozzola's suggestion in his monograph (1908) that the Hermitage *Prodigal Son* might be a copy from a now unknown ('di cui non si hanno più notizie') canvas, produced by the artist for Agostino Correggio, all the more surprising. Although the following year Ozzola (1909) admitted that he only knew the work from a photograph, his doubts reverberated in the following decades (see, for instance, Stanghellini 1914). It is now generally recognised that the Walpole picture is that which, according to Filippo Baldinucci (1681-1728), was in the possession of Agostino Correggio in Rome.

Luigi Salerno (1963) suggested that the *Prodigal Son* was inspired by an engraving by Dürer ('L'immagine del Figliol prodigo, inginocchiato fra le bestie, si ispira ad una nota incisione di Dürer, e che realizzasse qualcosa di più della pura pittura di genere ci è attestato dall'entusiasmo del Walpole').

On the basis of a preparatory drawing for the composition (Metropolitan Museum of Art, New York;

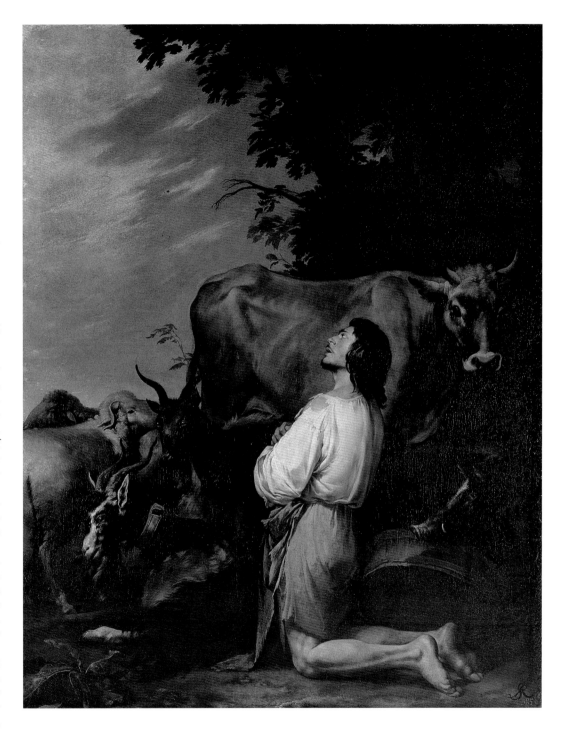

from the collection of Mariette) which also shows the pose of the young man in the landscape as he appears in the painting, this work should be dated to the first half of the 1650s. In the final picture, however, some of the details were altered. At one stage there was a sheet of sketches for the animals in the Odescalchi collection. Stampfle and Bean (1967) link two further drawings in the British Museum (Inv. Nos P.p.5-105 and P.p.5-107) with Rosa's *Prodigal Son*.

Most scholars believe that the picture in the Harrach collection (Rohrau, Austria, formerly Vienna) in the early twentieth century was a copy (with alterations) of the Hermitage picture. Part of the picture was engraved in 1766 by Richard Earlom as the 'head of a young man'.

S. V.

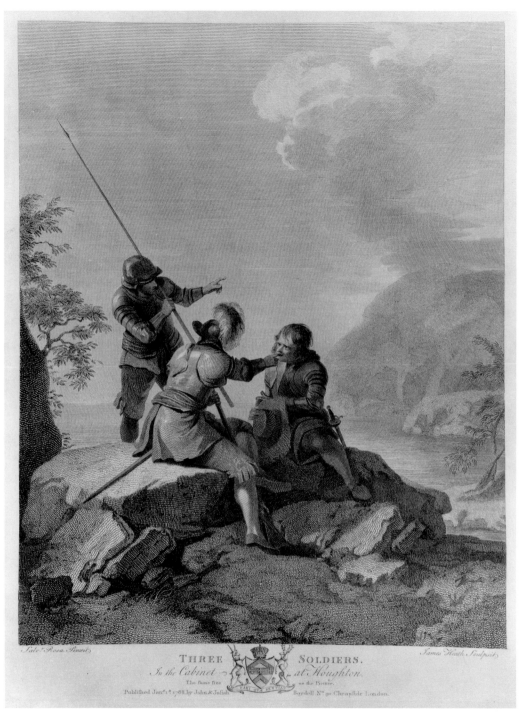

testa in piccolo con tre soldati sopra lo scoglio' (Rudolph 1995, p. 215, App. II, no. 71).

We should also note that Livret 1838 (p. 36, no. 3) mistakenly gave a Walpole provenance to a painting by Salvator Rosa (now in the Pushkin Museum of Fine Arts, Moscow) depicting four soldiers playing dice, which in fact came from the Pierre Crozat collection This error was repeated by Waagen (1864, p. 87, no. 223).

It is possible that Rosa's lost painting might still bear its Hermitage numbers '2904' on the front (as in Cat. 1797) and '5510' on the back (Inventory 1859), as well as its Gatchina inventory number on the back 'G 39022'. These numbers may eventually help to identify the picture.

Now known only from the print for Boydell's *Set of Prints . . .* engraved by James Heath.

S. V.

78

SALVATOR ROSA (1615-73)
Three Soldiers
Oil on panel, c.30 x 24
PROVENANCE: Sir Robert Walpole, 1736 Downing St (Lady Walpole's Drawing Room), later Houghton (Cabinet); 1779 Hermitage; from mid-19th century at Gatchina Palace; disappeared from the Palace during the Second World War; whereabouts unknown.

LITERATURE: *Aedes* 1752, p. 68; 2002, no. 165; Boydell II, pl. LX; Hand 1827, p. 286; Nagler 1835-52, vol. 13, p. 379.

It is possible that this painting may be identical with that in the collection of Marchese Niccolò Maria Pallavicini. In the inventory of his collection made in 1714 an anonymous composition with a similar subject and of similar size is listed as 'Un altro da mezza

79

ANDREA SACCHI (1599-1661), attributed to
Venus Resting in a Landscape
Oil on canvas, 58 x 76.5
Inv. No. 127
PROVENANCE: coll. Charles Jervas; 1739 acquired by Sir Robert Walpole at sale of Jervas collection for £52.10 (lot 401; Moore ed. 1996, p. 52; *Aedes* mistakenly gives the source as coll. Lord Halifax); Sir Robert Walpole, Houghton (Common Parlour); 1779 Hermitage.

LITERATURE: *Aedes* 1752, p. 45 (as 'Venus bathing, and Cupids with a Car, in a Landscape, by Andrea Sacchi'); 2002, no. 33; Boydell I, pl. XVII ('Venus Bathing & Cupids'); Ripley 1760, p. 2; Hand 1827, pp. 261-62; Nagler 1935-52, vol. 14, p. 132; Livret 1838, p. 240, no. 14; Cats. 1863-1916, no. 210; Waagen 1864, p. 81; Voss 1924, p. 690; Posse 1925, p. 17, 18; Refice 1950, p. 220; Cat. 1958, vol. I, p. 95; Bénézit 1976, vol. 9, p. 216; Cat. 1976, p. 93; Sutherland Harris 1977, p. 109, no. R.10; Moore ed. 1996, p. 52.

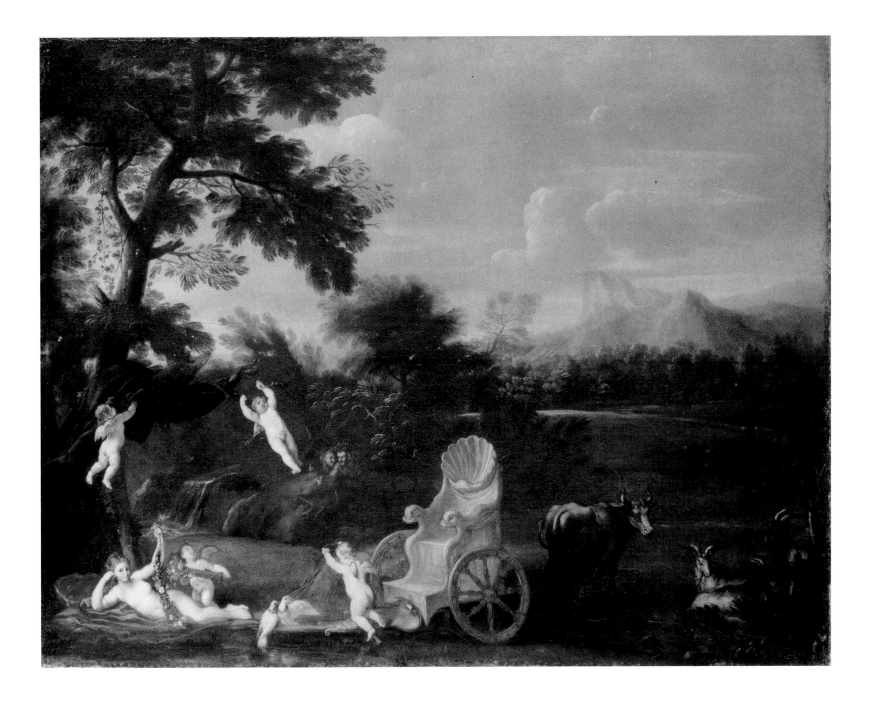

Until the early twentieth century the attribution to Sacchi was unchallenged although Waagen (1864) noted that this work was in the spirit of Albani, without rejecting the traditional attribution. Liphart, citing the opinion of Gustavo Frizzoni, included the work in the 1911 and 1916 catalogues as the work of Domenichino, an attribution which was retained (with some doubts) in the 1958 and 1976 Hermitage catalogues. Voss (1924) and Posse (1925) both reverted to the notion that it was an early work by Sacchi in the style of Albani.

There is little evidence to support this attribution since there is no landscape in Sacchi's oeuvre that could be compared with this painting. Worth noting, however, is the interesting opinion of Ann Sutherland Harris (1977), who attributes the picture to Giovanni Francesco Grimaldi (1606–80), although she states that 'it is possible that the figure staffage records a lost Venus by Sacchi formerly in the collection of Cardinal Mazarin'. Sutherland Harris sees the closest parallels to *Venus Resting in a Landscape* in 'the four exquisitely finished copper landscapes by Grimaldi in the Borghese Gallery in Rome.'

S. V.

80

ANDREA DEL SARTO (1486-1531)
The Holy Family
?Oil on panel. c.140 x 104
PROVENANCE: coll. Marchese de Maria, Genoa; Sir Robert Walpole, 1736 Downing St (Sir Robert's Dressing Room), later Houghton (Salon); 1779 Hermitage; whereabouts unknown.
LITERATURE: *Aedes* 1752, p. 56; 2002, no. 91; Vertue, vol. V, 1937-38, p. 125; Chambers 1829, vol. I, p. 526.

Listed as no. 2256 among the Walpole paintings in the Cat. 1773-85 as 'Andrea del Sarto. Une Ste. Famille. Outre la Vierge et l'Enfant, on y voi encore St. Jean tenu par sa Mère devant le petit Jésus; derrière la Vierge sont deux anges. Beau Tableau où l'on reconnaît le grand dessinateur et le bon Coloriste. Sur bois, 1 ar. 15½ v. X 1 ar. 7½ v.' (c.140.1 x 103.38). These dimensions are irreconcilably at odds with the picture listed in the *Aedes* whose dimensions are given as 3'1" x 2'7" (94.61 x 79.37).

The 1797 catalogue (no. 589) lists a painting with dimensions matching those in earlier Cat. 1773-85, i.e. 1 *arshin* 15 *vershki* x 1 *arshin* 7[?] *vershki* (c.140 x 104.5). The 1797 catalogue noted that the picture was 'in Studio', indicating that the painting was with the restorers, probably for transference from panel to canvas, as was then common practice. The painting is not mentioned in later catalogues and its present whereabouts are unknown.

The Walpole MS of 1736 (pp. 13-14) lists a *Holy Family* by Andrea del Sarto at Downing Street, in Sir Robert Walpole's Dressing Room, 'An Holy Family on Board. Andrea del Sarto – 4'7"x 3'4"'. These measurements (c.140 x 103 cm.) equate with those given in Cat. 1773-85. The confusion with dimensions is resolved when we look at the 1st edition of the *Aedes* (1747), which gives measurements in accordance with the painting as listed in Walpole MS 1736 and in Hermitage catalogues. The new measurements given in the 2nd edition of the *Aedes* in 1752 must be open to doubt. Vertue (vol. VI, 1948-50, p. 175) also mentions 'a Madonna and Elisabeth – holy Family. Andrea del Sarto' at Whitehall but fails to provide dimensions. He may well be referring to the same painting.

The *Holy Family* in Cat. 1773-85 is probably that from the Walpole collection, which had previously hung at Downing Street. The painting was valued at £250 when sold.

T. K.

Not reproduced

81

SASSOFERRATO (GIOVANNI BATTISTA SALVI) (1609-85)
The Virgin and Child
Oil on canvas, 73 x 60
Inv. No. 1506
PROVENANCE: Palazzo Zambeccari, Bologna; Sir Robert Walpole, Houghton (Gallery); 1779 Hermitage.
LITERATURE: *Aedes* 1752, p. 96 (as by 'Dominichino'); 2002, no. 275; Boydell II, pl. XXXV; Labensky 1805-9, vol. 2, bk. 4, p. 6; Hand 1827, pp. 222-23; Schnitzler 1828, pp. 49, 130; Livret 1838, p. 73, no. 42; Cats. 1863-1912, no. 260; Waagen 1864, p. 89; Bode 1882, Part 14, p. 10; Penther 1883, p. 44; Thieme-Becker 1907-50, vol. 29, p. 362; Voss 1924, p. 516; Cat. 1958, vol. I, p. 173; Bénézit 1976, vol. 9, p. 258; Cat. 1976, p. 133; Brownell 2001, pp. 28-34.

Horace Walpole acquired this painting in Bologna in 1741-42 with the help of the English painter Edward Penny (1714-91) for 300 doppie, i.e. c.£225 (HWC 17, pp. 226-68) as the work of Domenichino, under whose name it was listed in the *Aedes*. Brownell (2001) relates in detail the interesting story of its acquisition, noting how — even then — the attribution was doubted by specialists, amongst them the celebrated Bolognese painter Donato Creti, who all thought the picture a copy after Domenichino. After *The Virgin and Child* arrived in Florence from Bologna, Horace Mann wrote to Walpole on 6 November 1743 (HWC 18, p. 93): 'on my unpacking it I found on the back Sasso-Ferrato' and a few months later on 18 February 1743 (HWC 18, p. 162) he writes conspiratorially, 'I have scratched out the odious name myself so well that nobody can have the least suspicion.' This took place prior to despatching the painting to England, and it arrived at Houghton Hall later that year.

The picture was engraved by Valentine Green (1777) and Louis Le Saillard (1782) as by Domenichino, but Munich listed it in the 1773-85 Hermitage catalogue (no. 2248) as the work of Sassoferrato, on the basis that 'Tous les connaisseurs conviennent qu'il est du Sassoferrato et ne l'en estiment pas moins'. Henceforth the attribution remained unchanged, although Penther (1883) suggested that it may be by Pierre Mignard.

Confirming the authorship of Sassoferrato, Voss (1924) mentioned three versions of the composition: that in the Hermitage, one in the Church of Santa Maria Formosa in Venice, and one in the Pinacoteca in Turin. Pierre Rosenberg suggested that all these works attributed to Sassoferrato are in fact copies from a painting by Pierre Mignard, as an engraving of a similar composition by François de Poilly bears the inscription 'P. Mignard pinxit Romae' (see Rosenberg, *Inventaire des collections publiques françaises, 14. Rouen-Musée des Beaux-Arts. Tableaux français du XVII-ème siècle et italiens des XVII-ème et XVIII-ème siècles*, Paris, 1966, no. 90). In

addition to the de Poilly engraving mentioned by Rosenberg there are other prints in which the author of a similar composition is named as Pierre Mignard, including an oval print published by the Poilly brothers and others by Abraham Blooteling and by Rocco Pozzi (Nagler 1835-52, vol. 12, p. 7, no. 7). Mignard's composition may have been used by Sassoferrato, whose work contains other instances of borrowings both from Mignard and from other masters.

A painting like that from the Walpole collection was in the late nineteenth and early twentieth century in the collection of Ernst Liphart at Ratshof, near Derpt (now Tartu, Estonia). The Musée des Beaux-Arts, Rouen, has a similar version, differing only in the depiction of the Virgin, who is thought to have been copied from Mignard.

We should note that in Boydell II the signature beneath the engraving reads *Val. Green*, although the explanatory text to the prints gives the author as Saillard. Louis Le Saillard was in fact the author of a later engraving in 1782, made when the picture was already in the Hermitage.

S. V.

82

?MICHELE SEMINI (fl. c.1700)
Galatea
Oil on canvas, c.149 x 191.2
PROVENANCE: Sir Robert Walpole, 1736 Houghton (Coffee Room); 1779 Hermitage; from the mid-19th century in the Tauride Palace, St Petersburg; then Catherine Palace, Tsarskoye Selo (Pushkin); disappeared during the Second World War; whereabouts unknown.
LITERATURE: *Aedes* 1752, p. 44 (as by 'Zimeni'); 2002, no. 25; Vilchkovsky 1911, p. 116; Wrangell 1913, p. 157, no. 1093; Lukomsky 1918, p. 78; Golerbakh 1922, p. 36; Yakovlev 1926, p. 64; Vertue, vol. VI, 1948-50, p. 177; Catherine Palace 1940, p. 29; Lemus et al 1980, pp. 26, 27; Combined Cat. 1999, p. 111, no. 1280.

In the *Aedes* and the 1773-85 catalogue this work is attributed to Zimeni, although the Christie's manuscript list of paintings in the Walpole collection (Christie's Sale List) gives it to Simoni. In the 1773-85 catalogue (no. 2362) it is described as 'Tableau médiocre d'un peintre dont on n'a pu trouver le nom dans les auteurs Iconographes', and its dimensions are given as 2 *arshin* 1 *vershki* x 2 *arshin* 11 *vershki* (c.149 x 191.2). Here too the initial 'M' is placed before the

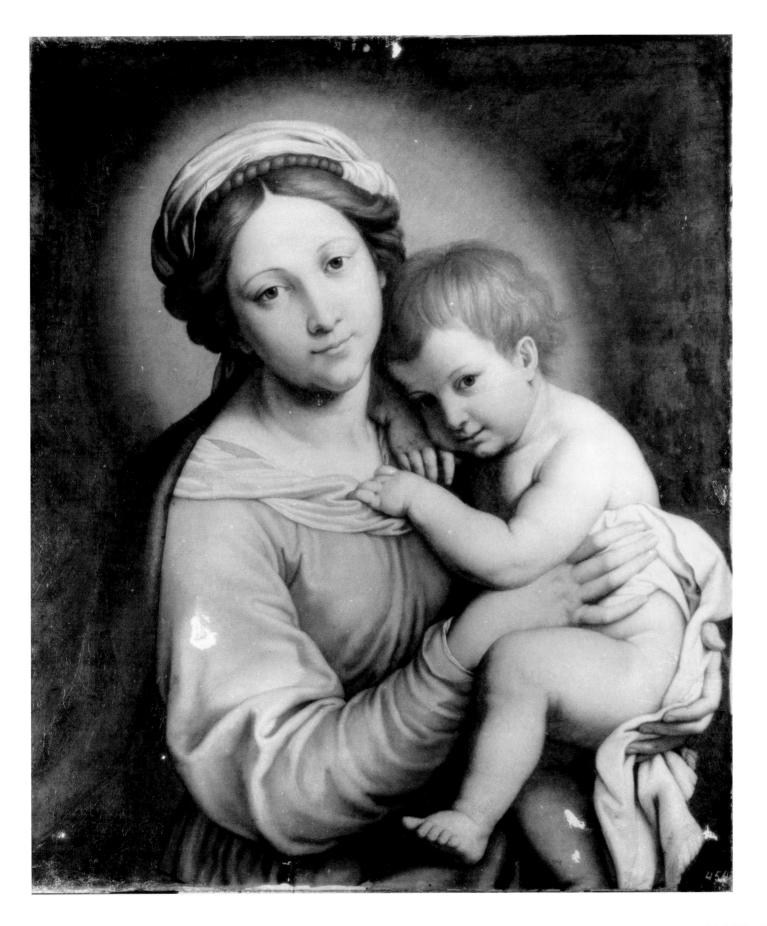

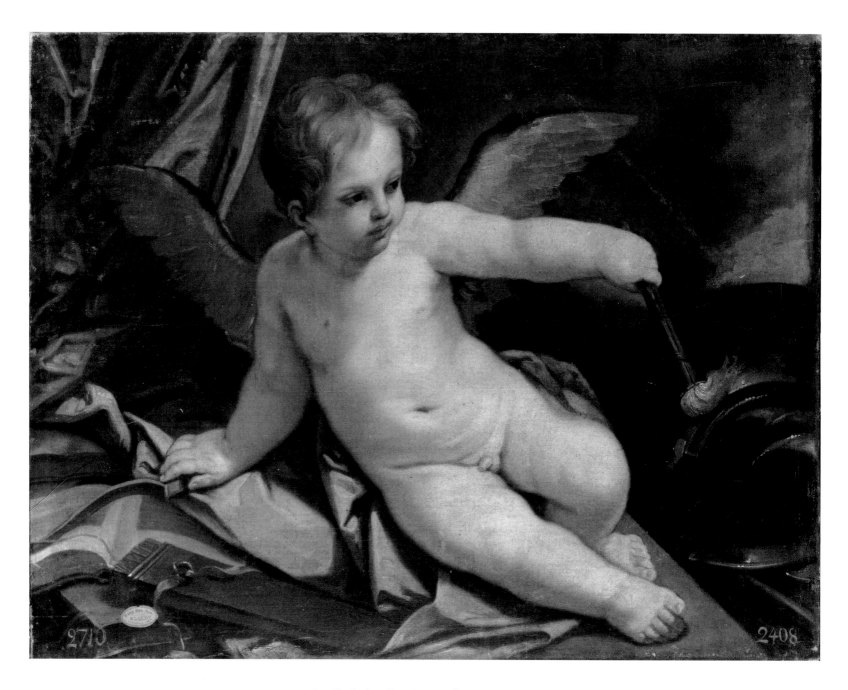

name Zimeni which does not appear in the *Aedes* or in any of the lists of the sale. This possibly suggests that there may have been a signature on the picture. The signature was probably only partly legible and could be read in different ways. It may point to the artist Michele Semini, a pupil of Carlo Maratti as the author. Nagler (1835-52, vol. 16, p. 235) states: 'Er malte Bilder, die aber dem Meister oder anderen Kunstlern beigelegt werden.'

In the Hermitage manuscript catalogues, *Galatea* was thought to be a pair to *The Rape of Europa*, a copy after Guido Reni by Pietro de' Pietris (cat. no. 61). Both were assigned for sale in 1854 when Nicholas I rationalised the Hermitage collections (Wrangell 1913), but they remained unsold and were relegated to the Tauride Palace in St Petersburg and then to the Catherine Palace at Tsarskoye Selo, outside the city, where they were set into the staircase ceiling. Lukomsky (1918) describes both canvases as 'Copies from the paintings by Guido Reni, The Rape of Europa and Galatea'. The Catherine Palace Museum listed the painting in 1940 as the work of an unknown eighteenth-century Italian master and gives the subject as *Amphitrite on Dolphins*. Judging by the description in the 1773-85 catalogue ('C'est la representation de Galathée couchée dans une Conque marine attelée de deux Dauphins'), it could indeed have been mistaken for a depiction of Amphitrite, but the present author chooses to retain here the subject (from Ovid, *Metamorphoses*, XIII, 750-897) as identified in the *Aedes*.

We should note that Vertue's notebooks for 1739 (Vertue, vol. VI, 1948-50) record two paintings at Houghton Hall, *Europa Carried on the Bull* and *Galatea*, by Guido ('fig as big as the life') and it is entirely likely that this and its companion are the two pictures to which he refers.

S. V.

Not reproduced

83

ELISABETTA SIRANI (1638–65)

Cupid Burning the Weapons of Mars

Oil on canvas, 67 x 84.5, inscription on the back, on
the stretcher: *Elisabetta Sirani Fe.*

Inv. No. 2584

PROVENANCE: Sir Robert Walpole, 1736 Downing St
(End Room Below, as 'Divine Love burning the
Arrows of Impure Love, school of Caracci'), later
Houghton (Gallery); 1779 Hermitage; from the mid-
19th century to 1926 at Gatchina Palace, Gatchina;
1926 returned to the Hermitage.

LITERATURE: *Aedes* 1752, p. 85 (as 'Cupid burning
Armour'); 2002, no. 240; Boydell II, pl. XXXIV;
Hand 1827, p. 220; Nagler 1835–52, vol. 16, p. 462;
Livret 1838, pp. 51–52, no. 65; Liphart 1916, p. 19;
Cat. 1958, vol. I, p. 177; Cat. 1976, p. 134.

In Sirani's notes (Malvasia 1678 [ed.1841], vol. 2, p.
396) several pictures depicting Cupid are mentioned.
Amongst these is a 'Cupid with a torch' and another
'Cupid with weapons', but neither composition is
compatible with the Hermitage picture. Malvasia,
however, states that the notes refer only to those pic-
tures which were put up for sale through the artist's
father, Andrea Sirani, while those sold by her mother
were not included in the list.

<div align="right">S. V.</div>

84

ALESSANDRO TURCHI (ALESSANDRO VERONESE OR
L'ORBETTO) (1578–1649)

The Virgin and Child

?Oil on *paragone*, 20.1 x 16.6

PROVENANCE: Sir Robert Walpole, 1736 Downing St
(Lady Walpole's Drawing Room), later Houghton
(Cabinet); 1779 Hermitage; from the mid-19th cen-
tury in the Catherine Palace, Tsarskoye Selo
(Pushkin); 1929 transferred to Antikvariat for sale;
whereabouts unknown.

LITERATURE: *Aedes* 1752, p. 68; 2002, no. 164; Boy-
dell II, pl. LVI.

The *Aedes* states that this picture was painted on black
marble, although the 1797 Hermitage catalogue merely
records that it was 'on stone'. Since Turchi often painted
on slate it seems possible that this medium was the base.

Although not seen since 1929, the painting may still
retain its Hermitage numbers which would prove the
key to its identification. It should bear the number
'444' on the front (as per Cat. 1797) and '4697' on the
back (1859 Inventory).

The painting is now known only from the Boydell
print, engraved by Picot, published 1 January 1784.

<div align="right">S. V.</div>

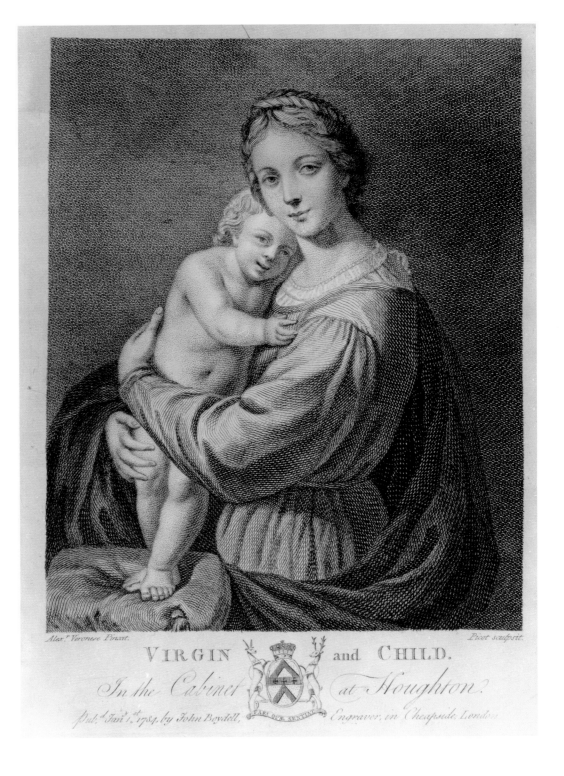

Alex.ʳ Veronese Pinxt. Picot sculpsit.

VIRGIN and CHILD.

In the Cabinet at Houghton.

Pub.ᵈ Jan.ʸ 1.ˢᵗ 1784 by John Boydell, Engraver, in Cheapside, London

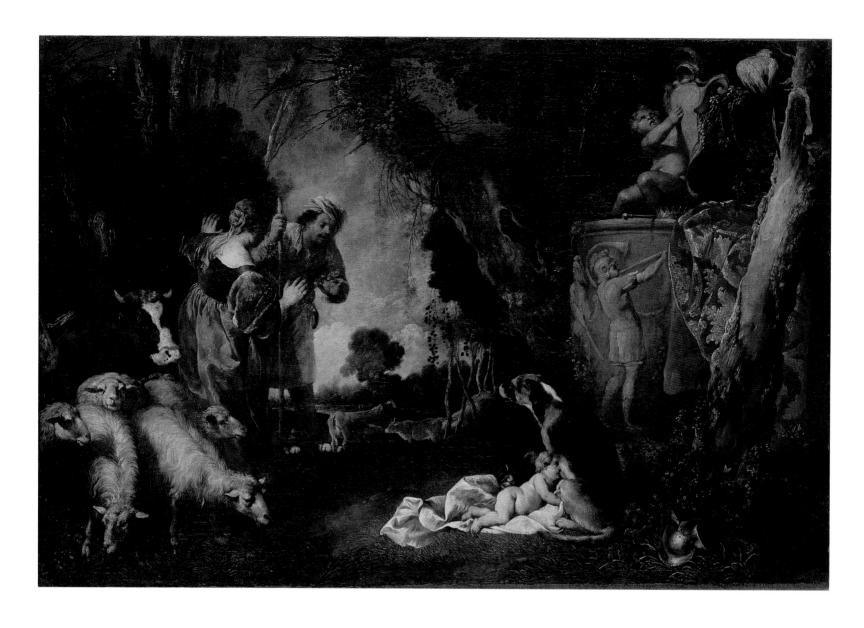

85

Antonio Maria Vassallo (1620–c.1664)
The Exposition of King Cyrus
Oil on canvas, 74.5 x 110
Inv. No. 221
PROVENANCE: Sir Robert Walpole, 1736 Downing St
(Sir Robert's Dressing Room, as by 'Castiglione'),
later Houghton (Gallery); 1779 Hermitage.
LITERATURE: *Aedes* 1752, p. 86 (as by 'Castiglione');
2002, no. 247; Boydell II, pl. XXVIII; Martyn 1766,
pp. 66-67; Gilpin 1809, p. 60; Hand 1827, p. 295;
Livret 1838, p. 216, no. 61; Viardot 1844, p. 472;
Viardot 1852, p. 295; Cats. 1912–16, no. 1928;
Liphart 1912a, pp. 22-23; Grosso 1922/23, pp. 511,
514; Lasareff 1930, p. 104; Delogu 1931, fig. 53; Cat.
1958, vol. I, p. 20; Italian Painting 1964, no. 150;
Wipper 1966, p. 113; Pittura a Genova 1971, pp. 165,

335; Percy 1971, p. 53; Cat. 1976, p. 81; Vsevolozh-
skaya 1981, no. 171; Pittura a Genova 1987, pp. 146,
303; Hermitage 1989, no. 35; Krawietz 1990, p. 192,
note 2; Gavazza, Lamera, Magnani 1990, p. 438.
EXHIBITIONS: 1992 Frankfurt-am-Main, no. 69.

When in the Walpole collection, *The Exposition of
King Cyrus* was thought to be the pair to the *Bac-
chus/Orpheus* (now Pushkin Museum of Fine Arts,
Moscow; cat. no. 86). However, they can hardly have
been conceived as a pair since there is no direct link
between the subjects: the subject of *The Exposition of
King Cyrus* is from Herodotus, *Historia*, I, 122 and
Justinus, *Epitoma Historiarum Philippicarum*, I, 4-10,
and that of *Orpheus* from Ovid's *Metamorphoses*, X,
86-105.

Both canvases were attributed to Giovanni Benedetto
Castiglione until the early twentieth century, when
Liphart (1912a) discovered on the *Bacchus/Orpheus* a half-
erased inscription, Ant. M. Vassallo. Some sources mis-
takenly suggest that the signature was found on *The Expo-
sition of King Cyrus* or that both pictures are signed.

It is interesting to note that the 1736 manuscript cat-
alogue (Walpole MS 1736) lists two pairs of works in
the Walpole collection under the name of Castiglione:
'The Exposition of Cyrus' and 'Its Companion a Man
with Cattle' (ff.11-12, dimensions 2'8" x 3'2"); and
'Cyrus found, suckled by a Wolf' – 'Its companion. The
subject is taken from the 19th Ode of the Second Book
of Horace' (ff.15-16). These latter are clearly the works
now considered to be by Vassallo. It is therefore unclear
which canvases were seen in 1722 by Vertue (vol. III,

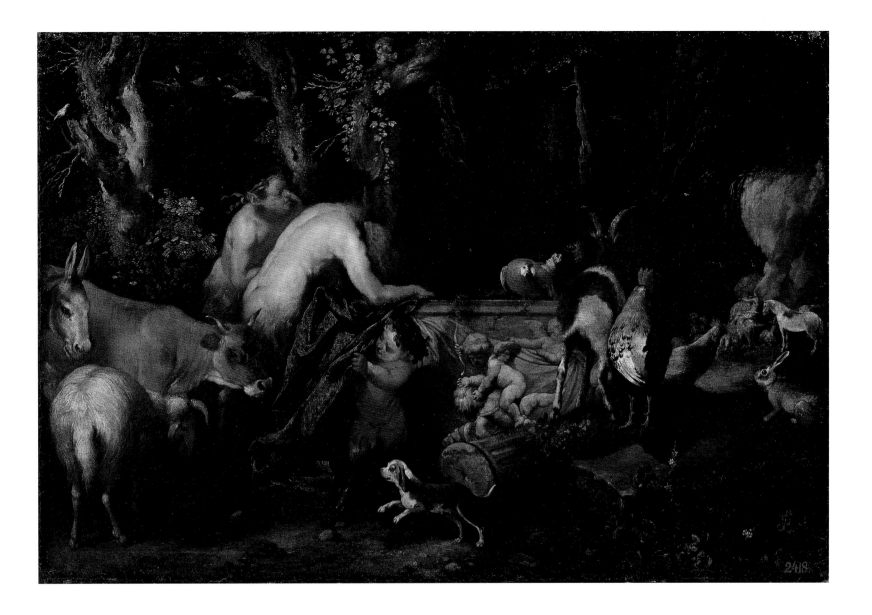

86

1933-34, p. 9) 'at Mr. Walpole's ... 2 fine paintings of Castiglione. especially one'.

Vassallo's *Exposition of King Cyrus* was clearly inspired by Castiglione's versions of the same subject in the Palazzo Durazzo Pallavicini, Genoa and in the National Gallery of Ireland, Dublin.

According to Newcome Schleier (1992 Frankfurt-am-Main, no. 69), these paintings by Vassallo date from his mature years in the 1640s-1650s. Schleier (*ibid.*) also mentions another picture of *The Exposition of King Cyrus* with an altered landscape in the background ('Ein späteres? Bild'), which appeared at auction at Drouot in Paris on 26 June 1992 (lot 6, 77 x 112). Several years ago a composition identical to the Hermitage picture (probably a copy) passed through the art market in Lyon.

S. V.

Antonio Maria Vassallo (1620-c.1664)
Orpheus
Oil on canvas, 75 x 110, signed bottom, on the fragment of stone: *Anto Ma Vassl/P*
Pushkin Museum of Fine Arts, Moscow, Inv. No. 2672
PROVENANCE: Sir Robert Walpole, 1736 Downing St (Sir Robert's Dressing Room, as by 'Castiglione'), later Houghton (Gallery); 1779 Hermitage; 1930 transferred to Museum of Fine Arts (now Pushkin Museum of Fine Arts), Moscow.
LITERATURE: *Aedes* 1752, p. 87 (as by 'Castiglione'); 2002, no. 248; Boydell II, pl. XXIX; Gilpin 1809, p. 61; Livret 1838, pp. 204-5; Viardot 1844, p. 472; Liphart 1912a, pp. 22-23; Cats. 1912-16, no. 1927; Grosso 1922/23, p. 510; Lazarev 1930, p. 20; Lasareff 1930, p. 104; Delogu 1931, p. 59; Pushkin Museum 1938, p.

110; Pushkin Museum 1948, p. 15; Pushkin Museum 1957, p. 23; Pushkin Museum 1961, p. 32; Wipper 1966, p. 113; Pushkin Museum 1986, p. 40; Markova 1992, pp. 238-39; Pushkin Museum 1995, pp. 140-41.
EXHIBITION: 1997 Tokyo–Tendo–Okasaki–Akita.

In the Walpole collection this work was mistakenly considered a pair to *The Exposition of King Cyrus* (cat. no. 85). Both were attributed to Benedetto Castiglione but Vassallo's authorship was established by A. Trubnikov (Liphart 1912a), who discovered the signature on the work now in Moscow.

The subject of the Moscow picture, from Ovid's *Metamorphoses*, X, 86-105, has led to much controversy. The centre of the composition is dominated by beasts and fauns set in richly wooded vegetation, while the

figure of Orpheus himself is barely decipherable in the depths. This perhaps explains why in the *Aedes* Horace Walpole stated decisively: 'The Subject ... seems at first to be the story of Orpheus, but certainly is not, from the principal Figure's being thrown into the distant Landscape.' Horace Walpole noted that his father guessed that the subject was taken from Horace's 19th Ode, book II, and quoted lines which suggest that Bacchus is the subject. Such an insistent rebuttal of the Orpheus theory, however, suggests that the Orpheus interpretation had been accepted well before the painting arrived in the Walpole collection. We should note that Richard Earlom's engraving for Boydell also gives the title as *Orpheus*. Gilpin, who visited Houghton Hall in 1769, also drew attention to the confusion: 'The subject of it certainly obscure. ... There are some objects, a cow, a dog disagreeably introduced: but everything else is beautiful' (Gilpin 1809).

Liphart (1912a) gave the painting the title *Bacchus*. In Hermitage catalogues published after 1912, the authorship of Vassallo remains unquestioned, yet the title changes several times from *Orpheus in the Underworld* (1914) to *Satyrs and Animals Listening to Orpheus's Song* (1916). Grosso (1922/23) and Lasareff (1930) also published the work with the title *Orpheus*, but in later catalogues and guides to the Hermitage and the Pushkin Museum of Fine Arts we also find it described otherwise, the most frequent variation being *Scene with Fauns*.

Very litte information about Vassallo's life and work has survived. There are just two religious subject paintings by the artist which bear the dates 1637 and 1648 respectively, clearly insufficient to establish a firm chronology. Vassallo studied under the Flemish artist Vincent (Vincenzo) Malo, who lived in Genoa and to whom he owed his interest both in the depiction of animals in a landscape and in expressive still-life elements. Vassallo gained renown as a painter of beasts and pastorales (Pittori genovese a Genova 1969, p. 94, no. 38), as in this work from his mature period. The skilled execution and expressive 'hot' colouring in the Walpole *Orpheus* is a typical example of the neo-Venetian tendency widespread in 17th-century Genoese painting.

The same motif, with two satyrs, is repeated in a small *Mythological Scene* in the Galleria di Palazzo Bianco, Genoa (oil on canvas, 53 x 83; Inv. No. 1097; Pagano Galassi 1988, fig. 595).

V. M.

87

PAOLO VERONESE (PAOLO CALIARI) (1528-88) and workshop
The Resurrection
Oil on canvas, 97 x 140
Pushkin Museum of Fine Arts, Moscow, Inv. No. 1607
PROVENANCE: Sir Robert Walpole, 1736 Grosvenor St (Parlour), later Houghton (Marble Parlour); 1779 Hermitage; second half of the 19th century at Gatchina Palace, Gatchina; 1920 returned to the Hermitage; 1928 transferred to Museum of Fine Arts (now Pushkin Museum of Fine Arts), Moscow.
LITERATURE: *Aedes* 1752, p. 73 (as 'The Ascension, by Paul Veronese'); 2002, no. 195; Livret 1838, p. 279, no. 29; Caliari 1888, p. 389; Liphart 1908, pp. 716, 717; Les anciennes écoles 1910, p. 37; Liphart 1915, pp. 7-8; Venturi A. 1929, p. 950; Lazarev 1930, p. 19; Pushkin Museum Guide 1938, p. 102; Pushkin Museum 1948, p. 19; Pushkin Museum 1957, p. 27; Berenson 1958, vol. 1, p. 136; Pushkin Museum 1961, p. 37; Piovene, Marini 1968, no. 348; Fomiciova 1974a; Fomociova 1974b, p. 472; Pignatti 1976, vol. 1, p. 153, no. 268; vol. 2, fig. 611; Fomiciova 1979, p. 135; Fomiciova 1983, p. 123; Pallucchini 1984b, p. 186, no. 217; Pushkin Museum 1986, p. 45; Pignatti, Pedrocco 1991, no. 218; Fomiciova 1992, p. 93; Markova 1992, p. 150, no. 118; Pushkin Museum 1995; pp. 90-91.
EXHIBITIONS: 1908 St Petersburg. no. 227; 1920 St Petersburg, p. 4.

The Gospels do not provide a detailed account of the Resurrection, stating simply that three days after the Crucifixion Christ rose from the dead (Matthew xxviii: 5-7; Mark xvi: 6; Luke xxiv: 6-7). In the aftermath of the Council of Trent, however, the subject began to be depicted as here, with the figure of Christ ascending above the sleeping soldiers posted to guard the tomb.

The attribution to Veronese was not challenged while the picture was in the Imperial collection and in an essay on the paintings at Gatchina, Liphart (1915, pp. 7-8) remarked on the high quality of this picture: 'The figure of Christ is not particularly good, but the face of the Saviour is executed with great beauty and most perfect nobility.' When the picture was transferred to Moscow in 1928 it was still attributed to Veronese but the inventory of the Pushkin Museum records that it was later attributed to an unidentified painter from Verona. Thereafter the attribution has been constantly questioned. Caliari (1888) and Venturi (1929) gave it to Veronese himself while Berenson (1957, 1958) suggested that it was a part studio work. More recently however Fomiciova (1974b), Pignatti (1976), Pallucchini (1984b), Pignatti and Pedrocco (1991, 1995) have all published the work as by Veronese himself although the latter did not exclude the possibility of studio participation in the painting of the secondary figures. The picture

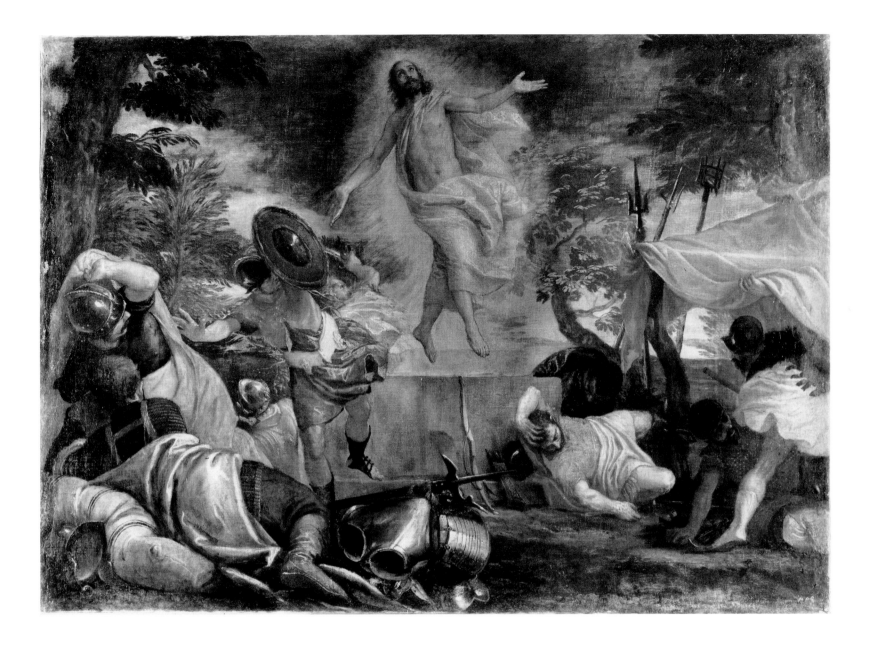

seen as the pair to this, the *Pentecost* (cat. no. 7), also formerly attributed to Veronese, has now been identified as the work of Veronese's pupil Alvise Benfatto del Friso (see Fomiciova 1992, no.58).

Veronese himself is known to have painted several versions of the *Resurrection*, including those in San Francesco della Vigna, Venice, in the Galerie Alte Meister, Dresden (Inv. No. 235) and in the Galleria Palatina, Palazzo Pitti, Florence (Inv. No. 264). All three are vertical in format but they share some features with the Moscow version. In the Dresden canvas, for instance, there is a helmeted soldier to the left with his body turned slightly differently. These works date to the later part of Veronese's career in the 1570s and most scholars believe them to have been painted with studio assis-

tance. Similarities can also be found in another somewhat inferior vertical *Resurrection* in the Hermitage (Inv. No. 2545) formerly given to Veronese (Pallucchini 1984b, p.179, no. 139) and dated to between 1572 and 1576 but now attributed to Alvise Benfatto del Friso (Fomiciova 1992, no.56), in which Christ is in the same pose as in the Moscow picture.

The Walpole picture shares various motifs with all these works, especially in the figure of Christ and the dramatic foreshortening of the soldiers. It is certainly a late work and has been dated to 1580-83 by Pallucchini (1984b) and to 1580 by Pignatti and Pedrocco (Pignatti 1976; Pignatti, Pedrocco 1991 and 1995).

V.M.

88

ANONYMOUS (Venice, 15th-16th century)
The Holy Family
Oil on panel, c.42.3 x 31
PROVENANCE: coll. John Laws; Sir Robert Walpole, 1736 Chelsea (Yellow Damask Bedchamber as by 'John Bellino'), later Houghton (Cabinet); 1779 Hermitage; 1797 in the Hermitage stores; whereabouts unknown.
LITERATURE: *Aedes* 1752, p. 70 (as 'The Holy Family, by John Bellino'); 2002, no. 18.

In Munich's Cat. 1773-85 (no. 2400) as 'Une Sainte Famille. Ce petit morceau précieux pour son antiquité représente la Vierge tenant devant elle l'Enfant Jésus debout sur une table où se voyant une orange coupée par la moitié et un couteau. S. Joseph, ou qui l'on voudra, regarde du dehors par la fenêtre. Il est peint sans barbe, une toque sur la tête et avec un livret posé sur la tablette de la fenêtre. Le fameux Laws fût autrefois possesseur de ce tableau.' The dimensions given are 9 x 7 *vershki* (42.3 x 31).

The 1797 catalogue (no. 553) states that the painting was then in the 5th Store of the Hermitage. It is not mentioned in later Hermitage inventories. It may eventually prove possible to identify the painting with the aid of its number in the 1797 catalogue, a red 553 in the bottom right corner.

I. A.

Not reproduced

89

ANONYMOUS (Venice, 16th-century)
The Virgin and Child with John the Baptist
Oil on panel. c.95 x 80
PROVENANCE: coll. Charles-Jean-Baptiste Fleuriau, Comte de Morville, French diplomat; Sir Robert Walpole, 1736 Houghton (Yellow Drawing Room, as 'Titian', then Salon); 1779 Hermitage; 1862 transferred to Rumyantsev Museum, Moscow; whereabouts unknown.
LITERATURE: *Aedes* 1752, p. 55 (as 'The Holy Family, by Titian'); 2002, no. 87.

The painting was already at Houghton by 1735, when it was seen by Rev. Jeremiah Milles (Milles MS 1735).

In the 1773-85 catalogue this picture is listed as no. 2384 and described as follows: 'Titien Vecelli. Une St. Famille. Pièce digne de trouver place dans les plus belles collections. On y voit la Vierge assise tenant l'Enfant Jésus debout sur ses genoux et devant eux le petit St. Jean, un maillot deroulé dans sa main.' It is not clear from this text why the work was thought to be a Holy Family since there is no mention of St Joseph. The dimensions given are 1 arshin 5 vershki by 1 *arshin* 2 *vershki* (c.95.6 x 80), which corresponds with the dimensions of 3'1" x 2'8" (c.94 x 81.3) recorded in Walpole MS 1736, but not with the 4'7" x 3'4" (c.141 x 103) given in the 1752 edition of the *Aedes Walpolianae*. This is not the only instance of the dimensions provided in the *Aedes* contradicting other sources.

It may eventually prove possible to identify the work with the aid of its inventory numbers, a red 2880 (as per Cat. 1797) in the bottom right corner on the front, or a black 2682 on the back of the canvas (Inventory 1859).

I. A.

Not reproduced

90

ANONYMOUS (Venice, mid-16th-century)
Midas Judging Between Pan and Apollo
Oil on canvas, c.20 x 35.6
PROVENANCE: Sir Robert Walpole, 1736 Downing St (Closet, as by 'Andrea Schiavoni') later Houghton (Cabinet); 1779 Hermitage; early 19th century in the Palace of Grand Duke Constantine Pavlovich (destr.), Pavlovsk; whereabouts unknown.
LITERATURE: *Aedes* 1752, p. 65 (as by 'Andrea Schiavone'); 2002, no. 146.

Pair to *The Judgment of Paris* (cat. no. 91)

Munich (Cat. 1773-85, no. 2239) provides the following short description of the picture: 'André Schiavone. Le Jugement de Midas. Joli petit morceau de quatre figures, s'avoir: Midas, avec un Vieillard assise et Apollon debout qui écoute le jeu de Pan, auquel le Peintre n'a pas jugé à propos de donner des pieds de Boeuf.'

The format and dimensions (4 x 8 *vershki* according to Munich, or c.20 x 35.6 cm) are characteristic of cassone panels, which were often decorated by painters. The subject of the contest between Apollo and Mars was frequently used to adorn musical instruments. In the eighteenth century nearly all small-figure compositions of this kind were attributed to Andrea Schiavone and the pair of pictures in the Walpole collection were no exception. In this case, however, neither composition was on panel (both are on canvas) and were therefore not intended as furniture decoration.

It may eventually be possible to identify the painting by means of a red inventory number, 448 (as per Cat. 1797) inscribed on the lower right corner of the front of the canvas.

I. A.

Not reproduced

91

ANONYMOUS (Venice, mid-16th century)
The Judgment of Paris
Oil on canvas, c.20 x 35.6
PROVENANCE: See cat. no. 90.
LITERATURE: *Aedes* 1752, p. 65 (as by 'Andrea Schiavone'); 2002, no. 145.

Pair to *Midas Judging Between Pan and Apollo* (cat. no. 90).

Like its companion, this picture is known only from the description in Munich's catalogue (Cat. 1773-85, no. 2238): 'Petit tableau bien de dessin mais gâté par les réparations qu'on y a faitent.' It is impossible to comment on the validity of the attribution since not one of the known representations of *The Judgment of Paris* or *Midas Judging Between Pan and Apollo* previously linked with Andrea Schiavone accords with the two small canvases from the Walpole collection (see F. Richardson, *Andrea Schiavone*, Oxford, 1980).

It may eventually be possible to identify the painting by means of a red inventory number 447 (as per Cat. 1797) inscribed on the lower right corner of the front of the canvas.

I. A.

Not reproduced

92

ANONYMOUS (Italian, 16th century)
The Return of the Prodigal Son
Oil on canvas, c.164 x 272
PROVENANCE: first quarter of the seventeenth century coll. George Villiers, 1st Duke of Buckingham; Sir Robert Walpole, 1736 Chelsea (Sir Robert's Dressing Room, as by 'Titian'), later Houghton (Small Breakfast Room); 1779 Hermitage; 1854 sold at auction; whereabouts unknown.
LITERATURE: *Aedes* 1752, p. 38 (as by 'Pordenone'); 2002, no. 3; Wrangell 1913, p. 148.

Although listed in Walpole MS 1736 (pp. 31-32) under the name of Titian, this attribution was modified in the *Aedes Walpolianae*: 'The Prodigal Son returning to his Father; a very dark Picture, by Pordenone, the Architecture and Landscape very good. ... This Picture belonged to George Villiers, the great Duke of Buckingham.' Munich (Cat. 1773-85, no. 2386) firmly reinstated it as a Titian: 'Titien Vecelli. Le retour de l'Enfant prodigue. Grand et beau tableau composé de beaucoup de figures et orné d'architecture. C'est le retour de l'Enfant prodigue représenté à genoux devant son père qui lui tient la main pour le relever. Ils sont environnés de plusieurs spectateurs témoins de cette action. La scène est se passé en face d'un grand Palais. Sur le devant à droit du tableau ce voit un chasseur à cheval et des valets à pied précedés de quelques levriers qui paroissent retourner de la chasse. Le fond est un grand paysage avec ... plusieurs figurines occupées à différents travaux rustiques; dans le lointain apparait une ville.'

In the 1797 catalogue (no. 236) it is listed as a copy after Titian. The work was sold at auction in 1854 (Wrangell 1913). If the picture survives it may still bear its inventory number, a red 236 in the lower right corner. The subject is not known in the work of Titian.

I. A.

Not reproduced

93

ANONYMOUS (Italian, 16th century)
The Holy Family with SS Catherine, Francis and John the Baptist
Oil on canvas, 96 x 69
Kuban Art Museum, Krasnodar, Inv. No. 2544
PROVENANCE: Sir Robert Walpole, 1736 Downing St (Great Room above Stairs, as by 'Raphael Reggio'), later Houghton (Common Parlour); 1779 Hermitage; 1925 transferred to Gatchina Palace; 1926 returned to the Hermitage; 1930 transferred to Kuban Art Museum, Krasnodar.
LITERATURE: *Aedes* 1752, p. 45 (as by 'Raphael da Reggio'); 2002, no. 34; Livret 1838, p. 230; Bruni 1861, p. 163.

When it entered the Hermitage, this *Holy Family* was attributed to an artist of the Roman school, Raffaello Motta (Raffaellino da Reggio, c.1550-78). This attribution was retained in Cat. 1773-85 which also noted that it was 'très estimable mais détériosé par les repeintre'. As early as 1861, Bruni suggested that this work was a copy of a painting by Raffaello Motta, but thereafter after this *Holy Family* ceased to be mentioned in the literature on the Hermitage collection. On its return from Gatchina the painting was listed in the Hermitage inventory as the work of an unknown sixteenth-century Italian artist.

T. K.

Not reproduced

94

Anonymous (Italian, 17th century)
The Archangel Gabriel
Oil on canvas, 56 x 47
Inv. No. 8790

PROVENANCE: Sir Robert Walpole, 1736 Houghton (Green Velvet Drawing Room, as by 'Guido Reni', then Carlo Maratt Room); 1779 Hermitage; mid-19th century to 1920s at Gatchina Palace; transferred to Museum of the Academy of Arts, Leningrad; 1931 returned to the Hermitage.

LITERATURE: *Aedes* 1752, p. 60 (as 'A profile Head of St. Catharine, by Guido'); 2002, no. 120; SbRIO 17, 1876, p. 399; Liphart 1916, pp. 19, 39, note 23; Vertue, vol. VI, 1948-50, p. 179.

There has always been confusion about the identity of the figure represented here. In the 1736 manuscript catalogue of Walpole's collection (Walpole MS 1736), the picture is entitled *Profile Head of a Woman*. Vertue (vol. VI, 1948-50) mentions a 'Head of a Saint wt a Lilly', while the *Aedes* describes the picture as 'A Profile Head of St Catharine'. However, in the list attached to a letter from Russian Ambassador in London, Alexey Musin-Pushkin, to Catherine II (SbRIO 17, 1876) it is entitled 'Angel announcing good news to the Virgin'. In the Hermitage, from the 1773-85 catalogue onwards the title *Archangel Gabriel* has been consistently used. The confusion probably arose because the wings behind the archangel's back were hardly visible.

Liphart (1916) rightly doubted the attribution to Guido Reni, noting the weak drawing and the mediocre quality of the painting. Only during the preparation of this catalogue has the Walpole provenance of this picture been uncovered.

S. V.

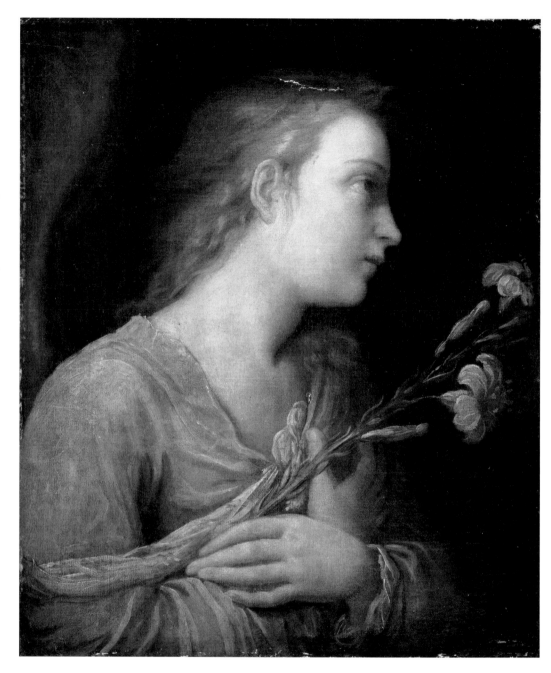

Seventeenth-century Flemish Paintings in the *Aedes Walpolianae* and in the Hermitage

Natalya Gritsay

In describing the Hermitage Picture Gallery in 1794 Johann Gottlieb Georgi wrote: 'In no other gallery in Europe is there such a choice, such a numerous and precious collection of paintings by Pieter Paul Rubens, Anthony Van Dyck, David Teniers II and several other great masters, as in the Russian Imperial [Gallery].'[1]

The abundance of works by the leading seventeenth-century Flemish masters described by Georgi was to a significant extent the result of Catherine II's acquisition in 1779 of the collection formed by Sir Robert Walpole. The Flemish pictures totalled forty-nine in number, that is to say close to a quarter of all the paintings acquired by the Empress from Houghton.[2] At Houghton Hall, the Flemish collection was second only to the Italian school and its arrival in the Hermitage marked the last major eighteenth-century addition to the Flemish section of the museum's Picture Gallery. Not until early in the twentieth century did the Russian Imperial collections in St Petersburg receive another significant boost to its holdings of Flemish art when, in 1915, the Hermitage was further enriched with the acquisition of the collection of the celebrated Russian geographer and traveller Pyotr Petrovich Semyonov-Tyan-Shansky (1827–1914) which brought the gallery twice as many seventeenth-century Flemish works as had the Walpole collection.[3] When compared with other collections acquired by Catherine II before 1779—such as those of the Berlin merchant Johann Ernst Gotzkowski (1764); of Count Johann Carl Philip Cobenzl (1768), Austrian envoy at Brussels; of Count Heinrich Brühl (1769), Minister to the Elector of Saxony, Augustus III; of the Geneva collector François Tronchin (1770); of the French financier Pierre Crozat and his nephew Louis-Antoine Crozat, baron de Thiers (1772)[4]—the Flemish section of Robert Walpole's collection was inferior in quantity only to that of the Crozat collection. In qualitative terms, however, the contribution made by the Houghton pictures to the Hermitage collection of seventeenth-century Flemish paintings was second to none.

Today, many of the Walpole paintings can be seen to contribute to the central core of the Hermitage's permanent exhibition. This, however, was not always the case and the fate of these paintings over the years has been somewhat mixed. Not all of them were placed on exhibition immediately. Some were tucked away in palace storerooms, others sent to Imperial Palaces in the vicinity of St Petersburg, whilst others were removed altogether from the museum. Changes were also made to the display itself, as a result of shifts in taste, the enlargement of the museum, and the growth of art historical knowledge. It is often possible to trace the movements of paintings within the museum (and indeed beyond) by means of notes in the early manuscript inventories and then in the later published catalogues of the Hermitage Picture Gallery that first appeared in 1863.

Amongst the earliest printed descriptions and catalogues of the Gallery from which we can draw information about Flemish paintings from the Walpole collection, the two most important are by Franz Labensky.[5] Only the briefest of references to a few Flemish works from the Walpole collection can be found in early nineteenth-century published descriptions of St Petersburg,[6] or in the room-by-room guide to the Hermitage compiled by G. H. Schnitzler with notes on those pictures which he considered most important.[7] All these publications include occasional assessments of the individual works and the artists who painted them and it is interesting to compare them to the comments of those English artists and writers who saw the Walpole paintings *in situ* at Houghton Hall itself. From these extremely varied and often fragmentary writings we also learn something of the esteem in which the Walpole paintings were held between the late eighteenth century and the year 1852, when the Hermitage ceased to be solely a private collection and became a public museum.

With the acquisition of the Walpole collection, the Picture Gallery gained works by twelve Flemish artists. Although all of these names were already represented in the Hermitage, the contribution made by the Walpole collection was of great significance. It brought to Russia renowned works by leading artists of the Antwerp school, the centre of artistic production in seventeenth-century Flanders. Almost two-thirds of these were by Pieter Paul Rubens and his most distinguished pupil, Anthony Van Dyck. The remaining paintings were also largely by painters of the Antwerp School, both those who worked closely with

Rubens himself—Jan Brueghel the Elder (Velvet Brueghel), Jacob Jordaens, Frans Snyders—and those who never had any contact with him whatsoever—Paul Bril, Hendrik van Steenwyck II and Jan Miel.

The variety of genres represented by these artists set Sir Robert Walpole distinctly apart from his contemporaries as a collector, for many English collections of European art tended to be dominated by portraits.[8] The Walpole collection, however, included a considerable number of works with biblical, mythological and allegorical subjects and Sir Robert seems to have had a particular interest in history painting: the Flemish part of his collection comprised only slightly fewer works in this latter category than portraits. Least numerous were such lesser genres as still life, sporting and animal paintings, landscapes, scenes from everyday life and a few odd architectural subjects.

In terms of breadth, the Houghton pictures rivalled those collections formed by leading European collectors such as Count Brühl (1700–63), Pierre Crozat (1665–1740) and his nephew Louis-Antoine Crozat, baron de Thiers (1699–1770). But Walpole's collection was remarkable—and thereby distinctly different from both German and French taste—in manifesting a distinct penchant for those large paintings that comprise more than a third of all his Flemish works. By contrast, Brühl and Crozat, although profoundly interested in all aspects of the work of the Old Masters,[9] both manifested a clear preference for oil sketches and small 'cabinet' pictures,[10] which enabled them to make qualitive judgements about colour and matters of connoisseurship. Large pictures, however, offered other possibilities. In a letter in 1621, Rubens noted that 'the large size of a picture gives one much more courage to express one's ideas clearly and realistically', admitting that, 'by natural instinct' he was 'better fitted to execute very large works than small curiosities'.[11] In fact, in eighteenth-century England the very concept of the seventeenth-century Flemish school was inextricably bound up with the notion of large works. Sir Joshua Reynolds, for instance, was inclined to group those artists born in Flanders but who worked on a small scale with tiny figures with the Dutch school; he did this in order, as it seemed to him, 'to distinguish those two schools rather by their style and manner, than by the place where the artist happened to be born'.[12] Even Horace Walpole, in the *Aedes Walpolianae*, described the small *Adoration of the Magi* by Velvet Brueghel (cat. no. 95) as 'finished with the greatest Dutch exactness'.[13]

This is not to suggest that Sir Robert Walpole attached little value to sketches and 'cabinet' works by Flemish masters, which were in fact represented in his collection by outstanding examples. Good examples include the series of six sketches that Rubens produced for decorations in the city of Antwerp to celebrate the arrival in 1635 of the new Spanish governor (cat. nos. 120–125), or such superb 'cabinet' pictures as Brueghel's *Adoration of the Magi* (cat. no. 95), Rubens's

Bacchanalia and *The Carters* (cat. nos. 131, 116) or Hendrick van Steenwyck II's *Italian Palace* (cat. no. 138). But Walpole rarely missed an opportunity to acquire large decorative canvases by the great Flemish masters. We know that he despatched special agents to the Austrian Netherlands and to the Republic of the United Provinces and that they acquired large paintings for him.[14] He acquired through their agency such large works as *Christ in the House of Simon the Pharisee* by Rubens (cat. no. 127), *The Rest on the Flight into Egypt* (*Virgin with Partridges*) by Van Dyck (cat. no. 110), Jordaens's *Self-portrait with Parents, Brothers and Sisters* (cat. no. 111), *Concert of Birds* (cat. no. 132) and the four vast *Markets* by Snyders (cat. nos. 133–136), and, in addition, a vast and very rare tapestry cartoon, in oil on paper, depicting *The Hunt of Meleager and Atalanta*, from Rubens's workshop (cat. no. 128). Even a 'cabinet' painter such as David Teniers II was represented at Houghton by what is virtually the largest work he ever executed, *The Kitchen*, an allegory of the four elements (cat. no. 139).[15]

Amongst these large-format Flemish paintings was a series of celebrated masterpieces from renowned collections. When the Walpole collection was sold to the Russian Empress, the highest prices (£1,600 each) were paid for two paintings, Rubens's *Christ in the House of Simon the Pharisee* and Van Dyck's *The Rest on the Flight into Egypt*. Both enjoyed wide fame and were considered to be among the best examples of seventeenth-century Flemish painting. The Reverend William Gilpin (1724–1804), who visited Houghton Hall in 1769, wrote of the former of these that it was 'one of the noblest monuments of the genius of Rubens, that is to be seen in England',[16] while Horace Walpole called *The Rest on the Flight into Egypt* 'the most celebrated Picture' by Van Dyck.[17] Both paintings had passed through several collectors' hands before being acquired by Sir Robert Walpole, but in both instances the most significant and interesting collections were those of their first known owners.

Christ in the House of Simon the Pharisee belonged first to Louis-François Armand de Vignerod Du Plessis, duc de Richelieu (1629–1715), great-nephew of the famous Cardinal Richelieu, from whom he appears to have inherited a taste for the arts and for collecting.[18] A great admirer of Rubens, the duc de Richelieu had assembled his collection during the 1670s and it contained some fourteen paintings by the great Flemish master.[19] By the time the Walpole painting arrived in the Hermitage, the museum already had two late works by Rubens, also from the collection of the duc de Richelieu: *Landscape with a Rainbow* and *Bacchus*.[20] The duc de Richelieu's Cabinet in Paris was described by the famous art critic, diplomat, writer, artist and theorist Roger de Piles (1635–1709).[21] A protagonist in the famous dispute between the 'Rubenists' (who put colouring above all else) and the 'Poussinists' (who admired purity of line and severe classical form), de Piles turned his analysis of the Flemish master's

paintings, published in 1677, into a theory of 'principles' and 'laws' applicable to painting overall. As the leading supporter of the French 'Rubenists', de Piles' complimentary remark about *Christ in the House of Simon the Pharisee*, published slightly later in 1681, is worth quoting: 'Et pour moy qui ay veu tout ce qu'il a de beau en France & en Italie du Titien & du Georgion, j'avouë que rien ne m'a tant frappé pour la force que ce Tableau.'[22]

Much admired during the artist's lifetime, the painting became even more popular thanks to publication of an engraving by Michael Natalis (1611–68)[23] and it also influenced works by some of the master's younger contemporaries.[24] It retained its popularity throughout the seventeenth and eighteenth centuries, when it was repeatedly copied and engraved.[25] Indeed, by the time the painting was acquired for the Hermitage, the Picture Gallery already contained two copies. One of these is a large painting (now in the State Art Gallery, Perm)[26] probably brought from Venice by Marchese Paolo Maruzzi (1720–90),[27] Russia's envoy to the Venetian Republic, and whilst in the Hermitage listed as the work of Anthony Van Dyck.[28] The second is a drawing that arrived in the Hermitage from the Cobenzl collection bearing the name of Jacob Jordaens.[29]

The original Rubens was described by Count Musin-Pushkin, Russian ambassador to London and intermediary in the purchase, as a 'major' work by the artist,[30] one of those paintings notable, according to Georgi, for their 'most superior beauty',[31] and immediately worthy of a key place in Hermitage displays. Significantly, of all the New Testament subject paintings by Rubens in the Hermitage, this was the only one to be copied by students of the Imperial Academy of Arts throughout the nineteenth century. When in 1830 the Academy Council singled out four outstanding students for further study and set them each the task of making a copy of an Old Master, the Rubens *Christ in the House of Simon the Pharisee* was one of the prescribed paintings.[32] For many years this work hung in the same room as the copy attributed to Van Dyck and both paintings were often compared, as the work of the master and his talented pupil: 'les remords de la pechéresse devant le Sauveur, et traités, l'un par Rubens, et l'autre par Vandyck. Ils n'est pas douteux que Vandyck ne l'ait copié de son maître; mais il est difficile de décider auquel appartient la préeminence, à l'original ou à la copie. Peut être seulement le disciple est-il resté un peu au dessous du maître pour la fraîcheur du coloris.'[33] Such an apparently naïve comparison says much about the prevailing attitudes which determined the appearance of the Hermitage.

Van Dyck's *The Rest on the Flight into Egypt*, also known in the eighteenth century as 'The Children's Dance' or 'Dance of Angels', had an equally distinguished provenance before entering the Walpole collection. Its first famous owner was Frederick Henry, Prince of Orange-Nassau (1584–1647) and from 1625 Stadhouder of the Republic of the United Provinces. A great collector and patron, he owned a number of works by Van Dyck, including some he commissioned directly from the artist.[34] According to published documents, *The Rest on the Flight into Egypt* was purchased in Antwerp by Frederick Henry in 1646, several years after the artist's death.[35] For many years it hung over a chimneypiece in a bedroom at Huis ten Bosch,[36] the palace of the House of Orange at The Hague, before being transferred to another Royal palace, Het Loo, at Apeldorn. It would seem to have been much prized, and we know that the Dutch architect Pieter Post (1608–69) designed a special frame for it.[37] The painting was sold at auction twice during the eighteenth century, in 1713 and 1731[38] and such high prices were asked for it that the engraving of another version of the composition by Schelte à Bolswert (1586–1659) came to be known among contemporary collectors as 'the twelve-thousand guilder print'.[39] This print, possibly issued with Van Dyck's direct involvement by the artist's publisher Martinus van den Enden (1605–74),[40] did much to increase the painting's fame. In the eighteenth century the part of the painting most admired was the group of dancing angels towards which both the Virgin and Child strain their eyes. But the picture was not without its detractors and was seen by one commentator as being 'a little frippery' and it was also considered that 'as a whole, it wants composition; a sobriety in the general complexion of the colouring; and a harmony in the tints'.[41] The Virgin herself was not universally admired and sometimes considered 'not handsome'. Horace Walpole even thought she might be a portrait,[42] a response which may have been coloured by the perception that Van Dyck, particularly when he was in England, was primarily a portrait painter. It was certainly as the portraitist par excellence (rather than as a history painter) that the artist was most highly prized, despite Sir Joshua Reynolds' remark that Van Dyck 'had truly a genius for history-painting, if it had not been taken off by portraits'.[43]

In Russia, Van Dyck's *Rest on the Flight into Egypt* was received with great enthusiasm and the picture was immediately given a central place in the Picture Gallery. The painting was described by the Russian ambassador to London, Count Musin-Pushkin, as a 'capital' work by the Flemish master,[44] and Georgi drew particular attention to it as the 'most excellent' of all Van Dyck's works in the Hermitage.[45]

Although we can judge the painting's popularity from references such as Alexander Pushkin's comparison in *Eugene Onegin* between his heroine Olga and 'Van Dyck's Madonna',[46] Labensky chose neither this work nor Rubens's *Christ in the House of Simon the Pharisee* when he published engravings from the best paintings in the Hermitage (although, admittedly, the publication was never completed).[47] Of the twelve seventeenth-century Flemish paintings that appeared in the two published volumes, four came from the Walpole collection, all of

them Van Dyck portraits. One was the portrait of *Henry Danvers, Earl of Danby* (cat. no. 101), presented to Sir Robert Walpole by Sir Joseph Danvers, great-nephew of the sitter, while the other three (*Charles I* and his wife *Henrietta Maria* and *Sir Thomas Wharton*, cat. nos. 98, 99, 109) were purchased by Sir Robert around 1725 from the heirs of the first owner, Philip, 4th Lord Wharton (1613–96).

In 1632, soon after Van Dyck's removal from Antwerp to London, Lord Wharton commissioned a portrait of himself (cat. no. 109) and thus became the Flemish master's first private client in England. According to some sources,[48] Lord Wharton commissioned from Van Dyck a whole series of portraits of members of his family between 1637 and 1639, and housed them in a purpose-built gallery at his new estate at Winchendon in Buckinghamshire. Here too he also hung the portraits of Charles I and Henrietta Maria, a gift from the King, and a number of portraits of contemporaries, which he continued to collect even after Van Dyck's death.[49]

Sir Robert Walpole's purchase of the Wharton pictures was undoubtedly one of his greatest coups as a collector, and, despite their uneven quality (depending on the extent of studio assistance), as a group these portraits were an important addition to the collection. As Sir Oliver Millar has quite properly noted, Philip, Lord Wharton, who commissioned the portraits, evidently attached as little importance to the extent of Van Dyck's involvement as did either Sir Robert Walpole or his son Horace, who in the *Aedes Walpolianae* hardly commented on the Wharton family portraits.[50] The fullest artistic assessment of them was provided by George Vertue (1684–1756) who in his notebooks described the portraits as 'right pictures, but not the most curious or finisht but done in a fine masterly manner, not studyed nor laboured many parts (especially the hand) tho' well disposed and gracefully are not determined the jewells hair trees flowers lace etc. loosely done appear well at a distance'.[51]

It is not clear just how many portraits by Van Dyck were in the Wharton gallery, a collection that also included portraits by other artists, notably Peter Lely. In his biographical anthology of European artists, the Dutch painter, engraver and art historian Arnold Houbraken (1660–1719) claimed that there were thirty-two Van Dycks there, of which fourteen were full-length.[52] George Vertue, however, noted that at the time of the sale of Lord Wharton's collection, it contained only eighteen portraits by Van Dyck himself, 'twelve whole lengths and six half lengths'.[53] This is confirmed by Horace Walpole, who wrote that his father purchased 'the whole collection of the Wharton family', in which there were 'twelve whole lengths and six half lengths'.[54] At some point before 1736, the full-length Van Dyck of Arthur Goodwin (1593/4–1643), father of Lord Wharton's second wife Jane, was presented by Sir Robert Walpole to William Cavendish, 3rd Duke of Devonshire, and it still hangs at Chatsworth

(see illustration on p. 34).[55] A further eight portraits (the lesser part of the Walpole collection of Van Dyck portraits including those works which were kept in London and at Richmond) were sold at auction in June 1751, after the death of the 2nd Earl of Orford.[56] So by the time the Houghton Hall pictures were acquired by Catherine II in 1779, only nine portraits by Van Dyck survived from what had been the Wharton gallery. The Walpole collection, however, included a further three English-period Van Dyck portraits, of Henry Danvers, Earl of Danby, of Inigo Jones and Sir Thomas Chaloner (cat. nos. 101, 103, 100). That of Inigo Jones was clearly acquired by Walpole by descent through from Jones's nephew, the architect John Webb (1611–72), while the provenance of the portrait of Sir Thomas Chaloner remains unknown.

Overall, the seventeenth-century Flemish portraits in the Walpole collection were notable for their considerable variety. All types of portrait were included, from the life study and the modest half-length to the grandest of full-lengths. In addition to works by Van Dyck, we also find several portraits by other seventeenth-century Flemish painters, some of which had formerly belonged to well-known English collectors. From the collection of Henry Bentinck (1709–62), Duke of Portland, for instance, Walpole acquired in 1722 Jordaens's *Self-Portrait with Parents, Brothers and Sisters* (cat. no. 111), recorded in the *Aedes* as 'Rubens's Family'.[57] From the equally distinguished collection of Thomas Scawen (d.1774), who inherited the art collections of his immensely wealthy uncle Sir William Scawen (d.1722) and his father Sir Thomas Scawen (d.1730), Walpole purchased the *Portrait of an Old Woman* by Cornelis de Vos,[58] then thought to be the work of Rubens (cat. no. 143).

There were also several genuine portraits by Rubens, including the *Head of a Franciscan Monk* (cat. no. 118), probably a life study, and a full-length female portrait (then attributed to Van Dyck) thought to be of Rubens's second wife Hélène Fourment (cat. no. 117). Of the latter, Horace Walpole mistakenly wrote that it 'was fitted for a Pannel in Rubens's Wife's own Closet in Rubens's house',[59] but it was certainly greatly prized as one of the stars of the collection. This was the picture that inspired numerous mid-eighteenth century portraits in 'Van Dyck' dress in England by Thomas Hudson, Allan Ramsay and others.

The *Aedes Walpolianae* sheds very little light on the Flemish portraits then hanging at Houghton Hall. Horace Walpole remarked, somewhat disparagingly, in his introduction that he did not intend to 'enter into any Detail of the Flemish Painters', which, in his opinion, 'are better known by their different Varnishes and the different kind of utensils they painted, than by any style of Colouring and Drawing'. He went on to state that 'Rubens is too well known in England to want any account of him', while his pupil Van Dyck was famous in

that he 'contracted a much genteeler Taste in his Portraits'.[60] A more detailed description of the Flemish paintings, including the portraits, can be found in William Gilpin's description of Houghton Hall.[61] Some sense of how the portraits were perceived at the time of the sale in 1779 can be deduced from the prices attached to them. The most expensive portrait in the entire collection was the full-length 'portrait of Rubens's wife', then erroneously attributed to Van Dyck, which was valued at £600 (cat. no. 118). Gilpin described it as 'an admirable portrait' and thought it worthy of the most extensive description, admiring it as one of the few paintings in which both colouring and composition were utterly in accord with his aesthetic tastes. He wrote that he 'should not hesitate to call [this portrait] a masterpiece', for 'nothing can be easier, more elegant, and graceful than this figure', and he concluded enthusiastically that he ranked it 'among the first' in the collection.[62]

Second in monetary value was *Self-Portrait with Parents, Brothers and Sisters* by Jacob Jordaens (then thought to depict Rubens' family) and valued at £400. It was clearly not to Gilpin's taste and he dismissed it as 'a mere collection of heads'.[63] The seven portraits by Van Dyck of Sir Thomas Chaloner, the daughters of Philip, Lord Wharton and the 4th Lord himself, Charles I, Henrietta Maria, Henry Danvers, Earl of Danby, and Sir Thomas Wharton (see cat. nos. 100, 107, 108, 98, 99, 101 and 109) were each valued at £200. The portrait of Sir Thomas Chaloner was described by Horace Walpole as 'an admirable Portrait',[64] a view endorsed by Gilpin who later referred to it as 'a very fine portrait'.[65] Of the other six, Gilpin considered only the portrait of Henry Danvers, Earl of Danby, worthy of a few lines, characterising it as 'excellent in all its parts, and in the management of the whole'.[66] Another eight seventeenth-century Flemish portraits (including works by Van Dyck) were valued at considerably less than the nine already mentioned.[67]

Count Johann Ernest Munich (1707–88), the compiler of the first detailed manuscript catalogue of the Hermitage Picture Gallery, in which he recorded all but one of the Walpole works immediately upon their arrival, provided a brief but complimentary description of nearly all the identified portraits from the Walpole collection.[68]

The Van Dyck portrait of the two Wharton girls was amongst paintings from the Hermitage used to produce hangings at the Imperial Tapestry Manufactory in St Petersburg during the 1780s and 1790s. 'From here', wrote Georgi of the Tapestry Manufactory, 'come elegant works, of which some can be described as rarities, but the work is produced solely for the court.'[69] A tapestry based on Van Dyck's portrait of Philadelphia and Elizabeth Wharton, woven in the finest coloured silk (Irkutsk Regional Art Museum, Irkutsk), was almost certainly created for the Imperial family, perhaps to hang in the rooms occupied by Paul I's daughters.[70]

With just a few exceptions, nearly all the seventeenth-century Flemish portraits from the Walpole collection were put on exhibition as soon as they arrived in St Petersburg. When the Empress Catherine's art collections were moved to the purpose-built Large Hermitage, the Flemish portraits from the Walpole collection remained on display except—as we learn from notes in the margins of the manuscript catalogue of the Picture Gallery begun in 1797 during the reign of Catherine's son Paul—that of Inigo Jones (cat. no. 104).[71] Only four of these portraits (Charles I and Henrietta Maria, Sir Thomas Wharton, and Henry Danvers, Earl of Danby) were consistently singled out as worthy of particular attention by the authors of publications about St Petersburg during the first third of the nineteenth century: The latter had been described as 'the very best' painting by Van Dyck in a letter to Catherine II from the Russian ambassador, Count Musin-Pushkin, during negotiations surrounding the purchase of the Walpole collection.[72]

Less numerous than portraits were the sporting and animal paintings and still lifes. Undoubtedly the most famous of these were the four unique large *Markets* by Frans Snyders (cat. nos. 133–136). The first owner of these works has now been firmly established. Research by the American scholar Susan Koslow has shown that they were commissioned by an important government official, Jacques van Ophem (d.1647), for his mansion in Brussels,[73] where they remained until, around 1723, they were purchased by Robert Walpole's secret agent, the spy John Macky (d.1726). Macky was extremely proud of his role in their acquisition, describing the Markets as 'the Ornament' of Brussels and stating that 'great sums of Money' were offered for them by the King of France himself. Macky proudly concluded 'they are now gone to England and in the possession of the Right Honourable Robert Walpole, Esq, Minister of State'.[74] Although described by George Vertue in his notebooks as 'capital pictures'[75] and referred to in the above-mentioned letter from Musin-Pushkin as the work of Snyders ('of his greatest skill'),[76] these works appear not to have initially enjoyed the same degree of celebrity in the Hermitage since they were not put on display for some years. It was probably only at the very end of the eighteenth century that three of them were hung in the Hermitage Theatre (1783–87),[77] designed by Giacomo Quarenghi (1744–1817). The fourth, *A Fruit Market* (also described as 'a most capital picture' in the text accompanying Richard Earlom's engraving for Boydell's two-volume set of engravings)[78] remained in storage.[79] It was only later still, apparently in the 1820s, that Labensky included all four paintings in the permanent exhibition.

Of all the large paintings from the Walpole collection, the saddest fate beset the rare *Hunt of Meleager and Atalanta* (cat. no. 128). This 'large cartoon, designed for Tapestry',[80] the sole survivor of seven cartoons from which a series of hunting tapestries was woven in the

workshop of Daniel Eggermans, was acquired in 1666 by Emperor Leopold I. Upon entering the Imperial collection in St Petersburg, the cartoon was immediately rolled-up and placed in the museum stores. There it languished until the middle of the nineteenth century, when the Court authorities decided to send it to the English Palace at Peterhof, one of the Imperial summer residences outside the city.[81] It eventually returned, but remained forgotten and was not included in any of the Hermitage printed catalogues.

While the cartoon's chequered fate was primarily due to its vast size, it is harder to find an explanation for the similar misfortune which befell Rubens' series of sketches for the decoration of Antwerp. These were designs for structures to be erected in the city to mark the arrival on 17 April 1635 of the new Spanish Governor of the Netherlands, Ferdinand, Cardinal Infante of Spain. Described as 'the six triumphs of Rubens' in the catalogue of the London auction of the property of the deceased Antwerp landscape artist and collector Prosper Henricus Lankrink (1628–92), they had possibly been brought to London by Lankrink himself.[82] All the sketches would seem to have initially been kept in the Antwerp Rathuis and were seen as the property of the Antwerp Magistrature which originally commissioned them. Captured for posterity in the engravings of Theodor van Thulden (1606–69),[83] the ephemeral decorative structures, which stood in situ for such a brief time, were much praised by Giovanni Pietro Bellori (c.1615–90),[84] one of Rubens's first biographers. Lankrink succeeded in gathering together most of the surviving sketches, which were consistently praised by those who saw them for the freedom and beauty of the artist's brushwork.[85] By the time they arrived in the Hermitage, the museum already possessed six small grisaille sketches for statues for a portico to honour the Hapsburg Emperors, also relating to the same project.[86] Although Munich wrote of the latter in his manuscript catalogue that 'On doit considerer ces six morceaux comme des restes précieux d'un grand Peintre et dignes par conséquent d'être conservés',[87] neither they nor the Walpole sketches were placed on view but were put in store. They were to go on display only many years later, after the reorganisation of the Hermitage and the opening of Leo von Klenze's (1784–1864) specially designed New Hermitage, opened to the select public in 1852.

A happier fate befell another sketch by Rubens, *The Apotheosis of James I* (cat. no. 119), described in the *Aedes Walpolianae* as 'The Banquetting-House Ceiling; it is the original Design of Rubens for the middle Compartment of that Ceiling'.[88] Formerly in the collection of Charles I,[89] it later entered the collection of the portrait painter Sir Godfrey Kneller (1646–1723), who, according to Horace Walpole, 'studied it much, as is plain from his Sketch for King William's Picture in the Parlour'[90] (the sketch for the equestrian portrait of William III

by Sir Godfrey Kneller, cat. no. 195). This Rubens sketch was much admired at Houghton Hall by William Gilpin.[91] It must have been studied attentively by Sir Joshua Reynolds, who mentioned it in his *Journey to Flanders and Holland*[92] after he saw, at the premises of the Brussels merchant J. B. Horion, 'two admirable sketches of the two ends of the ceiling of the Banquetinghouse' by Rubens. This presumably refers to *The Unification of the Kingdom* and *The Peaceful Reign of James I*, which Reynolds then acquired for his own collection.[93]

The Hermitage already contained two small sketches of the same subjects, which had arrived some time before 1774 as originals by Rubens and therefore formed part of the permanent exhibition.[94] Georgi mentioned them in his description of St Petersburg as 'two drawings for ceilings'.[95] During the reign of Paul I (1796–1801) these sketches were transferred to the Imperial Palace at Gatchina, the Emperor's favourite residence outside the city. Whilst the two other sketches by Rubens in the Hermitage rooms, *The Apotheosis of James I* from the Walpole collection and *The Unification of the Kingdom* from the Crozat collection, are indeed genuine works by Rubens, it transpires that those transferred to Gatchina are copies, probably from lost originals by the artist himself. Their compositions are close to the finished paintings inset in the ceiling of the Banqueting House itself.

Similarly varied was the fate of Walpole's Flemish 'cabinet' pictures. One of the very smallest works in the collection, *The Adoration of the Magi* by Jan Brueghel the Elder (Velvet Brueghel, cat no. 95) was, according to Pyotr Semyonov-Tyan-Shansky, presented by Emperor Paul I to an acquaintance,[96] and it thus passed into private hands. Semyonov-Tyan-Shansky purchased it many years later and it was as part of his collection that it re-entered the museum in 1915. This miniature-like work can almost certainly be identified as the painting sold at the auction of Baron Schonborn in Amsterdam on 16 April 1738.[97] The title and subject matter are the same and the dimensions are very close. The extravagant description in the auction catalogue and the high price paid—800 gulden—shows that it was valued considerably higher than another Rubens in the same sale: *Perseus and Andromeda*.[98] When sold to the Russian Empress, Brueghel's painting was priced on a par with Rubens's sketches and higher, for instance, than Hendrik van Steenwyck II's *Italian Palace* (cat. no. 138),[99] described by Horace Walpole in the *Aedes Walpolianae* as 'a fine Picture of Architecture in Perspective'.[100] Musin-Pushkin also described *The Adoration of the Magi* as a 'central' work.[101]

Sadly, not all the seventeenth-century Flemish paintings that entered the Hermitage from the Walpole collection are still there. For various reasons, eleven works from this part of the collection were sold. In the nineteenth century, four paintings were transferred to other palaces. Two works by Jan Miel are still at Peterhof Palace (cat. nos. 112, 113), while *Susanna and the Elders* from the workshop of Rubens

(cat. no. 130) and the tapestry cartoon *The Hunt of Meleager and Atalanta* (cat. no. 128) were returned to the Hermitage in the 1920s. In 1862, Van Dyck's portrait of Lady Philadelphia Wharton (cat. no. 106, present whereabouts unknown) was transferred to the Rumyantsev Museum in Moscow, along with *Landscape with Nymphs at Rest (Europa)* by Paul Bril (cat. no. 96, Pushkin Museum of Fine Arts, Moscow).

Those Flemish paintings from the Walpole collection that remained in the Hermitage could not avoid further upheavals during the Soviet period. Of the outstanding works sold by the Soviet government in the 1930s, four paintings came from the Walpole collection including the

two masterpieces, *?Hélène Fourment* by Rubens and Van Dyck's *Philip, Lord Wharton*, now in Lisbon and Washington respectively. Two more masterpieces by Rubens, the 'cabinet' *Bacchanalia* and one of the sketches for the decoration of Antwerp, *The Apotheosis of the Infanta Isabella* (cat. no. 125), were transferred in the 1930s to the Museum of Fine Arts, Moscow (now the Pushkin Museum of Fine Arts) under an extensive exchange agreement. One painting remains totally unaccounted for, the smallest Flemish picture in the Walpole collection, that attributed to Thomas Willeboirts Bosschaert, *The Virgin and Child with SS Elisabeth and John the Baptist* (cat. no. 145).

1 Georgi 1794, pp. 510–11 (1996 edition, p. 379). See Dukelskaya essay, above, p. 89 note 152.

2 Not including two paintings attributed to Charles Jervas which are copies of compositions by Paul de Vos (see cat. nos. 194, 195).

3 The Hermitage purchased from Semyonov-Tyan-Shansky 100 works by 17th-century Flemish artists.

4 Listed here are only those collections which made important additions to the collection of 17th-century Flemish paintings.

5 Franz Labensky (1769–1850), a painter of Polish origin, was keeper of the Hermitage Picture Gallery for 52 years, from 1797 until almost the very end of his life. He was responsible for publication of the first illustrated description of the Hermitage gallery, 6 books in 2 vols. published 1805–9. These included engravings of the best paintings and had parallel French and Russian texts: Labensky 1805–9. The first full catalogue of the paintings on exhibition appeared in 1838, compiled in French by Labensky: Livret 1838. This provided descriptions of paintings room by room, with information about some of the other works on display, occasionally with comments. It also provided brief notes on provenance and an indication of the presence of a signature and/or date.

6 Reimers 1805; Swignine 1821; Granville 1828.

7 Schnitzler 1828.

8 Such, for instance, were the collections of Sir Robert's contemporaries, the 4th Duke of Devonshire (1695–1755) at Devonshire House, London, and Thomas Scawen (d.1774).

9 Brühl and Pierre Crozat's love for everything connected with the old masters, especially sketches, was rooted in their common passion for the collecting of drawings. The Brühl drawings entered the Hermitage along with the rest of his collection.

10 By Rubens's time, the word 'cabinet' was applied in Antwerp not only to paintings set into cabinets or cupboards but also to whole private collections of various curiosities, paintings also being perceived as curiosities.

11 Letter from Rubens to William Trumbull of 13 September 1621. Cited in Magurn 1955, p. 77.

12 Reynolds 1996, p. 110.

13 *Aedes* 1752, p. 66.

14 The artist John Ellys in 1733 acquired in Rotterdam 'a large picture of the Virgin and the Angels by Vandyke', i.e. *The Rest on the Flight into Egypt (The Virgin with Partridges)* (cat. no. 110); the spy John Macky acquired in Brussels Snyders's series of four *Markets*. See Appendix I.

15 Only slightly smaller than Teniers' work of 1652, *Bird Hunt (Het vogelschieten voor de kerk van Onze-Lieve-Vrow van de Zavel [Notre-Dame-du-Sablon])* in the Kunsthistorisches Museum, Vienna.

16 Gilpin 1809, p. 46.

17 *Aedes* 1752, p. 54.

18 On Cardinal Richelieu's activities as a collector see *Richelieu et le monde de l'esprit*, Paris, 1985.

19 Teyssedre 1963.

20 *Landscape with a Rainbow* (Hermitage Inv. No. 482) entered the Hermitage in 1769 with the collection of Count Brühl, Dresden, and *Bacchus* (Hermitage Inv. No. 493) in 1772, with the Crozat collection, from Paris.

21 Roger de Piles, *Le Cabinet de Monseigneur le duc de Richelieu*, Paris, 1677.

22 de Piles 1681, p. 131.

23 V.-S. 1873, p. 29, no. 150. There is a version of this print in the Bibliothèque National in Paris with corrections by Rubens himself, and painted additions to both sides.

24 This applies for instance to two Antwerp artists whose work belongs stylistically to the pre-Baroque phase in Flemish painting: Artus Wolffort (1581–1641), whose *Christ in the House of Simon the Pharisee* (Musée Municipale, Bruges) is based on Rubens's composition (H. Vlieghe, *Flemish Art and Architecture*

1585–1700, London and New Haven, 1998, p. 44), and Matthys Voet, an artist known only from two works produced around 1617 for the cycle *The Fifteen Mysteries of the Rosary* in the Church of St Paul, Antwerp. In Voet's *Jesus at the Temple* we can identify two figures inspired by characters from Rubens: the young man in a turban in the centre against the arch, staring intensely at Christ, and the old man to the left, supporting his spectacles on his nose with one hand.

25 The composition was engraved nine times, see Varshavskaya 1975, p. 127. All but two of the surviving painted copies are considerably smaller than the original: one (larger than the original) figured at auction, Le Roy, Brussels, 9–10 March 1922 (lot 180; oil on canvas, 237 x 313; photograph in RKD [Rijksbureau voor Kunsthistorische Documentatie/ The Netherlands Institute for Art History] The Hague); the second (a little smaller than the original), was in the Schefer collection, Aachen, in 1956 (oil on canvas, 166 x 217).

26 Oil on canvas, 200 x 246.

27 According to a letter from Maruzzi cited by V. F. Levinson-Lessing (1986, p. 268), 1,000 sequins were asked for a large work by Rubens showing Christ at the feast with the Magdalene washing his feet: the sum was very high for the time. Maruzzi must have been referring to a painting which was in Venice in the 18th century, of which Mariette (1853–59, vol. V, p. 83) wrote that it was considered to be an original by Rubens but that he had his doubts. The composition of this work, which differed only insignificantly from Rubens's original now in the Hermitage, is reproduced in an engraving by Pietro Monaco (V.-S. 1873, p. 29, no. 153).

28 Waagen (1864, p. 156) attributed it to Jacob Jordaens, while Bode (1921, p. 359) thought it might be by Van Dyck. It is currently seen as the work of an unknown 17th-century master, after the painting by Rubens in the Hermitage. It was on display until 1911, when it was put into store. In 1914 it hung in the Church Hall of the Church of the Court Stables in St Petersburg. In 1924, the painting was transferred to the Museum of Fine Arts (now Pushkin Museum of Fine Arts), Moscow, from where it was transferred to Perm.

29 Drawing in black chalk, watercolour and body colour, 52 x 70.5, with additions top and bottom (Hermitage Inv. No. OR 4202). Included with an attribution to Jordaens at an exhibition of his work 1968–69 Ottawa (Jaffé, no. 143, p. 157). Yury Kuznetsov suggested in the exhibition catalogue 1979 Leningrad (p. 62, no. 37) that the drawing was produced in Rubens's workshop by one of his pupils and then corrected by Jordaens.

30 SbRIO 17, 1876, p. 398.

31 Georgi 1794, p. 503 (1996 edition, p. 374).

32 Cited in O. V. Mikats, *Kopirovaniye v Ermitazhe kak shkola masterstva dlya russkikh khudozhnikov XVIII–XIX vekov* [Copying in the Hermitage as a School for Russian Artists in the 18th and 19th Centuries], St Petersburg, 1996, p. 20.

33 Swignine 1821, pp. 73–74 (Russian reprint 1997, p. 270).

34 Gelder 1959, pp. 43–86.

35 *Ibid.* pp. 73–76.

36 Frederick Henry 1997, p. 48.

37 Design known from an engraving by an unknown master published in 1664. See Fock 1979, pp. 468, 470, fig. 10.

38 Sale at Amsterdam (property of Maria Luisa Friso, widow of Prince Johann Wilhelm Friso [died 1711], Het Loo, Apeldorn), 26 July 1713, lot 1 (sold for 12,050 gulden); sale of Cornelis Wittert van Valkenburg, 11 April 1731, lot 1 (Hoet, Terwesten 1752–70, vol. I, p. 366).

39 Carl Depauw and Ger Lijten, *Anthony van Dyck as a Printmaker*, exh. cat., 15 May–22 August 1999, Museum Plantin-Moretus/Stedelijk Prentenkabinet, Antwerp; 9 October 1999–9 January 2000,

Antwerpen Open/Rijksmuseum, Amsterdam, 1999, pp. 284, 286.

40 *Ibid.*, p. 286.

41 Gilpin 1809, p. 46.

42 *Aedes* 1752, p. 54.

43 Reynolds 1996, p. 24.

44 SbRIO 17, 1876, p. 398.

45 Georgi 1794, p. 504 (1996 edition, p. 375).

46 A. S. Pushkin, *Eugene Onegin*, chapter 3, verse 5, see *Pushkin ob iskusstve* [Pushkin on Art], with introductory essay and commentary by G. M. Koka, Moscow, 1962, p. 34; Yury Lotman felt that Van Dyck's *Virgin with Partridges* could not possibly have been that meant: neither the figure of the Virgin (a mature woman) nor her appearance in this painting could match Onegin's description of 16-year-old Olga. See Yu. M. Lotman, *Pushkin. Biografiya pisatelya. Stat'i i zametki. 1960–1990* [Pushkin. A Biography of the Writer. Essays and Notes. 1960–1990], 'Yevgeny Onegin. Kommentariy' ['Eugene Onegin. Commentary'], St Petersburg, 1995, p. 612.

47 Labensky 1805–9. Publication ceased due to lack of payment by subscribers, although the plates had already been produced for further volumes. See Levinson-Lessing 1986, p. 163.

48 Vertue, vol. I, 1929–30, pp. 29, 109.

49 *Portrait of William Laud, Archbishop of Canterbury*, acquired by Philip Wharton in 1656. See Jaffé 1982, p. 605.

50 Millar 1994, p. 519.

51 Vertue, vol. I, 1929–30, p. 109.

52 Houbraken 1718, p. 147.

53 Vertue, vol. I, 1929–30, p. 109.

54 Millar 1994, p. 522.

55 *Ibid.*, p. 523.

56 *Ibid.*, p. 523.

57 Vertue, vol. III, 1933–34, p. 9.

58 O. Manning, W. Bray, *the History of the Antiquities of the County of Surrey, commenced by O. Manning, continued and enlarged by W. Bray*, 3 vols., London 1804–14, vol. II, 1809, p. 510. From the same collection came the famous *Portrait of Govaert van Surpele (?) and his Wife* by Jacob Jordaens (National Gallery, London); see Martin 1970, p. 93.

59 *Aedes* 1752, p. 64. This legend is connected with *The Fur Coat (Het Pelsken)* and several other works in which Rubens depicted Hélène Fourment naked (Michel 1771, pp. 291–94).

60 *Aedes* 1752, p. xxxi.

61 Gilpin 1809.

62 *Ibid.*, p. 50.

63 *Ibid.*, p. 51.

64 *Aedes* 1752, p. 46.

65 Gilpin 1809, p. 45.

66 *Ibid.*, p. 54.

67 *Head of a Franciscan Monk* by Rubens was valued at £40, *Rubens's Wife, a Head* (*Head of a Girl*, school of Rubens) at £60, and portraits by Van Dyck thus: *Inigo Jones*, £50; *Sir Rowland Wandesford*, £150; *Lady Philadelphia Wharton* and *Lady Jane Goodwin*, £100 each.

68 See margin notes in Cat. 1773–85 to Nos 2354, 2347, 2355, 2370, 2371, 2369, 2366, 2372. He described the full-length portrait of 'Rubens's Wife' as 'tableau de plus précieux qu'on puisse voire', while the Jordaens group portrait was, to his mind, 'une pièce rare et peut être le plus beau de l'ouvrage de Jordaens'. The portrait of Sir Thomas Chaloner he described as 'admirable', that of Henry Danvers, Earl of Danby as 'superb portrait'; Thomas Wharton was 'beau tableau', Queen Henrietta Maria 'excellent portrait', Lord Philip Wharton 'très beau tableau', and the latter's two daughters, Philadelphia and Elizabeth 'charmant portrait'.

69 Georgi 1794, p. 224 (1996 edition, p. 189).

70 The fate of the tapestry in the 19th and 20th century is well documented. In 1805 it was included in a series of works intended as gifts for the Emperor of China and was sent to China with a Russian delega-

tion headed by Count Yu. Goolovkin (1762–1846). The journey was a failure, for Golovkin refused to agree to humiliating demands regarding the ceremonial surrounding the diplomatic delegation. The delegation thus never travelled as far as China, returning to Irkutsk, where the major part of the valuables was sold to local merchants. The tapestry was purchased by the then head of the city administration, Sibiryakov, and remained until 1917 in the house of the Governor General. In 1920 it was transferred to the Irkutsk Art Museum. See A. Martos, *Pis'ma o Vostochnoy Sibiri* [Letters on Eastern Siberia], Moscow, 1827, p. 153; A. D. Fat'yanov, *Sud'ba sokrovishch* [The Fate of Treasures], Irkutsk, 1967, pp. 22–23.

71 Cat. 1797.

72 SbRIO 17, 1876, p. 399.

73 Koslow 1995, pp. 112–13.

74 Cited in Koslow 1995, p. 116. See also Appendix I.

75 Vertue, vol. III, 1933–34, p. 18.

76 SbRIO 17, 1876, p. 399.

77 Notes in the margins of Cat. 1797 under Nos 777 (*Game Market*), 786 (*Vegetable Market*) and 776 (*Fish Market*) record that they were 'with the theatre'.

78 Boydell I, pl. XII.

79 Notes in the margin of Cat. 1797 under no. 719 (*Fruit Market*).

80 Gilpin 1809, p. 58.

81 Note in the margin of Inventory 1859, under no. 3988.

82 Lankrink 1945, p. 31.

83 Gevartius 1642.

84 Bellori 1672, pp. 221–48.

85 For instance, Gilpin 1809, p. 52.

86 Sketches for statues of emperors Rudolph I, Albert I, Frederick II, Charles V, Ferdinand II. They are exhibited in a single frame (Hermitage Inv. No. 510). Cat. 1773–85 and Cat. 1797 also record a sketch for a statue of Maximilian I, but no mention is made of this later.

87 Cat. 1773–85, no. 2456.

88 *Aedes* 1752, p. 69.

89 Millar 1958–60.

90 *Aedes* 1752, p. 69.

91 Gilpin 1809, p. 52.

92 Reynolds 1996, p. 21.

93 *Ibid.*, p. 156.

94 Now in the Hermitage stores: *The Peaceful Reign of James I* (Hermitage Inv. No. 2579) and *The Unification of the Kingdom* (Hermitage Inv. No. 2576); both oil on panel, 29 x 19.5. In my opinion they are 17th-century copies from final versions of Rubens's original sketches, which are either lost or simply unknown at the present time. Listed in Cat. 1773–85 under Nos 1875 and 1876; in Cat. 1797 under Nos. 1378 and 1379.

95 Georgi 1794, p. 502 (1996 edition, p. 374).

96 Semyonov 1906, pp. 37–38, no. 92.

97 Hoet, Terwesten 1752–70, vol. I, p. 507, lot 14. The auction of 1738 was part of one of Europe's most important collections, that of Lothar Franz von Schonborn (1655–1729), Elector-Archbishop of Mainz and Prince Bishop of Bamberg, founder of the palace of Weissenstein at Pommersfelden, and an outstanding cultural figure.

98 *Ibid.*, lot 8. *Perseus and Andromeda* was valued at 630 gulden. It eventually entered the Hermitage in 1779 as part of the collection of Count Heinrich Brühl.

99 Brueghel's painting was assessed at £100, and the Van Steenwyck at £80.

100 *Aedes* 1752, p. 45.

101 SbRIO 17, 1876, p. 309.

Flemish School

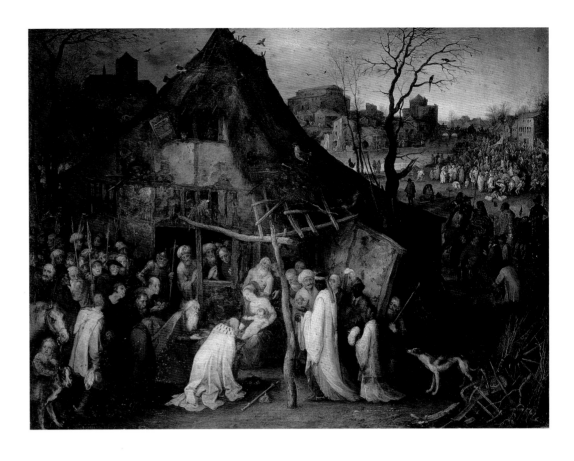

95

Jan I Brueghel (Velvet Brueghel) (1568–1625)

The Adoration of the Magi

Oil on copper, 26.5 x 35.2, signed bottom left:
BRUEGHEL

Inv. No. 3090

PROVENANCE: possibly figured in the Baron Schön-born sale, Amsterdam, 16 April 1738 (Lot 14); Sir Robert Walpole, Houghton (Cabinet); 1779 Hermitage; presented to an unknown individual in the circle of Emperor Paul I; coll. Pyotr P. Semyonov-Tyan-Shansky, St Petersburg; 1915 acquired from him for the Hermitage.

LITERATURE: *Aedes* 1752, p. 66; 2002, no. 148; Hoet, Terwesten 1752–70, vol. I, p. 507; Chambers 1829, vol. I, p. 530; SbRIO 17, 1876, p. 399; Semyonov 1885–90, part 1, pp. 107–8; Semyonov 1906, pp. 37–38, no. 92; Gerson, Ter Kuile 1960, pp. 57–58; Martin 1970, p. 14; Ertz 1979, pp. 422, 424, 564–66, no. 50; Balis 1989, p. 124; Ertz 1997, p. 84.

The subject is from Matthew ii: 1–12.

This is a reduced autograph variant of a composition known in two identical versions, both datable to 1598 (oil on copper, 33 x 48, Kunsthistorisches Museum, Vienna, Inv. G No. 908; gouache on parchment, 32.9 x 48, National Gallery, London, Inv. No. 3547). The changes affected the architectural setting and many small details, as well as some secondary figures and groups arranged in the foreground around the Virgin and Child with the kneeling Magi.

This Walpole variant can be dated to between 1598 and 1600. A version of the same composition, dated 1600, is in the Koninklijk Museum voor Schone Kunsten, Antwerp (oil on copper, 25.8 x 35.1, Inv. No. 922). A copy, probably by Jan II Brueghel, is in a private collection in Belgium (oil on copper, 26 x 36, Coppée Collection, Brussels; see *Catalogue de la collection Coppée*, Liège, 1991, p. 97).

The picture is mentioned in the list of works appended to a letter from Alexey Musin-Pushkin, Russian ambassador in London, to the Empress Catherine as ' "Adoration of the Magi" (capital), Velvet Bryukher' (SbRIO 17, 1876).

N. G.

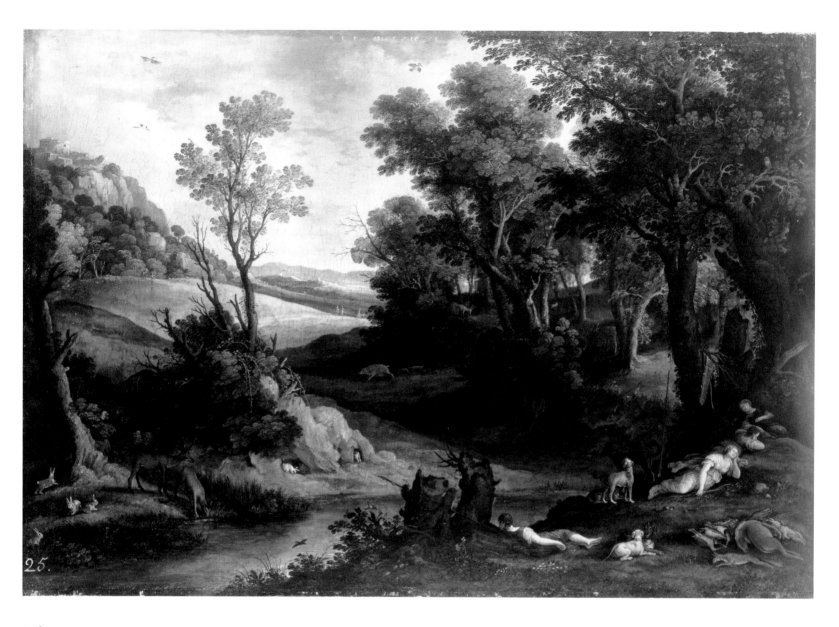

96

PAUL BRIL (1554–1626)
Landscape with Nymphs at Rest
Oil on canvas, 78 x 111
Pushkin Museum of Fine Arts, Moscow, Inv. No. 324
PROVENANCE: in or shortly after 1736 acquired by Sir Robert Walpole; Houghton (Gallery); 1779 Hermitage; 1862 transferred to Rumyantsev Museum, Moscow; 1924 transferred to Museum of Fine Arts (now Pushkin Museum of Fine Arts), Moscow.
LITERATURE: *Aedes* 1752, p. 86 (as 'Europa'); 2002, no. 244; Boydell I, pl. X; Livret 1838, p. 15, no. 35; Rumyantsev Museum 1862, no. 5; Rumyantsev Museum Guide 1872, no. 5; Pushkin Museum 1948, p. 12; Pushkin Museum 1957, p. 18; Pushkin Museum 1961, p. 26; Faggin 1965, pp. 24, 33, no. 65; Pushkin Museum 1986, p. 34; Berger 1993, pp. 27, 200; Pushkin Museum 1995, pp. 432–33 (Inv. No. mistakenly given as 329); Yegorova 1996, p. 49; Yegorova 1998, pp. 146–47.
EXHIBITIONS: 1994 Moscow, p. 12.

This picture is one of a group of works given in 1862 to the Rumyantsev Museum in Moscow (MS Moscow Public Museum 1862, no. 127).

The traditional attribution to Bril has never been doubted. This is a late work similar to those painted c.1621–23, such as *Landscape with Cephalus and Procris* (1621, Galleria Nazionale d'Arte Antica, Rome), *Landscape with Tobias and the Angel* (Galerie Alte Meister, Dresden, Inv. No. 261) and should be dated to this period. These works are characterised by a specific type of harmonious landscape with balanced masses of trees and rocks that anticipates Classicism.

The figures and animals were painted by another hand. In the Walpole collection the figures were attributed to Domenichino, a theory repeated in Livret 1838 although later rejected since there is no evidence to support it. The figures and animals were probably the work of one of the artist's assistants and are close to those in the Dresden painting.

When in the Walpole collection this painting was thought to form a pair with a landscape with exotic beasts formerly entitled *Africa* (*Landscape with Exotic Beasts*, cat. no. 97) also attributed to Bril, and it was therefore known as *Europe*. The 1797 catalogue dropped the title *Europe* and the work is usually recorded as *Diana Resting During the Hunt*, although none of the female figures has Diana's attribute, the half-moon over her forehead. It seems that the title given here is more fitting.

K. Ye.

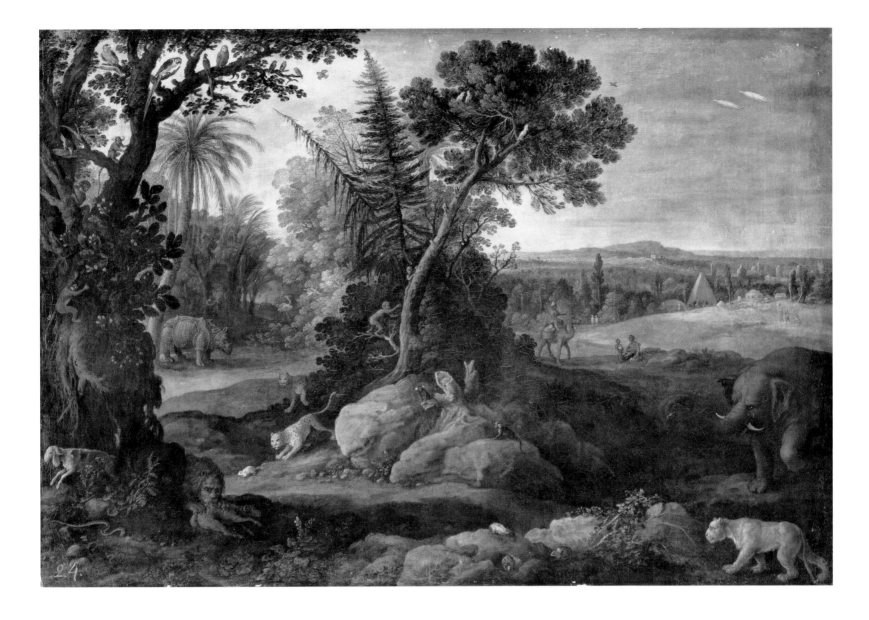

97

PAUL BRIL (1554–1626), circle of
Landscape with Exotic Beasts
Oil on canvas, 73.7 x 106.7
Inv. No. 1827
PROVENANCE: in or shortly after 1736 acquired by Sir
Robert Walpole; Sir Robert Walpole, Houghton
(Gallery); 1779 Hermitage.
LITERATURE: *Aedes* 1752, p. 86 (as 'Africa'); 2002, no.
245; Boydell I, pl. XI; Georgi 1794, p. 505 (1996 edi-
tion, p. 376); Chambers 1829, vol. I, p. 536; Livret
1838, p. 15, no. 38; Viardot 1852, p. 270; Andreyev
1857, p. 193; Somov 1859, p. 105; Yegorova 1998, p.
147.

The former title of this work, *Africa*, as cited in the *Aedes*,
is incorrect since the birds and animals depicted are also
to be found on the other continents of the world,
notably Asia (for the Indian rhinoceros) and America
(for the Callithrix monkeys and Ara parrot). Hence the
title used *Landscape with Exotic Beasts* is more accurate.

Like the work formerly thought to be its pair, *Land-
scape with Nymphs at Rest* (cat. no. 96; known in the
Walpole collection as *Europe*), this painting was until
the mid-nineteenth century thought to have been the
result of collaboration between Paul Bril and
Domenichino. Later, the picture was attributed to an
unidentified seventeenth-century Flemish artist. It was
not included in published catalogues of the Hermitage
Picture Gallery.

In compositional type and the treatment of foliage,
the landscape recalls late works by Bril, such as *Land-

scape with a Waterfall and the Temple of Vesta* at Tivoli
(1626, Niedersächsisches Landesmuseum, Hanover)
and *Mountain Landscape* (1626, Hermitage, Inv. No.
1955) although it is of inferior quality to both of these.
The animals were probably painted after engravings
and the rhinoceros in the background to the left
derives from Albrecht Dürer's *Rhinoceros* of 1515
(Bartsch, vol. VII, p. 147, no. 136).

N. G.

98

ANTHONY VAN DYCK (1599-1641) and workshop
King Charles I
Oil on canvas, 219 x 130 (traces of two old restored tears
with a loss of canvas along the right side of the figure, up
to 3 cm wide; length of one tear 41.5 cm, the other 83.5
cm), inscriptions (from the time of the first owner) at
bottom left: *P.Sr.Ant.Vandike*; and three lines bottom
right: *Charles King of / Great Britain / about 1638*
Inv. No. 537

PROVENANCE: c.1638 presented to Philip, 4th Lord
Wharton, by Charles I, kept at his estate at Winchendon,
near Aylesbury, Buckinghamshire; 1725 acquired by Sir
Robert Walpole from the heirs of Lord Wharton; Sir
Robert Walpole, 1736 Grosvenor St, London (Great
Room Above), later Houghton (Drawing Room); 1779
Hermitage.

LITERATURE: *Aedes* 1752, p. 51 (as by 'Vandyke'); 2002,
no. 65; Boydell I, pl. XLVIII; II, pl. LXVII; Labensky
1805-9, vol. 2, bk. 4, pp. 1-2; Swignine 1821, p. 73
(Russian reprint 1997, p. 269); Schnitzler 1828, p. 102;
Chambers 1829, vol. I, p. 523; Smith 1829–42, part III,
p. 125, no. 448, and Supplement, p. 37, no. 28; Livret
1838, pp. 346-47, no. 2; Andreyev 1857, p. 213; Cats.
1863–1916, no. 609; Waagen 1864, p. 151; SbRIO 17,
1876, p. 398; Neustroyev 1898, p. 182; Cust 1900, pp.
100, 101, 106, 123, 263, no. 11; Benois [1910], pp.
250–1; Lisenkov 1926, pp. 17–18; Vertue, vol. I, 1929-
30, pp. 29, 109; Glück 1931, pl. 390; Cat. 1958, vol. II,
p. 60; Varshavskaya 1963, p. 122, no. 16; Larsen 1980,
vol. II, no. 914; Cat. 1981, p. 40; Larsen 1988, pp.
312–13, no. 791; Millar 1994, p. 525, no. 1.
EXHIBITIONS: 1998–99 New York, no. 14.

Pair to *Queen Henrietta Maria* (cat. no. 99).

 Charles I (1600–49) was King of England and Scot-
land from 1625 until his execution in 1649. Here he is
dressed in armour and on his breast he wears a gold chain
with the insignia of the Order of the Garter. Many of
Van Dyck's portraits of Charles I show the monarch
wearing this insignia, the so-called Lesser George.

 Along with its pair, this work was commissioned
c.1638 by Charles I as a gift for Philip, Lord Wharton.
A 'Memoire' with an invoice for the most recent
works, which was presented to the King by Van Dyck
in 1638 and paid in 1639, was first published by W. H.
Carpenter in *Pictorial Notices ... Collected from Original
Documents*, London, 1844, pp. 67–68. Clearly painted
with the aid of studio assistants, as is confirmed by the fact
that both metal gloves are right-handed (an error pointed
out by Horace Walpole himself in the *Aedes*). Interest-
ingly, the list sent to Catherine II by Alexey Musin-
Pushkin, Russian Ambassador in London, in 1779, states
with regard to the *Charles I* and *Henrietta Maria* that 'it is
doubtful that they are Van Dyck's' (SbRIO 17, 1876).
Later Hermitage publications considered this work an
original by Van Dyck and it was, for instance, included in

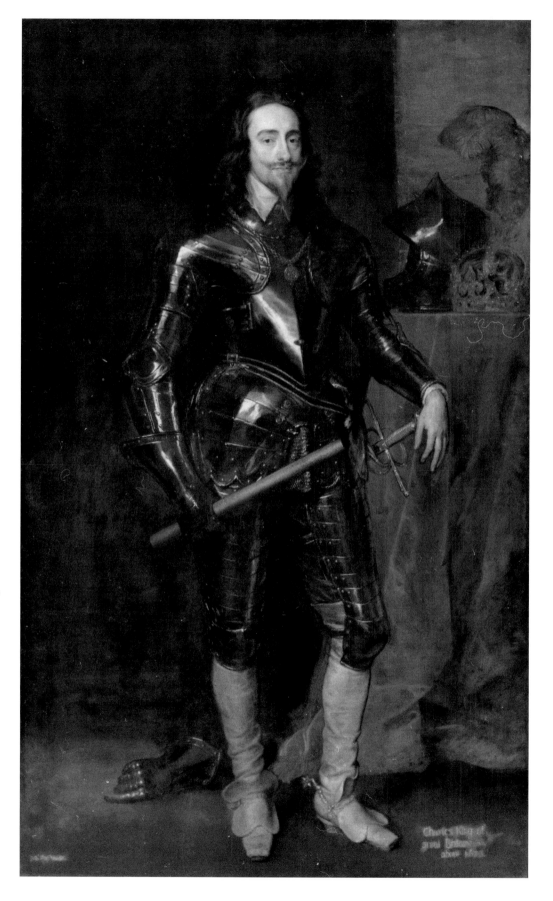

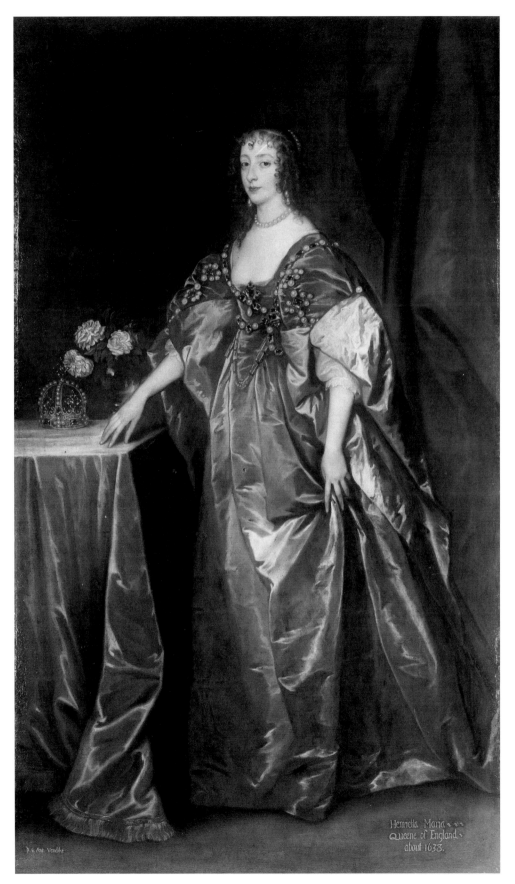

Labensky's description of the highlights of the Hermitage Picture Gallery (Labensky 1805-9).

Among the known versions based on this painting are waist-length portraits of Charles I in armour in the collection of the Duke of Norfolk, Arundel Castle (oil on canvas, 100 x 81.8); in the collection of the Earl of Radnor, Longford Castle (Glück 1931, pl. 370); in the Art Museum, Phoenix, Arizona, USA (Larsen 1980, no. 751); in the Somers collection, Eastnor Castle, UK (Glück 1931, pl. 386a).

N. G.

99

ANTHONY VAN DYCK (1599-1641) and workshop
Queen Henrietta Maria
Oil on canvas, 220 x 131.5, inscriptions (from the time of the first owner) at bottom left: *P.Sr.Ant.Vandike*; and three lines bottom right: *Henrietta Maria / Queen of England / about 1638*
Inv. No. 541
PROVENANCE: see cat. no. 99
LITERATURE: *Aedes* 1752, p. 51 (as by 'Vandyke'); 2002, no. 66; Boydell II, pl. LXVIII; Labensky 1805-9, vol. 2, bk. 4, pp. 3-4; Swignine 1821, p. 73 (Russian reprint 1997, p. 269); Schnitzler 1828, p. 102; Chambers 1829, vol. I, p. 523; Smith 1829-42, part III, p. 128, no. 465, and Supplement, p. 378, no. 35; Livret 1838, p. 347, no. 3; Andreyev 1857, p. 213; Cats. 1863-1916, no. 610; Waagen 1864, p. 151; SbRIO 17, 1876, p. 398; Neustroyev 1898, p. 182; Cust 1900, pp. 100-1, 106, 108, 123, 265, no. 26; Delarov 1902, p. 121; Benois [1910], pp. 251-52; Lisenkov 1926, pp. 17-18; Vertue, vol. I, 1929-30, pp. 29, 109; Glück 1931, pl. 391; Cat. 1958, vol. II, p. 60; Varshavskaya 1963, pp. 122-23, no. 17; Larsen 1980, vol. II, no. 915; Cat. 1981, p. 40; Larsen 1988, p. 340, no. 867; Millar 1994, p. 525, no. 2.
EXHIBITIONS: 1998–99 New York, no. 15.

Pair to *King Charles I* (cat. no. 98).

Henrietta Maria (1609–69) was the third daughter of Henri IV, King of France, and Maria de' Medici. She was the sister of Louis XIII, and married Charles I in 1625. She was resident in France from 1644.

Both the pose and the objects on the table (a crown, a vase with a bunch of roses) derive from a portrait of the Queen wearing a white dress in the Royal Collection (Windsor Castle), apparently a work from Van Dyck's studio (Glück 1931, pl. 383, p. 561). Another copy of the Windsor painting is in the collection of the Duke of Grafton and is dated 1636 (see *Paintings and Drawings by Van Dyck*, Nottingham University Art Gallery, 1960, no. 16). The Queen's pose and costume as in the Windsor portrait were repeated on numerous occasions in other female portraits from Van Dyck's studio, such as that of Lady Penelope Herbert from the collection of Lord

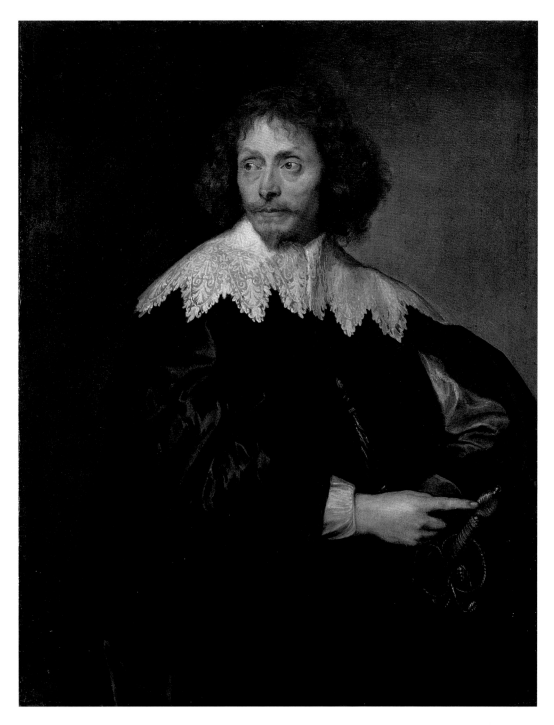

100

ANTHONY VAN DYCK (1599-1641)
Sir Thomas Chaloner
Oil on canvas, 104 x 81.5
Inv. No. 551
PROVENANCE: Sir Robert Walpole, 1736 Houghton (Little Bedchamber, as 'Sir William Chaloner', then Common Parlour); 1779 Hermitage.
LITERATURE: *Aedes* 1752, p. 46; 2002, no. 40; Boydell I, pl. XLVII; Gilpin 1809, p. 45; Chambers 1829, vol. I, p. 522; Smith 1829-42, part III, p. 189, no. 648, and Supplement, p. 394, no. 93; Livret 1838, p. 356, no. 11; Cats. 1863–1916, no. 620; Waagen 1864, p. 151; Guiffrey 1882, p. 260; Cust 1900, pp. 131, 272, no. 51; Schaeffer 1909, pl. 392; Benois [1910], p. 251; Lisenkov 1926, pp. 23–24; Glück 1931, pl. 445; Cat. 1958, vol. II, p. 60; Varshavskaya 1963, pp. 126–27, no. 23; Larsen 1980, vol. II, no. 933; Cat. 1981, p. 40; Larsen 1988, p. 311, no. 784.
EXHIBITIONS: 1990–91 Washington, no. 80; 2001 Toronto, no. 29.

Sir Thomas Chaloner (1595–1661) was in 1648 one of the judges who sentenced Charles I to be executed. On the Restoration of the monarchy in 1660 Chaloner was exiled from Britain and died at Middelburg in Holland. In the *Aedes* and in Hermitage inventories and catalogues right up to 1893, the sitter was confused with his father, Sir William Chaloner, who died in 1615.

The portrait is one of the last works entirely from the hand of Van Dyck himself, and is dated to the late 1630s. This proposed dating is in keeping with the light, almost sketch-like execution characteristic of his work at this period.

N. G.

Pembroke, Wilton House (Larsen 1980, vol. II, no. 962). In the Hermitage portrait the pose is retained but the dress is altered to accord with the fashion of the late 1630s. According to the inscription, the portrait was painted around 1638 and, with its pair (cat. no. 98), was commissioned from Van Dyck c.1638 by Charles I as a gift for Philip, Lord Wharton.

Like its pair, the portrait of *Henrietta Maria* was painted with assistance from the artist's studio, as is particularly noticeable in the execution of the dress

and setting. This is probably why the artist priced the work (like its pair) at just £50, while other smaller works were priced much higher (see the 'Memoire' containing an invoice presented to the King by Van Dyck in 1638; cat. no. 98). In a letter to Cole of 12 July 1779, Horace Walpole described the picture as 'very indifferent' (HWC 2, p. 169).

N. G.

101

ANTHONY VAN DYCK (1599-1641)
Henry Danvers, Earl of Danby
Oil on canvas, 223 x 130.6
Inv. No. 545

PROVENANCE: bequeathed to the Earl's nephew, John Danvers, and presented by his son, Sir Joseph Danvers, to Sir Robert Walpole; 1736 Houghton (Corner Drawing Room, then Marble Parlour); 1779 Hermitage.

LITERATURE: *Aedes* 1752, p. 72; 2002, no. 191; Boydell I, pl. IV; Labensky 1805-9, vol. 2, bk. 5, pp. 31-2; Gilpin 1809, p. 54; Swignine 1821, p. 73 (Russian reprint 1997, p. 269); Chambers 1829, vol. I, p. 532; Schnitzler 1828, p. 103; Smith 1829-42, part III, p. 188, no. 647, and Supplement, p. 394, no. 92; Livret 1838, p. 350, no. 16; Cats. 1863-1916, no. 615; Waagen 1864, p. 151; SbRIO 17, 1876, p. 400; Cust 1900, pp. 124, 273, no. 61; Hind 1923, p. 68; Glück 1931, pl. 247; Cat. 1958, vol. II, p. 56; Varshavskaya 1963, p. 127, no. 24; Larsen 1980, vol. II, no. 934; Cat. 1981, p. 40; Millar, in 1982 London, p. 62, no. 20; Larsen 1988, pp. 322–23, no. 819.

EXHIBITIONS: 1982 London, no. 20; 1996-7 New Haven–Toledo–St Louis, no. 3; 1998 St Petersburg, no. 3; 1999 Antwerp-London, no. 73; 2001 Toronto, no. 30.

Henry Danvers, Earl of Danby (1573–1644) was active in the military campaigns in the Southern Netherlands under the Stadhouder of the Netherlands, Maurice of Orange, and in Ireland and France (as part of the army of Henri IV of France). It was apparently during one of these campaigns that he received a head wound and the Hermitage portrait shows this wound covered with a patch (near the left eye). Danvers was the founder of England's first botanical garden, bequeathing land and monies for this purpose to Oxford University. He was celebrated at the court of James I for his love of art and was one of Rubens' patrons. In November 1633 he was made a Knight of the Order of the Garter.

In this portrait Danvers wears the red and white attire of the Order of the Garter, with a blue cloak lined with white. On the table rests the hat of a Knight of the Order.

The 1773-85 catalogue described the portrait as 'superb' and it is indeed one of Van Dyck's best works from his English period. This is the only full-length depiction of a Knight of the Order of the Garter by Van Dyck and the flowing, almost sketchy manner in which it is painted suggests that it dates from the very end of the 1630s. This work is mentioned in the 'Register of paintings in fresh and perfect condition' attached to the letter from Alexey Musin-Pushkin to Catherine (SbRIO 17, 1876, p. 399) as 'Earl Danby (the very best), Vandek.'

A preparatory drawing (knee-length) is in the British Museum, London (Vey 1962, no. 212). There are copies of the portrait in the Stamford Collection, Dunham-Massey and at Wentworth Castle and another copy with some alterations was sold at auction at Christie's, London, 22 November 1974 (lot 105).

N. G.

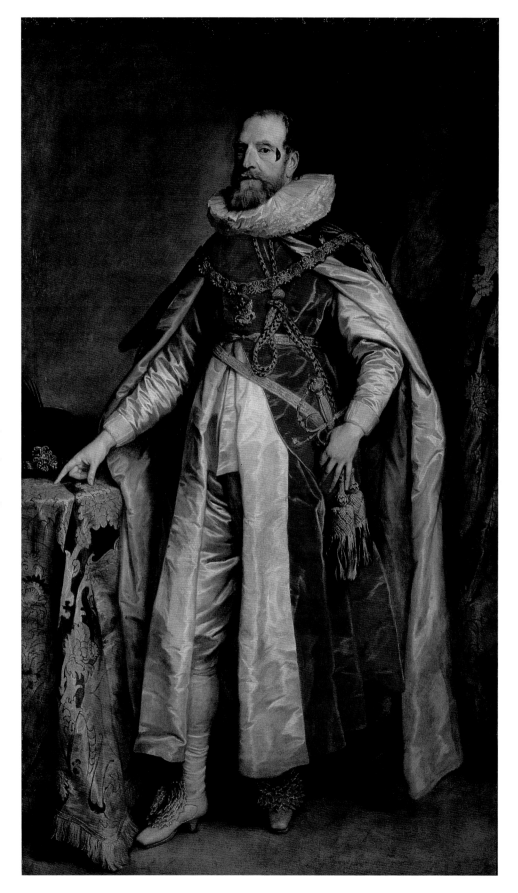

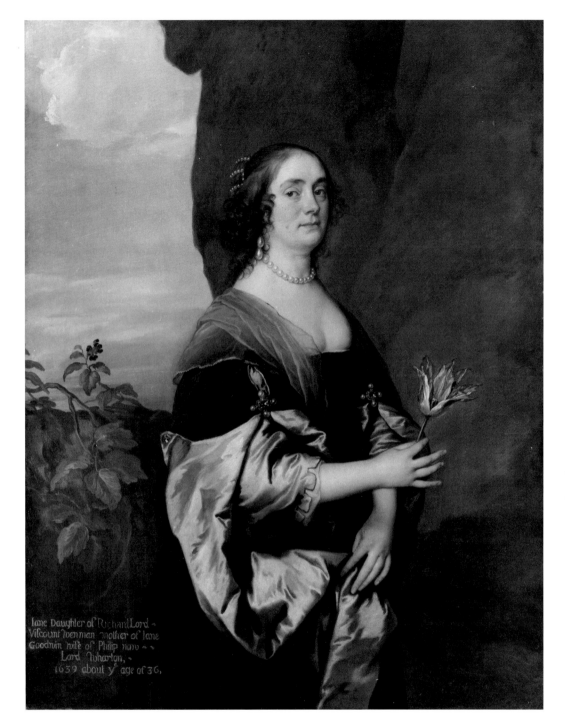

102

ANTHONY VAN DYCK (1599-1641)

Lady Jane Goodwin

Oil on canvas, 132.5 x 106, inscriptions (from the time of the first owner) at bottom right: *P.Sr. Ant. Vandike*; and five lines at bottom left: *Jane Daughter of Richard Lord ~/ Viscount Wenman mother of Jane/ Goodwin wife of Philip now/ Lord Wharton/ 1639 about ye age of 36*
Inv. No. 549

PROVENANCE: collection of Philip, 4th Lord Wharton, Winchendon, near Aylesbury, Buckinghamshire; 1725 acquired by Sir Robert Walpole from the heirs of Lord Wharton; Sir Robert Walpole, ?London, later Houghton (1736 Common Parlour, then Drawing Room); 1779 Hermitage.

LITERATURE: *Aedes* 1752, p. 52 (as 'Jane Daughter of Lord Wenman'); 2002, no. 71; Boydell II, pl. XII; Chambers 1829, vol. I, p. 524; Smith 1829–42, part III, p. 188, no. 465; Livret 1838, p. 431, no. 2; Waagen 1864, p. 282; Cats. 1863–1916, no. 619; Neustroyev 1898, p. 183; Cust 1900, pp. 123, 274, no. 84; Benois [1910], p. 252; Lisenkov 1926, pp. 21, 24; Vertue, vol. I, 1929-30, pp. 29, 109; Cat. 1958, vol. II, p. 63; Varshavskaya 1963, pp. 125–26, no. 21; Larsen 1980, vol. II, no. 958; Cat. 1981, p. 40; Larsen 1988, p. 333, no. 850; Millar 1994, p. 527, no. 13.

EXHIBITIONS: 1995-96 Tel Aviv, no. 28; 2001 Toronto, no. 26.

Jane Wenman, Lady Goodwin (c.1603–after 1639) was the wife of Arthur Goodwin (1593/4–1643), a rich Buckinghamshire landowner. Her daughter Jane Goodwin (1618–58) was sole heir of Arthur Goodwin and she married in 1637 Philip, Lord Wharton (see cat. no. 108).

Lady Jane holds a large pinkish-white tulip. This flower (of which this is the only depiction in any of Van Dyck's portraits) was then highly fashionable and extremely expensive, and rather than having any particular symbolic significance, serves here simply to complement the sitter's rich attire.

One of a group of portraits commissioned from Van Dyck by Philip, Lord Wharton in the years 1637-9 (see cat. no. 108), this work was executed by Van Dyck himself. Any possible participation by studio assistants only seems likely in the working up of the background. There is no reason to doubt the date, 1639, inscribed upon the portrait and it is entirely consistent with the smooth enamel-like surface of Van Dyck's works at that date. The style of the dress also accords with fashions in the late 1630s (see C. H. Collins Baker, 'The Chronology of English Van Dycks', *Burlington Magazine*, December 1921, pp. 267–73). This type of portrait, with the sitter shown three-quarter length against a rocky background, was typical of Van Dyck's work in the second half of the 1630s.

N. G.

103

ANTHONY VAN DYCK (1599-1641)

Inigo Jones

Oil on canvas, 64.5 x 53.2 (oval in a profiled frame set into a rectangle)

Inv. No. 557

PROVENANCE: collection of Inigo Jones (according to George Vertue the carved frame had the arms of Inigo Jones: Vertue, vol. III, 1933-4, p. 112); given by Jones to his nephew, the architect John Webb (Vertue, vol. I, 1929-30, p. 135); in or shortly after 1736 acquired by Sir Robert Walpole; Houghton (Common Parlour); 1779 Hermitage.

LITERATURE: *Aedes* 1752, p. 48; 2002, no. 51; Boydell I, pl. XVI; Chambers 1829, vol. I, pp. 522–23; Waagen 1864, pp. 151–52; Cats. 1863-1916, no. 626; Cust 1900, pp. 134, 276, no. 105; Vertue, vol. I, 1929-30, pp. 33, 135; Glück 1931, pl. 443; Vertue, vol. III, 1933-34, p. 112; Cat. 1958, vol. II, p. 63; d'Hulst, Vey 1960, pp. 124–25; Varshavskaya 1963, pp. 119–20, no. 13; Larsen 1980, no. 829; Cat. 1981, p. 40; Larsen 1988, p. 346, no. 885; Brown 1991, p. 232.

EXHIBITIONS: 1968–69 Belgrade, no. 16; 2001 Toronto, no. 27.

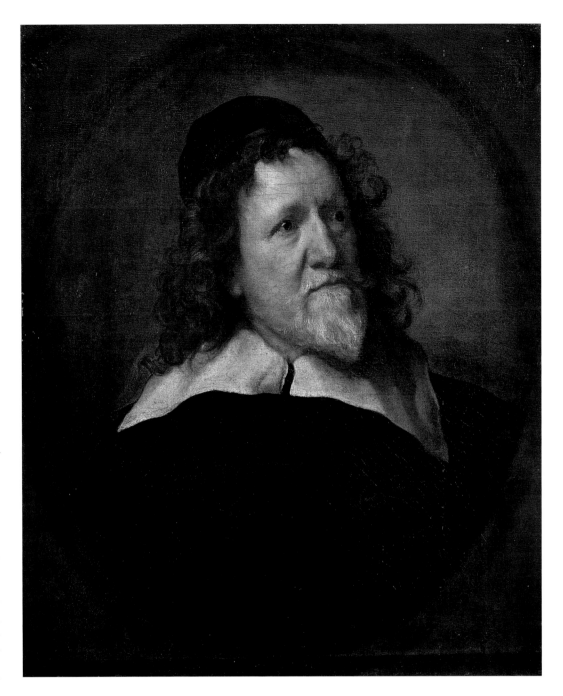

Inigo Jones (1573–1652) was a renowned architect, known as 'the English Vitruvius', as well as a painter and theatre designer.

Van Dyck may have begun work on the likeness of Jones as part of his *Iconography* project, conceived as an anthology of engraved portraits of the artist's famous contemporaries. Jones could have sat for Van Dyck only during the latter's stay in England between 1632 and March 1634, or in the spring of 1635 when Van Dyck returned from Flanders, for the portrait was certainly completed before the death of Robert van der Voerst (1597-1636), who engraved it for the *Iconography* in October 1636. A dating to the first half of the 1630s, between 1632 and 1636, is entirely consistent with the style of the painting and the generally dark tonality, which link the portrait with works of Van Dyck's second Antwerp period (between 1628 and 1632). In compositional terms, this portrait is related to the oval portrait of *Jan Brueghel the Elder* (coll. Lord Methuen, Corsham Court) which Larsen (1980, no. 615) also dates to the second Antwerp period.

In the Duke of Devonshire's collection at Chatsworth (Inv. No. 1002 A) is a portrait drawing of Inigo Jones by Van Dyck (Vey 1962, no. 271) from which van der Voerst produced his engraving (Mauquoy-Hendrickx 1956, no. 72). It depicts Jones turned just as in the Hermitage portrait and some scholars have seen the Chatsworth drawing as preparatory to the Hermitage work (d'Hulst, Vey 1960 and Varshavskaya 1963). The Hermitage portrait, however, creates a striking impression of having been taken from life, so very directly has the artist captured the sitter's upward gaze, an impres-

sion lacking in the drawing. As Christopher Brown (1991, no. 72) has noted, this drawing must have been based on the Hermitage portrait or on another (currently unknown) drawing from the life by Van Dyck.

According to George Vertue (vol. I, 1929-30, p. 135), several copies were made of this portrait. The following are currently known: 1) National Portrait Gallery, London; 2) formerly in the collection of the Earl of Listowel, sold at Christie's, London, 11 March (lot 92) and 27 May 1983 (lot 53); 3) Walters Art Gallery, Baltimore, Maryland (Larsen 1988, no. A 236/1–2).

N. G.

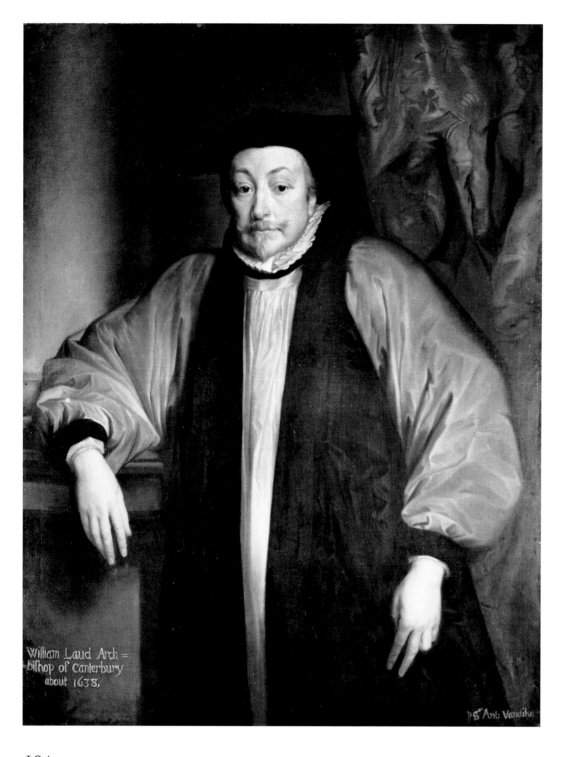

LITERATURE: *Aedes* 1752, p. 51 (as by 'Vandyke'); 2002, no. 67; Boydell II, pl. XI; Chambers 1829, vol. I, pp. 523–24; Smith 1829–42, part III, 159, no. 560; Livret 1838, p. 432-33, no. 8; Andreyev 1857, p. 214; Cats. 1863-1916, no. 612; Waagen 1864, p. 152; SbRIO 17, 1876, p. 400; Cust 1900, pp. 123, 129, 277, no. 115; Schaeffer 1909, pl. 374; Benois [1910], p. 252; Vertue, vol. I, 1929-30, pp. 29, 109; Glück 1931, pl. 443r; Puyvelde 1950, pp. 171–72; Cat. 1958, vol. II, p. 63; Varshavskaya 1963, p. 126, no. 22; Larsen 1980, 2, no. 925; Jaffé 1982, pp. 600, 605; Cat. 1981, p. 40; Larsen 1988, p. 350, no. 896; Millar 1994, p. 529, no. 23.

The theologian and politician William Laud (1573–1645) was a favourite of King Charles I and an advocate of the monarch's absolute power. Moving increasingly close to Catholicism, he became presbyter in 1601, royal chaplain in 1611, was appointed Bishop of London in 1628, and Archbishop of Canterbury in 1633. In 1640 he was impeached by the House of Commons, was tried in 1644 and although found not guilty by the House of Lords was executed on special orders.

Although in his *Aedes* Horace Walpole described this portrait as an original by Van Dyck himself, in a letter to Cole of 12 July 1779 he expressed some doubt regarding its authenticity (HWC 2, p. 169). In a letter to Lord Orford's solicitor, Carlos Cony, of 29 November 1778, James Christie said of the painting 'You may depend [it] is undoubtedly a copy' (see Dukelskaya essay, p. ******000). It appears in the appendix to a letter from Alexey Musin-Pushkin, Russian ambassador in London, to the Empress Catherine, listing works added to the Walpole sale 'without increasing the previous price' (SbRIO 17, 1876): 'Archbishop Laud, main culprit of the unhappy fate misfortunes of King I [i.e. Charles I], copy after Vandalk.'

Despite these doubts about it status, both manuscript and published catalogues of the Hermitage up to the 1893 catalogue list the painting as the work of Van Dyck himself. It was omitted from the 1911 to 1916 catalogues, since by then the painting was thought to be a copy of a work at Lambeth Palace (Cat. 1902). Glück (1931) however thought the Lambeth picture a studio version and reinstated the Walpole picture to Van Dyck's oeuvre. Varshavskaya (Cat. 1958, Cat. 1981) also thought the portrait was the work of Van Dyck himself, although with the involvement of assistants (Varshavskaya 1963). After restoration of the version in the Fitzwilliam Museum, Cambridge (oil on canvas, 121.6 x 97.2), it became clear that this was Van Dyck's original (see Jaffé 1982, pp. 600–6), thus confirming that the Walpole portrait is a repetition. Participation by assistants is particularly noticeable in the hands, clothes and background and this view is shared by the majority of scholars. Currently, only Larsen (1988) continues to view the Hermitage picture as superior to Fitzwilliam Museum version.

104

ANTHONY VAN DYCK (1599-1641), workshop
Archbishop William Laud
Oil on canvas, 122 x 93.5, inscriptions (from the time of the first owner) at bottom right: *P.Sr. Ant. Vandike*; and three lines at bottom left: *William Laud Arch=/-=bishop of Canterbury/about 1638*
Inv. No. 1698

PROVENANCE: collection of Sir Harry Vane, Raby Castle, UK; 1656 collection of Philip, 4th Lord Wharton, Winchendon, near Aylesbury, Buckinghamshire; 1725 acquired by Sir Robert Walpole from the heirs of Lord Wharton; Sir Robert Walpole, ?London, later Houghton (1736 Corner Drawing Room, then Drawing Room); 1779 Hermitage.

Other versions of the composition are at Lambeth Palace, London (oil on canvas, 127 x 102; dated 1633, follower of Van Dyck); Wentworth Woodhouse (oil on canvas, 125 x 95; Van Dyck's studio); St John's College, Oxford (oil on canvas, 125 x 100; Van Dyck's studio).

The portrait was engraved in reverse in 1640 by Wenceslaus Hollar (1606-67).

N. G.

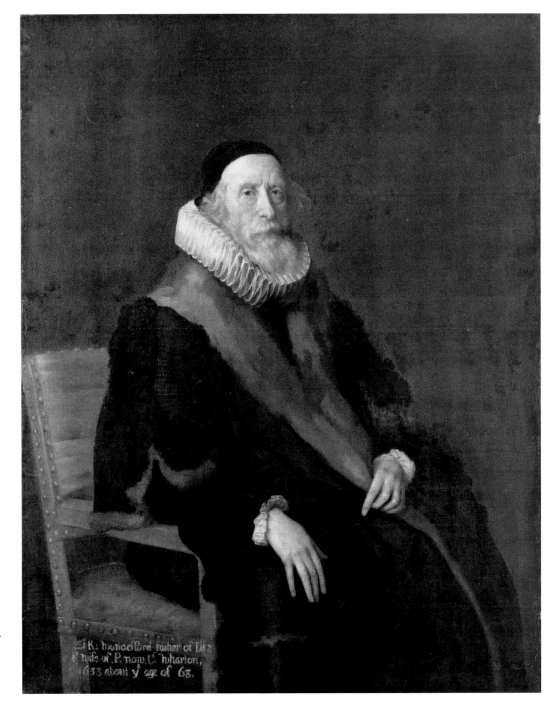

105

ANTHONY VAN DYCK (1599-1641) and workshop
Sir Rowland Wandesford
Oil on canvas, 132.5 x 106, inscriptions (from the time of the first owner) at bottom right: *P. Sr. Ant. Vandike*; and three lines bottom left: *Sr R. Wandesford father of 1st/ wife of P. now Ld Wharton,/ 1638 about ye age of 68*
Inv. No. 531
PROVENANCE: collection of Philip, 4th Lord Wharton, Winchendon, near Aylesbury, Buckinghamshire; 1725 acquired by Sir Robert Walpole from the heirs of Lord Wharton; Sir Robert Walpole, ?London, later Houghton (1736 Corner Drawing Room, then Drawing Room); 1779 Hermitage.
LITERATURE: *Aedes* 1752, p. 52 (as 'Lord Chief Baron Wandesford... Vandyke'); 2002, no. 69; Boydell I, pl. L; Chambers 1829, vol. I, p. 524; Smith 1829–42, part III, p. 189, no. 649; Livret 1838, p. 431, no. 1; Cats. 1863–1916, no. 621; Andreyev 1857, p. 214; Waagen 1864, p. 150; Neustroyev 1898, p. 183; Cust 1900, pp. 123, 285, no. 218; Lisenkov 1926, pp. 21–22; Vertue,

vol. I, 1929-30, p. 29; Cat. 1958, vol. II, p. 63; Varshavskaya 1963, p. 125, no. 20; Larsen 1980, vol. II, no. 930; Cat. 1981, p. 40; Larsen 1988, p. 401, no. 1029; Millar 1994, p. 526, no. 11.

Sir Rowland Wandesford (c.1570–after 1638) was the father of Elizabeth Wandesford, the first wife (married 1632) of Philip, 4th Lord Wharton (see cat. no. 108). In 1637 Sir Rowland became Attorney to the Court of Wards and Liveries.

One of the portraits commissioned from Van Dyck by Philip, Lord Wharton in the period 1637-9 (see cat. no. 108), this painting undoubtedly shows significant involvement by one of the master's assistants.

A half-length copy of the portrait was sold at Christie's, South Kensington, on 17 April 1997 (Lot 292), as the work of an artist from the circle of Caspar de Crayer (oil on canvas, 79.4 x 67.3).

N. G.

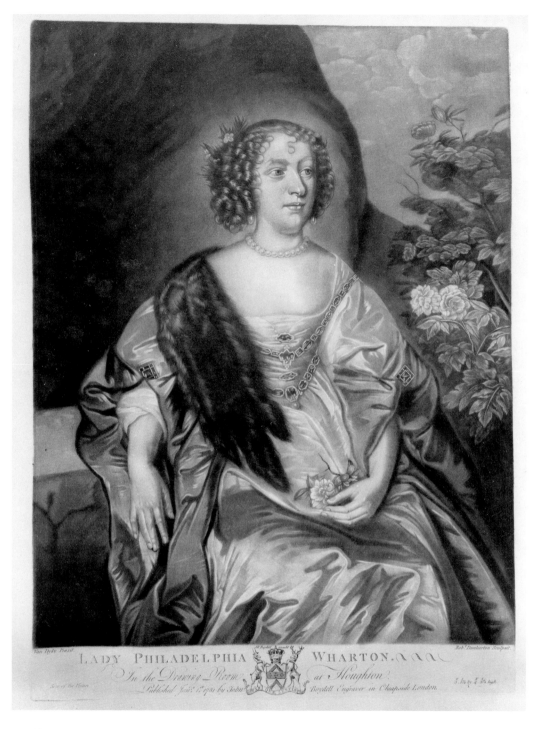

Lady Philadelphia Wharton (née Carey; 1593/94–after 1654/55) was the only daughter of Robert, 1st Earl of Monmouth. Her grandfather was Henry, Lord Hunsdon who through his mother, Mary Boleyn, was a first cousin of Queen Elizabeth I. In 1611, Philadelphia married Sir Thomas Wharton (1587–1622) of Aske near Richmond, Yorkshire (see cat. no. 109) and gave birth in 1613 to a male heir, Philip, later 4th Lord Wharton (see cat. no. 108).

Only Livret 1838 mentions the painting, which was eventually transferred to Moscow in 1862. The 1915 catalogue of the Rumyantsev Museum (Rumyantsev Museum 1915) stated that the face 'is lacking in expression and is inferior to the beautiful rendering of the satin dress', suggesting that Van Dyck was responsible only for the composition and left the actual execution to assistants. The painting is last mentioned in 1917 (Moscow Guide 1917) but it would seem to have remained in the Rumyantsev Museum until this was closed in 1924. Its present whereabouts is unknown.

There is a copy of the composition at Grimsthorpe Castle in Lincolnshire (Millar 1994, p. 526 note 51).

N. G.

106

ANTHONY VAN DYCK (1599–1641) and workshop
Lady Philadelphia Wharton
Oil on canvas, 123 x 106.5
PROVENANCE: collection of Philip, 4th Lord Wharton, Winchendon, near Aylesbury, Buckinghamshire; 1725 acquired by Sir Robert Walpole from the heirs of Lord Wharton; Sir Robert Walpole, ?London, later Houghton (1736 Common Parlour, then Drawing Room); 1779 Hermitage; 1862 transferred to the Rumyantsev Museum, Moscow (RM Inv. No. 623); since 1924 whereabouts unknown.
LITERATURE: *Aedes* 1752, p. 52; 2002, no. 70; Boydell II, pl. XXIII; Chambers 1829, vol. I, p. 524; Smith 1829–42, part III, pp. 187–88, no. 643; Livret 1838, p. 432, no. 5; Viardot 1852, p. 260; Andreyev 1857, p. 214; Rumyantsev Museum 1915, pp. 229, 240, no. 623; Moscow Guide 1917, p. 561; Millar 1994, p. 526, no. 10.

107

ANTHONY VAN DYCK (1599–1641) and workshop
Philadelphia and Elizabeth Wharton
Oil on canvas, 162 x 130, inscriptions (from the time of the first owner) at bottom right: *P. Sr Ant. Vandike*; and four lines at bottom left: *Philadelphia Wharton and Elizabeth/ Wharton ye only daughters of Philip/ now Lord Wharton by Elizabeth his/ first wife, 1640 about ye age of 4 and 5*
Inv. No. 533
PROVENANCE: collection of Philip, 4th Lord Wharton, Winchendon, near Aylesbury, Buckinghamshire; 1725 acquired by Sir Robert Walpole from the heirs of Lord Wharton; Sir Robert Walpole, ?London, later Houghton (1736 Yellow Drawing Room, then Drawing Room); 1779 Hermitage.

LITERATURE: *Aedes* 1752, p. 51 (as 'Two Daughters of Lord Wharton'); 2002, no. 62; Boydell II, pl. LXIX; Chambers 1829, vol. I, p. 523; Smith 1829–42, part III, p. 187, no. 642, and Supplement, p. 393, no. 90; Livret 1838, pp. 356–57, no. 14; Waagen 1864, p. 152; Cats. 1863–1916, no. 618; Cust 1900, pp. 123, 272, no. 48; Vertue, vol. I, 1929–30, pp. 29, 109; Glück 1931, pl. 486; Vertue, vol. III, 1933–34, p. 12; Cat. 1958, vol. II, p. 60; Varshavskaya 1963, pp. 124–25, no. 19; Larsen 1980, vol. II, no. 977; Cat. 1981, p. 40; Larsen 1988, p. 404, no. 1032; Millar 1994, p. 527, no. 14; Gritsay 1996b, p. 137.

EXHIBITIONS: 1982 London, no. 56; 1987 New Delhi, no. 32; 1992 Tokyo, no. 32; 1996–97 New Haven–Toledo–St Louis, no. 2; 1998 St Petersburg, no. 2; 1999 Antwerp-London, no. 103; 2001 Toronto, no. 32.

Elizabeth and Philadelphia were the daughters of Philip, 4th Lord Wharton (see cat. no. 108), by his first wife Elizabeth, daughter of Sir Rowland Wandesford (see cat. no. 105), whom he married in 1632. We know that the elder sister, Elizabeth, married Robert Bertie, later 3rd Earl of Lindsey in 1659 and she died in 1669 but since virtually nothing is known of the younger sister, Philadelphia, it seems likely that she died in childhood.

Despite the inscription on both the painting and the engraving taken from it, doubts have arisen about the identity of the sitters. Cust (1900), citing documentary evidence that Philip Wharton's first marriage produced only a single daughter, Elizabeth, suggested that the portrait shows Philip's cousins, Philadelphia, born 1631, and Elizabeth, born 1632, the daughters of his maternal uncle Thomas Carey. Cust's theory was accepted in Hermitage catalogues between 1902 and 1958. Varshavskaya (1963) rightly noted, however, that there is insufficient reason to challenge the inscription, made during the lifetime of Philip, Lord Wharton himself. Inscriptions similar in content and script are found only on those paintings that came from the Wharton collection. We know that Philip Wharton married three times and had about fifteen children, of whom six died in childhood. The Wharton family genealogy shows that Philip's second marriage produced four children 'with other issue' (Burke's *Genealogical and Heraldic History of the Peerage*, London, 1959, p. 2367). The last daughter from the second marriage was also named Philadelphia, perhaps in honour of the deceased elder child.

One of a group of works commissioned from Van Dyck in the period 1637–39 by Philip, Lord Wharton (see cat. no. 108), this double portrait is surely amongst the artist's most touching images of children. Van Dyck undoubtedly painted the figures himself without the aid of assistants, and in the outlines of the dresses pentimenti can be seen. The dry and somewhat schematic execution of the background (particularly in the landscape), however, is evidence of workshop participation.

N. G.

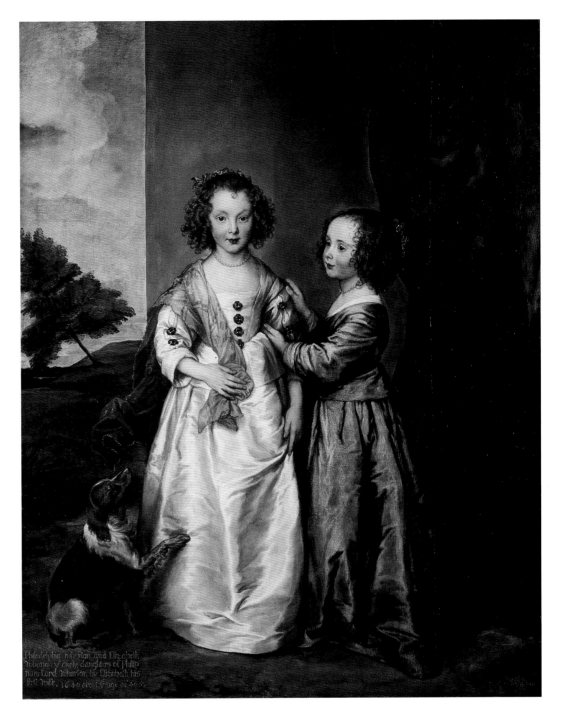

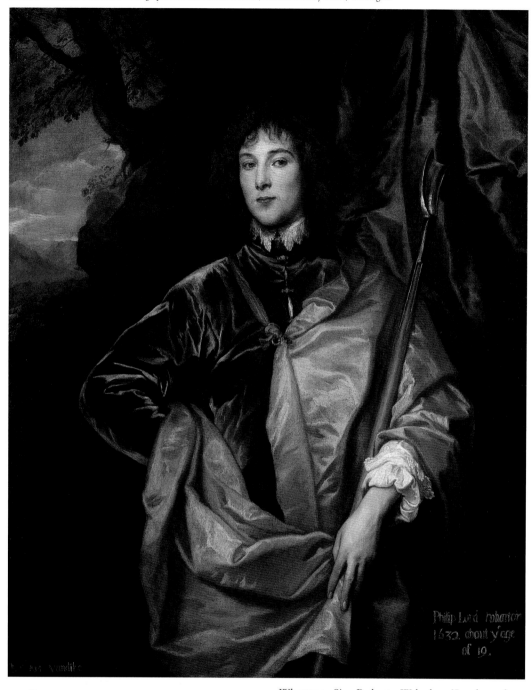

329; Cust 1900, pp. 121, 213, no. 85, p. 286, no. 222; Schaeffer 1909, p. 509, no.. 303; Weiner 1923, pl. 240; Vertue, vol. I, 1929-30, pp. 11-12; Glück 1931, p. XLIV, pl. 397; Puyvelde 1950, p. 173; NG Washington 1975, p. 118, no. 50; Larsen 1980, vol. II, no. 753; Brown 1982, p. 202; Stewart 1983a, p. 35 note 46; NG Washington 1985, p. 144; Larsen 1988, p. 402, no. 1029; Millar 1994, pp. 525-26, no. 7.

EXHIBITIONS: 1898 Amsterdam; 1899 Antwerp, no. 85; 1900 London, no. 61; 1990-91 Washington, no. 63; 1996-97 Norwich–London, no. 26.

Philip, Lord Wharton (1613-96) was the elder son of Sir Thomas Wharton (1587-1622) and his wife Philadelphia Carey (see cat. no. 106). He became 4th Baron Wharton in 1625 on the death of his grandfather. In 1632 he married Elizabeth, daughter of Sir Rowland Wandesford (see cat. no. 105) and after her death he married in 1637 Jane Goodwin (1619-58), daughter and heir to Arthur Goodwin (1593/4-1643) of Winchendon, Buckinghamshire. Although close to the court during the 1630s—he was presented with portraits of the royal couple by Charles I himself in 1638 (see cat. nos. 98, 99)—in 1648 he became a passionate supporter of Parliament. After the Restoration of the monarchy in 1660 he once again became a royal supporter, and in 1688 was one of the first to declare his support for William of Orange as King of England.

In this portrait the young nobleman is presented as an Arcadian shepherd, languidly holding a shepherd's staff or houlette. Painted in 1632, almost certainly to celebrate his marriage to Elizabeth Wandesford, the portrait is one of the first private commissions Van Dyck received after his arrival in England in March of that year.

Lord Wharton erected a purpose-built picture gallery in his new house on his Winchendon estate, near Aylesbury in Buckinghamshire (Vertue, vol. I, 1929-30, pp. 11-12). He commissioned a number of portraits of family members from Van Dyck, mainly in the period 1637-39, and these hung in the gallery along with Van Dyck's portraits of the King, Queen and several contemporaries such as Archbishop Laud. It would seem that inscriptions were added to the portraits whilst they were still at Winchendon and these additions, all in the same easily identifiable script, are to be found only on those paintings from the Walpole collection that came from the Wharton collection.

N. G.

108

ANTHONY VAN DYCK (1599-1641)
Philip, Lord Wharton
Oil on canvas, 135 x 107, inscriptions from the time of the first owner at bottom left: *P.Sr Ant: vandike*; and in three lines at bottom right: *Philip Lord Wharton/ 1632 about ye age/ of 19*
National Gallery of Art, Washington, Inv. No. 1937.1.50
PROVENANCE: collection of Philip, 4th Lord Wharton, Winchendon, near Aylesbury, Buckinghamshire; 1725 acquired by Sir Robert Walpole from the heirs of Lord Wharton; Sir Robert Walpole, ?London, later Houghton (1736 Corner Drawing Room, then Drawing Room); 1779 Hermitage; under register of 22 February 1930 removed from the Hermitage; 1932 acquired by Andrew Mellon; Mellon coll., Pittsburgh and Washington; 1937 A. W. Mellon Educational and Charitable Trust, Pittsburgh; National Gallery of Art, Washington.
LITERATURE: *Aedes* 1752, p. 52; 2002, no. 68; Houbraken [1718], pp. 147-48; Chambers 1829, vol. I, p. 524; Livret 1838, p. 432, no. 6; Viardot 1852, p. 260; Andreyev 1857, p. 214; Cats. 1863–1916, no. 616; Waagen 1864, p. 150; Anecdotes 1862, vol. I, pp. 322,

109

ANTHONY VAN DYCK (1599-1641)
Sir Thomas Wharton
Oil on canvas, 217 x 128.5, inscriptions (from the time of the first owner) at bottom left: *P.Sr.Ant. Vandike*; in three lines at right: *Sr Thomas Wharton brother/ to Philip now Lord Wharton/ 1639 about ye age of 25*

Inv. No. 547

PROVENANCE: collection of Philip, 4th Lord Wharton, Winchendon, near Aylesbury, Buckinghamshire; 1725 acquired by Sir Robert Walpole from the heirs of Lord Wharton; Sir Robert Walpole, ?London, later Houghton (1736 Corner Drawing Room, then Marble Parlour); 1779 Hermitage.

LITERATURE: *Aedes* 1752, p. 72; 2002, no. 192; Boydell I, pl. III; Schnitzler 1828, p. 103; Chambers 1829, vol. I, p. 532; Smith 1829–42, part III, p. 187, no. 640, and Supplement, p. 339, no. 89; Livret 1838, p. 350; Cats. 1863–1916, no. 617; Waagen 1864, p. 152; SbRIO 17, 1876, p. 400; Cust 1900, pp. 123, 286, no. 225; Rooses 1904, p. 115; Schaeffer 1909, pl. 353; Vertue, vol. I, 1929-30, p. 109; Glück 1931, pl. 468; Vertue, vol. II, 1931-2, p. 99; Vertue, vol. III, 1933-34, pp. 12, 44; Cat. 1958, vol. II, p. 60; Varshavskaya 1963, pp. 123–24, no. 18; Larsen 1980, vol. II, no. 865; Cat. 1981, p. 40; Larsen 1988, pp. 403–4, no. 1031; Millar 1994, p. 526, no. 9.

EXHIBITIONS: 1996–97 New Haven–Toledo–St Louis, no. 1; 1998 St Petersburg, no. 1.

Sir Thomas Wharton (1615–84) was the youngest son of Sir Thomas Wharton of Aske (1587–1622) and Philadelphia Carey (?–1654) and was the brother of Philip, 4th Lord Wharton (see cat. no. 108). A notable and influential member of the English aristocracy at court, he served for more than twenty years in the army of Ireland and was, according to contemporaries, like his father a deeply religious man. Together with his wife, Mary Carey, daughter of Henry Carey, Earl of Dover, he devoted much of his time to charitable works.

Wharton is here shown wearing the insignia of the Order of the Bath, which he was awarded in 1625. On a red ribbon thrown across his right shoulder we can identify the badge of the Order, a cross surrounded by three crowns, with a sceptre, rose and thistle at the centre. Also forming part of the attire of the Order are the metal breastplate and sword.

One of a group of works commissioned from Van Dyck between 1637 and 1639 by Philip, Lord Wharton (see cat. no. 108) this portrait may have been painted with the help of assistants, especially in the execution of the background and details of the sitter's attire (Varshavskaya 1963, p. 124). With the fine enamel-like smoothness to the picture surface, typical of the entire group of Wharton portraits, the style of this work is entirely in keeping with the date 1639 which is inscribed on the portrait itself.

In a letter of 29 November 1778 to Lord Orford's solicitor, Carlos Cony, James Christie described the work as 'undoubtedly a copy' (see Dukelskaya essay, p. 67). It is also mentioned in the postscript to a letter from Alexey Musin-Pushkin, Russian ambassador in London, to the Empress Catherine, listing works added to the Walpole sale 'without increasing the previous price' (SbRIO 17, 1876).

N. G.

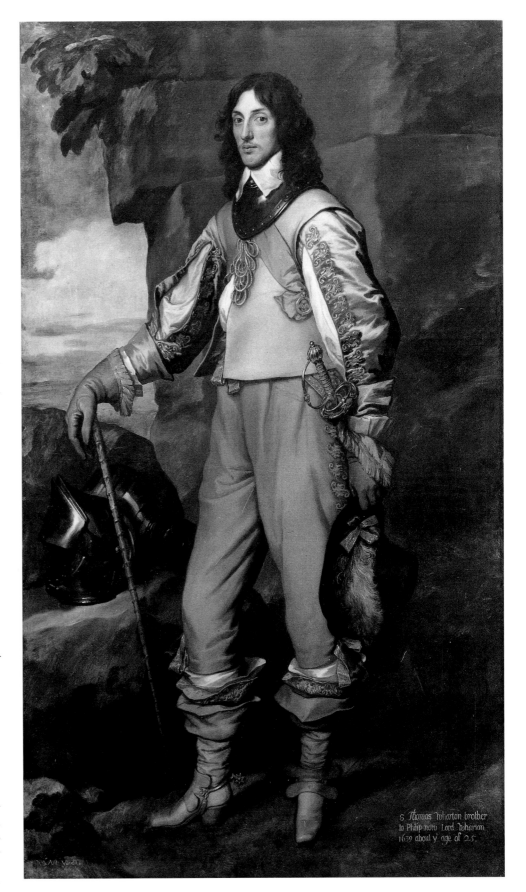

110

ANTHONY VAN DYCK (1599–1641)
PAUWEL (PAUL) DE VOS (1596–1678)
The Rest on the Flight into Egypt
(The Virgin with Partridges)
Oil on canvas, 215 x 285.5
Inv. No. 539

PROVENANCE: acquired before 26 March 1646, in Antwerp, by Frederick Henry, Prince of Orange; in 1667 at Huis ten Bosch, palace of the House of Orange, The Hague (Gelder 1959, pp. 73-76), where it hung over the fireplace in a bedroom (Frederick Henry 1997, p. 48); until 1713 coll. Princes of Orange; 1722 coll. Cornelis Wittert van Valkenburg, Rotterdam (Blanc 1857, p. cxxii); 11 April 1731 sale of the von Valkenburg collection, Rotterdam, lot 1; 7 October 1733 sale of the von Valkenburg collection, Rotterdam; there acquired for Sir Robert Walpole for 12,150 gulden by his agent John Ellys; Sir Robert Walpole, 1736 Downing St (Great Middle Room below), later Houghton (Salon); 1779 Hermitage.

LITERATURE: *Aedes* 1752, p. 54 (as 'The Holy Family'); 2002, no. 84; Boydell II, pl. LXIV ('A Dance of Boy Angels'); Bellori 1672, pp. 155, 157; Hoet, Terwesten 1752-70, vol. I, p. 366 (lot 1), p. 396 (lot 1); Georgi 1794, p. 504 (1996 edition, p. 375); Gilpin 1809, p. 46; Schnitzler 1828, p. 103; Chambers 1829, vol. I, p. 525; Smith 1829–42, part III, pp. 81–82, no. 268; Livret 1838, p. 348; Mariette 1853-59, vol. II, pp. 178-79; Cats. 1863-1916, no. 603; Waagen 1864, p. 148; Anecdotes 1862, vol. I, pp. 288, 321; SbRIO 17, 1876, p. 398; Cust 1900, pp. 246–47, Nos 10, 47, 49, 68; Rooses 1904, p. 116-17; Schaeffer 1909, pl. 116; Heidrich 1913, p. 171, pl. 142; Weiner 1923, pl. 248; Glück 1931, pl. 261; Réau 1957, p. 280; Bruyn, Emmens 1957, p. 96; Cat. 1958, vol. II, p. 56; Gelder 1959, pp. 73-76; d'Hulst, Vey 1960, p. 18; Millar 1958-60, p. 234; Varshavskaya 1963, pp. 112-19, no. 12; Fock 1979, pp. 468, 470; Larsen 1980, vol. II, no. 675; Larsen 1988, p. 290, no. 727; Held, in 1990-1 Washington, p. 329, note 11; Glen 1994, pp. 87-96; Roland 1994, pp. 121-33; Frederick Henry 1997, p. 48.

EXHIBITIONS: 1978a Leningrad, no. 13.

The subject is from The Pseudo-Evangeliary According to Matthew, xx-xxi; Matthew, ii: 13-15.

In the late seventeenth and early eighteenth century this picture was usually given the descriptive title, *The Virgin and Child with Joseph with Angels Dancing* (or a group of angels, as in the 1773-85 catalogue 'La Vierge avec l'Enfant Jesus et une troupe d'anges'). In the nineteenth century, however, the title *The Virgin with Partridges* became its accepted soubriquet. It was first described as such by Labensky (Livret 1838 'La Vierge au Perdrix'), although the partridges had already been singled out when Horace Walpole described the painting in the *Aedes*. Walpole found the composition 'too much crowded with Fruits and Flowers and Birds' for by this time its complex symbolism had already been forgotten. A detailed iconographical interpretation was first undertaken by Hermitage curator M. Varshavskaya (1963).

As demonstrated by Varshavskaya, an analysis of the symbolism of all the essential details raises this work above mere biblical illustration to the level of the cult of the Virgin Mary. Rising above the figure of Mary is a sunflower. Not just part of the landscape, this flower points to the image's hidden, spiritual meaning, Mary's divine essence and chastity (Bruyn, Emmens 1957). We should similarly interpret the meaning of the parrot on a branch to Mary's left (see J. J. M. Timmers, *Symboliek en iconographie der Christelijke kunst,* Roermond-Maseik, 1947, p. 510). According to Cesare Ripa's *Iconologia*, first published in 1593, partridges can be seen as an attribute of Lust, one of the seven deadly sins (Timmers, *op. cit.*, p. 567), and they thus indicate that Mary's purity puts all sins to flight. The fruit-laden apple tree beneath which the Holy Family sits (just as in Rubens' *Holy Family Under the Apple Tree,* Kunsthistorisches Museum, Vienna, which was the outer wing of an altarpiece dedicated to St Ildefonso, defender of the dogma of the Immaculate Conception) clearly symbolises original sin, overcome by Mary (Timmers, *op. cit.,* pp. 805-6). Behind the apple tree is a white rose bush, this flower being both one of Mary's attributes and a symbol of virgin purity, beauty, love and joy (Timmers, *op. cit.*, pp. 804-5). The chrysanthemums in the left foreground are also an attribute of the Virgin (M. Levi d'Ancona, *The Garden of the Renaissance,* Florence, 1977, p. 96).

Lying at Mary's feet are pieces of fruit, amongst which some apples and a pomegranate stand out. One meaning of the pomegranate was chastity and in particular Mary's virginity, as interpreted in Solomon's Song of Songs (iv: 13-15; see Guy de Tervarent, *Attributs et symboles dans l'art profane,* vol. II, Geneva, 1959, pp. 204-9; Levi d'Ancona, *op. cit.,* p. 315). But it could also be interpreted in other ways as, for instance, a symbol of the Resurrection, of Eternal Life and the Church. Its seeds could be seen to embody the Church's numerous members (see G. Ferguson, *Signs and Symbols in Christian Art,* London-Oxford-New York, 1989, p. 37). A similar meaning might also be attached to the fig and pumpkin that are both clearly visible. They can also be interpreted as symbols of the salvation of the Christian soul (Levi d'Ancona, *op. cit.*, pp. 136-37, 156).

Close study of the painting suggests that other details can be linked with the Christ Child and with the Church and Salvation. In particular, we can identify one of the most frequent attributes of Christ, 'the true vine', or grapes (Levi d'Ancona, *op. cit.*, pp. 159, 162), while clover and plantain ('way bread') in the foreground are also symbols of Salvation and were known for their protective properties (Levi d'Ancona, *op. cit.*, pp. 99-100, 310). The goldfinch flying towards the Virgin and Child is also a symbol of Christ's Passion (Ferguson, *op. cit.*, p. 19).

The composition's central theme is revealed, however, as the cult of the Virgin. As propaganda, the cult was particularly strong in the early seventeenth century and was used by both the Catholic Church and the Jesuits as a counterbalance to the Protestant notion that the deification of Mary and the saints was synonymous with the worship of idols (E. Mâle, *L'art religieux après le Concile de Trente*, Paris, 1932, pp. 29-48). Throughout Europe there were special 'brotherhoods of St Mary', one of these being the Confraternity of Bachelors at Antwerp Cathedral, of which Van Dyck became a lay member in 1628. Van Dyck painted two works for this Confraternity, *The Virgin and Child with SS Rosalie, Peter and Paul* in 1629, and in 1630 *The Mystic Marriage of the Blessed Herman Joseph* (both Kunsthistorisches Museum, Vienna). Varshavskaya suggested that the Hermitage's *Rest on the Flight into Egypt* should be associated with a commission by one of the brotherhoods of St Mary, notably the Confraternity of Bachelors, since other versions of this composition (especially *The Rest on the Flight into Egypt* in the Pitti Palace, Florence; oil on canvas, 134 x 159, probably from Van Dyck's workshop) lack the many details connected with the cult of the Virgin.

Varshavskaya's hypothesis does not conflict with the painting's style and is consistent with a dating to the late 1620s or very early 1630s. The figures of the Virgin and Child recall Van Dyck's experience of Venetian painting. In reverse, but barely altered, the group of figures in Titian's *Doge Francesco Donato Adoring the Virgin and Child* (lost in 1574 and now known only from an engraving by Niccolò Boldrini) are closely analogous to the figures in Van Dyck's composition. An outline sketch for this figure group, drawn during Van Dyck's stay in Italy, can be found in the artist's *Italian Sketchbook* (f. 15; British Museum, London). Neither should we exclude the possible influence of compositions with groups of putti in a landscape by the Bolognese painter Francesco Albani (1578-1660), as was emphasised by Rooses (1904), who drew attention to a work by Albani in the Brera, Milan, with angels playing the same game as in Van Dyck's painting. Varshavskaya was surely correct in emphasising the close link between the Hermitage picture and Rubens' works of the early 1630s, similarly inspired by Venetian painting, such as the *Holy Family Under the Apple Tree* and *Virgin and Child in a Landscape with St George and Other Saints* (Prado, Madrid). With a group of three small angels leading a lamb towards Christ, who has fallen asleep on his mother's knee, this work has much in common with Van Dyck's painting.

Stylistically, *The Rest on the Flight into Egypt,* belongs to the same group of works as *Rinaldo and Armida* (Baltimore Museum of Art), commissioned by Endymion Porter for Charles I and completed in December 1629. Both versions of *Venus at the Forge of Vulcan* (Louvre,

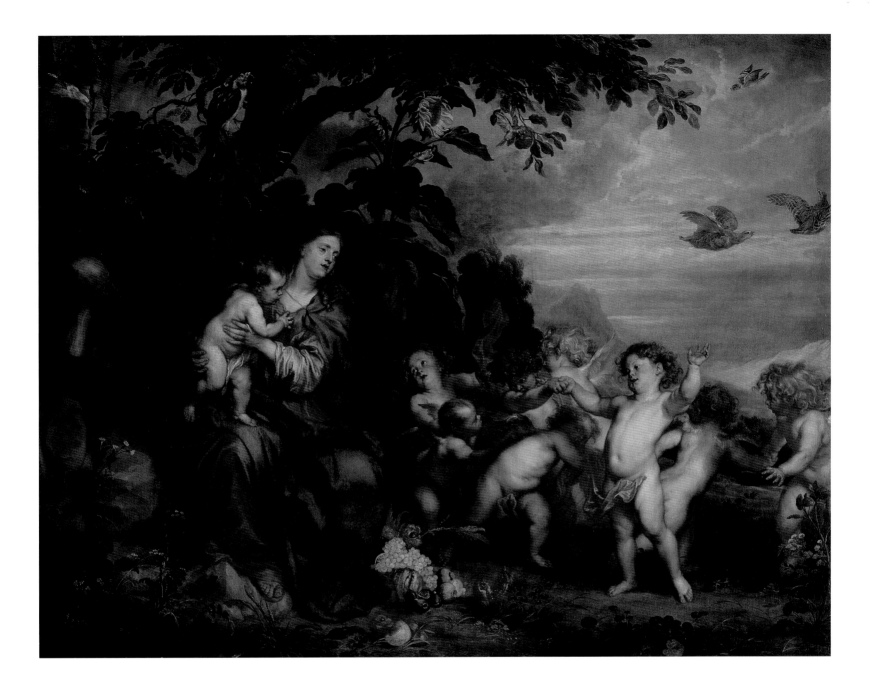

Paris, Inv. No. 12234, and Kunsthistorisches Museum, Vienna, Inv. No. 498) are also usually dated c.1630-32. The small angels in the Walpole painting relate closely to figures of putti in all these works, while the Baltimore picture is also close in terms of its landscape, notably in the way the leaves and the wild flowers in the background are painted. It can therefore be proposed that Van Dyck executed this painting no later than c.1630-32.

According to Bellori (1672), Van Dyck painted two versions of *The Virgin and Child with Little Angels*, the first for King Charles I's consort, Henrietta Maria and

the second for Prince Frederick Henry of Orange. Bellori states categorically that the version for Henrietta Maria was specifically designed to include the small angels in the clouds, whereas of the version for the Prince of Orange he states only that 'the Virgin and the Child Jesus [are] in front of several little dancing angels' (cited in Brown 1991, p. 19). With the aid of documents published in 1959 by van Gelder, Varshavskaya (1963) demonstrated convincingly that the Hermitage picture was formerly in the collection of the Princes of Orange. This confirmed the opinion of Somov (Cat. 1902), but contradicted the more widely

accepted view that the painting was more likely to be that commissioned by Henrietta Maria, which was until 1649 in the Royal Collection (Cust 1900; Glück 1931; d'Hulst, Vey 1960; Millar 1958-60).

Varshavskaya's opinion is reinforced by several points. First, the only provenance given in the *Aedes* is the House of Orange, and we know that Horace Walpole was usually well informed about the origin of paintings acquired by his father. Secondly, the painting from the Royal Collection was only sold after Charles I's death in 1649, yet the version acquired by Sir Robert Walpole was in 1646 already with the Princes of

Orange. Glen's suggestion that both compositions mentioned by Bellori were formerly in the royal collection (Glen 1994) is yet another theory although it is rather weak on both iconography and the significance of the sunflower as well as the likely dating and how the painting reached Flanders, where it was acquired by Sir Robert Walpole's agent. Also unlikely is the suggestion made by M. Roland (1994) that Bellori confused the two paintings and that the Princes of Orange owned a version of the composition now known only from a copy in the Pitti Palace, Florence, and an engraving by Schelte à Bolswert. Roland's hypothesis is based on the incorrect assumption that Schelte à Bolswert made his engraving without the knowledge or participation of Van Dyck. For information on the engraving see Carl Depauw and Ger Lijten, *Anthony van Dyck as a Print-maker*, exh. cat., 15 May–22 August 1999, Museum Plantin-Moretus/Stedelijk Prentenkabinet, Antwerp; 9 October 1999–9 January 2000, Antwerpen Open/Rijksmuseum, Amsterdam, 1999, pp. 284, 286).

Further support for the suggestion that the work was painted in Antwerp is provided by A. Balis (1996), who rightly noted the collaboration with Pauwel de Vos, who painted the birds. Confirmation of this is found in a comparison with accepted works by de Vos, particularly *Partridges Discovered by Three Spaniels* (Koninklijk Museum voor Schone Kunsten, Antwerp), where the same partridges as in the Hermitage canvas appear in the top right corner. Paul de Vos, it is important to note, never worked in London.

A preparatory sketch for the composition is in the Suermondt Museum, Aachen (oil on panel, 32 x 40). A much earlier study by Van Dyck of c.1616 (Museum voor Schone Kunsten, Ghent; oil on canvas, 50.5 x 38) was used for the head of Joseph.

There is a copy in the Glasgow Art Gallery and Museum (Inv. No. 298) and a fragmentary copy (depicting the Christ Child and part of the Virgin's face) is in a private collection (sold, Christie's, London, 20 February 1997, Lot 34; oil on canvas, 78.8 x 54.5).

The engraving by the brothers Siegmund Georg and Johann Gottlieb Facius in Boydell is in fact a copy of the engraving by Schelte à Bolswert (Hollstein 1949–81, vol. III, p. 76, no. 168).

N. G.

III

JACOB JORDAENS (1593–1678)
Self-portrait with Parents, Brothers and Sisters
Oil on canvas, 175 x 137.5
Inv. No. 484

PROVENANCE: probably Het Paradijs (home of Jordaens's parents) in Antwerp, now 13 Hoogstraat, which Jordaens purchased in 1634 at the sale of his deceased parents' property; coll. Henry Bentinck, Duke of Portland; 1722 acquired from him by Sir Robert Walpole; 1736 Downing St (Great Room above Stairs), later Houghton (Cabinet); 1779 Hermitage.

LITERATURE: *Aedes* 1752, p. 65 (as 'Rubens' Family'); 2002, no. 140; Boydell II, pl. XIX; Gilpin 1809, p. 51; Chambers 1829, vol. I, p. 529; Livret 1838, p. 339; Waagen 1864, p. 155; Cats. 1863–1916, no. 652; Buschmann 1905, pp. 85–86; Fierens-Gevaert 1906, p. 107; Rooses 1906, p. 54; Drost 1926, p. 99; Vertue, vol. III, 1933-34, p. 9; Held 1940, pp. 70–82; d'Hulst 1956, p. 22; Cat. 1958, vol. II, p. 65; Gritsay 1977, pp. 83–87; Cat. 1981, p. 49; Held 1982, pp. 9–24; d'Hulst 1982, pp. 266, 268; Lidtke 1989, pp. 164, 165, 168; Nelson 1990, pp. 105–19; Smolskaya 1991, pp. 8–9; Moore ed. 1996 pp. 49, 121, 138.

EXHIBITIONS: 1968–69 Ottawa, no. 3; 1977 Tokyo–Kyoto, no. 14; 1978a Leningrad, no. 15; 1979 Leningrad, no. 1; 1985 Rotterdam, no. 35; 1988 New York–Chicago, no. 42; 1992–93 Cologne, no. 62.1; 1992–93 Antwerp–Vienna, no. 56; 1993 Antwerp, no. A 5; 1996–97 Amsterdam, no. 83; 2001 Toronto, no. 33.

In the *Aedes* and for many years after its acquisition by the Hermitage, this portrait was attributed to Rubens and was thought to represent Isabella Brant and their children. The first to challenge this, in the 1797 catalogue, was Labensky who, without providing any evidence, identified the portrait as the *Family of Jordaens*. Gustav Waagen (1864) was the first to point out the error in the accepted identification of the sitters when he visited the Hermitage Picture Gallery in 1861-62. From 1863 the portrait was listed in Hermitage catalogues as *Flemish Family in a Garden* (Cat. 1863), *Family Meal* (Cat. 1870) and *Family Feast* (Cats. 1898-1916).

In the early twentieth century renewed attempts were made to identify the sitters. Buschmann (1905), Haberditzl (1908) and Fierens-Gevaert (1906) suggested that it represented the family of Jordaens's teacher and father-in-law, Adam van Noort. But while Buschmann and Haberditzl thought Jordaens himself was the young man playing the lute, Fierens-Gevaert suggested that the aged man holding a glass of wine in his hand was in fact a self-portrait of the artist. A much more convincing identification of the figures in the painting was proposed in 1940 by Julius Held. On the basis of documents published by Genard (J. S. Genard, 'Notice sur Jacques Jordaens', *Messager des scientes his-toriques*, Ghent, 1852, pp. 203 ff.), and taking into account both style and iconographical elements, Held established that the portrait depicts Jordaens's parents and relatives. An important argument in support of Held's identification is a note by George Vertue (vol. III, 1933-34), who saw the painting in 1722 when it was already in the Walpole collection, and described it as a portrait of Jordaens, his parents, brothers and sisters.

Jacob Jordaens the Elder was an Antwerp linen goods merchant, who married Barbara van Wolschaten. His son the artist is shown holding the lute and is with seven of his brothers and sisters. In the foreground are the twins Abraham and Isaac (born 1606) with Elizabeth (born 1613) on her mother's knee. The young woman to left of Barbara van Wolschaten is Maria (born 1596), and near her is Anne (born 1597). The girl looking over her mother's shoulder is Catherine (born 1600) whilst the child to right of the father is Madeleine (born 1608). Jordaens's parents had three more children, Anne (born 1595), Elizabeth (born 1605) and Susanne (born 1610), who presumably died in infancy. The putti with a laurel wreath (?) floating above the whole group should be seen as personifying the souls of those deceased children.

Jaffé (1968–69 Ottawa) suggested that the portrait depicted celebrations in honour of Jordaens's acceptance as a master in the Antwerp Guild of St Luke, and that it was painted specially to mark this event. This is debatable, however, since several details in the composition are traditional to family group portraits and bear specific traditional symbolic meanings. Thus the lute upon which the artist plays symbolises harmony (*concordia*), in the context of a family portrait indicating harmony within the marriage and the family. The dog in the foreground embodies conjugal faithfulness (see the engraving of a wedding in Andrea Alciati, *Emblematum libellus*, Paris, 1542, p. 138). The vine winding itself along the wall of the summer house can similarly be read as a symbol of permanence in love. Wine and bread are associated with the Eucharist or, in a broader sense, with religious faith, which unites parents and children (C. van de Velde, *Frans Floris. 1519/20–1570. Leven en Werken*, Brussels, 1975, p. 292). The platter of fruit carried by the servant can be interpreted as *pace frui* ('enjoyment of peace'; see d'Hulst in 1993 Antwerp). Overall, the content reflects traditional ideals of Christian morality. The father's gesture in raising a glass of wine in his right hand should probably be read as a precaution against excessive indulgence in vain earthly pleasures and as a reminder of the need for moderation, one of the most important Christian virtues (compare J. Bruyn, M. Thierry de Bye Dolleman, 'Maerten van Heemskercks 'Familiengroep' te Kassel: Pieter Jan Foppesz. en zijn gezin', *Oud Holland*, vol. 97, 1983, no. 1, pp. 20, 24).

Such an identification of the sitters leads us to date the work to early in Jordaens's career, around 1615. As

x-ray examination of the work has shown, however, that work continued in two distinct stages, with Jordaens repainting a number of details on the already finished picture. As far as can be ascertained from the x-ray photography, the three children in the foreground were originally shown naked. Maria held out her hand towards the little boys embracing each other in the foreground and a seated cat stood in place of the large wine-cooler with ewers and bottles in the bottom right corner. The artist's changes not only clothed the boys and altered Maria's gesture but also made the father raise his glass of wine. In addition he placed a white cloth on the table with and a basket of cheese upon it that Held thought was a pomegranate. Other additions include a small plate of bread, the wine-cooler with its bottles and a dog being stroked by one of the artist's younger brothers. All these new motifs – the glass, the wine-cooler, the bread and cheese, even the dog – can be found in Jordaens's works of the late 1630s-1640s such as the subject of *'The King Drinks'* (compare, for example, the versions in the Louvre, Paris; Musée des Beaux-Arts, Brussels, Inv. No. 3395; formerly in the collection of the Duke Devonshire at Chatsworth).

This *Self-portrait with Parents* can be linked with the latter works also in its use of the concept of moderation. In working on his paintings depicting the festival of the 'bean king', Jordaens would seem to have turned once more to his early *Self-portrait* (which he acquired together with the rest of his deceased parents' property) and turned it into a scene of feasting and merrymaking.

This picture is usually dated to late in Jordaens's career in the older literature on the artist (Fierens-Gevaert 1906; Drost 1926) and this can be explained by the artist's partial repainting of the canvas in the late 1630s to 1640s.

The composition was undoubtedly inspired by an altarpiece, *The Circumcision*, painted by Rubens around 1605 (Church of Sant'Ambrogio, Genoa), the sketch for which Rubens brought back with him from Italy (Gemäldegalerie der Akademie der bildenden Künste, Vienna; for more information see Gritsay 1977).

N. G

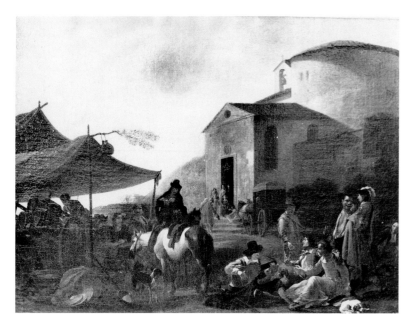

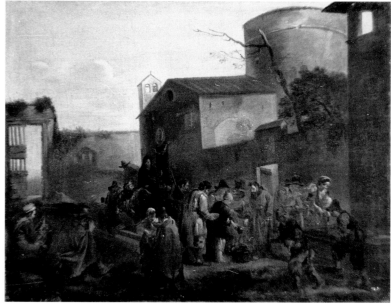

112

JAN MIEL (1599-1664)
Bivouac
Oil on canvas, 50 x 67
Gatchina State Museum Reserve, Inv. No. 1600 – III
PROVENANCE: Sir Robert Walpole, 1736 Downing St (Lady Walpole's Drawing Room), later Houghton (Cabinet); 1779 Hermitage; from the second half of the 19th century at Gatchina Palace, Gatchina; 1945 transferred to Pavlovsk Palace Museum, Pavlovsk; 1987 returned to Gatchina Palace Museum, Gatchina.
LITERATURE: *Aedes* 1752, p. 67; 2002, no. 156; Boydell II, pl. XXVII ('An Italian Fair'); Shchavinskiy 1916, pp. 76, 77.

Pair to *The Charity of St Anthony* (Peterhof, cat. no. 113).

The *Aedes* records two paintings by Jan Miel, the first entitled *Friars Giving Meat to the Poor* and the second described simply as 'Its Companion'. According to the letterpress on the engraving by James Fittler for Boydell, however, the second painting in the Walpole collection had the same dimensions as the first (1'7½" x 2'2") and was known as *Italian Fair*.

The 1773-85 catalogue lists a pair of works by Jan Miel, *Monks Feeding the Poor* and *Holiday at the Fair*, giving the dimensions (approximating to those given in the *Aedes*) as 11 x 15 *vershki* (c.48.9 x 66.75). The 1797 catalogue lists the paintings separately, as *Monks Giving Alms* and *Rural Holiday* and the 1859 Inventory records that the latter work was transferred to Gatchina Palace, where it is now known under the title *Bivouac*.

Shchavinskiy (1916) mistakenly published this work with an attribution to the Dutch artist Pieter van Laer, suggesting that he was unaware of Fittler's engraving, which is entirely consistent with the painting. Despite Shchavinskiy's attribution, the inventories of Gatchina and Pavlovsk palaces have traditionally given both works to Jan Miel.

N. B.

113

Jan Miel (1599-1664)
The Charity of St Anthony
Oil on canvas, 49 x 64
Peterhof State Museum Reserve, Inv. No. 664
PROVENANCE: Sir Robert Walpole, 1736 Downing St (Lady Walpole's Drawing Room), later Houghton (Cabinet); 1779 Hermitage; since the second half of the 19th century at Peterhof (now in the Hermitage Pavilion).
LITERATURE: *Aedes* 1752, p. 67 (as 'Friars giving Meat to the Poor'); 2002, no. 155; Gilpin 1809, p. 52.

Pair to *Bivouac* (Gatchina, cat. no. 112).

The 1773-85 and 1797 catalogues echoed the *Aedes* in describing the subject as monks feeding the poor. It was in the 1859 Inventory that the painting came to be described as *St Anthony Distributing Alms*, with a note that it had been transferred to Peterhof.

N. B.

114

ANTHONIS MOR DAN DASHORT (ANTONIO MORO) (1519-76)
Portrait of a Man (Sir John Gresham)
Dated to right, in black, as if carved in stone, 1550, oil on canvas, transferred from panel in 1848, 90 x 68, partially damaged inscription on the signet ring: *[t]e ipsum no[sce] (know thyself)*
Pushkin Museum of Fine Arts, Moscow, Inv. No. 2611
PROVENANCE: 1722 Sir Robert Walpole (Vertue, vol. III, 1933-34); 1736 Chelsea (Best Drawing Room), later Houghton (Common Parlour); 1779 Hermitage; 1930 transferred to Museum of Fine Arts (now Pushkin Museum of Fine Arts), Moscow.
LITERATURE: *Aedes* 1752, p. 47 (as 'Sir Thomas Gresham'); 2002, no. 41; Boydell II, pl. VI; Livret 1838, p. 480, no. 23 (incorrect description); Waagen 1864, p. 122, no. 482 (incorrectly giving base as panel, although painting already transferred to canvas); Anecdotes 1862, vol. I, p. 125; Cats. 1863-1916, no. 482; Wrangell [1909], p. 7, xxviii; Hymans 1910, pp. 50-51, 178; Friedländer 1924-37, vol. 13, pp. 122, 171, no. 347; Friedländer 1931; Vertue, vol. III, 1933-34, p. 9; Marlier 1934, p. 106, no. 76; Frerichs 1947, pp. 17-18; Pushkin Museum 1948, p. 53; Pushkin Museum 1957, p. 97; Pushkin Museum 1961, pp. 131-2; Friedländer 1967-76, vol. 13, pp. 64, 101, no. 347, pl. 172 (mistakenly as Hermitage); Pushkin Museum 1986, p. 126; Woodall 1989, vol. II, pp. 388-91; Moore ed. 1992; Pushkin Museum 1995, p. 416; Yegorova 1998, pp. 76-77.

When in the Walpole collection, this painting was thought to be a portrait of the English financier and

diplomat Sir Thomas Gresham (1519-79) but this identification of the sitter was soon discarded by the Hermitage. The subject is considerably older than Gresham, who was only thirty-one years old in 1550, and it is unlike known portraits of him. Hymans (1910) suggested that he might be Sir Thomas Chamberlain, English ambassador to the court at Brussels 1547-53, or another Englishman from his circle. The sitter is in fact Sir Thomas Gresham's uncle, Sir John Gresham (d. 1556), Lord Mayor of London (1547) and a member of the Mercers' Company. He was also a founder of the Russia Company. The Gresham family, like the Walpoles, had strong Norfolk connections. This identification was made by Dr Joanna Woodall in 1992 (Moore ed. 1992).

In the summer of 1550, Mor left Brussels for Spain, and in 1551 he was in Portugal. The most likely subject of a portrait dated 1550, would have been one of the members of the Hapsburg court who were in Brussels in late-1549/early-1550, and by the autumn of 1550 in Valladolid, Spain, in connection with the abdication of Emperor Charles V. The sitter also wears the colours of Philip II – the yellow camisole and black hat – and this gives weight to the notion that the sitter was probably a courtier from his suite (Woodall 1989). The emblematic device on the ring provides no additional clue since it was a common feature among the possessions of educated men at the time,

In his *Anecdotes of Painting in England* (Anecdotes 1862) Horace Walpole noted that this was 'a very good portrait'. The rather inept transference from panel to canvas caused considerable damage to the painting and there is much old retouching in the lower part of the painting including the parapet and hands.

While revealing some elements in common with Mor's earlier style, this portrait is closer to the new type of portraiture that he was to develop hereafter. The traditional attribution to Mor (supported by Friedländer (1931; 1924-37) and Frerichs (1947)) is based on a similarity to his works of c.1549-50. However, Hymans (1910) doubted that the work was by Mor himself and suggested that it might be by the artist's assistants, Conrad Schoot or Jan Maes. It was later listed by Marlier (1934) amongst those works with dubious attributions to Mor and in her unpublished dissertation, Woodall (1989) also rejected the attribution to Mor (in favour of Maes) on the basis that the face lacks the expressive modelling characteristic of the artist. Maes was Mor's chief assistant and would seem to have had passed on to him some of Mor's portrait commissions when the latter left Antwerp in the summer of 1550.

There is a closely related version dated 1550 in the collection of the Earl of Stamford, at Dunham Massey Hall, Cheshire, UK (National Trust), and this is probably also the same picture which is recorded in the collection of Sir Henry Grey, Enville Hall, Stourbridge, Staffordshire, UK (Hymans 1910, p. 51).

K. Ye .

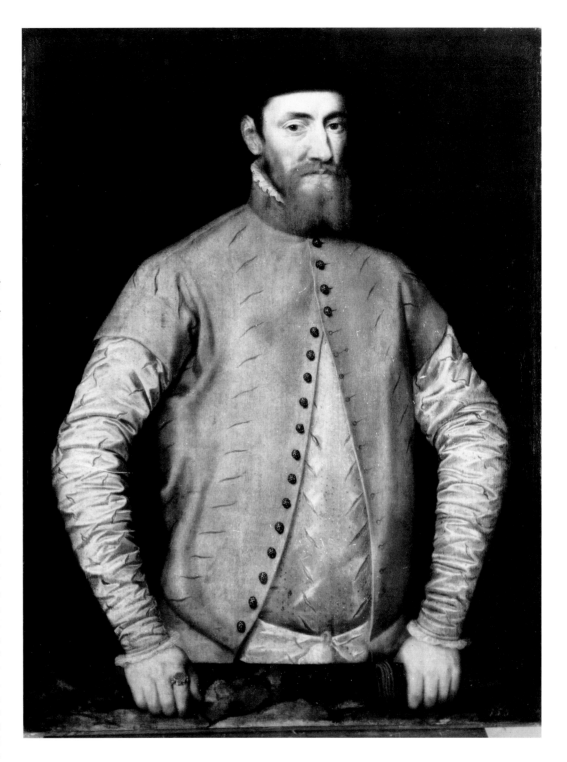

115

MARINUS VAN REYMERSWALE (1490–before 1567)
The Annuity Sellers
Oil on canvas, transferred from panel in 1841, 84.3 x 59.6
Inv. No. 423

PROVENANCE: Sir Robert Walpole, 1736 Downing St (End Room Below, as by 'Quintin Matzi'), then Houghton (Gallery); 1779 Hermitage.

LITERATURE: *Aedes* 1752, p. 85 (as 'An Usurer and his Wife, by Quintin Matsis'); 2002, no. 242; Gilpin 1809, pp. 59-60; Chambers 1829, vol. I, p. 536; Cats 1863-1916, No. 451 ('copy after Quintin Massys: Tax Collectors in Antwerp'; 1916 ('Martinus van Reymerswale: Merchants in an Office'); Waagen 1864, p. 118; Semyonov 1885-90, part I, p. 24; Benois [1910], p. 198; Mély 1910, p. 132; Steinbart 1930, p. 110; Cat. 1958, p. 30 ('Marinus van Roymerswaele: Money Changers'); Nikulin 1972, No. 85, pp. 147-50; Cat. 1981, pp. 24-25; Nikulin 1989, No. 103, p. 186; Mackor 1995, pp. 3-13.

THE INSCRIPTIONS being written into the book by the figure to the left have been partially deciphered by Adry Mackor (letter to the Hermitage staff, September 1999) [by line]:

1. Dit zijn alsulcke Renten als die stad
 These are those Rents which the city....
2. ruert Eerst van erfrenten die n[et] belast
 concerns. First about hereditary rents which are not [?] taxed [?]
3. Onsen ghenadighen Heere ov[er] zijn
 Our merciful Lord on his
4. domeynen C gr[ote]
 domains 100 pounds groats ★
5. Jonfr[ouw] Bouts cap[el]rie xvij lb.lj
 Honourable Miss Bouts "chapelry" ★★ *17 pounds 2 [s.?]*
6. Over drie cap[el]rie in't gasthuys iij sc[hellingen]
 On three "chapelries" in the hospital 3 shillings
7. Onser vrouwe gilde v sc[hellingen] iij ..
 Our Lady's Guild 5 shillings 3 [groats?]
8. Jannes Pietssz[oon] ov[er] Heer Heynr
 Jannes Piets[son] on Lord Henry...
9. Die Heeren van Rey[merswajle ov[er] Haer uutge[ven]?
 The Lords of Reymerswale on Their Spending[?]
10. Over meester Beyers cap[el]rie iiij sc[hellingen]
 On Master Beyers "chapelry" 4 shillings
11. Anthonis Craechout ov[er] zijn Reste en[?]...
 Anthonis Craechout on his Rests and [?]...
12. Rente[n] 't sjaers xxvj sc[hellingen] vij[?]...
 Rents per year 26 shillings 7 [groats]...
13. Piet de Cram[er] orn zijn Renten vj...
 Piet de Cramer on his rents 6...
14. Cornelis Marinus ov[er] zijn Reste[n] v[?] sc[hellingen]
 Cornelis Marinus[son] on his Rests 5[?] shillings...
15. Som[m]e 't same In als[?]

★ This payment is consistent with an annual payment made by the City of Reymerswale to the Count of Sealand, through the Treasurer at Western Scheldt.
★★ In Dutch 'capelrie' is the foundation and maintenance of services at a chapel in a church dedicated to the memory of a particular individual, by means of payment to a priest.

This picture is an example of one of the best-known and widespread compositional types in sixteenth-century Netherlandish painting. There are no less than sixty variations on this subject in museums and private collections around the world. Although these versions vary in quality they differ essentially only in secondary details such as costume and headgear and the objects that make up the still-life in the background. Not one of these paintings bears a genuine author's signature. Until the late nineteenth century these works were mostly listed as the work of Quintin Massys or copies after him. However, this type of composition later came to be linked with one of Massys' followers, Marinus Claeszoon, known after the town where he was born as Marinus van Reymerswale. The authorship of Marinus himself has been incontrovertibly accepted on the basis of stylistic analogies with his signed works for a version in the National Gallery, London which differs slightly from the other works in the placing of the figures. As for the other versions, only a few can be seen as author's replicas, the majority being either the product of the artist's workshop or the work of copyists and imitators.

The high quality of the Hermitage picture demonstrates many of the features of Marinus' own style, suggesting that it is an authentic work by the artist himself. This opinion was recently confirmed by a study of the texts and inscriptions in the painting by Adry Mackor, the Dutch expert on the work of Marinus van Reymerswale. His starting point was the observation that Marinus reproduced with great precision in his paintings real financial documents and had a recognisable calligraphic handwriting, whilst his assistants and imitators involuntarily revealed themselves through their very different, less elegant manner and frequent carelessness in the copying of texts. Mackor concluded that the text in the Hermitage painting is undoubtedly in the hand of Marinus himself (personal communication, during a visit to the Hermitage in September 1999).

The content of the text (to be published in full in Adry Mackor's forthcoming dissertation) forces us to re-assess the accepted subject matter of this painting. This supposed subject matter has altered slightly over the years. In the *Aedes*, for instance, the picture is described as 'An Usurer and his Wife' with identification of the figure to the right as a woman common in older descriptions of these compositions. The Hermitage catalogues described the subject as 'Antwerp Tax Collectors' (Cats 1863, 1902), 'Merchants in an Office' (1916), 'Money Changers' (1958), and again 'Tax Collectors' (Nikulin 1972, Cat. 1981, Nikulin 1989). The entries in the register shown in the Hermitage painting are linked, however, not with the collection of taxes (as is the case, for instance, in the copy in the National Museum, Warsaw), but with payment by the city to individuals of annuities on their investment of capital (Mackor 1995, p. 8).

Although the artist varies the precise occupation of the figures in the numerous versions of this composition (there are, for example, works where the subjects are indeed money-changers) he was evidently less concerned with their specific profession and more with the overall nature of their activities. The protagonists in these paintings are intent on their financial dealings, their goal being material enrichment. Nevertheless, clearly visible at the centre of the composition is a snuffed candle, an admonitory symbol of the transitory nature of life, intended to remind the viewer of the vanity and illusory nature of any earthly benefits. The scene can therefore be interpreted overall as a moralising allegory depicting the embodiment of the sin of avarice and passing judgement on greed (see K. P. F. Moxey, 'The Criticism of Avarice in Sixteenth-century Netherlandish Painting', *Netherlandish Mannerism. Papers Given at a Symposium in the Nationalmuseum Stockholm, 21–22 September 1984*, Stockholm, 1985). The wider sense of the painting is also stressed by the use of archaic costumes, which were totally unrelated to everyday life in the sixteenth century. The fancy head-dresses shown here, the so-called *chaperon*, had gone out of fashion by the middle of the 15th century and would have appeared decidedly anachronistic to the artist's contemporaries.

All scholars of the artist's work have agreed that Marinus would seem to have been heavily influenced by a lost painting of tax collectors by Quintin Massys, mentioned in the inventories of various collections. Although the original painting is not known, one hypothesis suggests that the version of this composition attributed to Reymerswale and now in the Royal Collection (Hampton Court Palace, formerly at Windsor, see Lorne Campbell, *The Early Flemish Pictures in the Collection of Her Majesty the Queen*, Cambridge, 1985, pp. 114-18, pls. 89, 90) is in fact an anonymous copy from Massys' original (Larry Silver, *The Paintings of Quinten Massys*, Montclair, 1984, p. 138, Cat. 19). If this hypothesis is correct, then in the Hermitage composition Marinus was copying very closely his predecessor's model, borrowing from Massys both the central figures and merely giving them a somewhat more acute characterisation and altering details of costume and the surrounding interior.

Both paintings, in the Walpole collection and the royal collection, were attributed to Quintin Massys in the *Aedes*, which also noted their close similarity. Walpole's assertion that the painting then at Windsor was painted by Massys for Charles I is clearly an error. Nonetheless, the painting once formed part of Charles' collection (according to Campbell, *op. cit.* p. 114): it was probably acquired by Charles I's mother, Anne of Denmark, since it was likely to be the picture listed as 'A picture of two Jewes Userers' and in her possession in the Great Gallery at Denmark [i.e. Somerset] House in 1619. The evidence for the statement that the version at Houghton Hall was 'painted for a Family in France' remains unknown.

The precise dating of the Hermitage painting (as for many other works by Marinus) is unclear, since the artist's style changed little over the years. We can only

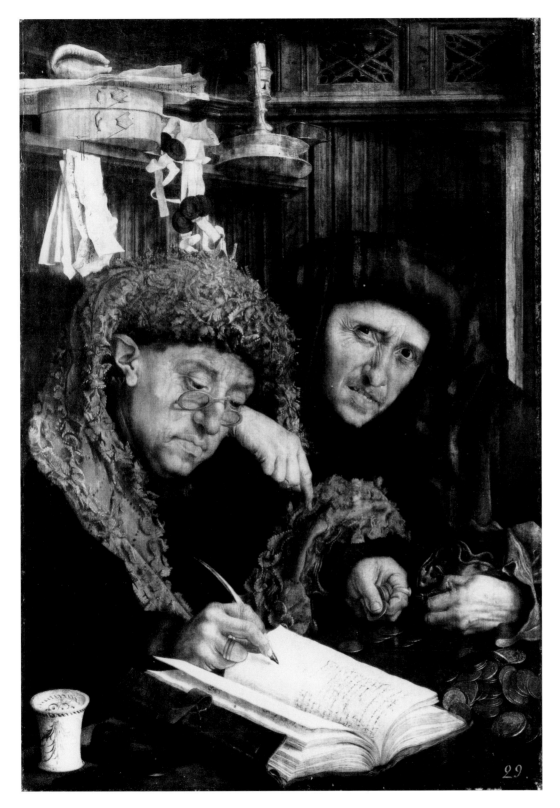

116

PIETER PAUL RUBENS (1577-1640)

The Carters

Oil on canvas, transferred from panel in 1823, 86 x 126.5
Inv. No. 480

PROVENANCE: 1661 probably coll. Cardinal Mazarin
(Inv. No. 1286); 19 May 1723, in sale of coll. D.
Potter, The Hague (lot 44); coll. 1st Earl of Cadogan;
sale of Cadogan coll., London, 14-22 February 1726;
Sir Robert Walpole, 1728 Arlington St, 1736 Down-
ing St (Lady Walpole's Drawing Room), later
Houghton (Gallery); 1779 Hermitage.

LITERATURE: *Aedes* 1752, p. 87 (as 'Moon-light Land-
scape with a Cart overturning'); 2002, no. 251; Boy-
dell I, pl. XXIII; Hoet, Terwesten 1752-70, vol. I, p.
293; Descamps 1753–64, vol. I, p. 316; Gilpin 1809,
pp. 61-62; Chambers 1829, vol. I, pp. 536-37; Smith
1829–42, part II, p. 157, no. 547; Livret 1838, p. 12,
no. 24; Cats. 1863–1916, no. 594; Waagen 1864, p.
143; Rooses 1886–92, vol. IV, pp. 369–70, no. 1178;
Rooses 1905, p. 575; Rosenberg 1905, pl. 404; Benois
[1910], p. 224; Oldenbourg 1921, pl. 285; Schmidt
1926b, p. 23; Kieser 1931, p. 15, 16, 23; Hermann
1936, p. 15, 34, 70, 81; Evers 1942, p. 392; Evers 1943,
p. 176, 350; Glück 1945, p. 17, 24, no. 7; Grossman
1951, p. 20, note 65; Cat. 1958, vol. II, p. 82; Held
1959, vol. I, pp. 34, 144, 146; Theuwissen 1966, p.
200; Varshavskaya 1975, pp. 127–31, no. 19; Cat. 1981,
p. 62; Adler 1982, pp. 80–82, no. 19; Vergara 1982, pp.
48–55; Jaffé 1989, p. 223, no. 402; Rubens Paintings
1989, pp. 94–99; Raupp 1994, p. 160–62; Brown 1996,
pp. 48–51.

EXHIBITIONS: 1967 Montreal, no. 80; 1972 Warsaw-
Prague-Budapest-Leningrad-Dresden, no. 84; 1975-
76 Washington, no. 16; 1977 Antwerp, no. 42; 1981
Vienna, p. 112–15; 1985 Sapporo, no. 27; 1988 New
York–Chicago, no. 46; 1992-93 Cologne-Vienna, no.
89.1; 1992-93 Antwerp, no. 127; 1993-94
Boston–Toledo, no. 89; 1996-97 London, no. 20;
2001 Toronto, no. 41.

The title *Charette embourbée* given to this picture by
Descamps (1753–64) was based on a misreading of the
narrative. In fact, a carter is shown pushing a wagon
heavily laden with stone across a ford, the whole set
against a steep, overgrown, rocky crag that rises up
between two sturdy oaks. This rocky outcrop, which
occupies the entire centre of the composition, its
crevices determining the river's path, forms a division
between two landscape motifs: to the right is a broad,
sunlit, hilly landscape disappearing into the distance,
and to the left a moonlit wooded landscape with a river.
This dual lighting effect, uniting both night and day
within one picture, led a number of scholars to associ-
ate the subject matter with late medieval traditions in
the depiction of the various cycles (*The Times of the
Day*, *The Seasons*, *Months*, etc.) and with the symbolism

suggest that it was painted earlier than the famous *Tax
Collectors* in the National Gallery, London, where the
composition is somewhat reworked and is less depend-
ent on Massys' prototype. Adry Mackor considers the

Hermitage picture to be the earliest of the Marinus'
versions of the subject, and suggests it was painted
before 1538 (letter to the author, 12 January 2001).

A.L.

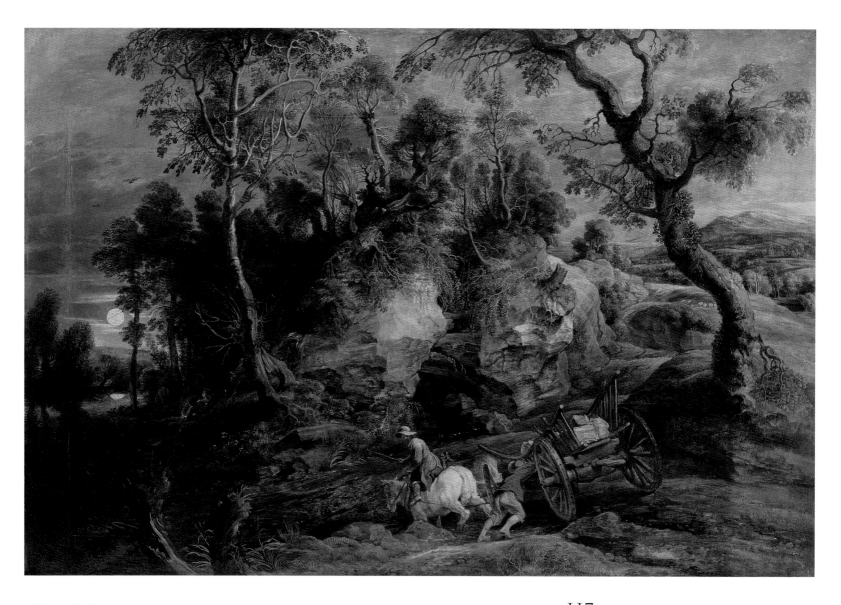

of life and death (Evers 1942; Vergara 1982). Considerably earlier, however, Smith (1829–42) had already provided a perfectly rational and totally natural explanation of Rubens' use of the dual lighting effect, pointing out that the artist was capturing the moment when the moon had already risen before the sun disappeared over the horizon. As Brown (1996) rightly noted, such atmospheric effects can be seen on evenings in late summer. It is possible, however, that the painting represents the notion expressed in Psalm 104 (verse 19): 'He appointed the moon for seasons: the sun knoweth his going down.'

Stylistically, *The Carters* can clearly be dated to early in Rubens' career. The majority of modern scholars date it to the late 1610s. d'Hulst (1977 Antwerp) and Adler (1982) both suggest c.1617 whilst Varshavskaya (1975) and Brown (1996) opt for a date c.1620.

A preparatory drawing of c.1615-16, *Farmyard with a Farmer and a Carriage*, formerly in the collection of the

Duke of Devonshire at Chatsworth, is in the J. Paul Getty Museum in Los Angeles.

The landscape on the left, showing the moon reflected in the water, is redolent of works by Adam Elsheimer (1578-1610), such as his *Flight into Egypt* of 1609 in the Alte Pinakothek, Munich.

Numerous copies of the painting survive. To the list of copies published by Adler (1982, p. 80) should be added that which was in 1965 in the collection of Pierre Rigaux, Antwerp. This composition includes the flight into Egypt as a minor episode within the landscape (see photograph at RKD [*Rijksbureau voor Kunsthistorische Dokumentatie* / The Netherlands Institute for Art History], The Hague).

N. G.

117

PIETER PAUL RUBENS (1577-1640)
Portrait of Hélène Fourment (?)
Oil on panel. 185.5 x 85
Calouste Gulbenkian Museum, Lisbon, Inv. No. 959
PROVENANCE: Sir Robert Walpole, 1736 Houghton (Corner Drawing Room, over the fireplace, as by 'Vandyke', then Cabinet); 1779 Hermitage; 1930 transferred to Antikvariat for sale; purchased by Calouste Gulbenkian, Portgual; now Calouste Gulbenkian Foundation, Lisbon.
LITERATURE: *Aedes* 1752, p. 64 (as 'Rubens' Wife, by Vandyke'); 2002, no. 139; Boydell II, pl. XXXVI; Gilpin 1809, pp. 50–51; Livret 1838, p. 354, no. 3 (Van Dyck); Smith 1829–42, part III, p. 188, no. 646 (Van Dyck); Cats. 1863-1916, no. 576; Rooses 1886-92, vol. IV, pp. 165–66, no. 943; Glück 1920/21, p. 89; Oldenbourg 1921, p. 329; Schmidt 1926b, pp. 14–15, 29; Glück 1933, p. 118–37; Vlieghe 1977, p. 144; Sauerlän-

der 1977, p. 340; Vlieghe 1983, pp. 108-9; Vlieghe 1987, p. 102; Jaffé 1989, p. 319, no. 1002 (c.1631).
EXHIBITIONS: 1977 Antwerp, no. 85 (1630–32).

This picture was erroneously attributed to Van Dyck in the *Aedes* and in Hermitage catalogues right up to the early 1860s. Before it left England in 1779 it was one of those works that inspired the mid-eighteenth century vogue for 'Van Dyck' dress in British portraiture. A number of works by artists such as Thomas Hudson and Allan Ramsay were inspired by it. Ironically, it is now unanimously accepted by scholars as one of Rubens' best works of the 1630s. There is still controversy, however, about the identity of the sitter. When in the Walpole collection and in the Hermitage the painting was identified as Rubens' second wife, Hélène Fourment (1614–75): 'a Sweet Picture of Rubens wife, drawn by himself who was certainly the properest Person to draw her' (Liverpool Papers 1741). This traditional identification was rejected by Glück (1920/21) who stated that the facial features differ from those in accepted portraits of Hélène Fourment, and that she appeared older than in other works. Glück proposed an alternative theory, suggesting, on the basis of the similarity in facial features and the sitter's costume, that the sitter was Hélène Fourment's elder sister Susanne, thought to be the same model used by Rubens in his celebrated *Chapeau de Paille* (National Gallery, London). This idea was accepted by some scholars, although the painting was identified at the anniversary exhibition of the work of Rubens as showing Hélène (Sauerländer 1977). While Vlieghe (1983) supported Glück's rejection of this, he was also unconvinced by the notion that it represented her sister Susanne. According to a document discovered in the Anwterp City Archives, Susanne Fourment died in 1628, while the woman's hairstyle in the Walpole painting only became fashionable in the Netherlands in the early 1630s. Vlieghe considered the Walpole picture a portrait of an unidentified young woman and did not include it in the volume of the Corpus Rubenianum Ludwig Burchard devoted to portraits of identified sitters painted in Antwerp.

A preparatory drawing in black and red chalk touched with white highlights is in the Albertina in Vienna (32 x 41, Inv. No. 8255).

N. G.

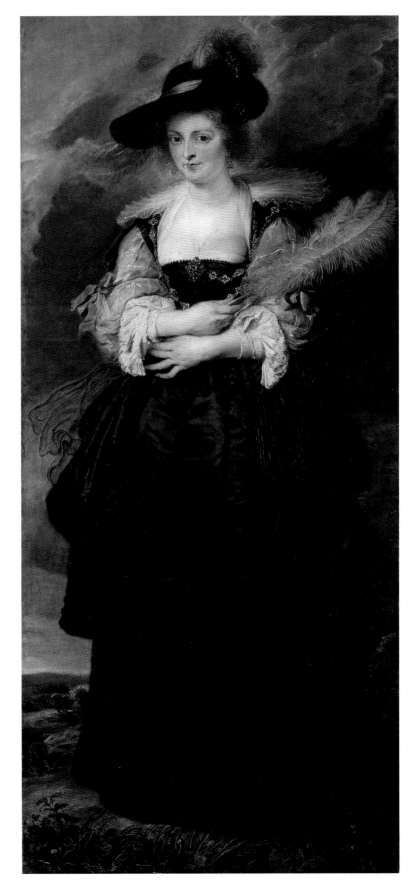

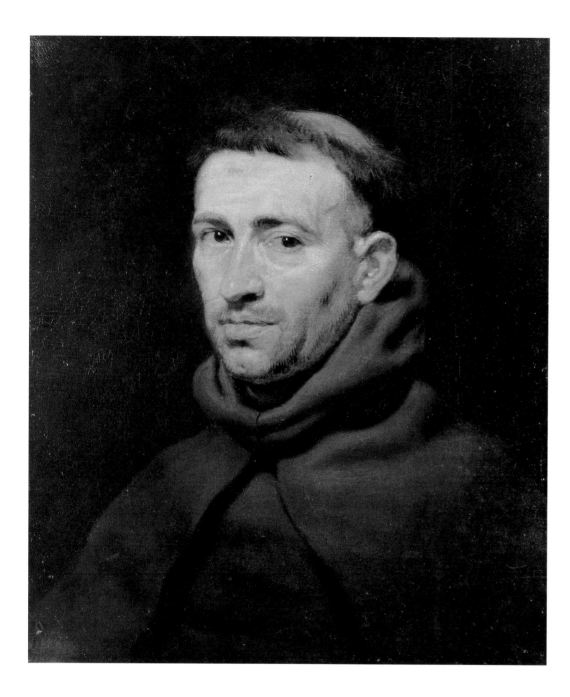

The emphatically individual characterisation of the image suggests that this is a portrait study. Stylistically, it recalls Rubens' *Two Satyrs* (Alte Pinakothek, Munich, Inv. No. 873), particularly the head in profile, and a portrait study of the same head was possibly used. The Hermitage sketch was clearly painted at the same time as *Two Satyrs*, c.1615.

N. G.

118

PIETER PAUL RUBENS (1577-1640)
Head of a Franciscan Monk
Oil on canvas, transferred from panel in 1842, 52 x 44
Inv. No. 472
PROVENANCE: Sir Robert Walpole, 1736 Downing St (Lady Walpole's Drawing Room), later Houghton (Common Parlour); 1779 the Hermitage.
LITERATURE: *Aedes* 1752, p. 47 ('A Friar's Head'); 2002, no. 43; Boydell II, pl. XXI; Gilpin 1809, p. 45; Chambers 1829, vol. I, p. 522; Livret 1838, p. 365, no. 20; Cats. 1863–1916, no. 584; Waagen 1864, p. 141; Rooses 1886–92, vol. IV, p. 305, no. 1117; Rosenberg 1905, pl. 99; Neustroyev 1909, pp. 72–73; Benois [1910], p. 221; Oldenbourg 1921, pl. 100; Schmidt 1926b, p. 14; Cat. 1958, vol. II, p. 80; Bazin 1958, pp. 12, 237 note 186; Varshavskaya 1975, pp. 99–101, no. 12; Cat. 1958, vol. II, p. 61; Jaffé 1989, p. 210, no. 325; Rubens Paintings 1989, pp. 69–70.
EXHIBITIONS: 1938 Leningrad, no. 167; 1968 Göteborg, no. 42; 1978a Leningrad, no. 27; 1987 New Dehli, no. 22; 1992 Tokyo, no. 33; 2001 Toronto, no. 21.

119

PIETER PAUL RUBENS (1577-1640)
The Apotheosis of James I
Oil on canvas, 89.7 x 55.3
Inv. No. 507
PROVENANCE: coll. King Charles I, London, 1639; coll. Godfrey Kneller, London; Sir Robert Walpole, 1736 Downing St (Great Room above Stairs), later Houghton (Cabinet); 1779 Hermitage.
LITERATURE: *Aedes* 1752, pp. 69-70 ('The Assumption of King James the First into Heaven'); 2002, no. 170; Gilpin 1809, p. 52; Smith 1829–42, part II, p. 237; Livret 1838, p. 357, no. 16; Waagen 1864, p. 145; Cats.

1863–1916, no. 573; Rooses 1886-92, vol. III, p. 281, no. 763; Rosenberg 1905, pl. 313; Oldenbourg 1921, pl. 332; Schmidt 1926b, pp. 20–22; Simson 1936, p. 384; Millar 1956, pp. 247–62; Per Palme 1956, pp. 260–62; Cat. 1958, vol. II, p. 93; Held 1970, p. 277; Varshavskaya 1975, pp. 192–95, no. 33; Held 1980, vol. I, pp. 201–3, no. 135; Cat. 1981, p. 63; Jaffé 1989, p. 320, no. 1004; Rubens Paintings 1989, pp. 149–52; Simson 1996, p. 321.

EXHIBITIONS: 1965 Brussels, no. 229; 1978a Leningrad, no. 44; 1991 Retretti, pp. 130–32; 1996 Nagaoka–Osaka, no. V-10; 2001 Toronto, no. 7.

This is a sketch for the central oval in the ceiling of the Banqueting House, Whitehall, the only decorative ensemble by Rubens to remain in its original location.

The Banqueting House was designed by Inigo Jones (see cat. no. 103) and built between 1619 and 1622. It was intended for use in court ceremonies and theatricals. The idea of commissioning Rubens to paint the ceiling can be traced to as early as 1621, but it was only in the winter of 1629-30, when the artist was on a diplomatic mission to London, conducting preliminary negotiations to conclude peace between Spain and England, that these plans took real shape. Rubens was officially commissioned to paint the work by Charles I. It was intended to glorify the deeds of his father James I (1603–25) as the ruler who united the kingdom and brought peace and prosperity.

In this central oval, the composition in general terms follows the scheme for depicting the apotheosis of Roman emperors (see *Reallexikon zur deutschen Kunstgeschichte,* Hrsg. von Otto Schmitt, vol. I, Stuttgart, 1937, kol. 847): James I, sceptre in his hand, sits on a globe borne by an eagle clutching lightning in its claws. This central figure is surrounded by various allegorical figures. To the right is Justice with her scales and sword, to the left before an altar is Religion and Faith with a book. A winged Victory with a caduceus and Minerva with her sword and shield jointly crown James with a laurel wreath, while hovering cupids— bearing the royal crown and orb, palm and olive branches—blow their trumpets.

Unlike the finished composition, the sketch is rectangular, but the remaining differences are largely insignificant. Justice holds forked lightning in the final work, and Minerva bears only a sword. In the sketch the figures are arranged more freely and are more foreshortened, particularly King James himself.

There are a number of preparatory works for the painting. The original sketch for the ceiling (Mrs Humphrey Brand Collection, Glynde Place, Sussex) includes seven of the nine compositions, including the central oval and also the side friezes and ovals. There is a sketch for the figures of Faith and Victory in the Louvre, Paris.

N. G.

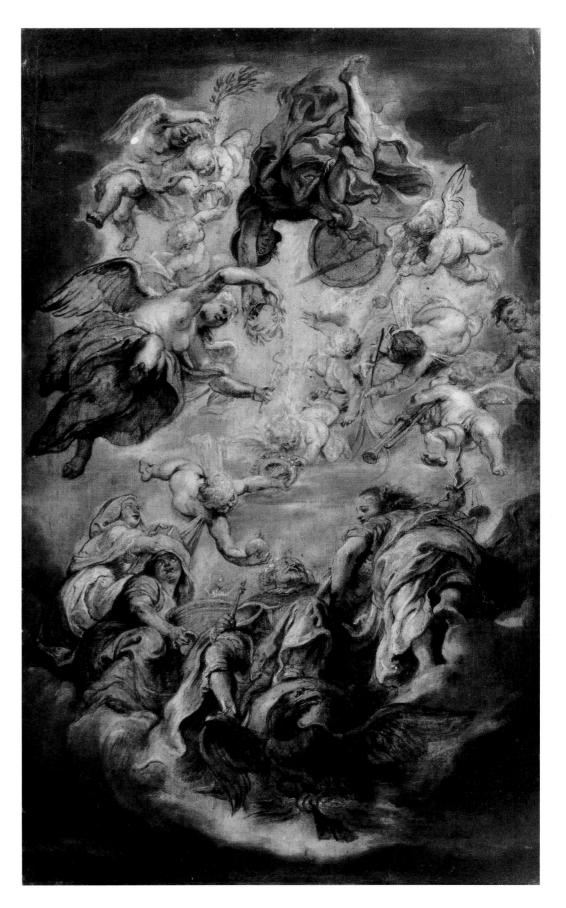

120–125

PIETER PAUL RUBENS (1577–1640)

Designs for State Decorations for the Triumphal Entry of Cardinal Infante Ferdinand into Antwerp, on 17 April 1635

Inv. Nos 498, 500, 501, 502, 503; Pushkin Museum of Fine Arts, Moscow, Inv. No. 2626

PROVENANCE: Antwerp Town Hall (property of the Magistrature); coll. Prosper Henricus Lankrink, London, 23 May 1693; Sir Robert Walpole, Houghton (Cabinet); 1779 Hermitage.

LITERATURE: *Aedes* 1752, p. 70 ('Six Sketches of Rubens for triumphal Arches, &c. on the Entry of the Infant Ferdinand of Austria into Antwerp'); 2002, nos. 171–76.

In November 1634 Rubens was commissioned by the Antwerp magistrates to produce designs for the triumphal entry into the city of the new Spanish governor of the Netherlands, Cardinal Infante Ferdinand (1609–41), heir to the Infanta Isabella and younger brother of King Philip IV. Rubens drew up a programme of decoration for the city with the renowned Antwerp humanist, burgomeister, learned patron and collector Nicolaas Rockox (1560–1640) and with the Secretary to the Magistrature, the writer and scholar of ancient literature Caspar Gevaerts ('Gevartius', 1593–1666).

In his overall scheme, Rubens followed established conventions for the triumphal entry – 'Joyeuse Entrée' or 'Blijde Incomst' – of a new ruler of the Southern Netherlands. Although the city had been decorated with imitations of three-dimensional architecture and sculpture, or with tableaux vivants on stages in the sixteenth century, on this occasion Rubens introduced painted works. Monumental arches and porticoes were made of flat wooden frames stretched with painted canvas, the only relief wood carving being in the entablatures and profiles, the columns and pilasters with their pedestals, bases and capitals, which framed the pictures. Statues, vases and candelabra surmounting the structures were, like the figures flanking the main painted works on the facades, painted on board (Martin 1972, pp. 228–55).

Rubens produced sketches for the nine main structures, and two large paintings, *Neptune Calming the Tempest/Quos ego* (also known as *The Happy Voyage of the Cardinal Infante Ferdinand*; Galerie Alte Meister, Dresden, Inv. No. 964 B) and *The Meeting of King Ferdinand of Hungary and the Cardinal-Infante Ferdinand at Nördlingen* (Kunsthistorisches Museum, Vienna, Inv. No. 525). The final paintings were based of Rubens' sketches and were executed under his guidance by a number of Antwerp painters (Martin 1972).

None of these temporary structures have survived. The paintings that decorated them were, by a resolution of the Antwerp Magistrature of 29 April 1636, presented to the Governor and the majority perished during a fire in the Palace on the Condenberg, Brussels, in 1731 (Rooses 1886–92, vol. III, pp. 292–336; Martin 1972). However, most of the sketches survive today in the Hermitage (cat. nos. 120–124) with the exception of *The Apotheosis of the Infanta Isabella*, which was transferred to the Museum of Fine Arts in Moscow in 1930 (cat. no. 125).

An impression of the overall appearance of the decorations can be gained from the engravings by Theodor van Thulden used to illustrate the book celebrating the event (Gevartius 1642), of which there is a copy in the Hermitage.

N. G.

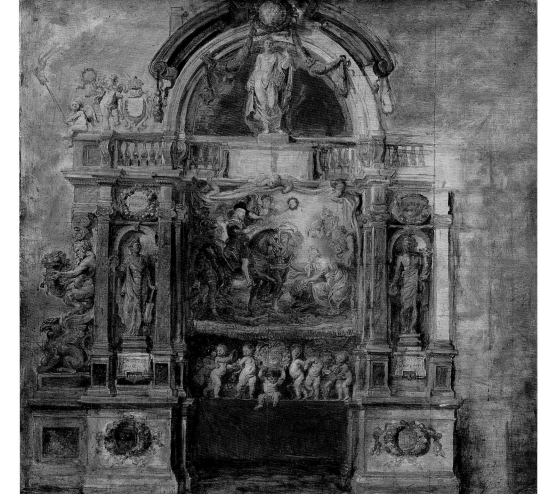

120

The Advent of the Prince (Adventus Seren. Princ. Gratulatio)
Oil on oak panel, thin layer of grisaille, touched with colour only in the opening of the arch, revealing black chalk beneath on a pale ground, right side unfinished, 73 × 78
Inv. No. 498

LITERATURE: Gilpin 1809, p. 52; Cats. 1863–1916, no. 562; Waagen 1864, pp. 145–46; Rooses 1886–92, vol. III, pp. 295–99, no. 772; Rooses 1905, pp. 555–56; Rosenberg 1905, pl. 345; Neustroyev 1909, p. 62; Benois [1910], p. 230; Weisbach 1919, p. 150; Oldenbourg 1921, pl. 361; Schmidt 1926b, pp. 20–22; Kieser 1933, p. 134; Vertue, vol. V, 1937–38, p. 56; Puyvelde 1939, p. 43; Lankrink 1945, p. 31; Puyvelde 1952, p. 159; Cat. 1958, vol. II, p. 93; Varshavskaya 1967, pp. 281, 288; Martin 1972, pp. 42–45; Varshavskaya 1975, pp. 205–8, no. 35; Held 1980, vol. I, pp. 225–57, no. 145; Cat. 1981, p. 64; Jaffé 1989, p. 337, no. 1116; Rubens Paintings 1989, pp. 161–65.

EXHIBITIONS: 1978a Leningrad, no. 46.

This is the first sketch for a portico that stood by the Church of St George (Joriskerk) near the entry to Antwerp via St George's Gate or Keyserport.

At the centre, in the form of a tapestry being unfurled by three cupids in the opening of an arch, is an allegorical depiction of the greeting of the new ruler. Ferdi-

nand, crowned by Victory and accompanied by Mars (*Mars Gradivus*), Valour and Fortune, rides a horse trampling beneath its hooves the corpses of the Swedes. He holds out his hand towards Antwerpia in a gesture of peace. At Antwerpia's feet is the lion of Belgium and behind her a personification of Welfare with a snake wound around her hand. Above them all is the genius of Antwerp with the city arms. A statue of Good Hope (*Bona Spes*) stands in the tympanum above them and more statues fill niches on either side of the arch. To the left is Public Joy with a wreath and helm and the inscription *Laetitia Publica* on the pedestal whilst to the right the genius of Antwerp with a chalice and cornucopia, with the inscription *Genius Urbis Ant.* can be seen on the pedestal. Above them the words *Vota Publica* appear twice. Beneath the tapestry a circle of dancing children with a hare and baskets of flowers symbolise fertility and plenty. One infant holds a cartouche with the inscription *Felicitas Tempor[um]* (Happiness of the Times). Rubens himself explained a similar motif of playing infants on one of his title pages (CDR 1887-1909, vol. VI, p. 200), stating that they symbolised 'the happiness of the times'.

The whole was not only intended to glorify Ferdinand as victor, but also to stress the importance of military victories as a means of establishing peace and prosperity (Varshavskaya 1975).

Probably executed before 3 December 1634 (Held 1980). The composition was engraved by Theodor van Thulden for Gevartius' 1642 publication (tab. 6, 7).

N. G.

121

The Arch of Ferdinand (back) (Arcus Ferdinandi {pars posterior})
Oil on canvas, transferred from panel in 1867; the greater part of the original ground survived transference to canvas, thin layer of grisaille touched with colour, revealing the black chalk drawing beneath, right hand side less well worked up, 104 x 72.5
Inv. No. 502

LITERATURE: Gilpin 1809, p. 52; Cats. 1863-1916, no. 564; Waagen 1864, pp. 145-46; Rooses 1886-92, vol. III, pp. 310-13, no. 783; Rooses 1905, p. 565; Rosenberg 1905, pl. 354; Neustroyev 1909, p. 64; Benois [1910], p. 230; Weisbach 1919, p. 150; Oldenbourg 1921, pl. 371; Schmidt 1926b, pp. 20-22; Vertue, vol. V, 1937-38, p. 56; Puyvelde 1939, p. 43; Evers 1943, pp. 188-89; Lankrink 1945, p. 31; Cat. 1958, vol. II, p. 94; Varshavskaya 1967, pp. 283, 289; Martin 1972, pp. 156-58; Held 1980, vol. I, pp. 236-38, no.160; Cat. 1981, p. 64; Jaffé 1989, p. 341, no. 1114; Rubens Paintings 1989, pp. 173-75.

EXHIBITIONS: 1968 Göteborg, pp. 28–30; 1977 Antwerp, no. 95; 1978a Leningrad, no. 48; 1979–80 Melbourne–

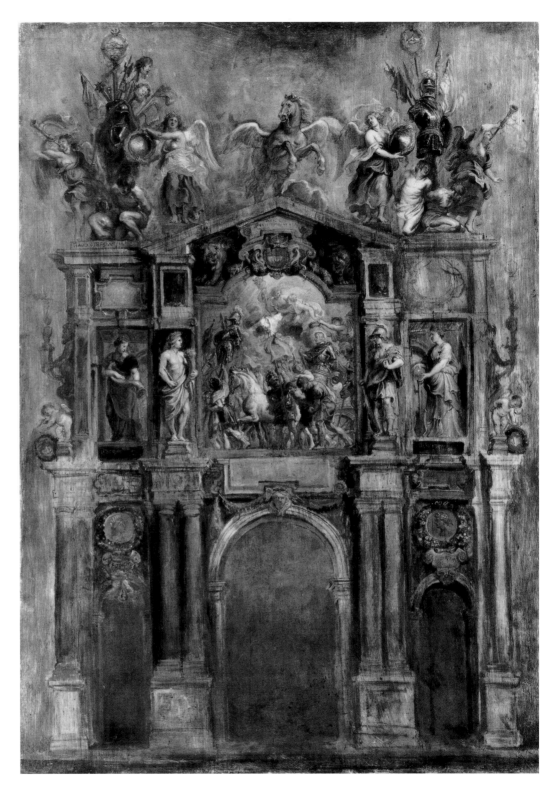

Sydney, no. 31; 1988 New York–Chicago, no. 47; 1991 Retretti, pp. 124-2; 2001 Toronto, no. 9.

This is a sketch for the rear of an arch by the entrance onto Lange Nieuw-straat or Longue Rue Neuve. This arch was painted to commemorate the joint victory over the Swedes at Nördlingen in Germany on 4-5 September 1634 by Cardinal Infante Ferdinand and Ferdinand, King of Hungary, the future Emperor Ferdinand III.

Above the arch's central span is a painting in a gold frame, *The Triumph of Ferdinand after the Battle of Nördlingen*. Ferdinand, in a chariot, is being crowned by Victory. Above his head, accompanied by Hope,

flies another Victory with a palm, the symbol of peace and a trophy. A half-length portrait of the genius of Nördlingen and a *labarum* or imperial standard with the letter 'F' are being carried in front of the chariot, which is surrounded by prisoners of war led by a soldier carrying trophies and a standard-bearer. Above the painting is the coat-of-arms of the Spanish King, protected by two lions, and over them the inscription *Auspice Philippi Magni regis* (under the auspices of King Philip the Great). To the sides of the painting are statues representing Honour to the left with a sceptre and cornucopia, and, to the right, Valour wearing a lion skin with a cudgel and sword. In the left niche is a figure pouring coins from a cornucopia, with beneath it the inscription *Liberalit. Regi* (The Liberality of the King). In the right niche is Foresight with a globe and helm and the inscription *Provident*. In medallions over the side spans are Nobility (left, inscribed *Nobilit*) and Ferdinand's Youth (right, inscribed *Juventas Ferd.P.*). At the top left and right are trumpeting Glories, trophies, and fettered prisoners, with Victories holding shields; the shield of the Victory to the right bears the inscription *Fides militum* (Loyalty of the Troops). On the cornice beneath the group of prisoners top left is an inscription, *Haud vires ac..[acquirit eundo]* (His Glory can Grow no More), paraphrasing a line from Virgil's *Aeneid* (IV, 175). The arch is surmounted with a winged horse and the barely discernible figure of the Morning Star (Lucifer) or Aurora.

The sketch was clearly painted before 24 November 1634 (Varshavskaya 1975; Held 1980). Theodor van Thulden engraved the composition for Gevartius' publication of 1642 (tab. 28, 29).

<div align="right">N. G.</div>

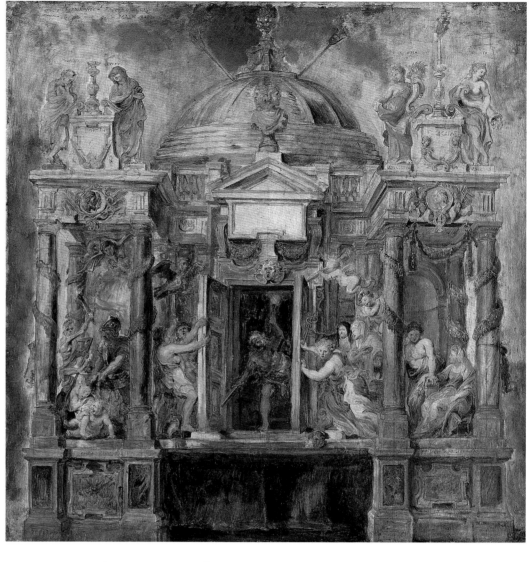

I22

The Temple of Janus (Templum Jani)
Oil on oak panel, cradled panel, 70 x 65.5. Along the upper left edge of the panel are three lines of half-obliterated Latin inscription, probably in Rubens' own hand: ... [Jan?] ... *post saecularis paen[e] belli* ... / [... *virtute?] Ferdinande Pace* ... / ... [t]*erra marique part[a] Janum [c]lud.* (... [Jan?] ... after a nearly century-long war ... / by the valour [?] of Ferdinand with peace ... / ... to the lands and seas granted by Janus closed.)
Inv. No. 500
LITERATURE: Gilpin 1809, p. 52; Cats. 1863–1916, no. 566; Waagen 1864, pp. 145–46; Rooses 1886–92, vol. III, pp. 314–17, no. 784; Rooses 1905, p. 565; Rosenberg 1905, pl. 355; Neustroyev 1909, p. 65; Benois [1910], p. 230; Weisbach 1919, p. 150; Oldenbourg 1921, pl. 372; Schmidt 1926b, pp. 20–22; Vertue, vol. V, 1937–38, p. 56; Puyvelde 1939, p. 43; Lankrink 1945, p. 31; Cat. 1958, vol. II, p. 94; Varshavskaya 1967, pp. 283–86; Martin 1972, pp. 169–73; Varshavskaya 1975, pp. 216–20, no. 38; Held 1980, vol. I,

pp. 238–40, no. 161; Cat. 1981, p. 64–65; Jaffé 1989, p. 342, no. 1151; Rubens Paintings 1989, pp. 176–80.
EXHIBITIONS: 1978a Leningrad, no. 49; 1998–99 Brussels, no. 406; 1999–2000 Madrid, no. 114; 2001 Toronto, no. 10.

This is the first sketch for the portico at the Dairy Market (Melkmarket).

According to legend as related by Plutarch and Macrobius, the Temple of Janus, the Ancient Roman god of time and beginnings, was erected by Numa Pompilius, who introduced the custom of keeping the temple gates closed in times of peace and open on the declaration of war. As noted by Varshavskaya (1975), the half-erased Latin inscription on the Hermitage sketch almost totally coincides with the text on a coin of the Emperor Nero cited by Caspar Gevaerts (Gevartius 1642): *Pace terra marique parta Janum clusit* (owing to the peace granted to the lands and seas he closed Janus).

In this sketch Discord (with her hair of snakes) and the fury Tisephone (overturning an urn of blood) together pull open the doors of the temple, as a bloodthirsty harpy flies overhead. Below we can see the half-erased inscription *Discordia Tisi[phone]*. Bursting from within is Fury, his eyes blindfolded, holding a sword and a flaming torch, with below him the inscription *Furor*. To the right, the goddess of Peace with a caduceus, the symbol of peaceful activity, overturns a cornucopia in her haste to close the right side of the door. Behind Peace is Piety with a chalice by an altar. In the background is the Infanta Isabella wearing the dress of a widowed nun, and below is the inscription *Pax Pietas*.

To the left, below the portico, are the horrors of war. A soldier drags a woman by her hair as she tries in vain to protect her child. Above her is Death (or Plague) with a scythe and torch, and the flying figure of Hunger below which is the half-erased inscription *Saevities belli* (the Cruelties of War). To the right, beneath the portico, is Security with hand on heart,

and Tranquillity, with tares and poppies in one hand and a palm in the other. Between them is a stone slab symbolising permanence and below is the inscription *Tranquilitas Securitas*. Above the figures of Security and Tranquillity is a medallion with a double profile of Honour and Virtue set within a wreath formed of a lyre, brushes, a palette, compass and ruler. To the left, above the scene showing the horrors of war, is a double profile of Pallor and Fear set within a wreath of thorns, whips and chains. Over the left portico are Poverty and Lamentation, with the inscription *Paupertas Luctus* above their heads. They lean towards a snuffed candle on the pedestal on which can be seen lowered funerary torches and the inscription *Infortuna* (Misfortune). Above the right portico is Plenty with tares and a cornucopia, and Fertility scattering gifts from her cornucopia. Over the heads of these two figures are the inscriptions *Abundantia* and *Ubertas*, which are repeated in different handwriting on the pedestals. Between Fertility and Plenty is a burning candle, on the pedestal of which are two crossed cornucopias with children's heads and the inscription *Felicitas* (Happiness).

The motif of the Temple of Janus with closed doors was long used in the decoration of 'secular apotheoses' and 'triumphal entries' to symbolise the idea of peace brought by a ruler to his subjects. Varshavskaya (1967, 1975) stressed that in the Hermitage sketch the open doors ring out as an insistent call to decisive action, a call aimed directly at the Governor: Ferdinand is called upon to follow the example of his predecessor, the Infanta Isabella, who sought peace, and thus to 'close up Janus' (*Janum cludere*).

The sketch must have been painted before 7 December 1634 (Varshavskaya 1975; Held 1980). Theodor van Thulden engraved the composition for Gevartius' 1642 publication (tab. 30, 31).

N. G.

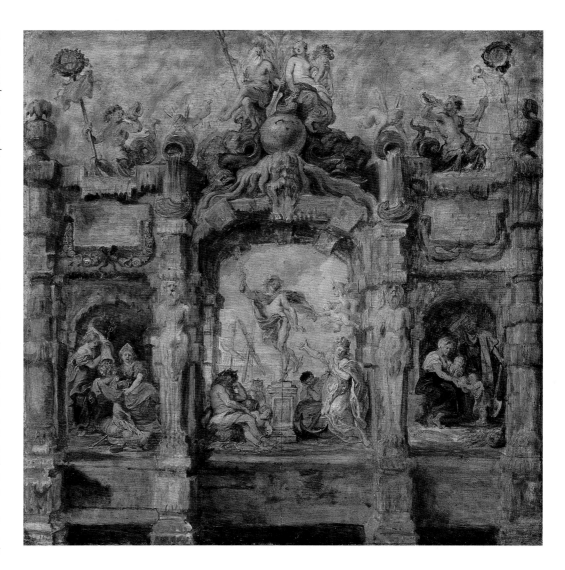

123

Mercury Leaving Antwerp (Mercurius Abituriens)
Oil on oak panel, cradled panel, elaborate grisaille touched with colour, the drawing visible in many places, 76 x 79
Inv. No. 501
LITERATURE: Gilpin 1809, p. 52; Cats. 1863–1916, no. 565; Waagen 1864, pp. 145–46; Rooses 1886–92, vol. III, pp. 318–20, no. 785; Rosenberg 1905, pl. 356; Oldenbourg 1921, pl. 377; Grimm 1949, pp. 68–69; Cat. 1958, vol. II, p. 94; Varshavskaya 1967, pp. 283, 285–86; Martin 1972, pp. 182–84; Varshavskaya 1975, pp. 220–25, no. 39; Vlieghe 1977, pp. 153–56; Held 1980, vol. I, pp. 240–43, no. 162; Cat. 1981, p. 65; Jaffé 1989, p. 342, no. 1156; Rubens Paintings 1989, pp. 181–85.
EXHIBITIONS: 1965 Brussels, no. 231; 1978a Leningrad, no. 50.

This is a sketch for a portico by St John's Bridge (Sint Jansbrug), reflecting the liberation of the mouth of the River Scheldt.

In the central span the Roman god of trade and crafts, Mercury, with a purse and caduceus, prepares to flee Antwerp, where there is nothing for him to do. The sails of the idle ships are folded, a sailor sleeps on an upturned boat with a rusty anchor, and the god of the Scheldt sleeps on fishing nets, his ankles in fetters. Cupids vainly seek to restrain Mercury. Antwerpia, wearing the city crown, kneels before Ferdinand as he passes by, calling on him to help alleviate the city's disastrous state. In a niche to the right is a dismal picture: a sailor's starving family has only a head of cabbage for sustenance and the sailor stands perplexed, holding a superfluous helm. In a niche to the left, meanwhile, we see a depiction of potential future prosperity: Plenty scatters her treasures into the lap of Wealth. Above are cartouches which have no text in the sketch but which in van Thulden's engraving have the inscriptions 'Ferdinand will launch the Golden Age' and 'Ferdinand will open up the Scheldt'. The central arch is topped with a mascaron in the form of a head of Ocean, supporting the Earth, seated upon which are the rulers of the sea, Neptune with a trident and a helm, and Amphitrite with a cornucopia and a ship rostrum. Around them are playing dolphins personifying the East (Baltic) and West (Northern) Seas whilst tritons with the arms of Antwerp blow on conches, and streams of water flow from overturned urns.

As a basis for the architectural design of the portico Rubens made partial use of the central span of an arch between the courtyard and garden at his own house in Antwerp, with their rectangular corners and columns with their powerful rusticated bands (Grimm 1949).

The sketch was probably executed before 5 December 1634 (Varshavskaya 1975; Held 1980). Theodor van Thulden engraved the composition for Gevartius' 1642 publication (tab. 33, 34).

N. G.

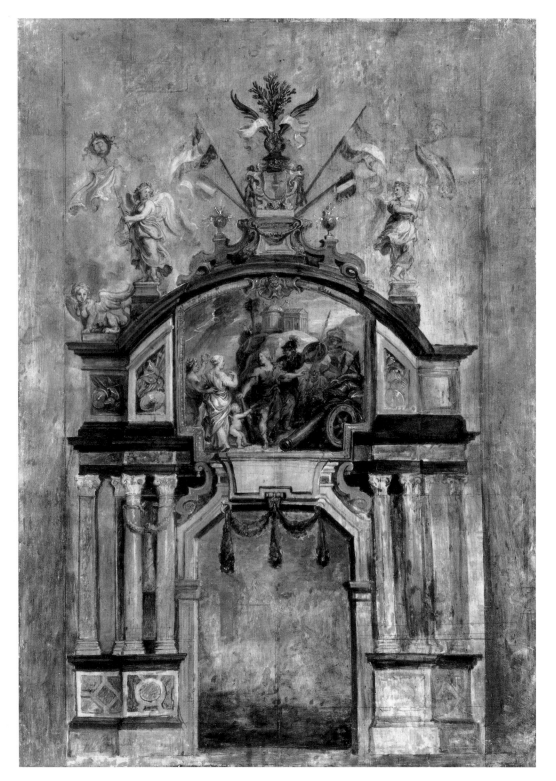

124

The Arch of Hercules (front) *(Hercules Prodicius {pars anterior})*
Oil on canvas, transferred from panel in 1871, grisaille
tinted with colour; some architectural and ornamental
details in the right half unfinished, underlying black
chalk drawing visible in many places, 103 x 72
Inv. No. 503
LITERATURE: Gilpin 1809, p. 52; Cats. 1863-1916, no.
563; Waagen 1864, pp. 145-46; Rooses 1886-92, vol.
III, pp. 322-23, no. 788; Rosenberg 1905, pl. 350;
Oldenbourg 1921, pl. 367; Panofsky 1930, p. 121;
Lankrink 1945, p. 31; Cat. 1958, vol. II, p. 94; Var-
shavskaya 1967, p. 283-85; Martin 1972, p. 208-9; Var-
shavskaya 1975, pp. 225-28, no. 40; Held 1980, vol. I,
pp. 245-46, no. 165; Cat. 1981, p. 65; Jaffé 1989, p.
342, no. 1162; Rubens Paintings 1989, pp. 186-87.
EXHIBITIONS: 1968-69 Belgrade, no. 20; 1977 Antwerp,
no. 96; 1978a Leningrad, no. 51; 1988 New York–
Chicago, no. 48; 1991 Retretti, pp. 122-23; 2001
Toronto, no. 8.

This is a sketch for the front of an arch in the ensemble
on Monastery Street (Sint-Michielsstraat), near the
entrance to the Governor's official residence, St
Michael's Abbey.

Above the arch is a picture of *Hercules at the Cross-
roads between Virtue and Vice*. Vice is represented by
Venus with Bacchus and Cupid and Virtue by Min-
erva, who summons the hero to the Temple of Glory.
The subject is taken from a tale by the sophist philoso-
pher, Prodicus, and hence the title Hercules Prodicius,
corrupted as Prodiceus, or 'Prodicus' Hercules'. The
story is quoted by Xenophon in his *Memoirs of Socrates*
(II, I, 21-34; also in Hesiod, *Works and Days,* 287-91).

The arch is crowned with a palm tree, the symbol of
virtue, justice and moral victory. The palm is winged,
which indicates that it should be understood as victory,
glory, peace and reason (G. de Tervarent, *Attributs et
symboles dans l'art profane* . . . , Geneva, 1958, pp. 10-12,
298-99). Beside the palm are banners and two Victo-
ries holding the monograms of Philip and Ferdinand.
On the cornice is a sphinx, symbol of firmness, agility
and prudence, and in van Thulden's engraving
(Gevartius 1642, tab. 37, 38) we see beneath the pic-
ture the inscription *Herculi Alexikakos* (To Hercules,
Victor over Evil).

It is possible that this sketch was painted between
December 1634 and January 1635 (Held 1980).

N. G.

125

The Apotheosis of the Infanta Isabella

Oil on oak panel, 69 x 70, Latin inscriptions: over the portal: HIC VIR, HIC EST ETC (Virgil, *Aeneid*, VI, 791); on the sacrificial altar surmounting the arch: MATRI PATRIAE / CAELO RECEPTAE (To the Mother of the Fatherland received into Heaven); by the bottom edge of the allegorical picture: IN VTRIUMQ[UE] PARATUS EN VINCE, the last two words partially overpainted ('ready for either' – *Aeneid*, II, 61); on the pedestals of the statues flanking the upper tier: left, SALUS PUBLICA (prosperity of the people); right, SECURITAS (security).

Pushkin Museum of Fine Arts, Moscow, Inv. No. 2626

PROVENANCE: See p. 220, introduction to cat. nos. 120-125; 1930 transferred to the Museum of Fine Arts (now Pushkin Museum of Fine Arts), Moscow.

LITERATURE: Cats. 1863-1916, no. 561; Waagen 1864, no. 561; Rooses 1886-92, vol. III, p. 310 (text to no. 781); Rooses 1890, p. 565; Rosenberg 1905, p. 352; Neustroyev 1909, pp. 63-64; Benois [1910], p. 230; Oldenbourg 1921, p. 370; Vertue, vol. V, 1937-38, p. 56; Puyvelde 1939, p. 43, no. 7; Lankrink 1945, p. 31, Nos 207-12; Pushkin Museum 1948, p. 71; Pushkin Museum 1957, p. 124; Pushkin Museum 1961, p. 169; Antonova, Malitskaia 1963, pp. 94-95; Varshavskaya 1967, pp. 286, 293; Martin 1972, pp. 135-37, no. 34a; Varshavskaya 1975, p. 204; Blunt 1977, p. 614, fig. 22; Held 1980, pp. 222-24, 234-35, no. 158, pl. 155; Pushkin Museum 1986, p. 156; Jaffe 1989, no. 1141; Rubens Paintings 1989, pp. 169-73, pp. 80-81; Bieneck 1992, p. 213-14; Pushkin Museum 1995, p. 450; Yegorova 1998, pp. 248-49.

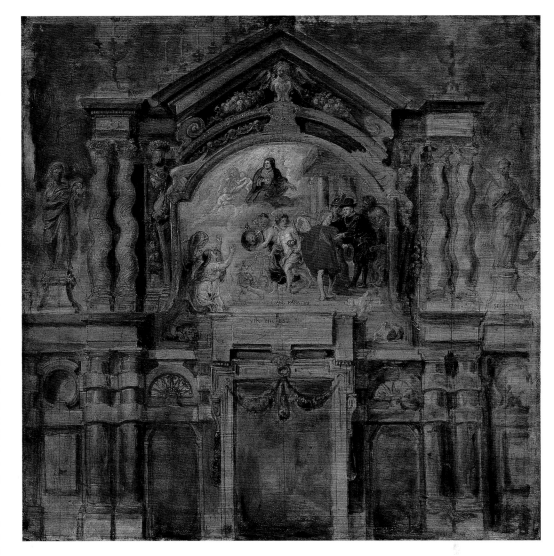

The southern entrance to the Church of St James, Antwerp was decorated with a construction in the form of a two-storey portal over which a vast painting was displayed. Caspar Gevaerts (Gevartius 1642) described the subject matter of the painting as the late Infanta Isabella, Ferdinand's predecessor as Governor of the Southern Netherlands seated on clouds dressed as a nun of the Order of St Clare. The woman with children symbolised the Infanta's motherly love for her Netherlandish subjects. At the bottom left are two matrons representing Sorrow (in a mourning cloak) and Belgium (kneeling) with the lion as her emblem. Belgium implores the aid of Isabella, who in turn directs them to Prince Ferdinand as protector (HIC VIR, HIC EST ETC). At the bottom right are Philip IV of Spain sending his brother Ferdinand to Belgium, accompanied by Jupiter and Minerva, with two winged genii leading the way, bear a shield with the Gorgon's head (the symbol of war) and a caduceus and cornucopia (symbolizing peace). The inscription IN VTRIUMQ[UE] PQRQTUS EN VINCE indicates Ferdinand's readiness for both war and peace in his protection of Belgium. The painting glorifies the memory of the late ruler and expresses the hopes placed in her successor. The activities of both are embodied in allegorical figures of Prosperity and Security (Gevartius 1642, pp. 94-98).

The sketch served as a model for the builders and for the artist Gerard Seghers, who produced the vast painting, a fragment of which, with only four figures, survives in the Rubenshuis, Antwerp (Bieneck 1992, no. A 100). The sketch was also used by Jan van Boeckhorst and Jan Borchgraef as the basis for panel paintings (which have not survived) depicting statues and bas-reliefs that decorated the frame of the painting. In the sketch, the painting is worked up in some detail, while the architecture is only vaguely outlined. In many places the light-coloured ground and drawing in black chalk is visible which does not always accord with the painted image. There are visible marks left by the nails used in transferring the sketch to paper, from which the working drawings were made.

The picture must have been executed between 13 November, when Ferdinand was invited to the Netherlands by the Antwerp Magistrature, and the first week of December 1634, since the contract with the builder of 11 December was concluded on the basis of working drawings which must have taken at least a week to produce.

In the sketch neither the stepped base nor the seven-branched candlestick at the top of the pediment shown in Van Thuden's etching are depicted. The overall dimensions of the decoration, together with the podium and candlestick was 17.04 by 13.63 metres. The back was covered with black cloth that fell around the sides from the pediment, and this gigantic mourning veil, together with the burning candles, recalled Isabella's funeral.

K. Ye.

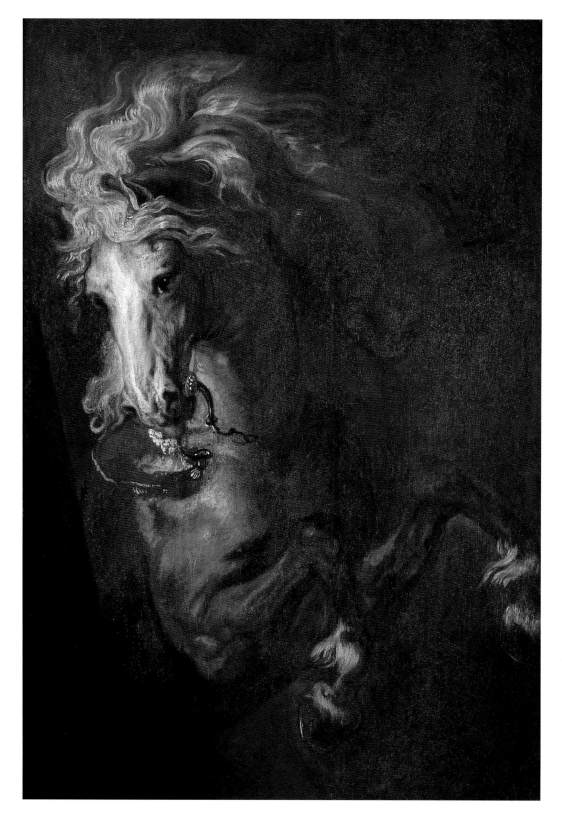

126

PIETER PAUL RUBENS (1577-1640)
A Horse's Head (A Rearing Horse)
Oil on canvas, transferred from panel in 1894 by M. Sidorov. 69.9 x 47.6
William Morris Collection, Houston, Texas, USA
PROVENANCE: Sir Robert Walpole, Houghton (Small Breakfast Room); 1779 Hermitage; 1929 transferred to Antikvariat; sold at auction by Lepke, Berlin, 12 May 1931 (lot 82; attributed to Van Dyck); Ernst Reinhardt, New York; Burt C. Norton, New York; Sotheby's, New York, 11 January 1996 (lot 66); there acquired by William C. Morris III, Houston, Texas, USA.
LITERATURE: *Aedes* 1752, p. 38 (as by 'Vandyke'); 2002, no. 4; Boydell I, pl. XLII (as by 'Vandyke'); Chambers 1829, vol. I, p. 520; Livret 1838, p. 221, no. 82 (Rubens); Smith 1829–42, Supplement, p. 297, no. 197 (Rubens); Cats. 1863–1908, no. 637; Waagen 1864, p. 153; Jaffé 1977, p. 114R, note 24 (Rubens).

George Vertue (1739) described the work as by Rubens, yet both the *Aedes* and the 1773-85 catalogue called this 'fine sketch' the work of Van Dyck. Labensky in the 1797 catalogue, Livret 1838, and later Smith (1829–42) attributed the painting to Rubens, but all later Hermitage catalogues reinstated Van Dyck as the author. From the time of Somov's catalogue of the Netherlandish and German schools (Cat. 1902), the work was considered to be a copy from a study in the Herzog Anton Ulrich-Museum, Braunschweig (Inv. No. 128; oil on panel, 60 x 50), which was thought to be the original by Van Dyck (since said by Dr Reinhold Wex, Curator at Braunschweig, to be a copy of *Horse's Head*). As a supposed copy, *Horse's Head* was not included in the 1916 catalogue.

Michael Jaffé (1977), however, established that *Horse's Head* shows significant similarities to rearing horses in two early works by Rubens, executed around 1604 and 1607: *The Destruction of Pharaoh's Host in the Red Sea* (see the second horse in Pharaoh's chariot, looking at the painting left to right; The Israel Museum, Jerusalem) and *St George Slaying the Dragon* (Prado, Madrid). Jaffé's scholarly opinion regarding the authorship of Rubens' *Horse's Head* has not been challenged.

N. G.

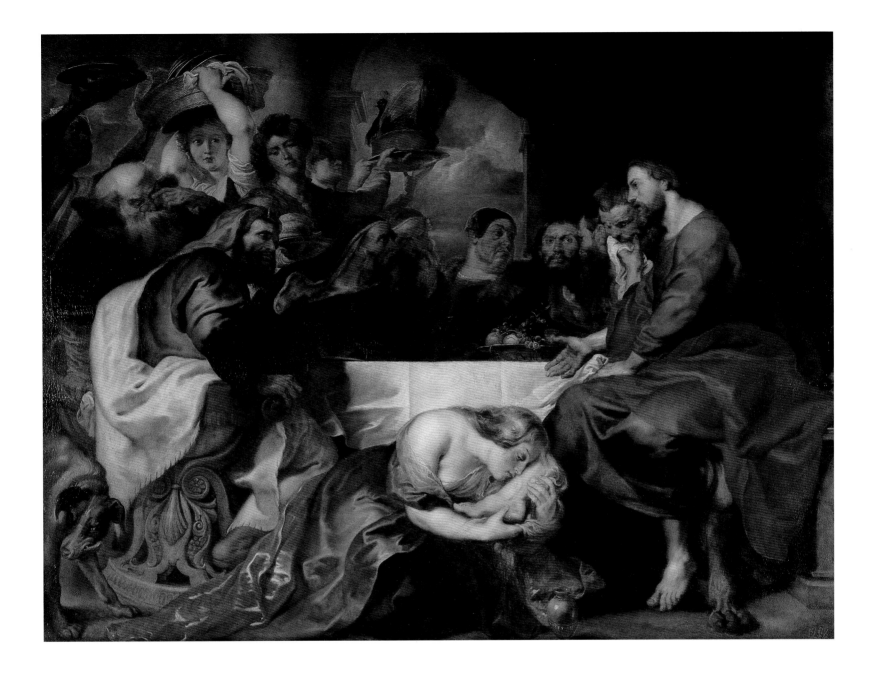

127

PIETER PAUL RUBENS (1577-1640) and workshop
and ANTHONY VAN DYCK (1599-1641)
Christ in the House of Simon the Pharisee
Oil on canvas, transferred from panel in 1821, 189 x 284.5
Inv. No. 479
PROVENANCE: 1681 coll. duc de Richelieu, Paris; coll.
Louis Phélypeaux, comte de Pontchartrain, French
Chancellor; coll. M. Cormery, from where it was
acquired by M. Bourvalais, Paris (Chambers 1829, vol. I,
p. 525); coll. Charles-Jean-Baptiste Fleuriau, Comte de
Morville, French diplomat; 1732 sold by his heirs to Sir
Robert Walpole for 15,000 livres (Mariette 1853-59); Sir

Robert Walpole, 1736 Downing St (Great Middle
Room below), later Houghton (Salon); 1779 Hermitage.
LITERATURE: *Aedes* 1752, p. 55 (as 'Mary Magdalen
washing Christ's Feet'); 2002, no. 85; Boydell I, pl.
LVII; de Piles 1681, pp. 125-31; Georgi 1794, p. 503
(1996 edition, p. 374); Gilpin 1809, pp. 46-47; Swig-
nine 1821, pp. 73-74 (Russian reprint 1997, p. 270);
Schnitzler 1828, pp. 101-2; Chambers 1829, vol. I, p.
525; Smith 1829-42, part II, pp. 156-58, no. 549; Livret
1838, p. 354, no. 4; Hasselt 1840, p. 245, No. 186; Mari-
ette 1853-59, vol. V, p. 83; Cats. 1863-1916, no. 543;
Waagen 1864, pp. 135-36; SbRIO 17, 1876, p. 398;

Rooses 1886-92, vol. II, p. 30, no. 254; Rooses 1905,
pp. 288-89; Rosenberg 1905, pl. 127; Haberditzl 1908,
pp. 217-19; Neustroyev 1909, p. 10; Benois [1910], p.
218; Oldenbourg 1921, pl. 179; Schmidt 1926b, p. 8;
Cat. 1958, vol. II, p. 80; Müller-Hofstede 1962, pp.
201, 214; Teyssèdre 1963, p. 293; Varshavskaya 1963,
pp. 95-97; Jaffé, in 1968-69 Ottawa, p. 41; Var-
shavskaya 1975, pp. 122-27, no. 18; Cat. 1981, p. 62;
Larsen 1988, p. 109; Jaffé 1989, pp. 243-44, no. 508;
Rubens Paintings 1989, pp. 88-93; Gritsay 1994, pp.
39-41; Schnapper 1994, p. 382; Brownell 2001, p. 44.
EXHIBITIONS: 1978a Leningrad, no. 31.

The engraving made during Rubens' lifetime by Michael Natalis (1611-88) does not provide a title for this work but instead carries an inscription describing the subject matter. Russian eighteenth and nineteenth-century sources, including Hermitage catalogues, describe the work variously as follows: *Washing the Feet* (SbRIO 17, 1876), *The Magdalen Washing the Feet of Jesus Christ* (Georgi 1794), *The Sinner's Repentance Before Christ the Saviour* (Swignine 1821), *The Saviour in the House of Simon the Pharisee* (Cats. 1863-1916; Benois [1910]) and *The Feast in the House of Simon the Pharisee* (Cat. 1958, Cat. 1981; Varshavskaya 1963 and 1975).

The subject is taken from the Gospel according to Luke vii: 36-50. Although Luke does not name the repentant sinner who rubbed Christ's feet with ointment in the house of Simon the Pharisee, John (xii: 3) identifies her as Mary, the sister of Martha and Lazarus of Bethany. The Western Christian Church (and hence Western art) identifies the sinner as Mary Magdalen, from whom Christ expelled seven devils (Luke viii: 2) and who was also present at the Crucifixion.

In Rubens' composition, Mary Magdalen with her long flowing hair is represented as the embodiment of repentance. Nearby is her usual attribute, a vessel containing ointment. Pressing her cheek to Christ's bare foot, she washes it with her tears and wipes it with her long, loose hair. In Christian iconography, the human foot, since it comes into contact with the dust of the earth, symbolises humility and voluntary subjection (G. Ferguson, *Signs and Symbols in Christian Art*, New York, 1989, p. 47). Washing Christ's feet with her tears in the house of Simon the Pharisee was Mary Magdalen's symbol of repentance and humility, and her sins were thus forgiven.

By contrast, the Pharisees throwing indignant glances in Christ's direction embody vice imitating virtue, an interpretation that enables an understanding of the various symbolic details in the composition. On the table before Christ stands a bowl of fruit, with apples and grapes, a combination that usually symbolises sin and redemption. A platter of peacock pâté is being carried over the heads of the Pharisees and this can be interpreted as symbolic of the sin of pride (Superbia), with which the peacock is traditionally associated (I. Bergstrom, 'Rembrandt's Double Portrait of Himself and Saskia', *Nederlands Kunsthistorisch Jaarboek*, vol. 17, 1966, pp. 157-58). It is surely deliberate that the plate with bread and the flat-bottomed wine vessel (symbols of the Eucharist) standing at the end of the table nearest the Pharisees, are thrown into deep shade. The tasselled taliph worn by Simon and the forehead plaque bearing words of Holy Writ hint at Christ's words denunciation of the hypocrisy of the Pharisees and their superficial honour and inner impurity (Matthew xxiii: 5). The spectacles worn by the Pharisee behind Simon suggest the Pharisees' short-sightedness, 'blind leaders of the blind' (Matthew xv: 14; xxiii: 16, 19, 24, 26). Spectacles were a common

symbol of blindness, lack of faith and untruth and even heresy in Netherlandish art. The dog stealing a bone should probably be interpreted as a symbol of heresy, for an old iconographical tradition employed the motif to symbolise the devil, heresy or paganism (A. de Vries, *Dictionary of Symbols and Imagery*, Amsterdam, 1984, p.139).

Rubens contrasts the Pharisees' obstinate rejection of true faith with Christ's calm and unshakable firmness and his complete confidence in his own spiritual force. True faith is therefore victorious over unbelief and heresy.

In the seventeenth and eighteenth centuries the painting was renowned as one of Rubens' key works (de Piles 1681). Waagen (1864) thought considered that it was painted entirely by Rubens although Rooses (1886-92, vol. II) thought it executed by the artist's pupils from a sketch by the master and then actually completed by Rubens himself. Somov (Cat. 1902) also detected the participation of pupils, notably Van Dyck, but Bode (1906 and 1921) doubted Van Dyck's involvement. James Schmidt considered the painting 'a studio work of most varied nature and quality', suggesting that Christ's right hand and the head of the apostles seated nearby were the work of Van Dyck (manuscript note in the Hermitage Archive, *Opis'* XVI-A, no. 9).

The painting was indeed produced in Rubens' studio after his own sketch (oil on panel, 31.5 x 41.5, Akademie der Bildenden Kunste, Gemäldegalerie, Vienna; Held 1980, no. 337) and then worked over by the master himself. Both the general layout and the nature of nearly all the figures in the Hermitage painting accord with the Vienna sketch, with the exception of the heads of the three apostles to Christ's right. These heads derive from studies by Anthony Van Dyck (the study en face is in the Staatliche Galerie Dahlem, Berlin; the inclined head with a napkin in the Gemäldegalerie, Augsburg; Glück 1933, p. 302). As Varshavskaya (1963 and 1975) demonstrated, Van Dyck also painted the heads in the finished work, as we can tell from a comparison with the painterly manner in Van Dyck's *Christ Appearing to his Disciples* (Hermitage, Inv. No. 542). Varshavskaya (1975) thought Van Dyck was the author of the head of the fat man in a cap. The profile head of the second apostle to Christ's right derives from a study formerly collection of Dr Lewis S. Fry (Essex, UK) which Jaffé (M. Jaffé: *Anthony Van Dyck's Antwerp Sketch-book*, London, 1966, vol. I, pl. IV) published as the work of Van Dyck. However, Held (1980) suggested that this figure might be the work of Rubens.

Jaffé (1966 and 1968-69 Ottawa) was of the opinion that Jordaens painted all the figures in the left part of the Hermitage picture, but the over-smooth, somewhat tired surface of the painting in this area (particularly the figures in the background) is not analogous to Jordaens's work from the late 1610s.

The head of a negro, not included in the Vienna sketch, derives from Rubens' *Four Heads of a Negro* (Musées Royaux des Beaux-Arts de Belgique, Brussels; J. S. Held: 'The Four Heads of a Negro in Brussels and Malibu', in: *Rubens and His Circle. Studies by Julius S. Held*, Princeton, New Jersey, 1982, pp. 149-55).

The composition overall bears close comparison with the works of Veronese on the same or similar themes from the Gospels such as *The Meal in the House of Simon* (Galleria Sabauda, Turin), *The Marriage at Cana* (Louvre, Paris) or the *Supper in the House of Levi* (Accademia, Venice). Some details in the composition also derive from Veronese's 'feasts', such as the fat man in his cap which can be compared with the *Supper in the House of Levi*. Some aspects of the Hermitage picture composition even invite comparison with Caravaggio, particularly the way Simon grasps the arm of the chair which recalls the figure of Christ's pupil in the left foreground of Caravaggio's *Supper at Emmaus* (National Gallery, London). Similarly, the old man behind Simon, adjusting the spectacles on his nose, recalls the figure to the left of Matthew in Caravaggio's *The Calling of Saint Matthew* (San Luigi dei Francesi, Rome).

Varshavskaya emphasised that Veronese's concept is enriched in Rubens' painting by the theme of passionate conflict that Rubens developed in his series of hunting and battle pictures painted between 1615 and 1621. Taking into account the combination of these new dynamic tendencies, typical of Rubens' work in the 1620s, and his interests from an earlier period (i.e. the decorative variety of purely local areas of colour), Varshavskaya placed this picture in a transitional stage in Rubens's work, between 1618 and 1620, a period when Van Dyck was an active member of his workshop.

In addition to those preparatory works already mentioned a compositional pen drawing (sold at the auction of the Hoet collection, The Hague, 25 August 1760; Hoet, Terwesten 1752-70, vol. III, p. 224; Varshavskaya 1975) should also be noted. The painting was copied and engraved on many occasions.

N. G.

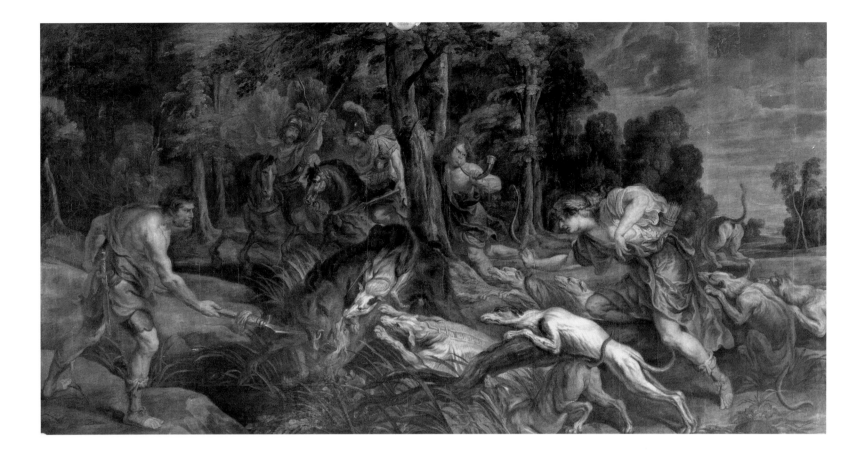

128

PIETER PAUL RUBENS, workshop (1577-1640) and
THEODOR VAN THULDEN (1606-69)
The Hunt of Meleager and Atalanta (Caledonian Hunt)
Oil on paper, glued onto canvas, 316 x 622 (horizontal
bands of paper, each c.30 cm wide)
Inv. No. 9647

PROVENANCE: 1643 possibly coll. Rubens' father-in-
law, Daniel Fourment (Denucé 1932, p. 113); 1677
coll. Jan Heck, Antwerp (Balis 1986, p. 221); coll.
General George Wade (1673–1748), England;
acquired from George Wade by Sir Robert Walpole;
Houghton (1736 Corner Drawing Room, then
Gallery); 1779 Hermitage; mid-19th century trans-
ferred to the English Palace, Peterhof; 1920 returned
to the Hermitage.

LITERATURE: *Aedes* 1752, p. 80 (as by 'Rubens'); 2002,
no. 229; Boydell II, pl. LI; Gilpin 1809, p. 58; Cham-
bers 1829, vol. I, p. 534; Smith 1829-42, part II, p. 157,
no. 548; Anecdotes 1862, vol. I, p. 312; Waagen 1864,
p. IV; Wessely 1886, pp. 32–33; Rooses 1886-92, vol.
III, p. 118, no. 639; Rooses 1905, p. 262; Wrangell
1908, pp. 688-89, no. 432; Schmidt 1909a, p. 177;
Wrangell 1910, pp. 90–91; Glück 1945, p. 38, No. 37;
Haverkamp Begemann 1953, p. 73, no. 54; Held 1980,
vol. I, p. 306; Balis 1986, p. 221; Moore ed. 1996, pp.
147-48; Brownell 2001, p. 42.

EXHIBITIONS: 1908 St Petersburg, no. 432.

According to Horace Walpole, this cartoon was
brought out of Flanders by General George Wade
(1673-1748) and sold to Sir Robert Walpole, since
there was no room in Wade's new house for a work of
this size (letter to George Montagu of 18 May 1748;
HWC 9, p. 56). In the *Aedes*, Horace Walpole stated
quite definitely that the composition was a cartoon for
a tapestry, an assertion repeated by Munich in the 1773–
85 catalogue. In the Hermitage the cartoon continued
to be attributed to Rubens himself, but was kept rolled
up in store. The cartoon spent some time at the (now
destroyed) English Palace in Peterhof, as we learn from
Wrangell in his catalogue to an (unrealised) exhibition
of works from private collections organised by the
journal *Staryye gody* in 1908 in which it was described as
'Un énorme tableau 'Meleager et Atalanta', peint sur
carton, - évidemment pour une tapisserie, . . . il est
dommage que le dit tableau soit très négligé et reste
relégué au Palais Anglais à Peterhof, dans les apparte-
ments occupés par les chantres' (Wrangell 1910).

Although in the 1908 exhibition catalogue the car-
toon was listed as Rubens, both Wrangell (1908), and
Schmidt (1909a) expressed doubts regarding this attri-
bution and suggested it was a studio work. Even ear-
lier, the same doubts had been expressed by Waagen,
who merely mentioned the work in his introduction
as a work 'sehr umfangreiches, ... welches des grossen
Namen Rubens, den es bisher gebragen, in keiner
Weise würdig ist' (Waagen 1864). After its return to
the Hermitage in 1920 (by which time the history of
the painting had been lost) it was listed in the inven-
tory as the work of an unknown seventeenth-century
Flemish artist. It was not included in any of the pub-
lished Hermitage catalogues. For many years it
remained on a roll, and was thus inaccessible to schol-
ars. Only in 1983 was the cartoon removed from the
roll and fully restored.

This is a working cartoon for the fifth tapestry in a
series of seven showing wild animal hunts, woven at
the manufactory of Daniel Eggermans in Brussels and
acquired in 1666 by the Austrian court from Viennese
merchant Bartholomeus Triangle. Until 1939 the
whole series was in the Kunsthistorisches Museum,
Vienna (Inv. No. xxxvi/1-7] but this tapestry is now in

a private collection in Southern Germany (reproduced in *Rubens' Textiles*, exh. cat., Hessenhuis, Antwerp, 28 June–5 October 1997, no. 16). In composition, the cartoon is a mirror image of the tapestry, coinciding even in its smallest details. Both cartoon and the scene on the tapestry have identical dimensions (although the tapestry measures 365 x 640 including its border and margins) and even the strips of paper of which the sketch is made coincide with the panels of which the tapestry itself is formed.

The compositions of six of the tapestries in the series (*The Hunt of Meleager and Atalanta, Diana and Nymphs Hunting Fallow Deer, The Bear Hunt, The Death of Adonis, The Hunt of the Wild Bull* and *A Lion Hunt*) derive from sketches by Rubens, while the seventh, *A Huntsman Resting with his Hounds*, reproduces the composition of a painting by Jordaens (Musée des Beaux-Arts, Lille) dated by the artist himself to 1635. Although opinions differ about their original purpose, Rubens' sketches, now dispersed in various collections, are dated by most scholars to the late 1630s. Some scholars (Glück 1945; Haverkamp Begemann 1953) suggested that they were designs for wall tapestries, while others (Held 1980; Balis 1986) linked them with a commission from Philip IV of Spain in 1639 for a series of decorative paintings for his palace in Madrid, suggesting that they were later adopted by the Brussels weavers as models for the tapestries.

Balis (1986) suggested that the tapestries themselves were specially commissioned for the marriage of Emperor Leopold I and the Infanta Margarita-Theresa of Spain and were not simply acquired from amongst works available on the market. On this assumption, he suggested a date of around 1660 for the cartoons.

In the opinion of the present author this notion is unlikely for the following reasons. First, on the occasion of Leopold I's marriage in 1666, the Austrian court acquired from Triangle not only the hunting tapestries but also *The Riding School,* a series of eight carpets after cartoons by Jacob Jordaens, and these can be reliably dated to c.1645 (1993 Antwerp, Nos A 94 – A 100, pp. 290-1).

Secondly, the painting of the figures in the cartoon for *The Hunt of Meleager and Atalanta* is close to works by Theodor van Thulden of the 1630s, and not at all in keeping with the style of Leopold I's court painter, Jan Thomas van Ypres (1617-78), whom Balis named as the possible author of the cartoons. For the modelling of the naked body, the details of the robes and the overall light tonality in the figures of *Meleager and Atalanta*, analogies can be found in van Thulden's works such as *Orpheus Surrounded by Animals, Hercules's Dog Discovers Tyrian Purple* (both Prado, Madrid), *The Hunt of Diana* (priv. coll., USA), *The Continence of Scipio the African* (Koninklijk Museum voor Schone Kunsten, Antwerp) and *The Martyrdom of St Barbara* (Musée des Beaux-Arts, Dijon). This suggests that van Thulden was in some way involved in producing the cartoon.

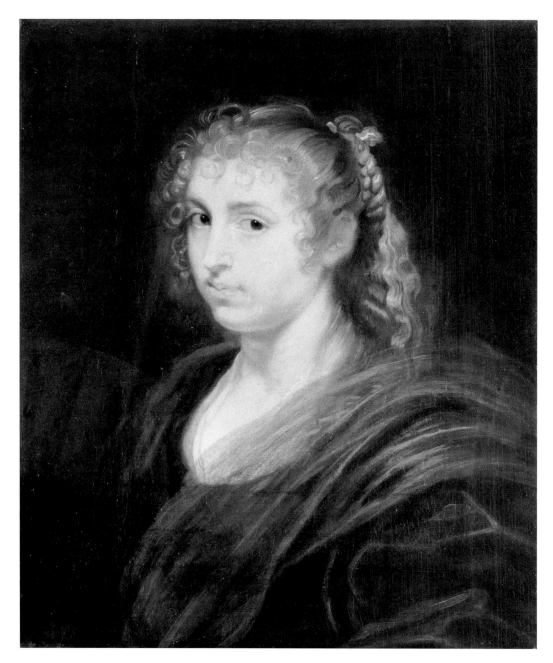

Thirdly, the technique of the cartoon is unusual in that it is painted in oil rather than watercolours, a process normally used to produce images for the weavers. The use of oil in tapestry cartoons was a notable feature in the practice of Rubens' studio.

Fourthly, the proportions of the cartoon are the same as those of a preparatory sketch for the composition by Rubens himself (oil on panel, 24.7 x 51.4; coll. Sir Francis Cook, Jersey; cf. Glück 1945, p. 38; Haverkamp Begemann 1953, p. 73). Finally, according to some documentary sources, Rubens designed a whole series of tapestries showing hunting scenes 'with large figures'

(J. Denucé: *Antwerp Art-tapestry and Trade*, The Hague, 1936, pp. lv, lvi, 321, 322, 341, 369, 370).

The use of some compositions from this series in work on the 1639 commission for Philip IV can surely be explained when we take into account the extremely short time allowed to Rubens – then suffering from severe bouts of illness – for the painting of eighteen large works.

The cartoon should probably be dated to the mid-1630s.

The subject is from Ovid, *Metamorphoses*, 8: 260-444

N. G.

129

PIETER PAUL RUBENS (1577-1640), school of
Head of a Girl
Oil on canvas, transferred from panel in 1868. 65 x 54
(with additions top and bottom)
Inv. No. 1692
PROVENANCE: Sir Robert Walpole, 1736 Downing St
(Lady Walpole's Drawing Room), later Houghton
(Common Parlour); 1779 Hermitage.
LITERATURE: *Aedes* 1752, p. 48 (as 'Rubens' Wife, a
Head, by Rubens'); 2002, no. 48; Boydell II, pl. V;
Chambers 1829, vol. I, p. 522; Livret 1838, p. 312, no.
53; Cats. 1863–1908, no. 577; Waagen 1864, p. 141;
Rooses 1886–92, vol. IV, p. 290; Bulletin Rubens
1882–1910, vol. V, p. 83; Rooses 1905, p. 313;
Shcherbachyova 1945b, p. 13; Cat. 1958, vol. II, p. 95;
Jaffé 1969, pp. 310–13; Varshavskaya 1975, p. 248, no.
11; Held 1980, vol. I, p. 613; Cat. 1981, p. 66.
EXHIBITIONS: 1978a Leningrad, no. 70.

The sitter has been identified at various times as
Isabella Brant and Hélène Fourment, Susanna Haecx
(wife of the painter Jan Janssens), and Catharina
Brueghel (van Marienburg, daughter of Jan Brueghel
the Elder).

The *Aedes* and later Hermitage inventories and cata-
logues until 1902 listed the painting as a portrait of
Hélène Fourment by Rubens. Rooses (1886–92 and
1905) and Somov (Cat. 1902) believed it to be a copy
of a portrait in Dresden (Galerie Alte Meister), which
they thought was an original by Rubens.
Shcherbachyova (1945b) identified the painting as the
work of Rubens and gave it the title *Portrait of a
Woman as St Catherine* (possibly a portrait of Catharina
Brueghel) on the basis of a likeness to the face in *The
Mystic Marriage of St Catherine* (formerly coll. Leopold
Koppel, Berlin; now Toledo Museum of Art, Ohio)
and dated it 1627–28. In the 1958 catalogue, *Girl's
Head* was listed as a work of Rubens' studio, while
Varshavskaya's monograph on Rubens (1975) and the
1981 catalogue both shared this view.

According to Varshavskaya (1975), the painting is one
of seven known versions of a lost original by Rubens.
Held (1980) thought the original was the version then in
the possession of Dr Armand Hammer (now Armand
Hammer Foundation, University of Southern Califor-
nia, University Galleries, Los Angeles).

N. G.

130

PIETER PAUL RUBENS (1577-1640), workshop
Susanna and the Elders
Oil on canvas, transferred from old canvas in 1840,
178.5 x 220
Inv. No. 496
PROVENANCE: Sir Robert Walpole, 1736 Houghton
(Hunting Hall); 1779 Hermitage; mid-19th century
transferred to Gatchina Palace; 5 March 1925 returned
to the Hermitage.
LITERATURE: *Aedes* 1752, p. 43 (as by 'Rubens'); 2002,
no. 21; Chambers 1829, vol. I, p. 521; Smith 1829–42,
part II, p. 172, no. 598; Rooses 1886–92, vol. I, pp.
170–71; vol. V, pp. 314-15; Schmidt 1926b, pp. 9–10,
29 (Rubens); Schmidt 1949, pp. 35–41; Puyvelde
1952, p. 117, note 72; Cat. 1958, vol. II, p. 82; Pergola
1967, pp. 11–14; Varshavskaya 1975, pp. 120–22, no.
17; Cat. 1981, p. 66; d'Hulst, Vandenven 1989, pp.
215–18; Prêtre 1990, pp. 86–87.
EXHIBITIONS: 1978a Leningrad, no. 57.

Although attributed to Rubens when in the Walpole
collection, this was thrown into doubt when the picture
was listed in the 1773-85 catalogue. In the 1797 catalogue
it was listed as a copy after Rubens. Although aware of its
uneven quality, Schmidt (1949) thought the picture was
by Rubens himself and suggested that it served as the
basis for an engraving by Christoffel Jegher. When the
1958 catalogue was published it was reinstated as a work
by Rubens but noting the rather loose and impersonal
execution, Varshavskaya (1975) thought it a studio work
and that was how it was entered in the 1981 catalogue.

This is the best of the surviving painted versions of
the composition (the subject taken from the Book of
Daniel, xiii: 15-25). It is known from an engraving by
Christoffel Jegher after a drawing by Rubens (for the
engraving see V.-S. 1873, p. 11, no. 94 which has the
addition of a tree with drapery tossed over it, and a
grotto, with a parkland landscape in the background).
As noted by Prêtre (1990), Susanna's pose, with her
head inclined towards her right shoulder, recalls the
figure of Christ in Titian's *Christ Crowned with Thorns*
(Alte Pinakothek, Munich, Inv. No. 2272).

According to Puyvelde (1952) and Pergola (1967), it
was the Hermitage picture that Rubens offered to the
English Ambassador to the United Provinces, Sir Dudley
Carleton, in a letter of 28 April 1618 (Magurn 1955, no.
28, p. 61). Varshavskaya (1975) although admitting that
this was an intriguing notion, had two objections. First,
Rubens indicated in his letter that the painting was ver-
tical in format, suggesting that he was referring to
another composition known only from an engraving by
Lucas Vorsterman I (V.-S. 1873, p. 84; Bodart 1977, pp.
68–9, no. 122). Secondly, on 1 September 1618 Sir
Dudley Carleton offered his collection, including
Susanna, for sale to a 'merchant of the King of Denmark'
(CDR 1887-1909, vol. II, p. 185); and the present

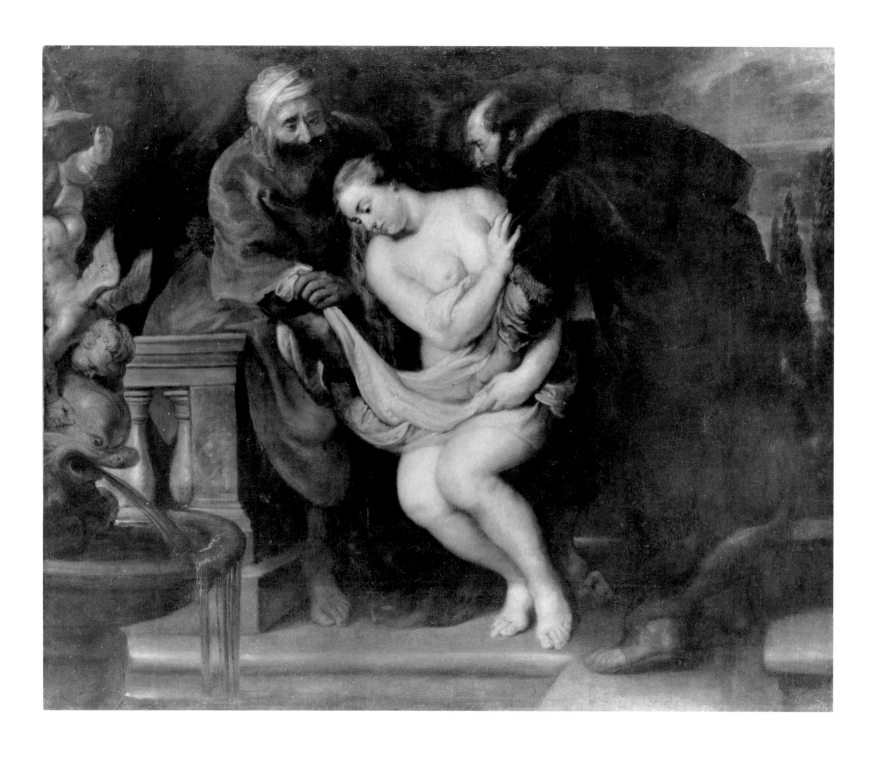

whereabouts of many of his paintings is unknown.

There is a version of the composition in the Galleria Sabauda, Turin (oil on canvas, 177 x 246) and another was sold by the antiquarian Hugo Helbing, Munich, 12 October 1909 (lot 50). A further version is in the Cailleux collection, Paris (Pergola 1967, p. 10).

N. G.

131

PIETER PAUL RUBENS (1577-1640)
Bacchanalia
Oil on canvas, transferred from panel in 1892, 91 x 107
Pushkin Museum of Fine Arts, Inv. No. 2606
PROVENANCE: probably one of two Bacchanalia by Rubens purchased by Sir Robert Walpole at the sale of the 1st Earl of Cadogan 1726/7, either day 1, lot 36 or day 2, lot 81 (Moore ed. 1996); Sir Robert Walpole,

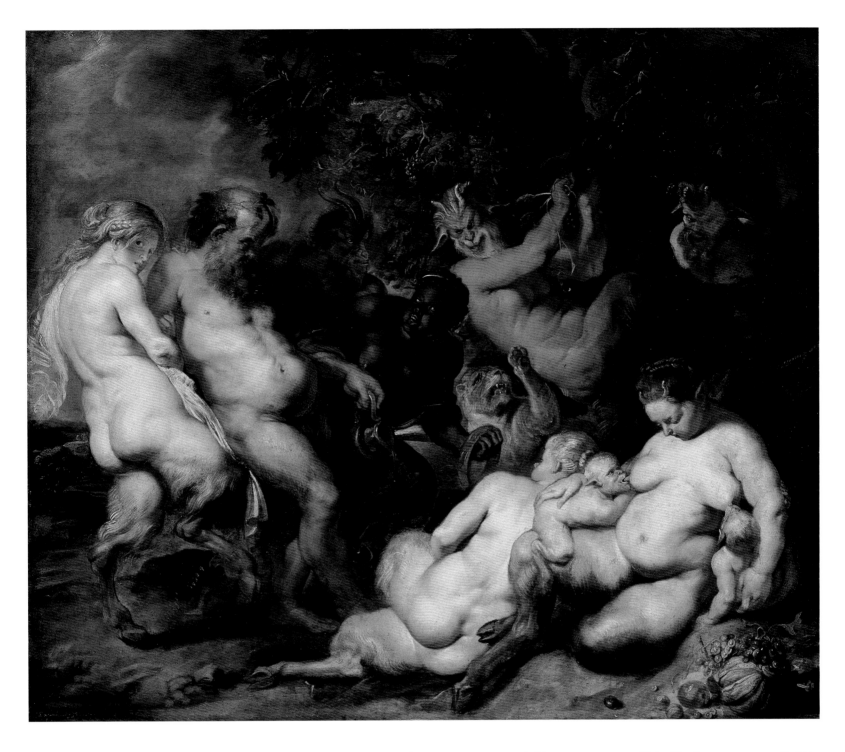

1728 Arlington St, 1736 Downing St (Sir Robert's Dressing Room), later Houghton (Common Parlour); 1779 Hermitage; 1930 transferred to Museum of Fine Arts (now Pushkin Museum of Fine Arts), Moscow.

LITERATURE: *Aedes* 1752, p. 46; 2002, no. 38; Boydell II, pl. LVII; Gilpin 1809, pp. 44-45; Schnitzler 1828, p. 102; Livret 1838, p. 363, no. 11; Anecdotes 1862, vol. I, p. 312; Cats. 1863-1916, no. 551; Waagen 1864, p. 138, no. 551; Goeler von Ravensbourg 1882, pp. 97-98; Rooses 1886-92, vol. III, pp. 161-62, no. 679 (with incorrect reference to table 208); Rooses 1890, p. 296, 325; Rosenberg 1905, p. 124; Wrangell [1909], pp. xxx, 75; Neustroyev 1909, pp. 19-20; Benois [1910], pp. 222, 226; Oldenbourg 1921, p. 82; Hind 1923, p. 22; Glück 1933, p. 191; Kieser 1933, p. 122-23; Vertue vol. IV, 1935-36, p. 175; Dobroklonsky 1940, p. 15; Evers 1943, p. 243-44; Pushkin Museum 1948, p. 70; Gershezon-Chegodayeva 1949, pp. 43-44; Puyvelde 1952, p. 132; Dobroklonsky 1955, p. 132; Pushkin Museum 1957, p. 54; Speth-Holterhoff 1957, p. 54; Pushkin Museum 1961, p. 163; Martin 1970, pp. 219, 222 note 28, 223 note 50; Kuznetsov 1974, text to table 8; Padrón 1975, vol. I, pp. 41, 62; vol. II, pls 28, 45; D'Hulst 1974, vol. II, p. 407; Pushkin Museum 1986, p. 155, ill. 40; Held 1986, p. 81, beneath no. 37; Jaffé 1989, no. 279; Rubens Paintings 1989, pp. 58-65, pls. 19-22; Van der Meulen 1994, vol. I, p. 87 note 86;

vol. II, p. 51; Pushkin Museum 1995, p. 449; Alpers 1995, pp. 103, 106, 120, 121, 123, 126, 168, ills. 65, 88; Moore ed. 1996, p. 52; Yegorova 1998, pp. 242-45. (A number of publications give location as Hermitage even after transfer to Moscow)

EXHIBITIONS: 1964 Leningrad, pp. 37-38; 1982 Moscow, no. 16; 1991 Retretti, pp. 140-43.

This painting is one of a group of works on the bacchic theme executed between 1612 and 1618 which employ a group of three figures in which the outer ones support the central figure. Its composition derives from an Antique relief and its source may be a group with the bearded Priapus supported by two satyrs from a Dionysian sarcophagus of the mid-second century AD which during Rubens' lifetime was in the Farnese collection in Rome (now Museo Nazionale, Naples, Inv. No. 27710; see van der Meulen 1994, vol. I, p. 87, note 86). The picture also employs motifs from reliefs taken from a marble sarcophagus with Dionysian scenes (c.210 BC) with which Rubens was acquainted and which is now, like the painting, in the Pushkin Museum of Fine Arts, Moscow (Inv. No. II, 1a 231). The the figure of Heracles with a ewer in his hand on the end panel served as the prototype for Silenus pouring wine. The composition as a whole recalls Antique reliefs with figures filling the foreground. For the figure of Silenus the artist used a drawing (British Museum, London, Inv. No. 5211-88, Held 1986, p. 81, no. 37, pl. 17; Van der Meulen 1994, vol. II, p. 51, no. 29 and vol. III, fig. 61) from an Antique statue formerly belonging to Agostino Chigi in Rome and now in the Skulpturensammlung, Dresden. The motif of the satyress feeding her two children probably derives from an engraving by Cornelis Matsys (*Cornelis Matsys, 1510/11-1556/57: oeuvre graphique*, exh. cat., edited by Jan van der Stock, Bibliothèque royale Albert Ier, Brussels, 1985, no. 29, ill.).

The paint layer is uneven and in places the sandy-grey ground is left visible and only partially covered with transparent brushstrokes. In technical terms, it relates to a period of experimentation c.1614-16, when the artist rejected the careful, finished effect used in his earlier works. A date of execution c.1615 is therefore likely for this work

There are a number of copies known including that in the collection of the Prince of Liechtenstein at Vaduz (Inv. No. 231). That in the Uffizi in Florence (Inv. No. 810) was mentioned in the *Aedes* and in the eighteenth century it was thought to be a sketch for this painting. It was displayed in a prominent place in the Tribuna. A drawing touched with oil (?) in the Crozat (1741) and Tallard (1756) auctions in Paris was thought by Smith (1829-42, part II, p. 158) to be a sketch for this painting. Other copies have also passed through the European art market at various times.

K. Ye.

132

FRANS SNYDERS (1579-1657)
A Concert of Birds
Oil on canvas, 136.5 x 240
Inv. No. 607

PROVENANCE: coll. Grinling Gibbons, London; November 1722 acquired by Sir Robert Walpole at sale of the Gibbons coll.; Sir Robert Walpole, 1736 Chelsea (Sir Robert's Dressing Room, as by Fiori), later Houghton (Small Breakfast Room); 1779 Hermitage.

LITERATURE: *Aedes* 1752, p. 38 ('Mario di Fiori'); 2002, no. 2; Boydell II, pl. III (with the addition of a landscape in the lower part of the composition); Chambers 1829, vol. I, p. 520; Cats. 1863–1916, no. 1324; Waagen 1864, p. 269; SbRIO 17, 1876, p. 399; Wurzbach 1906-11, vol. 2, p. 634; Benois [1910], p. 239; Levinson-Lessing 1926, p. 18; Pigler 1956, vol. 2, p. 574; Cat. 1958, vol. II, p. 99; Mirimonde 1964, pp. 265–66; Müllenmeister 1981, vol. 3, p. 63, No. 417; Cat. 1981, p. 69; Kirby Talley 1983, p. 204; Cat. Antwerp 1988, p. 219; Robels 1989, pp. 464–65, no. A 205 I; Koslow 1995, pp. 291, 296, 297; Moore ed. 1996, p. 89, no. 5.

EXHIBITIONS: 1985 Rotterdam, no. 39; 2001 Toronto, no. 67.

Judging by its dimensions and format, this picture may have originally been used as an overdoor. The subject matter includes an allegorical element in its mockery of the owl and probably derives from one of Aesop's fables, 'The Owl and the Birds', known from two speeches attributed to the Greek orator and philosopher Dio Cocceianus Chrysostomus (c.40–120; Speeches 12 and 72). Although the links with Aesop are fairly tenuous - primarily only the idea of birds gathered around an owl in a tree link the picture with the fable - the subject was also interpreted in this way during the medieval period (for further details see, P. Vandenbroeck: 'Bulbo Significans. Die Eule als Schlechtigkeit und Torheit, vor allem in der niederlandischen und deutschen Bilddarstellung und bei Jheronimus Bosch', in: *Jaarboek van het Koninklijk Museum voor Schone Kunsten*, Antwerp, 1985, pp. 26–30). Depictions of 'concerts of birds' also recall the proverb recorded by the Netherlandish poet Jacob Cats (1577-1660), 'Elck vogeltge singt soo't gebeckt is' (Every bird sings as it knows best, i.e. everyone speaks as he knows best; see: Robels 1989, p. 115). In the work of Flemish painters (particularly Jan Brueghel) such parodies were often intended to be read as allegories of Air or Hearing while allowing artists to demonstrate the variety of the bird kingdom (see A. P. de Mirimonde: 'Les concerts parodiques chez les maîtres du Nord', *Gazette des Beaux-Arts*, vol. 64, 1964, part II, pp. 264–70, 282, no. 28). In the Hermitage painting (as in the works of 'Velvet' Brueghel), depictions of different birds common in European

woods, forests and meadows and around rivers and lakes are brought together with decorative birds cultivated in Europe, such as peacocks and puffer-pigeons, and exotic species of the New World such as the toucan, the Amazonian parrot and the red ara.

In the Walpole collection and in the 1773-85 catalogue the painting was attributed to the Italian painter Mario Nuzzi, called di Fiori (c.1603–73), although in the *Aedes* Horace Walpole stressed the unusual nature of such a subject for this artist who was known mainly for his flower paintings. In all later Hermitage inventories and catalogues the picture was listed as the work of Frans Snyders. Only Robels (1989) doubted this attribution, suggesting that the Hermitage *Concert of Birds* is too dynamic and daring a composition for this artist. Robels attributed the painting to Paul de Vos, dating it to the 1630s, but his arguments have not convinced the present author.

The picture is mentioned in the appendix to a letter from Alexey Musin-Pushkin, Russian ambassador in London, to the Empress Catherine, listing works added to the Walpole sale 'without increasing the previous price' (SbRIO 17, 1876).

The same composition, but taller and with a landscape in the lower part, appeared auction at Christie's in London on 23 June 1967 (oil on canvas, 163.3 x 240; Lot 42, as Snyders). A copy, usually attributed to Jan I van Kessel, is in the Koninklijk Museum voor Schone Kunsten, Antwerp (oil on canvas, 170 x 234; Inv. No. 428); a partial copy of the composition is in the Musée des Beaux-Arts, Nantes (Inv. No. 447).

N. G.

133-136

FRANS SNYDERS (1579-1657) AND JAN WILDENS (1586-1653)
Markets
Inv. Nos. 596, 598, 602, 604

PROVENANCE: coll. Jacques van Ophem, Brussels; coll. Marie-Isabelle van Ophem, Brussels; coll. Jacques-Ferdinand de Villegas, baron of Hovors and seigneur of Bouchout, Viersel and Werston, Brussels; bought from de Villegas for Sir Robert Walpole by the spy John Macky, probably in 1723; Sir Robert Walpole, ?London, 1736 Houghton (Saloon, as by Rubens, then Gallery); 1779 Hermitage.

LITERATURE: *Aedes* 1752, p. 80; 2002, nos. 230-33, and see individual entries.

This series of four paintings are united by a common theme. In the eighteenth and the first half of the nineteenth century, the *Markets* were interpreted as an allegory of the four elements (see Descamps 1753-64; Mensaert 1763; Smith 1829-42, part II; Hasselt 1840). Earth was thought to be represented by fruits, herbs, vegetables and animals; Water by fish and aquatic

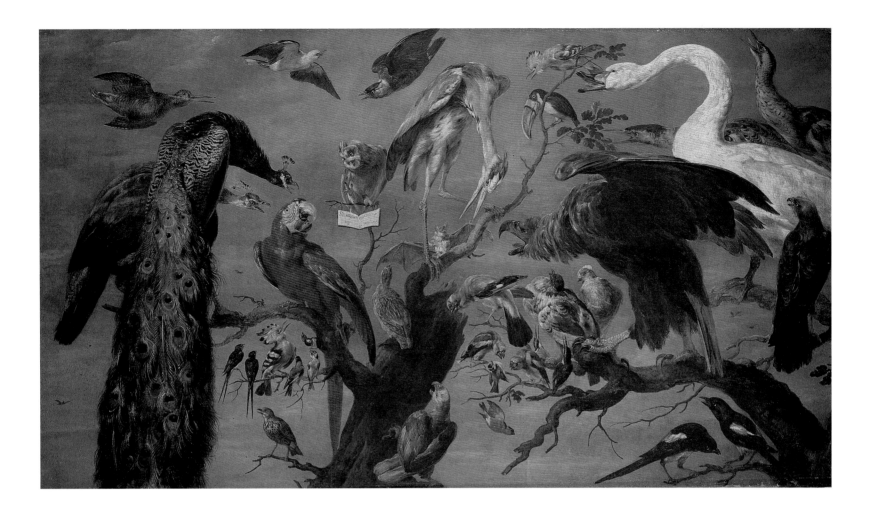

beasts; Air by birds; and Fire was implied in the depiction of kitchen implements.

As genre paintings, these works can be closely linked to the market scenes by the sixteenth-century Netherlandish artists Pieter Aertsen (1508-75) and Joachim Bueckelaer (c.1530–c.1573). Like their works, Snyders's *Markets* contain a hidden didacticism, notably in the use of motifs implying a call for moderation in all things. For instance, the little pickpocket cutting the purse of the housekeeper purchasing root vegetables (*Vegetable Market*, cat. no.136) is a motif that dates back to the paintings of Hieronimus Bosch (c.1450-1516) such as *The Conjuror* (Musée Municipale, Saint-Germain-en-Laye), and Pieter Brueghel the Elder (1525/30–1569), *Misanthrope* (Museo Capodimonte, Naples). In this particular context it serves as a reminder of the vanity and brevity of earthly pleasures, for the vast variety of herbs, mushrooms and vegetables not only demonstrates earthly abundance but they could also be interpreted negatively, as objects of sensual desire (Robels 1989). We should probably interpret similarly the depiction of scales in *The Fruit*

Market, that is to say we should see them as an ancient symbol of true measurement, recalling the words addressed to God in the apocryphal Wisdom of Solomon (xi: 20) 'thou hast ordered all things in measure and number and weight.'

Rather more obvious, however, are allusions to Man's ties to Nature, to elements in the extremely popular allegories of the turn of the sixteenth and seventeenth centuries such as the Four Elements, the Seasons and the Five Senses. Snyders uses these, however, simply as motifs, which he presents very much within a genre setting. He plays quite comically on the allegory of the senses, presenting Hearing, Taste, Sight, Touch and Smell in a very down-to-earth manner. As an allegory of hearing we should note the dogs barking at a cat in the *Game Market*, with the stall holder turning round to see what has caused the noise. A traditional symbol of Taste is the monkey in the centre of the *Fruit Market*, although it seems very likely that the horse in the *Vegetable Market*, munching energetically on a cabbage leaf, recalls the same idea. Sight is perhaps embodied in the little pickpocket carefully watching

every movement made by the housekeeper whose purse he is robbing in the *Vegetable Market*. Touch is suggested by the woman's gesture as she squeezes an apricot in the *Fruit Market*. Lastly, Smell is symbolised by the rich bouquet of roses and tulips that would otherwise seem totally out of place in the prosaic setting of an ordinary vegetable stall.

In this series overall Snyders embodies, through the use of still life, the concept of a renaissance of former prosperity, in a way particularly characteristic of Flemish painting during the Twelve Year Truce of 1609-21.

The Markets reveal a certain commonality of visual motifs with a series of paintings of *The Four Elements* by the Italian artist Vincenzo Campi (c.1530/35 – 1591) entitled *The Fruit Vendor* and *The Fish Vendors* (both Pinacoteca di Brera, Milan), *Poulterers* and *Kitchen Scene* (both Accademia di Brera, Milan). In particular, we frequently find in Snyders' pictures a worker pouring fish from a bowl into a large wooden tub by a wide stall, a motif that seems to derive from Campi's *Fish Vendors*, although in the latter's depiction the same activity is conducted by a young girl. Snyders was

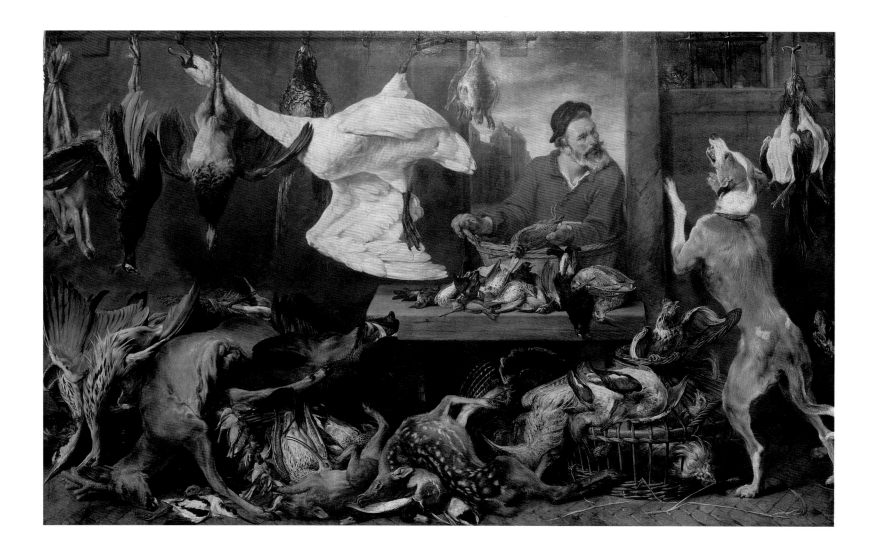

clearly attracted by the dynamism of the motif, and the same could be said of the household animals in a variety of dynamic poses that enliven Campi's compositions. These too Snyders adopted and worked up further. Even the three-tiered construction of his *Markets*, which was so typical of Flemish still life, finds a prototype in Campi's series. Unlike his predecessor Joachim Bueckelaer, Campi did not simply squeeze the stall right up to the frontal limits of the painting, but considerably extended the composition, adding space beneath and in front of the stall and filling it with various organic forms. In the eighteenth century, Campi's *Four Elements* were in Cremona, and Snyders would have been able to see them there in 1608-9 during his journey through Italy.

Until recently it was thought (on the basis of Michel 1771), that the *Markets* were painted for Bishop Antoon Triest (1576-1657) and were intended to hang in his palace in Bruges. The American scholar Susan Koslow (1995), however, has published earlier documents which suggest that the *Markets* were in fact

painted to adorn a mansion built in Brussels for Jacques van Ophem (?-1647), 'receveur général des domaines du roi au quartier de Bruxelles' at the court of the Archdukes, the Spanish Governors of the Southern Netherlands.

Compositional features suggest (Gritsay 1985) that the *Markets* were hung in the following sequence: *A Game Market*, then the pair of *A Fruit Market* and *A Vegetable Market* and, lastly, *A Fish Market*. Koslow (1995, p. 116) provided documentary evidence to support this hypothesis.

On the basis of style and indirect documentary evidence (see Koslow 1995) the paintings were executed during the reign of Philip III of Spain (i.e. before his death in 1621). The *Markets* can be dated to 1618-21 and this is confirmed by the likely participation in execution of the landscapes by Jan Wildens, who returned to Antwerp from Italy in 1618.

Until the middle of the nineteenth century the figures in the *Markets* were attributed to Rubens, then Waagen (1864) suggested the name of Jan van Boeck-

horst (1605-68) as their author. This attribution was rejected by Levinson-Lessing (1926), who rightly noted that the figures in the *Markets* are the work of several artists. Boeckhorst was still too young to be involved at the time Snyders began work on the *Markets*. It is not possible at present to identify those artists who collaborated with Snyders, but it does seem likely that they were from the workshop of Rubens, with which Snyders was closely associated at this time. We can also assert with some confidence that the figures in the *Markets* were painted by several (probably four) artists of varying degrees of skill and that they derive from lost drawings by Snyders himself. Known drawings by Snyders reveal that he usually conceived his still-life compositions together with the figures.

N. G.

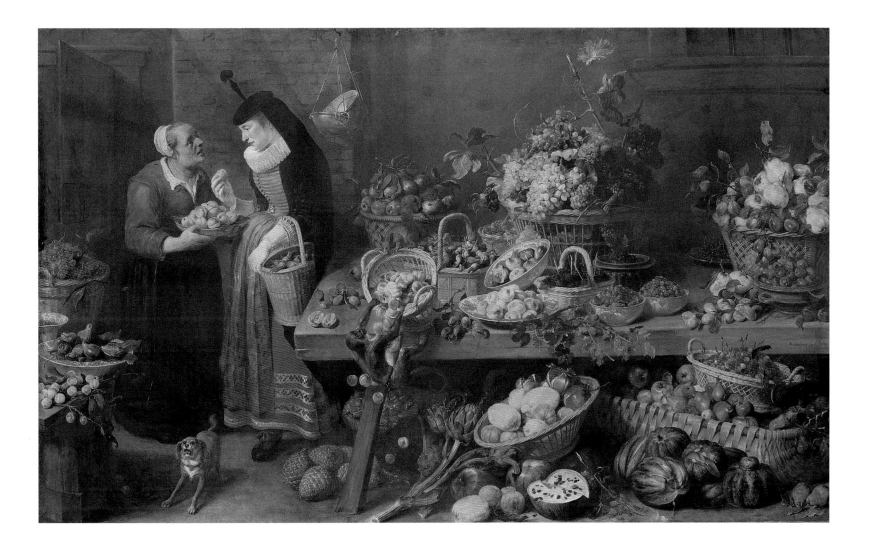

133

A Game Market

Oil on canvas, 207 x 341, signed right, on the edge of the table, *F. Snyders fecit*

Inv. No. 602

LITERATURE: Descamps 1753-64, vol. I, p. 333; Mensaert 1763, p. 62; Michel 1771, pp. 364-65; Gilpin 1809, p. 59; Chambers 1829, vol. I, pp. 534-35; Smith 1829-42, part II, p. 59, no. 166; Livret 1838, p. 206, no. 17; Hasselt 1840, p. 360; Cats. 1863-1916, no. 1315; Waagen 1864, p. 267-68; Rooses 1886-92, vol. IV, p. 89; Wurzbach 1906-11, vol. II, p. 634; Benois [1910], pp. 238-39, 240; Oldenbourg 1922, p. 189; Levinson-Lessing 1926, pp. 25-26; Vertue, vol. III, 1933-34, p. 18; Greindl 1956, p. 52; Cat. 1958, vol. II, p. 99; Robels 1969, pp. 55-57; Cat. 1981, p. 69; Gritsay 1985, pp. 53, 56, 57; Gritsay 1986, pp. 68-71; Greindl 1983, pp. 75, 374, no. 37; Robels 1989, p. 192-94, no. 28; Koslow 1995, pp. 109-11, 121-25; Gritsay 1996a, pp. 26-29; Honig 1998, p. 159.

The landscape background probably the work of Jan Wildens. A version of the composition dated 1614 is in The Art Institute of Chicago (Robels 1989, no. 17). Another version was sold at auction at Christie's, London, 10 March 1978 (lot 51).

Several copies are known, in the Fitzwilliam Museum, Cambridge (Inv. No. 315); in a private collection (reduced copy by ?Peter Angelis, Koslow 1995, p. 134). A copy of the right half of the composition was included in the auction of Frederik Müller, Amsterdam, 26 November 1940 (lot 21, as Jan Fyt).

N. G.

134

A Fruit Market

Oil on canvas, 206 x 342, signed right, on the edge of the table: *F. Snyders fecit*

Inv. No. 596

LITERATURE: Boydell I, pl. XII; Descamps 1753-64, vol. I, p. 333; Mensaert 1763, p. 62; Michel 1771, pp. 364-65; Gilpin 1809, p. 59; Livret 1838, pp. 212-13, no. 44; Cats. 1863-1916, no. 1312; Cat. 1958, vol. II, p. 99; Cat. 1981, p. 69; Greindl 1983, pp. 75, 374, no. 34; Gritsay 1985, pp. 53, 56, 58, 59, 60; Robels 1989, p. 190, no. 26; Stighelen 1990, pp. 87-88, 95, no. 3; Koslow 1995, pp. 109-11, 121-27; Moore ed. 1996, p. 147; Honig 1998, pp. 158-59.

The right hand side of the composition is repeated in Snyders's *Baskets and Plates with Fruit* (Statens Museum For Kunst, Copenhagen, Inv. No. Sp. 209), which Robels (1989) considers to be from Snyders's workshop. Copies known include that sold at Christie's, London, 13 December 1991 (oil on canvas, 211.8 x 330.5, Lot 185); Glamis Castle, Angus, Scotland (Inv. No. H.5846) and a copy in a private collection (reduced copy by ?Peter Angelis, Koslow 1995, p. 134). The still life is reproduced with slight alteration in a painting by Pieter van Boucle (?-1673), *The Fruit Seller* (Musée des Arts Décoratifs, Paris).

N. G.

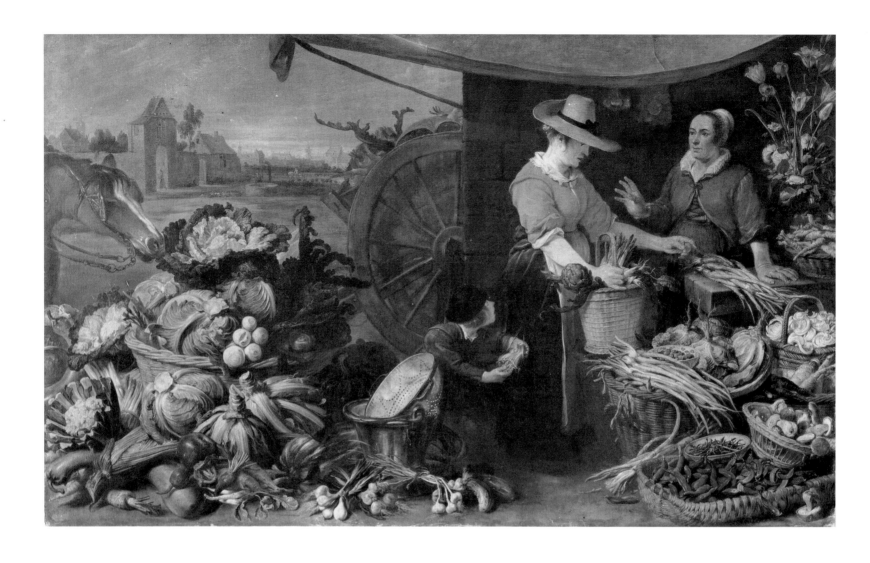

135

A Vegetable Market
Oil on canvas, 208 x 341, signed right, on the edge of
the table, *F. Snyders fecit*
Inv. No. 598
LITERATURE: Boydell I, pl. XIII; Descamps 1753-64,
vol. I, p. 333; Mensaert 1763, p. 62; Michel 1771, pp.
364-65; Gilpin 1809, p. 59; Livret 1838, p. 207, no. 23;
Cats. 1863-1916, no. 1313; Cat. 1958, vol. II, p. 99;
Kuznetsov 1966, p. 171, no. 10-11; Cat. 1981, p. 69;
Greindl 1983, pp. 75, 374, no. 35; Gritsay 1985, pp. 53,
56, 58-60; Robels 1989, p. 192, Cat. 27; Stighelen
1990, pp. 87-88; Koslow 1995, pp. 109-11, 121-27;
Honig 1998, pp. 158, 159.

The landscape background is stylistically close to the
work of Jan Wildens in the years just after his return
from Italy. Examples for comparison can be found in
the landscape backgrounds he painted in works by
Rubens such as *The Rape of the Daughters of Leucippus*

and *Fruit Garland* (both Alte Pinakothek, Munich). An
earlier version of the left hand side of the composition,
probably painted around 1614, is in the Kunsthalle,
Karlsruhe (Inv. No. 213). A reduced copy (by ?Peter
Angelis, Koslow 1995, p. 134) is in a private collection.

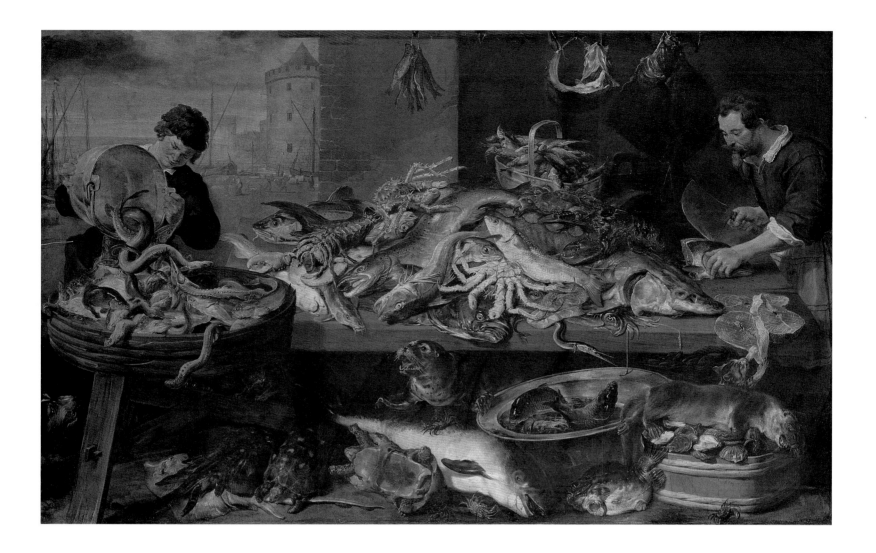

136

A Fish Market
Oil on canvas, 207 x 341, signed right, on the tub of oysters: *F. Snyders fecit*
Inv. No. 604
LITERATURE: Boydell II, pl. XLIX; Descamps 1753-64, vol. I, p. 333; Mensaert 1763, p. 62; Michel 1771, pp. 364-65; Gilpin 1809, pp. 58-59; Livret 1838, p. 204, no. 9; Cats. 1863-1916, no. 1320; Cat. 1958, vol. II, p. 99; Cat. 1981, p. 69; Greindl 1983, pp. 75, 374, no. 39; Gritsay 1985, pp. 53, 56, 57, 59-60; Robels 1989, p. 194, Cat. 29; Koslow 1995, pp. 109-11, 121-25, 140-42.

In the background can be seen part of the bank of the River Schelde at Antwerp, probably near het Bier-hoofd. This same stretch of embankment is shown in a painting by Jan Wildens, *View of Antwerp in Winter* (whereabouts unknown; reproduced Adler 1980, pl. 60, no. G 39). A preparatory drawing with some dif-ferences, signed by Snyders, was sold at auction at Sotheby's Mak van Waay, Amsterdam, 18 April 1977 (lot 58). Copies are known in the Louvre, Paris (Inv. No. 1848); in a private collection (sold at Christie's, London, 11 December 1986, lot 25). A reduced copy (by ?Peter Angelis, Koslow 1995, p. 134) is in a private collection. A free repetition, attributed to Alexander Adriaenssen, was sold at auction, Mak Van Waay in Amsterdam, 18 March 1919 (lot 1).

N. G.

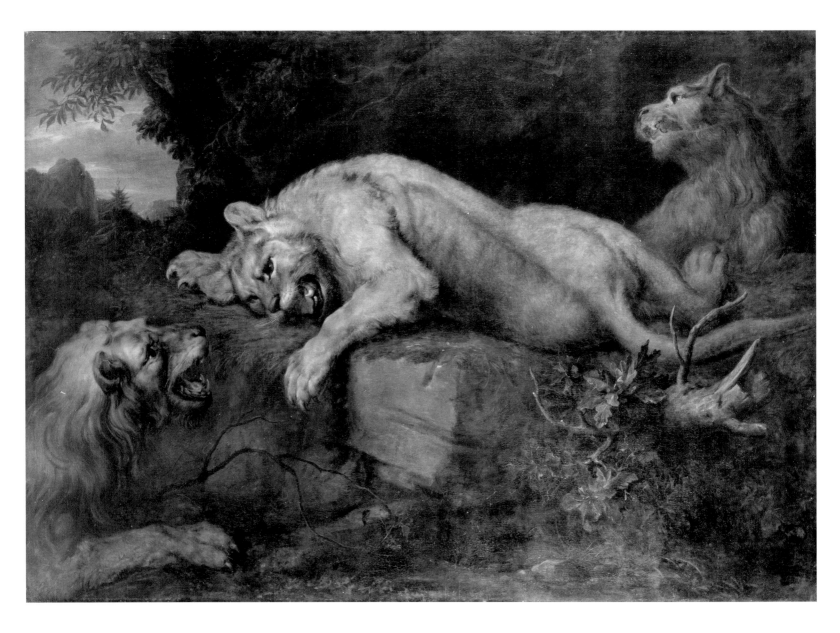

137

FRANS SNYDERS (1579-1657), school of
A Lioness and Two Lions
Oil on canvas, 171 x 248.5
Inv. No. 465

PROVENANCE: ?1722, Van Huls house sale, lot 238 'Rubens – Lions Courting', no buyer or price given, although Sir Robert Walpole was a purchaser at this sale; Sir Robert Walpole, 1736 Downing St (Great Middle Room below, as by Rubens), later Houghton (Gallery); 1779 Hermitage.

LITERATURE: *Aedes* 1752, p. 84 (as by Rubens); 2002, no. 236; Boydell II, pl. XXXVII; Gilpin 1809, p. 59; Chambers 1829, vol. I, p. 535; Livret 1838, p. 361, no. 5; Cats. 1863-1916, no. 592; Waagen 1864, p. 142; Rooses 1886-92, vol. IV, p. 351, no. 1164; Cat. 1958, vol. II, p. 95; Cat. 1981, p. 70.

When it entered the Hermitage, and in all later catalogues, this painting was listed as Rubens, an attribution supported by Waagen (1864) and Rooses (1888-92). In the 1893 catalogue Somov doubted that Rubens was author of the composition and he suggested that perhaps he 'went over' the figures of lions, which were painted by a pupil, while further suggesting that the landscape was painted by Jan Wildens. In the 1902-16 catalogues, the painting was listed as school of Rubens, and in the 1958 catalogue it was given to his workshop, with the proviso that it may have been the work of Frans Snyders. The 1981 catalogue listed it as 'school of Snyders', the attribution that remains current today. A version of the composition is *Lionesses Playing* (coll. the Earl of Normanton, Somerley), which Robels excluded from the oeuvre of

Frans Snyders (Robels 1989, A 227, p. 469).

According to Rooses (1886-92), the Hermitage painting may have come from the collection of Antwerp burgomeister Nicolaas Rockox, since in the posthumous (1640) inventory of his property we find reference to 'an oil painting on canvas, in a frame, showing three lions, by Rubens' ('Eene schilderye op doeck olieverwe in syn lyste wesende drye Leeuwen geschildert by den heer Rubbens'; Denucé 1932, p. 90). Engraved by Hen. Mackworth (V.-S. 1873, p. 230, no. 41).

N. G.

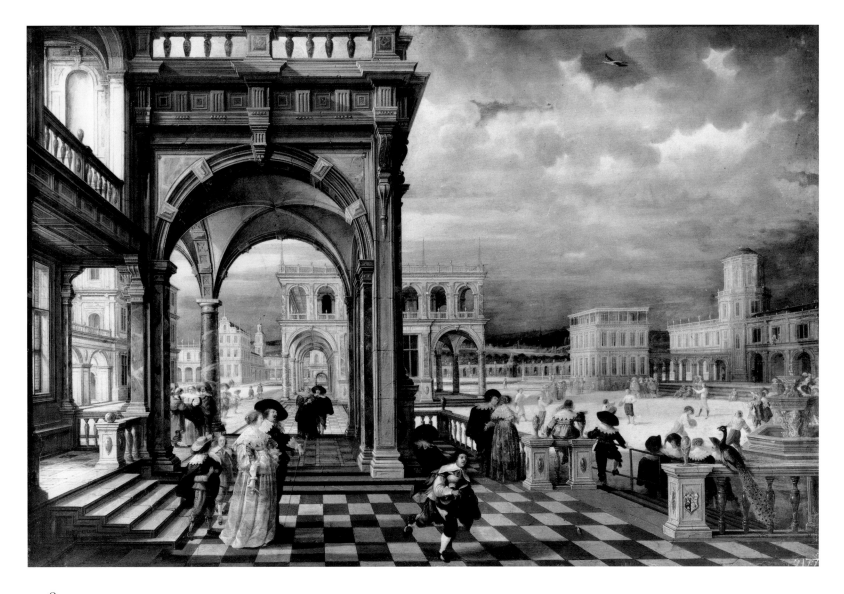

138

HENDRICK VAN STEENWYCK II (c.1580–c.1649)
Italian Palace
Oil on canvas, 54.5 x 80, signed and dated bottom
right: H.V.STEENW 1623
Inv. No. 432

PROVENANCE: Van Huls coll.; 1722 Van Huls sale, lot
110, 'Steenwick – A Noble Palace, Mr Walpole, price
52-10'; Sir Robert Walpole, 1736 Houghton (Common
Parlour); 1779 Hermitage.

LITERATURE: *Aedes* 1752, p. 45 (as 'Architecture in
Perspective'); 2002, no. 35; Livret 1838, p. 214, no. 50;
Cats. 1863-1916, no. 1197; Waagen 1864, p. 130;
Neustroyev 1898, p. 305; Wurzbach 1906-11, vol. 2,
p. 155; Benois [1910], p. 260; Jantzen 1910, p. 37; Cat.
1958, vol. II, p. 101; Wilenski 1960, vol. 1, p. 661; Bal-
legeer 1967, p. 60, afb. 7, 8; Bernt 1970, vol. 3, pl.
1122; Martin 1970, p. 242; Bénézit 1976, vol. 9, p. 796;
Jantzen 1979, p. 37, no. 465; Giltaij, Jansen 1991, p. 75;

Babina 1993, pp. 46, 47; Babina 1995, p. 10; Vermet
1995, pp. 34, 35.

Described in Walpole MS 1736 as 'A Piece of Build-
ing' (pp. 5-6), the painting has been variously
described. The *Aedes*, the 1773-85 catalogue and the
1797 catalogue called it *Architecture in Perspective*. The
1863 catalogue described it as *A Game of Ball*, and from
the 1870 catalogue onwards it has been known as *Ital-
ian Palace*. A game of ball is taking place in the middle
ground; all the players wear a special glove on their
right hands. The figures were clearly painted by
another, as yet unidentified, hand.

The *Aedes*, Cat. 1773-85, Cat. 1797 and Livret 1838
attributed the painting to Steenwyck, with no indica-
tion as to whether elder or younger. Although always
attributed to Steenwyck, the 1859 Inventory was the
first to attribute it to Steenwyck II.

It is in fact one of a significant group of works
painted by the younger Steenwyck over a number of
years on the theme of 'Figures on a Palace Terrace'.
Others include *A Man Kneels Before a Woman in the
Courtyard of a Renaissance Palace* (1610; National
Gallery, London) and *An Imaginary City Square* (1614;
Mauritshuis, The Hague).

Ballegeer (1967) suggested that the source of the
Italian Palace is the engraving *Dorica-Auditus* by Paul
Vredeman de Vries. The architectural motifs do
indeed repeat much that is in the engraving, notably
the main portico with its Doric elements.

Vermet (1995), who had not seen the original,
doubted the attribution to Hendrick van Steenwyck II.
Without any real justification he attributed both the
architecture and figures to the Dutch artist Dirck van
Delen. His suggestion that the signature is not authentic
cannot withstand comparison with similar signatures on

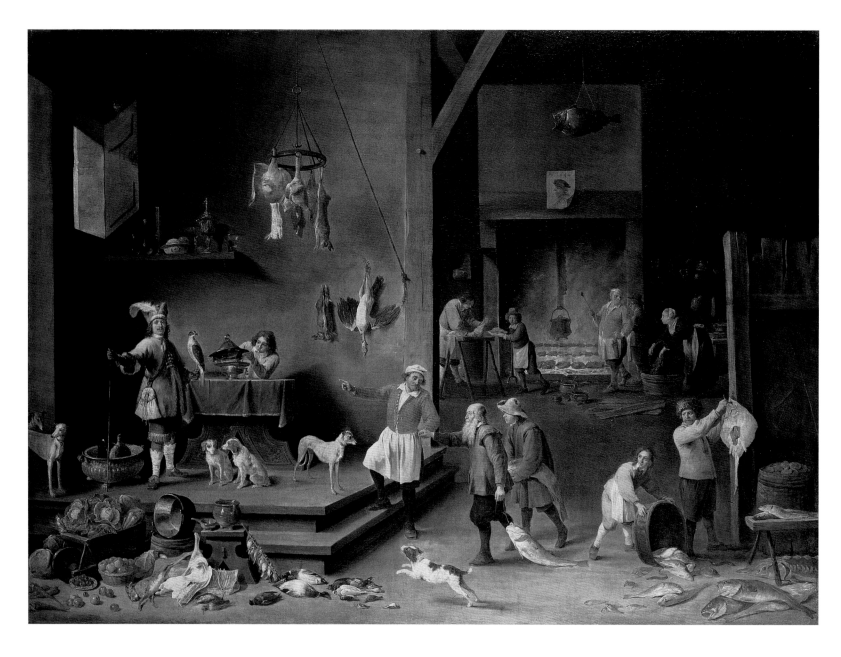

church interiors by Hendrick van Steenwyck II in Dresden (1609; Galerie Alte Meister) and Cambrai (1613; Musée Municipal). As for the figures, they are hardly like to have been by Dirck van Delen, who rarely painted them himself even in his own architectural scenes (see T. T. Blade, 'The Paintings of Dirck van Delen', PhD diss., University of Minnesota, 1976, p. 78). Nor are there any known works by other masters in which Dirck van Delen might have painted the figures. The only point of agreement between the present author and Vermet is that, judging from the costumes, the figures in the Hermitage painting (by an unknown master) were not added before 1630.

N. B.

139

Davıd Teniers II (1610-90)
Kitchen
Oil on canvas, 171 x 237, signed and dated left, on the step: *DAVID TENIERS 1646*; the date repeated on the drawing over the fireplace: *AN 1646*
Inv. No. 586
PROVENANCE: Sir Robert Walpole, 1736 Downing St (Parlour), later Houghton (Common Parlour); 1779 Hermitage.
LITERATURE: *Aedes* 1752, p. 45 (as 'A Cook's Shop'); 2002, no. 36; Boydell I, pl. XXII ('Teniers's Kitchen'); Schnitzler 1828, p. 52; Smith 1829-42, part III, p. 394, no. 507; Viardot 1844, p. 442; Somov 1859, p. 118; Cats. 1863-1916, no. 698; Clément De Ris 1879-80,

part III, p. 581; Rosenberg 1901, p. 64; Wurzbach 1906-11, vol. 2, p. 698; Cat. 1958, vol. II, p. 103; Bazin 1958, p. 118; Gerson, Ter Kuile 1960, p. 146; Wilenski 1960, vol. 1, p. 667; Cat. 1981, p. 73; Babina 1989, p. 4; Klinge, in 1991 Antwerp, pp. 154, 155, no. 49.
EXHIBITIONS: 1991 Antwerp, no. 49; 2001 Toronto, no. 84.

Most scholars have assumed that this painting represented either the interior of Teniers' own kitchen at his country house, Dry Toren (Cat. 1870; Clément de Ris 1879-80; Rosenberg 1901), or the kitchen in the palace of Archduke Leopold Wilhelm (Bazin 1958). However, the picture is inscribed and dated 1646 and Teniers only left for Brussels to become court artist to Leopold Wilhelm in 1651. Moreover, he did not acquire Dry Toren (in the neighbouring village of Perk) until 1662 or 1663 so that the kitchen is probably located at neither of these two places.

In the *Aedes*, Walpole suggested that Teniers depicted himself as the falconer, a idea not challenged until recently by Klinge (in 1991 Antwerp). According to Labensky (Livret 1838), Teniers took his father as the model for the blind man and this led Bazin (1958) to suggest mistakenly that the Hermitage painting depicted the biblical story of Tobit and Tobias.

Both Babina (1989) and Klinge (1991 Antwerp), see Teniers' Kitchen as an 'Allegory of the Four Elements'. In the Hermitage scene, as in an engraving by Jacques de Gheyn II (Hollstein 1949-81, vol. VII, p. 119, no. 1), the falconer with his bird embodies Air. To draw attention to such a meaning in an otherwise ordinary figure, Teniers places him beneath a window through which stream both air and light. Fire is symbolised by the brazier on the table, by the hearth and the figure of the cook nearby whilst Water is represented by the fishermen right and centre. In Teniers' interpretation, however, the falconer embodies not only Air, but also Earth, for he a hunter, shown surrounded by dogs and dead game, with sundry fruits of the earth at his feet. Teniers' sources for such a treatment of Earth, in addition to the works of Jacques de Gheyn II, who also used a hunter to symbolise Earth (Hollstein 1949-81, vol. VII, p. 119, no. 3), included an engraving, *Earth*, by Nicolaes de Bruyn (Hollstein 1949-81, vol. IV, p. 22, no. 3). This shows an abundance of attributes of Earth similar to those in the left foreground of Teniers's *Kitchen*.

It was important to Teniers to find a way to unite such figures and objects within a common setting, and the kitchen provided him with greater possibilities than was usual with the subject of the Four Elements. Snyders, for instance, in his famous series of market stalls (cat. nos. 134-137), dealt with each of the elements in a separate painting (Gritsay 1985, pp. 50-61).

A similar picture, a signed *Kitchen* by David Teniers II was sold at Christie's, London (6 July 1990, Lot 107). A copy of the Hermitage painting was also exhibited in London in 1969 (repr. Dennis Vanderkar Gallery. *Exhibition of Dutch and Flemish Old Masters*, London, 1 April–31 May 1969, no. 28).

N. B.

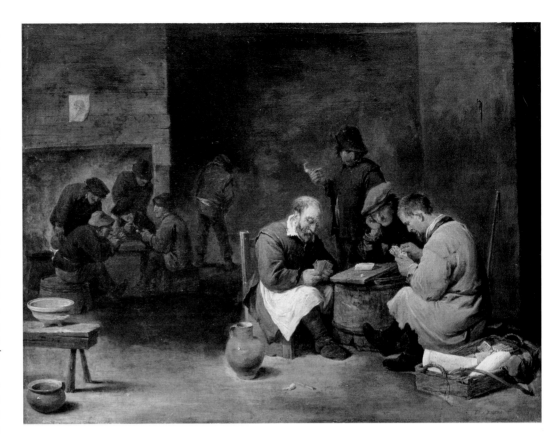

140

DAVID TENIERS II (1610-90)
Card Players
Oil on canvas, transferred from panel in 1867 by A. Sidorov. 39.4 x 52, signed bottom right: *D. TENIERS. F*
Inv. No. 577
PROVENANCE: Sir Robert Walpole, 1736 Downing St (Lady Walpole's Drawing Room), later Houghton (Cabinet); 1779 Hermitage.
LITERATURE: *Aedes* 1752, p. 65 (as 'Boors at Cards'); 2002, no. 143; Boydell II, pl. XVI ('The Gamesters'); Livret 1838, p. 104, no. 38; Smith 1829-42, Supplement, p. 462, no. 176; Cats. 1863-1916, no. 688; Waagen 1864, p. 161; Smolskaya 1962, pp. 7, 8; Babina 1989, p. 3.
EXHIBITIONS: 1983 Tokyo, no. 29; 1987-88 Belgrade-Ljubliana-Zagreb, no. 21; 1992 Tokyo, no. 40.

Both the subject matter and composition of this picture derive from the works of Adriaen Brouwer, who often turned to such themes (for example Kartenspielende Bauern in einer Schenke, Inv. No. 218; Alte Pinakothek, Munich.

Waagen (1864) dated the painting to 1645, noting the pale gold tone characteristic of Teniers' colouring about this time. This opinion was shared by Smolskaya (1962). A drawing by the David Teniers II, *Card Players*

(Graphische Sammlung Albertina, Vienna, Inv. No. 9279) is linked by Klinge with two paintings by Teniers of the same subject, both executed c.1644/45 (Klinge, in 1991 Antwerp, Nos 33, 34; priv. coll.). The Hermitage canvas should be grouped with these works.

An Interior by the younger Teniers (reproduced in *De El Greco a Tiepolo*, exh. cat. Buenos Aires, 1964, no. 115) reproduces the right half of this composition. Another work entitled *Card Players* (42 x 56) was sold at auction at Galérie Giroux, Brussels, 4 May 1956 (reproduced in *Connaissance des Arts*, September 1956, p. 46, no. 55). Attributed to Brouwer, it repeats the Hermitage composition in its entirety, and we must assume that it was in fact the work David Teniers II or a copy after him.

N. B.

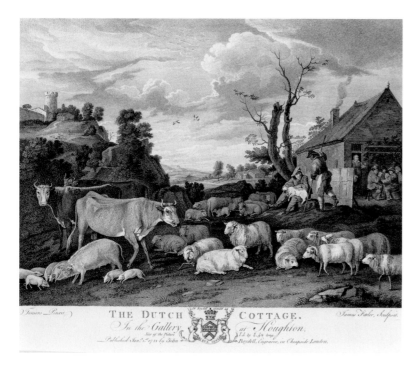

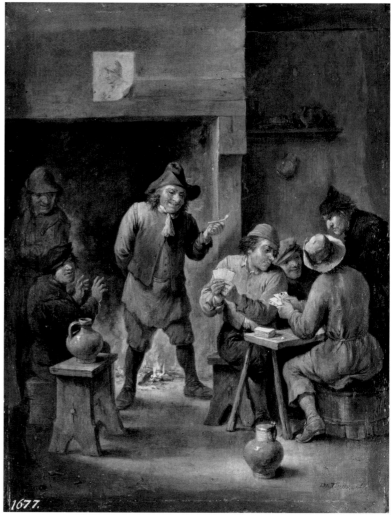

141

DAVID TENIERS II (1610-90)
Cows and Sheep
Oil on canvas, 58 x 86, inscription bottom right: D.
TENIERS. F
PROVENANCE: Sir Robert Walpole, 1736 Downing St
(Closet), later Houghton (Gallery); 1779 Hermitage;
1930 transferred to Antikvariat for sale; whereabouts
unknown.
LITERATURE: *Aedes* 1752, p. 93; 2002, no. 263; Boydell
II, pl. XXVI ('The Dutch Cottage'); Gilpin 1809, p. 44;
Livret 1838, p. 102, no. 30; Cats. 1863-1908, no. 706.

The only description of the appearance of this picture
is the following provided by Somov in the 1902 Her-
mitage catalogue 'Dans un site montueux, dans lequel
on voit à g., au fond, un cabaret de village près d'un
arbre à moitié desséché, et à dr., sur une colline, un
château fortifié, un paysan assis, tenant un chien sur ses
genoux, cause avec un pâtre qui s'appuie sur un long
bâton. Devant ce groupe, trois vaches, plusieurs brebis,
dont quelques-unes sont couchées, et une truie avec
ses petits. Près du cabaret, quatre paysans, assis autour
d'une table, jouent aux cartes; la cabaretière, une
cruche à la main, sort de la maison pour les servir.'

This painting may eventually be identified with the
help of inventory numbers painted on the stretcher,
'3195' (from the 1859 Inventory) or a black '1717' (the
Hermitage inventory number before the painting was
removed in 1930).

Now known only from the Boydell print, engraved
by James Fisher.

N. B.

142

?DAVID TENIERS II (1610-90)
Peasants in a Tavern
Oil on canvas, transferred from panel in 1825. 24 x
31.5, signed bottom right: D. TENIERS. F
Inv. No. 569
PROVENANCE: Sir Robert Walpole, 1736 Downing St
(Lady Walpole's Drawing Room), later Houghton
(Cabinet); 1779 Hermitage.
LITERATURE: *Aedes* 1752, p. 68 (as 'Boors at Cards');
2002, no. 159; Boydell I, pl. LIII ('Boors at Cards');
Cats. 1863-1916, no. 679; Waagen 1864, p. 161, Cat.
1958, vol. II, p. 107; Cat. 1981, p. 76.

Always thought to be by Teniers from the time of its
acquisition, it was not until the publication of the 1981
catalogue that the poor quality of the picture led to
doubts about the authenticity of the signature.

N. B.

143

CORNELIS DE VOS (1584-1651)

Old Woman in an Armchair

Oil on canvas, transferred from panel in 1846. 124.5 x 93.5, top left corner (57 x 37) a later addition

Inv. No. 483

PROVENANCE: coll. de Scawen, England; Sir Robert Walpole, Houghton (Gallery); 1779 Hermitage.

LITERATURE: *Aedes* 1752, p. 85 (as by Rubens); 2002, no. 238; Boydell I, pl. XLIX; Gilpin 1809, p. 59; Chambers 1829, vol. I, p. 535; Smith 1829-42, part II, p. 159, no. 554; Livret 1838, pp. 431–32, no. 4; Cats. 1863-1916, no. 578; Waagen 1864, p. 140; Rooses 1886-92, vol. IV, pp. 302–3, no. 1113; Schmidt 1926b, pp. 14, 29; Glück 1931, pl. 116, p. 532; Cat. 1958, vol. II, p. 63; Cat. 1981, p. 43.

EXHIBITIONS: 1993 Dijon, no. 37; 2001 Toronto, no. 37.

The top left corner of the painting almost certainly originally bore the arms of the patron, but this was lost before the painting was transferred from panel to canvas. Judging by the composition, the portrait would have formed a pair to a male portrait.

In the Walpole collection, and then for many years in the Hermitage, this portrait was thought to be the work of Rubens although Glück (1931) attributed it to Van Dyck. The authorship of Cornelis de Vos was proposed by M. Varshavskaya and published (with reservations) in the entry in the 1981 catalogue. Closest in style to the Hermitage painting is de Vos' *Portrait of a Woman* from the Musée des Beaux-Art in Ghent (reproduced in *Les amis du Musée de Gand, 65 ans d'activité,* 19 Oct–19 Jan 1964, Ghent; exh. cat., Ghent, 1963, no. 91, p. 30). Both portraits reveal a similar treatment of the eyes, the oval outline of the face, nose and lips and there are also similarities in the clothing and headwear.

The picture was probably painted in the 1630s. A reduced, half-length version (oil on canvas, 50 x 39) appeared as the property of Heinrich Hahn at auction in Frankfurt, 14 May 1911 (lot 152).

N. G.

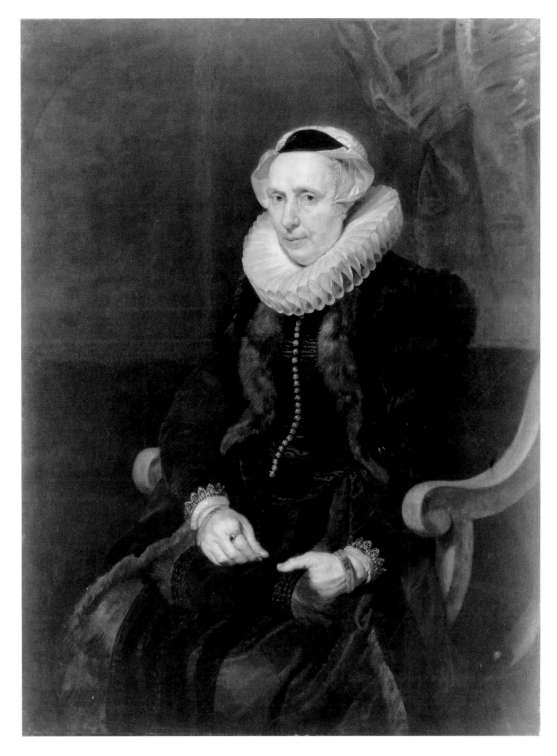

144

PAUWEL (PAUL) DE VOS (1596-1678)
Cook at a Kitchen Table with Dead Game
Oil on canvas, 176 x 245
Inv. No. 610
PROVENANCE: Sir Robert Walpole, 1736 Downing St (Parlour, as by Martin de Vos), later Houghton (Common Parlour); 1779 Hermitage.
LITERATURE: *Aedes* 1752, p. 46 (as 'Cook's Shop, by Martin de Vos'); 2002, no. 37; Boydell I, pl. XXI; Gilpin 1809, p. 44; Chambers 1829, vol. I, p. 522 (M. de Vos); Livret 1838, pp. 221-22, no. 83; Levinson-Lessing 1926, pp. 26, 35; Cat. 1958, p. 100; Cat. 1981, p. 69; Robels 1989, p. 432 (No. A 34).

In the Walpole collection this picture was attributed to Marten de Vos (1532–1603), who, in the *Aedes*, was mistakenly described as Frans Snyders's teacher. With this attribution the picture was entered in Hermitage manuscript catalogues. Livret 1838 listed it as the work of Simon de Vos (1603-76) whilst Levinson-Lessing (1926) thought it was the work of Snyders, to whom it was subsequently attributed in both the 1958 and 1981 catalogues. Levinson-Lessing (1926) also attributed the figure of the cook to Jacob Jordaens. A similar figure by Jordaens can be found in the following compositions in which the still life elements were painted by Paul de Vos and which can be seen as variations on the Hermitage picture: 1) *Cook in a Storeroom*, sold at Christie's, London, 23 March 1973 (Lot 97) as Frans Snyders and Jacob Jordaens; oil on canvas, 119.2 x 181.5. Robels (1989, no. A 34, p. 432) identified this picture as the work of Paul de Vos and Jacob Jordaens; 2) *Cook with Fish*, sold at auction Galerie H. Helbing, Munich, 16 April 1918 (Lot 117) as Paul de Vos; oil on canvas, 118 x 184; Robels (1989, no. A 35, p. 432) identified it as the work of Paul de Vos and Jordaens.

Robels (1989) rightly noted similarities between the motifs in Paul de Vos's mature style, as well as the treatment of the still life, and it is to the latter that the painting should clearly be attributed. Indirect confirmation of this lies in the traditional attribution to 'de Vos'. By the eighteenth century the name of Paul de Vos had been forgotten and animal still life paintings were often attributed to Snyders or Marten de Vos, who was thought to be his teacher.

Illustration reproduced from the Boydell plate, engraved by Richard Earlom.

N. G.

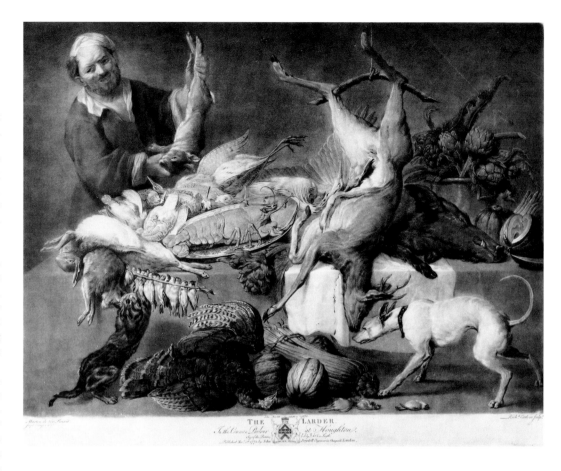

145

THOMAS WILLEBOIRTS BOSSCHAERT (1613/14–54)
The Virgin and Child with SS Elisabeth and John the Baptist
Oil on panel, 33.8 x 24
PROVENANCE: 1722 acquired by Sir Robert Walpole at the van Huls house sale; Sir Robert Walpole, 1736 Downing St (Sir Robert's Dressing Room), later Houghton (Cabinet); 1779 Hermitage; since 1924 whereabouts unknown.
LITERATURE: *Aedes* 1752, p. 68 (as 'Holy Family, with St. John on a Lamb, by Williberts'); 2002, no. 162; Boydell I, pl. II; Smith 1829–42, part II, pp. 156–57, no. 546; Livret 1838, p. 340, no. 3.

This is a considerably reduced version (with small changes such as a landscape background in place of an architectural setting) of a painting by Rubens which was engraved by Schelte à Bolswert (V.-S. 1873, p. 85, no. 96; Hollstein 1949-81, vol. III, p. 77, no. 174). Rubens' original (oil on canvas, 151 x 113) is in the Fondazione Thyssen-Bornemisza, Lugano, but several versions and variants by Rubens' pupils and followers are known. This one from the Walpole collection has traditionally been attributed to Willeboirts Bosschaert. At some point after 1838 the painting was removed from exhibition and was therefore not included in the 1863-1916 catalogues. A note added to the 1859 inventory tells us that the painting was still in the Hermitage in 1924 but its present whereabouts are unknown. It was certainly never entered in the new Hermitage inventory of paintings, begun around 1928.

N. G.

Not reproduced

Dutch School

146

FERDINAND BOL (1616-80)
Portrait of an Old Woman with a Book
Oil on canvas, 129 x 100 (rounded top edge), signed and dated bottom left corner: *Bol 1651*; inscribed nearby: *out 81 jaer*
Inv. No. 763
PROVENANCE: 1722 sold at auction of coll. Henry Bentinck, Duke of Portland (lot 67); purchased by the framemaker John Howard for Sir Robert Walpole; Sir Robert Walpole, 1736 Downing St (Great Room above Stairs), later Houghton (Gallery); 1779 Hermitage.
LITERATURE: *Aedes* 1752, p. 85 (as 'An old Woman reading'); 2002, no. 239; Boydell I, pl. XXVI; Livret 1838, p. 343, no. 15; Cats. 1863-1916, no. 854; Waagen 1864, p. 188; Bode 1873, p. 17; Benois [1910], p. 327; Bredius 1927, pp. 158-59, afb. 2; Isarlov 1936, p. 34; Cat. 1958, vol. II, p. 141; Cat. 1981, p. 105; Blankert 1982, pp. 32, 40, 58, no. 130; Sumowski 1983-[94], vol. I, no. 141, pp. 306-7.
EXHIBITIONS: 1991-92 Berlin-Amsterdam-London, no. 64; 1993 Frankfurt-am-Main, no. 7.

At Houghton Hall, Bol's painting formed a pendant to Cornelis de Vos' *Old Woman in an Armchair* (cat. no. 144), then attributed to Rubens. This manner of pairing works by different masters was entirely characteristic in the hanging of eighteenth-century galleries.

The 1773-85 catalogue described the work as 'Ferdinand Boll. Portrait de femme. Ce Tableau d'une expression admirable représente une femme agée en meditation tenant, entre les doigts de la main gauche, une feuille du livre qu'elle a sur ses genoux et de la droite une paire du lunettes.'

Bol's work is of the kind known as a 'portrait historié', popular amongst Rembrandt's pupils. The identity of the sitter has not been established, although her advanced age, 81, was recorded on the canvas by the artist. Details such as the open book on her knees, the broad cloak, the precious clasp at her breast, the column in the background as a symbol of steadfastness, indicating piety and spiritual force, suggest an association with a prophetess or Sibyl.

Ferdinand Bol came particularly close to the style of Rembrandt in works such as this and indeed Alexandre Benois, in his guide to the Hermitage of 1910, described the work as 'an utter pastiche of Rembrandt'. Tümpel (1971) sees the *Old Woman as the Prophetess Anna* by Rembrandt (Rijksmuseum, Amsterdam) as a parallel kind of work. The composition of the Hermitage painting was remarked on by

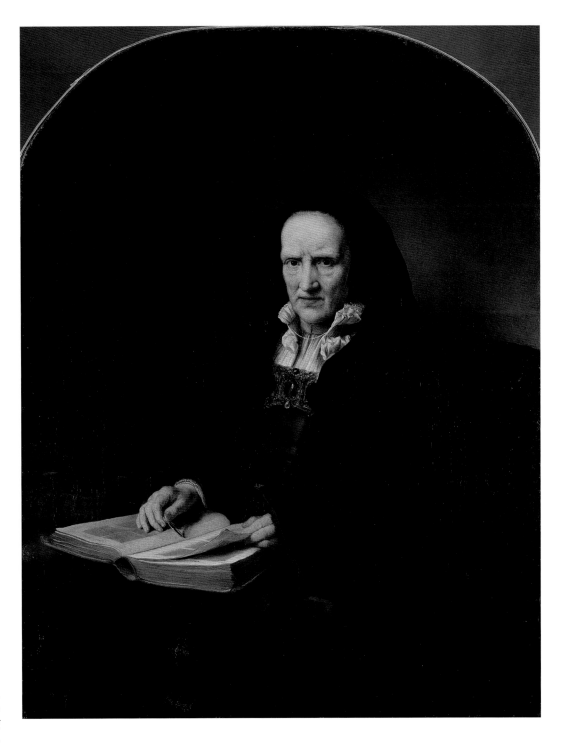

Blankert (1982) who recalled the engraved 'portrait of Rembrandt's mother' (Bartsch 1797, 344), formerly attributed to the master himself and now given to Bol or an anonymous pupil of Rembrandt. The authors of the 1993 Frankfurt-am-Main catalogue cite two drawings by Rembrandt which are close in subject (Benesch 1954-57, Nos 684, 685).

The painting's format, with its rounded top, appears to echo the arching outline of the cloak thrown over the sitter's head and, together with the folds falling softly over her shoulders, is an important element in the composition.

An old copy of this portrait, of rectangular format, was in the collection of Mr Arthur De Heuvel, Brussels in 1961.

I. S.

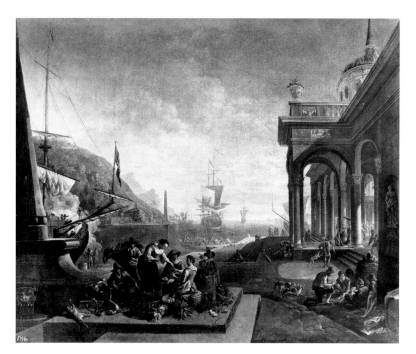

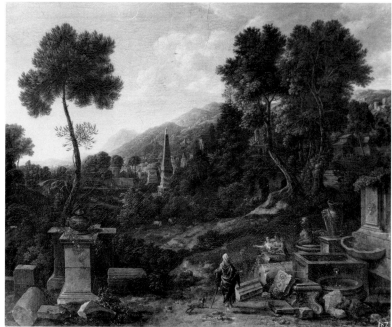

147

JAN GRIFFIER I (c.1645–1718)
Seaport
Oil on canvas, 103.2 x 126, signed bottom centre:
John Griffir
Pavlovsk State Museum Reserve, Inv. No. 3743-III
PROVENANCE: 1 April 1718 acquired for Sir Robert
Walpole at auction in London along with its pair,
Landscape with Ruins (Lot 155); Sir Robert Walpole,
1736 Houghton (Green Velvet-Bedchamber/Velvet
Bedchamber); 1779 Hermitage; after 1797 to 1932
Pavlovsk Palace, Pavlovsk; 1932 returned to the Her-
mitage; 1961 transferred to Pavlovsk Palace Museum,
Pavlovsk.
LITERATURE: *Aedes* 1752, p. 62; 2002, no. 128;
SbRIO 17, 1876, p. 400; Cat. 1958, vol. II, p. 188,
Cat. 1981, p. 128; Moore ed. 1996, p. 48.

Pair to *Landscape with Ruins* (Pavlovsk, cat. no. 148).
 Documentary evidence suggests that the two paired
landscapes by Jan Griffier the Elder were the among
the first acquisitions made by Sir Robert Walpole and
reflect his early taste (Moore ed. 1996, p. 48). In 1736
both paintings were in place over the doors in the
Green Velvet Bedchamber. In 1741 they were
recorded by a visitor, who noted in particular 'a very
pretty picture of a port and a Landscape by Greffier'
(Liverpool Papers 1741).
 The 1773-85 catalogue lists this work as: 'Jean Griffier.
Une Marine. Beau Morceau représentant un port de
Mer orné d'architecture et de beaucoup de figures. Sur le
devant se voit un Marché au Gibier et aux Legumes.'
According to the 1797 catalogue both Griffier landscapes

had by that date been transferred to Pavlovsk.
 On the basis of style, these Italianate landscapes can
be dated to late in Griffier's career and were probably
painted in England. Both are mentioned in the appen-
dix to a letter from Alexey Musin-Pushkin, Russian
ambassador in London, to the Empress Catherine, list-
ing works added to the Walpole sale 'without increas-
ing the previous price' (SbRIO 17, 1876).

<div align="right">I. S.</div>

148

JAN GRIFFIER I (c.1645–1718)
Landscape with Ruins
Oil on canvas, 103.2 x 126, signed bottom right:
J Griffir
Pavlovsk State Museum Reserve, Inv. No. 3744-III
PROVENANCE: see cat. no. 147.
LITERATURE: *Aedes* 1752, p. 62 (as 'A Landscape');
2002, no. 129; SbRIO 17, 1876, p. 400; Cat. 1958,
vol. II, p. 188; Moore ed. 1996, p. 48.

Pair to *Seaport* (Pavlovsk, cat. no. 147).
 Listed in the 1773-85 catalogue as 'Jean Griffier.
Un Paysage. Beau Morceau représentant un Site
montueux orné d'Architecture, de Ruines et de
quelques figures.'
 See cat. no. 147.

<div align="right">I. S.</div>

149

FRANS HALS (between 1581 and 1585–1666)
Portrait of a Young Man
Oil on canvas, 68 x 55.4, double monogram right of centre: *FH FH*
National Gallery of Art, Washington. Inv. No. 1937.1.71
PROVENANCE: Sir Robert Walpole, 1736 Chelsea (Lady Walpole's Drawing Room), later Houghton (Common Parlour); 1779 Hermitage; February 1930 transferred to Museum of Fine Arts (now Pushkin Museum of Fine Arts), Moscow; February 1931 sold via Matthiesen Gallery, Berlin; P. & D. Colnaghi & Co., London; M. Knoedler & Co., New York to Andrew W. Mellon; coll. Mellon, Pittsburgh and Washington; 1937 A. W. Mellon Educational and Charitable Trust, Pittsburgh; National Gallery of Art, Washington.
LITERATURE: *Aedes* 1752, p. 48 (as 'Francis Halls, Sir Godfrey Kneller's master, a Head by himself'); 2002, no. 44; Boydell I, pl. XXXIX ('Self-portrait'); Gilpin 1809, p. 69; Livret 1838, p. 254; Cats. 1863-1916, no. 770 ('Portrait of Frans Hals'); Waagen 1864, p. 172; Vosmaer 1868, p. 153; Bode 1873, p. 21; Bode 1883, pp. 90, 101; Semyonov 1885-90, vol. I, p. 254; Knackfuss 1896, p. 52; Hofstede de Groot 1907-28, vol. 3, 1910, p. 88; Bode, Binder 1914, vol. 2, p. 62; Valentiner 1921, p. 320, no. 219; Trivas 1941, no. 92; Slive 1970-4, vol. 1, pp. 52, 160-61; Grimm 1972, pp. 107, 205; Wheelock 1981, pp. 14-15; Grimm 1990, pp. 241-42; Wheelock 1995, Inv. 1937.1.71; Moore ed. 1996, pp. 95-96, no. 12.
EXHIBITION: 1996-97 Norwich and London, no. 12.

The double monogram 'FH FH' (unique in the master's work) may have encouraged the notion that this was not only a work by Frans Hals, but also a self portrait. The 1773-85 catalogue describes the painting thus: 'François Hals. Portrait d'homme. Morceau de beaucoup de force, représente la tête de Peintre Hals, peinte par lui-même.'

At the end of the nineteenth century Bode mistakenly suggested that the portrait was the work of the artist's son, Frans Hals the Younger, but he later rejected this theory. It is possible that this hypothesis influenced Benois ([1910], p. 286), who also noted that it was 'perhaps Hals's son, Frans the Younger'. The sitter has not been identified. On the basis of style Slive (1970) dated it to 1645 while more recently Wheelock (1995) suggested 1646/48.

I. S.

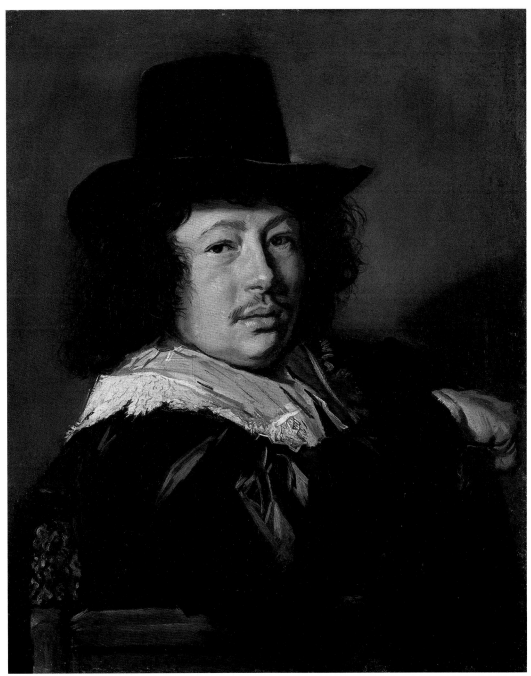

Andrew W Mellon Collection. Photograph © 2002 Board of Trustees, National Gallery of Art, Washington

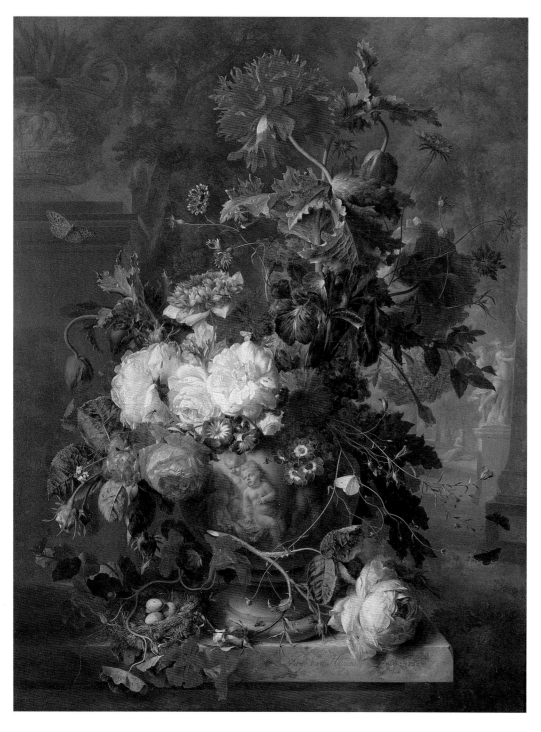

150

JAN VAN HUYSUM (1682-1749)
Flowers
Oil on canvas, transferred from panel in 1835. 79 x
60, signed and dated right, on the edge of the stone
parapet: *Jan Van Huysum fecit 1722*
Inv. No. 1051
PROVENANCE: Sir Robert Walpole, 1736 Houghton (Green
Velvet Drawing Room, then Cabinet); 1779 Hermitage.

LITERATURE: *Aedes* 1752, p. 70 ('Two Flower-
pieces'); 2002, no. 178; Boydell I, pl. LIX; Chambers
1829, vol. I, p. 531; Livret 1838, p. 470, no. 22; Smith
1829-42, part VI, no. 99; Cats. 1863–1916, no. 1379;
Waagen 1864, p. 275; Bode 1873, p. 45; Neustroyev
1898, p. 311; Shcherbachyova 1926, pp. 47, 57; Hof-
stede de Groot 1907-28, vol. 10, no. 68; Vertue, vol.
I, 1929-30, p. 80, note 7; Shcherbachyova 1945a, pp.
57, 70; Grant 1954, p. 328; Vertue, vol. VI, 1948-50,
p. 179; Fekhner 1981, pp. 34, 172; Kuznetsov, Linnik
1982, pl. 286; Moore ed. 1996, pp. 137-38.
EXHIBITIONS: 1983 Tokyo, no. 45; 1998-99 Stock-
holm, no. 404.

Pair to *Flowers and Fruit* (cat. no. 151).

According to Vertue (vol. I, 1929-30), Jan van
Huysum's pair of still-lifes, *Flowers* (1722) and *Flowers
and Fruit* (1723) was acquired by Sir Robert Walpole
for £300. Listed in the 1736 Walpole MS as 'A
Flower Piece with a Bird's Nest' and 'A Fruit Piece',
both paintings are described in detail as follows in the
Aedes: 'Two Flower-pieces, most highly finished, by
Van Huysum; his Brother lived with Lord Orford, and
painted most of the Pictures in the Attic Story
here.' Jan van Huysum's brother, the artist Michiel
van Huysum (1704–c.1760) did indeed work for Sir
Robert and is thought to have acted as intermediary
in the purchase of these pictures. In the nineteenth
century, Hermitage catalogues invariably recorded
that this still life and its companion were created 'at
the order of Lord Walpole', although there is no doc-
umentary evidence to support this statement. The
pair of van Huysums were among the most expensive
works in the Walpole collection, valued at £1,200
when they were sold to Catherine II.

In the 1773-85 catalogue, Munich described the
painting thus: 'Morceau rare pour la délicatesse de la
Touche et la Suavité des Couleurs'. He also praised its
pair: 'Ce morceau admirable pour l'expression et la
finesse de la touche, se distingue de son Compagnion
par un nid d'oiseau posé près du Vase.'

Paintings by the Dutch master Jan van Huysum
were much prized and extremely expensive in the
eighteenth century and *Flowers* is surely one of the
master's most virtuoso works. With its luxuriant mix-
ture of flowers from different seasons painted with
uneven light and shade this picture is characteristic of
his more rococo works from the 1720s. The playful
putti on the terracotta vase holding the bouquet recall
the reliefs of François Duquesnoy. The use of light
and the balance in this dynamic composition are
enhanced by a bright background, a parkland land-
scape of the kind which replaced the more tradition-
al dark ground in his mature works. In the depths of
the park there is a depiction of a piece of sculpture
which on closer inspection is revealed to be Gian-
lorenzo Bernini's *Apollo and Daphne*. The terracotta
urn decorated with a bacchic scene in relief was one
of van Huysum's favourite motifs, while the insects
and drops of dew on the leaves and petals are a tradi-
tional reminder of the 'Vanitas' theme.

Van Huysum's virtuosity was highly prized by his
powerful aristocratic patrons, who in addition to
Walpole, included the duc d'Orléans, the kings of
Poland and Prussia and the Elector of Saxony. His
skills were honed by his practice of working from

nature, combined with the use of preliminary studies both of whole flower compositions and of individual plants. This practice is referred to in a letter from Jan van Huysum himself dated 1742, in which the artist expresses regret that he would be unable to complete a still life, on which work has already begun, earlier than the following spring, when the yellow rose would again be in bloom (see John Walsh Jr, *Cynthia Schneider: A Mirror of Nature. Dutch Paintings from the Collection of Mr. and Mrs. Edward William Carter*, exh. cat., Los Angeles County Museum of Art; Museum of Fine Arts, Boston; Metropolitan Museum of Art, New York; 1981-82, p. 64). It is this yellow rose, the 'rosa huysumiana' now known only from eighteenth-century paintings, which is depicted in the lower left of the Hermitage composition.

Van Huysum's extremely painstaking technique in the finishing of the tiniest details required considerable effort, and work on his pictures proceeded very slowly. Evidence of this is provided by the dates of these paintings: the first is dated 1722 while the other was not completed until 1723.

An identical composition, *Flowers*, was in the collection of Sir Herbert Stanley, Wynberg, South Africa (Grant 1954, no. 229).

I. S.

151

JAN VAN HUYSUM (1682-1749)
Flowers and Fruit
Oil on panel, 80 x 60.5, signed and dated left on the edge of the parapet: *Jan Van Huysum / fecit 1723*
Inv. No. 1049
PROVENANCE: see cat. no. 150.
LITERATURE: *Aedes* 1752, p. 70 (as 'Two Flower-pieces'); 2002, no. 179; Boydell I, pl. LX; Chambers 1829, vol. I, p. 531; Livret 1838, p. 463, no. 2; Smith 1929-42, part VI, no. 98; Cats. 1863-1916, no. 1379; Waagen 1864, p. 275; Bode 1873, p. 45; Neustroyev 1898, p. 311, Benois [1910], p. 426; Shcherbachyova 1926, pp. 47, 57; Hofstede de Groot 1907-28, vol. 10, no. 180; Vertue, vol. I, 1929-30, p. 80, note 7; Shcherbachyova 1945a, pp. 57, 70; Grant 1954, no. 140; Cat. 1958, vol. II, p. 175; Kuznetsov 1966, p. 188, no. 51; Vertue, vol. VI, 1948-50, p. 179; Cat. 1981, p. 178; Fekhner 1981, pp. 34, 172; Kuznetsov, Linnik 1982, pl. 287.

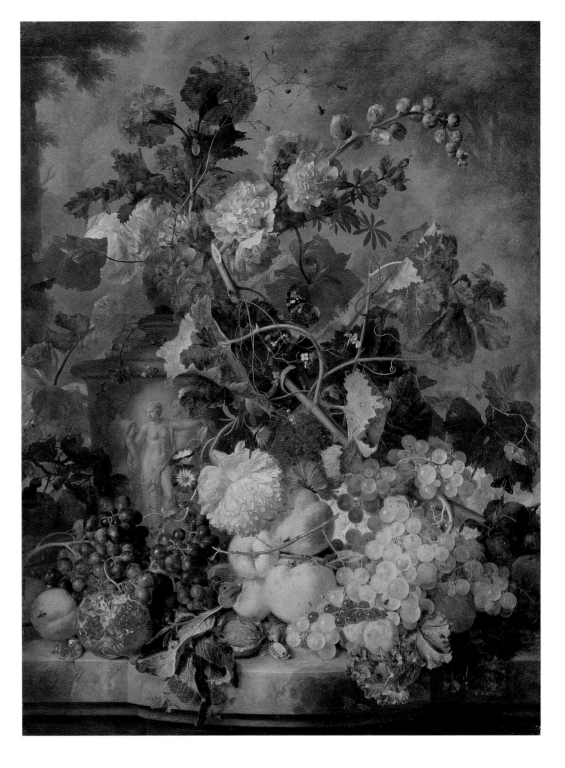

Flowers and Fruit is an even more dynamic composition than its pair, *Flowers* (cat. no. 150), with the flowers and fruit entwining themselves around the branch running diagonally across the stone parapet. The composition is balanced by a freely arranged group of vegetable motifs and by the terracotta vase with its neo-classical relief.

A signed but undated repetition, with some slight alterations, is in the Pushkin Museum of Fine Arts, Moscow (oil on canvas, 93 x 72; Inv. No. 1653). Another old copy passed through Christie's, New York, 25 November 1998 (Lot 8: 'Manner of Jan van Huysum').

An indication of this work's popularity in Russia is a porcelain vase decorated with a copy of the painting, produced at the Imperial Porcelain Manufactory in the 1830s-1840s (Kuskovo Estate, Museum of Ceramics, near Moscow). The vase was probably one of a pair in which the other bore a copy of van Huysum's *Flowers*.

For the iconography of this work see cat. no. 150.

I. S.

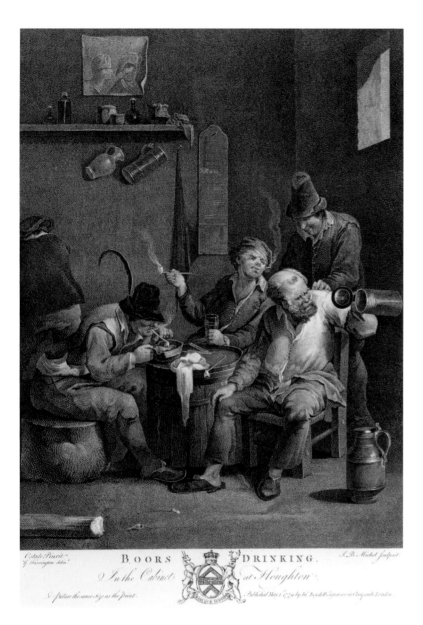

BOORS DRINKING.
In the Cabinet at Houghton.

A picture the same size as the print.

Published May 1 1779 by Jn: Boydell Engraver in Cheapside London.

152

ADRIAEN VAN OSTADE (1610-85)
Boors Drinking
Oil on canvas, c.31.5 x 25
PROVENANCE: Sir Robert Walpole, 1736 Downing St (Lady Walpole's Drawing Room), later Houghton (Cabinet); 1779 Hermitage; 1929 transferred to Antikvariat for sale; whereabouts unknown.
LITERATURE: *Aedes* 1752, p. 68; 2002, no. 160; Boydell I, pl. LIV; Chambers 1829, vol. I, p. 530; Livret 1838, p. 97; Cats. 1863-1916, no. 961; Waagen 1864, p. 210.

In 1736 the painting was hung at Sir Robert Walpole's Downing Street house alongside David Teniers's *Card Players* (cat. no. 140), which was then thought to be its companion (Walpole MS 1736, pp.

17-18). This arrangement was also maintained in the Hermitage. The painting was described in the 1773-85 catalogue under no. 2228 as 'Adriaen van Ostade. Des Paysans en débauche. Dans ce joli petit morceau se dinstingue un paysan regardant avec regret le fond de sa cruche vide. Sur toile. Haut 7v. L.5½. [c.31.5 x 25] Pend. du précédent [no. 2227 David Tenier. Des Paysans jouant aux Cartes].'

Waagen (1864) remarked on the painting's merits suggesting that stylistically it recalled the work of both Adriaen van Ostade and Adriaen Brouwer. In Hermitage catalogues of 1863-1916 the painting was listed as school of Adriaen van Ostade.

Reproduced here from the engraving by J. B. Michel, published 1 May 1779 for Boydell.

I. S.

153

REMBRANDT HARMENSZ VAN RIJN (1606-69)
Abraham's Sacrifice
Oil on canvas (transferred from old canvas in 1850), 193.5 x 132.8, signed and dated bottom left: *Rembrandt. f . 1635*
Inv. No. 727
PROVENANCE: in or shortly after 1736 acquired by Sir Robert Walpole; Sir Robert Walpole, Houghton (Gallery); 1779 Hermitage.
LITERATURE: *Aedes* 1752, p. 88; 2002, no. 255; Boydell II, pl. XXXIII; Schnitzler 1828, p. 58; Chambers 1829, vol. I, p. 537; Swignine 1821, p. 43 (Russian edition 1997, p. 252); Smith 1829-42, part VII, p. 1, no. 1; Kugler 1837, p. 180; Cats. 1863-1916, no. 792; Waagen 1864, p. 180; Bode 1873, p. 13; Vosmaer 1868, pp. 152, 507; Dutuit 1885, p. 37; Michel 1893, pp. 207, 566; Bode 1883, p. 431; Voll 1907, p. 179; Hofstede de Groot 1907-28, vol. 6, no. 9; Valentiner 1909, p. 170; Baudissin 1925, pp. 152-54; Weisbach 1926, pp. 63, 188; Muller 1929, pp. 64-77; Benesch 1935, p. 18; Rosenberg 1948, pp. 105, 225; Hamann 1948, pp. 249, 259-61; Knuttel 1956, p. 93; Levinson-Lessing 1956, p. 14; Cat. 1958, vol. II, p. 252; Fekhner 1965, no. 9; Von Moltke 1965, p. 13; Brochhagen, Knuttel 1967, pp. 72-75; Gerson 1968, no. 74; Haak 1969, p. 126; Stechow 1969, p. 150; Bredius, Gerson 1969, no. 498; Levinson-Lessing 1975, no. 10; White, Alexander, D'Oench 1983, no. 85; Schwartz 1985, pp. 171-73; Broos 1985, pp. 17-19; Tümpel 1986, p. 149; Rembrandt Corpus 1982–, vol. II, A 108; Rembrandt's Treasury 1999, p. 100.
EXHIBITIONS: 1936 Moscow-Leningrad; 1956 Moscow-Leningrad, p. 14; 1969 Amsterdam, no. 4a; 1987 New Delhi, no. 35; 1991-92 Berlin-Amsterdam-London, no. 21.

The 1736 MS catalogue of the Walpole collection lists this work amongst those acquired after the catalogue was compiled, that is to say in or shortly after 1736. It was one of four paintings attributed to Rembrandt in this collection. When the Walpole collection was sold to Catherine II, the painting was valued at just £300.

The 1773-85 catalogue effectively repeated the information provided in the *Aedes* and noted 'Paul Rembrandt. Le Sacrifice d'Abraham. ... La Surprise et l'étonnement d'Abraham y sont aussi très bien exprimés par le Couteau qui lui tombe des mains, quand l'Ange vient lui porter les Ordres de Dieu.'

In the eighteenth century, *Abraham's Sacrifice* was one of the most famous works in the Hermitage Picture Gallery, as is confirmed by numerous references to it in the notes of foreign travellers who visited St Petersburg.

Rembrandt's composition reveals both the artist's respect for the approach taken by his predecessors and his own desire to find greater expression in capturing

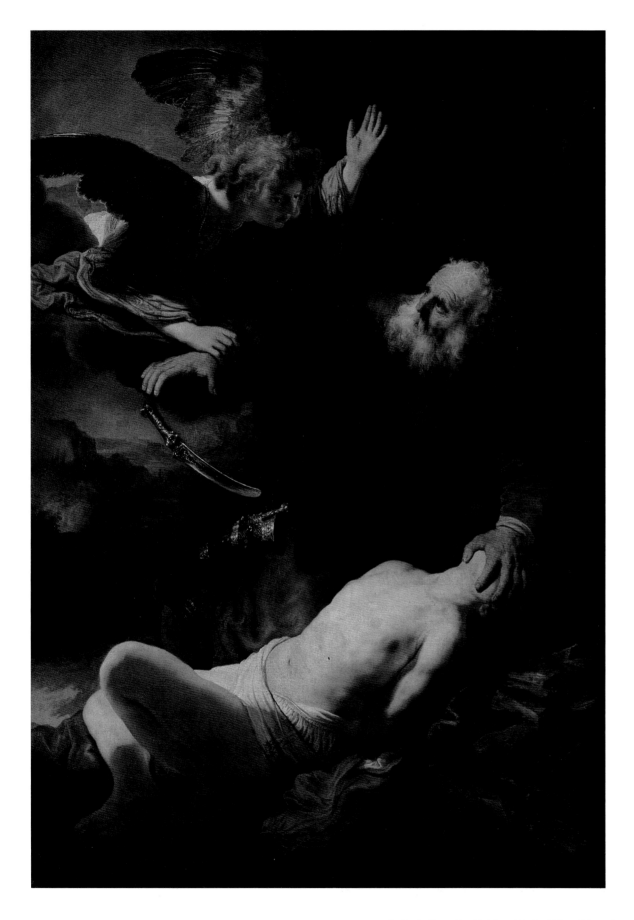

the culminating moment of the story (Genesis xxii: 1-13), which he does with great drama and dynamism. The descriptions of the painting in the *Aedes* and in the 1773-85 catalogue rightly note how successfully Rembrandt was in toning down the darker side of the Bible narrative: 'the Painter has avoided much of the Horror of the Story, by making Abraham cover the Boy's Face, to hide the Horror from himself' (*Aedes*).

A number of works have been suggested as possible sources of inspiration for Rembrandt. Ben Broos (1985) mentions a composition on the same subject by Rubens, known from a 1614 engraving by Andreas Stock. Another work suggested is that by Rembrandt's teacher Pieter Lastman (there is a version of Lastman's composition in Museum Het Rembrandthuis, Amsterdam and another in the Louvre, Paris). In the opinion of Weisbach (1926), the compositional scheme common to both works—with the figures almost life size—and the similar pose of the angel in Rembrandt's painting derive from Titian's ceiling for the Santo Spirito (now in Santa Maria della Salute, Venice).

Whilst borrowing important compositional motifs from his predecessors such as the submissively prostrate body of Isaac, whose hands are tied behind his back, and the movement of the angel who stops Abraham's hand before he can bring down the knife, Rembrandt introduces his own extremely expressive detail. Amazed by the sudden appearance of this heavenly saviour, Abraham drops the dagger, which falls towards the ground. That perfect gesture of the hands of both the angel and Abraham contain all the drama of the father's emotions as he is forced to sacrifice his own son. Despite the high esteem in which the work was held overall, this note of high drama was the subject of much criticism in the eighteenth century. Gilpin (1809), for instance, noted: 'We seldom see a Picture of this master in so good a style. We have here something like Italian elegance. … The falling knife is an unpleasant circumstance so near the eye.'

In 1636 Rembrandt produced a drawing (British Museum, London) with the angel positioned slightly differently, behind rather than to the left of Abraham. The same date of 1636 appears on a second version of the painting produced in Rembrandt's studio (Alte Pinakothek, Munich). The relationship between the two canvases—which is the original and which a studio copy—was debated for many years. The Munich work differs slightly from that in the Hermitage with the angel placed frontally and the vessel with the sacrificial fire omitted. Scholars have also interpreted the old inscription on the Munich canvas ('*Rembrandt verandert En over verschildert. 1636*') in different ways. In the nineteenth century both canvases were considered to be authentic works by Rembrandt himself but the Munich work is now thought to be a studio picture with Govaert Flinck and Ferdinand Bol the artists most frequently named as possible authors.

In addition to the Munich work, the Rembrandt Research Project includes another five old copies made from the Hermitage original.

A watercolour of 1858 by Edward Hau, showing the Dutch and Flemish room in the New Hermitage (see illustration on p. 81) reveals that in the mid-nineteenth century *Abraham's Sacrifice* was hung opposite the same artist's *Danaë*. Rembrandt's painting was also the inspiration for *Abraham Sacrificing Isaac* (Russian Museum, St Petersburg) by the Russian painter Gerhardt von Reutern (Yevgraf Reytern). During the reign of Nicholas I both compositions, by Rembrandt and Reutern, hung in the Hermitage and were engraved for a collection of prints in 1845 (*Galerie Impériale de l'Ermitage*, published by Paul Petit, St Petersburg, 1845, 2 vols).

I. S.

154

REMBRANDT HARMENSZ VAN RIJN (1606-69)
Portrait of an Old Woman
Oil on canvas, 87 x 72, signed and dated on the background: *Rembrandt f16[5] …*
Pushkin Museum of Fine Arts, Moscow, Inv. No. 2622
PROVENANCE: Sir Robert Walpole, Houghton (Common Parlour); 1779 Hermitage; 1930 transferred to Museum of Fine Arts (now Pushkin Museum of Fine Arts), Moscow.
LITERATURE: *Aedes* 1752, p. 48 (as 'Rembrandt's wife'); 2002, no. 47; Boydell I, pl. XXXIV; Gilpin 1809, p. 45; Smith 1829-42, part VII, p. 166, no. 517; Livret 1838, pp. 126-27, no. 28; Cats. 1863-1916, no. 823; Waagen 1864, p. 184; Vosmaer 1877, p. 581; Dutuit 1883, no. 321; Bode 1883, no. 345; Michel 1893, pp. 396, 567; Bode, Hofstede de Groot 1897-1905, no. 369; Valentiner 1909, p. 330; Hofstede de Groot 1907-28, vol. 6, no. 879; Hermitage Brief List 1926, p. 10; Bredius 1937, p. 371; Pushkin Museum 1948, p. 65; Pushkin Museum 1957, p. 17; Pushkin Museum 1961, p. 156; Wipper 1962, pp. 351, 366; Bauch 1966, no. 277; Yegorova 1966, pp. 72-73; Gerson 1968, pp. 389, 501, no. 315; Lecaldano 1969, p. 117, no. 327; Bredius, Gerson, 1969, no. 371; Vikturina, Dub, Yegorova 1975, pp. 400-2; Levinson-Lessing 1975, no. 18; Bolten, Bolten-Rempt 1978, no. 420; Schwartz 1985, p. 307; Pushkin Museum 1986, p. 148; Tümpel 1986, pp. 431-32, no. A 115 ('Rembrandt's workshop'); Slatkes 1992, p. 314, no. 203; Tümpel 1993, no. A 115 ('Rembrandt's Workshop'); Pushkin Museum 1995, p. 537; Senenko 2000, no. 276.
EXHIBITIONS: 1936 Moscow-Leningrad, no. 17; 1956 Moscow-Leningrad, p. 56; 1969 Moscow, pp. 10, 13-14, 19; 1990-91 Sapporo-Tokyo-Kyoto-Fukuoka, no. 60; 1993 Turku, no. 29.

The composition has been significantly altered by the cutting of a strip of canvas of probably approximately 4 cm from the right side. As a result the last figure of the inscribed date has been lost completely, and we see only partial remains of the previous one, which detailed analysis in 1970 suggested to be the figure '5' (Vikturina, Dub, Yegorova 1975). This is consistent with the dating suggested by Bode (Bode, Hofstede de Groot 1897-1905). An earlier date of c.1648 was suggested by Valentiner (1909), but, although stylistically it is closer to works of the previous decade, this work would seem to have been painted at the very beginning of the 1650s. The modelling of the face is characterised by the application of transparent and semi-transparent brushstrokes and it can be compared with, for instance, the portrait of *Bartjen Martens* of 1640 (Hermitage, Inv. No. 721). A certain similarity in style and treatment of details is also found in later works, such as *Portrait of a Man Holding Gloves* (Metropolitan Museum of Art, New York, Inv. No. 14 40 620) or *Portrait of an Old Man in Red* (Hermitage, Inv. No. 746).

In the Walpole collection, and initially in the Hermitage, the painting was erroneously entitled *Portrait of Rembrandt's Wife*. The sitter wears rather theatrical attire, her cloak thrown over her head recalling a Jewish prayer shawl, thus giving rise to associations with Rembrandt's images of biblical prophets (see Bauch 1966, p. 14, no. 262). There is, however, insufficient visual evidence to identify any specific subject.

Although generally recognised as genuine and included in one of the most recent catalogues of Rembrandt's work (Slatkes 1992), doubts have recently been expressed about its authorship. Without any supporting evidence Tümpel (1986, 1993) published it as a Rembrandt workshop picture. Since doubts still surround the status of many paintings by Rembrandt and the views of the authors of the Rembrandt Corpus have not yet been published, there is insufficient basis to reject the traditional attribution.

M. S.

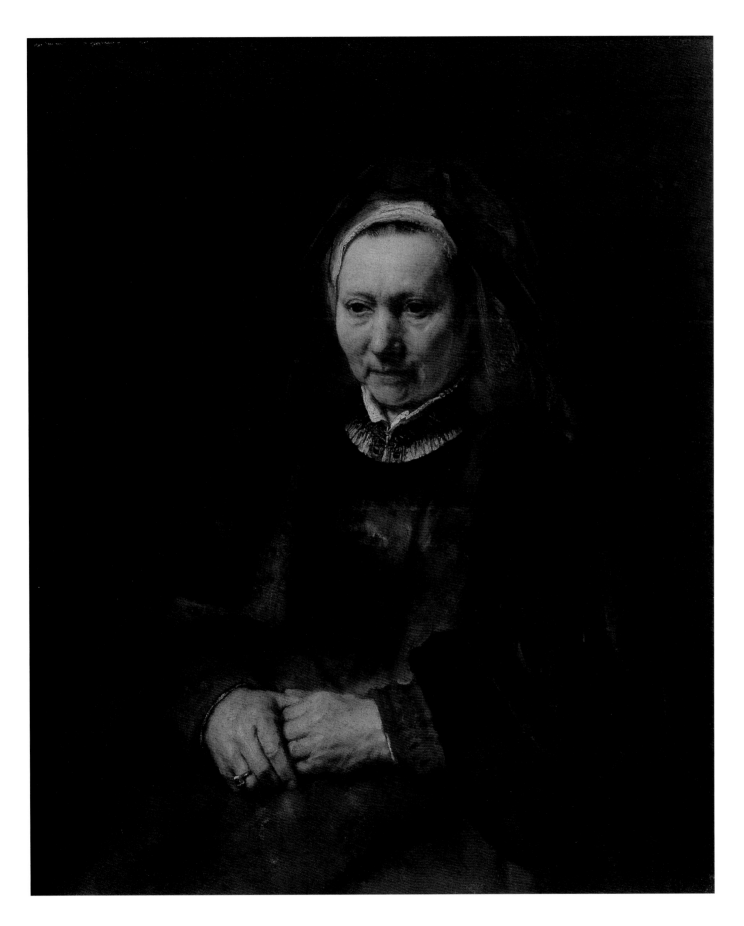

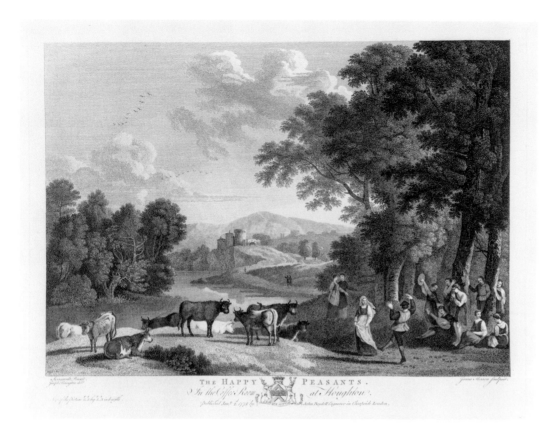

155

HERMAN SWANEVELT (c.1600-55)
A Landscape with Figures Dancing
Oil on canvas, c.54 x 97.6
PROVENANCE: Sir Robert Walpole, 1736 Houghton (Common Parlour, then Coffee-Room); 1779 Hermitage; since 1838 whereabouts unknown.
LITERATURE: *Aedes* 1752, p. 43; 2002, no. 23; Boydell I, pl. I ('The Happy Peasants'); Chambers 1829, vol. I, p. 521; Livret 1838, p. 13, no. 13.

The 1773-85 catalogue lists this picture under no. 2341: 'Herman Swanevelt. Un Paysage. Morceau exécuté dans le goût de Claude Lorrain, maître de ce peintre: Site bien choisi, beau Ciel, charmant feuiller. Il est orné de figures et de Betail; parmis les premiers on en distingue deux qui dansent. Sur toile. Haut 15½ v. Large 1 ar. 6v.' [c.54 x 97.6]

The 1797 catalogue mentions three works by Swanevelt (Nos. 2097, 2098 and 3206), but the dimensions of none of these accord with this work. Livret 1838 noted that the Swanevelt picture then hung in room 1 of the Picture Gallery, which contained forty landscapes by masters of various schools as well as the renowned gigantic Kolyvan Vase. No reference can be found to the picture after 1838.

The painting is reproduced from the Boydell plate, engraved by Joseph Farington/James Mason.

I. S.

156

ADRIAEN VAN DER WERFF (1659-1722)
Sarah leading Hagar to Abraham
Oil on canvas, 86 x 68.5, signed and dated in the bottom left corner: *Adrn v.Werff fec./ ano 1696*
Inv. No. 1064
PROVENANCE: 26 April 1713 sold at auction of Adriaen Paets' collection in Rotterdam; coll. James Brydges, 1st Duke of Chandos (1673-1744), London; presented by the Duke to Sir Robert Walpole; Sir Robert Walpole, 1736 Houghton (Yellow Drawing Room, then Cabinet); 1779 Hermitage.
LITERATURE: *Aedes* 1752, p. 70 (as 'Bathsheba bringing Abishag to David'); 2002, no. 177; Boydell II, pl. XX; Van Gool 1750-51, vol. II, p. 384; Hoet, Terwesten 1752-70, vol. I, p. 155, no. 7; Weyerman 1729-69, vol. II, p. 408; Chambers 1829, vol. I, p. 531; Smith 1829-42, part IV, p. 198, no. 58 ('Sarah presenting her Maid Hagar to Abraham. Collection of Adrian Paets'), and Supplement 1842, p. 550, no. 1 ('Bathsheba Presenting Abishag to David'); Cats. 1863-1916, no. 984; Waagen 1864, p. 214; Benois [1910], p. 431; Hofstede de Groot 1907-28, vol. 10, no. 11; Cat. 1958, vol. II, p. 156; Cat. 1981, p. 119; Kuznetsov, Linnik 1982, pl. 276; Gaehtgens 1987, no. 45; Hecht 1989, p. 262, fig. 58b; Moore ed. 1996, p. 53.
EXHIBITIONS: 1994-95 Rotterdam, no. 75.

Recorded in eighteenth-century Dutch sources, this painting was mistakenly described in the *Aedes* and in early Hermitage catalogues as *Bathsheba Bringing Abishag to David*. William Gilpin was impressed by the picture and noted that in Bathsheba 'you see the remains of a very fine woman: but in David there is a mixture of youth; which by no means gives us the idea of that total decrepitude under which the bible-history represents him. Abishag is the fair, young damsel of the text, and her modesty, and maidenly behaviour are finely expressed. - After all, we survey such high-finished pictures only as curiosities. Their style is an effect of vitiated taste. They barely please the eye' (Gilpin 1809).

In the 1773-85 catalogue Munich described it as 'Le Chevalier Adrien van der Werf. David et Avisag, la Sunamit. Tableau admirable pour la rondeur, le relief et le fini des figures. Il représente le vieux, Roi David sur son lit et la belle Sunamite introduite par une femme âgée. Sur toile.'

Along with its pair, *The Expulsion of Hagar* (Galerie Alte Meister, Dresden), this picture was painted by van der Werff for one of his patrons in Rotterdam, Adriaen Paets, a wealthy art lover and receiver at the Admiralty (see Gaehtgens 1987). A preparatory drawing for the Hermitage composition is in the Musée des Beaux-Arts, Besançon.

In their skilful execution, *Sarah Leading Hagar to*

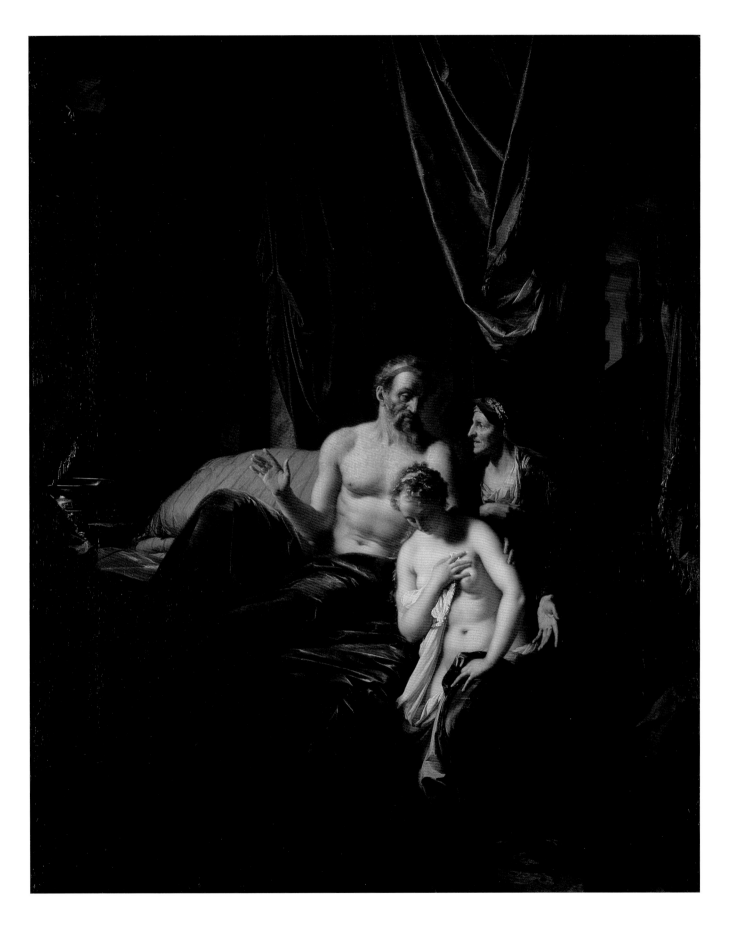

Abraham and *The Expulsion of Hagar* are amongst the best examples of van der Werff's work. Around 1700, the artist painted repetitions of these compositions for Elector Johann Wilhelm at the court of Düsseldorf (Alte Pinakothek, Munich; Rheinisches Landesmuseum, Bonn; the pair that was split up as early as the eighteenth century).

Jacob Campo Weyermann records that in 1713 van der Werff was present at the posthumous auction of Paets's collection in Rotterdam, at which the Hermitage painting was sold. *Sarah Leading Hagar to Abraham* was exhibited at the sale alongside Gerard de Lairesse's, *Antiochus and Stratonice* (Staatliche Kunsthalle, Karlsruhe) and Weyerman remarked on the comparative restraint of van der Werff's work in contrast to the abundance of gold, silver and bronze decoration in de Lairesse's picture (Gaehtgens 1987, p. 140).

Van der Werff, one of the leading masters of the Classical trend in Dutch painting, sets this biblical scene (from Genesis xvi: 3) in a majestic antique interior. The architectural details, drapery and landscape visible in the right half of the composition give the intimate scene a certain monumental quality. The figure of Abraham, half-lying on the bed, is derived from a sculpture of a river god known from an engraving of *Tiber* by François Perrier in *Segmenta nobilium signorum* (1638; see Gaehtgens 1987). Hagar's pose has analogies with antique images of 'Venus pudica'. These features were noted even in early commentaries on the painting.

The classicising nature of Van der Werff's composition was very much in keeping with eighteenth-century tastes. Of all the paintings acquired by Catherine as part of the Walpole collection, this was the only one to hang in Catherine's study. We find a reference to this in an inventory compiled after the Empress' death by Franz Labensky, keeper of the Hermitage Gallery ('Catalogue raisonné des Tableaux qui se trouvait dans le Cabinet de Sa Majesté L'Impératrice fait en 1797 par son très humble, très obéissant et très soumis serviteur François Labensky': no. 67, Adriaen van der Werff, David et Abisag, la Sunamite; MS in Hermitage Archives, Fund I, *Opis* VI, A, No. 143).

That the Hermitage painting was always admired is supported by the survival of a number of old copies (at least five are known at the present time: Gaehtgens 1987).

I. S.

157

PHILIPS WOUWERMAN (1619-68)
A Stud of Horses
Oil on panel, c.62.3 x 82.2
PROVENANCE: Sir Robert Walpole, ?1721, John Howard's framing account: 'Wouvermans – Horses' (Cholmondeley MSS); 1736 Houghton (Common Parlour); 1779 Hermitage; after 1797 transferred to the Marble Palace, St Petersburg; whereabouts unknown.
LITERATURE: *Aedes* 1752, p. 45; 2002, no. 32; Chambers 1829, vol. I, p. 522.

Munich listed the work in the 1773-85 catalogue under no. 2412 as 'Philippe Wouverman. Un haras de Chevaux. Sur une prairie ce voyent plusieures Chevaux, epars ça et la en differentes attitudes. Ce morceau n'est pa ce qu'il y a de plus beau de ce maître. Sur boix. Haut 14½ v. Large 1 ar. 2½ v.' [c.62.3 x 82.2]

In the 1797 catalogue (no. 3872) it is described as 'Landscape. Adorned with horses' and there is a handwritten note stating that it was 'In the stores of the Marble Palace'. It is not mentioned in later Hermitage catalogues. It may prove possible to identify the work with the aid of its 1797 inventory number, 3872, which should be inscribed in red in the bottom right corner on the front of the canvas.

I. S.

Not reproduced

French School

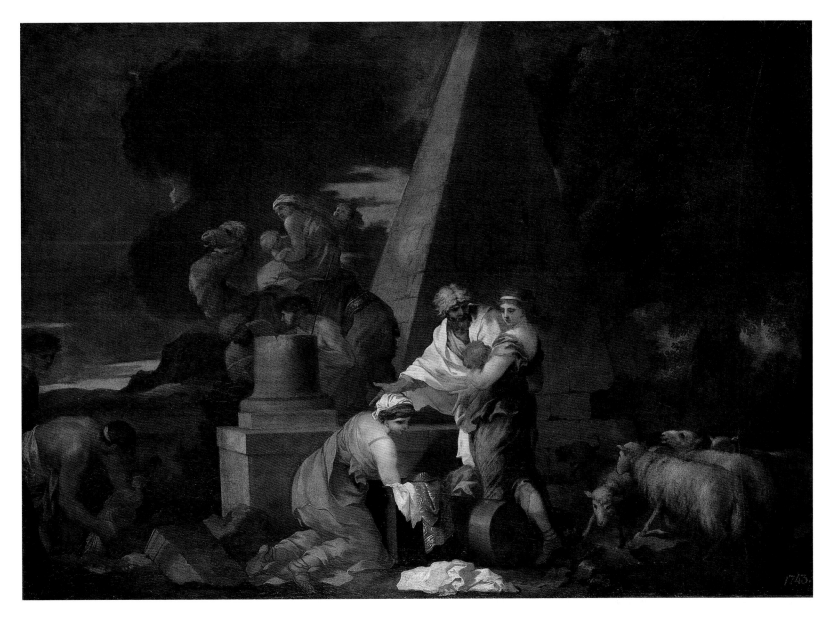

158

SEBASTIEN BOURDON (1616-71)
Jacob Burying Laban's Images
Oil on canvas, 100 x 140
Inv. No. 3682
PROVENANCE: Sir Robert Walpole, 1736 Grosvenor St (Back Parlour), later Houghton (Cabinet); 1779 Hermitage; 1854 transferred to the Academy of Arts, St Petersburg; 1922 returned to the Hermitage.
LITERATURE: *Aedes* 1752, p. 69 (as 'Laban searching for his Images'); 2002, no. 169; Boydell II, pl. XLII; Schnitzler 1828, p. 143; Livret 1838, p. 381, no. 33; Waagen 1864, p. 397; Academy of Arts 1874, no. 583; Auvray 1882-85, vol. 1, p. 147; Wrangell 1913, p. 73; Cat. 1958, vol. I, p. 260; Cat. 1976, p. 185; Moore ed. 1996, p. 136, no. 53, note 1; Thuillier 2000, p. 170.
EXHIBITIONS: 1955 Moscow, p. 23; 1956 Leningrad, p. 9; 1968 Göteborg, p. 12, no. 22; 1996-97 Amsterdam, no. 91; 1998 Florence, no. 87.

By 1736 Sir Robert Walpole owned four paintings by or attributed to Sebastien Bourdon. These hung in his Grosvenor Street house in London until two were sent up to Houghton around 1742. The small *Samson and the Lion* hung in the Closet at Downing Street.

The present work was one of the larger paintings to be displayed in the Cabinet (Moore ed. 1996, p. 136).

In eighteenth-century inventories and in nineteenth-century Hermitage catalogues the title of this picture is given incorrectly as 'Laban cherchant ses Idoles', presumably based on the mistake in the *Aedes*. Rather than being borne away, it seems clear that preparations are being made for the idols to be buried in a newly-dug hole. The man giving the order must surely be Jacob himself. Boydell was the first to correctly identify the subject, from Genesis xxxv: 1-4, as *Jacob Burying Laban's Images*.

The choice of this relatively rare subject, repeated

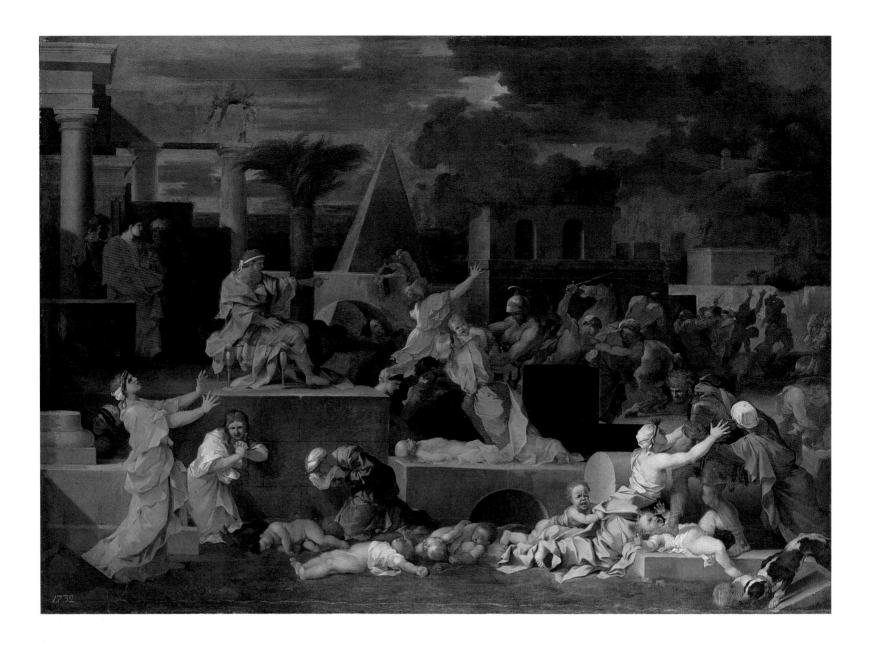

I59

SEBASTIEN BOURDON (1616-71)
The Massacre of the Innocents
Oil on canvas, 126 x 177
Inv. No. 1223
PROVENANCE: Sir Robert Walpole, 1736 Grosvenor St (Back Parlour), later Houghton (Cabinet); 1779 Hermitage.
LITERATURE: *Aedes* 1752, p. 71; 2002, no. 187; Chambers 1829, vol. I, p. 531; Livret 1838, p. 177, no. 46; Cats. 1863-1916, no. 1419; Waagen 1864, p. 289, no. 1420; Auvray 1882-85, vol. 1, p. 147; Ponsonhaille 1883, p. 299; Neustroyev 1898, p. 325; Réau 1929, p. 178, no. 19; Sterling 1957, p. 26; Cat. 1958, vol. I, p. 260; Cat. 1976, p. 185; Moore ed. 1996, p. 136, note 2; Thuillier 2000, p. 170.

by Bourdon on a number of occasions, is closely tied to the artist's religious beliefs. A Calvinist living in a staunchly Catholic country, Bourdon could easily identify with the concept of loyalty to one's faith in difficult circumstances.

Bourdon's eclecticism makes the dating of his works extremely difficult. In Rome, and for some time after his return to Paris, he imitated Pieter van Laer and Castiglione, while in the first half of the 1640s the influence of Poussin appeared in his work. This canvas reveals the undoubted influence of Castiglione as well as a clear manifestation of interest in Classicist principles of composition, suggesting a likely date of execution in the first half of the 1640s.

N. S.

EXHIBITION: 1956 Leningrad, p. 9.

In the early 1640s Bourdon's paintings increasingly revealed his interest in the work of Poussin, undoubtedly the result of the latter's stay in Paris in 1640-42. *The Massacre of the Innocents* (from Matthew ii: 16-18), with its overt classicism, seen above all in the planar division of the composition and its skilful alternation of masses, probably dates from this time.

There are copies of the work in Worcester Art Museum, Worcester, Mass., USA, and in the Pinacoteca Reale, Turin.

N. S.

160

JACQUES COURTOIS, called LE BOURGUIGNON (1621–75)
Cavalry Battle
Oil on canvas, 48 x 67
Inv. No. 1752
PROVENANCE: Sir Robert Walpole, 1736 Downing St
(Lady Walpole's Drawing Room), later Houghton
(Cabinet); 1779 Hermitage.
LITERATURE: *Aedes* 1752, p. 68; 2002, no. 158; Gilpin
1809, p. 52; Chambers 1829, vol. I, p. 530; Livret
1838, p. 328, no. 41; Cats. 1863–1916, no. 1533; Cat.
1958, vol. I, p. 290; Cat. 1976, p. 203; Moore ed.
1996, p. 49.
EXHIBITIONS: 1956 Leningrad, p. 30.

Pair to *Battlefield* (cat. no. 161).

Although Courtois received royal commissions he
was not (like the other great battle painter, van der
Meulen) among the king's official artists. Neverthe-
less, his Salvator Rosa-like battle pictures, which usu-
ally lack any precise historical context, were extreme-
ly popular. The artist served for some time in the
Spanish army and would seem to have made use of
sketches produced during actual battles. Gilpin (1809)
was generous in his praise of this pair of paintings:
'One of them represents a battle; the other, the field
after it; in which the principal group is a dying offi-
cer, confessing to a friar. Both are excellent pictures;
but the first is a masterpiece.'

N. S.

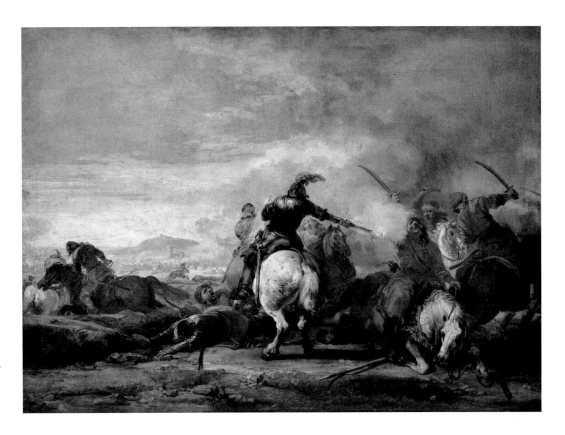

161

JACQUES COURTOIS, called LE BOURGUIGNON (1621–75)
Battlefield
Oil on canvas, 47.5 x 66.5
Inv. No. 1182
PROVENANCE: Sir Robert Walpole, 1736 Downing St
(Lady Walpole's Drawing Room), later Houghton
(Cabinet); 1779 Hermitage.
LITERATURE: *Aedes* 1752, p. 68 (as 'A Dying Officer
at Confession'); 2002, no. 157; Gilpin 1809, p. 52;
Chambers 1829, vol. I, p. 530; Livret 1838, p. 325,
no. 27; Cats. 1863–1916, no. 1532; Cat. 1958, vol. I,
p. 290; Cat. 1976, p. 203; Moore ed. 1996, p. 49.
EXHIBITIONS: 1956 Leningrad, p. 31.

Listed in the 1863 and 1892 catalogues as 'The Battle-
field After the Battle'. Pair to *Cavalry Battle* (cat. no.
160).

N. S.

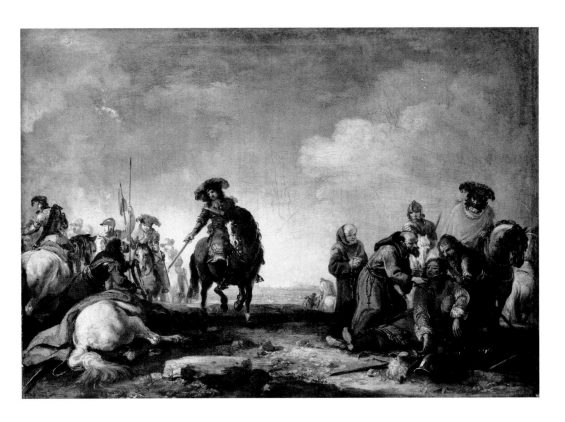

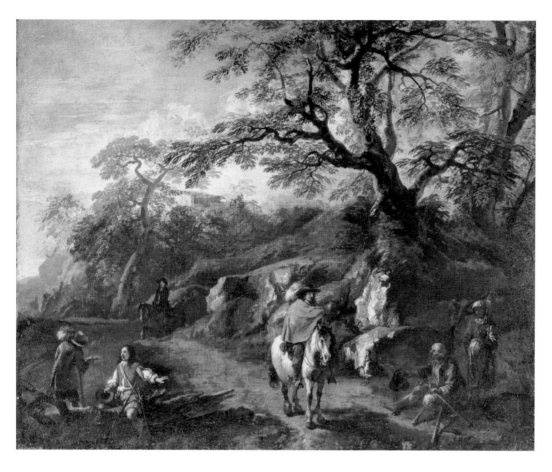

162

JACQUES COURTOIS, called LE BOURGUIGNON (1621-75)
Landscape with a Rider
Oil on canvas, 34.5 x 43.5
Inv. No. 1669
PROVENANCE: Sir Robert Walpole, 1736 Downing St (Great Middle Room below), later Houghton (Cabinet); 1779 Hermitage.
LITERATURE: *Aedes* 1752, p. 70 (as 'A Landscape with Figures'); 2002, no. 182; Boydell I, pl. XXXV ('Mendicants'); Gilpin 1809, p. 54; Livret 1838, p. 500, no. 22; Cat. 1976, p. 203 (ill. 106, mistakenly listed as Inv. No. 6405).
EXHIBITIONS: 1959 Leningrad, p. 18.

Pair to *View of the Seashore* (cat. no. 163)

Although attributed to Bourguignon in the *Aedes* ('in the Manner of Salvator Rose') the painting is not entirely consistent with that artist's work. It may have been painted by a pupil of both Salvator Rosa and Jacques Courtois, Pandolfo Reschi, an artist of German origin who worked in Rome. Works by Reschi such as *Caccia al Toro* (Galleria Doria Pamphilj, Rome) and *Scene from the Life of Genevieve of Brabant* in Florence (Depositi delle Gallerie) are certainly similar in style.

N. S.

163

JACQUES COURTOIS, called LE BOURGUIGNON (1621-75)
View of the Seashore
Oil on canvas, 34.5 x 43.5
PROVENANCE: Sir Robert Walpole, 1736 Downing St (Great Middle Room below), later Houghton (Cabinet); 1779 Hermitage; since 1912 whereabouts unknown.
LITERATURE: *Aedes* 1752, p. 70 (as 'Its Companion with Soldiers'); 2002, no. 183; Boydell I, pl. XXXVI ('Banditti'); Gilpin 1809, p. 54; Livret 1838, pp. 500-1.

Pair to *Landscape with a Rider* (cat. no. 162)

Listed in the 1773-85 catalogue under no. 2279, 'Une marine. Beaux morceaux peint dans le goût de Salvatore Rosa', and in the 1797 catalogue under no. 2498, 'Bourgignon. View of the Seashore'. The 1859 Inventory records that the painting was then hanging in one of the corridors of the Winter Palace. It was also noted that during a stock check in 1912 the picture was missing. Although there has been no trace of the work since that date it might prove possible to identify it by means of inventory numbers which may be painted on it, probably a red '2498' (as in the 1797 catalogue) in the bottom right corner on the front of the canvas, or a black '2877' on the back of the canvas (Inventory 1859).

Now known only through the Boydell print, engraved by James Peake, published 1 May 1777.

N. S.

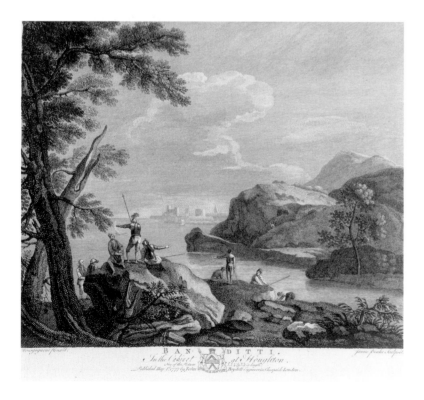

164

GASPARD DUGHET (1615-75)
Wooded Landscape
Oil on canvas, 97.5 x 136.5
Inv. No. 1205
PROVENANCE: coll. Marquis de Mari; coll. Mr. Edwin; Sir Robert Walpole, 1736 Downing St (End Room Below), later Houghton (Gallery); 1779 Hermitage.
LITERATURE: *Aedes* 1752, p. 94 (as one of 'Two Landscapes by Gaspar Poussin'); 2002, no. 269; Boydell I, pl. XIX ('The Sportsman'); Livret 1838, p. 11, no. 21; Cats. 1863-1916, no. 1427; Waagen 1864, p. 290; Clément de Ris 1879-80, part V, p. 264; Neustroyev 1898, pp. 323-24; Réau 1929, no. 93; Cat. 1958, vol. I, p. 284; Cat. 1976, p. 199; Boisclair 1986, no. 251, p. 250.
EXHIBITIONS: 1956 Leningrad, p. 24.

Dughet's landscapes depict nature for its own sake. As one scholar of the artist's work has written: 'Gaspard was one of the first to realise that out of the close poetic description of one or two trees a pure and complete landscape can emerge' (M. Waddington, 'The Dughet Problem', *Paragone*, 1963, no. 161, p. 38).

Similar to *Landscape with a Fisherman* (cat. no. 165), it can be dated to the same time, c.1655.

N. S.

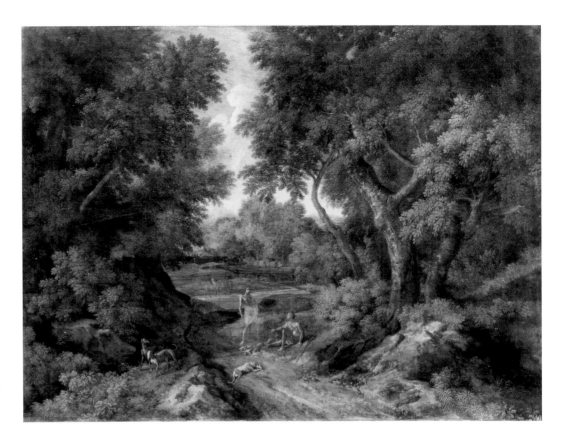

165

GASPARD DUGHET (1615-75)
Landscape with a Fisherman
Oil on canvas, 101 x 127
Inv. No. 1248
PROVENANCE: see cat. no. 164.
LITERATURE: *Aedes* 1752, p. 94 (as one of 'Two Landscapes by Gaspar Poussin'); 2002, no. 270; Boydell I, pl. XX ('The Fisherman'); Livret 1838, p. 9, no. 11; Cats. 1863-1916, no. 1423; Waagen 1864, p. 290; Neustroyev 1898, pp. 323-24; Réau 1929, no. 89; Sterling 1957, p. 216; Cat. 1958, vol. I, p. 285; Cat. 1976, p. 199; Boisclair 1986, no. 139, pp. 108-10, 215.
EXHIBITIONS: 1995 Shizuoka-Tochigi-Okayama-Kumamoto, pp. 86-87, no. 19.

Datable to c.1653-55, this landscape is close to *The Disobedient Prophet* in the Musée des Beaux-Arts, Le Havre (Inv. No. A318), probably painted c.1655.

N. S.

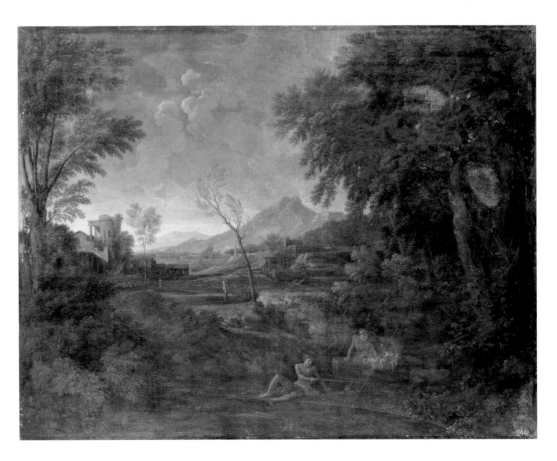

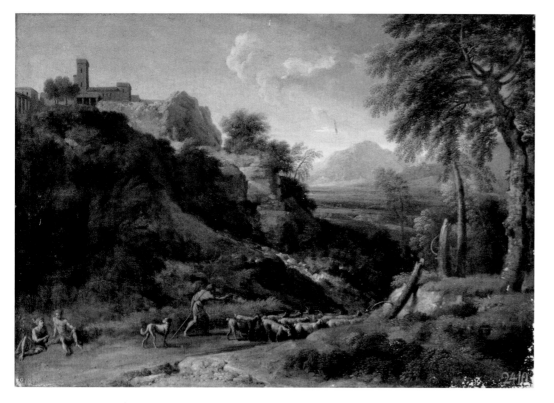

166

GASPARD DUGHET (1615-75)
Landscape with a Cascade and Sheep
Oil on canvas, 58.5 x 84.5
Inv. No. 1206

PROVENANCE: coll. Charles Montague, Earl of Halifax; 8 March 1739/40 acquired by Sir Robert Walpole at the sale of the Earl of Halifax (lot 87) by his agent John Ellys; Sir Robert Walpole, Houghton (Gallery); 1779 Hermitage.

LITERATURE: *Aedes* 1752, p. 93 (as 'Gaspar Poussin'); 2002, no. 264; Boydell II, pl. XLI ('The Cascade'); Livret 1838, p. 21, no. 17; Cats. 1863-1916, no. 1426; Waagen 1864, p. 290; Neustroyev 1898, pp. 323-24; Réau 1929, no. 92; Sterling 1957, p. 216; Cat. 1958, vol. I, p. 284; Cat. 1976, p. 199; Boisclair 1986, no. 288, pp. 260-61; Moore ed. 1996, pp. 52, 89, note 3.

Comparison with another Dughet landscape in the Louvre, Paris (Inv. No. 1060) suggests that this work can be dated to the late 1660s.

There is a variant at Ball State University, Muncie, Indiana (USA), which Boisclair (1986) suggests (citing Vertue, vol. I, 1929-30, p. 80, note 7) is a copy by James [i.e. Jan] van Huysum, done while the painting was at Houghton Hall. A copy in reverse by Jacob Hackert (possibly taken from the engraving by Vivares) passed through Christie's, 1 June 1973, lot 61.

N. S.

167

GASPARD DUGHET (1615-75)
Landscape with a Road (Landscape with the Ruins of the Baths of Caracalla)
Oil on canvas, 36.5 x 47
Inv. No. 1192

PROVENANCE: Sir Robert Walpole, 1736 Downing St (Great Middle Room below), later Houghton (Cabinet); 1779 Hermitage.

LITERATURE: *Aedes* 1752, p. 70 (as one of 'Two small Landscapes, by Gaspar Poussin'); 2002, no. 184; Boydell I, pl. LI; Livret 1838, p. 11, no. 19; Cats. 1863-1916, no. 1424; Waagen 1864, p. 290; Neustroyev 1898, pp. 323-24; Réau 1929, no. 90; Sterling 1957, p. 216; Cat. 1958, vol. I, p. 285; Cat. 1976, p. 199; Boisclair 1986, no. 407, p. 290.

Baldinucci 1681-1728 (vol. V, p. 302) tells us that Dughet often walked around the environs of Rome making sketches from nature that were then used in works such as this. The picture can be dated to c.1673-74 by comparison with *Landscape with the Ruins of the Baths of Diocletian*, formerly in the collection of the late Denys Sutton in London.

N. S.

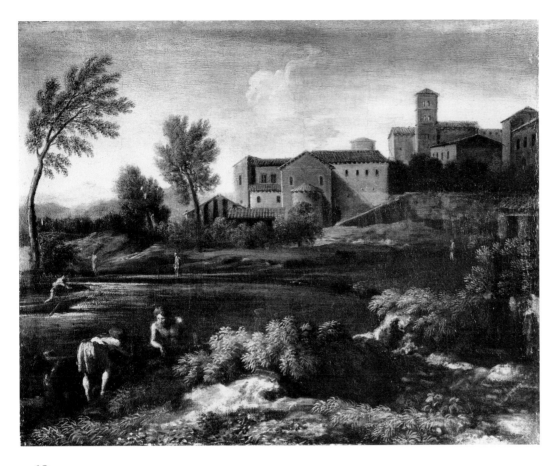

168

GASPARD DUGHET (1615–75)

A Small Town in Latium

Oil on canvas, transferred from panel, 34 x 41, signed bottom left in black: *Gasp. D.*

Pushkin Museum of Fine Arts, Moscow, Inv. No. 900

PROVENANCE: Sir Robert Walpole, 1736 Downing St (Great Middle Room below), later Houghton (Cabinet); 1779 Hermitage; 1862 transferred to Rumyantsev Museum, Moscow; 1924 transferred to Museum of Fine Arts (now Pushkin Museum of Fine Arts), Moscow.

LITERATURE: *Aedes* 1752, p. 70 (as one of 'Two small Landscapes, by Gaspar Poussin'); 2002, no. 185; Boydell I, pl. LII; Martyn 1766, p. 104; Rumyantsev Museum 1865, p. 21, no. 190; Rumyantsev Museum Guide 1872, p. 68, no. 190; Andreyev 1853–83, vol. 2, p. 143; Rumyantsev Museum Guide 1889, p. 36, no. 216; Rumyantsev Museum 1901, p. 52, no. 637; Rumyantsev Museum 1903, p. 69, no. 697; Rumyantsev Museum 1912, p. 120, no. 31; Bénézit 1911–13, vol. 2, p. 162; Rumyantsev Museum 1915, p. 186; Réau 1929, p. 78, no. 516; Pushkin Museum 1948, p. 30; Pushkin Museum 1957, p. 55; Pushkin Museum 1961, p. 79; Prokof'yev 1962, ill. 28; Boisclair 1974, p. 75; Boisclair 1976, no. 34; Kouznetsova, Gueorguievskaia 1980, no. 180, pl. 10; Kuznetsova

1982, pp. 123–24; Boisclair 1986, no. 297, fig. 336; Pushkin Museum 1986, p. 79; Kuznetsova 1991, p. 238; Pushkin Museum 1995, pp. 268–69.

Dated by Boisclair (1986) to 1667–68. Closest to this picture in terms of their compositional structure and architectural motifs are *A Village on a Hillside* (Galleria Nazionale d'Arte Antica, Rome, Inv. No. 445) and *Italian Landscape* (Helen Foresman Spencer Museum of Arts, University of Kansas, Lawrence, Kansas), also painted in the second half of the 1660s. Long thought to be a pair to another work in the Hermitage, *Landscape with the Ruins of the Baths of Caracalla* (cat. no. 167).

Ye. Sh.

169

CLAUDE GELLÉE, called LE LORRAIN (1602–82)

Morning in the Harbour

Oil on canvas, 97.5 x 120.5

Inv. No. 1243

PROVENANCE: coll. Charles-Jean-Baptiste Fleuriau, Comte de Morville, French diplomat; Sir Robert Walpole, 1728 Arlington St, 1736 Downing St (Sir Robert's Dressing Room), later Houghton (Gallery); 1779 Hermitage.

LITERATURE: *Aedes* 1752, p. 94 (as 'A Sea-port'); 2002, no. 267; Boydell I, pl. IX; Gilpin 1809, p. 65; Chambers 1829, vol. I, p. 538; Smith 1829–42, part VIII, no. 5, pp. 196–97; Livret 1838, p. 171, no. 24; Cats. 1863–1916, no. 1437; Waagen 1864, p. 293; Pattison 1884, pp. 108, 208, 246; Friedländer 1921, pp. 105–6, 139–40, note p. 242, 140; Cat. 1958, vol. I, p. 305; Rothlisberger 1961, vol. 1, pp. 102–5; vol. 2, figs. 32, 33; Rothlisberger 1968, vol. 1, p. 105; vol. 2, fig. 85; Cat. 1976, p. 200; Rothlisberger 1977, p. 89, no. 49; Moore ed. 1996, p. 59.

EXHIBITIONS: 1955 Moscow, p. 43; 1956 Leningrad, p. 35; 1972 Dresden, no. 56; 1972c Leningrad, no. 39; 1972 Warsaw-Prague-Budapest-Leningrad-Dresden, no. 125; 1977 Tokyo-Kyoto, no. 28; 1995 Shizuoka-Tochigi-Okayama-Kumamoto, pp. 88–89, no. 20.

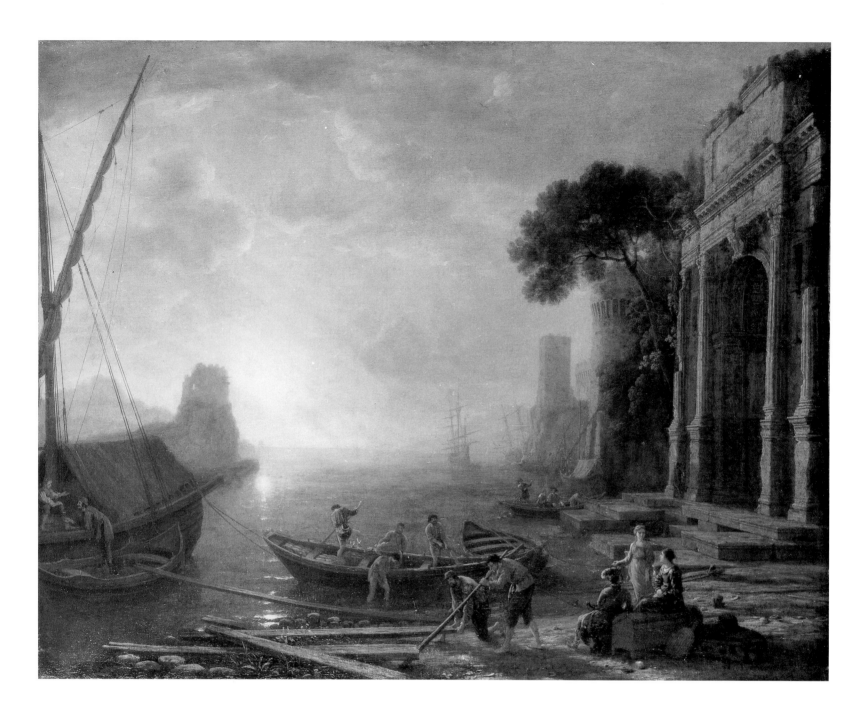

A date of 1634 is suggested for this painting on the basis of drawing no. 5 in Claude's *Liber Veritatis* (in which he recorded his pictures chronologically in the form of sketches). Since the etching (A. Blum, *Les eaux-fortes de Claude Gellée*, Paris, 1923, no. 10) taken from drawing no. 3 in the *Liber Veritatis* bears the date 1634, it seems likely that drawing no. 5 was produced in the same year or shortly after.

This date accords well with the work's stylistic features, typical of Claude's early port paintings – the lack of subject, the limited spatial depth, and the combination of the ancient Arch of Titus with trees and towers in the distance to create a romantic whimsical effect which disappears in the later, emphatically representative ports of the late 1630s and early 1640s. This notion was challenged by Pattison (1884) and Friedländer (1921), who suggested a later date of execution of 1649. Pattison's reasoning was the supposed identity of the patron who commissioned the work, identified on the back of the drawing in the *Liber Veritatis*: 'faict pour monsigneur l'avec du mant. Claudio fecit in vr'. Rothlisberger (1961), however, suggests that Pattison confused Charles de Beaumanoir, Bishop of Le Mans between 1601 and 1637, with a later

bishop, Philibert-Emmanuel de Beaumanoir, created Bishop of Le Mans in 1649.

Closest in composition and in its general treatment of space, light and details is the *Harbour Scene* (1637, *Liber Veritatis* 19) in the Royal Collection at Windsor. A version of this painting was executed in 1674 for Franz von Mayer (Alte Pinakothek, Munich, Inv. No. 381).

N. S.

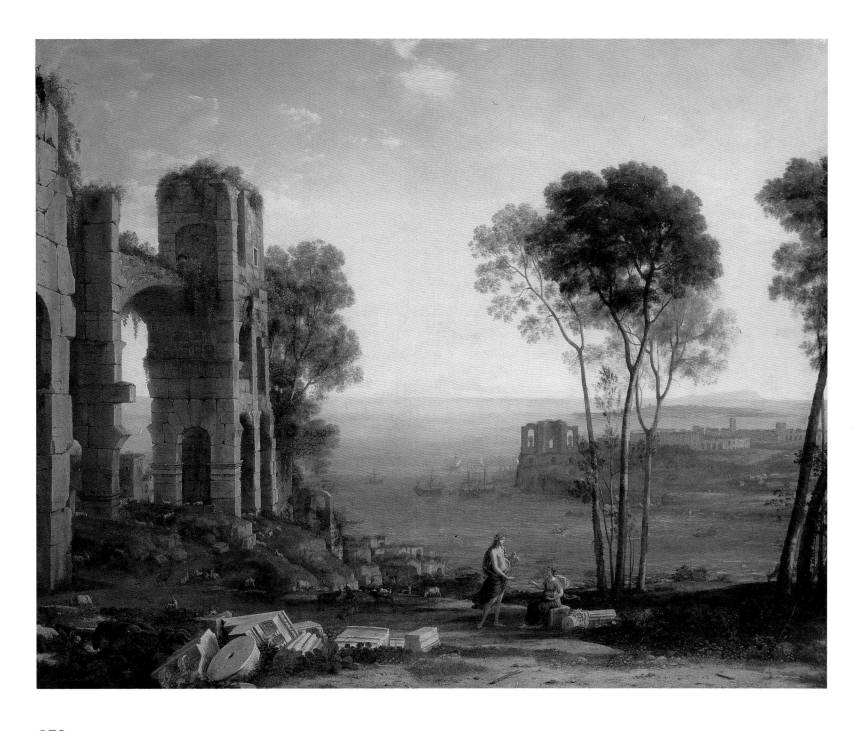

170

CLAUDE GELLÉE, called LE LORRAIN (1602-82)
Landscape with Apollo and the Cumaean Sibyl
Oil on canvas, 95.5 x 127, bottom left, on the column fragment, the remains of an inscription (illegible)
Inv. No. 1228

PROVENANCE: coll. Cardinal Massimi (1620-77); after his death, Massimi's collection passed to his brother Fabio; 1678 coll. Marchese Niccolò Maria Pallavicini; coll. Marquis de Mari; Sir Robert Walpole, 1728 Arlington St, 1736 Downing St (Sir Robert's Dressing Room), later Houghton (Gallery); 1779 Hermitage.

LITERATURE: *Aedes* 1752, p. 94 (as 'A calm Sea'); 2002, no. 268; Gilpin 1809, p. 65; Chambers 1829, vol. I, p. 538; Smith 1829-42, part VIII, no. 99, p. 244; Livret 1838, p. 180, no. 59; Cats. 1863-1916, no. 1432; Waagen 1864, p. 292; Pattison 1884, p. 107, no. 245; Neustroyev 1898, p. 327; Réau 1929, no. 225; Cat. 1958, vol. I, p. 305; Rothlisberger 1958, p. 225; Rothlisberger 1961, vol. 1, pp. 261-62; vol. 2, fig. 180; Cat. 1976, p. 200; Rothlisberger 1977, no. 164, p. 106; Boyer 2001, pp. 60-63.

EXHIBITIONS: 1985 Sapporo, no. 17; 1996 Nagaoka-Osaka, no. 5; 1998 Tokyo, no. 43; 2001 Epinal, no. 7.

Claude often included depictions of specific monuments in his works, but unlike Poussin he was unconcerned about archaeological exactitude. His introduction of famous ancient monuments into his landscapes was probably influenced by Cardinal Massimi (1620-76), Claude's patron in the period 1645-49, renowned

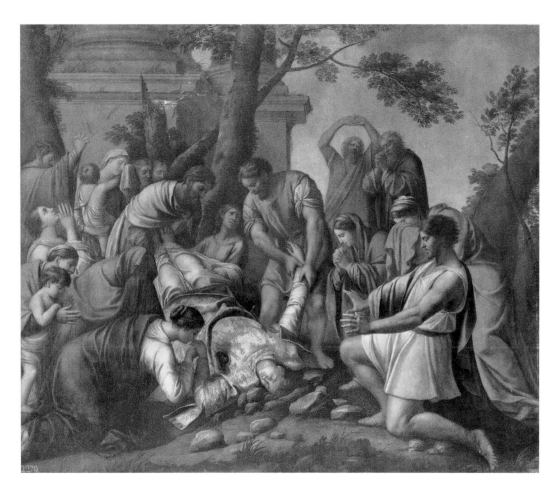

as an admirer of antiquities and owner of a celebrated collection of manuscripts. Ancient ruins were for Claude simply a standard component in Italian landscapes, a symbol of man's great past and the ideal world of the Ancients. In the foreground to the left of this work (*Liber Veritatis* 99) are free variations on the Coliseum, with the ruins of this famous structure itself outlined against the sea, and the Roman Marchia Aqueduct in the side arches of which the Trophies of Marius are visible.

The figures in this work are attributed to Filippo Lauri, the subject based on Ovid, *Metamorphoses*, XIV, 130-35. A pair to this landscape, *Landscape with Argus Guarding Io* (1644), is in the collection of the Earl of Leicester at Holkham Hall, Norfolk.

It is possible that the painting also passed through the hands of Humphrey Edwin ('Mr Edwin'), but the text of the *Aedes* is sufficiently ambiguous to make it uncertain: 'Two landscapes by Gaspar Poussin. ... These two and the latter Claude were in the Collection of the Marquis *Di Mari*. Mr *Edwin*, of whom these [?just the Gaspar Poussin/Dughet or the Claude also] were purchased, had two more.'

N. S.

171

?THOMAS GOUSSE (1627-58)
The Stoning of St Stephen
Oil on canvas, 296 x 349
Inv. No. 1170
PROVENANCE: Sir Robert Walpole, 1736 Houghton (Saloon, as by 'La Soeur'); 1779 Hermitage.
LITERATURE: *Aedes* 1752, p. 54 (as 'The Stoning of St. Stephen ... of Le Soeur'); 2002, no. 83; Boydell II, pl. XXXVIII; Labensky 1805-9, vol. 1, bk. 2, p. 43; Reimers 1805, vol. 2, p. 304; Landon 1814, no. 70; Swignine 1821, p. 57 (Russian edition 1997, p. 260); Réveil 1828-34, vol. 6, no. 382; Schnitzler 1828, p. 63, no. 16; Chambers 1829, vol. I, p. 525; Livret 1838, p. 162, no. 5; Cats. 1863-1916, no. 1449; Waagen 1864, p. 297; Linnik 1956, pp. 26-27; Cat. 1958, vol. I, p. 283; Sterling 1957, p. 216, note 42; Cat. 1976, p. 198; Merot 1987, no. R53.
EXHIBITIONS: 1956 Leningrad, pp. 16-17.

This painting entered the Hermitage as the work of Eustache Lesueur and remained under his name until 1955 (see Linnik 1956). The composition originates with a preparatory drawing by Laurent de la Hyre (Louvre, Paris, Inv. No. 27511) for a group of tapestries depicting the life of St Stephen for the Church of St Etienne-du-Mont in Paris. One of the Lesueur brothers subsequently also based cartoons for a tapestry on the design of this picture (Piganiol de La Force, *Description historique de la ville de Paris*, Paris, 1765, vol. VI, p. 115). The authors of the Louvre drawings catalogue, Guiffrey and Marcel (1921, vol. VII, p. 86), support the theory that the Hermitage work may have been painted by Thomas Gousse, a pupil and collaborator of Eustache Lesueur (and his brother-in-law), although Merot (1987) identifies the author of the canvas as Eustache's brother Antoine.

The tapestries, now lost, were produced in Paris in 1650 (H. Gobel, *Die Wandteppiche und ihre Manufakturen in Frankreich, Italien, Spanien und Portugal*, Leipzig, 1928, vol. I, p. 105) and the cartoons must therefore have been produced earlier.

The subject is from the Acts of the Apostles viii: 2.

N. S.

172

CHARLES LE BRUN (1619-90)
Daedalus and Icarus
Oil on canvas, 190 x 124
Inv. No. 40
PROVENANCE: Sir Robert Walpole, 1736 Houghton
(Saloon); 1779 Hermitage.
LITERATURE: *Aedes* 1752, p. 56 (as 'Daedalus flying on
Icarus's Wing'); 2002, no. 95; Boydell II, pl. X; Gilpin
1809, p. 48; Schnitzler 1828, p. 73; Livret 1838, p. 295,
no. 7 ('Feti'); Cats. 1863-1916, no. 235; Jouin 1889, p.
515; Cat. 1958, vol. I, p. 144; Wildenstein 1965, no.
152; Novosel'skaya 1969, pp. 15-18; Cat. 1976, p. 207;
Moore ed. 1996, p. 119.
EXHIBITIONS: 1994 Mito-Tsu-Tokyo, no. 6; 1997
Bonn, p. 192-93, no. 54.

When it entered the Hermitage the 1773-85 catalogue
gave this work the same attribution to Le Brun that it
carried in the Walpole collection. The attribution to Le
Brun, however, has always been disputed. Horace Wal-
pole was the first to express doubt about Le Brun's
authorship, noting in the *Aedes* that it was in 'a different
Manner from what he generally painted'. It has subse-
quently been attributed to both French and various
Italian schools. The Livret (1838) was more specific in
attributing it to Domenico Feti and in later nineteenth-
century catalogues it was in turn attributed to Andrea
Ansaldo, Francesco Mola and an unknown master of
the Genoese school. The 1958 catalogue listed it as the
work of an unknown seventeenth-century Italian
painter. Novoselskaya (1969) revived the attribution to
Charles Le Brun on the basis of stylistic parallels with his
early works of 1639-46, such as *Hercules and the Horses of
Diomedes* (1639-41; Castle Museum, Nottingham,
UK), *The Martyrdom of St John the Evangelist* (1642;
Church of Saint Nicolas du Chardonet, Paris), and *The
Death of Cato* (1646; Musée des Beaux-Arts, Arras).

Scholars generally agree on the inconsistency and
eclectic nature of Le Brun's work (see A. Blunt, 'The
Early Work of Charles Lebrun', *Burlington Magazine*,
July 1944; *Charles Le Brun, peintre et dessinateur*, exh. cat.,
by J. Thuillier and J. Montegu, Versailles, 1963, p. xxvii),
which makes the question of attribution more difficult.
In his study of the artist's stylistic evolution G. Chomer
('Charles Le Brun avant 1646', *Bulletin de la Société d'his-
toire de l'art français*, 1977, pp. 93-107), emphasised that by
the time he returned from Italy in 1646 there were
notable Italian influences in Le Brun's work, although
these were to be short-lived.

Such Italian influence is still very noticeable in the
Hermitage canvas and it is therefore reasonable to sug-
gest that *Daedalus and Icarus* (the subject from Ovid,
Metamorphoses, VIII, 183-235) was painted in or soon after
the artist's return from Italy. In this early work we can
already see the expressive and broad decorative style that
was to manifest itself more clearly in Le Brun's later
paintings. The most likely date of execution is c.1645-46.

N. S.

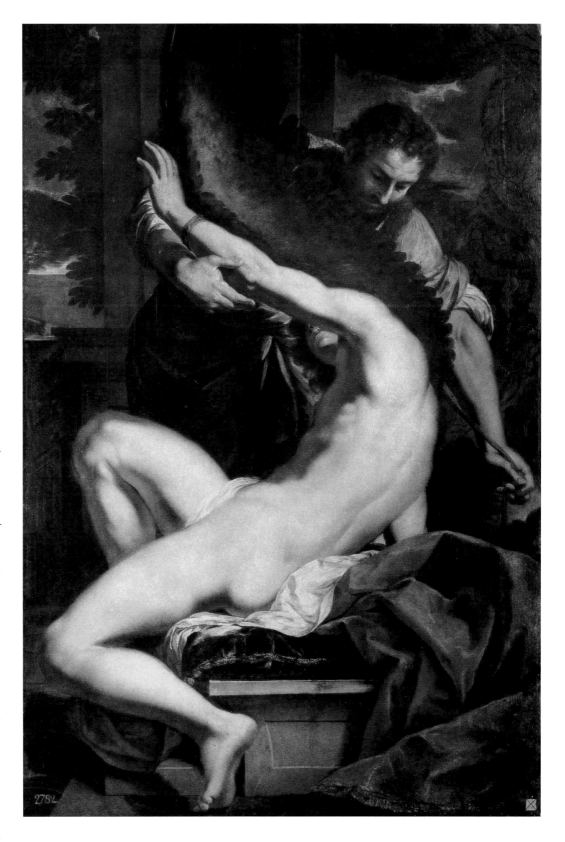

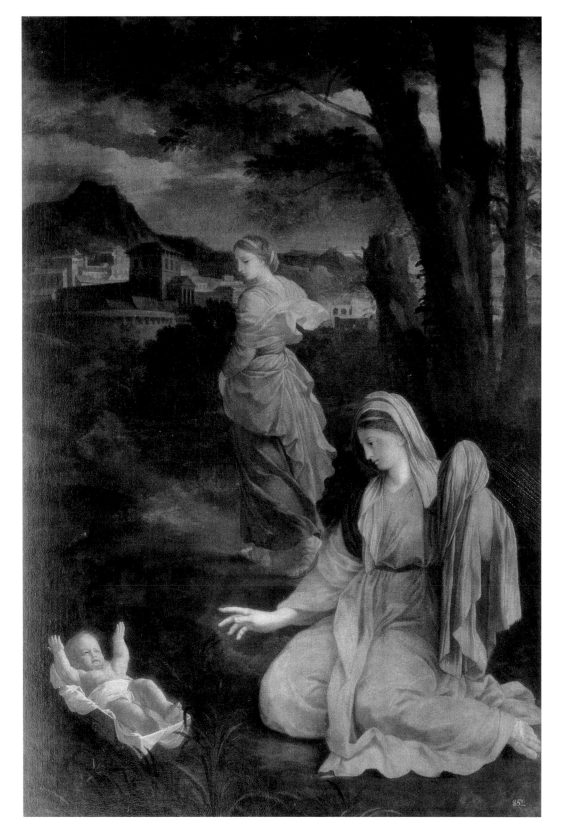

173

EUSTACHE LESUEUR (1616–55)
The Exposition of Moses
Oil on canvas, 218 x 148
Inv. No. 1251

PROVENANCE: presented to Sir Robert Walpole by John, 2nd Duke of Montagu; Sir Robert Walpole, 1736 Chelsea (Hall), later Houghton (Gallery); 1779 Hermitage.

LITERATURE: *Aedes* 1752, p. 93 (as 'Moses in the Bulrushes'); 2002, no. 261; Boydell II, pl. IX; Félibien 1725, p. 37; Gilpin 1809, pp. 45–46; Labensky 1805-9, vol. 2, bk. 4, pp. 23–24; Schnitzler 1828, p. 70; Livret 1838, p. 183, no. 69; Saint-Georges 1854, vol. I, p. 17; vol. II, pp. 56, 112; Le Blanc 1862, vol. I, p. 16; Cats. 1863–1916, no. 1444; Waagen 1864, p. 297; Clément de Ris 1879–80, part V, p. 266; Neustroyev 1898, p. 331; Rouches 1923, p. 65; Dimier 1926-27, vol. 2, p. 27; Réau 1929, no. 201; Cat. 1958, vol. I, p. 304; Rothlisberger 1971, no. 11, p. 76, note 13; Cat. 1976, p. 209; Sapin 1984, no. 12, fig. 7; Merot 1987, no. 108, p. 251, fig. 325; Moore ed. 1996, pp. 53–54; Brownell 2001, p. 53.

EXHIBITIONS: 1956 Leningrad, p. 34; 2000-1 Rome, no. 3.

Eustache Lesueur was the most gifted of Simon Vouet's numerous pupils and worked in a style so close to that of his teacher that his pictures have often been attributed to Vouet himself.

There is a preparatory drawing for the figure of Moses in the Louvre (Guiffrey, Marcel 1921, vol. IX, no. 9172). This same figure is repeated in another drawing in the Musée des Beaux-Arts, Besançon, which in turn is a preparatory work for a painting of *St Peter Raising Tabitha* in the Art Gallery of Ontario, Toronto (see A. Blunt, 'Un tableau d'Eustache Le Sueur', *Art de France*, 1964, no. IV, pp. 293–96; W. Vitzthum, 'Un dessin de Le Sueur', *Art de France*, 1964, no. IV, p. 296). A preparatory drawing for the entire composition is in the Kunsthalle, Hamburg (Inv. No. 24046).

According to Guillet de Saint-Georges, historian of the French Académie in the seventeenth century, this work was painted no later than 1649 for Gérome de Nouveau, Post Superintendent General, along with a second work, *The Finding of Moses*. This explains the error in the catalogue of Lesueur's work (Saint-Georges 1854, p. 56) which states incorrectly that the Hermitage has *The Finding of Moses* (rather than the Exposition), the dimensions of which are the same as this picture.

The subject derives from Exodus ii: 1–4.

N. S.

174

JEAN LE MAIRE called LE MAIRE-POUSSIN (1598-1659)
Alexander Adorning the Tomb of Achilles
Oil on canvas, 246.75 x 157.75
Tsarskoye Selo State Museum Reserve, Inv. No. 204-X
PROVENANCE: Sir Robert Walpole, 1736 Houghton
(Green Velvet Bedchamber, by 'Nicolas Poussin', then
Velvet Bedchamber'); 1779 Hermitage; in the 19th
century in a passage of the apartments of Empress
Yelizaveta Alexeyevna in the Tauride Palace, St Peters-
burg; late 1840s transferred to the Catherine Palace,
Tsarskoye Selo where it hung on the state marble stair-
case (undated MS Tsarskoye Selo Inventory s.d., f. 9,
no. 5861); autumn 1941 removed by German troops via
Luga, Pskov and Riga to Königsberg, arriving in April
1942; returned to Tsarskoye Selo from Berlin by order
of 6 January 1948; Catherine Palace, Tsarskoye Selo
(Pushkin), now hangs on the state marble staircase.
LITERATURE: *Aedes* 1752, p. 61 (as 'Alexander Adorn-
ing the Tomb of Achilles by Le Mer'); 2002, no. 127;
Catherine Palace 1918, p. 36.

Although Horace Walpole identified the literary source
for the subject of this work in *Aedes* 1752 as Book 2,
chapter 4 of Quintus Curtius Rufus (*Historiarum regis
Macedonum. De rebus gestis Alexandri Magni*), the first two
books of this work have in fact been lost and we effec-
tively know only the list of subjects they contained. The
subjects survive in works by later authors, the most
familiar being Plutarch's *Life of Alexander*, XV, 8.

Only the surname 'Le Mer' appears in the *Aedes*,
but when this painting and its companion (cat. no.
175) were entered in the 1773-85 catalogue on their
arrival in the Hermitage they were listed as the work
of Jean Le Mer. This attribution stood in all succes-
sive Hermitage inventories and catalogues, as well as
those compiled for the Catherine Palace at Tsarskoye
Selo during the nineteenth and twentieth centuries.
In recent years attempts (largely unsuccessful) have
been made to separate the work of Jean and Pierre Le
Maire, but there is no firm basis to attribute this work
to one rather than the other. Hence this catalogue
retains the traditional attribution.

Ancient Roman sarcophagi with high relief carving
often feature in Le Maire's work (see *Landscape with a
Hermit*, Prado, Madrid; *The Rest on the Flight to Egypt*,
priv. coll., Rome) as was indeed typical of artists
working in Rome. The subject in this instance (a bat-
tle scene) is in keeping with the subject of the paint-
ing. The figures in the picture are by another hand,
perhaps a follower of Pierre Mignard.

Along with cat. no. 175, this work was included in
the appendix to a letter from Alexey Musin-Pushkin
to Empress Catherine, listing works added to the
Walpole sale 'without increasing the previous price'
(SbRIO 17, 1876).

N. S.

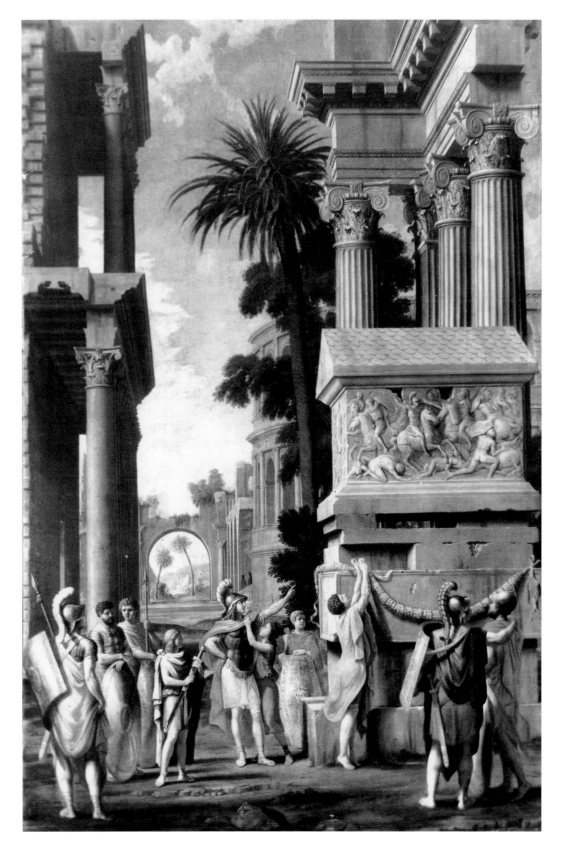

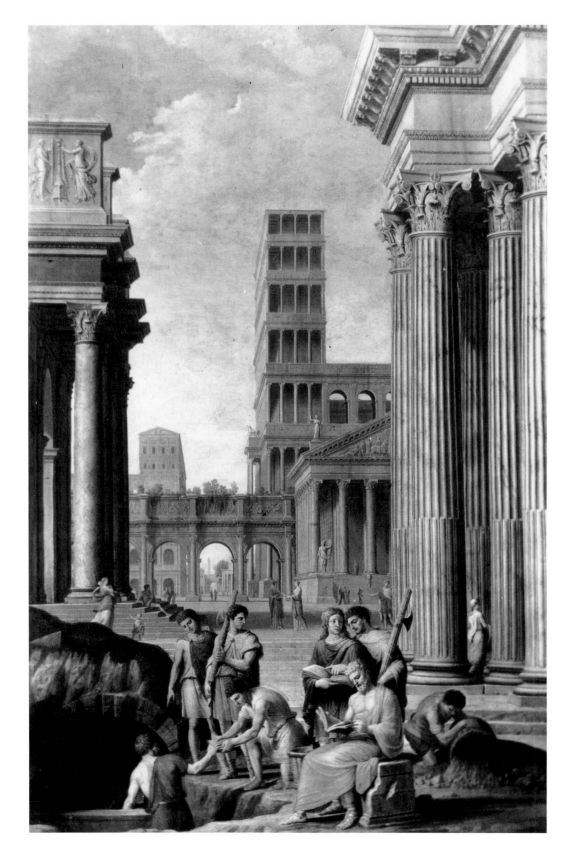

175

JEAN LE MAIRE called LE MAIRE-POUSSIN (1598–1659)
Consulting the Sibylline Oracles
Oil on canvas, 246.75 x 157.75
Tsarskoye Selo State Museum Reserve, Inv. No. 205-X
PROVENANCE: Sir Robert Walpole, 1736 Houghton
(Drawing Room with the Vandyke Hangings, as 'The
Finding of the Books of the Sibyl, by Nicolas
Poussin', then Dressing Room); 1779 Hermitage; in
the 19th century in a dark corridor in the apartments
of the Empress in the Tauride Palace; late 1840s trans-
ferred to the Catherine Palace, Tsarskoye Selo
(undated MS Tsarskoye Selo Inventory s.d., f. 9, no.
5855); autumn 1941 removed by German troops via
Luga, Pskov and Riga to Königsberg, arriving in
April 1942; returned to Tsarskoye Selo from Berlin by
order of 6 January 1948; Catherine Palace, Tsarskoye
Selo (Pushkin), now hangs on the state marble stair-
case.
LITERATURE: *Aedes* 1752, p. 62; 2002, no. 132;
Catherine Palace, 1918, p. 36.

Jean Le Maire (see cat. no. 174) made his name as a
painter of architectural landscapes in which scenes
from history are set against a background of antique
and renaissance structures, many of which have real
prototypes. The temple in the middle plane to the
right of this painting recalls that in Poussin's landscape
The Ashes of Phocion Collected by his Widow (Walker
Art Gallery, Liverpool). Poussin's source was a recon-
struction by Palladio of a temple at Trevi. To the left
of the temple is a structure with an arcade which
repeats a similar architectural motif in *View of an Imag-
inary Palace* by Le Maire (Louvre, Paris). As in *Alexan-
der Adorning the Tomb of Achilles* (cat. no. 174), which
was probably intended as this work's pair, the figures
are by another hand.

N. S.

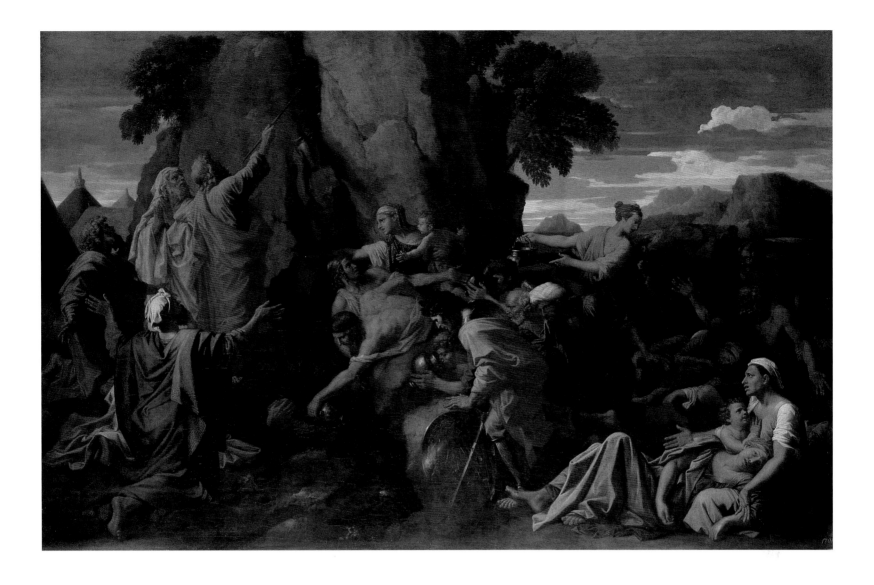

176

NICOLAS POUSSIN (1594-1665)
Moses Striking the Rock
Oil on canvas, 122.5 x 191
Inv. No. 1177

PROVENANCE: 1649 in the possession of the artist Jacques Stella, for whom it was painted; passed to his niece Claudine Bouzonnet–Stella, then to her niece, M. A. Molandier; Sir Robert Walpole, 1728 Arlington St, 1736 Downing St (End Room Below), later Houghton (Gallery); 1779 Hermitage.

LITERATURE: *Aedes* 1752, p. 92; 2002, no. 259; Boydell II, pl. LIII; Le Comte 1699-1700, vol. 3, p. 31; Félibien 1725, vol. 4, pp. 60-61, 91; Baldinucci 1681-1728, vol. VI, p. 102; Bellori 1672, pp. 271-73; Georgi 1794, p. 473 (1996 edition, p. 357); Gilpin 1809, p. 64; Labensky 1805-9, vol. 1, bk. 3, pp. 91-94; Le Breton 1809, p. 397; Landon 1814, no. XX; Delaroche 1819, no. 78; Swignine 1821, p. 61 (Russian edition 1997, p. 263); Schnitzler 1828, p. 69; Chambers 1829, vol. I, p. 536; Smith 1829-42, part VIII, pp. 15-17, no. 28; Livret 1838, p. 172, no. 25; Dussieux 1856, p. 441; Andresen 1863, nos. 57-62; Cats. 1863-1916, no. 1394; Waagen 1864, p. 285; Guiffrey 1877, pp. 18, 42; Clément de Ris 1879-80, part V, p. 263; Fréart de Chantelou 1885, p. 159; Benois [1910], pp. 152-53; Magne 1914, p. 155, no. 149; Friedländer 1914, pp. 91, 120; Grautoff 1914, vol. 1, p. 263; vol. 2, no. 139; Réau 1929, no. 275; Weisbach 1932, p. 92; Gerts 1941, pp. 149-66; Bertin-Mourot 1947, p. 56; Anikiyeva 1947, pp. 67-86; Sayce 1947, p. 246; Vertue, vol. VI, 1948-50, p. 175; Wildenstein 1955, no. 19; Sterling 1957, p. 32, pl. 19; Cat. 1958, vol. I, p. 331; Francastel 1960, p. 206; Lomenie de Brienne 1960, pp. 214, 218, 221; Panofsky 1960, p. 31; Waterhouse 1960, p. 290; Mahon 1962, p. 115; Alpatov 1963, pp. 284-85; Glikman 1964, pp. 69, 71; Friedländer 1965, pp. 53, 61; Blunt 1966, no. 23; Blunt 1967, p. 181 note 18, pp. 257, 258; Thuillier 1974, no. 161; Cat. 1976, p. 223; Zolotov 1979, p. 52; Wild 1980, vol. 1, pp. 148-49; vol. 2, no. 151; Zolotov 1985, p. 13; Zolotov 1988, p. 173; Zolotov, Serebriannaïa et al 1990, no. 33; Schnapper 1994, p. 231; Moore ed. 1996, pp. 59, 64, 133, 149; Brownell 2001, p. 58.

EXHIBITIONS: 1955 Moscow, p. 53; 1956 Leningrad, p. 49; 1960 Paris, p. 117, no. 88; 1978 Düsseldorf, no. 33A; 1981 Vienna, pp. 90-93; 1994-95 Paris, no. 185; 1995 London, no. 185; 2000 Rome; 2000-1 London, no. 20.

Although the story is to be found in the Old Testament, Exodus xvii: 5-6, Kozhina (1981 Vienna, pp. 90-93) thought that Poussin's literary source for this work might have been a translation of the *Judaean Antiquities* of Joseph Flavius, wherein the episode is described as represented in the Hermitage picture. This refers particularly to the fissure in the rocky outcrop and the stream of water which appeared: 'Moise frappa la roche avec sa verge; a l'instant mesme elle le sendit en deux, et il en sortit tres-grande abondance une eau tres claire' (*Histoire des Juifs, écrite par Flavius Joseph, sous le titre des Antiquités Judaiques*, Amsterdam, 1700, bk. III. ch. I, p. 65). The detail of the split in the rock is recorded in a letter from Poussin to Jacques Stella in September 1649 (Poussin Correspondence 1911, pp. 406-7).

The attribution and dating of the picture to 1649, based on Félibien (1725), Bellori (1672) and Baldinucci (1681-1728), have never been doubted. There are preparatory drawings in the Hermitage (OR 13549, OR 18548), the Louvre, Paris (Inv. No. 843) and in the National Museum, Stockholm. A variant of this composition is in the collection of the Duke of Sutherland (on loan to the National Gallery of Scotland, Edinburgh). The painting was copied and engraved on numerous occasions. Blunt (1966) listed nine copies.

N. S.

177

NICOLAS POUSSIN (1594-1665)
The Holy Family with SS Elisabeth and John the Baptist
Oil on canvas, 174 x 134
Inv. No. 1213

PROVENANCE: 1720, possibly coll. comte de Fraula, Brussels (Richardson 1722, p. 6); 1735 acquired by Lord Waldegrave for Sir Robert Walpole; Sir Robert Walpole 1736 Houghton (Work'd Bedchamber/ Embroidered Bedchamber); 1779 Hermitage.

LITERATURE: *Aedes* 1752, p. 64; 2002, no. 241; Boydell II, pl. XVIII; Le Comte 1699-1700, vol. 3, p. 32; Richardson 1722, p. 6; Félibien 1725, p. 64; Gilpin 1809, pp. 49-50; Labensky 1805-9, vol. 1, bk. 2, pp. 47-48; Landon 1814, no. 55; Schnitzler 1828, p. 68; Chambers 1829, vol. I, p. 528; Smith 1829-42, part VIII, pp. 39-40, no. 75; Livret 1838, p. 175, no. 40; C.R. 1856, p. 387; Dussieux 1856, p. 441; Andresen 1863, nos. 129, 130, 131; Cats. 1863-1916, no. 1398; Waagen 1864, p. 286; Fréart de Chantelou 1885, p. 124; Neustroyev 1898, p. 321; Poussin Correspondence 1911, pp. 376, 380, 387, 390, 391, 392, 394, 395, 396, 397, 399, 401, 409, 423, 426, 428, 429, 430, 433, 437, 443; Magne 1914, nos. 242, 249, p. 152; Grautoff 1914, vol. 1, p. 270; vol. 2, no. 132, p. 256; Friedländer 1914, no. 122; Réau 1929, no. 279; Friedländer, Blunt 1939-65, vol. 1, no. 59; Vertue, vol. VI, 1948-50, p. 180; Blunt 1950, p. 40; Blunt 1953, p. 177, pl. 135; Wildenstein 1955, nos. 49-50; Cat. 1958, vol. I, p. 331; Waterhouse 1960, p. 290; Mahon 1962, p. 120; Blunt 1965, p. 70; Friedländer 1965, p. 186; Blunt 1966, no. 56; Blunt 1967, pp. 214, 301; Thuillier 1974, no. 194; Cat. 1976, p. 224; Wild 1980, vol. 1, p. 155; vol. 2, no. 182; Zolotov 1988, p. 193; Zolotov, Serebriannaïa et al 1990, no. 45; Moore ed. 1996, pp. 53, 64, 133; Brownell 2001, p. 45.

EXHIBITIONS: 1956 Leningrad, p. 50; 1983-84 Paris, no. 207; 1990 New York-Chicago, no. 4; 1996-97 Norfolk-London, no. 51.

Sir Robert Walpole almost certainly acquired this painting in Paris through the agency of James, 1st Earl Waldegrave. Waldegrave manuscript sources demonstrate that Walpole was purchasing a work through Lord Waldegrave in 1734-35. Although the correspondence does not mention the title of the Poussin in question, it is evidently a major work for which Sir Robert was prepared to pay £400 in the belief that his was 'the highest price that was ever given for a Picture of Poussin'. Waldegrave wrote to Sir Robert on 16 August 1735: 'I hope that before this time you have received yr Poussin, now it is gone the People that were about it, would give more than you gave for it. I am heartily glad it is yours' (Houghton archives, File Lib. 45, see Moore ed. 1996, p. 133). Walpole finally pid £320. The 1736 inventory records eight paintings by Poussin in Walpole's col-

lection. These included *Moses Strking the Rock* (cat. no. 176) and *The Continence of Scipio* (cat. no. 178).

In the *Aedes* Horace Walpole considered this work 'one of the most Capital Pictures in this collection.' Commissioned by Fréart de Chantelou in 1647, the painting was completed and despatched in 1655. Poussin and Chantelou corresponded for many years and their letters contain frequent references to the work. Blunt (1967) considered this painting typical of Poussin's late style, while Friedländer (1965) noted the undoubted influence of Raphael. Thuillier (1974) emphasised Poussin's move away from the influence of Raphael in the mid-1650s towards a more monumental mode of expression.

A *Holy Family* in the Ringling Museum, Sarasota, Fla., painted slightly earlier, is the closest known version of the Hermitage canvas, but, in keeping with Poussin's style in the second half of the 1650s, the Hermitage painting is striking in its greater balance, majesty and monumentality. There are two preparatory drawings for the Hermitage and Sarasota works in the Hermitage. (OR 5142 and OR 5131 respectively), both dating from the middle and second half of the 1650s. Blunt (1966) lists three copies of the composition, each containing similar figures set in a landscape. One was in the Liechtenstein collection, Vienna (Grautoff 1914, vol. I, p. 271; vol. II, p. 282), and was later sold (Christie's, London, 2 February 1945, lot 82; Sotheby's, London, 17 December 1947, lot 90). Another also passed through Christie's, London, 18 January 1887, lot 866 and again on 29 January 1960, lot 56). A third is in a private collection in London.

N. S.

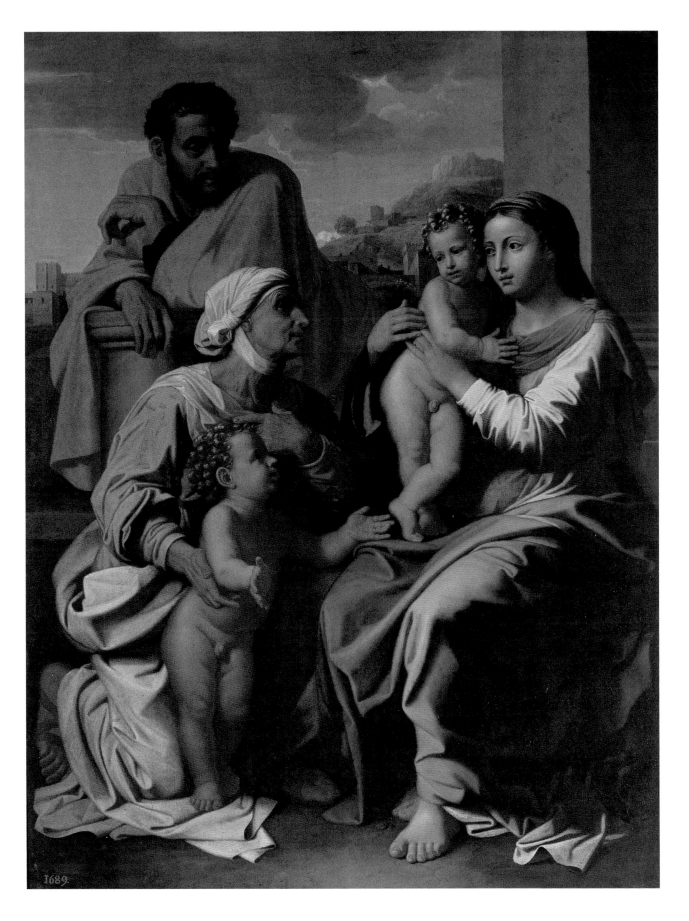

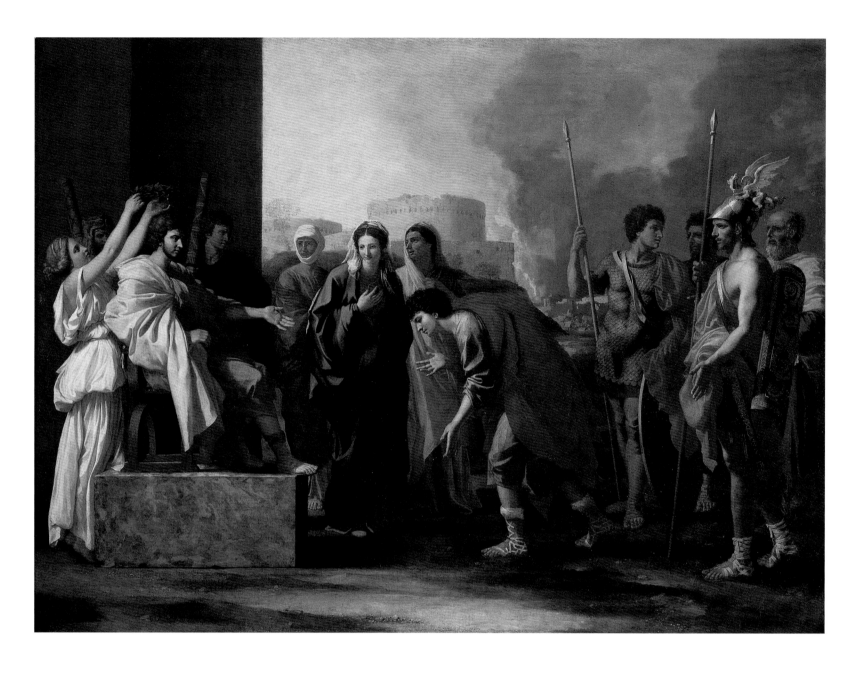

178

Nicolas Poussin (1594-1665)
The Continence of Scipio
Oil on canvas, 114.5 x 163.5
Pushkin Museum of Fine Arts, Moscow, Inv. No. 1048
PROVENANCE: 1640 purchased by Abbot Gian Maria Roscioli (1604-44) of Foligno for 70 scudi; coll. Michel Passart (?1612-94); coll. Charles-Jean-Baptiste Fleuriau, Comte de Morville, French diplomat; Sir Robert Walpole, 1728 Arlington St, 1736 Downing St (Sir Robert's Dressing Room), later Houghton (Gallery); 1779 Hermitage; 1924 transferred to Museum of Fine Arts (now Pushkin Museum of Fine Arts), Moscow.

LITERATURE: *Aedes* 1752, pp. 89-92; 2002, no. 258; Boydell II, pl. LII; Labensky 1805-9, vol. I, bk. 3, pp. 115-18; Gilpin 1809, pp. 63-64; Landon 1809, reproduced table 143; Swignine 1821, p. 61 (Russian edition 1997, p. 263); Reveil 1828-34, vol. 12, p. 864; Schnitzler 1828, pp. 68, 143; Smith 1829-42, part VIII, pp. 92-93, no. 171; Dussieux 1856, p. 440; Cats. 1863-1916, no. 1406; Andresen 1863, nos. 320, 321; Waagen 1864, p. 282; Andreyev 1853-83, vol. 3, p. 103; Grautoff 1914, vol. 1, pp. 222-23; vol. 2, p. 172, no. 107; Friedlander 1914, pp. 80, 117; Magne 1914, p. 199, no. 43; Réau 1929, p. 88, no. 617; Alpatov 1960, p. 193; Waterhouse 1960, p. 290; Pushkin Museum 1961, p. 152; Nersesov 1961, no. 2, p. 34; Prokof'yev 1962, p. 6; Mahon 1962, pp. 119, 134; Blunt 1966, no. 181; Blunt 1967, pp. 161, 257, pl. 153; Yerkhova 1971, pp. 130-33; Thuillier 1974, no. 135, p. 102; Barroero 1979, pp. 70, 72 note 4, 73 note 9, fig. 2; Michalkowa 1980, p. 46, fig. 64; Kouznetsova, Gueorguievskaia 1980, no. 442, pl. 3; Wild 1980, vol. 2, no. 109; Kuznetsova 1982, p. 169; Blunt 1982, p. 707; Zolotov 1986, p. 64; Pushkin Museum 1986, p. 143; Zolotov 1988, p. 235; Pears 1988, p. 263, no. 70; Thuillier 1988, pp. 153, 176; Wright 1989, no. 135, p. 203; Zolotov, Serebriannaïa et al 1990, no. 19, pp. 128-29; Schnapper 1994, p. 240; Pushkin Museum 1995, p. 286.

EXHIBITIONS: 1955 Moscow, p. 52; 1956 Leningrad, p. 49; 1982 Moscow, no. 22; 1994-95 Paris, no. 96, pp. 290-91.

The subject derives from Titus Livius, *Ad Urbe Condita*, XXV, L.

Although traditionally dated to the mid-1640s, the period after the artist's return to Rome from Paris, the discovery of new documents by Liliane Barroero in archives in Foligno and Rome (Barroero 1979) revealed a more precise dating and identified the picture's original owner as Gian Maria Roscioli, secretary to Pope Urban VIII. It appears from the inventory of the Roscioli collection, published by Barroero, that a *Continence of Scipio* of the same dimensions as the Walpole painting was acquired in 1640, i.e. before the artist departed for Paris.

Before it entered the Walpole collection it belonged to the financier Michel Passart, one of Poussin's most ardent French admirers, whose acquaintance he made during his stay in Paris.

We know of only one preparatory drawing for the painting, although its present location is unknown (reproduced in 1994-95 Paris, fig. 96 b). A drawing of the same subject in the Musée Condé, Chantilly (1994-95 Paris, no. 287), previously associated with the painting, was undoubtedly produced later. A preparatory drawing once thought to relate to the figure of Glory crowning Scipio (Hermitage, Inv. No. OR 5148) is not in fact a study but a copy from the painting.

Three copies of the painting are known; by John Smibert (1688-1751), dating from the early 1720s at Bowdoin College Museum of Art, Brunswick, Maine; one sold at Sotheby's, London, 31 October 1979, lot 141 and another sold at Christie's, New York, 10 October 1990, lot 35.

Ye. Sh.

179

JACQUES STELLA (1596-1657)
Solomon's Idolatry
?Oil on black marble, 58.5 x 73.5
Inv. No. 2130
PROVENANCE: Sir Robert Walpole, 1736 Downing St (Lady Walpole's Drawing Room), later Houghton (Gallery); 1779 Hermitage.
LITERATURE: *Aedes* 1752, p. 93; 2002, no. 266; Gilpin 1809, pp. 64-65.

When William Gilpin saw the picture at Houghton he described it (Gilpin 1809) as 'painted on black, and gold marble; which is, in many parts, left as the ground; and gives a great richness to the picture. - The characteristic of this piece is elegance, which is displayed in the whole, and in every part.'

Although listed in the 1773-85 catalogue and the 1797 catalogue as the work of Jacques Stella, the 1859 inventory described it as Flemish school and this was how the work was entered in the current inventory (begun c.1928), which also mistakenly gives the subject as *Sacrifice to Diana*.

The subject of *Solomon's Idolatry* is found in Kings I, xi: 8.

N. S.

Not reproduced

180

JEAN-BAPTISTE VANLOO (VAN LOO) (1684-1745)
Sir Robert Walpole
Oil on canvas, 229 x 143, signed and dated bottom right, on the base of the column: *f. p. J.B.Vanloo 1740*, coat of arms and motto left on the purse of office
Inv. No. 1130
PROVENANCE: Sir Robert Walpole, Houghton (Blue Damask Bedchamber, over the Chimney); 1779 Hermitage; from the mid-19th century to 1920 at Gatchina Palace; 1920 returned to the Hermitage.
LITERATURE: *Aedes* 1752, p. 50; 2002, no. 60; Boydell II, frontispiece; Dezallier d'Argenville 1745-52, vol. 3, p. 275; Georgi 1794, p. 479 (1996 edition, p. 461); Houssaye 1842, p. 498; Nagler 1835-52, vol. 19, p. 372 (Faber); SbRIO 17, 1876, p. 400; Trubnikov 1914, pp. 88-90, 98; Miller 1923, p. 65; Ernst 1928, p. 244; Réau 1929, no. 360; Vertue, vol. III, 1933-34, pp. 97, 109; Nemilova 1982, no. 25; Nemilova 1985, no. 281; Moore ed. 1996, pp. 83-84.

Sir Robert Walpole is depicted wearing the robes of the Lord Chancellor. In his right hand he holds his purse of office and he wears the insignia of the Order of the Garter, of which he was a Knight from 1726. When this portrait was painted in 1740 Walpole had not yet been enobled: he was created 1st Earl of Orford in February 1742.

Writing in 1738, Vertue (vol. III, 1933-34, pp. 83-84, 97) remarked on Vanloo's success in England and noted how highly the artist was praised by Sir Robert Walpole during work on another portrait of him: 'Sr Robt. Walpole having had one picture drawn of himself by Vanlo, lately since the death of Mr. Jarvis. sat to him for another (at whole len:) in the Conversation whilst sitting mention was made of the death of the Kings principal painter and Sr. Robt. made Vanlo this Compliment. that he so well likd and approvd of his painting that if it had not been for an Act of Parliament that prevents Foreigners of any Nation to have or enjoy places of Salary in the Government. he woud have presented him with the place of Kings Painter. this Mr. Vanlo said'.

In 1742, Vertue (vol. III, 1933-34, p. 109) mentioned an engraving by John Faber junior from Vanloo's portrait: 'Mr. Faber has lately finisht a large whole len. print of Sr. Rob.t Walpole in his robes. & holding the purse from a painting of Monsr. Vanlo.'

Andrew Moore (Moore ed. 1996) lists a number of known versions of this portrait at Lyme Park, Cheshire and at Lambeth Palace in London. Reduced versions are at Hampton Court Palace; Chequers, and Chatsworth and there is a half-length studio version in the National Portrait Gallery, London. A third type, derived from the prime version of Vanloo's portrait, is still in the Walpole family collection and a quarter-length version remains at Houghton Hall.

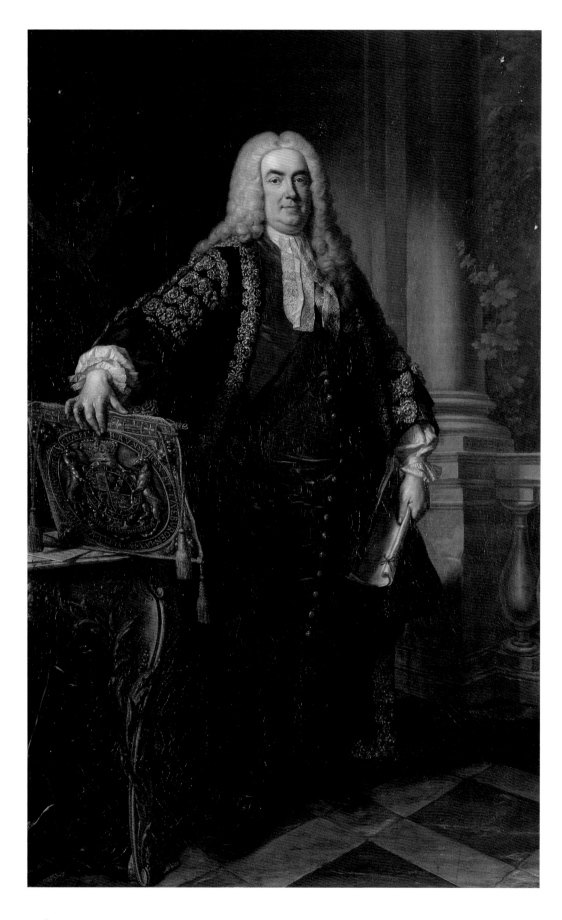

Given the disparity in scale, there is no foundation for the suggestion made in Hermitage catalogues that Vanloo's portraits of Sir Robert Walpole and Maria Skerrett (cat. no. 228) were a pair.

This portrait is mentioned in the appendix to a letter from Alexey Musin-Pushkin, Russian ambassador in London, to the Empress Catherine, among those works added to the Walpole sale 'without increasing the previous price' (SbRIO 17, 1876).

E. D.

Spanish School

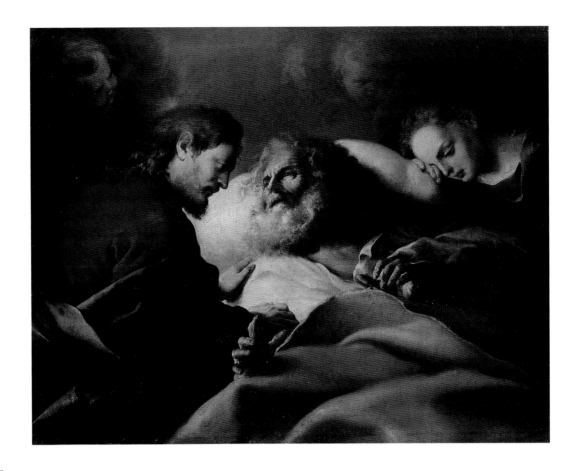

181

ALONSO CANO (1601-67), attributed to
The Death of St Joseph
Oil on canvas, 98 x 149.5
Inv. No. 1466
PROVENANCE: Sir Robert Walpole, 1736 Downing St
(Lady Walpole's Drawing Room, by 'Velasco'), later
Houghton (Cabinet); 1779 Hermitage.
LITERATURE: *Aedes* 1752, p. 71 (as by 'Velasco'); 2002,
no. 188; Boydell II, pl. XIV; Georgi 1794, p. 472
(1996 edition, p. 357); Gilpin 1809, p. 54; Hand 1827,
p. 366; Schnitzler 1828, p. 112; Chambers 1829, vol.
I, p. 531; Livret 1838, pp. 427-28; Viardot 1844, p.
463; Stirling-Maxwell 1848, vol. 3, p. 1394; Curtis
1883, p. 12, no. 19-a; Justi 1888, vol. 1, p. 150; Cat.
1958, vol. I, p. 144; Kagané 1987a, pp. 15, 17, 22, no.
13; Kagané 1994b, p. 10; Moore ed. 1996, p. 136.

Doubts about the attribution to Velázquez given in the
Aedes were first expressed by Viardot (1844) and the
painting was not included by Koehne in the 1863 cata-
logue. Waagen (1864) omitted the painting from his
book on the Hermitage Picture Gallery while Curtis
(1883) also rejected the attribution to Velázquez. Since
the later nineteenth century the picture has been listed
with unidentified works and has been ignored by schol-
ars. In the 1958 catalogue it was listed as the work of an
unidentified seventeenth-century Italian master but
was omitted altogether from the 1976 catalogue.

The painting certainly has no connection with the
work of Velázquez, but its high quality suggests that it
is the work of an outstanding hand. The composition,
use of colour and similar physical types can be found
in the work of Alonso Cano whose paintings are
often mis-attributed to Velázquez. The figure of
Christ in particular is close to Cano's *Dead Christ Sup-
ported by Angels* (1646-52, Prado, Madrid, Inv. No.
2637), *Christ After the Flagellation* (c.1646, Real Acad-
emia de Bellas Artes de San Fernando, Madrid) and a
number of other images, including *Christ and the
Woman of Samaria* (c.1650-52, Real Academia de Bel-
las Artes de San Fernando, Madrid). Attention should
also be drawn to the likeness between the Samarian
woman's face in the latter painting and that of Mary
in the Hermitage picture. Such small features as the
swelling over the eyelids and the dimples on the tem-
ples are typical of Alonso Cano and can be seen in his
Virgin and Child of c.1657-60 (Diputación [Regional
Council], Guadalajara). The figure of St Joseph,
meanwhile, recalls his *St Paul* of 1654-60 (Galerie
Alte Meister, Dresden). The angels also recall works
by Alonso Cano (*Holy Family*, 1653-57, Convento del
Angel Custodio, Granada). Cano liked to show fig-
ures daringly foreshortened, projecting out towards
the viewer, just as St Joseph is depicted in the Her-
mitage painting, and he repeated the gesture of an
outstretched hand particularly frequently (*St John the
Evangelist*, 1635, Museo del Arte Cataluña, Barcelona;
St John the Evangelist, 1635-37, Louvre, Paris; etc.).
These comparisons suggest that *The Death of St Joseph*
can be confidently attributed to Alonso Cano.

During his Seville period, Cano worked in the tene-
broso manner, whereas in Madrid he grew to be partic-
ularly interested in the Venetian painters, mastering
their multicoloured palette and free brushwork. The
Hermitage picture contains echoes of the former style
in the sharp contrasts of light and shade, the thick paint-
ing of Christ's robes and the folds of the blanket in the
foreground, but the central figures are painted more
softly and the combination of colours—dark blue, red
and yellow—employs a gradation of hues which allows
us to date the picture to c.1646-52, the artist's mature
period, when he was working in Madrid.

Curtis (1883) mentioned a drawing for this compo-
sition, attributed to Velázquez, in the Louvre.

The subject derives from the *History of Joseph the
Carpenter*, XIX.

L.K.

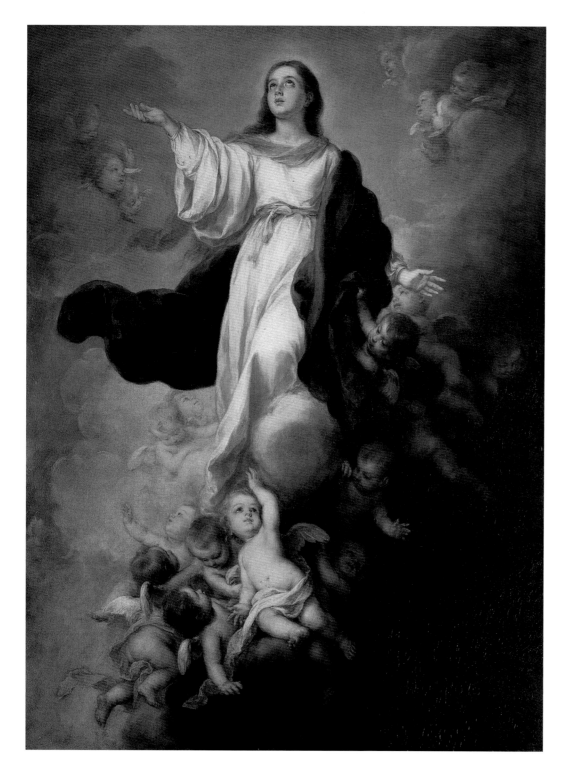

182

BARTOLOMÉ ESTEBÁN MURILLO (1617-82)
The Immaculate Conception
Oil on canvas, 195 x 145
Inv. No. 387

PROVENANCE: Sir Robert Walpole, 1736 Houghton
(Saloon); 1779 Hermitage.

LITERATURE: *Aedes* 1752, p. 56 (as 'The Assumption
of the Virgin… by Morellio'); 2002, no. 92; Boydell
I, XXV; Vertue, vol. VI, 1948-50, p. 178; Hand 1827,
p. 373; Schnitzler 1828, p. 114; Chambers 1829, vol.
I, p. 526; Livret 1838, pp. 415, 416; Viardot 1844, p.
465; Cats. 1863-1916, no. 371; Tubino 1864, p. 217;
Waagen 1864, p. 110; Dalton 1869, pp. 26, 36, 40-45;
SbRIO 17, 1876, p. 398; Bode 1882, vol. II, p. 14;
Curtis 1883, p. 140, no. 54; Justi 1892, p. 52; Lefort
1892, p. 72, no. 52; Beruete 1904, pp. 40, 41; Benois
[1910], pp. 138, 139; Mayer 1913, p. 167; Tormo y
Monsó 1914, pp. 205-7; Mayer 1922, p. 339; Schmidt
1926a, pp. 23-28; Mayer 1934, p. 14; Lafuente Ferrari
1953, p. 345; Lepicier 1956, p. 144; Cat. 1958, vol. I,
p. 237; Gaya Nuño 1958, p. 853, no. 1974; Levina
1969, p. 14; Maclaren, Braham 1970, p. 78; Cat. 1976,
p. 169; Brown 1976, p. 112; Kagané 1977, pp. 97-99;
Haraszti-Takács 1977, p. 10; Kagané 1978, p. 44;
Angulo Iñiguez 1988, vol. 1, pp. 415, 416; vol. 2, p.
142, no. 141; vol. 3, pl. 367; Braham 1981, pp. 10, 11;
Levinson-Lessing 1986, p. 186; Kagané 1987a, pp.
264, 266; Kagané 1987b, pp. 15, 22, no. 15; Kagané
1988, p. 10; Kagané 1994a, p. 256; Kagané 1994b, p.
10; Kagané 1995, pp. 22, 30, 148-55, no. 18; Moore
ed. 1996, p. 100; Kagané 1997, no. 64.

EXHIBITIONS: 1984 Leningrad, no. 30; 1996 Tokyo-
Mito-Tsu, no. 44; 1997 Bonn, pp. 156-57, no. 39.

The first recorded doubt as to the title given in the
Aedes, *The Assumption of the Virgin*, seems to appear in
the 1744 manuscript inventory of the paintings at
Houghton (HRO MS 1744), in which Horace Wal-
pole recorded his surprise at the apparent youth of the
Virgin Mary in the representation of such a subject
(Moore ed. 1996). Nonetheless, the traditional title
remained in force in all Hermitage catalogues and in
the literature, despite suggestions long ago by a num-
ber of authors that it should be 'The Immaculate
Conception'. In the eighteenth and nineteenth cen-
turies, works on the two subjects were often con-
fused, to such an extent that Louis Viardot wrote of
'les Assomptions (qu'on appelle plus communement
Conceptions, en Espagne)' (*Notice sur les principaux
peintres de l'Espagne*, Paris 1830, p. 41). Spanish art his-
torians A. Beruete (1904) and E. Tormo y Monsó
(1914) united in calling the picture *The Immaculate
Conception*, Beruete stating specifically that this paint-
ing was 'mistakenly seen as an *Assumption* in the Her-
mitage'. His opinion is indeed indisputable (Kagané
1995, 1997).

In Spain, the Immaculate Conception was a particularly common subject. As Francisco Pacheco wrote in *Arte de la pintura* (1649, pp. 576-77) the image 'should accord ... with the revelations of the Evangelist, confirmed by the Catholic Church and the authorities of the saints. ... In this purest mystery the Madonna should be painted in the bloom of her youth, between twelve and thirteen years of age, as a charming young girl with beautiful and serious eyes, mouth and nose of perfect form, with pink cheeks, marvellous golden hair let down, overall, as beautiful as can be shown with the brush. ... She should be painted in a white tunic and blue robe. ... She is illuminated by the sun ... crowned with the stars ... the moon beneath her feet. ... Usually God the Father or the Holy Spirit, or both, are shown at the top of the painting, with the words ... Tota pulchra est anima mea. The attributes of the land are introduced on the earth as they should be, and the heavenly, if such is wished, amongst the clouds. The painting is adorned with seraphim and angels full length, holding some attributes. ... But painters may improve on anything which I have mentioned.'

Murillo did not deviate much from Pacheco's instructions, although he did not adhere too strictly to them and, during his later period, he omitted many of the attributes of the subject. Around 1678 he painted a version of the subject for the Seville hospital Los Venerables Sacerdotes (now Prado, Madrid, Inv. No. 2809) where he included the moon but omitted all the other symbols of the Inmacculada. Both the figure and the overall composition of this work are very close to the Hermitage picture, except for a variation in the Virgin's gesture and the placement below the knee of the moon swathed in cloud. Further similarities in style suggest a date of c.1680 for the Hermitage picture.

Mayer (1934) suggested that a drawing in the Kunsthalle, Hamburg, is a preparatory work for the Hermitage canvas although this has been challenged by Angulo Iñiguez (1981), who noted that neither the Virgin's face nor her gesture are comparable in drawing and painting.

Unusually, this picture remains in the William Kent-designed frame in which it hung in the Walpole collection. Similar frames are shown in two drawings by Kent, dating from 1725, with suggested plans for hanging the paintings in the Saloon at Houghton (see endpapers to this publication).

In the *Aedes* this painting is described as forming a pair with *The Adoration of the Shepherds* (cat. no. 183).

L. K.

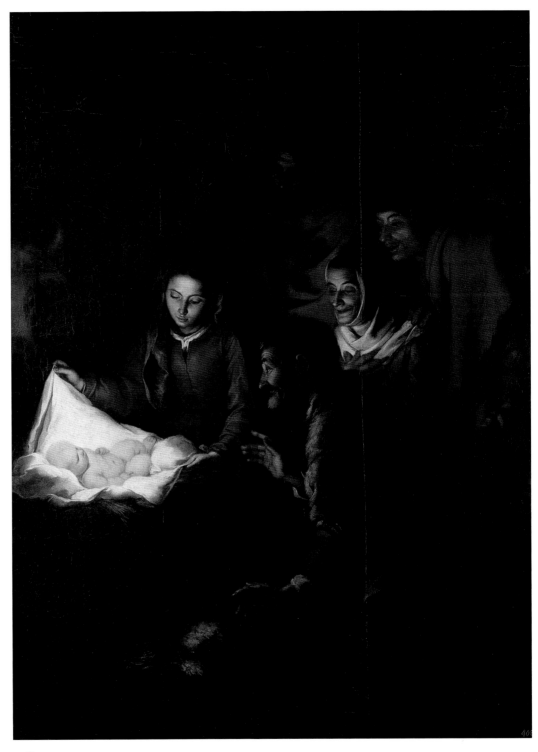

183

BARTOLOMÉ ESTEBÁN MURILLO (1617-82)
The Adoration of the Shepherds
Oil on canvas, 197 x 147
Inv. No. 316
PROVENANCE: Sir Robert Walpole, 1736 Houghton (Saloon); 1779 Hermitage.

LITERATURE: *Aedes* 1752, p. 56; 2002, no. 93; Boydell I, pl. XXIV; Vertue, vol. VI, 1948-50, p. 178; SbRIO 17, 1876, pp. 397, 398; Hand 1827, p. 375; Chambers 1829, vol. I, p. 526; Schnitzler 1828, p. 114; Livret 1838, p. 427; Viardot 1844, p. 465; Somov 1859, p. 72; Cats. 1863-1916, no. 363; Tubino 1864, p. 218; Waagen

1864, p. 109; Blanc et al 1869, Murillo, p. 16; Stromer 1879, p. 107; Curtis 1883, pp. 165, 166, no. 122; Justi 1892, p. 12; Lefort 1892, p. 76, No 120; Benois [1910], p. 138; Benois 1912, vol. IV, p. 90; Schmidt 1926a, pp. 6-8; Cat. 1958, vol. I, p. 237; Angulo Iñiguez 1964, p. 279; Braham 1965, p. 445; Levina 1969, p. 7; Cat. 1976, p. 169; Kagané 1977, pp. 91-92; Angulo Iñiguez 1981, vol. 1, pp. 283, 284; vol. 2, no. 219; vol. 3, pl. 63; Vyazmenskaya 1987, pp. 51-52; Kagané 1987a, pp. 264, 266; Kagané 1987b, pp. 15, 24, no. 16; Kagané 1988, p. 6; Kagané 1989, no. 176, p. 390; Kagané 1994a, p. 256; Kagané 1994b, p. 9; Kagané 1995, pp. 12, 30, 64-68, no. 2; Kagané 1997, no. 51.

EXHIBITIONS: 1984 Leningrad, no. 15; 1996 Tokyo-Mito-Tsu, no. 40.

The painters of Seville were given guidance on this subject by Francisco Pacheco's book *Arte de la Pintura* (1649). In describing how the Child should be depicted, the author mentioned two types: the Child lying naked on the ground with the Virgin Mary, Joseph and the angels kneeling before him, or the Child resting in a manger, gazed upon by shepherds, with animals close by. Pacheco particularly insisted that at the moment of the shepherds' arrival the Child should be swaddled, as mentioned in the Gospel According to St Luke, but he also notes that artists preferred to paint the Child naked, since 'thus could they best convey poverty' and 'the naked child is more beauteous than the swaddled' (Pacheco 1649, p. 604). In the Hermitage picture, the viewer's attention is drawn by the bright light emanating from the Child in the dark, a phenomenon which might have been suggested by the description of this scene in the Protevangelium of James XIX: 'And the cave was suddenly filled with a glow so bright that the eyes could not look upon it, and when this light gradually faded away, he saw a Child.'

The attribution of the work to Murillo is traditional and the painting was catalogued under Murillo's name in the Hermitage until 1912, after which doubt was expressed by Mayer (1913) and Schmidt (1926a). In the 1958 catalogue it was listed as school of Murillo, but Angulo Iñiguez (1964, 1981) and Braham (1965) insisted that the painting was the work of Murillo himself and the full attribution was restored in the 1976 catalogue. Murillo's authorship may have been doubted because of the cracking of the paint surface, not usually found in the artist's works, but this is in fact the result of previous restoration.

Similar in style to the Hermitage painting are *Angels' Kitchen* (1646, Louvre, Paris) and particularly *The Last Supper* (c.1650, Church of Santa Maria la Blanca, Seville) which both employ the strong use of light and shade characteristic of the artist's early period. The picture was first given an early date by Waagen (1864) and Curtis (1883) and more recently Angulo Iñiguez (1981) has convincingly dated it to c.1650.

In the *Aedes*, The Adoration of the Shepherds was thought to form a pair to the so-called *Assumption* (*Immaculate Conception*, cat. no. 182) but given the considerable difference in style and dating this notion seems untenable. A version of the *Adoration of the Shepherds* close in date to the Hermitage picture but horizontal in format is in the Prado, Madrid (1655-60, Inv. No. 961).

The painting has survived in the William Kent-designed frame in which it arrived from the Walpole collection (see also cat. no. 182).

L.K.

184

?BARTOLOMÉ ESTEBÁN MURILLO (1617-82)
The Virgin and Child
Oil on black marble, 30.4 x 24.3
PROVENANCE: Benjamin Keene (ambassador at Madrid); Sir Robert Walpole, Houghton (Cabinet); 1779 Hermitage; 1799 transferred to Gatchina Palace; before 1827 moved to Pavlovsk Palace; disappeared during the Second World War; whereabouts unknown.
LITERATURE: *Aedes* 1752, p. 69 (as 'The Virgin with the Child in her Arms, by Morellio'); 2002, no. 166; Chambers 1829, vol. I, p. 530; SbRIO 17, 1876, p. 398; Curtis 1883, p. 160, no. 12s; Angulo Iñiguez 1981, vol. 2, p. 398, no. 1012; Kagané 1987a, p. 266; Kagané 1987b, pp. 15, 17, 22, no. 14; Kagané 1995, p. 30; Moore ed. 1996, p. 53.

Although listed in the *Aedes* as an original by Murillo, this painting was entered in a manuscript catalogue of Pavlovsk Palace as the work of an unknown eighteenth-century Spanish artist (V. P. Zubov, 'Kriticheskiy katalog Pavlovskogo dvortsa-muzeya' [Critical Catalogue of Pavlovsk Palace Museum], Leningrad, 1926; Manuscript Department of the Russian National Library, St Petersburg, Fund 1000, *Opis*' 2, ed. khr. 511).

This small marble panel was presented to Robert Walpole by Benjamin Keene, who was in Madrid as agent for the South Sea Company and later (1724-39) as consul and plenipotentiary minister.

L. K.

Not reproduced

185

BARTOLOMÉ ESTEBÁN MURILLO (1617-82)
The Flight into Egypt
Oil on canvas, 101 x 62
Pushkin Museum of Fine Arts, Moscow, Inv. No. 2671
PROVENANCE: Sir Robert Walpole, 1736 Houghton (Green Velvet Drawing Room, then Carlo Maratt Room); 1779 Hermitage; 1930 transferred to the Museum of Fine Arts (now Pushkin Museum of Fine Arts), Moscow.
LITERATURE: *Aedes* 1752, p. 61; 2002, no. 123; Boydell I, pl. XLV; Vertue, vol. VI, 1948-50, p. 179; Hand 1827, p. 381; Livret 1838, p. 413; Viardot 1844, p. 465; Stirling-Maxwell, 1848, vol. 3, p. 1424; Somov 1859, p. 72; Cats. 1863-1916, no. 368; Waagen 1864, p. 110; Bode 1882, vol. X, p. 8; Curtis 1883, p. 168, no. 129; Neustroyev 1898, p. 128; Wrangell 1909, p. 50; Benois [1910], pp. 136, 139; Mayer 1913, pp. 52, 182; Malitskaya 1947, p. 173; Pushkin Museum 1948, p. 55; Pushkin Museum 1957, p. 100; Gaya Nuño 1958, p. 255, no. 1994 (location mistakenly given as Hermitage); Pushkin Museum 1961, p. 134; Haraszti-Takács 1978, p. 10; Gaya Nuño 1978, p. 110, no. 280; Angulo Iñiguez 1981, vol. 1, p. 420; vol. 2, p. 211, no. 233; vol. 3, pl. 318; Haraszti-Takács 1982, p. 64; Pushkin Museum 1986, p. 128; Kagané 1987a, p. 266; Kagané 1987b, pp. 15, 24, no. 17; Kagané 1988, p. 9; Kagané 1994b, p. 11; Kagané 1995, pp. 12, 30-31, 132-35, no. 15; Pushkin Museum 1995, p. 230.
EXHIBITIONS: 1984 Leningrad, no. 29; 1990-91 Sapporo-Tokyo-Kyoto-Fukuoka, no. 55; 1998 Moscow (not in catalogue).

In the Walpole collection this work was thought to form a pair with *The Crucifixion* (cat. no. 186), which Kagané (1995) suggests is supported not only by the similar dimensions (101 x 62 compared with 98 x 60.2), but also by the noticeably similar colour range. In compositional terms, however, the distribution of masses and colour accents are markedly different. After their arrival in Russia the canvases were re-lined using lead white (instead of glue) making X-ray analysis very difficult.

The subject of the flight into Egypt seems first to appear in Murillo's oeuvre in the mid-1640s (Galleria di Palazzo Bianco, Genoa). In this picture the figures occupy virtually the entire canvas and are characterised by a strongly emphasised sense of movement. The painting is large (205 x 161), and was possibly a studio work. Another *Flight into Egypt* in Budapest (Museum of Fine Arts, Inv. No. 775) is thought to form a pair with the *Holy Family with the Young John the Baptist* in the same museum (Inv. No. 779) and is dated between 1660 and 1670. Certainly the two works reveal some care in co-ordinating the placement of the figures and have similar dimensions (155.5 x 125 and 156 x 126 respectively).

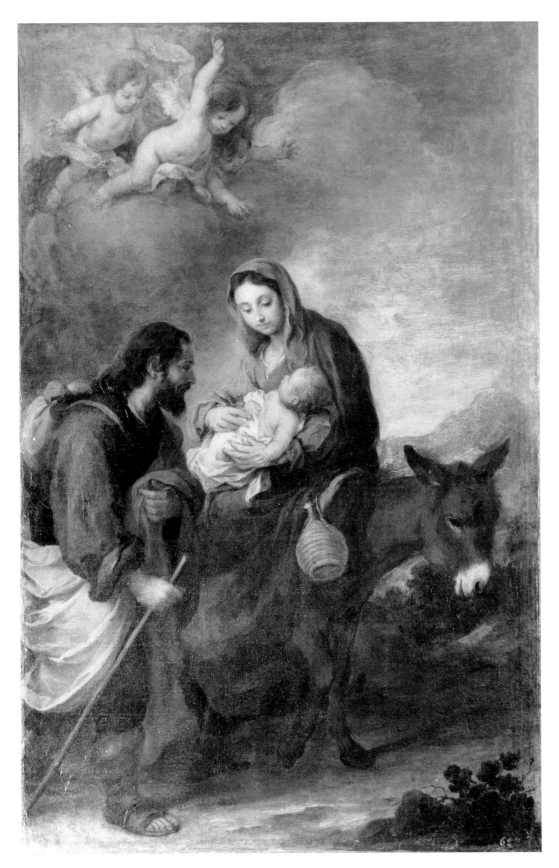

The Budapest *Flight into Egypt* is close to the variant in Moscow, but the latter is considerably reduced in size, making it more intimate in tone. The pose of the Child, who in the Budapest work is shown seated facing the viewer, has changed, the group of flying angels is in a different place, and the poses of Mary and Joseph also differ slightly from those in the Budapest painting. A more important role is played by the landscape, which now serves specifically to enhance the atmospheric and spatial conditions and results in the Moscow canvas evoking a marvellously poetic mood characteristic of the artist's late period. Mayer (1913) convincingly dated the Moscow work to 1675-82.

A mid-nineteenth-century copy of the Moscow work (smaller by 7cm on the vertical dimension) was on the Moscow art market in 1999.

This work was engraved by J. Spilsbury in 1778.

O. N.

186

BARTOLOMÉ ESTEBÁN MURILLO (1617-82)
The Crucifixion
Oil on canvas, 98 x 60.2, inscription at the top on the Cross: *INRI*
Inv. No. 345

PROVENANCE: Sir Robert Walpole, 1736 Houghton (Green Velvet Drawing Room/Carlo Maratt Room); 1779 Hermitage.

LITERATURE: *Aedes* 1752, p. 61; 2002, no. 124; Boydell I, pl. XLVI; Vertue, vol. VI, 1948-50, p. 179; Hand 1827, p. 374; Chambers 1829, vol. I, p. 528; Livret 1838, p. 413; Viardot 1844, p. 465; Somov 1859, p. 72; Cats 1863-1916, no. 370; Waagen 1864, pp. 109, 110; SbRIO 17, 1876, p. 398; Stromer 1879, p. 107; Curtis 1883, pp. 201, 202, no. 214; Lefort 1892, p. 82, no. 211; Mayer 1913, p. 185; Mayer 1922, p. 335; Schmidt 1926a, p. 28; Cat. 1958, vol. I, p. 237; Bazin 1958, p. 232, note 148; Gaya Nuño 1958, p. 255, no. 1996; Levina 1969, p. 29; Cat. 1976, p. 170; Angulo Iñiguez 1981, vol. 2, pp. 454-55, no. 1623; vol. 3, pl. 571; Kagané 1987b, pp. 15, 24, no. 18; Kagané 1988, p. 9; Kagané 1994b, p. 11; Kagané 1995, pp. 30-31, 136-41, no. 16; Kagané 1997, no. 61.

EXHIBITIONS: 1969 Travelling, pp. 5, 6, 14; 1984 Leningrad, no. 28; 1991 Seoul, no. 48.

The attribution to Murillo gave rise to no doubts until Angulo Iñiguez (1981) recently re-attributed the painting to school of Murillo.

The Crucifixion arrived in the Hermitage with *The Flight into Egypt* (Pushkin Museum of Fine Arts, Moscow, cat. no. 185), which was perceived as its pair. Works were often grouped in pairs quite by chance in the eighteenth century, and this in no way confirms that the works were originally conceived as

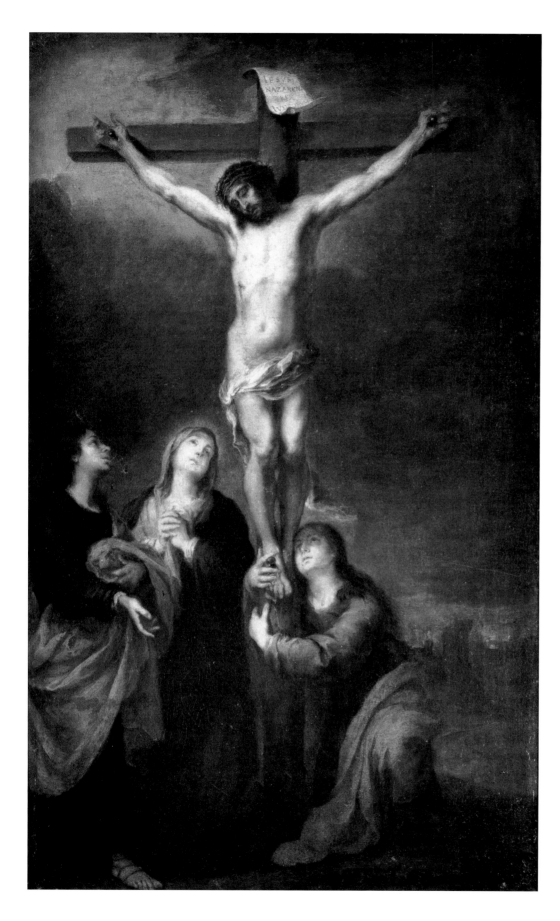

such by the artist. In the case of *The Crucifixion* and *The Flight into Egypt*, however, the two paintings are stylistically close, the manner of depicting landscape and folds of drapery is similar on both, and they would seem to have been painted for the same cycle at the same time. Another Hermitage picture by Murillo, *St Joseph Leading the Christ Child by the Hand* (Inv. No. 336), is also close in style to *The Crucifixion*, in which Christ's body is treated just as in a *Crucifixion* in the Prado, Madrid (Inv. No. 967), which raises no doubts regarding authorship.

Although the picture has suffered seriously from restoration, such parallels with other authentic works of Murillo permit no other conclusion than that this is a genuine work of the artist. Even as the painting was being acquired from Lord Orford, the Russian ambassador in London, Alexey Musin-Pushkin, wrote to Catherine II that 'Morel's Crucifixion is much blackened' (SbRIO 17, 1876). Later the paint surface was seriously damaged by cleaning.

A version of *The Crucifixion* (Meadows Museum, Dallas, Texas), close to that in the Hermitage, is also attributed by Angulo Iñiguez to school of Murillo.

Viardot (1844) placed the Hermitage work in Murillo's first period whilst Mayer (1913), on the contrary, dated it to 1675–82. The latter opinion is generally accepted in the literature and indeed, the small scale figures, the soft outlines and airy landscape background confirm a late dating for the work, c.1675.

L.K.

187

DIEGO VELÁZQUEZ (1599-1660), circle of
Pope Innocent X
Oil on canvas, 49.2 x 41.3
National Gallery of Art, Washington, Inv. No. 1937.1.80

PROVENANCE: 1725/26 acquired for Sir Robert Walpole by Andrew Hay for 11 guineas at a sale of paintings (Pears 1988, p. 87); Sir Robert Walpole, 1736 Downing St (Sir Robert's Dressing Room), later Houghton (Cabinet); 1779 Hermitage; 1930 acquired by Andrew Mellon, Pittsburgh and Washington; 1937 A. W. Mellon Educational and Charitable Trust, Pittsburgh; National Gallery of Art, Washington.

LITERATURE: *Aedes* 1752, p. 67 (as by 'Velasco'); 2002, no. 153; Boydell I, pl. XXXI; Vertue, vol. VI, 1948-50, p. 175; Gilpin 1809, p. 51; Hand 1827, p. 364; Schnitzler 1828, p. 114; Chambers 1829, vol. I, p. 530; Livret 1838, pp. 409-10; Viardot 1844, p. 463; Stirling-Maxwell 1848, vol. 3, p. 1402; Cats. 1863-

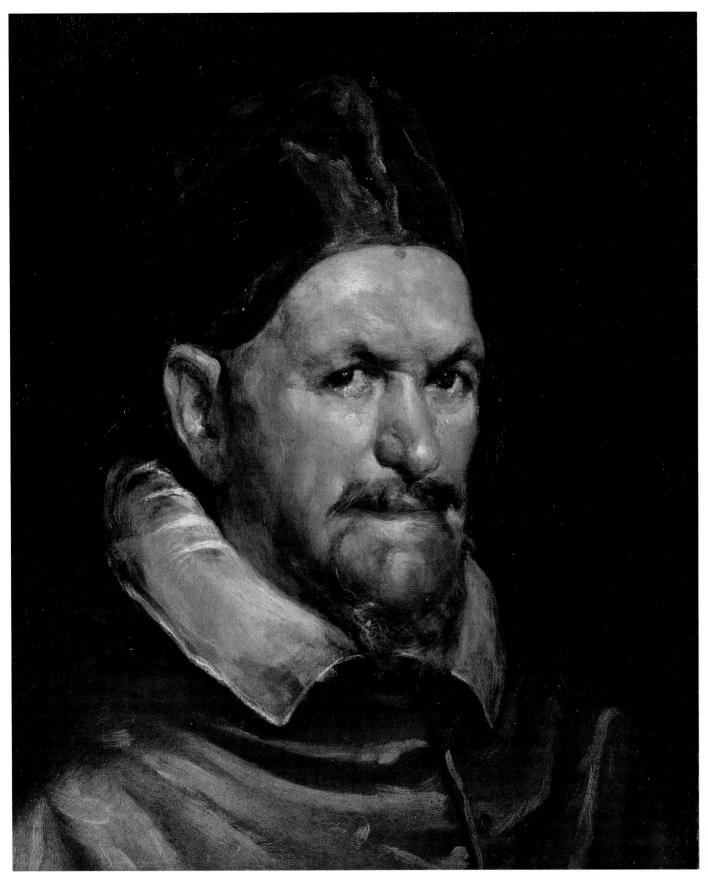

1916, no. 418; Waagen 1864, p. 106; Blanc et al 1869, Velazquez, p. 16; Clément de Ris 1879-80, part II, p. 347; Bode 1882, vol. II, p. 6; Curtis 1883, p. 77, no. 186; Justi 1888, vol. 2, p. 191; Lefort 1888, p. 86; Romanos 1899, p. 277; Beruete 1906, p. 86; Wrangell [1909], pp. x, xxxi; Benois [1910], pp. 132-33; Allende-Salazar 1925, pp. 130, 282; Kehrer 1926, pp. 132-33; Kehrer 1930, p. 373; Mayer 1936, p. 96, no. 411; Sánchez Cantón 1942, pp. 75, 81; Lafuente Ferrari 1943, p. 27, no. 97; Soria 1945, p. 214; Pantorba 1955, pp. 178-80, no. 99; Kaptereva 1956, p. 93; Gerstenberg 1957, pp. 155-56, no. 138; Gaya Nuño 1958, pp. 324-25, no. 2861; Walker 1960, p. 174; Lopez-Rey 1963, pp. 274-75, no. 448; Walker 1963, pp. 26, 166; Camón Aznar 1964, vol. 2, pp. 730, 940, 1005; Bardi 1969, no. 107-a; Kemenov 1969, pp. 279-83; Crombie 1973, p. 213; Gudiol 1974, pp. 267, 281, 337, no. 137; Hendy 1974, pp. 272-73; Lopez-Rey 1979, p. 128; McKim-Smith 1979, pp. 594-97; Brown 1986, p. 297, no. 24; Kagané 1987b, pp. 15, 17; Brown, Mann 1990, pp. 124-27; Kagané 1994a, p. 256; Kagané 1994b, p. 10; Moore ed. 1996, p. 135, no. 52.

EXHIBITIONS: 1941 Toledo (Ohio), no. 66; 1996-97 Norwich and London, no. 52.

Innocent X (Giovanni Battista Pamphilij, 1574-1655) was created a Cardinal in 1627 and elected Pope on 15 September 1644.

This portrait head was ideal for Sir Robert Walpole's cabinet of 'very small' pictures, where it hung against green velvet. Walpole also owned another work attributed to Velázquez, *The Death of St Joseph* (cat. no. 181).

The portrait of Innocent X arrived in St Petersburg with an attribution to Velázquez and was listed as such in all Hermitage catalogues until 1916. Viardot (1844) considered it a study for the celebrated portrait of Pope Innocent X painted by Velázquez during his stay in Rome in 1649-50 (Doria Pamphilij Gallery, Rome) although both Beruete (1906) and Mayer (1936) suggested that the robes were painted not by Velázquez himself but in his workshop. Lopez-Rey (1963, 1979) drew attention to the fact that the eyes are brown in the Walpole portrait but blue in the portrait in the Doria Pamphilij Gallery, thereby concluding that the portrait was not taken from life but was intended as a preparatory sketch or even a copy made from memory. He was later to decide that the Hermitage picture was a copy of a copy.

The first to reject the authorship of Velázquez himself was M. Soria, who expressed his views in a letter of 3 April 1945 to the National Gallery in Washington (Brown, Mann 1990). Brown (Brown, Mann 1990) studied X-rays photographs and the technique used in execution of the painting and concluded that the brushstrokes are much less confident in the Hermitage picture than in the Doria Pamphilij painting.

This is particularly noticeable in the painting of the ear and forehead, although the distribution of light and shade carefully follows the now recognised original. Meanwhile, X-ray photography also revealed considerable re-workings in the Hermitage picture, including the fact that the Pope was originally attired in winter robes edged with fur, whereas in the Doria Pamphilij portrait he wears summer attire. The majority of the existing copies show the Pope in summer dress, and in only a few is he dressed for winter. From this evidence we can suggest that there may have been an original by Velázquez (now lost) showing the sitter in winter clothes from which the Walpole work was originally copied, before being reworked on the basis of the portrait in Rome.

Documentary sources inform us that when Velázquez returned to Madrid, he took from Rome a bust-length portrait of Pope Innocent X. It was formerly thought that this was the Hermitage picture but Lopez-Rey (1979), suggested that it was in fact the portrait now in the Wellington Museum, Apsley House, London. Lopez-Rey (1963) lists a further ten versions or copies of the bust-length portrait of Innocent X. There is also a sketch for the head of Innocent X attributed to Velázquez in the Real Academia de Bellas Artes de San Fernando, Madrid.

L.K.

German School

188

ADAM ELSHEIMER (1578-1610)
St Christopher
Oil on canvas, 22.5 x 17.5
Inv. No. 694
PROVENANCE: presented to Sir Robert Walpole by Sir
Harry Bedingfield; Houghton (Cabinet); 1779 Her-
mitage.
LITERATURE: *Aedes* 1752, p. 71; 2002, no. 189; Cats.
1863-1916, no. 1984; Bode 1883, p. 297; Drost 1933,
pp. 44-45; Weizsacker 1936-52, vol. 1, pp. 102-4; vol.
2, p. 30, no. 33; Cat. 1958, vol. II, pp. 336-37; Libman
1972, p. 34; Andrews 1977, pp. 19, 140-41, no. 5; Cat.
1981, p. 213; Nikulin 1987, p. 69, no. 29; Roettgen, in
1991 Frankfurt-am-Main, p. 85, 106, ill. p. 107;
Brownell 2001, p. 52.
EXHIBITIONS: 1991 Frankfurt-am-Main, no. 18, p.
106; 1998-99 Munich, p. 204, no. 20 (ill.).

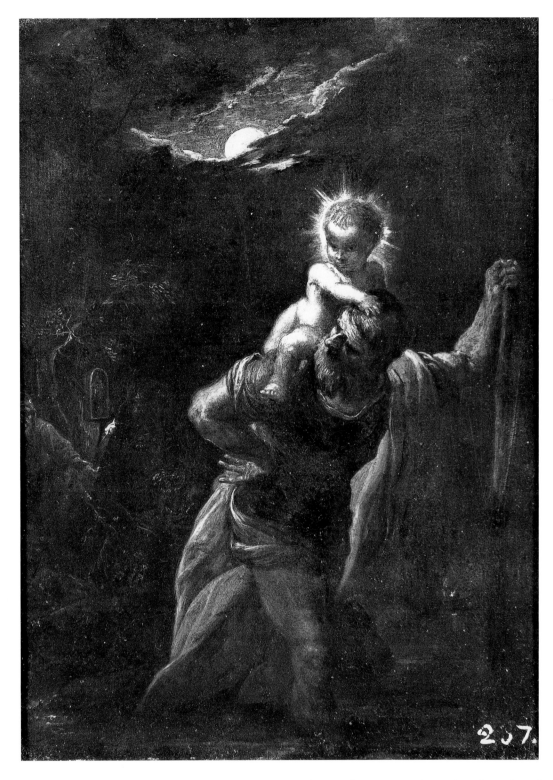

The connection between this *St Christopher* and
Dürer's engraving (Bartsch VII, 68, nos. 51-52) is vis-
ible in a number of borrowings such as the hermit
with a torch; the interpretation of the saint's power-
ful figure in the foreground and the position of the
Child's right hand gripping the giant's hair. The over-
all treatment of the subject also reveals, as noted by
Weizsacker (1936-52), Andrews (1977) and Nikulin
(1987), the influence of an engraving of St Christo-
pher by Jost Amman (Bartsch Ill. 20, part 2, p. 809,
no. 18). Elsheimer's chapel, like that of Jost Amman,
is set directly behind the hermit and not in the back-
ground, as in Dürer's work. In the painting this
chapel is dedicated to the Virgin, which led Horace
Walpole to reproach Elsheimer as follows: 'Here is a
very common Error among the Roman-catholic
Painters; in the distant Landscape is a Hermit, with an
Oratory of the Virgin *Mary*, at the Time that St.
Christopher is carrying *Jesus* yet a Child'.

A clear link with a number of works by Tintoretto
has been noted. The sculptural working of details has
been compared by Nikulin (1987) with *The Agony in
the Garden* (Santo Stefano, Venice), while Roettgen
(in 1991 Frankfurt-am-Main) draws stylistic parallels
in this striking night scene with Tintoretto's wall
paintings of the mid-1580s in the lower hall of the
Scuola di San Rocco, Venice.

Drost (1933) thought the Hermitage painting an
early work by Elsheimer, but Andrews (1977) dates it to
1598-99. Although concurring with the latter view,
Nikulin (1987) notes that it reflects a transition from the
old German tradition to a new stage in the artist's work:
in 1598 Elsheimer completed his studies under Uffen-
bach and in 1599 left Germany for ever, moving first to

Venice before finally settling in Rome in 1600.
Roettgen (in 1991 Frankfurt-am-Main) considers the
Hermitage *St Christopher* 'eines der "italienischten"
Bilder des Meisters', painted either in Venice or imme-
diately upon his arrival in Rome c.1599-1600. This
dating seems most convincing.

There has been some confusion about the quality of
the Hermitage picture. Without ever seeing the pic-
ture, Weizsacker (1936-52) mistakenly described it as a
poor copy, only attributed to Elsheimer after it was
acquired by Catherine II. Andrews (1977) rightly notes
that this is an original work of superb quality.

Rubens copied the head of the Child (see drawing in the British Museum, London, Inv. No. G.g.2.231) and seems to have been inspired by Elsheimer's painting for his *St Christopher* on the outer wing of his altarpiece, *The Descent from the Cross*, in the Liebfrauenkirche in Antwerp (1612-14). This is clearly apparent in the Child's similar pose on the saint's right shoulder and the hermit blessing their path as well as the common night theme.

Nikulin (1987) records three copies of the Hermitage painting: two at Windsor Castle (Inv. No. 2963l, oil on copper, 23.9 x 18.3; the second of higher quality and possibly the work of Leonard Bramer); a third would seem to be the work of David Teniers the Younger, and is in the collection of Lady Victoria Wemyss (Wemyss Castle, Fife, UK; oil on canvas on panel, 28.5 x 18.2).

The subject is from Jacopo da Voragine, *Legenda Aurea*, XXIV.

M. G.

189

PHILIP PETER ROOS (ROSA DA TIVOLI) (1657-1706)
The Shepherd
Oil on canvas, 95 x 134
PROVENANCE: Sir Robert Walpole, 1736 Houghton (Work'd Bedchamber/Embroidered Bedchamber); 1779 Hermitage; 1799 transferred to Gatchina Palace; 1920s transferred to Antikvariat for sale; whereabouts unknown.
LITERATURE: *Aedes* 1752, p. 64 (as 'two pieces of Cattle, by Rosa di Tivoli'); 2002, no. 138; Boydell I, pl. XXIX; Gilpin 1809, p. 50; Chambers 1829, vol. I, p. 529; Vertue, vol. III, 1933-34, p. 44.

Pair to *The Goats-Herd* (cat. no. 190).

In 1730 Vertue mentioned '2 large pieces of Rosa di Tivoli' in the Walpole collection (Vertue, vol. III, 1933-34). The manuscript catalogue of Walpole's collection (Walpole MS 1736, pp.5-6) refers to 'Cattle over the Doors' at Houghton Hall – a sufficiently ambiguous reference to indicate one or more paintings – with the dimensions 3' 1" x 4' 5" (95.25 x 134.62). The *Aedes* also records two paintings, both at Houghton in 'The Embroider'd Bed-Chamber ... Over the Doors, two pieces of Cattle, by Rosa di Tivoli'. We know the dimensions of these works from the reproductive engravings in Boydell as 3' 1½" x 4' 4¾" for both *The Goats-Herd* and *The Shepherd* (c.95 x 134) and the letterpress to plate XXIX describes them as 'Two of the finest and most agreeable pictures by the master.' Gilpin (1809), who visited Houghton Hall in 1769, also remarked on them but in less complimentary terms as 'Two Cattle pieces by Rosa of Tivoli: the Cattle in both are finely painted; but the composition of neither is good.'

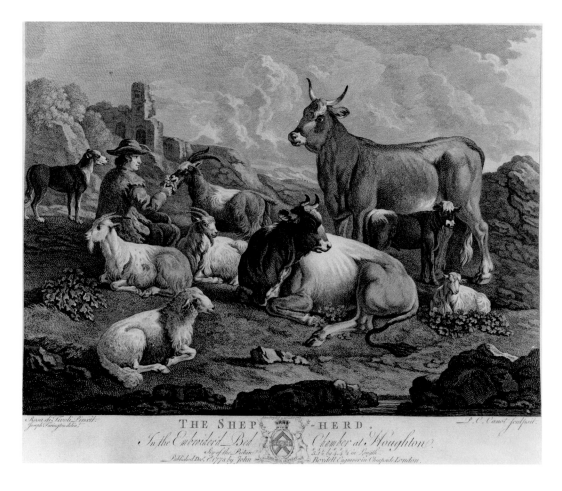

THE SHEP — HERD.
In the Embroider'd Bed Chamber at Houghton.

The two cattle pieces by Rosa da Tivoli were amongst the list of paintings added 'without increasing the previous price' in the list attached to a letter from Alexey Musin-Pushkin to Catherine II (SbRIO 17, 1876, p. 400).

When the Houghton Hall paintings arrived in the Hermitage they were entered consecutively in the 1773-85 catalogue. However, somewhat surprisingly, they are not listed as by Rosa da Tivoli but as by Chrétien Guillaume Dietriech (1712-74; nos. 2332 and 2333), an artist who does not figure in the Walpole collection. In fact, the descriptions and the dimensions given for these works (1 *arshin* 5.5 *vershki* by 1 *arshin* 14 *vershki*, 95.6 x 133.4), accord with the Houghton works by Rosa da Tivoli. Under no. 2333 in the catalogue there is a description which perfectly matches Boydell's engraving of *The Shepherd*: 'Chrétien Guillaume Dietrich. Pastorale. On y voit des vaches et quelques chèvres, à l'une des quelles le berger présente des feuilles. Le fond est un paysage montueux avec quelques ruines. Tableau froid de Couleur comme le précédent.'

In the 1797 catalogue they remain listed as *Flock in a Landscape* by C. D. Dietrich (under no. 3162) with a reference to number 2333 from the 1773-85 cata-

logue. There is no further reference to paintings by Dietrich with similar subjects in later Hermitage catalogues. It is possible however that Georgi (1794, 1996 edition, p. 364) included them in his description of the Hermitage as works by Rosa da Tivoli: 'Philipp Roos, named Rosa Romana or of Tivoli. Two pastoral scenes.' Both paintings were transferred to Gatchina Palace, near St Petersburg, in 1799 (Hermitage Archive, Fund 1, *Opis'* I). They appear in the 1859 inventory, which records that they were then 'At Gatchina Palace at the farm'. In the early twentieth century they were split up and *The Shepherd* would seem to have been transferred to Antikvariat for sale in the 1920s.

It is possible that the painting still bears its Hermitage numbers – '3162' on the front (as in the 1797 catalogue) and '1913' on the back (as in the 1859 inventory), as well as a Gatchina inventory number in red on the back. These numbers may eventually be of assistance in identifying the work in its present location.

Now known from the Boydell print, engraved by P. C. Canot, published 1 December 1778.

M. G.

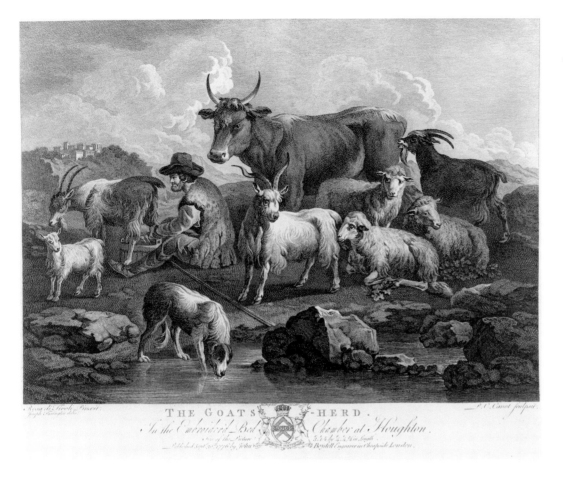

THE GOATS-HERD.
In the Embroider'd Bed Chamber at Houghton.

190

PHILIPP PETER ROOS (ROSA DA TIVOLI) (1657-1706)
The Goats-Herd
Oil on canvas, 95 x 134
PROVENANCE: Sir Robert Walpole, 1736 Houghton (Work'd Bedchamber/Embroidered Bedchamber); 1779 Hermitage; 1799 transferred to Gatchina Palace; disappeared during the Second World War; whereabouts unknown.
LITERATURE: *Aedes* 1752, p. 64 (as 'two pieces of Cattle, by Rosa di Tivoli'); 2002, no. 137; Boydell I, pl. XXVIII; see cat. no. 189.

This picture and its pair, *The Shepherd* (cat. no. 189), were overdoors in the Embroidered Bedchamber at Houghton and served as a reminder of the integrity of Sir Robert Walpole's decorative scheme since they echoed the pastoral themes of the Brussels tapestries that furnished the walls of this room and that remain in situ today.

Listed in the 1773-85 catalogue under no. 2332 as the work of Chrétien Dietriech: 'Pastorale. Une Vache, des Brebis, et une Bergère à genoux occupée à traire une chevre, sont les objets qui composent ce Tableau auquel on ne peut reprocher que d'être un peu froid de Couleur. S. Toile. ... Pend. du suivant.' There are some discrepancies between this description and Canot's engraving for Boydell—the shepherd milking the goat is in fact bearded and is seated rather than kneeling—but similar minor errors can be found in the catalogue entries for other paintings from the Walpole collection (for instance the description of Reymerswaele's *The Annuity Sellers* identifies the second male figure as female). In every other respect, including dimensions and other descriptive features, Munich's entry in the 1773-85 catalogue fully accords with the engraving.

If eventually found, the painting may still bear its Hermitage numbers, '3163' on the front (as in the 1797 catalogue) and '1910' on the back (as in the 1859 inventory), as well as its Gatchina inventory number (G 39045) in red on the back. These numbers may eventually be of assistance in identifying the work in its present location.

The painting is known only through its Boydell print, engraved by P. C. Canot, published 30 September 1776.

M. G

191

JOHANN ROTTENHAMMER (1564-1625)
The Holy Family with John the Baptist
Oil on copper, 17.3 x 14
Pushkin Museum of Fine Arts, Moscow, Inv. No. 321
PROVENANCE: 1722 acquired by Sir Robert Walpole at the van Huls house sale; Sir Robert Walpole, 1736 Downing St (Lady Walpole's Drawing Room), later Houghton (Cabinet); 1779 Hermitage; 1862 transferred to Rumyantsev Museum, Moscow; 1924 transferred to Museum of Fine Arts (now Pushkin Museum of Fine Arts), Moscow.
LITERATURE: *Aedes* 1752, p. 68; 2002, no. 163; Boydell II, pl. XXX; Livret 1838, p. 331, no. 54; Rumyantsev Museum 1862, no. 59; Rumyantsev Museum Guide 1872, no. 59; Bénézit 1911-13, vol. III, p. 662; Bénézit 1976, vol. 9, p. 121 (mistakenly as Musée Roumianzoff); Schlichtenmaier 1988, pp. 127, 238 (G1 no. 41), 339, 439 (St no. 24), 446 (St no. 39); Pushkin Museum 1995, pp. 594-95; Moore ed. 1996, p. 49.

From the end of the eighteenth century the Hermitage had two small paintings by Rottenhammer that were similar in both subject and dimensions. This picture was amongst a group of works transferred in 1862 to the Rumyantsev Museum in Moscow (MS Moscow Public Museum 1862, no. 105) to form the basis of a picture gallery that was later moved to the Museum of Fine Arts. St Joseph is to Mary's right, while to her left is the young John the Baptist, holding out a dish of fruit to the Christ Child. Through the Hermitage inventories we can trace this picture right back to the note referring to its arrival from the Walpole collection, a fact confirmed by Michel's engraving in Boydell.

The other small painting, on copper with a rounded top, showed John the Baptist to the right of the Madonna and did not include St Joseph (Peltzer 1916, pp. 346-47, no. 47, fig. 33). It was listed in the 1863-1916 catalogues as number 509, with an erroneous statement that it came from the Walpole collection, an error repeated by Peltzer. This work was transferred in 1929 to Antikvariat for sale and its present location is unknown.

The small *Holy Family* from the Walpole collection is mentioned in numerous catalogues of the Rumyantsev Museum from 1862 onwards, but in the Pushkin Museum of Fine Arts it remained largely unnoticed for many years. It was not included in the exhibition of German paintings and drawings in 1863 and is mentioned only in passing in the catalogue by M. J. Liebman of the exhibition of works from the circle of Rottenhammer. This lesser attribution was repeated in the museum catalogue of 1995 (Pushkin Museum 1995), even though the quality of the heads of Mary and St Joseph, finely drawn with the brush, and the smooth enamel-like surface texture are entirely in accordance with the artist's polished technique.

The Holy Family with John the Baptist was probably

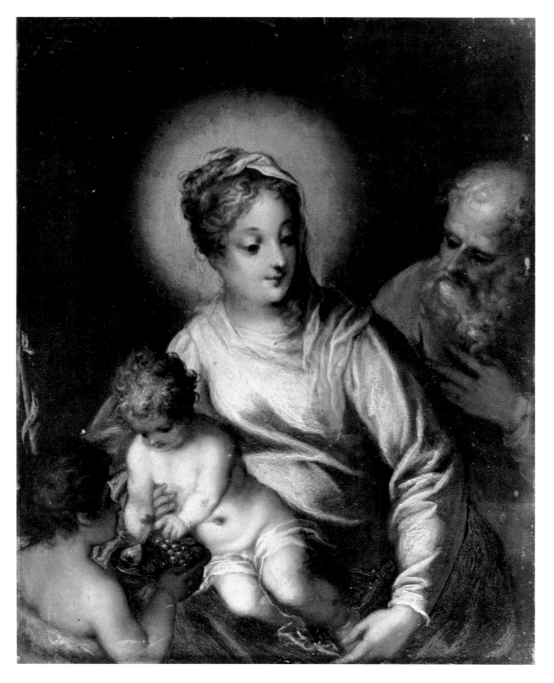

192

ANONYMOUS ARTIST (after Hans Holbein)
Portrait of Erasmus
c.76.2 x 63.5
PROVENANCE: Sir Robert Walpole, 1736 Houghton (Little Breakfast Room, then Common Parlour); 1779 Hermitage; whereabouts unknown.
LITERATURE: *Aedes* 1752, p. 47 (as by 'Holbein'); 2002, no. 42.

The great Renaissance humanist scholar Gerhard Praet, known as Desiderius Erasmus von Rotterdam (1467/69-1536), paid numerous visits to England, where he taught at Cambridge and became a close friend of Thomas More.

The work is listed in the 1736 manuscript catalogue of the Walpole collection (Walpole MS 1736 pp. 9-10) as 'Erasmus - Holbein − 2' 6" x 2' 1" [c.76.2 x 63.5]'. The *Aedes* provides neither the medium nor the dimensions of the picture. When the collection was sold to Catherine II this portrait was valued at £40. In the list of paintings for sale attached to a letter to Catherine II (SbRIO 17, 1876, p. 398) is a note that 'Erasmus. Holbein' is amongst those works that are 'slightly damaged'. This would seem to confirm that the portrait was despatched to Russia, although mysteriously, it does not appear to have been entered in the 1773-85 catalogue.

The next catalogue, however, that of 1797, lists 'Holbein. Portrait of Erasmus of Rotterdam' (under no. 38), with no reference to any number in Munich's catalogue of 1773-85. Its dimensions (1 *arshin* 1 *vershok* 14.5 *vershki*, c.75.6 x 64.5) are almost identical to the Walpole picture suggesting that it is the same work. This portrait is probably that mentioned in the 1859 inventory (no. 3455). In that source the dimensions (18 *vershki* x 14.5 *vershki* [c.80.1 x 64.5]) are provided but not the medium and there is a note in the margin stating 'Present in 1859'. In 1862 this painting was transferred to the Moscow Public and Rumyantsev Museum as an old copy after Holbein (MS Moscow Public Museum 1862, no. 121), but it has not proved possible to trace it thereafter.

Some confusion arose in later Hermitage catalogues (Cat. 1902, no. 465; Cat. 1958, vol. II, p. 308; Nikulin 1987, p. 199), where another portrait of Erasmus, acquired in 1772 with the Crozat collection, was mistakenly given a Houghton provenance. Only Cat. 1981 (p. 199) reinstates its correct provenance.

M. G.

Not reproduced

painted in Venice, where Rottenhammer spent ten very fruitful years between 1595/96 and 1606 and achieved international fame. The Rottenhammer scholar, Schlichtenmaier, sees this painting as one of the key works of the Venetian period and dates it to 1600-1, citing a group of similar works from these years and an engraving by Lucas Kilian (1579-1637). Kilian arrived in Venice from Augsburg c.1601 and was supported there by Rottenhammer, who introduced him to artists and collectors. The young Kilian produced engravings after Rottenhammer's works, one of the first being after another painting now in the Hermitage, *The Feast of the Gods* (Inv. No. 689).

K. Ye.

British School

193

WILLIAM DOBSON (1611-46)
Portrait of Abraham van der Doort
Oil on canvas, 45 x 38
Inv. No. 2103

PROVENANCE: coll. Jonathan Richardson, London; Sir Robert Walpole, 1736 Downing St (Sir Robert's Dressing Room), later Houghton (Cabinet); 1779 Hermitage.
LITERATURE: *Aedes* 1752, p. 66 (as 'Head of Dobson's Father'); 2002, no. 151; Boydell I, pl. XXX; Georgi 1794, p. 480 (1996 edition, p. 362); Fiorillo 1808, p. 369; Chambers 1829, vol. I, p. 530; Livret 1838, p. 446, no. 12; Anecdotes 1862, vol. 1, p. 269; vol. 2, p. 353; Waagen 1864, p. 277; Faré 1866, pp. 5-6, no. 1387; Cats. 1863-1916, no. 1387; H[olmes] M[ilner] 1911, p. 163; Collins Baker 1912, vol. 1, p. 99; vol. 2, p. 116; Vertue, vol. II, 1931-32, pp. 77, 130; vol. IV, 1935-36, p. 14; vol. VI, 1948-50, p. 175; Millar 1958-60, p. XVI; Millar 1963, text vol., p. 114; Piper 1963, pp. 357-58; Krol' 1969, p. 27; English Art 1979, no. 20; Rogers 1983, p. 9, fig. 1; Millar 1991, p. 14; Dukelskaya, Renne 1990, no. 42; British Art Treasures 1996, pp. 41, 156, no. 4; Moore ed. 1996, p. 63.
EXHIBITIONS: 1956 Moscow, p. 27; 1983 Moscow; 1996-97 New Haven-Toledo-St Louis, no. 4; 1998 St Petersburg, no. 4.

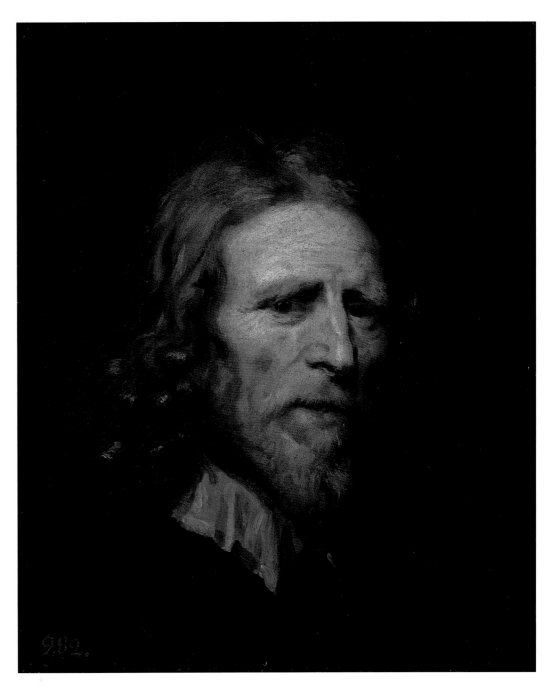

Little is known of the early career of Abraham van der Doort (c.1575/80-1640), although he may have been a medallist at the court of Rudolf II (Strong 1986) before his arrival in England sometime between 1609 and 1612. From 1612 he was Keeper of the Cabinet Room of Henry, Prince of Wales. After the latter's untimely death he remained in the service of Henry's brother, Prince Charles, who in 1625, as King Charles I, appointed him Surveyor of 'all our pictures'.

In the catalogue of 1736 (Walpole MS 1736), the painting was listed simply as 'An Old Man's Head', although when it was in the collection of Jonathan Richardson Sr it was identified as a portrait of Abraham van der Doort (Vertue, vol. II, 1931-32; vol. IV, 1935-36), and was recorded as such in Vertue's 1739 inventory of the paintings of Sir Robert Walpole ('In the Closet ... A Mans head Vdr, Dort. Dobson'; Vertue, vol. VI, 1948-50). An unfortunate error, however, crept into the *Aedes*, where Horace Walpole identified the picture as 'Head of Dobson's Father, by Dobson' although he corrected the mistake himself by noting later 'There is an admirable head of Vanderdort, by Dobson, at Houghton. In the *Aedes* Walpolianae, I have called this Dobson's father, as it was then believed; but I find by various notes in Vertue's MSS that it was bought of Richardson the painter, and is certainly the portrait of Vanderdort' (Anecdotes 1862, vol. 1, p. 269, note 5).

Unfortunately, the incorrect identification was repeated by Valentine Green in the letterpress on the engraving of 1776 for Boydell, and the error was later to recur in Hermitage catalogues and inventories of the eighteenth and nineteenth centuries. The 1773-85 catalogue, for instance, reads: 'Guillaume [sic] Dobson. Une Tête. C'est le portrait de Dobson père fait par son fils peintre Anglais'. Only after 1863 did Hermitage catalogues describe it correctly as a portrait of van der Doort.

On the basis of the sitter's age and the nervous expression on his face, which seems indicative of the worry and feelings of guilt which were ultimately to lead to his suicide, the picture is traditionally dated to the late 1630s (Millar 1958-60, p. xvi; Dukelskaya in Dukelskaya, Renne 1990, no. 42).

All those who have written on this portrait have noted the strong psychological characterisation of the sitter, the result of Dobson's innate realism and his skill as a portraitist. Only Holmes and Milner, who had not seen the actual portrait, expressed any doubt about the work's authenticity (H[olmes] M[ilner] 1911).

There is a copy of this portrait in the National Gallery, London (Inv. No. 1569).

E. R.

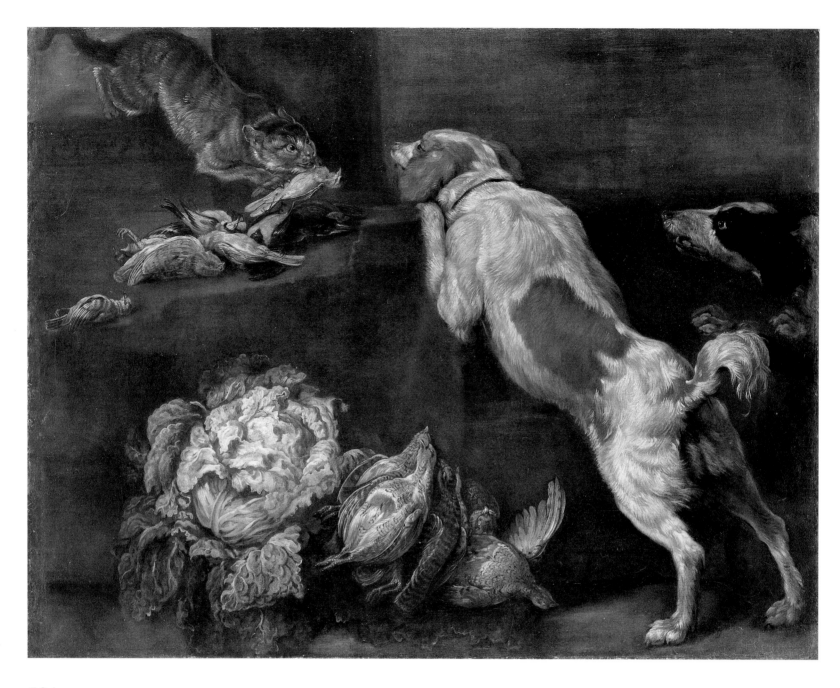

194

CHARLES JERVAS (c.1675–1739), attributed to
Dogs and Still Life
Oil on canvas, 102.5 x 129
Inv. No. 635
PROVENANCE: Sir Robert Walpole, 1736 Houghton
(Drawing Room with the Vandyke Hangings, over
the door, then Dressing Room); 1779 Hermitage.
LITERATURE: *Aedes* 1752, p. 63; 2002, no. 133; Boydell
I, pl. XXXVII; Chambers 1829, vol. I, p. 528; Livret
1838, p. 381, no. 31; Waagen 1864, p. 268; Cats.
1863–1916, no. 1325; SbRIO 17, 1876, p. 400; Cat.
1958, vol. II, p. 100; Moore ed. 1996, pp. 129-30.

Pair to *Deer, Dog and Cat* (cat. no. 195)

Together with its pair this work was attributed to the
English painter Charles Jervas whilst in the Walpole
collection and was engraved as his work by P. C. Canot
for Boydell. Hermitage manuscript catalogues and
inventories, as well as Livret 1838, Waagen 1864 and
Cat. 1863, listed it erroneously under the name of Frans
Snyders. Later Hermitage catalogues give it as school of
Snyders and, indeed, Jervas is known to have copied
Snyders's work (Moore ed. 1996, p. 130, n. 1). X-ray
analysis of its pair in 1966 revealed beneath the top
layers of paint an unfinished female portrait which is
possibly the work of Jervas.

Both compositions derive from Paul de Vos's
Hunters with Dogs by a Table with Game and Fruits (oil
on canvas, 121 x 170, priv. coll., Madrid), of which
the Hermitage has a larger repetition (159 x 230, Inv.
No. 5593). Notably, the Walpole painting includes
almost without any alteration the cat in the top left
corner and two dogs in the lower right corner of the
Madrid painting (in the Walpole canvas one dog is cut
off sharply at the composition's edge), and its pair
includes the dead deer, the cat from the bottom left
corner and the dog sniffing the floor around the table.

Although Jervas was mainly a portrait painter, we
know that he was commissioned by Sir Robert Wal-

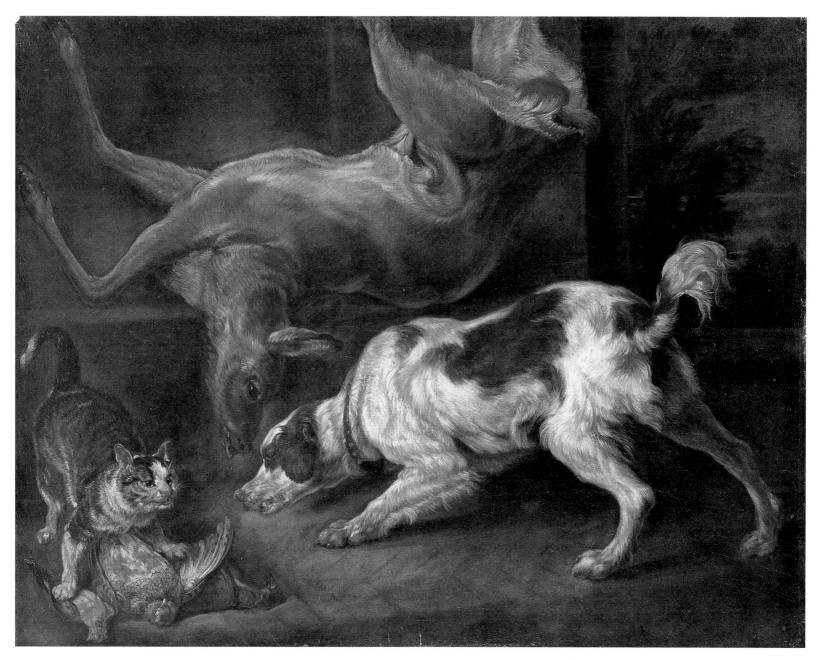

pole to produce copies of works in the latter's collection. The sale of Jervas's property soon after his death in November 1739, for instance, included his own copies of paintings by Van Dyck, Carlo Maratti and Frans Snyders in Walpole's possession (Moore ed. 1996, p. 130). It is very likely that both Hermitage works are copies by Jervas of works by Paul de Vos.

The picture and its pair are mentioned in the appendix to a letter from Alexey Musin-Pushkin, Russian ambassador in London, to the Empress Catherine, listing works added to the Walpole sale 'without increasing the previous price' (SbRIO 17, 1876).

N. G.

195

CHARLES JERVAS (c.1675-1739), attributed to
Deer, Dog and Cat
Oil on canvas, 102.5 x 129
Inv. No. 634
PROVENANCE: see cat. no. 194.
LITERATURE: *Aedes* 1752, p. 63; 2002, no. 134; Boydell I, pl. XXXVIII; Chambers 1829, vol. I, p. 528; Livret 1838, p. 378, no. 17; Waagen 1864, p. 268; Cats. 1863–1916, no. 1326; Cat. 1958, vol. II, p. 100.

Pair to *Dogs and Still Life* (cat. no. 194). See commentary to cat. no.194.

N. G.

196

SIR GODFREY KNELLER (1646/49-1723)
King William III

Oil on canvas, 129 x 107, on the back an old inscription: *A sketch for King William on he ... Invented and done by S. Godf. Kneller. 1697*

PROVENANCE: c.1723 Sir Robert Walpole, 1736 Houghton (Little Breakfast Room, then Common Parlour); 1779 Hermitage; from the 19th century to 1941 at Gatchina Palace; disappeared during the Second World War; whereabouts unknown.

LITERATURE: *Aedes* 1752, pp. 45, 69; 2002, no. 30; Georgi 1794, p. 483 (1996 edition, p. 364); Fiorillo 1808, p. 497; Gilpin 1809, pp. 44; Chambers 1829, vol. I, p. 521; Anecdotes 1862, vol. 2, pp. 587, 589-90; SbRIO 17, 1876, p. 400; Vertue, vol. V, 1937-38, p. 43; Trubnikov 1914, p. 90, reproduced opposite p. 89, notes pp. 98, 99; Ernst 1965, p. 425, fig. 46; Stewart 1983b, pp. 52, 53, 56, 139, no. 843, pl. 53a; Moore ed. 1996, pp. 50, 63, 94.

William III (1650-1702) was Prince of Orange, Stadhouder of the Netherlands from 1672, and from 1689 King of England.

This portrait was probably already at Houghton Hall in the 1720s. Moore suggests that it was acquired by Sir Robert Walpole in 1723 along with several other works by Kneller (Moore ed. 1996, p. 50).

The Walpole picture was a sketch for Kneller's vast equestrian portrait of William III with allegorical figures of 1701, 'probably his largest and iconographically most complex painting' (Stewart 1983b, p. 51). The finished portrait still hangs in the Presence Chamber at Hampton Court, for which it was probably originally intended (Millar 1963, no. 337). Horace Walpole noted the high quality of the sketch in the *Aedes*: 'King William, an exceeding fine Sketch by Sir Godfrey, for the large Equestrian Picture which he afterwards executed very ill at Hampton Court, and with several Alterations'. He paid particular attention to the sketch in his *Anecdotes of Painting* noting 'My opinion of what Sir Godfrey's genius could have produced, must not be judged by the historical picture of King William in the place just mentioned [Hampton Court]: it is a tame and poor performance. But the original sketch of it at Houghton is struck out with a spirit and fire equal of Rubens.' (Anecdotes 1862). Walpole felt that Kneller produced the sketch under the influence of the work of Rubens, noting particularly that 'original Design of Rubens' (*Apotheosis of James I,* cat. no. 119) which 'belonged to Sir Godfrey Kneller who studied it much, as is plain from his sketch for King William's Picture' (*Aedes* 1752, p. 69). Later he developed this idea in the *Anecdotes*: 'Latterly, Sir Godfrey was thought to give into the manner of Rubens; I see it no where but in the sketch of King William's equestrian figure, evidently imitated from Rubens's design of the ceiling for the banqueting house, which, as I have said, in the life of that painter, was in Kneller's

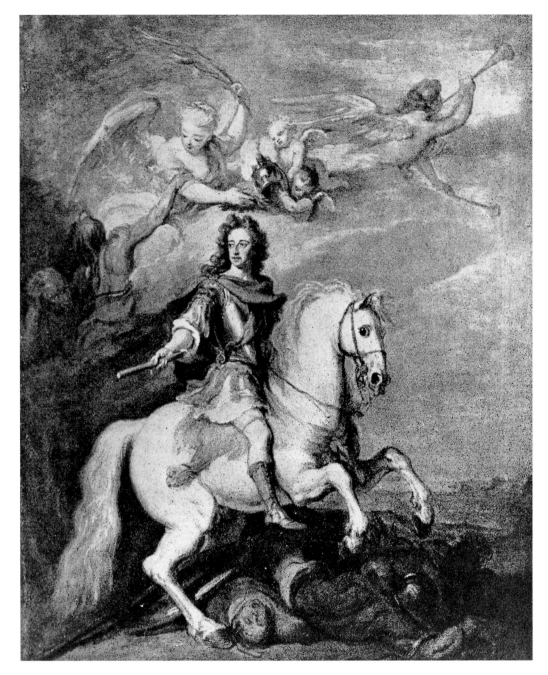

possession' (Anecdotes 1862, vol. 2, pp. 589-90).

Gilpin (1809) noted that 'The *freedom, spirit,* and *harmony* of this sketch are admirable. The great picture at Hampton-court, painted from it, hath none of these qualities'.

In composition, the Walpole sketch derives from a *Portrait of the Moroccan Ambassador, Mohammed Ohadu* (Chiswick House, London), painted by Kneller in 1684. It is also very close to a modello of 1706 (National Portrait Gallery, London) for a large unexecuted portrait of John Churchill, 1st Duke of Marlborough.

There is another more static sketch for the portrait (coll. Dr James Murphy, New York), which includes more allegorical figures. Probably produced later, it is closer to the finished picture than the sketch from the Walpole collection.

The Walpole portrait is mentioned in the appendix to a letter from Alexey Musin-Pushkin, Russian ambassador in London, to the Empress Catherine, among those works added to the Walpole sale 'without increasing the previous price' (SbRIO 17, 1876).

It was reproduced in the journal *Staryye gody,* in an essay by Trubnikov (1914) and this is the source of the poor quality illustration reproduced here.

E. R.

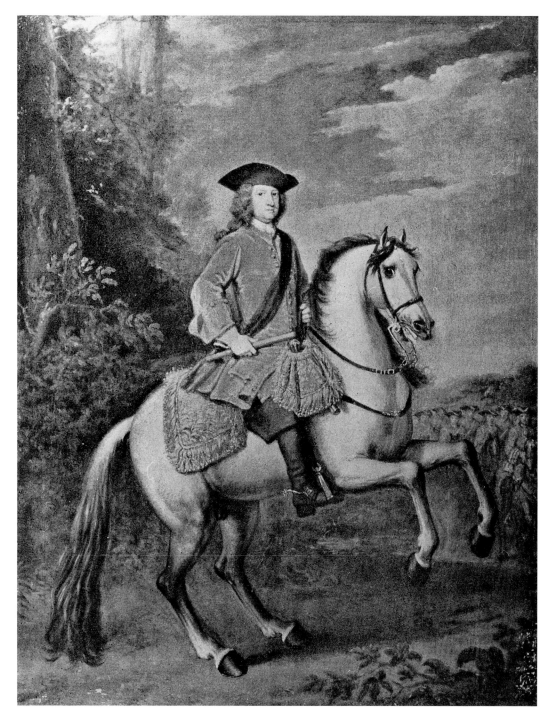

197

SIR GODFREY KNELLER (1646/49–1723) AND
JOHN WOOTTON (c.1682–1764)
King George I
Oil on canvas, c.136 x 107
PROVENANCE: before 1723 Sir Robert Walpole, 1736
Houghton (Little Breakfast Room, then Common
Parlour); 1779 Hermitage; from the 19th century to
1941 at Gatchina Palace; disappeared during the Sec-
ond World War; discovered in Germany 2002 and
returned to Russia.

LITERATURE: *Aedes* 1752, p. 45; 2002, no. 31; Georgi
1794, p. 483 (1996 edition, p. 364); Chambers 1829,
vol. I, pp. 521–22; Livret 1838, p. 498; Anecdotes
1862, vol. 2, p. 644; SbRIO 17, 1876, p. 400; Trub-
nikov 1914, p. 90, reproduced p. 92, p. 99 note; Ernst
1965, p. 426, pl. 47; Moore ed. 1996, pp. 50, 94, 96.

King George I (1660–1727) was from 1698 Elector of
Hanover, and from 1714 the first English King of the
Hanoverian dynasty.

In the *Aedes*, Horace Walpole described this portrait
as 'companion to the former [i.e. the portrait of
William III], but finished'. He also clarified the author-
ship: 'The Figure is by Sir Godfrey, which he took from
the King at Guilford Horse-Race. The Horse is new
painted by Wootton'. Chambers suggested that 'this is
the very picture which gave rise to Mr. Addison's beau-
tiful poem to Kneller' (Chambers 1829). The first lines
from Addison's poem 'To Sir Godfrey Kneller on his
picture of the King', however, read 'Kneller, with
silence and surprise / We see Britannia's Monarch rise,
/ A godlike form, by thee display'd / In all the force of
light and shade; / And, aw'd by thy delusive hand, / As
in the presence-chamber stand' and would seem to
refer to Kneller's coronation portrait of George I, still in
the Library at Houghton Hall, or the version formerly
in the Guildhall in London (destroyed during the
Second World War). In the Houghton equestrian por-
trait, Kneller depicted the King, according to Walpole,
with 'all that plain good-humoured simplicity and
social integrity, which peculiarly distinguished the
honest English private gentleman' (Anecdotes 1862).
The King is portrayed accordingly more as a private
individual than a majestic and awe-inspiring monarch,
even though this painting repeats the general viewpoint
used in the two coronation portraits.

When Trubnikov (1914) compared the portrait of
George I with the sketch for a portrait of William III,
he wrote 'what a great difference between the fiery
study, where all is in motion, whirling, moving, and
the boring rider, scampering woodenly on a card-
board horse. One can tell that the thing was made by
two sets of hands, and the expressive face, from the
brush of Kneller, seems strangely to overcome all the
rest.'

The text accompanying the picture in the 1773–85
catalogue reads 'C'est le Portrait du Roi George Pre-
mier à cheval devant servir de pendant au précédant
[i.e. portrait of William III], mais au bien d'être une
Esquisse c'est un petit Tableau fini'. This text is of
interest because it was misread and used as the basis to
suggest that the picture was a sketch, an error repeat-
ed in successive Hermitage catalogues and even as
recently as the essay by Ernst (1965).

Moore suggests that the portrait was acquired by
Robert Walpole in 1723 along with several other
works by Kneller (Moore ed. 1996, p. 50). It was
probably painted around 1720. The picture was
reproduced in Trubnikov's article for the St Peters-
burg journal *Staryye gody* in 1914, from which the
inadequate illustration reproduced here is taken.

E. R.

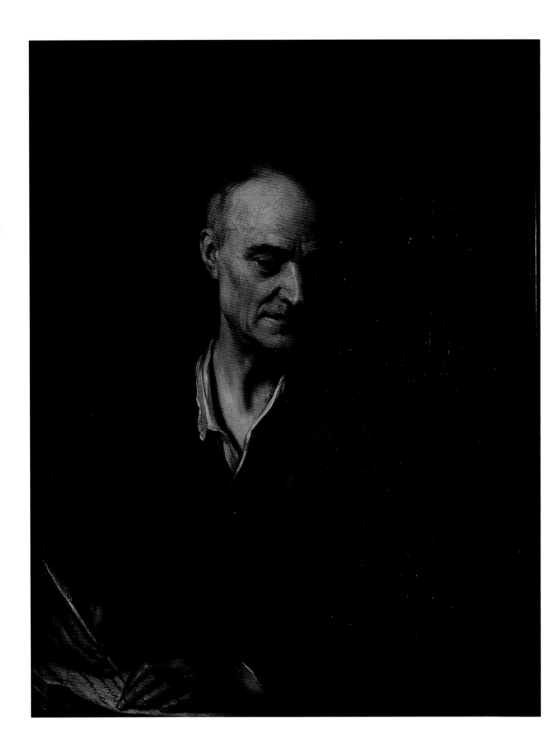

SIR GODFREY KNELLER (1646/49-1723)
Joseph Carreras
Oil on canvas, 72.5 x 63.7. Inscribed, lower right: *G. k.*
PROVENANCE: Sir Robert Walpole, 1736 Grosvenor
St (Drawing Room, 'A Man Writing'), then
Houghton (Common Parlour); Hermitage 1779;
1854 sold by Nicholas I; by 1913 Dr Okhotinsky, St
Petersburg; Baron Balthasar Ungern Sternberg; 1972
coll. Dr E. I. Michel, London; acquired 1975 by Lady
Cholmondeley; coll. Marquess of Cholmondeley.
LITERATURE: *Aedes* 1752, p. 48; 2002, no. 46; Boydell
I, pl. XV; Wrangell 1913, p. 151, no. 983; Vertue, vol.
III, 1935-36, p. 44; Walpole 1888, vol. II, p. 205;
Stewart 1971, pp. 61-62; Moore ed. 1996, p. 96.
EXHIBITIONS: 1971 London, no. 77; 1996 Nor-
wich–London, no. 13.
Kneller was the most influential society painter of his
time. Having setted in England in 1676 he was soon
taken up at court. His portrait of the Spanish poet
Joseph Carreras dates from before 1688, when the
artist was appointed Principal Painter to William and
Mary. It amply demonstrates his ability to interpret
character and likeness with, in this case, a subtlety of
palette that recalls the painters of the Venetian late
Cinquecento.

Horace Walpole commented of this portrait: 'A
portrait at Houghton of Joseph Carreras, a poet and
chaplain to Catherine of Lisbon, has the force and
simplicity of that master [Tintoretto], without owing
part of its merit to Tintoret's universal black drapery,
to his own afterwards neglected draperies, or to his
master Rembrandt's unnatural chiaroscuro' (Walpole
1888, vol. II, p. 205). George Vertue too esteemed
this portrait highly: 'a bold head of Kneller one of the
most capital' (Vertue, vol. III, 1935-36).

Sybil Cholmondeley rightly regarded her purchase
of this canvas in 1975 as a particular triumph, as it was
the only painting sold to Catherine the Great to
return to hang at Houghton.

A. M.

199

SIR GODFREY KNELLER (1646/49-1723)
Portrait of Grinling Gibbons
Oil on canvas, 125 x 90
Inv. No. 1346
PROVENANCE: c.1723 Sir Robert Walpole, 1736
Houghton (Common Parlour); 1779 Hermitage.
LITERATURE: *Aedes* 1752, pp. 44-45; 2002, no. 29;
Martyn 1766, p. 50; Georgi 1794, p. 483 (1996 edition, p.
364); Fiorillo 1808, p. 496; Gilpin 1809, p. 43; Chambers
1829, vol. I, p. 521; Livret 1838, p. 431, no. 33; Somov
1859, p. 97; Anecdotes 1862, vol. 2, pp. 556, 587-88;
Cats. 1863-1916, no. 1388; Waagen 1864, p. 277; Faré
1866, pp. 8-9, no. 1389; Williamson 1904, p. 15; Trub-
nikov 1914, p. 92; Vertue, vol. VI, 1948-50, p. 178; Cat.
1958, vol. II, p. 382; Krol' 1961, pp. 8-9, 79-80; Piper
1963, p. 137; Stewart 1965, pp. 478-79; Ernst 1965, p.
426; Krol' 1969, p. 82; English Art 1979, no. 46; Stewart
1983b, pp. 32, 47, 107, no. 302, p. 175, no. 79; Raupp
1984, p. 207, Anm. 173, Abb. 438; Dukelskaya, Renne
1990, no. 51; Moore ed. 1996, pp. 50, 63, 94; Esterby
1998, p. 206, pl. 173.

Grinling Gibbons (1648-1721), woodcarver and
sculptor, was celebrated for his virtuoso skill in carv-
ing decorative garlands of flowers and fruits, dead
game and plants. The sculptor also worked at
Houghton Hall where, according to the *Aedes*, this
portrait of him by Kneller hung over the chimney-
piece in the Common Parlour, framed with a virtu-
oso garland of pear-tree wood by Gibbons. Andrew
Moore suggests that this is the gilded garland still in
place there (Moore ed. 1996).

The sculptor holds a pair of compasses in his right
hand, while his left rests on a cast of the head of Pros-
erpine, from Bernini's famous group *Pluto and Proser-
pine*. Stewart suggests that the cast was in Kneller's
studio, for he drew it on numerous occasions (Stew-
art 1983b, p. 8, no. 32, pl. 11a & b).

Kneller painted this portrait of Gibbons no later than
1690, the date of an engraving taken from it by John
Smith. In his description of Houghton Hall, Martyn
(1766) records that the portrait cost 300 guineas.

One of Kneller's most famous works (the catalogue
of 1773-85 succinctly describes it as 'Bon Tableau'), this
portrait was, in the opinion of Horace Walpole, even
more outstanding than the image of a 'converted Chi-
nese in Windsor (*Michael Alphonsus Shen Fu-sung*,
Royal Collection). Of this, 'of all of his works, Sir God-
frey was most proud ... but his portrait of Gibbons is
superior to it. It has the freedom and nature of Vandyck,
with the harmony of colouring peculiar to Andrea
Sacchi; and no part of it is neglected' (Anecdotes 1862,
vol. 2, pp. 587-88). Sir Godfrey Kneller, noted Walpole,
'has shown himself as great in that portrait as the man
who sat to him' (*ibid*., p. 556), while William Gilpin
begrudgingly stated that 'This is one of the best pictures

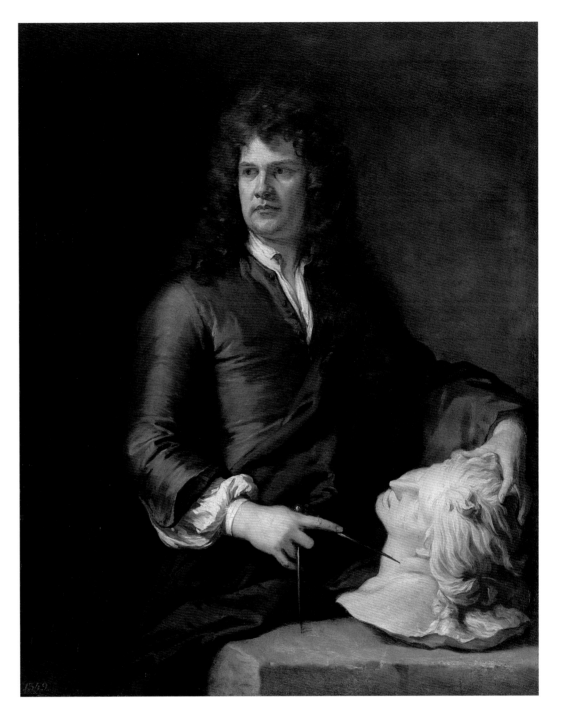

I have seen by this slovenly master' (*Gilpin* 1809).

Walpole was perfectly justified in comparing the por-
trait of Grinling Gibbons with the works of Van Dyck,
for here, as in other works of the 1690s, Kneller bor-
rowed compositional devices from the Flemish artist.

There is an engraving by Pieter Schenk of Amsterdam
which copies Kneller's portrait of Gibbons in all except
the face. An inscription beneath the engraving informs us
that Schenk took the print from a portrait of Peter van

der Plass by Kneller. There is no information to suggest
that Kneller painted van der Plass and even if he had done
so he would hardly have copied one of his own works so
precisely, simply replacing one face with another. The
engraver was more likely to have borrowed the painter's
idea, taking as his basis Smith's widely known mezzotint
from Kneller's portrait of Gibbons (Raupp 1984).

A version of the portrait is in the National Portrait
Gallery, London (Inv. No. 2925), while another was

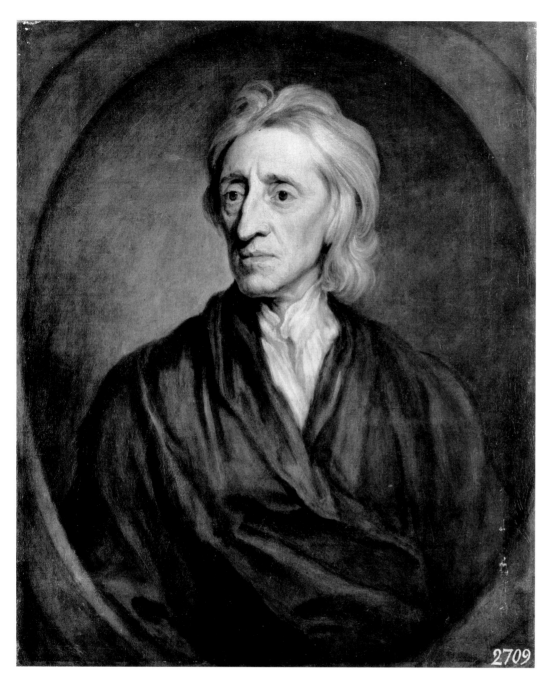

2709

LITERATURE: *Aedes* 1752, p. 48; 2002, no. 50; Locke 1768, vol. IV, p. 632; Georgi 1794, p. 483 (1996 edition, p. 364); Livret 1838, p. 344, no. 18; Anecdotes 1862, vol. 2, p. 597, note 1; Cats. 1863-1916, no. 1388; Waagen 1864, p. 277; Faré 1866, pp. 7-8, no. 1388; Williamson 1904, p. 15; Cat. 1958, vol. II, p. 382; Krol' 1961, pp. 9, 80; Ernst 1965, p. 426; Stewart 1965, pp. 478-79; Krol' 1969, p. 82; Locke 1979-82, vol. VI, pp. 503, 506; vol. VII, p. 574; Stewart 1978, p. 219; English Art 1979, no. 45; Stewart 1983b, p. 115, no. 440, pl. 54d; Dukelskaya 1987, pp. 13-15; Dukelskaya, Renne 1990, no. 52; Moore ed. 1996, p. 50; Egerton 1997, p. 275.

EXHIBITIONS: 1938 Leningrad, no. 71; 1956 Moscow, p. 31; 1972b Leningrad, no. 363; 1996-97 New Haven-Toledo-St Louis, no. 6; 1998 St Petersburg, no. 6.

The philosopher John Locke (1632-1704) sat for his portrait on a number occasions, notably to Kneller, John Greenhill (1672-76), Herman Verelst (1689) and Michael Dahl (1696).

There is documentary evidence that Kneller painted Locke twice, in 1697 and 1704. The 1704 portrait (Virginia Museum of Fine Arts, Richmond, Va.) was painted for the philosopher's young friend Anthony Collins. In a letter to Collins of 11 September 1704, Locke stated 'pray get Sir Godfrey to write upon ... the backside of mine, John Locke 1704. This he did on Mr. Molyneux's and mine, the last he drew; and this is necessary to be done or else the pictures of private persons are lost in two or three generations; and so the picture loses of its value; it being not known whom it was made to represent' (Locke 1768). In referring to his 'last' portrait, Locke probably had in mind that mentioned in a letter from his secretary, Sylvester Brounover, to Locke himself, dated 1 November 1698 in which he noted 'Mr. Molineux's picture is not finish'd, nor is yours any further than you saw at the last sitting' (Locke 1979-82). In a letter of 15 November, he states that the artist promises to complete the portrait in the near future. E. S. De Beer, editor of Locke's correspondence, suggested that Brounover was writing in this instance of a copy from the Hermitage portrait of 1697. Dukelskaya (1987) rightly considers that the reference was to the portrait itself, which remained for a long time in the artist's studio, only in 1703 being acquired by the famous London surgeon Alexander Geekie, who wrote of this to Locke 26 February 1703: 'Sir. G.-Kneller has been so kind to let me have that Picture he did of you upon some consideration' (Locke 1979-82). George Vertue's engraving of 1713 is entirely consistent with the Hermitage portrait and its inscription confirms that the work belonged to Geekie (F. O'Donoghue, H. Hake, *Catalogue of Engraved British Portraits Preserved in the Department of Prints and Drawings in the British Museum,* 1908-25, vol. III, p. 80, no. 16). A watercolour copy of the

sold at Christie's, London, on 23 November 1979 (lot 150). A reduced version attributed to George Clint is in the collecton at Petworth House (Petworth cat. no 147).

The picture is mentioned neither in James Christie's sale list nor amongst the additional works included 'without increasing the previous price' in the appendix to a letter from Alexey Musin-Pushkin, Russian ambassador in London, to Empress Catherine (SbRIO 17, 1876).

E. R.

200

SIR GODFREY KNELLER (1646/49-1723)

John Locke

Oil on canvas, lined, 76 x 64, two inscriptions on the back of the original canvas, of different character: 1) *Jn Lock* NAT: *1624 d:1704*; 2) *Mr John Lock By Sr GKneller 1697*

Inv. No. 1345

PROVENANCE: coll. Alexander Geekie; coll. William Geekie, London; Sir Robert Walpole, Houghton (Common Parlour); 1779 Hermitage.

portrait, probably also the work of Vertue, has the inscription: 'Sketched from a painting and afterwards, not long before his decease, finished up from the life by George Vertue' (sold at Christie's, London, 20 October 1955, Lot 306-3). The inscription on Vertue's engraving of 1738 records the name of the portrait's next owner, William Geekie, who inherited the work on his father's death in 1721. Since Vertue does not mention the portrait of Locke in his description of the collection of Sir Robert Walpole compiled in 1739 (Vertue, vol. V, 1937-38, pp. 175-80), it is likely that the portrait was acquired by Walpole after this date.

Judy Egerton (1997) suggested that the portrait from the Walpole collection was a copy from that made for Collins and that it may have been taken from Vertue's engraving of 1713. Her doubts were aroused by the inscription on the back of the portrait, 'Mr John Lock By Sr G Kneller', which Larissa Dukelskaya believed was made by the artist himself. Yet, even if this is not in the artist's own hand, and was added by one of the portrait's owners, it nevertheless serves to confirm what the quality of the painting already tells us, that the portrait is certainly the work of Godfrey Kneller. This becomes particularly clear when we compare X-rays of the portrait with other works by the artist.

The closest painted copies are those formerly in the collection of the Earl of Ilchester at Holland House (no. 216), and the version sold at Sotheby's, London, 5 February 1969 (lot 60).

Whilst in the Walpole collection, the portrait served as model for a statue of John Locke carved in 1759 by John Michael Rysbrack for Christ Church Library, Oxford (Stewart 1978). In 1794, when the portrait was already in Russia, Jean Dacier produced a medal based on it (Hermitage Inv. No. 10780) on the anniversary of the philosopher's death, as part of a series of portraits of outstanding individuals. In the nineteenth century a series of vases with pictures by Western European masters in the Hermitage was produced at the Imperial Porcelain Manufactory in St Petersburg, which included Kneller's portrait of John Locke. An example was presented by Alexander II to the South Kensington Museum (now Victoria and Albert Museum) after the International Exhibition of 1862.

The picture is not mentioned either in James Christie's sale list of the Walpole collection nor amongst the additional works included 'without increasing the previous price' in the appendix to a letter from Alexey Musin-Pushkin, Russian ambassador in London, to Empress Catherine (SbRIO 17, 1876).

E. R.

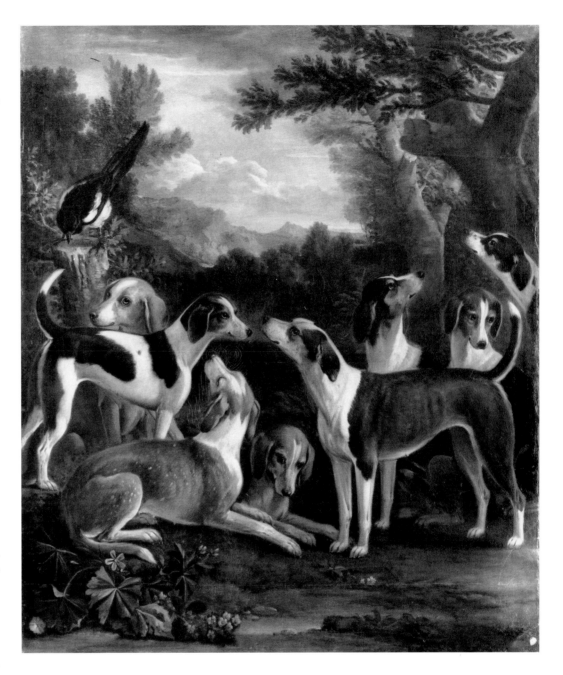

201

JOHN WOOTTON (c.1682-1764)
Hounds and a Magpie
Oil on canvas, 152 x 128, signed right, below the middle: *J Wootton pinx*
Inv. No. 9781

PROVENANCE: Sir Robert Walpole, 1736 Houghton (Little Breakfast Room/ Small Breakfast Room); 1779 Hermitage; from the 19th century at Gatchina Palace; 1958 returned to the Hermitage.

LITERATURE: *Aedes* 1752, p. 38 (as 'Picture of Hounds'); 2002, no. 1; Boydell I, pl. XIV; Georgi 1794, pp. 480, 501 (1996 edition, pp. 362, 373); Chambers 1829, vol. I, p. 520, p. 539 note j; Sparrow 1922, pp. 105, 109; Kendall 1932-33, p. 41, no. 13; Krol' 1969, pp. 21-22; English Art 1979, no. 71; Meyer 1984a, p. 80, no. 60; Meyer 1984b, p. 341; Dukelskaya, Renne 1990, no. 111; British Art Treasures 1996, pp. 41, 166, no. 9; Moore ed. 1996, pp. 50 fig. 27, 63, 87.

EXHIBITIONS: 1996-97 New Haven-Toledo-St Louis, no. 9; 1998 St Petersburg, no. 9.

It is likely that this picture was commissioned by Robert Walpole especially for Houghton. Meyer (1984) suggests that this picture is that referred to in a letter from Humphrey Wanley to Edward Harley of 18 October 1716 in which 'Wootton ... talks of a journey he must soon make into Norfolk in Order to make Pictures for a whole Pack of Hounds there'.

In the 1736 manuscript catalogue of the collection (Walpole MS 1736) the work is referred to as 'In the Rustick story at Houghton ... In the little Breakfast Room. Dogs, over the Chimney – Wootton 4'11" – 4'2".' The dimensions are more or less the same as those of the Hermitage picture, and cannot refer to any other known work by Wootton in the Walpole collection, such as the *Portrait of Hounds* or *Hunting Piece*, which are horizontal in format. In the *Aedes*, Horace Walpole repeats the same information about the picture's location, adding that it is 'a very good Picture'.

The letterpress on William Byrne's engraving for Boydell states that the picture depicts 'Portraits of favourite hounds, and a magpye which generally attended them at chase' and Arline Meyer has noted that Wootton often made use of the magpie motif. The closest analogy to the Hermitage picture is the Althorp *Hounds and a Magpie* in the collection of Earl Spencer at Althorp.

Gilpin, quoted in Chambers, provides the following description of the Walpole canvas: 'The picture of hounds, as you enter the breakfast parlour ... represents three harries, formerly belonging to lord Orford, afterwards to the late duke of Cumberlane, and three buck hounds belonging to King George II: considerable wages were laid on both sides, but the latter were remarkably defeated.'

The picture is not mentioned either in James Christie's sale list nor amongst the additional works included 'without increasing the previous price' in the appendix to a letter from Alexey Musin-Pushkin, Russian ambassador in London, to Empress Catherine (SbRIO 17, 1876).

E. R.

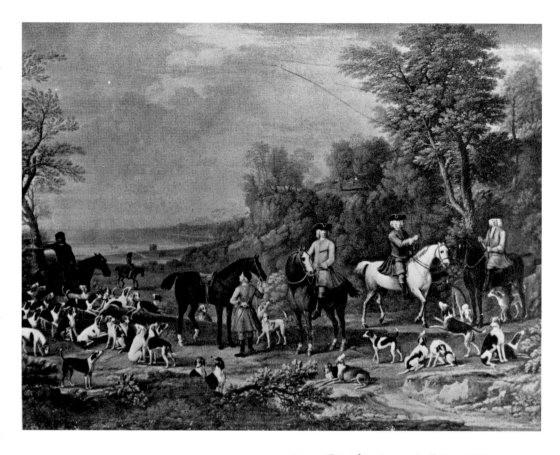

202

JOHN WOOTTON (c.1682-1764)
A Hunting Piece
Oil on canvas, 258 x 206

PROVENANCE: Sir Robert Walpole, 1736 Houghton (Hunting Hall); 1779 Hermitage; from the 19th century to 1941 at Gatchina Palace; disappeared during the Second World War; whereabouts unknown.

LITERATURE: *Aedes* 1752, p. 43; 2002, no. 22; Boydell I, pl. LVI; Georgi 1794, pp. 480, 501 (1996 edition, pp. 362, 373); Chambers 1829, vol. I, p. 521; SbRIO 17, 1876, p. 400; Trubnikov 1914 pp. 92, 99, ill. opposite p 91; Sparrow 1922, p. 105; Kendall 1932-33, p. 41; Meyer 1984a, pp. 79-80; Moore ed. 1996, pp. 49, 90-91.

This picture hung at Houghton Hall above a chimneypiece with an inset mirror in the appropriately-named Hunting Hall on the ground floor. Andrew Moore has suggested that this is the work listed amongst twenty-eight objects in the earliest known document relating to the acquisitions of Robert Walpole, an invoice of 20 January 1721: 'for inlargeing yor. Hon.rs Picture and preparing of it for Mr. Wooton £ 1-10-00; for a frame carv'd & gilt with gold to yr Hon.rs Pictures over the Chimney and Glass £33-00-00'. Moore considers that 'this elaborate frame could well have been for the 'Hunting

Piece, Sr Robt in Green, Coln Churchill in the middle' that hung in the Hunting Hall at Houghton in 1736 and had been commissioned from John Wootton less than six months earlier' (Moore ed. 1996, p. 49), that is to say earlier than the date of the invoice, at the very beginning of the 1720s. This suggestion is substantiated by a letter from Charles Churchill to Sir Robert (16 August 1720): 'Finding you must have forgott the Picture, beg ... to put you in mind that if you dont [?] soon the [time?] will be over, for Wootton wil be otherways imployed' (CUL Chol (Houghton) MSS, Correspondence 803).

Although it disappeared during the war, the picture is known from several sources including the illustration published by Trubnikov in the journal *Staryye gody* (Trubnikov 1914, p. 92) and in the engravings by George Bickham junior and by Daniel Lerpinière (dated 1778 and in reverse). The letterpress on the latter has an inscription, an abbreviated version of the text in the *Aedes* which reads 'Sir Robert Walpole is in Green, Colonel Charles Churchill in the middle; and Mr. Thomas Turner on one side'. A more detailed account is provided by Chambers (1829) who noted that 'Sir Robert Walpole ... is upon a white horse, called the Chevalier, which was taken in Scotland, in the year 1715, and was the only horse the Pretender mounted there'.

A large painting at Petworth House, *Sir Robert Walpole at the Hunstanton Meet*, was probably painted by

Wootton for Thomas Turner, since he is shown in the centre of the composition, with Walpole in a pose similar to that in the lost Hermitage canvas.

In 1726 Bernard Baron made engravings from Wootton's four hunting scenes painted for Lord Oxford (whereabouts unknown). Judging from these engravings, the first of the four pictures was close in composition to the Walpole *Hunting Piece*. The group of three riders is almost identical and the figure of the rider blowing a horn on the other side of the picture and the poses of the dogs are also very similar.

A curious appraisal of the picture is found in the 1773-85 catalogue which notes 'Jean Wootton. Tableau de Chasse. Parmi les figures qui ornent ce Tableau se trouve Sir Robert Walpole en habit vers ayant auprès de lui le Colonel Churchill et Mr. Thomas Turner. C'est tout ce qu'il y à remarquer au sujet de cette pièce médiocre'.

The picture is mentioned (as *Field Hunt*) in the appendix to a letter from Alexey Musin-Pushkin, Russian ambassador in London, to Empress Catherine, listing works added to the Walpole sale 'without increasing the previous price' (SbRIO 17, 1876).

E. R.

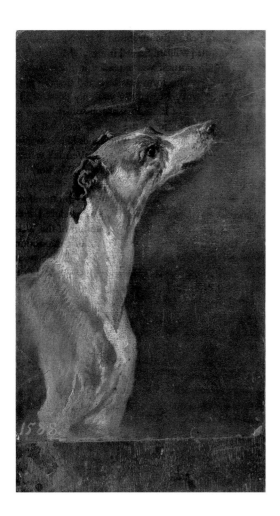

203

JAN WYCK (1645-1700)
A Greyhound's Head
Oil on paper, glued onto panel, 34 x 22
Inv. No. 1806
PROVENANCE: Sir Robert Walpole, Houghton (Small Breakfast Room); 1779 Hermitage.
LITERATURE: *Aedes* 1752, p. 38; 2002, no. 5; Boydell I, pl. XLIII; Chambers 1829, vol. I, p. 520; Anecdotes 1862, vol. 2, pp. 619, 706 (note 2); Cats. 1870-1912, no. 1327; SbRIO 17, 1876, p. 400; Dukelskaya, Renne 1990, no. 114; Moore ed. 1996, p. 87.

The small sketch showing 'A Grey-hound's Head, by old Wyck, who was Wootton's Master' (*Aedes* 1752) was hung as a pair to a sketch of a horse's head then attributed to Van Dyck (cat. no. 126). The pair was valued at 50 pounds when the collection was sold in 1779.

The authorship of Wyck is indicated on Earlom's engraving produced for Boydell's album. This would seem to be the sketch Horace Walpole mentioned in his biography of Wyck where he noted 'At Houghton is a grey hound's head of him, of admirable nature ' (Anecdotes 1862, vol. 2, p. 619), while in the notes we read 'a greyhound's head, of surprising effect, by Old Wyck, Wootton's master' (*ibid.*, p. 706, n. 2).

In the 1773-85 catalogue the picture was attributed to Thomas Wyck, father of Jan, and was described as follows: 'Ce n'est que la tête avec les jambes de devant d'un Levrier Anglais de petite race. Très jolie esquisse'. The 1797 catalogue attributes the work without any explanation whatsoever to Snyders, which is no doubt why it was entered thus in the 1859 inventory. For many years after this the work was attributed to the Dutch school (Cats. 1870-1912).

E. R.

204

ANONYMOUS (MID-16TH-CENTURY)
Portrait of King Edward VI
Oil on panel. 50.5 x 35.6
Inv. No. 1260
PROVENANCE: ?coll. Charles I; sold into Portugal; bought by Lord Tyrawley in Lisbon; presented by him to Sir Robert Walpole; Sir Robert Walpole, 1739 Downing St, later Houghton (Cabinet); 1779 Hermitage.
LITERATURE: *Aedes* 1752, p. 69 (as by 'Holbein'); 2002, no. 168; Chambers 1829, vol. I, p. 530; Livret 1838, p. 479, no. 20; Anecdotes 1862, vol. 1, p. 81; Cats. 1863-1908, no. 467; Vertue, vol. VI, 1935-36, p. 175; Cat. 1958, vol. II, p. 381; Millar 1958-60; Krol' 1969, p. 121; Millar 1963, text vol., pp. 64-65; plate vol., pl. 21; Millar 1970-72, p. 201, no. 257, p. 313; Krol' 1970, pp. 26-33; English Art 1979, no. 4; Cat. 1981, p. 247; Dukelskaya, Renne 1990, no. 93.
EXHIBITIONS: 1998 St Petersburg (Appendix to the catalogue, p. 4).

Edward VI (1537-53) reigned as King of England and Ireland between 1547 and 1553.

According to George Vertue's Notebooks this portrait was in 1739 in the Drawing Room of Robert Walpole's Downing St residence, 'Drawing room <a small figure> K.Edward ye 6' (Vertue, vol. VI, 1948-50, p. 175).

Horace Walpole mistakenly thought it was painted by Hans Holbein, describing it as 'an original small whole Length, by Holbein' (*Aedes* 1752). He also included it in a list of Holbein's English portraits (Anecdotes 1862, vol. 1, p. 81).

In the *Aedes*, Horace Walpole relates how the picture made its way from the Royal Collection to his father's possession via James O'Hara, 2nd Baron Tyrawley (1690-1773), British Envoy-Extraordinary and later ambassador to Lisbon (1728-41). Some of Charles I's paintings did indeed make their way to Lisbon, as we are told by, amongst others, Vertue: 'Many fine pictures Originals carryd to Lisbon when Queen Dowager left Somerset house, that belongd to the Crown' (Vertue, vol. I, 1929-30, p. 161). The absence of any mention of the portrait in the *Abraham van der Doort's Catalogue of the Collections of Charles I* (Millar 1958-60) is not proof that the picture was not at some time in the Royal collection but merely indicates that it was neither at Windsor or Whitehall.

It has not so far been possible to positively identify the portrait with any of the images of King Edward VI formerly belonging to Charles I and later sold. The list of paintings at Somerset House includes a portrait of 'King Edward ye 6 ... at length. Sold to Browne 7 Jan. 1649/50' (Millar 1970-72, p. 313), but there is no evidence to suggest that this was the portrait that eventually ended up at Houghton Hall.

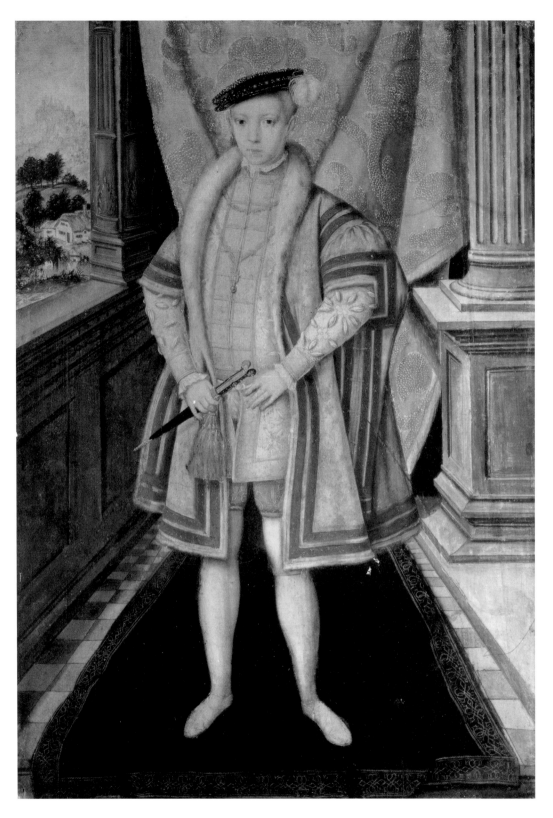

When it entered the Hermitage, right up until 1870, the portrait was in an old ebony frame which bore the inscription *Edvardus. Dei Gratia Sextus Rex Anglia et Francia et Hibernia*, as described in the *Aedes*. The 1773-85 catalogue recorded the work as: 'Jean Holbein ... Ce précieux petit Tableaux'. In the nineteenth century the attribution to Holbein was rightly doubted and the 1859 inventory listed it as school of Holbein. The 1914-16 catalogue described it as the work of an unknown French sixteenth-century artist, and the 1958 catalogue recorded it as the work of an unknown English sixteenth-century artist.

There is no documentary evidence to support A. Krol's attempt to link the picture with a portrait of Edward VI by Hans Hueet (Eworth), listed as being at Hampton Court in *The Inventories and Valuations of the Kings Goods* (Millar 1970-72, p. 201, no. 257) and there is even less basis to support her conclusion (Krol' 1970) that Eworth was author of the Hermitage portrait. Krol' included the picture in Hermitage catalogues as 'attributed' to Eworth (Krol' 1969; Cat. 1981). More recently, Larissa Dukelskaya rejected even this tentative attribution to Eworth (Dukelskaya, Renne 1990, no. 93).

The portrait is a reduced, reworked version of a knee-length image of Edward VI from Windsor Castle, which Millar suggests is 'the official portrait of the young King before the invention of the type associated with Strets [William Scrots] in 1550' (Millar 1963). The Windsor portrait was extended in the sixteenth century and in this form was seen and described by Vertue: 'this picture originally was only done to the knees. but since of late added at top something, and at bottom more to make the leggs & feet. but so ill and unjudiciously drawn. that he stands like a cripple' (Vertue, vol. IV, 1935-36s, p. 66). In Vertue's watercolour copy of 1745 (Royal Collection, Windsor) the portrait is shown with the extensions which were removed in the nineteenth century. We can therefore assume that the Walpole picture was produced after the extension of the original. The author of the Walpole version, which repeats the Windsor composition almost entirely, introduced some changes, the most important being in the landscape and in the addition of the garter beneath the left knee. King Edward was made a member of the Order of the Garter on 6 February 1547, nine days after he came to the throne and this prompted Dukelskaya to suggest that the Hermitage picture may have been executed between 1547 and 1550, when the portrait by Strets became the official image of the King.

The Hermitage version is closest to portraits of Edward VI at Petworth and in the National Portrait Gallery, London.

E. R.

CATALOGUE OF THE PAINTINGS, SCULPTURE AND WORKS OF ART REMAINING AT HOUGHTON

Andrew Moore

Family Portraits and Furnishing Pictures

205

JOHN MICHAEL WRIGHT (1617–1700), studio
Colonel Robert Walpole (1682)
Oil on canvas, feigned sculpted oval, 76.3 x 61
PROVENANCE: Robert Walpole; Sir Robert Walpole
(first recorded 1736, 'in the Little Breakfast Room',
Houghton); then by descent to David, 7th Marquess
of Cholmondeley.
LITERATURE: *Aedes* 1752, p. 40; 2002, no. 7; Musgrave
1732, pp. 35–36.

Robert Walpole (1650–1700) was the eldest son of Sir
Edward (see cat. no. 230) and the father of Sir Robert
Walpole. He married Mary (c.1652–1711), daughter
and heir of Sir Jeffery Burwell of Rougham, Suffolk
and was elected to Parliament as one of the Repre-
sentatives for the Borough of Castle-Rising from
1689 until his death in November 1700. He was
Deputy Lieutenant of Norfolk and Colonel of the
County Militia and, according to William Musgrave,
'bore several other Offices suitable to his Degree, as
his Ancestors had done before him, and was distin-
guished as one of the politest Men of his Time'. He
was a friend of Horatio, 1st Viscount Townshend of
Raynham and was named as an executor in Lord
Townshend's will: this friendship was directly alluded
to in the hang of portraits in the Breakfast Room at
Houghton (see cat. no. 231).

A replica of this portrait hangs at Wolterton Hall, the
seat of Colonel Robert's son Horatio (1678–1757).
The attribution of both portraits to John Michael
Wright is based upon Robert Walpole's Houghton
account book (see cat. no. 208). The sitter wears a blue
cloak and a white jabot, with full wig for the period.

This portrait was one of the series of Houghton
family portraits recorded in grey monochrome water-
colour copies by George Farington (1752–88), paint-
ed c.1775 (Walpole family collection, see cat. no.
230). A half-length portrait in oils in the Walpole
family collection, of a young boy, in a feigned oval
and traditionally called Sir Edward Walpole, may be
of Colonel Robert Walpole, c.1655.

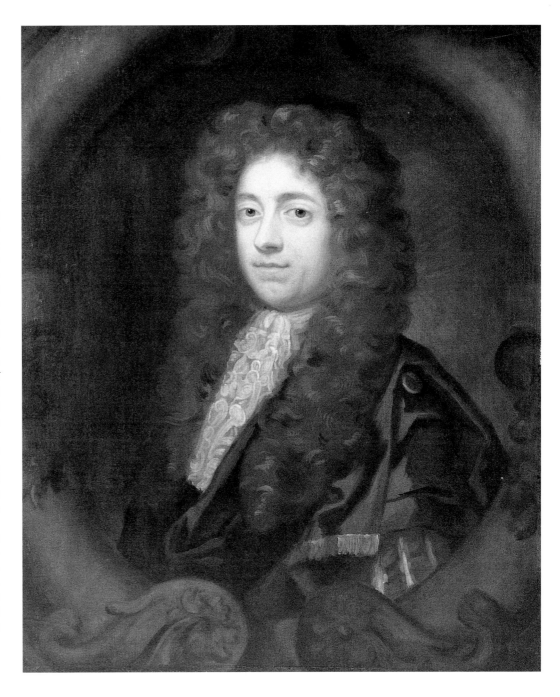

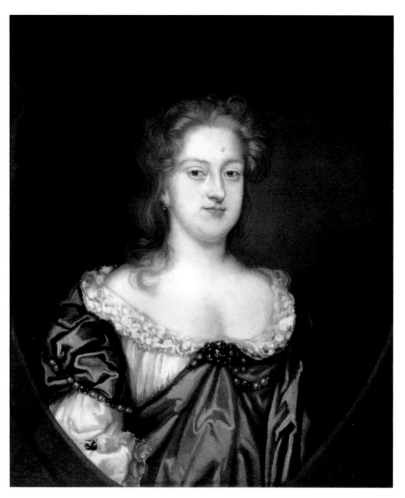
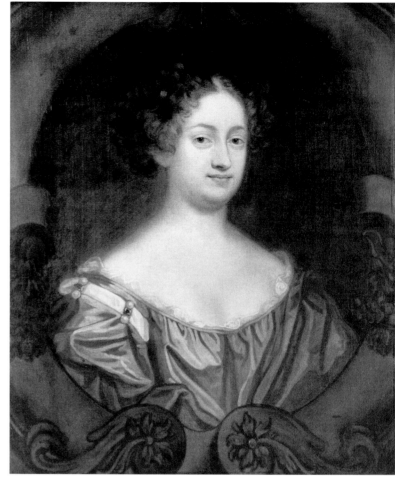

206

MARY BEALE (1633–99), studio
Anne Spelman, née Walpole (c.1670s)
Oil on canvas, in feigned oval, 76 x 61
PROVENANCE: Sir Robert Walpole by 1736, 'Little Breakfast Room. Four Aunts of Sir Robert's, Heads 2' 6" x 2' (1736 MS); 'Dining Parlour Ov. Doors. 4 Ladys, Walpole Family' (1744 MS); 'Supping Parlour' (*Aedes* 1747); then by descent at Houghton Hall, to David, 7th Marquess of Cholmondeley. See also cat. nos. 207–210.
LITERATURE: *Aedes* 1752, p. 42; 2002, no. 17; Musgrave 1732, p. 34.

Anne Walpole (1656–91) was the sixth child of Edward Walpole and his wife Susan Crane (see cat. no. 230). Anne married Mountfort (or Mundeford) Spelman of neighbouring Narborough in Norfolk. She died childless on 28 September 1691. Anne Walpole's marriage into the distinguished Spelman family was judicious if not adventurous.

One of four family portraits at Houghton by 1736 and specifically identified by Horace Walpole in the *Aedes*, nos. 17–20, Anne Walpole's portrait shows her as an attractive young woman in a grey dress and blue mantle and may mark the occasion of her marriage. The artist has not been identified with any certainty and has never been accorded an attribution.

The studio of Mary Beale is suggested by the characterful and sympathetic treatment of the head and assured if prosaic treatment of the drapery.

This portrait was one of the series of Houghton family portraits recorded in grey monochrome watercolour copies by George Farington (1752–88), painted c.1775 (Walpole family collection, see cat. no. 230).

John Guinness was the first to draw attention to the likely identification of the set of four portraits, cat. nos. 206–209, in a letter to Sybil, Dowager Marchioness Cholmondeley, 1981.

207

MARY BEALE (1633–99), studio
Dorothy Walpole (c.1680s)
Oil on canvas, in feigned oval, 74 x 61
PROVENANCE : See cat. no. 206.
LITERATURE : *Aedes* 1747, p. 42; 1752, p. 43; 2002, no. 18; Musgrave 1732, p. 35.

Dorothy Walpole (1659–94) was unmarried when she died on 5 October 1694. Horace Walpole's great-aunt, she was the eighth child of Edward Walpole and his wife Susan Crane (see cat. no. 230). The most demure and, in her portrait at least, most plainly dressed of Sir Robert's four aunts, this sitter has in recent times nevertheless been taken for Louise de Kerouaille, Duchess of Portsmouth, the celebrated mistress of Charles II. This portrait was listed in Houghton Inventories of 1888, 1900 and 1910/11 as no. 41, *A Lady*. The identity of the sitter was confused with that of another portrait at Houghton, Inventories 1888 and 1900, no. 103, *Duchess of Portsmouth* and 1910/11, *Duchess of Portsmouth with pearl necklace* (David Yaxley).

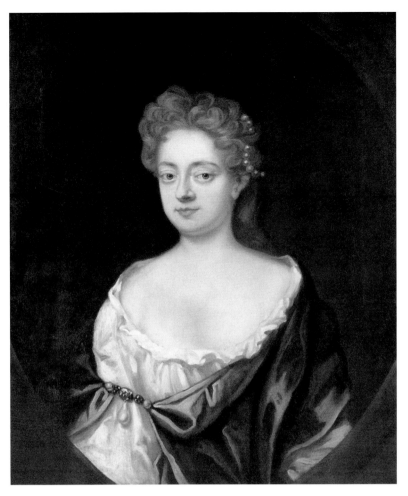

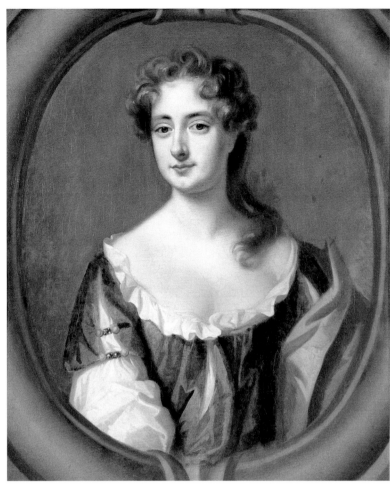

The portrait is typical of the products of Mary Beale's studio, which was in decline by the 1680s. See also cat. nos. 206, 208 and 209. This portrait was one of the series of Houghton family portraits recorded in grey monochrome watercolour copies by George Farington (1752–88), painted c.1775 (Walpole family collection, see cat. no. 230).

208

JOHN MICHAEL WRIGHT (1617–1700), studio
Mary Wilson, née Walpole (1682)
Oil on canvas, in feigned oval, 74 x 61
PROVENANCE: See cat. no. 206.
LITERATURE: *Aedes* 1752, p. 43; 2002, no. 19; Musgrave 1732, p. 34.

Mary Walpole (b. 1661) was the tenth child of Edward Walpole and his wife Susan Crane (see cat. no. 230). Born 11 August 1661, she married John Wilson of Leicestershire and died childless. This was one of the series of Houghton family portraits recorded in grey monochrome watercolour copies by George Farington (1752–88), painted c.1775 (Walpole family collection, see cat. no. 230).

The painter of this portrait has in recent years been associated with Charles Jervas, but the circle of John Michael Wright or Mary Beale, rather than of Godfrey Kneller, is more likely. The Houghton account book of Robert Walpole, Sir Robert's father, under 27 June 1682 reads 'for myne & sister Mary's Picture, A case of forks – frames for the pictures & pd Mr. Wright 12 li. 18s. 6d' (I am grateful to David Yaxley for this information). See also cat. nos. 206, 207 and 209.

209

MARY BEALE (1633–99), attributed
Elizabeth Hoste, née Walpole (c.1690)
Oil on canvas, in feigned oval, 76 x 61
PROVENANCE: See cat. no. 206.
LITERATURE: *Aedes* 1752, p. 43; 2002, no. 20; Musgrave 1732, p. 34.

Elizabeth Walpole was born 28 December 1665 and was the thirteenth child of Edward Walpole and his wife Susan Crane (see cat. no. 230). She married James Hoste of neighbouring Sandringham, Norfolk. The Hoste family acquired Sandringham House from the Cobbes in 1686.

Elizabeth Walpole is likely to have been the last of the four aunts of Sir Robert Walpole to have been painted, in the mid-1680s. This could have been a marriage portrait, commissioned to hang with those of Elizabeth's sisters at the Old Houghton Hall. See also cat. nos. 206, 207 and 208. This portrait was one of the series of Houghton family portraits recorded in grey monochrome watercolour copies by George Farington (1752–88), painted c.1775 (Walpole family collection, see cat. no. 230).

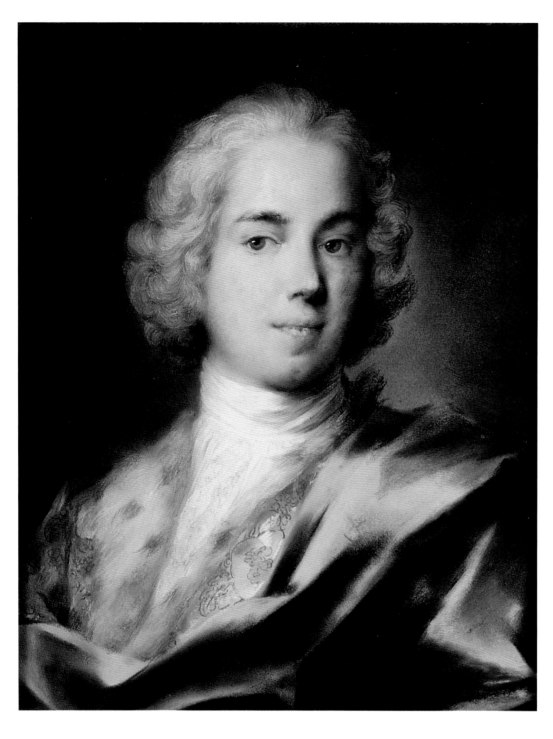

Sir Robert's eldest son was the first of the Walpole family to sit to Rosalba Carriera. It was this portrait that was to inspire Sir Robert to see that his two younger sons, Edward and Horace, also sat to Rosalba. In this set of three pastels we see Sir Robert subscribing to the taste of contemporary European travellers for souvenirs of the Grand Tour. Rosalba's ability to produce delicate and spontaneous likenesses in pastel gave her an eminence in the minds of British travellers which was to be matched only by Pompeo Batoni (1708–87).

Sir Robert's eldest son and heir, Robert (1701–51), was educated at Eton and was created in 1723 Baron Walpole of Walpole. William Musgrave records: 'having had all imaginable advantages in his Education at Home, set out on his Travels *Anno* 1720. And in consideration of the great Services of his Father, and Family, he was (before his Return) created a Peer of *Great Britain*, by the Name, Style, and Title, of Baron *Walpole of Walpole*, in the County of Norfolk, by Letters Patent bearing Date June 1, 1723.'

Musgrave further records the statement made in the Patent, explaining that the King had originally intended to honour Sir Robert by elevating him to the peerage. Instead Sir Robert, being 'more ambitious of meriting Honours, than acquiring them; that his Family might at least be ennobled', the honour went instead to the son: 'From which Gentleman, whatever is great, or glorious, may reasonably be expected. He has long since shewn a very Ripe Genius to *Literature* and the *Sciences*, and now [1723] resolves to bring whatever is worthy his Notice from Foreign Countries'. Musgrave was assured that 'he will deliver the Dignity, derived from his Father's Merits, enlarged to his Posterity'.

Robert Walpole is recorded at Padua on 11 October 1722 (with Captain 'H. Thomas') and it was presumably at that time that he sat to Rosalba. He was in Rome by 12 January 1723 and also visited Naples. Robert Walpole's most spectacular purchase while abroad was made in Rome on behalf of his father: the life-size bronze version of the *Laocoön* (see cat. no. 249). According to Sir Thomas Robinson, this cost '1,000 guin[eas] at Paris' (9 December 1731).

It was conceivably Robert Walpole who acquired Rosalba's *Apollo* (cat. no. 18) and its companion *Diana* (cat. no. 19), which were both recorded by Horace Walpole as in Downing Street in 1736.

A version of this pastel, formerly in the collection of Dorothy Neville, was sold Sotheby's 23 March 1971, lot 80.

210

ROSALBA CARRIERA (1675–1758)
Robert Walpole (c.1722)
Pastel, 61 x 49; inscribed (by HW) on the backboard: *Robert, Lord Walpole now Earl of Orford. / Painted by Rosalba.*
PROVENANCE: Sir Robert Walpole (first recorded 1736, in Lady Walpole's Drawing Room, Downing Street: 'A Head of Ld. Walpole in Crayons. Rosalba, 1.9 x 1.5'); Houghton Hall: 'Yellow Drawing Room ov. Settee in water colours in centre', 1744 MS; then by descent to David, 7th Marquess of Chomondeley.
LITERATURE: *Aedes* 1752, p. 52; 2002, no. 72; Musgrave 1732, pp. 43–46; Moore 1985, pp. 88–89; Sani, 1988, no. 94; Moore ed. 1996, p. 107; Ingamells 1997, pp. 976–77; see also Appendix I, Directory.
EXHIBITIONS: 1985 Norwich, no. 8; 1996–97 Norwich–London, no. 27.

211

ROSALBA CARRIERA (1675–1758)
Edward Walpole (c.1730)
Pastel, 60.5 x 48.5; inscribed (by HW) on the back-board: *Edward Walpole, Clerk of the Pells, 2nd son to Robert Walpole, Earl of Orford. Painted by Rosalba.*
PROVENANCE: Sir Robert Walpole (first recorded 1736, in Lady Walpole's Drawing Room, Downing Street: 'Mr Edward Walpole, ditto [i.e. in crayons,] Rosalba 1.10? x 1.5); Houghton Hall 'Yellow Dressing Room ov. settee in water colours R. H. Edwd. Walpole Esq. Do. [i.e. Rosalba]' (HRO MS 1744); then by descent to David, 7th Marquess of Cholmondeley.
LITERATURE: *Aedes* 1752, p. 52.; 2002, no. 73; Moore 1985, p. 89; Sani 1988, no. 95; Moore ed. 1996, p. 108; Ingamells 1997, p. 974.
EXHIBITIONS: 1985 Norwich no. 9; 1996–97 Norwich–London, no. 28.

Edward (1706–84) was the second son of Sir Robert Walpole and Catherine Shorter. Educated at Eton (1718) King's College (1725) Cambridge and Lincoln's Inn, he was called to the bar in 1727. He embarked upon his European tour in 1730, reaching Venice by 20 January in time for the Carnival. Edward's visit to Venice is mentioned in the correspondence of Colonel Elizeus Burges, who at that time was on his second mission and Resident in Venice. Burges records that two months later Edward had joined up with Gustavus Hamilton, 2nd Viscount Boyne (1710–46): 'Lord Boyne & Mr Walpole chuse to continue here till ye Opera begins at Picenza, rather than go to any other town in Italy' (17 March 1730, Brinsley Ford Archive (Paul Mellon Centre), Public Record Office SPF 99/63).

Edward's itinerary was delayed by illness. On 12 May Burges reported that he had been 'extremely ill here of a fever and was in so bad a way that nobody expected he would recover; but, God be thanked, he is now abroad again, and cannot fail of doing well, if he'll please to take a little care of himself: as he is a very pretty young Gentleman, everybody was under ye greatest concern imaginable for him'. Once recovered, Edward set out on an extended tour of Italy with Lord Boyne. They left for Padua, where they arrived on 11 July 1730. They returned to Padua by 3 November 'after having seen all ye great towns in Italy. A few days after they came there poor Mr Stuart died, who was a very worthy Gentleman that travell'd with 'em'. Edward finally left for England on 12 January 1731, in the company of Colonel William Kennedy and Captain Jasper Clayton. This itinerary suggests that Edward Walpole sat to Rosalba Carriera in 1730, quite probably during carnival time, along with his companion, Lord Boyne. A Rosalba portrait of Lord Boyne, now in a private collection, shows the sitter in carnival dress; this has been

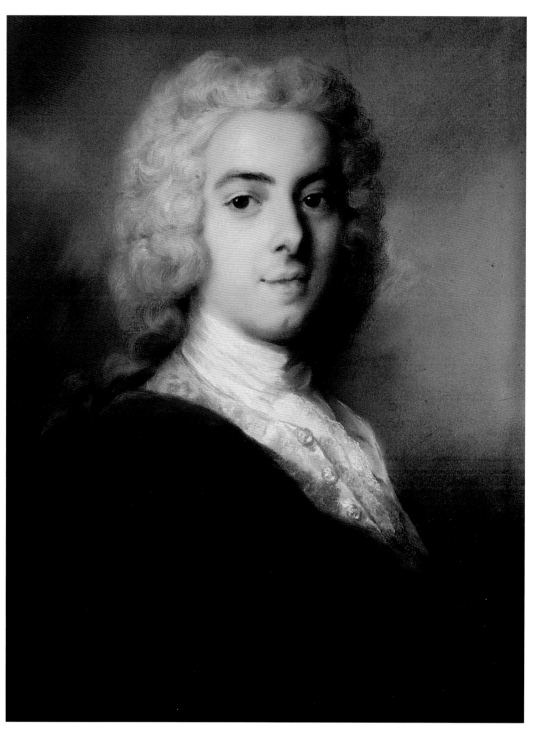

called a portrait of Horace Walpole (see Adams, Lewis 1968–70, pp. 9–10).

Edward maintained his interest in the arts and was an amateur draughtsman, musician, poet and caricaturist. His younger brother Horace carefully archived a number of his works in his library at Strawberry Hill (now Lewis Walpole Library). See also Appendix I.

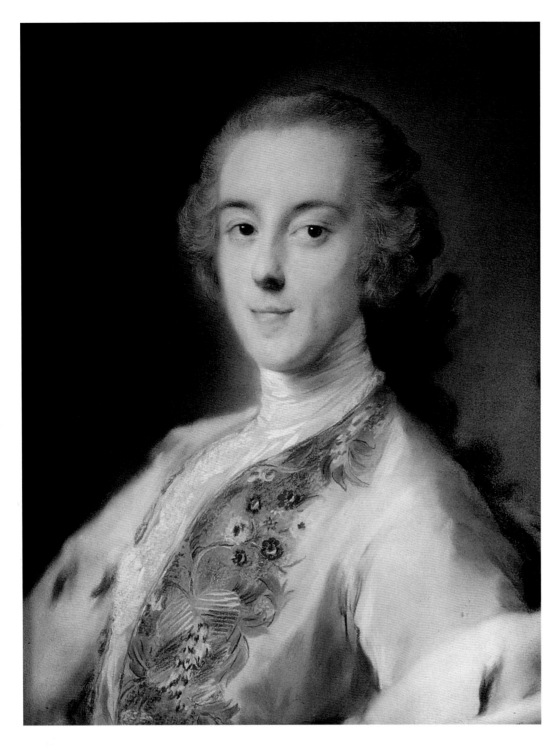

212

ROSALBA CARRIERA (1675–1758)
Horace Walpole (c.1741)

Pastel, 61 x 46.5; inscribed (by HW) in ink on the backboard: *Horace Walpole / 3rd son to Robert Earl of Orford / Anno Aetatis suae 23 / painted by Rosalba.*

PROVENANCE: Sir Robert Walpole; first recorded in the Yellow Drawing Room, Houghton, by 1744 'ov. Settee in water colours. L. H. Horatio Walpole Esq. Rosalba'; then by descent to David, 7th Marquess of Cholmondeley.

LITERATURE: *Aedes* 1752, p. 52; 2002, no. 74; Adams, Lewis 1968–70, pp. 9–10; Moore 1985, p. 133ff; Moore ed. 1996, pp. 108–9.

EXHIBITIONS: 1985 Norwich, p. 133; 1996–97 Norwich–London, no. 29.

Horace Walpole (1717–97) was in Venice between 9 June and 12 July 1741. Either this portrait or an unknown second portrait of Walpole was seen in Rosalba's studio by Mme Suares (1697–1773) and her daughters Vittorina and Teresina, in March 1742. Mme Suares wrote to Horace Mann of their visit, describing how Vittorina exclaimed, 'Oh. Mr. Walpole, how happy I am to see you here!' Teresina, meanwhile, 'for half an hour kept bowing and making compliments to the portrait'. Mme Suares added that 'Never in my life have I seen a portrait of such perfection and verisimilitude.' Rosalba responded that it had been sold to the English banker 'Smit'. This suggests that Consul Joseph Smith had been acting as an agent, quite possibly to Sir Robert: the portrait was clearly keenly awaited to complete the set of Rosalba portraits of the three sons.

According to the Rev. Joseph Spence (1699–1768) who had one of his 'chit-chats' with Rosalba, she had seen Horace 'but twice or thrice' while he was in Venice. She was able to give Spence as good an account of his character as 'I could have done myself'. This was in an effort to convince Spence that she was well able to 'know people's tempers by their faces' (Slava Klima, ed., *Joseph Spence: Letters from the Grand Tour*, 1975, p. 16). Rosalba provided what is certainly the most flattering of Horace's portraits from throughout his long life, providing further evidence of her ability to flatter as well as provide 'temper' (For a study of the numerous portraits of Horace Walpole see Adams, Lewis 1968–70). Horace himself considered that 'portraits at most exhibit character, not passions' (HW to Hamilton, 30 September 1792, HWC, vol. 35, p. 445). Horace later felt that he did not age so well as his older brother Edward, calling himself a 'wrinkled parchment' in comparison (HW to Horace Mann, 8 December 1775, HWC, vol. 24, p. 148).

213

MICHAEL DAHL (1659–1743)
Catherine Shorter, later Lady Walpole (c.1710)
Oil on canvas, 99 x 82.5
PROVENANCE: Sir Robert Walpole, in the Little Bed
Chamber, Houghton Hall, 'Sir Robert Walpole's
Lady, half length, Dahl, 3' 2" x 2' 8'" (1736 MS); 'In
his Bedchamber ov ch. 1st Lady Walpole Dayl [*sic*]'
(1744 MS); then at Houghton by descent to David,
7th Marquess of Cholmondeley.
LITERATURE: *Aedes* 1752, p. 49; 2002, no. 57; Moore,
Crawley 1992, pp. 105–6; Moore ed. 1996, p. 103.
EXHIBITIONS: 1959 London, no. 43; 1992 Norwich
no. 37; 1996–97 Norwich–London, no. 23.

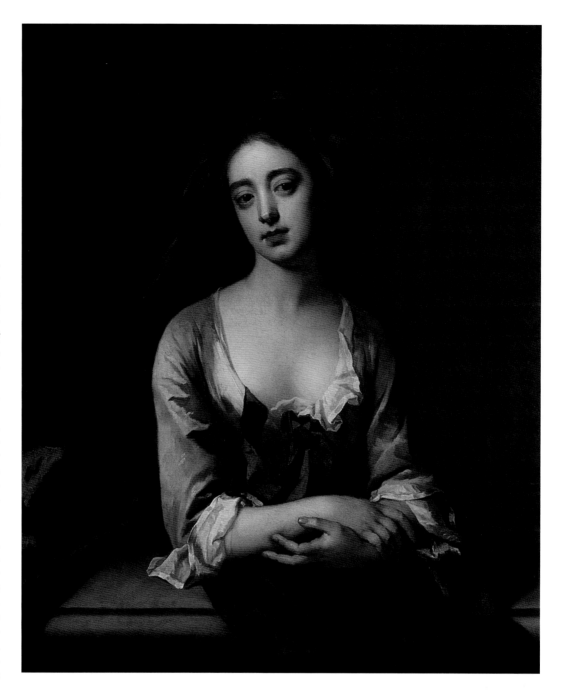

The young Robert Walpole was captivated by Cather-
ine Shorter (1682–1737) and her image remained dear
to him even as he paid court to his mistress, Maria Sker-
rett. This portrait hung over the chimney piece of his
private wainscoted bedchamber throughout Sir
Robert's time at Houghton. A full-length portrait of
Catherine Shorter by Kneller is also recorded in Wal-
pole's house at Chelsea, in the Yellow Damask Bed-
chamber, 1736.

Horace Walpole's apposite comment in the *Aedes* is
that Dahl's painting is 'an extreme good portrait'.
Michael Dahl had settled in London for good in
March 1689 and soon became the most popular por-
trait painter in England after Kneller. Although a Tory
by political persuasion, he was patronised by Tories
and Whigs alike, in common with most of the lead-
ing portraitists of this period. Nevertheless, he was
not especially well patronised by the Walpole family,
probably being suspected of Jacobite sympathies.

Catherine was also depicted in what was effectively a
double portrait with Sir Robert in the pair of engrav-
ings by George Vertue, dated 1748, which form a fron-
tispiece to the second edition of the *Aedes Walpolianae*
(1752). Both portraits are based on miniatures by Chris-
tian Friedrick Zincke (*Sir Robert Walpole*, now Man-
chester City Art Gallery, formerly Earl of Derby Col-
lection; *Catherine Shorter*, now Oxford, Ashmolean
Museum). Horace Walpole commissioned John Giles
Eccardt (with John Wootton) to paint a double portrait
in oils (now Lewis Walpole Library, Farmington, Con-
necticut) based upon the engraving (HW to Bentley, 18
May 1754). In both the engraving and Eccardt's oil, Sir
Robert is shown seated at a table on which there is the
Chancellor's seal and busts of George I and George II.
Catherine stands beside him, with flowers, shells, a
palette and pencils to mark her own love of the arts.
Later in life Horace Walpole was to recall how Cather-
ine entertained Voltaire to dinner (HW to Voltaire 21
June 1768). Catherine's own favourite portrait of her
husband was that 'painted by Richardson in a green
frock and hat, and the dogs and landscape by Wootton'
(HW to the Earl of Hardwicke, November 1772). The
prime version remains in the Walpole family collection
(see Moore ed. 1996, no. 2).

This portrait was one of the series of portraits
recorded in grey monochrome watercolour copies by
George Farington, c.1775 (Walpole family collection,
see cat. no. 230).

For another portrait of Catherine Shorter, see cat.
no. 216.

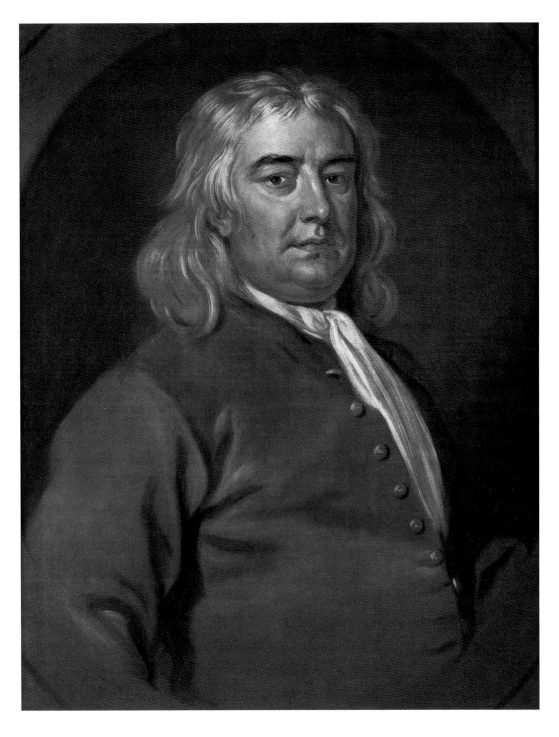

214

JOHN ELLYS (c.1701–57)
Fulke Harold, The Gardener (c.1736–43*)*
Oil on canvas, feigned oval, 71 x 53.3
PROVENANCE: Sir Robert Walpole, by 1744 'Below
Stairs in the Breakfast Parlour over the glass, Old
Harold yᵗ Gardener' (HRO MS 1744); then by
descent to David, 7th Marquess of Cholmondeley.

LITERATURE: *Aedes* 1752, p. 40; 2002, no. 7; Vertue
III, 1933-34, p. 95; 1792 MS Inventory (Houghton
M24C); Moore ed. 1996, pp. 88–89, no. 4.

The informal family character of the Breakfast Parlour
is reinforced by the inclusion of this portrait which
bespeaks a close relationship between this particular
servant and his master, although the portrait was
somewhat ignominiously hung high above the mirror
glass. Fulke Harold (d. April 1754) was gardener to
Robert Walpole from at least 1718 and was engaged
in laying out the garden and park. This portrait was
among the series of family portraits carefully recorded
by George Farington c.1775 and Horace Walpole's
inscription on the reverse of this version confirms the
sitter's identity (see also cat. no. 230).

Sir Robert's patronage of John Ellys is illuminating.
George Vertue records that in the mid-1730s John
Ellys (or Ellis) was the favourite painter of Lord Pem-
broke, but his relationship with Sir Robert seems, if
anything, just as involved. A pupil of Sir James
Thornhill (c.1716), Ellys is said to have worked with
him on the decorative scheme at Greenwich. Ellys
later studied in the Vanderbank Academy and gained
a reputation as a painter of portraits in the Kneller tra-
dition. It is not clear when Sir Robert became inter-
ested in Ellys, but it is quite possible that it was
through Walpole's influence that Ellys was appointed
Principal Painter to the Prince of Wales, succeeding
Philip Mercier in October 1736.

George Vertue records that Ellys received the
appointment of Master Keeper of the Lions in the
Tower of London through the favour of Sir Robert.
For this unique post he was paid nine shillings a day
for feeding 'the royal beasts'. Vertue further observes
that Ellys attended upon Sir Robert 'and did exert
himself privately to give his advice and purchasd pic-
tures for Sr. Robt. sometimes'. Ellys was, for exam-
ple, at the collection sale of Charles Montagu, Earl
of Halifax (3rd day, 8 March 1739/40, lot 87), where
he purchased 'A Landskip ... Highly Finished',
attributed to Gaspar Dughet on behalf of Walpole
(see cat. no. 166).

Ellys's 'exertion' on behalf of Sir Robert extended
to purchasing works of art abroad. Vertue records a
'large picture of the Virgin and the Angells by
Vandyke', bought for Walpole by Ellys for £800 in
Holland. This was Van Dyck's *Rest on the Flight into
Egypt* (cat. no. 111) which was with M. Valkenburg,
Rotterdam in 1731. See also Appendix I for Ellys's
other activities on behalf of the Orford family.

215

CHARLES JERVAS (c.1675–1739)
Sir Robert Walpole (c.1708–10)
Oil on canvas, 127 x 101.5

PROVENANCE: Sir Robert Walpole, by c.1710; in the Supping Parlour, Houghton Hall by 1736 (Walpole MS 1736 'Sr Robert Walpole, Jervase 4' 2" x 3' 4"); then by descent to David, 7th Marquess of Cholmondeley.
LITERATURE: *Aedes* 1752, p. 42; 2002, no. 12; Kerslake 1977, vol. I, p. 201; Moore ed. 1996, pp. 83–84; Bottoms 1997, pp. 44–48.

This is one of two principal images of Sir Robert Walpole (1676–1745) before his first period of Office as Chancellor and First Lord of the Treasury (the second is the Kit-Cat Club portrait by Sir Godfrey Kneller, 1710–15, commissioned by Jacob Tonson, now National Portrait Gallery, London; Kneller is also likely to be the painter of a three-quarter-length portrait of Robert Walpole, with later additions by Jervas, see Kerslake 1977, vol. I, p. 201, vol. II, pl. 586). The portrait, of the many of Walpole that survive, shows the sitter at his youngest, when 'Secretary at War to Queen Anne'. The 1747 edition of the *Aedes* states simply 'Secretary to Queen Ann'. Horace Walpole inserted manuscript correction 'at war' into many copies of the first edition. The treatment of both pose and drapery demonstrates the influence of the artist's earlier period in the studio of Sir Godfrey Kneller. It is one of the most attractive portraits of Walpole, painted when the sitter was in his early thirties and before his girth was to challenge the brush of most of the portraitists of Georgian England: these were to include Michael Dahl (?1659–1743), Thomas Gibson (c.1680–1751), John Theodore Heins (1697–1756), Thomas Hudson (1701–79), Hans Huyssing (1685–1753), Sir Godfrey Kneller (1646–1723), Jonathan Richardson (c.1665–1745), Jean-Baptiste Vanloo (1684–1745) and John Wootton (?1682–1764).

The sitter is depicted prior to receiving any honours for service and the portrait is therefore refreshingly bereft of any insignia, robes or accoutrements of office. However, the inkstand at his side is a signal of his status, as is the letter inscribed 'Walpole' that he holds. The young Walpole's stylish brown coat, blue mantle and full-bottomed wig date the portrait to c.1709. Jervas had recently returned to England from Italy to develop a successful practice as a fashionable portrait painter. A later, three-quarter-length portrait of Sir Robert Walpole attributed to Jervas shows Walpole in his Chancellor's robes and ribbon of the Bath (see Kerslake 1977, vol. II, pl. 585) and a comparable portrait by Jervas was destroyed by fire at Wolterton in 1952 (known through a watercolour copy by Elizabeth Walpole in the Walpole family collection). In 1709 *The Tatler* described Jervas as 'the last great painter Italy has sent us'. He caught the eye of Robert

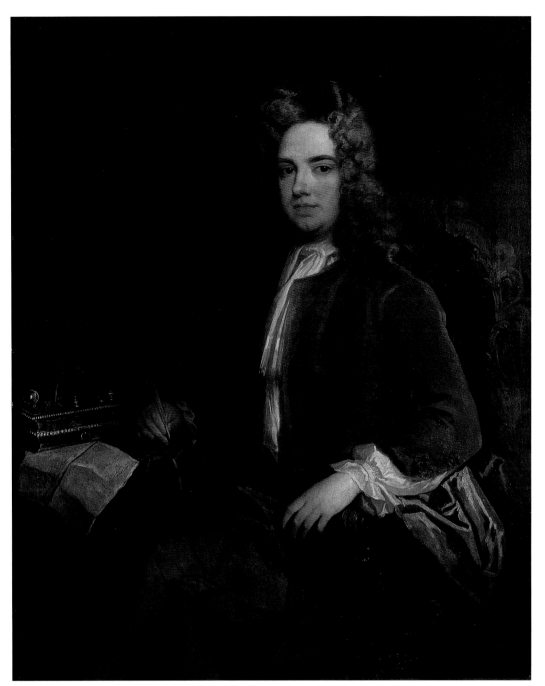

Photograph by Neil Jinkerson © The Marquess of Cholmondeley

Walpole and the commission for this portrait is the first example of the sitter's patronage of living artists. Jervas was to become a key figure in the development of Sir Robert's collection. See also cat. no. 41 for a work acquired by Jervas on behalf of Walpole.

This portrait was one of the series of Houghton family portraits recorded in grey monochrome watercolour copies by George Farington (1752–88), painted c.1775 (Walpole family collection, see cat. no. 230).

For other portraits by Jervas, see cat. nos. 216–218.

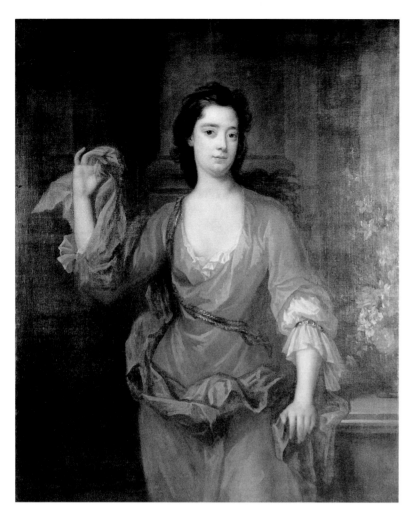

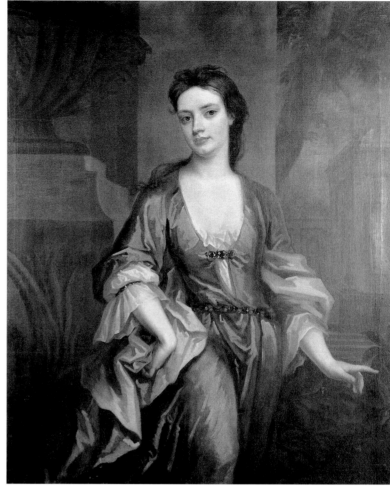

216

CHARLES JERVAS (c.1675–1739)
Catherine Shorter, Lady Walpole (c.1710)
Oil on canvas, 126 x 102
PROVENANCE: Sir Robert Walpole, by c.1710; in the Supping Parlour, Houghton Hall by 1736 (Walpole MS 1736 'His Lady, Ditto [Jervase], 4' 2" x 3' 4"); then by descent to David, 7th Marquess of Cholmondeley.
LITERATURE: *Aedes* 1752, p. 42; 2002, no. 13; Moore ed. 1996, p. 103; Bottoms 1997.

Sir Robert Walpole's biographer William Coxe describes Catherine Shorter (1682–1737) as 'a woman of exquisite beauty and accomplished manners'. Catherine was the daughter of John Shorter and his wife Elizabeth, who was the daughter of Sir Erasmus Philips, Bart, of Pembrokeshire. There appears to have been some haste or secrecy about the marriage at Knightsbridge Chapel on 30 July 1700. Francis Hare, writing to Robert Walpole on 8 August, mentions that Walpole's brother Horatio had only just learned of it the previous day. Catherine brought

Robert Walpole a dowry of £20,000, but was known for her extravagance as a woman of fashion. According to Horace Walpole her dowry was 'spent on the wedding and christening … including her jewels'.

This fashionable and outgoing personality is well captured by Jervas, whose portrait shows considerable élan for the period. Jervas specialised in portraits of fashionable beauties and here Sir Robert's young wife sports a low cut décolletage and a frozen but expansive gesture of the right arm. The flow of her cascading mantle mirrors the arrangement of flowers at her side. The mannered pose is softened by the treatment of the drapery which imitates that of Van Dyck. The paintings by Jervas hanging at Whitehall also included a portrait of Catherine's sister, Charlotte Shorter.

Catherine died at Chelsea on 20 August 1737 and was buried in the Henry VII Chapel, Westminster. She had borne Walpole three sons and two daughters. The sons were Robert, who succeeded as 2nd Earl of Orford, Edward and Horatio (or Horace) Walpole. The daughters were Mary, who married George, 3rd Earl of Cholmondeley, and Catherine, who died aged nineteen.

217

CHARLES JERVAS (c.1675–1739)
Dorothy, Lady Townshend
Oil on canvas, 124.5 x 99cm
PROVENANCE: Sir Robert Walpole; in the Supping Parlour, Houghton Hall, by 1736 (Walpole MS 1736, 'Dorothy Lady Townshend, sister to Sir Robert, Jervase, 4' 2" x 3' 4"); then by descent to David, 7th Marquess of Cholmondeley.
LITERATURE: *Aedes* 1752, p. 42; 2002, no. 16; Moore, Crawley 1992, pp. 106–7; Bottoms 1997, pp. 44–48.

Dorothy, Lady Townshend (1686–1726) was the daughter of Colonel Robert Walpole of Houghton and his wife Mary. She married, as his second wife, Charles, 2nd Viscount Townshend of Raynham (cat. no. 219). Chambers commented that 'this lady was a national treasure, for she cemented the political union of her husband Lord Townshend, and her brother Sir Robert Walpole' (Chambers 1829, vol. II, p. 549). Dorothy had known Charles Townshend since the days when her father was his guardian, but his first wife was Elizabeth, daughter of Thomas, Lord Pelham.

Dorothy made a flirtatious name for herself first in London and then Paris, leading a contemporary to record the 'yet greater folly of Lord Townshend [that] … had occasioned his being drawn in to marry her' in 1713. Her death in 1726 was officially given out as caused by smallpox, but a local rumour had her pushed at the top of the hall's great staircase.

Jervas's portrait of Dorothy Townshend was probably painted to mark the occasion of the alliance of the two families in 1713. The pose and style recall the artist's portrait of Catherine Shorter (cat. no. 216) and the two were hung close to each other in the Supping Parlour. Jervas here suggests a lively and expressive personality and he was to paint Lady Townshend more than once thanks to the joint patronage of the Townshend and Walpole families. A portrait of Dorothy Townshend by Jervas, c.1717, was formerly at Strawberry Hill (Strawberry Hill Sale, 21st day, 18 May 1842, lot 37; now Dulwich Picture Gallery, London), while a beautiful half-length in a feigned oval survives at Holkham Hall, the home of Sir Robert's chief electoral officer for Norfolk, Lord Lovell, and a less distinguished portrait is at Raynham Hall in Norfolk. A variant of cat no. 217 was at West Acre House, Norfolk, home of Sir Robert's sister Susan who married Anthony Hamond (photograph, National Portrait Gallery, Heinz Archive). A bust variant (in a feigned oval) remains in the Walpole family collection. In addition Dorothy Townshend herself commissioned Jervas 'immediately after the installation ceremony' to produce a full length of her husband in his new Garter robes. Documented in an account of 1733 now in the Townshend family archive, this was one of a number of Townshend family portraits by Jervas which hung at Raynham Hall in Norfolk (Chambers 1829, vol. I, p. 543).

This was one of the series of portraits recorded in grey monochrome watercolour copies by George Farington c.1775 (Walpole family collection, see cat. no. 230).

218

CHARLES JERVAS (c.1675–1739)
Mary Walpole, Viscountess Malpas (c.1730–31)
Crayons on pink preparation, 55.9 x 42
PROVENANCE: Sir Robert Walpole, by 1736, in Lady Walpole's Drawing Room, Downing Street, 'Lady Malpas, ditto [ie. 'A Head of Crayons'] Jervase, 1' 10" x 1' 5" (Walpole MS 1736); at Houghton by 1743; 'Yellow Drawing Room, ov. Settee in water colours, R. H. Lady Cholmondeley not finish'd Jervais', 1744 (Walpole MS 1744); by descent to ?George Cholmondeley, Viscount Malpas, later 3rd Earl of Cholmondeley (1703–70); by descent to David, 7th Marquess of Cholmondeley.
LITERATURE: *Aedes* 1752, p. 52; 2002, no. 75; Moore ed. 1996, pp. 157–58; Musgrave 1732, p. 43.

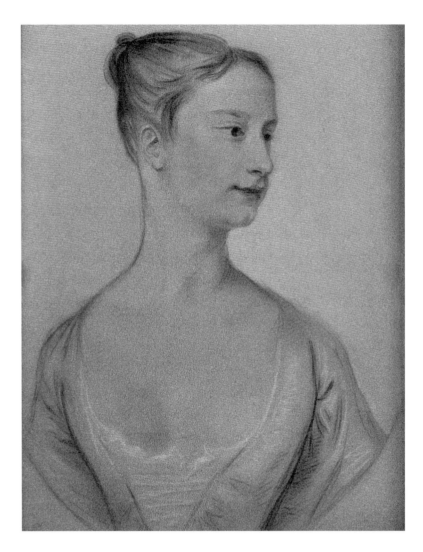

Mary (c.1705–31), only daughter of Sir Robert Walpole and his first wife Catherine Shorter, married George Cholmondeley, Viscount Malpas, later 3rd Earl of Cholmondeley (1703–70). Their youngest son Frederick was to die in 1734, while their son George (1724–64) was to succeed as Viscount Malpas in 1733.

This is the only recorded portrait of Mary Walpole, Lady Malpas in life. She died of consumption in France in January 1731. According to tradition her body was lost in a shipwreck while being brought home in April 1732. William Musgrave records, however, that she 'Died of a Consumption in France, 1731–32, but her corps was brought over, and interred at *Houghton*'. Horace Walpole, in his copy of Musgrave's *Memoirs of the Family of Walpole* (Lewis Walpole Library, Farmington, Conn.) corrects in pen her burial place to Cholmondeley, Cheshire.

Sir Robert is unlikely to have commissioned a portrait in watercolours from Jervas. It is probable that the 'sketch in profile' was as far as Jervas had managed in the course of a full commission for a portrait in oils, before Mary's departure for France.

Viscount Malpas commissioned a family portrait in commemoration of his newly deceased wife from William Hogarth. The portrait remains in the family collection (see Moore ed. 1996, p. 157, no. 76) and includes a portrait of Mary holding their youngest son Frederick. Her stiff pose suggests that Hogarth was copying her likeness from another picture, quite possibly this profile sketch by Jervas, which is recorded as a 'Head of Crayons' in 1736 (see provenance above).

219

GODFREY KNELLER (1646–1723)
Charles, 2nd Viscount Townshend (c.1713)
Oil on canvas, 127 x 102
PROVENANCE: Sir Robert Walpole, at Houghton by
1736 (1736 MS, 'In the Rustick Story ... In the Sup-
ping Parlour'); by descent to David, 7th Marquess of
Cholmondeley.
LITERATURE: *Aedes* 1752, p. 42; 2002 no. 15; Piper
1963, p. 350; Moore, Crawley 1992, pp. 104–5, nos.
35 and 36.

Educated at Eton and King's College, Cambridge,
Charles Townshend (1675–1738) embarked on the
Grand Tour in 1694, returning to take his seat in the
House of Lords in 1697. A diplomat under Queen
Anne, he was voted an enemy to his country in 1710.
On the accession of George I in 1714 he was made
Secretary of State. At this point Lord Townshend was
nominally head of government, but his brother-in-
law Robert Walpole gradually took the ascendant. In
1716 he was dismissed for his anti-French policy and
for his friendship with the Prince of Wales. He
returned to foreign affairs in 1720 and was active in
forming the northern alliance against the Habsburgs.
This period saw the deterioration of his friendship
with Walpole, whose ascendancy made him intensely
jealous. In 1730 he was forced to resign.

Charles Townshend spent his retirement from office
at Raynham, not far from Houghton, where he was
principally occupied by the improvement of his estates.
Chambers described him as 'rough, impatient, san-
guine, impetuous and overbearing ... though slow in
council and perplexed in speech, he was deep in pene-
tration and accurate in his plans'. He is celebrated for
the general introduction of the turnip. It was while in
attendance on George I at Hanover that he is said to
have observed the advantages of a turnip crop. In fact
two peasant farmers had been feeding their fat and dairy
cattle on turnips in the nearby Waveney valley in the
early 1660s. It was 'Turnip' Townshend's work in the
1730s, however, that established the idea and made it
widely known, despite the fact that by the late 1670s it
was being grown as a field crop on the Houghton estate
and on the Raynham estate by, at the latest, 1706 (*Nor-
folk Archaeology*, vol. XIX, pp. 41–42, 63–65).

Kneller's portrait emphasises the sitter's office, and in
the 1730s the portrait hung in the Supping Parlour at
Houghton in the company of Walpole family portraits.
Charles Townshend had married Sir Robert's sister
Dorothy, as his second wife, at Houghton on 6 July
1713 (he married his first wife Elizabeth Pelham on 3
July 1698). This portrait was one of the series of
Houghton family portraits recorded in grey mono-
chrome watercolour copies by George Farington
(1752–88), painted c.1775 (Walpole family collection;
see cat. no. 230).

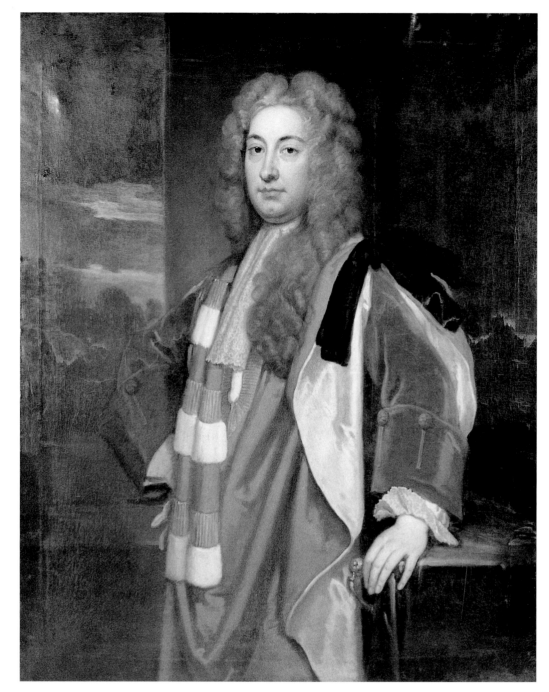

This portrait presumably dates from Kneller's later
years as a portraitist. Lord Townshend, almost cer-
tainly in his thirties, is depicted wearing a coat with
full sleeves, fashionable in the first decades of the
eighteenth century. The portrait quite possibly dates
from prior to his fall from political favour in 1710.
Kneller painted Lord Townshend's two young sons,
Horatio and Charles c.1704 (Moore, Crawley 1992,
pp. 104–5, no. 36; another portrait of Charles, 2nd
Viscount Townshend by Kneller hangs in the Marble
Hall at Raynham Hall, Norfolk), and this portrait

would date from this time if commissioned by Town-
shend himself. However, a more likely date for the
commission, probably by Sir Robert, would be
c.1713, the year of Charles Townshend's marriage to
Dorothy Walpole. This would account for the
mechanical treatment of the draperies, almost certain-
ly deriving from Kneller's assistants at this time.

Kneller was the most successful and prolific society
portrait painter of his period and had studied under Fer-
dinand Bol (and probably Rembrandt), before settling
in England in 1676 where he was soon employed at

Court. In Horace Walpole's opinion 'where he offered one picture to fame, he sacrificed twenty to Lucre', an opinion substantiated by this family portrait at Houghton. A full length of Charles, 2nd Viscount Townshend in garter robes, attributed to Kneller hangs at St Michael's Mount and a version signed by Kneller is at King's College, Cambridge (both formerly at Raynham; information kindly supplied by John Guinness). A Kneller studio three-quarter-length portrait of Charles Townshend from Raynham is now in the National Portrait Gallery, London.

See also cat. nos. 196–200, 220.

220

GODFREY KNELLER (1646–1725) and studio
George I
Oil on canvas, 206 x 124.5
PROVENANCE: Acquired by Sir Robert Walpole for the Library at Houghton; in situ by 1736: 'King George the first, whole length, in his coronation robes. Sr. Godfrey Kneller – 6.00 x 4.2'; then by descent to David, 7th Marquess of Cholmondeley.
LITERATURE: *Aedes* 1752, p. 49; 2002, no. 56; Kerslake 1977, vol. I, p.88.

It is uncertain whether this was a presentation portrait, but it is a high quality version of the coronation portrait of George I (1660–1727) which remains in the royal collection (see Millar 1963, p. 148). It was in situ in the Library by July 1735 when the Rev. Jeremiah Milles visited Houghton: 'They shew'd us Sr Robts Study, wch is not a very large one. in it is ye picture of ye late king by Sr. Godfrey Kneller' (BL Add. Mss 15, 776, ff. 61–66).

Sir Robert was establishing in visual terms a very personal relationship with the king who had witnessed his rise to power. The portrait dominates the book-lined room, establishing an ambience of royal kinship. It was George I who created Sir Robert's eldest son, Robert, a peer – Lord Walpole of Walpole – in 1723. The portrait remains in the original carved and gilded tabernacle frame of a typically Kentian style.

For other royal portraits in Sir Robert's collection see cat. nos. 196, 197. For works by Kneller see also cat. nos. 196–200, 219. Sir Robert also owned portraits of *Lady Walpole* (full-length; Chelsea, Yellow Damask Bedchamber, 1736, Appendix III, no. 381) and, seemingly, two self-portraits of the artist as a young man (Downing Street, Closet, 1736, Appendix III, no. 284; Grosvenor Street, Great Room above, Appendix III, no. 341). Kneller was also responsible for one of the finest portraits of Sir Robert as a young man, his Kit-Kat Club portrait of 1710–15 (National Portrait Gallery, London, NPG 3220).

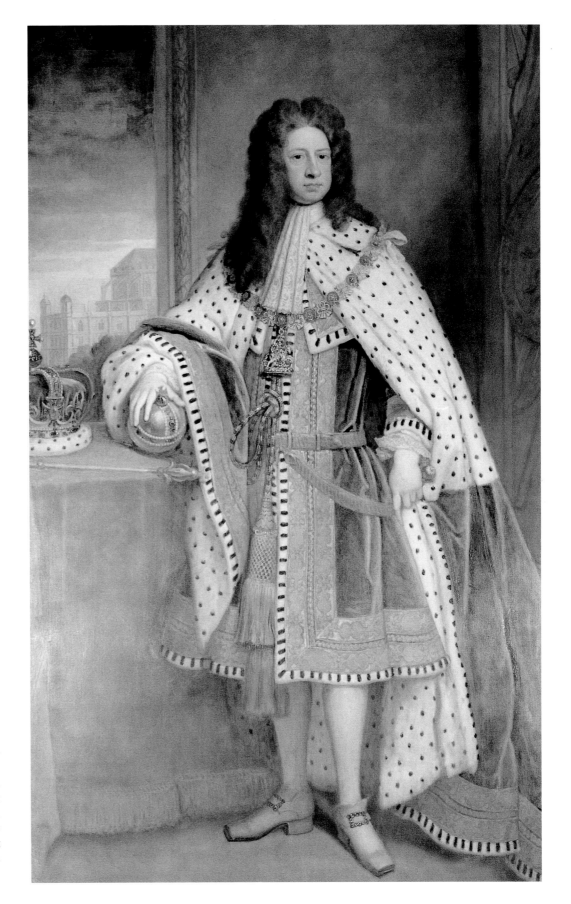

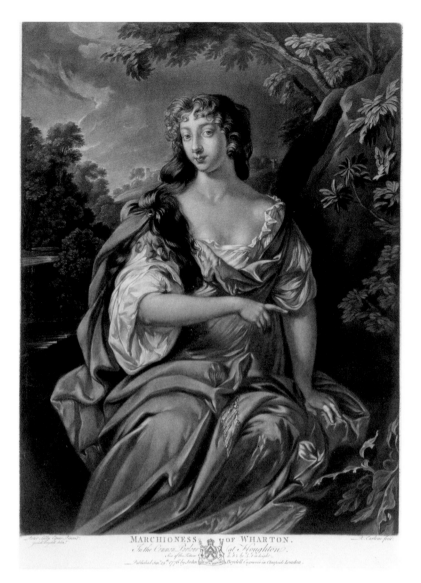

MARCHIONESS OF WHARTON.

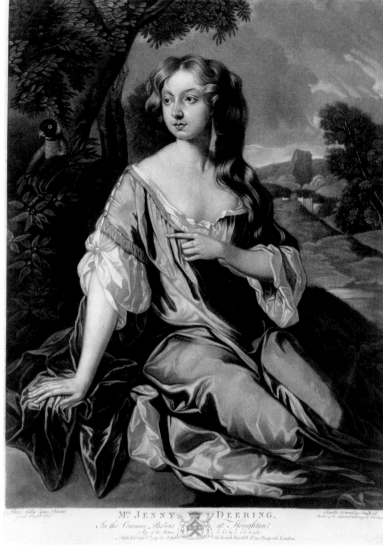

Mr. JENNY DEERING.

221

PETER LELY (1618–80)
*Ann Lee, daughter of Sir Henry Lee of Ditchley, afterwards
Lady Wharton* (c.1680)
Oil on canvas, ? 127 x 102

PROVENANCE: ? Sir Henry Lee of Ditchley; Philip
Lord Wharton, Winchendon, near Aylesbury, Buck-
inghamshire; bought from his heirs by Sir Robert
Walpole, 1725; at Houghton Hall, in the Common
Parlour, by 1736 'A Daughter of Sr. Harry Lee, with
dark brown hair. Sir Peter Lely. 4.1-3.3'; then by
descent to George, 4th Marquess of Cholmondeley;
sold Christies, 10 July 1886, lot 211; bought
Wertheimer; present whereabouts unknown.
LITERATURE: *Aedes* 1752, p. [48], 2002, no. 52; Boy-
dell I, pl. xxxiii; Millar 1994, p. 522.

Horace Walpole, in his account of Van Dyck in the
Anecdotes of Painting records: 'My father bought of the

last duke [Philip Wharton 1698–1731] the whole col-
lection of the Wharton family. There were twelve
whole lengths, the two girls, six half lengths and two
more by Sir Peter Lely; he paid an hundred pounds
each for the whole lengths and the double picture, and
fifty pounds each for the half lengths' (Anecdotes 1888,
vol. I, p. 322; Millar 1994, p. 522). The reference to the
two portraits by Lely must refer to cat. nos. 221 and 222.
These portraits, of both Lord Wharton's wife and mis-
tress, were evidently considered a pair from the time of
their commissioning. They were not Walpole family
portraits, but possibly it was their status as overdoors in
the Common Parlour which limited their appeal to
Catherine II and her agents. Whatever the reason, these
two Lely portraits were not included in the 1779 sale to
Catherine, although the portraits were both included
in Boydell's portfolio of prints. (It should be noted,
however, that not everything that was sold to Cather-
ine was reproduced by Boydell.)

Ann Lee (1659–85) was the younger of two daugh-
ters of Sir Henry Lee, of Quarrendon and Ditchley, 3rd
Bt., and Anne Danvers, the daughter of Sir John Dan-
vers. She was baptised 24 July 1659 on the day of her
mother's funeral at Spelsbury, Oxfordshire. She mar-
ried Thomas Wharton, Baron Wharton, later 1st Mar-
quess of Wharton (1648–1715) on 16 September 1673
at Adderbury, Oxfordshire, bringing an estate of
£2,500 a year and a dowry of £10,000. She was
described by her husband's biographer as an accom-
plished poet: 'She was a Woman of Wit and Virtue, yet
her person was not so agreeable to him as was necessary
to secure his Constancy [see cat. no. 222] … She … had
the Homage of most of the surviving Poets, who …
remembered her in Panegyrical Elegies. This Lady's
Temper … was reserv'd, severe and the very reverse of
gaiety and gallantry' (Cokayne 1910-59, vol. XII, p.
608). She died at the age of twenty-six at Adderbury on
29 October 1685 and was buried at Winchendon.

Lely had studied at Haarlem, coming to London during the early years of the Civil War and was described by 1645 as 'the best artist in England.' He was made Principal Painter to the King in 1661, being regarded as Anthony van Dyck's natural successor. As Lely's career developed he increasingly employed a studio of artists to assist him and it is likely that both these portraits were as much the product of Lely's studio as from his own hand. In an annotated copy of the Christie's sale catalogue (1886) now in the National Gallery Library the entry for the portrait of *Ann Lee* bears the ms note '? copy', that for *Mrs Jenny Dering*, 'good copy'. See also cat. no. 222.

222

PETER LELY (1618–80)
Jenny Dering
Oil on canvas, ? 127 x 102
PROVENANCE: ? Philip 4th Lord Wharton (1613–96), Winchendon, near Aylesbury, Buckinghamshire; bought from his heir, Philip, Duke of Wharton (1698–1731) by Sir Robert Walpole, 1725; at Houghton Hall, in the Common Parlour, by 1736, 'Mrs Jenny Deering, with fair hair, Sir Peter Lely, 4,1 x 3.3'; then by descent to George, 4th Marquess of Cholmondeley; sold Christies, 10 July 1886, lot 212; bought Wertheimer; present whereabouts unknown.
LITERATURE: *Aedes* 1752, p. 48; 2002, no. 53; Boydell II, pl. lxiii.

Miss Jane Dering was the fifth daughter of Sir Edward Dering (d. 1684), 2nd Baronet of Surrenden Dering. She was the mistress of Thomas Wharton, first Marquess of Wharton (1648–1716), the son of Philip Wharton, 4th Lord Wharton. Sir Thomas Wharton was described by his biographer Macky as 'brave in his person, much of a libertine', while G. M. Trevelyan described him as 'perhaps the most influential Whig of Anne's reign.' Jonathan Swift, however, regarded him in 1710 as 'the most universal villain I ever knew', maintaining himself 'without any visible effects of old age, either on his body or his mind, and in spight of a continual prostituion to those vices which usually wear out both. ... He bears the gallantries of his L—y with the indifference of a Stoick' (Cokayne 1910-59, vol. XII, pp. 608–9).

Jane Dering, to judge by her portrait, was more than worthy of Sir Thomas's attentions. There is a version of this portrait at Easton Neston, Northamptonshire (incorrectly called *Nell Gwyn*), but it is not clear whether this could be the version formerly at Houghton. A number of Wharton portraits are at Easton Neston (Lord Hesketh collection). There is a second version at Chatsworth (Inv. No. 377), where the sitter is called *Elizabeth Percy, Duchess of Somerset*. A third version has been clled *Hon. Mrs. Lucy Loftus, later*

Viscountess Lisburne (Christies 18 October 1973, lot 84). A fourth version, attributed to Simon Verelst, was at Netherby Hall (sold Sotheby's, 15 July 1987, lot 34, *Portrait of a Lady*, 124.5 x 99). Thanks go to John Guinness in helping to identify these variants.

Sir Robert also owned a third portrait by Sir Peter Lely, *Sir Harry Vane, the younger*, which in 1736 hung in Lady Walpole's Drawing Room at Downing Street. This was almost certainly one of the Wharton pictures acquired in 1725 (see Appendix III, probably purchased by Philip, 4th Lord Wharton from the collection of Sir Henry Vane the Elder (1589–1655). See Millar 1994, pp. 519–20). See also cat. no. 221.

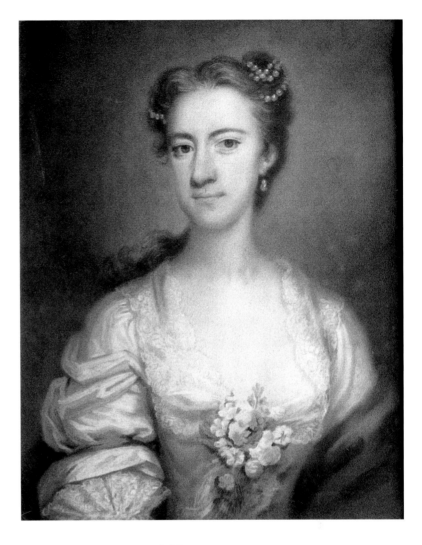

223

ARTHUR POND (c.1700–58)
Lady Maria Walpole (c.1742)
Crayons, 61 x 44.5
PROVENANCE: commissioned by Sir Robert Walpole, 1742; first recorded in 1744 MS, 'Yellow Drawing Room Ov. Settee in Water Colours [?] L. H. Lady Mary Walpole'; then by descent to David, 7th Marquess of Cholmondeley.
LITERATURE: *Aedes* 1752, p. 52; 2002. no. 76.

Maria Walpole (c.1725–1801) was the illegitimate and only daughter of Maria Skerret, Sir Robert Walpole's second wife (see cat. no. 228). Born about 1725, she was married on 17 February 1745 to Colonel Charles Churchill (c.1720–1812) at St Georges, Hanover Square. Sir Robert had evidently commissioned this portrait, which cost seven guineas, excluding the cost of the 'gold frame and plate glass' at £2.12s.6d (Arthur Pond's signed receipt, dated 20 January 1742/3, Cholmondeley (Houghton) MSS, Vouchers, CUL) from the artist so that it might hang together

with the Rosalba portraits of his sons, including Rosalba's recent grand tour portrait of Horace. All four portraits were finally hung together in the Drawing Room at Houghton, presumably by August 1743. Pond also engraved one of Sir Robert Walpole's paintings, Gaspar Dughet's *A landscape with a cascade and sheep*, an example of which Horace Walpole incorporated in his extra-illustrated *Aedes*, f. 93. (Metropolitan Museum of Art, New York).

Maria's marriage to Colonel Charles Churchill was the dynastic fruition of the long-standing friendship between Sir Robert Walpole and Lieutenant-General Charles Churchill (1679–1745). Later in life Maria was Housekeeper of Windsor Castle 1762–82. Her husband Charles Churchill retired from his army career in 1745, succeeding his father as Deputy Ranger of St. James's and Hyde Parks in that year (recorded in a list of 'Useless Sinecures' compiled for George III in 1782, Namier and Brooke eds. 1964, vol. 2, p. 215; thanks go to Martin Stiles for this information).

Arthur Pond had been to Rome c.1725–27 and on his return to England took up portraiture in crayons, in a style very similar to that of George Knapton (1698–1778). Knapton had himself already supplied Sir Robert and Lady Walpole with a portrait in crayons of their youngest son Horace, which in 1736 hung with the Rosalba portraits of Robert and Edward in Lady Walpole's Drawing Room at Downing Street (1736 MS; see Appendix III).

224

Jonathan Richardson senior (1665–1745)
Horatio, 1st Baron Walpole of Wolterton (c.1734)
Oil on canvas, 127 x 101.5
PROVENANCE: Sir Robert Walpole, by 1736 (Walpole MS 1736: 'In the Rustick Story at Houghton. In the Supping Parlour: Mr Horatio Walpole, Brother to Sr Robt, over the chimney 4' 2" x 3' 5"'); then by descent to David, 7th Marquess of Cholmondeley.
LITERATURE: *Aedes* 1752 p. 42; 2002, no. 11; Vertue V, p. 126; Kerslake 1977, pp. 201–2; Moore, Crawley 1992, pp. 110–11.

Horatio Walpole (1678–1757) was the younger brother of Sir Robert Walpole. Educated at Eton and King's College, Cambridge, he studied Law briefly at Lincoln's Inn. He served in the House of Commons consistently as a Whig for fifty-four years. Early in his career he represented Castle Rising and later Great Yarmouth and from 15 May 1734 represented Norwich. He was created a peer less than a year before his death due to 'the stone'.

Horatio Walpole spent much of his career abroad, his fortunes linked with those of his brother Sir Robert, but also those of Charles, 2nd Viscount Townshend (see cat. no. 219). In 1706 he was appointed Secretary under General James Stanhope

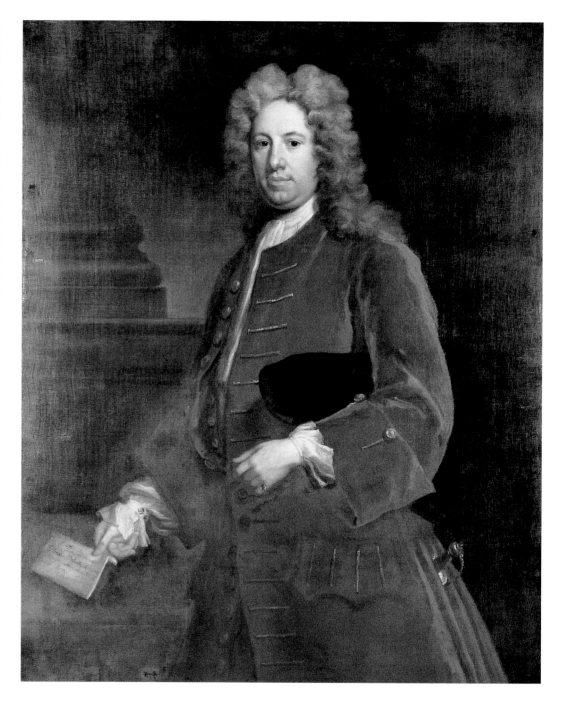

(afterwards 1st Earl Stanhope) and a year later acted as Chief Secretary to Henry Boyle, Lord Carleton. In 1709 he was attached to the British Embassy in The Hague and in 1710 became a close adviser to the Ambassador, Charles, 2nd Viscount Townshend. It was from this point that his diplomatic career followed the vagaries of power exercised by both Sir Robert Walpole and Charles Townshend.

This portrait marks a high point in the career of Horatio Walpole, having been commissioned when the

sitter was recently appointed Envoy and Minister-Plenipotentiary at The Hague, a post he held 1734–40. He holds in his left hand a letter inscribed 'A Mons Monsieur / Horatio Walpole. Ministre / Plenipotentiare de SMB / a la Haye'. The characteristically stiff pose selected by Jonathan Richardson was bettered by Jean Baptiste Vanloo some five years later for a portrait of Horatio towards the end of his appointment, although the motif of the hand-held and addressed envelope was retained (Lord and Lady Walpole collection, Wolterton Hall; a variant of this portrait, studio of

Vanloo, is in the same family collection; another version is recorded at Shrubland Park; and bust portraits, attributed to Vanloo, are recorded at West Acre High House, Norfolk and at Hardwick (an oval): information kindly supplied by John Guinness). It was during this period that Horatio oversaw the building of his new seat at Wolterton to the designs of Thomas Ripley, taking up the challenge of Sir Robert's building programe at Houghton. Ripley's design, solidly built but supported by a less prodigious purse, never rivalled Sir Robert's temple to the arts.

The comparison between Richardson's portrait of Horatio Walpole and that by Vanloo amply supports Horace Walpole's assessment of Richardson: 'he drew nothing well below the head and was void of imagination'. However, Horace owed much to Richardson, particularly his *Essays* on the theory of painting (1715), the science of the connoisseur (1719), and to his account (with his son) of the sculpture and works of art to be found in Italy (1722). Horace also admired Richardson's study of John Milton's *Paradise Lost*, published in 1734.

By 1731 Vertue identified Richardson as one of the three foremost artists of the day, along with Charles Jervas (see cat. nos. 215–218, 194, 195) and Michael Dahl (see cat. no. 213). Sir Robert Walpole presumably commissioned not only this portrait, but also that of his brother-in-law, Sir Charles Turner (see cat. no. 225). In addition the 1736 inventory of Sir Robert Walpole's pictures records the following portraits by Richardson: a full length of Sir Robert, in the Garter Robes (formerly in the Blue Damask Bedchamber, Houghton, 7' 6" x 4' 7" (Walpole MS 1736); possibly now Marble Parlour, Houghton; however the measurements of the latter, 84 x 58 inches, do not precisely match); a portrait of General Charles Churchill, hanging over the chimney in the Yellow Damask Bedchamber at Chelsea (present whereabouts unknown); a portrait of Horace Walpole hanging in the closet at Downing Street (now at Chewton Manor, Somerset; information kindly supplied by John Guinness); and also at Houghton portraits of Galfridus Walpole (see cat. no. 227) and Colonel Walpole (see cat. no. 226) in the Coffee Room.

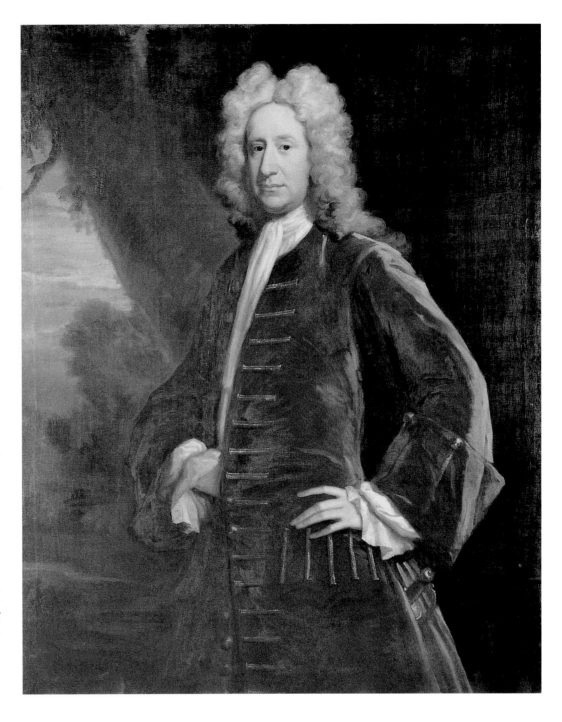

225

JONATHAN RICHARDSON SENIOR (1665–1745)
Sir Charles Turner (c.1725)
Oil on canvas, 127 x 101.5
PROVENANCE: Sir Robert Walpole, by 1736 ('In the Supping Parlour', Sir Charles Turner, Brother in Law to Sir Robert, 4' x" x 3' 5", Richardson'); by descent to David, 7th Marquess of Cholmondeley.
LITERATURE: *Aedes* 1752, p. 42; 2002, no. 14.

Sir Charles Turner (d. 1738) of Warham, Norfolk was a wine merchant of some standing and Member of Parliament for King's Lynn. In April 1689 he married Mary Walpole (1673–1701), Colonel Robert and Mary Walpole's second child. This alliance between the Walpole and Turner families resulted in their dual control of the borough for which Sir Robert was MP for most of his career. Charles himself was elected to Parliament for the second seat at King's Lynn in the general election of 1695 and soon afterwards received

a knighthood from William III. Sir Charles was to remain a lifelong supporter of Sir Robert, despite the early death of his wife Mary. Horace Walpole notes that Sir Charles Turner's preferment was as one of the Lords of the Treasury.

The attribution to Jonathan Richardson is made both in the 1736 inventory and in the *Aedes*. The portrait is a good example of a standard format by Richardson, who was probably responsible only for the head. The portrait dates from c.1725, showing Sir

Charles with a substantial and flattering coat. For a comparable portrait attributed to Richardson, see cat. no. 227. The portrait of Sir Charles Turner was one of the series of portraits recorded in grey monochrome watercolour copies by George Farington, c.1775 (Walpole family collection, see cat. no. 230). This portrait was first identified by John Guinness in a letter to Sybil, Marchioness Cholmondeley, April 1981.

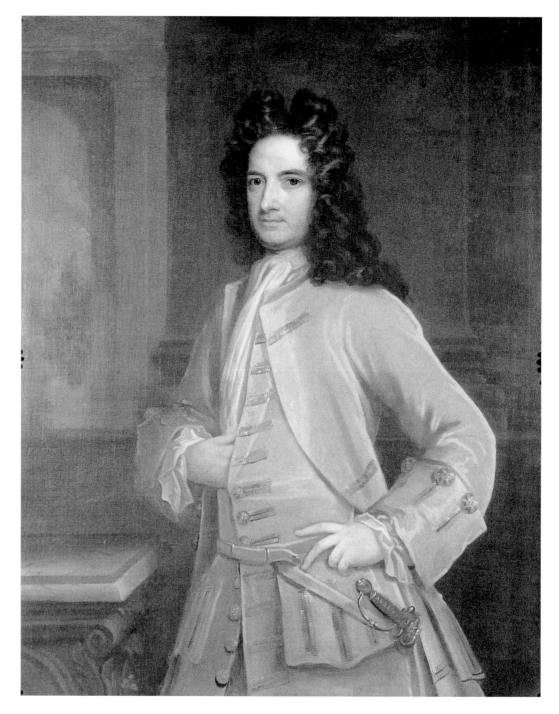

226

JONATHAN RICHARDSON SENIOR (1665–1745), ATTRIBUTED
Horatio Walpole (c.1691)
Oil on canvas, 127 x 101.5
PROVENANCE: Sir Robert Walpole 1717; at Houghton by 1736 ('Col. Walpole, Uncle to Sr Rob.t, in a black wig – Richardson 4.2 x 3.4'; 1736 MS, in the Coffee Room, called the 'Billiard Room', 1744 MS); then by descent to David, 7th Marquess of Cholmondeley.
LITERATUE: *Aedes* 1752, p. 44; 2002, no. 26.

Horatio Walpole (1663–1717) was one of thirteen children born to Sir Edward Walpole of Houghton (Sir Robert's grandfather), who had been created Knight of the Bath in 1661 and twice elected to parliament for the borough of King's Lynn (1660–61). Sir Edward's eldest son was Robert, father of Sir Robert Walpole. Sir Edward married Susan Crane in 1649 and Horatio Walpole was their eleventh (and final) child, born on 11 July 1663 (according to Cokayne 1910-59, but Musgrave 1732 gives 11 May 1663).

Horatio Walpole was a cavalry officer, marrying Lady Anne Osborne (1657–1722), daughter of Thomas Osborne (1631–1712), 1st Duke of Leeds, on 26 March 1691, at St Giles in the Fields (Cokayne 1910–59; Musgrave 1732 gives 17 October 1717). It was her second marriage: she was the widow of Sir Robert Coke of Holkham. Horatio Walpole died at Beckhall, Suffolk on 17 November 1717 and was buried at Houghton three days later.

The portrait of Colonel Horatio Walpole hung as a military 'foil' to that of Galfridus Walpole. In compiling the *Aedes* Horace Walpole had overlooked the fact that the artist responsible for this portrait, had been recorded as Jonathan Richardson in the Inventory of paintings made in 1736.

227

Jonathan Richardson senior (1665–1745)
Galfridus Walpole (c.1720)
Oil on canvas, 127 x 101.5
PROVENANCE: Sir Robert Walpole, in the Coffee Room at Houghton by 1736 (Walpole MS 1736); then by descent to David, 7th Marquess of Cholmondeley.
LITERATURE: *Aedes* 1752 p. 44; 2002, no. 27; Musgrave 1732, p. 37.

William Musgrave provides the most rounded summary of the brief career of Galfridus Walpole (1684–1726), younger brother of Sir Robert:

> Galfridus Walpole, chose a maritime Life for his Province, and was by a gradual Rise advanced to the command of the Lyon, a third Rate ship, which he bravely defended in an Engagement during the last War, and had his Right Arm shot off. Soon after the Accession of his late Majesty King George I he was elected a Member for the Borough of Leftwithiel [Lostwithiel] in Cornwal, and made Captain of the *Peregrine* (since named the *Carolina* Yacht) and Treasurer of Greenwich Hospital. He was afterwards joint Post-Master General, and Commissioner for the Management of the Post Office. He married Cornelia [Constant], Daughter of Mr Hayes of London; but departed this life without issue, August 7th, 1726.

This is an archetypal account of a public career eased through preferment and the support of the first Minister.

This portrait has in recent years been attributed to Charles Jervas. However, both the 1736 Inventory Manuscript and that of 1744 identifies the portrait as by Jonathan Richardson. It is difficult to believe that Sir Robert Walpole would not have known the artist responsible for this portrait of a favourite brother. The fact that the portrait is unattributed in the *Aedes* has obscured the original attribution. Another portrait of Galfridus, which remains in the Walpole family collection, shows the sitter three-quarter-length, dressed in blue, facing left against a similar background. This could well be by Charles Jervas. Attributions at this period of British portraiture, just after the death of Sir Godfrey Kneller, are notoriously interchangeable. Artists such as Jervas were, however, consciously and honourably engaged upon copying as well as relying upon studio support. It seems entirely likely that Sir Robert owned a Richardson portrait of his younger brother, while a Jervas variant went to Horatio at Wolterton. The Houghton portrait of Galfridus was one of the series of family portraits recorded in grey monochrome watercolour copies by George Farington, painted c.1775 (Walpole family collection, see cat. no. 230).

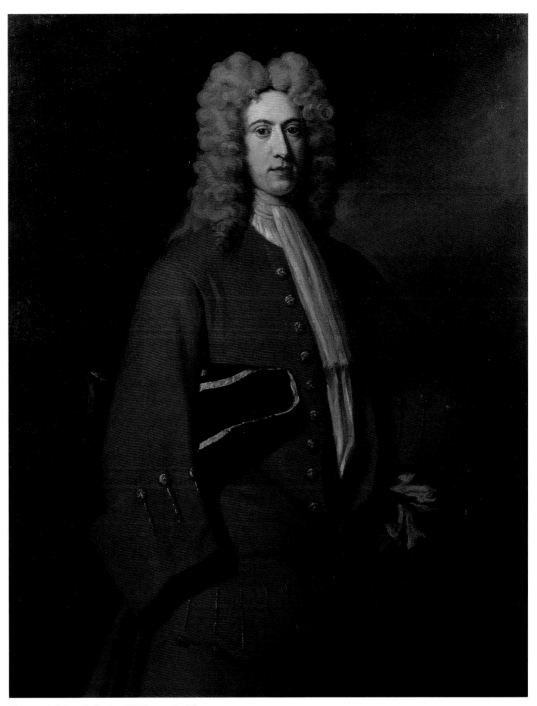

Photograph Private Collection / Bridgeman Art Library

228

JEAN-BAPTISTE VANLOO (1684–1745)
Maria Skerrett (c.1738)
Oil on canvas, 131 x 106
PROVENANCE: painted for Sir Robert Walpole; at Houghton by 1744 (in the bedchamber, HRO MS 1744); then by descent to David, 7th Marquess of Cholmondeley.
LITERATURE: *Aedes* 1752, p. 49; 2002, no. 58; Moore ed. 1996, p. 104, no. 24.

Maria (1702–38) was the daughter of Thomas Skerrett (1676–1734) and his wife Hester Stafford (b. 1680). Sir Robert maintained a relationship with Maria Skerrett during the course of much of his marriage to his first wife, Catherine Shorter, who died in August 1737.

Maria became identified in the public eye with the character Polly Peachum in *The Beggar's Opera* by John Gay. She was also reputed to have given rise to Alexander Pope's *Phryne*: 'Open she was, and unconfin'd like some free port of trade. ... At length she turns a Bride; In di'monds, pearls, and rich brocades, she shines the first of batter'd jades, And flutters in her pride'. As early as November 1737 there were rumours that Sir Robert had married Maria Skerrett; the marriage was privately celebrated in March 1738 but she died shortly afterwards in June 1738. Sir Robert engineered a reconciliation between his two wives in spirit by hanging their portraits together in his bedroom during the last years of his life.

Jean Baptiste Vanloo came to England in December 1737, leaving in October 1742. It is very likely that this portrait was among his earliest commissions in England. According to Vertue, Sir Robert 'so well likd and approvd of [Vanloo's] painting that had it not been for an Act of Parliament that prevented Forreigners of any Nation to have or enjoy places of salary in the Government, he would have presented him with the place of King's Painter.' Sir Robert also commissioned Vanloo to paint his own portrait in the Chancellor's robes (see cat. no. 180). Vanloo brought a cosmopolitan elegance to society portraiture in England, having worked in the leading European cities, notably Paris.

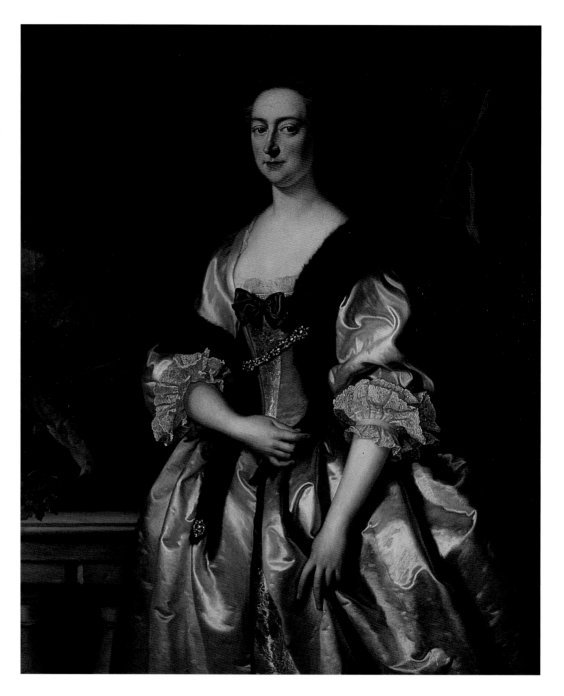

229

JOHN WOOTTON (c.1682–1764)
Classical Landscape, called *Landscape, in the Stile of Claude Lorraine* (c.1740)
Oil on canvas, 124 x 141
PROVENANCE: Sir Robert Walpole, by 1743, ? The Little Dressing Room, Houghton; ? 1744 MS: 'Antichamber, Ov. Chimney Landscape Wooton'; by descent to David, 7th Marquess of Cholmondeley.
LITERATURE: *Aedes* 1752, p. 50; 2002, no. 59; Vertue,

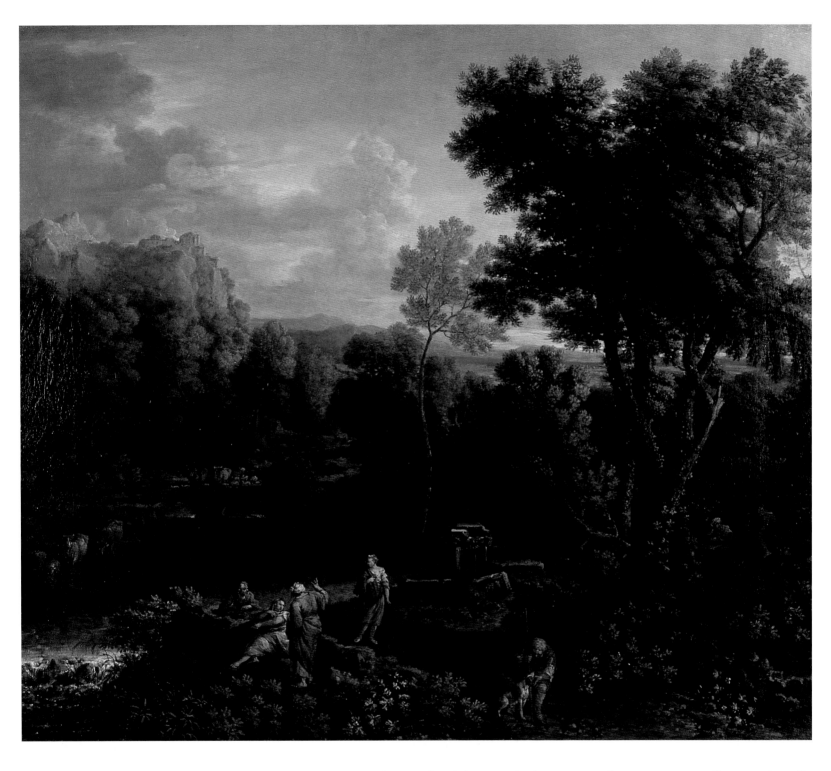

vol. I, 1929-30, p. 101; Meyer 1984a pp. 44–45; Moore ed. 1996, p. 104, no. 25.

Sir Robert Walpole's patronage of John Wootton was an important factor in the artist's career. His pre-eminence in England as a painter of sporting and landscape subjects during the first half of the eighteenth century was greatly strengthened by Sir Robert's patronage over a period which stretched from c.1716 (see cat. no. 201) until c.1740, the likely date of this painting. Walpole's patronage extended to a total of eighteen paintings recorded in the manuscript inventory, 1736, of works in Sir Robert's various London residences as well as at Houghton (inventory now New York, Pierpont Morgan Library; see Appendix III; nine paintings were included in 1751 sale, Houlditch MSS).

Those in London in 1736 included two overdoor landscapes in the Great Middle Room at Downing Street (each 41 x 51? inches including frame). Grosvenor Street housed the majority of Wootton's

sporting pictures, including *A White Hound*, which is now at Houghton Hall. This is not recorded in the *Aedes*. It presumably hung in the private family rooms at Houghton by 1743.

Wootton was also commissioned to paint three large overdoors for the Yellow Dressing Room at Houghton, again unrecorded in the *Aedes*. These are no longer in situ, although a portrait of Sir Robert with horse and groom which remains in the Cholmondeley family collection – in a fine Kentian frame – may well be related to this set. This composition is interesting for the inclusion of a house in the middle distance which could well represent Old Houghton Hall. A copy, probably by Ranelagh Barrett, is also at Houghton Hall. A second set of three overdoors was painted by Wootton for the Blue Damask Bedchamber and these do remain in situ. This set of classical landscapes precedes the painting of cat. no. 229. Two of these were reproduced in reverse by Lerpinière for Boydell's *Houghton Gallery*, Vol II, nos. 39, 40. They are incorrectly described as hanging 'In the Gallery at Houghton'. In place by 1736, they owe much to Gaspard Dughet, but include considerable detail in the foreground, prefiguring Wootton's subsequent interest in Claude, as evidenced by cat. no. 229. In the overdoors, Wootton's treatment of Arcadian motifs is more calmly depicted, his treatment of trees and foliage achieving a delicate texture enlivened by flecks of light pigment. By comparison with Wootton's canvases, surviving copies, commissioned by Sir Robert from Ranelagh Barrett, appear sombre and frankly dull. See also cat. nos. 197, 201, 202.

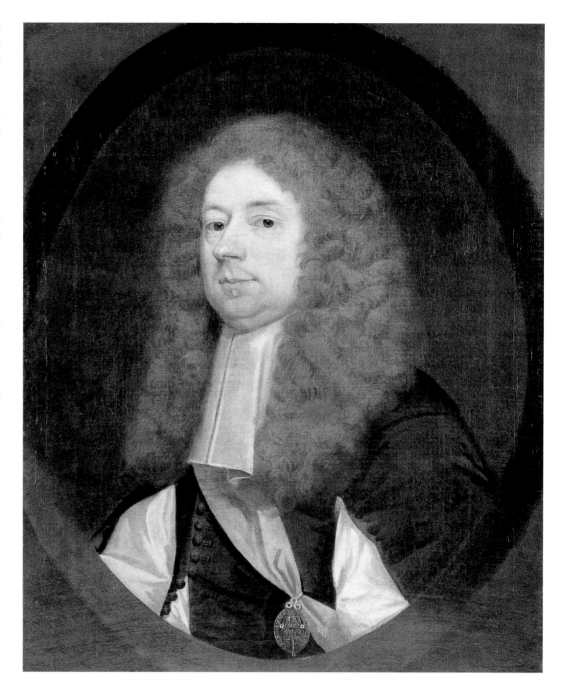

230

JOHN MICHAEL WRIGHT (1617–1700), circle
Sir Edward Walpole (c.1660)
Oil on canvas, feigned oval, 76.3 x 61cm
PROVENANCE: ?Sir Edward Walpole; Sir Robert Walpole (first recorded at Houghton, 1736); then by descent to David, 7th Marquess of Cholmondeley.
LITERATURE: *Aedes* 1752, p. 38–39; 2002, no. 6; Musgrave 1732, pp. 33–34.

Edward Walpole (1621–68), the grandfather of Sir Robert and builder of the first Houghton Old Hall, was the first Walpole for ten generations to be knighted. He was the only son (of four children) to Robert Walpole (1593–1663) and Susan, daughter of Sir Edward Barkham (died 1622). Edward Walpole himself married a Susan, the daughter and co-heir of Sir Robert Crane of Chilton, Suffolk (1630–67), in 1649. He became MP for King's Lynn and was one of those who voted for the

return of the King on 25 April 1660. He was prepared to join with Sir Horatio Townshend to raise forces for the defence of King's Lynn and the King if Charles had not been 'restored peaceably'. It was for this loyalty that Edward was made a Knight of the Bath at the coronation of King Charles II. Sir Edward remained member for King's Lynn during the so-called long parliament. He died at the age of forty-eight and was buried at Houghton on 9 March 1668 (NS).

William Musgrave, in his eulogy of Sir Robert Walpole and his family, wrote of Sir Edward: 'He was held in the highest Esteem and Honour by all that knew him; and so vast a sense had the Corporation of Lynn of his Integrity, and the great services he had performed in the House of Commons, that they presented him with a noble Piece of Plate, and an Inscription shewing their high Esteem of his eminent Worth and Abilities'. The informal character of the Breakfast Room, plainly finished and furnished, was a fitting environment for just two historic family portraits. While modest in scale, the portrait of Sir Edward, together with that of his son Robert (cat. no. 205) established the local significance of the family in the informal sporting ambience of the 'rustick story'. Horace Walpole devotes more than a page of the *Aedes* to a tribute to his great-grandfather. The sitter is depicted in the black and white robes of office with the crimson sash of a Knight of the Bath.

This portrait was one of the series of Houghton family portraits recorded in grey monochrome watercolour copies by George Farington (1752–88), painted c.1775 (Walpole family collection). This series was traditionally assumed to be by Jonathan Richardson, having been sold as such from Strawberry Hill (SH Sale, George Robins, May 1842, day 19, lot 13). They were bought by Lord Walpole and remain in the family collection. The series bear Horace Walpole's inscriptions on the reverse of each backing panel. Two bear the initials 'GF' on the sheets, confirming the attribution of the set to George Farington who, together with his more celebrated brother Joseph, was among the artists employed by Boydell to record the Houghton collection (information kindly supplied by Martin Stiles). See also cat. nos. 205–209, 213–215, 219, 225, 227, 230.

231

UNIDENTIFIED ARTIST
Sir Horatio Townshend, 1st Viscount Townshend (c.1665)
Oil on ?canvas, ? 114 x 91

PROVENANCE: ?Robert Walpole before 1700; Sir Robert Walpole ((first recorded 1736, 'in the Little Breakfast Room', Houghton); 1744 MS, p. 6 'Below stairs, In the Breakf. Parlour Over the Scritoire One of ye Townshend Family'; present whereabouts unknown.

LITERATURE: *Aedes* 1752, p. 40; 2002, no. 8; Rye 1913, p. 931; C. Hussey, 'Raynham Hall, Norfolk, II', *Country Life*, 21 November 1925, p. 784.

Sir Horatio Townshend (1630–87) was the second son of the builder of neighbouring Raynham Hall, Sir Roger Townshend, 1st Baronet (d. 1637). Horatio succeeded his elder brother in 1648, marrying ten years later Mary, sole heir of Edward Lewkenor of Denham, Suffolk. An ardent supporter of the Restoration, he hatched a plot with Lord Willoughby of Parham to seize King's Lynn as a base for an invasion for which they both spent a period in the Tower of London. Released, he was free in 1660 to go to The Hague as one of the deputation inviting the return of the King. He received a number of local honours, including the Governorship of King's Lynn and the Vice-Admiralty of Norfolk. In 1661 he was raised to the peerage as Baron Townshend of Lynne Regis. He was granted a Viscountcy in 1682.

The family connections between the Townshends and the Walpoles developed out of the close acquaintance of Colonel Robert Walpole and Horatio Townshend (see also cat. no. 205). By his second wife Mary, daughter of Sir Joseph Ashe of Twickenham, his son and heir was Charles Viscount Townshend (1675–1738), whose own second wife was Dorothy Walpole (1686–1726), daughter of Colonel Robert Walpole (for Dorothy, Lady Townshend, see cat. no. 217).

There are essentially three prime portrait types of Sir Horatio Townshend, as represented by two portraits formerly at Raynham (Singh 1927, vol. II, p. 213, no. 102; p. 214, no. 104; Christies, 4 July 1927, lot 21, unattributed, bought Wiggins, 20 guineas; lot 12, Sir Peter Lely, bought Ellie Smith, 40 guineas), and one formerly at Balls Park, Hertfordshire. Of the Raynham portraits, a full length by Sir Peter Lely (Durham 1926, p. 16; exhibited 1997 London, no. 11; now National Museum of Wales) is a less likely prototype for the missing Houghton portrait. There are no contemporary engravings of either type, although W. C. Edwards later produced a line engraving of a three-quarter length image of Horatio Townshend, standing and resting an arm on a parapet from one of the portraits at Raynham (O'Donoghue, vol. IV, p. 297, a Lely school version is at Felbrigg Hall, Nor-

folk). The Houghton portrait most likely is a variant of the smallest Raynham portrait, which showed the sitter 'in armour, with flowing hair, resting his hand upon his stick, 45" x 36". At Balls Park, Hertford 1926' (Durham 1926, p. 11). This would have hung as a natural pendant to the portrait of Colonel Robert Walpole. A second portrait (also Durham 1926, p. 11) 'Portrait of Horatio, First Viscount Townshend. In red dress, with white lawn sleeves, and flowing wig. 49" x 39"' is also possible. This is a reduced version of the Lely full-length mentioned above.

Not reproduced

Classical Sculpture

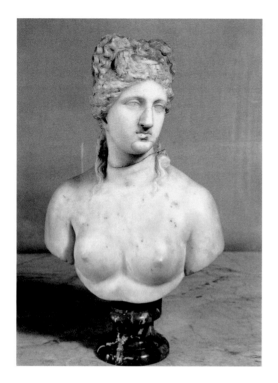

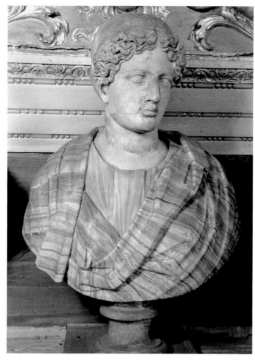

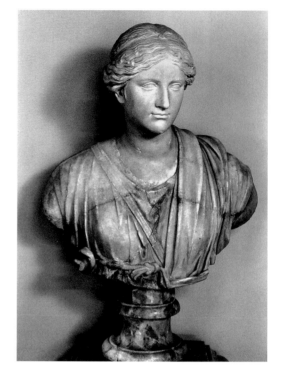

232

ROMAN, 2ND CENTURY AD
Head of Venus
White marble head on 18th-century veined marble bust, height 76
PROVENANCE: Sir Robert Walpole; Houghton Hall by 1743; by descent to David, 7th Marquess of Cholmondeley.
LITERATURE: *Aedes* 1752, p. 53; 2002, no. 77; Vermeule 1995, p. 136.

The smaller scale and the purity of its white marble made this bust well suited to the broken pediment over the black and 'white' veined marble fireplace in the Saloon. The head is based upon the *Capitoline Venus* (now Capitoline Museums, Rome), which in Sir Robert's time was in the collection of the Stazi family, the original sculpture having been found in the Stazi family gardens near S. Vitale. In 1752 the sculpture was purchased by Pope Benedict XIV and presented to the Capitoline Museum (see Haskell and Penny 1981, no. 84).

Sir Robert's bust is centred around the face, which is original, c. mid-2nd century AD. The nose and chin are restored, while the rest of the head is a pastiche, placed upon an eighteenth-century veined marble bust (thanks go to Susan Walker for her comments and advice concerning the origins of the Houghton marbles). The Stazi Venus had a good reputation,

which vied with that of the Medici Venus, and was much copied. According to Helbig, the Stazi version was early Antonine in date, itself derived from a Hellenistic statue, ultimately derived from the work of Praxiteles (Haskell and Penny 1981, no. 84, n. 22).

The entire saloon is a tribute to the Roman gods and goddesses. Apollo and Diana feature in Kent's ceiling and friezes, as do Neptune and Cybele, the goddess of fertility and the mistress of wild nature. Venus shares her centre-stage position with a carved version of the Garter Star, dating the concept for the room as post-1726.

233

ROMAN, 2ND CENTURY AD
Head of a Woman, possibly Sappho
White marble head on 18th-century marble bust, height 76
PROVENANCE: Sir Robert Walpole; Houghton Hall by 1743; by descent to David, 7th Marquess of Cholmondeley.
LITERATURE: *Aedes* 1752, p. 53; 2002, no. 78; Vermeule 1995, p. 136.

It is not absolutely clear whether this bust can be confirmed as the original bust placed above the door into the garden. One would expect the placement of a bust in this position to rely upon its subject and scale rather than necessarily its quality. These criteria do apply to this work: only the head is ancient.

The attribution of the type to Sappho was made by Vermeule (also Geoffrey Waywell, 'Hand-Guide to the classical sculptures of Holkham Hall, Chatworth, Castle Howard, Duncombe Park and Newby Hall', International Congress of Classical Archaeology, London 1978, p. 13). This goddess, recognised for her poetry as well as her beauty, was known as the tenth Muse. Only two poems by Sappho were extant, one of which was *Invocation to Aphrodite*, in Longinus. This is likely to be of significance for Kent when establishing the placement of this bust in association with that of *Venus* (Aphrodite). See cat. no. 232.

234

ROMAN, 1ST–2ND CENTURY AD; 18TH CENTURY
Bust of a Woman
Marble, height 61
PROVENANCE: See cat. no. 255.
LITERATURE: *Aedes* 1752, p. 74; 2002, no. 204; Michaelis 1882, p. 324, no. 1; Poulsen 1923, p. 12.

This is an eighteenth-century head set on an ancient bust. The latter has been pieced together from several fragments held together by iron clamps visible at the back. It was very probably cut down from a statue of Artemis. Poulsen was unable to make an assessment when he visited Houghton as the bust could not be found in situ at that time. See also cat. no. 255.

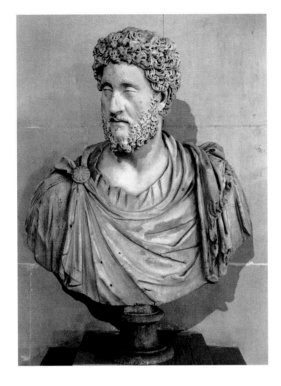

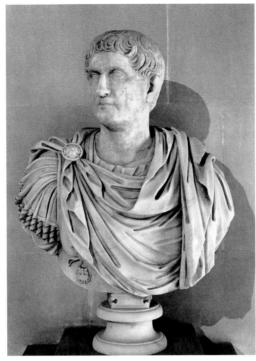

235

ROMAN, 2ND HALF OF THE 2ND CENTURY AD /
180–192 AD
Bust of Commodus, called *Marcus Aurelius*
Marble, restored, height 73.5
PROVENANCE: Sir Robert Walpole, Houghton, The
Hall, probably by c.1730; by descent to David, 7th Mar-
quess of Cholmondeley. See also *Aedes* 2002, p. 388 n. liv.
LITERATURE: *Aedes* 1752, p. 74; 2002, no. 206;
Michaelis 1882, p. 324, no. 3; Bernoulli 1882–94, ii, 2,
p. 171, no. 68; Poulsen 1923, p. 12; Wegner 1939, 255;
Wegner 1939, vol. II, p. 81; Fittschen and Zanker 1985,
no. 76, pp. 83–85, Beilage 59 a-b.

Poulsen comments that this bust is 'so retouched that it
has quite lost its character' and this could be one reason
for Horace Walpole's preferred identification as Marcus
Aurelius. Horace was an admirer of Marcus Aurelius,
regarding him as approaching perfection 'perhaps with
a little ostentation; yet even vanity is an amiable
machine, if it operates to beneficence' (HW to Dr
Robertson, 4 March 1759, HWC vol. 15, p. 51). The
Hall at Houghton required a reference to such virtues.

One of the most important statues to have survived
unburied from antiquity is the bronze equestrian statue
of Marcus Aurelius (now Rome, Piazza del Campi-
doglio, see Haskell and Penny 1981, no. 55), identified
as such since about 1600. This statue was engraved

more than any other work of antiquity and copies were
many, including a full-scale bronze replica in the gar-
dens at Wilton in the early eighteenth century.

This bust may now be identified as of the Roman
Emperor Commodus, whose likeness is most famous-
ly identified by the bust now in the Palazzo dei Con-
servatori. Fittschen and Zanker list sixteen examples
of this type (this is no. 4 in the Fittschen and Zanker
1985 list, and see also cat. no. 238).

236

ROMAN, LATE 1ST–EARLY 2ND CENTURY AD
Head of a military officer, called *Trajan*
Marble, height 73.5, set upon a modern bust
PROVENANCE: Sir Robert Walpole, Houghton, The
Hall, probably by c.1730; by descent to David, 7th
Marquess of Cholmondeley. See cat. no. 235 and
Aedes 2002, p. 388 n. liv.
LITERATURE: *Aedes* 1752, p. 74; 2002, no. 207;
Michaelis 1882, p. 324, no. 4; Bernoulli 1882–94, ii,
2, p. 81, no. 53; Poulsen 1923, p. 69, no. 51; Oehler
1980, p. 73, no. 67, pl. 31; Zanker 1980, pp. 196-203;
Fejfer 1997, p. 53.

The lack of a beard and the fall of the hair point to
the age of Trajan, although not exclusively to Trajan
himself. Horace Walpole was more than happy to
allude to the qualities of this celebrated Roman Gen-
eral in his title for this antique head. Trajan figured in
'that marvellous period in the Roman history, when
five excellent princes, though possessed of absolute
power, succeeded to one another, Nerva, Trajan,
Hadrian, and the two Antonines' (HW to the Count-
ess of Upper Ossory 9 July 1785, HWC, vol. 33, p.
479). There was a learned humility in placing heads of
Trajan and Hadrian (see cat. no. 243) in the Hall at
Houghton, on consoles which enabled the bust of Sir
Robert himself to gaze almost upon the level with
two Roman generals: 'for though Trajan and Adrian
had private vices that disgraced them as men, as
princes they approached to perfection' (HW to Dr
Robertson 4 March 1759, HWC, vol. 15, p. 50).

The head has been restored from the base of the
neck, nose, left ear and the tip of the right ear. The sur-
face of the face has been lightly smoothed over to
remove discolouration. The condition is otherwise
excellent (information supplied by Geoffrey Waywell
and Susan Walker).

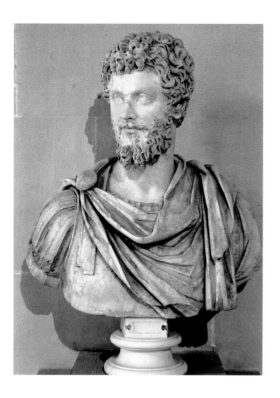

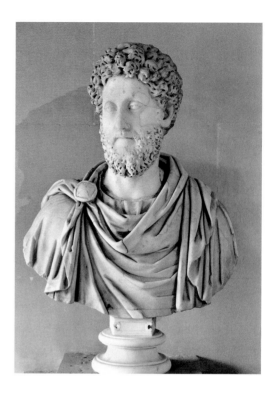

237

ROMAN, LATE 2ND–EARLY 3RD CENTURY AD
Bust of Septimius Severus (AD 193–211)
Marble, height 73.5
PROVENANCE: Alessandro Albani (1692–1779); given by Albani to Charles Churchill (c.1679–1745), illegitimate son of General Charles Churchill (1656–1714), Rome July 1731; given by Churchill to Sir Robert Walpole c.1731; by descent to David, 7th Marquess of Cholmondeley.
LITERATURE: *Aedes* 1752, p. 75; 2002, no. 208; Michaelis 1882, p. 324, no. 5; Bernoulli 1882-94, ii, 3, p. 27, no. 64; Poulsen 1923, p. 102, no. 96; McCann 1968, no. 65, pl 64; Soechting 1972, no. 71.

The fine quality of this bust is entirely consistent with its having previously been in the collection of the antiquarian and collector, Cardinal Alessandro Albani. This bust, together with cat. no. 238 were given by Albani to Charles Churchill while the latter was on a brief tour of Italy, June–July 1731. Their meeting was arranged by the antiquarian, collector and diplomatic agent, Baron Philip von Stosch (1691–1757).

The combination of Stosch and Churchill made for a powerful lobby working in the interests of Sir Robert Walpole. Albani also presented Churchill with two alabaster vases with which, according to Stosch, Churchill was well pleased. It is from Stosch that we learn that the two vases were subsequently also given to Walpole (presumably the Salon; cat no. 247).

A bust of Septimius Severus could be seen as a fitting gift to Sir Robert. From his accession in AD 193 Septimius Severus was recognised as a particularly able leader, who waged defensive campaigns while reorganising and improving the military and social structures of his empire. It would have been left to Sir Robert's detractors to point up to the more ruthless aspects of the Emperor's reign.

This bust is of superb quality. The head, neck, and bust (on a new pedestal) are ancient and unbroken, with a repair to the lower support inside the bust, but with little restoration. Susan Walker has pointed out that the nose is repaired and there are several joins to the drapery. Thanks also go to Geoffrey Waywell.

238

ROMAN, 2ND CENTURY AD
Bust of Emperor Commodus (AD 180-92)
Marble, height 71
PROVENANCE: Alessandro Albani (1692–1779); given by Albani to Charles Churchill (c.1679–1745), illegitimate son of General Charles Churchill (1656–1714), Rome July 1731; given by Churchill to Sir Robert Walpole c.1731; by descent to David, 7th Marquess of Cholmondeley.
LITERATURE: *Aedes* 1752, p. 75 p. 72; 2002, no. 209; Michaelis 1882, p. 324, no. 6; Bernoulli, ii, 2, p. 231, no. 18; Poulsen 1923, pp. 98–99, no. 90; Wegner 1939, 255; Fittschen and Zanker 1985 no. 78, p. 86 no. 2, Beilage 61 a–b.

The Emperor is here presented in the garb of a general and appears a noble and expressive companion to cat. no. 237, also from the Albani collection. Aurelius Antoninus Commodus was the son of Marcus Aurelius and succeeded his father, only to become one of the least savoury of rulers in antiquity. His place in the Hall at Houghton presumably owed as much to an avowed appreciation of the dangers of absolute power as to the taste for antique carving.

The bust displays a certain amount of restoration, notably the left cheek and eyebrow, tip of the nose, lower half of the nose and nostrils. There are patches to the draped bust in several places, including the lowest part above the pedestal, which is new. The neck is unbroken (information supplied by Geoffrey Waywell).

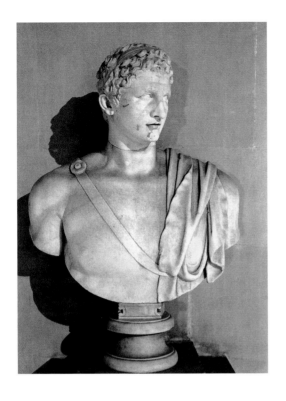

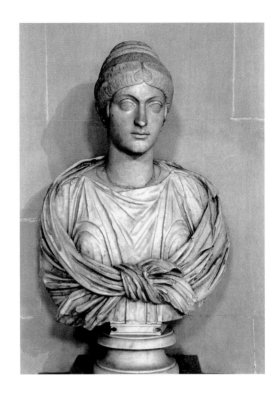

239

ROMAN, 1ST HALF OF THE 2ND CENTURY AD

Head of a Diadochus, called *A Young Hercules*

Marble head on a modern bust, height 79

PROVENANCE: Sir Robert Walpole, Houghton, The Hall, probably by c.1730; by descent to David, 7th Marquess of Cholmondeley. See also *Aedes* 2002, p. 388 n. liv.

LITERATURE: *Aedes* 1752, p. 75; 2002, no. 210; Michaelis 1882, p. 324, no. 7; Poulsen 1923, p. 39, no. 11; Lawrence 1929, p. 99; Oehler 1980, p. 73, no. 66, pl. 22; Smith 1988, pp. 65–66, 157, cat. 11.

The head, despite slight damage to the hair and temples, is in excellent condition, showing restoration on the nose, part of the lower lip, back of the right ear, and tip of the left ear. The eighteenth-century bust is carved from a piece of Greek marble and joined to the head at the mid-neck. This feature may also be seen on cat. no. 255 (Geoffrey Waywell, correspondence with Andrew Moore). The animated expression is closely related to the *Hercules* later acquired by Lord Shelbourne (1737–1805, later 1st Marquess of Lansdowne), as well as a number of other representations of Hercules, including one acquired by Thomas Hope (? 1770–1831) of Deepdene, Surrey.

However, Poulsen identified this head as a portrait variant of a head of a Diadochos, one of the generals of Alexander the Great (356–323 BC), now in the Vatican. The identity should still be regarded as uncertain. Waywell has pointed out a closeness to

Demetrios I Poliorketes (337–283BC). This was suggested earlier by von Heintze 1963, vol. I, p. 78, n. 6 to no. 1086; see also Stewart 1977, p. 144, no. 39.

240

ROMAN, 2ND-CENTURY AD HEAD ON 3RD-CENTURY AD BUST

Called *Bust of Faustina the Elder*

Marble, height 81

PROVENANCE: Sir Robert Walpole, Houghton, The Hall, probably by c.1730; by descent to David, 7th Marquess of Cholmondeley. See also *Aedes* 2002, p. 388 n. liv.

LITERATURE: *Aedes* 1752, p. 75; 2002, no. 212; Michaelis 1882, p.324, no. 8; Poulsen 1923, p.12; Moore ed. 1996, p.116, no. 34; Fittschen and Zanker 1983, III no. 97, p. 74 n. 7.

This is an exceptionally fine bust, with deeply cut and dynamic modelling of the knotted robe, typical of Rome, 3rd Century AD. The head, with a restored nose, did not originally belong to the bust, but has been added. The features are not those of Faustina (d. AD 140), but represent a woman of that time. As other versions are known in Rome and Naples, it is possible that the subject was a minor member of the Roman

imperial court around AD 140. Fittschen has suggested that the head is an eighteenth-century replica, modelled on the antique example in the Museo Nazionale, Rome. However, the marble is Greek and the early acquisition date makes this unlikely. The Houghton head is more probably an antique portrait, close to that in the Naples Museum (Naples inv. 6197; information supplied by Geoffrey Wayland).

The attribution to Faustina was a logical one for the English collector of the early eighteenth century. Faustina the Elder was the aunt of Marcus Aurelius and wife of Antoninus Pius (Emperor AD 137–61). She died (in AD 141) before her husband, who founded a charity for girls, the Puellae Faustinianae, in her memory. Faustina was, in this respect, a model female character to be represented in English collections: Lord Arundel possessed a bust of Faustina and Matthew Brettingham was soon to acquire one (c.1750–60) on behalf of Charles Wyndham, 2nd Earl of Egremont for his collection at Petworth House, Sussex.

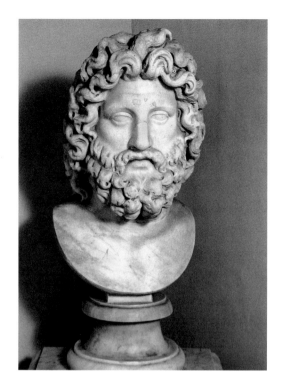
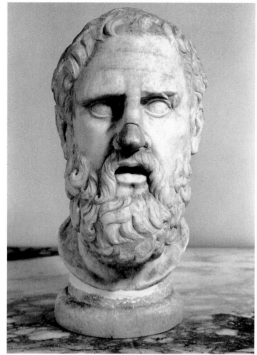
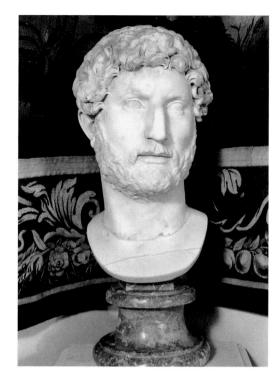

241

ROMAN, 2ND CENTURY AD
Zeus, a Colossal Head
Marble head, height 61
PROVENANCE: Sir Robert Walpole, Houghton, The
Hall, probably by c.1730; by descent to David, 7th
Marquess of Cholmondeley. See also *Aedes* 2002, p.
388 n. liv.
LITERATURE: *Aedes* 1752, p. 75 called 'Jupiter'; 2002,
no. 216; Michaelis 1882, p. 324, no. 10; Poulsen 1923,
p. 11, fig. 8.

Poulsen recognised this head, with its deep technique
of drilling, as a copy of the second century AD, after an
original of the fourth century BC, ascribed to Bryaxis.
Another replica in an English collection is that formerly
at Ince Blundell Hall (Ashmole no. 2, now in the Liv-
erpool Museum). Jupiter's place in classical mythology
was unassailable, both as Master of the Empire of the
World and of the Kingdom of Heaven.

242

ROMAN, ?1ST CENTURY AD
Head of a Greek Poet
Marble head, height 35
PROVENANCE: Sir Robert Walpole, Houghton, The
Hall, probably by c.1730; by descent to David, 7th
Marquess of Cholmondeley. See also *Aedes* 2002, p.
388 n. liv.
LITERATURE: *Aedes* 1752, p. 75, as 'A Philosopher';
2002, no. 217; Michaelis 1882, p. 324, no. 14; Poulsen
1923, p. 34–35, fig. 6; Ashmole 1924, p. 124.

The laurel wreath in the hair of this figure identifies
it as a poet. The treatment of the hair and beard is
reminiscent of Sophocles as an old man and the orig-
inal Greek marble on which this is based is probably
fourth century BC.

The physiognomy of this head links it to a series of
long-bearded portrait heads, usually thought to be
philosophers, which justifies the eighteenth-century
identification of this head as a philosopher rather than
a poet.

243

ROMAN, 1ST HALF OF 2ND CENTURY AD
Head of Hadrian
Marble, height 29, on red marble socle
PROVENANCE: Sir Robert Walpole, Houghton, The
Hall, probably by c.1730; by descent to David, 7th
Marquess of Cholmondeley. See also *Aedes* 2002, p.
388 n. liv.
LITERATURE: *Aedes* 1752, p. 75; 2002, no. 218;
Michaelis 1882, p. 324, no. 12; Bernoulli 1882-94, ii,
2, p. 116 no. 96; Poulsen 1923, p. 75, no. 59, fig. 59;
Oehler 1980, p. 74, no. 68, pl. 33; Wegner 1939, vol.
II, 3, 8.

This is a particularly fine portrait head, with a lively
mien and expressive modelling of the hair and mouth.
Hadrian (AD 117–138), the adopted son of Trajan, was
seen as an active, learned and accomplished man, who
had come to Britain, to protect the Britons from the
incursions of the Caledonians. Sir Robert no doubt
had Hadrian's tondo in mind when he commissioned
Michael Rysbrack to portray him in antique mode.
See also cat. no. 264.

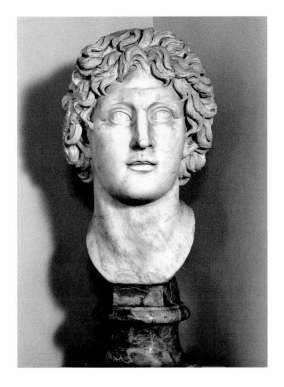

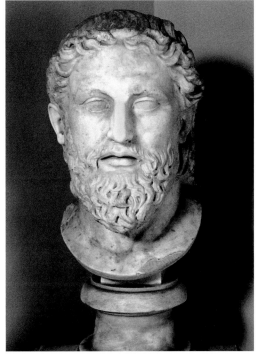

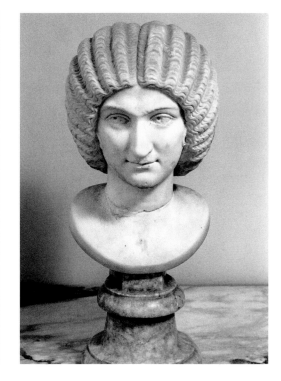

244

ROMAN, 2ND CENTURY AD
Head of Dioskuros
Marble, height 43, on grey marble socle
PROVENANCE: Sir Robert Walpole, Houghton, The
Hall, probably by c.1730; by descent to David, 7th
Marquess of Cholmondeley. See also *Aedes* 2002, p.
388 n. liv.
LITERATURE: *Aedes* 1752, p. 75, called 'Pollux'; 2002,
no. 219; Michaelis 1882, p. 324, no. 13; Poulsen 1923,
p. 12, fig. 9; Lawrence 1927, p. 95.

This over-life-size head may be identified as a
Dioskuros from the pilos, or bonnet, covering the
back of the head. The twin brothers Castor and Pol-
lux, known as the Dioskuri, were the offspring of
Leda, but only Pollux was believed to be the son of
Jupiter, as Leda was already pregnant when Jupiter
raped her. It was presumably in the interests of
mythological narrative that this marble was named
Pollux, when in the company of Jupiter, cat. no. 241.
Lawrence suggests this is an Antonine version of a
type developed in Hellenistic Alexandria.

245

ROMAN, 2ND CENTURY AD
Head of a Priest of Dionysus
Marble height 32, on turned socle
PROVENANCE: Sir Robert Walpole, Houghton, The
Hall, probably by c.1730; by descent to David, 7th
Marquess of Cholmondeley. See also *Aedes* 2002, p.
388 n. liv.
LITERATURE: *Aedes* 1752, p. 75, called 'A Philoso-
phers' Head'; 2002, no. 224; Michaelis 1882, p. 324,
no. 11; Poulsen 1923, pp. 47–49, no. 21.

Poulsen was the first to identify this head by compar-
ison with a portrait head found in the Bakcheion at
Athens. The treatment of the hair and eyes shows a
strong appreciation of work dating from the fifth and
fourth centuries BC. The wreath of ribbon in the hair
identifies the figure as a priest.

The Dionysian references for this figure were lost
to Horace Walpole and his contemporaries. Priests of
Dionysos sported hair styles in which the hair is
brushed upwards on the temples and drawn together
under the ribbon.

246

ROMAN, 3RD CENTURY AD
Head of Julia Domna, called *Julia Pia Severi*
Marble, height 25, on turned socle
PROVENANCE: Sir Robert Walpole, Houghton, The
Hall, probably by c.1730; by descent to David, 7th
Marquess of Cholmondeley. See also *Aedes* 2002, p.
388 n. liv.
LITERATURE: *Aedes* 1752, p. 75; 2002, no. 225;
Michaelis 1882, p. 324, no. 15; Poulsen 1923, p. 102,
no. 97, fig. 97; Fittzen, Zanker 1983, p. 27, no. 28,
replica no. 7.

While this remains recognisably a portrait of the wife
of Septimius Severus, this head has suffered from
much modern restoration and retouching, quite apart
from the restoration of the nose, neck and bust. Julia
Domna was celebrated for her learning, but the status
of this bust, quite probably because of its condition,
did not earn it a place in The Hall. Instead it was
placed in an outside porch, in the company of con-
temporary busts by Camillo Rusconi (see cat. nos.
260–263), also all based upon well-known original
sculptures. The most celebrated statue of Julia Domna
was that known as the *Ceres*, published by Paolo
Alessandro Maffei in 1704. This is an example of the
first type of Julia Domna's portraits, also known as the
'Gabii type', of which some forty surviving replicas
are known.

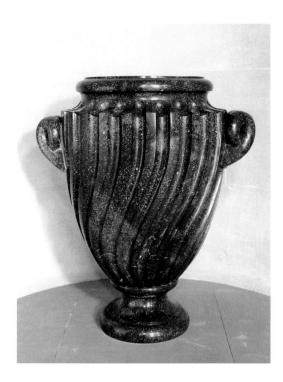

European Sculpture 16th to 18th Centuries

247

?ANTIQUE
Two Vases, in 'oriental' style
Egyptian porphyry, height 78; width 73
PROVENANCE: ? Cardinal Albani; Sir Robert Walpole; in situ in the Saloon, Houghton Hall by 1743; 'two lesser marble tables, with an Oriental Agate Urn on Each', Saloon, 1745 MS Inventory; 'A pair of occidental alabaster vases' the Saloon, 1792 MS Inventory; then by descent to David, 7th Marquess of Cholmondeley.
LITERATURE: *Aedes* 1752, p. 53; 2002, nos. 80, 81.

The various descriptions of cat. no. 247 (see Provenance) make it difficult to be certain that these vases are indeed those identified by Horace Walpole. The description 'oriental' is the one stylistic term that links this pair of vases which remain at Houghton with those described by Horace. The stone is not alabaster but Egyptian porphyry, but it is the case that alabaster originates also from Egypt (used for Roman cinerary urns) and Horace may have been using the word in a colloquial sense (thanks go to Susan Walker for this information).

Horace Walpole himself owned a vase at Strawberry Hill which he described as an urn 'of oriental alabaster, given to Sir Robert Walpole by general Charles Churchill'. This is a different urn from that recorded in the Great North Bedchamber at Strawberry Hill in 1774 (see cat. no. 274). It may, however, provide a provenance for these two vases which appear to have remained at Houghton Hall (see Appendix I under Cardinal Albani and General Charles Churchill).

248

HUBERT LE SUEUR (1590–1658)
The Borghese Gladiator (c.1631)
Bronze, height 183
PROVENANCE: Philip Herbert, 4th Earl of Pembroke (1584–1650); by descent to Thomas Herbert, 8th Earl of Pembroke (1656–1733); by whom given to Sir Robert Walpole, by 1731; by descent to David, 7th Marquess of Cholmondeley
LITERATURE: *Aedes* 1752, p. 44 (as by 'John of Boulogne'); 2002, no. 28; Isaac de Caus, *Le Jardin de Vuillton, construit par les noble et tres puissant seigneur Philippe Comte de Pembroke et Montgomerie (1626–30)*, pls. 2, 4 and 20; Watson 1965, pp. 231–32; Haskell and Penny 1981, p. 221, no. 43; C. Avery, 'Hubert Le Sueur, the 'Unworthy Praxiteles' of King Charles I' *The Walpole Society*, vol. XLVIII, 1982, cat. no. 194; Moore ed. 1996, pp. 53, 110–11.

The marble statue (now Paris, Louvre), known as the *Borghese Gladiator* is first recorded on 11 June 1611 when being restored, having just been discovered at Nettuno, near Anzio. It was subsequently taken to Cardinal Borghese's estate and became one of the chief attractions in the Villa Borghese, before being purchased by Napoleon Bonaparte in 1807.

A cast by Le Sueur was made for Charles I and stood at the end of the canal in St James' Park until it was removed to Hampton Court for William III, where it would have been familiar to Sir Robert Walpole. It is now at Windsor Castle. The Houghton *Gladiator* is a second version, which was made, by permission of King Charles, for installation in the oval circus of the gardens at Wilton, in Wiltshire, designed by Isaac de Caus for the 4th Earl of Pembroke. Horace Walpole's attribution for Pembroke's sculpture to Giambologna probably originated from the Earl of Pembroke. Sir Andrew Fountaine, Sir Robert Walpole's Norfolk neighbour and advisor, was also a key advisor to the Pembrokes at Wilton. A copy of Richard Cowdry's *A Description of the Curiosities, in Wilton-House* (1751) is inscribed with the comment: 'NB – there must be some allowances for Ld. Pembroke's fancy in the names of Statues, Busts, Artists etc – tho it has been a little corrected in this account by Sir Andrew Fountaine' (Lewis Walpole Library).

The significance of this gift to Sir Robert Walpole's collection cannot be fully considered without reference to the decorative scheme within which it was placed. The Great Staircase at Houghton guides visitors from the Arcade with its low ceilings through an internal space which has all the grandeur of a court-

yard, apparently open to the air. The inspiration for Kent's design came from Inigo Jones, in this instance his design for Whitehall Palace. The illusion of being in an exterior space is enhanced by the giant plinth upon which the bronze figure stands. Sir Thomas Robinson, visiting in 1731, was struck by the theatrical effect:

> a fine gilt gladiator, given him by Lord Pembroke and which is very prettily placed on four Doric columns with their proper entablature, which stands in the void ... the figure stands ... and fronts the door which goes into the hall and has a very fine effect when you go out of that room.

The following year Edward Harley, 2nd Earl of Oxford, visited Houghton and was deeply critical. He found the plinth 'a most clumsy pedestal' and the statue 'very ill-placed, for you cannot stand anywhere to have a good view of it'. Yet Kent's decorative scheme certainly reflects the intention to house the gladiator at its centre. The imagery of the painted grisaille and gold decorations extends the theme of martial and sporting valour with two full-scale scenes in simulated Kentian frames: *The Killing of the Calydonian Boar* and *Meleager Presenting the Boar's Head to Atalanta*. Painted busts of Diana and trophies with boars' and foxes' heads complete the scheme.

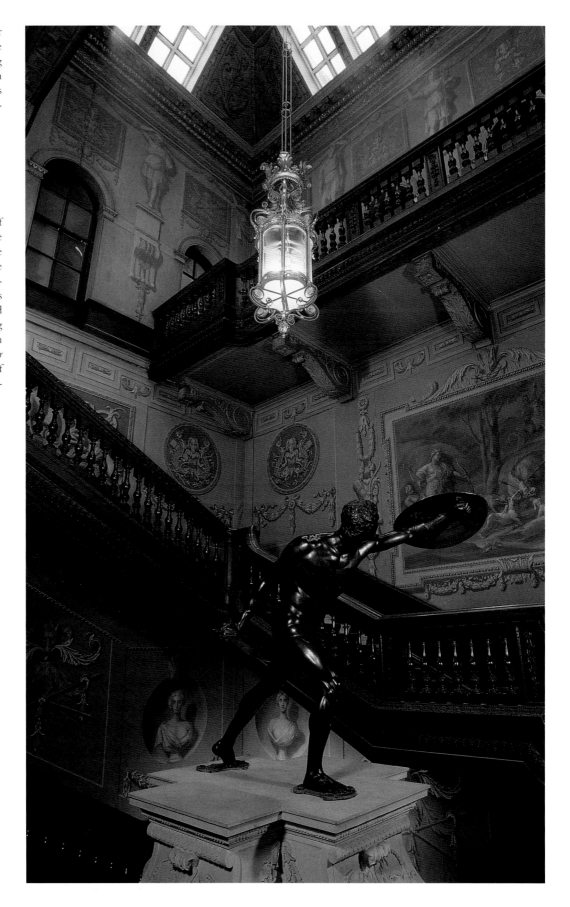

Photograph Neil Jinkerson 1996, courtesy of Jarrold Publishing

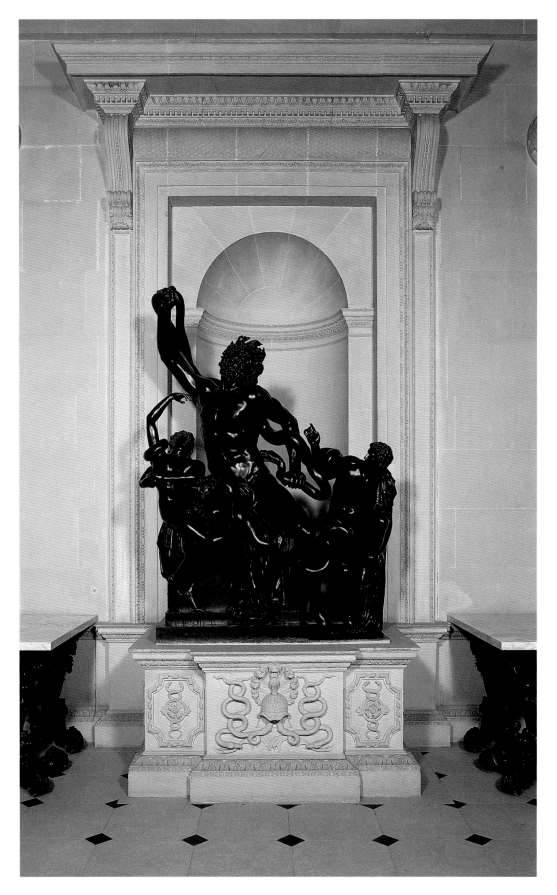

249

FRANÇOIS GIRARDON (1628–1715)
The Laocoön (c.1690)
Bronze group, height 219
PROVENANCE: Purchased c.1722–23 by Robert Walpole, eldest son of Sir Robert Walpole; by descent to David, 7th Marquess of Cholmondeley.
LITERATURE: *Aedes* 1752, p. 74; 2002, no. 199; Watson 1965, p. 227; Haskell and Penny 1981, p. 244; Moore 1985, pp. 88–89, no. 8; Moore ed. 1996, pp. 107, 114.

Horace Walpole records that it was his older brother Robert, Lord Walpole, who purchased this 'fine cast in bronze' while in Paris. The Prime Minister's eldest son spent much of the period 1722–23 abroad on his grand tour and was the first of Sir Robert's three sons to venture abroad with the aim of acquiring works of art on his behalf.

This spectacular acquisition, a life size bronze cast of the marble *Laocoön*, celebrated since its discovery in Rome in 1506, was a stunningly appropriate addition to the classical references of the Hall at Houghton. Pliny had referred to the marble group, when an ornament of the Palace of Titus, as 'of all paintings and sculptures, the most worthy of admiration' (Pliny, XXXVI, 37). A small number of marble copies were made, the earliest by Baccio Bandinelli as a present for François I of France. Bandinelli's version (now Uffizi, Florence) did not make it to France. However, a bronze copy was made for Fontainebleau and a version in bronze by Sansovino also went to France, presented in 1534 to the Cardinal of Lorraine.

During the first half of the eighteenth century the original sculpture was admired for the dignified restraint and taste with which the dying agonies of the Laocoon were envisaged. Jonathan Richardson, senior and junior, published their comments in the year the young Robert Walpole embarked upon his grand tour.

Sir Robert Walpole's bronze version was made in Paris, from casts prepared by the Kellers under the direction of François Girardon.

Robert Walpole secured the group at a cost of 1000 guineas (HRO MS 1744). Brought over from Paris, it was placed eventually in pride of place in a niche opposite the fireplace and upon a plinth designed specifically for it by William Kent.

Photograph by Neil Jinkerson © The Marquess of Cholmondeley

250

?FRENCH OR ITALIAN WORKSHOP
The Tiber (? c.1700)
Table bronze, measurements unknown
PROVENANCE: Sir Robert Walpole, Houghton, The Hall, by 1732; still at Houghton in situ, MS Inventory 1792, 'very valuable' HW; present whereabouts unknown.
LITERATURE: *Aedes* 1752, p. 74; 2002, no. 200; Haskell and Penny 1981, pp. 310–11.

The marble statue upon which this reduced replica was based, was excavated in Rome, in January 1512 and was acquired by Pope Julius II within weeks. It was very soon one of the most drawn and engraved of antique statues and a bronze copy was made for François I between 1540 and 1543 and installed at Fontainebleau (destroyed 1792). A marble copy by Pierre Bourdy reached France in 1715 and was sited at Marly by Louis XIV.

The Houghton replica could well have come from a French workshop, such as those in the collection of François Girardon. It is first recorded by the 2nd Earl of Oxford in his diary, 1732: 'There are the casts of two river gods The Tiber and the Nile, very fine ones' (HMC, Portland Manuscrips, vol. VI, p. 160). It is highly likely that cat. nos. 250 and 251 were acquired by either Sir Robert's brother Horatio (Ambassador to Paris 1723–30) or his eldest son Robert, who was responsible for the purchase of Girardon's *Laocoön*, 1722–23.

Both cat. nos. 250 and 251 wee offered for sale through Christie's, 15 July 1886, lot 89, and again 19 July 1887, lot 147. On both occasions they remained unsold (thanks to Lynda McLeod for this information).

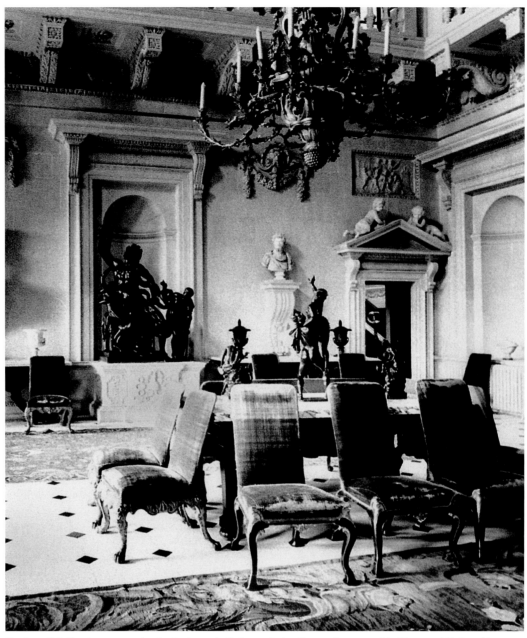

The Stone Hall, Houghton, c.1900, showing the river-god table bronzes in situ. Photograph courtesy of the Marquess of Cholmondeley

251

?FRENCH OR ITALIAN WORKSHOP
The Nile (? c.1700)
Table bronze, measurements unknown
PROVENANCE: Sir Robert Walpole, Houghton, The Hall, by 1732; still at Houghton in situ, MS Inventory 1792, 'very valuable' HW; present whereabouts unknown.
LITERATURE: *Aedes* 1752, p. 74; 2002, no. 201; Haskell and Penny 1981, pp. 272–73.

It is almost certain that the original marble statue on which cat. no. 251 was based was excavated from the same site in Rome as *The Tiber*, probably the following year, 1513. The two statues, regarded as a pair in the critical canon, do not have precisely the same history. *The Nile* was, in particular, regarded as the more curious, with its rather more exotic attribute of the sphinx and the broken fragments of sixteen putti representing the sixteen cubits by which the river could rise in spate.

A plaster cast was made for François I, and a marble copy carved by Lorenzo Ottoni for Louis XIV 1687–92. This was placed in the gardens of Marly in 1715 in the company of *The Tiber* (both now in the Tuilleries Gardens). The Houghton bronze is likely to have excluded the putti.

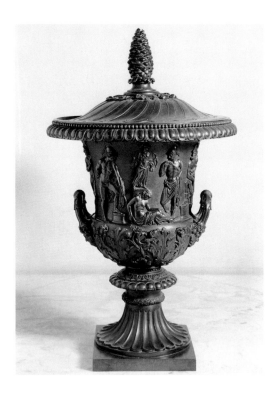

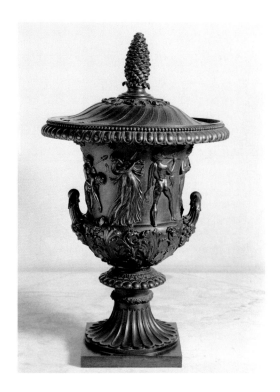

252

FRENCH WORKSHOP, attributed
Table bronze, after the antique Medici Vase (c.1700)
Bronze, 65.5 x 38
PROVENANCE: Sir Robert Walpole, Houghton, The
Hall, by 1743, by descent to David, 7th Marquess of
Cholmondeley.
LITERATURE: *Aedes* 1752, p. 74; 2002, no. 202; Coop-
er 1965, p. 232; Haskell and Penny 1981, pp. 315–16;
Moore ed. 1996, pp. 116–17, no. 35.

This, a pair to cat. no. 253, is a reduced version of the
celebrated antique marble Medici Vase, displayed in the
Villa Medici, Rome, by 1598 (now Uffizi Gallery, Flo-
rence). The Medici Vase features a scene which was
believed to represent the sacrifice of Iphigenia to Diana.

The reference to Diana would have been particularly
fitting as part of Kent's decorative scheme for the Great
Staircase. It may well be the case that cat. no. 252 and its
pair were originally displayed there, where Sir Thomas
Robinson recorded 'several other fine bronzes' in addi-
tion to the *Bronze Gladiator* (Sir Thomas Robinson to
Lord Carlisle, 9 December 1731, HMC, vol. XV,
Appendix pt. vi, p. 84). However, no bronzes other
than the *Gladiator*, are recorded on the staircase by
Horace Walpole in 1743.

The Medici and Borghese Vases were much repro-
duced in the seventeenth and eighteenth centuries,
notably in a fine etching by Stefano della Bella (1656)
and in marble replicas placed round the Bassin de
Latone at Versailles. The two Houghton vases have

distinctive fluted lids with pine-cone finials, details
which have nothing to do with the originals.

It is possible that the Houghton vases originated
from a French workshop, quite possibly that of Girar-
don. If this was so, Sir Robert could have received
them as a gift from his brother Horatio, Ambassador
to Paris 1723–30.

253

FRENCH WORKSHOP, attributed
Table bronze Urn, after the antique Borghese Vase (c.1700)
Bronze, 65 x 38
PROVENANCE: Sir Robert Walpole, Houghton, The
Hall, by 1743; by descent to David, 7th Marquess of
Cholmondeley.
LITERATURE: *Aedes* 1752, p. 74; 2002, no. 203; Coop-
er 1965, p. 232; Haskell and Penny 1981, pp. 314–15;
Moore ed. 1996, pp. 116–117, no. 35.

The marble Borghese Vase was discovered in Carlo
Mutti's garden in Rome around 1569, but had been
removed to the Villa Borghese by 1645 (now Paris,
Louvre). The frieze scene is a Bacchic procession,
thought to include a drunken Silenus. The Borghese
marble is without handles, but copies adopt the Krater
shape of the Medici Vase for the sake of symmetry.

Of the numerous copies of the Medici and Borgh-
ese vases, those at Houghton are among the earliest.
Similar copies are today at Osterley House, Middle-
sex and Longford Castle, Wiltshire.

The possibility that cat. nos. 252 and 253 may be
Italian workmanship is enhanced if a letter from
Horace Mann in Florence, dated 14 May 1740, to
Horace Walpole refers to these vases. Mann discusses
a gift from himself to Sir Robert, and mentions '4 cas-
sette 3 con urne d'alabastro ed una con bronzi; olivet-
ti per Londra di regalo al sig. Cav. Roberto Walpole'
(HWC, vol. 17, p. 24 n2, Florence State Archive,
a reference first noticed by Sebastian Edwards).

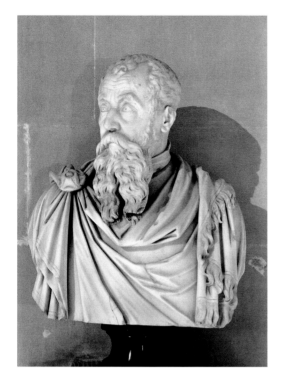

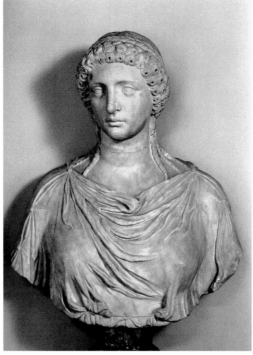

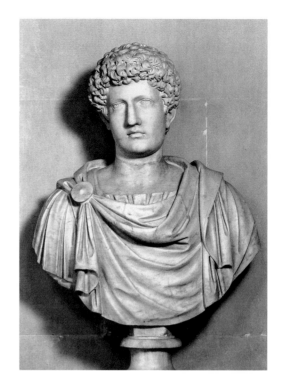

254

ALESSANDRO VITTORIA (1524–1608)
Bust of a Bearded Man, called *Baccio Bandinelli, by himself*
(?1570s)
Marble, height 66
PROVENANCE: ?Mr. Dobson, Collection Sale 1726, lot
90, 'B. Bandinelli by Himself' (Houlditch MSS); Sir
Robert Walpole, Houghton, The Hall, probably by
c.1730; by descent to David, 7th Marquess of Chol-
mondeley. See also *Aedes* 2002, p. 388 n. liv.
LITERATURE: *Aedes* 1752, p. 75; 2002, no. 211; Moore
ed. 1996, p. 114.

This sculpture was the odd one out in Sir Robert's
decorative scheme for the Hall, which otherwise con-
sisted of classical sculpture or contemporary refer-
ences to antiquity.

Baccio Bandinelli (1488–1560) was much patron-
ised by the Medici and he was one of the most polit-
ical of sculptors in the eyes of the Florentines. The
antique mien of this portrait bust allowed a Late
Renaissance contribution to the ensemble, which was
by no means out of place.

Charles Avery was the first to identify the hand of
Alessandro Vittoria in this portrait head, an attribu-
tion substantiated by Dr. M. Leithe-Jasper (Charles
Avery correspondence with Sebastian Edwards,
1996). Vittoria, a pupil of Jacopo Sansovino in
Venice, was adept at producing realistic portrait busts
of Venetian figures in particular.

255

ITALIAN
Bust of a Woman, called *Roman Empress* (c.1700)
Marble head on ancient Roman bust, joined at mid-
neck
PROVENANCE: Twickenham Park (*Aedes* 1747, p. 68);
?Arnold Joost van Keppel (1669–1718); Thomas
Vernon (died 1726); Mrs Vernon; bought (with cat. no.
234) Sir Robert Walpole, Houghton, The Hall, c.1726;
by descent to David, 7th Marquess of Cholmondeley.
LITERATURE: *Aedes* 1752, p. 74; 2002, no. 205;
Michaelis 1882, p. 324, no. 2; Poulsen 1923, p. 12.

It is significant that cat. nos. 254 and 255, although
gracing the Hall, did not achieve the status of being
placed as part of Kent's decorative scheme on the
console brackets and 'terms' despite the fact that two
consoles were still empty in December 1731 (see
below). Neither bust consisted of entirely antique
fragments and neither could be readily identified as a
significant historical figure.

Cat. no. 255 is an entirely eighteenth-century bust,
and not as described by Horace Walpole. The identi-
ty of a particular figure was important to the early
eighteenth-century appreciation of portrait busts in
particular. Late in life Horace Walpole gave voice in
a letter to Sir William Hamilton (30 September 1792)
to the limitations of his admiration for classical sculp-
ture: 'I admire, nobody more, the productions of the
ancients … but where they were extremely defective,
I cannot applaud. … I conclude from the multitudes
of statues and busts which remain, that the ancients

were as fond of portraits as we are, and portraits at
most exhibit character, not passions.' Horace's expec-
tations of portrait busts were far more limited than his
admiration for the great statues of antiquity such as
the *Laocoön* or the *Borghese Gladiator.*

256

ITALIAN WORKSHOP
Head of a Young Commodus (early 1700s)
Marble, height 63.5
PROVENANCE: Sir Robert Walpole, Houghton, The
Hall, probably by c.1730; by descent to David, 7th
Marquess of Cholmondeley. See also *Aedes* 2002, p.
388 n. liv.
LITERATURE: *Aedes* 1752, p. 74; 2002, no 213;
Michaelis 1882, p. 324, no. 9; Poulsen 1923, p. 12, as
'an eighteenth century forgery'.

This is a skilfully classicised modern bust, the drilling of
the hair typically *all' antica.* The join of the head and
bust comes at mid-neck, in common with cat. nos. 239
and 255 (as pointed out by Geoffrey Waywell), which
may suggest a common contemporary source for a
number of the busts at Houghton. Cat. no. 256 was no
doubt part of Sir Robert's earliest collection of antique
busts for the Hall. As such, the inclusion of this bust in
Sir Robert's decorative scheme is more concerned with
an association with the Roman Empire as to any per-
sonal inclination or assessment of individual character.
The bust could have been made specifically to com-
plete the decorative scheme.

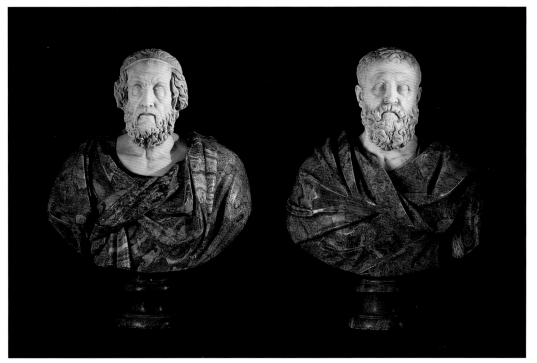

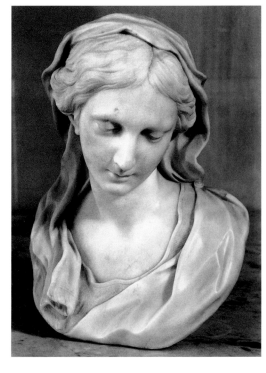

Photograph courtesy of Christie's Images Ltd.

257

ITALIAN, 17TH CENTURY
Homer
White marble and alabaster bust, after the antique,
height 91.5
PROVENANCE: Sir Robert Walpole, Houghton, The
Hall, probably by c.1730; by descent to David, 7th
Marquess of Cholmondeley. See also *Aedes* 2002, p.
388 n. liv. Sold Christies, 8 December 1994, lot 133
(one of a pair with cat. no. 258).
LITERATURE: *Aedes* 1752, p. 75, as 'Homer Modern';
2002, no. 214.

It is interesting to see Sir Robert Walpole interspers-
ing busts *all' antica* amongst antique prototypes. The
closest parallel is with the major series of busts at
Wilton, assembled by Thomas Herbert, Earl of Pem-
broke (1656–1733). It was a taste also shared by Sir
Robert's Norfolk neighbours, Sir Andrew Fountaine
(1676–1753) and Sir Thomas Coke (1697–1759).
Indeed, Fountaine is here a common link, as respect-
ed advisor to the Herberts, Coke and Walpole.

The inclusion of a head of the greatest and earliest
Greek poet lent a literary erudition to Sir Robert's
hall of classical fame.

258

ITALIAN, 17TH CENTURY
Hesiod
White marble and alabaster bust, after the antique,
height 92
PROVENANCE: Sir Robert Walpole, Houghton, The
Hall, probably by c.1730; by descent to David, 7th
Marquess of Cholmondeley. See also *Aedes* 2002, p.
388 n. liv. Sold Christies, 8 December 1994, lot 133
(one of a pair with cat. no. 257).
LITERATURE: *Aedes* 1752, p. 75 as 'Hesiod Ditto' [i.e.
modern]; 2002, no. 215.

The iconography for the representation of the cele-
brated Greek poet, often coupled or contrasted with
Homer, is limited. A very different poet from Homer,
Hesiod's two most celebrated works are *Theogeny
(The Birth of the Gods)* and W*orks and Days*, a work of
agriculture which includes a calendar for the working
farmer.

Both cat. nos. 257 and 258 are high quality and rep-
resent the high status attached to the work of seven-
teenth- and eighteenth-century sculptors working in
the antique style.

259

CAMILLO RUSCONI (1658–1728)
Bust of the Madonna (early 1700s)
Marble, height 40.5
PROVENANCE: Sir Robert Walpole; in the Drawing
Room, Houghton Hall by 1743; then by descent to
David, 7th Marquess of Cholmondeley.
LITERATURE: *Aedes* 1752, p. 51; 2002, no. 61; Honour
1958, pp. 223–24; Martin 2000, pp. 85, 88.

Sited on the mantlepiece of the Drawing Room sur-
rounded by family portraits and an eclectic range of
mythological and religious imagery, Rusconi's 'gen-
teel' bust was divorced of any overt devotional qual-
ity. It remains 'one of the finest examples of early
eighteenth-century Italian sculpture in England' and a
key work to understanding Rusconi's work on this
scale, very different from his larger lifesize figures.
Hugh Honour points to the similarity in style to the
figure of *Religion* on Rusconi's monument to Pope
Gregory XIII in St Peter's, executed between 1720
and 1723 (Frank Martin has also drawn attention to
the affinity with Rusconi's bust of *Giulia Albani*,
Kunsthistorisches Museum, Vienna). The head also
shows affinity to François Duquesnoy's *St Susanna* in
the church of S. Maria di Loreto, Rome, which was
widely admired at this period, confirming one of
Rusconi's key influences throughout his career. See
also cat. nos. 260–263.

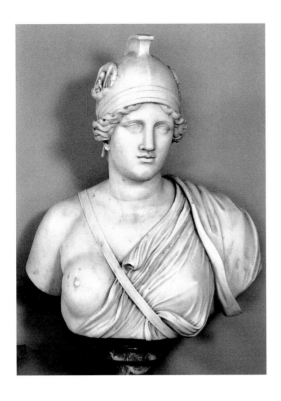

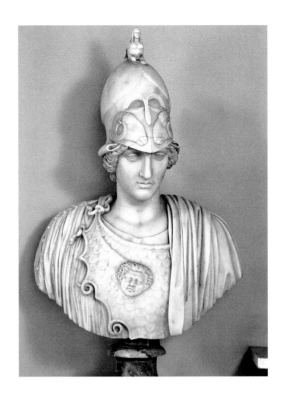

260

CAMILLO RUSCONI (1658–1728) AND WORKSHOP
Rome, after the antique (c.1720s)
White marble, height 78.5
PROVENANCE: Sir Robert Walpole, by 1743; then by descent to David, 7th Marquess of Cholmondeley.
LITERATURE: *Aedes* 1752, p. 75; 2002, no. 220; Honour 1958, pp. 220–26; Martin [1996], pp. 126–31; Martin 2000a, pp. 51–68; Martin 2000b, pp. 81–91.

Cat. nos. 260–263 have all the appearance of having been conceived as a set, composed for an English grand tourist, in the studio of Camillo Rusconi. Rusconi was celebrated in Rome for his many religious works in the grand manner and also for memorials which would feature portrait busts. The workmanship of these replica busts is clinically accurate and one would expect the hand of a pupil rather than the master. Indeed, the manuscript inventory compiled in 1745 on the death of Sir Robert makes no mention of the authorship of these four busts, referring to them simply as 'bustos'. The inventory compiled in 1792 is only slightly more informative: 'Four Bustos modern copied from the antique in statuary marble'.

The four Houghton busts may be seen as important examples within the context of Rusconi's oeuvre. It is notoriously difficult to be certain of the authorship of sculpture based upon the antique on stylistic grounds alone. It is also the case that Rusconi enjoyed considerable success in England, a notable example being the *Four Seasons*, which his biographer Lione

Pascoli reports as having entered the collection of George I at a high price and now flank the royal swimming pool at Windsor (grateful thanks go to Frank Martin for his comments on the attribution to the Rusconi workshop). Horace Walpole's attribution is here given qualified acceptance. There are identified examples of copies after the antique by Rusconi, notably a *Fawn* in Berlin, while Pascoli records his small–scale terracotta copies after antique sculptures. These examples add credence to Horace Walpole's original association of this set with Rusconi.

Rome is here clearly identifiable by the she-wolf and Romulus and Remus on her helmet. The antique statue *Roma* was placed by Clement XI in the courtyard of Palazzo dei Conservatori in 1719. The replica is of the head and bust only, the original marble being a seated figure.

261

CAMILLO RUSCONI (1658–1728) AND WORKSHOP
Minerva, after the antique (c.1720s)
White marble bust, height 84
PROVENANCE: Sir Robert Walpole, by 1743; then by descent to David, 7th Marquess of Cholmondeley.
LITERATURE: *Aedes* 1752, p. 75; 2002, no. 221; Haskell and Penny, 1981, pp. 269–71, no. 63. See also under cat. no. 260.

The *Minerva Giustiniani* (now Rome, Vatican) was one of the most distinguished marbles in the Giustiniani collection, although Jonathan Richardson was not that impressed when he saw it: 'Tis not very fine and has no sweep' (1722, p. 155). The glamour associated with Minerva is here directly linked to Athena as symbol of Athens and the Parthenon, a true companion of *Rome* for the collector of the antique and sculpture *all' antica*. See cat. no. 260 concerning the attribution of nos. 260–263.

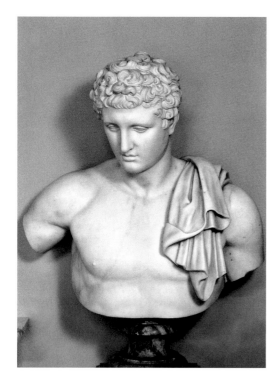

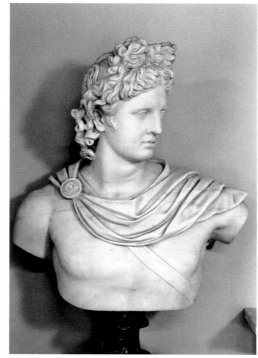

262

CAMILLO RUSCONI (1658–1728) AND WORKSHOP
Antinous, after the antique (c.1720s)
White marble bust, height 66
PROVENANCE: Sir Robert Walpole, by 1743; then by descent to David, 7th Marquess of Cholmondeley.
LITERATURE: *Aedes* 1752, p. 75; 2002, no. 222; Haskell and Penny 1981, pp. 141–43, no. 4. See also under cat. no. 260.

The full length *Belvedere Antinous* is recorded in the Belvedere Statue Court by 1545. It became one of the most celebrated statues in Rome, a bronze cast being made for Charles I of England and one of the bust only for Philip IV of Spain. William Hogarth, who never saw the original, commented upon its 'utmost beauty of proportion … allowed to be the most perfect … of any of the antique statues'.

It was entirely appropriate to seek to own a copy of this famous statue by an equally celebrated artist of the day. The drapery on the figure's left shoulder is fully modelled rather than a direct copy of the original, while the sculptor achieves a latter-day sensitivity of expression which pays full tribute to that of the original. In a hitherto unknown *Vita* of Camillo Rusconi a copy after the Antinous is documented. This is most probably a small-scale terracotta copy (information kindly supplied by Frank Martin). See cat. no. 260 concerning the attribution of nos. 260–263.

263

CAMILLO RUSCONI (1658–1728) AND WORKSHOP
Apollo Belvedere, after the antique (c.1720s)
White marble bust, height 68.5
PROVENANCE: Sir Robert Walpole, by 1743; then by descent to David, 7th Marquess of Cholmondeley.
LITERATURE: *Aedes* 1752, p. 75; 2002, no. 223; Haskell and Penny 1981, pp. 148–51, no. 8; Androssov 1991, p. 134, cat. no. 134. See also under cat. no. 260.

No eighteenth-century sculpture collection was complete without a representation of the famous *Apollo Belvedere* in some form. The marble had been in situ in the Belvedere Statue Court since at least 1523, exciting admiration from all who saw it. Cat. no. 263 is a free rather than faithful replica that invites comparison and contrast with the accompanying *Belvedere Antinous*, displayed in a latterday English courtyard setting. A small-scale terracotta copy by Rusconi after the *Apollo Belvedere* is in the Ca' d' Oro in Venice.

Lione Pascoli, in his biography of Rusconi, mentions a copy Rusconi made of the *Apollo Belvedere* on behalf of Niccolo Maria Pallavicini. This was very probably a small-scale model. After the Marchese's death the copy went to England.

Grateful thanks go to Frank Martin for his advice concerning the career of Camillo Rusconi. See under cat. no. 260 concerning the attribution of this group of Houghton busts.

264

JOHN MICHAEL RYSBRACK (1694–1770)
The Sacrifice to Bacchus
Overmantel relief, marble, 132 x 172
PROVENANCE: Sir Robert Walpole, 1732; by descent to David, 7th Marquess of Cholmondeley.
LITERATURE: *Aedes* 1752, p. 71; 2002, no. 190; Tipping 1921, p. 98; Webb 1954, pp. 128, 228; 1982 Bristol, p. 40; Moore ed. 1996, pp. 27, 139–40.

When Edward Harley visited Houghton for the second time in 1737 he praised the Marble Parlour which had not been completed on his first visit: 'The fine marble room is finished, and a most beautiful chimneypiece made by Rysbrack as can be seen'. Rysbrack's design was in place by 1733, as is recorded by a voucher for masons to insert the 'barsrelieve', during the course of construction, 22 September–6 October 1733. The relief is similar to Rysbrack's overmantel made for Clandon Park, around 1731–35.

The design is deeply cut and is a virtuoso creation which takes up the themes of sacrifice in the decorative scheme of the adjacent Stone Hall as well as the Bacchic subject matter of Kent's Marble Dining Room. Rysbrack can be seen at Houghton working closely with both designer and patron, taking inspiration from engravings of Roman reliefs as befits the classical character of these two spaces. Rysbrack's work at Houghton included cat. no. 265, the marble relief for the chimneypiece in the Stone Hall (also a sacrificial scene), stone reliefs and reclining figures over doors in the Stone Hall and a group of Neptune and Britannia on the façade of the original entrance, 1730. In addition, Timothy Stevens has identified two plaster oval medallions of Sir Robert and Lady Walpole, recently discovered at Houghton, as part of Rysbrack's projected decorative scheme.

This bas-relief is closely observed in its sacrificial details; trumpeters to the left celebrate as a ram is bled in the foreground, the blood running into a bowl, as an ox awaits slaughter to the right. A burning pyre is maintained by two elders, while grapevines cascade from the broken pediment above to the foreground below. These elements strongly suggest that Rysbrack was also involved in the carving of the chimneypiece, although the London carver Abraham Swan was also responsible, perhaps under Rysbrack's direction (Geoffrey Beard in Moore ed. 1996, p. 27). For a long time Rysbrack's full-scale design drawing for the overmantel survived at Houghton, eventually being presented by the 5th Marquess of Cholmondeley to the British Museum in 1952 (BM 1952-10-11-1, exhibited 1996–97 Norwich–London, no. 57).

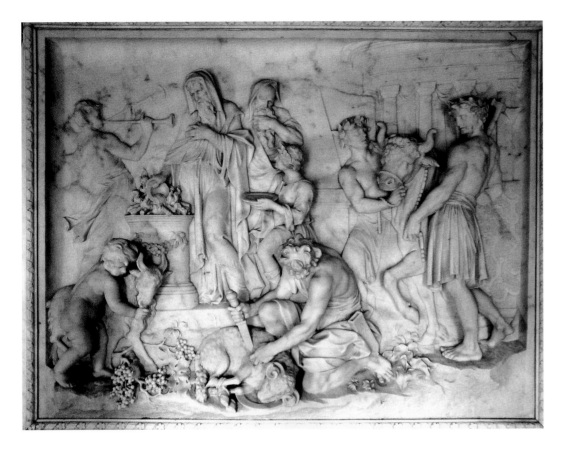
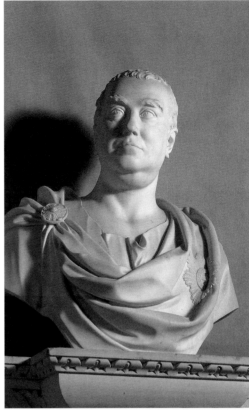

Photograph by Neil Jinkerson © The Marquess of Cholmondeley

265

JOHN MICHAEL RYSBRACK (1694–1770)
Bust of Sir Robert Walpole (c.1726)
Marble, height 63.5
PROVENANCE: Made for Sir Robert Walpole, for Houghton Hall, c.1726; by descent in situ to David, 7th Marquess of Cholmondeley.
LITERATURE: *Aedes* 1752, p. 74; 2002, no. 198; Vertue, vol. III, pp. 31, 104; Webb 1954, pp. 128–29; Cooper 1965, p. 226; Kerslake 1977, pp. 197–98; 1982 Bristol, p. 9; Sebastian Edwards in Moore ed. 1996, p. 115, no. 33.

George Vertue saw this bust, or a clay model for it in Rysbrack's studio in 1726, 'modelled from the life … a large head, broad face,' and including the Garter and Star. The finished marble arrived at Houghton in December 1730, as reported in the *Norfolk Gazette*. (19–24 December 1730): 'a few days since a curious Busto of the Rt Hon. Sir Robert Walpole, done by Mr Risbach, the famous Sculptor, was sent to Sir Robert's seat at Houghton.' According to a later note by Vertue, Rysbrack's likeness of Sir Robert was 'very much like him and approved of' (Vertue vol. III, 1933-34, p. 56).

While the bust was almost certainly commissioned to survey the Hall from the bracket in front of Rysbrack's overmantel relief showing a *Sacrifice to Diana*, this is not altogether clear. A drawing now in a private collection shows a design by Kent, dated 1728, for the West Wall of the Marble Parlour, with a plain overmantel, in front of which stands Sir Robert's bust, facing to his right towards the entrance to the room. In the event a second overmantel was commissioned from Rysbrack, this time for the Marble Parlour, and Sir Robert's bust *all' antica* assumed its position in the Hall, where it remains today. A drawing by Kent and ?Henry Flitcroft, dated 1726, demonstrates that this position was the original intention (Courtauld Institute Galleries, Moore ed. 1996, no. 32). However, in that drawing the bust faces in the opposite direction to the finished work, which suggests a confusion in the instructions given to Rysbrack.

Sir Robert's commission was idiosyncratic for the time. He is portrayed without a wig and wearing a toga, which was to become a standard mode for statesmen and politicians. However, the inclusion of the Garter Star, also to be seen in the centre of the ceiling above, rendered the bust unmistakably of the day. Sebastian Edwards has pointed out that Lord

Chesterfield also was to use this formula, having the Garter Star prominent on both his bust and on the ceiling of his London villa.

A terracotta version of cat. no. 265 is now in the National Portrait Gallery, dated 1738 (NPG 2126), and another marble version remains in the Walpole family collection. In addition, both L. Natter and J. Dassier modelled versions of Rysbrack's likeness of Sir Robert in 1742 and 1744 respectively, the latter for his series of 'Illustrious Men'. Natter's medal was in two versions: the first bore a reverse image of Cicero, the second featured the inscription: 'I AM KICKED OUT OF DOORS', marking Sir Robert's resignation (information kindly supplied by David Cholmondeley).

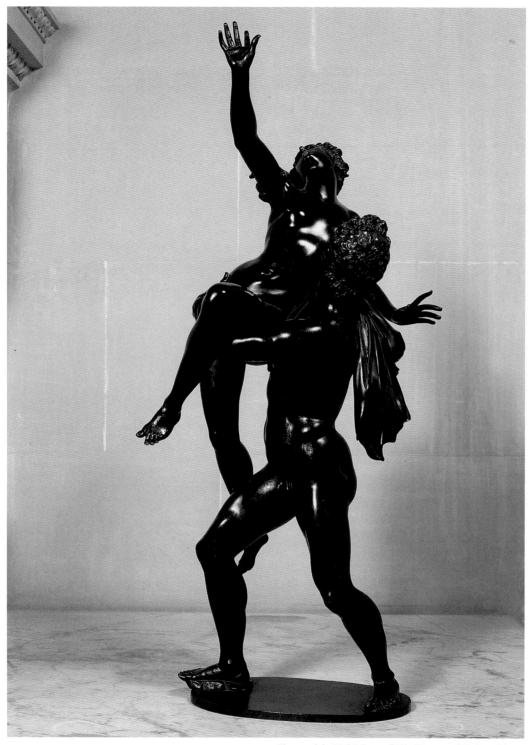

Despite Horace Walpole's assertions in the *Aedes* concerning this bronze being based upon the original marble group in the Loggia de' Lazzi of the Piazza del Gran Duca at Florence, he is not entirely correct. Giambologna had started work on a bronze two-figure group for the Duke of Parma in 1579. It was this composition that he later developed as the full-scale three figure marble group of the *Rape of the Sabine Woman*.

Horace Mann's gift to Sir Robert appears to be an early copy after the principal versions, all of which display slight variations. Giambologna's assistant, Antonio Susini, developed an extensive workshop in Florence, which was known for the high quality of its output. The workshop specialized in replica bronzes at this time and the tradition continued into the seventeenth century under the leadership of Ferdinando Tacca. The chasing and modelling of this bronze is consistent with a workshop of the late sixteenth or early seventeenth century. The closest parallel is with a similar bronze in the Kunsthistorisches Museum, Vienna (cf. London 1978, no. 57). Two other prime versions are in the Museo e Gallerie di Capodimente, Naples and the Metropolitan Museum of Art, New York. There is also a wax model in the collection of the Victoria & Albert Museum that illustrates the development of the sculpture (V&A, Sculpture 4125-1854).

Horace Mann sent the bronze from Florence and it duly arrived on Sir Robert's birthday, 26 August 1743. On arrival it was placed at the far end of the Picture Gallery, which was lit for the occasion with sixty-four candles. Horace was evidently as pleased with the gift as his father: 'I have a commission from my Lord to send you ten thousand thanks for his bronze: he admires it beyond measure. It came down last Friday, on his birthday, and was placed at the upper end of the gallery, which was illuminated on the occasion: indeed, it is incredible what a magnificent appearance it made! There were sixty-four candles, which showed all the pictures to great advantage.' Horace Mann was inevitably delighted with this response and replied on 1 October, suggesting that it might be placed on a turntable in order to appreciate it in the round: 'My Lord has done me an infinite deal of honour by so graciously receiving the *bronzo*, for which I beg my humblest thanks through your means, suitable to the veneration and respect you know I profess. You must tell me on what it was set at the upper end of the gallery, and what pedestal you have had made, and if on a *perno* or pivot, to turn round'. The bronze group's final position at Houghton, after this dramatic unveiling, was on the 'great table' in the Salon.

266

GIOVANNI BOLOGNA (GIAMBOLOGNA) (1529–1608), FLORENTINE WORKSHOP, after
Rape of the Sabine Woman (?early 17th century)
Bronze, height 98
PROVENANCE: gift of Horace Mann to Sir Robert Walpole, August 1743; HH, the Salon; by descent to David, 7th Marquess of Cholmondeley.
LITERATURE: *Aedes* 1752, p. 53; 2002, no. 79; HWC, vol. 18, pp. 298–89, 312–13; Cooper 1965, p. 232; 1978 London, nos. 56, 57; Avery 1987, pp. 78–80, 109–14, 143, 254; 1996-97 Norwich–London, no. 44.

Decorative Arts

267

WILLIAM KENT (1685–1748), design attributed to
Lapis Lazuli Pier Table (c.1731)
Oil-gilded pine, lapis lazuli marble.
PROVENANCE: made for Sir Robert Walpole,
Houghton Hall; in situ in the Carlo Maratti Room by
1743; by descent to David, 7th Marquess of Chol-
mondeley.
LITERATURE: *Aedes* 1752, p. 57; 2002, no. 96; Moore
ed. 1996, p. 127.

First recorded as in the Carlo Maratti Room by
Horace Walpole, this table was almost certainly
designed for this room. A design for a pier table,
inscribed on the verso 'For Sr Rt Walpole at
Houghton. Novr. 1731' is illustrated here. This links
the preliminary design and the table to this stage of
the building programme at Houghton and the com-
pletion of the Carlo Maratti Room (Victoria & Albert
Museum, London, Prints and Drawings 815b; exhib-
ited 1996–97 Norwich–London, no. 47).

The table is unusual for its veneered top of the blue
and yellow lapis lazuli and is well described by Sebast-
ian Edwards: 'Kent's design uses classical ornament
along the top rails of the table, overlaid with more
sculptural elements that give it a Baroque feeling; cor-
nucopiae of fruit, ribbon-tied swags and a lion's mask in
the centre. He builds up the extraordinary legs from a
number of components: a fish-scale pattern scroll at the
top is placed on a fluted, square section baluster and the
whole leg ends with a bun foot. However, the way in
which each ornament relates to the others ensures that
the result, both in the drawing and in the table, is
entirely convincing' (Moore ed. 1996, p. 127).

Kent's design for this table sets the style for a number
of Kentian tables at Houghton, notably that in the
Marble Parlour, but also those in the Saloon (see Corn-
forth in Moore ed. 1996, pp. 29–40). Kent's designs for
furniture at Houghton were a superb manifestation of
his design philosophy, seeking to integrate his control
of motif throughout a series of decorative schemes and
setting new standards of magnificence in interior
design. Kent's approach was to prevail during this
period of building boom throughout the country,
c.1720–40, and was a match for the architectural inno-
vation of Houghton's novel floorplan (Saumarez-
Smith 2000, p. 62; and for a contextual overview of the
impact of new building and design at this period,
including the work of Kent, see *ibid*. pp. 59–91).

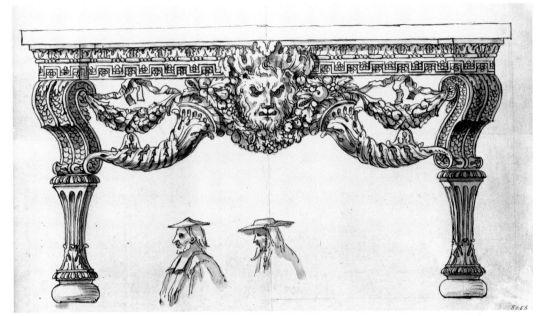

Attributed to William Kent, design for a pier table, inscribed on the verso 'For Sr Rt Walpole at Houghton. Novr. 1731'
(Victoria & Albert Museum, London, Prints and Drawings 815b).

268

?WILLIAM HUBERT
Two Silver Sconces (c.1730)
Silver, size unknown
PROVENANCE: Sir Robert Walpole, Houghton Hall;
in situ in the Carlo Maratti Room by 1743; present
whereabouts unknown.
LITERATURE: *Aedes* 1752, p. 57; 2002, nos. 97, 98.

It is unclear whether Horace Walpole's description, 'at
each End [of the Carlo Maratti Room] are two sconces
of massive silver' refers to a total of two or four sconces.
The large scale of these sconces were such as to cause
Horace to refer to them to the exclusion of any other
elements of Sir Robert's silver collection, which is
known to have included some fine pieces. A significant
amount of Walpole family silver was sold from Straw-
berry Hill (SH Sale, George Robins, May 1842, day 11,
lots 114–160), however the sconces were not included
in this dispersal.

A list of 'mettle branches' and girandoles 'delivered
to Lord Walpole by William Hubert', dated 8 May
1730 strongly suggests that these sconces could have
dated from this period of the furbishment of
Houghton Hall (Houghton Archives, R.B.1,47).

Hubert's bill, receipted 16 May 1730, details main-
ly repair work to five pairs of girandoles as well as
eight 'branches' for the 'two oval large glass sconces
finely Repair'd at 17:6 each'. The most valuable was
'A Pair of French Mettle Branches with oval Backs &
Masks fine Repair'd : £16:0:0'. Although none of
these is likely to have been those of 'massive silver'

the bill does make it clear that this was the period
when Hubert was working for Sir Robert. The 'two
oval large glass sconces' do remain at Houghton; one
of these is shown in Kent's early design for the west
wall of the Marble Parlour, dated 1728 (private col-
lection: 1996–97 Norwich–London, no. 58). These
sconces are also shown in the plan for the picture
hang in the cabinet, c.1742 (Houghton MSS A84;
Norwich–London 1996–97, no. 56).

A second account survives at Houghton which
itemizes the sale of plate and pictures by Abraham
Langford and Christopher Cock on behalf of Robert,
2nd Earl of Orford: on 4 September 1747, Langford
records 'By Cash rec'd. of Talbot for the sconces –
£4:11' (Houghton Archive R.B.1,47).

Although Horace Walpole makes only this brief
mention of furnishing silver, Sir Robert in fact owned
some spectacular pieces, including work by Paul de
Lamerie, William Lukin and David Willaume (Nor-
wich–London 1996–97, nos. 60–62; see also an oval
cake basket and a pair of candelabra (Gilbert collection)
and two 'Kentian' soup tureens, by George Wickes
(1738) and Paul Crespin (1733)). This indicates a strong
likelihood that the sconces in the Carlo Maratti Room
were by French metalworkers working in England,
perhaps working to a 'Kentian' design. For further lit-
erature on the Walpole silver see Barr 1980, pp. 24–25;
Hartop 1996, pp. 178–81.

Not reproduced

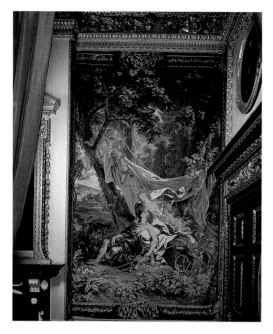 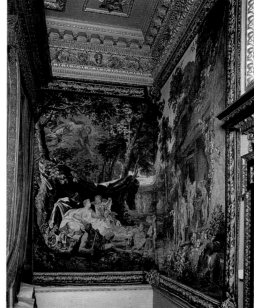 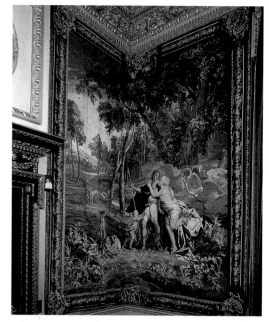

269

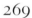

AFTER FRANCESCO ALBANI
The Loves of Venus and Adonis
Brussels tapestry, woven in wool silk, by J. de Vos, all bearing the signature of the weaver and the Brussels mark, c.1720s; panels 382 x 259; 382 x 350; 382 x 559; 382 x 442
PROVENANCE: Sir Robert Walpole, Houghton Hall; in situ at Houghton Hall by 1743, but almost certainly sooner, c.1731, then by descent to David, 7th Marquess of Cholmondeley; accepted in situ, in lieu of tax, by the Victoria and Albert Museum, 2002.
LITERATURE: *Aedes* 1752, p. 61; 2002, no. 126; Marillier 1930; Cornforth in Moore ed. 1996, pp. 35–37.

The furnishings of the Green Velvet Bedchamber remain virtually unchanged today. John Cornforth describes the room as 'dedicated to Venus, Goddess of Love and Sleep, and that is expressed in the ceiling, the frieze, the tapestries, the green velvet and the design of the bed. The ceiling unlike those in the preceding rooms, is painted not in grisaille but in colours, albeit soft ones, evidently at Sir Robert's insistence. It shows *Aurora Rising*. The frieze takes up the idea of Cupids' heads in the Drawing Room, but they are given wings and they are repeated in the chimney piece'.

The tapestries are based on designs by Francesco Albani, which were also disseminated through engravings, published in Paris by B. Audran (HW MSS extra-illustrated *Aedes*, f. 46. Metropolitan Museum of Art, New York). The tapestries emphasize the idyllic, rural nature of the loves of Venus and Adonis for each other and for the hunt. In one scene Venus relaxes with Vulcan in a sylvan setting, surrounded by cupids busy, practicing archery, forging and sharpening their arrows,

while Aurora looks on. In the next, Venus descends from her shell chariot drawn by swans to interrupt Adonis hunting. In the third tapestry Adonis joins the naked Venus, who awaits him, surrounded by putti at play. One tosses a rose in the air, a portent of the myth of Venus, or Aphrodite, as she was to prick her foot on a white rose in her haste to tend her dying love. Stained with her blood, the rose turned forever red. Another version of the myth has Aphrodite making a blood red anemone spring from Adonis's blood as a token of her grief. The final scene in the sequence shows Adonis reclining on Venus's lap, with putti hovering to provide shelter in the sylvan setting. The decorative cycle completes the ensemble of the room, the tapestry borders imitating picture frames, their decoration echoing that of the mahogany door casements, featuring oak leaves with shells at the corners. The entire room is redolent of seduction, the green velvet bed itself sporting the shell of Venus's triumphal chariot.

Sir Robert was a serious collector of tapestry, some of which has since been sold from Houghton. Tapestries formerly at Houghton included examples from the Mortlake manufactory and also Flemish tapestry (sold Christie's 24 June 1902, lots 136, 137). It should also be noted that Lady Catherine Walpole's house sale at Dover Street in 29 April 1741, included 'Number VII, lot 10: 'Five pieces of fine historial tapestry hangings, about 10 feetdeep, at 3 s. per Ell, Flemish'). Sir Robert also commissioned a set from the Gobelins factory newly set up in Paris (*ibid.*, lot 135: 'A set of four large panels, of old French tapestry, with peasants carousing and other subjects after Teniers, and with the coat-of-arms and crest of the Walpole family above, in frame-pattern border' purchased by Duveen). The Gobelins factory was visited by his brother Horatio who acquired

tapestries on his own account, but who also seems to have scouted on behalf of Sir Robert, visiting in May 1727 ('His Excellency Mr. Walpole hath seen these works with which he seemed satisfied, and can give an account of their perfection', Jans, 'Tapestry Maker in Ordinary to the King', 17 May 1727. Houghton Archives R.B.I.42). Sir Robert even received an approach from J. C. Le Blon who styled himself 'Your Honour's Memorialist' when seeking his 'patronage and protection' on behalf of the factory. Le Blon was seeking Sir Robert Walpole's support in enabling the Gobelin's factory to produce a tapestry set based on 'the Noble cartoons of Raphael' in the royal collection (Houghton Archive. RB 26.1/2). This enterprise was not connected with the Gobelins manufactory. I am grateful to Wendy Hefford for her comments. See also Marillier 1930, pp. 98–100.

270

MORTLAKE TAPESTRY, SERIES BY FRANCIS POYNTZ
The Stuart Dynasty: James I, Anne of Denmark, Charles I, Queen Henrietta Maria, Christian IV of Denmark (1672)
Woven in wools, silk and metal thread; total size 382 x 1066.8
PROVENANCE: Sir Robert Walpole, Houghton Hall by September 1732 (2nd Earl of Oxford: 'There is a room where there are hangings done from the pictures of King James the First; his Queen with her little dogs and horse, the King of Denmark her father [*sic*] and King Charles the First'); by descent to David, 7th Marquess of Cholmondeley; accepted in situ, in lieu of tax, by the Victoria and Albert Museum, 2002.

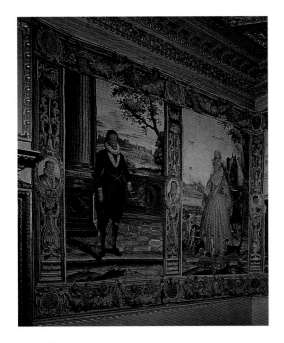

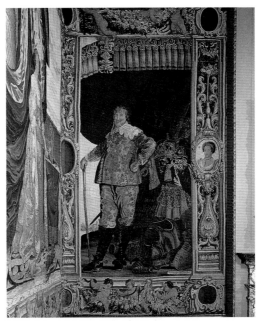

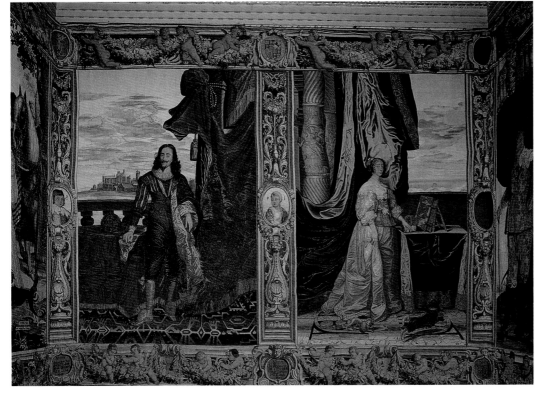

James, Duke of York (later James II (1633–1701); and finally Elizabeth, daughter of James I (1596–1661), who was to marry Frederick V, Elector Palatine of the Rhine and King of Bohemia. The dynastic relevance of this set of tapestries was therefore made clear in the context of the new Houghton Hall: it was Sophia, the daughter of Elizabeth and Frederick who married (in 1658) the Duke of Brunswick, Elector of Hanover (d. 1661) whose eldest son became George I.

It is a dynastic message which made the otherwise relatively old fashioned style of this set of tapestries entirely acceptable for current taste in the 1720s. Seventeenth-century tapestries were the equal of their painted equivalents. In this case the original full-length portraits upon which the tapestries were based were all in the royal collection: Paul Van Somer's portraits of James I and Anne of Denmark; Van Dyck's portraits of Charles I and Henrietta Maria; and finally Karel van Mander the Younger's portrait of Christian IV (now at Hampton Court). The maker of the series was Francis Poyntz, who held the post of yeoman arrasworker at the Great Wardrobe from the Restoration to his death in 1684. He had his initials and the date 1672 woven into the Queen Anne panel. A second set of initials 'I B' woven (bottom right) into this panel, are those of James Bridges, the Brussels 'Tapistry-worker' who was working for Poyntz during the second half of the 1670s and who was to witness Poyntz's will in 1683 (Hefford 1988; I am grateful to Wendy Hefford to her advice).

Poyntz and his weavers achieved brilliant effects at his workshop in Hatton Garden and the Houghton set are exceptional examples of their artistry. The rendition of fabrics is breath-taking, even in their subdued colour values as they survive today. In the portrait of Charles I, the treatment of the silk table cover, contrasting with that of the turkey carpet, the King's suit and the drapes which establish the interior setting is a virtuoso rendition of the Van Dyck original. The tapestries were as impressive as the Wharton Van Dycks and certainly examples of Sir Robert's taste for courtly portraiture (Mortlake tapestry panels were sold from Houghton at Christies 24 June 1902, lots 132–34; these were of pastoral and husbandry subjects).

The tapestries were adapted to fit their surroundings by the alteration of woven borders which literally 'framed' the portraits, the leaf motif of the pilasters is echoed in Kent's door casement carvings. Cherubic boys bearing fruit garlands cavort along the lower border, while their counterparts hold flower garlands in the upper 'frame'. The floral motif is completed by Kent's painted ceiling representing Flora, the Italian goddess of flowers who watches over rural life, including the vine and cultivated crops. These details reveal the extent to which Kent planned the interior decoration of each room at Houghton. The cavorting boys also appear in Artari's stucco decoration in the Stone Hall.

LITERATURE: *Aedes* 1752, p. 62; 2002, no. 130; Tipping 1921 pp. 101–4; Hussey 1955, p. 83; Sebastian Edwards in Moore ed. 1996, p. 129.
Woven for Charles II in the 1670s from the original design of 1672, this unique series cost £1,416.13s.11d. Poyntz still had one piece on the loom in 1677, to be finished in 1678 (PRO, London LC3/61; Hefford 1988). The set is of five tapestries after portraits of James I and Anne of Denmark, Charles I and Henrietta Maria, and Christian IV of Denmark and may well have been in the Old Hall at Houghton. Transposed to Houghton Hall they form a dynastic tribute to the royal line. Each of the Stuart children are represented in the roundels: Charles, Duke of York (afterwards Prince of Wales and Charles I); Henry, Prince of Wales (1593–1612); Charles II as a boy;

271

'*Glass Case filled with a Large Quantity of Silver Philegree*'
Quantity and size unknown
PROVENANCE: collection of Catherine, Lady Walpole;
presumed dispersed; present whereabouts unknown.
LITERATURE: *Aedes* 1752, p. 62; 2002, no. 131.

It is typical of Horace Walpole that he should record his
mother's collection of silver filigree, or openwork dec-
orative objects. These were most likely small decora-
tive items such as caskets, dishes, spoon and fork han-
dles, quite possibly products of such centres as Genoa,
Augsburg and Bergen, or from northern Spain. Their
subsequent whereabouts can only be a matter for con-
jecture, although there are some clues. The display cab-
inet itself, now untraced, may well have been acquired
from Christopher Cock in 1734 (Cholmondeley
(Houghton MSS), Vouchers (CUL): 'Nov : 6 : 1734.
Rec[eiv]ed of the Rt. Hon.ble The Lady Walpole by ye
hand of Mr. Grosvenor the sum of one Hundred and
Thirteen pounds 16 : 5. In full for a fine philligrew cab-
inet and all Demands. Chr. Cock').

Lady Catherine's talents as a watercolourist and col-
lector of virtù were inherited by Horace Walpole and it
is quite likely that a number of items from this collec-
tion entered his possession. Certainly Horace's own
archive copy of the *Description of Strawberry Hill* records
a number of items formerly in his mother's collection,
although no single group of filigree objects is noted.
Horace's collection included: 'in a closet with glazed
doors between the gallery and round chamber, and
fitted up in 1779, is a large collection of ancient porce-
laine of china which belonged to Catherine Lady Wal-
pole' (HW ms note in his own copy of *A Description of
the Villa of Horace Walpole*, SH, 1774, p. 73, LWL).

An even more personal item was 'a silver gilt heart,
within, the arms of Sir Robert and Catherine Lady
Walpole, his first present to her on their marriage'
(*ibid*. p. 83). A glass case at Strawberry Hill, one of a
number, contained 'a small gold watch, given by
George 2d. when Prince of Wales to Catherine Lady
Walpole'. Horace described this as 'an ancient Ger-
man watch curiously chased in silver gilt, and in a
square form' (*ibid*. p. 87, HW ms note).

Perhaps more pertinent, was 'a spoon of English
pebble, with gold handle of foliage' and 'a round flat
box of silver philigree' (*ibid*. p. 92). Horace annotat-
ed his personal copy of the *Description*: 'there were a
dozen of these spoons made by order of Catherine
Lady Walpole as a present to Queen Caroline, after
whose death Mr. W. met with this and the handle of
another in a toyshop'. This is slender evidence, but an
indication both of Lady Catherine Walpole's tastes
and of one of the possible subsequent homes for her
silver filigree collection.

Not reproduced

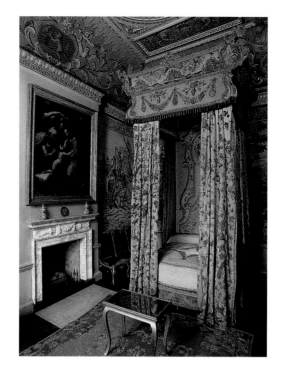

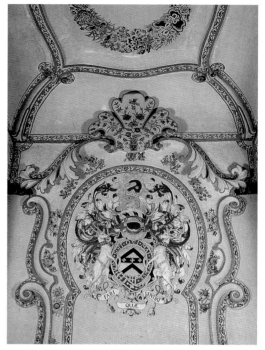

272

State Bedstead, bearing the Walpole arms (c.1715 and
1726–31)
Indian needlework with moulded and waved canopy,
turned columns to the base and an elaborate arched
headboard covered in contemporary 'Indian' needle-
work, featuring birds, flowering trees and plants on a
quilted linen (possibly cotton) ground; height 445,
width 180, length 213
PROVENANCE: Sir Robert Walpole; in situ at
Houghton by c.1731; by descent to David, 7th Mar-
quess of Cholmondeley; accepted in situ, in lieu of
tax, by the Victoria and Albert Museum, 2002.
LITERATURE: *Aedes* 1752, p. 64; 2002, no. 135; *Dictio-
nary of English Furniture*, vol. I, p. 60, fig. 43; Jackson-
Stops, Pipkin 1993, pp. 166–70; Sebastian Edwards in
Moore ed. 1996, pp. 131–32; Beard 1997, p. 174, ill.
144–50.

Horace Walpole's description of this needle-work as
'Indian' was a common term for embroidered textiles
that were either imported or copied from the Far
East. The 1745 inventory describes the bed as having
'Wrought Hangings'.

The Walpole arms on the headcloth include the
garter, showing that the armorial elements of the bed
must have been ordered after 1726. The bed was
ready for use in 1731 when the Duke of Lorraine,
future Emperor Francis I of Austria, visited
Houghton, the occasion for one of Sir Robert's most
celebrated Houghton Congresses.

The colours remain fresh and vivid, as do most of the
textiles in the room. The scale of the bed, in the con-
text of the relatively compact proportions of the room,
lend it an added grandeur. The addition of the Walpole
arms at the corners of the tester (three cross-crosslets
or, on a fesse between two chevrons sable), encircled
by the Order of the Garter and surmounted by the
Saracen's head crest are an extraordinarily sumptuous
endorsement of status for the state bed, enhanced by
the architectural moulding of the tester itself. The
wooden elements are covered with the embroidered
textile, with added English woven braids and fringes.
The bright flowers and birds are worked in chain-
stitch on a white quilted ground, imitating examples of
Coromandel lacquer and Chinese silks then being
imported through the East Indian Company. Thanks
go to Annabel Westman for advice concerning the ori-
gins of different elements of the bedstead, valance and
tester. Horace Walpole also refers to the second state
bed at Houghton, William Kent's green velvet bed in
the Velvet Bedchamber, which in 1732 cost over
£1200 for the drapes and 'gold lace', *Aedes* 1752, p. 61
(see note for the Velvet Bed Chamber).

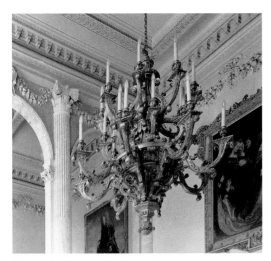

273

ENGLISH, EARLY GEORGIAN
Copper gilt Chandelier
Size unknown.
PROVENANCE: Purchased by Sir Robert Walpole; in situ in The Hall at Houghton by September 1732; still in situ in 1745 (Houghton 1745 MS: 'one large lanthorn'); in situ in 1747/8 (publication of *Aedes Walpolianae*, first edition); sold to the 4th Earl of Chesterfield (1694–1773) by 1752 (2nd edition of *Aedes*); ? Chesterfield House Sale, Sotheby's, 7 April 1932, lot 195; present whereabouts unknown.
LITERATURE: *Aedes* 1752 p. 73; 2002, no. 197.

The large lantern, acquired by Sir Robert for Houghton, was sold at some point after the publication of the first edition of the *Aedes Walpolianae* (1747/8) and the publication of the second edition (1752) in which Horace Walpole added the final sentence to his footnote: 'This Lantern has since been sold to the Earl of Chesterfield, and is replaced by a French Lustre' (see *Aedes* 1752, p. 73).

The lantern had achieved some notoriety as a result of being satirized in *The Craftsman* which was the most significant of the broadsheets published to promote political opposition to Sir Robert Walpole's administration. *The Craftsman* first appeared on 5 December 1726 and Sir Robert himself was often pilloried in its pages. In the process *The Craftsman* became a highly influential publication. When Lord Oxford visited Houghton in September 1732 he commented 'In this hall hangs the much talked of lanthorn, which the "Craftsman" was so idle to take notice of. In the first place it is very ugly, and in the next it is not really big enough for the room it hangs in. It cost Sir Robert Walpole at an auction one hundred and seventy pounds' ('Report on the MSS of His Grace the Duke of Portland, preserved at Welbeck Abbey', vol. VI, p. 161, HMC, vol. 29, 1901). As far as Edward Harley, Lord Oxford was concerned, the lantern was already dated.

The lantern was among the items to be disposed of after Sir Robert's death by Robert, Lord Walpole, 2nd Earl of Orford. By December 1747 Philip Stanhope, 4th Earl of Chesterfield was able to remark that his hall and staircase at the newly built Chesterfield House in Mayfair 'will really be magnificent'. It would have been piquant to hang the notorious chandelier at Chesterfield House where it almost certainly remained in situ until its sale in 1932. A number of artefacts formerly belonging to the Earl of Newcastle were removed when the house was sold in 1869. Many of these were subsequently returned by Lord Lascelles on the sale of the contents of Bretby (Tipping 1922, p. 241–42. Thanks go to Edward Bottoms for this information). Lot 195 was illustrated as the frontispiece to the catalogue and described: 'A very fine gilt chandelier of early Georgian type, the central stem ranged in two tiers heavily carved with acanthus foliage and recurring scrolls, supporting three tiers of candle branches carved with long acanthus foliage with spreading leaves at the tops forming grease-pans, the central stem terminating at the base with an inverted pineapple motif' (Chesterfield House was completed in 1749, the probable date when the lantern was sold from Houghton). The replacement 'French Lustre' is more rococo by comparison and has every possibility of having been designed by a French Huguenot silversmith such as William Hubert who provided and repaired a number of sconces, girandoles and 'metal branches' for Houghton. William Hubert's bill, presented on 8 May 1730, remains at Houghton, Archive RB1, 47 (1996–97 Norwich–London, no. 16 (3)).

274

ITALIAN, FIRST HALF OF THE 18TH CENTURY
A Boat-shaped vase and cover
Veined cream alabaster, width 46
PROVENANCE: Sir Robert Walpole; in situ in the Vestibule at Houghton Hall by 1743; 'six Italian Marble vases in Nitches', 1745 MS Inventory; then by descent to David, 7th Marquess of Cholmondeley.
LITERATURE: *Aedes* 1752, p. 76; 2002, no. 226.

It is highly likely that cat. no. 274 is one of the set of 'six vases of Volterra Alabaster' originally recorded by Horace Walpole in the Vestibule at the entrance to the Picture Gallery. However, only one now remains at Houghton, although at least two are recorded in photographs of the interiors at Houghton dating from the late nineteenth century (photograph album compiled by Mr. C. G. Gooch of Colchester, a shooting tenant at Houghton in the 1890s, given to Sybil, Marchioness Cholmondeley in June 1975, which records two alabaster urns in the Stone Hall, one without its base).

The Vestibule to the Picture Gallery no longer remains in its original form. Horace Walpole's description suggests that there were originally six niches in the Vestibule, although a design drawing survives which shows a total of ten niches (plan and elevation, pencil and wash, 48.2 x 37, Houghton Archive, A/10).

Alabaster is a fine-grained form of gypsum or limestone, with transparent qualities, which is easily carved and gained increasing popularity in Italy during the eighteenth century. The stone for the vase resembles that of late Hellenistic Etruscan urns from Volterra which are made of the local alabaster (thanks go to

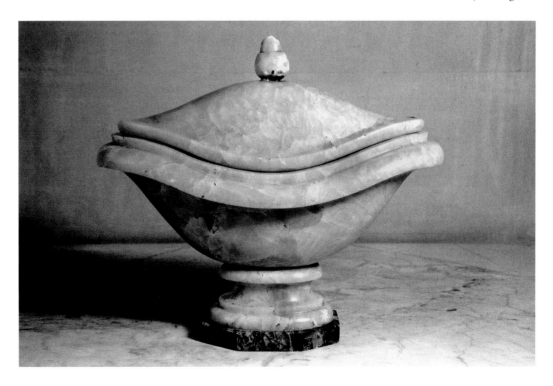

Susan Walker for her comments and for pointing out the similarity of these stones). Its fragility may well account for the disappearance of five of these urns. The present example is repaired.

One of these vases may well have been at Strawberry Hill. Horace Walpole's *Description of Strawberry Hill* (1774) includes 'An urn and cover of Volterra alabaster' in the Great North Bedchamber (p. 110). Horace's collection at Strawberry Hill included a number of works of art which had once been in Sir Robert's collection and some of these were subsequently sent to Houghton ('A List of Pictures in London to be sent to Houghton if the law suit is decided in favour of Lord Cholmondeley,' HWC, vol. 30, pp. 370–71; this does not include decorative art objects). However, these were primarily works which had not previously been at Houghton. The Picture Gallery and Vestibule were destroyed by fire in 1789, which almost certainly accounts for the majority of the missing vases.

AEDES WALPOLIANAE :

OR, A

DESCRIPTION

OF THE

Collection of Pictures

AT

Houghton-Hall in *Norfolk*

by

HORACE WALPOLE

edited by

Andrew Moore

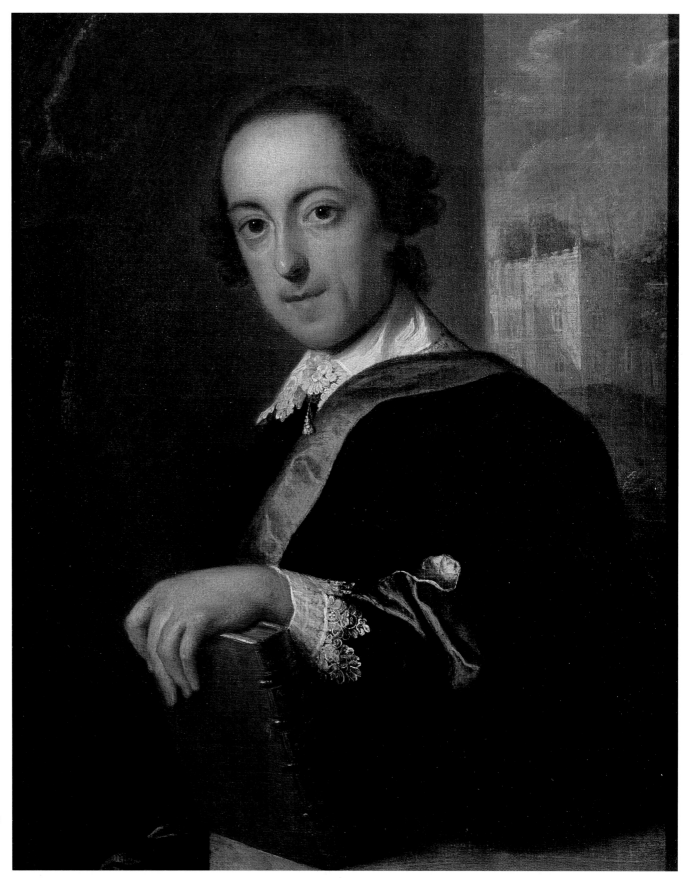

John Eccardt
Horatio (Horace) Walpole, 4th Earl
of Orford, 1754, oil on canvas
39.4 x 31.8
National Portrait Gallery,
London

AEDES WALPOLIANAE :

OR, A

DESCRIPTION

OF THE

Collection of Pictures

AT

Houghton-Hall in *Norfolk,*

The SEAT of the Right Honourable

Sir *ROBERT WALPOLE,*

EARL of *ORFORD.*

The SECOND EDITION with ADDITIONS.

Artists and Plans reliev'd my solemn Hours;
I founded Palaces, and planted Bow'rs.
PRIOR*'s Solomon.*

LONDON:

Printed in the YEAR M DCC LII

* A full explanation of the states and variants of the first edition of 1747 (actually published in 1748, owing to HW's numerous corrections which necessitated cancels and delayed distribution), is given in A. T. Hazen, *A Bibliography of Horace Walpole*, New Haven, Yale University Press, London 1948, pp. 26-32. There are numerous states and variants of the 1747/48 edition. HW made MS corrections in all copies prior to distribution, essentially on the frontispiece, three plates and some twenty-two pages. However, not all the copies have all the corrections and HW inevitably continued to make corrections to his own copy after the edition had been distributed. HW's copy, with MS additions and corrections (SH Sale 1842, iv, lot 155) is preserved in the Dyce Collection, Victoria and Albert Museum.

The 1752 edition incorporates these corrections and the present edition aims to track those subsequent notes that reveal more of the collection's history rather than repeat the strictly bibliographical approach already undertaken by Hazen. By concentrating upon the edition owned and annotated by HW himself, together with his MS printer's copy, the numerous reported and replicated comments of owners of copies of all the editions have not been incorporated, unless specifically adding to our knowledge of the collection. Appendix IV lists the principal copies and grangerised editions for research purposes.

The third edition, a close reprint of the second, was published in 1767. Most of the text of HW's 'Description' was prefixed to the second edition of Isaac Ware and Thomas Ripley's *The Plans, Elevations, and Sections; Chimney-pieces and Ceilings of Houghton in Norfolk ...*, published by Fourdrinier in 1760. HW 's 'Description' was also included in the first volume of *The English Connoisseur*, 1766, in John Boydell's *A set of Prints Engraved After the Most Capital Paintings in the Collection of Her Imperial Majesty The Empress of Russia, Lately in the Possession of the Earl of Orford at Houghton Hall in Norfolk*, 2 vols, previously published in portfolios, 1774–88, and in R. Beatniffe's *The Norfolk Tour*, Norwich, 1777 and subsequent editions. These reprints of the 'Description' divorced from the rest of the text have served to distract attention from the integrated nature of HW's achievement in compiling the *Aedes Walpolianae* at just thirty years of age.

This edition presents Horace Walpole's original text in a diplomatic facsimile which reproduces the second edition of the *Aedes Walpolianae* (published by Robert Dodsley, 10 March 1752) with the addition of new textual interventions, mainly in the form of sidenotes and new itemised catalogue numbers. The original pagination is given in square parentheses within the body of the text.

Horace Walpole's original footnotes are prefaced with the initials 'HW' to distinguish between these and the editor's sidenotes. The latter aim to relate Horace Walpole's art historical comments and assessments to the paintings he knew at the time of publication and those he either inventoried or catalogued on behalf of his father. When given in association with HW's text the Editor's notes are placed in square parentheses.

The 1752 edition of the *Aedes* has been selected for this modern edition as it is the version whereby Horace Walpole was able to incorporate a large number of corrections and amplifications, notably a complete remeasurement of the collection of oil paintings at Houghton, additions in the form of footnotes and some specific corrections to the text.*

The catalogue is divided into two sections: *The Houghton Collection at the Hermitage* and *Works of Art Remaining at Houghton*. The catalogue entries reproduce almost all the works of art originally detailed in *Aedes Walpolianae*. This provides a first opportunity to assess the extent and quality of this hugely influential collection. The catalogue entries and appendices support this process of assessment. The latter publish for the first time Horace Walpole's inventory of the complete collection of paintings in 1736, when housed in London as well as Norfolk, the sale catalogues for the first dispersals of the pictures in 1748 and 1751 and also the 1779 valuation of the old masters, together with a list of principal grangerised and annotated copies of the *Aedes*.

ABBREVIATIONS

HW	Horace Walpole
RW	Sir Robert Walpole
SH	Strawberry Hill
no.	276 works of art are itemized by HW in the *Aedes* and these are given consecutive numbers in this edition. References to '*Aedes* 2002, no.' are to this sequence, which retains the order of HW's text and is a guide to an appreciation of those works that were hung in close proximity. The two catalogue sections follow a separate sequence, arranged by School of Painting, in alphabetical order; references to 'cat. no.' are to this sequence. The Concordance, Appendix IX, provides direct correlation of information.
HW MS (Met)	HW's MS text of the *Aedes* prepared for the printer and subsequently interleaved with prints collected to illustrate the collection and allied material. SH Sale, 1842, lot 1124; now Collection, Metropolitan Museum of Art, New York.
HW MS (PML)	HW's personal copy of the 1752 edition (Collection, Pierpont Morgan Library, New York) has many manuscript additions and includes inlaid his own 1736 MS inventory (36 pp.) of RW's collection as hung throughout his residences at that time. The latter is given here as Appendix III. The MS additions are given within the sidenotes to the modern facsimile.
1744 MS (Herts)	A manuscript inventory, *Pictures at Houghton 1744*, not in HW's hand.

AEDES WALPOLIANAE :

OR, A

DESCRIPTION

OF THE

Collection of Pictures

AT

Houghton-Hall in *Norfolk*

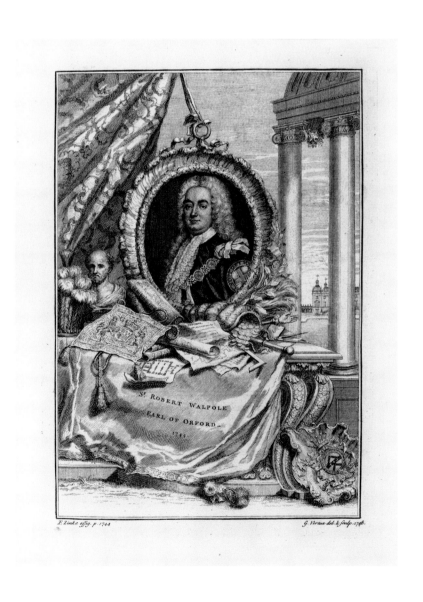

F. Zinke effig. p. 1744 G. Vertue del. & sculp. 1748.

TO

LORD *ORFORD*

SIR,

YOU will easily perceive how different this address is from other dedications. They are generally calculated, by praising the noble, the powerful, the rich, to engage protection and favour to the work : and [**iv**] when the timidity or obscurity of the author may be prejudicial to his book, he borrows virtues from other men to patronize and shelter his own blemishes.

This is not the case of what I offer You : it is a work of your own; a plain description of the effects of your own taste.[1] If I design'd to compliment You, the Book itself would supply me with topics.[2] If I mentioned the Ornaments of the House, your Star ,[3] your Coronet[4] are panegyrics on your Nobility ; the True Nobility, as Y o u are the fountain of it in our Family; [**v**] and however the sense of the world may differ from me, I own, I had rather be the first Peer of my Race than the hundredth.[5]

Your power and your wealth speak themselves in the grandeur of the whole Building-----And give me leave to say, Sir, your enjoying the latter after losing the former ,[6] is the brightest proof how honest were the foundations of both.

Could those virtuous men your Father[7] and Grandfather[8] arise from yonder church,[9] how would they be amazed to see this noble edifice[10] and spa-[**vi**] cious plantations,[11] where once stood their plain homely dwelling ![12] How would they be satisfy'd to find only the Mansion-house, not the Morals of the Family altered !

May it be long, Sir, ere You join Them ![13] And oh ! as You wear no stain from Them, may You receive no disgrace from

> Your dutiful
>> and affectionate Son,

HOUGHTON,
Aug. 24, 1743.

1 In 1739 George Vertue (1684–1756) endorsed the quality and importance of Sir Robert's creation: 'Houghton Hall Sr Robert Walpoles fine and rare collection of Paintings statues Busts &c the most considerable now of any in England.' (Vertue, vol. I, p. 6).

2 It does so.

3 RW was invested with the Order of the Bath in 1725.

4 RW resigned the Order of the Bath in order to receive the order of the Garter, for which he gained the nickname 'Sir Bluestring'.

5 HW reveals a family sensitivity to their new status within the aristocracy. William Musgrave chose an arguably more successful form of flattery in his *Genuine Memoirs of the Life and Character of the Right Honourable Sir Robert Walpole, and of the Family of the Walpoles*, 1732, by returning to the apocryphal origins of the family: 'The family of Walpole (which took its Denomination from a Town of that Name in Norfolk) was seated in England before the Conquest, as is manifest from several Authorities cited by Camden, where he assures us that the Owner of Walpole gave both that, and Wisbeech in the Isle of Ely, at the same Time, that he made his younger son Alwin a Monk there.'

6 RW announced his retirement on 3 February 1742. On 9 February he was created Earl of Orford. On 11 February he resigned, receiving a promise of a £4,000 annual pension.

7 Robert Walpole (1650–1700). See *Aedes* 2002, no.7.

8 Sir Edward Walpole (1621–1667). See *Aedes* 2002, no. 6.

9 Church of St Martin, Houghton.

10 Houghton Hall was built on a site just to the east of the old mansion. The foundation stone is dated 1722. Building continued into the early 1730s and was complete by c.1736.

11 In 1728 Sir Matthew Decker (1679–1749) remarked: 'The gardens in which you go out of the salon, and where will be a fine portico … have a very fine prospect over the park towards a hill or rising ground; before it a large grass platt fit for a bowling green, then a large gravel walk, on each side grass plattes, as also two fine woods of oak and beech hedges extremely handsomely cut out in divers walkes and pleasant arbours' (Wilton House Archives, Wiltshire). Four years later Sir John Clerk of Penicuik (1684–1755) described how 'On the garden side there is a large parterre all of green Turff with a gravel walk round on each side of this a large Wilderness very handsomely laid out & the trees and hedges being of hornbeam are come to a great height'. (Scottish Record Office, GD 18/2107).

12 Houghton Old Hall had been built in the sixteenth century and earlier. Edward Walpole (Sir Robert's grandfather) rebuilt or added to it. The Hall was improved by Robert Walpole, first in early 1701 and again in 1716 and 1719. It was demolished as part of RW's rebuilding programme in the early 1720s.

13 RW died of exhaustion from the pain of his disease on 18 March 1745, aged 68. He was buried at Houghton on 25 March.

14 HW, renowned for his caustic wit and sharp opinions, remained true to his father's memory throughout his own lifetime.

THE following account of LORD ORFORD'S Collection of Pictures, is rather intended as a Catalogue than a Description of them.[i] The mention of Cabinets in which they have formerly been, with the addition of the measures ★, will contribute to ascertain their originality, and be a kind of pedigree to them.[ii]

In Italy, the native soil of almost all Vertü, descriptions of great Collections are much more common and much more ample.[iii] The Princes and Noblemen there, who lov'd and countenanc'd the ARTS, were fond of letting the world know the Curiosities in their possession. There is scarce a [viii] large Collection of Medals but is in print. Their Gems, their Statues, and Antiquities are all publish'd. But the most pompous works of this sort are the ÆDES BARBARINÆ[iv] and GIUSTINIANÆ, the latter of which are now extremely scarce and dear.

Commerce, which carries along with it the Curiosities and Arts of Countries, as well as the Riches, daily brings us something from Italy. How many valuable Collections of Pictures are there established in England on the frequent ruins and dispersion of the finest Galleries in Rome and other Cities![v] Most of the famous Pallavicini[vi] Collection have been brought over ; many of them are actually at Houghton. When I was in Italy, there were to be sold the Sagredo Collection at Venice, those of the Zambeccari[vii] and San Pieri[viii] palaces at Bologna ; and at Rome, those of the †Sacchetti[ix] and Cardinal Ottoboni ;[x] and of that capital one I mention'd, the Barbarini:[xi] but the extravagant [ix] prices affix'd had hinder'd the latter from being broke.[xii] Statues are not so numerous, and consequently come seldomer, besides that the chief are prohibited from being sold out of Rome:[xiii] a silent proof, that the sums sent thither for purchases are not thrown away, since the prohibition arose from the profits flowing into the City by the concourse of Strangers who travel to visit them. For however common and more reasonable the pretext, I believe, Ten travel to see the Curiosities of a Country, for One who makes a journey to acquaint himself with the Manners, Customs, and Policy of the Inhabitants.

There are not a great many Collections left in Italy more worth seeing than this at Houghton :[xiv] In the preservation of the Pictures, it certainly excells most of them. That noble one in the Borghese palace at Rome, is almost destroy'd by the damps of the apartment where it is kept.

★ HW: They have been newly measured, and are more correct than in the first edition.

† HW: The Sacchetti Collection has been since purchased by Pope Benedict XIVth and placed in the Capitol.

i The introduction, completed summer 1743, is HW's first published art criticism. Horace Mann wrote to HW on 20 June 1749 recounting the opinion of Dr Antonio Cocchi, who 'was very sincere, and as you know he is a judge, I can't help telling you that he thinks the observations extremely just, is pleased with the idea of the whole as being quite new, and thinks it the best compendium on painting that has been wrote, and that the characters of the great masters are most judicious.'

ii HW here introduces the idea of provenance as adding lustre to a collection. He was later to bemoan the existence of his catalogue as it seemed, by omission, to diminish the status of the remainder of his father's collection: 'We have already begun to sell the pictures that had not found place at Houghton: the sale [13–14 June 1751] gives no great encouragement to proceed (though I fear it must come to that!) the large pictures were thrown away; the whole length Vandykes went for a song! I am mortified now at having printed the catalogue.' HW to Mann, 18 June 1751.

iii Having just returned from his European tour HW was well placed to subscribe to this current view.

iv It is uncertain if HW owned a copy of Hieronymus Tetius, *Aedes Barberinae ad Quirinalem … descriptae*, Rome, 1642 as early as 1743, but a copy may well have been among the uncatalogued books in the Glass Closet at Strawberry Hill. A copy was sold at the SH 1842 sale, vii lot 69.

v ' I am persuaded that in an hundred years Rome will not be worth seeing; 'tis less so now than one would believe. All the public pictures are decayed or decaying; the few ruins cannot last long; and the statues and private collections must be sold, from the great poverty of the families. There are now selling no less than three of the principal collections, the Barberini, the Sacchetti, and the Ottoboni: the latter belonged to the Cardinal who died in the Conclave.' HW to West, 7 May 1740.

vi RW acquired a number of works by Carlo Maratti from the collection of Marchese Nicolo Maria Pallavicino, probably through the agency of Charles Jervas (see Appendix I).

vii HW had visited the collection of Monsignore Francesco Zambeccari and, through Horace Mann acquired the 'Domenichino' for his father from that collection. See *Aedes* 2002, no. 275.

viii The Sampieri Collection in Bologna was subsequently the focus of an attempt at purchase by the agent William Kent on behalf of Sir Nathaniel Curzon (1726–1804). However, Richard Dalton, Librarian and Keeper of Antiquities to George III, found otherwise: 'And it was supposed that he who got hither first would be masters of it, as I believe the price was to be no obstacle; but Dalton found that not a single picture of that collection will be sold during the present possessor's life'. Mann to HW, 19 August 1758.

ix The Sacchetti Collection consisted mainly of works of the Bolognese School and had been formed by Cardinal Sacchetti, papal legate at Bologna and Ferrara, the previous century. HW's footnote refers to the purchase of the collection in 1744 by Benedict XIV. HW had purchased a 'picture of Pietro Cortona' from this collection for 300 crowns according to a torn and folded sheet of paper recording his purchases in Italy (Lewis Walpole Library MS). See *Aedes* 2002, nos. 144, 254.

x Pietro Ottoboni (1667–1740) created cardinal, 1689, by Alexander VIII. 'I bought the famous Bust of Vespasian in Bisaltes, at this Cardinal's sale' HW Add MS (PML).

xi HW was himself later to acquire 'the head of Jupiter Serapis, in basaltes. The divine majesty and beauty of this precious fragment prove the great ideas and consummate taste of the ancient sculptors. This bust was purchased, with the celebrated vase, from the Barberini collection at Rome, by Sir William Hamilton; and was sold with the

vase to the Duchess of Portland, and on her Grace's death was bought by Mr Walpole. Description of SH, Works ii, p.505.

xii ie.sold.

xiii According to Mathew Brettingham and William Kent, Thomas Coke was arrested and almost imprisoned for attempting to export a statue of Diana without a licence. See also *Aedes* 2002, no. 227 for Pope Innocent XIII's attempt to retain Guido Reni's *The Fathers of the Church*.

xiv Dr. Charles Burney, musicologist of King's Lynn, was to recall when in Venice in 1770, that his 'rage for painting' had in fact been engendered by the hours he had spent in the prime collections of his native county of Norfolk during the 1750s. Houghton Hall housed the closest neighbouring collection at that time.

xv Although typical of the optimistic assessments of the average owner, in comparative terms this was a valid claim, echoed by George Vertue in 1739 (see above) and in the journals of numerous visitors.

xvi The one work attributed to Correggio in RW's collection in 1736, Inventory no. 179, *A naked venus sleeping*, was almost certainly reattributed by HW in the *Aedes* to Annibale Carracci, *Aedes* 2002, no. 150.

xvii ie. Giotto and his contemporaries

xviii See *Aedes* 2002, no. 91.

xix See *Aedes* 2002, nos. 88, 227, 243, 257.

xx 'Some blamed me for undervaluing the Flemish and Dutch painters in my preface to the *Aedes Walpolianae*. [James] Barry the painter, because I laughed at his extravagances, says in his rejection of that school, "But I leave them to be admired by the Honourable H. W. and such judges!" — Would not one think I had been their champion?' HW to Cole, 5 February 1780. HW later appreciated 'the warm nature of Flemish colouring'. HW to Montagu, 25-30 March 1761.

xxi See *Aedes* 2002, nos. 82, 276 and 1736 Inventory no 177.

xxii HW here subscribes to one of his father's favourite painters. See *Aedes* 2002, nos. 99–110, 262 and Appendix, 1751 Sale, day 1, lot 55, and day 2, lot 41.

xxiii This is the first of numerous references by HW in the *Aedes* to the writings of Pliny the Elder (Gaius Plinius Secundus, AD 23/24–79), principally to Book xxxv. HW owned a fine collection of classic texts all bound in red morocco, given to him when at Eton by a supporter of RW, Augustus William, Duke of Brunswick, who died in 1731. HW's copy of Pliny, *Naturalis historiae*, was edited by Joannes Fridericus Gronovius, 3 vols, Leyden, 1699.

xxiv See *Aedes* 2002, nos. 136, 258 and 259; also 1736 Inventory nos. 167, 298, 299.

xxv See *Aedes* 2002, no. 163.

xxvi See *Aedes* 2002, nos. 244 and 245.

[**x**] The Italian Collections are far more numerous and more general. LORD ORFORD has not been able to meet with a few very principal Hands:[xv] but there are enough here for any man who studies Painting, to form very true ideas of most of the chief Schools, and to acquaint himself with most of the chief Hands. Knowledge of this sort is only to be learnt from Pictures themselves. The numerous volumes wrote on this Art have only serv'd to perplex it. No Science has had so much jargon introduc'd into it as Painting : the bombast expression of the Italians, and the prejudices of the French, join'd to the vanity of the Professors, and the interested mysteriousness of Picture-merchants, have altogether compiled a new language. 'Tis almost easier to distinguish the Hands of the Masters, than to decypher the Cant of the Virtuosi. Nor is there any Science whose productions are of so capricious and uncertain a value. As great as are the prices of fine Pictures, there is no judging from them of the [**xi**] Several merits of the Painters ; there does not seem to be any standard of estimation. You hear a Virtuoso talk in raptures of Raphael, of Correggio's[xvi] Grace, and Titian's Colouring ; and yet the same Man in the same breath will talk as enthusiastically of any of the first Masters,[xvii] who wanted all the excellencies of all the Three. You will perhaps see more paid for a Picture of Andrea del Sarto,[xviii] whose Colouring was a mixture of mist and tawdry, whose Drawing hard and forc'd, than for the most graceful air of a Madonna that ever flowed from the pencil of Guido.[xix] And as for the Dutch Painters,[xx] those drudging Mimicks of Nature's most uncomely coarsenesses, don't their earthen pots and brass kettles carry away prices only due to the sweet neatness of Albano,[xxi] and to the attractive delicacy of Carlo Maratti?[xxii] The gentlest fault that can be found with them, is what Apelles said of Protogenes ; "Dixit enim omnia sibi cum illo paria esse, aut illi meliora, sed uno se præstare, quod manum ille de tabula nesciret tollere." Plin. Lib. 35. [**xii**] cap. 10. Their best commendation was the source of their faults ; their application to their Art prevented their being happy in it. "Artis summa Intentio, & ideo minor Fertilitas."[xxiii] Nicolo Poussin[xxiv] had the greatest aversion for Michael Angelo Carravaggio, for debasing the Art by imitations of vulgar and unrefined Nature. His lights and shades are as distinct and strongly opposed, as on objects seen by candle-light. It was not so much want of Genius in the Flemish Masters, as for want of having search'd for something better. Their only idleness seems to have been in the choice of their Subjects. Rottenhamer[xxv] and Paul Brill,[xxvi] who travelled into Italy, contracted as pleasing a Stile as any of the Italian Masters. LORD ORFORD's Landscapes of the latter are very near as free, as pure and as genteel as Claude's and Titian's.

There was something in the Venetian School, especially in Paul Veronese, which touches extremely upon the servile imitation of the Dutch : [**xiii**] I mean their ornaments of Dress and gawdy embroider'd Garments. It puts me in mind of a story of

Apelles, who looking on a Picture just finished by one of his Scholars, which was mightily decked out with gold and jewels ; "At least, my lad, said he, if you cou'd not make her Handsome, you have made her Rich."[xxvii]

If ever Collections could be perfect, the present age seems to be the period for making them so.[xxviii] Another century may see half the works of the great Masters destroy'd or decaying : and I am sorry to say, that there seems to be a stop to any farther improvements, or continuation of the perfection, of the Art.[xxix] We seem to be at Pliny's period, "Hactenus dictum fit de dignitate artis morientis." I know none of the Professors who merit the name (for if ever Solimeni[xxx] did, which I scarce think, he is now past the use of his pencil) except Rosalba[xxxi] and Zink[xxxii]—two Artists whose manners are the most opposite---*Hers, as perishable as it is [**xiv**] admirable : †His, almost as lasting as it deserves to be. Tho' there are no remains of this kind of Painting among the Antients, yet they certainly knew it ; for Pliny, in the fourth chapter of his thirty-fifth book, absolutely mentions a kind of Enamel, where he says, Augustus bought a Picture which "Nicias scripsit se inussisse." They call'd it the Encaustic manner of Painting, and had three different sorts of it.‡ It is not at all improbable that Time should discover something of this sort too.[xxxiii] I believe, till within these six years, it was agreed among the Virtuosi that the Antients knew little or nothing of Perspective ; but among the very fine pieces of Painting dug out from the new-discovered underground Town at Portici near Naples, which is supposed the ancient Herculaneum, destroy'd by an Earthquake with several other Towns in the reign of Titus, there was found an excellent and perfect piece of Perspective, consisting of a view of a Street with several Edifices on [**xv**] each side, which is now preserv'd in the King of Naples's closet.[xxxiv]

In one part of Painting indeed, their ignorance was very extraordinary ; for they were amaz'd at a Picture of Minerva, which seem'd to look at you wherever you stood. Pliny in the above-cited book says, "Amulii erat Minerva spectantem aspectans quacunque aspiceretur." One is astonish'd how they could ever paint Portraits, and not perceive this common effect. I don't imagine they drew all Portraits in Profile, as they did the Heads on their Medals, till about Justinian's time. Some of their Busts and Statues have Eye-balls mark'd, and consequently have the effect of other Portraits.

In another particular, the Painters had a method very common among the Moderns, which was, to make their Mistresses sit for the ideal Goddesses they were to draw. One example Pliny mentions of Arellius, "semper alicujus Foeminæ amore flagrans, [xvi] &

★ HW: Crayons

† HW: Enamel.

‡ HW: See PLINY, Lib. xxv. Cap. II.

xxvii As far as HW was concerned the lack of a significant Veronese in the collection was no drawback.

xxviii HW reflects the confidence of the British collectors of the period. They were in no small part responsible for creating the contemporary market for European works of art and antiquities.

xxix HW can perhaps be forgiven for subscribing to the Whig view of history.

xxx Of the four paintings attributed to Solimeni which hung at Downing Street in 1736, none were to be transferred to Houghton. The taste for Francesco Solimena (1657–1747) in Britain, so important in the early years of the century, seems to have dissipated by c.1740. See 1736 Inventory nos. 121, 122, 174, 228.

xxxi Rosalba Carriera (1675–1758). See *Aedes* 2002, nos. 72, 73, 74, 117, 118.

xxxii Christian Friedrich Zincke (1685–1767). Zincke's miniature of RW in Garter robes, painted in 1744, is now on loan to Manchester City Art Gallery from the collection of the Earl of Derby. This was engraved by Vertue in 1748 and forms the frontispiece for the second edition (1752) of the *Aedes*, together with his engraving of Zincke's 1735 miniature of HW's mother, Catherine Shorter.

xxxiii HW was right. Anne-Claude-Philippe de Tubieres (1692–1765), Comte de Caylus discovered a new method of painting in encaustic enamels and published his findings in his *Memoire sur la peinture a l'encaustique*, Geneva, 1755.

xxxiv HW was in Naples in June 1740: 'They have found among other things some fine statues, some human bones, some rice, medals and a few paintings extremely fine. These latter are preferred to all the ancient paintings that have ever been discovered. We have not seen them yet, as they are kept in the King's apartment, whither all these curiosities are transplanted; and 'tis difficult to see them—but we shall'. HW to West, 14 June 1740. HW subsequently saw them with Thomas Gray at the royal palace of Charles IV of Naples. See HWC vol. 13, p. 223.

xxxv See *Aedes* 2002, no. 149.

xxxvi See *Aedes* 2002, no. 85.

xxxvii See *Aedes* 2002, no. 48.

xxxviii See *Aedes* 2002, no. 139.

xxxix See *Aedes* 2002, no. 140.

xl HW returns to his theme that the Dutch School symbolises 'drudging Mimicks of Nature's most uncomely coarsenesses'. His purpose is to elevate by comparison the poem *Protogenes and Apelles* by Matthew Prior which 'Every body has read'. In the following passage HW gives a final flourish to this stage of his text, before embarking upon a more sober account of the history of art as exemplified by his father's collection.

ob id Deas pingens, sed dilectarum imagine : itaque in Pictura ejus scorta numerabantur." Among the Moderns, Baroccio[xxxv]always drew his Madonna's from his Sister : Rubens all his principal Women from his three Wives. In the Luxemburg Gallery at Paris, he has painted them for the three Graces. In LORD ORFORD'S Picture of Christ at the house of Simon the Leper, he has taken the idea of the last for the Magdalene.[xxxvi]Lord ORFORD has a Head[xxxvii] of the same Woman by him, and her Portrait at length in that celebrated Picture of her by Vandyke.[xxxviii] The first is with him in his Family piece by his scholar Jordans of Antwerp;[xxxix] the second was a dark Woman.

Sir Peter Lely was employ'd by the Duchess of Cleveland to draw Her and her Son the Duke of Grafton for a Madonna and little Jesus, which she sent for an Altar-piece to a Convent of Nuns in France. It staid there two years, when the Nuns discovering whose Portrait it was, return'd it.

[**xvii**] I cannot conclude this topic of the ancient Painters, without taking notice of an extreme pretty instance of Prior's taste ; and which may make an example of that frequent subject, the resemblance between Poetry and Painting, and prove that Taste in the one will influence in the other. Every body has read his Tale of Protogenes and Apelles. If they have read the story in Pliny, they will recollect, that by the latter's account, it seem'd to have been a trial between two Dutch Performers.[xl] The Roman Author tells you, that when Apelles was to write his name on a board, to let Protogenes know who had been to enquire for him, he drew an exactly strait and slender line. Protogenes return'd, and with his Pencil, and another Colour, divided his Competitor's. Apelles, on seeing the ingenious minuteness of the Rhodian Master, took a third Colour, and laid on a still finer and divisible line.------But the English Poet, who could distinguish the emulation of Genius from nice experiments about splitting hairs, took the story [**xviii**] into his own hands, and in a less number of trials, and with bolder execution, comprehended the whole force of Painting, and flung Drawing, Colouring, and the doctrine of Light and Shade into the noble Contention of those two absolute Masters. In Prior, the First wrote his name in a perfect design, and

-------with one judicious stroke

On the plain ground Apelles drew

A circle regularly true.

Protogenes knew the hand, and show'd Apelles that his own Knowledge of Colouring was as great as the other's Skill in Drawing.

★Upon the happy Line he laid

Such obvious Light and easy Shade,

That Paris' Apple stood confest,

Or Leda's Egg, or Cloe's Breast.

[**xix**] Apelles acknowledged his Rival's Merit, without jealously persisting to refine on the Masterly Reply : "†Pugnavere pares, succubuere pares."

I shall not enter into the History of either ancient or modern Painting:[xli] 'tis sufficient to say that the former expir'd about the year 580, and reviv'd again in the person of Cimabue, who was born in 1240. Some of his Works are remaining at Florence ; and at Rome and in other Cities are to be seen the performances of his immediate Successors : But as their Works are only curious for their Antiquity, not for their Excellence ; and as they are not to be met with in Collections, I shall pass over those Fathers of Painting, to come to the year 1400, soon after which the chief Schools began to form themselves. Andrea Mantegna was born in the year 1431, and of himself form'd that admirable Stile, which is to be seen in his Triumphs of Julius Cæsar at Hampton-Court.[xlii] A Stile which Raphael, Julio,[xliii] and Polidore,[xliv] seem rather to have [**xx**] borrow'd from him, as he had drawn it from the Antique, than to have discover'd it themselves.

The ROMAN School

The First and acknowledged Principal School was the ROMAN : it was particularly admir'd for Drawing, Taste, and great Ideas ; all flowing from those models of improv'd Nature, which they had before their eyes in the Antique Statues and Bas-reliefs. Their faults were, minute and perplex'd Draperies, and a hardness of Colouring: faults arising from the same source as their perfections, they copied too exactly the wet Draperies which the ancient Statuaries used to cling round their Figures very judiciously, to show the formation of the limbs, and to give lightness to the Marble, which would not endure to be encumber'd with large folds and flowing garments, but which are the great beauties of Painting. Raphael towards the end of his life grew sensible of this, and struck out a greater Stile in his Draperies. Their hard Colouring too was owing to their close Application [**xxi**] to the study of the Antique, and neglecting Nature.[xlv] Raphael's superior Genius made him alone comprehend both. The many volumes wrote on his Subject make it needless to say more of Raphael. Michael Angelo Buonarotti[xlvi] alone of all the Roman School fell into the contrary extreme : he follow'd Nature too closely, so enamour'd with that ancient piece of anatomical skill, the Torso, that he neglected all the purer and more delicate-proportion'd Bodies. He was as much too fond of Muscles, as Rubens afterwards was of Flesh;[xlvii] each overloaded all their Compositions with their favourite Study. This great School, after

⋆ HW: Mr. Vertue, the Engraver, made a very ingenious conjecture on this Story ; he supposes that Apelles did not draw a strait Line, but the Outline of a human Figure, which not being correct, Protogenes drew a more correct Figure within His ; but That still not being perfect, Apelles drew a Smaller and exactly proportioned One within Both the Former.

† HW: M A R T I A L.

xli HW's following account sets out his view of the history of art as influenced by his reading of standard texts such as those of the classical authors, Vasari, Roger de Piles, George Vertue and the Richardson brothers but also the experience of his Grand Tour and a tireless engagement with his father's collection. It was also a time when he was developing his own collection and about to embark upon the acquisition of his own aedes, Strawberry Hill.

xlii Andrea Mantegna's nine canvases comprising the *Triumph of Caesar* were bought by Charles I in 1627 and remain at Hampton Court today.

xliii Giulio Pippi (c.1492–1546), called Giulio Romano. See *Aedes* 2002, nos. 10 and 237, neither of which now lay any claim to Romano.

xliv Polidoro Caldara (c.1495/1500–1543), known as Polidoro da Caravaggio.

xlv 'and to their neglect of Nature' HW Add MS (PML).

xlvi See *Aedes* 2002, no. 274.

xlvii Memorable art history.

xlviii See *Aedes* 2002, no. 33.

xlix See *Aedes* 2002, nos. 144, 254.

l ie. *Aedes* 2002, no. 144.

li Ciro Ferri (1634–1689).

lii See *Aedes* 2002, nos. 99–110, 262.

liii See *Aedes* 2002, nos. 111, 112.

liv See *Aedes* 2002, nos. 113 –116 and 1736 Inventory , nos. 413 and 414.

lv See *Aedes* 2002, nos. 87, 90 and 1736 Inventory nos. 259, 262, 263, 305, 376, 398. HW later confessed to an ignorance of Titian in common with Mrs Damer: 'Of Titian she had no idea (nor have I a just one, though great faith) as at Venice all his works are now coal-black'. HW to Mary Berry, 12 May 1791. Lewis 11, p. 266.

lvi See *Aedes* 2002, no. 3.

lvii See *Aedes* 2002, nos. 195, 196, 246. Bearing in mind HW's comments on Veronese above it is no surprise to find the artist under-represented in RW's collection. See also *Aedes* 2002, no. 164 and 1736 Inventory nos. 78, 293. HW later appreciated Veronese enough to dismiss the Earl of Halifax's version of *The Marriage Feast at Cana* as a 'poor tawdry copy' (MS note on sale catalogue, Christie and Ansell, 20 April 1782, lot 76. Lewis Walpole Library).

lviii Jacopo Robusti (1512–94). An *Adoration of the Kings* attributed to Tintoretto was sold 1751 Sale, day 2, lot 17.

lix See *Aedes* 2002, nos. 141, 142, 161 and 1748 Sale, day 2, lot 36; 1751 Sale, day 2, lot 49.

lx See *Aedes* 2002, no. 253.

lxi See *Aedes* 2002, nos. 145, 146 and 1748 Sale, day 1, lot 62.

lxii See *Aedes* 2002, nos. 249, 250 and 1736 Inventory no. 302.

lxiii ie. colouring.

lxiv HW's knowledge of Giorgione (c.1477–1511) was limited.

lxv 'Sanderson in his Graphice, an affected but sensible book, observes that the picture of the Deluge by Bassan, then at St James's, had so many pots & dripping pans, blue coats & dogs, that it seemed rather a disordered and confused kithen, than Noah's flood' HW Add MS (PML).

lxvi See *Aedes* 2002, no. 271.

lxvii See *Aedes* 2002, no. 274.

the death of the Disciples of Raphael and Michael Angelo, languisht for several years, but reviv'd in almost all its Glory in the person of ★ Andrea Sacchi,[xlviii] who carry'd one part of the Art to greater perfection than any before him or since, the Harmony of Colours. His Countryman and Competitor Pietro Cortona[xlix] was a great Ornament to Rome. He had rather a great richness than a fruitfulness of Fancy. There is too remarkable [**xxii**] a sameness in his ideas, particularly in the Heads of his Women ; and too great a composure in his expression of the Passions. No Collection can be compleat without one Picture of his hand, and none wants more than one, except of his greater and less sort, for his small Pieces are his best. Lord ORFORD has one in his Cabinet, which is very capital.[l] He had an extreme good Scholar, Ciro Ferri.[li] Andrea Sacchi bred up a most admir'd Scholar, the famous Carlo Maratti.[lii] This latter and his Scholars form'd a new Roman School, and added Grace, Beauty and Lightness, to the Majesty, Dignity, and Solemnity of their Predecessors. Indeed Carlo Maratti has unluckily been one of the Destroyers of Painting, by introducing that very light Stile of Colouring, which in less skillful Hands has degenerated into glare and tawdry. The Drawing-Room in this Collection, call'd the Carlo-Marat Room, is a perfect School of the Works of Him, Nicolo Beretoni,[liii] and Giuseppe Chiari,[liv] his Disciples.

The VENETIAN School

[**xxiii**] Cotemporary with the Elder Roman School was the Venetian, as renown'd for their Colouring, as the other for their Drawing. Titian,[lv] Giorgione, Pordenone,[lvi] Paul Veronese,[lvii] Tintoret,[lviii] the Bassans,[lix] Paris Bourdon,[lx] Andrea Schiavoni,[lxi] and the Palma's,[lxii] were the chief Masters of it : Titian and Paul Veronese by far the best. The Landcapes of the former, and the Architecture of the latter, were equal to their Carnations.[lxiii] Giorgione[lxiv] had great ideas. Pordenone and Tintoret were dark and ungraceful. The Palma's were stiff, and the Bassans[lxv] particular. The elder Palma is remarkable for ill-drawn Hands and Arms, of which he was so sensible, that he seldom has shown above one of each figure. The Bassans have always stooping Figures, and delighted in drawing the Backs of them. Their Landscapes are dark, and their greatest Lights consist in the Red Draperies, which they promiscuously distributed to almost every Figure

The MILANESE School

[**xxiv**] The same Century produc'd that universal Genius, Lionardo da Vinci,[lxvi] whose Colouring of Flesh does not yield in roundness to Titian's; nor his skill in Anatomy to his Contemporary Michael Angelo's;[lxvii] his Judgment in it was greater. Tho' he was not born at Milan, yet his residence there establisht a kind of Milanese

★ HW: He first study'd under *Albano*

School. It was the fate of that City not to have its greatest Ornaments born its Natives. The Procacini,[lxviii] who were of Bologna, retir'd thither on some disputes with the Caracci.[lxix] Camillo, who was most known of the Three, was very particular in his Colouring. The variety of Tints in his Flesh, the odd disposition of his Lights on the verges of the Limbs, and his delighting in clustering Groupes, made his Pictures extremely easy to be known.

The FLORENTINE School

There is little to be said of the Florentine School, as there was little variety in the Masters; and except Andrea del Sarto,[lxx] and the two Zuc-[**xxv**]chero's,[lxxi] their names are scarce known out of Tuscany. Their Drawing was hard, and their Colouring gawdy and gothic.[lxxii]

The LOMBARD School

The Lombard School was as little universal, but far more known by producing those two great Men Correggio[lxxiii] and Parmegiano:[lxxiv] the first, for Grace and Sweetness confest the first of Painters ; and the latter as celebrated for the Majesty of his Airs. His :Works are easily known by long Necks and Fingers, and by a certain greenness in his Colouring. To Correggio seems applicable what Pliny tells us of Apelles ; "cum aliorum opera admiraretur, collaudatis omnibus, deesse iis unam illam Venerem dicebat, quam Græci Charita (Grace) vocant : cætera omnia contigisse, sed hac soli sibi neminem parem. Lib. 35. Cap. IO." Frederico Barroccio[lxxv] was a great imitator of Correggio, but seems rather to have study'd what Correggio did, than what he did well ; his beau-[**xxvi**]tiful colouring and bad Drawing are both like Correggio's

The NEAPOLITAN School

The Neapolitan School has produc'd little good ; in Lanfranc[lxxvi] was a good Painter, which in my own mind I do not think, he was bred up in the School of the Caracci. His manner was wild, glaring, and extravagant. What Luca Jordano[lxxvii] did well, he ow'd to his Master Pietro Cortona.[lxxviii] His careless and hasty manner prevented his Pictures from almost ever[lxxix] being excellent. His hand is often difficult to be known, as it was the most various and uncertain. There cannot be three manners more unlike, than in the Cyclops,[lxxx] the Judgment of Paris,[lxxxi] and the two small ones in the Carlo-Marat Room,[lxxxii] all by him. Generally indeed his Pictures are to be distinguisht by deep blue Skies, blue and white Draperies, and vast confusion of unaccountable Lights, particularly on the extremities of his Figures. His Genius was like Ovid's, flowing, abundant, various, and incorrect.

lxviii See *Aedes* 2002, no. 241.

lxix For Annibale Carracci, see *Aedes* 2002, no. 150; for Agostino, see *Aedes* 2002, no. 89; for Ludovico, see *Aedes* 2002, no. 260. See also Appendices for inconclusive references.

lxx See *Aedes* 2002, no. 91.

lxxi See 1736 Inventory nos. 302, 405 and SH 1842 Sale, day 21, lot 53.

lxxii HW here uses the word gothic in the sense of 'barbarous' as opposed to medieval or romantic.

lxxiii See 1736 Inventory *Aedes* 2002, no. 179.

lxxiv See *Aedes* 2002, no. 147 and 1751 Sale, Day 1, no.6.

lxxv See *Aedes* 2002, no. 149.

lxxvi RW had no work attributed to Giovanni Lanfranco (1582–1647). Horace Mann tried to interest HW half heartedly in a portrait of St. Anthony (Mann to HW, 3 September 1743) but HW replied 'My Lord does not admire the account of the Lanfranc; thanks you, and will let it alone' (HW to Mann 17 September 1743). HWC, vol. 18, p. 311.

lxxvii See *Aedes* 2002, nos. 63, 64, 94, 121, 122 and 1736 Inventory nos. 310 and 412. See also 1748 Sale, day 1, no 58 and day 2, no.55.

lxxviii See *Aedes* 2002, nos. 144, 254.

lxxix 'almost always' HW Add MS (PML).

lxxx See *Aedes* 2002, no. 94.

lxxxi See *Aedes* 2002, no. 63.

lxxxii See *Aedes* 2002, nos. 121, 122.

lxxxiii See *Aedes* 2002, nos. 49, 165, 228, 256 and 1736 Inventory no. 358. See also 1751 Sale, day 1, no. 20 and day 2, nos. 43, 44.

lxxxiv 'This picture has been engraved in the most exquisite manner by Strange'. HW Add MS (PML). Now private collection.

lxxxv See *Aedes* 2002, no. 228.

lxxxvi RW owned nothing attributed to the 'foul' Michelangelo Merisi Caravaggio (1573–1610).

lxxxvii See *Aedes* 2002, no. 256.

lxxxviii Rosa's celebrated portrat of Justinian's great general *Belisarius* hung at neighbouring Raynham Hall. See also lxxxiv above.

lxxxix By 1736 RW owned seven paintings attributed to Jacques (1621–75) and Guillaume (1628–79) Courtois, collectively known as Il Borgognone (1736 Inventory nos. 141, 142, 157, 207, 208, 285, 450). Four of these were removed to Houghton, *Aedes* 2002, nos. 157, 158, 182, 183.

xc See 1736 Inventory no. 406.

xci Prospero's fishlike slave in The Tempest.

xcii See 1736 Inventory nos. 441, 442.

xciii See *Aedes* 2002, nos. 153, 188.

xciv See *Aedes* 2002, nos. 92, 93, 123, 124, 166·

[**xxvii**] The greatest Genius Naples ever produc'd resided generally at Rome ; a Genius equal to any that City itself ever bore. This was the great Salvator Rosa.[lxxxiii] His Thoughts, his Expression, his Landscapes, his knowledge of the force of Shade, and his masterly management of Horror and Distress, have plac'd him in the first Class of Painters. In Lord Townshend's Belisarius,[lxxxiv] one sees a Majesty of Thought equal to Raphael, an Expression great as Poussin's. In Lord ORFORD'S Prodigal[lxxxv] is represented the extremity of Misery and low Nature ; not foul and burlesque like Michael Angelo Caravaggio;[lxxxvi] nor minute, circumstantial and laborious like the Dutch Painters. One of them would have painted him eating Broth with a wooden Spoon, and have employed three days in finishing up the Bowl that held it. In the Story of the old man and his sons,[lxxxvii] one sees Drawing and a taste of Draperies equal to the best collected from the Antique. Salvator was a Poet and an excellent Satirist. Here again was [**xxviii**] a union of those Arts. His Pictures contain the true genius and end of Satire. Tho' heighten'd and expressive as his Figures are, they still mean more than they speak. Pliny describ'd Salvator in the person of Timanthes : "In omnibus ejus operibus intelligitur plus semper quam pingitur." Does not the very pity and indignation which the Figure of Belisarius excites, silently carry with it the severest Satire on Justinian?[lxxxviii] This great Master had a good Co[n]temporary, who imitated his Manner very happily : It was Bourgognon,[lxxxix] the Battle-Painter. There was a sort of Genius sometime before like Salvator's, but which for want of his strength of Mind, soon degenerated into capricious Wildnesses, and romantic Monstrousness. This was Pietro Testa.[xc] The comparison of these two, leads me to another between Salvator, and that great English Genius, Shakespear, of whom it was said, that he not only invented new Characters, but made a new Language for those Characters. His Caliban,[xci] and Salvator's Monster at the Duke of Rutland's, have [**xxix**] every Attribute which seem proper to those imaginary Species.

Spanish MASTERS.

Naples was the general Residence too of Spagnolet,[xcii] one of the few good Painters produc'd by Spain. His Pictures breathe the Spirit of his Country ; fierce and dark Colouring ; barbarous and bloody Subjects. Velasco and Morellio were the only other Spanish Painters who have made any figure. Velasco's[xciii] Manner was bold and strong ; his Colours dash'd on in thick Relief. Morellio's[xciv] Taste was much sweeter than that of his Countrymen. He imitated Vandyke's Stile in History Pieces so nearly, that at first they may be mistaken for them.

INTRODUCTION.

The FRENCH School

The French School has flourish'd with several extreme good Masters.[xcv] One Character runs thro' all their Works, a close imitation of the Antique, unassisted by Colouring. Almost all of them made the voyage of Rome.[xcvi] Nicolo Poussin[xcvii] was a per-[**xxx**]fect Master of Expression and Drawing, though the proportion of his Figures is rather too long. Le Soeur,[xcviii] his Disciple, to the style of his Master, and the study of the Antique, join'd an imitation of Raphael, which, had his life been longer, would have raised him high above Poussin. The Man kneeling on the Fore-ground in Lord ORFORD'S Saint Stephen,[xcix] might be taken for the hand of Raphael. And in the Moses in the Bullrushes,[c] the distant Woman is quite in that great Master's Taste. The Cloyster painted by him at the Chartreuse at Paris,[ci] is, in my Opinion, equal to any Composition extant, for the Passions and fine Thoughts. His Fault was in his Draperies ; the Folds are mean and unnatural. Sebastian Bourdon[cii] was liker Poussin, only that as Poussin's Figures are apt to be too long, his are generally too short, and consequently want the Grace which often consists in over-lengthen'd Proportions. Le Brun's Colouring[ciii] was better than any of the French, but his Compositions are generally confused and [**xxxi**] Crouded. Lord ORFORD'S Icarus[civ] is much beyond and very unlike his usual Manner. It is liker to Guercino, without having the Fault of his too black Shadows. France and Lorrain have produc'd two more Painters, who in their way were the greatest ornaments to their Profession ; Gaspar Poussin[cv] and Claude Lorrain[cvi] : the latter especially was the Raphael of Landcape-Painting.

Flemish MASTERS.

I shall not enter into any detail of the Flemish Painters, who are better known by their different Varnishes, and the different kind of utensils they painted, than by any style of Colouring and Drawing.[cvii] One great Man they had, who struck out of the littlenesses of his Countrymen, tho' he never fell into a character of graceful beauty: but Rubens[cviii] is too well known in England to want any account of him. His Scholar Vandyke[cix] contracted a much genteeler Taste in his Portraits. But what serv'd other Painters for models of beauty, was to him a standard of miscarrying : All his Portraits [**xxxii**] of Women are graceful[cx]; but his Madonnas, which he probably drew from some Mistress, are most remarkable for want of beauty.

The BOLOGNESE School

It will easily be observed that I have yet omitted one of the principal Schools, the Bolognese ; but as I began with the Roman, I reserv'd this to conclude with.[cxi] This, which was as little inferior to the Roman, as it was superior to all the rest : This was the

xcv HW's assessment of the French School, although brief, is of interest at this period because he considers the works in RW's collection by lesser known artists and not simply those of Poussin and Claude.

xcvi Evidence of study in Rome by a non Italian artist was the prime criterion for serious consideration by collectors at this period.

xcvii The 1736 Inventory records six paintings (nos. 46, 152, 167, 298, 299) attributed to Nicolo Poussin in RW's collection. Three of these are included in the *Aedes* 2002, nos. 136, 258, 259.

xcviii See *Aedes* 2002, nos. 83, 261.

xcix See *Aedes* 2002, no. 83.

c See *Aedes* 2002, no. 261.

ci HW had visited the convent of Chartreuse (demolished 1796) with Thomas Gray in May 1739. He found it a place for 'melancholy, meditation, selfish devotion, and despair'. 'What we chiefly went to see was the small cloister, with the history of St. Bruno, their founder, painted by Le Soeur. It consists of twenty-two pictures, the figures a good deal less than life. But sure they are amazing! I don't know what Raphael may be in Rome, but these pictures excel all I have seen in Paris and England.' HW to West, c. 15 May 1739. HWC, vol. 13, p. 169-70. The series have been in the Louvre since 1793.

cii See *Aedes* 2002, nos. 169, 187. See also 1736 Inventory nos. 227, 316.

ciii See *Aedes* 2002, nos. 45, 95.

civ See *Aedes* 2002, no. 95.

cv See *Aedes* 2002, nos. 184, 264, 269, 270. See also 1736 Inventory, no. 313.

cvi See *Aedes* 2002, nos. 267, 268 and 1736 Inventory, no. 312.

cvii For HW on the Dutch and Flemish masters, see p. xi above.

cviii See *Aedes* 2002, nos. 21, 38, 43, 48, 85, 139, 170–76, 229, 236, 238, 251. See also 1736 Inventory nos. 300, 306, 404 and 1748 Sale, day 2, nos. 40, 47, 56, 59, 64 and 1751 Sale, day 2, nos. 31, 67. These do not appear to be duplicate records.

cix See *Aedes* 2002, nos. 4, 40, 51, 62, 65-71, 84, 139, 191, 192 and also 1736 Inventory nos. 55, 78, 327-31, 361, 363. In addition to these works the following are recorded which do not appear to duplicate the above : 1751 Sale, day 1, nos. 46-9 and day 2, nos. 32, 51, 54.

cx Bearing in mind that *Aedes* 2002, no. 139 is now recognised as a portrait by Rubens.

cxi HW here reveals the crux of his assessment of the history of painting, conveniently forgetting to include the British School.

cxii Palazzo Farnese, Rome.

cxiii See *Aedes* 2002, no. 150. In addition HW records another painting attributed to Annibale Carracci as having been in the collection of RW: SH Sale, 1842, day 13, lot 28, *Young Hercules with serpents (cabinet gem)*, bought Earl of Derby.

cxiv See *Aedes* 2002, nos. 88, 120, 227, 243, 257 and 1748 Sale, day 1, nos. 23, 28, 48.

cxv See *Aedes* 2002, no. 257.

cxvi See *Aedes* 2002, nos. 82, 276 and 1736 Inventory, no. 177.

cxvii See *Aedes* 2002, nos. 234, 235 and 1736 Inventory, no. 392. See also 1751 Sale, day 1, no. 51.

cxviii Palazzo Barberini, Rome.

cxix Pietro Berrettini da Cortona (1596–1669). HW would also have known Cortona's ceiling cycle painted at the Palazzo Pitti, 1637–47.

cxx See *Aedes* 2002, no. 234.

cxxi See 1748 Sale, nos. 12, 13, 35.

cxxii See *Aedes* 2002, no. 275 for one of HW's most notorious attribution debates.

cxxiii See *Aedes* 2002, no. 260.

cxxiv See *Aedes* 2002, no. 227.

cxxv The following account is a worthy summary of HW's viewpoint, a well expressed series of opinions which are delivered with style and pace: a fitting 'recapitulation' which both develops in argument and justifies his own understanding and critical standpoint.

School, that to the dignity of the Antique, join'd all the beauty of living Nature. There was no Perfection in the others, which was not assembled here. In Annibal Caracci one sees the ancient Strength of Drawing. In his Farnese Gallery,[cxii] the naked Figures supporting the Ceiling are equal to the exerted Skill of Michael Angelo, superiorly colour'd. They talk of his Faults in Drawing, but those Figures and Lord ORFORD'S little Venus[cxiii] are standards of Proportion for Men and Women. In Guido[cxiv] was the Grace and Delicacy of Correggio, and Colouring as natural as Titian's. I can not [**xxxiii**] imagine what they mean, who say he wanted knowledge in the Chiaro Oscuro: It was never more happily apply'd and diffus'd than in Lord ORFORD'S Adoration of the Shepherds.[cxv] In Albano[cxvi] was Finishing as high as in the exactest Flemish Masters. His Scholar Mola[cxvii] form'd compositions as rich as the fam'd Barbarini Ceiling[cxviii] by Pietro da Cortona[cxix] ; Lord ORFORD'S Curtius[cxx] is an instance. There are numbers of Figures less crouded, more necessary, and with far more variety of expression. If Nature and Life can please, the sweet Dominichini[cxxi] must be admir'd. These two never met in one Picture in a higher degree than in Lord ORFORD'S Madonna and Child, by him.[cxxii] One can't conceive more expression in two Figures so compos'd, and which give so little room for showing any passion or emotion. Ludovico Caracci,[cxxiii] the Founder of this great School, was more famous for his Disciples than his Works ; tho' in Bologna they prefer him to Annibal : but his Drawing was incorrect, and his Hands and Feet almost always too long. In one Point I [**xxxiv**] think the Bolognese Painters excell'd every other Master ; their Draperies are in a greater taste than even Raphael's. The largeness and simplicity of the folds in Guido's Dispute of the Doctors,[cxxiv] is a pattern and standard for that sort of Painting.

I shall conclude with these few Recapitulations.[cxxv] I can admire Correggio's Grace and exquisite Finishing ; but I can not overlook his wretched Drawing and Distortions. I admire Parmegiano's more majestic Grace, and wish the length of Limbs and Necks, which forms those graceful Airs, were natural. Titian wanted to have seen the Antique ; Poussin to have seen Titian. Le Soeur, whom I think in Drawing and Expression equal to Poussin, and in the great Ideas of his Heads and Attitudes, second to Raphael, like the first wanted Colouring, and had not the fine Draperies of the latter. Albano never painted a Picture, but some of the Figures were stiff, and wanted Grace ; and then his scarce ever succeeding in large Subjects, will throw [**xxxv**] him out of the list of perfect Painters. Dominichini, whose Communion of Saint Jerome is allow'd to be the second Picture in the world, was generally raw in his Colouring, hard in his Contours, and wanted clearness in his Carnations, and a knowledge of the Chiaro Oscuro. In short, in my opinion, all the qualities of a perfect Painter, never met but in RAPHAEL, GUIDO, and ANNIBAL CARACCI.

A
DESCRIPTION
OF THE
COLLECTION OF PICTURES
AT
HOUGHTON-HALL in *NORFOLK*

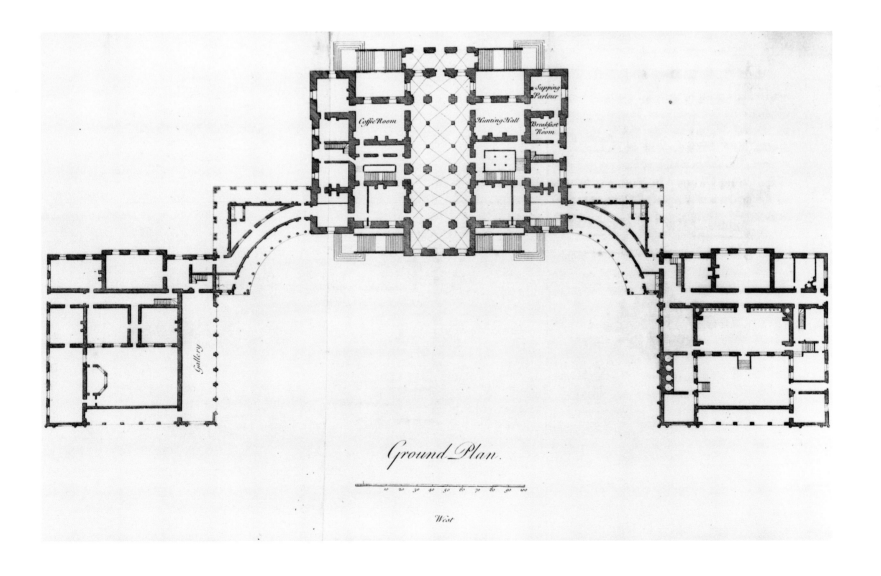

Ground Plan.

West

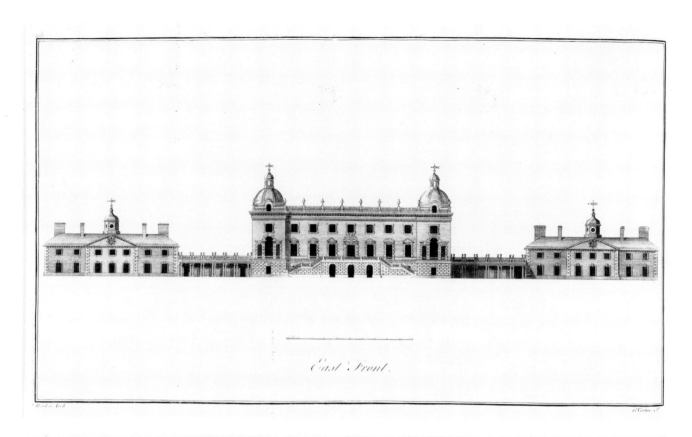

East Front.

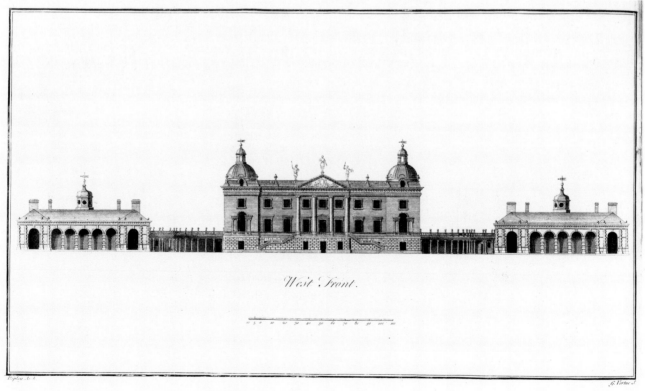

West Front.

A
DESCRIPTION
OF
HOUGHTON-HALL.[i]

THE common Approach to the House is by the South-end Door, over which is Engraved this Inscription.

ROBERTUS WALPOLE

HAS ÆDES

ANNO S. MDCCXXII.

INCHOAVIT,

ANNO MDCCXXXV.

PERFECIT.

[38]
On the Right-hand you enter a small
BREAKFAST ROOM.[ii]

1. OVER the Chimney is a very good Picture of Hounds, by *Wootton*.

2. A Concert of Birds, by *Mario di Fiori*; a very uncommon Picture, for he seldom painted any thing but Flowers; it belong'd to *Gibbins* the Carver, and is four Feet seven Inches high, by seven Feet nine and a quarter wide.

3. The Prodigal Son returning to his Father; a very dark Picture by *Pordenone*, the Architecture and Landscape very good. It is five Feet five Inches high, by eight Feet eleven and half wide. This Picture belong'd to *George Villiers*, the great Duke of *Buckingham*.

4. A Horse's Head, a fine Sketch, by *Vandyke*.

5. A Grey-Hound's Head, by old *Wyck*, who was *Wootton's* Master.

6. Sir *Edward Walpole*, Grand-Father to Sir *Robert Walpole*.

 He was made a Knight of the Bath at the Coronation of King *Charles* the Second, and made a great Figure in Parliament. Once on a very warm Dispute in the House, he propos'd an Expedient, to which both Parties immediately concurred: *Waller* the Poet moved that he might be sent to the Tower, for not having composed the Heats sooner, [39] when he had it in his Power. He married *Susan*, Daughter to Sir *Robert Crane*, on whose Death he wrote these Verses in his Bible, which is now in the Church here:

i 'Sir Rob. Walpole used to say that he had taken the idea of the towers from Osterley Park near Brentford' HW MS (PML).

ii The Breakfast Room forms part of a suite of three rooms referred to by Sir Edward Harley, 2nd Earl of Oxford as the 'Hunting Apartment' (1737/8). These first rooms were plainly furnished and the hunting theme was alluded to here in key paintings, notably *Aedes* 2002, nos. 1, 2, 4, and 5, as was that of family and friends. *The Prodigal Son* (*Aedes* 2002, no. 3), was a fitting subject in this context. The room was plainly decorated, with white-painted panelling and a Corinthian cornice. The furniture recorded in the room in 1745 shows that it was used more as an office than for eating, the room where 'tenants come to account' (Sir Matthew Decker, 1728). There were walnut chairs, some with leather covers, two tables and a bureau. The furniture that survives at Houghton today reveals that these furnishings were plain, robust and well made—suitable for withstanding the rigours of RW's regular hunting parties. This and the following room descriptions are indebted to the work of John Cornforth (Cornforth 1987 and Moore 1996) and Sebastian Edwards (Moore ed. 1996).

iii Henry Bland (died 1746), DD., was Dean of Durham (1728–46), headmaster of Eton (1720–28) and provost of Eton (1733–46). He was also Canon of Windsor, 1723. His friendship with RW went back to 1716 when he was Chaplain to the King. He was second chaplain to Chelsea Hospital (1715) and chaplain (1724). (Venn, *Alumni Cantab.*). His son, Rev. Henry Bland (c.1703–68), DD. 1747, became prebendary of Durham, 1737 and was tutor to HW at Eton.

iv This was the second room in the 'Hunting Apartment' and was more formal, the room in which guests first encountered RW in private, surrounded by portraits of his family and friends, with one prime Roman School painting lending gravitas (*Aedes* 2002, no. 10), acting as a portent of splendours to come. Sir Edward Harley described a typical breakfast with RW: 'The next morning all go down and breakfast in the hunting parlour, where Horace Walpole's picture (*Aedes* 2002, no. 11) is ... For breakfast every body calls for what he will; people do not all come at a time, which is wrong.'

v 'There was one of these (probably this very picture) in the collection of King James 2d. See his catalogue published by Bathoe p. 22 no. 240.' HW MS (PML).

She Lives, Reigns, Triumphs in a State of Bliss:
My Life no Life, a daily Dying is.
If Saints for Pilgrims here concern'd can be,
I'm confident she now remembers me.
My Love for her not lessen'd by her Death,
I'm sure will last unto my latest Breath.

Thus turn'd into *Latin* by Dr. * BLAND,[iii] Dean of *Durham* :

Vivit adhuc, Regnat, cœlesti in sede Triumphat:
 At vita, heu! mors est quotidiana mihi.
Tangere si qua potest miserorum cura beatos,
 Sat scio non curas negligit illa meas.
Occidit illa mihi, sed amor non occidit unà;
 Nec nisi cum pereat Vita, peribit Amor.

He is buried in *Houghton* Church with this plain Epitaph:

" Here lies Sir *Edward Walpole: Cœtera si quæras, narrabit fama superstes.*"

7. [**40**] *Robert Walpole*, Son to Sir *Edward*, and Father to Sir *Robert Walpole*: he was Member for *Castle-Riseing*, from the first of *William* and *Mary* till his Death in 1700. His Wife was *Mary*, only Daughter to Sir *Jeffery Burwell*, by whom he had Nineteen Children.

8. *Horatio* Lord *Townshend*, Father to *Charles* Lord Viscount *Townshend*.

9. *Harold*, Gardener to Sir *Robert Walpole*, a Head, by *Ellis*.

The SUPPING PARLOUR.[iv]

10. THE Battle of *Constantine* and *Maxentius*, a Copy, by *Julio Romano*, of the famous Picture in the *Vatican*, which he executed after a Design of *Raphael*. It is four Feet eight Inches and half high, by nine Feet seven and a quarter wide.[v] The Story is thus told by *Zosimus*, Hist. Lib. 2. "Tantis cum ambo copiis instructi essent, Maxentius pontem supra Tiburim flumen faciebat, non connexum prorsus à ripa, qua urbem spectat, ad alteram usque ripam; sed duas in partes ita divisum, ut in medio flumine ea, quæ partem utramque pontis explebant, inter se quodam modo concurrentem sibulis ferreis, quo revellebantur, quoties pontem quis junctum nollet, simul imperabat fabris, quamprimum viderent exercitum Constantini junc[**41**]turæ pontis insistere, fibulas rev-

* HW: He also drew up the *Latin* Inscription, Engraved on the Foundation-Stone.

ellerent ac pontem solverent, ut quotquot huic insisterent, in fluvium dilaberentur. Ac Maxentius quindem hæc struebat. Constantinus autem cum exercitu Romam usque progressus, ante urbem castra metabatur in campo, qui & late patet & equitatui est opportunus. Maxentius intra muros inclusus, Diis victimas offerebat, & extispices de belli eventu consulebat, ipsis quoque Sibyllinis oraculis pervestigatis. Quumq; reperisset oraculum, quo significaretur in fatis esse, ut qui ad perniciem P.R. spectantia designaret, miserabili morte periret: de semetipso id accipiebat, quasi qui Romam adortos eamque capere cogitantes, propulsaret. Eventus autem comprobavit id, quod verum erat. Nam cum Maxentius copias ex urbe produxisset, jamque pontem, quem ipse junxerat, transiisset; infinita quædam multitudo noctuarum devolans, muros complebat. Quo conspecto, suis Constantinus, ut aciem struerent imperabat. Quum exercitus utrimque cornibus adversis starent, equitatum Constantinus immisit. Is equitatum hostilem adortus, sudit. Peditibus quoque signo sublato, rite compositeque in hostem illi tendebant. Acri conserto prælio, Romani quidem ipsi & Itali socii segniores ad obeunda pericula se præbebant, quod acerba tyrannide se liberari optarent. Reliquorum vero militum innumerabilis quædam multitudo cecidit, tum [**42**] ab equitibus proculcata, tum à peditibus interempta. Enimvero quum diù resistebat Equitatus, aliqua Maxentio spes esse reliqua videbatur: sed equitibus jam succumbentibus, fuga cum reliquis abrepta, per pontem fluminis ad urbem contendebat. Tignis autem minime sustinentibus eam vim oneris, adeoq; ruptis, cum cætera multitudine Maxentius etiam fluminis impetu abripiebatur.”

11. Over the Chimney, Horace Walpole, Brother to Sir Robert Walpole. He was Ambassador in France and Holland, Cofferer of the Houshold, and lastly one of the Tellers of the Exchequer.[vi] Three Quarters Length, by Richardson.

12. Sir *Robert Walpole*, when Secretary at War to Queen *Anne*. Three Quarters by *Jervase.*

13. *Catharine* Lady *Walpole*, his first Wife; Ditto.

14. Sir *Charles Turner*, one of the Lords of the Treasury. He married to his first Wife, *Mary*, eldest Sister to Sir *Robert Walpole*. Three Quarters, by *Richardson.*

15. *Charles* Lord Viscount *Townshend* Secretary of State to King *George* the First and Second. Three Quarters, by Sir *Godfrey Kneller.*

16. *Dorothy*, his second Wife, and the second Sister to Sir *Robert Walpole*. Three Quarters, by *Jervase.*

17. *Anne Walpole*, Aunt to Sir *Robert Walpole* (a Head.) She was Wife to Mr. *Spelman* of *Narborough* in *Norfolk.*

vi ‘& created a Baron a little before his death’ HW MS (PML).

vii The Hunting Hall served as the principal eating room on the ground floor and was used for both breakfast and dinner. By 1736 the room was dominated by Wootton's *Hunting Piece* (*Aedes* 2002, no. 22) and the only other painting in the room, the slightly smaller *Susannah and the Elders* (*Aedes* 2002, no. 21). This was presumably the setting for RW's Norfolk Congresses, where the celebrated Houghton Hogen was quaffed, with meals served on plain trestles. In 1731 Lord Hervey described the the ground floor to the Prince of Wales as 'dedicated to fox hunters, hospitality, noise, dirt, and business'.

viii 'There are prints of this picture. He is upon a white horse called the Chevalier, which was taken in Scotland in the year 1715, & was the only one the Pretender mounted there.' HW MS (PML).

ix The Coffee Room was completely panelled, the doors with shallow arched heads in common with a number of the rooms immediately adjoining it. The panelling displayed bolection mouldings in keeping with the marble chimneypiece. In 1745 the room contained seven tables, twenty two chairs, a pier glass, a settee, four stands, a thermometer, four brass and two glass sconces and two pairs of blue window curtains (later described as damask in 1792). The large amounts of furniture in this room and in this part of the house testify to the peripatetic nature of RW's entertaining. The portraits of RW's brothers were accompanied by frankly sensual depictions of *Europa* and *Galatea*.

x The Arcade is a long, vaulted room, minimally furnished, which was the formal entrance to the ground floor and the main circulation space for both family and servants. It acted as a long gallery where family and guests could stroll. According to Lord Hervey, writing to the Prince of Wales in July 1731, it was 'for walking and quid-nuncing' (ie. 'chewing the cud' or similar).

xi The staircase is notable for William Kent's effective use of top–lighting to give an impression of both height and an exterior space created by the arcade of windows and niches. On the bedchamber landing Kent painted simulated Arcadian statues standing on consoles, interspersed with trophies, an effect Charles Townshend was to emulate at nearby Rainham Hall. See also *Aedes* 2002, no. 28.

xii ' I should imagine that this is the statue mentioned in the catalogue of King Charles Ist, & which was sold for 300£. It was possibly cast by Hubert Le Sueur, who lived in St. Bartholomew's Close, a scholar of John of Boulogne, not by him himself. It stood in the Garden at St. James's palace.' 'See Vertues MSS' is crossed out. HW MS (PML).

xiii The Common Parlour acted as an ante-room to RW's personal apartment, which consisted of his Library and Bedchamber beyond. In this respect it probably served a similar function to the Middle Room on the first floor of 10 Downing Street which HW records as his 'Levee Room'. In that room too hung paintings attributed to Rubens and Van Dyck, as well as works of the Italian School (HW MS (Met.)). At Houghton the choice of paintings was of predominantly seventeenth-century grand court portraits with mythological, religious and genre pictures, together with royal portraits which demonstrated loyalty to the Whig ascendancy. These paintings may have been specially framed in the type of Kentian, eared frames shown as overdoors in Isaac Ware's cross-section of this room in his *The Plans, Elevations, and Sections; Chimney-pieces and Ceilings of Houghton Hall in Norfolk*, 1735.
 Ribbon and flower mouldings ornament the panelling, while the volutes of the windows sprout trails of husks at the bottom. HW mentions the 'fine Pear-tree carving', which he attributes to Grinling Gibbons and which framed Godfrey Kneller's portrait of Gibbons. The carving may well have come from the Old Hall. The chimneypiece is of contrasting white marble with purple-and-white Seravezza marble. The white marble bears a central Bacchic libation urn, swagged with oak leaves while the frieze above is filled with vine leaves.

18. **[43]** *Dorothy Walpole*, Ditto (died unmarried.)

19. *Mary Walpole*, Ditto, married to *John Wilson*, Esq; of *Leicestershire*.

20. *Elizabeth Walpole*, Ditto, second Wife to *James Host*, Esq; of *Sandringham* in *Norfolk*.

The HUNTING HALL.vii

21. SUSANNAH and the two Elders, by *Rubens*; five Feet eleven Inches and half high, by seven Feet eight Inches and a quarter wide.

22. A Hunting Piece.viii Sir *Robert Walpole* is in Green; Colonel *Charles Churchill* in the Middle; and Mr. *Thomas Turner* on one Side. By *Wootton*, six Feet ten Inches high, by eight Feet five wide.

The COFFEE - ROOM.ix

23. OVER the Chimney a Landscape with Figures dancing, by *Swanivelt*, two Feet three Inches high, by three Feet three wide.

24. *Jupiter* and *Europa*, after *Guido*, by *Pietro da Pietris*; four Feet ten Inches high, by six Feet two wide.

25. **[44]** *Galatea*, by *Zimeni*; four Feet ten Inches high, by six Feet two wide.

26. *Horatio Walpole*, Uncle to Sir *Robert Walpole*. He married Lady *Anne Osborn*, Daughter of *Thomas* the first Duke of *Leeds*, and Widow of *Robert Coke*, Esq; of *Holkham* in *Norfolk*, Grandfather to the present Earl of *Leicester*. Three Quarters.

27. *Galfridus Walpole*, younger Brother to Sir *Robert*, and one of the General Post-Masters. He was Captain of the *Lion* in Queen *Anne*'s Wars, and was attacked by five *French* Ships on the Coast of *Italy* against three *English*, two of which deserted him, but his own he brought off, after fighting bravely and having his Arm shot off.

28. Returning thro' the *Arcade*,x you ascend the Great Stair-Case, which is painted in *Chiaro Oscuro*, by *Kent*.xi In the middle four *Doric* Pillars rise and support a fine Cast in Bronze of the Gladiator,xii by *John* of *Boulogne*, which was a Present to Sir *Robert* from *Thomas* Earl of *Pembroke*.

The COMMON PARLOUR.xiii

THIS Room is thirty Feet long by twenty-one broad. Over the Chimney is some fine Pear-tree Carving, by Gibbins, and in the middle of it hangs a Portrait of him by

29. [**45**] Sir *Godfrey Kneller*. It is a Master-piece, and equal to any of *Vandyke's*. Three Quarters.

30. King *William*, an exceeding fine sketch by Sir *Godfrey*, for the large Equestrian Picture which he afterwards executed very ill at *Hampton Court*, and with several Alterations. Four Feet three Inches high, by three Feet six wide★ .

31. King *George* the First, a Companion to the former, but finished. The Figure is by Sir *Godfrey*, which he took from the King at *Guilford* Horse-Race. The Horse is new painted by *Wootton*.[xiv]

32. A Stud of Horses by *Wovermans*; two Feet one Inch and three quarters high, by two Feet nine wide.

33. *Venus* Bathing, and *Cupids* with a Carr, in a Landscape, by *Andrea Sacchi*; one Foot ten Inches and half high, by two Feet six Inches wide. It was Lord *Halifax*'s.

34. A Holy Family by *Raphael da Reggio*, a Scholar of *Zucchero*; two Feet two Inches and three quarters high, by one Foot and a quarter wide.

35. A fine Picture of Architecture in Perspective, by *Steenwyck*, one Foot nine Inches high, by two Feet eight wide.

36. A Cook's Shop, by *Teniers*. It is in his very best Manner. There are several Figures; in particular his own, in a Hawking Habit, with Spaniels; and in the Middle an old [**46**] Blind Fisherman, finely painted. Five Feet six Inches and three quarters high, by seven Feet seven and three quarters wide.

37. Another Cook's Shop, by *Martin de Vos*, who was *Snyders's* Master, and in this Picture has excell'd any thing done by his Scholar. It is as large as Nature. There is a Greyhound snarling at a Cat, in a most masterly manner. Five Feet eight Inches high, by seven Feet ten and half wide.

38. A *Bacchanalian*, by *Rubens*. It is not a very pleasant Picture, but the Flesh of the *Silenus* and the Female Satyrs are highly colour'd. There is a small Design for this Picture revers'd, in the Great Duke's Tribune at *Florence*. Two Feet eleven Inches and three quarters high, by three Feet six wide.

39. The Nativity, by *Carlo Cignani*. The Thought of this Picture is borrow'd (as it has often been by other Painters) from the famous *Notte of Correggio* at *Modena*, where all the Light of the Picture flows from the Child. Three Feet seven Inches and half high, by two Feet ten and half wide.

40. Sir *Thomas Chaloner*, an admirable Portrait, three Quarters, by Vandyke. Sir *Thomas* was Governor to *Henry* Prince of *Wales*,[xv] [Vide *Strafford* Papers, Vol. I. page 490.] and in 1610 appointed his Lord Chamberlain.[Vide

xiv 'I suppose this is the very picture which gave rise to Mr. Addison's beautiful poem to Kneller.' HW MS (PML).

xv 'He had been so to the celebrated Duke of Northumberland, the bastardized son of the Earl of Leicester. v. Wood's Athens vol. 2 p. 126' This Sr Thomas gave a piece of ground to ArchBp Grindal's Executors for that Prelate's free school at St [?] Bagh's, & 40 loads of coal yearly to it out of his mines there, reserving a right of placing two scholars, by the name of Chaloner's Scholars. Biogr. Brit.p. 2439.' HW MS (PML).

★HW: Mrs *Barry* and another Actress sat for the Two Emblematic Figures, on the Fore-ground, in the great Picture.

xvi HW added a series of five ms footnotes to his printed note on Sir Thomas Chaloner in his own copy of the 1752 edition of the *Aedes* as follows: on the Isle of Man: 'It was dedicated to G. D. Fairfax, the Parl. General whom he celebrates for his taste & patronage of antiquities. v. Thoresby, Leeds, p. 525; the Duke of Somerset: 'The Duke at the same time sent his Wife a jewel. Engl. Worthies. P. 535; His voyage to Algier 1541: 'Villegaignon, an Extraordinary Adventurer, wrote an Account of the same Expedition, in Latin. v. Gen. Diction. Vol 10. p. 1.'; A poem in Ten Books in Latin Verse: 'He wrote this book in Spain, when he was no better housed as he himself says in his preface, then lieve [stet] in [? Furro], a state in [?]. He took for his motto, Frugality is the left hand of fortune & diligence the right. Eng. Worthies p. 535. Puttenham names Master Chaloner with Sir P. Sidney as excellent for eclogue & pastoral poesy.' At the end of the footnote HW concludes: 'His epitaph in latin and English was written by Dr. Walter Haddon, Master of requests to q. Eliz. v. Hackett's collect of Epitaphs, vol. 2d. p. 184 his portrait was engraved by Holler. In the year 1616 an earthen pot full of brass money of the Emperors Carausius & Allectur was found under the root of a tree in Steeple Claydon parish near the Great Pond, in the woods of Sir Thomas Chaloner. v. Kennet's parochial Antiq. P. 11.' HW MS (PML).

xvii 'There is a mezzotinto from this picture.' HW MS (PML).

xviii 'It is the only Picture of Mr Locke & was bought of Dr. Goochy's Brother'. 1744 MS (Herts).

xix Anne. HW MS (PML).

xx 'See her Article in the General Dictionary, vol. 10th where are two letters of Hers in a very amiable style, & some of Dr. Burnets in a very wretched one'. HW MS (PML).

Sand-[47]*ford's* Genealogical Tables, page 529.] He died in 1615, and was buried at *Chiswick.*★xvi

41. Sir *Thomas Gresham*, the Founder of Gresham-College, by *Antonio More*. Two Feet six Inches and a quarter high, by two Feet and half wide.

42. *Erasmus*, by *Holbein*, a half Length, smaller than Life.

43. A Friar's Head, by *Rubens*.

44. [4[8]] *Francis Halls*, Sir *Godfrey Kneller's* Master, a Head by himself.

45. The School of *Athens*, a Copy (by *Le Brun*) of *Raphael's* fine Picture in the Vatican. Three Feet two Inches high, by four Feet two and three quarters wide.

46. *Joseph Carreras*, a *Spanish* Poet, writing: He was Chaplain to *Catherine* of *Braganza*, Queen of Charles II. Half Length, by Sir *Godfrey Kneller.*xvii

47. *Rembrandt's* Wife, half Length, by *Rembrandt*.

48. *Rubens's* Wife, a Head, by *Rubens*.

49. A Man's Head, by *Salvator Rosa*.

50. Mr. *Locke*, a Head, by Sir *Godfrey Kneller.*xviii

51. *Inigo Jones*, a Head, by *Vandyke*.

52. Over the Door, a Daughterxix of Sir *Henry Lee*, three Quarters, by Sir *Peter Lely*. She was married to Mr. *Wharton*, afterwards created a Marquiss; and was herself a celebrated Poetess. *Waller* has address'd a Copy of Verses to her on the Death of Lord *Rochester*, whose great Friend and Relation she was.xx

53. Over another Door, Mrs. *Jenny Deering*, Mistress to the Marquiss of *Wharton*. These Two came out of the *Wharton* Collection.

54.55. Over the two other Doors, Two Pieces of Ruins, by *Viviano*.

★ HW: He wrote a Treatise on the Virtue of NITRE, Printed at *London* 1584, some other Philosophic Works, and a Pastoral. He discovered the Allom-Mines at *Gisburg* in *Yorkshire* (where he had an Estate) towards the latter End of Queen *Elizabeth's* Reign; but they being adjudged to be Mines Royal, little Benefit accrued to the Family, tho' the Long Parliament afterwards restored them to his Sons, who were from these Causes engaged on the Parliament Side; and *Thomas* and *James*, two of them, sat as Judges on King *Charles* the First. *James*, who wrote a Treatise on the *Isle of Man*, and made several Collections of Antiquities, poisoned himself with a Potion prepared by his Mistress 1660, on an Order for taking him into Custody. *Thomas*, who was one of the Yorkshire Members, had been a Witness against Archbishop Laud, and one of the Council of State, and died in Exile at *Middleburg* in *Zeland* 1661. He wrote an Answer to the *Scotch* Papers concerning the Disposal of the Person of the King; A Justification of that Answer; A true and exact Relation of finding the Tomb of *Moses* near Mount *Nebo*; And a Speech containing a Plea for Monarchy in 1659. *Thomas*, his Grandfather, was a celebrated Wit, Poet and Warrior, having served in the Expedition against *Algier* under *Charles* the Fifth, where being shipwrecked, and having swam till his Arms failed him, he caught hold on a Cable with his Teeth and saved himself. He was knighted by the Duke of *Somerset*, for his Valour, after the Battle of *Musselborough*; and by Queen *Elizabeth* sent Ambassador to the Emperor *Ferdinand* and to King *Philip* the Second, where he resided four Years, and died soon after his Return in 1565, and was buried with a sumptuous Funeral in St. *Paul's*. He wrote a little Dictionary for Children: A Poem in Ten Books in Latin Verse, De Republicâ Anglorum Instauranda, printed 1579, with an Appendix, De Illustrium quorundam Encomiis, cum Epigrammatibus & Epitaphiis nonnullis: His Voyage to *Algier* 1541: And translated from the *Latin*, the Office of Servants, written by *Gilbert Cognatus*: And *Erasmus's* Praise of Folly, 1549, and Re-printed 1577. [Vide Wood's *Athenæ Oxon.*]

[49] *The* LIBRARY.[xxi]

56. THIS Room is twenty-one Feet and half, by twenty-two and half. Over the Chimney is a whole Length, by Sir *Godfrey Kneller*, of King *George* I. in his Coronation-Robes, the only Picture for which he ever sat in *England*.

The LITTLE BED-CHAMBER.[xxii]

57. THIS Room is all wainscoted with Mahogany; and the Bed, which is of painted Taffaty, stands in an Alcove of the same Wood. Over the Chimney is a half Length, by *Dahl*, of *Catharine Shorter*, first Wife of Sir *Robert Walpole*, and eldest Daughter of *John Shorter*, Esq; of *Bybrook* in *Kent*, by *Elizabeth* Daughter of Sir *Erasmus Phillips* of Picton-castle in *Pembrokeshire*. This is an exteme good Portrait.

58. On the other Side, a Portrait of *Maria Skerret*, second Wife to Sir *Robert Walpole*, three quarters, by *Vanloo*.

[50] *The* LITTLE DRESSING-ROOM.[xxiii]

59. A Landscape by *Wootton*, in the Stile of *Claude Lorrain*, over the Chimney.

The BLUE DAMASK BED-CHAMBER[xxiv]

Is of the same Dimensions with the Library, and is hung with Tapestry. Chimney, Sir *Robert Walpole*, afterwards Earl of ORFORD, Prime Minister to King *George* I. and to King *George* II.

> *Quem neque Tydides, nec Larissœus Achilles,*
> *Non Anni domuere Decem.*

He built this House, and made all the Plantations and Waters here. A whole

60. Length, in the Garter-Robes, by *Vanloo*.

The DRAWING-ROOM[xxv]

Is thirty Feet by twenty-one, and hung with yellow Caffoy. The Cieling is exactly taken, except with the Alteration of the Paternal Coat for the Star and Garter, from one that was in the Dining-Room of the old House, built by Sir *Edward Walpole*, Grandfather to Sir *Robert*.

xxi Sir Matthew Decker in 1728 described the effect of RW's Library 'in which are many valuable books bound, and so neatly and well placed that it makes a perfect picture'. Although a relatively small room in one of the corner towers of the house, the effect is well proportioned, ordered and imposing. The bindings of the books are designed to echo and enhance the architecture of the room. The mahogany presses fill an arched recess, which is in turn flanked by 'pilasters' of gilt spines: the whole ensemble mirrors the window opposite, with its external Palladian style. The bookshelves are all finely carved with architectural detail. The whole ensemble is an impressive record of the finer turn of RW's mind. The books themselves were a scholarly if conventional collection and included a number from the collection of RW's father. They were almost certainly consulted by HW as he prepared his catalogue of his father's collection while away from his own early and growing book collection. The Library was dominated by Kneller's full-length portrait of George I, which remains there today, in a heavy Kentian frame (*Aedes* 2002, no. 56).

xxii The Little Bed Chamber was RW's own bedchamber which, like the Library, is still entirely lined with mahogany, this time with ionic pilasters. In 1732 the Earl of Oxford described RW's bedroom with some disdain: 'I took notice of Sir Robert's own bedchamber; the bed shut up in a box, a case made of mahogany with glass, as if it was a cabin.' By 1745 a painted taffeta bed had replaced the 'great damask bed' that Sir Matthew Decker had seen in 1728. This relatively plain room was at first enlivened by the single portrait by Dahl of RW's first wife, Catherine Shorter (*Aedes* 2002, no. 57), over the grey-and-white marble chimneypiece. This was joined by Van Loo's sensitive portrait of Maria Skerrett (*Aedes* 2002, no. 58), presumably shortly after the early death of Maria.

xxiii The Little Dressing Room formed the closet to the main family apartment on the principal floor and by comparison with RW's Bed Chamber has a lighter touch in its decorative elements, with Corinthian pilasters and painted wainscoting. The selection of a landscape by John Wootton (*Aedes* 2002, no. 59) as the single painting for this private room is a telling tribute to the esteem in which RW held the artist.

xxiv The Blue Damask Bed-Chamber, a rather larger room in comparison with the preceding rooms in the suite, was directly accessible from the Saloon and the state apartments. In consequence the room, in the south-west corner of the house, was decorated with some gilding to the architectural elements. Should an approach be made to visit RW from the state apartments Vanloo's grand whole length portrait of RW in garter robes (*Aedes* 2002, no. 60) greeted the visitor, announcing that this was no longer a purely private room. This was the route Sir Matthew Decker took on his visit in 1728 and it was here that he spent the night: 'out of the salon on the left hand, you come in a handsome drawing room, and from thence is a fine bedchamber, hung with a good tapestry of the seasons of the year; a blue damask bed, Sir Robert's picture … and in this room stands the costly chair wherein the present Queen was crowned. Here I had the honour to lay, and on the side of the house next to this, is a dressing room and a little room for a servant to lay'. In addition to the blue hangings of the bed , there were blue case curtains and the 1745 inventory records at that moment a table, two stands, a looking glass, an India cabinet, an inlaid cabinet, ten chairs and a stool.

xxv HW precisely describes the Drawing Room (on the West Front), the principal family room on the piano nobile. Despite its family ambience it was clearly a room with formal pretensions, with a significant emphasis upon RW's official position and the future of the family as represented by the Walpole children, rather than any emphasis upon the past. The white stucco ceiling bears the Garter Star at its centre, an instant reminder that RW had been the first commoner to receive the Garter in recent times. The Wharton Van Dyck portraits were hung on yellow caffoy damask, a woollen and silk material of a

xxv cont.

lesser quality than the silk used in the state apartment. It is possible that the room was designed in tandem with the purchase of this collection in 1725. George Vertue records seeing eleven Van Dycks from Lord Wharton's collection (bought by RW) in the workshop of John Howard the framer and these could well have been framed up for their new setting. The portrait of Lord Wharton's two daughters held centre stage over the fireplace, while the prime Van Dyck full lengths hung on either side of them. On the opposite wall above a settee were grouped the pastel portraits of RW's children (nos 72–76), while the two large works by Luca Jordano completed a classic collection ambience of mythological painting and court portraiture (1744 MS (HRO)). In 1745 the furniture comprised a marble-topped, giltwood pier table and glass, a suite of yellow caffoy –upholstered chairs, settees and a couch, a card table, a pair of curtains and a chandelier hanging from the centre of the Garter Star: all suitable accompaniments to an evening of informal diversion.

xxvi 'This Lord in his youth was handsome & a beau; in the Civil War he sided with the Parliament & had a Regiment of Horse, but his Courage was called in question. He left the House when the last violences were determined against the King, but was one of Oliver's Privy Council & Peers, & narrowly escaped being excepted in the general Act of Indemnity, tho he expended some thousand p[oun]ds to make a figure in the cavalcade at the King's Restoration, in particular having Diamond buttons to the mourning which He was then wearing for his second wife. He was committed to the Tower with the D of Bucks & Ld Shaftesbury on their asserting the Dissolution of the Long Parliament, but his ch[ie]f merits were a patriot [?] by which he procur'd the passing the Habeas Corpus Act, being one of the Tellers in the House of Lords, when he outwitted his partner and gave in a false majority and by preparing for an Abrogation [?] of the old Oaths of Allegiance, & substituting the present plain oath in their stead. He was one of the first that appear'd for the Revolution, & died in 1694. He laid out a large sum at Woburn in Buckinghamshire, & made the fine collection of Vandyke's & Lely's, which were removed to Winchendon by his son the Marquis of Wharton, & sold to Sr Robert Walpole by the late Duke his grandson. Vide Memoirs of the Life of [?] of Wharton.' HW MS (PML).

xxvii 'Sir Christopher Wandesford, Head of the Castlecomer Family; Lord Deputy of Ireland in 1640, in which year he died…'. HW MS (PML).

xxviii 'Philadelphia. Daught. Of Robert Carey, Earl of Monmouth, wife of Sr Thomas Wharton'. HW MS (PML).

xxix 'He was created Knight of the Bath in August 1753'. HW MS (PML).

xxx HW MS (PML). 'Mr Walpole did afterwards find a small head of her in crayons, now at Strawberry Hill'. HW MS note in his 1767 edition of the *Aedes*, subsequently owned by William Frederick, 9th Earl of Waldegrave (now Lewis Walpole Library).

61. [51] Over the Chimney is a genteel Bust of a *Madonna* in Marble, by *Camillo Rusconi*.

62. Above, is Carving by Gibbins, gilt, and within it a fine Picture by *Vandyke*, of two Daughters of Lord *Wharton*, out of whose Collection these came, with all the other *Vandykes* in this Room, and some others at Lord *Walpole's* at the Exchequer. Five Feet four Inches high, by four Feet three wide.

63. The Judgment of *Paris*, by *Luca Jordano*. There is an odd Diffusion of Light all over this Picture: The *Pallas* is a remarkably fine Figure. Eight Feet high, by ten Feet eight and a quarter wide.

64. A sleeping *Bacchus*, with Nymphs, Boys, and Animals; its Companion.

65. King *Charles* I. a whole Length, in Armour, by *Vandyke*. By a Mistake, both the Gauntlets are drawn for the Right Hand.★

66. *Henrietta Maria* of *France*, his Queen, by ditto.

67. Archbishop *Laud*, the Original Portrait of him; three Quarters, by *Vandyke*. The University of Oxford once offered the *Wharton* Family Four Hundred Pounds for this Picture.

68. [52] *Philip* Lord *Wharton*, three Quarters, by *Vandyke*.xxvi

69. Lord Chief Baron *Wandesford*,xxvii Head of the *Castlecomer* Family; three Quarters, sitting, by *Vandyke*.

70. Lady *Wharton*,xxviii three Quarters, by Ditto.

71. *Jane* Daughter of Lord *Wenman*; Ditto. The Hands, in which *Vandyke* excelled, are remarkably fine in this Picture.

72. *Robert* Lord Walpole. eldest Son to Sir *Robert Walpole*, by *Catharine* his first Wife; a Head in Crayons, by *Rosalba*. He succeeded his Father in the Earldom, and died in 1751, being Knight of the Bath, Auditor of the Exchequer, and Master of the Fox-Hounds to the King.

73. *Edward Walpole*,xxix second Son to Sir *Robert Walpole*, ditto.

74. *Horace Walpole*, third Son to Sir *Robert Walpole*, ditto.

75. *Mary* Lady Viscountess *Malpas*, second Daughter to Sir *Robert Walpole* by his first Wife, and married to *George* Lord *Malpas*, Master of the Horse to *Frederick* Prince of *Wales*, and Knight of the Bath; afterwards Earl of *Cholmondeley*, and Chancellor of the Dutchy of *Lancaster*, and Lord Privy Seal. She died of a Consumption at *Aix* in *Provence*, Ætatis suæ 29. A Profile Sketch, by *Jervase*.

N.B. There is no Portrait [here]xxx of Catharine Walpole, eldest Daughter to Sir Robert Walpole, who died at Bath of a Consumption, Ætatis suæ 19.

★HW: When the Picture was in the *Wharton* Collection, old *Jacob Tonson*, who had remarkably ugly Legs, was finding Fault with the two Gauntlets; Lady *Wharton* said, Mr. *Tonson*, why might not one Man have two Right Hands, as well as another two Left Legs?

76. Lady *Maria Walpole*, only Child to Sir *Robert Walpole* Earl of *Orford* by *Maria* his second Wife, married to *Charles Churchill*, Esq; in Crayons, by *Pond*.

[53] *The* SALON^{xxxi}

Is forty Feet long, forty high, and thirty wide; the Hanging is Crimson flower'd Velvet; the Cieling painted by *Kent*, who design'd all the Ornaments throughout the House. The Chimney-piece is of Black and Gold Marble, of which too are the Tables.

77. In the broken Pediment of the Chimney stands a small antique Bust of a *Venus*;

78. and over the Garden-Door is a larger antique Bust.

79. On the great Table is an exceeding fine Bronze of a Man and Woman, by *John* of *Boulogne*. When he had made the fine Marble Groupe of the Rape of the *Sabine* in the *Loggia* of the *Piazza del Gran Duca* at *Florence*, he was found Fault with, for not having exprest enough of the Softness of the Woman's Flesh, on which he modell'd this, which differs in it's Attitudes from the other, and has but two Figures; but these two are Master-pieces for Drawing, for the Strength of the Man, and the tender Delicacy of the Woman. This Bronze was a Present to Lord *Orford* from *Horace Mann*, Esq; the King's Resident at *Florence*.

80. 81 On the other Tables are two Vases of Oriental Alabaster.

82. Over the Chimney, Christ baptized by St. *John*, and most capital Picture of *Albano*. His large Pieces are seldom good, but [54] this equal both for Colouring and Drawing to any of his Master *Caracci*, or his Fellow-Scholar *Guido*. It is eight Feet eight Inches high, by six Feet four and a half wide. There is one of the same Design in the Church of *San Giorgio* at *Bologna*, with an Oval Top, and God the Father in the Clouds, with different Angels; two are kneeling, and supporting *Christ*'s Garments. The Picture belong'd to Mr. *Laws*, first Minister to the Regent of *France*.

83. The Stoning of St. *Stephen*; a capital Picture of *Le Sœur*. It contains nineteen Figures, and is remarkable for expressing a most Masterly Variety of Grief. The Saint, by a considerable Anachronism, but a very common one among *Roman* Catholics, is drest in the rich Habit of a modern Priest at high Mass. Nine Feet eight Inches and a half high, by eleven Feet three and three quarters wide.

84. The Holy Family, a most celebrated Picture of *Vandyke*. The chief Part of it is a Dance of Boy-Angels, which are painted in the highest Manner. The *Virgin* seems to have been a Portrait, and is not handsome; it is too much crowded with Fruits and Flowers and Birds. In the Air are two Partridges finely painted. This

xxxi The Salon, or Saloon, was the largest and most splendid of the parade rooms at Houghton. Lord Hervey saw the room virtually complete in 1731: ' Behind the hall is the salon, finished in a different taste, hung, carved and gilt large glasses between the windows, and some of his finest pictures round the three other sides of the room.' Hervey was right to find the style of this room dramatically different from that of the bare stone Hall. The grandeur of this room was one of scale, but also the decoration was rich in every visible detail. The wall covering was (and—remarkably—still is) of crimson caffoy, a cut and uncut velvet made of wool in silk, richer in effect than that in the Drawing Room. This material had been supplied by Thomas Roberts, the second royal craftsman so named, between April 1729 and January 1730, at a cost of £118: 18s.

William Kent had begun his overall design plan for the Saloon in 1725. His two highly finished design proposals for the elevations of the north and south walls (private collection) demonstrate the integral nature of his plans in common with his approach to decorative schema throughout Houghton. His original proposal was altered to reflect RW's newly honoured status by including the Star and Garter in the stucco work and to incorporate medallions of Neptune and Cybele (the Earth Mother) and the Four Seasons. The ceiling is painted in his 'mosaic' manner, in imitation of ancient Roman decorative schemes. In the heavily gilded the Moon Goddess depicted in the frieze. The paintings chosen to complement this scheme were mostly New Testament subjects, admired more for their Italian style than their religious piety, and also two mythological scenes (*Aedes* 2002, nos. 94, 95).

The furnishings of this room complete the scheme. The mahogany joinery is part gilded, black-and-gold marble is used for the chimneypiece and table slabs and the seat furniture is covered in caffoy identical to that on the walls. In 1745 the room was relatively sparsely furnished: besides the seating there were giltwood wall lights and torchères.

xxxii 'It belonged originally to Charles Ist & is mentioned in the cat-
alogue of his pictures p. 171. There is a fine print of it'. HW MS
(PML). HW was presumably referring to the print by Martinus van
Enden after Bolswert's copy of *Aedes* 2002, no.84 stuck down in his
MS version of the *Aedes* (HW MS (Met), folio 40).

xxxiii 'It was Monsieur de Morville's & had belonged to Monsr
Bourvalais, a Financier, who bought it from the collection of Monsr
Cormoy [?], a Fermier General. It is engraved. See Descript de Paris.
Vol I. P. 226 Edit. of 1706' HW MS (PML). HW's print was 'Pet Paul
Rubens Pinxit Michael Natalis sculpsit Abraham Depenbeke excudit
Antwerpia', plate size 423 x 502 mm. HW MS (Met).

xxxiv 'Lord Egremont has another of these & Ld Exeter another.'
HW MS (PML).

xxxv '[Mr Gideon has lately receiv'd deleted] Sr Sampson Gideon
has another [from Spain deleted] in which the virgin is much older
than in this at Houghton, but finely painted: the boys are fewer and far
inferior and one corner is too destitute of objects. There is a half moon
revers'd under the feet of the Virgin.' HW MS (PML).

Picture was twice sold for Fourteen Hundred Pounds: Since that, it belonged to the House of *Orange*. The Princess of *Friesland*, Mother to the present Prince of *Orange*, sold it during his Minority, when Sir *Robert* brought it. 'Tis seven Feet and [55] half an Inch high, by nine Feet one and three quarters wide.xxxii

85. *Mary Magdalen* washing *Christ*'s Feet; a capital Picture of *Rubens*, finished in the highest Manner, and finely preserved. There are fourteen Figures large as Life. The *Magdalen* is particularly well coloured. Six Feet and three quarters of an Inch high, by eight Feet two wide. It was Monsieur de *Morville*'s.xxxiii

86. The Holy Family in a Round, by *Cantarini*. The Child is learning to read. Three Feet six Inches every way.

87. The Holy Family, by *Titian*. It belonged to Monsieur de *Morville*, Secretary of State in *France*. Four Feet seven Inches and a half high, by three Feet four and a half wide.

88. *Simeon* and the Child; a very fine Picture of *Guido*. The Design is taken from a Statue of a *Silenus* with a young *Bacchus*, in the *Villa Borghese* at *Rome*. This was in Monsieur de *Morville*'s Collection. Three Feet two Inches and a half high, by two Feet seven and a half wide. There is another of these, but much less finished, in the Palace of the Marquis *Gerini* at *Florence*.

89. The *Virgin* with the Child asleep in her Arms, by *Augustine Caracci*. Three Feet six Inches high, by two Feet nine and three quarters wide.

90. [56] An old Woman giving a Boy Cherries, by *Titian*. It is his own Son and Nurse, four Feet ten Inches high, by three Feet six and three quarters wide.

91. The Holy Family, by *Andrea del Sarto*.xxxiv This and the last were from the Collection of the Marquis *Mari* at *Genoa*. Three Feet one Inch and a quarter high, by two Feet seven and a quarter wide.

92. The Assumption of the *Virgin*;xxxv a beautiful Figure supported by Boy-Angels, in a very bright Manner, by *Morellio*. Six Feet four Inches and three quarters high, by four Feet nine and half wide.★

93. The Adoration of the Shepherds, its Companion: All the Light comes from the Child.

94. The *Cyclops* at their Forge, by *Luca Jordano*. There is a Copy of this at St. *James*'s, by *Walton*. This belong'd to *Gibbins*. Six Feet four Inches high, by four Feet eleven wide.

★ HW: The Duke of *Bedford* has a large Picture like this, except that it wants the Virgin, by the same Hand, brought out of *Spain* by Mr. *Bagnols*, from whose Collection the Prince of *Wales* bought some fine Pictures. ['I call it the Ascension of our Saviour & have Ld. Orford's Authority for it; but tis commonly call'd the Assumption of the V. Mary tho' indeed ye Figure is too young for either' (1744 MS HRO, note not by HW)].

95. *Dædalus* and *Icarus*, by *Le Brun*. In a different Manner from what he generally painted. Six Feet four Inches high, by four Feet three wide. For the Story, see it twice told in *Ovid's Metamorphosis*, Lib. 8. andLib. 2. *de Arte Amandi*.

[57] *The* CARLO MARATT *Room*xxxvi

96 IS thirty Feet by twenty-one. The Hangings are Green Velvet,

–98. the Table of Lapis Lazuli; at each End are two Sconces of massive Silver.

99. Over the Chimney is ★*Clement* the Ninth,xxxvii of the *Rospigliosi* Family; three quarters sitting, a most admirable Portrait, by *Carlo Maratti*. It was bought by *Jervase* the Painter out of the *Arnaldi* Palace at *Florence*, where are the remains of the great *Pallavicini* Collection, from whence Sir *Robert* bought several of his Pictures. Nothing can be finer than this, the Boldness of the Penciling is as remarkable as his Delicacy in his general Pictures, and it was so much admired, that he did several of them; one is at Lord *Burlington*'s at *Chiswick*.

100. The Judgment of *Paris*, drawn by *Carlo Maratti*, when he was eighty-three Years old, yet has none of the Rawness of his latter Pieces; the Drawing of the *Juno* is very faulty, it being impossible to give so great a turn to the Person as he has given to this Figure; it came out of the *Pallavicini* Collection. The Earl of *Strafford* has a very good Copy of it, by *Gioseppe Chiari*. Five Feet nine Inches and three quarters high, by seven Feet seven and a quarter wide.xxxviii

101. [58] *Galatea* sitting with *Acis, Tritons* and *Cupids*; its Companion. Five Feet eight Inches and three quarters high, by seven Feet seven and a half wide.

102. The Holy Family, an unfinish'd Picture, large as Life, by *Carlo Maratti*, in his last Manner. Three Feet two Inches and three quarters high, by two Feet eight and a quarter wide.

103. The *Virgin* teaching *Jesus* to read, by *Carlo Maratti*. Two Feet three Inches and a quarter high, by one Foot ten and a quarter wide. *Gioseppe Chiari* has executed this Thought in the *Barberini* Palace at *Rome*, but with Alterations. In this the *Virgin* is in Red. *Gioseppe*'s is in White, and instead of St. *John*, St. *Elizabeth*, and the Angels, he has drawn a Cardinal reading.

104. St. *Cæcilia* with four Angels playing on Musical Instruments,xxxix Companion to the former.

> *Or drest in Smiles of sweet CÆCILIA, shine*
> *With simp'ring Angels, Palms and Harps divine.*
> POPE.

★ HW: He was a Poet. See an account of him in the *Sidney* Papers published by *Collins*. Vol. II. page 714. and *Firmani's Seminar. Roman.* Pag[e] 189.

xxxvi This room was also known as the Green Velvet Drawing Room, after the upholstery, in inventories made after RW's death. HW's title reflects both his and RW's esteem for Carlo Maratti and the fact that works by the artist and his followers and contemporaries dominated the room. RW's taste for Maratti was shared by collectors and connoisseurs across Europe in the artist's lifetime and immediately after the artist's death in 1713. The room acts as the ante-room to the State Bedchamber in the north-west corner of the house and Kent's decorative imagery introduces the theme of Love, which is carried on throughout the rest of the apartment. In this setting some of the religious subjects might seem out of place, but this is typical of the response Roman Catholicism received when mirrored in paintings at this time (see 'A Sermon on Painting'). The ceiling is divided into polygonal compartments with decorative beams, a putto's head at each angle. In the borders the principal pagan deities offer their attributes towards Venus, seated in her shell at the centre. Kent's decorative scheme is inspired by ceiling designs from sixteenth- and seventeenth-century drawings taken from ancient Roman houses. Venus's scallop shell also features on the green velvet-upholstered chairs. In 1731 Lord Hervey saw the room in progress: 'the furniture is to be green velvet and tapestry, Kent designs of chimneys, the marble gilded and modern ornaments. Titian and Guido supply those that are borrowed from antiquity'.

xxxvii 'He was Nuncio at Madrid, when the 6 Royalists, who had murdered Ascham, Parliament's [?]Resident, were taken out of sanctuary, and insisted upon their being redelivered, which he prevailed upon the bigoted King to order. Five of them, Catholics, were suffered to escape; the sixth, a Protestant, was so wretched, that He was retaken on his Flight and put to death. v. Peck's Desid. Curios lib.12. p.2.' HW MS (PML). 'Given by Card Fleury to Ld. Orf.' 1744 MS (Herts).

xxxviii 'It was engraved by Giacomo Freei' HW MS (PML).

xxxix 'It has been engraved by Strange, but He has not preserved the extreme beauty of the faces.' HW MS (PML).

These two last are most perfect and beautiful Pictures in his best and most fin-ish'd Manner, and were in the *Pallavicini* Collection.

105. [59] The Assumption of the *Virgin*, by *Carlo Maratti*. She has a blue Veil all over her. Two Feet three Inches and three quarters high, by one Foot ten and a quarter wide.

106. The *Virgin* and *Joseph* with a young *Jesus*, a fine Picture, by *Carlo Maratti*, in the Manner of his Master *Andrea Sacchi*. Two Feet five Inches and a quarter high, by two Feet wide.

107. The Marriage of St. *Catharine*, by *Carlo Maratti,* two Feet seven Inches high, by one Foot ten and a half wide.

108. Two Saints worshiping the *Virgin* in the Clouds, by *Carlo Maratti*. Two Feet three Inches and a half high, by one Foot nine and a half wide.

109. St. *John* the Evangelist, its Companion.

110. A naked *Venus* and *Cupid* , by *Carlo Maratti,* in a very particular Stile. Three Feet one Inch and a half high, by four Feet four and a half wide.

111. The Holy Family, by *Nicholo Beretoni, Carlo*'s best Scholar: This Picture is equal to any of his Master's. The Grace and Sweetness of the *Virgin*, and the Beauty and the Drawing of the young *Jesus*, are incomparable. Three Feet one Inch and a half high, by four Feet four and a half wide.

112. The Assumption of the *Virgin*, by ditto. Two Feet two Inches and a half high, by one Foot eight and a half wide.

113. [60] The Pool of *Bethesda*, by *Gioseppe Chiari*, another of *Carlo's* Scholars. Three Feet three Inches high, by four Feet five wide.

114. *Christ*'s Sermon on the Mount, ditto.

115. *Apollo* and *Daphne*, ditto.

116. *Bacchus* and *Ariadne*, ditto, the best of the Four; the *Bacchus* seems to be taken from the *Apollo Belvedere*, as the Ideas of the *Ariadne*, and the *Venus*, evidently are from the Figures of Liberality and Modesty in the famous Picture of *Guido*, in the Collection of Marquis del *Monte* at *Bologna*. There are Four Pictures about the Size of these in the *Spada* Palace at *Rome*, by the same Hand; two, just the same with these two last, the other two are likewise Sto-ries out of the Metamorphosis.

117. *Apollo*, in Crayons, by *Rosalba*. Two Feet two Inches high, by one Foot eight wide.

118. *Diana*, its Companion.

119. A profile Head of a Man, a Capital Drawing, in a great Stile, by *Raphael*.

120. A profile Head of St. *Catharine*, by *Guido*

121. The Birth of the *Virgin*, by *Luca Jordano*. Two Feet one Inch high, by one Foot

and a quarter of an Inch wide.

122. The Presentation of the *Virgin* in the Temple, its Companion. These two are finish'd Designs for two large Pictures, [**61**] which he painted for the fine Church of the *Madonna Della Salute* at *Venice*.

123. The Flight into *Egypt,* by *Morellio*, in the manner of *Vandyke*. Three Feet two Inches and a quarter high, by one Foot eleven and a quarter wide.

124. The Crucifixion, its Companion.

125. *Hercules* and *Omphale*, by *Romanelli*. Three Feet one Inch and half high, by four Feet three Inches wide.

The VELVET BED-CHAMBER^{xl}

Is twenty-one Feet and half, by twenty-two Feet and half, the Bed is of Green Velvet, richly embroider'd and laced with Gold, the Ornaments designed by

126. *Kent*; the Hangings are Tapestry, representing the Loves of *Venus* and *Adonis*, after *Albano*.

127. *Alexander* adorning the Tomb of *Achilles*, by *Le Mer*. The Subject is taken from the Fourth Chapter of the Second Book of *Quintus Curtius*. Achillem, *cujus origine* (Alexander) *gloriebatur, imprimis mirari solitus, etiam circum cippum ejus cum amicis nudus decucurrit, unctoque coronam imposuit.* The Head of *Alexander* is taken from his Medals, the Figures are in the true Antique Taste, and the Buildings fine. Eight Feet two Inches and three quarters high, by five Feet two and a half wide.

128. [**62**] Over one of the Doors, a Sea-port, by old *Griffier*. Three Feet two Inches and half high, by four Feet one Inch wide.

129. A Landscape over the other Door, by ditto.

The DRESSING-ROOM^{xli}

130. Is hung with very fine gold Tapestry after Pictures of *Vandyke*. There are Whole-Length Portraits of *James* the First, Queen *Anne* his Wife, Daughter to *Frederick* the Second King of *Denmark*, *Charles* the First, and his Queen, and *Christian* the Fourth King of *Denmark*, Brother to Queen *Anne*; they have fine Borders of Boys with Festoons, and Oval Pictures of the Children of the Royal Family. At the upper end of this Room is a Glass Cafe filled with a large Quantity of

131. Silver Philegree, which belong'd to *Catharine* Lady *Walpole*.

132. Over the Chimney, the consulting the *Sibylline* Oracles, a fine Picture, by *Le Mer*;

xl The Velvet Bed Chamber is dedicated to Venus, Goddess of Love and Sleep, a theme expressed in the ceiling, the frieze, the tapestries (see *Aedes* 2002, no. 126), and the design of the green velvet bed. The ceiling is here painted in colours rather than in grisaille and shows Aurora Rising. Cupid heads appear, this time with wings, in both the frieze and the chimneypiece. The tapestries were evidently commissioned for the room and fit exactly and only a single overmantle painting and two overdoors were necessary to complete the scheme. Kent's State Bed in green velvet consists of a canopy in the form of an architectural entablature with a deep fringe of gold and silver lace and a pedimented bedhead in the form of a double shell, turning it into Venus's triumphal car. The 1732 bill from the suppliers of the trimmings survives: Turner, Hill and Pitter charged the princely sum of £1219.3s.11d.

xli This room is entirely characterised by the Mortlake tapestries, believed to have been acquired by RW's father for the old Hall (see *Aedes* 2002, no. 130). The painting by Jean Le Maire was deliberately hung as a companion to Alexander adorning the tomb of Achilles (see *Aedes* 2002, no. 127) by the same artist in the adjacent Velvet Bed-Chamber. Kent's painted ceiling represents Spring (or Flora), while the windows were hung with 'Two rich green Velvet hang down Window Curtains lined with green silk and trimmed with gold lace Valens, fringed' (1792 MS Houghton). A gilt-gesso side table with a mirrored glass top bore RW's arms.

xlii There is a small lobby between the Dressing Room and the Embroidered Bed Chamber, which leads to a service stair. The bed of oriental needlework must have been ordered soon after the Garter had been conferred upon RW: it was at Houghton in time for the Duke of Lorraine's visit in 1731. The hangings, of Indian manufacture, were specially designed for the bed and not simply cut for it (John Cornforth op.cit.). The backcloth displays the Walpole arms, while the curtains are worked with trees of life, flowers and birds. The chairs too were (and are) covered in green velvet. Kent's ceiling depicts, in the central panel, the story of Luna with the shepherd Endymion, and the design appears as a night canopy, with owls and bats against a dark ground. The overmantel displayed one of RW's prized Poussins (see *Aedes* 2002, no. 136).

xliii 'There is a print of it.' HW MS (PML). HW's print inscribed 'ALILLma. MIA SIGra ET PADRONA COLLma LA SIGra THODORA DAL POZZO DDD Nicolaus Poussin Inventor Giovanni Dughet', plate size 329 x 251 mm. HW MS (Met), folio 47.

Companion to that in the Bed-Chamber, the Architecture of this is rather the better. The Painter has mistaken, and represented a large Number of Books; whereas the Histories say, that when the *Sibyl* offer'd them at first to *Tarquinius Superbus*, there were but Nine, and on his Twice refusing them, she burnt Six, and then made him pay the first demanded Price for the [**63**] remaining Three, which were kept in a Stone Vault with the greatest Care; and only consulted on extraordinary Occasions, by two of the Nobility who had the Charge of them. This Number in Time of the Commonwealth was encreased to Ten, and in *Sylla's* Time, the last Time they were consulted, to Fifteen. The Year before his Dictatorship, the Capitol was burnt, and they with it. There were some dispers'd *Sibylline* Oracles afterwards collected, but never much credited, which remain'd to the Reign of *Honorius*, when *Stilicho* burnt them.[*] There is an Anacronism in this Picture, which may be pardoned in a Painter: He has thrown in among the Buildings, the Septizonium Severi; now *Sylla's* Dictatorship began in the Year 672 U.C. and *Severus* did not begin his Reign till 945 U.C. or 193 A.D.

133. Over the Door, Dogs and Still Life, by *Jervase*.

134. Over the Door; its Companion.

[64] *The* EMBROIDER'D BED-CHAMBER.[xlii]

135. THE Bed is of the finest Indian Needle-work. His Royal Highness *Francis* Duke of *Lorrain*, afterwards Grand Duke of *Tuscany*, and since Emperor, lay in this Bed, which stood then where the Velvet one is now, when he came to visit Sir *Robert Walpole* at *Houghton*. The Hangings are Tapestry.

136. Over the Chimney, the Holy Family, large as Life, by *Nicolo Poussin*. It is one of the most Capital Pictures in this Collection, the Airs of the Heads, and the Draperies are in the fine Taste of *Raphael*, and the Antique, *Elizabeth's* Head is taken from a Statue of an old Woman in the *Villa Borghese* at *Rome*, the Colouring is much higher than his usual manner; the *Virgin's* Head and the young *Jesus* are particularly delicate. Five Feet seven Inches high, by four Feet three and three quarters wide.[xliii]

137.138. Over the Doors, Two pieces of Cattle, by *Rosa di Tivoli*.

[*] HW: In the Reign of *Tiberius*, an Act passed in the Senate at the Motion of one of the Tribunes, to add a Book to the *Sibylline* Oracles, at the Request of *Caninius Gallus*, one of the *Quindecim Viri*. The Emperor reprimanded the Fathers, and told them, that *Augustus, quia multa Vana sub nomine celebri vulgabantur, sanxisse,quem intra Diem ad Prætorem Urbanum deferrentur, neque habere privatim liceret.* He added, *à Marjoribus quoque decretum erat, post exustum sociali Bello Capitolium, quæsitus Samo, Ilio, Erythris, per Africam etiam ac Siciliam, et Italicas Colonias, Carminibus Sibyllæ (Una, seu plures suere) datoque Sacerdotibus negotio, quantum humanâ ope potuissent, Vera discernere.* Tacit. Ann. 6. 12. It is probable that *Tiberius's* Strictness on this Subject proceeded from his Apprehensions of the People being excited by Prophecies to rebel against him; he having but a little Time before put several Persons to Death for publishing a Prediction that he had left *Rome* in such a Conjunction of the Planets as for ever to exclude his Return, *Ann. 4. 58.*

The CABINET[xliv]

xliv Kent's ceiling shows Minerva, with the Walpole arms on her shield, crushing Envy. She surveys RW's prized cabinet pictures, the choicest jewels in the collection. The Cabinet underwent a series of rehangs as RW increased the size and quality of his collection, primarily after the influx of paintings from Downing Street just prior to HW's writing of the *Aedes*. The largest painting in the room was *Hélène Fourment* (see *Aedes* 2002, no. 139), in a giltwood overmantel the design of which echoed Kent's marble fireplace. The surviving hanging plan for this room reveals a strongly architectural approach which mirrors that adopted for the book collection in the Library on the opposite corner of the piano nobile.

139. Is twenty-one Feet and a half, by twenty-two and a half, hung with Green Velvet. Over the Chimney is a celebrated Picture of *Rubens*'s Wife, by *Vandyke*; it was [65] fitted for a Pannel in her own Closet in *Rubens*'s House. She is in black Sattin with a Hat on, a whole Length; the Hands and the Drapery are remarkably good.

140. *Rubens*'s Family, by *Jordano* of *Antwerp*; *Rubens* is playing on a Lute, his first Wife is sitting with one of their Children on her Lap, and two others before her. There are several other Figures, and Genii in the Air. Five Feet nine Inches high, by four Feet five Inches and a half wide; this Picture belong'd to the Duke of *Portland*.

141. A Winter-Piece, by *Giacomo Bassan*. Three Feet eight Inches and a half high, by five Feet eleven and three quarters wide.

142. A Summer-Piece, by *Leonardo Bassan* . Three Feet eight Inches and a half high, by five Feet eleven and three quarters wide. These two were in the Collection of *Monsieur de la Vrilliere*.

143. Boors at Cards, by *Teneirs*. One Foot four Inches high, by one Foot ten wide.

144. *Christ* appearing to *Mary* in the Garden, an exceeding fine Picture, by *Pietro da Cortona*. One Foot nine Inches and a half high, by one Foot eight Inches wide.

145. The Judgment of *Paris*, by *Andrea Schiavone*.
 Note, That all the Pictures in this Room, except the Portraits, that have not the Sizes set down, are very small.

146. *Midas* judging between *Pan* and *Apollo*, by ditto.

147. [66] *Christ* laid in the Sepulchre, one of the finest Pictures that *Parmegiano* ever painted, and for which there is a Tradition, that he was knighted by a Duke of *Parma*; there are eleven Figures; the Expression, the Drawing and Colouring, the Perspective, and *Chiaro Scuro*, are as fine as possible. The Figure of *Joseph* of *Arimathea* is *Parmegiano*'s own Portrait; there are two Drawings in the Grand Duke's Collection for this Picture, but with variations from what he executed: In one of these, *Joseph* has his Hands extended like *Paul* preaching at *Athens*, in the Cartoon of *Raphael*; there have been three different Prints made of this Picture, and the Drawings for it.

148. The Adoration of the *Magi*, by *Velvet Brueghel*; there are a Multitude of little Figures, all finished with the greatest *Dutch* exactness; the Ideas too are a little *Dutch*, for the *Ethiopian* King is drest in a Surplice with Boots and Spurs, and brings for a Present a Gold Model of a Modern Ship.

xlv 'In four different mss of Vertue, I find that this picture belonged to Richardson, and is certainly the portrait of Vanderdost, Keeper of King Charles's pictures, & who, on having mislaid a fine small picture and not being able to find it when asked for it by the King, hanged himself. v. Sanderson's Graphice.' HW MS (PML).

xlvi 'There is another of these at Burleigh.' HW MS (PML).

xlvii 'There is a half length at Chiswick of the same Pope by the same painter. In Howel's letters are the following particulars relating to this Pope; "among others pasquils this was one Papa magis amat olympian quam olympiem". Lett 48. Book 4th and afterwards "Tis true he is one of the most favoured Popes that sat in the chair a great while, so that some call him L'Uomo di tre pele, the man with three hairs, for he hath no more beard upon his chin."' HW MS (PML).

149. The *Virgin* and *Child*, a very pleasing Picture, by *Baroccio*, but the Drawing is full of Faults.

150. Naked *Venus* Sleeping, a most perfect Figure, by *Annibal Caracci*; the Contours and the Colouring excessively fine.

151. Head of *Dobson's* Father, by *Dobson*.[xlv]

152. [67] St. *John*, a Head, by *Carlo Dolci*.[xlvi]

153. Head of *Innocent* the Tenth, by *Velasco*;[xlvii] he was sent by the King of *Spain* to draw this Pope's Picture; when the Pope sent his Chamberlain to pay him, he would not receive the Money, saying the King his Master always paid him with his own Hand: The Pope humour'd him. This Pope was of the *Pamphilii* Family, was reckoned the ugliest Man of his Time, and was rais'd to the Papacy by the Intrigues of his Sister-in-law *Donna Olimpia*, a most beautiful Woman and his Mistress. ★

154. A Boy's Head with a Lute, by *Cavalier Luti*.

155. Friars giving Meat to the Poor, by *John Miel*. One Foot seven Inches and a half high, by two Feet two Inches wide.

156. Its Companion.

157. [68] A dying Officer at Confession, by *Bourgognone*; very bright Colouring and fine Expression. One Foot six Inches and a half high, by 2 Feet one Inch and three quarters wide.

158. Its Companion.

159. Boors at Cards, by *Teniers*.

160. Boors drinking; its Companion, by *Ostade*.

161. *Christ* laid in the Sepulchre, by *Giacomo Bassan*; a very particular Picture, the Lights are laid on so thick that it seems quite Basso Relievo.. It is a fine Design for a great Altar-piece which he has painted at *Padua*. This Picture was a Present to Lord *Orford*, from *James* Earl of *Waldegrave*, Knight of the Garter, and Embassador at *Paris*.

162. Holy Family, with St. *John* on a Lamb, by *Williberts*, a Scholar of *Rubens*, who has made a large Picture, from whence this is taken, now in the Palace *Pitti*, at *Florence*: This is finely finish'd, and the Colouring neater than *Rubens*.

163. Holy Family, by *Rottenhamer*.

★ HW: *Amelot de la Houssaie* relates the following remarkable Story as the Foundation of this Pope's Hatred to the French, and of his Persecution of the Family of his Predecessor *Urban* the Eighth. While Cardinal *Barberini*, *Urban's* Nephew, was Legate in *France*, he went to see the curious Library and Collection of the Sieur *Du Moustier*. Monsignor *Pamphilio*, who attended him, slipped a small and scarce Book into his Pocket. As they were going away, the Legate shut the Door, and desired *Du Moustier* to examine whether he had lost any Book: He immediately missed the stolen One. The Cardinal bid him search all his Train, but *Pamphilio* refusing to be examined, they came to Blows, and *Du Moustier* getting the better by the Prelate's being encumbered in his long Habit, beat him severely and found the Book in his Pocket. *Mem. Histor* Vol.I. Pag.362

164. **[69]** The *Virgin* and *Child*, by *Alexander Veronese*; painted on black Marble.

165. Three Soldiers; a fine little Picture, by *Salvator Rosa,* in his brightest manner.

166. The *Virgin* with the *Child* in her Arms, by *Morellio*, on black Marble. A Present, from *Benjamin Keene*, Embassador at *Madrid*.

167. The *Virgin* with the *Child* in her Arms asleep, by *Sebastian Concha*

168. *Edward* the Sixth, an original small whole Length, by *Holbein*; it was in the Royal Collection, and upon the Dispersion of King *Charles*'s Pictures in the Rebellion, sold into *Portugal*, where it was bought by Lord *Tyrawley*, Embassador to the Court of *Lisbon*, and by him sent as a Present to Lord *Orford*, within the Frame is wrote in Golden Letters, *Edvardus Dei Gratii Sextus Rex* Anglia, & Francia, & Hibernia.

169. *Laban* searching for his Images, by *Sebastian Bourdon*. When *Jacob* withdrew privately from *Laban*, *Rachel* stole her Father's Idols, which he pursued them to demand. *Gen.* xxxi. 33. Three Feet one Inch three quarters, by four Feet four Inches and a half wide.

170. The Banquetting-House Cieling; it is the original Design of *Rubens* for the middle Compartment of that Cieling, and represents the Assumption of King *James* the First into Heaven; it belonged to Sir *Godfrey Kneller*, who studied it much, as is plain from his Sketch for King *William*'s **[70]** Picture in the Parlour. Two Feet eleven Inches high, by one Foot nine Inches and a half wide.

171– Six Sketches of *Rubens* for triumphal Arches, &c. on the Entry of the Infant

175. *Ferdinand* of *Austria* into *Antwerp*; they are printed with a Description of that Festival.

176. They are about two Feet and a half square.[xlviii]

177. *Bathsheba* bringing *Abishag* to *David*; an exceeding high finish'd Picture in Varnish, by *Vanderwerffe*; a Present to Lord *Orford*, from the Duke of *Chandos*. Two Feet ten Inches high, by two Feet three wide.

178.179. Two Flower-pieces, most highly finish'd, by *Van Huysum*; his Brother lived with Lord *Orford*, and painted most of the Pictures in the Attic Story here. Two Feet seven Inches high, by two Feet two wide.

180. *Christ* and *Mary* in the Garden, by *Philippo Laura*.

181. The Holy Family, by *John Bellino*; it belong'd to Mr. *Laws*.

182. A Landskip with Figures, by *Bourgognone*, in the Manner of *Salvator Rosa*.

183. Its Companion with Soldiers.

184.185. Two small Landskips, by *Gaspar Poussin*.

186. Over the Door into the Bed-chamber, the Holy Family, by *Matteo Ponzoni,* a most uncommon Hand, and a very fine Picture. Three Feet seven Inches

xlviii 'They were Mr. Norton's and cost him 180£ at Sir Peter Lely's sale.' HW MS (PML).

xlix 'A present from Sir Henry Bedingfeld'. HW MS (PML).

l 'In Evelyn's preface to his translation of the idea of the perfection of painting, he mentions a picture of Moses in the bullrushes by Paul Veronese, in which Pharoah's Daughter is attended by a guard of Swiss'. HW MS (PML). Here HW shows his sympathy with the contemporary argument concerning the errors of Roman Catholicism in painting, of which Charles Lamotte was a prime example. See summary note for HW's 'Sermon on Painting'.

li The Marble Parlour, or Great Dining Room (1745 MS Houghton), was the final room to be completed. In 1731 Sir Thomas Robinson recorded his impression: ' There is only one dining room to be finished and which is to be lined with marble, and will be a noble work'. The principal features of Kent's completed design (based on a first concept by Gibbs and developed 1728-32) are the double buffet alcoves in variegated marbles, set beside the central fireplace, within an arched screen. The room displays a profusion of Bacchic ornamentation, featuring putti and grape vines. Two overdoors continued this theme (*Aedes* 2002, nos. 193, 194), but an otherwise eclectic display focused upon two full length Van Dycks and two overdoors attributed to Veronese.

lii 'Lord Danby built the house at Cirencester, now Ld. Bathurst's.' HW MS (PML).

and a half high, by five feet two and a half wide. It belonged to Count *Plattemberg*, the Emperor's Minister at *Rome*, who had carried all [**71**] his Pictures thither and died there. They were sent to *Amsterdam* to be sold, where Mr. *Trevor* bought this for Sir *Robert Walpole*. Lord *Burlington* has a Head by the same Master, who was a *Venetian;* there are no others in *England* of the Hand.

187. Over the Parlour Door, the Murder of the Innocents, by *Sebastian Bourdon*. Four Feet and half an Inch high, by five Feet eight wide.

188. Over the other Door, the Death of *Joseph*, by *Velasco*. Three Feet three Inches high, by four Feet ten wide.

189 Saint *Christopher*, a very small Picture, by *Elsheimer*.[xlix] Here is a very common Error among the *Roman Catholick* Painters; in the distant Landskip is a Hermit, with an Oratory of the Virgin *Mary*, at the Time that Saint *Christopher* is carrying *Jesus* yet a Child. At *Bologna* there is an old Picture of the Salutation, where the Angel finds the Virgin *Mary* praying before a Crucifix, with the *Officium beatæ Virginis* in her Hand.[l]

The MARBLE PARLOUR.[li]

ONE intire side of this Room is Marble, with Alcoves for Side-boards, supported with Columns of *Plymouth* Marble. Over the Chimney is a fine Piece

190. of *Alto Relieve* in Statuary-Marble, after the Antique, by *Rysbrack*, and before one of the Tables, a large Granite Cistern.

191. [**72**] *Henry Danvers* Earl of *Danby,* a fine whole Length in the Garter Robes, by *Vandyke*. This Lord was Son of Sir *John Danvers*, by *Elizabeth* Daughter of *John Nevil* Lord *Latimer*, Son-in-Law of Queen *Catharine Parr*, and was first distinguished by his Behaviour in the War in the *Low Countries*, where he served under Prince *Maurice*, and afterwards in *France* under *Henry* IV. where he was knighted for his Valour. In the *Irish* Wars, he was Lieutenant General of the Horse, and Serjeant-Major of the whole Army, under *Robert* Earl of *Essex*, and *Charles* Lord *Mountjoy*. In the First of King *James* I. he was made Baron of *Dauntesey*, and afterwards Lord President of *Munster* and Governor of *Guernsey*. By King *Charles* I. he was created Earl of *Danby*, made a Privy Counsellor and Knight of the Garter. He founded the Physic-Garden at *Oxford*, and died aged 71, 1643, at *Cornbury,* 191.and is buried at *Dauntesey* in *Wiltshire*, where he built an Alms-House and Free-School. His elder Brother Sir *Charles* lost his Life in the Earl of *Essex*'s Insurrection, Temp. Eliz. This Picture was given to Lord *Orford*, by Sir *Joseph Danvers*.[lii]

192. Sir *Thomas Wharton*, Brother to *Philip* Lord *Wharton*, and Knight of the Bath, whole Length, by *Vandyke*, (from the *Wharton* Collection.)

193. [**73**] Two Fruit-pieces over the Door, by *Michael Angelo Campidoglio*, from Mr.

194. *Scawen*'s Collection.

195. The Ascension, by *Paul Veronese*, over a Door.

196. The Apostles after the Ascension, ditto.

The HALL[liii]

Is a Cube of Forty, with a Stone Gallery round Three Sides. The Cieling and the Frieze of Boys are by *Altari*. The Bass-reliefs over the Chimney and Doors are from the Antique.

The Figures over the great Door, and the Boys over the lesser Doors, are by *Rysbrack*. In the Frieze are Bass-reliefs of Sir *Robert Walpole* and *Catharine* his First Lady, and of *Robert* Lord *Walpole* their Elder Son and *Margaret Rolle* his Wife.

197. From the Cieling hangs a ★ Lantern for Eighteen Candles, of Copper gilt

198. [**74**] Over the Chimney is a Bust of Sir *Robert Walpole*, Earl of *Orford*, by *Rysbrack*.

199. Before a Nich, over against the Chimney, is the *Laocoon*, a fine Cast in Bronze, by *Girardon*, bought by Lord *Walpole*, at *Paris*.

200.201. On the Tables, the *Tiber* and the *Nile* in Bronze, from the Antiques in the Capitol at *Rome*.

202.203. Two Vases in Bronze, from the Antiques in the Villas of *Medici* and *Borghese* at *Rome*.

204. The Bust of a Woman, a most beautiful Antique.

205. The Bust of a *Roman* Empress, Antique.[†]

★HW: *Ben Johnson,* in his Forest, Poem 2d. has these Lines on *Penshurst.*
 Thou art not, *Penshurst*, built to envious show,
 Of Touch or Marble; nor can'st boast a Row
 Of polish'd Pillars, or a Roof of Gold,
 Thou hast no Lantern, whereof Tales are told.
I imagine there was some old Pamphlet or Ballad wrote on a Lantern of some great Man at that Time, from whence was taken the *Craftsman*, which made so much Noise about this Lantern at *Houghton*. This Lantern has since been sold to the Earl of *Chesterfield*, and is replaced by a French Lustre.

†HW: This and the Last were bought from Mrs. *Vernon*'s at *Twickenham* Park, which belonged to *Robert* Earl of *Essex,* the celebrated Favourite of Queen *Elizabeth,* who having promised Sir *Francis Bacon* to get him made Sollicitor-General, just before his own Disgrace, and not being able to perform it, gave Sir *Francis* this Villa to make him amends. Sir *Francis* entertained the Queen here, and presented her with a Sonnet of his own composing, to intercede for the Earl's Pardon. He soon after sold *Twickenham* Park for Eighteen Hundred Pounds. From thence it came into the Earl of *Cardigan*'s Family; they sold it to King *William*: he gave it to his Favorite Lord *Albemarle,* who sold it to Mr. *Vernon,* after whose Widow's Death, Lord *Montrath* bought it for Fifteen Thousand Pounds. [HW adds an MS note to his own copy: 'Bacon in a letter to his brother Antony calls it, "that wholesome pleasant lodge & finely designed garden". Bacon papers vol. I. 486.' HW MS (PML)].

liii The formal entrance hall to Houghton provides a suitably imperial introduction to what is effectively the palace or temple of the arts built to the eternal glorification of Britain's first 'prime' minister. The visitor is left in no doubt of the magnificence of the achievement of RW. Lord Hervey records his reaction in 1731: 'the first room is a hall, a cube of 40 foot finished entirely with stone, a gallery of stone around it and the ceiling of stucco, the best executed of anything I ever saw in stucco in any country.' William Kent had collaborated with the stuccoists (the Artari brothers) and the sculptor Michael Rysbrach to develop the original design of Colin Campbell (RIBA, Campbell 7/19), featuring the Walpole arms and the now inevitable motif of the Garter Star in the Ceiling decoration.

liv HW here lists ten busts and four heads on console brackets and 'terms' round the Hall, many of which are indicated in Isaac Ware's engravings of 1735. Most are antique, made up from antique fragments, and were acquired by at least 1731. Lord Hervey noted in the Hall, 'round the sides marble bustos, and over against the chimney the famous group of Laocoon and his two sons' in his letter to Frederick, Prince of Wales, 14 July 1731 (Ilchester 1950, pp. 70-2). RW almost certainly acquired his antique busts from those acting on his behalf abroad. Indeed it seems that his elder sons were specifically charged with finding him sculpture at an early stage in the creation of their father's collection, specifically to grace the Hall at Houghton. RW both wished and needed to project an image of classical erudition and of political power through the decorative scheme and contents of the principal Hall.

Robert Walpole (c.1701-51), RW's eldest son was on his grand tour in 1722-23 and it was presumably then that he acquired Girardon's *Laocoon* group in Paris, reportedly for 1000 guineas (Sir Thomas Robinson to Lord Carlisle, 9 December 1731, HMC, 15, 1897, Appendix 6 (42), p86). He could also have acquired marbles at that time. RW's second son, Edward (1706-84), was abroad 1730-31, and he too showed a direct interest in purchasing sculpture on behalf of his father while in Italy: 'I have seen every statue and piece of that kind of antiquity that is worth seeing at Rome among which there is nothing to be had that could possibly serve your purpose'. In the same letter he asserts that he will try to obtain some pieces and at the best price possible (Plumb 1960, p. 88 n. 2).

On 9 December 1731 Sir Thomas Robinson also records '12 noble busts in the hall. His statues for two niches are not yet bought; the Laocoon stands before that which is opposite to the chimney'. This confirms that the scheme was complete by 1731 apart from two busts, which were quite possibly those only acquired by Charles Churchill in July that year (see *Aedes* 2002, nos. 208, 209). The fact that William Kent designed the Hall at Houghton with terms and consoles for busts, rather than figures, suggests that he was designing the architectural space with the collection already in existence in 1725. Kent was in effect recreating an antique atrium, the main entrance hall of a Roman Classical house.

lv RW had been planning a picture gallery at Houghton since at least 1731. He would have been aware of the great continental picture cabinets through HW and the reports of other well-travelled advisors. He also knew well the earliest portrait of the clerestoried Tribune Gallery in the Uffizi, *Sir Andrew Fountaine and Friends in The Tribune* by Giulio Pignatta (1715), hanging at neighbouring Narford Hall in Norfolk. Sir Thomas Robinson reported proposals in 1731 'for a large room which looks on the parterre, designed for a gallery, there being the same in the opposite wing for a green house'. This is actually a somewhat confused understanding as he refers to the 'opposite wing for a green house' when this area contained the sculleries. Although Isaac Ware shows a large side-lit gallery in his plans published in 1735, the 1736 Inventory makes no mention of pictures hanging there. The influx of paintings from London in 1742 occasioned a major rehang, in a Gallery which now boasted a top-lit clerestory, enabling all four walls to be utilised. For a discussion of the designing of the Gallery see Yaxley 1995. The hang was dominated by the large Flemish works that had proved too large to house in either the Cabinet or the Saloon (see *Aedes* 2002, nos. 229–233) and also the enormous canvases by Mola (see *Aedes* 2002, nos. 234, 235).

HW describes the walls as covered with Norwich (ie. wool) damask. His pen and monochrome wash drawing of Serlio's design for the ceiling of the inner library of San Marco, Venice is preserved in his *Aedes* MS (Met) folio 53. In 1745 there were five tables, twenty four armchairs and twelve India chairs, with a couch and lacquer screens. It was a splendid space for a noble collection which was entirely modern in its ambition to show off the collection which until 1742 had been split between the London residences and latterly Houghton.

On Terms and Consoles round the HALL are
the following BUSTS and HEADS.[liv]

206. *Marcus Aurelius*, Antique.

207. *Trajan*, Ditto.

208. [**75**] *Septimius Severus*, Ditto } These two were given to General *Churchill*, by

209. *Commodus*, Ditto. } Cardinal *Alexander Albani*, and by him to Sir *Robert Walpole*.

210. A Young *Hercules*, Ditto.

211. *Baccio Bandinelli,* by himself.

212. *Faustina* Senior, Antique

213. A Young *Commodus*, Antique.

214. *Homer*, Modern.

215. *Hesiod*, Ditto.

216. *Jupiter*, Antique. }

217. A Philosopher, Ditto. }

218. *Hadrian*, Ditto. } Heads.

219. *Pollux*, Ditto. }

Going from the SALON, down the great Steps through the Garden, you enter a
Porch adorn'd with BUSTS of

220. *Rome*, }

221. *Minerva*, } by *Camillo Rusconi*.

222. *Antinous*, }

223. *Apollo Belvedere*, }

224. A Philosopher's Head, } Antique.

225. *Julia Pia Severi*, }

226. [**76**] Out of this you go into a Vestibule, round which in the Niches are Six Vases of *Volterra* Ala- baster. This leads into

The GALLERY,[lv]

WHICH is Seventy-three Feet long, by Twenty-one Feet high, the Middle rises eight Feet higher, with Windows all round; the Cieling is a Design of *Serlio*'s in the Inner Library of St, *Mark*'s, at *Venice*, and was brought from thence, by Mr. *Horace Walpole* Junior; the Frieze is taken from the *Sybils* Temple at *Tivoli*. There are two Chimnies, and the whole Room is hung with *Norwich* Damask. It was intended originally for a Green-house; but on Sir *Robert Walpole*'s resigning his Employments *February* 9, 1742, it was fitted up for his Pictures, which had hung in the House in *Downing-Street*. That House belonged to

the Crown; King *George* the First gave it to Baron *Bothmar*, the *Hanoverian* Minister, for Life. On his Death the present King offer'd it to Sir *Robert Walpole*, but he would only accept it for his Office of First Lord of the Treasury, to which post he got it annexed for ever.

227. Over the farthest Chimney is that Capital Picture, and the First in this Collection, The Doctors of the Church: they [**77**] are Consulting on the Immaculateness of the Virgin, who is above in the Clouds. This has been a most controverted Point in the *Romish* Church. *Bonosus*, Bishop of *Naissus* in *Dacia,* was one of the First, who held, that the Virgin *Mary* had other Children after Christ, which was reckon'd a great Heresy. He was condemn'd for it by Pope *Damasus*, suspended by the Council of *Capua*, censured by the Bishops of *Macedon*, who declared their Abhorrence of this detestable Error, as they call'd it; and wrote against by Pope *Syricius*. His followers were styled *Bonosiacs*, or *Bonosians*. This Doctrine had been taught before by *Helvidius* Anno 383, and before him by *Tertullian*. Those who opposed the perpetual Virginity of the Virgin *Mary*, were styled *Antidicomarianites*. St. *Jerom* and St. *Ambrose* were two of the principal Champions for the Virginity, and are probably the Chief Figures in this Picture. Vide *Bower's* History of the Popes, Vol. I. 263. This pretended Heresy is founded on the 25th Verse of the first Chapter of St. *Matthew*, where it is said, that *Joseph* knew not his Wife till she had brought forth her First-born; and from *James* and *John* being frequently called the Brethren of *Christ*. In Answer to this last Evidence, the Orthodox say, that among the Jews all near Relations are called Brothers, and that *James* and *John* were only first Cousins to *Christ*. It is observable, that *Raphael* has followed the Opinion of [**78**] the Virgin *Mary* having had other Children, in many of his Pictures, particularly in the Last Supper in this Collection, he having drawn St. *James* extremely like *Jesus Christ*. There has been another Controversy in the *Romish* Church, which is more properly called the Question of the Immaculate Conception: *viz.* Whether the Virgin conceived in Original Sin, though sanctified in her Mother's Womb, or was preserved from that Stain of general Infection by a special Privilege, on the Foresight of the Merits of *Christ*, whom She was to bear. *Albertus Magnus* and his Followers maintained the First against many learned Doctors, who defended her Exemption from Original Sin; and the Debate grew so warm, that it was judged necessary to put an End to it by a Public Disputation. It was in Defence of the Immaculate Conception that the famous *Duns Scotus* obtained the Name of the *Subtile Doctor*. Vide Antiquities of the *English Franciscans*, page 129. I cannot help observing, that the celebrated Picture at *Windsor* of this Doctor must be Ideal,

lvi 'Paul 5th had been pressed to make it an article of faith, but he had been so mortified with the event of his rupture with [the] interdict of the Venetians that he wd not venture occasioning a new schism. He contented himself to forbid the contrary to be taught publicly. v. Voltaire univ. hist. Vol.4. 222.' HW MS (PML).

lvii 'Montfaucon relates, that when he visited Italy, Signor Beloreddi of Pavia had a library full of books [o]n behalf of the Immaculate Conception, most of them written by Franciscans. Diar. Ital. qu. 26.

'In the year 1670 Innocent 11th suppressed the missal or office of the Immaculate Conception of the Virgin. In Spain they write under all her pictures, Concebida sin peccado originale. In [?] Sussan's Hist. of Charles 6th it is said, p. 173. vol. 2 that the Dominicans in the year 1389 made a fund of 120000 crowns (avast sum at that time) to carry on their cause of the Immaculate Conception.

'There is a passage in Rabelais , book Ist, chap. 7 which attends to this controversy, where he says that Scotus's opinion was reckoned heretical, who affirmed that Gargantua's own mother gave him suck, & c[oul]d draw out of her breasts at one time 1402 [?]& nine pails of milk. The Jacobins who were always unpopular for denying the Immac. Concept got a triumph in the 15th century by a Cordelier's maintaining that during the three days of Christ's Interment, the Hypostatic Union was dissolved: This drew great odium on the Cordeliers. v. Hume's Diss. On Religion p. 48.' HW MS (PML).

lviii 'It was in the collection of the Marquis Angeli, & was engraved by Giacomo Freii'. HW MS (PML).

lix 'This gentleman, I suppose, had a collection: a picture of Michael Angelo della Battaglie at Wilton is said to have belonged to him & to have cost 300 pistoles. See Kennedy's Acct. of Wilton p. 70.' HW MS (PML).

lx 'When General Wade built his House in Burlington Gardens Ld Burlington gave the design for it. The only direction the General gave ,was that there might be a particular place for this picture, but when the great room was finished, there were so many ornaments and corresponding doors that there was no room for the picture, & the general not knowing what to do with it sold it to Sr. R.W.' HW MS (PML).

for he died in the Year 1308, when there was no such Thing as a tolerable Painter; besides, that Portrait represents him as an elderly Man, whereas he was not Thirty-four when he died. In the Year 1387, the *Dominicans* were expelled the University of *Paris,* for Opposing the Doctrine of the Immaculate Conception, and many of them were kill'd. In 1438, the Council of *Basil* [79] declared it Immaculate; and lastly, in 1655, *Alexander* VII. peremptorily determined it to be so.[lvi]

About the Year 1670, the *Spanish Jesuits* prevail'd on *Charles* II. to request from the Court of *Rome,* that a Definition might be made of the Immaculate Conception, and the famous Cardinal *Nidhard,* who had been Prime Minister to the Queen Regent, and was then in honorable Banishment a Embassador to *Clement* IX. was order'd to write for the Question, which he did, and pretended to prove that the Immaculate Conception was morally, physically, metaphysically and infallibly certain. The Court of *Rome* gave a Bull that was rather favourable to the *Dominicans.* Vide *Bayle* in Artic. *Nidhard;* and for a more particular Account, the Article of *Mill,* in the General Dictionary, Vol.VII. page 559, and *Geddes*'s Tracts, Vol. III. page 113. 189.[lvii]

In this Picture, which is by *Guido* in his brightest Manner, and perfectly preserved, there are six old Men as large as Life. The Expression, Drawing, Design, and Colouring, wonderfully fine. In the Clouds is a beautiful Virgin all in White, and before her a sweet little Angel flying. Eight Feet eleven Inches high, by six Feet wide. After Sir *Robert* had bought this Picture, and it was gone to *Civita Vecchia* to be shipt for *England, Innocent* XIII. then Pope, remanded it back, as being too fine to be let go out of *Rome*; [80] but on hearing who had bought it, he gave Permission for its being sent away again. It was in the Collection of the Marquiss *Angeli.*[lviii]

228. Over the other Chimney, the Prodigal Son, by *Salvator Rosa.* This fine Picture was brought out of *Italy* by Sir *Robert Geare,*[lix] and carried back by him when he went to live there. On his Death it was sent back to *England* to be sold. Eight Feet three Inches high, by six Feet five and a half wide.

229. *Meleager* and *Atalanta,* a Cartoon, by *Rubens,* larger than Life; brought out of *Flanders* by General *Wade*: it being design'd for Tapestry, all the Weapons are in the Left Hand of the Figures. Ten Feet seven Inches high, by twenty Feet nine and a half wide.[lx] For the Story see *Ovid's* Metamorphosis, Lib. III.

230 Four Markets, by *Snyders,* One of Fowl, and another of Fish,

−233. another of Fruit, and the Fourth of Herbs. There are

Two more of them at *Munich*, a Horse and a Flesh Market;

each six Feet nine Inches and a half high, by eleven Feet one and a half wide. Mr. *Pelham* has four Markets by *Snyders* like these, which he bought at *Marshal Wade*'s Sale, the Figures by *Long John*.

234. *Marcus Curtius* leaping into the Gulph, and exceeding fine Picture, by *Mola*. There are Multitudes of Figures, fine Attitudes, and great Expressions of Passion. To ornament the distant Prospect, he has committed some Anachronisms, [**81**] by placing among the Buildings an Amphitheater, which were of far later Invention, and the *Pantheon* with the Portico of *Agrippa*; now *Pompey* was the first that made a lasting Theater, before him they were temporary, and often destroyed by Public Authority. *Statilius Taurus* built the First Amphitheater in the Fourth Consulship of *Augustus*. This Action of *Curtius* happen'd in the Year 391. U. C. and the Portico was built by *Agrippa* (who died 741. U. C.) in his third Consulship, as appears by the Inscription still remaining: *M. Agrippa. L. F. Cos. III fecit*. The Story of this Exploit is thus told by *Livy*.

"Eodem anno (scil. U. C. 391) seu motu terræ, seu quâ vi aliâ, Forum medium fermè specu vasto collapsum in immensam altitudinem dicitur: neque eam voraginem conjectu terræ, quam pro se quisque gereret, expleri potuisse, prius quam Deûm monitu quæri cœptum, quo plurimùm P. R. posset. Id enim illi loco dicandum Vates canebant, si rempublicam *Romanam* perpetuam esse vellent. Cum Marcum Curtium juvenem bello egregium, castigasse serunt dubitantes, an ullum magis *Romanum* bonum, quam arma virtusque esset. Silentio facto, Templa Deorum Immortalium, quæ Foro imminent, Capitoliumque intuentem, et manus nunc in cœlum, nunc in patentes Terræ Hiatus, ad Deos Manes porrigentem se devovisse: equo deinde quam poterat maxime exornato insidentem, [**82**] armatum se in specum immisisse, donaque ac fruges super eum à multitudine virorum ac mulierum congestas: lacumque Curtium non ab antiquo illo T. Tatii milite Curtio Metio, sed ab hoc appellatum." Lib. VII. Cap. 6. This Picture is six Feet four Inches and a half high, by eleven Feet four Inches and a quarter wide. And, with the next, belong'd to *Gibbins* the Carver.

235. *Horatius Cocles* defending the Bridge. Its Companion. Thus described by *Livy*, Lib. II. Cap. 10.

"Quum hostes adessent, pro se quisque in urbem ex agris demigrant: urbem ipsam sepiunt præsidiis: alia muris, alia Tiberi objecto videbantur tuta: pons sublicius iter pæne hostibus dedit; ni unus vir suisset, *Horatius Cocles* (id munimentum illo die fortuna urbis *Romanæ* habuit) qui positus forte in statione

lxi 'When Tomo Chachi, the Indian King, and his company were in England about the year 1736, they were extremely surprized at the lions in the Tower, Animals they had never seen. It was said in the public papers, that they were frightened, which being told to Tomo Cacchi, He replied, that He who had ventur'd Himself into so strange & distant a country at his great Age, cou[l]d not easily be afraid of anything. Afterwards seeing this Picture at Sr. Rob. Walpole's in Downing Street, He said He was still more surprized that any man coud draw those Beasts so well; and begg'd a copy, which was painted for him by Verelst.' HW MS (PML).

pontis, quum captum repentino impetu Janiculum, atq; inde citatos decurrere hostes vidisset: trepidamque turbam fuorum arma ordinesq; relinquere, reprehensans singulos, obsistens, obtestansq; Deûm & hominium fidem, testabatur: *nequicquam deserto præsidio eos fugere, si transitum pontem à tergo reliquissent: jam plus hostium in Palatio Capitolioque, quam in Janiculo fore.* Itaque monere, præcipere, *ut pontem ferro, igni, quacunque vi possent, interrumpant: se impetum hostium, quantum corpore uno posset obsisti,* excepturum. Vadit inde in primum aditum pontis: insignisq; [**83**] inter conspecta cedentium pugnæ terga, obversis cominus ad ineudum prælium armis, ipso miraculo audaciæ obstupefecit hostes: duos tamen cum eo pudor tenuit, Sp. Larcium ac T. Herminium, ambos claros genere factisque: cum his primam perculi procellam, & quod tumultuosissimum pugnæ erat, parumper sustinuit, deinde eos quoque ipsos exigua parte pontis relicta, revocantibus qui rescindebant, cedere in tutum coegit. Circumferens inde truces minaciter oculos ad proceres Etruscorum: nunc singulos provocare: nunc increpare omnes: *servitia regum superborum, suæ libertatis immemores, alienam oppugnatum venire.* Cunctati aliquamdiu sunt, dum alius alium, ut prælium incipiant, circumspectant: pudor deinde commovit aciem, & clamore sublato undiq; in unum hostem tela conjiciunt: quæ quum in objecto cuncta scuto hæsissent, neque ille minus obstinatus ingenti pontem obtineret gradu: jam impetu conabantur detrudere virum, quum simul fragor rupti pontis, simul clamor Romanorum alacritate perfecti operis sublatus, pavore subito impetum sustinuit. Tum Cocles, *Tiberine pater,* inquit, *te sancte precor, hæc arma & hunc militem propitio flumine accipias*: ita sic armatus in Tiberim defiluit: multisque super incidentibus telis incolumis ad suos tranavit, rem ausus plus famæ habituram ad posteros, quàm fidei. Grata erga tantan virtutem civitas fuit: [**84**] statua in comitio posita: agri quantum uno die circumaravit, datum, privata quoque inter publicos honores studia eminebant: nam in magna inopia pro domesticis copiis unusquisque ei aliquid, fraudans se ipse victu suo, contulit."

236. A Lioness and two Lions, by *Rubens.*[lxi] Nothing can be livelier, or in a greater Stile than the Attitude of the Lioness. Five Feet 6 Inches high, by eight Feet wide.

237. Architecture; it is a kind of a Street with various Marble Palaces in Perspective, like the *Strada Nuova* at *Genoa*; the Buildings and Bass-reliefs are extreamly fine, the latter especially are so like the Hand of *Polydore,* that I should rather think that this Picture is by this Master, than by *Julio Romano,* whose it is called. There are some Figures, but very poor ones, and undoubtedly not by the same

Hand as the rest of the Picture; there is an Officer kneeling by a Woman, who shows the Virgin and Child in the Clouds sitting under a Rainbow.

About the Year 1525, *Julio Romano* made Designs for *Aretine's Putana Errante*, which were engraved by *Marc Antonio*, for which the latter was put in Prison, and *Julio* fled to *Mantua*. Two Years after *Rome* was sack'd by *Charles* V. who made Public Processions and Prayers for the Delivery of the Pope [*Clement* VII.] whom he kept in Prison; 'tis supposed the Figure kneeling in this Picture is *Charles* V. [**85**] who is prompted by Religion to ask Pardon of the Virgin (above in the Clouds) for having so ill treated the Pope: The Figure sitting on the Steps is certainly *Aretine*, and the Man in Prison in the Corner *Marc Antonio*. Vide *Bayle* in *Artic*. Aretine. This Picture was a Present to Lord *Orford,* from General *Charles Churchill*. Five Feet six Inches three quarters high, by six Feet eleven wide.

238. An old Woman sitting in a Chair, a Portrait three quarters, by *Rubens*, bought at Mr. *Scawen's* Sale.

239. An old Woman reading, an extream fine Portrait, by *Boll*, bought at the Duke of *Portland'* s Sale, when he went Governor to *Jamaica*.

240. *Cupid* burning Armour, by *Elisabetta Sirani*, *Guido's* Favourite Scholar. Two Feet one Inch and half high, by two Feet seven and a half wide.

241. The Holy Family, a Groupe of Heads, by *Camillo Procaccino*. One Foot nine Inches high, by two Feet three and three quarters wide.

242. An Usurer and his Wife, by *Quintin Matsis*, the Blacksmith of *Antwerp*: This Picture is finished with the greatest Labour and Exactness imaginable, and was painted for a Family in *France*; it differs very little from one at *Windsor*, which he did for *Charles* the First. Two Feet eight Inches and half high, by one Foot ten and three quarters wide.[lxii]

243. [**86**] *Job's* Friends bringing him Presents; a fine Picture, by *Guido*, which he has executed in large, and in his brightest manner in the Church of the *Mendicants* at *Bologna*; this is Dark; but there is most masterly Skill in the Naked, and in the Disposition of the Figures. Three Feet one Inch high, by two Feet four and a half wide.

244. *Europa*, a fine Landscape, by *Paul Brill*, the Figures by *Dominichini*. Two Feet five high, by three Feet five and three quarters wide.

245. *Africa*. Its Companion.[lxiii]

246. *Dives* and *Lazarus*, by *Paul Veronese*. There are few of him better than this, the Building is particularly good. Two Feet seven and half high, by three Feet five wide; it belong'd to Monsieur de *Morville*, Secretary of State in *France*.

247. The Exposition of *Cyrus*, by *Castiglione*; a very Capital Picture of this Master the Subject is taken from *Justin*. Lib. I. Cap. 4.

lxii 'There is a copy of this picture at Hinchinbrooke, and another at Boughton'. HW MS (PML).

lxiii 'These two came out of the numerous collection of the Countess de la Verrue at Paris.' HW MS (PML).

lxiv I saw Bacchus today:
In a wild gorge he lay,
Teaching his sacred melodies. O years
To come, credit my glimpse
Of the attentive nymphs
And goat-foot satyrs cocking pointed ears.
James Michie, *The Odes of Horace*, 1964, XIX, p. 129.

lxv 'and has been engraved'. HW MS (PML). HW's print inscribed: 'Ornatissimo Viro CORNELIO DE WAEL Pictori in farius maximo; ac genio eius munifico, Amicorumqye Amico MARTINUS VANDEN ENDEN D.C.L. Petrus P. Rubbens pinxit S. 'a Bolswert sculpsit Martinus vanden Enden excudit Antwerpi cum privilegio', plate size, 340 x 465 mm. HW MS (Met).

lxvi 'Mr Charles Stanhope has another of the same Design, but much darker.' HW MS (PML).

"Pastori regii pecoris puerum exponendum tradit. Ejus uxor audita regii infantis expositione, summis precibus rogat sibi afferri ostendique puerum. Cujus precibus fatigatus pastor, reversus in silvam, inventit juxta infantem canem fœminam, parvulo ubera præstantem, & à feris alitibusque defendentem." Two Feet four Inches and half high, by 3 Feet six and a quarter wide.

248. **[87]** Its Companion; the Subject, which seems at first to be the Story of *Orpheus*, but certainly is not, from the principal Figure's being thrown into the distant Landscape, was guessed by Lord *Orford* to be taken from this Stanza of the 19th Ode, Lib. II. of *Horace*.

> *Bacchum in remotis carmina rupibus*
> *Vidi docentem; (credite posteri)*
> *Nymphasque discentes, & aures*
> *Capripedum Satyrorum acutas.*lxiv

249. The Adoration of the Shepherds, by old *Palma*, from the Collection of Monsieur de la *Vrilliere*, Secretary of State in *France*. Two Feet six Inches high, by three Feet ten wide.

250. The Holy Family, by Ditto. Two Feet seven Inches and half high, by four Feet wide, from Monsieur *Flinck*'s Collection.

251. A fine Moon-light Landscape with a Cart over-turning, by *Rubens*. Two Feet ten Inches high, by four Feet one wide. (It was Lord *Cadogan*'s.)lxv

252. A Nymph and Shepherd, by *Carlo Cignani*. Three Feet four Inches high, by four Feet one and a half wide.lxvi

253. **[88]** Two Women, an Emblematical Picture, by *Paris Bourdon*. Three Feet six Inches high, by four Feet two wide, from Mr. *Flinck*'s Collection.

254. *Abraham, Sarah,* and *Hagar,* by *Pietro Cortona.* The Great Duke has a small Sketch of this, but revers'd, and with the *Sarah* and other Figures at a Distance, the *Hagar* is much fairer than in this. Six Feet ten Inches high, by six Feet one wide.

255. *Abraham*'s Sacrifice, by *Rembrant. Abraham*'s Head, and the naked Body of *Isaac,* are very fine; the Painter has avoided much of the Horror of the Story, by making *Abraham* cover the Boy's Face, to hide the Horror from himself. Six Feet three Inches high, by four Feet three and three quarters wide.

256. The Old Man and his Sons with the Bundle of Sticks, by *Salvator Rosa* in his fine Taste. Six Feet high, by four Feet two and a half wide.

257. The Adoration of the Shepherd's, Octagon, a most perfect and Capital Picture of *Guido*, not inferior to the Doctors: The Beauty of the Virgin, the Delicacy of her and the Child, (which is the same as in the *Simeon*'s Arms in the Salon) the Awe of the Shepherds, and the *Chiaro Oscuro* of the whole Picture, which

is in the finest Preservation, are all incomparable; you see the Shepherds ready to cry out one to another, *Deus! Deus ille, Menalca!* There is one of [**89**] this same Design in the Church of the *Chartreuse* at *Naples*, large as Life, Oblong, with many more Figures, but unfinish'd: This belong'd to Monsieur de la *Vrilliere*. Three Feet three Inches and a half every way.^{lxvii}

lxvii 'There is a fine Print of it'. HW MS (PML). HW's print inscribed with title and signed: 'Guid Ren Bon in F. de Poilly sculpsit et excudit cum Privil Regis Et Verbum caro factum est, et habitavit in nobis Joan c.i.' plate size: 436 x 414 mm. HW MS (Met).

258. The Continence of Scipio, by *Nicolo Poussin*; painted with all the Purity and Propriety of an ancient Bass-relief. The Story is told by *Livy*, Lib. XXVI. Cap. 50. "Captiva deinde à militibus adducitur ad eum adulta virgo, adeo eximia forma, ut quacunque incedebat, converteret omnium oculos. *Scipio* percuntatus patriam, parentesque, inter cætera accepit, *desponsatam eam principi Celtiberorum adolescenti, "cui Allucio nomen erat.* Extemplo igitur parentibus, sponsoque ab domo accitis, quum interim audirect deperire eum sponsæ amore; ubi primum venit, accuratiore eum sermone quam parentes alloquitur. *Juvenis,* inquit, *juvenem appello: quo minus sit inter nos. hujus sermonis verecundia. Ego, quum sponsa tua capta à militibus no stris ad me deducta esset, audiremque eam tibi cordi esse, & forma faceret fidem; quia ipse, si frui liceret ludo œttais (præsertim recto & legitimo amore) & non Respublica animum nostrum occupasset, veniam mihi dari sponsam impensius amanti vellem: tuo ,cujus possum, amori faveo. Fuit sponsa tua apud me eâdem, quâ apud soceros tuos parentesque suos verecundiâ: servata tibi est, ut inviolatum & dignum me teque dari tibi donum posset. Hanc* [**90**] *mercedem unam pro eo munere paciscor, amicus populo Romano sis: & si me virum bonum credis esse, quales patrem, patruumque meum jam ante hœ gentes norant, scias multos nostri similes in civitate Romana esse: nec ullum in terris populum hodie dici posse, quem minus tibi hostem tuisque esse velis, aut amicum malis.* Quum adolescens simul pudore, gaudioque persusus, dextram Scipionsis tenens, *Deos omnes invocaret ad gratiam illi pro se referendam: quoniam sibi nequaquam satis facultatis pro suo animo, atque illius erga se merito, esset.* Parentes inde, cognatique virginis appellati. Qui quoniam gratis sibi redderetur virgo; ad quam redimendam satis magnum attulissent auri pondus: orare Scipionem, *ut id ab se donum acciperet, cœperunt: haud minorem ejus rei apud se gratiam futuram esse affirmantes, quam redditæ inviolatœ foret virginis.* Scipio, *quando tante opere peterent, accepturum* se pollicitus, poni ante pedes jussit: vocatoque ad se Allucio: *Super dotem,* inquit, *quam accepturus à socero es, hœc tibi à me dotalia dona accedent, aurumq;* tollere, ac sibi habere jussit. His lætus donis honoribusque dimissus domum, implevit populares laudibus & meritis Scipionis: *Venisse Diis simillimum juvenem, vincentem omnia quum armis, tum benignitate ac beneficiis.*"

[**91**] When Thus the virtuous Consul had decreed,

A captive Virgin to his Tent they lead:

In her each Motion shin'd attractive Grace,

And Beauty's fairest Features form'd her Face.
A *Celtiberian* Prince her destin'd Spouse,
But, more than Int'rest, Love had bound their Vows,
Allucius was his Name. When *Scipio* heard
How fond the Youth, how for his Bride he fear'd;
He summons to his Tribune all her Friends:
Allucius in that Number chief attends.
To him the Consul most address'd his Word,
To him, her anxious Lover and her Lord.
"A Youth myself, to thee a Youth I call,
"Left distant Awe thy freer Speech appall.
"When to my Tent this beauteous Maid was brought,
"When of your mutual Passion I was taught,
"And soon her Charms confirm'd the Story true
"(For *Scipio*' s self could idolize like you)
"Durst I indulge the Character of Age,
"And in a youthful, lawful Love engage;
"Did not the Commonwealth employ me whole,
"And all majestick *Rome* possess my Soul:
"Oh! I could love to like thee; like thee cou'd pine;
"Like thee cou'd—-But, *Allucius*, she is thine!
[**92**] "Inviolate have I preserv'd the Maid;
"Not purer in her native Courts she stay'd:
"Pure, as becomes a *Roman* Chief to give;
"Pure, as becomes thy Passion to receive.
"The sole Return for this fair Boon I ask:
"To live a Friend to *Rome* be all thy Task:
"And if in me some Virtue you have known,
"As other *Scipio*'s in this Realm have shown;
"Think many such spring from her glorious Womb,
"And learn to love the virtuous Sons of *Rome*."

This Picture belong'd to Monsieur *de Morville*, and is three Feet eight Inches and three quarters high, by five Feet two wide.

259. *Moses* striking the Rock; by *Nicolo Poussin*. There is a great Fault in it; *Moses* is by no means the principal Figure, nor is he striking the Rock angrily, and with a great Air, but seems rather scraping out the Water: The Thirst in all the Figures, the Piety in the young Man lifting his Father to the Stream, and the Devotion in others, are extreamly fine. It was painted for *Stella*, and bought

of a *French* Nobleman, in the beginning of the last War between *France* and the Emperor *Charles* VI. who declared he sold it to pay for his Campaign Equipage. Three Feet eleven Inches and a half high, by six Feet three and a half wide.[lxviii]

260. [93] The placing Christ in the Sepulchre, over the Door, by *Ludovico Caracci.* Six Feet three Inches high, by five Feet one wide.

261. *Moses* in the Bulrushes, by *Le Sœur*; a Present to Lord *Orford* from the Duke of *Montague.* Seven Feet one Inch high, by four Feet eight and a half wide.[lxix]

262. The Adoration of the *Magi,* by *Carlo Maratti.* He has painted another of them in the Church of the *Venetian* St. *Mark* at *Rome.* Six Feet eleven Inches high, by four Feet four wide.

263. Cows and Sheep, by *Teniers*, in his best Manner; one Foot eleven Inches high, by two Feet nine wide.

264. A Landscape with a Cascade and Sheep; a very fine Picture, by *Gaspar Poussin.* It was bought at the late Earl of *Halifax*'s Sale.[lxx] One Foot eleven Inches high, by two Feet nine wide.

265. The last Supper, by *Raphael.* It was in the *Arundel* Collection, and is printed in the Catalogue of those Pictures; from thence it came into the Possession of the Earl of *Yarmouth*, and from him to Sir *John Holland*, of whom Lord *Orford* bought it. It is in fine Preservation. One Foot eight Inches high, by two Feet eight and a half wide.[lxxi]

266. *Solomon*'s Idolatry, by *Stella.* It is painted on black and gold Marble, which is left untouch'd in many Places for the Ground. There are many Figures finely finished, and several [94] beautiful Airs of Women's Heads. One Foot ten Inches high, by two Feet five and a quarter wide.

267. A Sea-port; a fine Picture of *Claude Lorrain.* There is a bright Sun playing on the Water, and the whole Shine of the Picture is in his very best Manner. It belong'd to Monsieur *Morville.* Three Feet one Inch and a quarter high, by four Feet two and a half wide.

268. A calm Sea, ditto. A most pleasing and agreeable Picture. There are two Figures on the fore Ground, *Apollo* and the *Sibyl*; she is taking up a handful of Sand, for every Grain of which she was to live a Year. *Apollo* granted her this Boon as the Price of her Person, which afterwards she refus'd him. The Promontory is designed for the *Cumæ,* the Residence of the *Sibyl.* Among the Buildings are the Ruins of the *Castellum Aquæ Martiæ*, with the Trophies of *Marius*, which are now placed in the *Capitol*; the Remains of the Building itself stand near the *Colisæum.* Three Feet two Inches and three quarters high, by four Feet one wide.

lxviii It has been engraved.' HW MS (PML). HW's print signed and inscribed within image: 'N. Poussin pinxit, ex Museo Anthij Stella, parisijs Claudia Stella sculp et excudit cum privil. Regis. 1687.' HW MS (Met).

lxix There is a print of it'. HW MS (PML). HW's print signed and inscribed: 'Moyses infantalus in Carecto ripae Nili a parentibus Expositus. Exod. Capit 2 Nobillissimo Illustrissimo Principi Joanni Duci de Montagu &c Prima Cahortis Equitum Regis Mag. Brit. Supremo Praefecto atque Nobilissimi Ordini Periscelidio Equiti bonarum artium maecenati atque Cultori Prestantissimo hanc tabulam al Eustachio Le Sueur Pictam ac 'a Bernardo Baron sculptam grati animi Ergo et in obsequij monumentum. R. Pelletier offert D.D. Eustachio Le Sueur pinxit B. Baron Del. Et sculp. 1720 sold at Mr. Pelletier in Queen Street Golden Square et se vend chez G. Du change graveur du Roy rue St. Jacques 'a Paris. Cum privilegio Regio 1720. J:Whitwood' [in dots]. HW MS (Met).

lxx 'Pond published a print of it'. HW MS (PML). HW's print inscribed and signed: 'In the Collection of the Right Honourable Sr Robert Walpole Gaspar Poussin pinx. Vivares sculp. 2feet 9inch: _ wide 2f.–1inch: 1/4 high', plate size 308 x 397 mm. HW MS (Met).

lxxi 'There are various prints from it'. HW MS (PML). HW's print was of indifferent quality, unsigned and uninscribed, cut to image size, 182 x 280 mm. HW MS (Met).

lxxii 'There is a print of it'. HW MS (PML). HW was referring to his own print (of some quality), inscribed: 'GANIMEDIS.IVVENIS - TROIANUS-RAPTUS-A-IOVE ANT, LAFRERI SEQUANI FORMIS'. HW MS (Met).

lxxiii In modern editions this is given as the beginning of Epigram 6: 'As the eagle bore the boy through the airs of heaven, the timid talons did not harm their clinging freight.'D. R. Shackleton-Bailey (ed. & transl.), *Martial Epigrams*, I, 1993, p. 47.

269.270. Two Landscapes by *Gaspar Poussin,* in his dark Manner, that at the upper End of the Gallery is fine. These two and the latter *Claude* were in the Collection of the Marquis *di Mari*. Mr. *Edwin*, of whom these were purchas'd, had two more; the Prince of *Wales* bought the fine one of *Jonah* in the Storm, the only Sea-piece, I believe, of that Hand. [95] Three Feet three Inches and a quarter high, by four Feet five and a quarter wide each.

271. The *Joconda*, a Smith's[★] Wife, reckon'd the handsomest Woman of her Time: She was Mistress to *Francis* I. King of *France*; by *Lionardo da Vinci*. She would often sit half naked, with Musick, for several Hours together, to be drawn by him. Mr. *Richardson* had another of them. This was Monsieur *de Morville*'s. Two Feet nine Inches high, by two Feet and a quarter wide.

272. *Apollo*, by *Cantarini* a Contemporary of *Guido*, whose Manner he imitated. Two Feet seven Inches high, by two Feet and a quarter wide.

273. The Holy Family, with Angels, by *Valerio Castelli,* who studied *Vandyke*. Two Feet five Inches high, by one Foot eleven and half wide.

274. The Eagle and *Ganymede*, by *Michael Angelo Buonarotti*; a Subject he has often repeated, but with Alterations. The King has one larger, and the Queen of *Hungary* another, printed in *Teniers*'s Gallery: There is another in the *Altieri* Palace at *Rome*. Two Feet eleven Inches high, by one Foot eleven wide.^{lxxii}

[96] *Ætherias Aquila puerum portante per auras,*

lIlæsum timidis unguibus hæsit onus.

MART. LIB.I. Ep. 7.^{lxxiii}

275. The Virgin and Child, a most beautiful, bright, and capital Picture, by *Dominichino*. Bought out of the *Zambeccari* Palace at *Bologna*, by *Horace Walpole*, junior. Two Feet four Inches high, by one Foot eleven and a half wide.

276. The Salutation, a fine finished Picture, by *Albano*. The Angels are much the same with those in the great Picture by this Master in the Salon. Two Feet high, by one Foot six Inches and a half wide.

★HW: *Mezeray* calls her *La Ferroniere*, and says, her Husband being enraged at the King's taking her, caught on purpose a very violent Distemper, which he communicated thro' her to the King, who never recover'd it. The same Story is told of Lord *Southesk* and King *James* II. when Duke of York.

A
S E R M O N
O N
P A I N T I N G

Preached before the EARL of
O R F O R D,
At HOUGHTON, 1742.

PSALM CXV. Ver. 5.

They have Mouths, but they speak not : Eyes have they, but they see not : Neither is there any
Breath in their Nostrils.

THESE Words, with which the Royal Prophet lashes the Insensibility of the Gods of Paganism, are so descriptive of modern Idolatry, that tho' so frequently applied, they still retain all the Force [**100**] of their swift Severity. I do not design to run into the Parallel of ancient and modern Superstition, but shall only observe with Concern, that the same Arguments which at last exploded and defeated the Heathenism of the Gentiles, have not yet been able to conquer the more obstinate Idolatry of Christians. The blind, the mis-led Pagans, bow'd and ador'd the first Ray of Truth that broke in upon them : but We have Eyes, and will not see !

I must remark to you, that the Words in the Text, tho' spoken of Images, which were more particularly the Gods of the Ancients, are equally referable to the Pictures of the *Romish* Church and to them I shall chiefly confine this Discourse.

Indeed, so gross is the Error of adoring the Works of the Creature, that the Folly seems almost greater than the Sin ; seems rather to demand Pity, than provoke Indignation! They would worship ! they bow to a Shadow! —— They would adore the incomprehensible God! but they revere the faint Produce of their own Idea! Instead of him who is the Eye of the universal World; who speaks through all Nature, who breathes Life into every Being; instead of him, [**101**] they adore Shadows, that have Eyes, but see not ; Mouths, but speak not; neither is there any Breath in their Nostrils. These are thy Gods, O *Rome*!

It has been observed, that the Evil Principle has with the most refined Policy always chose to spread his Law under the Covert of the true one; and has never more successfully propagated Sin, than when introduced under the Veil of Piety. In the present Case, has he not deluded Men into Idolatry by passing it on the World for Religion? He preached up Adoration of the Godhead, but taught them to worship the Copy for the Original. Nay, what might have tended to heighten their Devotion, he perverted to the

BACKGROUND CIRCUMSTANCES

The *Sermon on Painting* takes Psalm 115, verses 5-6 as its text and directly references two dozen paintings newly hung at Houghton. The Book of Psalms is an unparalleled hymnal of resource for public and private devotion—the original title in Hebrew translates as 'Praises'—and HW sets out to praise his father, but also to amuse him. HW's note to the sermon in the Waldegrave MSS 2.57 recalls 'This sermon was preached at Houghton before Lord Orford, and is a sort of essay on his collection of pictures there. 1742.' In his Short Notes, Horace is more specific: 'In the summer of 1742 I wrote "A Sermon on Painting," for the amusement of my father in his retirement. It was preached before him by his chaplain; again before my eldest brother at Stanno near Houghton: and was afterwards published in the *Aedes Walpolianae*.' It is interesting to see Sir Robert's chaplain involved in the amusement. This was presumably the Rev. Thomas Deresly, who had been presented to the vicarage of Houghton Church (St. Martin) by Sir Robert in 1731. The church itself had been rebuilt by Sir Robert shortly after the completion of the Hall. Deresly evidently found HW's text entirely acceptable and exhorted the immediate family by taking in the congregation at nearby Stannhoe, where Robert Walpole, Lord Walpole (1700–50) was based at the Manor House with his mistress, Hannah Norsa.

The sermon could as easily have been delivered in the homes of Sir Robert and his eldest son, in that Stanhoe too had been recently hung with paintings from Downing Street. However, the respective churches were eminently suitable for a Sermon that was not simply an amusement but also a eulogy to Sir Robert.

HW's MS copy of the text in his Commonplace Book (Lewis Walpole Library, Hazen 2616 II) gives the subtitle to the sermon as ' On the Use and Abuse of Painting'. HW's serious intent with this sermon may be contrasted with another nearly two decades later 'On abstaining from Birthdays on certain occasions; preached before the Right Honourable Lady Mary Coke, on Sunday, May 31st, 1761, by H.W., D.D., Chaplain to her Ladyship, and Minister of St. Mary, Strawberry–hill.'

A SERMON *on* PAINTING

HORACE WALPOLE'S INFLUENCES

HW had a penchant for religious tracts and sermons which was reflected in his library collection. A serious spirit of enlightened enquiry informed his notion of 'amusement' and his Sermon should in no way be seen as a parody of the form. His collection included a number of seventeenth-century funeral sermons (Hazen 1969, 2756) including Edmund Calamy's *Compleat Collection of Farewell Sermons*, 1663 (Hazen 1969, 2755) and three sermons by Thomas Fuller (1593–1667) (Hazen 1969, 2757).

The form was an important communication tool, popular in the early eighteenth century, gaining a wide usage beyond the pulpit. HW owned volumes of sermons by his contemporaries, including Thomas Ashton, Philip Bearcroft, John Gilbert, John Hume and Matthew Hutton (Hazen 1969, 1346). On 24 July 1749 HW wrote to Mann 'You ask me about the principles of the Methodists: I have tried to learn them, and have read one of their books', presumably a reference to George Whitefield's *Sermons on Various Subjects*, 1739 which was in his library (Hazen 1969, 1427). The seriousness of the form did not prevent HW from enjoying the drama of a presentation: some years later in the convent chapel of the Magdalen-House in Goodman's Fields, he witnessed a sermon by Rev. William Dodd (1729–77) ' a young clergyman, one Dodd; who contributed to the Popish idea one had imbibed, by haranguing entirely in the French style, and very eloquently and touchingly. He apostrophised the lost sheep, who sobbed and cried from their souls … In short, it was a very pleasing performance, and I got the most illustrious to desire it might be printed.' (HW to Montagu 28 January 1760, HWC, vol. 9, p. 274).

Means of their Destruction. Painting, in itself, is innocent; No Art, no Science can be criminal; 'tis the Misapplica-tion that must constitute the Sin. Can it be wrong, to imitate or work after the Works of the Divinity, as far as Man can copy the Touches of the great Artificer? 'Tis when with impious Eyes we look on the Human Performance as Divine; when we call our own trifling Imitations of the Deity, inimitable gods: 'Tis then we sin; This is Vanity! this is Idolatry! Would we with other Eyes regard these Efforts of Art; how conducive to Reli-[**102**] gion ! What subjects for devout Meditation! How great that Being, that could give to his Productions the Power even to work after his Almighty Hand, to draw after his Heavenly Designs! Could we so inform our Labours, our Creations; then were Idolatry more excusable; then might the Vessel say to the Potter, *How hast thou made me thus* ?

And here I can but reflect on that infinite Goodness, whose Thought for our Amusement and Employment is scarce less admirable than his Care for our Being and Preservation. Not to mention the various Arts which he has planted in the Heart of Man, to be elaborated by Study, and struck out by Application; I will only mention this one of *Painting*. Himself from the Dust could call forth this glorious Scene of Worlds; this Expanse of azure Heavens and golden Suns; these beautiful Landscapes of Hill and Dale, of Forest and of Mountain, of River and of Ocean! From Nothing, he could build this goodly Frame of Man, and animate his universal Picture with Images of himself. To Us, not endowed with Omnipotence, nor Masters of Creation, he has taught with formless Masses of Colours and Diversifications of Light and Shade, to call forth little Worlds from the blank Canvass, and to people our mimic Land-[**103**] scapes with almost living Inhabitants; Figures, who tho' they see not, yet have Eyes; and have Mouths that scarce want Speech. Indeed so great is the Perfection to which he hath permitted us to arrive, that one is less amazed at the poor Vulgar, who adore what seems to surpass the Genius of human Nature; and almost excuse the Credulity of the Populace, who see Miracles made obvious to their Senses by the Hand of a *Raphael* or a *Guido*. Can we wonder at a poor illiterate Creature's giving Faith to any Legend in the Life of the *Romish* Virgin, who sees even the Doctors of the † Church disputing with such Energy on the marvellous Circumstances ascribed to her by the Catholicks? He must be endowed with a Courage, a Strength of Reasoning above the common Standard, who can reject Fables, when the Sword enforces, and the Pencil almost authenticates the Belief of them. Not only Birds have peckt at painted Fruit, nor Horses neigh'd at the colour'd Female; *Apelles* himself, the Prince of the Art, was deceived by one of its Performances. —— No wonder then the Ignorant should adore, when even the Master himself could be cheated by a Resemblance.

† HW: See the Picture by *Guido*, in the Gallery [*Aedes* 2002, no. 227]

A SERMON on PAINTING

[104] When I thus soften the Crime of the Deceived, I would be understood to double the Charge on the real Criminal; on those Ministers of Idolatry, who calling themselves Servants of the living God, transfer his Service to inanimate Images. Instead of pointing out his Attributes in those Objects, that might make Religion more familiar to the common Conceptions; they enshrine the frail Works of Mortality, and burn Incense to Canvass and Oil!

Where is the good Priest? where the true charitable Levite, to point out the Creator in the Works of the Creature? To aid the Doubting; to strengthen the Weak, to imprint the eternal Idea on the frail Understanding? Let him lead the poor unpractised Soul through the Paths of Religion, and by familiar Images mould his ductile Imagination to a Knowledge of his Maker. Then were Painting united with Devotion, and ransom'd from Idolatry; and the blended Labours of the Preacher and the Painter might tend to the Glory of God; Then were each Picture a Sermon; each Pencil *the Pen of a heavenly Writer.*

[105] Let him say, Thus humble, thus resign'd look'd the Son of GOD, when he deign'd to receive Baptism from the Hand of Man; while ministring Angels with holy Awe beheld the wondrous Office.[1]

Thus chastly beauteous, in such meek Majesty shone the Mother of GOD! Thus highly-favour'd among Women was the Handmaid of the Lord! Here behold the heavenly Love of the Holy Family! the tender Care, the innocent Smiles, the devout Contemplation![2] Behold inspired Shepherds bowing before the heavenly Babe, and the holy Mother herself adoring the Fruit of her Womb![3] Whilst good *Simeon* in Raptures of Devotion pronounces the Blessings of that miraculous Birth![4]

Then let him turn his Eyes to sadder Scenes![5] to Affliction! to Death! Let him behold what his God endured for his Sake! Behold the pale, the wounded Body of his Saviour; wasted with Fasting! livid from the Cross! See the suffering Parent swooning! and all the Passions express'd, which she must have felt at that melancholy Instant! Each Touch of the Pencil is a Lesson of Contrition; each Figure an Apostle to call you to Repentance.

[106] This leads me to consider the Advantages of *Painting* over a Sister Art, which has rather been allotted the Preference, I mean *Poetry.* The Power of Words, the Harmony of Numbers, the Expression of Thoughts, have raised Poetry to a higher Station, than the mute Picture can seem to aspire to. But yet the Poem is almost confined to the

CONTEMPORARY CLIMATE OF OPINION

Perhaps the most apposite contemporary publication with respect to HW's 'Sermon' is *An Essay upon Poetry and Painting with relation to Sacred and Profane History* by Charles Lamotte DD FRS, published in 1730. Lamotte was a member of the Society of Antiquaries and Chaplain to the Duke of Montagu. His essay was over two hundred pages long and and divided into 'letters'. In the first letter Lamotte compares poetry and painting, assessing the advantages of both. He concludes that images are best considered as instructional aids, rather than as objects of worship. He emphasises, however, that if images are to be instructive, then they must be accurate or 'corect'. There are often inconsistencies in 'costume', 'truth', 'manners' or 'correctness' with regard to establishing the period in which an event took place.

In his second letter Lamotte goes through the standard subjects tackled by painters, illustrating their 'errors'. He claims as his evidence the Scriptures and various 'histories'. For example in depictions of Abraham and Isaac Lamotte prescribes that Isaac should be lain on an altar and not kneeling as sometimes depicted. In the case of the *Adoration of the Magi*, the scene is some weeks after the birth of Jesus and should not be set in a stable, while the wise men were philosophers, not kings. To give the Magi individual identities is not supported by the Scriptures.

Lamotte criticises also the tendency to increase the magnificence of a scene: 'The Christian Religion disclaims such false and deceitful props, and such imaginary Helps as these. A judicious Painter therefore, in Matters so sacred and solemn, should be more prudent and cautious, should strictly confine himself to Truth' (Lamotte 1730, p. 71). Lamotte subscribes to the current post Reformation view that religion was an essentially rational and moral entity, which should be guarded against distortion. It is not recorded whether HW owned Lamotte's *Essay* among his many tracts on the 'sister arts' but it bears direct comparison and supports an appreciation of HW's purpose in setting out with serious intent to 'amuse' with his sermon.

1 HW: See the Picture by *Albano* in the Salon [*Aedes* 2002, no. 82]

2 HW: Several Pictures of *Madonna's,* particularly in the *Carlo Maratt* Room, and Holy Families [e.g. *Aedes* 2002, nos. 102–8]

3 HW: The Octagon Picture of the Adoration by *Guido,* in the Gallery. [*Aedes* 2002, no. 257]

4 HW: A *Simeon* and the Child, by *Guido,* in the Salon. [*Aedes* 2002, no. 88]

5 HW: See the Picture of Christ laid in the Sepulchre, by *Parmegiano,* in the Cabinet. [*Aedes* 2002, no. 147]

A SERMON *on* PAINTING

HORACE WALPOLE'S ARGUMENT

HW's text is unique in its adoption of the form of the sermon to assess a particular collection. He starts with an address direct to those who may be regarded as philistines or pagans. Obstinate idolatry can be found in some Christians who 'have eyes but do not see'. Some paintings of the Roman Catholic Church should be judged for their narrative and religious content alone: those who worship pictures as if they were idols deserve pity, not indignation.

It is Satan, 'The Evil Principle' who encourages a worship of copies (ie. paintings) rather than the original source of inspiration. These paintings should heighten Devotion, not pervert it. A core idea is that 'Painting, in itself is innocent' of any idolatrous purpose (p. 101). God, the Creator, is the ultimate artist, and has passed on considerable powers to artists, to the extent that their work may encourage idolatry. One sight of Guido Reni's miraculous *The Doctors of the Church* (see *Aedes* 2002, no. 227) is enough to convince the illiterate or unwary of the truth of the Roman Catholic faith as evidenced by the life story of the Virgin Mary.

The real criminals in this context are those who encourage the worship of images. The good priest is the one who uses images to point out the work of the Creator, in which case each painting becomes a Sermon (p. 104). HW emphasises the use of simile and demonstrates how pictures may be illustrative of narrative. He also employs metaphor in encouraging engagement with the work of art: 'Each Touch of the Pencil is a Lesson of Contrition' (p. 105).

HW recounts well travelled ideas concerning the advantages of Painting over Poetry. Painting is a language every Eye can read and needs no translation. He reveals a total disregard for the Pope as the Creator's representative on earth: the Popes' main claim to the Seat of Infallibility is their 'near Approach to the Grave' (p. 107). Paintings can preserve Likeness, but also they can serve as 'Lectures of Piety' and 'Admonitions to Repentance'. In *The Judgement of Paris* by Carlo Maratti we see Paris as 'the true Philosopher' as he turns from three of the most perfect goddesses that either Paganism or Painting can produce (see *Aedes* 2002, no. 63). Similarly, *Mary Magdalen washing Christ's Feet* by Rubens (see *Aedes* 2002, no. 85) inspires repentance in the onlooker while Simeon the Pharisee inspires 'abhorrence and indignation' at his 'haughty' worldliness (p. 108).

HW argues that each painting demonstrates the Scriptures made real, depicting, for example, Sin, Folly and Repentance. It is dangerous to adore 'Romish

Nation where it was wrote: However strong its Images, or bold its Invention, they lose their Force when they pass their own Confines; or not understood, they are of no Value; or if translated, grow flat and untasted. But *Painting* is a Language every Eye can read: The pictured Passions speak the Tongue of every Country.

The Continence of *Scipio* shines with all its Lustre, when told by the Hand of a *Poussin*;[6] while all the Imagination of the Poet, or Eloquence of the Historian, can cast no Beauty on the virtuous Act, in the Eye of an illiterate Reader.

When such Benefits flow from this glorious Art, how impious is it to corrupt its Uses, and to employ the noblest Science to the mercenary Purposes of Priestly Ambition! to lend all the Brightness with which the Master's Hand could adorn Virtue, to deck [**107**] the persecuting, the barbarous, the wicked Head of a sainted Inquisitor, a gloomy Visionary, or an imaginary Hermit! Yet such are deified, such are shrouded in Clouds of Glory, and exposed for Adoration, with all the Force of Study and Colours! How often has a consecrated Glutton, or noted Concubine, been drest in all the Attributes of Divinity, as the Lewdness of Impiety of the Painter or Pontiff has influenced the Picture! —— the Pontiffs! those Gods on Earth! those Vicegerents of Heaven! whose Riches, whose Vices, nay, whose Infirmities and near Approach to the Grave has perhaps raised them to the Seat of Infallibility; soon proved how frail, how mortal, when the only Immortality they can hope, is from the masterly Pencil of some inestimable Painter![7]

This is indeed not one of the least Merits of this, I may say, heavenly Art —— its Power to preserve the Form of a departed Friend, or dear Relation dead! To show how severely just look'd the good Legislator! how awfully serene the humane, the true Patriot! It shows us what Fire, what Love of Mankind, WILLIAM flew to save Religion and Liberty! It expresses how honest, how benign the Line of HANOVER![8] It helps our Gratitude to conse-[**108**]crate their Memory; and should aid our Devotion to praise the Almighty Goodness, who by those his Instruments has preserved his People *Israel*!

When we can draw such Advantages from the Productions of this Art, and can collect such Subjects for Meditation from the Furniture of Palaces, need we fly to Deserts for Contemplation, or to Forests to avoid Sin? Here are stronger Lectures of Piety, more Admonitions to Repentance. Nor is he virtuous who shuns the Danger, but who conquers in the Contest. He is the true Philosopher, who can turn from three the brightest Forms that Paganism or Painting could ascribe to ideal Goddesses;[9] and can

6 HW: See the Picture on this Subject in the Gallery [*Aedes* 2002, no. 258]

7 HW: See the Picture of Pope *Clement* IX. In the *Carlo Marat* Room. [*Aedes* 2002, no. 99]

8 HW: See the Portraits of King *William* III and King *George* I by Sir *Godfrey Kneller* in the Parlour. [*Aedes* 2002, nos. 30, 31]

9 HW: See the Judgment of *Paris* by *Carlo Maratt* [*Aedes* 2002, no. 100] and by *Luca Jordano* [*Aedes* 2002, no. 63] in the Yellow Drawing room

prefer the penitent, the contrite Soul of the *Magdalene*, whose big-swoln Eye and dishevel'd Hair speak the Anguish of her Conscience; her costly Offering, and humble Embraces of her Saviour's Feet, the Fervency of her Love and Devotion ; who can see this without Repentance?[10] who view the haughty worldly Pharisee, without Abhorrence and Indignation?

Sights like these, must move, where the Preacher fails ; for each Picture is but Scripture realized; and each Piece a Comment on the History; they are [**109**] Explications of Parables, that seeing *ye may see and understand*. The Painter but executes Pictures, which the Saviour himself designed. He drew in all the Colours of Divine Oratory, the rich, the pamper'd Nobleman, swelling in Purple and fine Linen, and sumptuously banquetting his riotous Companions: He drew poor anguish'd *Lazarus*, sighing without the proud Portal for the very Crumbs that fell from the Rich Man's Table, while the Dogs came and lick'd his Sores![11] Who can hear this Description without Sentiments of Compassion, or Emotions of Anger? Who can see it represented, without blaming the one, or shedding a charitable Tear for the other? —— Who can, — is as the Idol that has *A Mouth but speaks not, and Eyes that cannot see*.

Again, behold the Divine Master sketching out new Groups of Figures, which every Day compose Pictures of Sin, of Folly and Repentance! Hear him paint the luxurious Prodigal given up to Riot and Debauchery; hear him draw the consequential Ills, the Miseries, the Want, that tread hard upon his Profusion and Excess. See that Prodigal, half naked, half in Rags, uncouth and foul, kneeling among [**110**] Swine, and cursing the Vices that drew on him such Extremity of Distress[12] — With him let us arise and say, *I will go to my Father, and say unto him, Father, I have sinned against Heaven and thee, and am no more worthy to be called thy Son!* That Father will hear, will not turn from the Cry of the Penitent: He is not like those Idols, that have Ears and hear not. —— Will the *Romish* Saints do thus? Can their hallowed *Madonna*'s thus incline to their Supplications? Can those gaudy Missionaries, whose consecrated Portraits elbow the Altars of the living GOD, can they cast their unseeing Eyes on their prostrate Votaries? Can their speechless Mouths say, *I will, be thou clean*? — Alas! those Saints which those worship'd Pictures represent, may themselves want the very Pardon, which their deluded Adorers so idolatrously demand of them. Thus, be it as we affirm, that they worship them and their Images; or as they pretend, that they only pray to them to pray to GOD. How lamentable is their Option!

Saints' who may themselves need the intercession of Christ. Instead of bartering for pardon, such as 'droning Monks' who build hospitals, people should be seeking Mercy. HW has little truck with 'Romish Saints' who often have little merit in deserving universal esteem other than perhaps a 'churlish Recluseness', or — even worse — have sought to eradicate heresies through tormenting others (p. 112). By contrast past heroes such as Curtius or Cocles (*Aedes* 2002, nos. 234, 235) 'are left to the Chance of Fame'

To complete his argument HW embarks upon an extended simile, likening RW to 'the Great Moses' himself. RW is 'that slighted Patriot' who 'in his Youth … undertook the Cause of Liberty', bearing the 'Clamours and Cabals of factious People', to lead his people to 'the Enjoyment of Peace, and to the possession of a Land flowing with Milk and Honey'. By a nice conceit the listener is brought back to a key and favourite (of RW's) painting in the collection, Poussin's *Moses striking the Rock* (*Aedes* 2002, no. 259). The aptness of the comparison is calculated to appeal to RW who himself diverted the waters at Houghton to achieve his own Temple of the Arts in the then 'barren Desert, where Sands and Wilds overspread the dreary Scene'.

10 HW: See the Picture of Christ at the House of *Simon* the Pharifee, by *Rubens*, in the Salon. [*Aedes* 2002, no. 85]

11 HW: See the Picture of *Dives* and *Lazarus* by *Paul Veronese*, in the Gallery [*Aedes* 2002, no. 246]

12 HW: See the Picture on this Story by *Salvator Rosa* in the Gallery. [*Aedes* 2002, no. 228]

Either to adore Idols instead of the Divinity; or to beg their Intercession, who themselves want all the Intercession of the Son of GOD.

[**111**] One really knows not how to account for the Prevalence of this Sin. Men fly from GOD into all the various Crimes which human Nature is capable of committing; and when Apprehensions of Futurity or Decay of Appetite overtake them, instead of throwing themselves into the Arms of eternal Mercy or infinite Goodness, they barter for Pardon with impotent Images, or perished Mortals, who died with the Repute of a few less Sins than the rest of Mankind! — But could these supposititious Deities attend to their Prayers: - Why should Canvass or Stone, why Men, who when living were subject to all the Obduracy, ill Nature, and Passions of Humanity, why be supposed more capable of Pity, more sensible of our Sorrows, than that Fountain of Tenderness and Compassion, who sacrificed his Best-loved for the sake of Mankind? Or why prefer the Purchase of Pardon from interested mercenary Saints, to the free Forgiveness of him, who delighteth not in Burnt Offerings? who hath no Pleasure in the Death of a Sinner, but rather that he should turn from his Wickedness and live?

[**112**] Yet still this Prodigality of Devotion is the favourite, the fashionable Religion! This builds those Hospitals for droning Monks; this raises those sumptuous Temples, and decks their gorgeous Altars. Misers, who count Farthings with such Labour and Exactness, with such careful Minuteness, who would deny a Mite to the Fatherless and Widow; here squander their precious Treasures and darling Exactions.[13] View but the Tabernacle of a Saint in Vogue ! How Offerings pour in! what Riches are shower'd upon their Altars! Not happy Job, when reliev'd from his Misfortunes, and replaced on the Seat of Felicity, saw such Treasures, such Oblations heap'd on him by the Bounty and Munificence of his returning Friends.[14]

How great is one's Surprize, on coming to enquire into the Merits that are the Foundation of this universal Esteem! Perhaps a churlish Recluseness; a bold Opposition of lawful Magistrates; a dogmatical Defence of Church-Prerogatives; a self-tormenting Spirit; or worse, a Spirit that has tormented others, under Colour of eradicating Heresies, or propagating the Faith, is the only Certificate they can show for [**113**] their Titles to Beatitude. No Love of Society; no Publick Spirit; no Heroick Actions, are in the Catalogue of their Virtues. A morose *Carthusian*, or bloody *Dominican*, are invested with Robes of Glory, by Authority of Councils and Consistories; while a *Curtius* or a *Cocles* are left to the Chance of Fame, which a private Pencil can bestow on them.[15]

13 HW: See the Picture of the Usurers, by *Quint.Matsis,* in the Gallery. [*Aedes* 2002, no. 242]

14 HW: See the Picture on this Subject, by *Guido,* in the Gallery. [*Aedes* 2002, no. 243]

15 HW: See the two Pictures on their Stories, by *Mola,* in the Gallery. [*Aedes* 2002, nos. 234, 235]

But it is not necessary to dive into profane History for Examples of unregarded Merit: The Scriptures themselves contain Instances of the greatest Patriots, who lie neglected, while new-fashion'd Bigots or noisy Incendiaries are the reigning Objects of publick Veneration. See the Great *Moses* himself![16] the Lawgiver, the Defender, the Preserver of *Israel*! peevish Orators are more run after, and artful *Jesuits* more popular. Examine but the Life of that slighted Patriot: how boldly in his Youth he undertook the Cause of Liberty! Unknown, without Interest, he stood against the Face of *Pharaoh*! he saved his Countrymen from the Hand of Tyranny, and from the Dominion of an idolatrous King: How patiently did he bear for a Series of Years the Clamours and Cabals of factious People, wandering after strange Lusts, and exasperated by ambitious Ringleaders! How oft did he intercede **[114]** for their Pardon, when injured himself! How tenderly deny them specious Favours, which he knew must turn to their own Destruction! See him lead them through Opposition, through Plots, thro' Enemies, to the Enjoyment of Peace, and to the Possession of *a Land flowing with Milk and Honey*! Or with more Surprize see him in the barren Desert, where Sands and Wilds overspread the dreary Scene, where no Hopes of Moisture, no Prospect of undiscover'd Springs could flatter their parching Thirst;[17] see how with a miraculous Hand

He struck the Rock, and strait the Waters flow'd.[18]

Whoever denies his Praise to such Evidence of Merit, or with jealous Look can scowl on such Benefits, is like the senseless Idol, *that has a Mouth that speaks not, and Eyes that cannot see*.

Now to GOD the Father, &c.

16 HW: The Allusion to Lord *Orford's* Life is carried on through this whole Character.

17 HW: Alludes to the Waters made at *Houghton,* and to the Picture of *Moses* striking the Rock, by *Poussin,* in the Gallery. [*Aedes* 2002, no. 259]

18 HW: A Line of *Cowley.* [The line is adapted from one of Abraham Cowley's Pindaric Odes (1668), ' To Dr. Scarborough', 2, verse 4.]

A
JOURNEY
TO
HOUGHTON,
The SEAT of the Right Honourable
ROBERT WALPOLE, Earl of Orford,
In the County of Norfolk

A POEM.
By the Reverend Mr. WHALEY.

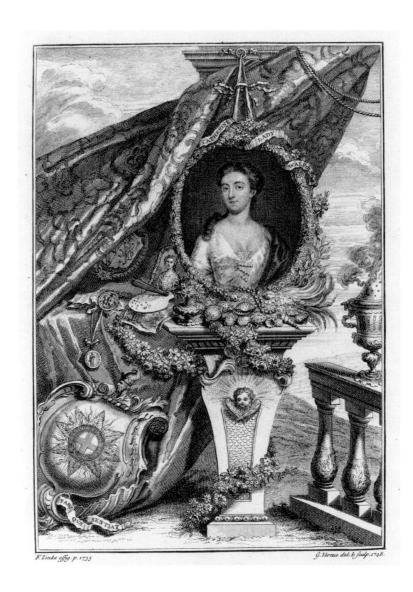

[115]
A
J O U R N E Y
T O
H O U G H T O N,

A POEM.
By the Reverend Mr. WHALEY.[i]

[117] Sweet Nymphs,[ii] that dwell on *Pindus*' verdant side,
And o'er the Woods, without a Blush, preside,
Celestial Muses, deign your Bard a Lay,
As on the winding Banks of *Yare* [iii] I stray.
[118] Yet if the Nymphs from *Pindus* scorn to bow,
Nor deign to listen to a Voice so low;[iv]
Their pride I will repay, and in despite,
While such my Theme, of all the Muses write.
　　　Recall we then, for still 'twill please, to mind
The Morn we left dull *Norwich* Smoke behind,
When, as the lofty Spire[v] just sunk from View,
To a fair verdant water'd Vale we drew;
Where 'midst fair Liberty's all-joyous Plains
Pop'ry[vi] still seems to hug her galling Chains.
The Dragon in *Hesperian* Gardens old
Thus slumb'ring lay, and tasted not the Gold;[vii]
Thus, mid'st th' eternal Spring *Judaea* keeps,
The lazy Poison of *Asphaltus* [viii] sleeps.
　　　Bend then, my Muse, thy Flight to *Weston's* Plains,[ix]
(No Verse can flow where Papal Slav'ry reigns)
[119] *Weston!* Whose Groves not envy *Pindus* Shade,
Nor blest with *Ridley*,[x] want *Apollo*'s Aid.
Here Vertue reigns, and o'er the fruitful Land
Religion walks, with Freedom Hand in Hand;
His little Flock the pious Priest informs,
And ev'ry Breast with Heav'n-born Doctrine warms,

i　　John Whaley (Norwich 1710–Norwich 1745) was at school at Eton where he became an assistant master, c.1738–43. He was a Fellow of King's College, Cambridge, 1731–45, and published two volumes of verse: *A Collection of Poems*, 1732 and *A Collection of Original Poems and Translations*, 1745. HW was a subscriber to the former and the Dedicatee of the latter ('To The Honourable Horatio Walpole, Esq. Usher of His Majesty's Exchequer; These Poems Are most humbly inscribed, By his most obliged, and obedient humble Servant, J. Whaley'). His 1732 collection included a thirty-seven-page poem, *An Essay on Painting*, which traced the history of painting from the time of Cimabue and ended in tribute to Le Brun by way of homage to the martial prowess of the Duke of Marlborough on the battlefield at Blaregnies and the Duke of Brunswick at Oudenarde. This is an indication of the fount at which Whaley's talents as a versifier lay. The same volume included 'An Epistle To the Right Honourable Sir Robert Walpole' and a poem 'On The Statue of Laocoon, At the Right Honourable Sir Robert Walpole's Seat, at Houghton, in Norfolk'. Whaley's 1745 edition included 'A Journey to Houghton' and HW was republishing it in tribute to RW and his recently deceased friend. This edition also included 'An Ode , to the Right Honourable Sir Robert Walpole, Knight of the most noble Order of the Garter, February 6.1741. On his ceasing to be Minister.' If not by Whaley himself the latter is probably the work of a fellow poetaster, Rev. Sneyd Davies, also a Fellow of King's College, Cambridge and Rector of Kingsland, Herefordshire. Whaley was ordained Deacon, 1745.

ii　　Nymphs generally presided over waters or springs which were believed to inspire those who drank from them. Nymphs were essentially endowed with prophetic or oracular powers, with the ability to confer the gift of poetry. See Theocritus, 7, 92.

iii　　The river Yare. 'This river rises at West Rudham [near Houghton], and runs a course of near 40 miles before it gets to Norwich, whence it is navigable down to Yarmouth, which is thirty miles more'. R. Beatniffe, *The Norfolk Tour*, Norwich 1777, p. 101.

iv　　The appropriate humility of the antique poet.

v　　Norwich Cathedral: 'a large venerable Gothic free-stone building, of excellent workmanship, founded in the year 1096, by Bishop Herbert, who laid the first stone. The steeple, being 105 yards and two feet from the pinnacle to the pavement of the choir, is the highest in England except Salisbury.' Beatniffe 1777 p. 13.

vi　　A reference to the Roman Catholicism of the Jerningham family of Costessey Hall four miles outside Norwich. Grateful thanks to Ron Fiske for this and the following topographical suggestion.

vii　　The golden apples of the Hesperides were plucked from their tree as the dragon lay sleeping.

viii　　The Dead Sea (?) formed by the paper mill at Taverham, outside Norwich (Ron Fiske). Asphaltus is a bituminous substance consisting of a mixture of hydrocarbons, sometimes known as 'Jew's pitch' and in the Old Testament as 'slime'.

ix　　Weston Longville, eight miles from Norwich.

x　　Glocester Ridley (1702–74) had become a Fellow of New College, Oxford in 1724. As a young man he was fond of acting and versifying and some of his verses and translations are now in the BL (Add MSS 28717). Ridley was ordained and in 1733 appointed by his College to the small benefice of Weston Longville, outside Norwich. His literary leanings led him into friendships with poets Christopher Pitt and in particular Joseph Spence, with whom he shared a friendship with HW.

A Journey *to* Houghton:

xi A reference to the transfer of the See to Norwich.

xii An infelicitous phrase with which to saddle the image of the young priest for the sake of a couplet.

xiii Vile: ie. despicable on moral grounds

xiv Sir Richard Blackmore (died 1729) physician and voluminous poet who was appointed physician to William III and knighted for his services. Dryden and Pope were among those who derided his versifying but Blackmore was unstoppable in his publications, becoming something of a byword for controversy.

xv White's *Directory of Norfolk*, 1836, records only the Bell Inn and the Lion at Brisley (see n. xvii below).

xvi Meagre: ie. lean and emaciated.

xvii Mileham and Brisley: villages en route.

xviii A public house at Mileham. White's *Directory of Norfolk*, 1836.

xix The Gods of Hospitality are at hand: the Goddess of corn and the God of the vine.

xx Whaley is following the tradition of the Pindaric Ode in seeking to add a moral tone to his journey, invoking the achievement of others and raising awareness of the vulnerability of those achievements without due recognition, celebration and memorialisation.

Soft flows his Stream of Eloquence along,
And Truths Divine come mended from his Tongue.
Here the known Bounty of the Place we blest,
And to our Number join'd the chearful Priest.
Thro' ancient ★*Elmham* next our Way we take,
And gravely nodding, wise Reflections make;
How strongest Things destructive Time o'erturns,
And the waste Town its ravish'd Mitre[xi] mourns;
Mitre! Repeats the Priest with simp'ring Leer,[xii]
'Twill sit at *Norwich* full as well as here.

 [120] But now, my Muse, in Blushes hide thy Face,
Nor deign the next vile[xiii] Town in Verse a Place;
Unless thou canst indite in *Blackmore's*[xiv] Strain,
And say, we call'd full hungry the *Swan,*[xv]
But found no Hay for Horse, nor Meat for Man.
Dire Hunger! that with meagre[xvi] Visage stalks,
And never fails to cross the Poet's Walks,
But three short Miles soon brought us bounteous Aid,
And *Mileham's* Fulness *Brisley's*[xvii] Want o'erpaid,
See! the gay Unicorn[xviii] the Wood adorn,
Fair sign of Plenty with his Iv'ry Horn!
Here *Ceres* spread her Fruits with lavish Hand,
And *Bacchus* laughing waited our Command.[xix]

 Hence pleas'd and satisfy'd we take our Road,
And sometimes laugh and talk, but oftner nod.
Yet this soft Indolence not long we kept,
But wak'd to see where faster slept;
[121] ★Where *Coke's* Remains beneath the Marble rot,
His Cases and Distinctions all forgot;
His body honour'd and to Fame consign'd,
For Virtues flowing from th' immortal Mind.[xx]
What would avail this sumptuous Mass of Stone,
Were he not from his Works for ever known?
Let the Survivors of such great Men's Dust,
Ne'r think to add to Virtue by a Bust;
If false, Posterity will find the Lie;
If true, without it, it will never die;

★ HW: *Elmham*, now a small Village, formerly the Bishop's See, which is now at *Norwich*.

But thro' succeeding Ages shine the fame,
Or from some *Leic'ster* ˣˣⁱcatch a brighter Flame.
[**122**] But farewel Death and tombs, and mould'ring Urns,
Our Eye with Joy on neighb'ring †*Rainham* turns;
Where Pleasures undecaying seem to dwell,
Such as the Happy in *Elysium* feel,
Where Heroes, Statesmen, and the virtuous Croud,
Receive the geat Reward of being Good.ˣˣⁱⁱ
Such Pleasures ev'n on Earth had Heav'n ordain'd,
For him who once our tott'ring State sustain'd;
Who join'd the glorious Freedom-loving Crew,
Fixt to great *Caesar*ˣˣⁱⁱⁱ what was *Caesar's* Due,
And then, Dictator-like, to Fields withdrew.
Fair ran the Current of his Age, serene
As the pure Lakeˣˣⁱᵛ that bounds the various Scene.
Here whate'er Nature beauteous boasts we find,
Charming when sep'rate, but more charming join'd,
[**123**] Pleasures, tho' chang'd we meet where'er we rove,
On Hill, in Dale, on Plain, in shady Grove;
Here swell the Hillocks crown'd with golden Grain,
There, at their Feet, fair flows the liquid Plain,
O'er those the Larks extend their labour'd Note,
On this the Swans in snowy Grandeur float.

 To *Houghton* then we take our pleasing Way
Thrice happy Bound'ry of a well-spent Day;
Here chearful Plenty met the wearied Guest,
And splendid Welcome doubly crown'd our Rest.

 Thou then, *Apollo,*ˣˣᵛ aid the Poet's Lay,
Thy Beams gave Lustre to the following Day;ˣˣᵛⁱ
When in one House more Beauties join'd we found,
Than e'er thou seest in all thy glorious Round;
Where *Walpole* plac'd with curious happy Cost,ˣˣᵛⁱⁱ
Whate'er Magnificence or Taste can boast;
[**124**] Where, in what Building noblest has, we find
Preserv'd what Painting liveliest e'er design'd.

xxi A tribute to forthcoming generations and the then Thomas Coke, Earl of Leicester whose own memorial was to be added in the Church at Tittleshall.

xxii ie. Charles, Second Viscount Townshend . For an account of Charles Townshend see *Aedes* 2002, no. 15.

xxiii ie. RW

xxiv 'Rainham, the seat of the Lord Viscount Townshend, built by that excellent architect, Inigo Jones. The country around it is rich, and charmingly cultivated. The situation of the house, a park finely planted, and a beautiful lake of water render it very desirable.' Beatniffe 1777, pp. 49–50.

xxv Apollo was the God of Poetry and also the Sun.

xxvi The following paeon of praise precisely recognises the achievement of RW in the creation of Houghton and reflects HW's own standpoint.

xxvii It was important to relieve RW of any suspicion that he had paid over the odds for his collection and for Houghton. ' I do believe now that he did not plunder the public, as he was accused (as they accused him) of doing, he having died in such circumstances'. HW to Mann 15 April 1745. HWC, vol. 19, pp. 31-32.

* HW: *Tittleshall,* a Village, in the Church of which is the Burial-Place of the noble Family of *Coke,* and a very fine Marble Monument of the Right Honourable Sir *Edward Coke,* Lord Chief Justice of the *King's Bench* in the Reign of King *James* I. And Ancestor to the present Right Honourable *Thomas* Earl of *Leicester*

† HW: *Raynham,* the Seat of the Right Honourable *Charles* Viscount *Townshend.*

A Journey *to* Houghton:

xxviii Whaley begins his tour in the hall with a brief description of the work of art to which he had already published a poem. See note i above. For Michael Rysbrack see *Aedes* 2002, nos. 190, 198.

xxix Phidias was the Athenian sculptor, born c. 490 B.C. He is credited with the Athena Promachos, the largest ever metal statue made at Athens. He was commissioned by Pericles to design the marble sculptures of the Parthenon.

xxx ie.bronze.

xxxi We should draw the conclusion that new hypocrites are not far away.

xxxii This is a less common use of 'plastic', applied here as an adjective to something immaterial - Pow[e]r—being rather more usually applied to the plastic arts.

xxxiii Prometheus was worshipped as the supreme craftsman, associated with fire and the creation of man.

xxxiv Seraphim were from an early period recognised by Christian interpreters for the burning fervour of their love.

See!xxviii Sculpture too her Beauties here disclose,
Such as old *Phidias*xxix taught, and *Rysbrack* knows.
Laocoon here in Pain still seems to breath,
While round his Limbs the pois'nous Serpents wreath;
Life struggling seems thro' ev'ry Limb to pass,
And dying Torments animate the Brass.xxx
　　　The Pencil's Pow'r the proud *Salon* displays,
And struck with Wonder on the Paint we gaze.
　　　See! the proud †*Rabbins* at the sumptuous Board,
Frown on the Wretch who kneels before her Lord,
[**125**] And the rich Unguent, in Devotion meet,
Pours, mixt with Tears, on her Redeemer's Feet.
In vain with Hypocriticxxxi Rage they glow,
While Mercy smooths the Heavenly Stranger's Brow,
He the true Penitent with Ease descries,
Sees the Heart speaking in the melting Eyes,
Bids ev'ry Tear with full Effect to stream,
And from his Vengeance all her sins redeem.
　　　On the next ‡Cloth behold *Vandyke* display
Celestial Innocence, immortal Day,
His Pencil here no more with Nature vies,
Above her plasticxxxii Pow'r his Genius flies;
Soars on *Promethean*xxxiii Wing aloft, and there
Steals Forms which Heav'n-born Cherubs only wear;
[**126**] Pours Airs divine into the human Frame,
Darts thr'o his Children's Eyes Seraphicxxxiv Flame,
While o'er the sacred Forms such Beauties reign,
As not belie the Sainthood they contain.
　　　Behold! Where § *Stephen* fainting yields his Breath,
By great *Le Sueur* again condemned to Death;
With strange Surprize we view the horrid Deed,
And then to Pity melted turn the Head,

* HW: The Statue of *Laocoon* in Bronze by Girardon, *from the Antique.* [See *Aedes* 2002, no. 199].

† HW: The Picture of *Mary Magdalene* washing *Christ's* Feet, by Sir *Peter Paul Rubens,* born at *Antwerp* 1577, and died 1640. [See *Aedes* 2002, no. 85].

‡ HW: The Holy Family with a Dance of Angels, by Sir *Anthony Vandyke,* a Scholar of *Rubens,* born at *Antwerp* 1599, and died 1641. [See *Aedes* 2002, no. 84]

§ HW: The Stoning of St. *Stephen,* by *Eustache Le Sueur,* born at *Paris* 1617, and died 1655. [See *Aedes* 2002, no. 83].

Left, as Spectators of the Martyr's Fall,
We innocently share the Crime of *Saul*.
Here too **Albano's* Pencil charms the Eye;
Morellio here unfolds the azure Sky.
[**127**] †Sweet modest Charms the Virgin's Cheek adorn,
To Heav'n on Wings of smiling Seraphs born.
The next gay Room is known by ‡*Carlo's* Name,
Fair *Mausoleum*xxxv of *Maratti's* Fame!
Such Strokes, such equal Charms each Picture boasts,
We venture not to say which pleases most.
Thus on the Galaxy with Joy we gaze,
Nor know which Star emits the brightest Rays.
Yet if beyond himself he ever flew,
Amidst the Glow that from that Purple breaks,
Look on yon § Pope, nor wonder if he speaks.
[**128**] With Length of Days and Fame *Maratti* blest,
Ne'er wept departed Genius from his Breast;
But when just drooping, sinking to the Ground,
‖ Spread sportive Loves, and laughing Cherubs round;
E'en Death approaching, smil'd, and made a stand,
And gently stole the Pencil from his Hand.
Thus falls the Sun, and, as he fades away,
Gilds all th' Horizon with a parting Ray.
 Next on the gorgeous Cabinetxxxvi we gaze,
Which the full Elegance of Paint displays,
In strong Expressions of each Master's Mind,
The various Beauties of this Art we find;
Here vast Invention, there the just Design,
Here the bold Stroke, and there the perfect Line,
[**129**] With Ease unequall'd here the Drawing flows,
And there inimitable Colour glows.

xxxv The original Mausoleum, the tomb of Mausolus of Caria and built of white marble, was described by Pliny and regarded as one of the seven wonders of the ancient world. Whaley is responding to the impact of RW's Carlo Maratti Room.

xxxvi The paintings described so far were all in the Saloon.

★ HW: *John* baptizing *Christ*, by *Francis Albani*, who died 1662. [See *Aedes* 2002, no. 82].

† HW: An Assumption of the Virgin *Mary*, by *Morellio*. [See *Aedes* 2002, no. 92].

‡ HW: The Green Velvet Drawing is called the *Carlo-Marat* Room, from being filled with Pictures of that Master and his Scholars. *Carlo-Maratti* was born at *Rome* 1625, was a Scholar of *Andrea Sacchi*, and died 1713.

§ HW: A Portrait of *Clement* IX. [See *Aedes* 2002, no. 99].

‖ HW: He painted the Judgment of *Paris* in this Room, when he was 83. [See *Aedes* 2002, no. 100].

A Journey *to* Houghton:

xxxvii See *Aedes* 2002, nos. 143, 159 in the Cabinet.

xxxviii See *Aedes* 2002, nos. 157, 158, 182, 183.

xxxix The visitor wanders in wonderment just as did Aeneas in the Stygian fields. The figures to be seen in the Drawing Room are, however, portraits not ghosts.

With Summer here the Cloth ★*Bassano* warms
There locks the World in Winter's hoary Arms;
On the warm View we look with pleas'd Amaze,
Then turn to Frost, and shudder as we gaze.
 Mirth unrestrain'd in Rusticks humble Cells
On chearful *Teniers'* laughing Canvass dwells,
Nor ever are his warm Expressions faint,
But laughing we enjoy the comic Paint; xxxvii
'Till Scenes more horrid break upon your Eye,
Effects of *Borgognone's* too cruel Joy.xxxviii
Strong was his Fancy, and his Genius good,
But bred in Camps, he mix'd his Tints with Blood;
[**130**] Alternate bore the Pencil and the Sword,
And the same Hands that fought, the Fight record.
 But lo! And let the pious Tear be shed,
On the sad †Cloth the World's great Master dead.
The Mother see! in Grief amazing drown'd,
And Sorrow more than mortal spread around.
What striking Attitudes! What strong Relief!
We see, we wonder at, we feel the Grief.
Who could such Pow'r of speaking Paint employ?
Own, *Parma*, own thy darling Son with Joy;
Still to his Memory fresh Trophies rear,
Whose Life insatiate War ‡itself cou'd spare.
[**131**] No Arms he needed 'midst the fatal Strife,
But to his potent Pencil ow'd his Life,
The wond'rig Soldier dropp'd the lifted Sword,
Nor stain'd those Hands he only not ador'd.
 §Now as *Aeneas* in the *Stygian* Glades xxxix
Wond'ring beheld departed Heroes Shades,

★ HW: The *Bassans*, Father and Son, were very eminent Landscape-Painters, about the Middle and towards the End of the Sixteenth Century. [See *Aedes* 2002, nos. 141, 142].

† HW: *Christ* laid in the Sepulchre, by *Parmegiano*. [See *Aedes* 2002, no. 147].

‡ HW: *Francis Mazzuoli*, commonly called *Parmegiano,* was born 1504, and died 1540. There is a Story of this Master at the taking of *Parma*, like that of *Archimedes*, and also like that of *Protogenes*, at the taking of *Rhodes*, while he was painting his famous *Ialysus*.

§ HW: In the Yellow Drawing [Room] are Portraits by *Vandyke*, of Lord Chief Baron [Sr. Christopher] *Wandesford*, Lord and Lady *Wharton*, their Daughters, Archbishop *Laud,* King *Charles* I. And his Queen. The Portrait of the Earl of *Danby*, now hangs in the Great Parlour. [HW Add MS (PML). See also *Aedes* 2002, nos. 62, 65-71.]

Amidst the Forms of Worthies dead we range,
By eternizing Paint preserv'd from Change.
Here Law and Learning dwell in *Wandesford's* Face
While valiant *Whartons* shine with martial Grace;
And the soft Females of the Race declare,
That these no braver were, than those were fair;
[**132**] In garter'd Glory drest here *Danby* stands,
And *Laud* with Air imperious still commands.

 The next great *Form with melancholy Eye,
And inauspicious Valour seems to sigh.
Peace to his Soul! Howe'er 'gainst Right he fought,
Be in his dreadful Doom his Sin forgot;
Too much misled to leave his Honour clear,
Too wretched not to claim a genrous Tear!
A Wretch to Virtue's still a sacred thing:
How much more sacred then, a murder'd King!
But be our Wrath, as it deserves, apply'd
To his Two Guides, still closest to his Side,
Laud^{xl} and the Queen,^{xli} whose fatal Conduct show,
What bigot Zeal, and headstrong Pride cou'd do.
[**133**] But see where †*Kneller* now our Eye commands
to pictur'd Kings, familiar to his Hands;
Kings, to support a free-born People made,
Kings, that but rul'd to bless the Lands they sway'd;
Sov'reigns, whose inoppressive Pow'r has shown
Freedom and Monarchy, well-join'd, are One.

 See mighty ‡*William's* fierce determin'd Eye,
Freedom to save, or in her Cause to die;
As when on *Boyne's* important Banks he stood,
And, as his Deeds surpriz'd the swelling Flood,
All torn and mangled false Religion^{xlii} fled,
And crush'd Oppression snarl'd beneath his Tread.
 [**134**] Next, in the steady Lines of §*Brunswick's* Face,

xl See *Aedes* 2002, no. 67.

xli See *Aedes* 2002, no. 66.

xlii Whaley here reflects the strong resentment of Roman Catholicism of this period, just prior to the 1745 Jacobite uprising.

* HW: King *Charles* the First. [See *Aedes* 2002, no. 65].

† HW: Sir *Godfrey Kneller.*

‡ HW: K. *William* III. On Horseback. [See *Aedes* 2002, no. 30].

§ HW: K. *George* I. On Horseback [See *Aedes* 2002, no. 31].

A Journey to Houghton:

xliii A Whig view of the Hanoverian Succession.

xliv By addressing the portrait *in situ* Whaley achieves a neat conceit which enables him to laud RW and his family as well as the first George.

xlv Whaley now moves down the staircase to the Arcade, the vaulted sub hall which runs the depth of the house. This was the formal entrance to the ground floor, where RW's hunting parties gathered.

xlvi Presumably light breezes ruffle the hangings.

xlvii Vulcan, in Roman mythology, was the god of fire and of metal working, corresponding to the Greek Hephaestus. Whaley may also be alluding to the hypothetical planet supposed to have its orbit between the Sun and Mercury.

xlviii A more satirical view of RW's hospitality is given in *The Norfolk Congress; or A full and true Account of the Hunting, Feasting and Merrymaking of Robin and his Companions* … in the appendix to the third volume of *The Craftsman*, 1731, pp. 317-22.

xlix 'Henry Pelham, afterwards Chancellor of the Exchequer
Richard, Ist Lord Edgcumbe
William Cavendish, 3rd Duke of Devonshire
Sr William Yonge, Secretary at War.' HW Add Ms (PML).
Sir William Yonge was the author of a broadsheet hunting ballad *The Norfolk Garland: or, The Death of Renard the Fox. To the Tune of , A Begging we will go*, &c. HW's copy of this ballad is in the Lewis Walpole Library (illustrated on p. 15 of this book).

l The sister Arts are here Painting and Poetry and it is to the newly hung Gallery that Whaley turns.

li Whaley's *Journey* has brought the reader not only to Houghton but to the inner sanctum of the Goddess of Painting.

Majestick manly Honesty we trace;
Pleas'd as on *Sarum*'s Plain with glad Accord,
When willing Thousands hail'd their new-come Lord,
And (far beyond a Tyrant's baleful Glee)
The King rejoic'd to find his People free.[xliii]
Good Prince, whose Age forsook thy native Land
To bless our *Albion* with thy mild Command,
Long may this sacred Form of Thee remain,
Here plac'd by him whose Counsels bless'd thy Reign,
And ever may his Sons with Joy relate,
That He as Faithful was as Thou wert Great.[xliv]
 But now, my Muse, to sob'rer Pomp descend,
And to the cool Arcade my Steps attend.[xlv]
[135] Here, when the Summer Sun spreads round his Ray,
Beneath the bending Arch young *Zephyrs*[xlvi] play,
And, when it farther from our Orb retires,
Old *Vulcan* [xlvii] smiling lights his chearful Fires.
Hither the jolly Hunter's Crew resort,
Talk o'er the Day, and re-enjoy their Sport;[xlviii]
Here too, with Brow unbent, and chearful Air,
The mighty Statesman oft forgot his Care;
Knew Friendship's Joys, and still attentive hung
On *Pelham, Edgcumbe, Devonshire*, or *Yonge*,[xlix]
In Senates form'd or private Life to please,
These shared his Toil, and here partook his Ease.
 Here be thy Stay, my Muse, tho' pleas'd, not long,
Thy Sister[l] Painting claims again my Song,
Where thron'd in State the Goddess we descry
As the gay *Gall'ry* opens on our Eye.
[136] Here in her utmost Pomp well-pleas'd she reigns
Nor weeps her absent *Rome*, or *Lombard* Plains;[li]
Here the great Masters' Genius still survives,
Breathes in the Paint, and on the canvas lives.
*Whate'er in Nature's forming Pow'r is plac'd,
Fair to the Eye, and luscious to the Taste,
Is by our cheated Sense with Joy perceiv'd,

* HW: The Four Markets, by *Rubens* and *Snyders*. [See *Aedes* 2002, nos. 230-33.]

A POEM

Pausing and loth to be convinc'd we stand,
Lest the fair Fruit should suffer from our Hand,
Lest the press'd Plum our ruder Touch should own,
Or swelling Peach bewail its injur'd Down;
Less dare we to the Fish of Fowl draw near,
Tho' tempting, strongly guarded they appear,
[**137**] Frighted we scarce can brook the horrid Looks
Of Dogs, and snarling cats, and swearing Cooks.
What Strokes, what Colours *Snyders* could command!
How great the Power of *Rubens'* daring Hand!
Immortal *Rubens*! Whose capricious Mind,
Of the vast Art to no one Part confin'd,
Pierc'd like the Sun's quick beam, all Nature thro';
And whatsoe'er the Goddess form'd, he drew.
See! **Mola* next the *Roman* Deeds displays,
That bid our Hearts be Patriot as we gaze.
Here †*Julio's* wond'rous Buildings still appear,
And swelling Domes still seem to rise in Air.
[**138**] Great Shade of ‡ *Poussin*, from the Muse receive
All the Renown a Verse, like hers, can give.
Genius sublime! To reach thy soaring Praise,
A Muse like *Maro's*[lii] should renew her Lays;
Rival of *Raphael*! such thy wond'rous Line,
Tis next to his, and only not divine.

 Ye Maids, employ'd in spotless *Vesta's*[liii] Sight,
Lend me a Beam of your Eternal Light;
Full on yon Picture throw the sacred Ray,
And high Imperial Chastity display.
See! the great *Roman* on his martial Throne,
Outdo whate'er in War his Arms had done;
See him rise far beyond a Soldier's Fame,
And *Afric's* Victor but a second Name.
[**139**] Valiant and Great he trod the Field of Blood,

lii Maro is a cognomen of the poet Virgil.

liii Vesta was the Roman hearth goddess, served by the vestal virgins.

* HW: The Stories of *Curtius* and *Cocles*, by *Mola*, born 1609, died 1665. [See *Aedes* 2002, nos. 234, 235].

† HW: A Piece of Architecture, by *Julio Romano*, born 1492, and died 1546. [See *Aedes* 2002, no. 237].

‡ HW: Here are the stories of *Scipio's* Continence, and of a *Moses* striking the Rock, by *Nicolo Poussin*, born 1594, and died 1665. [See *Aedes* 2002, nos. 258, 259.]

liv Mount Horeb was the site of the burning bush and where Moses delivered the Laws.

lv In the Dedication of the *Aedes Walpolianae* HW chose to see his father in the role of Moses the Law Giver.

lvi Avernus was a deep and gloomily wooded lake near Puteoli, which was thought to lead to the underworld.

But here is Virtuous, Bountiful, and Good;
Resists the utmost Pow'r of Female Charms,
Feels all the Force, yet gives 'em from his Arms,
And Lord of all the Passions of his Breast,
Defeats e'en Love, and makes his Rival blest.
Wonderful Strokes, that thro' the Eye impart
Such various Motions to the human Heart!
Thro' it a thousand floating Passions move,
We pity, wonder, weep, rejoice and love.
 The moral Tale thus exquisitely told,
His Colours now diviner Truths unfold;
At *Horeb's*^{liv} Rock in sacred Awe we stand,
And pencil'd Miracles our Faith command.
The mighty Law-giver his Rod displays,^{lv}
And the tough Flint his potent Touch obeys;
[140] Quick into Streams dissolves the solid Stone,
And floats the Waste with Waters not its own.
See into Health, or lighten into Joy;
As eager, crouding in the Draught they join,
Revivng Thousands bless the Stroke Divine.
But thou, fair Damsel, with distinguish'd Worth,
Emblem of filial Piety, stand forth;
Forgot her own consuming inward Fire,
She lifts untouch'd the Vessel to her Sire;
With the cool Draught his heaving Breast relieves,
And, as she sooths his Pain, her own deceives.
 With *Scenes too sad *Salvator* strives to please,
Since what creates our Wonder spoils our Ease;
[141] We give the wretched Prodigal a Tear,
And with his kind forgiving Father near.
 As on *Avernus'*^{lvi} Banks the Hero stood,
Scar'd at the dreary Darkness of the Wood,
'Till thro' the Leaves fair shot th' auspicious Light,
And with the branching Gold reliev'd his Sight;
So rescu'd from the horrid Scene we stand,

* HW: A very capital Picture of the Prodigal Son on his Knees at Prayers amidst the Herd of Swine, by *Salvator Rosa*, born 1614, and died 1673. [See *Aedes* 2002, no. 228].

By the sweet Effluence of *Guido*'s Hand.
Soft to the Sight his ev'ry Colour flows,
As to the Scent the Fragrance of the Rose.
Pure Beams of Light around the *Virgin play,
Clad in the Brightness of celestial Day;
Be as they may the Broils of fierce Divines,
Pure and unspotted here at least she shines.

[**142**] Thee too, †*Lorraine*, the well-pleased Muse should name,
Nor e'er forget ‡*Domenchini*'s Fame;
But sudden Sorrow stops the flowing Line.
§Behold where all the Charms that Heav'n could give,
Blended in one sweet Form, still seem to live;
Then sink to Tears, nor stop the bursting Groan,
When thou art told that all those Charms are gone.
Relentless Death still forcing to the Grave
The Good, the Fair, the Virtuous, and the Brave,
Here the whole Malice of his Pow'r put on,
And aim'd a Dart that slew them all in one.
[**143**] How Fair, how Good, how Virtuous was the Dame,
A thousand Hearts in Anguish still proclaim;
How brave her Soul, against all Fear how try'd,
Sad fatal Proof she gave us when she dy'd.

Thou then, my Friend, no farther Verse demand,
Full swells my Breast, and trembling shakes my Hand,
And these sad Lines conclude my mournful Lay,
Since we too once must fall to Death a Prey,
May we like *Walpole*[lvii] meet the fatal Day.

F I N I S
[*Printed by* John Hughs, *near Lincoln's-Inn-Fields*.][lviii]

* HW: the famous Picture, by *Guido*, of the Doctors of the Church disputing on the Immaculate Conception. *Guido Reni*, born 1575, and died 1642. [See *Aedes* 2002, no. 227].

† HW: *Claud. Gille of Lorraine*, born 1600, and died 1682. [See *Aedes* 2002, nos. 267, 268].

‡ HW: *Domencio Zampieri*, commonly called *Domenichini*, born 1561, and died 1641. [See *Aedes* 2002, no. 275].

§ HW: The Portrait of *Catharine Shorter*, first Wife to Sir *Robert Walpole*. She died *Aug.* 20, 1737. [See *Aedes* 2002, no. 57; this did not hang in the Gallery. Whaley has found a suitably tragic ending with a tribute to HW's mother possible in the light of the death of RW's second wife Maria Skerrett, within less than a year of Catherine Shorter.]

lvii Presumably a reference to Catherine Walpole rather than RW himself. Whaley was himself to die all too soon, Christmas 1745.

lviii John Hughs (c.1703–71) was the printer of both the second and third editions of the *Aedes* and most probably the first edition as well. Hughs was the usual printer for the poet and bookseller Robert Dodsley (1703–64).

Picture Hangs at Houghton: some contemporary sketches and modern reconstructions
Andrew Moore and David Yaxley

A series of picture hanging plans survive for Houghton Hall which provide a fascinating insight into the process of picture hanging as it unfolded at Houghton. The need to assimilate important new works from Downing Street led to the fulfillment of plans to create the new Picture Gallery and a second phase of picture hanging. The surviving plans fall into three categories: initial designs by William Kent for the Salon (private collection, see endpapers and Moore ed. 1996, cat. nos. 39, 40); preparatory ideas for possible arrangements in the Common Parlour (Houghton MS A65; see Moore ed. 1996, cat. no. 14, illustrated) and the Cabinet (Houghton MS A84; see Moore ed. 1996, cat. no. 56, illustrated), and a series of drawings for the Picture Gallery, some of which may or may not have been fully realised, and therefore include records of actual arrangements.

With the evidence of the surviving plans—in parallel with the *Aedes Walpolianae*, the Walpole MS 1736 picture list, and the HRO MS 1744 inventory—it is possible to reconstruct the picture hangs in a number of rooms at Houghton as well as the Picture Gallery. This has been done by David Yaxley (see pp. 425–28). He has provided logical reconstructions of the picture hangs in the Common Parlour, the Carlo Maratt Room (also known in the eighteenth century as the Green Velvet Drawing Room), the Cabinet and the Salon. In this last reconstruction, reproductions of the paintings are provided to indicate the visual effect, where the paintings were hung against red wool damask. The plans and records are not universally consistent and no one arrangement is the true one throughout the lifetime of the collection at Houghton. For David Yaxley's reconstruction of the hang in the Picture Gallery, see Yaxley 1996.

The Salon

William Kent's original designs for the Salon at Houghton are among the most important surviving documents not only of Kent's own creative process, but also of the means by which the designer involved the patron in the overall scheme for the interior. They also reveal the thinking behind those schemes. Until recently it was not clear that they were no more than proposals, and did not necessarily show works that were all demonstrably in the Walpole collection at the time, c.1725. It can now, however, be seen that all the most important works were known to Kent and in Walpole's collection at the time he drew up his proposals, making clear the relationship between the European old master collection and the concepts behind their setting.

At first Kent's designs were proposals that acknowledged the central importance of some of the most significant works in Robert Walpole's collection, notably the four great market scenes by Snyders and Jan Wildens (cat. nos. 133-136) and the two major overmantels by Jordaens (cat. no. 111) and the Rubens studio. The latter was in fact a version of Van Dyck's *Frans Snyders with his Wife and Child* (*Family Portrait*, State Hermitage Museum, St Petersburg). Walpole's version, almost certainly one of those mentioned (by ?Antoine-Joseph Dezallier d'Argenville) in Fougeroux MS 1728 (see p. 23 above, as by Rubens), hung over the chimney in Grosvenor Street in 1736. Attributed in 1736 to 'Long John' Boeckhorst, this never went to Houghton, being sold subsequently in 1751 to the financier Sampson Gideon (see Appendix VII, lot 66, *Snyders, and his Wife and Child* still attributed to 'Long Jan'; grateful thanks go

to Alastair Laing for help in tracing this painting to the Friedanthal Collection).

These six major Flemish works did not ultimately hang in the Salon: the first arrangement of the four market scenes was completely unsuccessful to the eye of Lord Harley in 1732 (see Moore ed. 1996, cat. no. 39). Instead a more varied and classic arrangement was finally installed of works from the European Schools (see *Aedes* 2002, nos. 77-95), providing a less specifically didactic hang. Kent's intentions were probably more closely followed in the adjacent Carlo Maratt Room (*Aedes* 2002, nos. 96-125), where a more contemporary Roman School arrangement was followed (see *Aedes* 2002, n. xxxvi).

In summary, Kent's designs provide the evidence for our understanding of Walpole's active involvement as patron, both rejecting and developing the designer's initial submission. They were based upon his patron's ambitions as a man of taste, but also responded to specific paintings in the collection. Kent's fully worked up designs also show a deliberate schema that introduces decorative mythological scenes that were conceivably intended to mirror the subject matter of the paintings collection directly and also to make manifest the classical predilections of the owner. This was also the case for the final scheme, completed in 1731.

The Common Parlour and The Cabinet

Designs in the Houghton archive record the hang as it was conceived at the time of the removal of paintings from London. These are in sepia and black ink on laid paper and are by an unknown draughtsman. They are of interest as records of process, making manifest the detail of the attempts to reinstall the paintings at Houghton following Sir Robert Walpole's retirement.

The plan for the Common Parlour shows that a total of twenty-seven pictures hung on three walls opposite the window façade, matching the number recorded in the room by Horace Walpole in the *Aedes*. This is not, however, the same number as recorded in the 1744 inventory, HRO MS 1744 and excludes Sacchi's *Venus Bathing with Cupids in a Car* (cat. no. 79), Cignani's *Nativity* (cat. no. 26) and Van Dyck's *Sir Thomas Chaloner* (cat. no. 100), all recorded by Horace Walpole in the *Aedes*. In addition a series of portraits by Mor, Hals, Kneller, Rembrandt, Rosa and Rubens are not mentioned. This suggests that the plan was made prior to the arrival of the additional pictures from London.

A similar conclusion can be drawn from the plan for the picture-hang in the Cabinet. In 1736 the 'Corner Drawing Room' simply housed two full-lengths and three half-lengths from the Wharton collection, the huge cartoon of the *Meleager and Atalanta* (cat. no. 128) and the full-length of *Hélène Fourment* (cat. no. 117). The decision to transform the room into a Cabinet Room to show a massed display of mainly small-scale easel paintings in common with contemporary fashion was possible once the Picture Gallery was complete. Horace Walpole records in the *Aedes* a host of fifty-one pictures hung in the Cabinet, while this plan records only thirty-eight on just two walls (including *Hélène Fourment* over the chimney, a single work on the third wall). We see therefore a scenario in which an intermediary hang is recorded, dating the plan to c.1742, after the Picture Gallery was complete, but prior to the final hang recorded by Horace Walpole in the summer of 1743.

There are two picture hanging plans for the Gallery which survive at Houghton: MS A29 (illustrated, p. 424, bottom) and A66 (illustrated opposite); in addition four survive inserted in the second edition of the *Aedes* now in the Fitzwilliam Museum, Cambridge (illustrated, pp. 421–23); and also appended to the 1744 MS Inventory (HRO MS 1744) is a workmanlike representation of the picture order (illustrated p. 424, top). MS A29 at Houghton records the south wall of the Gallery in a purely schematic manner, including sizes. MS A66, meanwhile, illustrates the east and west wall elevations on one sheet. This is the most worked-up drawing in the series, giving a good impression of the interior detail of the Gallery and the symmetrical manner in which the paintings were hung. All of the paintings shown on the west wall are listed in the *Aedes*; only those attributed to Le Sueur, Carracci and the pair known as Palma Vecchios from the east or entrance wall remained in the room according to the *Aedes*. This indicates once again that the drawings do not represent the final arrangement, insofar as the *Aedes* may be regarded as recording the final hang in Sir Robert Walpole's lifetime.

The Fitzwilliam drawings represent a less precise record, giving in addition an impression of the Gallery (73 feet long by 22 feet wide), with its classical entrance from the vestibule and two chimneys on the north side, with flourishes of the pen that conjure something of the Kentian frames and furniture which adorned the Gallery as well as the paintings. The overall impression was of a balanced hang, with a concentration of the most 'capital' works in the collection. Here at last the full scale of the collection becomes apparent, the largest paintings themselves dwarfed by the company they kept, both in terms of size and also quality. Horace Walpole records just how many more pictures there were than could be accommodated even in the new Gallery: 'so far from unfurnishing any part of the house, there are several pictures undisposed, besides numbers at Lord Walpole's at the Exchequer, at Chelsea, and at New Park. Lord Walpole has taken a dozen to [Stanhoe, Norfolk]' (Horace Walpole to H. Mann, 10 June 1743, HWC vol. 18, p. 249).

The genesis of the Picture Gallery is described elsewhere (see p. 43 and *Aedes* 2002, n. lv; also Yaxley 1995 and Sebastian Edwards in Moore ed. 1996, pp. 145-46). Sir Robert would also have known the Gallery of another Norfolk neighbour (apart from Sir Andrew Fountaine's 'Tribune Gallery', built to display his maiolica collection): that of the amateur and virtuoso William Talman of Ranworth. A sheet of studies, c.1702, survives in the Victoria and Albert Museum for a Gallery by Talman's son John, who accompanied William Kent on his European tour, 1711-12 (Harris 1985). Talman's designs can lay claim to being the earliest known by an English architect for a complete interior decorative scheme, including sculpture and furniture. The importance of the Houghton Gallery lies in its early rationalization in England of a long, rectangular and windowless room of real scale, daylit from above by means of a clerestory system. Pen and ink designs for the Gallery survive in the Houghton Archive, which clearly show the recommended approach to the fenestration (Houghton MS A24). Another design shows the fenestration in two possible permutations, with a flat roof (Houghton MS A26). In addition two ceiling designs appear to show alternative decorative schemes (Houghton MS A27, A28). A design for the vestibule to the Gallery shows the entrance to the Gallery on the West Side directly opposite the Chapel to the north (Houghton MS A11). The precise interpretation of these plans must remain conjectural as the Gallery was burnt to the ground in 1789.

The replacement Gallery that survives today is fenestrated, providing reduced space for picture-hanging, and can only hint at the original splendour of the effect that captivated so many visitors in the eighteenth century – an effect that Horace Walpole believed 'would not yield even to the [Palazzo] Colonna' in Rome, which boasted one of the great private European galleries of the day (Horace Walpole to John Chute, 20 August 1743, HWC vol. 35, p. 44).

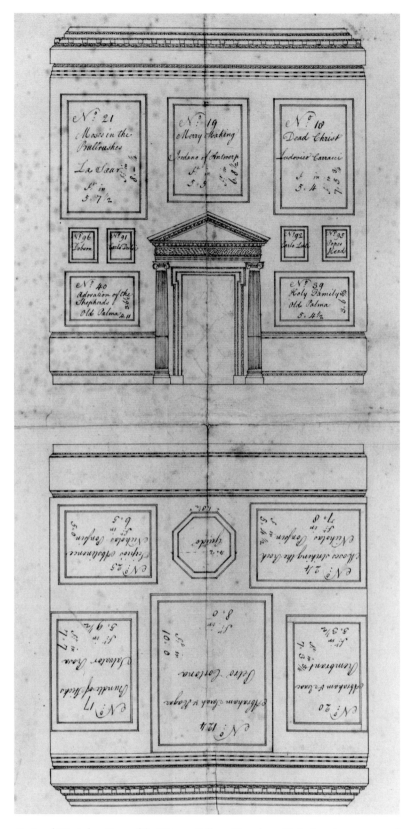

East and West elevations of the Picture Gallery, Houghton Hall, showing a proposed picture hang, c.1742, pencil, black and brown ink on paper, 75.5 X 54. The Marquess of Cholmondeley

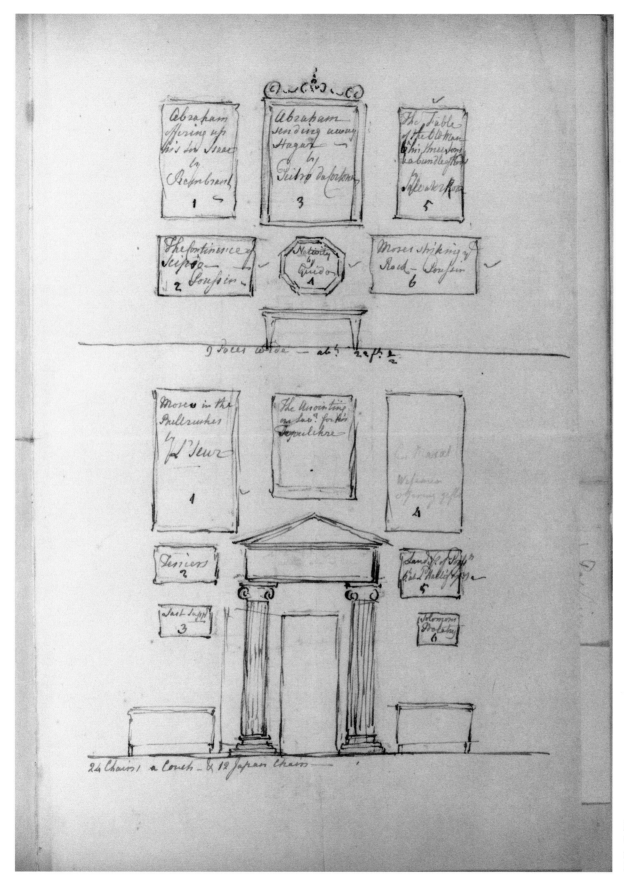

East and West elevations of the Picture Gallery, Houghton Hall, showing a picture hang, with furniture, C.1742
Fitzwilliam Museum, Cambridge

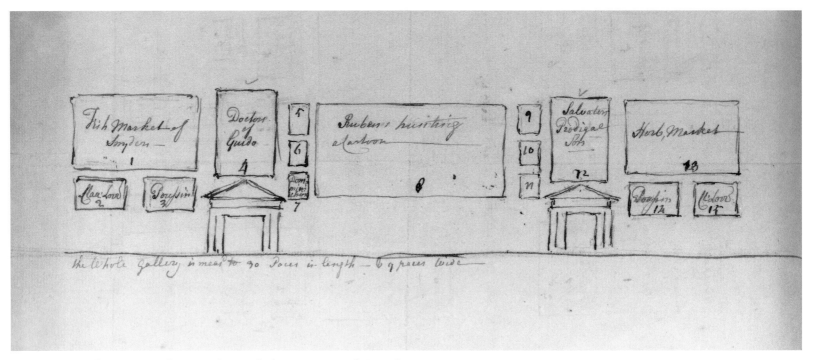

North elevation of the Picture Gallery, Houghton Hall, showing a proposed picture hang, c.1742
Fitzwilliam Museum, Cambridge

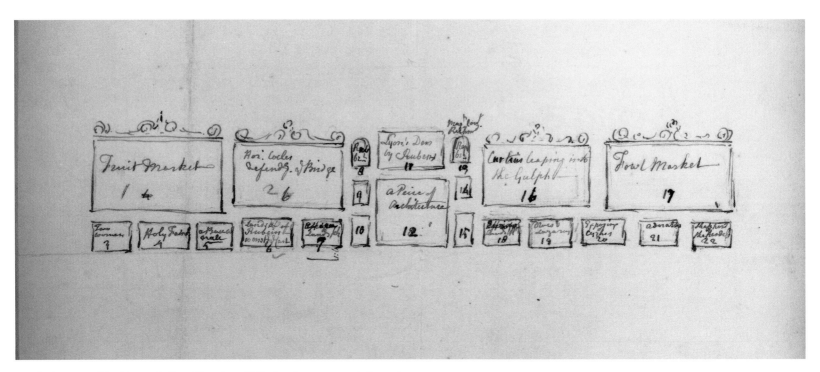

South elevation of the Picture Gallery, Houghton Hall, showing a proposed picture hang, c.1742
Fitzwilliam Museum, Cambridge

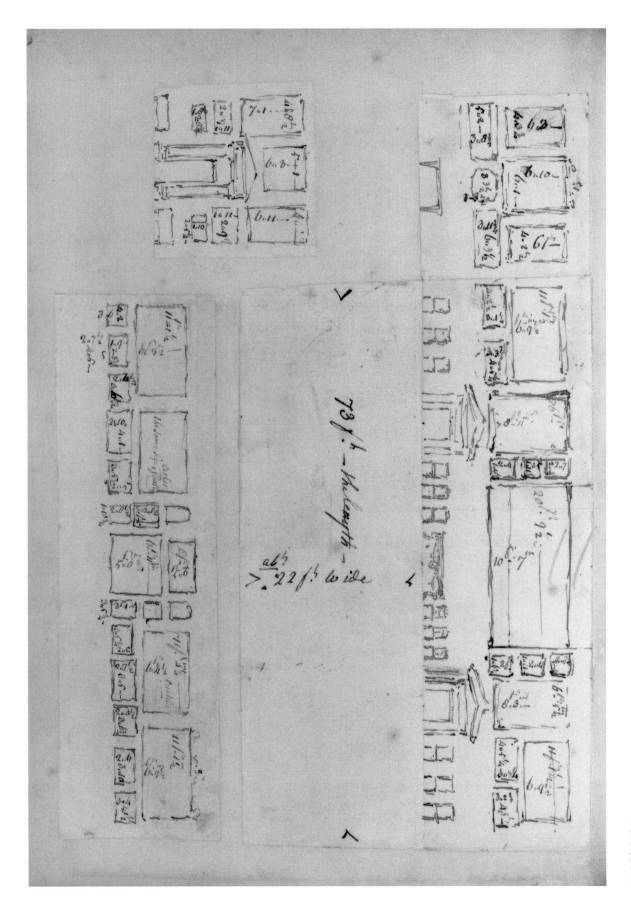

Elevations of the Picture Gallery,
Houghton Hall, showing a plan for a
picture hang and the layout of furniture,
C.1742.
Fitzwilliam Museum, Cambridge

Plan of a picture hang in the Picture Gallery at Houghton Hall, f.7 in An Inventory of Pictures at Houghton 1744, pen and ink, 18.5 x 30
Lytton Family Archive, on loan to Hertfordshire Record Office, K1547, courtesy of Lord David Cobbold

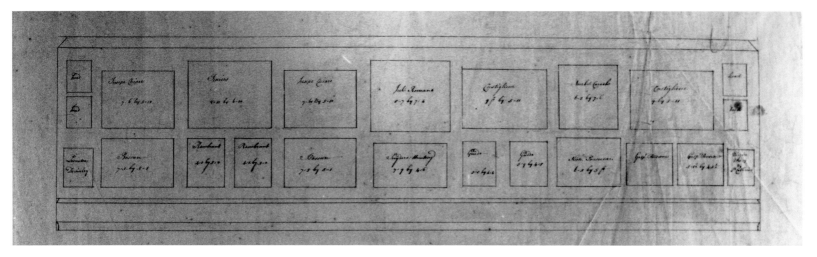

South elevation of the Picture Gallery, Houghton Hall, showing a plan of a picture hang, c.1742
The Marquess of Cholmondeley

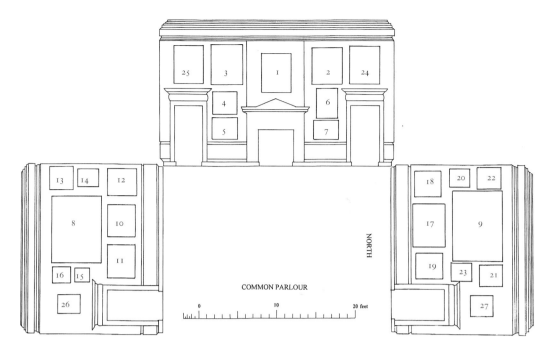

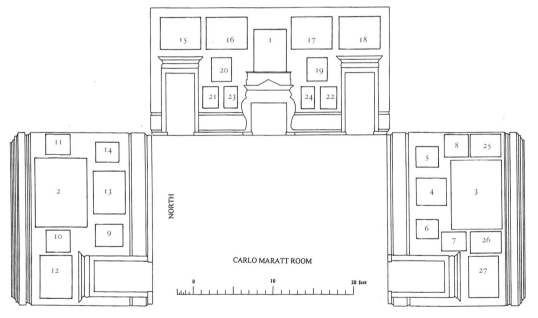

SIMONE CANTARINI, CALLED
PESARESE (1612-48)
*The Holy Family with the Infant
John the Baptist and St Elisabeth*
Oil on canvas, diameter 108
(tondo)
Aedes 2002, no. 86
Cat. no. 14

Missing:
ANONYMOUS (VENICE, 16TH-
CENTURY)
*The Virgin and Child with John the
Baptist*
Oil on panel. c.95 x 80
Aedes 2002, no. 87
Cat. no. 89

GUIDO RENI (1575-1642)
St Joseph Holding the Christ Child
Oil on canvas, 98 x 82
Aedes 2002, no. 88
Cat. no. 71

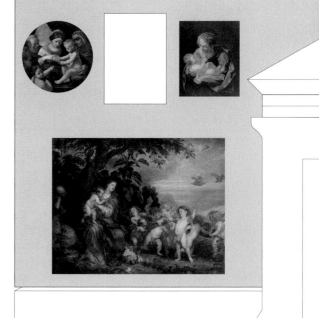

ANTHONY VAN DYCK (1599-1641)
The Rest on the Flight into Egypt, or
The Virgin with Partridges
Oil on canvas, 215 x 285.5
Aedes 2002, no. 84
Cat. no. 110

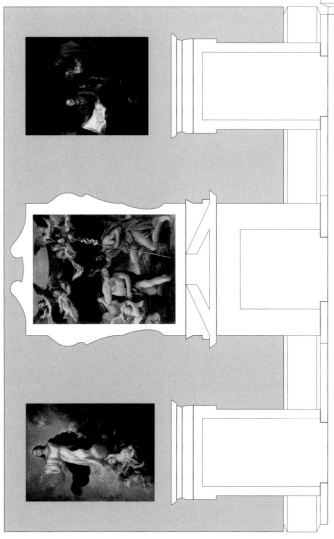

BARTOLOMÉ ESTEBÁN MURILLO
(1617-82)
The Adoration of the Shepherds
Oil on canvas, 197 x 147
Aedes 2002, no. 93
Cat. no. 183

FRANCESCO ALBANI (1578-1660)
The Baptism of Christ
Oil on canvas, 268 x 195; inscribed on
the ribbon around the cross in the hand
of John the Baptist: *ECCE AGNUS DEI*
(John i: 29, 36)
Aedes 2002, no. 82
Cat. no. 2

BARTOLOMÉ ESTEBÁN MURILLO
(1617-82)
The Immaculate Conception
Oil on canvas, 195 x 145
Aedes 2002, no. 92
Cat. no. 182

The SALON

IS forty Feet long, forty high, and thirty wide; the Hanging is Crimson flower'd Velvet; the Cieling painted by *Kent*, who design'd all the Ornaments throughout the House. The Chimney-piece is of Black and Gold Marble, of which too are the Tables.

. . .

82. Over the Chimney, **Christ baptized by St.** *John*, **and most capital Picture of** *Albano*. His large Pieces are seldom good, but this equal both for Colouring and Drawing to any of his Master *Caracci*, or his Fellow-Scholar *Guido*. It is eight Feet eight Inches high, by six Feet four and a half wide. There is one of the same Design in the Church of *San Giorgio* at *Bologna*, with an Oval Top, and God the Father in the Clouds, with different Angels; two are kneeling, and supporting *Christ*'s Garments. The Picture belong'd to Mr. *Laws*, first Minister to the Regent of *France*.

83. **The Stoning of St.** *Stephen*; **a capital Picture of** *Le Sœur*. It contains nineteen Figures, and is remarkable for expressing a most Masterly Variety of Grief. The Saint, by a considerable Anachronism, but a very common one among *Roman* Catholics, is drest in the rich Habit of a modern Priest at high Mass. Nine Feet eight Inches and a half high, by eleven Feet three and three quarters wide.

84. **The Holy Family, a most celebrated Picture of** *Vandyke*. The chief Part of it is a Dance of Boy-Angels, which are painted in the highest Manner. The *Virgin* seems to have been a Portrait, and is not handsome; it is too much crowded with Fruits and Flowers and Birds. In the Air are two Partridges finely painted. This Picture was twice sold for Fourteen Hundred Pounds: Since that, it belonged to the House of *Orange*. The Princess of *Friesland*, Mother to the present Prince of *Orange*, sold it during his Minority, when Sir *Robert* brought it. 'Tis seven Feet and half an Inch high, by nine Feet one and three quarters wide.

85. *Mary Magdalen* washing *Christ*'s **Feet; a capital Picture of** *Rubens*, finished in the highest Manner, and finely preserved. There are fourteen Figures large as Life. The *Magdalen*

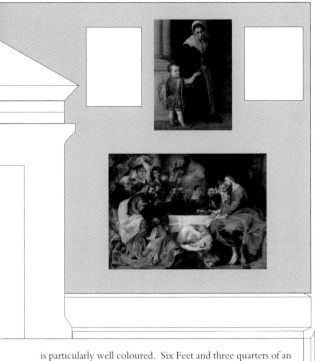

Missing:
AGOSTINO CARRACCI (1557-1602)
The Virgin with the Christ Child Asleep in her Arms
Oil on canvas, 107 x 87
Aedes 2002, no. 89
Cat. no. 16

?ALESSANDRO BONVICINO, called IL MORETTO DA BRESCIA (c.1498-1554)
Portrait of a Boy with his Nurse
Oil on canvas, 150 x 105, inscription on the back: *La vecchia serva ritratta dal famoso Titiano con il di lui figlio*
Aedes 2002, no. 90
Cat. no. 57

Missing:
ANDREA DEL SARTO (1486-1531)
The Holy Family
?Oil on panel, c.140 x 104
Aedes 2002, no. 91
Cat. no. 80

PIETER PAUL RUBENS (1577-1640) AND WORKSHOP
ANTHONY VAN DYCK (1599-1641)
Christ in the House of Simon the Pharisee
Oil on canvas, transferred from panel in 1821, 189 x 284.5
Aedes 2002, no. 85
Cat. no. 127

is particularly well coloured. Six Feet and three quarters of an Inch high, by eight Feet two wide. It was Monsieur de *Morville*'s.

86. **The Holy Family in a Round, by** *Cantarini*. The Child is learning to read. Three Feet six Inches every way.

87. The Holy Family, by *Titian*. It belonged to Monsieur de *Morville*, Secretary of State in *France*. Four Feet seven Inches and a half high, by three Feet four and a half wide.

88. *Simeon* **and the Child; a very fine Picture of** *Guido*. The Design is taken from a Statue of a *Silenus* with a young *Bacchus*, in the *Villa Borghese* at *Rome*. This was in Monsieur de *Morville*'s Collection. Three Feet two Inches and a half high, by two Feet seven and a half wide. There is another of these, but much less finished, in the Palace of the Marquis *Gerini* at *Florence*.

89. The *Virgin* with the Child asleep in her Arms, by *Augustine Caracci*. Three Feet six Inches high, by two Feet nine and three quarters wide.

90. **An old Woman giving a Boy Cherries, by** *Titian*. It is his own Son and Nurse, four Feet ten Inches high, by three Feet six and three quarters wide.

91. The Holy Family, by *Andrea del Sarto*. This and the last were from the Collection of the Marquis *Mari* at *Genoa*. Three Feet one Inch and a quarter high, by two Feet seven and a quarter wide.

92. **The Assumption of the** *Virgin***; a beautiful Figure supported by Boy-Angels, in a very bright Manner, by** *Morellio*. Six Feet four Inches and three quarters high, by four Feet nine and half wide.

93. **The Adoration of the Shepherds**, its Companion: All the Light comes from the *Child*.

94. **The** *Cyclops* **at their Forge, by** *Luca Jordano*. There is a Copy of this at St. *James*'s, by *Walton*. This belong'd to *Gibbins*. Six Feet four Inches high, by four Feet eleven wide.

95. *Dædalus* **and Icarus, by** *Le Brun*. In a different Manner from what he generally painted. Six Feet four Inches high, by four Feet three wide. For the Story, see it twice told in *Ovid's Metamorphosis*, Lib. 8. and Lib. 2. *de Arte Amandi*.

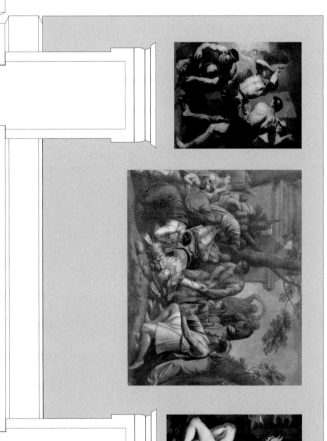

LUCA GIORDANO (1634-1705)
Vulcan's Forge
Oil on canvas, transferred from old canvas in 1848, 192.5 x 151.5
Aedes 2002, no. 94
Cat. no. 33

?THOMAS GOUSSE (1627-58)
The Stoning of St Stephen
Oil on canvas, 296 x 349
Aedes 2002, no. 83
Cat. no. 171

CHARLES LE BRUN (1619-90)
Daedalus and Icarus
Oil on canvas, 190 x 124
Aedes 2002, no. 95
Cat. no. 172

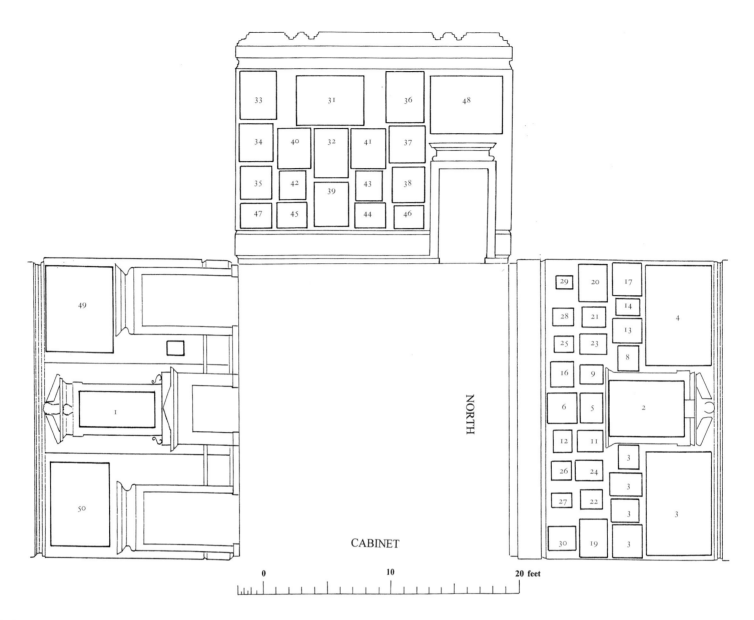

NORTH

CABINET

0 10 20 feet

Cabinet

1	Van Dyke, *Rubens' Wife* (cat. no. 117)	18	Miel, *[Italian Fair]* (cat. no. 112)	35	Rubens, *Triumphal Arch* (cat. no. 123)	
2	Jordaens, *Rubens' Family* (cat. no. 111)	19	Bourgognone, *Dying Officer* (cat. no. 161)	36	Rubens, *Triumphal Arch* (cat. no. 124)	
3	Giacomo Bassano, *Winter Piece* (cat. no. 5)	20	Bourgognone, *Landscape* (cat. no. 160)	37	Rubens, *Triumphal Arch* (cat. no. 125)	
4	Leandro Bassano, *Summer Piece* (cat. no. 4)	21	Teniers, *Boors at Cards* (cat. no. 140)	38	Rubens, *Triumphal Arch* (cat. no. 126)	
5	Teniers, *Boors at Cards* (cat. no. 140)	22	van Ostade, *Boors Drinking* (cat. no. 152)	39	Vanderwerf, *Bathsheba and David* (cat. no. 156)	
6	da Cortona, *Christ Appearing* (cat. no. 30)	23	Gia. Bassano, *Christ in Sepulchre* (cat. no. 6)	40	van Huysum, *Flower Piece* (cat. no. 150)	
7	Schiavone, *Judgement of Paris* (cat. no. 91)	24	Willeborts, *Holy Family* (cat. no. 145)	41	van Huysum, *Flower Piece* (cat. no. 151)	
8	Schiavone, *Judgement of Midas* (cat. no. 90)	25	Rottenhamer, *Holy Family* (cat. no. 191)	42	Lauri, *Christ and Mary* (cat. no. 38)	
9	Parmigianino, *Christ in Sepulchre* (cat. no. 60)	26	Alex. Veronese, *Virgin and Child* (cat. no. 84)	43	Bellini, *Holy Family* (cat. no. 88)	
10	Jan Breughel, *Adoration of the Magi* (cat. no. 95)	27	Rosa, *Three Soldiers* (cat. no. 78)	44	Bourgognone, *Landscape* (cat. no. 162)	
11	Barocci, *Virgin and Child* (cat. no. 3)	28	Murillo, *Virgin and Child* (cat. no. 184)	45	Bourgognone, *Landscape* (cat. no. 163)	
12	Annibale Carracci, *Venus* (cat. no. 17)	29	Concha, *Virgin and Child* (cat. no. 29)	46	Gaspar Poussin, *Landscape* (cat. no. 167)	
13	Dobson, *Head* (cat. no. 193)	30	Holbein, *Edward VI* (cat. no. 204)	47	Gaspar Poussin, *Landscape* (cat. no. 168)	
14	Dolci, *Head of St John* (cat. no. 32)	31	Bourdon, *Laban and his Images* (cat. no. 158)	48	Ponzoni, *Holy Family* (cat. no. 64)	
15	Velasquez, *Innocent X* (cat. no. 187)	32	Rubens, *Banquetting Ho. Ceiling* (cat. no. 119)	49	Bourdon, *Murder of the Innocents* (cat. no. 159)	
16	Luti, *Boy with Lute* (cat. no. 40)	33	Rubens, *Triumphal Arch* (cat. no. 121)	50	Velasquez, *Death of Joseph* (cat. no. 181)	
17	Miel, *Friars giving Meat* (cat. no. 113)	34	Rubens, *Triumphal Arch* (cat. no. 122)	51	Elsheimer, *St Christopher* (cat. no. 188)	

APPENDIX I
Directory of Agents, Buyers and Collectors
Edward Bottoms

The following directory outlines the careers of the principal agents, collectors and dealers who were active during the first half of the eighteenth century and were involved in the creation of the art collection of Sir Robert Walpole. The biographies are drawn from a group of key sources for the period, notably eighteenth-century sales catalogues, the manuscripts of the antiquarian Richard Houlditch, the correspondence of Horace Walpole and the notebooks of George Vertue. The Cholmondeley MSS held at Cambridge University Library and the Houghton Archive (Houghton Hall) provide information relating to individual acquisitions for the Walpole collection. Manuscript and Literature references are given at the end of each entry, and full reference to these sources is given in the main bibliography.

ALBANI, CARDINAL ALESSANDRO (1692–1779)

Born in Urbino, Albani studied law in Rome before embarking upon an ecclesiastical career. He was appointed secretary of memorials by his uncle, Pope Clement XI, and in 1720 was sent as the extraordinary nuncio to Vienna. The following year saw his appointment as Cardinal of the Church of San Adriano by Pope Innocent XIII and he subsequently played an increasingly important role in papal politics. With Britain holding no official diplomatic ties with the papal government, Sir Robert Walpole relied heavily upon the influence of Albani and Baron Philip Stosch (1691–1757) as his agents in Rome.

As an antiquarian, Albani had few rivals in Rome and his early collection, housed in the Palazzo Albani del Drago at the Quattro Fontane, was swelled with finds from his ambitious series of excavations begun under the guidance of the scholar Francesco Bianchini (1662–1729). Whilst continually augmenting his collection with new additions, Albani also seems to have freely given away or sold pieces as his tastes, interests and financial needs dictated. In 1733 a large segment of the Albani collection was bought en bloc by Clement XII, the Pope being alarmed at the dispersal of Roman sculptural treasures to Augustus II of Poland via an Albani sale of 1728. Just two years prior to Clement XII's purchases, Albani also presented General Charles Churchill with busts of Septimus Severus and Commodus (cat. nos. 237, 238) and two alabaster vases (cat. no. 247). Churchill, in turn gave them to Sir Robert Walpole, who housed them at Houghton in the Salon and Hall, respectively.

Albani's grand villa, located outside the Aurelian Walls, on the Via Salaria, was started in 1746 to designs by Carlo Marchionni (1702–1786). Here Albani displayed his collection of sculpture. The decorative scheme for the interior included work by such artists as Anesi, Marchionni and Anton Raphael Mengs, whose influential 'Parnassus' ceiling featured in the main salon. Albani also patronised the German scholar, Johann Joachim Winckelmann (1717–1768), whom he employed as his librarian and who published, with Albani's encouragement, his *I monumenti antichi inediti* (Rome, 1767). Albani also held a close relationship with the English representative in Florence, Horace Mann, and on his recommendations sponsored a number of English artists in Rome, including such figures as Joseph Wilton, Robert Strange and Richard Wilson. Sales of art and antiquities to English collectors were also facilitated by Albani, for example, assisting Mathew Brettingham in his search for classical statues for Thomas Coke, 1st Earl of Leicester. Such services were recognised in London and in 1761 he was made an honorary member of the Society of Antiquaries. The following year Robert and James Adam negotiated the sale of a quantity of Albani's old master drawings and sketches by Carlo Maratti to George III.

Literature: Bowron, Rishel 2000, pp. 77–78; Dictionary of Art 1996, vol. I, pp. 532–33; Howard 1992, pp. 27–38; Ingamells 1997, pp. 1053; Lewis 1961, pp. 38–90; Moore ed. 1996, p. 53; Wilton, Bignamini 1997, pp. 23, 33, 77, 174.

ARNALDI

On the death of the Marchese Niccolò Pallavicini the Arnaldi family of Florence inherited a portion of the great Pallavicini collection of paintings. Little is known about the Arnaldis themselves and details regarding the subsequent dispersal of the Pallavicini pictures are also uncertain. However, it appears that a number of the works were sold almost immediately, with a further batch being dispersed during the 1720s, Christopher Cock, for example, holding a sale in London in 1729/30 of 74 lots of pictures from the 'Palavicini Pictures'. Seven paintings confirmed as having Pallavicini provenance (cat. nos. 44, 45, 48, 49, 50, 51, 52) are recorded in the Walpole collection prior to 1736, but none of these were obtained from the Cock sale and it seems that other, unrecorded transactions took place, with perhaps Sir Humphrey Edwin as the dealer or middleman involved. Edwin is known to have bought at least four pictures from the Arnaldi family and offered one, a Gaspard Poussin *Sea Storm*, to Sir Robert before selling them all to Frederick, Prince of Wales. The death of Giovan Domenico Arnaldi in March 1736 seems to have prompted further sales from the Arnaldi family and in 1738 the portrait painter Charles Jervas purchased the portrait of Clement IX from them (cat. no. 41) for Sir Robert. Records of yet more Arnaldi sales exist from the 1740s and 1750s, Marchese Franco Tommasso Arnaldi offering a number of the Pallavicini paintings to King Augusto III of Poland in 1743 and endeavouring to sell 117 lots from the Pallavicini inheritance to Marchese Vicenzo Riccardi for 68,870 scudi romani. In 1758 Horace Mann and a dealer by the name of Dalton were involved in the purchase of works by Carlo Maratti and Gaspard Dughet from that collection, whilst in the same year William Kent also made a number of purchases for Sir Nathanial Curzon.

Manuscripts: BL Add. MSS 15,776, ff.61–66; Walpole MS 1736, nos. 12–13, 16–17, 19–21,153, 154; Houlditch MSS.

Literature: DBI, pp. 245–47; Dictionary of Art 1996, vol. I, p. 874; Ingamells 1997, pp. 635–37; Rudolph 1995, pp. 143–44, 154–59, 210–11, 231–32, 239; Vertue, vol. VI, 1948–50, pp. 175–80.

BEDINGFIELD, SIR HENRY ARUNDELL (c.1685–1760)

The Bedingfelds of Oxburgh Hall, near Swaffham, Norfolk, were a long established Catholic family whose fortunes had suffered during the Civil War. A baronetcy was granted by Charles II in 1661 but their beliefs excluded them from major public office. Sir Henry, the 3rd baronet, was educated on the Continent under 'Tutor Marwood' and, on 28 August 1719, married Lady Elizabeth Boyle, the sister of Richard, 3rd Earl of Burlington. He is described in Horace Walpole's correspondence as 'a most bigoted Papist in Norfolk' but some connection with Sir Robert Walpole may be inferred. Hanging today at Oxburgh Hall is a presentation portrait after Hysing of Sir Robert and in Horace's own copy of the *Aedes* the *St Christopher* by Adam Elsheimer (cat. no. 188), which hung in the cabinet at Houghton, is given as having come from 'Sir Harry Bedingfield'. Vertue, writing of Sir Henry's collection of pictures, also records a half-length of Sir Thomas Gresham, noting, perhaps significantly, that also 'Sr. Rob. Walpole has a small picture of him' (cat. no. 114).

Literature: Bedingfeld 1987; Burke's Peerage 1999, pp. 220; HWC vol. 20, pp. 552; Vertue, vol. IV, 1935–36, p. 162.

BENTINCK, HENRY, 1ST DUKE OF PORTLAND (1682–1726)

The son of William of Orange's trusted advisor, Hans William Bentinck, 1st Earl of Portland, Henry Bentinck was born 17 March 1682. Styled Viscount Woodstock, Bentinck travelled on the continent from 1701 to 1703 with his tutor Paul de Rapon, a noted Huguenot historian. Setting out from The Hague in October 1701, they passed through Cologne and Vienna, reach-

ing Venice on 3 March, before moving on to Bologna, Rome and Florence. Bentinck was back in The Hague by May 1703 and on 9 June the following year married Elizabeth Noel, daughter of the 2nd Earl of Gainsborough. He acted as MP for Southampton (1705–8) and Northants (1708–9), succeeding his father as 2nd Earl of Portland in late 1709.

By early 1710 Bentinck had acquired the freehold for St Albans House in St James's Square and immediately set about improving it. Vertue records that Giovanni Antonio Pelligrini (1674–1741) painted 'the hall & Staircase & one or two of the great rooms'. The leases for adjoining coach-houses and stable yards were also purchased by Portland and a range of rooms erected along the eastern side of the courtyard (destroyed 1938). A survey undertaken in 1937 reveals in the south room of the principle floor rich baroque plasterwork and a coved ceiling containing painted scenes from the life of Hercules. Sebastiano Ricci (1659–1734) has been suggested, on stylistic grounds, as the author of these works, and John Thornhill's *Memorandum* of 1717 records that Ricci received £1,000 for 3 rooms at Bentinck's St James's Square residence. Ricci also undertook extensive works for Bentinck at Bulstrode House, Buckinghamshire (destroyed 1847) and played a role in advising Bentinck on the purchase of pictures. Indeed, Vertue recounts Bentinck acquiring on Ricci's advice an 'Antiently painted' *Nativity* for 300 guineas, only to discover it to have been painted by one 'Casinni', with Ricci himself having contributed the head of an ass. Not all of Portland's purchases seem so ill advised, however, and in March 1712 he attended James Graham's sale of pictures, buying a Claude *Landscape, Evening, Temple of Bacchus* for £210 (now National Gallery of Canada, Ottawa).

On 6 July 1716 Bentinck was created Marquis of Titchfield and 1st Duke of Portland, holding the position of Lord of the Bedchamber from 1717 until his death. He invested heavily in South Sea stock, suffering considerable losses in the crash and was obliged to accept the Governership of Jamaica, selling his collection of pictures in February 1722. It was at this sale that the frame-maker John Howard, acting for Sir Robert Walpole, purchased *An Old Woman with a Book* by Ferdinand Bol for £50 (cat. no. 146), which by 1736 was hanging in the dining room at Sir Robert's house in Downing Street. Horace Walpole states in the *Aedes* that '*Rubens*' *Family* by Jordano of Antwerp' (cat. no. 111) also came from the Portland collection, possibly lot 28 in the 1722 sale; '*His Wife and Three daughters by himself ... Rubens*', recorded in the Houlditch MSS as having been sold to Lord Scarborough for £54.2s. Other major collectors were represented at the sale, with the Duke of Devonshire paying £200 for a '*Quintus Cincinnatus ... P. da Cortona*'. By June of that year Bentinck had also sold his St James's Square house to the trustees of the 8th Duke of Norfolk, for a reputed £10,000. Subsequently occupied by Frederick, Prince of Wales from 1738–41, the original buildings were demolished in 1748 to make way for the construction of Norfolk House for the 9th Duke of Norfolk. Bentinck's death on 4 July 1726, at St Jago de La Veda seems to have left debts unpaid and a quantity of plate valued at £8,347 was conveyed back to England, together with a quantity of jewellery.

Manuscripts: BL Eg. 1706; Houlditch MSS; University of Nottingham Library, P1 F1/2/7.

Literature: Daniels 1975, pp. 94–97; Daniels 1976, pp. 40, 41, 62, 66; Ingamells 1997, pp. 1017–18; Pears 1988, pp. 71–72, 243–44; Survey of London, XXIX, pp. 187–94, 200–3, 565–67; Sutton 1981, vol. III, p. 324; Vertue, vol. I, 1929–30, pp. 38–39; vol. II, 1931–32, p. 30; vol. IV, 1933–34, pp. 47–48, 82, 139; vol. V, 1935–36, pp. 140, 70–71.

BRYDGES, JAMES, 1ST DUKE OF CHANDOS (1673–1744)

James Brydges, son of the 8th Lord Chandos, was educated at New College, Oxford, becoming MP for Hereford in 1698. The office of Paymaster General of the Army Abroad, which Brydges held until from 1705 until 1712, was a highly lucrative one and he appears to have used it to amass a considerable fortune. His first wife, Mary Lake, died in 1712 and the following year Brydges acquired property at Cannons, Middlesex from her uncle. George Loudon was employed to lay out new gardens and alterations to the existing house were carried out, in turn, by William Talman, John James, John Vanbrugh and, from 1716 to 1719, James Gibbs. Decorative painting for the interior of the house and for the Church of St Lawrence, Stanmore, which Brydges completely rebuilt, was provided by, amongst others, Louis Laguerre, Antonio Bellucci and Sir James Thornhill. The Duke's patronage of musicians is well known, with a full choir and musicians being supported and Handel serving as his director of music from 1716 to 1720.

Chandos was also an enthusiastic purchaser of paintings and his surviving letters provide a wealth of information regarding his network of agents. In 1705 a John Drummond and Dr Charles Davenent of Amsterdam are recorded as shipping over four cases of paintings, including pieces from the collection of Joan de Vries, the Burgomaster of Amsterdam. In Rotterdam, John Senserf was chief amongst Chandos' buyers and in 1712 is recorded as sending him a portrait of Charles V by Rubens via the household goods of the States envoy, thus avoiding customs duty. In February of the following year, the Brydges' correspondence reveal Chandos returning a sale catalogue to Senserf, the lots marked with one tick to indicate those pictures to be purchased at reasonable cost and two ticks for those to be acquired at any price. By 28 April Senserf had made his purchases, the most important of which was a work by Van der Werff, 'the finest finished picture that ever came over'. This was almost certainly *Sarah leading Hagar to Abraham* (cat. no. 156), sold at the auction of Adriaen Paet's collection on 26 April and subsequently given by Chandos to Sir Robert Walpole. The pictures were apparently brought back to England by Mathew Decker, who also provided Chandos with velvet, lace and scarves. In Paris, the Duke's contacts included the painter and dealer Jacques Arlaud (1668–1743), Anthony Hammond and Brydges' nephew, William Leigh. In Italy, Henry Davenent, the son of Charles, was the principle buyer, amongst his purchases being works from the collections of Don Livio Odescalchi and Count Bardi. Davenent was also responsible for buying five tapestry cartoons thought to have been by Raphael. Brydges initially tried to re-sell these substantial pieces, suggesting in a letter of March 1724 that Robert Walpole, who 'is making a noble collection' could buy them at cost price. Indeed, Chandos' purchases seem to have been on a similarly grand scale to Walpole's, and whilst contemporaries associated Chandos with the figure of Timon in Pope's 'Epistle to the Earlo of Burlington (Moral Essay IV), it has been argued that Houghton Hall was at least partially the model for Timon's villa.

Following Chandos' death on 9 August 1744, Christopher Cock presided over a series of sales beginning, on 12 March 1747, with the dispersal of the Chandos library. A selection of the pictures were auctioned from 6 May and furniture and fabrics followed suit, the last auction being recorded in May 1748. The house was destroyed soon after the sales, some of the ceilings being transported to the chapel at Witley Court, Worcestershire. The grand staircase was bought by Lord Chesterfield for his London house, where the huge two-tiered Houghton Lantern (cat. no. 273), was hung over it.

Manuscripts: BL 7805.e.5(2); Bodl. MUS. Bibl.III.8 66(2); CUL Syn.5.74.3; BL MSS P.R.2.a.39

Literature: Baker, Baker 1949, pp. 69–92, 214; DNB, vol. 3, pp. 162–63; Dunlop 1949, pp. 1950–54; Dictionary of Art 1996, vol. 5, p. 65; Sutton 1981, III, pp. 318–19; Vertue, vol. II, 1931–32, pp. 48, 80; vol. III, 1933–34, p. 136; vol. IV, 1935–36, pp. 17–18.

CADOGAN, WILLIAM, 1ST EARL CADOGAN (1675–1726)

Described by Bishop Atterbury as 'a big, bad, bold, blustering, bloody, blundering booby', William Cadogan was in fact one of the ablest staff officers produced by the British Army in the eighteenth century. Born the son of Henry Cadogan, a councillor-at-law in Dublin, William served in Ireland and Flanders under King William. Cadogan acted as the Duke of Marlborough's quarter-master general at The Hague in April 1702 and was promoted to brigadier general following the Battle of Blenheim. Under the continued favour of Marlborough, Cadogan was sent on missions to Hanover and Vienna. He was instrumental in the taking of Ghent and Antwerp and was appointed envoy and minister plenipotentiary to Holland, the position of lieutenant-general being granted him in 1709. With Marlborough's decline, however, Cadogan went into voluntary exile in Holland, resigning his employment and offices under the Crown. On the accession of George I, his fortunes were reversed and he was re-instated as lieutenant-general and envoy extraordinary, with additional posts as Master of the King's Robes and colonel in the Coldstream Guards. Military successes continued, with Cadogan playing a key role in quelling the 1715 Jacobite Rising. Rewarded with the title of Baron Cadogan in June 1716, William was to continue his services in Holland, signing the Treaty of the Triple Alliance at the Hague in June 1717. His earldom was conferred in May the following year.

Little is known about Cadogan's patronage of the arts. Vertue reports that the Dutch painter Herman Van Der Mijn (1684–1741) 'came into England recommended by Ld Codagan. & others' and that Cadogan's portrait was painted by both Louis Laguerre (1663–1721) and Francesco Monti (1645–1712). His picture collection appears to have been of some note and it was from this source that Sir Robert Walpole was to acquire one of his finest paintings, Rubens' *The Carters* (cat. no. 116). Following the Earl's death, a picture sale took place in February 1727 at which Sir Robert purchased two Bacchanals by Rubens, one of which was to hang in the Common Parlour at Houghton (see cat. no. 131). The sale was remarkable in that catalogues were printed in French as well as English and also included the dimensions of the pictures. Other English collectors and dealers to make purchases there included Sir Paul Methuen, Lord Oxford, Lord Essex and the Duke of Marlborough, who paid £140 for a self-portrait by Sophistra Angeli (Sofonisba) Anguisciola.

Manuscripts: BL C119h.3(6); BL S.C.550(14); Houlditch MSS.

Literature: DNB, vol. 3, pp. 634–39; Pears 1988, p. 93; Vertue, vol. I, 1929–30, p. 91; vol. III, 1933–34, p. 34; HWC vol. 20, p. 125; vol. 33, p. 112; vol. 43, p. 352.

CHURCHILL, GENERAL CHARLES (c.1678–1745)

The natural son of General Charles Churchill (1656–1714), Charles took his first position in 1688, as an ensign in the 3rd Regiment of Foot. He served in Flanders for his father's regiment in 1679 and acted as his father's aide-de-campe at the Battle of Blenheim. Appointed colonel of the 1st Foot in 1709, the 16th Dragoons in 1713, and the 10th Dragoons in 1723, Churchill distinguished himself as an officer, rising to the rank of lieutenant-general in 1739. A personal and family friend of Sir Robert Walpole, Churchill was returned as MP for the Norfolk borough of Castle Rising (1715–45) and granted the position of Deputy Ranger of St James' Park.

Churchill certainly encouraged Walpole's interest in the visual arts and a letter to Sir Robert in August 1720 urges haste as 'Wootton Will be otherwise imployed' – almost certainly a reference to the hunting piece containing portraits of Sir Robert, Charles Turner and Churchill, completed by Wootton in the early 1720s (cat. no. 202).

In 1731 Churchill set out for Italy, calling at Florence, Lucca, Leghorn and Rome. Whilst in Rome Churchill was introduced to Cardinal Alessandro Albano (1692–1779) by the connoisseur and diplomat Baron Philipp von Stosch (1691–1757). Albani presented to Churchill antique busts of Septimus Severus and Commodus, together with a pair of antique alabaster vases, all of which Churchill subsequently gave to Sir Robert (cat. nos. 237, 238). Churchill is also known to have acquired paintings whilst in Italy, again through the auspices of Stosch, possibly including the painting of 'Architecture' by Julio Romano (now Paris Bordone, cat. no. 10) recorded as hanging in Walpole's Downing Street residence in 1736.

Churchill was the lover of the celebrated actress Anne Oldfield, and their son Charles Churchill (1720–1812) married Sir Robert Walpole's daughter, Lady Mary Walpole, in 1746.

Manuscripts: Walpole MS 1736 no. 158; CUL Chol (Houghton) MSS, Correspondence 803, 834

Literature: DNB, vol. 4, pp. 308–9; Ingamells 1997, pp. 204–5; Lafler 1989, pp. 120–23, 168–70, 222–23; Lewis 1961, pp. 92–95, 244–45; HWC vol. 13, p. 66; vol. 17, p. 271; vol. 30, p. 289.

COCK, CHRISTOPHER (d.1748)

Likely to have been related to the auctioneer and print seller John Cock (d.1714), Christopher Cock is first recorded in 1717, when George Vertue noted the 'Sale of Sir Geo Hungerfords Pictures, sold at the Blew Posts. in the Haymarkett ... Mr Lovejoy. & young Cock concerned.' By the mid-1720s he had established himself as one of the major London auctioneers, his sales from this period including the collections of the Marquis of Powis (May 1725), Sir Godfrey Kneller (January 1726), and paintings acquired for sale by the dealer Andrew Hay (February 1726). The Hay sale was advertised as taking place at 'Mr Cock's New-Auction-Room in Poland street, the Corner of Broad street near Golden Square' but in 1731 Cock took over nos. 9–10 The Piazza, Covent Garden and erected auction rooms on land to the rear. In the following years, the sales of Peter Tillemans (18–20 April 1733), Sir James Thornhill (24–25 February 1734) and Bernard Lens (14–21 February 1737) were all carried out under Cock's direction, together with those of Sir William Stanhope (25 April–1 May 1733) and Bridget, Dowager Duchess of Leeds (17–23 April 1734). In September

1741 he was contracted to sell the effects of Edward Harley, 2nd Earl of Oxford, and in 1747 undertook the similarly huge -scale auctions of James Brydges, Duke of Chandos. These included the picture collection, together with his furniture, property, outhouses and library from Cannons, Middlesex.

Cock also appears to have undertaken the restoration and cleaning of paintings, acting for John Hervey, John Montagu and the Duke of Chandos. The work done for Chandos, however, resulted in a long-running dispute, with Chandos refusing payment, claiming that Cock had cut out a head of a Raphael cartoon and replaced it with a newly painted one. The matter was settled out of court following the withdrawal of Sir Andrew Fountaine (1676–1753), Sir James Thornhill (1676–1734) and Jacob Cristof Le Blon (1667–1741), who had agreed to act as arbitrator and witnesses, respectively.

Sir Robert Walpole and his agents regularly attended Cock's auctions, purchasing at sales including those of Andrew Hay (19 February 1726), Thomas Scawen (25–28 January 1743), Sir Robert Gayer (5–6 April 1726) and John Holland (1730). Following Walpole's death, Cock was also involved in the dispersal of his collection and property, corresponding in 1747 with Robert Walpole, 2nd Lord Orford. He encouraged him to sell his father's house at Chelsea as it was akin to 'An Old Fellow keeping a Girl'. An account presented by Cock to Orford in June of the following year details a private sale held in 1747 which included a quantity of plate (cat. no. 271) and a number of sconces (cat. no. 268). Also recorded is a sale held on 28 April 1748 of a quantity of Sir Robert's pictures housed at his Chelsea home (see Appendix VI). From the latter sale, a total of £1,041.8s was raised, Cock deducting his commission of £78.1s.6d.

In the last year of his life, Cock seems to have developed a business relationship with Abraham Langford, a fellow dealer, and a sale of February 1748 gives their joint names as the directors. Indeed, following Cock's death Langford was to take over Cock's rooms and presumably his business.

Manuscripts: BLC.119h.3(4); Houlditch MSS; CUL Chol (Houghton) MSS, Correspondence of the later Orfords: 6th April 1747; Houghton Archive: Cock Account

Literature: Baker, Baker 1949, pp. 83–91; Dictionary of Art 1996, vol.7, p. 500; Learmount 1985, pp. 22–28, 103–4; Lugt 1938, vol. I; Pears 1988, pp. 59, 64–65, 239, 241; Survey of London, vol. XXXVI, p. 87; Vertue, vol. I, 1929–30, pp. 43, 90; vol. III, 1933–34, pp. 21, 27, 160.

DANVERS, SIR JOSEPH (1686–1753)

The eldest son of Samuel Danvers of Swithland Hall, Leicestershire, Joseph trained at Lincoln's Inn before inheriting the estates of his mother and her second husband (John Danvers, d.1721), in 1721. In the same year he was appointed Sheriff of Leicestershire and on 7 December married Francis Babington of Rothley Temple, Leicestershire. With the assistance of the Duke of Newcastle and Lord Sunderland, Joseph gained a seat in the House of Commons, sitting as the member for Boroughbridge from 1722 to 1727, the member for Bramber from 1727 to 1734 and the member for Totnes from 1734 to 1747. Characterised by Horace Walpole as 'a rough rude beast' who 'now and then mouths out some humour', Joseph was counted amongst the supporters of Sir Robert Walpole.

The *Aedes* informs us that it was from him that Sir Robert acquired the Van Dyck portrait of Henry Danvers, Earl of Danby (1573–1644, cat. no. 101), first noted in the Walpole collection in the 1736 inventory. This painting, of Joseph's

great uncle, had been inherited by John Danvers and passed down to Joseph. Whilst in the Walpole collection a copy appears to have been made by Charles Jervas and sold at his sale of 1739, possibly one of the versions known to exist in the Stamford collection at Dunham Massey and at Wentworth Castle. After nearly thirty years service as an MP, Joseph retired from parliament with a Baronetcy in July 1746, dying in October 1753. He was interred at St Leonard's, Swithland, half in and half out of the churchyard, so as to allow one of his dogs to be buried next to him.

Manuscripts: Walpole MS 1736, no. 50; Houlditch MSS; Glasgow University Library SM 1536

Literature: DNB, vol. 5, pp. 487–91; HWC vol. 17, p. 232; Pevsner: Leicestershire and Rutland, pp. 400–2; Sedgwick 1970, vol. I, pp. 603–4.

EDWIN, HUMPHREY (1673–1747)

Fourth son of Sir Humphrey Edwin (1642–1707), Lord Mayor of London, Humphrey was almost certainly the 'Mr Edwin' through whom Sir Robert Walpole acquired two Dughet landscapes (cat. nos. 164, 165) and possibly the *Calm Sea* by Claude (cat. no. 170) from the collection of the Marchese di Mari. The details of his life are not clear but, in addition to owning property in Berkshire and Savile Row, London, he appears to have spent a considerable amount of time travelling on the Continent. He is likely to have been the Mr Edwin, son of 'Sr Oumphery Edwin', used by William Kent in 1716 to send prints and drawings from Rome to Burrell Massingberd (c.1684–1744). A 'Mr Edwin' is likewise recorded in Rome in May 1724 visiting van Lint's studio in the company of the antiquarian Richard Rawlinson (1690–1755), before moving on to Florence. Firmer evidence is available for a trip made in the early 1730s in the company of his niece, Catherine Edwin (d.1771), 'who travels for her health in company with an Uncle and a Brother [Charles Edwin (1699–1756)]'. The itinerary took in Rome in late 1730 and Venice by June 1731, moving on to Bologna and Rome in the summer of 1732, before returning to Venice by mid-July 1733. Relations between Humphrey and his niece must have been close as she was made his sole executrix and residuary legatee by his will, dated 3 December 1747, five days prior to his death. A sale of fifty-seven lots from Humphrey Edwin's collection was held in London by Langford on 16 March 1750, attended by a number of major dealers and collectors including John Ellys and G. F. Handel.

His activities as an agent or dealer seem to have been extensive and as well as the Poussins (Dughets) and the Claude he acquired for Walpole he is likely to have been the source for the *Holy Family* by Andrea del Sarto (cat. no. 80), which also came from the collection of the Marquis di Mari. According to Vertue, Frederick, Prince of Wales, bought works from Edwin's collection, something borne out by the *Aedes*, where Horace Walpole states that the Prince of Wales purchased from Edwin a fine depiction of *Jonah in the Storm* by Gaspard Poussin. Edwin's name frequently occurs as the purchaser at London sales and auctions, buying works by Ruisdael and Metsu totalling £58.10s. at the van Huls sale in 1722 and works by Carlo Maratti and Ghisolfi at 'Mr Phillip's sale' of 1728. He is also recorded purchasing works attributed to Rembrandt and Pietro dei Petris at Samuel Pariss sale in May 1738 and Charles Jervas' sale of 1739, respectively. Finally, in the year of his death, his name is amongst the buyers attending the auction of the collection of James Bridges, Duke of Chandos.

Manuscripts: Houlditch MSS.

Literature: DNB, vol. 6, pp. 553–55; Edwin-Cole 1871, pp. 54–62; Ingamells 1997, p. 332; Pears 1988, p. 241; Pevsner: Wales 1986, pp. 392–94; Rudolph 1995, p. 143; Vertue, vol. III, 1933–34, p. 142.

ELLYS, JOHN (1701–57)

According to Vertue, the portraitist John Ellys studied under Sir James Thornhill (1675–1734) at the age of fifteen, before gaining instruction from Rudolphus Schmutz (1670–1715). He subscribed to the academy established in 1720 at St Martin's Lane by Louis Cheron (1660–1725) and John Vanderbank (1694–1739) and by the mid-1720s was sufficiently well placed to obtain 'a warrant from their royal highnesses. to copy any pictures at their palaces'. Ellys' style reveals the influence of Sir Godfrey Kneller and John Vanderbank and amongst his best surviving work are portraits of Lord Whitworth and his nephew (1727, Knowle, Kent), and Mrs Hester Booth (sold Sotheby's, London, 15 November 1989).

Ellys was a central figure in the London art world, taking over Vanderbank's house and practice and, eventually, the position of 'Tapestry Maker to the King'. Together with Hogarth, he initiated the second St Martin's Lane academy in 1735, remaining a director there until 1747, and was one of the signatories of the 1755 'Plan of an Academy'. In 1736 he replaced Philip Mercier (1689–1760) as principle painter to Frederick, Prince of Wales, and was granted in 1739 the position of 'Master keeper of the Lyons in the Tower of London'. This was almost certainly the reward for helping to acquire works of art for Sir Robert Walpole, including Van Dyck's *The Rest on the Flight into Egypt* (cat. no. 110) which Ellys was sent to Holland to buy.

Only one picture by Ellys is recorded in Walpole's possession (cat. no. 214) but Ellys' relationship with Sir Robert's collection appears to have been of lasting importance. In April 1751, just prior to the sale of that year, he was writing to the third Lord Orford hoping that 'not one of these fine pictures should Ever belong to any Body but you, and Your family … and whilst I live they shall cost you not any thing Keeping in Order.' He was also the dedicatee of *An Ode to Mr Ellis Occasioned by a Beautiful Painting Of the Honourable Mr Walpole*, quite possibly written by the Rev. Whaley. This portrait, currently unidentified, was presumably of George Walpole, later 3rd Earl of Orford.

Following his death in 1757, Elly's own collection of pictures was sold in conjunction with those of George Frederick Handel, by Langford in February 1760.

Manuscripts: CUL Chol (Houghton) MSS, Correspondence of the later Orford,: 6th April 1747; Houlditch MSS; Frick, 27–28 February 1760; Chetham 4C6–14(3).

Literature: Bignamini 1988, pp. 53, 74, 79, 90, 91, 93, 99, 100, 104, 115, 119, 134; DNB, vol. 6, pp. 724–25; Moore ed. 1996, pp. 52, 56–57, 88–89; Vertue, vol. III, 1933–34, pp. 2, 5, 30, 38, 47, 79, 87, 95, 123.

FLEURIAU, CHARLES-JEAN-BAPTISTE FLEURIAU D'ARMENONVILLE, COMTE DE MORVILLE (1686–1732)

Son of Joseph-Jean-Baptist Fleuriau, Charles-Jean-Baptiste was born in Paris on 20 October 1686 and granted the titles of Bailli, Capitaine and Governeur de la ville de Chartres and Seigneur d' Armenonville. His rise to ministerial position was rapid, obtaining the position of 'Avocat du Roi au Chatelet de Paris' in 1706 and 'Conseiller a Parlement de Paris' in 1709. In 1711 he received the appointment of 'Procureur-General du Grand Conseil par Provisions' and was installed as Ambassador to Holland, a post he was to hold until 1718. On his return to France he was awarded the Croix de l'Ordre de Saint-Louis and became 'Conseiller d'honneur au Grand-Conseil'. In 1722 he was appointed Secretary of State for the Marine and on 10 August the following year, Secretary of State for Foreign Affairs. In receipt of at least £4,000 per annum from the British Secret Service fund by 1720, Morville developed close relations with Sir Robert 's brother, Horatio Walpole, who arrived in Paris in 1723, taking over the post of envoy extraordinary and minister plenipotentiary.

Direct correspondence between Fleuriau, Horatio and Sir Robert appears to have been extensive, with two volumes being published in Paris in 1767 under the title *Testament politique du chevalier Walpoole…*. Horatio is also recorded, however, as having regarded Morville as being 'noways equal to his bussyness, weake, tricking and irresolate' and he also fostered relations with Cardinal Fleury, keeping him informed of Morville's tactics. In 1727, Fleury engineered the replacement of Morville's father as Keeper of the Seals and Fleuriau himself resigned in August of the same year.

Morville appears to have been a man of letters with a deep interest in the arts and was received into the Académie Française in 1723, becoming 'Protecteur de l'Académie des Sciences & des Arts de la ville de Bordeaux' in 1726. He was also a collector of some note and seems to have taken an active role in the promotion of young French artists. In a competition organised to encourage painters of the Académie, Noel-Nicolas Coypel's *Rape of Europa* failed to win, despite being hailed by critics, but was bought by Morville for 1,500 livres, equalling the prize money set out by Louis XV. He is also recorded as having owned pieces by Dom Fetti, Alessandro Turchi, Paolo Veronese, Giorgione and Andrea Del Sarto.

Indeed, it was from Morville's collection that Sir Robert acquired Benedetto Caliari's *Dives and Lazarus* (cat. no. 12), Claude's *Morning in the Harbour*, by (cat. no. 169), Nicolas Poussin's *Continence of Scipio* (cat. no. 178) and Guido Reni's *St Joseph Holding the Christ Child* (cat. no. 71). In addition to these major paintings Walpole purchased a female nude, thought to have been by Leonardo Da Vinci (cat. no. 39), a *Christ in the House of Simon the Pharisee* from the workshop of Rubens (cat. no. 127) and a *Virgin and Child with John the Baptist,* thought to have been by Titian (see cat. no. 89). The route by which these pieces reached Sir Robert's collection is unclear, but it seems likely that they were all bought at a sale organised by Morville's heirs following his death. The sale of his library took place in June 1732 and it is from a sale of the same year that Mariette (1853–59) records the *Mary Magdalen Washing Christ's feet* (cat. no. 127) being bought by Walpole for 15,000 livres. Certainly all seven works were in the Walpole collection by 1736, when six were recorded as hanging in Downing Street, with the *Virgin and Child with John the Baptist* (cat. no. 89) in situ at Houghton.

Literature: Blunt 1966, p. 129; Campbell 1996, pp. 76–77, 122–24, 319; DBF 1932-, vol. 20, p. 14; DN 1866, vol. 8, pp. 99–102; HMC Polwarth IV 1911–16, p. 80; Plumb 1960, pp. 185–86.

FLINCK, NICOLAES ANTHONIS (1646–1723)

Nicolaes Flinck was born in Amsterdam, the son of Goevaert Flinck (1615-60), the pupil and follower of Rembrandt. On Goevaert's death, Nicolaes moved to Rotterdam, where he was brought up by an uncle. At the age of seventeen he entered Leiden University to study law, marrying in 1669 the daughter of the Mayor of Rotterdam. A director of the East India Company, Nicolaes is best remembered today as a collector of prints, drawings and paintings. A number of pieces were inherited from his father and Vertue records in Mr Motteaux's sale of 1724 a cartoon, said to have been by Raphael, which Motteaux had purchased for one hundred guilders from Nicolaes and which had been previously owned by Govaert. Indeed, Flinck's collection was especially strong in drawings, with works attributed to Baccio Bandinelli, Leonardo and Rembrandt and including eight portraits attributed to Van Dyck.

Sculpture also formed part of Flinck's collection and he is recorded as having purchased items from the 1st Duke of Buckingham. These works were presumably housed at Flinck's residence on the Korte Hoogstraat in Rotterdam, which boasted a ceiling painted by Adriaen van der Werff. Flinck's advice seems to have been much in demand and Jonathan Richardson, writing on the back of a drawing attributed to Raphael in his own collection, remarks that 'This drawing, being bought by my son in Holland, was carefully considered by Mr. Flinck and him, and compared wth several of Raffaele's in Mr. Flinck's collection, and that connoisseur adjudged this to be undoubtedly of that master.'

John Senserf, a dealer in Rotterdam, appears to have introduced Nicolaes to James Brydges, Duke of Chandos, around 1716 and Flinck acted as a consultant to the Duke, selling him works attributed to Hans Rottenhammer and Paul Bril. Sir Robert Walpole also acquired works from the Flinck collection; an *Adoration of the Shepherds* by Bonifazio de Pitati [Bonifazio Veronese] (cat. no. 62) and Paris Bordone's *Venus, Flora, Mars and Cupid* (cat. no. 11), both of which were hanging in the Marble Parlour at Houghton by 1736. Likewise, the 2nd Duke of Devonshire benefited from Flinck's collection, purchasing 500 drawings for 12,000 florins in 1724, a year after Flinck's death. A final auction dispersing the collection was held in Rotterdam on 4 November 1754, consisting of the remainder of THE prints and drawings, together with fifty paintings.

Manuscripts: Walpole MS 1736, nos. 57, 60

Literature: Baker, Baker 1949, pp, 78–79; Dictionary of Art 1996, vol. 11, pp. 168–70; Pouncey, Gere 1962, no. 16; Sutton 1981, I, p. 318; Vertue, vol. I, 1929–30, p. 128.

FOUNTAINE, SIR ANDREW (1676–1753)

Born in Salle, Norfolk, to an old Norfolk family, Andrew was educated at Eton and under Dean Aldrich at Christ Church, Oxford. In 1696 he was presented at the court of William III, knighted in 1699 and in 1701 went with Lord Macclesfield to carry the Act of Succession to the Elector of Hanover. He continued on a Grand Tour taking in Berlin where, according to a letter from his friend, the philosopher William Leibnitz, he was admitted as a member of the Berlin Royal Academy. En route to Italy, Fountaine passed through Leipzig and Munich, reaching Vienna by December 1701, then moving on to Salzburg. When in Italy he visited Venice, Padua and Florence, where he became a favourite at the court of Duke

Cosimo III de Medici. He is recorded in Rome in April 1702, where he consulted the numismatist Cardinal Noris and had his portrait drawn in red chalks by Carlo Maratti (priv. coll.), before returning to London by late 1703. Vertue records that Fountaine was 'all his time intimate & familiar with the old Earl Pembroke' and in 1705 Fountaine's *Numismata Anglo-Saxonica et Anglo-Danica illustrata* was published using the Earl's coin collection as the basis for his study. The following year, on the death of his father, Fountaine inherited the family estates and Narford Hall, Norfolk. In 1714 he embarked upon a second Grand Tour, spending time in Paris before travelling to Italy where he again found favour at Cosimo III's court at Florence. There Giulio Pignatta painted his *Sir Andrew Fountaine and Friends in the Tribuna of the Uffizi* (1715). This was also the year of Antonio Selvi's medal of Sir Andrew Fountaine (priv. coll.) and William Kent, writing from Rome in March 1716, stated that Fountaine was also making a collection of drawings.

In 1725 Sir Andrew was appointed vice-chamberlain to Princess Caroline, later becoming tutor to her son Prince William, Duke of Cumberland. In 1727 Fountaine succeeded Sir Isaac Newton to the post of Warden of the Mint. Much of his coin collection appears to have been sold in the 1720s, the Earl of Pembroke purchasing a large number of items. A sale of a number of Fountaine's pictures was held in 1731/2, when a total of 83 paintings were sold, including works attributed to Rembrandt, Van Dyck and Rubens. This sale seems likely to have been in preparation for Fountaine's move from his London residence in St James's Place to Narford Hall and in early 1733 a number of his remaining paintings were placed in storage at White's Chocolate house in St James's Street. Disaster struck on 28 April, however, when a fire gutted the building, together with three houses, the King and Prince of Wales being 'present on Foot for above an Hour ... and encouraged the Fireman and People at the Engines to work'. The extent of Fountaine's losses cannot be established but it appears that most of his collection of miniatures perished. Vertue, on a visit to Narford in 1739, recorded works by 'Hemskirk', Sir Peter Lely, 'Vander Mynn' and Clermont Benten, noting a glut of paintings, 'every room ... [having] pictures of divers masters – too numerous to mention particulary'. An incomplete inventory of Narford, made in 1738, also reveals Sir Andrew's collection to have been of quality, containing three Van Dycks and five large Pellegrini canvases, the latter being gifts from Lord Burlington. Fountaine's fine collection of majolica was also installed at Narford, placed in a special room, set with shelves from floor to ceiling and viewed through a glass door lit from above. Containing pieces adorned with designs thought to be after Raphael, Romano and del Sarto, the collection was regarded by Vertue as 'the most compleat collection of the kind in this part of Europe yet'.

Fountaine also appears to have dabbled in architecture, designing the first Hamond's Charity School at Swaffham in 1736, and a room for Sir Mathew Decker's Richmond Green residence. Highly respected as a connoisseur, his advice was sought by, amongst others, the Earl of Pembroke, for whom he acquired a number of pieces of sculpture, and Lord Leicester, of Holkham Hall, Norfolk.

His relationship with another of his Norfolk neighbours, Sir Robert Walpole, also seems to have been close. Beatniffe writing in 1795 states that Fountaine was 'said to have purchased for Sir Robert Walpole some of the finest paintings in the Houghton collection'. The extent of Fountaine's influence is hard to determine but at least two paintings within Walpole's collection have been noted as originating from Fountaine's sale of 1731/2 (lot nos. 65, 66). The *Country People dancing* and *Men playing at Nine Pins,* attributed to 'Angelist' in the 1736 inventory of Sir Robert's Chelsea residence, were subsequently sold to Lord Egremont at the 1751 Orford sale (see Appendix VII, day 1, lot nos. 13, 14). It is also likely that Fountaine played a part in the 8th Earl of Pembroke's gift of the *Borghese Gladiator* (cat. no. 248) which plays a central role in Kent's decorative scheme for the main staircase at Houghton. Indeed, a similar idea seems to have been employed at Narford, with the placing of Claude David's *Vulcan Chained to the Rock* (Victoria & Albert Museum, London) at the base of Fountaine's staircase.

Manuscripts: Walpole MS 1736, nos. 353, 354; Houlditch MSS.

Literature: Beatniffe 1795, pp. 219; DNB, vol. 7, pp. 515-16; Ford 1985, pp. 352-65; Dictionary of Art 1996, vol. 11; Ingamells 1997, pp. 376-77; Moore ed. 1985, pp. 27-31, 93-112; Moore 1988a, pp. 8, 12-13, 16, 95-96, 159; Moore 1988b, pp. 435-47; Survey of London, vol. XXX, pp. 464-65, 592; Sutton 1981, vol. III pp. 320-21; Vertue, vol. III, 1933-34, pp. 94, 127; vol. IV, 1935-36, pp. 10, 161; vol.V, 1937-38, pp. 120-21.

GEARE, SIR ROBERT

Horace Walpole states in the *Aedes* that the *Prodigal Son* by Salvator Rosa (cat. no. 77) 'was brought out of Italy by Sir Robert Geare, and carried back by him when he went to live there. On his death it was sent back to England to be sold'. The identity of this man remains something of a mystery.

One possible candidate is Sir Robert Gayer (d.1702), son of the mayor of London, Sir John Gayer (d.1649). The date of his death, however, seems to preclude his being a direct link to Sir Robert's collection. His son and heir, also Sir Robert Gayer (1672-after 1737), is more likely, although no records have been traced of anyone of that name visiting Italy. He inherited Stoke Park in Stoke Poges, Buckinghamshire but was forced to sell it in 1723 in order to honour his father's legacies, moving to Hurley, Berkshire. Sheriff of Berkshire from 1735 to 1737, he also stood as MP for New Windsor in 1715 and was returned with a majority of one vote but was unseated on petition. A sale of 'the remaining collection of Sir Robert Gayer's pictures' was held by Christopher Cock from 5 April 1726. An incomplete record of the sale exists within the Houlditch MSS, detailing a collection of considerable quality, which included pieces attributed to Carlo Maratti, 'Viviano', 'Borgognone' and Snyders. Vertue also records the sale of a Sir Robert Gayer's possessions, noting '2 pictures of fowles & still life. by Ferguson. well painted in a masterly manner', together with a carving in bass-relieve by Grinling Gibbons 'said to be the piece that recommended him to K. Charles'. The surgeon Alexander Geekie is listed as a purchaser, buying a head painted on board by Goltzius. It is not inconceivable that a work such as Walpole's *Prodigal Son* by Rosa (cat. no. 77) should have originated from a collection of this quality.

Manuscripts: Frick, 5-6 April 1726; Houlditch MSS.

Literature: DNB, vol. 7, pp. 970-72; HMC Ormonde 1920, p. 46; Sedgwick 1970, vol. II, p. 62; Survey of London, vol. XXIX, pp. 33, 44-45, 277; vol. XXX, 553-55, 574, 575; Vertue, vol. II, 1932-32, pp. 10-11; Victoria: Berkshire 1906-27, vol. 3, p. 155; Victoria: Buckinghamshire 1906-27, vol. 3, pp. 346-47, 348.

GEEKIE, ALEXANDER (d.1721)

A London surgeon of some distinction, Alexander Geekie was a companion of George Vertue, sharing his interests in collecting and drawing. He is recorded as having joined the Great Queen Street Academy in 1711, its first year. According to Vertue, he made a copy of the famous Van Dyck portrait of Inigo Jones, presumably when it was in the possession of Jones' niece to whom Geekie was related. Sir Robert Walpole was to purchase this Van Dyck in, or just after, 1736, hanging it in the Common Parlour at Houghton (cat. no. 104). Hung adjacent to this portrait was Sir Godfrey Kneller's portrait of John Locke (cat. no. 200), purchased from William Geekie, Alexander's son. John Locke seems to have been a favourite of Geekie, who is known to have offered Greenhill £50 for another portrait of the philosopher.

Little is known about Alexander's collection but it appears that he had some pieces of merit. Vertue records that Alexander purchased from the sale of Sir Robert Geare (see above) a head, on board, by Goltzius, and also remarks upon 'a Moddel head in wax. of a flex colour. of alto relievo. the whole face wigg & band of an Eminent Apotecary' by Abraham Symonds (c.1622-c.1692). Amongst other items recorded in his collection were works by Dobson and Isaac Fuller and 'a fine half length Picture of Van helmont a famous dutch Philosopher'.

Manuscripts: Walpole MS 1736, no. 438; Houlditch MSS; Bodl. Vet A4e.

Literature: Bignamini 1988, pp. 74, 134; Vertue, vol. I, 1929-30, pp. 33, 73, 84, 134, 135, 39; vol. II, 1931-32, p. 11; vol. III, 1933-34, p. 112, vol. V, 1937-38, p. 62.

GIBBONS, GRINLING (1648-1721)

The foremost decorative woodcarver of his day, Gibbons was born in Rotterdam to English merchant parents. According to Vertue, he had moved to England and was living in York by 1667, before moving to Deptford in 1671, where he was discovered by the diarist John Evelyn (1620-1706). His employment by the Crown was extensive and included work at the Royal Apartments, Windsor, between 1677 and 1682 and at Kensington Palace during the 1690s. In 1693 he was appointed Master Carver to the Crown and by 1696 was engaged on one of his most significant surviving works, the decorative carvings for the choir at St Paul's Cathedral. Aside from such commissions, Gibbons also produced a significant body of work for wealthy private clients such as the Duke of Marlborough and the Duke of Devonshire. Amongst his most admired performances is the 'carved room' at Petworth House, executed in the early 1690s for Charles Seymour, 6th Duke of Somerset. Gibbons also sculpted in bronze, stone and marble, he and his studio producing over forty monuments and statues, including that of James II in Trafalgar Square.

Less well documented are Gibbons' activities as a picture dealer. On 2 June 1684, together with Mr Parry Walton, the Supervisor and Repairer of the Kings Pictures, Gibbons was permitted to hold an auction of pictures at the prestigious venue of the Banqueting Hall, Whitehall. Two years later a similar event took place at the same venue with Gibbons and Walton selling 'A Collection of the best Italian Masters, both Ancient & Modern'. A member of St Luke's Club, Gibbons' own collection of paintings, drawings, books and models, presumably housed in the picture gallery at his Bow Street residence, were sold from 15 November 1722. Their sale attracted

many of the major collectors of the day, with Sir Robert Walpole purchasing Luca Giordano's *Vulcan's Forge* (cat. no. 33), which was to hang in the Salon at Houghton. Not recorded in the sale catalogue are the two large pieces by Mola (cat. nos. 55, 56) and the *Concert of Birds* by Mario de Fiori (now Snyders, cat. no. 133) which Horace Walpole informs us also came from the Gibbons collection.

Manuscripts: BL Harley MSS 5947, 120; Houlditch MSS.

Literature: DNB, vol. 7, pp. 1138-40; Beard 1989, pp. 41-42; Green 1964, pp. 36, 111; *London Gazette* Nos. 2136 (6-10 May 1686), 2139 (May-June 1686); Vertue, vol. I, 1929-30, pp. 40, 125-26; vol. III, 1933-34, pp. 9-10; vol. IV, 1935-36, p. 11; vol. V, 1937-38, p. 34; HWC vol. 9, pp.97-98; Woodward 1963, pp. 250-52.

GRIFFIER, JAN I (c1645–1718)

Apprenticed in Amsterdam to the landscape painter Roclant Roghman (1620-86), soon after 1666 Griffier moved to London, where he studied under Jan Looten (1618-81). In 1677 he was admitted to the Company of Painter-Stainers. By 1695 he was back in Holland, returning to England once more c.1705.

Griffier seems to have been a versatile artist and in addition to a large number of small, very highly finished Rhineland views, his English landscapes and topographical views are of considerable merit. Amongst his best pieces are the *View from One Tree Hill: The Queen's House and the Royal Observatory, Greenwich* (National Maritime Musuem, London) and *Hampton Court Palace* (Tate Gallery, London). An accomplished etcher, Griffier is known to have engraved mezzotint portraits in the style of Lely and Kneller, along with a number of plates of birds after Frank Barlow (1626-1704). Griffier also painted his own still-lives, his *Turkey and other Fowl* (Tate Gallery, London), perhaps being related to the *Cock and Hens* by 'Griffier' recorded as hanging in Sir Robert Walpole's closet at Chelsea in 1736. Two other works by Griffier, a sea port and a landscape (cat. nos. 147, 148) are recorded in the *Aedes* as hanging in the Green Velvet Bedchamber at Houghton. The purchase of these paintings, for £15.5s, on 1 April 1718 is recorded in an account book for that year, held within the Cholmondeley MSS. A sale of Griffier's paintings also took place in 1717, consisting of 113 lots, containing three works attributed to Van Dyck and six pieces attributed to Rubens. Also sold were a quantity of works by Griffier in the manner of such diverse masters as Salvator Rosa, Nicolas Poussin, Guido Reni, Berchem, Wouvermans, and Van der Werff, suggesting that Griffier also found employment as a copyist.

Manuscripts: Walpole MS 1736, no. 402; CUL Chol (Houghton) MSS, Account Book 20a); Houlditch MSS.

Literature: Dictionary of Art 1996, vol. 13, p. 647; Redgrave 1970, p. 187; Survey of London, vol. XXX, p. 547; Vertue, vol. I, 1929-30, pp. 50-51, 100, 128; vol. II, 1931-32, p. 31; vol. V, 1937-38, p. 69; Walpole 1888, pp. 129-31; Waterhouse 1981, p. 150.

HAY, ANDREW (?Fife–d.1754)

Hay trained as a painter under Sir John Medina (1659-1710) in Edinburgh and by 1716 was in Italy, where he seems to have embarked upon his career as a dealer. His first recorded purchases included pictures for Edward Harley, later 2nd Earl of Oxford, and drawings for Thomas Coke, later 1st Earl of Leicester. He travelled extensively and, according to Vertue,

made six journeys into Italy and fourteen visits to France. Following his return from an Italian trip in 1722 he was accused of Jacobite sympathies and was summoned to appear at Westminster Hall. Hay appealed directly to Robert Walpole and the Duke of Devonshire, successfully avoiding prosecution.

By the early 1720s he had established himself as an independent dealer, his London auctions attracting major collectors such as the Duke of Devonshire, Lord Burlington and Lord Cavendish. One auction at Christopher Cock's on 19 February 1725/6 raised the sum of £1,730.14s, with Sir Robert Walpole's purchases including a portrait head of *Innocent X* (circle of Velasquez), *Hercules and Omphale* by 'Romanelli' and *Abraham, Sarah and Hagar* by Pietro da Cortona (cat. nos. 187, 73, 31). Whilst Hay's early sales were wide ranging and included antique statues, bronzes, marble busts and books, from the mid-1720s he began to focus primarily upon paintings and prints geared mainly towards the lower end of the market. It is perhaps of significance that it was in the year of the '45 uprising that Hay decided to retire to his native Scotland. A member of the Virtuosi of St Luke (1723-37), the Rose and Crown Club and the Academy of St Luke in Edinburgh, he was described on his death as 'a noted antiquary' by *The Scots' Magazine*.

Manuscripts: BL C.119h.3(4); BL S.C.429(2); BL C.119h.3(13*); Houlditch MSS.

Literature: Bignamini 1988, p. 135; Dictionary of Art 1996, vol. 14, p. 259; Ingamells 1997, p. 475; Moore ed. 1996, pp. 48, 51; Pears 1988, pp. 57, 77-87, 89, 92, 103, 198, 199, 244, 245, 246; Vertue, vol. I, 1929-30, pp. 42, 56, 146; vol. III, 1933-34, pp. 14, 125.

HERBERT, THOMAS, 8TH EARL OF PEMBROKE (1656–1733)

The third son of the 5th Earl of Pembroke, Thomas was educated at Christ Church, Oxford, succeeding to his title on 29 August 1683. He held major offices of state under William III and Queen Anne, being appointed First Lord of the Admiralty in 1690, acting as plenipotentiary at the treaty of Ryswick and being made Lord Lieutenant of Ireland in 1707. Pembroke built upon the foundations of the 4th Earl of Pembroke's collection of paintings. The catalogue of his pictures at Wilton, published in 1731, details how 'This Lord has not increased the number, he has only changed many Jerman and Flanders to make a greater variety of Italian Painters'. Pre-dating Horace Walpole's *Aedes Walpolianae* by eighteen years, this catalogue was produced by Carlo Gambarini 'of Lucca', a favourite of Pembroke's. Dismissed by Vertue as 'a jargon of language & stile' the catalogue nevertheless provides us with details of over 270 Italian paintings owned by the Earl, consisting of a remarkably broad survey of the Italian schools. Sir Andrew Fountaine, the Norfolk neighbour and advisor to Robert Walpole, appears to have played a key role in the formation of the collection of paintings at Wilton. As well as using Pembroke's coins as the basis for his *Numismata Anglo-Saxonica & Anglo-Danica illustrata* of 1705, Fountaine was involved in the acquisition of sculpture and according to Vertue was 'all his time intimate & familiar with the old Earl Pembroke'.

Statuary seems to have been Pembroke's principle enthusiasm and as early as 1678 he purchased part of the Arundel Marbles and, around the turn of the century, a large portion of Cardinal Mazarin's collection. He continued to purchase statues later in life and in the 1720s is recorded buying over a thousand pieces from the Giustiniani collection in Rome. Likewise, in 1720 sculptures from the Valetta family in Napoli were purchased via the dealer Andrew Hay and in 1726 Pem-

broke snapped up some freshly unearthed Roman pieces from the Duke of Beaufort. Indeed, John Macky, writing in 1714, describes 'three rooms [so] crowded with Greek and Roman Antique Bustos, that I fancied myself at the Villa Borghese near Rome', going on to report a 'fine gilt Gladiator better than that at Hampton-Court'. This presumably was the Hubert Le Sueur *Borghese Gladiator* (cat. no. 248) given as a present to Sir Robert Walpole by the 8th Earl of Pembroke, which still occupies the key position within Kent's decorative scheme for the Great Staircase at Houghton Hall. Thomas's son, 'the architect earl', Henry Herbert, 9th Earl of Pembroke (1689-1733), continued his father's relationship with the Walpoles and was responsible for the design of the Palladian Water House at Houghton Hall.

Manuscripts: BL 141.e.8

Literature: Cornforth 1968a, pp. 748-51; Cornforth 1968b, pp. 834-35; DNB, vol. 9, p. 668; Gambarini 1731; Dictionary of Art 1996, vol. 14, pp. 435-36; Macky 1714, pp. 43-47; Pears 1988, pp. 80, 163-64, 245; Pembroke 1968; Survey of London, vol. XIII, pp. 176-79; Sutton 1981, vol. II, p. 309; Vertue, vol. III, 1933-34, pp. 156-57; vol. IV, 1935-36, pp. 180, 184-86; vol.V, 1937-38, pp. 129-30.

HOLLAND, SIR JOHN (? – c1724)

Norfolk neighbours of the Walpoles. The Holland family house was built by Sir Thomas Holland (?-1629) c.1606, at Quidenham, near Thetford. Sir Thomas' son, John Holland (1603–1701) matriculated from Christ's College, Cambridge in 1621, entered the Middle Temple in 1623 and was created a baronet in 1629. He stood for Castle Rising in the Long Parliament and was one of a number of MPs 'secluded' in 1648. Elected a member of the Council of State in 1659/60 and standing as MP for Aldeburgh, Suffolk, from 1661 to 1679, he was Deputy-Lieutenant of Norfolk under Townshend. His grandson, also Sir John Holland, succeeded to the baronetcy in 1701 and is recorded as an 'MP for Norfolk' between 1701 and 1710 and as Comptroller of the Household to Queen Anne from 1709 to 1711. Sir Robert Walpole, keen to cement his ties amongst the Norfolk squirearchy, maintained his family's friendship with the Hollands and relations appear to have been good between the two men. It is not known whether it is the grandfather or grandson who is referred to in Vertue's notebooks as being one of a group of gentleman who, 'Ingenious in their private delight [in oil painting], are become Juditious Practitioners herein'. Certainly the collection of paintings at Quidenham was considerable and following the death of the last baronet, Sir William Holland (1700-29), Christopher Cock was engaged to auction them in London on 14 April 1730. The *Aedes* tells us that a *Last Supper,* thought to have been by Raphael (cat. no. 67), was bought from Sir John Holland. Originally from the Arundell collection, this painting seems certain to have been brought into the Holland family through the second baronet's marriage to Rebecca Paston, daughter and co-heiress of William, the last Earl of Yarmouth. It seems likely that this picture was purchased by Walpole at the 1730 sale, where Walpole also appears to have made purchases from the collection of John Law (cat. nos. 2, 88). A catalogue of the sizeable library assembled by Sir John and his son, Sir William, was published at Norwich in 1729, in preparation for their sale and Quidenham Hall was sold c.1740 to a Mr John Bristow. The third Earl of Albemarle purchased the house in 1763 and the property remained in the Keppels' possession until 1948, when it became a Carmelite Nunnery.

Manuscripts: Bodl. Johnson.d.778

Literature: Ketton-Cremer 1948, p. 58; Miller 1999, pp. 844-75; Milward 1938, pp. 305-6; Pevsner; Norfolk 1997, pp. 596-97; Plumb 1956, pp. 98, 136; Vertue, vol. I, 1929-30, p. 106; vol. IV, 1935-36, p. 31; vol. V, 1937-38, p. 45.

HOWARD, JOHN (?–1746)

John Howard succeeded John Norris (*fl.*1690-1710) as the king's frame maker in 1714, a position he held until 1727, when he was succeeded by his son Gerrard. Alongside his work for the crown, he found extensive employment with Sir Robert Walpole and included amongst his clients William, 2nd Duke of Devonshire (1672-1729), Benjamin Mildmay, 1st Earl of Fitzwalter (d.1756) and Lord Effingham. A bill of work done for Walpole, dated January 20th 1721, lists 28 paintings for which Howard provided frames or various accessories, at a total cost of £95.6s.2d. Of particular interest is a reference to 'Inlargeing yor Hon^rs Picture and preparing of it for Mr. Wooton £1-10-00; for a frame Carv'd & gilt with gold to Y^r Hon.^rs Picture over the Chimney & Glass £33-00-00'. This presumably concerns the large hunting piece containing portraits of Sir Robert, Charles Churchill and Charles Turner, which was hung in the Hunting Hall at Houghton (cat. no. 202). Amongst his other works, Howard's gilt frames made 'according to Mr Kent's designs' for the Gallery at Kensington Palace, stand out as of exceptional quality. He also appears to have operated as a dealer and agent, attending many London auctions, buying for Walpole at the Duke of Portland sale of 1722 (cat. no. 146). He continued to work for Walpole through the 1720s and a bill drawn up in 1729 details work done to the cost of £78.1s.2d. *The London Evening Post* of 4-6 September 1746 recorded his death at his house in Newport street, reporting that 'the Business of Picture Frame Making' had rewarded him with 'a handsome fortune'.

Manuscripts: CUL Chol (Houghton) MSS, Vouchers 1721; Houghton Archive, RBI, 45; Houlditch MSS.

Literature: Moore ed. 1996, pp. 48, 49, 51, 52, 99, 105; Simon 1996, pp. 125, 130-31, 203.

JERVAS, CHARLES (1675-1739)

Born at Clonliske, Kings County, Ireland, by the 1690s Jervas was living in London, where, according to Vertue, he 'dwel'd with Kneller, one year ... [and] was first put to study painting'. He was amongst the earliest artists to copy the newly-hung Raphael Cartoons at Hampton Court. Following their completion he set off for the Continent, visiting Paris before moving on to Rome by March 1698. He remained in Italy until 1708, apparently dividing his time between studying, amassing a large collection of paintings and prints, and acting as an agent for, amongst others, the poet Matthew Prior (1664-1721), the antiquary Dr George Clarke (1661-1736) and the under secretary of state, John Ellis (?1643-1738). On his return to England he was hailed in *The Tatler* of 16 April 1709 as 'the last great painter Italy has sent us' and his stylised portraits of ladies, typically in the guise of milkmaid or shepherdess, rapidly become fashionable. He moved in the literary circle of Swift, Addison and Pope (to whom he taught painting in 1713) and quickly acquired important clients including the Duke of Marlborough and the Duke of Newcastle.

Sir Robert Walpole commissioned a considerable number of paintings from him including family portraits (cat. nos. 215, 216, 217, 218) and several 'presentation' pieces. He also seems to have employed Jervas as a copyist (cat. nos. 194, 195), allowing Jervas access to copy works from his own collection. Indeed, it was with Walpole's assistance that in 1723 Jervas succeeded Kneller as Principal Portrait Painter to the King, a position he was to hold for the rest of his life. Amongst the works produced in this capacity were coronation portraits of George II and Queen Anne and a portrait of the young Prince William, Duke of Cumberland.

Alongside painting, Jervas pursued literary ambitions and edited with Pope an edition of Du Fresnoy's *De Arte Grafitica* (1716). His most successful literary work, however, has proved to be his translation of Cervantes' *Don Quixote*, a translation which has now passed its hundredth edition, the latest being published by Oxford University Press in 1992. In 1738, as his health was failing, Jervas advertised that he was setting out to Italy 'to purchase pictures for the Royal Family'. He survived the trip but died of an asthmatic condition in November 1739, the sale of his considerable collection starting in March 1740. Lasting well over seven weeks, the sale included large quantities of paintings, prints, and drawings, as well as statues, medals and Raphael Ware. Amongst those attracted were Sir Paul Methuen, Dr Johnson, Alexander Pope and the painters and dealers Arthur Pond and John Ellys. Also present were Charles 2nd Viscount Townshend, Thomas Coke (later 1st Earl of Leicester) and Sir Robert Walpole, whose purchases included works by Snyders, A. Sacchi and Rembrandt (cat. no. 154).

Manuscripts: Bodl. MSS Eng. Lett. C275 (18-19); BL Blenheim 61635, ff.9; CUL Chol (Houghton) MSS, Vouchers 1725; Houlditch MSS; Glasgow University Library, SM 1536; Worcester MS 181.

Literature: Bottoms 1997, pp. 44-48; Vertue, vol. III, 1933-34, pp. 17, 61-62, 85, 99, 103; vol. IV, 1935-36, p. 15; vol. V, 1937-38, pp. 14, 126; Walpole 1888, vol. II, pp. 653-57; HMC Bath 1904-8, vol. III, p. 432.

KEENE, BENJAMIN (1697-1757)

Benjamin Keene was the eldest son of Charles Keene, alderman and Mayor of King's Lynn, Norfolk (1714). Charles Keene maintained a close connection with the Walpole family and both his surviving sons, Benjamin and Edmund (later Bishop of Ely), benefited from the growing influence of Robert Walpole. Indeed, it was as a direct result of such patronage that Benjamin was appointed agent to the South Sea Company in Madrid in 1723 and British Consul in 1724, receiving promotion to minister plenipotentiary in 1727. Little is known of his attitude towards art collecting but he was reputedly a great lover of books and involved himself in the publication of a Spanish edition of *Don Quixote*, printed in England by Tonson in 1738. On the declaration of war against Spain in 1739, Keene was recalled to England and was found positions in parliament representing Maldon, Essex (1739-41) and West Looe, Cornwall (1741-47). During this period his relationship with Sir Robert Walpole continued and his present of a Murillo (cat. no. 184) was first recorded at Houghton in 1743. Indeed, Keene lived as a tenant of Walpole's at Richmond Lodge and was described by Sir Robert in 1745 as 'almost the only friend I have in this world of any consequence'. Keene was recalled to foreign service once more in 1746, being dispatched to Portugal as envoy extraordinary and minister plenipotentiary, charged with making peace with Spain. By October 1748 he returned again to Madrid and concluded a commercial treaty with Spain in 1750. At his investiture as a Knight of the Bath in 1754 the King of Spain paid the unusual tribute of personally conducting the ceremonies. On 15 December 1757, shortly after retiring, Keene died at his residence in Madrid.

Literature: DNB, vol. 10. pp. 1189-90; Lodge ed. 1933, pp. 7-12, 15; Moore ed. 1996, p. 53; HWC vol. 21, p. 166.

KNELLER, SIR GODFREY (1646-1723)

The leading portrait painter at the English court over four decades, Kneller was born in Lubeck and studied at Amsterdam and Rome before moving to England in 1676. He rapidly gained the attention of the Royal Court, his 1678 portrait of Charles II proving successful and by the early 1680s was firmly established as a fashionable painter of society portraits. He became a naturalised citizen in 1683 and the following year was dispatched to France by Charles II to paint Louis XIV. Following Charles' death in 1685, Kneller continued to receive royal favour, holding the position of 'principle painter to the Crown' until his death. A knighthood was awarded in 1692, followed by a baronetcy in 1715 - an unprecedented honour for a painter. From the large number of works to emerge from his studio, amongst the most celebrated are his *Michael Alphonsus Shen Fu-Tsung* (Royal Collection, London) and his series of 'Hampton Court Beauties', modelled upon Peter Lely's earlier set of portraits of court ladies painted for Windsor Palace. His more than forty portraits of Kit-Kat Club members, painted in the first two decades of the eighteenth century for Jacob Tonson (1656-1736), popularised a new format (36 x 28 inches) in England and reads as a 'who's who' of Whig politicians and writers. Portraiture appears to have been a lucrative business for Kneller and he invested in farming land and various properties, including an inn. His studio was located in the northeast corner of The Piazza, Covent Garden from c.1682, expanding to 55-58 Great Queen Street, London, c.1703. In 1709 he began a grand country house at Whitton, near Twickenham, thought to have been designed by Wren. Boasting a staircase painted by Louis Laguerre (1663-1721), the house was presumably the location for the bulk of Kneller's art collection, with Vertue noting works by masters including Van Dyck, Rembrandt and Rubens. Following Kneller's death, a sale of his remaining works was arranged by Christopher Cock. It ran from 18 to 20 April 1726 and attracted a number of major collectors, Sarah Churchill, Duchess of Marlborough buying five works. A number of his drawings and unfinished paintings were bequeathed to his studio assistant Edward Byng, who later finished a number of them.

Sometime before 1736, Sir Robert Walpole acquired from the Kneller collection Ruben's sketch for the central medallion of the ceiling in the Banqueting House, Whitehall, the *Apotheosis of James I* (cat. no. 120). Also likely to have come from his collection were the two self-portraits, painted 'when young' (Walpole MS 1736, nos. 287, 345), seen at Downing Street and Grosvenor Street, respectively, in 1736. Other works by Kneller owned by Walpole included depictions of Lady Walpole (Walpole MS 1736, . no. 386) and Charles Lord Viscount Townshend (cat. no. 219), an oil sketch of King William III (cat. no. 196) and versions of King George I (cat. no. 220), George II, 'when Prince' (Walpole MS 1736,

no. 452) and Queen Caroline, 'when Princess' (Walpole MS 1736, no. 453). In addition portraits of John Locke (cat. no. 200), Joseph Carreras (cat. no. 198) and Grinling Gibbons (cat. no. 199) were also hung at Houghton. Sir Robert's own portrait, for the Kit-Cat Club, was painted by Kneller c.1710-15 and a later portrait, signed and dated 1716, formerly hung at Raynham Hall, Norfolk. Indeed, Walpole appears to have been commissioning pieces right up until the last year of Kneller's life, an account within the Cholmondeley MSS revealing the artist to have been paid the substantial sum of £82.4s on 22 June 1723.

Manuscripts: CUL Chol (Houghton) MSS, Accounts 22, Cash book of Edward Jenkins; Frick, 18 April 1726.

*Literature:*DNB, vol. 11, pp. 240-43; Dictionary of Art 1996, vol. 18, pp. 144-47; Howarth ed. 1993, pp. 255-63; Killanin 1948, pp. 84-86, 94-95; Stewart 1971, pp. 6-7; Stewart 1983, p. 83; Vertue, vol. I, 1929-30, pp. 27, 28, 39, 108; vol. II, 1931-32, pp. 68, 121, 125; vol. III, 1933-34, pp. 12, 42, 44, 56, 57, 112; vol. IV, 1935-36, p. 123; vol. V, 1937-38, pp. 85, 121.

LAW, JOHN (1671-1729)

The son of a goldsmith, John Law was educated in Edinburgh and moved to London by the time he was twenty-one. In April 1694 he killed Edward 'Beau' Wilson in a duel, was convicted of murder, imprisoned and subsequently escaped to the Continent. The first decade of the eighteenth century saw him travelling in Italy, France and Holland, engaged chiefly in gambling, before returning to Scotland where he published several pamphlets urging financial reforms. He gained favour with the Duke of Orleans (subsequently Regent) and on the death of Louis XIV was permitted to establish a private bank with the power to issue notes. By late 1719 Law was in control of the French Mint and had taken responsibility for almost the entire national debt. Meanwhile, his 'Compagnie d'Occident' took over the bulk of France's non-European trade and its shares rocketed at the prospect of huge profits from Law's 'Mississippi Scheme', speculation reaching a climax in the winter of 1719/20. By May 1720 the bubble had burst and Law's 'System' crashed with catastrophic effect. His house in Paris was attacked by the mob and he fled to Brussels, his estates in France confiscated.

After a brief period in Italy, Law was formally presented to George I on 22 October 1721. He cultivated relations with Robert Walpole, eventually being dispatched to Munich in 1725 on a clandestine diplomatic mission. Vertue remarks that in 1723 'the King bought 6 Large paintings of Mr Laws' including *The Toilet of Venus* (Royal Collection, attributed to studio of Reni), totalling £4,000. Indeed, it appears that Law invested a considerable sum of money in paintings and an inventory made in 1729, following his death in Venice, lists amongst 81 boxes of sculpture, furniture and musical instruments, a total of 488 paintings. The subsequent history of Law's collection is difficult to establish. An attempt was made in autumn 1729 to ship the paintings to Holland but the boat, taking in water during a storm, was forced to return to Venice. A Dottore Ricini was subsequently employed to restore the damaged paintings, the insurers stating that they would be bankrupted if forced to pay full damages. Nevertheless, pictures belonging to a John Law, the Rt. Hon. General Stuart and Sir John Holland were advertised by Christopher Cock as being for sale on 14 April 1730, at General Stuart's London house. The *Aedes Walpolianae* records Sir Robert Walpole as having owned a *Christ Baptised by St John*, by Albano (cat. no.

2) and a *Madonna and Child and St John,* by Bellino (cat. no. 88), both of which came from John Law's collection. In the absence of an existing sale catalogue, however, we can only conjecture that it was at this sale that Walpole made his purchases, although that is borne out by the existence within Walpole's collection of a *Last Supper* (cat. no. 67) then thought to have been by Raphael, bought from Sir John Holland, presumably at the same sale. Another sale appears to have taken place in Holland in 1735, with a further 15 of his pictures being sold in London on 22 May 1765. In addition, 77 of his paintings were sold by Christie's on 16 February 1782, when Horace Walpole bought a portrait in crayons of Law, by Rosalba (sold, SH 1842, day 21, lot 73, bought T. B. Brown).

Manuscripts: CUL Chol (Houghton) MSS, Papers 83, 1/c; Bodl. Johnson.d.778.

Literature: Baschet 1875, p. 207; Cellard 1996, pp. 112, 394-95; DNB, vol. 11, pp. 671-75; Hujis 1978, pp. 9-31, 97-125; Montgomery Hyde 1969, pp. 188-89, 212-13; Murphy 1997, pp. 326-28, 363-65; Vertue, vol. I, 1929-30, p. 102; vol. III, 1933-34, p. 19; HWC vol. 15, pp. 167, 192; vol. 42, pp. 386-87.

MACKY, JOHN (? – d. Rotterdam 1726)

Of Scottish birth, John Macky had early success as an English agent, detecting French expeditionary plans in 1692 and 1696. He was appointed inspector of the coast from Harwich to Dover in 1693 and in 1697 was given charge of the packet boats from Dover to France and Flanders. Following the death of King William in 1702 Macky spent several years in Italy, but by early 1706 was back in England, controlling direction of the packet boats to Ostend. He fell from favour with Bolingbroke in 1711 and 'his creditors were hounded out upon him'. Imprisoned until the accession of George I in 1714, Macky attempted, on his release, to establish a packet boat service to Ireland. A manuscript version of his memoirs (posthumously published in 1733), however, dedicated to Sir Robert Walpole, seems to have resulted in his recall to important government service. Macky was dispatched in 1723 to spy on the exiled Bishop Atterbury and soon established himself as the lynchpin of Walpole's Continental anti-Jacobite espionage ring. He successfully gained Rochester's confidence whilst also managing to add to Walpole's pay list both the Postmaster of Calais and François Jaupain, the Director General of Postal Services in the Austrian Netherlands.

Macky was also active as a writer, his first publication *A View of the Court of St. Germain…* (London, Dublin, Amsterdam, 1696) was a great success, selling around 30,000 copies by Macky's own count. Subsequently, his *A Journey Through England* (vol. I, London, 1714; vol. II, London, 1722), *A Journey Through Scotland* (London, 1723) and *A Journey Through the Austrian Netherlands* (London, 1725) drew upon his extensive travels and reveal a detailed knowledge of many of the major picture collections. Indeed, whilst the guise of 'art collector' or 'connoisseur' was a common cover for spies, Macky seems to have actively involved himself in dealing. In 1710 he endeavoured to sell to Sir Hans Sloane (1660-1753) part of a large collection available in Bruges and in 1723/4 he played the leading role in Sir Robert Walpole's purchase of Snyders' *Four Markets* (cat. nos. 133-136). The latter transaction was carried out whilst disguised as a Jacobite and monitoring the movements of Atterbury. He died in 1726 in Rotterdam, where he was buried.

Manuscripts: BL Add.MSS 4042, f.142, BL Add.MSS 32,686, f.330; CUL Chol (Houghton) MSS, Correspondence 1036, 1050, 1054, 1067, 1097.

Literature: DNB, vol. 12, pp. 189-190; Fritz 1975, pp. 115-20; Koslow 1995, pp. 112-16; Ingamells 1997, pp. 626; Macky 1725, pp. 34; Macky 1733, pp. xvi-xix.

MANN, SIR HORACE (1706-86)

The British representative at Florence from 1738 to 1786, Mann was at the hub of the social life of British residents and travellers in the city. His first visit to Italy was in 1732, when he saw Naples, Rome, Padua, Venice and Verona. Due to the influence of Sir Robert Walpole, he was appointed assistant to the British minister in Florence by February 1738, taking over the position itself in April of that year. A baronetcy was granted in 1755 and ten years later he was made the British envoy. Investiture as a Knight of the Bath followed in 1768. His appointment as envoy extraordinary and minister plenipotentiary came in 1782. Mann dedicated himself to entertaining and assisting British visitors to Florence, 'the politeness of his manners, and the prudence of his conduct … [being] shining examples both to the Britons and Italians'. His regular Saturday night conversazione at the Palazzo Manetti became an important social event, providing introductions to Florentine society and to the network of British residents. His guest house, the Casa Ambrogli, accommodated many travellers and amongst those artists he is recorded as having assisted are the watercolourist Robert Skelton and the engraver Robert Strange, for whom he obtained permission to copy works at a number of Florentine galleries. Mann also patronised and encouraged Johann Zoffany (1733-1810) and is depicted at the heart of his portrait of the British in the *Tribuna degli Uffizi* commissioned by Queen Charlotte in 1772. Indeed, Mann was ideally situated to supplement his income with picture dealing, facilitating purchases for his visitors and for collectors back in England. Amongst his acquisitions for Sir Robert Walpole was a 1743 birthday present of the *Rape of the Sabine Woman* (cat. no. 266), after Giambologna, which was placed in the Salon at Houghton. He purchased two Poussins and a Maratta from the Arnaldi collection for Henry Hoare II of Stourhead and negotiated, through Robert Strange, for a *Magdalene* by Guido Reni for Lord Royston, later 2nd Earl of Hardwicke. To Horace Walpole, his friend and correspondent of over forty-five years, Mann dispatched numerous works of art including an antique bust of Caligula excavated at Herculeaneum and several paintings by his friend and Florentine neighbour Thomas Patch (1725-82).

Literature: DNB, vol. 12, pp. 926-28; Dictionary of Art 1996, vol. 20, pp. 276-77; Ingamells 1997, pp. 635-36, 904-6; Moore ed., 1996, pp. 117, 123, 159; Sutton 1981, vol. IV, p. 331; HWC vol. 18, pp. 298-99, 312-13; Wilton, Bignami eds. 1997, pp. 55, 133.

MARI, MARCHESE DI

Five pictures within the Walpole collection are recorded as having come from the collection of the Marchese di Mari. There is potential for confusion as to the exact identity of their owner—all five of the sons of the Doge of Genoa, Stefano di Mari, having named their first born sons Stefano. In addition, two cousins of the same family also bore the name Stefano di Mari. The most likely candidate, however, is the Marchese Stefano Mari (d.1748), a Vice-Admiral of Spain,

described by Horace Mann in a letter to Walpole in 1741 as 'Marquis di Mari, Spanish ambassador at Venice'. Certainly Horace Walpole made contact with a Marchese di Mari whilst on his Grand Tour, presumably whilst passing through Genoa (November 1739, July 1741) or Venice (10 June–12 July 1741). Horace's letter of 14th August 1743 reveals a promise to send the Marchese an 'Italian greyhound' from England. It appears, however, that the pictures within Sir Robert's collection were all acquired in Genoa prior to Horace's Grand Tour. The *Portrait of a Boy with his Nurse* attributed to Moretto da Brescia (cat. no. 57) was recorded as hanging in Grosvenor Street in 1736 whilst the Andrea del Sarto *Holy Family* (cat. no. 80), the Claude *Landscape with Apollo and the Cumaean Sibyl* (cat. no. 170), and the two Gaspard Poussin (Dughet) landscapes (cat. nos. 164, 165) were all noted in Downing Street by 1736. The *Aedes* tells us that a 'Mr Edwin', almost certainly Humphrey Edwin (1673-1747), brought the Claude and the Poussins out of Italy and it seems probable that Edwin was also the purchaser of the Moretto and the Andrea del Sarto. No further details of the transaction between Edwin and Mari seem to have survived but it is likely to have taken place between 1730 and 1733 when Edwin is recorded as travelling in Italy with his niece.

Manuscripts: Walpole MS 1736, nos. 153, 154, 163, 166, 349.

Literature: DBI, vol. 38, pp. 509-11; Ingamells 1997, p. 332; HWC vol. 17, p. 293; vol. 18, p. 226.

MONTAGU, CHARLES, EARL OF HALIFAX (1661-1715)

Educated at Westminster School and Trinity College, Cambridge, Montagu gained early acclaim for his parody, *The Town and Country Mouse* (1687), written in conjunction with Mathew Prior. He was amongst the signatories of the letter of invitation to William of Orange and entered parliament in 1689 as MP for Malden, taking the position of Clerk of the Privy Council. In March 1692 he became a Lord of the Treasury and proposed a bill to raise one million pounds sterling by means of a loan, thus establishing the National Debt. Two years later Montagu was instrumental in passing the Tonnage Bill, establishing the Bank of England and raising yet another million. He was then promoted to Chancellor of the Exchequer in April of that year, in which post he was responsible for the re-coinage of 1695. With the Tories gaining power in 1699, Montagu withdrew from major office and accepted the title of Baron Halifax. Attempts to impeach him in 1701 and 1703 failed and in April 1706 he was appointed as a commissioner negotiating the union with Scotland. With the accession of George I, Montagu returned to the position of First Lord of the Treasury and was created a Knight of the Garter, Earl of Halifax and Viscount Sunbury. Macky notes that Halifax had 'a Noble Apartment adjoyning to, and under the House of Commons, finely fitted up, and furnished with a Noble Collection of Original Paintings and a handsome Garden opening to the River'. Robert Walpole, 2nd Lord Orford, was later to move into these apartments as Auditor of the Exchequer and to use them to hang a quantity of paintings acquired by his father.

The auction of Halifax's paintings, which took place 6-9 March 1740, details a substantial collection incorporating a number of portraits of English writers such as Shakespeare, Chaucer, Milton, Dryden and Congreve. The Italian, French and Flemish schools were also well represented with works by

artists such as Carlo Maratti, Salvator Rosa, Guido Reni, Claude, Rubens and Van Dyck. Vertue relates that Halifax also used his influence to encourage 'our country men', securing Sir James Thornhill the commission to paint the Prince of Wales' apartments at Hampton Court Palace, over the claims of Sebastiano Ricci. Indeed, it was to Halifax that Thornhill was to submit a series of detailed architectural drafts and plans for the creation of a royal academy of painting, 'consisting of many apartments convenient for such a purpose'. Amongst those who attended the auction of Halifax's collection were many of the major collectors of the day and Lord Chesterfield, Dr Mead, the Earl of Oxford, Lord Hervey and Lord Carlisle all made purchases. Sir Robert Walpole bought, via his agent, John Ellys, one of the most expensive pieces, 'G. Poussin – A landscape, Highly Finished', lot 87, 3rd day, at £115-1-0 (cat. no. 166). Also recorded in the *Aedes* as having been in Lord Halifax's collection was *Venus Bathing, and Cupids with a Carr, in a Landscape* by Andrea Sacchi (cat. no. 79), but this seems in fact to have been purchased by Walpole at the sale of Charles Jervas in 1739.

Manuscripts: Houlditch MSS; BL 1481.f.4; Glasgow University Library, SM 1536.

Literature: Brown 1993, pp. 21-22, 29; DNB, vol. 13, pp. 665-70; Macky 1714, p. 137; Pears 1988, pp. 69-70, 242; Vertue, vol. I, 1929-30, pp. 44, 87; vol. III, 1933-34, pp. 31, 70, 74; vol. IV, 1935-36, p. 165.

MONTAGU, JOHN, 2ND DUKE OF (1690–1749)

The eldest surviving son of Ralph Montagu, Charles II's ambassador to the French Court, John completed his Grand Tour (1700-2) in the company of the Huguenot physician, Pierre Sylvestre. He married Mary Churchill, daughter of the Duke of Marlborough, on 31 March 1705 and succeeded to the dukedom on his father's death in 1709. Awarded the Order of the Garter in 1719 and the Order of the Bath in 1725, he is chiefly remembered for a disastrous attempt to colonise the islands of St Vincent and St Lucia in 1722. Landing six ships, he was opposed by French forces from Martinique and forced to withdraw, at a personal cost said to have been close to £40,000.

Characterised by Horace Walpole as 'a most amiable man, and one of the most feeling I ever knew', Montagu was a Fellow of both the Royal Society and the Royal College of Physicians and also a director of the Royal Academy of Music. An amateur architect, he began making modifications to the gatehouse at Beaulieu, his Hampshire home, around 1714, transforming it into the keep of a castle-style house, complete with drawbridges, a moat and corner towers – nearly forty years before Horace Walpole started to gothicise Strawberry Hill. A similar scheme, at Ditton, also seems to have been undertaken and during the 1740s his friend, the antiquarian William Stukeley, drew up a number of Gothic projects including a bridge for the park at Boughton. Whilst this was never realised, Montagu did make significant changes at Boughton, adding the Audit Gallery and, with the aid of designs by Charles Bridgeman, making extensive alterations to the grounds, laying out long avenues of elm and lime. In London, Montagu employed Henry Flitcroft to assist with designs for 'a large and substantial house, with outhouses and appartanances' (demolished 1850s). At a total cost of £3,755, the property was erected on land adjoining the Privy Garden at Whitehall, London and is celebrated by Samuel Scott's *The Thames with a View of Montagu House* (Boughton) commis-

sioned c.1749 by the Duke. Vertue reveals that at the Duke's 'Cabinet of pictures at Whitehall' were 'a great number of curious limnings ... some of Is. Oliver. S. Cooper. L. Crosse – and some markt LD. Dixon. Limner'. Montagu's own portrait was painted, as a youth, by Arlaud and later by Sir Godfrey Kneller. He celebrated his elevation to the Order of the Garter with a full-length by Charles Jervas (Boughton), of which several versions seem to have been produced. During the 1720s Mary, Lady Montagu, was also painted full-length by Jervas, in Turkish costume, complete with page-boys (Boughton). A portrait by Thomas Hudson produced in the last year of the Duke's life shows Montagu in the insignia of both the Garter and the Bath, against the background of the Tower of London, presumably a reference to his position of Master-General of the Ordinance, held 1740-41 and 1743-49. Montagu's friendship with Sir Robert Walpole is recorded by Horace who recalls that his father 'had a great opinion of his understanding' and letters in the Cholmondeley archive, dated 1740-41, show Walpole to have been pressing the King for a regiment for the Duke. Such a relationship was not one-sided, and the *Aedes* states that it was the Duke who gave his fellow Kit Kat Club member the Eustache Le Sueur *Exposition of Moses* (cat. no. 173), first recorded as hanging in the hall of Sir Robert's house at Chelsea in 1736. William Stukeley, following the Duke's death in 1749, remarked that 'we had exactly the same taste for old family concerns, genealogy, pictures, furniture, coats of arms, the old way of building and gardening'.

Manuscripts: Walpole MS 1736, no. 411; CUL Chol (Houghton) MSS, Correspondence 3069.

Literature: Cornforth 1971a, pp. 421-25; Cornforth 1971b, pp. 478-79; Cornforth 1992, pp. 58-61; DNB, vol. 21, pp. 700-2; Metzger 1987, p. 266; Murdoch ed. 1992, pp. 23-27, 34-40, 75, 182; Survey of London, vol. V, pp. 65–66; vol. XIII, pp. 214-18, 247; Vertue, vol. IV, 1935-36, pp. 118, 153; HWC vol. 10, pp. 351, 335; vol. 20, p. 79; Walpole 1928, pp. 54-55.

O'HARA, JAMES, BARON KILMAINE AND 2ND BARON TYRAWLEY (1680-1773)

The son of Sir Charles O'Hara, 1st Baron Tyrawley, James O'Hara was characterised by Horace Walpole as 'imperiously blunt, haughty and contemptuous' but with 'a great deal of humour and occasional good breeding'. He began his military career with an appointment, at the age of twenty-three, to a lieutenantship in the Royal Fusiliers, his father's regiment. Serving under Marlborough, O'Hara survived severe wounds sustained at the Battle of Malplaquet in 1709 and succeeded his father as colonel of the Royal Fusiliers in 1713. Given an Irish peerage in 1722, he received the title of Baron Kilmaine, and on the death of his father in 1724 took the title of 2nd Baron Tyrawley. A member of the Privy Council, O'Hara served as an aide-de-camp to George II in 1727, before being appointed in January 1728 as envoy extraordinary to Portugal, remaining there as ambassador until 1741. It seems likely that the version of Holbein's portrait of *Edward VI* (cat. no. 204), which the *Aedes* states as having been in Charles I's collection, was presented to Sir Robert Walpole sometime prior to 1739, the year in which O'Hara was promoted to major general. This was a singular brush with the arts on behalf of the prime minister. He served as ambassador extraordinary in Russia from November 1743 to February 1745, before resuming his ambassadorial duties in Portugal in 1752 and acting as Governor of Minorca until the Gibraltar expedition of 1756. O'Hara's last major diplomatic

post was in 1762 as plenipotentiary and general of the English forces in Portugal but he was retired with the title of field marshall in 1763. His marriage to Mary Stuart, daughter of the 2nd Viscount Mountjoy was childless but on O'Hara's death at Twickenham on 14 July 1773, he was survived by illegitimate issue, including the actress George Anne Bellamy (?1731-88) and General Charles O'Hara (?1740-1802), subsequently also governor of Gibralter and whose engagement with Mary Berry is chronicled in detail in Horace Walpole's letters.

Literature: DNB, vol. 14, pp. 956-57; Vertue, vol. IV, 1935-36, p. 175; Walpole 1985, vol. III, pp. 14-15; HWC vol. 12, pp. 171-73, 210, 211; vol. 43, p. 156.

PALLAVICINI, MARCHESE NICCOLÒ MARIA (1650–1714)

The illegitimate son of Carlo Pallavicini (1612-77), Marchese Niccolò Maria Pallavicini became one of Rome's leading patrons, collecting on a grand scale. He commissioned a number of works from such artists as Christian Berentz (1658-1722), Domenico Piola (1627-1703), Jans Frans van Bloemen (1662-1749) and Francesco Trevisani (1656-1746). His favourite artist, however, appears to have been Carlo Maratti (1625-1713), from whom he commissioned at least eighteen works. Edward Wright, writing in 1723 after visiting the Marquis' palace, remarked upon a double portrait 'of Carlo Maratti, painting that of the marquis [together with] A great many other paintings by Carlo Marat, and many of Gaspar Poussin; particularly a very fine sea storm, with Jonah and the Whale.' A number of these works were sold to English collectors and dealers by the Arnaldi family of Florence, to whom part of the Marquis' collection passed c.1714. The double portrait of Maratti is now at Stourhead, whilst the Gaspar Poussin (Dughet) *Sea Storm* was offered to Sir Robert Walpole by the dealer Humphrey Edwin, before eventually being sold to the Prince of Wales. Purchases from the Pallavicini collection allowed the creation of the Carlo Maratti room at Houghton, with a total of eight Maratti pictures confirmed as coming from that source (cat. nos. 41, 44, 45, 48, 49, 50, 51, 52). Unfortunately, it is unclear who was involved in such major purchases, although Edwin seems to have been a likely candidate. Moreover, it seems that the paintings were not necessarily obtained at the same time or via a single agent. The portraitist Charles Jervas is given as the source for the *Clement IX* (cat. no. 41) and this purchase must have been made during his visit to Italy in 1738. Pallavicini pictures appear to have been available in England for a number of years before this date, however, with a sale of 74 lots from a collection of that name being organised by Christopher Cock in London in 1729/30. It is possible that the large *Rape of Ganymede* by Michaelangelo Buonaroti (cat. no. 54) which hung in the Common Parlour at Houghton by 1735, was lot no. 46 at this sale. Seven other Pallavicini paintings were in Sir Robert's possession by 1736, when they were recorded in the inventory of that year. Further works from the Marchese's collection were also brought into Britain in the late 1750s, with Horace Mann buying works by Maratti and Gaspard Dughet from the Arnaldi family in 1758. In the same year, Richard Dalton (?1713-91) and William Kent (*fl.*1742-61) also acquired Pallavicini pictures - the latter dealer offering a number of the pieces to Sir Nathaniel Curzon for the sum of £2,800.

Manuscripts: Houlditch MSS; Walpole MS 1736, nos. 12, 13, 16, 17, 19, 20, 21.

Literature: DBI, pp. 245-47; Dictionary of Art 1996, vol. 23, pp. 873-74; Ingamells 1997, pp. 571-72; Rudolph 1995, pp. 143, 154-59, 210-32, 239; Wright 1730, vol. I p. 190; Vertue, vol. III, 1933-34, p. 96.

PHÉLYPEAUX FAMILY

Secretary of State under Louis XIII from 1629 until 1654, Louis Phélypeaux, Seigneur de La Vrillière, married Marie Particelli d'Emery in 1635, adding 336,000 livres to his family's already considerable fortune. In the same year construction began on Louis Phélypeaux's grand town house, L'hôtel de La Vrillière, on the rue des Petits-Champs, to designs by François Mansart. Of prime importance in the decorative scheme of the house was the upper gallery, whose vault was decorated with subjects relating to the Four Elements and a *Chariot of Apollo*, painted by François Perrier. A series of ten Classical subjects, painted by Nicolas Poussin, Carlo Maratti, Pietro da Cortona, Guido Reni, Alessandro Turchi and Guercino were likewise commissioned for this space between 1635 and 1660. An inventory taken in the presence of 'Pierre Bourguignon, peintre ordinaire du roi', following Phélypeaux's death in 1681, provides detailed descriptions of 247 paintings hung at the hôtel, together with those located at Vrillière's chateaux at Châteaux-sur-Loire. The emphasis of the whole collection seems to have been on sixteenth- and seventeeth-century Italian schools, outstanding examples being the *Persée et Andromède* of Titian (Wallace Collection, London) and Raphael's *La Vierge au diadème bleu* (Louvre, Paris). Recorded in the inventory is '[39] Item un tableau d'une forme octagone' representing the 'nativité de nostre Seigneur avec plusieurs pasteurs qui l'adorant', identifiable as Guido Reni's *Adoration of the Shepherds* (cat. no. 69) acquired from that collection by Sir Robert Walpole. Indeed, paintings from the Vrillière collection constituted a major addition to the Wapole collection, with three other works coming from that source, a *Sacra Conversazione* of Bonifazio de' Pitati (cat. no. 63) and *Summer* and *Winter* pieces by Francesco Bassano (cat. nos. 4, 5). The Hôtel de La Vrillière and it's contents were inherited by Louis' son, Balthazard, who in turn passed the house on to his own son Louis Phélypeaux, Marquis de La Vrillière (1672-1725). It seems likely that it was from this man, or his son Louis Compte de St Floretin, Duc de la Vrillière (1707-77), both Secretaries of State, that Walpole made his purchases. In 1705 the Hôtel was sold to Louis Raulin Rouillé, mâitre des requetes, before being purchased in 1713 by the Compte de Toulouse. With the revolution the dispersal of the Vrillière collection continued and a quantity of paintings were noted in October 1793 as 'reserves pour la Republique'. Today, a portion of the house survives, incorporated into the Banque de France.

Literature: Cotté 1985, pp. 89-93; DN, vol. 15, pp. 789-90; Dictionary of Art 1996, vol. 24; Schnappes 1994, pp. 166-71.

PLETTENBERG EN WITTEM, FERDINAND GRAAF VAN (1690-1737)

The nephew of Prince-Bishop Friedrich Christian von Plettenberg (1688-1706), Ferdinand was born in Lenhausen, Westfalen, and rose rapidly to a position of great political influence within the Holy Roman Empire, holding positions as kurkölnischer Minister und Obristhofmeister. He was awarded the title of Reichsgraf in 1724 and acted as intermediary between the Holy Roman Emperor and Louis XVI in the early 1730s, playing a significant role in the drawing up of the Pragmatischen Sanktion of 1732. Following the death of his elder brother in 1712, Ferdinand inherited Schloss Nordkirchen, near Dusseldorf, begun by Friedrich Christian in 1703 to designs by Gottfried Laurenz Pictorius (1663-1729)

and Peter Pictorius II (1673-1735). Shortly after his elevation to the status of Reichgraf, Ferdinand employed Johann Conrad Schlaun (1695-1773) to complete the castle (c.1725-34), adding pavilions, an orangery, a ballroom, a pheasant house and a hospital. In addition to being responsible for the interior decoration and furnishing of the whole house, Schlaun also drew up plans for the parkland, creating boating lakes and canals. Indeed, Plettenberg seems to have been a major patron of Schlaun and employed the architect to design the Cappuchin monastery founded in Wittem in 1732. In addition to Schloss Nordkirchen, Ferdinand also owned a house in Bonn, the gift of Clemens Augustus (1700-61), for whom Ferdinand helped obtain the bishopric of Munster and Paderborn in 1719. It is known that Plettenberg amassed a substantial library and collection of paintings and the *Aedes* informs us that when the Count travelled to Italy to take up his appointment as the Emperor's minister in Rome he carried his pictures with him. Ferdinand, however, was to die in Vienna before his post could be officially bestowed upon him and his pictures were sent to Amsterdam to be sold. Judging from the catalogue of the sale, which took place on 2 April 1738, Ferdinand had transported across the Continent a collection of significant size and value, the catalogue consisting of 140 lots, amongst which was an 'Heylige Familie, van Matteo' (lot 24). This was presumably the Matteo Ponzone *Holy Family* (cat. no. 64) which the *Aedes* reports Robert Trevor (1706-88) as having purchased in Amsterdam for Sir Robert Wapole. This painting is first recorded in a list appended to the 1736 inventory of the Walpole collection (Walpole MS 1736, no. 434), under the heading of 'Pictures bought since the Catalogue was made'. It is therefore unlikely that this Ponzone work was purchased at the second, much smaller, sale of Plettenberg pictures which took place in Amsterdam at the later date of 11 April 1743.

Manuscripts: Walpole MS 1736, no. 434; Bibliothek der Staatlichen Museen, 2 April 1738.

Literature: Dictionary of Art 1996, vol. 24, p. 740; vol. 25, pp. 105-7; NDB, pp. 536-37.

RICHARDSON, JONATHAN (1665-1745)

At the age of twenty Richardson began studying as a portraitist under John Riley (1646-91) and early works such as his *Lady Catherine Herbert and her Brother Robert* (1698, Wilton House) and *Edward Colston* (1702, City Estates Committee, Bristol) have been seen as evidence of his teacher's influence. In 1711 he was a founding member of the Great Queen Street Academy and by 1731 was considered by Vertue to be amongst the three leading portraitists of the age, alongside Charles Jervas and Michael Dahl. Sir Robert Walpole commissioned Richardson to paint a number of his friends and relatives, and portraits of Horatio Walpole, 1st Baron Walpole (cat. no. 224), Galfridus Walpole (cat. no. 227) and Sir Charles Turner (cat. no. 225) are recorded at Houghton, together with a portrait of Sir Robert in his Garter robes (Walpole MS 1736, no. 78). A depiction of Sir Robert in the less formal attire of his hunting dress is also recorded as hanging in the bedchamber at Downing Street (Walpole MS 1736, no. 220), whilst a whole-length of General Charles Churchill, (Walpole MS 1736, no. 385) hung in Sir Robert's house at Chelsea.

Richardson also held ambitions as a writer and his most influential works included *An Essay on the Theory of Painting*

(London, 1715) and *An Essay on the Whole Art of Criticism as it Relates to Painting and an Argument on Behalf of the Science of the Connoisseur* (London, 1719). Both these works made extensive reference to drawings within Richardson's own collection, a practice continued in *An Account of Some of the Statues, Bas-reliefs, Drawings and Pictures in Italy* (London, 1722), expanded from the travel notes made by Richardson's son, Jonathan (1694-1771), whilst on a tour of Italy c.1720-21. Richardson's collection of drawings rivalled, in size and scope, that of Sir Peter Lely, at whose sale he made some of his earliest purchases. We know that by 1719 Richardson's collection filled 30 volumes and that by his death he was in possession of nearly 4,750 Old Masters. Purchases are recorded as also having been made at the sales of John, Baron Somers and Solomon Gautier and it seems likely that his son acquired a number of pieces for him whilst abroad. Indeed, Jonathan records Richardson Jnr. as having consulted with the dealer and connoisseur Nicolaes Flinck concerning the attribution to Raphael of one of his father's drawings, during one of his visits to Holland in 1716 and 1720. Following Richardson's death, nearly one thousand of the drawings were sold at Cock's auction rooms on eighteen evenings from 22 January 1747, raising a total of £2,060. Vertue reports that at the sale 'there was allwayes a crowd of the Virtuosi … [and] there appeard an unexpected ardor in the purchasers and they sold all very well and some to extraordinary prices.' Purchasers included Thomas Hudson, Uvedale Price, the Duke of Rutland, Richard Houlditch and Horace Walpole. From the evidence of the sale it appears that Rembrandt was a favourite of Richardson's: 122 of his drawings were attributed to this artist. Likewise, Parmigiano, Polidore, Annibale Carracci and Corregio were exceptionally well represented.

Richardson's collection of paintings also appears to have included works of considerable merit and the portrait by William Dobson of *Abraham van der Doort* (cat. no. 193), first recorded in Sir Robert Walpole's collection at Downing Street in 1736, is noted by Vertue as having originated from this source. The sale of Richardson's remaining collection of paintings took place 3-4 March 1747, again directed by Cock, and consisted of 122 lots, raising around £500.

Manuscripts: Houlditch MSS; Walpole MS 1736, nos.78, 220, 386.

Literature: Gibson-Wood 2000, pp. 89-104, 244-45; Dictionary of Art 1996, vol. 26, pp. 344-46; Pouncey, Gere 1962, no. 16; Vertue, vol. II, 1931-32, p. 77; vol. III, 1933-34, pp. 7, 100, 134-35; vol. V, 1937-38, p. 60; Walpole 1888, vol. II, pp. 324-26.

SCAWEN, THOMAS (after 1695–1774)

In 1722 Thomas succeeded his uncle, Sir William Scawen, a successful city merchant and financier, inheriting estates in Carshalton, Surrey. In the same year he commissioned the architect James Leoni to design him Carshalton Park, a substantial country house influenced by Colen Campbell. Now destroyed, Leoni's designs for the house are illustrated in an appendix (dedicated to Thomas) in Leoni's translation of Alberti's *De re aedificatoria*. A neighbouring house, Stone Court, built 1712 by one John Carter, had been mortgaged to Sir William Scawen and in 1729 the house reverted to Thomas. No substantial changes appear to have been made to the house but Thomas set about landscaping the grounds, creating a canal, pond and a fine, three-bayed grotto. A bridge of Portland stone in the grounds has traditionally been ascribed to Leoni. One year after his uncle's death, Thomas also acquired

a large London property, that of No. 7, St James Square. Bought from the family of Charles Robartes, 2nd Earl of Radnor, the house would have been a grand setting for Scawen's collection of paintings. Vertue notes that when Radnor 'beautify'd his house [he] imploy'd several of the most Ingenious Artists then living in England to paint for him', including Louis Laguerre who contributed a staircase, and a number of Dutch decorative painters. As well as purchasing the house, Scawen also attended the Radnor sale of paintings of 22 April 1724, where he purchased, for 505 guineas, *Deborah Kip, Wife of Sir Balthasar Gerbier, and Her Children* by Rubens (National Gallery of Art, Washington). In 1725 Thomas married Tryphena Russel, the heir of Lord James Russel, and sat as MP for Surrey between 1727 and 1741. A quantity of Scawen's paintings, statues and bronzes was sold in London by Christopher Cock, for four days from 25 January 1743, the collection being especially strong in works by Rubens. It was at this sale that Sir Robert Walpole purchased *A piece of Fruit, and its companion M. Angelo* for £16-5-6 (Day 4, lot 37) (see nos. 193, 19) and *A Lady half-length a Capital Portrait Rubens* for £34-12- (Day 2, lot 48) (cat. no. 143). These purchases are particularly interesting in that they show Sir Robert continuing to acquire pictures in the years following his resignation from high office in early 1742.

Manuscripts: Houlditch MSS.

Literature: Pevsner: Surrey 1982, pp. 132-37; Sedgwick 1970, vol. II, pp. 410-11; Survey of London, vol. XXIX, pp. 72, 109, 112, 114, 115; Vertue, vol. I, 1929-30, p. 132; HWC vol. 33, p. 111.

TREVOR, ROBERT , VISCOUNT HAMPDEN (1706–88)

The third son of Thomas, Baron Trevor of Bromham, Robert was educated at Queen's College, Oxford, matriculating in February 1723. He entered the Secretary of State's office as a clerk in 1729 before being appointed in 1734 as secretary to the legation at The Hague, under Horatio Walpole. An able diplomat, Trevor maintained a very close relationship with Horatio Walpole and is recorded in the *Aedes* as buying for Sir Robert Walpole a Ponzone *Holy Family* (cat. no. 64), acquired from the collection of 'Count Plattemberg, the Emperor's Minister at Rome'. This seems likely to have been bought at the Plettenberg sale held in Amsterdam from 2 April 1738 (lot 24). In September the following year Trevor was made envoy extraordinary and in 1741 was granted the position of minister plenipotentiary, an office he was to hold until his recall in 1746. Trevor seems to have taken an active interest in the arts, being elected a fellow of the Royal Society (1764) and writing a number of poems in Latin, published in Parma by his son, John, under the title of *Poematia Hampdeniana* (1792). In addition, Robert was an amateur architect of some note, his designs including projects for a house adjacent to St James Park, London, and for a Palladian country residence of nine bays. He also prepared drawings for an unexecuted design for Radcliffe Library, Oxford, and for a church at Glynde, East Sussex. Drawings for a polygonal house with five circular towers and for a gothic chair are also preserved in the RIBA Drawings Collection, along with designs for an obelisk, chimney piece and classical temple. Some of the latter may relate to Hampden House, Buckinghamshire, a property which passed to Robert in 1754 from his cousin John Hampden. As a condition of the inheritance, Robert took the name of Hampden by royal license. Ten years later, following the death of his half-brother John Trevor, Robert gained the title of 4th Baron

Bromham, together with another residence, Bromham Hall, Bedfordshire. He received the title of Viscount Hampden in 1776.

Manuscripts: Bibliothek der Staatlichen Museen, 2 April 1738.

Literature: Collett-White ed. 1995, pp. 194-97; DNB, vol. 19, pp. 1153-55; Pevsner: Buckinghamshire 1994, pp. 346-48; RIBA 1969-89, vol. G, pp. 85-86; Vertue, vol. II, 1931-32, p. 144.

VAN HULS, WILLIAM (?–c.1722)

William Van Huls seems likely to have come to London on the accession of William III, together with his brother, the Dutch Secretary. In 1689 the brothers were granted lodgings over the Holbein Gate, Whitehall Palace, and by 1700 William had been appointed Clerk of the Queen's Robes and Wardrobes. He appears to have acted as an advisor to Robert Harley, 1st Earl of Oxford (1661-1724), and in early 1711 was dispatched to the Hague to keep an eye on negotiations with France and the Netherlands, conducting a series of interviews with the participants. This proving successful, Van Huls was sent on two further missions to the Netherlands, in November 1713 and June 1714, and acted as an intermediary between Harley and Arnold Joost van Keppel, 1st Earl Albermarle (1669-1718). He managed to amass a considerable fortune, investing £5,000 in the 'South Sea Trade' and acquiring property in Kent and Chelsea. In early 1712 he petitioned the Crown for permission to build upon land next to Holbein Gate, constructing a four-storied house between the gate and the Banqueting Hall. Van Huls also invested in paintings and a series of sales took place following his death. The first, at his Whitehall house, from 6 August 1722 saw 'Mr Walpole' purchase at least five works, including *The Birth of Elizabeth* and *Her Confirmation* by Luca Giordano (cat. nos. 37, 36), a *Holy Family* by Rottenhamer (cat. no. 191), an *Italian Palace* by Steenwyck (cat. no. 138) and a *Holy Family* by Willeboirts Bosschaert (cat. no. 145). A second sale ran from 3 September 1722, at Van Huls' Chelsea residence, with one further sale reported by Vertue as 'at ye Hague 1736. Van Hulse collections of drawings one book bound containing. La Danse des Mortes en 60 Tableaux. a la piere rouge par Holben'. In August 1759 Van Huls' house adjacent to Holbein Gate was demolished in order to ease the passage of traffic along Whitehall.

Manuscripts: Houlditch MSS; University of Nottingham Library, Pw2 Hy 1094–1477; Frick, 6 August 1722; Frick, 3 September 1722.

Literature: Survey of London, vol. XIV, pp. 17-21, 59; Vertue, vol. III, 1933-34, pp. 9, 56.

VERNON, THOMAS (d.1726)

Little is known concerning the figure of Thomas Vernon. His career appears to have begun as secretary to the Duke of Monmouth and he is recorded as acting as a commissioner of trade and foreign plantations for a year from September 1713. He sat as a Tory for Whitchurch from 1710 until 1721 and from 1722 until his death in 1726. Vernon's residence, Twickenham Park House, was purchased from Arnold Joost van Keppel, 1st Earl or Albermarle (1669-1718) in 1702, on the Earl's return to Holland. Whilst no major alterations to the house seem to have been undertaken during Vernon's time, much landscaping and planting seems to have been carried out by Batty Langley (1696-1751). On Vernon's death in 1726, Twickenham Park House and the estate passed to his

wife, who survived until 1740, the Earl of Mountrath paying £13,000 for it to her trustees in 1743. In the same year an antique bust of a woman (cat. no. 234) and an eighteenth-century Italian bust (cat. no. 255) acquired from the Vernon collection were first recorded in Sir Robert Walpole's collection at Houghton Hall. These appear to have been part of the Earl of Albermarle's collection, presumably purchased by Thomas Vernon when he bought Twickenham Park House.

Literature: Sedgwick 1970, vol. II, p. 499; Urwin 1984, pp. 25-26, 35-36.

VERRUE, JEANNE-BAPTISTE D'ALBERT DE LUYNES, COMTESSE DE (1670-1736)

Born in Paris, the daughter of Charles de Luynes, Jeanne-Baptiste was married at the age of thirteen to Manfredo Ignazio di Scaglia, Conte di Verrua. Presented at the court of Victor-Amadeus II, Duke of Savoy, she became the Duke's acknowledged mistress by 1685. Verrue bore a son and a daughter with Savoy and began building a collection of paintings, furniture and medals, Prince Eugene of Savoy and Prince Emanuele of Carignan apparently acting as advisers and obtaining works of art for her. In 1699, however, her position appears to have become untenable and she fled in disguise to a convent in Paris, selling in 1701 her collection of antique gold medals to the Duchess of Orleans, Elisabeth-Charlotte (1652-1722). In 1704 the Conte di Verrua died and Jeanne-Baptiste took an hôtel on the rue du Cherche-Midi, where she built a picture gallery facing out over the gardens. Also owning a small house at Meudon, near Paris, she spent profusely on furniture and the decorative arts and built up an important library of over 15,000 volumes. By her death she is recorded as owning over 400 paintings, including such important pieces as Claude Lorrain's *Landscape with Aeneas at Delos* (National Gallery, London) and Murillo's *Young Girl with Flowers* (Dulwich Picture Gallery, London). She collected and commissioned works by contemporary French artists such as Jean-Baptiste Oudry (1686-1755), Nicolas Lancret (1690-1743), and Jean-Baptiste Pater (1695-1736). Louis Boullogne II (1654-1733) was employed to decorate her house and also appears to have acted as an adviser and agent, assisting her in the purchase of several pictures. Other agents included the connoisseur and man of letters, Jean-François de La Faye, who purchased a number of paintings for the countess whilst in the Low Countries on diplomatic duties.

Unusually for the period, Verrue collected large numbers of Dutch and Flemish genre and landscape pieces, together with Spanish seventeenth-century genre paintings. French seventeenth-century landscape also seems to have been a favourite, with Verrue owning seven works by Claude Lorraine and nine works by Gaspard Poussin (Dughet). Following her death in 1736, Verrue left a quantity of paintings to the Prince de Carignan as well as 46,000 livres worth of pictures to the Comte de Lassay, including Van Dyck's celebrated portrait of Charles I, *Le Roi a la chasse* (Louvre, Paris). Two sales were held at her house on the Rue du Cherche-Midi in early 1737, the first, beginning 27 March, consisted of 128 lots, whilst the second, the following month, disposed of 27 pictures. These sales were major events and many of the leading collectors of the day made expensive purchases, including Augustin Blondel de Gagny (1695-1777), Jean-Denis Lempereur II (1701-79) and Marie-Joseph d'Hosten,

Duc de Tallard (1683-1755). Sir Robert Walpole also seems likely to have been represented at the sale, Horace's annotated *Aedes* stating that the *Landscape with Nymphs at Rest* and *Landscape with Exotic Beasts*, then attributed to Paul Bril and Domenichino (cat. nos. 97, 98), were previously owned by Verrue. The paintings are first recorded as part of Sir Robert's collection in a list of paintings purchased in or just after 1736, making one of the 1737 sales the likely origin.

Manuscripts: Walpole MS 1736, nos. 442, 443.

Literature: Dictionary of Art 1996, vol. 4, pp. 166-67; vol. 19, pp. 143-44; vol. 23, pp. 513-14; vol. 30, p. 274; vol. 32, p. 368; Scott 1973, pp. 20-24.

WADE, FIELD MARSHAL GEORGE (1673-1748)

Thought to have been born in Westmeath, Ireland, Wade joined the army in 1690 as an ensign in the Earl of Bath's regiment. He rose rapidly through the ranks, fighting in Flanders and Portugal, before being awarded the brevet rank of colonel in August 1704. Returning from Spain in 1707 he was given the position of brigadier-general and made second-in-command to James Stanhope (later 1st Earl Stanhope) on the successful Minorca campaign of 1708. His promotion to major-general followed in October 1714 and the following year he took a seat in parliament for Hindon, Wiltshire. In 1724 Wade was appointed commander-in-chief in Scotland and began an ambitious project of military road and bridge construction. Wade seems to have had a keen interest in architecture and is listed as a subscriber to both Campbell's *Vitruvius Brittanicus* and Kent's *The Designs of Inigo Jones*. Following Wade's election in 1723 as MP for Bath, Lord Burlington designed his Palladian town house in Cork Street, London, considered by Horace Walpole to be 'worse contrived on the inside than is conceivable, all to humour the beauty of the front'. Horace also relates how Wade directed Lord Burlington to allow room for a large cartoon of Rubens which he had brought from Flanders but that Burlington 'found it necessary to have so many corresponding doors that there was at last no room for the picture'. This cartoon of *Meleager and Atalanta* (cat. no. 129) was bought by Sir Robert Walpole and was seen in the cabinet at Houghton in 1735 by the Rev. Jeremiah Milles, extending 'all along one side of yr room' (Milles MS 1735). A director of the Royal Academy of Music, Wade also appears to have been a collector of some note. Subsequent sales of his paintings in 1758 and 1797 included works attributed to Rembrandt, Cuyp, Claude, Poussin and Raphael. His portrait was painted by both Thomas Hudson (1701-1779) and Johan Vandiest (*fl.*1695-1757), who produced for him a series of portraits of the Mayor and Aldermen of Bath (1728, Guildhall, Bath). The final years of Wade's life were marked by military failure, both in Flanders and during the '45 when his troops were comprehensively out-manoeuvred by the Jacobite forces. Following his death, his Cork Street house was sold by auction in May 1748 and finally demolished in 1935.

Manuscripts: Milles MS 1735, ff.61-66; Christie's, 19 April 1785; Christie's, 27 March 1797.

Literature: DNB, vol. 20, pp. 413-16; Kingsbury 1995, pp. 59-71, 91-92; HWC vol. 9, pp. 56, 931; vol. 20, p. 110; Survey of London, vol. XXXII, pp. 500-5, 587.

WALDEGRAVE, JAMES, 1ST EARL (1684-1741)

Henry, Baron Waldegrave of Chewton, was dispatched by James II as envoy to the court of Louis XIV in November 1688 and was shortly followed into exile by his family. His son James was thus brought up a Catholic, receiving his education at the Jesuit college of La Flèche, in Anjou and spending from 1704 to 1706 at the Medici court in Florence. In 1714 he married a Catholic, Mary Webb, the daughter of Sir John Webb of Hatherop, Gloucestershire, and shortly after her death during childbirth in 1719 he converted to Protestantism, taking his seat in the House of Lords in 1722. In 1723 he was appointed Gentleman of the Bedchamber to George I and in 1725, through the influence of Townshend, gained the position of envoy extraordinary in Paris, conveying the King's congratulations on Louis XV's marriage. His loyalty and ability demonstrated, Waldegrave developed a close friendship with Robert Walpole and his career as a diplomat flourished. In 1727, on Horatio Walpole's recall to England following the death of George I, Waldegrave took on the role of chargé d'affaires in Paris, prior to his new post as plenipotentiary and ambassador in Vienna. In 1729 he was granted the title of Viscount Chewton and Earl Waldegrave and in April of the following year became ambassador at the French court in Paris, an office he was to hold for the next ten years. By 1729 Waldegrave's house on his estate at Navestock seems to have been completed, his family taking up residence there. Built in the Palladian style with nine bays occupying the south front and two low wings of three bays each, it was described by Horace Walpole, who visited it in 1759, as 'a dull place though it does not want prospect backward'. The interior, he regarded as 'ill-finished' but with 'an air seigneurial in the furniture; French glasses in quantities, handsome commodes, tables, screens, etc. goodish pictures in rich frames, and a great deal of noblesse à la St. Germaine'. Indeed, the picture hang seems to have reflected such tastes, with a succession of Jacobite portraits 'a little leavened with the late King, the present King, and Queen Caroline'.

Waldegrave, nevertheless, seems to have been employed by Sir Robert Walpole to acquire paintings for his collection from France and in early 1735 negotiations were carried out for a Poussin, possibly either the *Holy Family with Saints* (cat. no. 177) or *Moses Striking the Rock* (cat. no. 176). Walpole eventually offered £400, the 'highest price that was ever given for a picture of Poussin'. The *Aedes* also tells us that *Christ laid in the Sepulchre* (cat. no. 6), then believed to have been by the hand of Giacomo Bassan, which hung in Sir Robert's cabinet at Houghton, was a present from Waldegrave. This painting is recorded in a list of pictures bought in or shortly after 1736, dating the gift to around the time when Waldegrave was granted the Order of the Garter.

On Waldegrave's death, Navestock was passed on to his son James, 2nd Earl of Waldegrave (1715-63), a close friend of Horace Walpole and the husband of Maria Walpole, natural daughter of Sir Edward Walpole. A quantity of the fittings and portraits noted by Horace seem to have been subsequently sold at auction in November 1763, following the death of the 2nd Earl, the house itself being demolished in 1811.

Manuscripts: Walpole MS 1736, no. 433; L/1328; CUL Chol (Houghton) MSS 2459.

Literature: Barrell 1996, pp. 11, 12; DNB, vol. 20, pp. 473-75; Burke's Peerage 1999, p. 2912; Kenworthy-Browne, Reid 1981, p. 64; Plumb 1960, p. 221; HWC vol. 9, pp. 243-44.

WALPOLE, EDWARD (1706-84)

The second son by Sir Robert Walpole's marriage to Catherine Shorter, Edward was educated at Eton, King's College, Cambridge, and Lincoln's Inn, before being called to the bar in 1727. He embarked upon the Grand Tour in 1730, arriving in Venice in January for the carnival and moving on to Piacenza and Bologna. In July 1727 he was in Rome with Lord Boyne, but he also appears to have visited Naples, Florence and Milan. In Venice, Edward sat to Rosalba Carriera for his portrait in pastels (cat. no. 211), which by 1743 was hanging in the Drawing Room at Houghton, together with Carriera's earlier portrait of Robert Walpole, later 2nd Earl of Orford (cat. no. 210), and her pastel of Horace Walpole (cat. no. 212). Edward made further attempts to add to his father's collection, writing that he had viewed 'every statue and piece of that kind of antiquity that is worth seeing at Rome' and that he had engaged Owen MacSwinney (1674-1754), the theatre impresario, to procure a few pieces for Sir Robert's collection. Whilst documentary evidence is unavailable, it is possible that one or more of the pieces of statuary placed in the Hall and Porch at Houghton (cat. nos. 250-54, 235-36, 239-46, 254, 256-58, 260-63) could have come from this source.

On his return to England, Edward stood as MP for Lostwithiel (1730-34) and Great Yarmouth (1734-68). Possessed of the life sinecures of Master of Pleas and Escheats, Clerk of the Pells and Joint Collector in the Customs House, he was described by Horace Walpole as being of 'ample fortune and un-ambitious temper'. His energies seem to have been directed more toward the arts and he was noted by Horace as an extremely good player of the bass-viol and as the inventor of a 'most touching instrument, which, from the number of its strings, he called a pentachord'. In the late 1740s he took up painting and from the two surviving sketches of his father, Sir Robert Walpole (Lewis Walpole Library), seems to have possessed some ability in that field. Louis François Roubiliac (1702-1762) benefited from Edward's patronage, Horace stating that it was his recommendation that gained Roubiliac the commission for the Duke of Argyll's monument in Westminster Abbey. A portrait bust of Edward, considered by Esdaile to be of Roubiliac's work, is recorded in the collection of Mr F. Leverton Harris. Walpole also appears to have used his position and connections to obtain a post in the exchequer for the landscape painter William Augustus Barron (fl.1777).

From around 1740, Walpole lived in a house built by Thomas Ripley, Comptroller of the King's Works, on the South side of Pall Mall, London, the house having been assigned to his father two years earlier. *London and Its Environs Described* (1761) relates how Sir Robert Walpole had purchased the house in order to frustrate Sarah, Duchess of Marlborough, in her plans to construct a passage directly onto the Mall from Marlborough House. Edward appears to have lived in this house until c.1778 when he gave it over to his daughter Laura, widow of the Hon. Frederick Keppel. It was demolished shortly after 1830, making way for the Oxford and Cambridge University Club. Walpole appears to have lived the remaining years of his life in his house in Wimpole street, which was inherited on his death by his youngest daughter Charlotte, Lady Dysart (1738-89).

Literature: Esdaile 1928, pp. 25-26; Ingamells 1997, p. 974; Sedgwick 1970, vol. II, pp. 594-95; Survey of London, vol. XXIX, pp. 378-79; HWC vol. 2, p. 330; vol. 9, p. 14; vol. 10, p. 11; vol. 19, pp. 368-69; vol. 28, p. 196; vol. 36, p. 53; vol. 42, p. 463.

WALPOLE, HORACE, 4TH EARL OF ORFORD (1717-97)

Horace Walpole's participation in the creation and cataloguing of Sir Robert's great collection was undoubtedly a formative experience influencing his later writings on art and his own activities as a collector and as the creator of Strawberry Hill, Twickenham. It is possible that the inventory of the four hundred plus paintings which hung at his father's residences in Downing Street, Chelsea, Arlington Street and Houghton (see Appendix III) was compiled by Horace, who would then have been 19 years of age. Three years later, following his graduation from King's College, Cambridge, Horace embarked upon the Grand Tour in the company of his friend, the poet Thomas Gray. Departing from Dover in March 1739, the pair visited Paris, Rheims, Dijon, Lyon and Geneva. They visited most major Italian cities, including Genoa, Bologna, Rome and Venice, Horace staying with the British representative in Florence, Horace Mann, for over a year. He also embarked upon his own collecting, purchasing a number of busts, one of the most important being one of the Emperor Vespasian acquired from Cardinal Ottobani's collection. Alongside a number of tables and medals, Horace also appears to have purchased at least ten paintings, including works attributed to Carlo Maratti (1625-1713), Pietro da Cortona (1596-1669) and Paolo Panini (c.1691-1765). In Venice Horace sat for his portrait to Rosalba Carriera (1675-1757) (cat. no. 212), being the third of Sir Robert's sons to have been painted by this artist (cat. nos. 210, 211).

On his return to England in September 1741 Horace set about putting his newly acquired artistic education to good purpose. He asked Horace Mann to acquire for Sir Robert a Domenichino *Madonna and Child* which he had seen in the Zambeccari Palace in Bologna and a piece by Correggio located within a convent in Parma. The convent proved unwilling to sell but the Domenichino, now attributed to Giovanni Sassoferrato (cat. no. 81), was eventually purchased with the help of the painter Edward Penny (1714-91). Horace also began writing on the subject of art, concluding his *Sermon on Painting* in the summer of 1742. During this period major alterations were also being made to the hang of the Walpole collection following Sir Robert's retirement from politics and his removal from Downing Street. Horace was closely involved in the new picture hang, travelling from London in the spring of 1743 to assist his father. The *Aedes Walpolianae*, completed in 1743, informs us that Horace also provided the decorative scheme for the gallery ceiling, based upon 'a Design of Serlio's in the Inner Library of St. Mark's, at Venice'. The publication of the *Aedes* in 1747 marks a turning point in Horace's life, being the same year in which he took up the lease on Strawberry Hill, where he was to embark upon his Gothicising and establish his own collection.

Following Sir Robert's death, Horace could do little more than watch the dispersal of the Houghton collection from a distance. Sir Robert's huge debts were compounded by those of his son, Robert 2nd Earl of Orford, leaving his grandson, George 3rd Earl of Orford, 'the most ruined young man in England'. Horace lamented the sales of pictures in 1748 and 1751 (see Appendices VI and VII), noting that 'the large pictures were thrown away; the whole length Vandykes went for a song'. He acknowledged, however, the need to sell his father's collection and in 1758, during a market high, described himself as 'mad to have the Houghton pictures sold now; what an injury to the creditors to have it postponed'. Nevertheless, Horace was appalled by the sale to Catherine

the Great, which he considered to have been occasioned by 'the villainous crew about him [George, 3rd Earl of Orford], knowing they could not make away clandestinely with the collection in case of his death … [preferring] money, which they can easily appropriate'. In a last vain attempt to save the collection Horace appears to have used his cousin, Francis Conway, to appeal to the King but his letters report on 4 August 1779 the deal done: 'The sum stipulated is forty or forty five thousand pounds, I neither know or care which.'
Manuscript: Walpole MS 1736.

: Brownell 2001; DNB, vol. 20, pp. 627-30; Dictionary of Art 1996, vol. 32, pp. 824-26; Ingamells 1997, pp. 974-76; Moore ed. 1992, pp. 49-55, 56-64; Sedgwick 1970, vol. II, pp. 510-13; Sutton 1982, pp. 365-72; HWC vol. 17, pp. 167, 199, 226-27, 240-41, 267-68, 462; vol. 18, pp. 57-58, 63, 285, 308; vol. 20, p. 261; vol. 21, p. 200; vol. 24, pp. 441, 502; vol. 35, pp. 17, 18.

WALPOLE, HORATIO (1678-1757)

The fifth son of Robert Walpole (1650-1700) and younger brother of Sir Robert Walpole, Horatio was educated at Eton and King's College Cambridge, spending a brief period from 1700 studying law at Lincoln's Inn. His diplomatic career progressed rapidly, moving from the position of secretary to General James Stanhope in 1706, to chief secretary to Henry Boyle, Lord Carleton in 1707. He gained the confidence and trust of Townshend, accompanying him to the peace conferences at Gertruydenberg in 1710. Upon Robert Wapole's appointment in 1715 as 1st Lord and Chancellor of the Exchequer he was made Secretary to the Treasury. In 1723 he was sent to Paris, usurping Sir Luke Schaub's position of envoy extraordinary and minister plenipotentiary in Paris - an office he was to hold until 1730. Disparaged by Horace Walpole as 'one who knew something of everything but how to hold his tongue or how to apply his knowledge', Horatio clearly was a capable diplomat and played a key role in Sir Robert Walpole's foreign policy. He fostered a close relationship with Cardinal Fleury and helped to construct the defensive alliance between Spain, France and England at the Treaty of Seville in 1729. Made a member of the Privy Council in 1730, Walpole was once again sent abroad, acting as envoy and minister plenipotentiary at The Hague 1734-40. He stood as MP for Castle Rising, Norfolk (1702, 1710-15), Lostwithiel, Cornwall (1710), Bere Alston, Devon (1715), East Looe, Cornwall (1718), Great Yarmouth, Norfolk (1722-34) and Norwich, Norfolk (1734-56). He held the appointment of the plantation revenues (America) of the Crown for life, his London residence fronting Whitehall.

Horatio's patronage of the arts appears to have been influenced by his elder brother's tastes and in 1727, whilst Horatio was still serving in Paris, work began on his house at Wolterton, Norfolk, to designs by Thomas Ripley, the supervisor of building work at Houghton. Charles Bridgeman, who had undertaken work for Sir Robert at Houghton, was likewise employed to landscape the grounds. A number of portraits by Charles Jervas, reputedly Sir Robert's favourite portraitist, were also prominent within the picture hang at Wolterton; these included depictions of Oliver Cromwell, Lord Townshend, Louis XIV, George II and Queen Caroline. The two latter portraits had been given to Horatio by Caroline, together with six portraits of the Queen's family by Jacopo Amigoni, in recognition of his diplomatic services. A series of Gobelin tapestries showing scenes of Venus and Adonis were

likewise gifts from Cardinal Fleury. Indeed, Horatio's positions and contacts in Paris and The Hague must have provided him with the ideal opportunity to obtain art works for his elder brother and it seems highly likely that he was involved in the acquisition of two bronzes depicting the Tiber and the Nile (cat. nos. 250-51), which were first recorded in Sir Robert's collection in 1732. A portrait of Sir Robert was painted for Horatio by Steven Slaughter (1697-1765). His own likeness was painted by Jean Baptiste Van Loo (1684-1745). One year prior to his death, and immediately following his eldest son's marriage to a daughter of the Duke of Devonshire, Horatio was created Baron Walpole of Wolterton.

Manuscripts: BL Add. MSS 15,776, ff.61-66.

Literature: Bottoms 1997, pp. 47-48; DNB, vol. 20, pp. 623-27; Moore 1992, pp. 35-38, 104, 111; Moore ed. 1996, pp. 116, 164-66; Sedgwick 1970, vol. II, pp. 509-10; Walpole 1864, pp. 140-41.

WALPOLE, ROBERT , 2ND EARL OF ORFORD (1700-51)

The eldest son of Sir Robert Walpole and Catherine Shorter, Robert was educated at Eton before setting off on the Grand Tour. He is recorded as having visited Paris, Padua and Rome and by early 1723 was in Naples, sharing the company of the Hon. Edward Finch of Kirby Hall, Northants (?1697-1771). The first of Sir Robert Walpole's sons to embark on the Grand Tour, Robert purchased in Paris, for 1,000 guineas, a François Girardon bronze cast of the Laocoon (cat. no. 249). This was given to his father and placed in pride of place in the hall at Houghton. A portrait in crayons of Robert, by Rosalba Carriera (cat. no. 210), likewise remains at Houghton, hung alongside portraits of Sir Robert's other sons, Edward and Horace (cat. nos. 211, 212), who also sat to Carriera on their respective Grand Tours. On his return to England in 1723, Robert was created Baron Walpole of Walpole, marrying Margaret Rolle, heiress of Heaton, Devonshire the following year. The marriage was short-lived, Margaret setting off for Italy in 1733, where she was to remain for the rest of her life. In 1725 Robert was made a Knight of the Bath and the next year was appointed ranger of Richmond New Park, his father becoming deputy ranger.

In addition to having contributed works of art to his father's collection, Robert Walpole also appears to have played the role of custodian to a large number of the paintings acquired by his father. George Vertue, writing in around 1730, lists 'many excellent pictures. part of Sr. Roberts purchasing' housed at Lord Walpole's residence, including at least three of the Van Dyck portraits purchased from Lord Wharton in 1725 and works by Snyders and Carlo Maratti. In 1739 Robert gained the position of Auditor of the Exchequer and occupied a property in the Palace of Westminster adjoining the House of Commons on the south side and Westminster Hall on the East. It was here that Horace Walpole, writing in 1743, noted a number of Sir Robert's pictures were being stored, despite the creation of a new, purpose-built picture gallery at Houghton. A dozen works were also kept by Robert at Stanhoe Manor House, Norfolk, where he lived with his mistress, the singer Hannah Norse. On his father's death, Robert inherited Houghton Hall, the picture collection and, according to Horace Walpole, debts of over £50,000. Several attempts seem to have been made to pay off at least part of the debts and an account submitted by the auctioneer Christopher Cock details a private sale of plate and of the two massive silver sconces (cat. no. 268) as having taken place in September 1747. The account also reveals that an auction of paintings was carried out in London on 28 April 1748, making, after Cock's commission, £963.6s.6D. A further sale of pictures followed and is recorded in the Houlditch MSS, complete with the details of purchasers and prices achieved (see Appendix VI). The sheer scale of Sir Robert's collecting is apparent in that the pieces sold all came from the surplus which could not be hung at Houghton Hall. For the first sale, John Ellys was involved in the transportation of pictures from Sir Robert's house in Chelsea: he was also paid a separate cash sum of £800 by Cock. Whether this payment was intended for Walpole or whether it was a settlement for purchases made by Ellys for Sir Robert or his son is unclear. Certainly, it seems that Ellys was still buying paintings for the Walpoles in the late 1740s as a picture in the 3rd Lord Orford's 1751 sale (see Appendix VII, day 2, lot 46) is recorded by Richard Houlditch as having been bought by Ellys at the Richardson sale a few years earlier. Further efforts to lessen his debts seem to have been made by Robert, the huge 'Houghton Lantern' (cat. no. 273) was sold to Lord Chesterfield and a letter from Christopher Cock, dated 6 April 1747, urged Walpole to dispose of the house in Chelsea as the expenses it involved were akin to 'An Old Fellow keeping a Girl for Young Sinners'. Nevertheless, Robert was to die heavily in debt, leaving his son George, the 3rd Earl of Orford, in Horace Walpole's words 'the most ruined young man in England'.

Manuscripts: CUL Chol (Houghton) MSS, Correspondence of the later Orfords, 6 April 1747; Houghton Archive, Cock Account; Houlditch MSS.

Literature: Ingamells 1997, pp. 976-77; Vertue, vol. III, 1933-34, p. 44; HWC vol. 20, pp. 238-39.

WHARTON, PHILIP, DUKE OF (1698-1731)

The son of the Whig statesman, Thomas, Marquis of Wharton (1648-1714), Philip was educated at home before setting off for Geneva in early 1716. He spent time in Lyon before gaining an audience with the Pretender at his court in Avignon. On Wharton's return to England in December 1716 he hastened to align himself with the anti-Jacobite cause and moved to Ireland, taking a seat in the Irish House of Peers. He was granted a Dukedom in January 1718, in an attempt by the Whigs to secure his loyalty, and on his entry to the House of Lords, in December 1719, was painted by Charles Jervas. Wharton's powers of oratory, however, soon distinguished him in opposition to the Stanhope ministry and he quickly turned against the Walpole and Townshend faction. His bi-weekly opposition paper *The True Briton* (June 1723–February 1724), gained him some notoriety but by 1724 Wharton had dissipated his fortune and run up huge debts, a profligate, flamboyant lifestyle compounded by huge losses in the South Sea Bubble. His estates in Rathfarnham were sold in 1723, followed by those at Winchendon, bought in 1725 by the trustees of the Duke of Marlborough. The magnificent collection of Van Dyck and Lely portraits acquired by his grandfather, the staunchly Whig Philip, 4th Baron Wharton (1613-96), was also dispersed. Five full-length Lelys entered the collection of Sir William Stanhope but the majority went to Sir Robert Walpole, with 'twelve whole lengths, the two girls, six half lengths and two more by Sir Peter Lely' being recorded by Horace Walpole (cat. nos. 98, 99, 102, 104-109, 221, 222). The last remnants of Wharton's estates were confiscated in 1729, by which time he had taken up with the Pretender and fought for Philip IV in the Siege of Gibraltar. His final years were spent destitute, travelling Europe, and he died in a monastery in Catalonia in May 1731.

Manuscripts: Houlditch MSS.

Literature: DNB, vol. 20, pp. 1321-24; Millar 1994, pp. 517-30; Vertue, vol. III, 1933-34, p. 11; Walpole 1888; HWC vol. 30, p. 371; vol. 42, p. 126.

ZAMBECCARI, FRANCESCO MARIA FILIPPO, CONTE (c.1685-1749)

One of the most detailed sources of information regarding the collection of Francesco Maria Filippo, Conte Zambeccari, which was housed in the Zambeccari Palace in Bologna, comes from a description of a visit made by Charles De Brosses (1709-77) in 1739. This document reveals the collection to have been one of considerable merit which included, amongst the fifty works mentioned by Brosses, seven works attributed to Ludovico Carraci, a *San Francesco* attributed to Domenichino, a *Venere e Adone* attributed to Rubens and works thought to have been by Guido Reni, Paolo Veronese, Salvator Rosa and Bourgognone. Also recorded by Brosses in the Zambeccari Palace was '*Una Vergine col Bambino*, del Domenichino, quandro di grande pregio e di stile limpido'. This was presumably the 'Virgin and Child' (cat. no. 81) seen by Horace in December of the same year when he and Thomas Gray visited the city. Walpole appears to have been informed that the Zambeccari collection was to be put up for sale but on asking could not ascertain a price for the Domenichino. Nevertheless, on his return to England Horace set about pursuing the work for his father's collection and in October 1741 engaged Horace Mann, the British representative in Florence, to negotiate with Conte Zambeccari. Mann, in turn, employed the painter Edward Penny (1714-91) to make private enquiries and, according to Mann, 'after a thousand difficulties the canonico who is the master of it told him he would give it for 300 doppie'. Penny also, however, obtained the opinions of the connoisseurs Donato Creti and Ercole Leli, who pronounced the piece an excellent work but undoubtedly a copy after Domenichino. Now recognised as by Sassoferrato, Horace Walpole held confidence in the attribution to Domenichino, cataloguing it under that artist's name in the *Aedes*, reasoning that as 'it came out of the Zambeccari collection; an hundred English have seen it under the denomination of a Dominichin'. The provenance of the painting prior to Francesco Maria's ownership is unclear: the Zambeccari were a family of collectors and Francesco is known to have inherited a number of pictures from Giuseppe Luigi Zambeccari (d. c.1699). The Zambeccari collection appears to have continued to grow following Francesco's death and by the time of an inventory of 1795, contained 490 paintings – a quantity of which passed into the Pinacoteca Nazionale, Bologna, in the nineteenth century.

Literature: D'Amico 1979, pp. 193-208; Emiliani 1973, pp. 23-31; Moore ed. 1992, p. 51; HWC vol. 17, pp. 167, 199, 226-27, 240, 241, 256-57, 167-68, 442, 462; vol. 18, pp.57-58, 67, 285; vol. 25, p. 12; vol. 35, pp. 17-18.

APPENDIX II

Sir Robert Walpole: A Chronology of his Life

1676 26 August, born Houghton, Norfolk, the son of Robert Walpole (1650-1700), an influential Whig leader in Norfolk, and Mary Burwell (d. 1711)

1690 4 September, admitted to Eton College

1695 22 April, admitted to King's College, Cambridge

1698 25 May, resigns his scholarship, and leaves Cambridge, having become heir to the Houghton Estate on his brother's death

1700 30 July, marries, at Knightsbridge Chapel, Catherine Shorter, daughter of John Shorter of Bybrook, Kent
18 November, succeeds to his father's estates (nine manors in Norfolk and one in Suffolk), with a rent roll of £2,169 a year

1701 11 January, returned as MP for the borough of Castle Rising, a seat he later (July 1702) transfers to his uncle Horatio; first serves on a committee for privileges and elections

1702 23 July, returned as MP for the borough of King's Lynn, for which he sat during the rest of his career in Parliament

1705 28 June, appointed to the council to Prince George of Denmark, Lord High Admiral of England, husband of Queen Anne

1708 25 February, appointed by the Duke of Marlborough as Secretary at War

1710 21 January, appointed Treasurer of the Navy
7 October, general election; returned for King's Lynn, although the Whigs were defeated

1711 becomes Leader of the Opposition in the House of Commons; accused with Godolphin (leader of the Whigs in the House of Lords), of raising an unaccounted-for deficit in public funds; Walpole produces two pamphlets, *The Debts of the Nation Stated and Considered* and *The Thirty Five Millions Accounted For.*

1712 January, accused of corruption over the issue of two forage contracts, and expelled from the House of Commons (by 22 votes) committed to the Tower of London until 8 July; regarded by some as a political martyr

1714 1 October, sworn a privy councillor

1715 17 March, leader of the House of Commons in the new Parliament, although his brother-in-law Lord Townshend nominally head of government
11 October, appointed First Lord of the Treasury and Chancellor of the Exchequer

1717 10 April, resigns as Chancellor of the Exchequer; on the same day introduces a bill to establish the first Sinking Fund to reduce the national debt

1720 The South Sea Company offers to assist the Government in managing the national debt; despite opposing the scheme Walpole buys considerable South Sea Stock, sells out before the market peaks and then buys shares, losing heavily

1721 8 April, appointed Chancellor of the Exchequer and First Lord of the Treasury

1722 May, learns of the Atterbury Plot and also of a plot to assassinate Walpole himself

1723 10 May, introduces an Act for raising taxes on the estates of Roman Catholics and also non-jurors, (probably his least judicious act)
10 June, the King creates Walpole's eldest son, Robert, a peer: Lord Walpole of Walpole

1725 Walpole invested with the newly reinstated Order of the Bath

1726 Walpole resigns the Order of the Bath in order to receive (on 26 June) the Order of the Garter, for which he gained the nickname 'Sir Bluestring'
A rift grows between Walpole and Townshend over foreign affairs
December, the first edition of *The Craftsman,* an opposition journal

1727 12 June, death of George I
24 June, Walpole reappointed First Lord of the Treasury and Chancellor of the Exchequer by the new King, George II

1729 9 November, the Treaty of Seville deprives the Jacobites of hope of foreign aid from Spain

1730 15 May, Townshend resigns, Walpole's hold on foreign affairs strengthened
7 November, *The Craftsman* claims that the housekeeping bills at Houghton amount to £1,500 per week

1732 reimposes the Salt Tax, which he had repealed in 1730

1733 attempts unsuccessfully to introduce full tax on wine and tobacco imports; dubbed by the opposition, the Excise Bill

1733-35 Pursues a non-interventionist foreign policy to great effect

1737 20 November, Queen Caroline dies, and Walpole's influence with the King wanes
20 August, Walpole's first wife Catherine dies at Chelsea; buried in King Henry VII's chapel, Westminster Abbey

1738 early March, privately marries Maria Skerrett; she dies of a miscarriage, 4 June
Walpole, suffering from gout and stones, gradually loses his hold on Parliament

1742 3 February, Walpole announces his retirement
9 February, created Earl of Orford
11 February, resigns, receiving a promise of a £4,000 annual pension

1745 18 March, dies of exhaustion from the pain of his disease, aged 68
25 March, buried at Houghton

Sir Robert Walpole's Collection of Pictures 1736

This anonymous manuscript consists of 18 folios bound into Horace Walpole's personal copy of the *Aedes Walpolianae...*, 2nd edn. of 1752, now in the Pierpont Morgan Library, New York: PML 7586; referred to in the text as Walpole MS 1736. It is possible that Horace Walpole himself was the author of this inventory.

A CATALOGUE OF SIR ROB.ᵗ WALPOLE'S PICTURES AT HOUGHTON IN NORFOLK.

IN THE SALOON

1 *Over the Chimney; Christ baptiz'd by John: the figures are as big as life. An Angel holds up Christ's Garments*. Albano. 8-7½ x 6-4¼

2 *The Stoning of S.ᵗ Stephen. There are nineteen figures*. La Soeur. 9-9 x 11-4

3 *The Assumption of the Virgin Mary. She is ascending in the Clouds, supported by Angels*. Morellio. 6-5 x 4-9½

4 *The Adoration of the Sheperds. All the Light in y.ᵉ Picture comes from the Child*. Morellio. ditto

5 *The Cyclop's forge. There is the Copy of this at St James's*. Luca Jordano. 6-4 x 4-11

6 *Daedalus tying on Icarus's Wings*. Le Brun. 6-4 x 4-3

7, 8, 9, 10. *Four Markets of Fowls, Fish, Herbs & Fruit by Snyders, the figures* Rubens. 13-10 x 11-2

IN THE GREEN VELVET DRAWING ROOM

11. *Over the Chimney; the Wise Men offering*. Carlo Maratti. 6-11 x 4-4

12. *The Judgement of Paris; He is giving the Apple to Venus: Juno turns angry away; Minerva is dressing; drawn at the age of eighty two years*. Carlo Maratti. 5-9½ x 7-7

13. *Galatea sitting on the Sea, with Acis, Tritons, & Cupids*. Carlo Maratti. 5-9 x 7-8

14. *The Virgin, Child (whole figure) & St John*. Carlo Maratti. 3-3 x 2-8½

15. *The Assumption of the Virgin; she has a blue Veil on Her Head, her arms cross on Her breast*. Carlo Maratti. 2-2 x 1-8½

16. *The Virgin teaching Jesus to read, with Angels*. Carlo Maratti. 2-3¼ x 1-10½

17. *St Cecilia with a book; Angels with Musical Instruments*. Carlo Maratti. 2-3 x 1-10

18. *The Virgin, & Joseph with a young Jesus*. Carlo Maratti. 2-5 x 2-0

19. *The Marriage of Christ & St Catherine; He sits on the Virgin's lap, & puts the Ring on St Cath.ˢ finger. She is kneeling*. Carlo Maratti. 2-7 x 1-10½

20. *Two Saints Worshipping the Virgin in the Clouds*. Carlo Maratti. 2-3½ x 1-9½

21. *St John the Evangelist*. Carlo Maratti. 2-3½ x 1-9½

22. *A Naked Venus; Cupid pulling a thorn out of her foot*. Carlo Maratti. 3-2 x 4-4½

23. *The Adoration of the Sheperds; octagon*. Guido Reni. 3-3 x 3-3

24. *The Profile Head of a Woman*. Guido Reni. 1-9½ x 1-6

25. *Christ in the Garden with Mary Magdalen*. Pietro Cortona. 1-10 x 1-8

26. *The flight into Egypt*. Morellio. 3-2 x 1-11

27. *Our Saviour on the Cross*. Morellio. 3-2½ x 1-11

28. *The Assumption of the Virgin; Her arms supported by Angels*. Nicola Beretoni. 2-4 x 1-10½

29. *The Virgin, Child, Elizabeth, & St John; Joseph at a Distance; Angels with the Ass*. Nicola Beretoni. 3-1½ x 4-4

30. *Samuel presented to Eli; on the Steps of the Temple*. Luca Jordano. 2-1 x 1-1½

31. *The Nativity*. Luca Jordano. 2-1½ x 1-0

32. *Our Saviour preaching on the Mountain*. Joseppi Chiari. 3-4 - 4x6

33. *The Sick Man at the Pool of Bethesda*. Joseppi Chiari. 3x3 x 4-5½

34. *Apollo and Daphne*. Joseppi Chiari. 3-3 x 4-9

35. *Bacchus and Ariadne*. Joseppi Chiari. 3-3 x 4-10

36. *A Flower Peice, with a Bird's nest*. Jac:Van Huysum. 2-7 x 2-0

37. *A Fruit Peice*. Jac:Van Huysum. 2-7 x 2x-0

IN THE GREEN VELVET-BEDCHAMBER.

38. *Alexander adorning the Tomb of Achilles*. Nicola Poussin. 8-2 x 5-2

39. 40. *A Sea Port & a Landscape, over the Doors*. Griffier. 3-4 x 4-1

41. IN THE DRAWING ROOM WITH THE VANDYKE HANGINGS.

42. *The finding the books of the Sibylls*. Nicola Poussin. 8-2½ x 5-4

43, 44. *Two Peices of Dogs, over the Doors*. Jervase. 3-2½ x 4-1

IN THE WORK'D-BED CHAMBER.

45. *The Holy Family as large as life*. Nicola Poussin. 5-7 x 4-3½

46, 47. *Cattle, over the Doors*. Rosa da Tivoli. 3-1½ x 4-5

IN THE CORNER DRAWING ROOM

48. *Over the Chimney, Rubens's Wife in black Satten, whole length*. Vandyke. 6-2 x 4-10.

49. *Meleager & Atalanta, larger than life, hunting the Boar; His two Uncles, A Huntsman & Dogs; Cartoon*. Rubens. 10-7 x 20-11

50. *Earl of Danby, whole length; the only one in Garter Robes of*. Vandyke. 7-4 x 4-3

51. *Sir Thomas Wharton, whole Length*. Vandyke. 7-1½ x 4-2½

52. *Arch-Bishop Laud*. Vandyke. 4-0 x 3-1½

53. *Lᵈ Cheif Baron Wandesford; Head of the Castlecomer Family*. Vandyke. 4-4½ x 3-5

54. *Philip Lord Wharton; the three last are half lengths*. Vandyke

IN THE MARBLE PARLOUR

55. *The Fine Picture of the Doctors of the Church, consulting about the Immaculate Conception of the Virgin, who is in the Clouds. This Picture was bought at Rome, & sent to Civita Vecchia to be shipp'd for England, but was stopp'd & carry'd back; but at last releas'd, by Innocent 13ᵗʰ*. Guido Reni. 8-11 x 6-0

56. *The Prodigal son kneeling with the Swine*. Salvator Rosa. 8-3½ x 6-5½

57. *Two Women, a Cupid, & a Soldier; over the Door into the Hall*. Paris Burdon. 3-6 x 4-2

58. *A Sheperd, Sheperdess, two Boys & a Sheep; over a Door*. Carlo Chiniani. 3-4 x 4-1½

59, 60. *An Holy Family, & an Adoration of the Sheperds, over the other Doors*. Palma Vecchio. 2-7½ x 4-5

IN THE COMMON PARLOUR

61. *Gibbins the Carver, over the Chimney*. Sir Godfrey Kneller. 4-1 x 3-2

62. *The Nativity; the Light comes from the Child*. Carlo Chiniani. 3-7½ x 2-10½

63. *The Eagle & Ganymede; the King has one of the same*. Mich. Angelo Buonarotti. 2-11 x 1-11

64. *A Studd of Horses*. Woverman. 2-2 x 2-9

65. *Cows & Sheep*. Teniers. 1-11 x 2-9

66. *A Landscape with figures dancing*. Swanivelt. 2-3 x 3-3

67. *A Peice of Building*. Stenwick. 1-9 x 2-8

68. *A Boar Hunting*. Hondius. 7-10 x 9-10

69. *A Stag Hunting*. Hondius. 7-10 x 9-10

70. *A Daughter of Lᵈ Wenman, with a Tulip*. Vandyke. 4-4 x 3-5

71. *Lady Wharton in white Satten*. Vandyke. 4-4 x 3-5

72. *A Daughter of Sr Harry Lee, with dark Brown Hair*. Sir Peter Lely. 4-1 x 3-3

73. *Mrs Jenny Deering, with fair Hair*. Sir Peter Lely. 4-1 x 3-3

IN THE LIBRARY

74. *King George the first, whole length, in his Coronation robes*. Sr Godfrey Kneller. 6-8 x 4-2

IN THE LITTLE BEDCHAMBER

75. *Sir Robert Walpole's Lady, half length*. Dahl. 3-2 x 2-8

76. *Sr Will. Chaloner, Preceptor to Charles the first's Children*. Vandyke. 3-5 x 2-8

IN THE LITTLE DRESSING ROOM

77. *Christ, the Virgin, & St Catherine*. Vandyke. 3-9 x 3-9

IN THE BLUE DAMASK BEDCHAMBER

78. *Sir Robert Walpole, whole length, in the Garter Robes*. Richardson. 7-6 x 4-7

79, 80, 81. *Three Landscapes over the Doors*. Wootton. 2-5 x 4-5

IN THE YELLOW DRAWING ROOM

82. *Two Daughters of Ld Wharton, whole lengths, over the Chimney*. Vandyke. 5-4 x 4-3

83. *The Judgment of Paris; Mercury is behind; Venus has the evening Star over her head; Juno sits; Pallas undressing with her back to the Spectators, & Cupid shooting at Paris, who is viewing the Goddesses.* Luca Jordano. 8-0 x 10-9

84. *A Sleeping Bacchus, with Nymphs, Boys, ?tygers & Cattle*. Luca Jordano. 8-0 x 10-9

85. *Abraham bringing back Hagar to Sarah; an Angel pushing Hagar forward*. Pietro Cortona. 6-10 x 6-1

86. *An Holy Family*. Titian. 3-1 x 2-8

87. *The Israelites bringing Presents to Moses for the Tabernacle*. Guido Reni. 3-1 x 2-5

88. *Bathsheba bringing Abishag to David, painted in Varnish*. Vanderwerffe. 2-10 x 2-3

89, 90, 91. *Three Landscapes over the Doors*. Wootton. 4-1 x 4-9

IN THE RUSTICK STORY AT HOUGHTON
IN THE LITTLE BREAKFAST ROOM

92. *Dogs, over the Chimney*. Wootton S.r. 4-11 x 4-2

93. *King William 3d on Horseback; the Design for the Large one at Hampton Court*. S.r Godfrey Kneller. 4-3 x 3-6

94. *Moses found in the Bullrushes, by Pharaoh's Daughter*. Romanelli. 2-9 x 5-0

95. *Nymphs & Swains*. Romanelli. 2-9 x 5-0

96. *Sir Edward Walpole Knight of the Bath, Grandfather to Sr Robert*. . 2-5 x 2-0

97. *Erasmus*. Holbein. 2-6 x 2-1

98. *Apollo*. Cantarini. 2-7 x 2-0

99. *A Man's Head*. . 2-7 x 2-0

100. *Sr Robert Walpole's Father*. . 2-5 x 2-0

101. *Horatio, Ld Townshend in armour; Father to Charles Ld Townshend*. . 2-5 x 2-1

102. *King George the first on Horseback*. S.r Godfrey Kneller. 4-5 x 3-6

IN THE SUPPING PARLOUR

103. *The Battle of Constantine & Maxentius*. Julio Romano. 4-8 x 9-8

104. *Mr Horatio Walpole, brother to Sr Robt, over the Chimney*. Richardson. 4-2 x 3-5

105. *Sr Robert Walpole*. Jervase. 4-2 x 3-4

106. *His Lady*. Jervase. 4-2 x 3-4

107. *Sr Charles Turner, Brother in Law to Sr Robert*. Richardson. 4-2 x 3-5

108. *Charles, Ld Viscount Townshend*. Sr God. Kneller. 4-2 x 3-5

109. *Dorothy Lady Townshend, Sister to Sr Robert*. Jervase. 4-2 x 3-4

110, 111, 112, 113. *Four Aunts of Sr Robert's, Heads*. 2-6 x 2-0

IN THE HUNTING HALL

114. *Susanna & the Two Elders*. Rubens. 6-0 x 7-3

115. *A Hunting Peice, Sr Rob.t in Green, Col.l Churchill in the middle*. Wootton. 6-10 x 8-5

IN THE COFFEE ROOM

116. *Jupiter & Europa*. Pietro di Peters. 4-10 x 6-2

117. *Galatea*. Zimeni. 4-10 x 6-2

118. *Coll. Walpole, Uncle to Sr Rob.t, in a black Wig*. Richardson. 4-2 x 3-4

119. *Mr Galfridus Walpole, Youngest Brother to Sr Rob.t*. Richardson. 4-2 x 3-4

All the Pictures over the Chimneys & Doors in the Attic Story are drawn by a Brother of Van Huysum's, who lived in Sr Robert's House

A CATALOGUE OF SIR ROBERT WALPOLE'S PICTURES IN DOWNING STREET, WEST-MINSTER

IN THE PARLOUR

121. *A Young Christ, with God the Father, the Virgin, & Angels*. Solimeni. 7feet 1inch x5F 5½ In.

122. *Christ after his Resurrection, with the Virgin &c*. Solimeni. 7-1½ x 5-5¼

123. *A Cook's Shop with several figures; Teniers himself like a Falconer*. Teniers. 5-7¼ x 7-8½

124. *A Cook as large as life with a Greyhound, Cats, & Dead Fowl &c*. Martin de Vos. 5-7½ x 7-10½

125. *The Doge of Venice in His Barge, with Gondola's & Masqueraders*. Canaletti. 2-9½ x 4-5¾

126. *A View of Venice*. Canaletti. 2-9½ x 4-5¾

127, 128. *Two Pictures of Boys with Fruit*. . 2-4 x 3-2

129. *The Exposition of Cyrus*. Castiglioni. 2-8¾ x 3-2¼

130. *Its Companion. A Man with Cattle*. Castiglioni. 2-8¾ x 3-2¼

131. *A Landscape*. Swanivelt

IN THE GREAT MIDDLE ROOM BELOW

132. *A Lioness & two Lions*. Rubens. 5-5¾ x 8-0¼

133. *The Virgin, Child, & Joseph, with a Dance of Angels*. Vandyke. 7-1 x 9-5

134. *Christ at the House of Simon the Pharisee; Mary Magdalen is anointing his feet; several figures as large as life*. Rubens. 6-1 x 8-2

135. *The Child lying along, with the Virgin's & two more Heads*. Camillo Procacino. 1-9 x 2-3¾

136. *The Holy Family in a round; the Child stands in the Virgin's lap, learning to read*. Cantarini. 3-6½ x 3-6½

137. *Apollo, half length in Crayons*. Rosalba. 2 2 x 1-8

138. *Diana with a Greyhound, Ditto*. Rosalba. 2-2 x 1-8

139. *A Landscape*. Gaspar Poussin. 1-1¾ x 1-6

140. *Its Companion*. Gaspar Poussin. 1-1¾ x 1-6

141, 142. *Two Landscapes with several little figures*. Borgognone. 1-1¼ x 1-4¾

143, 144. *Two Landscapes, over two of the Doors*. Wootton. 3-5 x 4-3¼

145, 146. *Two Sea Peices, over the other Doors*. Scott. 3-5¾ x 4-1

IN THE END ROOM BELOW

147. *A Dead Christ, with the Virgin, St John, St Joseph, Mary Magdalen, & an Angel; the Figures are rather smaller than life: over the Chimney*. Annibal Caracci. 6-2¾ x 5-0½

148. *The Virgin & Child asleep in her Arms*. Ludovico Caracci. 3-6¼ x 2-9¾

149. *Simeon & the Child*. Guido Reni. 3-2½ x 2-8

150. *A Smith's Wife of Antwerp, Mistress to Francis the first of France; reckon'd the handsomest Woman of her time, half length naked*. Leonardo di Vinci. 2-9 x 2-1½

151. *An Usurer & his Wife: highly finish'd; This Picture is very near the same with one in the Gallery at Windsor.* Quintin Matzi. 2-8½ x 1-11¾

152. *Moses striking the Rock; several figures.* Nicolas Poussin. 3-11¾ x 6-3¼

153. *A Landscape.* Gaspar Poussin. 3-3½ x 4-5¼

154. *It's Companion.* Gaspar Poussin. 3-3¼ x 4-1¼

155. *A Winter Peice.* Giacomo Bassan. 3-8½ x 5-11¾

156. *A Summer Peice.* Leonardo Bassan. 3-8½ x 5-11¾

157. *A Battle.* Borgognone. 2-3½ x 6-0.

158. *A Large Picture of Architecture, with some small figures.* Julio Romano. 5-6¾ x 6-11

159. *A Picture of Ruins.* Viviano. 2-5½ x 3-2

160. *Its Companion.* Viviano. 2-6 x 3-3½

161. *Divine Love burning the Arrows of Impure Love.* Of the School of Caracci. 2-4¾ x 3-2½

IN SIR ROBERT'S DRESSING ROOM

162. *The Fable of the Old Man, & his Sons trying to break the Bundle of Sticks.* Salvator Rosa. 6-0 x 4-2¼

163. *An Holy Family, on board.* Andrea del Sarto. 4-7¼ x 3-4½

164. *The Rich Man & Lazarus.* Paul Veronese. 2-7½ x 3-5

165. *A Sea Peice, with the Sun playing on the Water.* Claud Lorrain. 3-1¼ x 4-2½

166. *A Calm Sea with Ruins; Apollo & the Sibyll on the Strand .* Claud Lorrain. 3-3 x 4-1

167. *Scipio's Abstinence. He is sitting crown'd by Chastity; Indibilis is bowing; His Mistress is in blue; Roman Soldiers, &c..* Nicolas Poussin. 3-8¾ x 5-2

168. *The Education of Jupiter.* Nicolas Poussin. 3-9¼ x 4-11¾

169. *A Bacchanal.* Rubens. 2-11¾ x 3-6

170. *Cyrus found, suckled by a Wolf.* Castiglioni. 2-4½ x 3-6¼

171. *It's Companion. The Subject is taken from the 19.th Ode of the Second Book of Horace:. Bacchum in remotis carmina rupibus. Vidi decentem; credite Posteri;. Nymphasa discentes, & aures. Capripedum Satyranum acuta*s. Castiglioni. 2-4¼ x 3-6¾

172. *An Old Man's head.* Dobson. 1-5½ x 1-2½

173. *Innocent the Tenth.* Velasco. 1-6¾ x 1-3¼

174. *Diana & Endymion. [Luca Jordano crossed out] [Solimeni – added in 4th coloumn].* 1-7¼ x 2-0¼

175. *The Salutation of the Virgin Mary; God & Angels above.* Albano. 2-0¼ x 1-6½

176. *An Holy Family.* Williberts. 1-1½ x 0-9¼

177. *Venus, Cupid, & a Satyr piping.* Albano. 0-7¾ x 0-11¾

178. *The Virgin reading with the Child.* Baroccio. 1-4¼ x 1-0¼

179. *A Naked Venus sleeping.* Corregio. 0-9¼ x 1-1½

180 . *[** here is lately bought a Dead Christ with the Virgin & several other figures; an exceeding fine but small picture, by Parmigiano]*

IN THE GREAT ROOM ABOVE STAIRS **

181. *A Family Peice, & Merry making.* Jordan of Antwerp. 5-9 x 4-5½

182. *Lucius Curtius, jumping into the Gulph; with many figures.* Mola. 6-3¾ x 11-4

183. *Horatius Cocles defending the Bridge against Porsena.* Mola. 6-4 x 11-4

184. *An Old Woman reading; the top of the Picture is arch'd.* Boll. 4-2½ x 3-3½

185. *An Old Man writing; Ditto.* Gerard Dow. 4-2½ x 3-3½

186. *King James the First, ascending into Heaven: the Sketch for the Cieling of the Banquetting House at Whitehall.* Rubens. 2-11 x 1-9½

187. *The Virgin, Child, St John, St Catherine, Two Fryors & Angels.* Raphael Reggio. 1-1¼ x 2-2¾

188,189. *Two Peices of Fruit, over two of the Doors.* Mich. Angelo Campidoglio. 3-0¼ x 4-2½

190, 191. *Two, Ditto*

IN LADY WALPOLE'S DRAWING ROOM

192. *Dido & Aneas in the Storm.* Diepenback. 4-3½ x 5-5

193. *A Head of L.d Walpole in Crayons.* Rosalba. 1-9 x 1-5

194. *Mr Edward Walpole, ditto.* Rosalba. 1-10¼ x 1-5

195. *Mr Horace Walpole, ditto.* Knapton. 1-10 x 1-5

196. *Lady Malpas, ditto.* Jervase. 1-10 x 1-5

197. *Fryars giving Broth to the Poor.* John Miele. 1-7½ x 2-1¾

198. *Its Companion.* Ditto. 1-7½ x 2-2

199. *A Dream of Watteau's. Himself asleep by a Rock; Several Dancers & Grotesque figures in the clouds. .* Watteau. 2-1 x 2-7¼

200. *Solomon's Idolatry; painted on black & Gold Marble, which is left for the Ground in several places.* Stella. 1-10½ x 2-5¼

201. *Christ at Emaus with his two Disciples.* Giovachino Axaretta. 3-11½ x 4-9

202. *Hercules & Omphale.* Romanelli. 3-1¾ x 4-3

203. *An Old Man Dying.* Velasco. 3-2¾ x 4-9¾

204. *A Landscape by Moonlight with a Cart Overturning.* Rubens. 2-10 x 4-1

205. *An Old Man's Head.* Rembrant. 1-11¼ x 1-6¾

206. *A Fryar's Head.* 1-8 x 1-5

207, 208. *Two Battle Peices.* Borgognone. 1-6½ x 2-1¾209. *Boors at Cards.* Teniers. 1-4 x 1-10

210. *Boors drinking.* Ostade. 1-3½ x 1-9½

211. *A Small one of Boors at cards.* Teniers.

212. *One Ditto, drinking.*

213. *The Virgin & Child on Marble.* Alexander Veronese

214. *The Holy Family.* Rottenhamer

215. *Two Soldiers with a Captive.* Salvator Rosa

216. *The Virgin with the Child asleep in her arms.* Sebastian Concha

NB These Six last are very small

217. *Sir Harry Vane, the younger.* Sr Peter Lely. 2-5¼ x 2-0½

218. *A Woman's Head.* Rubens. 2-1 x 1-8½

219. *Fuller the Painter in a Storm.* Fuller. 2-8½ x 2-4½

IN THE BEDCHAMBER

220. *Sr Robert Walpole, in an hunting Dress.* Richardson. 5-0 x 4-9¾

221. *A Cat & Fowls.* Du Porte. 3-2½ x 3-10½

222. *A Dog & Fowls.* Cradock. 3-2½ x 3-10½

223. *A Picture of Birds.* Bugdan. 3-2½ x 3-10¼

IN THE CLOSET

224. *Mr Horace Walpole.* Richardson. 4-0¾ x 3-3

225. *A Hawk & Fowls.* Feti. 3-4¼ x 4-2

226. *The Parting of Hector & Andromache, Drawn with a Pen.* Michael de Serre. 1-7 x 2-4

227. *Samson & the Lion.* Sebastian Burdon. 1-8½ x 2-1½

228. *The Judgement of Solomon.* Solimeni. 1-8¼ x 2-1¼

229. *A Landscape with figures.* Teniers. 1-11¾ x 2-4¾

230. *The Holy Family, with little Angels.* Artois. 1-5¾ x 2-3

231. *A Landscape.* Gobbo Caracci. 1-6 x 2-3

232. *The Last Supper.* Raphael. 1-8 x 2-8¾

233, 234. *Two battle peices. .* 1-3¾ x 2-4¾

235, 236. *Two Dutch Entertainments.* Palamedes. 1-3¾ x 1-7¼

237. *A Battle on a Bridge*

238. *Three Men, two Sitting*

239. *Two Dogs, over the Door.* Wootton

N.B. *All these that follow are very small*

240. *A Man with a Book.* Quintin Matzi

241. *A Woman in Crayons.* Rosalba

242. *A Girl & Cat.* Ditto

243. *Christ healing the Blind, on copper.* Roland Savery

244. *The Good Samaritan, its companion.* Ditto

245, 246. *Polenburgh & his Wife, Ovals.* Corn. Polenburgh

247, 248. *Two Landscapes with figures.* Ditto

249. *Boys – a peice for a ceiling.* Philippo Laura

250. *Boors reading.* Brower

251, 252. *Two long dark landscapes, with Cattle.*

253. *Apollo, Pan & Marsyas.* Andrea Schiavoni

254. *The Judgment of Paris.* Ditto

255, 256. *Two round Landscapes.* Francisco Melli

257. *Pan & Syrinx.* Philippo Laura

258. *Jupiter, Io & Juno.* Ditto

259. *A Landscape with a great many small figures.* Breughel

260. *A Farm Yard.* Teniers

261. *Christ in the Garden with Mary Magdalen.* Philippo Laura

262. *The Virgin & Child, Heads as big as life.* Titian

263. *The Ascension.* Teniers after P. Veronese

264. *The Holy Family*

265. *A Woman's Head.* Titian

266. *A Man's Ditto.* Ditto

267. *The Blind leading the Blind into a Ditch.* Breughell

268. *A Country Surgeon dressing a Peasant's leg.*

269. *A Dead Christ.* Michael Roche

270. *A Madonna with Angels, it's companion.* Ditto

271. *A Peice of Rocks*

272. *Thomas putting his finger into Christ's Side*
273. *A Man & Woman, half lengths*
274 – 286. *Twelve Water Colour Landscapes.* Ritzi
287. *S^r Godfrey Kneller when young – very small.* S^r Godf
Keller

A CATALOGUE OF S.^r ROBERT WALPOLE'S PICTURES IN GROSVENOR STREET

IN THE PARLOUR

288. *A Battle Peice, over the Chimney.* Borgognone. 3-1 x 4-7½
289. *A Dutch Entertainment.* 1-9¾ x 2-3¼
290. *The Israelites with the Golden Calf.* Old Franc. 1-10 x 2-9½
291. *The Inside of a Church.* De Neffe. 1-10 x 2-8
292. *The Woman caught in Adultery, with large Buildings.* Ghisolfi. 1-10½ x 2-4
293. *The Ascenscion from the Disciples.* Paul Veronese. 3-3¼ x 4-5½
294. *The Angels declaring the Ascension.* Ditto. 3-0¾ x 4-5¼
295. *Extreme Unction.* 1-1½ x 1-5½
296. *Jupiter & Europa.* Teniers after Paul Veronese. 1-1½ x 1-8
297. *Charity & her children.* Francheschini of Bologna. 1-4½ x 1-10
298. *It's Companion.* Ditto. 1-4½ x 1-10¼
299. *Beggar Boys.* Pasquilini. 1-1½ x 1-9
300. *Men on Horseback.* Woverman. 1-5 x 1-9½
301. *A Landscape.* Nicolas Poussin. 2-5¼ x 3-3½
302. *It's Companion.* Ditto. 2-6½ x 3-2¾
303. *Pan & Syrinx.* Rubens. 1-9½ x 2-4
304. *Boors.* 1-8¼ x 1-3½
305. *The Nativity.* Young Palma. 1 -
306. *A Man's Head.* Raphael. 1-8 x 1-5
307. *A Landscape with figures.* . 1-6½ x 2-3¾
308. *A Virgin & Child.* Titian. 1-8 x 1-3
309. *Diana & Her Nymphs hunting a Stag. N.B. Mr Young has made a print from this Picture.* Rubens. 3-9 x 7-2
310. *A Sea Fight.* Vandervelde. 3-2¼ x 4-9½
311, 312. *Two Landscapes, over the Doors.* Orizonti. 1-5½ x 4-4½

IN THE BACK PARLOUR

313. *Jacob & Laban, over the chimney.* Sebastian Bourdon. 3-1¾ x 4-4¼
314. *Diana with her foot hurt.* Luca Jordano. 4-5 x 5-10
315. *The Murder of the Innocents.* Sebastian Bourdon. 4-1 x 5-8¼
316. *A Landscape.* Claud Lorrain. 3-1½ x 4-9¼
317. *A Landscape with an Hurricane.* Gaspar Poussin. 3-1 x 4-3¾
318. *Two Landscapes.* Bergham & Bote. 3-8¼ x 4-4½

IN L.^D WALPOLE'S DRESSING ROOM

319. *A landscape with figures, over the Chimney.* Sebastian Burdon. 3-1¼ x 3-10¾
320. *A Fox Hunting.* Hondius. 5-6¼ x 7-9½
322. *Snake, a Horse of S^r Robert Walpole's with a Groom.* Wootton. 8-1¼ x 11-8
323. *A Hunting Peice.* Ditto. 3-6 x 4-10¼
324. *The Finding of Romulus & Remus.* from Carlo Maratti. 3-0 x 4-5

325, 326. *Two Pictures of Dogs & Birds, over the Doors.* . 2-0½ x 2-5¾

IN THE GREAT ROOM ABOVE

327. *Snyders, His Wife & Child, over the Chimney.* Long John. 5-2 x 4-0½
328. *King Charles the first in Armour, whole length.* Vandyke. 7-1 x 4-2
329. *His Queen.* Ditto. 7-1 x 4-2
330. *Philip Lord Wharton.* Ditto. 7-1 x 4-2
331. *His Lady, Daughter of Arthur Goodwin.* Ditto. 7-0¾ x 4-2
332. *Margaret, Wife of Thomas Carye.* Ditto. 7-0¾ x 4-2
333. *Countess of Chesterfeild.* Ditto. 7-0¾ x 4-2
334. *Lady Rich, Daughter of the Earl of Devonshire.* Ditto. 7-0¾ x 4-2
335. *Lady Worcester, Daughter of the Earl of Thomond.* Ditto. 7-0¾ x 4-2
N.B. These Vandykes were in the Wharton Collection
336. *A White Hound.* Wootton. 3-3¼ x 4-1
337, 338, 339. *Three pictures of Horses.* Ditto. 3-3¼ x 4-1

IN THE DRAWING ROOM

340. *Ruins, over the chimney.* Marco & Ritzi. 4-5 x 5-8¼
341. *The Conversion of S.^t Paul.* Zeloti. 6-2½ x 10-9
342. *A Dead Swan & Fowl.* Snyder. 7-7 x 8-7
343, 344. *Two Pictures of Cattle.* Rosa di Tivoli. 4-8 x 7-1
345. *S^r Godfrey Kneller, when young.* S^r Godfrey Kneller. 2-5¼ x 2-0¼
346. *An Old Man's Head.* Ditto. 2-5¾ x 2-1
347. *A Man writing.* S^r Godf. Kneller. 2-6½ x 2-1
348. *A Man's Head.* Salvator Rosa. 2-6½ x 2-1

IN THE BEDCHAMBER

349. *An Old Woman & Boy.* Titian. 5-2 x 3-6¾
350. *A Woman Sleeping.* 2-4 x 3-2½ .
351. *A Man & Woman.* 3-0 x 3-10

THERE ARE ABOVE STAIRS

352. *A Peice of Fruit with a Carpet.* John Maltese
353. *A Picture of Birds.* Cradock

A CATALOGUE OF S.ʳ ROBERT WALPOLE'S PICTURES AT CHELSEA

IN THE PARLOUR

354. *Charlotte Lady Conway, over the Chimney.* Jervase
355. *Rebekah, & Abraham's Servant returning, with Cattle.* Castiglioni. 4-7½ x 7-7¾
356. *Jacob returning to Canaan, it's Companion.* Ditto. 4-7½ x 7-7¾
357. *Country People dancing.* Angelist
358. *Men Playing at Nine Pins, it's companion.* Ditto
359, 360. *Two Views of Venice.* Canaletti
361. *A Landscape with several figures*
362. *A Picture of Rocks.* Salvator Rosa
363. *The Egyptians drown'd in the Red Sea.* Old Franc

IN THE BEST DRAWING ROOM

364. *A Peice of Ruins, over the Chimney.* Marco & Ritzi. 4-3½ x 6-1
365. *The Countess of Carlisle, whole Length.* Vandyke. 7-0¾ x 4-2
366. *S.ʳ Robert Walpole.* Hyssing
367. *A Bacchanal.* Vandyke. 5-0 x 7-1½
368. *A Bear Hunting.* Snyders
369. *St Andrew leading to his crucifixion, w.ᵗʰ many figures. This Picture is a copy from Guido, in the Vatican.* 6-9¼ x 8-10½
370. *A Family at Prayers in a Church.* Holbein
371. *S.ʳ Thomas Gresham.* Antonio More. 2-9 x 2-1
372. *An Holy Family.* Benvenuto Garofalo
373. *A dead Hare & Birds.* Hondercouter.
374. *A Man's Head.*
375. *A Picture in the Stile of Bassan.* Ritzi
376. *William the first, Prince of Orange*
377. *Prince Maurice, ditto*

IN SIR ROBERT'S DRESSING ROOM

378. *A Picture of Ruins, over the Chimney.* La Mer
379. *A Concert of Birds.* Fiori. 4-5 x 7-9
380. *The Prodigal Son return'd home.* Titian. 5-4½ x 8-11
381, 382. *Two Landscapes.* In the manner of Salvator
383, 384. *Two Pictures of fruit & Flowers.* Old Baptist

IN THE YELLOW DAMASK BEDCHAMBER

385. *General Charles Churchill, over the Chimney.* Richardson
386. *Lady Walpole, whole length.* S.ʳ Godfrey Kneller
387. *A peice of Flowers.* Rysbrach
388. *An Holy Family.* John Bellino.
389. *A peice of Insects*
390, 391. *Two flower peices*
392. *A Sea peice*
393. *Pan & Syrinx: nb. These four last are very small*

IN THE CLOSET

394. *A Peice of Architecture, over the chimney*
395, 396. *Two peices of Ruins with figures.* Paulo Panini

397. *Hercules & Omphale*
398. *An Old Woman & Cattle.* Mola
399, 400. *Two flower peices: these four small*
401. *A Woman with a Candle*
402. *Cock & Hens.* Griffier
403. *A very small landscape*
404. *A Boy's Head.* Titian
405. *Lewis the fifteenth*
406. *Stenwick, His Wife & two Sons.* Stenwick
407. *Esther & Ahasuerus, small*
408. *Bird & fruit, in water colours – small*
409. *Ruins with small figures; small.* Corn. Polenburgh

IN THE HALL

410. *Neptune & Amphitrite.* Rubens. 6-8¾ x 5-4
411. *Moses in the Bullrushes.* La Sour. 7-1 x 4-8½
412. *Perseus turning Men into Stone.* Pietro di Testa. 5-4½ x 7-11
413. *St John the Baptist.* Guerchino. 5-9¼ x 7-6¾
414. *St Jerome.* Ditto. 5-2¼ x 6-6¾
415. *An Usurer, His Wife & Death*
416, 417. *Two Landscapes.* Orizonti

IN LADY WALPOLE'S DRAWING ROOM

418. *The Conversion of St Paul, over the chimney.* Luca Jordano. 4-2 x 5-11
419. *The Elements offering to Venus.* Joseppi Chiari. 5-0 x 6-8
420. *The Story of Neptune & the Nymph turn'd into a Raven.* Ditto. 5-0 x 6-8
421. *An Holy Family.* Diepenback
422. *Samuel presented to Eli in the Temple.* La Hire
423, 424. *Two Landscapes.* Patelli
425, 426. *Two Flower peices.* Jac. Van Huysum
427. *A Boy with a flute.* Cavaliero Luti
428. *St John – head.* Carlo Dolci.
429. *A Dutch Merry-making*
430. *Francis Halls, Master to S.ʳ Godfrey Kneller.* Francis Halls
431. *A Profile head of a Man in a Round*
432. *Henry Howard Earl of Surrey, beheaded y.ᵉ last year of Henry 8ᵗʰ*

PICTURES BOUGHT SINCE THE CATALOGUE WAS MADE

433. *A dead Christ carrying to the Sepulcher.* Giacomo Bassan
434. *An Holy Family.* Matheo Ponzoni
435, 436. *Two Pictures of Dogs & dead Game.* Old Wenix
437. *Abraham going to Sacrifice Isaac.* Rembrandt
438. *Inigo Jones.* Van dyke
439. *Two Pictures, the figures by Coypel, with Wreathes of Flowers.* Baptist
440. *Christ taking down from the Cross after.* Dan.ˡ de Volterra
441. *A Landskip of Europe.* Paul Brill
442. *D.º of Africa.* Paul Brill
443, 444. *Two Landskips.* Swanevelt
445. *A large Battle-Peice.* Vandermulen
446. *A Head of S.ʳ Francis Walsingham.*
447. *Jacob stealing the Blessing.* Spagnolet
448. *Joseph with the Baker & Butler of Pharaoh.* Ditto
449. *Queen Caroline, whole length.* Jervase
450. *K. George the first, Ditto.* Sr. Godf. Kneller
451. *K. George the Second, when Prince, ditto.* Ditto
452. *Queen Caroline, when Princess, Ditto.* Ditto
453, 454. *Two Emblematical Birds.* Hundercouter
456. *The Birds stripping the Daw of her borrow find.* Do
457. *Christ and two Disciples at Emaus.* John Giachinetti Gonzales, called il Borgognone delle Teste

APPENDIX IV
Principal Grangerised and Annotated Copies of *Aedes Walpolianae*

1 Horace Walpole's MS, prepared for the printer, Metropolitan Museum of Art, New York. Carefully laid out, it includes an undated MS title-page, dedication, description and sermon, but not Whaley's *Journey to Houghton*. Folio Magna, illustrated with 120 architectural drawings and prints of paintings in Robert Walpole's Collection; the original drawings by Ware and Ripley for *The Plans, Elevations and Sections; Chimney-pieces and Ceilings of Houghton in Norfolk...*, London, 1735; some additional drawings by Rubens (School), Kent, Maratti and Horace Walpole. Original marbled boards, with Horace Walpole's bookplate. Listed in the Description of Strawberry Hill, 1774 and 1784; Strawberry Hill 1842 Sale, lot 1124, bought Lilly; bought 1925, Metropolitan Museum of Art, New York.

2 Horace Walpole's copy of 1747 edition, Dyce Collection, Victoria and Albert Museum, London. Has Walpole's own MS additions and corrections and his list of 83 recipients of Copies (Appendix V). Vellum. Strawberry Hill 1842 Sale, iv, lot 155, bought Thorpe.

3 Horace Walpole's copy of the second edition, 1752, Pierpont Morgan Library, New York. Has many MS additions and laid in at the end a MS catalogue of 1736 (Appendix III) of Sir Robert Walpole's complete collection of paintings then housed in both London residences and at Houghton (possibly the work of Horace Walpole himself). Rebound in red morocco by F. Bedford. Possibly the copy listed in Strawberry Hill 1842 Sale, vii, lot 45; bought Holloway.

4 A copy of the 2nd edition (1752), bequeathed in 1952 by Sir Robert Hyde Greg to the Fitzwilliam Museum, Cambridge. Contains MS notes and values. Principal interest lies in diagrams of picture hangs (see pp. 421-23).

5 A copy of the 2nd edition (1752), with additions, from the library of Sir James Colquhoun of Luss (with his bookplate), now collection of R. C. Fiske, Norfolk. Marbled boards, contemporary half spine. Contains the most finished original diagram of the picture hang in the Gallery at Houghton.

6 A copy of the 2nd edition (1752) in the University Library, Cambridge (Rare Books VIII.2.420) is of interest for the list of values inserted into it (p. 96ff.). This is a working copy and the prices given on the first five sheets are added up to give a total of £33,770. The sixth sheet consists of values 'to be added after Friars giving alms', a total of a further twenty-four works. The seventh sheet is of works 'Omitted in the Gallery', a total of sixteen works. The final list includes works which had presumably only recently been hung in the Gallery, notably Rembrandt's *Abraham Sacrificing Isaac*, Rubens' *Moonlit Landscape with Cart Overturning* and Rosa's *Old Man and His Sons* (valued, like the Rosa, at £250). The purpose of this list is explained by the fair copy statement written on the final page of the 'Description':

'This is to certify that this collection was valued at forty thousand five hundred pounds by Mr. James Christie of Pall Mall. & that the said collection was purchased by her Imperial Majesty at said valuation, £40,000. Witness the signature of the Russian Ambassador.

Mr. Tassaert, Spring Gardens assisted Mr. James Christie in valuing those paintings, & the manuscript Catalogue in front of this book is in M: T's own handwriting. He died in Dean St. at his friend's house Mr Harlow, also a painter.

Copied from Mr. Christie's catalogue Nov. 9th 1824.'

7 Amongst the many other lists with valuations, all or which vary to some degree, we should note: a copy of the 3rd edition (1767), with a MS valuation dated 39 July 1779, totalling £36,610, i.e. less than the sale price given in most other lists; another copy in the Hermitage Library (Rare Books Department R.K.37.2.52), with prices on each page and the sum of £40,555 on the last page, copied from prices given in *The European Magazine*; a copy of the 2nd edition (British Library G.2646) with MS notes and a valuation totalling £39,805.

8 A copy of the 3rd edition (1767), bound in red leather with gold stamping along the edge of the binding, now in the Hermitage Library (Rare Books Department R.K.5.4.24). Placed in the margins against each picture are prices and at the bottom of the page is a sum total of the prices on that page, divided off by a double line. The value of the whole collection is not indicated. On the last page, p. 96, stands the inscription: 'NB the Pictures which are not valued are considered to be rather as family and furniture Pictures adapted to certain Places, than as Pictures of Value.' Presumably one of those 'intended as presents', presumably for Catherine II and her Ambassador (see pp. 65-66).

9 A manuscript catalogue (i.e. not a full copy of the *Aedes* but only the 'Description') in the Hermitage Archives (Fund I, *Opis* VI A, *yed. khr.* 145). This manuscript is bound in greyish brown marbled paper. Against each painting intended for sale, as in the leather-bound copy of *Aedes* (see No. 7 above), is the word 'Lot' and the price. On the last page is the word 'End' and no indication of the total price. The copy was made, as indicated on the title page, from the 1767 edition of the *Aedes Walpolianae*.

10 A Russian translation of the *Aedes* (Hermitage Archives, Fund I, *Opis'* VI A, *yed. khr.* 146). This manuscript translation (bound in red leather and decorated around the edges with fine gold stamping) was presumably made for the Empress, as she was not familiar with English. The translation was taken not from the printed copy of the *Aedes* which was presented to Catherine II, but from the manuscript copy reproducing only the 'Description' from the *Aedes* (No. 8 above).

In the Archive of the Russian Federation Ministry of Foreign Affairs, Fund 35, *Opis'* 35/6, *delo* 287, ff.19-20, attached to a letter of 15 December (OS 4 December) 1778 from Musin-Pushkin to Catherine II, is a separate sheet of paper which provides a list of the page numbers in the *Aedes* and the total value of the paintings on that page, without any commentaries: eg.'Page 38 ... 50£; Page 40 ... 150£ etc'. After page 96 is a line and below that the overall sum of 40,550 £. St. [pounds sterling]. This should probably be seen as a supplement or appendix to the Russian translation of the *Aedes*.

APPENDIX V

List of persons to whom Horace Walpole Presented *Aedes Walpolianae* (1747/48)

The following list of persons to whom Horace Walpole presented the first edition of the *Aedes* is based on the MS List in Horace Walpole's hand which records a total of 83 names, now in the Dyce Collection, Victoria and Albert Museum (SH, 4, lot 155). See Hazen 2483. The list represents a network of friends and family of Horace, c. 1748-50, with relatively few of Sir Robert's intimates by comparison.

1 *Mr Ashton* [Rev. Thomas Ashton (1715-75), HW's correspondent]

2 *Mr H. Fox* [Henry Fox (1705-74), cr. (1763) Baron Holland; MP]

3 *Mr G. Montagu* [George Montagu (1716-71), 2nd Earl of Halifax, 1739 (after 1741, Montagu Dunk)]

4 *Mr Rigby* [Richard Rigby (1722-88), politician; MP]

5 *Ld Orford* 3 [copies] [Robert Walpole (1701-51), cr. (1723) Baron Walpole; 2nd Earl of Orford, 1745; HW's eldest brother (3 copies)]

6 *Mr Gal. Mann* [Galfridus Mann (1706-56), army clothier; Horace Mann's twin brother]

7 *Mr T. Gray* [Thomas Gray (1716-71), poet; HW's friend and correspondent]

8 *Mrs Leneve* [Isabella Le Neve (c.1686-1759), daughter of Oliver Le Neve]

9 *Mr J. Chute* [John Chute (1701-76), of The Vyne, HW's friend and correspondent]

10 *Mr Ripley* [Thomas Ripley (died 1758), architect engaged on Houghton Hall, 1722-35; Wolterton Hall, 1724-30]

11 *Dr Middleton* [Rev. Conyers Middleton (1683-1750), DD; writer and classical scholar]

12 *Mr Brand* [Thomas Brand (1718-70); of the Hoo; MP]

13 *Miss Norsa* [Hannah Norsa (died 1785); mistress of 2nd Earl of Orford]

14 *Mr Hor. Mann* [Sir Horatio (Horace) Mann (1706-86); cr. (1755) Bt.; KB; HW's correspondent]

15 *Dr Ant. Cocchi* [Antonio Cocchi (1695-1758); Florentine physician]

16 *Mr Hor Townshend* [Hon. Horatio Townshend (c. 1717-64); HW's cousin]

17 *Mr James West* [James West (1703-72), MP; politician, connoisseur, antiquary]

18 *Count St Germain* [St.Germain (died 1784); colourful adventurer, cleared by Newcastle of Jacobitism]

19 *Lord Hartington* [William Cavendish (c. 1720-64), styled Marquess of Hartington, 1729-55; 4th Duke of Devonshire, 1755]

20 *Mr Whithed* [Francis Whithed (formerly Thistlethwayte) (1719-51); MP]

21 *Col. E. Cornwallis* [Hon. Edward Cornwallis (1713-76); army officer; MP; groom of the Bedchamber, 1747]

22 *Col. H. Conway* [Hon. Henry Seymour Conway (1719-95); secretary of state; field-marshal; MP; HW's cousin]

23 *Mr R. Trevor* [Hon. Robert Hampden (until 1754, Trevor) (1706-83); 4th Baron Trevor, 1764; cr. (1776) Viscount Hampden; desc. of John Hampden]

24 *Mr J. Davis* [John Davis (c. 1696-1778) of Watlington, Norfolk; painter]

25 *Mr J. Hill* [John Hill (c. 1690-1753), of Thornton, near Malton, Yorks; politician; MP; Commissioner of Customs, 1723-47]

26 *Mr Churchill* [Charles Churchill (?1720-1812); MP; HW's brother-in-law]

27 *Lady Fawkener* [Harriet Churchill (1726-77, married 1. (1747) Sir Everard Fawkenor, Kt; married 2. (1765) Hon. Thomas Pownall]

28 *Mr H. Harris* 30 [copies in total] [Henry Harris (died 1761); commissioner of Wine Licence Office]

29 *Gen Campbell* [John Campbell (1723-1806), styled Marquess of Lorne 1761-70; 5th Duke of Argyll 1770; army officer; MP]

30 *Mr Ranby* [John Ranby (1703-73); principal sergeant-surgeon to George II]

31 *Lord Strafford* [William Wentworth (1722-91); 2nd Earl of Strafford, new creation, 1739; HW's correspondent]

32 *Lord Edgcumbe* [Richard Edgcumbe (1680-1758), cr. (1742) Baron Edgcumbe, MP]

33 *Mr Edgcumbe* [Richard Edgcumbe (1716-61), 2nd Baron Edgcumbe, 1758; MP]

34 *Rev. Mr Spence* [Rev. Joseph Spence (1699-1768), writer; professor of poetry at Oxford 1728-38; regius professor of modern history, 1742]

35 *Lord Conway* [Francis Seymour Conway (1718-94), 2nd Baron Conway; cr. (1750) Earl and (1793) Marquess of Hertford; HW's cousin and correspondent]

36 *Sr Luke Schaub* [Sir Luke Schaub (1690-1758), Kt., 1720; diplomat]

37 *Lord Radnor* [John Robartes (1686-1757), 4th Earl of Radnor]

38 *Mr Edw Mann* [Edward Louisa Mann (1702-75) of Linton; Horace Mann's brother]

39 *Sr Tho. Robinson* [Sir Thomas Robinson (?1702-77), cr. (1731) Baronet, of Rokeby; MP]

40 *Mrs Talbot* [?Catherine Clopton (d. 1754), m. (1725) Henry Talbot; a cousin of Catherine Shorter]

41 *Mr Bedford* [Grosvenor Bedford (d. 1771), HW's deputy in the Exchequer]

42 *Countess Fitzwilliam* [Lady Anne Watson Wentworth (died 1769)]

43 *Lord Duncannon* [William Ponsonby (c. 1704-93), styled Viscount Duncannon; 2nd Earl of Bessborough, 1758; MP]

44 *Mr Briton* [Sir William Breton Kt. (d. 1773), Kt. 1761; groom of the chamber and Privy Purse bearer to Frederick, Prince of Wales; MP]

45 *Sr Danvers Osborn* [Sir Danvers Osborn (1715-53), 3rd Baronet; MP]

46 *Lord Doneraile* [Arthur Mohun St Leger (1718-50), 3rd Viscount Doneraile, 1734; MP; Prince of Wales's Lord of the Bedchamber, 1747-50]

47 *Lord Talbot* [?William Talbot (1710-82), 2nd Baron Talbot, 1737, cr. (1761) Earl Talbot]

48 *Mr Vertue* [George Vertue (1684-1756), engraver and antiquary, sponsor of HW 's Fellowship of Society of Antiquaries, 19 April 1753]

49 *Mr Martin* [Samuel Martin (1714-88), MP; Secretary to the Treasury 1758-63]

50 *Sr Wm. Yonge* [Sir William Yonge (c.1693-1755), 4th Bt, 1731; MP; versifier]

51 *Eton Col. Library* [Eton College Library; HW planned to give his library to Eton College (Cole to Granger 21 Oct 1774, BL Add MS 5825, f. 151 v)]

52 *Mr Bryant* [Jacob Bryant (1715-1804) classical scholar; Fellow of King's College, Cambridge]

53 *Dr Meade* [Dr. Richard Mead (1673-1754), MD; physician and collector; in 1749-50 Mead was collecting subscriptions for Cocchi's proposed book Graecorum chirurgici libri, remitting 50 through Galfridus Mann]

54 *Miss Evelyn* [Elizabeth Evelyn (1723-94); m. (1750) Peter Bathurst, of Clarendon, Wilts; HW's 'old love'(Duchess of Gloucester to HW 14 Sept 1777)]

55 *Lady Buckingham*

56 *Lady Townshend* [Etheldreda (or Audrey) Harrison (c. 1703-88), m. (1723) Charles Townshend, 3rd Viscount Townshend; celebrated for her frank manner]

57 *Mr W. Cole* [Rev. William Cole (1714-82), antiquary; HW's correspondent]

58 *Uncle Horace Walpole* [Horatio (Horace) Walpole (1678-1757), cr. (1756) Baron Walpole of Wolterton; diplomat; MP]

59 *H. Walpole Junr.* [Hon. Horatio (Horace; Horry; Celadon; HW) Walpole, 4th Earl of Orford, 1791; MP; collector; man of letters]

60 *The Prince of Wales* [Frederick Louis (1707-51), Prince of Wales 1727-51]

61 *Sr Ch. Hanbury Williams* [Sir Charles Hanbury Williams (1708-59), KB, 1744; diplomatist, wit, poet, MP]

62 *Capt. Jackson* [?George Jackson (c 1692-1764), consul at Genoa 1737-40; Leghorn merchant]

63 *Earl of Leicester* [Thomas Coke (1697-1759), cr. KB (1725)Lord Lovell (1728) and 1st Earl of Leicester (1744); builder of Holkham Hall; collector]

64 *Mr G. Selwyn* [George Augustus Selwyn (1717-91), MP; wit; HW's correspondent]

65 *Mr Hampden* [John Hampden (c. 1695-1754) MP]

66 *Earl of Kinnoul* [George Henry Hay (1689-1758), 8th Earl of Kinnoul; ambassador to Turkey, 1729-36]

67 *Miss M. Townshend* [Mary Townshend, eldest daughter of Hon. Rev. Edward Townshend]

68 *Mr Bentley* [Richard Bentley (1708-82), HW's correspondent; 'Cliquetis']

69 *Mr R. Cholmondeley* [Rev. Hon. Robert Cholmondeley (1727-1804), 2nd son of George, 3rd Earl of Cholmondely; HW's nephew]

70 *Mr Fowle* [John Fowle (died 1772), barrister; auditor of excise; RW's esquire at Bath installation]

71 *Mr Cleland* [John Cleland (1709-89), writer; author of Fanny Hill (1750)]

72 *Mr Bevan* [Probably the son of Arthur Bevan (c. 1688-1743), of Laugharne, Co. Carmarthen 1727-41]

73 *Mr Arthur* [Robert Arthur (died 1761), proprietor (1736-55) of White's Club, noted Chocolate House]

74 *Mr Pond* [Arthur Pond (c. 1705-58), painter and dealer; FRS]

75 *Mr Campbell of Pemb.* [John Campbell (1695-1777) of Calder and Stackpole Court; lord of the Admiralty 1736-42 and of the Treasury 1746-54; MP Pembrokeshire 1727-47]

76 *Mr Gashry* [Francis Gashry (1702-62), MP Aldeburgh, 1741, East Looe 1741-62; directr of the South Sea Company; Comptroller of the victualling accounts 1744-47]

77 *Mr Lyttleton* [Charles Lyttelton (1714-68), Bishop of Carlisle, 1762; 'Goody Carlisle'; HW's sponsor at Society of Antiquaries]

78 *Dr Chauncey* [Charles Chauncy (1706-77); physician, antiquary and collector; MD, 1739; FRS 1740]

79 *Mr J. Harris* [John Harris (?1690-1767) of Hayne; MP; Master of George II's household; possibly James Harris (1709-80); MP; Secretary to Queen Charlotte]

80 *Sr J. Evelyn* [Sir John Evelyn (1682-2763) cr. (1713) baronet; builder of the library at Wotton, Surrey; FRS and Commissioner of Customs]

81 *Mr Edw Walpole* [Sir Edward Walpole (1703-84), KB , 1753; MP; Master of the Pleas in the Exchequer, 1727; Clerk of the Pells, 1739]

82 *Mr Ross* [George Ross (1681-1754), 13th Lord Ross of Halkhead, 1738; Commissioner of Customs and Salt, 1744, 1746, 1751.]

83 *Mr Reynolds* [Sir Joshua Reynolds (1723-93); Kt, 1769; painter]

APPENDIX VI

Walpole Collection: Picture Sale (by Robert Walpole, 2nd Earl of Orford) 1748

The following text reproduces verbatim the manuscript copy of the Catalogue of the 1748 London Sale contained within the Houlditch MSS (National Art Library, Victoria & Albert Museum, London). The spelling of titles and artist attributions are those of the MS. Where possible, the identities of the purchasers at the sale have been given in square parentheses. This material is given to assist in tracing works of art formerly in the Walpole collection, notably in London residences, which were not catalogued by Horace Walpole in the *AedesWalpolianae*. It may be seen that a large number of works subsequently entered British collections: Sir Robert Walpole's European master paintings were not all lost to Britain and many remain in public and private collections today.

Lot, *Title*, Artist, (Buyer), Price

DAY 1

1 *Two small Upright Landskips, and a Cartoon of Le [Bloris]* Le [Bloris] (——) 0-12-

2 *Architecture, and Figs.* Vivano (Bragge) 1-12-

3 *Two pieces of Still Life, and dead game* Weenix (——) 0-15-

4 *Fruit* after M. Angelo (——) 1-10-

5 *A Boy, by Candle light* Ger. Honthurst (——) 0-11-6

6 *A long view, wit Fortifications* —— (Bragge) 0-10-6

7 *Mars and Venus* school of J. Romano (——) 1-0-

8 *A Conversation* M. Angelo ([Harene]) 1-1-

9 *A Miser and Death* Long John of Antwerp (——) 0-16-

10 *An Old man smoking, 3 qrs* —— (——) 0-11-6

11 *A Madonna* after Rubens (——) 0-16-

12 *A Ceiling* Dominichino (——) 0-19-

13 *A Landschape, and Figures* Ditto (Weldon) 3-15-

14 *Birds* Ferguson (Sr. P. Methuen) 1-2-

15 *Architecture and Figs.* Harvey (——) 1-15-

16 *Its Companion* Ditto (——) 1-15-

17 *A white Peacock, and other Birds* Bogdani (——) 2-4-

18 *Flowers, large* Baptiste (——) 4-7-

19 *A Sleeping Venus* after Titian (——) 1-2-

20 *A large Bacchanalian of boys* Vandyck (Ld. [....] Arundel) 8-0-

21 *A Landskip, & Figs.* Rosa of Tivoli (Burrell) 3-13-6

22 *It's Companion* Ditto (Weldon) 3-8-

23 *Martyrdom of St. Peter* Guido (Ldy Cath. Pelham) 5-5-

24 *A large Turkish Battle* Vandermeulen ([Spenceley]) 8-0-

25 *A Man's head 3 qrs, in a round* from the Antique (——) 1-15-

26 *A small History* stile of Vandyck (Harene) 1-1-

27 *A Man's Head, 3 qrs,* —— (——) 1-1-

28 *St. Teresa's Head, 3 qrs* Guido (Burrell) 1-13-

29 *St. Francis* D. Teniers (——) 2-8-

30 *A view, with Figs., on Copper* Scoevoerts (Weldon) 5-10-

31 *Two small Landskips, and Figs* Bambots (Bragge) 2-4-

32 *A Landskip, and Figs.* Horizonti (Cap. Browne) 10-10-

33 *Feast of Belzhazzer, flowers* Old Baptist (Burrell, with Lot 34)

34 *The Woman taken in Adultery, it's Compn.* Old Baptist (Burrell) 6-10-

35 *A small Landscape & Figs on copper* Dominichino (D. Rutland) 16-0-

36 *A small Holy Family* [S. Vouet] (Campbell) 2-0-

37 *Insects* [Otho Marsaus] (Cap. Browne) 6-16-6

38 *Our Saviour att Emaus* Cavr. Benasci (Brand) 7-15-

39 *A Landskip and Figs manner of G. Pousin* F. Hilles (Ld. Petersham) 12-12-

40 *It's Companion* Ditto (——) 5-7-

41 *A sleeping Venus, with a Satyr and Cupids* N. Poussin (Bragge) 6-0-

42 *Apollo and Cupid* Guercino (Brand) 2-10-

43 *A Conversation* Tilborch (Ld. Duncannon) 9-9-

44 *Ditto* M. Angelo (D. Rutland) 14-0-

45 *A small Holy Family* P. Perugino (Bragge) 12-1-6

46 *Cupids, with Grapes* P. Laura (Hor. Walpole) 23-2-

47 *A Drawing* —— (——) 6-0-

48 *Pan and Syrina* F. Laura (P. Wales) 21-0-

49 *Neptune and Amphitrite* G. Chiari (H. Fox) 15-15-

50 *It's Companion* Ditto (Ditto) 15-15-

51 *Architecture, and Figs.* M & S Ricci (Ld. Duncannon) 22-1-

52 *It's Companion* Ditto (Ditto) 23-2-

53 *A Landschape, and Figs* Seb. Bourdon (Pond) 15-15-

54 *A large piece of Birds, hieroglyphical* Hondicooter (Bragge) 17-17-

55 *It's Companion* Ditto (Ditto) 16-16-

56 *Fruit* M. Angelo (Ldy Cath. Pelham) 6-6-

57 *It's Companion* Ditto (——) 3-3-

58 *A Sea Triumph of Venus* L. Giordano (Ldy Cath. Pelham) 9-0-

59 *Flight into Egypt* Bene Castiglione (as below with Lot 60)

60 *The finding of Pyrrhus, it's Comp.* Ditto (Ld. Gadbury) 16-16-

61 *The Conversion of St. Paul* L. Giordano (Barnard) 26-15-6

62 *The Wisdom of Solomon* And. Schiavoni (Sr. Thos Robinson) 6-6-

63 *Isaac Blessing Jacob* Spagnioletto (Spenceley) 33-12-

64 *Joseph interpreting dreams to Pharaoh's Servants, it's Comp.* Ditto Ditto 33-12-

65 *Flowers* Capital Van Huysum (Rosier) 53-11-

66 *It's Companion* Ditto Ditto 50-8-

67 *Perseus turning Atlas k. of Mauritania into stone* N. Poussin (Raymond) 28-17-6

DAY 2

1 *Mary Q. of Scots, and Ben Johnson's Head* —— (——) 0-10-

2 *Two Landskips, on Copper* after Breughel (——) 2-4-

3 *A small Landscape, & our Saviour, and St. Thomas* Italian (Bragge) 3-13-6

4 *A View, with Figures* Old Breughel (Smart) 01-11-6-

5 *Old Hobbs, 3qrs, with his Leviathan* —— (——) 0-5-6-

6 *Two pieces of Flowers* —— (——) 1-6-

7 *A Turkish Nobleman, whole Length* —— (——) 1-18-

8 *Two Upright pieces of Architecture & Figs.* after Vivano (——) 1-19-

9 *Fowls* Craddock (——) 1-11-6-

10 *A Carret, with Fruit* Maltese & M. Angelo (Ldy Cath. Pelham) 2-16-

11 *A Peacock, and other Birds* Bogdani (Raymond) 2-11-

12 *The Descent from the Cross.* after Dan de Volterra (Gen. Guise) 6-10-

13 *A Small piece of Flowers* —— (——) 0-19-

14 *Architecture, and Figures* Agos. Tasso (——) 2-4-

15 *Two Pictures of Beggar Boys* after Morillios (——) 4-4-

16 *Saint Jerom* Guercino (Maxwell) 4-14-6

17 *Saint John* Ditto (Ditto) 4-0-

18 *A Landskip and Figs.* Horizonti (Smart) 4-6-

19 *It's Companion* Ditto (Ditto) 5-10-

20 *Ruins, and Figures,* style of N. Poussin (Bragge) 7-7-

21 *Two small pieces of Flowers* Casteels (——) 4-5-

22 *The Ascension* School of P. Veronese (Ld Moreton) 2-16-

23 *A Mans head* Ant. More (Sr. P. Methuen) 1-7-

24 *A Dead Hare* Old Weenix (Smart) 2-16-

25 *Hercules, and Omphale* P. de Mattei ([Dr. Chauncey?]) 3-6-

26 *A Nobleman's head, 3qrs* Cor. Janssen (——) 1-9-

27 *Ditto* Ditto (——) 1-14-

28 *The Wisdom of Solomon* [Solimens?] (Ld. Moreton) 5-12-6-

29 *The Nativity* young Palma Zuccaro (Sr. P. Methuen) 17-0-

30 *A Landskip, Figs. & Cattle* Italian (Bragge) 1-13-

31 *A Festoon of Flowers* [Old Verelot?] (——) 1-11-6-

32 *A Heron Hunting* Fyt [as below]

33 *A Duck Hunting, it's Compn.* Ditto (Cook) 3-9-

34 *A small Madonna, on copper* G. Chiari (Hor. Walpole) 7-7-

35 *A Calm* Van de Velde (——) 3-5-

36 *A Crucifixion, on stone* Bassano (——) 2-12-6-

37 *A Vanity* Eliz. Sirani (Sr. P. Methuen) 1-7-

38 *A small Dead Christ* Carracci (——) 2-10-

39 *A Holy Family* P. Perugino (Ld. Moreton) 1-2-

40 *A Nobleman, his Lady, and Family att their devotions* Rubens (Ld. Moreton) 3-6-

41 *Flowers* Old Baptist (Hor. Walpole) 2-2-

42 *Saint Francis* Agos Carracci (Kellaway) 7-5-

43 *A Peacock, and other Birds* Desportes ([Hayes]) 7-10-

44 *Narcissus* De La Hire (Kellaway) 13-

45 *A Dead Christ* Mich. Rock [as below]

46 *A Magdalen, with Angels, it's Compn.* Ditto (Ld Moreton) 11-15-

47 *St. Bartholomew's head, 3qrs* Rubens (Sr. P. Methuen) 4-14-6-

48 *St. Peter's Ditto* Guido (Barrett) 2-3-

49 *A History* De La Hire (Col. Littleton) 6-0-

50 *A Battle* Borgognone [as below]

51 *It's Companion* Ditto (Col. Littleton) 18-18-

52 *A small Conversation* Watteaux (Hor. Walpole) 3-3-

53 *A Battle* Parocelle (Gen. Skelton) 5-0-

54 *An Ecce Homo* Guercino (Ellys) 1-10-

55 *Diana* L. Giordano (——) 7-12-6-

56 *A Hunting* Rubens (Sr. Thos Robinson) 13-0-

57 *The Fable of the Raven* Hondicooter (Ellys) 18-18-

58 *A Landschape and Figs* Poelenburgh (——) 6-16-6-

59 *The Brazen Serpent* Rubens (——) 7-0-

60 *Pan and Syrinx* F. Laura [as below]

61 *Jupiter and [female?], it's Compn.* Ditto (Bragge) 21-10-6-

62 *Watteaux's dream* Watteaux (Ld. Moreton) 6-10-

63 *A Conversation* Paterre (Rosier) 6-15-

64 *A Holy Family* Rubens (Ditto) 13-5-

65 *Marriage of St. Catherine* P. Veronese (Sr. Thos Robinson) 16-16-

66 *Jacob's Journey into Egypt* B. Castiglioni (Ld. Moreton) 43-11-6-

67 *It's Companion* Ditto (Sr. Thos Robinson) 35-3-6-

APPENDIX VII

Walpole Collection: Picture Sale (by George, 3rd Earl of Orford) 13–15 June 1751

The following text reproduces verbatim the manuscript copy of the Catalogue of the 1751 London Sale contained within the Houlditch MSS (National Art Library, Victoria & Albert Museum, London). The spelling of titles and artist attributions are those of the MS. Where possible, the identities of the purchasers at the sale have been given in square parentheses. This material is given to assist in tracing works of art formerly in the Walpole collection, notably in London residences, which were not catalogued by Horace Walpole in the *Aedes Walpolianae*. It may be seen that a large number of works subsequently entered British collections: Sir Robert Walpole's European master paintings were not all lost to Britain and many remain in public and private collections today.

Lot, *Title*, Artist, (Buyer), Price

DAY 1

1 *The parting of Hector and Andromache, a fine Drawing* —— (Mann) 1-5-

2 *Count Bonneval, 3qrs, in Crayons* —— (——) 0-8-6-

3 *A piece of Flowers, on glass* —— (——) 1-5-

4 *Three Small Heads* Holbien (——) 3-3-

5 *The good Samaritan* Ag. Caracci (——) 1-2-

6 *A Madona* Parmeggiano (——) 4-6-

7 *Pan and Syrinx, in a Landschape* Flemish (——) 0-17-

8 *A Conversation* Palamedes (——) 2-8-

9 *It's Companion* Ditto (——) 3-13-6-

10 *Our Saviour in the Garden* Italian (——) 0-16-

11 *A Landschape, with Horse and Groom* Wooton (——) 6-10-

12 *It's Companion* Ditto (——) 6-8-6-

13 *A Merry making* Angelles (——) 6-11-

14 *It's Companion* Ditto (——) 5-15-

15 *A Charity* Romanelli (Ld. Egremont) 18-18-

16 *It's Companion* Ditto (Ditto) 15-15-

17 *A Madona* Dom Fetti (——) 1-18-

18 *A Black Prince* Holbien (——) 1-1-

19 *Two Small Sea pieces* L. G. Dittan (——) 1-12-6-

20 *A Landschape and Figures* Sal. Rosa (Raymond) 11-5-

21 *The Famous Horse Snake, big as the Life* Wooton (——) 11-5-

22 *Bacchus and Ariadne* De La Hire (Mann) 4-15-

23 *It's Companion* Ditto (Ditto) 4-4-

24 *Hounds* Wooton (——) 7-10-

25 *A Long Landschape* P. Neapolitano (——) 2-13-

26 *It's Companion* Ditto (——) 3-5-

27 *A Dog's Head* Old Ross (——) 3-15-

28 *The Virgin, our Saviour, and Joseph in 3 pictures* Italian (——) 2-3-

29 *A Landskip and Figs* Vinckaboon (——) 4-12-6-

30 *It's Companion* Ditto (——) 6-10-

31 *Neptune and Amphitrate* after Rubens (Raymond. Pond ——

32 *Vases* —— (——) ——

33 *Vases* —— (——) ——

34 *Vases* —— (——) ——

35 *Vases* —— (——) ——

36 *A Man's Head, 3qrs* Corn. Janssen (——) 3-13-6-

37 *A Merry making* Schtleven (Slaughter) 10-10-

38 *The P. of Conde* Old Fuller (Pond) 12-5-

39 *A Sea Calm* Scott (——) 8-5-

40 *It's Companion* Ditto (——) 7-5-

41 *A Small Oval Hunting* Wyck (Mann) 8-8-

42 *A Large Wolf Hunting* Snyders (Gen. Skelton) 17-6-6-

43 *A Landschape, with Figures and Cattle* Rosa of Tivoli (Slaughter) 21-10-6-

44 *It's Companion* Ditto (——) 8-8-

45 *A Holy Family* Ben. Luti ([C?] Parker) 3-13-6-

46 *The Countess of Worcester whole Length* Vandyke (Raymond) 27-16-6-

47 *Philip Ld. Wharton* Ditto (Pond) 21-10-6-

48 *Ld. Wharton's Mother* Ditto (Eckard) 29-8-

49 *Prince Rupert* Ditto (Leeson) 22-1-

50 *A Landschape and Figures* Gobbo. Carracci (——) 3-4-

51 *A Holy Family in a Landschape* Mola (Mann) 10-15-

52 *Jupiter and Europa* P. Veronese (Leeson) 6-6-

53 *A Landschape and Figs.* Swanivelt (Raymond) 22-1-6-

54 *It's Companion* Ditto (——) 12-12-

55 *A Sleeping Boy* C. Maratti (Cap. [Montelieu?]) 6-15-

56 *A Landschape and Figs.* Poelenburgh (Howard) 5-15-

57 *It's Companion* Ditto (Ditto) 7-10-

58 *The Inside of a Church* Deneef (Mann) 6-6-

59 *The breaking of the Tables* Old Frank (Dr. [Chauncey?]) 21-0-

60 *A large Historical Picture* Solimeni (Gen. Guise) 25-4-

61 *It's Companion* Ditto (Ditto) 27-6-

62 *A large piece of Dead Game* Old Wenix (———) 34-13-

63 *It's Companion* Ditto (Ld. Duncannan) 59-17-

64 *A View in Venice* Cannaletti (Raymond for Gideon) 36-15-6-

65 *the Doge marrying the Sea, it's Companion* Ditto (Ditto for Ditto) 34-13-

66 *A Fox Hunting* Martin De Vos (Ld. Fortescue) 17-17-

67 *A Battle, Joshua stopping the [sun?] called Borgoge.* L. Giordano (Raymond) 26-15-6

Day 2

1 *King George 1st., whole Length* ——— (———) 5-5-

2 *King George 2d. Ditto* ——— (———) 10-0-

3 *Q. Caroline Ditto* ——— (———) 3-3-

4 *Hercules and Dejanira* Al. Durer (———) 1-2-

5 *A Fox Hunting* after Snyders (———) 2-10-

6 *Howard E. of Surrey, whole Length* Zuccaro (Vertue) 27-6-

7 *A Conversation after Miens and a Lady, half Length* ——— (———) 5-7-6-

8 *A Conversation* Laroon (———) 2-7-

9 *A Man's Head, 3qrs* Sr. G. Kneller (Raymond) 2-6-

10 *Hounds &c* Wooton (———) 15-4-6-

11 *A Landschape, with a Horse and Groom* Ditto (———) 12-0-

12 *It's Companion* Ditto (———) 9-19-6-

13 *A Small Battle* Percelles (Howard) 2-3-

14 *A Man's Head, 3qrs with a drinking glass* Flemish (———) 10-10-

15 *A Landskip with a Horse and Groom* Wooton (———) 8-18-6-

16 *A Landskip with Figs. and Hounds* Ditto (———) 22-1-

17 *The Adoration of the Kings* Tintoretto (Leeson) 4-0-

18 *Fowls* Craddok (———) 9-0-

19 *A piece of Architecture* Vivano (Slaughter) 4-17-6-

20 *A Landskip with Figures, and Cattle* Rosa of Tivoli (Col. Fitzwilliams) 7-17-6-

21 *A piece of Fowls* F. Imperialis (Ld. C. Parker) 6-0-

22 *A Cupid, and Still Life* Maltese (Lane) 15-15-

23 *Cain and Abel* Guercino (Leeson) 7-15-

24 *A large Stag Hunting* Al. Hondius ([Blackiston?]) 15-0-

25 *A Bear Hunting, it's Companion* Ditto (Ld. Belfield) 25-14-6-

26 *A large piece of Dead Game* Snyders (Raymond) 29-18-6-

27 *A Landskip with Figs. and Cattle* D. Teniers (Slaughter) 7-0-

28 *The passage of the Red Sea* Old Frank ([Rivers?]) 5-12-6-

29 *A Landschape, Figures and Cattle* Berghem (Pinchbeck) 8-12-6-

30 *It's Companion* Ditto (———) 11-0-

31 *A Boar's Head* Rubens Ld. Fortescue 16-16-

32 *A Lady, half Length, a black Drapery* Vandyke (———) 12-17-

33 *Stone Figures etc* ——— (———) ———

34 *Stone Figures etc* ——— (———) ———

35 *Stone Figures etc* ——— (———) ———

36 *Stone Figures etc* ——— (———) ———

37 *Stone Figures etc* ——— (———) ———

38 *A Landschape, with a Horse and Groom* Wooton (———) 8-8-

39 *Q. Caroline, whole Length* Jervaise (———) 9-9-

40 *A Landschape, with Figures and Cattle* Weenix (Eckard) 7-2-6-

41 *The Finding of Moses* C. Maratti (———) 12-0-

42 *A History piece* Seb. Bourdon (———) 2-16-

43 *A Landskip & Figures* S. Rosa (Smith) 9-10-

44 *It's Companion* Ditto (Mann) 7-12-6-

45 *Fruit and Flowers* [Montingo] (———) 4-5-

46 *His own Head, 3qrs* Sr. God. Kneller (Raymond) 13-13-

47 *A Landschape, Figs. and horses* Wouvermans (Eckard) 10-5-

48 *A Stable with a white horse* [J. Miels], or Teniers (———) 7-5-

49 *A History piece* Bassano (Ld. C. Parker) 7-7-

50 *A Conversation* Pasqualini (———) 5-15-6-

51 *The Countess of Chesterfield, whole Length* Vandyke (West) 31-10-

52 *The Countess of Carlisle Ditto* Raymond (Smart) 47-5-

53 *Jane Goodwin, Second wife of Ld. Wharton* Ditto (Ditto) 33-1-6-

54 *Lady Rich, daughter of the E. of Devonshire* Ditto (Ditto) 40-8-6-

55 *A History piece* Brahmer (———) 2-2-

56 *A Landschape and Figures* Old Patel ([Ld. Rolfield?]) 6-11-

57 *Fruit and Dead Game* Snyders (Anderson) 7-7-

58 *An Upright piece of Architecture and Figs.* P. Panini (Piers) 17-17-

59 *It's Companion* Ditto (Cleveland) 13-13-

60 *A Landskip, Figs. and Cattle* Wooton (———) 28-7-

61 *It's Companion* Ditto (———) 21-0-

62 *A Landskip and Figures* Old Patel (Armstrong) 12-15-

63 *The La Hague Fight* Old W. Van de Veld (———) 39-18-

64 *A Fox hunting* Mar. De Vos (Col. Townshend) 26-0-

65 *A Bear Hunting, it's Companion* Ditto (Col. Townshend) 21-0-

66 *Snyders, and his wife, and Child* Long Jan (Raymond for Gideon) 84-0-

67 *A Stag Hunting* Rubens (Ld. ———) 52-10-

CONCORDANCE
Notes to Concordance

Columns 1-6 provide basic information about each work of art, its first recorded location at Houghton Hall and current whereabouts. Columns 7-13 provide historical information tracing the fate of each painting over the years.

Column 1 (Attribution)
Current attributions are given in upper case, Horace Walpole attributions are lower case.

Column 2 (Title)
Current titles are given first, titles as recorded in the Aedes are in square brackets.

Column 3 (Cat. No.)
Numbers within the current book.

Column 4 (Aedes No.)
For ease of reference within the scope of this publication, all the works listed in the Aedes Walpolianae have been given a consecutive number within Horace Walpole's text.

Column 5 (Aedes Room)
Establishes in which room the work of art was kept in 1743, by which time the Aedes Walpolianae was compiled.

Column 6 (Present Location)
abbreviations used:

Academy of Arts	Research Museum of the Academy of Arts, St Petersburg
Alupka	Alupka State Palace and Park Museum Reserve, Alupka, Crimea, Ukraine
Gatchina	Gatchina State Museum Reserve, near St Petersburg
GMII	Pushkin Museum of Fine Arts, Moscow
Gulbenkian	Calouste Gulbenkian Museum, Lisbon
Houghton	Houghton Hall, Norfolk
Khabarovsk	Far Eastern Art Museum, Khabarovsk
Krasnodar	Kuban Art Museum, Krasnodar
Morris, Houston	William Morris Collection, Houston, Texas
Palekh	Museum of Palekh, Russia
Perm	State Art Gallery, Perm, Russia
Peterhof	Peterhof State Museum Reserve, near St Petersburg
Tsarskoye Selo	Tsarskoye Selo State Museum Reserve
Pavlovsk	Pavlovsk State Museum Reserve, near St Petersburg
Sevastopol	M. P. Kroshitskiy Art Museum, Sevastopol [Sebastopol], Crimea, Ukraine
SHM	State Hermitage Museum, St Petersburg
Washington	National Gallery of Art, Washington, DC

Column 7 (1736 Inventory)
Records where a work was already in the possession of Sir Robert Walpole in 1736 and in which house it was kept.

Column 8 (Valuation)
A large number of lists of prices paid for Walpole's works by Catherine the Great are in existence (see Appendix IV, items 6, 7), varying slightly in some details. The sources of most of these lists are unknown. The prices given in this column are based on the red-leather bound copy of the Aedes Walpolianae which was probably one of those presented to Catherine the Great by Lord Orford prior to the sale (Appendix IV, item 8).

Column 9 (Cat. 1773–85)
All but one of the paintings acquired by Catherine the Great were entered upon their arrival in the manuscript catalogue of the Hermitage compiled by Ernst Munich between 1773 and 1785.

Column 10 (Cat. 1797)
Cat. 1797 was begun after the death of Catherine the Great by command of her son, Paul I, and was continued into the 19th century.

Column 11 (Inv. 1859)
A full inventory was taken of works belonging to the Hermitage starting in 1859; when paintings were moved to other locations, or found to be missing during periodical inventories, this was entered in the margins of Inv. 1859.

Column 12 (Cats. 1863-1916)
Catalogues of the Picture Gallery of the Hermitage were published regularly during the period 1863 to 1916, but these covered only the paintings on display in the galleries themselves. The same numbers were used for each painting throughout all these catalogues, which were produced in two editions, one in Russian, one in French.

Column 13 (Boydell 2 vols.)
Some of the paintings at Houghton were for John Boydell's two-volume publication, A Set of Prints Engraved After the Most Capital Paintings in the Collection of Her Imperial Majesty the Empress of Russia, Lately in the Possession of the Earl of Orford at Houghton in Norfolk, 1788; Boydell 1788).

Column 14 (Directory)
Refers to Appendix I, which provides information about the collectors, agents and dealers through whom the works acquired by Sir Robert Walpole had already passed.

Current Attribution [H.W. Attribution]	Present Title [H.W. Title]	Cat. No.	Aedes No.	Aedes Room	Present Location	Location in 1736 (Appendix III)	1778 Valuation (Catherine II)	Cat. 1773-85	Cat. 1797	Inv. 1859	Cats. 1863-1916	Boydell 2 vols.	Directory (Appendix I)
ALBANI, Francesco [Albano]	The Annunciation [The Salutation]	1	276	Gallery	SHM 86	Downing St – Sir Robert's Dressing Room (no. 175)	£200	2230		2287	202		
ALBANI, Francesco [Albano]	The Baptism of Christ [Christ baptised by St John]	2	82	Salon	SHM 29	Houghton – Saloon (no. 1)	£700	2319	3875	2183	203		Law
Albani, Francesco: see also UNIDENTIFIED													
Bandinelli, Baccio: see VITTORIA													
BAROCCI, Federico [Baroccio]	The Virgin and Child [The Virgin and Child]	3	149	Cabinet	Whereabouts unknown	Downing St – Sir Robert's Dressing Room (no. 178)	£50	2236					
BASSANO, Francesco [Leonardo Bassan]	Summer [A Summer-Piece]	4	142	Cabinet	SHM 232	Downing St – End Room Below (no. 156)	£200 (with cat. no. 5)	2253	464	4609	161		Phélypeaux
BASSANO, Francesco [Giacomo Bassan]	Winter [A Winter-Piece]	5	141	Cabinet	SHM 233	Downing St – End Room Below (no. 155)	£200 (with cat. no. 4)	2252	465	4626			Phélypeaux
BASSANO, workshop of [Giacomo Bassan]	The Entombment [Christ laid in the Sepulchre]	6	161	Cabinet	SHM 1573	Bought in or shortly after 1736 (no. 433)	£40	2309	2437	248	166		Waldegrave
BEALE, Mary, studio of [unidentified]	Anne Spelman, née Walpole [Anne Walpole]	206	17	Supping Parlour	Houghton	Houghton – Supping Parlour (nos. 110, 111, 112, 113)							
BEALE, Mary, studio of [unidentified]	Dorothy Walpole [Dorothy Walpole]	207	18	Supping Parlour	Houghton	Houghton – Supping Parlour (nos. 110, 111, 112, 113)							
BEALE, Mary, attributed [unidentified]	Elizabeth Hoste, née Walpole [Elizabeth Walpole]	209	20	Supping Parlour	Houghton	Houghton – Supping Parlour (nos. 110, 111, 112, 113)							
Bellini, Giovanni: see UNIDENTIFIED													
BENFATTO DAL FRISO, Alvise [Paul Veronese]	Pentecost [The Apostles after the Ascension]	7	196	Marble Parlour	SHM 152	Grosvenor St – Parlour (no. 293)	£200 (with cat. no. 87)	2322	402	2440			
BERRETTONI, Niccolò [Nicholo Beretoni]	The Assumption of the Virgin [The Assumption of the Virgin]	8	112	Carlo Maratt Room	SHM 2654	Houghton - Green Velvet Drawing Room (no. 28)	£80	2261	3499	7247	II. 46		
BERRETTONI, Niccolò [Nicholo Beretoni]	The Virgin and Child with SS Elizabeth, John the Baptist and Joseph [The Holy Family]	9	111	Carlo Maratt Room	Tsarskoye Selo 155–X	Houghton - Green Velvet Drawing Room (no. 29)	£200	2338	2415	4515	I.44		
BOL, Ferdinand [Boll]	An Old Woman with a Book [An old Woman reading]	146	239	Gallery	SHM 763	Downing St - Great Room above Stairs (no. 184)	£200 (with cat. no. 144) No price marked in Christie's Sale List	2335	1358	1379	854	I. 26	Bentinck /Howard
BORDONE, Paris [Julio Romano]	Augustus and the Sibyl [Architecture]	10	237	Gallery	GMII 4354	Downing St - End Room Below (no. 158)	£300	2314	623	5755			Churchill?
BORDONE, Paris [Paris Bourdon]	Venus, Flora, Mars and Cupid [Two Women, an Emblematical Picture]	11	253	Gallery	SHM 163	Houghton – Marble Parlour (no. 57)	£200	2325	680	2467	1846		Flinck
Boulogne, John of, see LE SUEUR													
BOURDON, Sebastien [Sebastian Bourdon]	Jacob Burying Laban's Images [Laban searching for his Images]	158	169	Cabinet	SHM 3682	Grosvenor St – Back Parlour (no. 313)	£200	2249	1747	8313	II. 42		
BOURDON, Sebastien [Sebastian Bourdon]	The Massacre of the Innocents [the Murder of the Innocents]	159	187	Cabinet	SHM 1223	Grosvenor St – Back Parlour (no. 315)	£400	2254	1732	3406	1419		
Bourguignon, Le, see COURTOIS													
BRIL, Paul [Paul Brill, the Figures by Dominichini]	Landscape with Nymphs at Rest [Europa, a Landscape]	96	244	Gallery	GMII 324	Bought in or shortly after 1736 (no. 442)	£300 (with cat. no. 56)	2303	25	3607	I. 10		Verrue

Current Attribution [H.W. Attribution]	Present Title [H.W. Title]	Cat. No.	Aedes No.	Aedes Room	Present Location	Location in 1736 (Appendix III)	1778 Valuation (Catherine II)	Cat. 1773-85	Cat. 1797	Inv. 1859	Cats. 1863-1916	Boydell 2 vols.	Directory (Appendix I)
BRIL, Paul, circle of [Paul Brill, the Figures by Dominichini]	Landscape with Exotic Beasts [Africa]	97	245	Gallery	SHM 1827	Bought in or shortly after 1736 (no. 443)	£300 (with cat. no. 55)	2304	24	1608		I. 11	Verrue
BRUEGHEL, Jan, I [Velvet Brueghel]	The Adoration of the Magi [The Adoration of the Magi]	95	148	Cabinet	SHM 3090		£100	2260	3752	7621			
CALIARI, Benedetto [Paul Veronese]	Dives and Lazarus [Dives and Lazarus]	12	246	Gallery	Provincial Russian Museum	Downing St - Sir Robert's Dressing Room (no. 164)	£100	2395	633	2474			Fleuriau
CAMPIDOGLIO, Michele Pace del [Michael Angelo Campidoglio]	Still Life with Grapes [Two Fruit-pieces]	58	193	Marble Parlour	SHM 2486	Downing St – Great Room above Stairs (nos. 188, 189)	no extra price	2344	1173	1721	143	I. 41	Scawen
CAMPIDOGLIO, Michele Pace del [Michael Angelo Campidoglio]	Still Life with Melon [Two Fruit-pieces]	59	194	Marble Parlour	SHM 2485	Downing St – Great Room above Stairs (nos. 188, 189)	no extra price	2345	1172	1722		II. 45	Scawen
CANO, Alonso, attributed to [Velasco]	The Death of St Joseph [the Death of Joseph]	181	188	Cabinet	SHM 1466	Downing St – Lady Walpole's Drawing Room (no. 203)	£200	2257	591	2092		II. 14	
CANTARINI, Simone [Cantarini]	Apollo [Apollo]	13	272	Gallery	SHM 2089	Houghton – little Breakfast Room (no. 98)	£50	2348	2882	4509		II. 55	
CANTARINI, Simone [Cantarini]	The Holy Family with the Infant John the Baptist and St Elisabeth [The Holy Family in a Round]	14	86	Salon	GMII 37	Downing St - Great Middle Room below (no. 136)	£300	2403	641	2245	196		
CARRACCI, Agostino [Ludovico Caracci]	Pietà with Saints [The placing Christ in Sepulchre]	15	260	Gallery	SHM 1489	Downing St - End Room Below (no. 147)	£300	2353	6926	2215	166	I. 6	
CARRACCI, Agostino [Augustine Caracci]	The Virgin with the Christ Child Asleep in her Arms [The Virgin with the Child asleep in her Arms]	16	89	Salon	Whereabouts unknown	Downing St – End Room Below (no. 148)	£200	2402					
CARRACCI, Annibale, circle of [Annibal Caracci]	Sleeping Venus [Naked Venus Sleeping]	17	150	Cabinet	SHM 146	Downing St – Sir Robert's Dressing Room (no. 179)	£70	2307	446	2427	177	II. 65	
CARRIERA, Rosalba [Rosalba]	Apollo [Apollo, in Crayons]	18	117	Carlo Maratt Room	SHM OR 17961	Downing St – Great Middle Room below (no. 137)	£80 (with cat. no. 19)	2419				II. 44	
CARRIERA, Rosalba [Rosalba]	Diana [Diana]	19	118	Carlo Maratt Room	SHM OR 17960	Downing St – Great Middle Room below (no. 138)	£80 (with cat. no. 18)	2420				II. 43	
CARRIERA, Rosalba [Rosalba]	Robert Walpole [Robert Lord Walpole]	210	72	Drawing Room	Houghton	Downing St – Lady Walpole's Drawing Room (no. 193)							
CARRIERA, Rosalba [Rosalba]	Edward Walpole [Edward Walpole]	211	73	Drawing Room	Houghton	Downing St – Lady Walpole's Drawing Room (no. 194)							
CARRIERA, Rosalba [Rosalba]	Horace Walpole [Horace Walpole]	212	74	Drawing Room	Houghton								
?CASTELLO, Valerio or ?CASTIGLIONE, Giovanni [Valerio Castelli]	The Holy Family with Angels [The Holy Family, with Angels]	20	273	Gallery	Whereabouts unknown		£200	2231	656	4472			Cock/ Horace Walpole
Castiglione, Giovanni, see CASTELLO; VASSALLO													
CHIARI, Giuseppe Bartolomeo [Gioseppe Chiari]	Bacchus and Ariadne [Bacchus and Ariadne]	21	116	Carlo Maratt Room	SHM 7495	Houghton – Green Velvet Drawing Room (no. 35)	£450 (with cat. nos. 22, 23, 24)	2391	2406	2648	71		
CHIARI, Giuseppe Bartolomeo [Gioseppe Chiari]	Apollo and Daphne [Apollo and Daphne]	22	115	Carlo Maratt Room	Perm 40	Houghton - Green Velvet Drawing Room (no. 34)	£450 (with cat. nos. 21, 23, 24)	2390	2432	2650	73		

Current Attribution [H.W. Attribution]	Present Title [H.W. Title]	Cat. No.	Aedes No.	Aedes Room	Present Location	Location in 1736 (Appendix III)	1778 Valuation (Catherine II)	Cat. 1773-85	Cat. 1797	Inv. 1859	Cats. 1863-1916	Boydell 2 vols.	Directory (Appendix I)
CHIARI, Giuseppe Bartolomeo [Gioseppe Chiari]	The Pool of Bethesda [The Pool of Bethesda]	23	113	Carlo Maratt Room	Whereabouts unknown	Houghton - Green Velvet Drawing Room (no. 33)	£450 (with cat. nos. 21, 22, 24)	2388	2433	2644	67		
CHIARI, Giuseppe Bartolomeo [Gioseppe Chiari]	Christ's Sermon on the Mount [Christ's Sermon on the Mount]	24	114	Carlo Maratt Room	Sevastopol 227	Houghton - Green Velvet Drawing Room (no. 32)	£450 (with cat. nos. 21, 22, 23)	2389	2707	2647	70		
CIGNANI, Carlo [Carlo Cignani]	Shepherd and Shepherdess [A Nymph and Shepherd]	25	252	Gallery	SHM 7009	Houghton - Marble Parlour (no. 58)	£200	2320	640			I. 18	
CIGNANI, Carlo [Carlo Cignani]	The Adoration of the Shepherds [The Nativity]	26	39	Common Parlour	Tsarskoye Selo 197-X	Houghton – Common Parlour (no. 62)	£250	2311	2447			II. 17	
Claude, see GELLEE													
CODAZZI, Viviano [Viviano]	Architectural Fantasy with a Scene of Christ Healing the Man Possessed of Devils [Two Pieces of Ruins]	27	55	Common Parlour	Whereabouts unknown	Downing St – End Room Below (nos. 159, 160)	£40 (with cat. no. 28)	2399	33	5326			
CODAZZI, Viviano [Viviano]	Architectural Fantasy with a Scene of Feasting [Two Pieces of Ruins]	28	54	Common Parlour	Whereabouts unknown	Downing St - End Room Below (nos. 159, 160)	£40 (with cat. no. 27)	2398	30	5320			
CONCA, Sebastiano [Sebastian Concha]	The Virgin with the Child in her Arms Asleep [The Virgin with the Child in her Arms asleep]	29	167	Cabinet	SHM 2256	Downing St - Lady Walpole's Drawing Room (no. 216)	£20	2229	2270			II. 31	
CORTONA, Pietro da [Pietro da Cortona]	The Appearance of Christ to Mary Magdalene [Christ appearing to Mary in the Garden]	30	144	Cabinet	SHM 166	Houghton – Green Velvet Drawing Room (no. 25)	£200	2306	564	2470	280	II. 25	
CORTONA, Pietro da [Pietro da Cortona]	The Return of Hagar [Abraham, Sarah, and Hagar]	31	254	Gallery	GMII 135	Houghton - Yellow Drawing Room (no. 85)	£1000	2318	386	2587		I. 27	Hay
COURTOIS, Jacques [Bourgognone]	Cavalry Battle [Its Companion]	160	158	Cabinet	SHM 1752	Downing St - Lady Walpole's Drawing Room (nos. 207, 208)	£50	2352	2514	3317	1533		
COURTOIS, Jacques [Bourgognone]	Battlefield [A dying Officer at Confession]	161	157	Cabinet	SHM 1182	Downing St - Lady Walpole's Drawing Room (nos. 207, 208)	£100	2351	1916	3351	1532		
COURTOIS, Jacques [Bourgognone]	Landscape with a Rider [A Landskip with Figures]	162	182	Cabinet	SHM 1669	Downing St - Great Middle Room below (nos. 141, 142)	£100 (with cat. no. 163)	2280	2497	2876		I. 35	
COURTOIS, Jacques [Bourgognone]	View of the Seashore [Its Companion with Soldiers]	163	183	Cabinet	Whereabouts unknown	Downing St – Great Middle Room below (nos. 141, 142)	£100 (with cat. no. 162)	2279	2498	2877		I. 36	
DAHL, Michael [Dahl]	Catherine Shorter, later Lady Walpole [Catharine Shorter]	213	57	Little Bed Chamber	Houghton	Houghton – Little Bed-chamber (no. 75)							
DOBSON, William [Dobson]	Portrait of Abraham van der Doort [Head of Dobson's Father]	193	151	Cabinet	SHM 2103	Downing St – Sir Robert's Dressing Room (no. 172)	£25	2284	282	4197	1387	I. 30	
DOLCI, Carlo [Carlo Dolci]	Head of a Young Man (Boy?) [St John, a Head]	32	152	Cabinet	Whereabouts unknown	Chelsea – Lady Walpole's Drawing Room (no. 428)	£70	2379	526			II. 13	Richardson
Domenichino: see BRIL; SASSOFERRATO													
DUGHET, Gaspard [Gaspar Poussin]	Wooded Landscape [Two Landscapes]	164	269	Gallery	SHM 1205	Downing St – End Room below (nos. 153, 154)	£250 (with cat. no. 165)	2343	2440	3372	1427	I. 19	Mari/ Edwin
DUGHET, Gaspard [Gaspar Poussin]	Landscape with a Fisherman [Two Landscapes]	165	270	Gallery	SHM 1248	Downing St - End Room below (nos. 153, 154)	£250 (with cat. no. 164)	2342	2441	3436	1423	I. 20	Mari/ Edwin
DUGHET, Gaspard [Gaspar Poussin]	Landscape with a cascade and sheep [A Landscape with a Cascade and Sheep]	166	264	Gallery	SHM 1206		£100	2410	2187	3375	1426	II. 41	Charles Montagu/ Ellys

Current Attribution [H.W. Attribution]	Present Title [H.W. Title]	Cat. No.	Aedes No.	Aedes Room	Present Location	Location in 1736 (Appendix III)	1778 Valuation (Catherine II)	Cat. 1773-85	Cat. 1797	Inv. 1859	Cats. 1863-1916	Boydell 2 vols.	Directory (Appendix I)
DUGHET, Gaspard [Gaspar Poussin]	Landscape with a Road (Landscape with the ruins of the Baths of Caracalla) [Two small Landskips]	167	184	Cabinet	SHM 1192	Downing St – Great Middle Room below (no. 139)	£40 (with cat. no. 168)	2247	1716	3347	1424	I. 51	
DUGHET, Gaspard [Gaspar Poussin]	A Small Town in Latium [Two small Landskips]	168	185	Cabinet	GMII 900	Downing St – Great Middle Room below, (no. 140)?	£40 (with cat. no. 167)	2246	?1715			I. 52	
DYCK, Anthony van, and workshop [Vandyke]	King Charles I [King Charles I]	98	65	Drawing Room	SHM 537	Grosvenor St – Great Room above (no. 328)	£400 (with cat. no. 100)	2368	1337	3041	609	II. 67	Wharton
DYCK, Anthony van, and workshop [Vandyke]	Queen Henrietta Maria [Henrietta Maria of France]	99	66	Drawing Room	SHM 541	Grosvenor St – Great Room above (no. 329)	£400 (with cat. no. 99)	2369	1244	3047	610	II. 68	Wharton
DYCK, Anthony van [Vandyke]	Sir Thomas Chaloner [Sir Thomas Chaloner]	100	40	Common Parlour	SHM 551	Houghton – Little Bed-chamber (no. 76)	£200	2355	1324	3061	620	I. 47	
DYCK, Anthony van [Vandyke]	Henry Danvers, Earl of Danby [Henry Danvers Earl of Danby]	101	191	Marble Parlour	SHM 545	Houghton – Corner Drawing Room (no. 50)	£200	2370	1306	3052	615	I. 4	Danvers
DYCK, Anthony van [Vandyke]	Lady Jane Goodwin [Jane Daughter of Lord Wenman]	102	71	Drawing Room	SHM 549	Houghton – Common Parlour (no. 70)	£100	2365	1077	3057	619	II. 12	Wharton
DYCK, Anthony van [Vandyke]	Inigo Jones [Inigo Jones]	103	51	Common Parlour	SHM 557	Bought In or shortly after 1736 (no. 438)	£50	2292	3212	3074	626	I. 16	
DYCK, Anthony van, and workshop [Vandyke]	Sir Rowland Wandesford [Lord Chief Baron Wandesford]	105	69	Drawing Room	SHM 531	Houghton – Corner Drawing Room (no. 53)	£150	2373	1076	3029	621	I. 50	Wharton
DYCK, Anthony van [Vandyke]	Philadelphia and Elizabeth Wharton [two Daughters of Lord Wharton]	107	62	Drawing Room	SHM 533	Houghton – Yellow Drawing room (no. 82)	£200	2372	1205	3057	619	II. 69	Wharton
DYCK, Anthony van [Vandyke]	Philip, Lord Wharton [Philip Lord Wharton]	108	68	Drawing Room	Washington 1937.I.50	Houghton – Corner Drawing Room (no. 54)	£200	2366		3066	616		Wharton
DYCK, Anthony van [Vandyke]	Sir Thomas Wharton [Sir Thomas Wharton]	109	192	Marble Parlour	SHM 547	Houghton – Corner Drawing Room (no. 51)	£200	2371	1275	3054	617	I. 3	Wharton
DYCK, Anthony van, and workshop [Vandyke]	Lady Philadelphia Wharton [Lady Wharton]	106	70	Drawing Room	Whereabouts unknown	Houghton – Common Parlour (no. 71)	£100	2367		3065		II. 23	Wharton
DYCK, Anthony van, workshop [Vandyke]	Archbishop William Laud [Archbishop Laud]	104	67	Drawing Room	SHM 1698	Houghton – Corner Drawing Room (no. 52)	no extra price	2363	?2755	3051	612	II. 11	Wharton
DYCK, Anthony van, and VOS, Pauwel de [Vandyke]	The Rest on the Flight into Egypt [The Holy Family]	110	84	Salon	SHM 539	Downing St – Great Middle Room below (no. 133)	£1600	2285	1290	3043	603	II. 64	Ellys
DYCK, Anthony van: see also RUBENS													
ELLYS, John [Ellis]	Fulke Harold, The Gardener [Mr Harold]	214	9	Breakfast Room	Houghton	Houghton – little Breakfast Room (no. 99?)							
ELSHEIMER, Adam [Elsheimer]	Saint Christopher [Saint Christopher]	188	189	Cabinet	SHM 694		£50	2242	237	4781	1984		Bedingfield
Fiori, see SNYDERS													
FLORENTINE WORK-SHOP, after Giovanni Bologna [Giambologna]	Rape of the Sabine Woman [Bronze of a Man and Woman]	266	79	Salon	Houghton								Mann
GELLEE, Claude [Claude Lorrain]	Morning in the Harbour [A Sea-port]	169	267	Gallery	SHM 1243	Downing St – Sir Robert's Dressing Room (no. 165)	£1200 (with cat. no. 170)	2336	2430	3440	1437	I. 9	Fleuriau
GELLEE, Claude [Claude Lorrain]	Landscape with Apollo and the Cumaean Sibyl [A calm Sea]	170	268	Gallery	SHM 1228	Downing St – Sir Robert's Dressing Room (no. 166)	£1200 (with cat. no. 169)	2337	2434	3414	1432		Mari/ Edwin

Current Attribution [H.W. Attribution]	Present Title [H.W. Title]	Cat. No.	Aedes No.	Aedes Room	Present Location	Location in 1736 (Appendix III)	1778 Valuation (Catherine II)	Cat. 1773–85	Cat. 1797	Inv. 1859	Cats. 1863–1916	Boydell 2 vols.	Directory (Appendix I)
Giambologna: see FLORENTINE													
GIORDANO, Luca [Luca Jordano]	Vulcan's Forge [The Cyclops at their Forge]	33	94	Salon	SHM 188	Houghton – Saloon (no. 5)	£200	2404	826	2610	1638	II. 66	Gibbons
GIORDANO, Luca [Luca Jordano]	Sleeping Bacchus [A sleeping Bacchus, with Nymphs, Boys and Animals]	34	64	Drawing Room	SHM 197	Houghton – Yellow Drawing Room (no. 84)	£500 (with cat. no. 35)	2272	2485	2684	293	II. 2	
GIORDANO, Luca [Luca Jordano]	The Judgment of Paris [The Judgment of Paris]	35	63	Drawing Room	SHM 9965	Houghton – Yellow Drawing Room (no. 83)	£500 (with cat. no. 34)	2271	2528	2689	294	II. 1	
GIORDANO, Luca, copy after [Luca Jordano]	The Presentation of the Virgin in the Temple [The Presentation of the Virgin in the Temple]	36	122	Carlo Maratt Room	SHM 1609	Houghton – Green Velvet Drawing Room (no. 30)	£60 (with cat. no. 37)	2295	562	2687			Van Huls
GIORDANO, Luca, copy after [Luca Jordano]	The Birth of the Virgin [The Birth of the Virgin]	37	121	Carlo Maratt Room	Whereabouts unknown	Houghton – Green Velvet Drawing Room (no. 31)	£60 (with cat. no. 36)	2294	561	2685			Van Huls
GIRARDON, François [Girardon]	The Laocoon [Laocoon, a fine Cast in Bronze]	249	199	Hall	Houghton								Robert Walpole
GOUSSE, Thomas ? [Le Soeur]	The Stoning of St Stephen [The Stoning of St Stephen]	171	83	Salon	SHM 1170	Houghton – Saloon (no. 2)	£500	2270	3823	3303	1449	II. 38	
GRIFFIER, Jan I [Old Griffier]	Sea Port [a Sea-port]	147	128	Velvet Bed Chamber	Pavlovsk 3743-III	Houghton - Green Velvet Bedchamber (over door) (no. 39)	no extra price	2329	3164	4554			Jan Griffier I
GRIFFIER, Jan I [Old Griffier]	Landscape with Ruins [A Landscape]	148	129	Velvet Bed Chamber	Pavlovsk 3744-III	Houghton - Green Velvet Bedchamber (over door) (no. 40)	no extra price	2330	3165				Jan Griffier I
HALS, Frans [Francis Halls]	Portrait of a Young Man [Francis Halls, a head by himself]	149	44	Common Parlour	Washington 1937.1.71	Chelsea - Lady Walpole's Drawing Room (no. 430)	£40	2356	1260	4118	770	I. 39	
HOLBEIN, Hans, copy after [Holbein]	Portrait of Erasmus [Erasmus]	192	42	Common Parlour	Whereabouts unknown	Houghton – little Breakfast Room (no. 97)	£40		?38	3455			
Holbein: see also UNIDENTIFIED													
HUYSUM, Jan van [Van Huysum]	Flowers [Two Flower-pieces]	150	178	Cabinet	SHM 1051	Houghton - Green Velvet Drawing Room (no. 36)	£1200 (with cat. no. 151)	2225	1452	2984	1379	I. 59	
HUYSUM, Jan van [Van Huysum]	Flowers and Fruits [Two Flower-pieces]	151	179	Cabinet	SHM 1049	Houghton - Green Velvet Drawing Room (no. 37)	£1200 (with cat. no. 150)	2224	1453	2982	1378	I. 60	
JERVAS, Charles, attributed [Jervase]	Dogs and Still Life [Dogs, and Still Life]	194	133	Dressing Room	SHM 635	Houghton - Drawing Room with the Vandyke Hangings (nos. 43, 44)	no extra price	2327	3133	3535	1325	I. 37	
JERVAS, Charles, attributed [Jervase]	Deer, Dog and Cat [Its Companion]	195	134	Dressing Room	SHM 634	Houghton - Drawing Room with the Vandyke Hangings (nos. 44, 43)	no extra price	2328	3134	3534	1326	I. 38	
JERVAS, Charles [Jervase]	Sir Robert Walpole [Sir Robert Walpole]	215	12	Supping Parlour	Houghton	Houghton - Supping Parlour (no. 105)							
JERVAS, Charles [Jervase]	Catherine Shorter, Lady Walpole [Catharine Lady Walpole]	216	13	Supping Parlour	Houghton	Houghton – Supping Parlour (no. 106)							
JERVAS, Charles [Jervase]	Dorothy, Lady Townshend [Dorothy, his second Wife]	217	16	Supping Parlour	Houghton	Houghton – Supping Parlour (no. 109)							
JERVAS, Charles [Jervase]	Mary Walpole, Viscountess Malpas [Mary Lady Viscountess Malpas]	218	75	Drawing Room	Houghton	Downing St – Lady Walpole's Drawing Room (no. 196)							
JORDAENS, Jacob [Jordano of Antwerp]	Self-portrait with Parents, Brothers and Sisters [Rubens's Family]	111	140	Cabinet	SHM 484	Downing St – Great Room above Stairs (no. 181)	£400	2347	1338	3069	652	II.19	Bentinck

Current Attribution [H.W. Attribution]	Present Title [H.W. Title]	Cat. No.	Aedes No.	Aedes Room	Present Location	Location in 1736 (Appendix III)	1778 Valuation (Catherine II)	Cat. 1773-85	Cat. 1797	Inv. 1859	Cats. 1863-1916	Boydell 2 vols.	Directory (Appendix I)
KNELLER, Godfrey [Sir Godfrey Kneller]	King William III [King William…Sketch]	196	30	Common Parlour	Disappeared from Gatchina	Houghton – little Breakfast Room (no. 93)	no extra price	2406	2877	4310			
KNELLER, Godfrey [Sir Godfrey Kneller]	The Poet Joseph Carreras [Joseph Carreras, a Spanish Poet, writing]	198	46	Common Parlour	Houghton	Grosvenor St - Drawing Room (no. 347)	no extra price	2235	39			I. 15	
KNELLER, Godfrey [Sir Godfrey Kneller]	Grinling Gibbons [Gibbins…a Portrait of him]	199	29	Common Parlour	SHM 1346	Houghton – Common Parlour (no. 61)	no extra price	2364	1349	4464	388		
KNELLER, Godfrey [Sir Godfrey Kneller]	Portrait of John Locke [Mr Locke, a Head]	200	50	Common Parlour	SHM 1345	?Grosvenor St - Drawing Room (?no. 346)	no extra price	2357	2709	4430	1388		Geekie
KNELLER, Godfrey [Sir Godfrey Kneller]	Charles, 2nd Viscount Townshend [Charles Lord Viscount Townshend]	219	15	Supping Parlour	Houghton	Houghton – Supping Parlour (no. 108)							
KNELLER, Godfrey [Sir Godfrey Kneller]	George I [King George I]	220	56	Library	Houghton	Houghton – Library (no. 74)							
KNELLER, Godfrey, and WOOTTON, John [Sir Godfrey Kneller … Wootton]	King George I [King George the First]	197	31	Common Parlour	Disappeared from Gatchina	Houghton – little Breakfast Room (no. 102)	no extra price	2407	1592	4311			
LAURI, Filippo [Philippo Laura]	The Appearance of Christ to Mary Magdalene [Christ and Mary in the Garden]	38	180	Cabinet	SHM 1514	Downing St – Closet (no. 261)	£100	2310	472	2321	311	II. 59	
LE MAIRE, Jean [Le Mer]	Alexander Adorning the Tomb of Achilles [Alexander adorning the Tomb of Achilles]	174	127	Velvet Bed Chamber	Tsarskoye Selo 204 X	Houghton – Green Velvet Bedchamber (no. 38)	no extra price	2415	2855	5861			
LE MAIRE, Jean [Le Mer]	Consulting the Sybilline Oracles [the consulting the Sibylline Oracles]	175	132	Dressing Room	Tsarskoye Selo 205 X	Houghton – Drawing Room with the Vandyke Hangings (no. 42)	no extra price	2416	2856	5855			
LE SUEUR, Hubert [John of Boulogne]	The Borghese Gladiator [Cast in Bronze of the Gladiator]	248	28	Stairs	Houghton								Herbert
LEBRUN, Charles [Le Brun]	Daedalus and Icarus [Doedalus and Icarus]	172	95	Salon	SHM 40	Houghton – Saloon (no. 6)	£150	2313	2782	2201	235	II. 10	
Lebrun, Charles: see also RAPHAEL													
LELY, Peter [Sir Peter Lely]	Anne Lee, later Lady Wharton [a Daughter of Sir Henry Lee]	221	52	Common Parlour		Houghton – Common Parlour (no. 72)						I. 33	Wharton
LELY, Peter [Sir Peter Lely]	Jenny Dering [Mrs. Jenny Deering]	222	53	Common Parlour		Houghton – Common Parlour (as Lely) (no. 73)						II. 63	Wharton
LEONARDO da Vinci, follower of [Lionardo da Vinci]	Female Nude (Donna Nuda) [The Joconda, a Smith's Wife]	39	271	Gallery	SHM 110	Downing St - End Room Below (no. 150)	£100	2236	114	2335	15	I. 7	Fleuriau
LESUEUR, Eustache [Le Soeur]	The Exposition of Moses [Moses in the Bulrushes]	173	261	Gallery	SHM 1251	Chelsea – Hall (no. 411)	£150	2283	852	3439	1444	II. 9	Montagu
LUTI, Benedetto [Cavalier Luti]	Boy with a Flute [A Boy's Head with a Lute]	40	154	Cabinet	SHM 131	Chelsea – Lady Walpole's Drawing Room (no. 427)	£20	2378	527	2389	289	II. 15	
MARATTI, Carlo [Carlo Maratti]	Pope Clement IX [Clement the Ninth]	41	99	Carlo Maratt Room	SHM 42		£250	2219	2401	2204	307	II. 24	Pallavicini/ Arnaldi/ Jervas
MARATTI, Carlo [Carlo Maratti]	The Virgin and Child with John the Baptist [The Holy Family, an unfinish'd Picture]	43	102	Carlo Maratt Room	SHM 1560	Houghton – Green Velvet Drawing Room (no. 14)	£80	2346	2373	2443	302		
MARATTI, Carlo [Carlo Maratti]	The Virgin Teaching Jesus to Read [The Virgin teaching Jesus to read]	44	103	Carlo Maratt Room	SHM 1500	Houghton – Green Velvet Drawing Room (no. 16)	£200	2265	651	2310	306		Pallavicini/ Arnaldi

Current Attribution [H.W. Attribution]	Present Title [H.W. Title]	Cat. No.	Aedes No.	Aedes Room	Present Location	Location in 1736 (Appendix III)	1778 Valuation (Catherine II)	Cat. 1773-85	Cat. 1797	Inv. 1859	Cats. 1863-1916	Boydell 2 vols.	Directory (Appendix I)
MARATTI, Carlo [Carlo Maratti]	St Cecilia with Angels [St Caecilia with four Angels playing on musical Instruments]	45	104	Carlo Maratt Room	Alupka 86	Houghton – Green Velvet Drawing Room (no. 17)	£260	2266	652	2264			Pallavicini/ Arnaldi
MARATTI, Carlo [Carlo Maratti]	The Assumption of the Virgin [The Assumption of the Virgin]	46	105	Carlo Maratt Room	SHM 1544	Houghton – Green Velvet Drawing Room (no. 15)	£100	2264	2451	2403			
MARATTI, Carlo [Carlo Maratti]	The Vision of Joachim and Anna [Two Saints worshipping the Virgin in the clouds]	48	108	Carlo Maratt Room	SHM 8724	Houghton – Green Velvet Drawing Room (no. 20)	£60	2262	657	129		II. 62	Pallavicini/ Arnaldi
MARATTI, Carlo [Carlo Maratti]	St John the Evangelist (St John's Vision on Patmos) [St John the Evangelist]	49	109	Carlo Maratt Room	Alupka 527	Houghton – Green Velvet Drawing Room (no. 21)	£60	2263	3498	7246		II. 61	Pallavicini/ Arnaldi
MARATTI, Carlo [Carlo Maratti]	Acis and Galatea [Galatea sitting with Acis, Tritons and Cupids]	50	101	Carlo Maratt Room	Khabarovsk 617	Houghton – Green Velvet Drawing Room (no. 13)	£500 (with cat. no. 51)	2382	2410	5828			Pallavicini/ Arnaldi
MARATTI, Carlo [Carlo Maratti]	The Judgment of Paris [The Judgment of Paris]	51	100	Carlo Maratt Room	Tsarskoye Selo 820-X	Houghton – Green Velvet Drawing Room (no. 12)	£500 (with cat. no. 50)	2381	2425	5543			Pallavicini/ Arnaldi
MARATTI, Carlo [Carlo Maratti]	The Mystic Marriage of St Catherine [The Marriage of St Catharine]	52	107	Carlo Maratt Room	Whereabouts unknown	Houghton – Green Velvet Drawing Room (no. 19)	£100	2267					Pallavicini/ Arnaldi
MARATTI, Carlo [Carlo Maratti]	Venus and Cupid [A naked Venus and Cupid]	53	110	Carlo Maratt Room	Whereabouts unknown	Houghton – Green Velvet Drawing Room (no. 22)	£150	2331	2409			II. 8	
MARATTI, Carlo, copy after or studio [Carlo Maratti]	The Adoration of the Magi [The Adoration of the Magi]	47	262	Gallery	SHM 2657	Houghton – Green Velvet Drawing Room (no. 11)	£300	2583	3503	7250			
MARATTI, Carlo? [Carlo Maratti]	The Holy Family Beneath a Palm Tree [The Virgin and Joseph with a young Jesus]	42	106	Carlo Maratt Room	Palekh 68	Houghton – Green Velvet Drawing Room (no. 18)	£150	2268	653	2377	300	II. 47	

Mario de' Fiori: see SNYDERS

Massys, Quintin: see REYMERSWALE

Current Attribution [H.W. Attribution]	Present Title [H.W. Title]	Cat. No.	Aedes No.	Aedes Room	Present Location	Location in 1736 (Appendix III)	1778 Valuation (Catherine II)	Cat. 1773-85	Cat. 1797	Inv. 1859	Cats. 1863-1916	Boydell 2 vols.	Directory (Appendix I)
MICHELANGELO Buonarotti, copy after [Michael Angelo Buonarotti]	The Rape of Ganymede [The Eagle and Ganymede]	54	274	Gallery	SHM 2064	Houghton – Common Parlour (no. 63)	£100	2305	3829				
MIEL, Jan [John Miel]	Bivouac [Its Companion]	112	156	Cabinet	Gatchina 1600-III	Downing St – Lady Walpole's Drawing Room (no. 198)	£120 (with cat. no. 114)	2234	1867	1543		II. 27	
MIEL, Jan [John Miel]	The Charity of St Anthony [Friars giving Meat to the Poor]	113	155	Cabinet	Peterhof 664	Downing St – Lady Walpole's Drawing Room (no. 197)	£120 (with cat. no. 113)	2233	2155	511			
MOLA, Pier Francesco [Mola]	Horatio Cocles Holding the Sublicius Bridge [Horatius Cocles defending the Bridge]	55	235	Gallery	Academy of Arts 63	Downing St – Great Room above Stairs (no. 183)	£400	2278	380	5797			Gibbons
MOLA, Pier Francesco [Mola]	Marcus Curtius Leaping into the Gulf [Marcus Curtius leaping into the Gulph]	56	234	Gallery	Academy of Arts 62	Downing St – Great Room above Stairs (no. 182)	£400	2277	382	5798			Gibbons
MOR, Anthonis van Dashort [Antonio More]	Portrait of a Man (Sir John Gresham) [Sir Thomas Gresham]	114	41	Common Parlour	GMII 2611	Chelsea – Best Drawing Room (no. 371)	£40	2269	156	3546	482	II. 6	
MORETTO DA BRESCIA, Alessandro Bonvicino? [Titian]	A Boy with his Nurse [An old Woman giving a Boy Cherries]	57	90	Salon	SHM 182	Grosvenor St – Bedchamber (no. 349)	£100	2385	414	2568	1636	I. 58	Mari

Current Attribution [H.W. Attribution]	Present Title [H.W. Title]	Cat. No.	Aedes No.	Aedes Room	Present Location	Location in 1736 (Appendix III)	1778 Valuation (Catherine II)	Cat. 1773-85	Cat. 1797	Inv. 1859	Cats. 1863-1916	Boydell 2 vols.	Directory (Appendix I)
MURILLO, Bartolome Esteban [Morellio]	The Immaculate Conception [The Assumption of the Virgin]	182	92	Salon	SHM 387	Houghton – Saloon (no. 3)	£700	2316	409	2709	371	I. 25	
MURILLO, Bartolome Esteban [Morellio]	The Adoration of the Shepherds [The Adoration of the Shepherds]	183	93	Salon	SHM 316	Houghton – Saloon (no. 4)	£600	2317	408	2030	363	I. 24	
MURILLO, Bartolome Esteban [Morellio]	The Virgin and Child [The Virgin with the Child in her Arms]	184	166	Cabinet	Disappeared from Gatchina		£80	2282	535				Sir Benjamin Keene
MURILLO, Bartolome Esteban [Morellio]	The Flight into Egypt [The Flight into Egypt]	185	123	Carlo Maratt Room	GMII 2671	Houghton - Green Velvet Drawing Room (no. 26)	£300	2349	627	2085	368	I. 45	
MURILLO, Bartolome Esteban [Morellio]	The Crucifixion [The Crucifixion]	186	124	Carlo Maratt Room	SHM 345	Houghton - Green Velvet Drawing Room (no. 27)	£150	2350	628	2083	370	I. 46	
OSTADE, Adriaen van [Ostade]	Boors Drinking [Boors drinking]	152	160	Cabinet	Whereabouts unknown	Downing St - Lady Walpole's Drawing Room (no. 210)	£30	2228	1778	3184	961	I. 54	
Palma: see PITATI													
PARMIGIANINO, copy after [Parmegiano]	The Entombment [Christ laid in the Sepulchre]	60	147	Cabinet	SHM 139	Downing St – Sir Robert's Dressing Room (no. 180)	£150	2240	468	2114	86	II. 54	
PIETRO de' Pietris [after Guido, by Pietro da Pietris]	The Rape of Europa [Jupiter and Europa]	61	24	Coffee Room	Disappeared from Tsarskoye Selo	Houghton – Coffee Room (no. 116)	£40	2361	370	5834			
PITATI, Bonifazio de (Bonifazio Veronese) [old Palma]	The Adoration of the Shepherds [The Adoration of the Shepherds]	62	249	Gallery	SHM 33	Houghton – Marble Parlour (over door) (no. 60)	£250	2258	2334	2188	90		Flinck
PITATI, Bonifazio de (Bonifazio Veronese) [old Palma]	Sacra Conversazione [the Holy Family]	63	250	Gallery	SHM 39	Houghton – Marble Parlour (over door) (no. 59)	£200	2259	639	2198	92		Phélypeaux
POND, Arthur [Pond]	Lady Maria Walpole [Lady Maria Walpole]	223	76	Drawing Room	Houghton								
PONZONE, Matteo [Matteo Ponzoni]	The Holy Family [the Holy Family]	64	186	Cabinet	Pavlovsk 1791-III	Bought in or shortly after 1736 (no. 434)	£160	2250	466			I. 32	Plettenberg/ Trevor
Pordenone: see UNIDENTIFIED													
Poussin, Gaspard, see DUGHET													
POUSSIN, Nicolas [Nicolo Poussin]	Moses Striking the Rock [Moses striking the Rock]	176	259	Gallery	SHM 1177	Downing St - End Room below (no. 152)	£900	2251	1701	3313	1394	II. 53	
POUSSIN, Nicolas [Nicolo Poussin]	The Holy Family with SS Elisabeth and John the Baptist [the Holy Family]	177	136	Embroi- der'd Bed Chamber	SHM 1213	Houghton – Work'd Bed Chamber (no. 45)	£800	2387	1689	3391	1398	II. 18	
POUSSIN, Nicolas [Nicolo Poussin]	The Continence of Scipio [The Continence of Scipio]	178	258	Gallery	GMII 1048	Downing St – Sir Robert's Dressing Room (no. 167)	£600	2255	1698	3324	1406	II. 52	Fleuriau
PROCACCINI, Giulio Cesare [Camillo Procaccino]	The Mystic Marriage of St Catherine [The Holy Family, a Groupe of Heads]	65	241	Gallery	SHM 94	Downing St – Great Middle Room below (no. 135)	£250	2411	548	2299	264	I. 5	
Rafaellino, Raphael da Reggio; see UNIDENTIFIED													
RAPHAEL, 16th-Century copy after [Raphael]	The Last Supper [The last Supper]	67	265	Gallery	SHM 1536	Downing St – Closet (no. 232)	£500	2308	665		44		Holland
?RAPHAEL [Raphael]	A Profile Head of a Man [A profile Head of a Man]	68	119	Carlo Maratt Room	Whereabouts unknown	Grosvenor St – Parlour (no. 306)	£100	2418					

Current Attribution [H.W. Attribution]	Present Title [H.W. Title]	Cat. No.	Aedes No.	Aedes Room	Present Location	Location in 1736 (Appendix III)	1778 Valuation (Catherine II)	Cat. 1773-85	Cat. 1797	Inv. 1859	Cats. 1863-1916	Boydell 2 vols.	Directory (Appendix I)
RAPHAEL, 17th-Century copy after [Le Brun]	The School of Athens [The School of Athens]	66	45	Common Parlour	SHM 1781		£250	2392	678	3400	46		
REMBRANDT, Harmensz. van Rijn [Rembrandt]	Abraham's Sacrifice [Abraham's Sacrifice]	153	255	Gallery	SHM 727	Bought in or shortly after 1736 (no. 437)	£250	2290	1245	4044	792	II. 33	
REMBRANDT, Harmensz. van Rijn [Rembrandt]	Portrait of an Old Woman [Rembrandt's Wife]	154	47	Common Parlour	GMII 2622		£300	2244	1394	4070	823	I. 34	Jervas
RENI, Guido [Guido]	The Adoration of the Shepherds [The Adoration of the Shepherds]	69	257	Gallery	GMII 1608	Houghton - Green Velvet Drawing Room (no. 23)	£400	2394	642	2251	182	II.48	Phélypeaux
RENI, Guido [Guido]	The Fathers of the Church [The Doctors of the Church]	70	227	Gallery	SHM 59	Houghton - Marble Parlour (no. 55)	£3500	2291	401	2241	187	II. 58	
RENI, Guido [Guido]	St Joseph Holding the Christ Child [Simeon and the Child]	71	88	Salon	Whereabouts unknown	Downing St - End Room Below (no. 149)	£150	2393	646	2239		II. 4	Fleuriau
RENI, Guido, copy after [Guido]	The Triumph of Job [Job's Friends bringing him Presents]	72	243	Gallery	SHM 2714	Houghton - Yellow Drawing Room (no. 87)	£200	2401	609	4517			

Reni, see also UNIDENTIFIED

REYMERSWALE, Marinus van [Quintin Matsis]	The Annuity Sellers [An Usurer and his Wife]	115	242	Gallery	SHM 423	Downing St - End Room Below (no. 151)	£200	2281	29	3574	451		
RICHARDSON, Jonathan [Richardson]	Horatio, 1st Baron Walpole of Wolterton [Horace Walpole]	224	11	Supping Parlour	Houghton	Houghton - Supping Parlour (no. 104)							
RICHARDSON, Jonathan [Richardson]	Sir Charles Turner [Sir Charles Turner]	225	14	Supping Parlour	Houghton	Houghton - Supping Parlour (no. 107)							
RICHARDSON, Jonathan [unidentified]	Galfridus Walpole [Galfridus Walpole]	227	27	Coffee Room	Houghton	Houghton - Coffee Room (no. 119)							
RICHARDSON, Jonathan, attributed to [unidentified]	Horatio Walpole [Horatio Walpole]	226	26	Coffee Room		Houghton - Coffee Room (no. 118)							
ROMANELLI, Giovanni Francesco [Romanelli]	Hercules and Omphale [Hercules and Omphale]	73	125	Carlo Maratt Room	SHM 1601	Downing St - Lady Walpole's Drawing Room (no. 202)	£100	2339	3883	2653		II. 7	Hay
ROMANO, Giulio, copy after [Julio Romano after Raphael]	The Battle between Constantine and Maxentius [The Battle of Constantine and Maxentius]	74	10	Supping Parlour	Whereabouts unknown	Houghton - Supping Parlour (no. 103)	£150	2220	2926				

Romano, Giulio: see also BORDONE

ROOS, Philip Peter [Rosa di Tivoli]	The Shepherd [Two pieces of Cattle]	189	138	Embroider'd Bed Chamber	Whereabouts unknown	Houghton - Work'd Bed Chamber (nos. 46, 47)	no extra price	2333	3162	1913		I. 29	
ROOS, Philip Peter [Rosa di Tivoli]	The Goats-Herd [Two pieces of Cattle]	190	137	Embroider'd Bed Chamber	Whereabouts unknown	Houghton - Work'd Bed Chamber (nos. 46, 47)	no extra price	2332	3163	1910		I. 28	

Rosa da Tivoli: see ROOS

ROSA, Salvator [Salvator Rosa]	Democritus and Protagoras [The Old Man and his Sons with the Bundle of Sticks]	75	256	Gallery	SHM 31	Downing St - Sir Robert's Dressing Room (no. 162)	£250	2315	407	2185	222	I. 55	
ROSA, Salvator [Salvator Rosa]	Portrait of a Man [A Man's Head]	76	49	Common Parlour	SHM 1483	Grosvenor St - Drawing Room (no. 348)	£40	2243	663	2187	225	I. 40	
ROSA, Salvator [Salvator Rosa]	The Prodigal Son [the Prodigal Son]	77	228	Gallery	SHM 34	Houghton - Marble Parlour (no. 56)	£700	2288	385	2191	220	I. 8, II.32	Geare

Current Attribution [H.W. Attribution]	Present Title [H.W. Title]	Cat. No.	Aedes No.	Aedes Room	Present Location	Location in 1736 (Appendix III)	1778 Valuation (Catherine II)	Cat. 1773-85	Cat. 1797	Inv. 1859	Cats. 1863-1916	Boydell 2 vols.	Directory (Appendix I)
ROSA, Salvator [Salvator Rosa]	Three Soldiers [Three Soldiers]	78	165	Cabinet	Disappeared from Gatchina	Downing St – Lady Walpole's Drawing Room (no. 215)	£40	2232	3904	5510		II. 60	
Rosalba: see CARRIERA													
ROTTENHAMMER, Johann [Rottenhamer]	The Holy Family with John the Baptist [Holy Family]	191	163	Cabinet	GMII 321	Downing St – Lady Walpole's Drawing Room (no. 214)	£40	2245	435	4721		II. 30	Van Huls
RUBENS, Pieter Paul [Rubens]	The Carters [Moon-light Landscape with Cart over-turning]	116	251	Gallery	SHM 480	Downing St – Lady Walpole's Drawing Room (no. 214)	£300	2323	1174	3025	594	I. 23	Cadogan
RUBENS, Pieter Paul [Vandyke]	Portrait of Hélène Fourment (?) [Picture of Rubens's Wife]	117	139	Cabinet	Gulbenkian 959	Houghton – Corner Drawing Room (no. 48)	£600	9354	1359	3026	576	II. 36	
RUBENS, Pieter Paul [Rubens]	Head of a Franciscan Monk [A Friar's Head]	118	43	Common Parlour	SHM 472	Downing St – Lady Walpole's Drawing Room (no. 206)	£40	2414	1228	3017	584	II. 21	
RUBENS, Pieter Paul [Rubens]	Apotheosis of James I [The Banquetting-House ceiling]	119	170	Cabinet	SHM 507	Downing St – Great Room above Stairs (no. 186)	£100	2302	1214	3116	573		Kneller
RUBENS, Pieter Paul [Rubens]	The Advent of the Prince [Six Sketches of Rubens for triumphal Arches, &c]	120	171	Cabinet	SHM 498		£600 (for cat. nos. 121–126)	2296	1180	3104	562		
RUBENS, Pieter Paul [Rubens]	The Arch of Ferdinand (back) [Six Sketches of Rubens for triumphal Arches, &c.]	121	172	Cabinet	SHM 502		£600 (for cat. nos. 121–126)	2300	1171	3108	564		
RUBENS, Pieter Paul [Rubens]	The Temple of Janus [Six Sketches of Rubens for triumphal Arches, &c.]	122	173	Cabinet	SHM 500		£600 (for cat. nos. 121–126)	2301	1292	3106	566		
RUBENS, Pieter Paul [Rubens]	Mercury Leaving Antwerp [Six Sketches of Rubens for triumphal Arches, &c.]	123	174	Cabinet	SHM 501		£600 (for cat. nos. 121–126)	2297	1179	3107	565		
RUBENS, Pieter Paul [Rubens]	The Arch of Hercules (front) [Six Sketches of Rubens for triumphal Arches, &c.]	124	175	Cabinet	SHM 503		£600 (for cat. nos. 121–126)	2299	1172	3109	563		
RUBENS, Pieter Paul [Rubens]	The Apotheosis of the Infanta Isabella [Six Sketches of Rubens for triumphal Arches, &c]	125	176	Cabinet	GMII 2626		£600 (for cat. nos. 121–126)	2298	1291	3105	561		
RUBENS, Pieter Paul [Vandyke]	A Horse's Head (Rearing Horse) [A Horse's Head]	126	4	Breakfast Room	Morris, Houston		£50	2374		3120	637	I. 42	
RUBENS, Pieter Paul [Rubens]	Bacchanalia [A Bacchanalian]	131	38	Common Parlour	GMII 2606	Downing St - Sir Robert's Dressing Room (no. 169)	£250	2324	1299	3003	551	II. 57	Cadogan
RUBENS, Pieter Paul, school of [Rubens]	Head of a Girl [Rubens's Wife, a Head]	129	48	Common Parlour	SHM 1692	Downing St – Lady Walpole's Drawing Room (no. 218)	£60	2358	1249	3004	577	II. 5	Van Huls?
RUBENS, Pieter Paul, workshop [Rubens]	Susanna and the Elders [Susannah and the two Elders]	130	21	Hunting Hall	SHM 496	Houghton – Hunting Hall (no. 114)	£80	2340	1569	3101			
RUBENS, Pieter Paul and workshop and DYCK, Anthony van [Rubens]	Christ in the House of Simon the Pharisee [Mary Magdalen washing Christ's feet]	127	85	Salon	SHM 479	Downing St – Great Middle Room below (no. 134)	£1600	2286	1298	3024	543	I. 57	Fleuriau
RUBENS, Pieter Paul, workshop and VAN THULDEN, Theodor [Rubens]	The Hunt of Meleager and Atalanta (Caledonian Hunt) [Meleager and Atalanta, a Cartoon]	128	229	Gallery	SHM 9647	Houghton - Corner Drawing Room (no. 49)	£300	2413				II. 51	Wade

Rubens: see also SNYDERS

Rubens: see also VOS, Cornelis de

Current Attribution [H.W. Attribution]	Present Title [H.W. Title]	Cat. No.	Aedes No.	Aedes Room	Present Location	Location in 1736 (Appendix III)	1778 Valuation (Catherine II)	Cat. 1773-85	Cat. 1797	Inv. 1859	Cats. 1863-1916	Boydell 2 vols.	Directory (Appendix I)
RUSCONI, Camillo [Camillo Rusconi]	Bust of the Madonna [Bust of the Madonna]	259	61	Drawing Room	Houghton								
RUSCONI, Camillo [Camillo Rusconi]	Rome, after the Antique [Busts of … Rome]	260	220	Porch	Houghton								
RUSCONI, Camillo [Camillo Rusconi]	Minerva, after the Antique [Busts of … Minerva]	261	221	Porch	Houghton								
RUSCONI, Camillo [Camillo Rusconi]	Antinous, after the Antique [Busts of …Antinous]	262	222	Porch	Houghton								
RUSCONI, Camillo [Camillo Rusconi]	Apollo Belvedere, after the Antique [Busts of …Apollo Belvedere]	263	223	Porch	Houghton								
RYSBRACK, John Michael [Rysbrack]	The Sacrifice to Bacchus [Alto Relievo in Statuary-Marble]	264	190	Marble Parlour	Houghton								
RYSBRACK, John Michael [Rysbrack]	Bust of Sir Robert Walpole [Bust of Sir Robert Walpole]	265	198	Hall	Houghton								
SACCHI, Andrea, attributed [Andrea Sacchi]	Venus Resting in a Landscape [Venus Bathing, and Cupids with a Carr, in a Landscape]	79	33	Common Parlour	SHM 127		£80	2222	478	2376	210	I. 17	Montagu/ Jervas
SARTO, Andrea del [Andrea del Sarto]	The Holy Family [The Holy Family]	80	91	Salon	Whereabouts unknown	Downing St – Sir Robert's Dressing Room (no. 163)	£250	2256	589				Mari/ Edwin?
SASSOFERRATO, Giovanni Battista Salvi [Dominichino]	The Virgin and Child [The Virgin and Child]	81	275	Gallery	SHM 1506		£100	2248	454	2271	260	II. 35	Zambeccari/ Horace Walpole
Schiavone, Andrea: see UNIDENTIFIED													
SEMINI, Michele? [Zimeni]	Galatea [Galatea]	82	25	Coffee Room	Disappeared from Tsarskoye Selo	Houghton – Coffee Room (no. 117)	£40	2362	371	5833			
SIRANI, Elisabetta [Elisabetta Sirani]	Cupid Burning the Weapons of Mars [Cupid burning Armour]	83	240	Gallery	SHM 2584	Downing St – End Room Below (no. 161)	£60	2408	2710	5559		II. 34	
SNYDERS, Frans [Mario di Fiori]	A Concert of Birds [A Concert of Birds]	132	2	Breakfast Room	SHM 607	Chelsea – Sir Robert's Dressing Room (no. 379)	no extra price	2360	2359	3533	1324	II. 3	Gibbons
SNYDERS, Frans, and WILDENS, Jan [Snyders]	A Game Market [Four markets, by Snyders, One of Fowl …]	133	230	Gallery	SHM 602	Houghton – Saloon (no. 7)	£1000 (for cat. nos. 134-137)	2276	777	3582	1315	II. 50	Macky
SNYDERS, Frans, and WILDENS, Jan [Snyders]	A Fruit Market [Four markets, by Snyders, … another of Fruit,]	134	231	Gallery	SHM 596	Houghton – Saloon (no. 8)	£1000 (for cat. nos. 134-137)	2273	719	3521	1312	II. 49	Macky
SNYDERS, Frans, and WILDENS, Jan [Snyders]	A Vegetable Market [Four markets, by Snyders… the Fourth of Herbs]	135	232	Gallery	SHM 598	Houghton – Saloon (no. 10)	£1000 (for cat. nos. 134-137)	2274	786	3523	1313	I. 12	Macky
SNYDERS, Frans, and WILDENS, Jan [Snyders]	A Fish Market [Four markets, by Snyders, … another of Fish]	136	233	Gallery	SHM 604	Houghton – Saloon (no. 9)	£1000 (for cat. nos. 134-137)	2275	776	3530	1320	I. 13	Macky
SNYDERS, Frans, school of [Rubens]	A Lioness and Two Lions [A Lioness and two Lions]	137	236	Gallery	SHM 465	Downing St – Great Middle Room below (no. 132)	£100	2376	1288	3007	592	II. 37	
STEENWYCK, Hendrick, II van [Steenwyck]	Italian Palace [Picture of Architecture in Perspective]	138	35	Common Parlour	SHM 432	Houghton – Common Parlour (no. 67)	£80	2293	2177	3823	1197		Van Huls
STELLA, Jacques [Stella]	Solomon's Idolatry [Solomon's Idolatry]	179	266	Gallery	SHM 2130	Downing St – Lady Walpole's Drawing Room (no. 200)	£250	2417	3827	4653			
Sueur, see LE SUEUR													

Current Attribution [H.W. Attribution]	Present Title [H.W. Title]	Cat. No.	Aedes No.	Aedes Room	Present Location	Location in 1736 (Appendix III)	1778 Valuation (Catherine II)	Cat. 1773-85	Cat. 1797	Inv. 1859	Cats. 1863-1916	Boydell 2 vols.	Directory (Appendix I)
SWANEVELT, Herman [Swanivelt]	A Landscape with Figures Dancing [Landscape with Figures dancing]	155	23	Coffee Room	Whereabouts unknown	Houghton – Common Parlour (no. 66)	£30	2341				I. 1	
TENIERS, David II [Teniers]	Kitchen [A Cook's Shop]	139	36	Common Parlour	SHM 586	Downing St – Parlour (no. 123)	£800	2287	1628	3206	698	I. 22	
TENIERS, David II [Teniers]	Card Players [Boors at Cards]	140	143	Cabinet	SHM 577	Downing St – Lady Walpole's Drawing Room (no. 209)	£150	2359	1665	3191	688	II. 16	
TENIERS, David II [Teniers]	Cows and Sheep [Cows and Sheep]	141	263	Gallery	Whereabouts unknown	Houghton – Common Parlour (no. 65)	£150	2409	1605	3195	706	II. 26	
TENIERS, David II? [Teniers]	Peasants in a Tavern [Boors at Cards]	142	159	Cabinet	SHM 569	Downing St – Lady Walpole's Drawing Room (no. 211)	£50	2227	1677	3175	679	I. 53	
THULDEN, Theodor van, see RUBENS													
Titian, see MORETTO DA BRESCIA; UNIDENTIFIED													
TURCHI, Alessandro [Alexander Veronese]	The Virgin and Child [The Virgin and Child]	84	164	Cabinet	Whereabouts unknown	Downing St – Lady Walpole's Drawing Room (no. 213)	£40	2241	444	4697		II. 56	
Van Dyck, Anthony, see DYCK													
VANLOO, Jean-Baptiste [Vanloo]	Sir Robert Walpole [Sir Robert Walpole]	180	60	Blue Damask Bed Chamber	SHM 1130			2375		1474		II. frontispiece	
VANLOO, Jean-Baptiste [Vanloo]	Maria Skerret [Maria Skerret]	228	58	Little Bed Chamber	Houghton								
VASSALLO, Antonio Maria [Castiglioni]	The Exposition of King Cyrus [The Exposition of Cyrus]	85	247	Gallery	SHM 221	Downing St – Sir Robert's Dressing Room (no. 170)	£300 (with cat. no. 86)	2396	2417	4447	1928	II. 28	
VASSALLO, Antonio Maria [Castiglioni]	Bacchus/Orpheus [seems at first to be the Story of Orpheus, but certainly is not]	86	248	Gallery	GMII 2672	Downing St – Sir Robert's Dressing Room (no. 171)	£300 (with cat. no. 85)	2397	2418	4448	1927	II. 29	
VELAZQUEZ, Diego de, circle of [Velasco]	Pope Innocent X [Head of Innocent the Tenth]	187	153	Cabinet	Washington 80	Downing St – Sir Robert's Dressing Room (no. 173)	£60	2221	520	2195	418	I. 31	Hay
Velazquez, see also CANO													
Veronese, Alessandro, see TURCHI													
Veronese, Bonifazio, see PITATI													
VERONESE, Paolo Caliari, and workshop [Paul Veronese]	The Resurrection [The Ascension]	87	195	Marble Parlour	GMII 1607	Grosvenor St – Parlour (no. 294)	£200 (with cat. no. 7)	2321	403	2485			
Veronese, Paul: see also CALIARI, Benedetto													
Veronese, see also BENFATTO DAL FRISO													
VITTORIA, Alessandro [Baccio Bandinelli]	Bust of a Bearded Man [Baccio Bandinelli]	254	211	Hall	Houghton								
VOS, Cornelis de [Rubens]	Old Woman in an Armchair [An old Woman sitting in a Chair]	143	238	Gallery	SHM 483		£200 (with cat. no. 146)	2334	1362	1356	578	I. 49	Scawen
VOS, Pauwel de [Martin de Vos]	Cook at a Kitchen Table with Dead Game [Cook's Shop]	144	37	Common Parlour	SHM 610	Downing St – Parlour (no. 124)	£200	2289	916	3543		I. 21	

Current Attribution [H.W. Attribution]	Present Title [H.W. Title]	Cat. No.	Aedes No.	Aedes Room	Present Location	Location in 1736 (Appendix III)	1778 Valuation (Catherine II)	Cat. 1773–85	Cat. 1797	Inv. 1859	Cats. 1863–1916	Boydell 2 vols.	Directory (Appendix I)
VOS, Pauwel de, see also RUBENS													
WERFF, Adriaen van der [Vanderwerffe]	Sarah leading Hagar to Abraham [Bathsheba bringing Abishag to David]	156	177	Cabinet	SHM 1064	Houghton – Yellow Drawing Room (no. 88)	£700	2223	1791	3682	984	II. 20	Brydges
WILDENS Jan, see DYCK													
WILLEBOIRTS BOSSCHAERT, Thomas [Williberts]	Madonna and Child with SS Elisabeth and John the Baptist [Holy Family, with St John on a Lamb]	145	162	Cabinet	Whereabouts unknown	Downing St – Sir Robert's Dressing Room (no. 176)	£40	2237	755	3615			Van Huls
WOOTTON, John [Wootton]	Hounds and a Magpie [Picture of Hounds]	201	1	Breakfast Room	SHM 9781	Houghton – little Breakfast Room (no. 92)	no extra price	2422		6140		I. 14	
WOOTTON, John [Wootton]	A Hunting Piece [A Hunting Piece]	202	22	Hunting Hall	Disappeared from Gatchina	Houghton – Hunting Hall (no. 115)	no extra price	2421		6134		I. 56	
WOOTTON, John [Wootton]	Classical Landscape [Landscape]	229	59	Little Dressing Room	Houghton								
Wootton, John and Kneller, Godfrey, see KNELLER, Godfrey													
WOUWERMAN, Philips [Wovermans]	A Stud of Horses [A Stud of Horses]	157	32	Common Parlour	Whereabouts unknown	Houghton – Common Parlour (no. 64)	£250	2412	3872				
WRIGHT, John Michael, studio [unidentified]	Colonel Robert Walpole [Robert Walpole]	205	7	Breakfast Room	Houghton	Houghton – little Breakfast Room (no. 100)							
WRIGHT, John Michael, studio [unidentified]	Mary Wilson, nee Walpole [Mary Walpole]	208	19	Supping Parlour	Houghton	Houghton – Supping Parlour (nos. 110, 111, 112, 113)							
WRIGHT, John Michael, circle of [unidentified]	Sir Edward Walpole [Sir Edward Walpole]	230	6	Breakfast Room	Houghton	Houghton – little Breakfast Room (no. 96)							
WYCK, Jan [old Wyck]	A Greyhound's Head [A Grey-Hound's Head]	203	5	Breakfast Room	SHM 1806		no extra price	2380	1588	3537	1327	I. 43	
Zimeni, see SEMINI													
Unidentified 15th–16th-Century Venetian [John Bellino]	The Holy Family [The Holy Family]	88	181	Cabinet	Whereabouts unknown	Chelsea – Yellow Damask Bedchamber (no. 388)	£60	2400	553				Law
Unidentified 16th-Century Venetian [Titian]	The Virgin and Child with John the Baptist [The Holy Family]	89	87	Salon	Whereabouts unknown	Houghton – Yellow Drawing Room (no. 86)	£100	2384	2880	2682			Fleuriau
Unidentified 16th-Century Venetian [Andrea Schiavone]	Midas Judging between Pan and Apollo [Midas judging between Pan and Apollo]	90	146	Cabinet	Whereabouts unknown	Downing St – Closet (no. 253)	£60 (with cat. no.91)	2239	448				
Unidentified 16th-Century Venetian [Andrea Schiavone]	The Judgment of Paris [The Judgment of Paris]	91	145	Cabinet	Whereabouts unknown	Downing St – Closet (no. 254)	£60 (with cat. no. 90)	2238	447				
Unidentified 16th-Century Italian [Pordenone]	The Return of the Prodigal Son [The Prodigal Son returning to his Father]	92	3	Breakfast Room	Whereabouts unknown	Chelsea – Sir Robert's Dressing Room (no. 380)	no extra price	2386	236				
Unidentified 16th-Century Italian [Raphael da Reggio]	The Holy Family with SS Catherine, Francis and John the Baptist [Holy Family]	93	34	Common Parlour	Krasnodar 2544	Downing St – Great Room above Stairs (no. 187)	£70	2226	107	2671			

Current Attribution [H.W. Attribution]	Present Title [H.W. Title]	Cat. No.	Aedes No.	Aedes Room	Present Location	Location in 1736 (Appendix III)	1778 Valuation (Catherine II)	Cat. 1773-85	Cat. 1797	Inv. 1859	Cats. 1863-1916	Boydell 2 vols.	Directory (Appendix I)
Unidentified 17th-Century Italian [Guido]	The Archangel Gabriel [A profile Head of St. Catharine]	94	120	Carlo Maratt Room	SHM 8790	Houghton – Green Velvet Drawing Room (no. 24)	£20	2377		5652			
Unidentified 16th-Century [Holbein]	Portrait of King Edward VI [Edward the Sixth]	204	168	Cabinet	SHM 1260		£100	2405	1564	3499	467		O'Hara
Unidentified [unidentified]	Sir Horatio Townshend, 1st Viscount Townshend [Horatio Lord Townshend]	231	8	Breakfast Room		Houghton – little Breakfast Room (no. 101)							
Unidentified [unidentified]	Head of Venus [antique Bust of a Venus]	232	77	Salon									
Unidentified [unidentified]	Head of a Woman, possibly Sappho [antique Bust]	233	78	Salon									
Unidentified Roman [Antique]	Bust of a Woman [The Bust of a Woman]	234	204	Hall	Houghton								Vernon
Unidentified Roman 2nd Century AD [Antique]	Bust of Commodus [Marcus Aurelius]	235	206	Hall	Houghton								
Unidentified Roman 1st-2nd Century AD [Antique]	Head of a Trajan General [Trajan]	236	207	Hall	Houghton								
Unidentified Roman 2nd-3rd Century AD [Antique]	Bust of Septimius Severus [Septimius Severus]	237	208	Hall	Houghton								Albani/Churchill
Unidentified Roman 2nd Century AD [Antique]	Bust of Emperor Commodus [Commodus]	238	209	Hall	Houghton								Albani/Churchill
Unidentified Roman 2nd Century AD [Antique]	Head of a Diadochus [A Young Hercules]	239	210	Hall	Houghton								
Unidentified Roman 2nd Century AD [Antique]	Bust of Faustina the Elder [Faustina Senior]	240	212	Hall	Houghton								
Unidentified Roman 1st-2nd Century AD [Antique]	Zeus, a Colossal Head [Jupiter]	241	216	Hall	Houghton								
Unidentified Roman ?1st Century AD [Antique]	Head of a Greek Poet [A Philosopher]	242	217	Hall	Houghton								
Unidentified Roman 1st Century AD [Antique]	Head of Hadrian [Hadrian]	243	218	Hall	Houghton								
Unidentified Roman [Antique]	Head of Dioskuros [Pollux]	244	219	Hall	Houghton								
Unidentified Roman 2nd Century AD [Antique]	Head of a Priest of Dionysus [A Philosopher's Head]	245	224	Hall	Houghton								
Unidentified Roman [Antique]	Head of Julia Domna [Julia Pia Severi]	246	225	Hall	Houghton								
Unidentified [unidentified]	Two Vases in 'Oriental' style [two Vases of Oriental Alabaster]	247	80	Salon									Albani/Churchill
Unidentified [unidentified]	Two Vases in 'Oriental' style [two Vases of Oriental Alabaster]	247	81	Salon									Albani/Churchill

Current Attribution [H.W. Attribution]	Present Title [H.W. Title]	Cat. No.	Aedes No.	Aedes Room	Present Location	Location in 1736 (Appendix III)	1778 Valuation (Catherine II)	Cat. 1773–85	Cat. 1797	Inv. 1859	Cats. 1863–1916	Boydell 2 vols.	Directory (Appendix I)
Unidentified French or Italian workshop c.1700 [unidentified]	The Tiber [the Tiber...in Bronze, from the Antiques in the Capitol at Rome]	250	200	Hall	Houghton								Horatio Walpole
Unidentified French or Italian workshop c.1700 [unidentified]	The Nile [...the Nile in Bronze, from the Antiques in the Capitol at Rome]	251	201	Hall									Horatio Walpole
Unidentified ?French workshop, c.1700 [unidentified]	Table bronze, after the antique Medici Vase [Two Vases in Bronze, from the Antiques in the Villas of the Medici and Borghese at Rome]	252	202	Hall	Houghton								
Unidentified ?French workshop, c.1700 [unidentified]	Table bronze Urn, after the antique Borghese Vase [Two Vases in Bronze, from the Antiques in the Villas of the Medici and Borghese at Rome]	253	203	Hall	Houghton								Mann?
Unidentified c.1700 Italian [Antique]	Bust of a Woman (called 'Roman Empress') [The Bust of a Roman Empress]	255	205	Hall	Houghton								Vernon
Unidentified Italian workshop c.1700 [Unidentified]	Head of a Young Commodus [A Young Commodus]	256	213	Hall									
Unidentified 17th-Century Italian [Modern]	Homer [Homer]	257	214	Hall	Houghton								
Unidentified 17th-Century Italian [Modern]	Hesiod [Hesiod]	258	215	Hall	Houghton								
Unidentified [unidentified]	Lapis Lazuli Pier Table [Table of Lapis Lazuli]	267	96	Carlo Maratt Room	Houghton								
Unidentified [unidentified]	Two Silver Sconces [two Sconces of massive Silver]	268	97	Carlo Maratt Room									
Unidentified [unidentified]	Two Silver Sconces [two Sconces of massive Silver]	268	98	Carlo Maratt Room									
Unidentified [after Albano]	The Loves of Venus and Adonis [Tapestry, representing the Loves of Venus and Adonis after Albano]	269	126	Velvet Bed Chamber	Houghton								
Unidentified, series by Francis Poyntz [after Vandyke]	Mortlake Tapestry [gold Tapestry after Pictures of Vandyke]	270	130	Dressing Room	Houghton	Houghton – Dressing Room (no. 41)							
Unidentified [unidentified]	Glass Case with a large Quantity of Silver Philegree [Glass Case with a large Quantity of Silver Philegree]	271	131	Dressing Room									
Unidentified [unidentified]	State Bedstead [Bed is of the finest Indian Needle-work]	272	135	Embroider'd Bed Chamber	Houghton								
Unidentified [unidentified]	Copper gilt Chandelier [Lantern for Eighteen Candles]	273	197	Hall									
Unidentified [unidentified]	A Boat-shaped Vase and Cover [Six Vases of Volterra Alabaster]	274?	226	Hall	Houghton								

BIBLIOGRAPHY
Manuscripts

Bibliothek der Staatlichen Museen, 2 April 1738
Plettenberg Sale Catalogue, 2 April 1738 (Lugt 480), Bibliothek der Staatlichen Museen, Berlin

BL 1481
'A Catalogue of the Entire and valuable Collection of Paintings Bronzes, Busts in Porphyry and Marble, and other Curiosities, Of the most NOBLE CHARLES Earl of HALFAX, deceas'd. Which will be sold by AUCTION On Thursday the 6th of March next, and the Three following Days, at the Great Apartment over Exeter-Change in the Strand', British Library, London: BL 1481.

BL 141.e.8
'[Etchings by Cary Creed, with accompanying captions, of the antique marbles in the collection of the Earl of Pembroke at Wilton House]… to be had of me Cary Creed at the Tarr between Cecil and Salisbury-Streets, and Mr Prevost the bookseller near it. Anno, 1731', British Library, London: BL 141.e.8

BL 7805.e.5(2)
'A Catalogue of the Genuine Collections of Picture of His Grace James Duke of Chandos Lately Deceas'd…sold by Auction by Mr. Cock. on Wednesday May 6, 1747', British Library, London: BL 7805.e.5(2)

BL Add. MSS 4042
Letter from John Macky to Hans Sloane, dated 10 June 10 1710, Bruges, British Library, London: Add. MSS 4042

BL Add. MSS 32, 686
Letter from John Macky to Sir Robert Walpole, dated 21 September 1723, Brussels, British Library, London: Add. MSS 32,686

BL Blenheim 61635
'Letter from Jervas to Duke of Marlborough. Dated Aug. 21st, 1706, Rome', British Library, London: Blenheim 61635

BL C.119.3(4)
'A collection of fine pictures, brought from abroad by Mr Andrew Hay. Will be sold by auction, at Mr. Cock's new-auction room in Poland-Street… on Saturday the 19th of this inst. February, 1725-6', British Library, London: C.119h.3(4)

BL C.119h.3(6)
'A Catalogue of the rich furniture of the Right Hon. the Earl of Cadogan… which will be sold by auction… on Tuesday 14th of February, 1726-7', British Library, London: C.119h.3(6)

BL C.119h.3(13★)
'A catalogue of Mr. Andrew Hay's pictures, bronzes, marble bustos, bass relievos, books, &c. by him collected abroad. To be sold by auction, at Mr. Cock's.. on Friday and Saturday the 4th and 5th of May 1739…', British Library, London

BL Eg 1706
'A catalogue of the large and valuable library of the most noble and learned James Duke of Chandos, lately deceas'd… sold by auction by Mr. Cock. on Thursday the 12th of March 1746-7', British Library, London: Eg 1706 (another copy British Library, London: MSSP.R.2.a.39)

BL Harley MS 5947
Catalogue of sale of 'A Collection of the best Italian Masters, both Ancient & Modern' to be held by Gibbons and Perry Walton in the Banquetting Hall, Whitehall, 1686, British Library, London: Harley MS 5947

BL Harley MS 120
British Library, London: Harley MS 120

BL MSS P.R.2.a.39
'A catalogue of the large and valuable library of the most noble and learned James Duke of Chandos, lately deceas'd… sold by auction by Mr. Cock. on Thursday the 12th of March 1746-7', British Library, London: MSS P.R.2.a.39 (another copy of BL Eg. 1706)

BL S.C.429(2)
'A Catalogue of a curious collection of Italian, French, and Flemish prints and drawings, by the most eminent masters… collected abroad by Mr Andrew Hay, & Mynheer Wilkins… which will be sold by acution, on Monday the 14th of January 1739-40', British Library, London: S.C.429(2)

BL S.C.550(14)
'Catalogue des tableaux, de l'argenterie, vaiselle doree, et pierries, apperenans son Exellence le Comte de Cadogan … Mardi 21 et Mecredi 22… de Fevrier…', British Library, London: S.C.550(14)

BM Musgrave 1797
Brief listing of Musgrave collection, British Museum, London: Mugrove MSS, Additional MS 6391

Bodl. Johnson.d.778
'A Catalogue of the dwelling-house of the Rt. Honourable General Stuart… To which is added, the collection of paintings… belonging to John Law's Esq… and of the Hon. Sir John Holland of Norfolk…', Bodleian Library, Oxford: d. 778

Bodl. MSS Eng. Lett. C275 (18-19)
'Letter from Charles Jervas to Bishop John Hough. Dated Feb. 24th, 1703, Rome', Bodleian Library, Oxford: MSS Eng. Lett. C275 (18-19)

Bodl. MUS.Bibl.III.8 66(2)
'A Catalogue of all the genuine household furniture, &c. of His Grace James Duke of Chandos, deceas'd, at his late seat call'd Cannons, near Edgeware in Middlesex… sold by auction, by Mr. Cock, on Monday the 1st June, 1747', Bodleian Library, Oxford: MUS.Bibl.III.8 66(2)

Bodl. Vet A4e
'A catalogue of the entire libraries of Dr. Rathbone and Mr. A. Geekie, surgeon, (both deceas'd) Consisting of the choicest most valuable books in almost all languages and faculties… October, 1740', Bodleian Library, Oxford: Vet A4e

Cat. 1773-85
[E. Munich,] 'Catalogue raisonné des tableaux qui se trouvent dans les Galeries, Sallons et Cabinets du Palais Impérial de S.Pétersbourg, commencé en 1773 et continué jusqu'en 1785 ', in 3 volumes − vols 1-2 1773-83, vol. 3 1785; Hermitage Archives: Fund 1, *Opis'* VI-A, *delo* 85

Cat. 1797
'Katalog kartinam, khranyashchimsya v Imperatorskoy galeree Ermitazha, v Tavricheskom i Mramornom dvortsakh, sochinyonnyy […] pri uchastii F. I. Labenskogo' [Catalogue of Paintings Kept in the Imperial Hermitage Gallery, the Tauride and Marble Palaces, compiled… with the participation of F. I. Labensky], 1797, in 3 volumes; Hermitage Archives: Fund 1, *Opis'* VI-A, *delo* 87

Christies 19 April 1785
'A catalogue of… Pictures… of the late Gen. Wade, 19th April, 1785', Christie's, London

Christies, 27 March 1797
Christies, London: 'A catalogue of .. Pictures.. of John Wade…originally collected by his father Field Marshall Wade, 27 March 1797'

Christie's Sale List
'A Catalogue of the Pictures at Houghton, the Seat of Lord Orford, with the Prices they Sold at, to the Empress of Russia', MS, Christie's, London, 14 pp., n.d. Location unknown; copy in Lewis Walpole Library

Chetham 4C6-14(3)
'An Ode To Mr Ellis Occasioned by a Beautiful Painting Of the Honourable Mr Walpole, Only Son to the Right Hon. Lord Walpole', ?London, ?1740, Chetham's Library, Manchester: 4C6-14(3)

CUL Chol (Houghton) MSS, Acct. Book 20a)
Cambridge University Library, Cambridge: Cholmondeley (Houghton) MSS, Account Book 20a) 1714-18

CUL Chol (Houghton) MSS 2459
Waldegrave MSS, copy by Coxe, Cambridge University Library, Cambridge: Cholmondeley (Houghton) MSS 2459

CUL Chol (Houghton) MSS, Accounts 22
Cash book of Edward Jenkins, Cambridge University Library, Cambridge: Cholmondeley (Houghton) MSS, Accounts 22

CUL Chol (Houghton) MSS, Correspondence of the later Orfords
Correspondence of the later Orfords, Cambridge University Library, Cambridge: Cholmondeley (Houghton) MSS

CUL Chol (Houghton) MSS, Correspondence 803, 834, 1036, 1050, 1054, 1067, 1097, 3069
Cambridge University Library, Cambridge: Cholmondeley (Houghton) MSS Correspondence 803, 834, 1036, 1050, 1054, 1067, 1097, 3069

CUL Chol (Houghton) MSS, Papers 83, 1/c
Cambridge University Library, Cambridge: Cholmondeley(Houghton) MSS Papers 83, 1/c

CUL Chol (Houghton) MSS, Vouchers 1721
Cambridge University Library, Cambridge: Cholmondeley (Houghton) MSS, Vouchers 1721

CUL Chol (Houghton) MSS, Vouchers 1725
Cambridge University Library, Cambridge: Cholmondeley (Houghton) MSS, Vouchers 1725

CUL Syn.5.74.3
'A catalogue of the materials of the dwelling-house, out-houses, &c. of His Grace James Duke of Chandos, deceas'd, at his late seat call'd Cannons, near Edgware in Middlesex…sold by auction by Mr. Cock, on Tuesday, the 16th of June, 1747', Cambridge University Library, Cambridge: Syn.5.74.3

Decker 1728
Sir Mathew Decker, 1728, 'An Account of a journey done into Hartford, Cambridgeshire, Suffolk, Norfolk and Essex, from 21st June to the 12th July, being 22 days', Wilton House Archives, Wiltshire

Fitzwilliam Museum, Cambridge, Hyde Greg MS
Horace Walpole, *Aedes Walpolianae*, 1752, with MSS notes, values and diagrams (picture hangs); bequeathed by Sir Robert Hyde Greg, 1953

Fougeroux MS 1728
?Abbé Fougeroux [?Antoine-Joseph Dezllier d'Argenville (1680-1765), 'Voiage D'Angleterre D'Hollande Et de Flandre fait en L'année 1728', National Art Library, Victoria & Albert Museum, London: MS 86 NN 2

Frick, 6 August 1722
'A catalogue of pictures by the best Italian, French, Flemish and Dutch Masters; collected by the late William Van Huls Esq; at his late dwelling-house at Whitehall… sold by auction on Monday the 6th August, 1722', Frick Art Reference Library, New York

Frick, 3 September 1722
'A catalogue consisting of two house… lately belonging to William Van Huls Esq: Which will begin to be sold by auction... on Monday the third day of September, 1722', Frick Art Reference Library, New York

Frick, April 5-6, 1726
'A catalogue of the remaining collection of Sir Robert Gayer's fine pictures… sold by auction... on Tuesday the 5th. of April 1726', Frick Art Reference Library, New York

Frick, April 18, 1726
'A Catalogue of all the remaining works of the late Sir Godfrey Kneller…', Frick Art Reference Library, New York: April 18, 1726

Frick, February 27-28, 1760
'A catalogue of the genuine and entire collecions of Italian, Flemish and Dutch pictures of John Ellys Esq… at his [Mr Langford] house in the Great Piazza, Covent Garden… 27th & 28th of … February 1760', Frick Art Reference Library, New York

Glasgow University Library, SM 1536
'A Catalogue of the Most Valuable Pictures, Prints, and Drawings Late of Charles Jervis March 11th, 1739', Glasgow University Library, Glasgow: SM 1536

Houghton 1745 MS (M24h)
'INVENTORY of HOUGHTON May the XXV MDCCXLV', taken at RW's death, Houghton Archive: MS (M24h)

Houghton 1792 MS (M24c)
'An inventory of the Elegant Household Furniture Fixtures Marble Statues, Busts capital Bronzes Pictures Tapestry Hangings Linen, China, Glass and numerous other Effects the Property of the Rt. Honble. The Earl of Orford deceased taken at Houghton Hall in Norfolk June 17 1792 and following days;' endorsed and approved by James Christie on 27 June 1793; taken at the death of the 3rd Earl of Orford and annotated by Horace Walpole, Houghton Archive: MS (M24c)

Houghton Archive, File Lib 45 cat. 177
Miscellaneous private papers, Houghton Archive: File Lib 45

Houghton Archive, RBI, 45
Miscellaneous private papers, Houghton Archive: RBI, 45

Houghton Archive: Cock Account
Cock Account September 1747, Houghton Archive

Houlditch MSS
Houlditch MSS 86.00.18/19: two volumes of sale catalogues of the principal collections of pictures (170 in total), sold by auction in England, 1711-59, the majority with MS additions giving prices and names of purchasers, National Art Library, London. See Appendices VI, VII

HRO MS 1744
'Pictures at Houghton 1744', 7 folios; The Cobbold family, on deposit to Hertfordshire Record Office

Inventory 1859
'Opis' kartinam i plafonam, sostoyashchim v zavedovanii II otdeleniya imperatorskogo Ermitazha' [Inventory of Paintings and Ceilings in the Care of the II Department of the Imperial Hermitage], 1859-1929; Hermitage Archives: Fund 1, Opis' XI-b, delo 1

Liverpool Papers 1741
'Diary of a Journey from Cambridge, through Suffolk and Norfolk, Lincolnshire and Yorkshire', British Library, London: Add. MSS 38.488, ff. 17b-49, Houghton, Sunday 29 - Monday 30 July 1741. To be published in full in C. Rawcliffe, C. Harper-Bill, R. G. Wilson, eds., Studies in East Anglian History in Honour of Norman Scarfe (forthcoming)

Lugt 1328
'A catalogue of all the genuine household Furniture, Capital Pictures, Curious Bronzes…… Belonging to the Right Honourable Earl Waldegrave, (Deceas'd)… Which will be sold by Auction, by Mr. Prestage, on Wednesday the 16th of November, 1763'; Lugt 1328, see Lugt 1938-

LWL
Numerous Walpole (Horace Walpole and family) MSS, Lewis Walpole Library (Yale), Farmington, CT

Milles MS 1735
Rev. Jeremiah Milles, 'An Account of the Journey Mr Hardiess & I took in July 1735', British Library, London: Add. MSS 15,776.

MS Moscow Public Museum 1862
'Delo o kartinakh, vybrannykh G. Vagenom dlya Moskovskogo Publichnogo muzeya i ob otpravlenii onykh. Raport nachal'nika II otedeleniya Ermitazha F. Bruni… s prilozheniyem spiska, odobrennogo Gosudarem Imperatorom 26 maya 1862 g' [File on paintings selected by G. Waagen for the Moscow Public Museum and on their despatch. Report by Head of the II Department of the Hermitage, F. Bruni… with an appended list approved by His Majesty the Emperor on 26 May 1862], Hermitage Archives: Fund 1, Opis' II, 1862, delo 10

NRO (BL VIb (vi))
Harry Bradford Lawrence Bequest, 1967, including letters regarding the valuations made of pictures at Houghton, 1778, Norfolk & Norwich Record Office, Norwich: BL VIb (vi)

Tsarskoye Selo Inventory s.d.
'Opis' kartinam, nakhodyashchimsya v B. Tsarskosel'skom Dvortse' [Inventory of Paintings in the Great Tsarskoye Selo Palace], s.d., Hermitage Archives: Fund 4, Opis' VII, Lit. E, No. 5a

University of Nottingham Library, P1 F1/2/7
Portland (London) Collection, Family and Financial Papers, University of Nottingham Library: P1 F1/2/7

University of Nottingham Library, Pw2 Hy 1094 – 1477
Foreign Papers and Correspondence of Robert Harley, 1st Earl of Oxford, University of Nottingham Library: Pw2 Hy 1094 – 1477

Walpole MS 1736
'A Catalogue of the Right Hon.ble Sir Robert Walpole's Collection of Pictures, 1736', anonymous MS [by Horace Walpole?], 18 folios bound into the author's copy of Aedes Walpolianae… 2nd edn, London, 1752, Pierpont Morgan Library, New York: PML 7586. See Appendix III

Worcester Ms.181
Worcester College Library, Oxford: MS 181

Hermitage Catalogues

NOTES

Volumes of catalogues of the Imperial Hermitage Picture Gallery were issued regularly between 1863 and 1916. These included ONLY those works which were actually on display in the galleries, but they were united by a common numbering system throughout (i.e. a painting retained the same number throughout all editions).

Volumes appeared in separate French and Russian editions, although these were only rarely published in the same year.

References such as 'Cat. 1863-1916' indicate that the work appeared repeatedly in catalogues issued between those years. A single reference to one specific catalogue indicates that particular attention is being drawn to this item.

Single references to catalogues produced between 1863 ane 1916 are usually to the Russian language edition.

No more general catalogues were produced between 1916 and 1958. Catalogues of the paintings appeared in 1958 (2 vols) and 1976-81 (Italy, Spain, France, Switzerland = vol. I, 1976, other schools = vol. II, 1981). From 1958 onwards the numbering system employed is specific to each catalogue.

Cat. 1863
[B. de Koehne:] *Ermitage Impérial. Catalogue de la Galerie des Tableaux*, St Petersburg, 1863. Russian ed.: [B. Fon Kyone:] *Imperatorskiy Ermitazh. Katalog kartin* [The Imperial Hermitage. Catalogue of Paintings], St Petersburg, 1863.

Cat. 1869
[B. de Koehne:] *Catalogue de la Galerie des Tableaux*, 2nd ed., vol. I, *Les écoles d'Italie et d'Espagne*, St Petersburg, 1869; Russian ed.: [B. Fon Kyone:] *Imperatorskiy Ermitazh. Katalog kartinnoy galerei* [The Imperial Hermitage. Catalogue of the Picture Gallery], 2nd ed., vol. 1, *Ital'yanskiye i ispanskiye shkoly* [Italian and Spanish Schools], St Petersburg, 1869

Cat. 1870
[B. de Koehne:] *Ermitage Impérial. Catalogue de la Galerie des Tableaux*, 2nd ed., vol. II, *Les écoles germaniques*, St Petersburg, 1870. Russian ed.: [B. Fon Kyone:] *Imperatorskiy Ermitazh. Katalog kartinnoy galerei* [The Imperial Hermitage. Catalogue of the Picture Gallery], 2nd ed., vol. II, *Germanskie shkoly* [The German Schools], St Petersburg, 1870

Cat. 1871
[B. de Koehne:] *Ermitage Impérial. Catalogue de la Galerie des Tableaux*, 2nd ed., vol. III, *Les écoles anglaise, française et russe*, St Petersburg, 1871

Cat. 1885
[B. de Koehne:] *Ermitage Impérial. Catalogue de la Galerie des Tableaux*, 2nd ed., vol. II, *Les écoles germaniques*, St Petersburg, 1885

Cat. 1887
[B. Fon Kyone:] *Imperatorskiy Ermitazh. Katalog kartinnoy galerei* [The Imperial Hermitage. Catalogue of the Picture Gallery], 2nd ed., vol. II, *Germanskie shkoly* [The German Schools], St Petersburg, 1887

Cat. 1887a
[B. de Koehne:] *Catalogue de la Galerie des Tableaux*, 2nd ed., vol. I, *Les écoles d'Italie et d'Espagne*, St Petersburg,

Cat. 1887b
[B. De Koehne:] *Ermitage Impérial. Catalogue de la Galerie des Tableaux*, 2nd ed., vol. III, *Les écoles anglaise, française et russe*, St Petersburg, 1871

Cat. 1888
[B. Fon Kyone:] *Imperatorskiy Ermitazh. Katalog kartinnoy galerei* [The Imperial Hermitage. Catalogue of the Picture Gallery], 2nd ed., vol. 1, *Ital'yanskiye i ispanskiye shkoly* [Italian and Spanish Schools], St Petersburg, 1888

Cat. 1889
Imperatorskiy Ermitazh. Katalog kartinnoy galerei [The Imperial Hermitage. Catalogue of the Picture Gallery], 3rd ed., vol. I, *Ital'yanskaya i ispanskaya zhivopis'* [Italian and Spanish Painting], selected and with additional material by E. Brüiningk and A. Somov, St Petersburg, 1889

Cat. 1891
Ermitage Impérial. Catalogue de la Galerie des Tableaux, 3rd ed., vol. I, *Les écoles d'Italie et d'Espagne*, revue, augmentée et remaniée par E. Brüiningk et A. Somoff, St Petersburg, 1891

Cat. 1892
Imperatorskiy Ermitazh. Katalog kartinnoy galerei [The Imperial Hermitage. Catalogue of the Picture Gallery], 3rd ed., vol. I, *Ital'yanskaya i ispanskaya zhivopis'* [Italian and Spanish Painting], revised and enlarged, with a foreword by A. Somov, St Petersburg, 1892

Cat. 1893a
Imperatorskiy Ermitazh. Katalog kartinnoy galerei [The Imperial Hermitage. Catalogue of the Picture Gallery], 2nd ed., vol. III, *Angliyskaya, frantsuzskaya i russkaya shkoly* [English, French and Russian Painting], with a foreword by B. Koehne, St Petersburg, 1893

Cat. 1893b
Imperatorskiy Ermitazh. Katalog kartinnoy galerei [The Imperial Hermitage. Catalogue of the Picture Gallery], 3rd ed., vol. II, *Niderlandskaya i nemetskaya zhivopis'* [Netherlandish and German Painting], revised, edited and totally reworked, with a foreword by A. Somov, St Petersburg, 1893

Cat. 1894
Ermitage Impérial. Catalogue de la Galerie des Tableaux, 3rd ed., vol. II, *Ecoles néerlandais et école allemande*, revue, completée et entièrement remaniée par A. Somoff, St Petersburg, 1894

Cat. 1895a
Ermitage Impérial. Catalogue de la Galerie des Tableaux, 3rd ed., vol. I, *Les écoles d'Italie et d'Espagne*, revue, completée et entièrement remaniée par A. Somoff, St Petersburg, 1895

Cat. 1895b
Imperatorskiy Ermitazh. Katalog kartinnoy galerei [The Imperial Hermitage. Catalogue of the Picture Gallery], 3rd ed., vol. I, *Ital'yanskaya i ispanskaya School* [Italian and Spanish School], with a foreword by A. Somov, St Petersburg, 1895

Cat. 1897a
Imperatorskiy Ermitazh. Katalog kartinnoy galerei [The Imperial Hermitage. Catalogue of the Picture Gallery], 3rd ed., vol. III, *Angliyskaya, frantsuzskaya i russkaya shkoly* [English, French and Russian Schools], revised, enlarged and totally reworked by A. Somov, St Petersburg, 1897

Cat. 1897b
Imperatorskiy Ermitazh. Katalog kartinnoy galerei [The Imperial Hermitage. Catalogue of the Picture Gallery], 3rd ed., vol. II, *Niderlandskaya i nemetskaya zhivopis'* [Netherlandish and German Painting], revised, edited and totally reworked by A. Somov, St Petersburg, 1897

Cat. 1899
Ermitage Impérial. Catalogue de la Galerie des Tableaux, vol. I, *Les écoles d'Italie et d'Espagne*, par A. Somof, St Petersburg, 1899

Cat. 1900a
Kratkiy katalog galerei imperatorskogo Ermitazha [Brief Catalogue of the Gallery of the Imperial Hermitage], St Petersburg, 1900

Cat. 1900b
Imperatorskiy Ermitazh. Katalog kartinnoy galerei [The Imperial Hermitage. Catalogue of the Picture Gallery], vol. III, *Angliyskaya i frantsuzskaya zhivopis'* [English and French Painting], by A. Somov, St Petersburg, 1900
[NB Russian Painting was removed from the Hermitage to the newly founded Alexander III Imperial Russian Museum in 1898)

Cat. 1901a
Ermitage Impérial. Catalogue de la Galerie des Tableaux, vol. II, *Ecoles néerlandais et école allemande*, par A. Somof, St Petersburg, 1901

Cat. 1901b
Imperatorskiy Ermitazh. Katalog kartinnoy galerei [The Imperial Hermitage. Catalogue of the Picture Gallery], vol. I, *Ital'yanskaya i ispanskaya Zhivopis* [Italian and Spanish Painting], compiled by A. Somov, St Petersburg, 1901

Cat. 1902a
Imperatorskiy Ermitazh. Katalog kartinnoy galerei [The Imperial Hermitage. Catalogue of the Picture Gallery], vol. II, *Niderlandskaya i nemetskaya zhivopis'* [Netherlandish and German Painting], by A. Somov, St Petersburg, 1902

Cat. 1902b
Kratkiy katalog galerei imperatorskogo Ermitazha [Brief Catalogue of the Gallery of the Imperial Hermitage], St Petersburg, 1902

Cat. 1903
Ermitage Impérial. Catalogue de la Galerie des Tableaux, vol. III, *Ecole anglaise et école française*, St Petersburg, 1903

Cat. 1907
Kratkiy katalog galerei imperatorskogo Ermitazha [Brief Catalogue of the Gallery of the Imperial Hermitage], St Petersburg, 1907

Cat. 1908a
Imperatorskiy Ermitazh. Katalog kartinnoy galerei [The Imperial Hermitage. Catalogue of the Picture Gallery], vol. III, *Angliyskaya i frantsuzskaya zhivopis'* [English and French Painting], by A. Somov, St Petersburg, 1908

Cat. 1908b
Kratkiy katalog galerei imperatorskogo Ermitazha [Brief Catalogue of the Gallery of the Imperial Hermitage], St Petersburg, 1908

Cat. 1909
Ermitage Impérial. Catalogue de la Galerie des Tableaux, vol. I, *Les écoles d'Italie et d'Espagne*, par A. Somof, St Petersburg, 1909

Cat. 1911
Kratkiy katalog galerei imperatorskogo Ermitazha [Brief Catalogue of the Gallery of the Imperial Hermitage], St Petersburg, 1911

Cat. 1912
Imperatorskiy Ermitazh. Katalog kartinnoy galerei [The Imperial Hermitage. Catalogue of the Picture Gallery], vol. I, *Ital'yanskaya i ispanskaya zhivopis* [Italian and Spanish Painting], with a foreword by E. Liphart [Lipgart], St Petersburg, 1912

Cat. 1914
Kratkiy katalog galerei imperatorskogo Ermitazha [Brief Catalogue of the Gallery of the Imperial Hermitage], St Petersburg, 1914

Cat. 1916a
Kratkiy katalog galerei imperatorskogo Ermitazha [Brief Catalogue of the Gallery of the Imperial Hermitage], Petrograd, 1916

Cat. 1916b

Catalogue abrégé de l'ermitage Impérial, Petrograd, 1916

Cat. 1958

Gosudarstvennyy Ermitazh. Otdel Zapadnoyevropeyskogo iskusstva. Katalog Zhivopis' [The State Hermitage. Department of Western European Art. Catalogue of Painting], vol. I (Italy, Spain, France, Switzerland), vol. II (Netherlands, Flanders, Belgium, Holland, Germany, Austria, England, Sweden, Denmark, Norway, Finland, Hungary, Czechoslovakia), Leningrad-Moscow, 1958

Cat. 1976

Gosudarstvennyy Ermitazh. Zapadnoyevropeyskaya zhivopis. Katalog 1. Italiya, Ispaniya, Frantsiya, Shveytsariya [The State Hermitage. Western European Painting. Catalogue 1. Italy, Spain, France, Switzerland], Leningrad, 1976

Cat. 1981

Gosudarstvennyy Ermitazh. Zapadnoyevropeyskaya zhivopis. Katalog 2. Niderlandy, Flandriya, Belgiya, Gollandiya, Germaniya, Avstriya, Angliya, Daniya, Norvegiya, Finlyandiya, Shvetsiya, Vengriya, Polsha, Rumyniya, Chekhoslovakiya [The State Hermitage. Western European Painting. Catalogue 2. Netherlands, Flanders, Belgium, Holland, Germany, Austria, England, Denmark, Norway, Finland, Sweden, Hungary, Poland, Romania, Czechoslovakia], Leningrad, 198

Exhibition Catalogues

1898 Amsterdam

Orange-Nassau Exhibition, Rijksmuseum, Amsterdam, 1898

1899 Antwerp

Exposition Van Dyck à l'occasion du 300e anniversaire de la naissance du maître, Koninklijk Museum voor Schone Kunsten, Antwerp, 1898

1900 London

Exhibition of Works by Van Dyck, Royal Academy of Arts, London, 1900

1908 St Petersburg

Staryye shkoly zhivopisi vo dvortsakh i chastnykh kollektsiyakh Rossii. 'Staryye gody.' Katalog vystavki kartin. Noyabr'-dekabr' 1908 [The Old Painting Schools in Palaces and Private Collections in Russia. 'Years of Old.' Catalogue of an Exhibition of Paintings. November–December 1908], St Petersburg, 1908

1920 Petrograd

Gosudarstvennyy Ermitazh. Pervaya ermitazhnaya vystavka [State Hermitage. First Hermitage Exhibition], Petrograd, 1920

1936 Moscow-Leningrad

Rembrandt. Vystavka proizvedeniy. Kartiny. Risunki. Oforty [Rembrandt. Exhibition of Works. Paintings. Drawings. Etchings], State Pushkin Museum of Fine Arts, Moscow; State Hermitage Museum, Leningrad; Moscow-Leningrad, 1936

1938 Leningrad

Vystavka portretov [Exhibition of Portraits], issue 3, *Portret epokhi vozrozhdeniya i barokko* [Portraiture of the Renaissance and Baroque Eras], Hermitage Museum, Leningrad, 1938

1941 Toledo (Ohio)

Spanish Painting, Toledo Museum of Art, Ohio, 1941

1944-45 Leningrad

Gosudarstvennyy Ermitazh. Vremennaya vystavka pamyatnikov iskusstva i kul'tury ostavshikhsya v Leningrade vo vremya blokady [The State Hermitage. Temporary Exhibition of Artistic and Cultural Monuments Remaining in Leningrad During the Siege], Leningrad, 1945

1954 Travelling

Peredvizhnaya vystavka proizvedeniy zapadnoyevropeyskogo iskusstva XV-XIX vv. Zhivopis'. Skul'ptura. Iz fondov Gosudarstvennogo Ermitazha [Travelling Exhibition of Western European Art of the 15th-19th Centuries. Painting. Sculpture. From the Reserves of the Hermitage], Leningrad, 1954

1955 Moscow

Vystavka frantsuzskogo iskusstva XV-XX vv. [Exhibition of French Art of the 15th–20th Centuries], State Pushkin Museum of Fine Arts, Moscow, 1955

1956 Leningrad

Vystavka frantsuzskogo iskusstva XII-XX vv. [Exhibition of French Art of the 12th–20th Centuries], State Hermitage Museum; Moscow, 1956

1956 Moscow

Vystavka proizvedeniy angliyskogo iskusstva… iz muzeyev SSSR [Exhibition of Works of English Art… from Museums in the USSR], State Pushkin Museum of Fine Arts, Moscow, 1956

1956 Moscow-Leningrad

Vystavka proizvedeniy Rembrandta i yego shkoly v svyazi s 350-letiyem so dnya rozhdeniya [Exhibition of Works by Rembrandt and His School on the 350th Anniversary of His Birth], State Hermitage, St Petersburg, State Pushkin Museum of Fine Arts, Moscow; Moscow, 1956

1959 London

The Houghton Pictures, Thomas Agnew & Sons Ltd.,1959

1960 Paris

Exposition Nicolas Poussin, Musée du Louvre, Paris, 1960

1961 London

Architectural Drawings from the Witt Collection, Courtauld Institute of Art, London, 1961

1961 Moscow

Gosudarstvennyy muzey izobrazitel'nykh iskusstv imeni A. S. Pushkina. Vystavka ital'yanskoy zhivopisi XVII-XVIII vekov iz fondov muzeya [State Pushkin Museum of Fine Arts. Exhibition of Italian 17th-18th-Century Painting from the Museum Reserves], compiled by I. A. Antonova, M. Ya. Libman, K. M. Malitskaya etc, introductory essay by M. Ya. Libman, ed. B. R. Wipper, Moscow, 1961

1964 Leningrad

Zapadnoyevropeyskaya zhivopis' iz muzeev SSSR. Vystavka k dvukhsotletiyu Gosudarstvennogo Ermitazha [Western European Painting from Museums in the USSR. Exhibition on the 200th Anniversary of the State Hermitage], State Hermitage Museum, Leningrad, 1964

1965 Brussels

[L. van Puyvelde:] *Le siècle de Rubens*, 15 October - 12 December 1965, Musées Royaux des Beaux-Arts de Belgique, Brussels, Brussels, 1965

1965 Moscow

Gosudarstvennyy muzey izobrazitel'nykh iskusstv imeni A. S. Pushkina. Vystavka kartin zapadnoyevropeyskikh masterov XV-XVIII vv. Iz muzeyev SSSR i chastnykh sobraniy [State Pushkin Museum of Fine Arts. Exhibition of Paintings by Western European Masters of the 15th to 18th centuries. From Museums of the USSR and Private Collections], Moscow, 1965 [booklet]

1967 Montreal

Terre des Hommes. Exposition internationale des Beaux-Arts. Expo 1967, 28 April - 27 October 1967, Montreal, 1967

1968 Göteborg

Hundra målmingar och teckninger från Eremitaget, Leningrad, 1968; *Eremitaget i Leningrad. 100 malningar och teckningar fran ranassans till 1700-tal*, Konstmuseum, Göteborg, 1970

1968-69 Belgrade

Narodni muzej u Beogradu. Drzhavni Ermitazh u Leningradu. Dela Zapadnoevropskikh slikara 16.–18. veka iz zbirki Drzhavnog Ermitazha [National Museum in Belgrade. State Hermitage in Leningrad. Works of Western European Art of the 16th to 18th Century from the Collection of the State Hermitage], November 1968 – January 1969, Ljubljana, 1969 (no catalogue)

1968-69 Ottawa

Jacob Jordaens (1593-1678), selection and catalogue by Michael Jaffé, National Gallery of Canada, Ottawa, 29 November 1968 – 5 January 1969, Ottawa, 1968

1969 Amsterdam

Rembrandt 1669-1969, Tentoonstelling ter herdenking van Rembrandts sterfdag op 4 oktober 1669, Rijksmuseum, Amsterdam; Amsterdam, 1969

1969 Leningrad

Rembrandt. Yego predshestvenniki i posledovateli [Rembrandt. His Predecessors and Followers], State Hermitage Museum, Leningrad, 1969

1969 Moscow
Rembrandt. Vystavka proizvedeniy k 300-letiyu so dnya smerti khudozhnika. Kartiny, risunki, oforty iz sobraniya GMII im. A. S. Pushkina [Rembrandt. Exhibition of Works on the 300th Anniversary of the Artist's Death. Paintings, Drawings, Etchings from the Collection of the Pushkin Museum of Fine Arts], Pushkin Museum of Fine Arts, Moscow, 1969

1969 Travelling
Zapadnoyevropeyskoye iskusstvo XV-XIX vekov [Western European Art of the 15th to 19th Centuries], travelling exhibition from the reserves of the Hermitage, Leningrad, 1969

1971 London
Sir Godfrey Kneller, National Portrait Gallery, London, 1971

1972 Dresden
Europäische Landschaftsmalerei 1550-1650, Eine Gemeinschaftsausstellung des National Museums Warschau, der Nationalgalerie Prag, des Museums der Bildenden Kunste Budapest, der Staatlichen Ermitage Leningrad und der Gemäldegalerie Alte Meister Dresden; Albertinum, Dresden, 29 April – 11 June 1972, Dresden, 1972

1972a Leningrad
Gosudarstvennyy Ermitazh. Pasteli zapadnoevropeyskikh masterov XVII – XX vekov [The State Hermitage. Pastels by Western European Masters of the 17th to 20th Centuries], compiled by A. Kantor-Gukovskaya, Leningrad, 1972

1972b Leningrad
Gosudarstvennyy Ermitazh. Iskusstvo portreta [The State Hermitage. Art of the Portrait], Leningrad, 1972

1972c Leningrad
Zapadnoyevropeyskiy peyzazh 1550-1650 [Western European Landscape 1550-1650], exh. cat., works from the GDR State Museums, Polish State Museums, Budapest Museum of Fine Arts, National Gallery in Prague, State Hermitage in Leningrad; Leningrad, 1972

1972d Leningrad
Gosudarstvennyy Ermitazh. Iskusstvo portreta. Drevniy Yegipet. Antichnost'. Vostok. Zapadnaya Yevropa [The State Hermitage. The Art of the Portrait. Ancient Egypt. Antiquity. The Orient. Western Europe], Leningrad, 1972

1972 Warsaw-Prague-Budapest-Leningrad-Dresden
Europäische Landschaftsmalerei 1550-1650. Eine Gemeinschaftsausstellung des Nationalmuseums Warschau, der Nationalgalerie Prag, des Museum der Bildenden Kunste Budapest, der Staatlichen Ermitage Leningrad und Gemäldegalerie Alte Meister Dresden, Dresden, 1972

1973 Budapest
Olasz mesterek a Leningrádi Ermitázs és a Moszkvai Puskin Múzeum gyüjteményéböl [Old Masters from the Leningrad Hermitage and the Pushkin Museum of Fine Arts], Szépmüveszeti Múzeum, Budapest, 1973

1975-76 Washington etc
Master Paintings from the Hermitage and the Russian Museum, Leningrad, Washington, New York, Detroit, Los Angeles, Houston, Mexico, Winnipeg, Montreal, 1975-6

1977 Antwerp
P. P. Rubens. Paintings - Oil Sketches - Drawings, 29th June – 30th September 1977, Royal Museum of Fine Arts, Antwerp, 1977

1977 Milan
L'Ermitage a Milano. Dipinti italiani dal XV al XVIII secolo, Comune di Milano, Palazzo Reale, Sala delle Cariatidi, 24 March – 24 May 1977; Milan 1977

1977 Tokyo-Kyoto
Master Paintings from the Hermitage Museum, Leningrad, The National Museum of Western Art, Tokyo, 10 September – 23 October 1977; The Kyoto Municipal Museum of Art, 4 November – 11 December 1977; Tokyo, 1977

1978 Düsseldorf
Nicolas Poussin, Stadtische Kunsthalle, Düsseldorf, 27 January – 12 March 1978; Düsseldorf, 1978

1978a Leningrad
Rubens i flamandskoe barokko. Vystavka k 400-letiyu so dnya rozhdeniya P. P. Rubensa. 1577-1977 [Rubens and the Flemish Baroque. Exhibition on the 400th Anniversary of the Birth of P. P. Rubens], State Hermitage, Leningrad, 1978

1978b Leningrad
Paolo Veronese. K 450-letiyu so dnya rozhdeniya. Zhivopis'. Skul'ptura. Prikladnoe iskusstvo. Iz sobraniy Ermitazha [Paolo Veronese. On the 450th Anniversary of his Birth. Painting. Sculpture. Applied Art. From the Hermitage Collections], State Hermitage Museum, Leningrad, 1978

1978 London
Giambologna, Arts Council, London, 1978

1979 Leningrad
Yakob Iordans (1593-1678). Zhivopis. Risunok. Katalog vystavki k 300-letiyu so dnya smerti Ya. Iordansa [Jacob Jordaens (1593-1678). Painting. Drawing. Catalogue of an Exhibition on the 300th Anniversary of the Death of J. Jordaens], State Hermitage, Leningrad, 1979

1979 Sofia
Mezhdunarodna khudozhestvena izlozhba Leonardo da Vinchi i negovata shkola [International Art Exhibition of Leonardo da Vinci and his School], Branch of the National Gallery of Art, Crypt of the Alexander Nevsky Monument Church, Sofia, 2 November – 2 December 1979; Sofia, 1979

1979-80 Melbourne-Sydney
USSR. Old Master Paintings, National Gallery of Victoria, Melbourne, 17 October – 2 December 1979; Art Gallery of New South Wales, Sydney, 12 December 1979 – 10 February 1980; Melbourne, 1979

1981 Vienna
Gemälde aus der Eremitage und dem Puschkin-Museum. Ausstellung von Meisterwerken des 17. Jahrhunderts aus den Staatlichen Museen von Leningrad und Moskau, Kunsthistorisches Museum, Vienna, 13 May–9 August 1981; Vienna, 1981

1982 Bristol
Michael Rysbrack, Bristol Museum and Art Gallery, 1982

1982 London
Van Dyck in England, catalogue by O. Millar, National Portrait Gallery, London, 1982

1982 Moscow
Antichnost' v yevropeyskoy zhivopisi XV – nachala XX veka [Antiquity in European Painting of the 15th to Early 20th Century], paintings and drawings from museums in the USSR, GDR, Netherlands and France; State Pushkin Museum of Fine Arts, Moscow, 1969

1983 London
The Genius of Venice. 1500-1600, Royal Academy, London, 1983

1983 Moscow
Angliyskiy portret XVI-XVIII vv. [English Portraits of the 16th to 18th Centuries], State Pushkin Museum of Fine Arts, Moscow (no catalogue)

1983 Tokyo
17th-Century Dutch and Flemish Paintings and Drawings from the Hermitage Leningrad, The National Museum of Western Art, Tokyo, 10 September – 23 October, 1983; Tokyo, 1983

1983-84 Paris
Raphael et l'art français, Galéries nationales du Grand Palais, Paris, 15 November 1983 – 13 February 1984; Paris, 1983

1984 Leningrad
[L. L. Kagane:] *Muril'o i khudozhniki Andalusii XVII veka v sobranii Ermitazha* [Murillo and 17th-century Artists of Andalucia in the Hermitage Collection], State Hermitage, Leningrad, 1984

1984 London
John Wootton 1682-1764, The Iveagh Bequest, Kenwood, London, 1984

1985 Kingston upon Hull
A Tercentenary Tribute to William Kent, Ferens Gallery, Kingston upon Hull, 1985

1985 Norwich
Norfolk & The Grand Tour, Norwich Castle Museum, Norwich, 5 October – 24 November 1985

1985 Rotterdam
Meesterwerken uit de Hermitage Leningrad. Hollandse en Vlaamse schilderkunst van 17de eeuw, 19 May – 14 July 1985, Museum Boymans van Beuningen, Rotterdam, 1985

1985 Sapporo
Works by Western European Masters from the Hermitage Collection, Hokkaido Museum of Modern Art, Sapporo, 13 July – 22 August 1985; Sapporo, 1985 [In Japanese with some Russian]

1987 London
Designs for English Picture Frames, Arnold Wiggins & Sons Ltd., London, 1987

1987 Moscow
GMII im. A. S. Pushkina. Vystavka novykh postupleniy (1981-1986). K 75-letiyu muzeya, 1987 [State Pushkin Museum of Fine Arts. Exhibition of New Acquisitions (1981-1986). For the 75th Anniverary of the Museum in 1987], Moscow, 1987

1987 New Delhi
Masterpieces of Western European Art from the Hermitage, Leningrad, The National Museum, New Delhi; Leningrad, 1987

1987-88 London
Manners and Morals, Hogarth and British Painting 1700-1760, 15 October 1987 - 3 January 1988, Tate Gallery, London

1987-88 Belgrade-Ljubliana–Zagreb
Svetski majstori iz riznica Ermitaza od XV-XVIII veka [Hermitage Masterpieces. Paintings and Drawings, 15th- 18th Centuries], Narodni muzej, Belgrade, October – November 1987; Narodna Galerija, Ljubliana, December 1987 - January 1988; Muzejski Prostor, Zagreb, January -February 1988; Belgrade, 1987

1988 New York-Chicago
Dutch and Flemish Paintings from the Hermitage, 26 March– 5 June 1988, The Metropolitan Museum of Art, New York; 9 July– 18 September 1988, The Art Institute of Chicago; New York, 1988

1990 London
Paul de Lamerie, At the sign of the Golden Ball, An Exhibition of the Work of England's Master Silversmiths 1688-1751, Goldsmith's Hall, London, 1990

1990 Milan
Da Leonardo a Tiepolo. Collezioni italiane dell'Ermitage di Leningrado, Palazzo Reale, Milan, 6 June – 30 September, 1990; Milan, 1990

1990 New York-Chicago
From Poussin to Matisse. The Russian Taste for French Paint-ing. A Loan Exhibition from the USSR, The Metropolitan Museum of Art, New York, 20 May – 29 July; The Art Institute of Chicago, 8 September - 25 November 1990; New York, 1990

1990-91 Sapporo-Tokyo-Kyoto-Fukuoka
500 Years of European Art. Exhibition of Paintings and Draw-ings from the Collection of the Pushkin Museum of Fine Arts, Tokyo, Kyoto, Fukuoka, Sapporo [in Japanese]

1990–91 Washington
Anthony van Dyck, 11 November 1990 – 24 February 1991, The National Gallery of Art, Washington, 1990

1991 Antwerp
David Teniers the Younger. Paintings. Drawings, Koninklijk Museum voor Schone Kunsten, Antwerp, 11 May – 1 September 1991; Antwerp, 1991

1991 Frankfurt-am-Main
Von Lucas Cranach bis Caspar David Friedrich. Deutsche Malerei aus der Ermitage, Hrsg. von Sybille Ebert-Schifferer, Schirn Kunsthalle Frankfurt; Munich, 1991

1991 Retretti
Rubens (1577-1640), 25 May – 1 September 1991, Retretti Art Center (Punkaharju, Finland), 1991

1991 Seoul
The Masterpieces of European Paintings of the Hermitage [sic], Seoul, 1991

1991-92 Berlin-Amsterdam-London
Rembrandt. De Meester & zijn Werkplaats. Schilderijen, Gemäldegalerie, Staatliche Museen Preussischer Kulturbe-sitz, Berlin; Rijksmuseum, Amsterdam; National Gallery, London; 1991-2; 2 vols, Amsterdam-Zwolle, 1991

1991-92 London-Edinburgh
Palaces of Art, Art Galleries in Britain 1790-1990, Dulwich Pic-ture Gallery, 27 November 1991 – 1 March 1992; National Gallery of Scotland, Edinburgh, 12 March – 3 May 1992

1992 Frankfurt-am-Main
Kunst in der Republik Genua, Frankfurt am Main, 1992

1992 Norwich
Norfolk Portraits, Norwich Castle Museum, 5 September – 29 November 1992

1992 Tokyo
Dutch and Flemish Art of the 17th Century from the State Her-mitage Museum, Tobu Museum of Art, Tokyo, 10 June – 18 August 1992; Tokyo, 1992

1992-93 Cologne-Antwerp-Vienna
Cologne/Vienna: *Von Brueghel bis Rubens. Das goldene Jahrhundert der flamischen Malerei*, Wallraf-Richartz-Museum der Stadt Koln, 4 September – 22 November 1992; Kunsthistorisches Museum, Vienna, 2 April – 20 June 1993
Antwerp: *De Bruegel à Rubens. L'école de peinture anversoise 1550-1650*, Koninklijk Museum voor Schone Kunsten Antwerpen, 12 December 1992 – 8 March 1993; Konin-klijk Museum voor Schone Kunsten, [s.a.]

1993 Antwerp
Jacob Jordaens (1593-1678). Paintings and Tapestries. Draw-ings and Engravings, 27 March – 27 June 1993, Koninklijk Museum voor Schone Kunsten, Antwerp, 1993

1993 Dijon
L'Age d'or flamand et hollandais. Collections de Catherine II. Musée de l'Ermitage, Saint-Pétersbourg, 20 June – 27 Septem-ber 1993, Musée des Beaux-Arts de Dijon, Dijon, 1993

1993 Frankfurt-am-Main
Leselust. Niederlandische Malerei von Rembrandt bis Vermeer, Schirn Kunsthalle, Frankfurt-am-Main, 1993

1993 St Petersburg
Russkoye i zapadnoyevropeyskoye iskusstvo XVII – nachala XX v. Zhivopis'. Risunok. Skul'ptura. Gravyura. Litografiya [Russian and Western European Art of the 17th to Early 20th Cen-turies. Paintings. Drawings. Sculpture. Prints. Lithographs], [catalogue of an exhibition from the reserves of the Museum of the Academy of Arts], St Petersburg, 1993

1993 Turku
The Age of Rembrandt, Wäinö Aaltonen Museum of Art, Turku; Åbo, 1993

1993-94 Boston-Toledo
The Age of Rubens, 22 September 1993 – 2 January 1994, Museum of Fine Arts, Boston; 2 February – 24 April 1994, Toledo Museum of Art; Ghent, 1993

1993-94 Tokyo – Mie – Ibaraki
Italian Renaissance and Baroque Art from the State Hermitage Museum, Tokyo – Mie – Ibaraki, 1993-1994 full details

1994 Mito-Tsu-Tokyo
French Baroque and Rococo Art from the State Hermitage Museum, The Museum of Modern Art, Ibaraki, Mito, 25 June – 31 July 1994; Mie Prefectural Art Museum, Tsu, 6 August – 18 September 1994; Tobu Museum of Art, Tokyo, 25 September – 25 October 1994; Tokyo, 1994

1994 Moscow
Peyzazh v niderlandskoy zhivopisi XVI-XVII vekov. Vystavka iz fondov muzeya [Landscape in Netherlandish Painting of the 16th to 17th Centuries. Exhibition from the Museum Reserves], Pushkin Museum of Fine Arts, Moscow, 1994

1994-95 Paris
Nicolas Poussin. 1594-1665, by Pierre Rosenberg, Grand Palais, Paris, 27 September 1994 - 2 January 1995, Paris, 1994

1994-95 Rotterdam
Rotterdamse Meesters uit de Gouden Eeuw, Het Schielandhuis te Rotterdam, 15 October 1994 – 15 January 1995, Zwolle, 1994

1995 London
Nicolas Poussin, by R. Verdi with an essay by P. Rosenberg, Royal Academy of Arts, London, 19 January - 9 April 1995, London, 1994

1995 Shizuoka-Tochigi-Okayama-Kumamoto
Stikhiya vody [The Watery Elements], exhibition of paint-ings and prints from the collection of the State Hermitage, Shizuoka Prefectural Museum of Art, 15 April – 8 June 1995; Tochigi Prefectural Museum of Fine Arts, 14 June – 23 July 1995; The Okayama Prefectural Museum of Art, 29 July – 31 August 1995; Kumamoto Prefectural Museum of Art, 9 September – 15 October 1995, [In Japanese with some Russian]

1995 Vienna
La prima donna pittrice. Sofonosba Anguissola. Die Malerin der Renaissance (um 1535-1625), Kunsthistorisches Museum, Vienna, 17 January – 26 March 1995; Vienna, 1995

1995-96 Tel Aviv
Van Dyck and his Age, exh. cat. by D. J. Lurie, 29 October 1995 – 28 January 1996, Tel Aviv Museum of Art, 1995

1996 Nagaoka-Osaka
God and Man. Great Art Treasures of the State Hermitage Museum, 1 August – 17 October 1996, Niigata Prefectural Museum of Modern Art, Nagaoka; 27 October – 15 December 1996, ATC Museum, Osaka; Nagaoka, 1996

1996 St Petersburg
Yekaterina II i Akademiya Khudozhestv. Vystavka iz fondov Nauchno-issledovatel'skogo muzeya Rossiyskoy Akademii Khu-dozhestv [Catherine II and the Academy of Arts. Exhibi-tion from the Reserves of the Scientific Research Museum of the Russian Academy of Arts], St Petersburg, 1996

1996 Tokyo-Mito-Tsu
[L. Kagane, M. Dedinkin:] *Spanish Art of the XVI-XIX Centuries from the State Hermitage Museum*, Tobu Museum of Art, Tokyo, 13 July – 1 September; The Museum of Modern Art, Ibaraki, Mito, 10 September – 20 October; Mie Prefectural Art Museum, Tsu, 29 October – 15 December; Tokyo, 19969

1996-97 Amsterdam
Catharina, de keizerin en de kunsten. Uit de schatkamers van de Hermitage/ Catherine, the Empress and the Arts. Treasures from the Hermitage, De Nieuwe Kerk, Amsterdam, 17 Decem-ber 1996 – 13 April 1997; Amsterdam, 1996

1996-97 London
Making and Meaning: Rubens' s Landscapes, by C. Brown, The National Gallery, London, 16 October 1996 – 19 Jan-uary 1997; London, 1996

1996-97 New Haven-Toledo-St Louis
British Art Treasures from Russian Imperial Collections in the Hermitage, ed. by B. Allen and L. Dukelskaya; 5 October 1996 – 5 January 1997, Yale Center for British Art, New Haven, Connecticut; 13 February – 11 May 1997, Toledo Museum of Art, Toledo, Ohio; 27 June – 7 September 1997, Saint Louis Art Museum, Saint Louis, Missouri; New Haven-London, 1996

1996-97 Norwich & London
Houghton Hall: The Prime Minister, The Empress and The Heritage, Norwich CastleMuseum, 12 October 1996 – 5 January 1997; The Iveagh Bequest, Kenwood, London, 23 January – 20 April 1997

1997 Bonn
Zwei Gesichter der Eremitage. Von Caravaggio bis Poussin, Bd. II, *Die großen Sammlungen VI*, Kunst- und Austellungs-halle der Bundesrepublik Deutschland, Bonn, 21 February – 11 May 1997, Bonn, 1997

1997 St Petersburg
Svobodnym khudozhestvam. 240 let Akademii Khudozhestv. Russkoye i zapadnoyevropeyskoye iskusstvo kontsa XVI – nachala XX veka [To the Free Arts. 240 Years of the Acad-emy of Arts. Russian and Western European Art of the Late 16th to Early 20th Century],[Catalogue of an exhibi-tion from the reserves of the Museum of the Academy of Arts], St Petersburg, 1997

1997 Tokyo-Tendo-Okazaki-Akita
Italian Paintings and Drawings of the 17th to 18th Centuries from the Collection of the Pushkin Museum of Fine Art, Tokyo, Tendo, Okazaki, Akita, February-September, 1997; Tokyo 1997 [in Japanese]

1998 Florence
Catarina di Russia: L'imperatrice e le arti, Palazzo Strozzi, Florence, May – August 1998; Florence, 1998

1998 Moscow
Muzei mira – partnyori Gosudarstvennogo Muzeya izo-brazitelnogo iskusstva imeni A. S. Pushkina [World Museums – Partners of the Pushkin Museum of Fine Arts], edited and compiled by K. S. Yegorova, Pushkin Museum of Fine Arts, Moscow, 1998

1998 St Petersburg
S beregov Temzy – na berega Nevy. Shedevry iz sobraniya britan-skogo iskusstva v Ermitazhe [From the Banks of the Thames

to the Banks of the Neva. Masterpieces from the Collection of British Art in the Hermitage], State Hermitage, 1996

1998 Tokyo
Claude Lorrain and the Ideal Landscape, The National Museum of Western Art, Tokyo, 15 September - 6 December 1998; Tokyo, 1998

1998-99 Brussels
Albert et Isabelle. 1598-1621, Musées Royaux d'Art et d'Histoire, Bruxelles; Brepols, 1998

1998-99 Munich
Die Nacht, Haus der Kunst, München; Bonn, 1998

1998-99 New York
Royal Persian Paintings. The Qajar Epoch 1785-1925, Brooklyn Museum of Art, 23 October 1998 – 24 January 1999; New York, 1998

1998-99 St Petersburg
T. K . Kustodieva: *Proizvedeniya shkoly Leonardo da Vinchi v sobranii Ermitazha* [Works from the School of Leonardo da Vinci in the Hermitage Collection], State Hermitage Museum, St Petersburg, 22 December 1998 – 14 March 1999; St Petersburg, 1998

1998-99 Stockholm
Catherine the Great and Gustav III, Nationalmuseum, Stockholm, 9 October 1998 – 28 February 1999; Helsingborg, 1999

1999 Antwerp-London
Van Dyck. 1599-1641, Koninklijk Museum voor Schone Kunsten, Antwerp, 15 May – 15 August 1999; Royal Academy of Arts, London, 11 September – 10 December 1999; Antwerp, 1999

1999 Tokyo
Florence and Venice. Italian Renaissance Paintings and Sculpture from the State Hermitage Museum, The National Museum of Western Art, Tokyo, 20 March – 20 June 1999, Tokyo, 1999

1999-2000 Madrid
El Arte en la Carte de los Archiduques Alberto de Austria e Isabel Clara Eugenia (1598-1633). Un Reino Imaginado, Palacio Real, Madrid, 2 December 1999 – 27 February 2000; Madrid, 1999

2000 Rome
L'Idea del bello. Viaggio per Roma nel Seicento con Giovan Pretio Bellor, Palazzo delle Esposizione, Rome, March - June 2000

2000-1 London
Treasures of Catherine the Great, Hermitage Rooms at Somerset House, London, November 2000 - March 2001; London, 2000

2000-1 Rome
Le Dieu caché. Les peintures du Grand Siècle et la vision de Dieu, Académie de France à Rome, October 2000 - January 2001

2001 Bassano-Barcelona
Cinquecento veneto. Dipinti dall'Ermitage, ed. Irina Artemieva, Museo Civico, Bassano del Grappa, 8 April - 19 August 2001; Museu Nacional d'Art de Catalunya, 6 September - 9 December 2001; Milan, 2001

2001 Épinal
Claude le Lorrain et le monde des dieux, Musée départemental d'Art ancien et contemporain, Épinal, 11 May - 20 August 2001; Épinal, 2001

2001 Toronto
Rubens and his Age. Treasures from the Hermitage Museum, Russia, ed. Christina Corsiglia, Art Gallery of Ontario, Toronto, 2001

BIBLIOGRAPHY
Literature

Academy of Arts 1874
Kartinnaya galereya Imperatorskoy Akademii Khudozhestv [The Picture Gallery of the Imperial Academy of Arts], II, *Katalog proizvedeniy inostrannoy zhivopisi (originalov i kopiy)* [Catalogue of Works of Foreign Painting (Originals and Copies)], compiled by A. Somov, St Petersburg, 1874

Adams and Lewis 1970
C. K. Adams & W. S. Lewis, 'The Portraits of Horace Walpole', *Walpole Society,* XLII, 1968-70

Adler 1980
W. Adler, *Jan Wildens. Der Landschaftsmitarbeiter des Rubens*, Fridingen, 1980

Adler 1982
W. Adler, *Landscapes and Hunting Scenes*, vol. I, *Landscapes*, in the series *Corpus Rubenianum Ludwig Burchard*, part XVIII, London, 1982

Alekseyev 1982
M. P. Alekseyev, *Russko-angliyskiye literaturnyye svyazi (XVIII vek—pervaya polovina XIX veka)* [Russo-English Literary Connections (18th to First Half of the 19th Century)], Moscow, 1982

Allende-Salazar 1925
Allende-Salazar, *Velázquez*, Berlin-Stuttgart-Leipzig, 1925 (*Klassiker der Kunst in Gesamtausgaben*, vol. 6)

Alpatov 1960
M. Alpatov, 'Poussin peintre d'histoire', *Nicolas Poussin (Actes du Colloque International, Paris, 19-21 September 1958)*, 2 vols., Paris, 1960, vol. 2, pp. 189-99

Alpatov 1963
M. V. Alpatov, 'Klassicheskoye techeniye vo frantsuzskoy zhivopisi XVII veka' [The Classical Trend in French 17th-century Painting], in *Etyudy po istorii zapadnoyevropeyskogo iskusstva* [Studies in the History of Western European Art], Moscow, 1963, p. 282

Alpers 1995
S. Alpers, *The Making of Rubens*, New Haven-London, 1995

Alupka 1992
Alupka. Dvorets i park [Alupka. The Palace and Park], Kiev, 1992

Andresen 1863
A. Andresen, *Nicolas Poussin. Verzeichniss der nach seinen Gemälden gefertigten Gleichzeitigen und späteren Kupferstiche etc*, Leipzig, 1863

Andrews 1977
K. Andrews, *Adam Elsheimer*, Oxford, 1977

Andreyev 1853-83
A. N. Andreyev, *Kartinnyye galerei Yevropy* [Picture Galleries of Europe], 3 vols., St Petersburg, 1853-83

Andreyev 1857
Zhivopis' i zhivopistsy glavneyshikh yevropeyskikh shkol. Nastol'naya kniga dlya lyubiteley izyashchnykh iskusstv s prisovokupleniyem opisaniya zamechatel'neyshikh kartin, nakhodyashchikhsya v Rossii s shestnadtsat'yu tablitsami monogramm izvestneyshikh khudozhnikov. Sostavil po luchshim sovremennym izdaniyam A. N. Andreyev [Painting and Painters of the Main European Schools. Table Book for Lovers of the Fine Arts with the Addition of a Description of the Most Marvellous Paintings in Russia with Sixteen Tables of Monograms of the Most Famous Artists. Compiled from the best contemporary publications by A. N. Andreyev], St Petersburg, 1857

Androssov 1991
S. Androssov, ed., *Alle origini di Canova, Le terrecotte della collezione Fassetti*, exh. cat., Venice and Rome, Venice 1991

Anecdotes 1862
Horace Walpole, *Anecdotes of Painting in England, with an account of the Principal artists; and Incidental notes on other arts…*, new revised ed., with notes by Ralph N. Wornum, 3 vols., London, 1862

Angulo Iñiguez 1964
D. Angulo Iñiguez, 'Murillo: El retrato de Nicolas Omazur adquirido por el Museo del Prado. Varios bocetos. La Adoración de Leningrado', *Archivo Español de Arte*, vol. XXXVII, 1964, no. 148, pp. 269-80

Angulo Iñiguez 1981
D. Angulo Iñiguez, *Murillo*, 3 vols., Madrid, 1981

Anikiyeva 1947
V. N. Anikiyeva, 'Ot zamysla k kartine (Nikola Pussen)' [From Idea to Painting (Nicolas Poussin)], *Trudy Vserossiyskoy Akademii Khudozhestv* [Papers of the All-Russian Academy of Arts], issue I, Moscow-Leningrad, 1947, pp. 67-86

Annibale Carracci e i suoi incisori 1986
Annibale Carracci e i suoi incisori, exh. cat., via della Lungara 230, Rome, 4 October – 3 November 1986; Rome, 1986

Anthal 1962
F. Anthal, *Hogarth and His Place in European Art*, New York, 1962

Antonova, Malitskaia 1963
Les grands maîtres de la peintre au Musée de Moscou, introduction by I. Antonova, text by K. Malitskaia et al, Paris, 1963

Arslan 1960
E. Arslan, *I Bassano*, 2 vols., Milan, 1960

Ashmole 1924
B. Ashmole, *Journal of Hellenic Studies*, vol. XLIV, 1924,

Austin 1999
Anne Austin, 'George Walpole, Third Earl of Orford, Viscount Walpole and Sixteenth Baron Clinton. "The most ruined young man in England"', in *The History of the Clinton Barony 1299-1999*, priv. pub. by Lord Clinton, 1999

Auvray 1882-5
Dictionnaire général des artistes de l'école française depuis l'origine des arts du dessin jusqu'à nos jours, 2 vols., Paris, 1882-5

Avery 1982
C. Avery, 'Hubert Le Sueur, the "Unworthy Praxiteles" of King Charles I', *Walpole Society*, XLVIII (1980-82) Leeds,1982

Avery 1987
C. Avery, *Giambologna*, Oxford, 1987

Babina 1989
N. Babina, *David Teniers the Younger (Masters of World Painting)*, Leningrad, 1989

Babina 1993
N. P. Babina, 'Kartiny Khendrika van Steynveka Mladshego v sobranii Ermitazha' [Pictures by Hendrick van Steenwyck the Younger in the Hermitage Collection], *Problemy razvitiya zarubezhnogo iskusstva. Sbornik nauchnykh trudov, Chast I* [Questions in the Development of Foreign Art. Anthology of Scholarly Papers, Part I], Repin Institute of Painting, Sculpture and Architecture, St Petersburg, 1993, pp. 43-9

Babina 1995
N. P. Babina, *Arkhitekturnyy zhanr vo flamandskoy zhivopisi XVII veka (po materialam ermitazhnoy kollektsii)* [The Architectural Genre in Flemish 17th-century Painting (From material in the Hermitage collection)], Summary of a Dissertation presented for the title of Candidate of Art History, St Petersburg, 1995

Bailo, Biscaro 1900
L. Bailo, G. Biscaro, *Della vita e delle opere di Paris Bordon*, Treviso, 1900

Baker, Baker 1949
C. Baker, M. Baker, *The Life and Circumstances of James Brydges, First Duke of Chandos: Patron of the Liberal Arts*, Oxford, 1949

Baldinucci 1681-1728
F. Baldinucci, *Notizie de'Professori del Disegno da Cimabue in qua*, 1681-1728, cited from ed.: 7 vols., Florence, 1974-76

Balis 1986
A. Balis, *Rubens Hunting Scenes*, in the series *Corpus Rubenianum Ludwig Burchard*, part XVIII, vol. II, London-Oxford-New York, 1986

Balis 1989
A. Balis et al, *Flamishe Malerei im Kunsthistorischen Museum Wien*, Zurich-Antwerp, 1989

Balis 1996
A. Balis, 'Paul de Vos', in *The Dictionary of Art*, ed. Jane Turner, 34 vols., New York-London, 1996

Ballegeer 1967
J. P. C. M. Ballegeer, 'Enkele voorbeelden van de invloed van Hans en Paulus Vredeman de Vries op de architectuurschilders in de Nederlanden gedurende de XVI-e en XVII-e eeuw.', *Overdruk uit de Gentse Bijdragenn tot de kunstgeschiedenis en de oudheidkunde*, 1967, no. 20

Banister 1989
J. Banister, *'The Walpole Inkstand'* Octagon, XXV, no. 3, pp. 36-9 1989

Bardi 1969
P. M. Bardi, *L'opera completa di Vel?zquez*, Milan, 1969

Baroque and Rococo 1965
The Hermitage, Leningrad. Baroque and Rococo Masters, Prague-Leningrad, 1965

Barr 1980
Elaine Barr, *George Wickes 1698–1761, Royal Goldsmith*, London, 1980, pp. 24–25

Barrell 1996
R. Barrell, *The French Correspondence of James, 1st Earl Waldegrave (1684-1741)*, Studies in British History vol. 38, Lampeter, 1996

Barroero 1979
L. Barroero, 'Nuove acquisizioni per la cronologia di Poussin', *Bollettino d'Arte*, vol. LXIV, no. 4, October-December 1979, pp. 69-74

Bartsch
A. Bartsch, *Le peintre graveur*, 21 vols., Vienna, 1802-21

Bartsch 1797
Adam Bartsch, *Catalogue raisonné de toutes les estampes de Rembrandt, et ceux de ses principaux imitateurs…*, nouvelle edition, 2 vols., 1797, 1ère partie

Bartsch Ill.
The Illustrated Bartsch, New York, 1978-[2000]

Baschet 1875
A. Baschet, *Histoire du depot des archives des Affaires Estrangeres*, Paris, 1875

Bauch 1960
Kurt Bauch, *Der frühe Rembrandt und seine Zeit. Studien zur geschichtlichen Bedeutung seines Frühstil*, Berlin, 1960

Bauch 1966
K. Bauch, *Rembrandts Gemälde*, Berlin, 1966

Baudissin 1925
Klaus Baudissin, 'Rembrandt und Cats', *Repertorium für Kunstwissenschaft*, 45, 1925

Bazin 1958
Germain Bazin, *Musée de l'Ermitage*, Paris, 1958

Beard 1975
G. Beard, *Decorative Plasterwork in Great Britain*, London, 1975

Beard 1981
G. Beard, *Craftsmen and Interior Decoration in England, 1660-1820*, London, 1981

Beard 1986
G. Beard, 'William Kent', *Antiques*, June 1986, p. 1282

Beard 1989
G. Beard, *The Work of Grinling Gibbons*, London, 1989

Beard 1997
G. Beard, *Upholsterers and Interior Furnishings in Enland 1530–1840*, 1997, p. 174; ills. 144–50

Beard and Gilbert 1986
G. Beard and C. Gilbert, *Dictionary of English Furniture Makers, 1660-1840*, Leeds, 1986

Beatniffe 1795
R. Beatniffe, *The Norfolk Tour: or, the Traveler's Pocket Companion…*, 5th edn., Norwich, 1795

Bedingfeld 1987
H. Bedingfeld, National Trust, *Oxburgh Hall; The First 500 Years*, Norwich, 1987, unpaginated

Béguin 1968
S. Béguin, 'Une Annonciation de Paris Bordon', *La revue du Louvre et des Musées de France*, XVIII, 1968, nos. 4-5, pp. 195-204

Béguin 1985
S. Béguin, 'Paris Bordon en France', in *Paris Bordon e il suo tempo*, Atti del Convegno Internazionale di studi, Treviso, 28-30 ottobre 1985, Milan, pp. 9-27

Béguin 1993
[S. Béguin], *Le siècle de Titien. L'age d'or de la peinture à Venise*, Paris, 1993

Bellori 1672
Giovanni Pietro Bellori, *Le vite de' pittori, scultori, ed architetti moderni, co' loro ritratti al naturale scritte da Gio: Pietro Bellori*; 2nd ed., … accresciute colla vita e retratto del cavaliere D. Luca Giordano…, Rome, 1728

Bellori 1942
G. P. Bellori, *Vite di Guido Reni, Andrea Sacchi e Carlo Maratti*, MS 1695, M. Piacenti, ed., Rome, 1942

Benesch 1935
Otto Benesch, *Rembrandt. Werk und Forschung*, Vienna, 1935

Benesch 1954-57
Otto Benesch, *The Drawings of Rembrandt. A Critical and Chronological Catalogue*, 6 vols., 1954-57

Bénézit 1911-13
Dictionnaire critique et documentaire des peintres, sculpteurs, dessinateurs et graveurs…, Sous la direction de E. Bénézit, 3 vols., Paris 1911-13

Bénézit 1976
E. Bénézit, *Dictionnaire critique et documentaire des Peintres, Sculpteurs, Dessinateurs et Graveurs*, new ed., 9 vols., Paris, 1966

Benois [1910]
A. Benua [Benois], *Putevoditel' po kartinnoy galeree imperatorskogo Ermitazha* [Guide to the Picture Gallery of the Imperial Hermitage], St Petersburg [1910]

Benois 1912
A. Benois, *Istoriya zhivopis' vsekh vremyon i narodov* [The History of Painting of all Ages and Peoples], 4 vols., Petrograd, 1912; vol. IV: *Ispanskaya zhivopis' s XVI po XVIII vek* [Spanish Painting from the 16th to 18th Century]

Berenson 1907
B. Berenson, *The Florentine Painters of the Renaissance*, New York-London, 1907

Berenson 1932
B. Berenson, *Italian Pictures of the Renaissance. A List of the Principal Artists and Their Works, with an Index of Places*, Oxford, 1932

Berenson 1938
B. Berenson, *The Drawings of the Florentine Painters*, Chicago, 1938

Berenson 1957
B. Berenson, *Italian Pictures of the Renaissance. Venetian School*, 2 vols., London, 1957; vol. I (pl. 1-628); vol. II (pl. 629-1333)

Berenson 1958
B. Berenson, *Pitture Italiane del Rinascimento. La scuola veneta*, 2 vols., London, 1958

Berger 1993
A. Berger, *Die Tafelgemälde Paul Brils*, Münster, 1993

Bernoulli 1882-94
J. J. Bernoulli, *Römische Ikonographie*, Stuttgart, 1882-94

Bernt 1970
W. Bernt, *Die Niederlandischen Maler des 17. Jahrhunderts*, Munich, 3 vols., 1970

Bertin-Mourot 1947
Th. Bertin-Mourot, 'Moïse frappant le rocher', *Bulletin de la Société Poussin*, I, June 1947, pp. 56-65

Beruete 1904
A. Beruete y Moret, 'Museo del Ermitage. Escuela española', *La Lectura*, no. 41, May 1904, pp. 33-44

Beruete 1906
A. Beruete y Moret, *Velázquez*, London, 1906

Bieneck 1992
D. Bieneck, *Gerard Seghers. 1591-1651. Leben und Werke des antwerpener Historienmalers*, vol. 6 in the series *Flämische Maler im Umkreis der grossen Meister*, Lingen, 1992

Bignamini 1988
I. Bignamini, 'George Vertue, Art Historian, and Art Institutions in London, 1698-1768', *The Walpole Society*, LIV, pp. 1-148, Oxford, 1988

Bindman 1997
D. Bindoman, Scott Wilcox, eds., *'Among the Whores and Thieves.' William Hogarth and the Beggar's Opera*, New Haven and London, 1997

Blanc 1857
Charles Blanc, *Le Trésor de la Curiosité tiré des catalogues de ventes… Précédé d'une lettre à l'auteur sur la curiosité et les curieux par A. Thibaudeau*, vol. I, Paris, 1857

Blanc 1873
Charles Blanc, *L'oeuvre de Rembrandt décrit et commenté par M. Charles Blanc, … Catalogue raisonné de toutes les estampes du maître et de ses peintures…*, 2 vols., Paris, 1873

Blanc et al 1869
C. Blanc, W. Burger, P. Mantz, L. Viardot, P. Lefort, *Histoire des Peintres des toutes les Ecoles. Ecole Espagnole*, Paris, 1869

Blankert 1982
A. Blankert, *Ferdinand Bol (1616-1680). Rembrandt's Pupil*, Doornspijk, 1982

Blunt 1950
A. Blunt, 'Poussin Studies IV: Two Rediscovered Late Works', *The Burlington Magazine*, vol. XCII, no. 563, February 1950, pp. 38-41

Blunt 1953
A. Blunt, *Art and Architecture in France, 1500-1700*, in the series *The Pelican History of Art*, Harmondsworth, 1953; 3rd ed., 1973

Blunt 1965
A. Blunt, 'Poussin and his Roman Patrons', in *W. Friedländer zum 90. Geburtstag*, Berlin, 1965, pp. 58-75

Blunt 1966
A. Blunt, *The Paintings of Nicolas Poussin. A Critical Catalogue*, London, 1966

Blunt 1967
A. Blunt, *Nicolas Poussin, The A. W. Mellon Lectures in the Fine Arts 1958*, National Gallery of Art, Washington; New York, 1967

Blunt 1977
A. Blunt, 'Rubens and Architecture', *The Burlington Magazine*, vol. CXIX, no. 890, August 1977, p. 609-21

Blunt 1982
A. Blunt, 'French Seventeenth-Century Painting: The Literature of the Last Ten Years', *The Burlington Magazine*, vol. CXXIV, no. 956, November 1982, pp. 705-11

Blunt, Cooke 1960
A. Blunt, H. Cooke, *The Roman Drawings of the XVII and XVIII Centuries in the Collection of Her Majesty the Queen at Windsor Castle*, London, 1960

Bodart 1977
Didier Bodart, *Rubens e l'incisione nelle collezioni del Gabinetto Nazionale delle Stampe*, exh. cat., Villa della Farnesina alla Lungara, Rome, 8 February – 30 April 1977; Rome, 1977

Bode 1873
W. Bode, *Die Gemälde-Galerie in der Kaiserlichen Eremitage. Die Meisterwerke der holländischen Schule*, St Petersburg, 1873

Bode 1882
W. Bode, *Kaiserliche Gemäldegalerie der Ermitage in St. Petersburg*, Berlin, 1882

Bode 1883
W. Bode, *Studien zur Geschichte der holländischen Malerei*, Braunschweig, 1883

Bode 1906
W. von Bode, *Rembrandt und seine Zeitgenossen*, Leipzig, 1906

Bode 1921
Wilhelm Bode, *Die Meister der hollandischen und vlamischen Malerschulen*, Leipzig, 1921

Bode, Binder 1914
W. von Bode, M. J. Binder, *Frans Hals, sein Leben und seine Werke*, 2 vols., Berlin, 1914

Bode, Hofstede de Groot 1897-1905
W. Bode, C. Hofstede de Groot, *Rembrandt. Beschreibendes Verzeichnis seiner Gemälde*, Paris, 1897-1905 NOT FOUND

Boehn 1910
M. von Boehn, *Guido Reni*, Leipzig, 1910

Boisclair 1974
M. Boisclair, 'Documents inédits relatif à Gaspard Dughet', *Bulletin de la Société de l'histoire de l'art français*, Année 1973, Paris, 1974

Boisclair 1976
M. Boisclair, 'Gaspard Dughet: une chronologie revisée', *Revue de l'art*, 1976, no. 34

Boisclair 1986
M. N. Boisclair, *Gaspard Dughet. Sa vie et son oeuvre (1615-1675)*, Préface de J. Thuillier, Paris, 1986

Bologna 1984
Bologna 1584. Gli esordi dei Carracci e gli affreschi di Palazzo Fava, Bologna, 1984

Bolognini Amorini 1839
A. Bolognini Amorini, *Vita del celebre pittore Guido Reni*, Bologna, 1839

Bolten, Bolten-Rempt 1978
J. Bolten, H. Bolten-Rempt, *The Hidden Rembrandt*, Oxford, 1978

Bottoms 1997
E. Bottoms, 'Charles Jervas, Sir Robert Walpole and the Norfolk Whigs'. *Apollo*, vol. CXLV, February 1997, pp. 44-48

Bowden-Smith 1987
R. Bowden-Smith, *The Water House, Houghton Hall*, Woodbridge, 1987

Bowron 1979
E.-P. Bowron, *The Paintings of Benedetto Luti (1666-1724)*, A dissertation in the Department of Fine Arts submitted to the faculty of the Graduate School of Arts and Science in partial fulfillment of the requirements for the degree of Doctor of Philosophy at New York University, June 1979, copyright by E.-P. Bowron, 1979

Bowron, Rishel 2000
E. Bowron, J. Rishel, eds., *Art In Rome In The Eighteenth Century*, Philadelphia, 2000

Boydell 1788
Set of Prints Engraved after the most capital paintings In the Collection of Her Imperial Majesty the Empress of Russia. Lately in the Possession of the Earl of Orford at Houghton in Norfolk. With Plans, Elevations, Sections, Chimney Pieces & Ceilings, published by John and Josiah Boydell, 2 vols., London, 1788 [description of plates numbered with large Roman numerals but the plates themselves un-numbered)

Boydell, Most Capital Paintings… 1792
A Collection of Prints Engraved after the Most Capital Paintings in England, published by John Boydell, 9 vols., 1769 – (c. 1792)

Boyer 2001
Jean-Claude Boyer, in *Épinal 2001* , pp. 60-63

Braham 1965
A. Braham, 'The Early Style of Murillo', *The Burlington Magazine*, vol. XVII, no. 750, September 1965, p. 445

Braham 1981
A. Braham, *El Greco to Goya. The Taste for Spanish Paintings in Britain and Ireland*, exh. cat., National Gallery, London, 1981

Bredius 1927
A. Bredius, 'Rembrandt, Bol oder Backer?', *Festschrift für Max J. Friedländer*, Leipzig, 1927, pp.156-60

Bredius 1935
A. Bredius, *Rembrandt schilderijen*, Utrecht, 1935; German ed. *Rembrandt. Gemälde*, Vienna, 1935

Bredius 1937
A. Bredius, *The Paintings of Rembrandt*, Vienna-London, 1937

Bredius, Gerson 1969
A. Bredius, *Rembrandt. The Complete Edition of the Paintings*, Revised by H. Gerson, London, 1969

Briganti 1962
G. Briganti, *Pietro da Cortona o della pittura barocca*, Firenze, 1962

Briganti 1982
G. Briganti, *Pietro da Cortona o della pittura barocca*, Firenze, 1982

British Art Treasures 1996
British Art Treasures from Russian Imperial Collections in the Hermitage, ed. by B. Allen and L. Dukelskaya, exh. cat., Yale Center for British Art, New Haven, New Haven-London, 1996

Brochhagen, Knuttel 1967
E. Brochhagen, B. Knuttel, *Holländische Malerei des 17.Jahrhunderts. Alte Pinakothek*, Munich, 1967

Broome 1985
Rev. J. H. Broome, *Houghton and the Walpoles*, London-King's Lynn, 1985

Broos 1985
Ben Broos, *Rembrandt en zijn Voorbeelden*, exh. cat., Museum Het Rembrandthuis, Amsterdam, 2 November 1985 – 5 January 1986; Amsterdam, 1985

Brown 1976
J. Brown, *Murillo and his Drawings*, Princeton, 1976

Brown 1982
C. Brown, *Van Dyck*, Oxford, 1982

Brown 1986
J. Brown, *Velazquez. Painter and Courtier*, New Haven-London, 1986

Brown 1991
C. Brown, *Van Dyck Drawings*, exh. cat., London, 1991

Brown 1993
C. Brown, 'Patrons and Collectors of Dutch Painting in Britain During the Reign of William and Mary', in D. Howarth, ed., *Art and Patronage in the Caroline Courts; Essays in Honour of Sir Oliver Miller*, Cambridge, 1993

Brown 1996
C. Brown, *Making and Meaning: Rubens's Landscapes*, exh. cat., National Gallery, London, 1996

Brown, Mann 1990
J. Brown, R. G. Mann, *The Collections of the National Gallery of Art. Systematic Catalogue: Spanish Paintings of the Fifteenth through Nineteenth Centuries*, Washington, 1990

Brownell 2001
M. Brownell, *The Prime Minister of Taste: A Portrait of Horace Walpole*, New Haven-London, 2001

Bruni 1861
F. Bruni, 'Kartiny ital'yanskikh shkol', in [F. Gilles:] *Muzey imperatorskogo Ermitazha. Opisaniye razlichnykh sobraniy, sostavlyayushchikh muzey, s istoricheskim vvedeniyem ob Ermitazhe Yekateriny II i o obrazovanii muzeya Novogo Ermitazha*

[The Imperial Hermitage Museum. Description of Various Collections Making up the Museum, with a historical introduction on the Hermitage of Catherine II and the formation of the New Hermitage Museum], St Petersburg, 1861

Bruntjen 1985
Sven H. A. Bruntjen, *John Boydell, 1719-1804. A Study of Art Patronage and Publishing in Georgian London,* Garland, 1985

Bruyn, Emmens 1957
J. Bruyn, J. A. Emmens, 'The Sunflower Again', *The Burlington Magazine,* vol. XCIX, no. 648, March 1957, pp. 96-7

Buchanan 1824
W. Buchanan, *Memoirs of Painting,* 2 vols., London, 1924

Bulletin Rubens 1882-1910
Bulletin Rubens. Annales de la comission officielle, instituée… pour la publication des documents relatifs à la vie et aux oeuvres de Rubens, 5 vols., Antwerp-Brussels, 1882-1910

Burke's Peerage 1999
C. Mosley ed., *Burke's Peerage & Baronetage,* 106th edn., London, 1999

Buschmann 1905
P. Buschmann, *Jacques Jordaens et son oeuvre,* Brussels, 1905

C.R. 1856
C.R., 'Le traité de la peinture de Léonard de Vinci illustré par Poussin', *Bulletin du bibliophile belge,* XI, 1856

Caliari 1888
P. Caliari, *Paolo Veronese, sua vita e sue opere,* 2nd ed., Rome, 1888

Camón Aznar 1964
J. Camón Aznar, *Velázquez,* 2 vols., Madrid, 1964

Campbell 1725
C. Campbell, *Vitruvius Britannicus* III, London, 1725

Campbell 1996
P. Campell, *Power and Politics in Old Regime France 1720-1745,* London, 1996

Canova 1961
G. Canova, 'I viaggi di Paris Bordon', *Arte Veneta,* XV, 1961, pp. 77-88

Canova 1964
G. Canova, *Paris Bordon,* Venice, 1964

Canova 1981
G. Mariani Canova, in *Da Tiziano a El Greco. Per la storia del Manierismo a Venezia 1540-1590,* exh. cat., Milan, 1981

Canova 1984
G. Mariani Canova, *Paris Bordon,* exh. cat., Palazzo del Trecento, Treviso, 1984

Canova 1985
G. Canova, 'Paris Bordon. Problematiche cronologiche', in *Paris Bordon e il suo tempo, Atti del Convegno Internazionale di studi, Treviso, 28-30 ottobre 1985,* Milan, pp. 137-58

Cantarini 1997
Simone Cantarini detto il Pesarese, 1612-1648, exh. cat., curated by A. Emiliani, Pinacoteca Nazionale/Accademia di Belle Arti, Bologna, 11 October 1997 – 6 January 1998, Milan, 1997

Cat. Antwerp 1988
Koninklijk Museum voor Schone Kunsten. Catalogus schilderkunst. Oude Meesters, Antwerpen, 1988

Catherine Palace 1918
Kratkiy katalog muzeya Bol'shogo Ekaterininskogo dvortsa i yego istoricheskiy ocherk [Brief Catalogue of the Museum in the Great Catherine Palace and an Outline of its History], compiled by G. K. Lukomskiy, Petrograd, 1918

Catherine Palace 1940
Yekaterininskiy dvorets-muzey i park v g. Pushkine [The Catherine Palace Museum and Park in the Town of Pushkin], Leningrad, 1940

Caus 1626-30
Isaac de Caus, *Le Jardin de Vuillton, construit par le noble et tres puissant seigneur Phillippe Comte de Pembroke et Montgomerie,* 1626-30

CDR 1887-1909
Correspondance de Rubens et documents épistolaires concernants sa vie et ses oeuvres, publiés, traduits et annotés par Ch. Ruellens et M. Rooses, 6 vols., Anvers, 1887-1909 (*Codex Diplomaticus Rubenianus*)

Cellard 1996
J. Cellard, *John Law et la Régence 1715-1729,* [?France], 1996

Chambers 1829
J. Chambers, *A General history of the County of Norfolk, Intended to Convey all the Information of a Norfolk Tour,* 2 vols., Norwich and London, vol. I, pp. 515-41

Chinnery 1953
G. A. Chinnery, *A Handlist of the Cholmondeley (Houghton) MSS. Sir Robert Walpole's Archive,* Cambridge, 1953

Christie's 1994
Works of Art from Collections of the Cholmondeley Family and the Late Sir Philip Sassoon, Bt, from Houghton, Christie's sale catalogue, London, 8 December 1994

Clayton 1997
Timothy Clayton, *The English Print 1688-1802,* New Haven-London, 1997

Cleaned Pictures 1955
The Cleaned Pictures. An Exhibition of Pictures from the Collection of the Walker Art Gallery, Liverpool, Walker Art Gallery, Liverpool, 10 September – 22 October 1955; Liverpool, 1955

Clément de Ris 1879-80
L. Clément de Ris, 'Musées du Nord. Musée Impérial de l'Ermitage à Saint-Pétersbourg', *Gazette des Beaux-Arts,* in five parts; I) vol. 19, 1879, pp. 178-89; II) *Ibid.,* pp. 342-52; III) *Ibid.,* pp. 573-84; IV) 1879, vol. 20, pp. 377-89; V) vol. 21, 1880, pp. 262-73

Cokayne 1910-59
G. E. Cokayne, ed., *The Complete Peerage …,* revised and enlarged edition, 11 vols., 1910-59

Collett-White 1995
J. Collett-White, ed., 'Inventories of Bedfordshire Country Houses 1714-1830', *Publications of the Bedfordshire Historical Record Society,* vol. 74, 1995

Collins Baker 1912
C. H. Collins Baker, *Lely and the Stuart Painters,* 2 vols., London, 1912

Colombi Ferretti 1992
A. Colombi Ferretti, 'Simone Cantarini', *La senda di Guido Reni,* ed. E. Negro and M. Pirondini, Modena, 1992, pp. 109-32

Combined Cat. 1999
Svodnyy katalog kul'turnykh tsennostey, pokhishchennykh i utrachennykh v period Vtoroy mirovoy voyny [Combined Catalogue of Cultural Valuables Stolen and Lost During the Second World War], vol. 1, *Gosudarstvennyy Muzey-zapovednik Tsarskoye Selo. Yekaterininskiy dvorets* [Tsarskoye Selo State Museum Reserve. Catherine Palace], book I, Moscow-St Petersburg, 1999

Constable 1989
W.G. Constable, *Canaletto: Giovanni Antonio Canal 1697-1768,* 2nd ed., revised J.G. Links, Oxford, 1989

Cook 1909
H. Cook, 'The Newly-discovered Leonardo', *The Burlington Magazine,* vol. XV, no. LXXIV, May 1909, pp. 108-13

Cooper 1965
D. Cooper, *Great Family Collections,* includes J. F. B. Watson, 'Houghton Hall', London, 1965

Copertini 1932
G. Copertini, *Il Parmigianino,* Parma, 1932

Corberon 1901
M. D. B. de Corberon, *Un diplomat français à la cour de Catherine II. Journal intime du Chevalier de Corberon, chargé d'affaires de France en Russie,* Paris, 1901

Cornforth 1968a
J. Cornforth, 'Conversations with Old Heroes: the Collections of Thomas, 8th Earl of Pembroke (1656-1733)', *Country Life,* vol. CXLIV, 26 September 1968, pp. 748-51

Cornforth 1968b
J. Cornforth, 'A Virtuoso's Gallery: the 8th Earl of Pembroke's Collection of Pictures', *Country Life,* vol. CXLIV, 3 October 1968, pp. 834-41

Cornforth 1971a
J. Cornforth, 'Boughton House, Northamptonshire IV', *Country Life,* vol. CXLIX, 25 February 1971, pp. 420-23

Cornforth 1971b
J. Cornforth, 'Boughton House, Northamptonshire V', *Country Life,* vol. CXLIX, 4 March 1971, pp. 476-80

Cornforth 1987a
J. Cornforth, 'Houghton Hall, Norfolk', *Country Life,* vol. CLXVIII, 30 April 1987, pp. 124-29; 7 May 1987, pp. 104-8

Cornforth 1987b
J. Cornforth, 'The Growth of an Idea', *Country Life,* vol. CLXVIII, 14 May 1987, pp. 162-68

Cornforth 1988
J. Cornforth, *The Search for a Style, Country Life and Architecture 1897-1935,* London, 1988

Cornforth 1992
J. Cornforth, 'Castles for a Georgian Duke', *Country Life,* vol. CLXXXVI, 8 October 1992, pp. 58-61

Cornforth 1996
J. Cornforth, *Houghton Hall: Guide Book,* Norwich, 1996 (new edition in preparation)

Cotté 1985
S. Cotté, 'Inventaire après décès de Louis Phélypeaux de La Vrillière', *Archives de l'Art Français,* vol. XXVII, May 1985, pp. 89-100

Coxe 1798
W. Coxe, *Memoirs of the Life and Administration of Sir Robert Walpole,* 3 vols., 1798 (another ed. 1800)

Coxe 1803
William Coxe, *Travels in Poland, Russia, Sweden and Denmark, illustrated with charts and engravings … in three volumes,* London, 1803

Crombie 1973
T. Crombie, 'The Legacy of Vitoria: Spanish Paintings at Apsley House', *Apollo*, vol. XLVIII September 1973, pp. 210-15

Cross 1997
A. Cross, *By the Banks of the Neva. Chapters from the Lives and Careers of the British in Eighteenth-Century Russia*, Cambridge, 1997

Crowe, Cavalcaselle 1912
J. A. Crowe, G. B. Cavalcaselle, *A History of Painting in North Italy, Venice, Padua, Vincenza, Verona, Ferarra, Milan, Friuli, Brescia from the Fourteenth to the Sixteenth Centuries*, 3 vols., London, 1912

Curtis 1883
C. Curtis, *Velazquez and Murillo*, London, 1883

Cust 1900
Lionel Cust, *Anthony Van Dyck. An Historical Study of his Life and Works*, London, 1900

d'Amico 1979
R. d'Amico, *La Raccolta Zambeccari*, Bologna, 1979

d'Hulst 1956
R.-A. d'Hulst, *De tekeningen van Jakob Jordaens*, Brussels, 1956

d'Hulst 1974
R.-A. d'Hulst, *Jordaens Drawings*, 4 vols., Brussels, 1974

d'Hulst 1982
R.-A. d'Hulst, *Jacob Jordaens*, Stuttgart, 1982

d'Hulst, Vandenven 1989
R.-A. d'Hulst, M. Vandenven, *P. P. Rubens. The Old Testament*, in the series *Corpus Rubenianum Ludwig Burchard*, part III, London, 1989

d'Hulst, Vey 1960
Roger A. d'Hulst, Horst Vey, *Van Dyck. Tekeningen en olieverfschetsen. Catalogus*, Amsterdam-Rotterdam, 1960

Dalton 1869
H. Dalton, *Murillo und seine Gemälde in der K. Eremitage zu St. Petersburg*, St Petersburg, 1869

Daniels 1975
J. Daniels, 'A Bozzetto by Sebastiano Ricci for Palazzo Marucelli', *The Connoisseur*, vol. 190, no. 764, October 1975, pp. 94-97

Daniels 1976
J. Daniels, *Sebastiano Ricci*, Hove, 1976

Davison 1988
A. Davison, *Six Deserted Villages in Norfolk, East Anglian Archaeology*, 44, 1988

DBF 1932-
Dictionnaire de Biographie Française, sous La Direction de J. Balteau, et al, Paris, 1932-

DBI
Dizionario Biografico Degli Italiani, Institute Della Enciclopedia Italiana, Fondata Giovanni Treccani, Rome [ongoing]

De Cosnac 1885
G. J. De Cosnac, *Les richesses du Palais Mazarin*, Paris, 1885

de Piles 1681
Roger de Piles, *Dissertation sur les ouvrages des plus fameux peintres . . .*, Paris, 1681

Delaroche 1819
H. Delaroche, *Catalogue de tableaux, dessins, estampes et autres objets de curiosité, composant la collection de feu M. Leon Dufourny*, Paris, 1819

Delarov 1902
P. V. Delarov, *Kartinnaya galereya imperatorskogo Ermitazha* [The Picture Gallery of the Imperial Hermitage], St Petersburg, 1902

Delogu 1931
G. Delogu, *Pittori minori liguri, lombardi e piemontesi del Sei e Settecento*, Venezia, 1931

Delogu 1962
G. Delogu, *Natura morta italiana*, Bergamo, 1962

Denucé 1932
J. Denucé, *Antwerp Art Galleries. Inventories of the Art Collections in Antwerp in the 16th and 17th Centuries*, 's-Gravenhage, 1932, vol. II in the series *Historical Sources for the Study of Flemish Art*

Descamps 1753-64
J. B. Descamps, *La vie des peintres flamands, allemands et hollandais*, 4 vols., Paris, 1753-64

Descargues 1956
Pierre Descargues, *The Hermitage*, London, 1956.

Dezallier d'Argenville 1745-52
[A. N. Dezallier d'Argenville], *Abrégé de la vie des plus fameux peintres avec leurs portraits gravés en taille-douce. Par M. ★★★*, 3 vols., Paris, 1745-52

Dictionary of Art 1996
The Dictionary of Art, ed. Jane Turner, 34 vols., London, 1996

Dictionary of English Furniture 1954
The Dictionary of English Furniture, revised edn., 1954

Dimier 1926-27
L. Dimier, *Histoire de la peinture française du retour de Vouet à la mort de Lebrun. 1627 à 1690*, 2 vols., Paris and Brussels, 1926-27

Dimsdale 1989
An English Lady at the Court of Catherine the Great. The Journal of Baroness Elizabeth Dimsdale, 1781, edited, with an introduction and notes by A. G. Cross, Cambridge, 1989

Disegni e dipinti 1987
Disegni e dipinti leonardeschi dalle collezioni milanesi, Milan, 1987

DN 1866
Dictionnaire de la Noblesse, par De la Chenaye-Desbois et Badier, 3rd ed., Paris, 1866

DNB
Dictionary of National Biography, edited by Leslie Stephen, London, 1832-1904

Dobroklonsky 1940
M. V. Dobroklonskiy, *Risunki Rubensa* [Drawings by Rubens], no. III in the series *Katalogi sobraniy Gosudarstvennogo Ermitazha* [Catalogues of the Collections in the State Hermitage Museum], Moscow-Leningrad, 1940

Dobroklonsky 1955
M. V. Dobroklonskiy, *Risunki flamandskoy shkoly XVII-XVIII vekov* [Drawings of the Flemish School. 17th-18th Centuries], no. IV in the series *Katalogi sobraniy Gosudarstvennogo Ermitazha* [Catalogues of the Collections in the State Hermitage Museum], Moscow, 1955

Dodsley 1761
R. and J. Dodsley, *London and its Environs Described, containing an account of whatever is most remarkable… in the city and in the country twenty miles arounde, it, etc…*, 6 vols., London, 1761

Drost 1926
W. Drost, *Barockmalerei in den germanischen Ländern*, Wildpark-Potsdam, 1926

Drost 1933
W. Drost, *Adam Elsheimer und sein Kreis*, Potsdam, 1933

Dukel'skaya 1987
L. A. Dukel'skaya, 'O portrete Dzhona Lokka, ispolnennom G. Nellerom' [On a Portrait of John Locke by G. Kneller], *Soobshcheniya Gosudarstvennogo Ermitazha* [Proceedings of the State Hermitage], issue LII, 1987, pp. 13-15

Dukelskaya, Renne 1990
L. A. Dukelskaya, E. P. Renne, *The Hermitage Catalogue of Western European Painting: British Painting, Sixteenth to Nineteenth Centuries*, Florence-Moscow, 1990

Dunlop 1949
I. Dunlop, 'Cannons, Middlesex: A Conjectural Reconstruction', *Country Life*, vol. CVI, 30 December 1949, pp. 1950-54

Durham 1926
J. Durham, *The Collection of Pictures at Raynham Hall*, privately printed, 1926

Dussieux 1856
L. Dussieux, *Les artistes français à l'étranger*, Paris, 1856

Dutuit 1883
E. Dutuit, *L'oeuvre complet de Rembrandt*, Paris, 1883

Dutuit 1885
Eugène Dutuit, *Tableaux et dessins de Rembrandt. Catalogue historique et descriptif*, Paris, 1885

Edwin-Cole 1871
J. Edwin-Cole, 'Memoir of the family of Edwin', *The Herald and Genealogist*, J. G. Nichols, ed., 1871, vol. VI, pp. 54-62

Egerton 1997
J. Egerton, 'British Art Treasures from Russian Imperial Collections in the Hermitage', exh. review, *The Burlington Magazine*, vol. CXXXIX, no. 1129, April 1997, p. 275

Ekserjian 1999
D. Ekserjian, 'Paris Bordone and the Aedes Walpolianae', *Apollo*, vol. CXLX, N.S. no. 448, June 1999, pp. 51-52

Emiliani 1973
A. Emiliani, *La Collezione Zambeccari nella Pinacoteca Nazionale di Bologna*, Bologna, 1973

English Art 1979
The Hermitage: English Art Sixteenth to Nineteenth Century. Paintings, Sculpture, Prints and Drawings, Minor Arts, Leningrad, 1979

Ernst 1928
S. Ernst, 'L'Exposition de la peinture française des XVIIe et XVIIIe siècles au Musée de l'Ermitage à Petrograd. 1922-1925', *Gazette des Beaux-Arts*, vol. XVII, April 1928, pp. 238-52

Ernst 1965
S. Ernst, 'Portraits by Kneller in Russia', *The Burlington Magazine*, vol. CVII, August 1965, pp. 425-6

Ertz 1979
K. Ertz, *Jan Brueghel der Altere (1568-1625). Die Gemälde. Mit kritischen Oeuvrekatalog*, Cologne, 1979

Ertz 1997
Pieter Breughel der Jüngere - Jan Brueghel der Ältere. Flämische Malerei um 1600. Tradition und Fortschritt, Kulturstiftung Ruhr, Villa Hugel, Essen, 16 August – 16 November

1997; Kunsthistorisches Museum, Vienna, 9 December 1997 – 14 April 1998; Koninklijk Museum voor Schone Kunsten, Antwerp, 2 May – 26 July 1998; Lingen, 1997

Esdaile 1928
K. Esdaile, *The Life and Works of Louis François Roubiliac*, London, 1928

Esterby 1998
D. Esterby, *Grinling Gibbons and the Art of Carving*, London, 1998

Evers 1942
H. G. Evers, *Peter Paul Rubens*, Munich, 1942

Evers 1943
H. G. Evers, *Rubens und sein Werk*, Neue Forschungen, Brussels, 1943

Fabbrini 1896
N. Fabbrini, *Pietro Berrettini da Cortona pittore e architetto*, Cortona 1896

Faggin 1965
G. T. Faggin, 'Per Paolo Brill', *Paragone*, 1965, no. 185 (NS 5), pp. 21-35

Faldi 1966
I. Faldi, 'I dipinti chigiani di Michele e Giovan Battista Pace', *Arte antica e moderna*, 1966, nos. 34, 35, 36, pp. 144-50

Faré 1866
I. de Faré, *Description of the English Pictures*, St Petersburg, 1866

Fejfer 1997
J. Fejfer, *The Ince Blundell Collection of Classical Sculpture, I, The Portraits, Part 2, The Roman Male Portraits*, Liverpool, 1997

Fekhner 1949
Ye. Yu. Fekhner, *Niderlandskaya zhivopis' XVI v.* [16th-Century Netherlandish Painting], Leningrad, 1949

Fekhner 1965
Ye. Yu. Fekhner, *Rembrandt. Proizvedeniya zhivopisi v muzeyakh SSSR* [Paintings in USSR Museums], Leningrad-Moscow, 1965

Fekhner 1981
Gollandskiy natyurmort XVII veka v sobranii Gosudart-stvennogo Ermitazha [Dutch 17th-century Still Lives in the Collection of the State Hermitage], Moscow, 1981

Félibien 1725
André Félibien, *Entretiens sur les vies et les ouvrages des plus excellens peintres*, Trevoux, 1725

Ferrand 1994
J. Ferrand, *Histoire et Généalogie des nobles et comtes Moussine-Pouchkine*, Préface du Comte A. Moussine-Pouchkine, Paris, 1994, p. 92.

Ferrari, Scavizzi 1966
O. Ferrari, G. Scavizzi, *Luca Giordano*, Napoli, 1966, 3 vols

Ferrari, Scavizzi 1992
O. Ferrari, G. Scavizzi, *Luca Giordano. L'opera completa*, Napoli, 1992

Fierens-Gevaert 1906
H. Fierens-Gevaert, *Jordaens*, Paris, 1906

Finer and Savage 1965
A. Finer and G. Savage, *The Selected Letters of Josiah Wedgwood*, London 1965

Fiocco 1928
G. Fiocco, *Paolo Veronese*, Bologna, 1928

Fiocco 1956
G. Fiocco, 'Un capolavoro di Pietro Marescalchi', *Arte Veneta*, X, 1956, pp. 104-6

Fiorillo 1808
J. D. Fiorillo, *Geschichte der Kunste und Wissenschaften zweyete Ubtheilung Geschichte der eichunden Kunste*, vol. 5, *Die Geschichte der Mahlerey in Gross-britannien enthaltend*, Gottingen, 1808

Fittschen and Zanker 1983
K. Fittschen and P. Zanker, *Katalog der römischen porträts in den Capitolinischen Museen und den auderen kommunden sammlungen der stadt Rom., I, Kaiser-und Prinzenbildnisse*, Mainz, 1983

Fock 1979
C. W. Fock, 'The Princes of Orange as Patrons of Art in the Seventeenth Century', *Apollo*, vol. CX, December 1979, pp. 466-75

Fomiciova 1970
T. D. Fomichova, 'Arkhitekturnyy peyzazh Parisa Bordone' [An Architectural Landscape by Paris Bordone], *Iskusstvo* [Art], 1970, no. 2, pp. 54-57

Fomiciova 1971
T. Fomichova, 'An Architectural Perspective by Paris Bordone', *The Burlington Magazine*, vol. CXII, no. 816, March 1971, pp. 152-55

Fomiciova 1973
T. Fomichova, *Paolo Veroneze* [Paolo Veronese], Moscow, 1973

Fomiciova 1974a
T. Fomichova, 'Le opere di Paolo Veronese e della sua scuola nelle raccolte dell'Ermitage', *Arte Veneta*, vol. XXVIII, 1974, pp. 123-32

Fomiciova 1974b
Tamara Fomicieva, 'Venetian Painting from the Fifteenth to the Eighteenth Centuries', *Apollo*, vol. C, N.S. no. 154, December 1974, pp. 468-79

Fomiciova 1979
T. Fomichova, 'Opere di allievi del Veronese nella collezione dell'Ermitage. Nuove attribuzioni', *Arte Veneta*, vol. XXXIII, 1979, pp. 131-36

Fomiciova 1981
T. Fomicieva, 'I dipinti di Jacopo Bassano e dei figli Francesco e Leandro nelle collezione dell'Ermitage', *Arte Veneta*, vol. XXXV, 1981, pp. 86-94

Fomiciova 1983
T. Fomichova, 'Khudozhniki iz masterskoy Paolo Veroneze v sobranii Ermitazha' [Artists from the Workshop of Paolo Veronese in the Hermitage Collection], *Muzey* [Museum], issue 4, Moscow, 1983, pp. 118-23

Fomiciova 1992
T. Fomicheva, *The Hermitage Catalogue of Western European Painting. Venetian Painting. Fourteenth to Eighteenth Centuries*, Florence, 1992

Ford 1985
B. Ford, 'Sir Andrew Fountaine: One of the Keenest Virtuosi of his Age.' *Apollo*, vol. CXXII, November 1985, pp. 352-364

Foster 1888
Joseph Foster, *Alumni Oxonienses: The Members of the University of Oxford, 1715-1886*, 4 vols., London, 1887-88

Francastel 1960
P. Francastel, 'Les paysages composés chez Poussin: Académisme et classicisme', *Nicolas Poussin (Actes du Colloque International, Paris, 19-21 Septembre 1958)*, 2 vols., Paris, 1960, vol. 1, pp. 201-14

Fréart de Chantelou 1885
P. Fréart de Chantelou, 'Journal de voyages 1885 de cavalier Bernin en France. Paris, 1885', *Nicolas Poussin (Actes du Colloque International, Paris, 19-21 Septembre 1958)*, 2 vols., Paris, 1960, vol. 2

Frederick Henry 1997
The Collection of Frederick Henry of Orange and Amalia of Solms in the Hague. Princely Patrons? exh. cat., Mauritshuis, The Hague, 6 December 1997–29 March 1998; Zwolle, 1997

Freedberg 1950
S. J. Freedberg, *Parmigianino. His Work in Painting*, Cambridge, MA, 1950

Freedberg 1975
S. J. Freedberg, *Painting in Italy. 1500-1600*, in the series *The Pelican History of Art*, Harmondsworth, 1975

Frerichs 1947
L. C. J. Frerichs, *Antonio Moro*, Amsterdam, 1947

Friedländer 1914
W. Friedländer, *Nicolas Poussin. Die Entwicklung seiner Kunst*, Munich, 1914

Friedländer 1921
W. Friedländer, *Claude Lorrain*, Munich, 1921

Friedländer 1924-37
M. J. Friedländer, *Die altniederländische Malerei*, 14 vols., Berlin-Leyden, 1924-37

Friedländer 1931
M. J. Friedländer, 'Mor (Moor), Anthonis', in Thieme-Becker 1908-50, vol. 25, pp.110-12

Friedländer 1965
W. Friedländer, *Nicolas Poussin. A New Approach*, London, 1966

Friedländer 1967-76
M. J. Friedländer, *Early Netherlandish Painting*, 14 vols., Leyden, 1967-76

Friedländer, Blunt 1939-65
W. Friedländer, A. Blunt, *The Drawings of Nicolas Poussin. A Catalogue Raisonné*, 6 vols., London, 1939-65

Fritz 1975
P. Fritz, *The English Ministers and Jacobitism Between the Rebellions of 1715 and 1745*, Toronto, 1975

Frölich-Bum 1915
L. Frölich-Bum, 'Handzeichnungen des Parmigianinos zu einigen seiner bekannten Gemälde', *Die Graphischen Künste*, Beilage 1, 1915, pp. 1-12

Frölich-Bum 1921
L. Frölich-Bum, *Parmigianino und Manierismus*, Vienna, 1921

Gaehtgens 1987
B. Gaehtgens, *Adriaen van der Werff 1659-1722*, Munich, 1987

Gambarini 1731
L. Gambarini, *A description of the Earl of Pembroke's pictures*, London, 1731

Garas 1985
K. Garas, 'Opere di Paris Bordon in Augusta', in *Paris Bordon e il suo tempo, Atti del Convegno Internazionale di studi, Treviso, 28-30 ottobre 1985*, Milan, pp. 71-8

Garboli, Baccheschi 1971
C. Garboli, E. Baccheschi, *L'Opera completa di Guido Reni*, Milano, 1971

Garlick and Macintyre 1978
K. Garlick and A. Macintyre, eds., *The Diary of Joseph Farington*, vol. II, *January 1795-August 1796*, New Haven-London, 1978

Gatto 1971
G. Gatto, 'Per la cronologia di Rosalba Carriera', *Arte Veneta*, XXV, 1971

486 BIBLIOGRAPHY

Gavazza, Lamera, Magnani 1990
E. Gavazza, F. Lamera, L. Magnani, *La pittura in Liguria. Il Secondo Seicento*, Genova, 1990

Gaya Nuño 1958
J. A. Gaya Nuño, *La pintura española fuera de España*, Madrid, 1958

Gaya Nuño 1978
J. A. Gaya Nuño, *L'opera completa di Murillo*, Milan, 1978

Gelder 1959
J. G. van Gelder, 'Anthonis van Dyck in Holland in de zeventiende eeuw', *Bulletin des Musées Royaux des Beaux-Arts de Belgique, Brussels*, 1959, no. 1-2, March-June, pp. 43-86

Gemäldegalerie Berlin 1986
Gemäldegalerie Berlin. Gesamtverzeichniss der Gemälde, Staatliche Museen Preussischer Kulturbesitz, Berlin, 1986

Gensel 1905
W. Gensel, *Velazquez: des Meisters Gemälde*, Stuttgart-Leipzig, 1905 (*Klassiker der Kunst*, vol. 6)

Georgi 1794
I. G. Georgi, *Opisaniye rossiysko-imperatorskogo stolichnogo goroda Sankt-Peterburga i dostopamyatnostey v okrestnostyakh onogo, 1794-1796* [A Description of the Russian Imperial Capital City of St Petersburg and the Sights in its Environs, 1794-1796], St Petersburg, 1794; reprinted St Petersburg, 1996.
References are given to both publications because most Western national libraries have the 18th century edition, but in Russia itself the reprint is widely available.
It should be noted that the German and French editions of this book (*Versuch einer Beschreibung der Rußisch Kaiserl. Residentzstadt St. Petersburg under der Merkwürdigkeiten der Gegend, von Johann Gottlieb Georgi*, Riga, 1793; *Description de la Ville de St. Pétersbourg det de ses environs, traduite de l'allemand de Mr. Georgi*, St Petersburg, 1793) do not include the description of the Hermitage.

Gershezon-Chegodayeva 1949
N. M. Gershezon-Chegodayeva, *Flamandskiye zhivopistsy* [Flemish Painters], Moscow, 1949

Gerson 1968
H. Gerson, *Rembrandt Paintings*, Amsterdam, 1968

Gerson, Ter Kuile 1960
H. Gerson, E. N. Ter Kuile, *Art and Architecture in Belgium. 1600-1800*, in the series *The Pelican History of Art*, Harmondsworth, 1960

Gerstenberg 1957
K. Gerstenberg, *Diego Velazquez*, Würzburg, 1957

Gerts 1941
V. K. Gerts, 'Ermitazhnaya kartina Pussena 'Moisey, issekayushchiy vodu iz skaly' v svyazi s problemoy geroicheskoy tematiki v klassitsizme' [Poussin's 'Moses Striking Water from the Rock' as Regards the Heroic Theme in Classicism], *Trudy Otdela zapadnoyevropeyskogo iskusstva Gosudarstvennogo Ermitazha* [Papers of the Western European Department of the State Hermitage], vol. II, 1941, pp. 149-66

Gevartius 1642
C. Gevartius, *Pompa Introinus … Ferdinandi Austriaci… a Pet. Pauolo Rubenio… inventas et delineatas… Libroque commentario illustrabat Casperius Gevartius… delineavit et sculpsit Theod. a Thulden*, Antwerpiae, apud Meursium, 1642

Gibson-Wood 2000
C. Gibson-Wood, *Jonathan Richardson: Art Theorist of the English Enlightenment*, New Haven-London, 2000

Gille 1860
Musée de l'Ermitage Impérial. Notice sur la formation de ce musée et description des diverses collections qu'il renferme avec un introduction historique sur l'Ermitage de Catherine II, by F. Gille, St Petersburg, 1860 [Russian ed.: *Muzey imperatorskogo Ermitazha. Opisaniye razlichnykh sobraniy sostavlyayushchikh muzey s istoricheskim vvedeniyem ob Ermitazhe imp. Yekateriny II i ob obrazovanii muzeya Novogo Ermitazha*, by F. Zhil [Gille], St Petersburg, 1861]

Gilpin 1802
W. Gilpin, *An Essay on Prints*, London, 1802

Gilpin 1809
Rev. William Gilpin, *Observations on the Several Parts of the Counties of Cambridge, Norfolk*, London, 1809

Giltaij, Jansen 1991
J. Giltaij, G. Jansen, *Perspectives: Saenredam and the Architectural Painters of the 17th Century*, exh. cat., Museum Boymans-van Beuningen, Rotterdam, 15 September – 24 November 1991; Rotterdam, 1991

Ginzburg 1980
C. Ginzburg, 'Tiziano, Ovidio e i codici della figurazione erotica nel '500', *Tiziano e Venezia, Atti del Convegno internazionale di studi, Venezia, 1976*, Vicenza, 1980, pp. 125-35

Girouard 1978
M. Girouard, *Life in the English Country House: A Social and Architectural History*, New Haven-London, 1978

Glen 1994
Th. van Glen, 'Van Dyck's "Rest on the Flight into Egypt" in the Hermitage: Another Religious Picture for Henrietta Maria of England', *Gazette des Beaux-Arts*, vol. CXXIV, 1994, pp. 87-96

Glikman 1964
A. S. Glikman, *Nikola Pussen* [Nicolas Poussin], Leningrad, 1964

Glück 1920/21
G. Glück, 'Rubens' Liebesgarten', *Jahrbuch der kunsthistorischen Sammlungen in Wien*, vol. XXXV, 1920/21, pp. 49-98

Glück 1931
Van Dyck. Des Meisters Gemälde in 571 Abbildungen, Herausg. und eingeleitet von G. Glück. 2 vollig neubearbeitete Aiflage, Stuttgart-Berlin, 1931 (*Klassiker der Kunst in Gesamtausgaben*, vol. 13)

Glück 1933
G. Glück, *Rubens, Van Dyck und ihr Kreis*, Vienna, 1933

Glück 1945
G. Glück, *Die Landschaften von P. P. Rubens*, Vienna, 1945

Goeler von Ravensbourg 1882
F. Goeler von Ravensbourg, *Rubens und die Antike*, Jena, 1882

Golerbakh 1922
E. Golerbakh, *Detskosel'skiye dvortsy-muzei i parki. Putevoditel'* [Detskoye Selo Palace Museums and Parks. A Guide], Petrograd, 1922

Grabski 1985
J. Grabski, 'Rime d'amore di Paris Bordon. Strutture visuali e poesia rinascimentale', in *Paris Bordon e il suo tempo, Atti del Convegno Internazionale di studi, Treviso, 28-30 ottobre 1985*, Milan, pp. 203-21

Grant 1954
M. H. Grant, *Jan van Huysum*, Leigh-on-Sea, 1954

Granville 1828
A. B. Granville, *St. Petersburgh. A Journal of Travels to and From the Capital; through Flandres, the Rhenish provinces, Prussia, Russia, Poland, Silesia, Saxony … and France*, 2 vols., London, 1828

Grautoff 1914
O. Grautoff, *Nicolas Poussin: sein Werk und sein Leben*, 2 vols., Munich, 1914

Green 1964
D. Green, *Grinling Gibbons. His Work As Carver And Statuary. 1648-1721*, London, 1964

Greindl 1956
E. Greindl, *Les peintres flamands de nature morte au XVIIe siècle*, Brussels, 1956

Greindl 1983
E. Greindl, *Les peintres flamands de nature morte au XVIIe siècle*, Sterrebeek, 1983

Grigor 1847
J. Grigor, *The Eastern Arboretum*, London-Norwich, 1847

Grimm 1949
G. G. Grimm, 'Arkhitektura v kartinakh Rubensa' [Architecture in Rubens's Pictures], *Trudy Otdela zapadnoyevropeyskogo iskusstva Gosudarstvennogo Ermitazha* [Papers of the Department of Western European Art of the Hermitage], vol. III, Leningrad, 1949, pp. 61-71

Grimm 1972
C. Grimm, *Frans Hals. Entwicklung, Werkanalyse, Gesamtkatalog*, Berlin, 1972

Grimm 1990
C. Grimm, *Frans Hals. The Complete Work*, New York, 1990

Gritsay 1977
N. Gritsay, 'Portrety Yakoba Iordansa v Ermitazhe' [Portraits by Jacob Jordaens in the Hermitage], *Trudy Gosudarstvennogo Ermitazha* [Papers of the State Hermitage], issue XVIII, 1977, pp. 83-95

Gritsay 1985
N. I. Gritsay, 'O soderzhanii "Lavok," ispolnennykh F. Sneydersom dlya A. Trista' [On the Content of the 'Market Stalls' Produced by F. Snyders for A. Triste], *Trudy Gosudarstvennogo Ermitazha* [Papers of the State Hermitage], issue XXV, 1985, pp. 50-61

Gritsay 1986
N. I. Gritsay, 'O nekotorykh osobennostyakh ikonografii rannikh bol'shikh natyurmortov Fransa Sneydersa' [On Some Peculiarities of the Iconography in the Large Early Still Lifes by Frans Snyders], in *Veshch' v iskusstve. GMII im. A. S. Pushkina. Materialy nauchnoy konferentsii* [The Object in Art. State Pushkin Museum of Fine Arts. Materials from a Scholarly Conference], issue 17, 1984, Moscow, 1986, pp. 65-73

Gritsay 1994
N. I. Gritsay, 'Yazyk predmetov v izobrazhenii 'Trapez Gospdnikh'; u Rubensa i yego masterskoy [The Language of Objects in the Depiction of 'Holy Feasts' in the Work of Rubens and his Workshop], in the anthology *Problemy razvitiya zarubezhnogo iskusstva* [Questions in the Development of Foreign Art], part 1, St Petersburg, 1994 (series: *Rossiyskaya Akademiya khudozhestv, Sankt-Peterburgskiy gosudarstvennyy akademicheskiy Institut zhivopisi, skul'ptury i arkhitektury im. I. Ye. Repina. Sobrnik nauchnykh trudov* [Russian Academy of Arts, St Petersburg State Academic Repin Institute of Painting, Sculpture and Architecture. Anthology of Scholarly Works), pp. 34-41

Gritsay 1996a
N. I. Gritsay, 'K voprosu ob ikonografii serii 'Lavok' Fransa Sneydersa iz sobraniya Ermitazha' [On the Iconography of the Series of 'Market Stalls' by Frans Snyders in the Hermitage Collection], in the anthology *Problemy razvitiya zarubezhnogo iskusstva* [Questions in the Develop-

ment of Foreign Art], St Petersburg, 1996 (series: *Rossiyskaya Akademiya khudozhestv, Sankt-Peterburgskiy gosudarstvennyy akademicheskiy Institut zhivopisi, skul'ptury i arkhitektury im. I. Ye. Repina. Sobrnik nauchnykh trudov* [Russian Academy of Arts, St Petersburg State Academic Repin Institute of Painting, Sculpture and Architecture. Anthology of Scholarly Works), pp. 26-69

Gritsay 1996b
N. Gritsai, *Anthony van Dyck*, Bournemouth-St Petersburg, 1996

Grossmann 1951
F. Grossmann, 'Holbein, Flemish Painting and Everhard Jabach', *The Burlington Magazine*, vol. XCIII, no. 574, January 1951, pp. 16-25

Grosso 1922/23
O. Grosso, 'A.M. Vassallo e la pittura d'animali nei primi del 1600 a Genova', *Dedalo*, 1922/23, pp. 502-22

Gudiol 1974
J. Gudiol: *Velazquez. 1599-1660*, London, 1974

Guido Reni und Europa 1988
Guido Reni und Europa. Ruhm und Nachruhm, Katalog herausgegeben von Sybille Ebert Schifferer, Andrea Emiliani, Erich Schleier, Schirn Kunsthalle, Frankfurt, 2. Dezember 1988- 26. Februar, 1989; Frankfurt, 1988

Guiffrey 1877
'Testament et inventaire des biens, tableaux, dessins, planches de cuivre, bijoux, etc., de Claudine Bouzonnet-Stella, Redigés et écrits par ell-mème (1693-1697)', ed. J. G. Guiffrey, *Nouvelle Archive d'Art Français*, 1877, pp. 1-117

Guiffrey 1882
Jules Guiffrey, *Antoine Van Dyck, sa vie et son oeuvre*, Paris, 1882

Guiffrey, Marcel 1921
J. Guiffrey, P. Marcel, *Inventaire Général des dessins du Musée du Louvre et du Musée de Versailles*, Paris, 1921

H[olmes], M[ilner] 1911
M. Holmes, 'Two Recent Additions to the National Portrait Gallery', *The Burlington Magazine*, vol. XIX, no. 99, June 1911, p. 163

Haak 1969
B. Haak, *Rembrandt. Zijn leven, zijn werk, zijn tijd*, Amsterdam, 1969

Haberditzl 1908
F. M. Haberditzl, 'Die Lehrer des Rubens', *Jahrbuch der Kunsthistorischen Sammlungen des Allerhochsten Kaiserhauses*, Vienna, 1908, pp.161-235

Haggerty 2001
George E. Haggerty, 'Walpoliana', *Eighteenth-Century Studies*, vol. 34, no. 2, Winter 2001, pp. 227-50

Hamann 1948
R. Hamann, *Rembrandt*, Potsdam, 1948

Hand 1827
F. Hand, *Kunst und Alterthum in St. Petersburg*, Weimar, 1827

Haraszti-Takács 1977
M. Haraszti-Takács, *Murillo*, Budapest, 1977; German ed. Berlin, 1978

Haraszti-Takács 1982
M. Haraszti-Takács, 'Oeuvres de Murillo dans les collections hongroises', *Bulletin du Musée Hongrois des Beaux-Arts*, 1982, nos. 58-59, pp. 55-80

Harck 1896
F. Harck, 'Notizen über italienische Bilder in Petersburger Sammlungen', *Repertorium für Kunstwissenschaft*, 1896, vol. 19, pp.413-34

Harley 1732
E. Harley (2nd Earl of Oxford), *Historic Manuscripts Commission*, Portland, vol. VI, p. 160 et seq., 1732

Harley 1737/8
E. Harley (2nd Earl of Oxford), *Historic Manuscripts Commission*, Portland, vol. VI, p. 171 et seq., 1737/8

Harris 1844
The Diaries and Correspondence of James Harris, First Earl of Malmesbury; containing an account of his missions to the Courts of Madrid, Frederick the Great, Catherine the Second, and the Hague…, 4 vols., London, 1844

Harris 1964
J. Harris, 'The Prideaux Collection of Topographical Drawings', *Architectural History*, 7, 1964, pp. 17-39

Harris 1973
J. Harris, 'Colen Campbell', *Catalogue of the Drawings Collection, Royal Institute of British Architects*, London, 1973

Harris 1985
J. Harris, 'John Talman's Design for his Wunderkammern', *Furniture History*, vol. XXI, 1985, pp. 211-14

Harris 1988
J. Harris, 'James Gibbs, Eminence Grise at Houghton', *Georgian Group Annual Symposium*, London, 1988, pp. 5-9

Harris 1989
J. Harris: 'Who designed Houghton?', *Country Life*, no. 183, 2 March 1989, pp. 92-94

Hartop 1996
Christopher Hartop, *The Huguenot Legacy: English Silver 1680–1760*, 1996, pp. 178–81

Harris and Savage 1990
E. Harris and N. Savage, *British Architectural Books and Writers, 1556-1785*, Bath, 1990

Haskell and Penny 1981
F. Haskell and N. Penny, *Taste and the Antique*, New Haven-London, 1981

Hasselt 1840
A. van Hasselt, *Histoire de P.P. Rubens…*, Brussels, 1840

Haverkamp Begemann 1953
E. Haverkamp Begemann, *Olieverfschetsen van Rubens*, exh. cat., Museum Boymans, Rotterdam, 1953

Hazen 1969
A.T. Hazen, *A Catalogue of Horace Walpole's Library*, 3 vols., New Haven-London, 1969

Hecht 1989
Peter Hecht, *De Hollandse fijn schilders. Van Gerard Dou tot Adriaen van der Werff*, exh. cat., Rijsmuseum, Amsterdam – Gary Schwartz, SDU, Amsterdam-Maarssen, s'Gravenhage, 1989

Hefford 1988
W. Hefford, 'Introducing James Bridges: New Light on an English Series of Eucharist Tapestries', *Arts in Virginia*, vol. 28, nos.. 2-3, 1988

Heidrich 1913
E. Heidrich, *Vlamishe Malerei*, Jena, 1913 (*Die Kunst in Bildern*)

Heintze 1963
H. von Heintze, *Führer durch die öfffentlichen Sammlungen klassischer Altertümer in Rom*, 4 Auflage, Tübingen, 1963

Held 1940
J. S. Held, 'Jordaens' Portraits of His Family', *The Art Bulletin*, vol. 22, June 1940, pp. 70-82

Held 1959
J. S. Held, *Rubens. Selected Drawings*, 2 vols., London, 1959

Held 1970
J. S. Held, 'Rubens's Glynde Sketch and the Installation of the Whitehall Ceiling', *The Burlington Magazine*, vol. CXII, no. 806, May 1970, pp. 274-81

Held 1980
Julius S. Held, *The Oil Sketches of Peter Paul Rubens. A Critical Catalogue*, 2 vols., Princeton, New Jersey, 1980; vol. 1 text, vol. 2 illustrations

Held 1982
J. S. Held, *Rubens and his Circle*, Princeton, New Jersey, 1982

Held 1986
J. S. Held, *Rubens. Selected Drawings*, 2nd ed., Oxford, 1986

Hendy 1974
Philip Hendy, *European and American Paintings in the Isabella Stewart Gardner Museum*, Boston, 1974

Hermann 1936
H. Hermann, *Untersachungen über die Landschaftsgemälde von Rubens*, Stuttgart, 1936

Hermitage 1989
The Hermitage. Western European Painting of the Thirteenth to Eighteenth Centuries, Leningrad, 1989

Hermitage Brief List 1926
Gosudarstvennyy Ermitazh. Kartinnaya Galereya. Kratkiy perechen' kartin gollandskoy shkoly [The State Hermitage. Picture Gallery. Brief List of Paintings of the Dutch School], Leningrad, 1926; 2nd amended ed., 1928

Herrmann 1999
F. Herrmann, *The English as Collectors. A Documentary Source-book*, selected, introduced and annotated by Frank Herrmann, London, 1999

Hervey 1731
J. Hervey (Lord Hervey), Letter to Frederick, Prince of Wales, July 14 1731, quoted in J. Hervey, *Memoirs of the Reign of George II*, London, 1884

Hevesy 1952
A. de Hevesy, 'L'historie véredique de la Joconda', *Gazette des Beaux-Arts*, vol. XL, July-August 1952, pp. 5-26

Hill 1989
B. Hill, *Sir Robert Walpole*, London, 1989

Hind 1923
Arthur Hind, *Catalogue of Drawings by Dutch and Flemish Artists Preserved in the Department of Prints and Drawings in British Museum*, vol. II, *Drawings by Rubens, Van Dyck and Other Artists of the Flemish School of the 17th Century*, London, 1923

HMC Bath 1904-8
Calendar of the Manuscripts of the Marquis of Bath preserved at Longleat, Wiltshire, 4 vols, Great Britain, Royal Commission on Historical Manuscripts, no. 58, London, 1904-8

HMC Ormonde 1920
Calendar of the Manuscripts of the Marquess of Ormonde. K.P. preserved at Kilkenny Castle, Great Britain, Royal Commission on Historical Manuscripts, New Series, Vol. VIII, London, 1920

HMC Polwarth IV 1911-16
Report on the Mss of Lord Polwarth formerly Preserved in Mertoun House, Berwickshire, Rev. Henry Paton, ed., 5 vols., Great Britain, Royal Commission on Historical Manuscripts, London, 1911-16

Hoet, Terwesten 1752-70
G. Hoet, *Catalogus of naamlyst van schildereyen, met derzelver pryzen, zedert een langen reeks van jaaren zoo in Holland als op andere plaatzen in het openbaar verkogt ...* , vols I-II, 's-Gravenhage, 1752; P. Terwesten, *Catalogus of naamlyst van schilderyen... zedert den 22 aug. 1752 tot den 22 Nov. 1768... verkogt...,* vol. III, 's-Gravenhage, 1770; reprint ed. Soest, 1976

Hofstede de Groot 1907-28
?. Hofstede de Groot, *Beschreibendes und kritisches Verzeichnis der Werke der hervorragendsten hollandischen Maler des XVII. Jahrhunderts,* Paris-Erlingen, 10 vols., 1907-28

Hollstein 1949-81
F. W. H. Hollstein, *Dutch and Flemish Etchings, Engravings and Woodcuts. 1450-1700,* Amsterdam, 24 vols., 1949-81

Hommage à Léonard 1952
Hommage à Léonard de Vinci. Exposition en l'honneur du cinquième centenaire de sa naissance, Louvre, Paris, 1952

Honig 1998
E. A. Honig, *Painting and the Market in Early Modern Antwerp,* New Haven – London, 1998

Honour 1958
H. Honour, 'English Patrons and Italian Sculptors in the First Half of the Eighteenth Century', *The Connoisseur,* no. 141, no. 570, June 1958, pp. 220-226

Hoogewerff 1936-47
G. J. Hoogewerff, *De Noord-Nederlandsche Schilderkunst,* 5 vols., 's Gravenhage, 1936-47

Houbraken 1718
A. Houbraken, *De groote Schouburgh der Nederlantsche Konstschilders en Schilderessen...,* vol. I, Amsterdam, [1718]

Houssaye 1842
A. Houssaye, 'Les Vanloo', *Revue des deux mondes,* vol. 31, July-September 1842, pp. 487-512

Howard 1992
S. Howard, 'Albani, Winckelmann And Cavaceppi; The Transition From Amateur To Professional Antiquarianism', *Journal of the History of Collection,* vol. 4, no. 1, 1992, pp. 27-38

Howarth 1993
D. Howarth, ed., *Art and Patronage in the Caroline Courts: Essays in Honour of Sir Oliver Millar,* Cambridge, 1993

Hujis 1978
Th. Hujis, *Inventaire des archives de John Law et de William Law 1715-34,* Maastricht, 1978

Hussey 1925
C. Hussey, 'Raynham Hall, Norfolk', I, *Country Life,* 14 November 1925, pp. 742-50; II, *ibid.,* 21 November 1925, pp. 782-89

Hussey 1955
C. Hussey, *English Country Houses: Early Georgian, 1715-1760,* London, 1955

Hussey 1963
C. Hussey, 'Houghton Hall, Norfolk', *Country Life Album,* 1963, p. 28 et seq.

HW 1757
Horace Walpole, *Advertisement to a Catalogue and Description of King Charles the First's Capital Collection of Pictures, Statues, Bronzes, Medals, &c.,* Strawberry Hill, 1757

HW Works 1798
Horace Walpole, *The Works of Horatio Walpole, Earl of Orford,* 5 vols., London, 1798

HWC
W. S. Lewis, ed., *The Yale Edition of Horace Walpole's Correspondence,* 48 vols., New Haven, 1937-83

Hymans 1910
H. Hymans, *Antonio Moro. Son oeuvre et son temps,* Brussels, 1910

Ilchester 1950
Ilchester, *Lord Hervey and his friends, 1726-38,* London, 1950

Ingamells 1997
J. Ingamells, *A Dictionary of British And Irish Travellers In Italy, 1701-1800. Compiled from the Brinsley Ford Archive,* New Haven-London, 1997

Isarlov 1936
G. Isarlov, 'Rembrandt et son entourage', *La Renaissance,* July-September 1936

Italian Painting 1964
S. N. Vsevolozhskaya, I. S. Grigor'yeva, T. D. Fomichyova, *Ital'yanskaya zhivopis' 13 – 18 vekov v sobranii Ermitazha* [Italian Painting of the 13th to 18th Centuries in the Hermitage Collection], Leningrad, 1964

Jackson-Stops 1985
G. Jackson-Stops, ed., *The Treasure Houses of Britain: Five Hundred Years of Private Patronage and Art Collecting,* New Haven-London, 1985

Jackson-Stops 1989
G. Jackson-Stops, ed., 'The Fashioning and Function of the British Country House', *Studies in the History of Art,* Washington, 25, 1989

Jackson-Stops, Pipkin 1984
G. Jackson-Stops, J. Pipkin: *The English Country House: A Grand Tour,* London, 1984 ; another edn. 1993

Jaffé 1966
M. Jaffé, 'A Landscape by Rubens and Another by Van Dyck', *The Burlington Magazine,* vol. CVIII, no. 761, August 1966, pp. 410-14

Jaffé 1969
M. Jaffé, 'The Girl with the Golden Hair', *Apollo,* vol. XV, no. 92, October 1969 [Rubens Girls' Head]

Jaffé 1977
M. Jaffé, *Rubens and Italy,* Oxford, 1977

Jaffé 1982
M. Jaffé, 'Van Dyck Studies I: The Portrait of Archbishop Laud', *The Burlington Magazine,* vol. CXXIV, no. 955, October 1982, pp. 600-6

Jaffé 1989
M. Jaffé, *Rubens. Catalogo completo,* Milan, 1989

Jantzen 1910
H. Jantzen, *Das niederlandische Architekturbild,* Leipzig, 1910

Jantzen 1979
H. Jantzen, *Das Niederlandische Architekturbild, 2, Auflage,* Braunschweig, 1979

Jouin 1889
H. Jouin, *Charles Le Brun et les arts sous Louis XIV,* Paris, 1889

Jourdain 1948
M. Jourdain, *The Work of William Kent,* London, 1948

Justi 1888
C. Justi, *Diego Velazquez und sein Jahrhundert,* 2 vols., Bonn, 1888

Justi 1892
C. Justi, *Murillo,* Leipzig, 1892; reprinted 1904

Kagané 1977
L. Kagané, *Ispanskaya zhivopis' XVI-XVIII vekov v Ermitazhe. Ocherk-putevoditel'* [Spanish 16th-18th-century Painting in the Hermitage. Essay Guide], Leningrad, 1977

Kagané 1978
L. L. Kagané, in *The Hermitage. Western European Painting of the Thirteenth to Eighteenth Centuries,* with an introduction by E. Kozhina, Leningrad, 1978, pp. 32-45

Kagané 1987a
L. L. Kagané, 'Ermitazhnyye kartiny Muril'o. Istoriya sobraniya' [Hermitage Paintings by Murillo. The History of the Collection], *Muzey* [Museum], issue 7, *Khudozhestvennyye sobraniya SSSR* [Art Collections in the USSR], Moscow, 1987, pp. 263-79

Kagané 1987b
L. L. Kagané, 'Sobraniye ispanskoy zhivopisi v Ermitazhe v XVIII veke' [The Collection of Spanish Painting in the Hermitage in the 18th Century], *Gosudarstvennyy Ermitazh. Zapadnoyevropeyskoye iskusstvo XVIII veka. Publikatsii i islledovaniya. Sbornik statey* [The State Hermitage. Western European 18th-century Art. Publications and Research. Anthology of Essays], Leningrad, 1987, pp. 12-27

Kagané 1988
L. L. Kagané, *Murillo,* Leningrad, 1988 (separate editions in English and Spanish)

Kagané 1989
L. Kagané, 'Spain', in Hermitage 1989, pp. 372-82, pls. 160-81

Kagané 1994a
L. Kagané, 'La historia del coleccionismo de la pintura española en el Ermitage, desde el siglo XV hasta comienzos del XIX', *6 Congreso de Historia,* Madrid, 1994, pp. 254-67

Kagané 1994b
L. L. Kagané, *Istoriya ermitazhnogo sobraniya ispanskoy zhivopisi XV – nach. XIX veka i problemy yego izucheniya* [The History of the Hermitage Collection of Spanish Painting of the 15th to Early 19th Century and Questions Relating to its Study], Author's summary of dissertation for the degree of Doctor of Art History, St Petersburg, 1994

Kagané 1995
L. Kagané, *Bartolomé Estebán Murillo. El maestro español del siglo XVII,* Bournemouth- St Petersburg, 1995 (separate editions also in English, French and German)

Kagané 1997
L. L. Kagané, *The Hermitage Catalogue of Western European Painting. Spanish Painting. Fifteenth to Nineteenth Centuries,* Moscow-Florence, 1997.

Kamenskaya 1960
T. D. Kamenskaya, *Gosudarstvennyy Ermitazh. Pasteli khudozhnikov zapadnoyevropeyskikh shkol XVI-XIX vekov* [The State Hermitage. Pastels by Artists of Western European Schools of the 16th to 19th Centuries], Leningrad, 1960

Kaptereva 1956
T. Kaptereva, *Velazquez und die spanische Porträtmalerei,* Leipzig, 1956

Kehrer 1926
H. Kehrer, *Spanische Kunst von Greco bis Goya,* Munich, 1926

Kehrer 1930
H. Kehrer, 'Köpfe des Velazquez', *Estudios in memoriam de Adolfo Borilla y San Martin,* Madrid, 1930

Kemenov 1969
V. Kemenov, *Kartiny Velaskesa* [Paintings by Velazquez], Moscow, 1969

Kendall 1932-3
G. E. Kendall, 'Notes on the Life of John Wootton with a List of Engravings after his Pictures', *Walpole Society*, XXI, 1932-3, pp. 23-52

Kent 1727
W. Kent, *The Designs of Inigo Jones…, 2 vols.,* London, 1727

Kenworthy-Browne, Reid 1981
J. Kenworthy-Browne, P. Reid et al., *Burke's and Savills Guide to Country Houses*, vol. III: *East Anglia*, London, 1981

Kerber 1968
B. Kerber, 'Giuseppe Bartolomeo Chiari', *The Art Bulletin*, vol. L, no. 1, March 1968, pp. 75-86

Kerber 1973
B. Kerber, 'Kupferstiche nach Gianfrancesco Romanelli', *Giessener Beiträge zur Kunstgeschichte*, Bd II, 1973, pp. 133-70

Kerber 1979
B. Kerber, 'Addenda zu Giovanni Francesco Romanelli', *Giessener Beiträge zur Kunstgeschichte*, vol. 4

Kerslake 1977
J. Kerslake, *Catalogue of the Eighteenth-Century Portraits in the National Portrait Gallery,* London, 1977

Ketton-Cremer 1940
R. Ketton-Cremer, *Horace Walpole: A Biography,* New York, 1940

Ketton-Cremer 1948
R. W. Ketton-Cremer, *A Norfolk Gallery,* London 1948

Kieser 1931
E. Kieser, 'Tizians und Spaniens Einwirkungen auf die späteren Landschaften des Rubens', *Münchner Jahrbuch der bildenden Kunst*, N.F. vol. VIII, 1931, pp. 281-91

Kieser 1933
E. Kieser, 'Antikes im Werke des Rubens', *Münchner Jahrbuch der bildenden Kunst*, N.F. vol. X, 1933, pp. 110-37

Killanin 1948
Lord Killanin, *Sir Godfrey Kneller and his Times, 1646-1723; Being a Review of English Portraiture of the Period,* London, 1948

Kingsbury 1995
P. Kingsbury, *Lord Burlington's Town Architecture,* London, 1995

Kirby Talley 1983
M. Kirby Talley, 'Small, Usual and Vulgar Things: Still-life Painting in England 1635-1760', *Walpole Society,* XLIX, 1983, pp. 133-223

Klima 1975
S. Klima, ed., *Joseph Spence: Letters from The Grand Tour,* Montreal 1975

Knackfuss 1896
H. Knackfuss, *Frans Hals,* Bielefeld and Leipzig, 1896

Knuttel 1956
G. Knuttel, *Rembrandt. De meester en zijn werk,* Amsterdam, 1956

Korenev 1931
A. G. Korenev, *Sevastopol'skaya kartinnaya galereya: Putevoditel'-katalog* [Sevastopol Picture Gallery: Guide and Catalogue], Simferopol, 1931

Koslow 1995
S. Koslow, *Frans Snyders. The Noble Estate. Seventeenth-century Still-life and Animal Painting in the Southern Netherlands,* Antwerp, 1995

Kouznetsova, Gueorguievskaia 1980
I. Kouznetsova, E. Gueorguievskaia, *La peinture française au musée Pouchkine,* Leningrad, 1980

Krawietz 1990
C. Krawietz, 'Un itinerario nell'opera pittorica di Anton Maria Vassallo', *Arte Documento*, 3, Udine, 1990

Krol' 1961
A. Ye. Krol', *Angliyskaya zhivopis' XVI-XIX vekov v Ermitazhe* [English Painting of the 15th to 19th Centuries in the Hermitage], Leningrad, 1961

Krol' 1969
A. Ye. Krol', *Gosudarstvennyy Ermitazh.Angliyskaya zhivopis'. Katalog* [The State Hermitage. English Painting. Catalogue], Leningrad, 1969

Krol' 1970
A. Ye. Krol', 'Ob avtore 'Portreta Eduarda VI' v Ermitazhe' [On the Author of the 'Portrait of Edward VI' in the Hermitage], in the anthology *Zapadnoyevropeyskoye iskusstvo* [Western European Art], Leningrad, 1970

Kugler 1837
Fr. Kugler, *Handbuch der Geschichte der Malerei in Deutschland, den Niederlanden, Spanien, Frankreich und England,* Berlin, 1937

Kuhnel-Kunze 1962
I. Kuhnel-Kunze, 'Zur Bildniskunst der Sofonisba und Lucia Anguisciola', *Pantheon*, vol. XX, March-April 1962

Kunsthistorisches Museum 1965
Kunsthistorisches Museum. Katalog der Gemäldegalerie, vol. I, Vienna, 1965

Kurz 1937
O. Kurz, 'Guido Reni', *Jahrbuch der Kunsthistorischen Sammlungen in Wien*, N.F. vol. 11, 1937

Kusche 1992
M. Kusche, 'Sofonisba Anguissola, Retratista de la Corte Española', *Paragone*, 1992, no. 509-11, pp. 3-34

Kusche 1995
M. Kusche, in *La prima donna pittrice. Sofonsba Anguissola. Die Malerin der Renaissance (um 1535-1625),* Kunsthistorisches Museum, Vienna, 17 January – 26 March 1995; Vienna, 1995

Kustodieva 1989
T. Kustodieva et al, *The Hermitage, Leningrad: Western European Painting of the 13th to the 18th Centuries,* Leningrad 1989

Kustodieva 1991
T. Kustodieva, 'Leonardeschi all'Ermitage', *Achademia Leonardi Vinci. Journal of Leonardo Studies & Bibliography of Vinciana*, ed. Carlo Pedretti, vol. IV, 1991

Kustodieva 1994
Tatiana K. Kustodieva, *The Hermitage Catalogue of Western European Painting. Italian Painting Thirteenth to Sixteenth Centuries,* Moscow-Florence, 1994

Kustodieva 1998-9
T. K. Kustodieva, *Proizvedeniya shkoly Leonardo da Vinchi v sobraniii Ermitazha* [Works from the School of Leonardo da Vinci in the Hermitage Collection], exh. cat., State Hermitage Museum, St Petersburg, 22 December 1998 – 14 March 1999; St Petersburg, 1998

Kuznetsov 1966
Yu. Kuznetsov, *Zapadnoyevropeyskiy natyurmort* [Western European Still Life], Leningrad-Moscow, 1966

Kuznetsov 1974
Yu. I. Kuznetsov, *Risunki Rubensa* [Rubens' Drawings], Moscow, 1974

Kuznetsov, Linnik 1982
J. Kuznetsov, I. Linnik, *Dutch Paintings in Soviet Museums,* Amsterdam-Leningrad, 1982

Kuznetsova 1982
I. A. Kuznetsova, *Gosudarsvennyy Muzey izobrazitel'nykh iskusstv imeni A. S. Pushkina. Frantsuzskaya zhivopis' XVI – pervoy poloviny XIX veka. Katalog* [State Pushkin Museum of Fine Arts. French Painting of the 16th to First Half of the 19th Century. Catalogue], Moscow, 1982

Kuznetsova 1991
I. Kuznetsova, *Frantsuzskaya zhivopis'. XVI – pervaya polovina XIX veka. Gosudarstvennyy muzey izobrazitel'nykh iskusstv imeni A. S. Pushkina* [French Painting. 16th to First Half of the 19th Century. State Pushkin Museum of Fine Arts], Moscow, 1991

Labensky 1805-9
Galérie de l'Ermitage. Gravée au trait d'après les plus beaux tableaux qui la composent avec la description historique. Ouvrage publié par F. X. De Labensky, St Petersbourg, 1805-9, in 2 volumes (6 books); parallel French and Russian edn

Lafler 1989
J. Lafler, *The Celebrated Mrs Oldfield: The Life And Art Of An Augustan Actress,* Carbondale, Southern Illinois, 1989

Lafuente Ferrari 1943
E. Lafuente Ferrari, *Velazquez,* London, 1943

Lafuente Ferrari 1953
E. Lafuente Ferrari, *Breve historia de la Pintura española,* Madrid, 1953

Landon 1809
C. P. Landon, *Nicolas Poussin,* Paris, 1809, in the series *Vie et oeuvres des peintres les plus célèbres de toutes les écoles…,* 25 vols., Paris, 1803-17

Landon 1814
C. P. Landon, *Vie et oeuvre complete de Nicolas Poussin,* Paris, 1814

Landon 1819
C. P. Landon, *Choix de tableaux et statues des plus célèbres Musées et Cabinets étrangers,* Paris, 1819

Lankrink 1945
P. H. (editorial), 'Lankrink's Collection', *The Burlington Magazine*, vol. LXXXVII, February 1945

Larsen 1980
E. Larsen, *L'opera completa di Van Dyck,* 2 vols., Milan, 1980

Larsen 1988
E. Larsen, *The Paintings of Anthony van Dyck,* 2 vols., Freren, 1988

Larsons 1929
M. J. Larsons [M. Y. Lazerson], *An Expert in the Service of the Soviets,* London, 1929

Lasareff 1930
V. Lasareff, 'Uber einige neue Bilder von Benedetto Castiglione. Studien zur Geschichte des Pastorale', *Städel-Jahrbuch*, 1930, vol. 6, 96-108

Lawrence 1929
A.W. Lawrence, *Later Greek Sculpture,* London, 1929

Lazarev 1930
V. N. Lazarev, 'Kartinnaya galereya GMII (Yeyo sostyaniye i perspektivy)' [State Pushkin Museum of Fine Arts Picture Gallery (Its Condition and its Future)], *Zhizn' muzeya. Byulleten' GMII* [The Life of the Museum. State Pushkin Museum of Fine Arts Bulletin], August 1930, pp. 17-22

Le Blanc 1848
Ch. Le Blanc, *Catalogue de l'oeuvre de Robert Strange, graveur*, Leipzig, 1848

Le Blanc 1862
C. Le Blanc, *Histoire des peintres de toutes les écoles. Ecole française*, Paris, 1862

Le Blanc 1970
C. Le Blanc, *Manuel de l'amateur d'estampes*, Amsterdam 1970

Le Breton 1809
Le Breton, 'La Galérie de l'Ermitage', *Mercure de France*, May 1809

Le Comte 1699-1700
Florent Le Comte, *Cabinet des singularités d'architecture, peinture, sculpture et graveure*, 3 vols., Paris, 1699-1700

Learmount 1985
B. Learmount, *A History of the Auction*, Barnard & Learmount, 1985

Lecaldano 1969
P. Lecaldano, *L'opera pittorica completa di Rembrandt*, Milan, 1969

Lefort 1888
P. Lefort, *Velazquez*, Paris, 1888

Lefort 1892
P. Lefort, *Murillo et ses élèves. Catalogue raisonné de ses principaux ouvrages*, Paris, 1892

Lemus et al 1980
V. V. Lemus, L. V. Yemina, Ye. S. Gladkova, G. P. Balog, *Muzei i parki Pushkina* [Museums and Parks of Pushkin], Leningrad, 1980

Leonardo e il leonardismo 1983
Leonardo e il leonardismo a napoli e a Roma. Catalogo a cura di Alesandro Vezzosi. Testi introdutivi di Carlo Pedretti, Florence, 1983

Lepicier 1956
A. M. Lepicier, *L'Immaculée Conception dans l'Art et l'Iconographie*, Spa, 1956

Les anciennes écoles 1910
P. Weiner, E. Liphart, J. Schmidt, *Les anciennes écoles de peinture dans les palais et collections privées russes représentée à l'exposition organisée à St.-Pétersbourg en 1909 par la Revue d'art ancien 'Starye Gody'*, Brussels, 1910

Levina 1969
I. M. Levina, *Kartina Muril'o v Ermitazhe* [A Painting by Murillo in the Hermitage], Leningrad, 1969

Levinson-Lessing 1926
V. F. Levinson-Lessing, *Sneyders i flamandskiy natyurmort* [Snyders and the Flemish Still Life], Leningrad, 1926

Levinson-Lessing 1956
V. F. Levinson-Lessing, *Vystavka proizvedeniy Rembrandta i yego shkoly v svyazi s 150-letiyem so dnya rozhdeniya* [Exhibition of Works by Rembrandt and his School in Honour of the 350th Anniversary of his Birth], Moscow, 1956

Levinson-Lessing 1975
W. Loewinson-Lessing, ed., *Rembrandt Harmensz van Rijn. Paintings from Soviet Museums*, with notes on the plates by X. Egorova, 4th ed., Leningrad, 1975

Levinson-Lessing 1986
V. V. Levinson-Lessing, *Istoriya kartinnoy galerei Ermitazha (1784-1917)* [The History of the Hermitage Picture Gallery (1784-1917)], Leningrad, 1986 (2nd ed., with index)

Lewis 1961
L. Lewis, *Connoisseurs and Secret Agents in Eighteenth-Century Rome*, London, 1961

Libman 1972
M. Libman, *Nemetskaya zhivopis' v muzeyakh Sovetskogo Soyuza* [German Painting in Museums of the Soviet Union], Moscow, 1972

Lidtke 1989
W. A. Lidtke, 'Flemish Painting from the Hermitage. Some Notes to an Exhibition Catalogue with Special Attention to Rembrandt, Van Dyck and Jordaens', *Oud Holland*, vol. 103, 1989, no. 3, pp. 134-68

Limentani Virdis 1985
C. Limentani Virdis, 'Paris Bordon. La seduzione e il mondo nordico', in *Paris Bordon e il suo tempo*, Atti del Convegno Internazionale di studi, Treviso, 28-30 ottobre 1985, Milan, pp. 83-9

Linnik 1956
I. V. Linnik, 'Novoye opredeleniye kartiny Estasha Lesyuyera 'Oplakivaniye tela svyatogo Stefana" [A New Identification of Eustache Lesueur's Painting 'The Lamentation over the Body of St Stephan'], *Soobshcheniya Gosudarstvennogo Ermitazha* [Reports of the State Hermitage], issue VIII, 1956, pp. 26-8

Liphart 1908
E. Liphart [Lipgart], 'Ital'yanskays shkola' [The Italian School], *Staryye gody* [Years of Old], November – December 1908, pp. 702-16

Liphart 1910
E. K. Liphart [Lipgart], 'Imperatorskiy Ermitazh. Priobreteniya i pereveski' [The Imperial Hermitage. Acquisitions and Rehangings], *Staryye gody* [Years of Old], January 1910

Liphart 1912a
E. Lipgart [Liphart], 'Kartiny v sobranii knyazey L. M. i Ye. L. Kochubey' [Paintings in the Collections of Princes L. M. and Ye. L. Kochubey], *Staryye gody* [Years of Old], January 1912

Liphart 1912b
E. Liphart, 'Kritische Gänge und Reiseeindrücke', *Jahrbuch der Königlich Preuszischen Kunstsammlungen*, vol. 33, 1912, pp. 193-225

Liphart 1915
E. Liphart [Lipgart], 'Ital'yanskaya zhivopis' XVI veka v Gatchinskom dvortse' [The 16th-century Italian School of Painting at Gatchina Palace], *Staryye gody* [Years of Old], January-February 1915, pp. 3-22

Liphart 1916
E. Lipgart [Liphart], 'Ital'yantsy 17 stoletiya v Gatchinskom dvortse' [17th-century Italians at Gatchina Palace], *Staryye gody* [Years of Old], June-September 1916

Liphart 1928
E. Liphart [Lipgart], *Leonardo da Vinchi i yego shkola* [Leonardo da Vinci and his School], Leningrad, 1928

Lippincott 1983
Louise Lippincott, *Selling Art in Georgian England. The Rise of Arthur Pond*, New Haven-London, 1983, pp. 113-14

Lisenkov 1926
Ye. G. Lisenkov, *Van Deyk* [Van Dyck], Leningrad, 1926

Livret 1838
Livret de la Galerie Impériale de l'Hermitage de Saint-Pétersbourg. Contenant l'explication des Tableaux qui la composent, avec de courtes notices sur les autres objects d'art ou de curiosité qui y sont exposés, St Petersburg, 1838

Locke 1768
J. Locke, *The Works*, 4 vols., London, 1768

Locke 1979-82
J. Locke, *The Correspondence*, ed E. S. De Beer, 8 vols., Oxford, 1979-82

Lodge ed. 1933
R. Lodge, ed., *The Private Correspondence of Sir Benjamin Keene, KB*, Cambridge. 1933

Lomenie de Brienne 1960
Louis Henri Lomenie, Comte de Brienne, 'Discours sur les ouvrages des plus excellens peintres anciens et nouveaux avec un traité de la peinture composé et imaginé par Mre L. H. de L. C. de B. Reclus', in J. Thuillier, 'Pour un 'Corpus Pussinianum', *Nicolas Poussin (Actes du Colloque International, Paris, 19-21 Septembre 1958)*, 2 vols., Paris, 1960, vol. 2

Longhi 1957
R. Longhi, 'Annibale, 1584 ?', *Paragone*, 1957, no. 89, pp. 33-42

Lopez-Rey 1963
J. Lopez-Rey, *Velázquez. A Catalogue Raisonné*, London, 1963

Lopez-Rey 1979
J. Lopez-Rey, *Velázquez. The Artist as Maker*, Lausanne-Paris, 1979

Lost Hermitage 2001
Ermitazh, kotoryy my poteryali. Dokumenty 1920–1930 godov [The Hermitage which we have Lost. Documents 1920–1930], St Petersburg, 2001 (Lost Hermitage 2001).

Loudon 1841
J. C. Loudon, *The Gardener's Magazine*, 1841, p. 271

Lugt 1938-
F. Lugt, *Repertoire des Catalogues de Ventes Publiques Interessant l'Art ou la Curiosite*, La Haye, 1938-

Lukomsky 1918
G. K. Lukomskiy, *Kratkiy katalog muzeya Bol'shogo Yekaterininskogo dvortsa i yego istoricheskiy ocherk* [Brief Catalogue of the Museum of the Great Catherine Palace and a Historic Outline], Petrograd, 1918

Mackie 1901
C. Mackie, *Norfolk Annals: A Chronological Record of Remarkable Events in the 19th Century*, 2 vols., Norwich, 1901

Mackor 1995
A. Mackor, 'Are Marinus' Tax Collectors Collecting Taxes?', *Bulletin du Musée National de Varsovie*, vol. XXXVI, 1995, nos. 3-4

Macky 1714
J. Macky, *A Journey Through England in Familiar Letters From a Gentleman Here to a Friend Abroad…*, vol. I, London, 1714

Macky 1721
J. Macky, *A Journey Through England in Familiar Letters From a Gentleman Here to a Friend Abroad…*, vols. I, II, London, 1721

Macky 1725
J. Macky, *A Journey Through the Austrian Netherlands… To which is prefixed, an introduction, containing the ancient history of the whole Seventeen Provinces…*, London, 1725

Macky 1733
J. Macky, *Memoirs of the Secret Services of John Macky… including, also, the true Secret History of the … English and Scots Nobility, …. And other persons of distinction, from the Revolution*, London, 1733, ed. A.R., La Haye, 1733

Maclaren, Braham 1970
N. Maclaren, A. Braham, *National Gallery Catalogues: The Spanish School*, London, 1970

Macquoid 1906 (1987 edn)
P. Macquoid, *A History of English Furniture: The Age of Mahogany*, London 1906 (1987 edn)

Macquoid and Edwards 1954
P. Macquoid and R. Edwards, *The Dictionary of English Furniture*, 3 vols., 2nd edn, London 1954

Magne 1914
E. Magne, *Nicolas Poussin, premier peintre du Roi*, Brussels-Paris, 1914

Magurn 1955
The Letters of Peter Paul Rubens, translated and edited by Ruth Saunders Magurn, Cambridge, MA, 1955; reprinted 1971

Mahon 1962
D. Mahon, 'Poussiniana. Afterthoughts Arising from the Exhibition', *Gazette des Beaux-Arts*, vol. CIV, July-August 1962, pp. 1-138; Volume séparé avec même pagination et introduction, Paris-New York-London, 1962

Mahoney 1977
M. Mahoney, *The Drawings of Salvator Rosa*, New York – London, 1977

Malitskaya 1939
K. M. Malitskaya, 'K probleme realizma v ispanskom iskusstve XVII veka' [On the Question of Realism in Spanish 17th-century Art], in *Trudy GMII im. A. S. Pushkina* [Papers of the State Pushkin Museum of Fine Arts], Moscow-Leningrad, 1939

Malitskaya 1947
K. M. Malitskaya, *Ispanskaya zhivopis' XVI-XVII vekov* [Spanish Painting of the 16th-17th Centuries], Moscow, 1947

Malmesbury Letters
A Series of Letters of the First Earl of Malmesbury, His Family and Friends from 1745 to 1820, edited, with notes &c., by his Grandson, the Right Hon. The Earl of Malmesbury G.C.B…, 2 vols., London [s.d.]

Malvasia 1678 [ed. 1841]
C. C. Malvasia, *Felsina pittrice. Vite de' Pittori Bolognesi. (Bologna, 1678)*, ed. cons. Felsina Pittrice. Con aggiunte, correzioni e note inedite dallo stesso autore, di Giampietro Zanotti ed altri scrittori viventi, Bologna, 1841, 2 vols

Mancigotti 1975
M. Mancigotti, *Simone Cantarini il Pesarese*, Pesaro, 1975

Mandel 1996
Corinne Mandel, 'Paris Bordone', in *The Dictionary of Art*, ed. Jane Turner, 34 vols., New York-London, 1996

Maratti 1975
J. K. Westin, R. H. Westin, *Carlo Maratti and His Contemporaries. Figurative Drawings from the Roman Baroque*, Museum of Art, Pennsylvania State University, 1975

Mariette 1853-59
Abecedario de P.-J. Mariette et autres notes inédites de cet auteur sur les arts et les artistes, 5 vols., Paris, 1853-59 (*Archives de l'art français*, IV)

Marillier 1926
H. C. Marillier, *Christie's, 1766-1925*, London, 1926

Marillier 1930
H. C. MArillier, *English Tapestries of the Eighteenth Century: A Handbook to the Post-Mortlake Production of English Weavers*, London, 1930

Marini 1968
R. Marini, *Tutta la pittura di Paolo Veronese*, Milan, 1968

Markova 1986
V. E. Markova, *Kartiny ital'yanskikh masterov XIV-XVIII vekov iz muzeyev SSSR* [Paintings by Italian Masters of the 14th to 18th Centuries from Museums in the USSR], Moscow, 1986

Markova 1992
V. E. Markova, *Ital'yanskaya zhivopis' XIII-XVIII vekov v sobranii GMII* [Italian 13th-18th-Century Painting in the Collection of the State Pushkin Museum of Fine Arts], Moscow, 1992

Marlier 1934
G. Marlier, 'Anthonis Mor van Dashort (Antonio Moro)', *Académie royale de Belgique, Classe des Beaux-Arts, Memoires*, 2me série III, fasc. 2, Brussels, 1934

Marlier 1954
G. Marlier, *Erasme et la peinture flamande de son temps*, Damme, 1954

Martin 1970
G. Martin, *National Gallery Catalogues: The Flemish School circa 1600 - circa 1900*, London, 1970; reprinted 1986

Martin 1972
R. Martin, *The Decorations for the Pompa Introitus Ferdinandi*, in the series *Corpus Rubenianum Ludwig Burchard*, part XVI, Brussels, 1972

Martin 1996
F. Martin, 'Camillo Rusconi: Il Fauno di Berlino e una ipotesi', *Antologia di Belle Arti. La scultura II (Studi in onore di Andrew S. Chiechanowiecki)*, 52-55 [1996], pp. 126-31

Martin 2000a
F. Martin, 'Camillo Rusconi's English Patrons', in Cinzia Sincca Bursill Hall, Alison Yarrington, eds., *Material Culture and the History of Sculpture in England and Italy from the 18th to the 19th Century*, Leicester, 2000, pp. 51-68

Martin 2000b
F. Martin, 'La scultura a Roma al tempo di Francesco Robba', in J. Hofler, ed., *Francesco Robba and the Venetian Sculpture of the Eighteenth Century; Papers from an International Symposium, Ljubljana 16-18 October 1998*, Ljubljana, 2000

Martyn 1766
F. Martyn, *The English Connoisseur, containing an account of whatever is curious in painting, sculpture etc., in the palaces and seats of the nobility and principal gentry of England, both in town and country*, London, 1766

Mauquoy-Hendrickx 1956
Marie Mauquoy-Hendrickx, *L'Iconographie d'Antoine van Dyck. Catalogue raisonné*, 2 vols., Brussels, 1956

Mayer 1913
A. L. Mayer, *Murillo. Des Meisters Gemälde*, Stuttgart-Berlin, 1913 (*Klassiker der Kunst*, vol. 22)

Mayer 1922
A. L. Mayer, *Geschichte der Spanischen Malerei*, Leipzig, 1922

Mayer 1934
A. L. Mayer, 'Anotaciones a obras murillescas', *Boletin de la Sociedad Española de Excurciones*, vol. 42, 1934, p. 14

Mayer 1936
A. L. Mayer, *Velazquez. A Catalogue Raisonné*, London, 1936

McCann 1968
A. M. McCann, *The Portraits of Septimus Severus A.D. 193-211*, Rome, 1968

McKim-Smith 1979
G. McKim-Smith, 'On Velazquez's Working Method', *The Art Bulletin*, vol. 61, December 1979, pp. 589-603

Mély 1910
F. Mély, 'Deux tableaux signés de Corneille de Lyon', *Fondation Eugène Piot. Monuments et Mémoires, publiés par l'Académie des Inscriptions et Belles-Lettres*, vol. 18, Paris, 1910, p. 321

Mémoires secrètes 1862
Mémoires secrètes et inédites de Stanislas Auguste – comte Poniatowski – dernier roi de Pologne. Journal privé du roi Stanislas Auguste pendant son voyage en Russie pour le couronnement de l'empéreur Paul I-er, Leipzig, 1862

Menegazzi 1957
L. Menegazzi, 'Ludovico Toeput (il Pozzoserrato)', *Saggi e Memorie di Storia dell'Arte*, I, 1957, pp. 165-223

Mensaert 1763
G. P. Mensaert, *Le peintre amateur et curieux ou description générale des tableaux des plus habile Maîtres, qui font l'ornement des Eglises, Couvents, Abbayes, Prieures et Cabinets particuliers dans l'étendue des Pays-Bas Autrichiens*, Brussels, 1763

Merot 1987
A. Merot, *Eustache Le Sueur (1616-1655)*, Paris, 1987

Metzger 1987
E. Metzger, *Ralph First Duke of Montagu. 1638-1709*, New York, 1987

Meyer 1984a
A. Meyer, *John Wootton, 1682-1764: Landscape and Sporting Art in Early Georgian England*, exh. cat., Kenwood, London, 1984

Meyer 1984b
A. Meyer, 'Household Mock-Heroics, The Dog Portraits of John Wootton (1682-1764)', *Country Life*, vol. CLXXV, 9 February 1984, pp. 340-2

Mezzetti 1955
A. Mezzetti, 'Contributi a Carlo Maratti', *Rivista dell' Istituto Nazionale di Archeologia e Storia dell'arte*, 1955

Michaelis 1882
A. Michaelis, *Ancient Marbles in Great Britain*, transl. C. A. M. Fennell, Cambridge, 1882

Michalkowa 1980
J. Michalkowa, *Nicolas Poussin*, Leipzig, 1980

Michel 1771
J. F. M. Michel, *Histoire de la vie de P. P. Rubens*, Brussels, 1771

Michel 1893
Emile Michel, *Rembrandt. Sa vie, son oeuvre et son temps*, Paris, 1893

Millar 1956
O. Millar, 'The Whitehall Ceiling', *The Burlington Magazine*, vol. XCVII, no. 641, August 1956, pp. 258-65

Millar 1958-60
'Abraham van der Doort's Catalogue of the Collection of Charles I', edited with an introduction by Oliver Millar, *Walpole Society*, XXXVII, 1958-60, Oxford, 1960

Millar 1963
O. Millar, *The Tudor, Stuart and Early Georgian Pictures in the Collection of Her Majesty The Queen*, 2 vols., London, 1963

Millar 1970-72
O. Millar, 'The Inventories and Valuations of the King's Goods 1649-1651', *Walpole Society*, XLIII, 1970-72

Millar 1991
Sir O. Millar, 'Caring for The Queen's Pictures: Surveyors Past and Present', in C. Lloyd, *The Queen's Pictures. Royal Collectors through the Centuries*, exh. cat., National Gallery, London, 1991

Millar 1994
Oliver Millar, 'Philip, Lord Wharton, and his Collection of Portraits', *The Burlington Magazine*, vol. CXXXVI, no. 1097, August 1994, pp. 517–30

Miller 1923
M. F. Miller, 'Frantsuzskaya zhivopis' XVII-XVIII vv. v novykh zalakh Ermitazha' [French 17th-18th Century Painting in the New Rooms of the Hermitage], *Gorod* [Town], 1923, no. 1

Miller 1999
J. Miller, 'A Moderate in the First Age of Party: The Dilemmas of Sir John Holland, 1675-85', *The English Historical Review*, vol. CXIV, no. 458, September 1999

Milward 1938
C. Robbins, ed., The *Diary of John Milward, Esq. Member of Parliament for Derbyshire, September, 1666 to May 1668*, Cambridge, 1938

Mirimonde 1964
A. P. de Mirimonde, 'Les concerts parodiques chez les maîtres du Nord', *Gazette des Beaux-Arts*, vol. LXIV, no. 2, November 1964, pp. 253-84

Montgomery Hyde 1969
H. Montgomery Hyde, *John Law, the History of an Honest Adventurer*, London, 1969

Moore 1985
A. Moore, *Norfolk and the Grand Tour. Eighteenth-Century Travellers Abroad and Their Souvenirs*, Norfolk Museums Service, 1985

Moore 1988a
A. Moore, *Dutch and Flemish Painting in Norfolk: A History of Taste and Influence, Fashion and Collecting*, London, 1988

Moore 1988b
A. Moore, 'The Fountaine Collection of Majolica', *Burlington Magazine*, vol. CXXX, 1988, pp. 435-47

Moore 1993
A. Moore, 'La collection de Sir Robert Walpole (Houghton, 1676 – Londres, 1745)', in *L'Age d'or flamand et hollandais, collections de Catherine II, Musée de L'Ermitage, Saint Petersbourg*, Musée des Beaux – Arts de Dijon, 1993, pp. 65-71

Moore 1996
Andrew Moore, 'The Houghton Sale', in British Art Treasures 1996, pp. 46-55

Moore ed. 1985
A. Moore, ed., *Norfolk and the Grand Tour: Eighteenth-Century Travellers Abroad and Their Souvenirs*, Norwich, 1985

Moore ed. 1992
A. Moore. ed., *Family and Friends; a regional survey of British Portraiture*, London, 1992

Moore ed. 1996
A. Moore, ed., *Houghton Hall. The Prime Minister, The Empress and The Heritage*, London, 1996; including: John. Cornforth, 'The Genesis and Creation of a Great Interior', pp. 29-40; Andrew Moore, 'Sir Robert Walpole: The Prime Minister as Collector', pp. 48-55; Andrew Moore, 'The Sale to Catherine the Great', pp. 56-64; Gregory Rubinstein, 'The Genesis of John Boydell's "Houghton Gallery"', pp. 65-73; Sebastian Edwards, Andrew Moore, Chloë Archer, 'The Catalogue', pp. 82-161

Morrison 1887-97
A. Morrison, *Catalogue of the Collection of Autograph Letters and Historical Documents...*, printed for private circulation, 1887-97

Moschini 1923
V. Moschini, 'Benedetto Luti', *L'Arte*, anno XXVI, 1923, pp. 89-114

Moscow Guide 1917
Progulki po Moskve i yeyo khudozhestvennym i prosvetitel'nym uchrezhdeniyam [Walks Through Moscow and its Artistic and Educational Establishments], edited by N. A. Geynike, N. S. Yelagin, etc, Moscow, 1917, reprinted 1991

Mowl 1996
T. Mowl, *Horace Walpole. The Great Outsider*, London, 1996

Müllenmeister 1981
K. J. Müllenmeister, *Meer und Land im Licht des 17. Jahrhunderts*, vol. 3, Bremen, 1981

Muller 1929
K. Muller, 'Studien zu Lastman und Rembrandt', *Jahrbuch der Preuszischen Kunstsammlungen*, vol. L, 1929, part 1, pp. 45-83

Müller-Hofstede 1962
J. Müller Hofstede, 'Zur Antwerpener Frühzeit von P. P. Rubens', *Münchener Jahrbuch der bildenden Kunst*, III Folge, vol.13, 1962

Murdoch ed. 1992
T. Murdoch, ed., *Boughton House: The English Versailles*. London, 1992

Murphy 1997
A. Murphy, *John Law: Economic Theorist and Policy-Maker*, Oxford, 1997

Musées de France 1988
A. Brejon de Lavergnée, N. Volle, O. Menagaux, *Musées de France. Repertoire des peintures italiennes du 17 siecle*, Paris, 1988

Musgrave 1732
W. Musgrave, *Genuine Memoirs of the Life and Character of the Right Honourable Sir Robert Walpole, And of the Family of the Walpoles, From their first settling in England, before the Conquest, to to the present Times: Containing several curious Facts, and Pieces of History hitherto unknown. Extracted from Original Papers, and Manuscripts, never yet printed ...* London, 1732

Nagler 1835-52
G. K. Nagler, *Neues allgemeines Künstler–Lexikon*, Munich, 22 vols., 1835-52

Namier and Brooke eds. 1964
Sir Lewis Namier and John Brooke, eds., *The House of Commons 1754-1790*, 3 vols., London, 1964

Natura morta 1989
La natura morta in Italia, Direzione scientifica Federico Zeri, 2 vols., Milan, 1989

Natura morta italiana 1964
La natura morta italiana, exh. cat., Naples-Zurich-Rotterdam, October 1964 – March 1965, Milan, Milano, 1964

NDB
Neue Deutsche Biographie, (Schriftleitung: Otto Graf zu Stolberg-Wernigerode), Berlin 1953-

Nelson 1990
K. Nelson, 'Jacob Jordaens: Family Portraits', in *Nederlandse portretten: bijdragen over de portretkunst in de Nederlanden uit zestiende, zeventiende en achttiende eeuw*, vol. VIII (1989) in the series *Leids kunsthistorisch Jaarboek*, The Hague, 1990

Nemilova 1982
I. S. Nemilova, *Frantsuzskaya zhivopis' XVIII veka v sobranii Ermitazha* [French 18th-century Painting in the Hermitage Collection], catalogue, Leningrad, 1982

Nemilova 1985
I. S. Nemilova, *Gosudarstvennyy Ermitazh. Sobraniye zapadnoyevropeyskoy zhivopisi. Katalog. Frantsuzskaya zhivopis'. XVIII vek* [The State Hermitage. Collection of Western European Painting. Catalogue. French Painting. 18th Century], Moscow, 1985

Nersesov 1961
N. Nersesov, *Nikola Pussen* [Nicolas Poussin], Moscow, 1961

Neustroyev 1898
A. A. Neustroyev, *Kartinnaya galereya imperatorskogo Ermitazha*, [The Picture Gallery of the Imperial Hermitage], St Petersburg, 1898

Neustroyev 1909
A. A. Neustroyev, 'Rubens i yego kartiny v galereye imperatorskogo Ermitazha' [Rubens and His Paintings in the Gallery of the Imperial Hermitage], *Staryye gody* [Years of Old], January-February 1909, pp. 3-23, 59-84

NG Washington 1975
National Gallery, Washington. European Paintings: An Illustrated Summary Catalogue, Washington, 1975

NG Washington 1985
National Gallery, Washington. European Paintings: An Illustrated Catalogue, Washington, 1985

Nikulin 1972
N. N. Nikulin, *Niderlandskaya zhivopis' XV-XVI vekov v Ermitazhe* [15th to 16th-Century Netherlandish Painting in the Hermitage], Catalogue, Leningrad, 1972

Nikulin 1987
N. N. Nikulin, *The Hermitage Catalogue of Western European Painting. German and Austrian Painting. Fifteenth to Eighteenth Centuries*, Florence, 1987

Nikulin 1989
Nikolay N. Nikulin, *The Hermitage Catalogue of Western European Painting, vol. 5, Netherlandish Painting: Fifteenth and Sixteenth Centuries*, Florence, 1989

Novitsky 1889
A. Novitskiy, *Khudozhestvennaya galereya Moskovskogo Publichnogo i Rumyantsevskogo muzeyev. Kritiko-istoricheskiy ocherk* [The Art Gallery of the Moscow Public and Rumyantsev Museums. A Critical and Historical Essay], Moscow, 1889

Novosel'skaya 1969
I. N. Novosel'skaya, 'Ranyeye tvorchestvo Sharlya Lebrena i kartina Ermitazha "Dedal i Ikar"' [The Early Work of Charles Lebrun and the Hermitage Painting 'Daedalus and Icarus'], *Soobshcheniya Gosudarstvennogo Ermitazha* [Reports of the State Hermitage], issue XXX, 1969, pp. 15-18

O'Donoghue 1908-25
F. O'Donoghue, *Catalogue of Engraved British Portraits Preserved in the Department of Prints and Drawings in the British Museum*, London, 1908-25

Oehler 1980
H. Oehler, *Foto + Skulptur.Römische Antiken in englischen Schlössern*, exh. cat., Römisch-Germanischen Museum, Cologne, 1980

Oldenbourg 1921
P. P. Rubens. *Des Meisters Gemälde in 538 Abbildungen*, Herausgeg. von R. Oldenbourg...4. neu bearbeitete Auflage, Stuttgart—Berlin, [1921] (*Klassiker der Kunst in Gesamtausgaben*, vol. 4)

Oldenbourg 1922
Rudolf Oldenbourg, *Die flamische Malerei des XVII. Jahrhunderts*, 2Aufl., Berlin-Leipzig, 1922

Ottino Della Chiesa 1967
L'opera completa di Leonardo pittore. Presentazione di M. Pomilio. Apparti critici e filologici di A. Ottino Della Chiesa, Milan, 1967

Ozzola 1908
L. Ozzola, Vita e opere di Salvator Rosa, pittore, poeta e incisore, con poesie e documenti inediti, Strasbourg, 1908

Ozzola 1909
L. Ozzola, 'Opera di Salvator Rosa a Vienna', Monatshefte für Kunstwissenschaft, vol. II, 1909

Pacheco 1649
F. Pacheco, El arte de la pintura (1649). Edición, introducción y notas de Bonaventura Bossegoda i Hugos, Madrid, 1990

Padrón 1975
M. D. Padrón, Museo del Prado, Catalogo de pinturas, 2 vols., vol. I, Escuela flamenca. Siglo XVII, Madrid, 1975

Pagano Galassi 1988
P. Pagano, M. C. Galassi, La pittura del '600 a Genova, Milan, 1988

Pallucchini 1960
R. Pallucchini, La pittura veneziana del Settecento, Venice, 1960

Pallucchini 1981
R. Pallucchini, 'Per la storia del Manierismo a Venezia', in Da Tiziano a El Greco. Per la storia del Manierismo a Venezia. 1540-1590, exh. cat., Milan, 1981

Pallucchini 1984a
R. Pallucchini, 'Paris Bordon e la cultura pittorica del suo tempo', in Paris Bordon, exh. cat., Palazzo del Trecento, Treviso, 1984, pp. 15-27

Pallucchini 1984b
R. Pallucchini, Veronese, Milan, 1984

Panofsky 1930
E. Panofsky, Hercules am Scheidewege und andere Antike Bildstoffe in der neueren Kunst, Leipzig-Berlin, 1930

Panofsky 1960
E. Panofsky, A Mythological Painting by Poussin [called 'Liber pater, qui et Apollo est'] in the Nationalmuseum Stockholm, Stockholm, 1960; Nationalmusei skriftserie no. 5

Pantorba 1955
B. de Pantorba, La vida y la obra de Velázquez. Estudio biográfico y crítico, Madrid, 1955

Pattison 1884
Mrs. Mark Pattison [Emilia Francis Strong Dilke], Claude Lorrain, sa vie et ses oeuvres d'après des documents inédits, Paris, 1884

Paulson 1971
R. Paulson, Hogarth: His Life, Art and Times, 2 vols., New Haven-London, 1971

Pears 1988
J. Pears, The Discovery of Painting. The Growth of Interest in the Arts in England. 1680–1768, New Haven-London, 1988

Pedretti 1959
C. Pedretti, 'Uno 'studio' per la Gioconda', L'Arte, no. 1924, 1959, no. 3, pp.

Pedretti 1996
C. Pedretti, 'Quella puttana di Leonardo', Achademia Leonardi Vinci. Journal of Leonardo Studies & Bibliography of Vinciana, ed. Carlo Pedretti, vol. IX, 1996

Peinture en Europe 1905
George Lafenestre, Eugène Richtenberger, La peinture en Europe: Rome, les Musées, les collections particulières, les palais, Paris, 1905

Peldan 1912
Peldan, 'La Joconde. Historie d'un tableau', Les Arts, 1912, no. 121

Peltzer 1916
R. A. Peltzer, 'Hans Rottenhammer', Jahrbuch der kunsthistorischen Sammlungen des Allerhöchsten Kaiserhauses, vol. XXXIII, 1916, pp. 293-365

Pembroke 1968
Sidney, 16th Earl Pembroke, A Catalogue of the Paintings and Drawings in the Collection at Wilton House, Salisbury, Wiltshire, London, 1968

Penther 1883
D. Penther, Kritischer Besuch in der Ermitage zu St. Petersburg, Vienna, 1883

Pepper 1984
S. Pepper, Guido Reni. A Complete Catalogue of his Works with an Introductory Text, Oxford, 1984

Pepper 1988
S. Pepper, Guido Reni, Novara, 1988

Per Palme 1956
Per Palme, The Triumph of Peace. A Study of the Whitehall Banqueting House, Stockholm, 1956

Percy 1971
A. Percy, Giovanni Benedetto Castiglione, Master Draughtsman of the Italian Baroque, Philadelphia, 1971

Pergola 1967
P. della Pergola, 'P. P. Rubens e il tema della Susanna a bagno', Bulletin des Musées Royaux des Beaux-Arts de Belgique, 1967

Perm Catalogue 1963
Permskaya gosudarstvennaya khudozhestvennaya galereya. Katalog proizvedeniy zhivopisi, skul'ptury, grafiki [Perm State Art Gallery. Catalogue of Painting, Sculpture and Graphics], Perm, 1963

Peters 1991
B. Peters, 'The Development of Wolterton Hall', MA Diss., Centre of East Anglian Studies/University of East Anglia 1991

Pettorelli 1924
L. A. Pettorelli, Salvator Rosa pittore, incisore, musicista e poeta, Torino, 1924

Pevsner: Bedforshire 1968
N. Pevsner, Bedfordshire and the County of Huntingdon and Peterborough, 1968

Pevsner: Buckinghamshire 1994
N. Pevsner, E. Williamson, G. Brandwood, Buckinghamshire, 2nd edn., London, 1994

Pevsner: Leicestershire and Rutland 1984
N. Pevsner, Leicestershire and Rutland, 2nd edn., revised by E. Williamson and G. Brandwood, Hardmondsworth, 1984

Pevsner: Norfolk 1997
N. Pevsner, B. Wilson, Norwich and North East Norfolk, 2nd edn., Harmondsworth, 1997

Pevsner: Surrey 1982
N. Pevsner, I. Nairn, B. Cherry, Surrey, 2nd edn., Harmondsworth, 1982

Pevsner: Wales 1986
N. Pevsner, J. Newman, E. Hubbard, The Buildings of Wales, Harmondsworth, 1986

Pigler 1956
A. Pigler, Barockthemen. Ein Auswahl von Verzeichnissen zur Ikonographie des 17. und 18. Jahrhunderts, 2 vols., Budapest, 1956

Pigler 1967
A. Pigler, Szepmuveszeti Museum Budapest. Katalog der Galerie Älter Meister, 2 vols., Budapest, 1967

Pigler 1974
A. Pigler, Barockthemen. Eine Auswahe von Verzeichnissen zur Ikonographie des 17. und 18. Jahrhunderts, Budapest, 1974

Pignatti 1976
T. Pignatti, Veronese. L'opera completa, 2 vols., Venice, 1976

Pignatti, Pedrocco 1991
T. Pignatti, F. Pedrocco, Veronese, Catalogo completo, Florence, 1991

Pignatti, Pedrocco 1995
T. Pignatti, F. Pedrocco, Veronese, 2 vols., Milan, 1995

Piotrovskiy 1990
B. B. Piotrovskiy, 'Istoriya Ermitazha' [The History of the Hermitage], Ermitazh. Istoriya i sovremennost' [The Hermitage. History and the Present Day], Moscow, 1990

Piotrovskiy 2000
B. B. Piotrovskiy, Istoriya Ermitazha. Kratkiy ocherk. Materialy i dokumenty [The History of the Hermitage. A Brief Outline. Materials and Documents], Moscow, 2000, I: 'Kratkiy ocherk' [Brief Outline], pp. 70-74; II: 'Materialy i dokumenty' [Materials and Documents], pp. 270-302

Piovene, Marini 1968
G. Piovene, R. Marini, L'Opera completa del Veronese, Milan, 1968

Piper 1963
D. Piper, Catalogue of the Seventeenth Century Portraits in the National Portrait Gallery, 1625-1714, Cambridge 1963

Pittori genovesi a Genova 1969
Mostra dei pittori genovesi a Genova, exh. cat., Genoa, 1969

Pittura a Genova 1971
La pittura a Genova e in Liguria dal Seicento al primo Novecento, Genova, 1971

Pittura a Genova 1987
La pittura a Genova e in Liguria dal Seicento al primo Novecento, Genova 1987

Plumb 1956
J. Plumb, Sir Robert Walpole: I, The Making of a Statesman. London 1956 (1972 edn.)

Plumb 1960
J. Plumb, Sir Robert Walpole: The King's Minister, London, 1960

Ponsonhaille 1883
C. Ponsonhaille, Sebastien Bourdon, sa vie et son oeuvre, Paris, 1883

Posner 1971
D. Posner, Annibale Carracci, London, 1971

Posse 1925
H. Posse, Der romischer Maler Andrea Sacchi, Leipzig, 1925

Poulsen 1923
F. Poulsen, Greek and Roman Portraits in English Country Houses, transl. by Rev. G.C. Richards BD, Oxford, 1923

Pouncey, Gere 1962
P. Pouncey, J. Gere, Italian Drawings in the Department of Prints and Drawings at the British Museum: Raphael and his Circle, 2 vols., London, 1962

Poussin Correspondence 1911
Correspondance de Nicolas Poussin publié d'après les originaux par Charles Jouanny, vol. 5 in the series Nouvelle Archive d'Art Français, Paris, 1911

Prêtre 1990
J.-C. Prêtre, *Suzanne. Le procès du modèle*, Paris, 1990

Prokof'yev 1962
Frantsuzskaya zhivopis' v muzeyzkh SSSR [French Painting in USSR Museums], with an introductory essay by V. Prokof'yev, Moscow, 1962

Puglisi 1991
C. R. Puglisi, *A Study of the Bolognese – Roman painter Francesco Albani*, Ann Arbor, Michigan, 1991

Puglisi 1999
C. R. Puglisi, *Francesco Albani*, New Haven-London, 1999

Pushkin Museum 1948
Gosudarstvennyy muzey izobrazitel'nykh iskusstv im. A. S. Pushkina. Katalog Kartinnoy Galerei [State Pushkin Museum of Fine Arts. Catalogue of the Picture Gallery], compiled by K. M. Malitskaya and V. K. Shileyko, ed. B. R. Vipper, Moscow, 1948

Pushkin Museum 1957
Gosudarstvennyy muzey izobrazitel'nykh iskusstv im. A. S. Pushkina. Katalog Kartinnoy Galerei. Zhivopis', skul'ptura [Pushkin State Museum of Fine Arts. Catalogue of the Picture Gallery. Painting, Sculpture], Moscow, 1957

Pushkin Museum 1961
Gosudarstvennyy muzey izobrazitel'nykh iskusstv im. A. S. Pushkina. Katalog Kartinnoy Galerei. Zhivopis', skul'ptura [Pushkin State Museum of Fine Arts. Catalogue of the Picture Gallery. Painting, Sculpture], Moscow, 1961

Pushkin Museum 1986
Gosudarstvennyy muzey izobrazitel'nykh iskusstv im. A. S. Pushkina. Katalog Kartinnoy Galerei. Zhivopis', skul'ptura, miniatyura [Pushkin State Museum of Fine Arts. Catalogue of the Picture Gallery. Painting, Sculpture, Miniatures], Moscow, 1986

Pushkin Museum 1995
Gosudarstvennyy muzey izobrazitel'nykh iskusstv imeni A. S. Pushkina. Katalog zhivopisi [State Pushkin Museum of Fine Arts. Catalogue of Painting], Moscow, 1995

Pushkin Museum Album 1989
Gosudarstvennyy muzey izobrazitel'nykh iskusstv imeni A. S. Pushkina [State Pushkin Museum of Fine Arts], with introductory essay by I. A. Antonova, Leningrad, 1989

Pushkin Museum Guide 1938
Gosudarstvennyy muzey izobrazitel'nykh iskusstv imeni A. S. Pushkina. Kratkiy putevoditel' [State Pushkin Museum of Fine Arts. A Brief Guide], compiled by A. N. Zamyatina, Moscow, 1938

Pushkin Museum Guide 1994
V. N. Tyazhelov, *Gosudarstvennyy muzey izobrazitel'nykh iskusstv imeni A. S. Pushkina. Putevoditel' po zalam muzeya* [State Pushkin Museum of Fine Arts. Guide to the Museum Rooms], Moscow, 1994

Puyvelde 1939
L. van Puyvelde, *Skizzen des Peter Paul Rubens*, Frankfurt-am-Main, 1939

Puyvelde 1950
Leo van Puyvelde, *Van Dyck*, Brussels-Amsterdam, 1950

Puyvelde 1952
L. van Puyvelde, *Rubens*, Paris-Brussels, 1952

Raupp 1984
H.-J. Raupp, *Untersuchengen zu Künstlerbildnis und Künstler-darstellung in den Niederlanden im 17. Jarhundert*, Hildesheim, 1984

Raupp 1994
H.-J. Raupp, 'Zeit in Rubens' Landschaften', *Wallraf-Richartz-Jahrbuch*, vol. 55, 1994, pp. 159-70

Rearick 1985
W. Rearick, 'The Drawings of Paris Bordon' , in *Paris Bordon e il suo tempo, Atti del Convegno Internazionale di studi, Treviso, 28-30 ottobre 1985*, Milan, pp. 47-64

Réau 1912
L. Réau, 'La Galerie de tableaux de l'Ermitage et la collection Semenov 1', *Gazette des Beaux-Arts*, 54e année, 2e semestre, 1912, pp. 379-96

Réau 1929
L. Réau, *Catalogue de l'art français dans les musées russes*, Paris, 1929

Réau 1932
L. Réau, 'Correspondance Artistique de Grimm avec Catherine II', *Archives de l'Art Français*, N.P., vol. 17, 1932

Réau 1957
L. Réau, *Iconographie de l'art chrètien*, vol. II, *Iconographie de la Bible. II. Nouveau Testament*, Paris, 1957

Redgrave 1970
S. Redgrave, *Dictionary of Artists of the English School, etc.*, 2nd edn., Bath, 1970

Redford 1888
George Redford, *Art Sales. A History of Sales of Pictures and Other Works of Art*, 2 vols., London, 1888

Refice 1950
A. Refice, 'Andrea Sacchi, disegnatore', *Commentari*, 1950

Reimers 1805
H. von Reimers, *St. Petersburg am Ende seines Ersten Jahrhunderts*, St Petersburg, 1805

Reinach 1922
S. Reinach, *Répertoire de peintures du Moyen Age et de la Renaissance (1280-1580)*, 6 vols., 1905-23, Paris, vol. 5

Reitlinger 1961
G. Reitlinger, *The Economics of Taste: The Rise and Fall of the Picture Market, 1760-1960*, London, 1961

Rembrandt Corpus 1982-
J. Bruyn, B. Haak, S. H. Levie, P. J. J. van Thiel, E. van de Wetering, *A Corpus of Rembrandt Paintings*, The Hague, Boston & London, (Stichting Foundation Rembrandt Research Project), 3 vols so far; vol. 1, 1982

Rembrandt's Treasury 1999
Bol van den Boogert (ed.), Ben Broos, Roelot van Gelder, Jaaf van der Veen, *Rembrandt's Treasury*, exh. cat., Rembrandtshuis, Amsterdam, 25 September 1999 – 9 January 2000; Zwolle, 1999

Reu 1966
J. D. Reu, 'Leonardo da Vinci', *Jardin des Arts*, 1966, no. 142

Réveil 1828-34
Musée de peinture et de sculpture ou Recueil des principaux tableaux, statues et bas-reliefs des collections publiques et particulièes de l'Europe, engraved by Réveil, notes by Duchesne Aîné, 17 vols., Paris, 1828-34

Reynolds 1996
Sir Joshua Reynolds, *A Journey to Flanders and Holland*, H. Mount, ed., Cambridge, 1996

RIBA 1969-89
Catalogue of the Drawings Collection of the Royal Institute of British Architects, 20 vols., Farnborough, 1969-89

Richardson 1722
J. Richardson, *An Account of the Statues, Basreliefs, Drawings and Pictures in Italy, France, etc*, London, 1722

Rinaldis 1939
A. de Rinaldis, *Lettere inedite di Salvator Rosa a G. B. Ricciardi*, Rome, 1939

Ripley 1760
T. Ripley, *The Plans, Elevations and Section… of Houghton in Norfolk*, London, 1760

Ritratto italiano 1927
Il Ritratto italiano dal Caravaggio al Tiepolo, ed. U. Ojetti, Bergamo, 1927

Robels 1969
H. Robels, 'Frans Snyders' Entwicklung als Stilleben-maler', *Wallraf-Richartz-Jahrbuch*, vol. 31, 1969, pp. 43-94

Robels 1989
H. Robels, *Frans Snyders' Stilleben und Tiermaler, 1579-1657*, Munich, 1989

Robinson 1731
Sir Thomas Robinson, *Historic Manuscripts Commission*, XV, Appendix part VI, Carlisle, p. 84

Roettgen 1999
Steffi Roettgen, *Anton Raphael Mengs 1728-1779. Das malerische und zeichnerische Werk*, Munich, 1999

Rogers 1983
M. Rogers, *William Dobson. 1611-46*, exh. cat., National Portrait Gallery, London, 1983

Roland 1994
M. Roland, 'Van Dyck' s "Holy Family with Partridges": Catholic and Classical Imagery at the English Court', *Artibus et historiae*, 15, no. 29 (1994), pp. 121-33

Romanos 1899
M. M. Romanos, *Velázquez fuera del Museo del Prado*, Madrid, 1899

Rooses 1886-92
M. Rooses, *L'oeuvre de P. P. Rubens. Histoire et description de ses tableaux et dessins*, 5 vols., Antwerp, 1886-92

Rooses 1890
Max Rooses, *Rubens. Leben und Werke*, Berlin-Leipzig, 1890

Rooses 1904
M. Rooses, 'Die Flamische Meister in der Ermitage – Antoon Van Dyck', *Zeitschrift für bildende Kunst*, 1904, pp. 114-7

Rooses 1905
Max Rooses, *Rubens' Leben und Werke*, Stuttgart-Berlin-Leipzig, 1905

Rooses 1906
Max Rooses, *Jacob Jordaens. Leben und Werke*, Stuttgart-Berlin-Leipzig, 1906

Rosenberg 1901
A. Rosenberg, *Teniers der jüngere*, Bielefeld & Leipzig, 1901

Rosenberg 1905
P. P. Rubens. Des Meisters Gemälde in 551 Abbildungen, Hrsg. von Adolf Rosenberg, 2 Auffl., Stuttgart-Leipzig, 1905 (*Klassiker der Kunst in Gesamtausgaben*, vol.5)

Rosenberg 1948
J. Rosenberg, *Rembrandt*, 2 vols., Cambridge, MAA, 1948

Rossi 1980
P. Rossi, *L'opera completa del Parmigianino*, Milan, 1980

Rothlisberger 1958
M. Rothlisberger, 'Les pendants dans l'oeuvre de Claude Lorrain', *Gazette des Beaux-Arts*, vol. LI, April 1958, pp. 215-28

Rothlisberger 1961
M. Rothlisberger, *Claude Lorrain: The Paintings*, 2 vols., London, 1961

Rothlisberger 1968
M. Rothlisberger, *Claude Lorrain. The Drawings*, Berkeley-Los Angeles, 1968.

Rothlisberger 1971
M. Rothlisberger, 'Quelques tableaux inédits du XVII-ème siècle français. Lesueur, Lorrain, La Fosse', *Revue de l'art*, 1971, no. 11

Rothlisberger 1977
M. Rothlisberger, 'Le Paysage comme idéal classique', in *Tout l'oeuvre peint de Claude Lorrain*, Introduction et catalogue raisonné par M. Rothlisberger assisté de Doretta Cecchi, Paris, 1977

Rouches 1923
G. Rouches, *Eustache Le Sueur*, Paris, 1923

Rubens Paintings 1989
M. Varshavskaya, X. Yegorova et al, *Peter Paul Rubens. Paintings from Soviet Museums*, Leningrad, 1989

Rubinstein 1991
G. Rubinstein, 'Richard Earlom (1743-1822) and Boydell's "Houghton Gallery"', *Print Quarterly*, VIII, no. I March 1991, pp. 2-27

Rudolph 1995
S. Rudolph, *Niccolò Maria Pallavicini. L'ascesa al Tempio della Virtu attraverso il Macenatismo*, Rome, 1995

Rumyantsev Museum 1862
Katalog kartin Moskovskogo Publichnogo muzeuma [Catalogue of Paintings in the Moscow Public Museum], Moscow, 1862

Rumyantsev Museum 1865
Katalog kartin Moskovskogo Publichnogo muzeuma [Catalogue of Paintings in the Moscow Public Museum], Moscow, 1865 (reprint of above)

Rumyantsev Museum 1901
Moskovskiy Publichnyy i Rumyantsevskiy muzey. Katalog kartinnoy galerei [Moscow Public and Rumyantsev Museum. Catalogue of the Picture Gallery], Moscow, 1901

Rumyantsev Museum 1903
Moskovskiy Publichnyy i Rumyantsevskiy muzey. Katalog kartinnoy galerei [Moscow Public and Rumyantsev Museum. Catalogue of the Picture Gallery], Moscow, 1903

Rumyantsev Museum 1909
Moskovskiy Publichnyy i Rumyantsevskiy muzei. Katalog kartinnoy galerei [The Moscow Public and Rumyantsev Museums. Catalogue of the Picture Gallery], Moscow, 1909

Rumyantsev Museum 1910
Moskovskiy Publichnyy i Rumyantsevskiy muzei. Katalog kartinnoy galerei [The Moscow Public and Rumyantsev Museums. Catalogue of the Picture Gallery], Moscow, 1910

Rumyantsev Museum 1912
Moskovskiy Publichnyy i Rumyantsevskiy muzey. Katalog kartinnoy galerei [Moscow Public and Rumyantsev Museum. Catalogue of the Picture Gallery], Moscow, 1912; reprinted 1913

Rumyantsev Museum 1915
Imperatorskiy moskovskiy Publichnyy i Rumyantsevskiy muzei. Otdeleniye izyashchnykh iskusstv. Katalog kartinnoy galerei s illyustratsiyami i poyasnitel'nym tekstom [The Imperial Moscow Public and Rumyantsev Museums. Department of Fine Arts. Catalogue of the Picture Gallery with Illustrations and an Explanatory Text], Moscow, 1915

Rumyantsev Museum Guide 1872
Guide dans le Musée publique et le Musée Roumianzov. Guide dans la galerie des tableaux, Moscow, 1872

Rumyantsev Museum Guide 1889
Moskovskiy Publichnyy i Rumyantsevskiy muzey. Putevoditel' po kartinnoy galereye [Moscow Public and Rumyantsev Museum. Guide to the Picture Gallery], Moscow, 1889

Russell 1989
F. Russell, 'The Hanging and Display of Pictures 1700-1850', in Jackson-Stops 1989, pp. 133-53

Safarik 1968
E. Safarik, 'Un capolavoro di Paolo Veronese', *Saggi e memorie do storia dell'arte*, 6, 1968, pp. 79-110

Saint-Georges 1854
Guillet de Saint-Georges, *Mémoires inédits sur la vie et les ouvrages des membres de l'Académie Royale de peinture et de sculpture*, 2 vols., Paris, 1854

Salerno 1963
L. Salerno, *Salvator Rosa*, Firenze, 1963

Salerno 1975
L. Salerno, *L'Opera completa di Salvator Rosa*, Milano, 1975

Salerno 1984
L. Salerno, *La natura morta italiana. 1560-1805*, Rome, 1984

Sánchez Cantón 1942
F. J. Sánchez Cantón, 'Como vivia Velázquez: Inventario descubierto por D. F. Rodriguez Marín', *Archivo Español de Arte*, 15, 1942

Sani 1988
B. Sani, *Rosalba Carriera*, Turin 1988

Sapin 1984
M. Sapin, 'Précisions sur l'histoire de quelques tableaux d'Eustache Le Sueur', *Bulletin de la Société d'histoire de l'art français, année 1984*, Paris, 1986

Sauerlander 1977
W. Sauerlander, exhibition review - 'P. P. Rubens – Schilderijen, Schetsen, Tekeningen, Koninklijk Museum voor Schone Kunsten, Antwerp, 29.6 – 30.9.77', *Pantheon*, vol. XXXV, October–December 1977, pp. 338-41

Saumarez-Smith 2000
C. Saumarez-Smith, *The Rise of Design: Design and the Domestic Interior in Eighteenth-Century England*, Pimlico 2000

Sayce 1947
Sayce, 'Saint-Armand and Poussin', *French Studies*, I, 1947

SbRIO 18, 1876
Various documents, including 'A. Musin-Pushkin. Pis'mo Yekaterine II ot 4 (15) dekabrya 1778' [A. Musin-Pushkin. Letter to Catherine II of 4 (15) December 1778], *Sbornik Imperatorskogo Russkogo Istoricheskogo Obshchestva* [Anthology of the Imperial Russian Historical Society], vol. 18, St Petersburg, 1876

SbRIO 23, 1878
Catherine the Great's letters to Baron Grimm, published in: *Sbornik Imperatorskogo Russkogo Istoricheskogo Obshchestva* [Anthology of the Imperial Russian Historical Society], vol. 23, St Petersburg, 1878

SbRIO 44, 1885
Letters from Baron Brimm to Catherine II and Paul I, published in: *Sbornik Imperatorskogo Russkogo Istoricheskogo Obshchestva* [Anthology of the Imperial Russian Historical Society], vol. 44, St Petersburg, 1885

Schaak 1970
E. von Schaak, *Francesco Albani, 1578-1660*, Ann Arbor, Michigan, 1970

Schaeffer 1909
Van Dyck. Des Meisters Gemälde in 537 Abbildungen, Herausgeg. von Emil Schaeffer, Stuttgart-Leipzig, 1909 (*Klassiker der Kunst in Gesamtausgaben*, B.13)

Schlichtenmaier 1988
H. Schlichtenmaier, *Studien zum Werk Hans Rottenhammers des Älteren (1564-1625) Maler und Zeichner. Mit Katalog*, PhD dissertation, Thübingen, 1983, **S. I. 1988**

Schmidt 1909a
J. von Schmidt, 'Gemälde alter Meister in Petersburger Privatbesitz', *Monatshefte für Kunstwissenschaft*, vol. II, 1909, pp. 161-99

Schmidt 1909b
J. Schmidt [D. A. Shmidt], 'Leonardo ili Lyukas?' [Leonardo or Lucas?], *Staryye gody* [Years of Old], December 1909

Schmidt 1926a
J. Schmidt [D. A. Shmidt], *Muril'o* [Murillo], Leningrad, 1926

Schmidt 1926b
D. A. Shmidt [James Schmidt], *Rubens i Iordans* [Rubens and Jordaens], Leningrad, 1926

Schmidt 1949
D. A. Shmidt (James Schmidt), '"Susanna i startsy" Rubensa v sobranii Ermitazha' [Susanna and the Elders by Rubens in the Hermitage Collection], *Trudy Otdela zapadnoyevropeyskogo iskusstva Gosudarstvennogo Ermitazha* [Papers of the Department of Western European Art of the Hermitage], vol. III, Leningrad, 1949, pp. 35-41

Schnapper 1994
Antoine Schnapper, *Curieux du Grand Siècle. Collections et collectionneurs dans la France du XVIIe siècle*, Paris, 1994, II, *Oeuvres d'Art*

Schnitzler 1828
[J. H. Schnitzler:] *Notice sur les principaux tableaux du Musée Impérial de l'Ermitage à Saint-Pétersbourg*, St Petersburg-Berlin, 1828

Schulze 1912
H. Schulze, *Das weibliche Schönheitsideal in der Malerei*, Jena, 1912

Schwartz 1985
G. Schwartz, *Rembrandt. His Life, His Paintings*, Harmondsworth, 1985; previously published as *Rembrandt: zijn leven, zijn schilderijen*, Maarssen, 1984

Scott 1973
B. Scott, 'The Comptesse de Verrue: A Lover of Dutch and Flemish Art.' *Apollo*, January 1973, pp. 20-24

Scott 1995
J. Scott, *Salvator Rosa. His Life and Times*, New Haven-London, 1995

Sedgwick 1970
R. Sedgwick, *The House of Commons 1715-1754*, (*The History of Parliament*), 2 vols., London, 1970

Semyonov 1885-90
P. P. Semyonov, *Etyudy po istorii niderlandskoy zhivopisi na osnovanii eyo obraztsov, nakhodyashchikhsya v publichnykh i chastnykh sobraniyakh Peterburga* [Studies in the History of Netherlandish Painting on the Basis of Examples in Public and Private collections in St Petersburg], St Petersburg, 1885-90, 2 parts

Semyonov 1906
P. P. Semenov, *Catalogue de la collection Semenov à Saint-Pétersbourg*, St Petersburg, 1906

Senenko 2000
Marina Senenko, *Gosudarstvennyy Muzey Izobrazitel'nykh iskusstv imena A. S. Pushkina. Gollandiya XVII – XIX veka. Sobraniye zhivopisi* [State Pushkin Museum of Fine Arts. Holland 17th–19th Centuries. Collection of Paintings], Moscow, 2000

Seymour 1734-35
Robert Seymour [pseudonym of John Mottley], *A Survey of the Cities of London and Westminster... brought down from the year 1633... to the present time... The whole being an improvement of Mr. Stow's, and other surveys*, etc., 2 vols., London, 1734-35

Shchavinskiy 1916
V. Shchavinskiy, 'Kartiny gollandskikh masterov v Gatchinskom dvortse' [Paintings by Dutch Masters at Gatchina Palace], *Staryye gody* [Years of Old], July–September 1916, pp. 76, 77

Shcherbachyova 1926
M. I. Shcherbachyova, *Gollandskiy natyurmort* [Dutch Still Life], Leningrad, 1926

Shcherbachyova 1945a
M. I. Shcherbachyova, *Natyurmort v gollandskoy zhivopisi* [Still Life in Dutch Painting], Leningrad, 1945

Shcherbachyova 1945b
M. I. Shcherbachyova, 'Vnov' opoznannyy zhenskiy portret raboty Rubensa' [A Rediscovered Female Portrait by Rubens], *Soobshcheniya Gosudarstvennogo Ermitazha* [Bulletin of the State Hermitage], issue 3, 1945, p. 13

Shearman 1972
John Shearman, *Raphael's Cartoons in the Collection of Her Majesty the Queen and the Tapestries for the Sistine Chapel*, London, 1972

Simon 1996
J. Simon, *The Art of the Picture Frame; Artists, Patrons and the Framing of Portraits in Britain*, London, 1996

Simonetti 1986
S. Simonetti, 'Profilo di Bonifacio de'Pitati', *Saggi e memorie di storia dell'arte*, 15, 1986, pp. 83-133

Simson 1936
O. G. von Simson, *Zur Genealogie der weltlichen Apotheose im Barock, besonders der Medicigalerie des P. P. Rubens*, Strasburg, 1936

Simson 1996
O. von Simson, *Peter, Paul Rubens (1577-1640). Humanist, Maler und Diplomat*, Mainz, 1996

Singh [1928]
Prince Frederick Duleep Singh, *Portraits in Norfolk Houses*, E. Farrer, ed., 2 vols., Norwich, ?1928

Slatkes 1992
L. J. Slatkes, *Rembrandt. Catalogo completo dei dipinti*, Florence, 1992

Slive 1970-4
S. Slive, *Frans Hals*, 3 vols., London – New York, 1970-4

Smith 1829-42
A Catalogue Raisonne of the Works of the Most Eminent Dutch, Flemish and French Painters..., by John Smith, 8 parts and Supplement, London, 1829-42

Smith 1988
R. R. R. Smith, *Hellenistic Royal Portraits*, Oxford, 1988

Smolskaya 1962
N. F. Smol'skaya, *Tenirs* [Teniers], Leningrad, 1962

Smolskaya 1991
N. Smol'skaya, 'K voprosu o sozdanii semeynykh portretov Yakoba Iordansa', *Soobshcheniya Gosudarstvennogo Ermitazha* [Bulletin of the State Hermitage], issue LV, 1991, pp. 8-11

Soechting 1972
D. Soechting, *Die Porträts des Septimus Severus*, Bonn, 1972

Somov 1859
A. Somov, *Kartiny imperatorskogo Ermitazha* [Pictures in the Imperial Hermitage], St Petersburg, 1859

Sonino 1991
A. Sonino, *Marco Ricci 1676-1729*, Milan, 1991

Soria 1945
M. Soria, 'Review of Enrique Lafuente Ferrari: The Paintings and Drawings of Velazquez', *The Art Bulletin*, vol. 27, September 1945, pp. 214-16

Sotheby's 1992
British Drawings, sale catalogue, Sotheby's, London, 19 November 1992

Souchal 1977
F. Souchal, *French Sculptors of the 17th and 18th Centuries*, I, Oxford 1977

Sparrow 1922
W. S. Sparrow, *British Sporting Artists from Barlow to Herring*, London, 1922

Spear 1997
R. E. Spear, *The 'Divine' Guido. Religion, Sex, Money and Art in the World of Guido Reni*, New Haven-London, 1997

Speth-Holterhoff 1957
S. Speth-Holterhoff, *Les peintres flamands de cabinets d'amateurs*, Brussels, 1957

Stählin 1990
Jacob Stählin, *Zapiski Yakoba Stelina ob izyashchnykh iskusstvakh v Rossi* [Jacob Stählin's Notes on the Fine Arts in Russia], 2 vols., Moscow, 1990

Stampfle, Bean 1967
F. Stampfle, J. Bean, *Drawings from New York Collections, II. The Seventeenth Century in Italy. The Metropolitan Museum of Art. The Pierpont Morgan Library*, New York, 1967

Stanghellini 1914
A. Stanghellini, 'Due quadri ignorati di Salvator Rosa in una collezione privata a Firenze', *Rassegna d'arte*, 1914, anno 1, May

Starikova, Likhalo 1966
Katalog. Dalnevostochnyy khudozhestvennyy muzey [Catalogue. The Far East Art Museum], compiled by V. G. Starikova and V. G. Likhalo, Leningrad, 1966

Stechow 1969
W. Stechow, 'Some Observations on Rembrandt and Lastman', *Oud Holland*, vol. LXXXIV, 1969, nos. 2-3, pp. 148-62

Steinbart 1930
K. Steinbart, 'Marinus (Claeszon) van Reymerswaele', in Thieme-Becker 1908-50, vol. 24, pp. 109-11

Sterling 1957
C. Sterling, *Musée de l'Ermitage. La Peinture française de Poussin à nos jours*, Paris, 1957

Stewart 1965
J. D. Stewart, review of D. Green, *Grinling Gibbons*, in *The Burlington Magazine*, vol. CVII, September 1965, pp. 478-9

Stewart 1971
J. D. Stewart, *Sir Godfrey Kneller*, London, 1971

Stewart 1977
A. F. Stewart, *Skopas of Paros*, Park Ridge, 1977

Stewart 1978
J. D. Stewart, 'New Light on Michael Rysbrack: Augustan England's Classical Baroque Sculptor', *The Burlington Magazine*, vol. CXX, April 1978, pp. 215-22

Stewart 1983a
J. Douglas Stewart, '"Hidden Persuaders": Religious Symbolism in Van Dyck's Portraiture. With a Note on Durer's "Knight, Death and Devil"', in *Essays on Van Dyck*, Ottawa, 1983, pp. 57-68

Stewart 1983b
J. D. Stewart, *Sir Godfrey Kneller and the English Baroque Portrait*, Oxford, 1983

Stighelen 1990
K. van der Stighelen, 'Het problem van een samenwerking: niet Jan Boeckhorst, maar Cornelis de Vos', in *Jan Boeckhorst. 1604-1668. Medewerker van Rubens*, Freren, 1990

Stirling Maxwell 1848
W. Stirling Maxwell, *Annals of the Artists of Spain*, 3 vols., London, 1848

Stromer 1879
T. Stromer, *Murillo. Leben und Werke*, Berlin, 1879

Strong 1986
Roy Strong, *Henry, Prince of Wales and England's Lost Renaissance*, London, 1986

Stroud et al. 1870-1952
British Museum, Department of Prints and Drawings, *Catalogue of Prints and Drawings ... Political and Personal Satires*, 10 vols., London, 1870-1952

Stukeley 1880
W. Stukeley, *The Family Memoirs of the Rev. William Stukeley*, Surtees Society, vol. III, London, 1880

Suida 1929
W. Suida, *Leonardo und sein Kreis*, Munich, 1929

Sumowski 1983-(94)
Werner Sumowski, *Gemälde der Rembrandt-Schuler*, Landau/Pfalz, 6 vols., 1983-[94]

Surtees 1995
V. Surtees, ed., *The Grace of Friendship: Horace Walpole and the Misses Berry*, Wilby, 1995

Survey of London
London County Council, *The Survey of London*, London, 1900-

Sutherland Harris 1977
A. Sutherland Harris, *Andrea Sacchi. Complete Edition of the Paintings with a Critical Catalogue*, Oxford, 1977

Sutton 1966
D. Sutton, 'A King of Epithets: A Study of James Christie', *Apollo*, November 1966, pp. 364-75

Sutton 1981
D. Sutton, 'Aspects of British Collecting Part I: II London as an Art Centre; III, Augustan Virtuosi; IV The Age of Sir Robert Walpole', *Apollo*, November 1981, pp. 298-312, 313-27, 328-39

Sutton 1982
D. Sutton, 'Aspects of British Collecting, Part II: New Trends', *Apollo*, December 1982, pp. 358-72

Swignine 1821
Paul Swignine, *Description des objets les plus remarquables de S-t. Petersbourg et de ses environs*, 5 vols., St Petersburg, 1816-28; book IV, 1821.
Published with parallel French and Russian text, this book is often confusingly listed in library catalogues and bibliographies only under its Russian title, as P. Svin'in, *Dostopamyatnosti SanktPeterburga i yego okrestnostey* [The Notable Sights of St Petersburg and its Environs]. The Russian text ONLY was republished under that title, St Petersburg, 1997 (Hermitage description pp. 233-89). References are given to both publications because most Western national libraries have the 18th century edition, but in Russia itself the reprint is widely available.

Teyssedre 1963
B. Teyssedre, 'Une collection française de Rubens au XVIIe Siècle: Le Cabinet du Duc de Richelieu décrit par Roger de Piles (1676—1681)', *Gazette des Beaux-Arts*, vol. LXII, November 1963, pp. 241-300

Theatrum pictorum
Davidis Teniers Antverpiensis pictoris et a cubiculis: Sermix Principibus Leopoldo Guil. Archiduci… Theatrum Pictorum… Antverpiae, M. DC. LXXIV

Theuwissen 1966
J. Theuwissen, 'De kar en de wagen in het werken van Rubens', *Jaarboek van het Koninklijke Museum voor schone Kunsten te Antwerpen*, 1966

Thieme-Becker 1907-50
U. Thieme, F. Becker, *Allgemeines Lexikon der bildenden Künstler von der Antike bis zur Gegenwart*, Leipzig, 37 vols., 1907-50 (reprinted 1979-90)

Thomson 1930
W. G. Thomson, *A History of Tapestry from the Earliest Times Until the Present Day*, London, 1930

Thornton 1993
P. Thornton, 'Soane's Kent Tables', *Furniture History*, 1993, pp. 59-69

Thuillier 1974
J. Thuillier, *Tout l'oeuvre peint de Poussin*, Paris, 1974

Thuillier 1988
J. Thuillier, *Nicolas Poussin*, Paris, 1988

Thuillier 2000
Jacques Thuillier, *Sebastien Bourdon. 1616-1671. Catalogue critique et chronologique de l'oeuvre complet*, Paris, 2000

Tipping 1921
H. A. Tipping, 'Houghton Hall, Norfolk', *Country Life*, vol. XLIX, I, 8, 15, 22 January 1921, pp. 14, 40, 64, 98 et seq.

Tormo y Monsó 1914
E. Tormo y Monsó, 'La Inmaculada y el arte español', *Boletín de la Sociedad Española de Excurciones*, vol. 22, 1914, pp. 108-32

Trivas 1941
N. Trivas, *The Paintings of Frans Hals*, London–New York, 1941

Trubnikov 1914
Trubnikov, 'Staryye portrety starogo zamka' [Old Portraits from an Old Castle], *Staryye gody* [Years of Old], July–Sept 1914

Tubino 1864
F. M. Tubino, *Murillo, su época, su vida, sus cuadros*, Seville, 1864

Tümpel 1971
Christian Tümpel, 'Ikonographische Beiträge zu Rembrandt. Zur Deutung und Interpretation einzelner Werke', *Jahrbuch der Hamburger Kunstsammlungen*, vol. 16, 1971, pp. 20-38

Tümpel 1986
Christian Tümpel, *Rembrandt*, with contributions by Astrid Tümpel, Amsterdam, 1986; also published in French, German and English, 1986

Tümpel 1993
C. Tümpel, *Rembrandt*, New York, 1993

Turner 1980
N. Turner, *Italian Baroque Drawings*, British Museum, London, 1980

Urwin 1984
A. Urwin, *The Houses And Gardens Of Twickenham Park 1227-1805*, Borough of Twickenham Local History Society, paper no. 54, London, 1984

V.-S. 1873
G. G. Voorhelm-Schneevoogt, *Catalogue des estampes gravées d'après P. P. Rubens*, Haarlem, 1873

Valentiner 1909
W. R. Valentiner, *Rembrandt. Des Meisters Gemälde*, 3 Aufl., Stuttgart-Leipzig, 1909

Valentiner 1921
M. Valentiner, *Frans Hals, des Meisters Gemälde*, Stuttgart-Berlin, 1921 (*Klassiker der Kunst in Gesamtausgaben*, vol. 28)

van der Meulen 1994
M. van der Meulen, *Rubens's Copies after the Antique*, in the series *Corpus Rubenianum Ludwig Burchard*, part XXIII, vols I–III, London, 1994

Van Gool 1750-1
J. van Gool, *De nieuwe schouburg der Nederlantsche kunstschilders en schilderessen*, 2 vols., The Hague, 1750-1

Vardy 1744
J. Vardy, *Some Designs of Mr Inigo Jones and Mr William Kent*, London, 1744

Varshavskaya 1963
M. Ya. Varshavskaya, *Van Deyk. Kartiny v Ermitazhe* [Van Dyck. Paintings in the Hermitage], Leningrad, 1963

Varshavskaya 1967
M. Varchavskaya, 'Certains traits particuliers de la decoration d'Anvers par Rubens pour l'Entrée triomphale de l'Infant-Cardinal Ferdinand en 1635', *Bulletin des Musées Royaux des Beaux-Arts de Belgique*, 1967

Varshavskaya 1975
M. Varshavskaya, *Kartiny Rubensa v Ermitazhe* [Paintings by Rubens in the Hermitage], Leningrad, 1975

Varshavsky, Rest 1985
Sergei Varshavsky, Boris Rest, *The Ordeal of the Hermitage*, Leningrad and New York, 1985.

Venturi A. 1920
A. Venturi, *Leonardo da Vinci pittore*, Bologna, 1920

Venturi A. 1929
A. Venturi, *Storia dell'arte italiana*, 9 vols., 1901-39; vol. 4, *La pittura del Cinquecento*, Milan, 1929

Venturi L. 1912
L. Venturi, 'Saggio sull'opere d'arte italiana a Pietroburgo', *L'Arte*, anno XV, 1912, pp.122-40, 210-17

Vergara 1982
L. Vergara, *Rubens and the Poetics of Landscape*, New Haven-London, 1982

Vermet 1995
B. Vermet, 'Tableaux de Dirck van Delen (v.1604/05 – 1671) dans les musées français', *Revue du Louvre*, June 1995, pp. 30-44

Vermeule 1955
C. C. Vermeule, 'Notes on a New Edition of Michaelis', *American Journal of Archaeology*, no. 59, 1955, pp. 129-50

Vertue, vols. I-VI, 1929-50
G. Vertue, 'Notebooks I-VI', *Walpole Society*, XVIII, 1929-30 [I]; XX, 1931-32, [II]; XXII, 1933-34, [III]; XXIV, 1935-36, [IV]; XXVI, 1937-38, [V]; XXIX, 1940-42, [Index to Notebooks I-V]; XXX, 1948-50, [VI]; all six volumes reprinted 1968

Vey 1962
H. Vey, *Die Zeichnungen Anton van Dyck*, 2 vols., Brussels, 1962

Viardot 1844
L. Viardot, *Les musées d'Allemagne et de Russie*, Paris, 1844

Viardot 1852
L. Viardot, *Les musées d'Angleterre, de Belgique, de Hollande et de Russie*, Paris, 1852

Victoria and Albert Museum 1984
Drawings by William Kent from the Print Room Collection, Victoria and Albert Museum, London, 1984

Victoria: Berkshire 1906-27
W. Page, ed., *A History of Berkshire*, (*The Victoria History of the Counties of England*), London, 1906-27

Victoria: Buckinghamshire 1906-27
W. Page, ed., *A History of Buckinghamshire* 3 vols., (The Victoria History of the Counties of England), London, 1906-27

Vikturina, Dub, Yegorova 1975
M. P. Vikturina, A. L. Dub, K. S. Yegorova, 'Issledovaniye kartin Rembrandta' [Study of Rembrandt's Pictures], in *Pamyatniki kul'tury. Novyye otkrytiya. Pis'mennost', iskusstvo, arkheologiya* [Cultural Monuments. New Discoveries. Writing, Art, Archaeology], Moscow, 1975

Vilchkovsky 1911
S. N. Vil'chkovskiy, *Tsarskoye Selo*, St Petersburg, 1911

Vivian 1907
R. Vivian, 'Houghton Hall: I', *Country Life*, 27 July 1907, pp. 126-34; 'Houghton Hall: II', *Country Life*, 3 August 1907, pp. 162-71

Vlieghe 1977
H. Vlieghe, *De schilder Rubens*, Antwerp, 1977

Vlieghe 1983
Hans Vlieghe, 'Some Remarks on the Identification of Sitters in Rubens' Portraits', *The Ringling Museum of Art Journal*, no. 1 (sole issue), 1983, pp. 106-15

Vlieghe 1987
H. Vlieghe, *De schilder Rubens*, Antwerp, 1977

Voll 1907
K. Voll, 'Das Opfer Abrahams von Rembrandt in Petersburg und in München', *Vergleichende Gemälde Studien*, 3 vols., Munich-Leipzig, 1907-10; vol. 1, 1907

Von Below 1932
S. Von Below, *Beitrage zur Kenntnis Pietro da Cortonas*, PhD Dissertation, Munich, 1932

Von Moltke 1965
J. W. von Moltke, *Govaert Flinck*, Amsterdam, 1965

Voronikhina 1983
A. N. Voronikhina, *Vidy zalov Ermitazha i Zimnego dvortsa v akvarelyakh i risunkakh khudozhnikov serediny XIX veka* [Views of the Hermitage and Winter Palace in Watercolours and Drawings by Artists of the Mid-19th Century], Moscow, 1983

Vosmaer 1868
C. Vosmaer, *Rembrandt Harmens van Rijn. Sa vie et ses oeuvres*, The Hague, 1868; 2^nd ed. 1877

Vosmaer 1877
C. Vosmaer, *Rembrandt, sa vie et son oeuvre*, 2^nd ed., The Hague, 1877

Voss 1924
H. Voss, *Die Malerei des Barock in Rom*, Berlin, 1924

Vsevolozhskaya 1981
S. Vsevolozhskaya, *The Hermitage Leningrad. Italian Painting 13^th to 18^th Century*, Leningrad, 1981

Vsevolozhskaya and Kostenevich 1984
S. Vsevolozhskaya and A. Kostenevich, *Italian Painting, The Hermitage*, Leningrad, 1984

Vyazmenskaya 1987
L. P. Vyaz'menskaya, 'Tekhniko-tekhnologicheskoye issledovaniye kartin Muril'o iz sobraniya Gosudarstvennogo Ermitazha' [Technico-technological Study of Paintings by Murillo from the Collection of the State Hermitage], *Soobshcheniya Gosudarstvennogo Ermitazha* [Reports of the State Hermitage], issue LII, 1987, pp. 51-7

Waagen 1864
G. F. Waagen, *Die Gemäldesammlung in der Kaiserlichen Ermitage zu St. Petersburg nebst Bemerkungen über andere dortige Kunstsammlungen*, Munich, 1864, 2^nd ed., St Petersburg, 1870

Waliszewski 1894
R. Waliszewski, *The Romance of an Empress: Catherine II of Russia*, vol. II, London, 1894

Walker 1960
J. Walker, 'Velazquez and Visualistic Painting', in *Varia Velazqena*, Madrid, 1960

Walker 1963
J. Walker, *National Gallery of Art, Washington, DC*, New York, 1963

Walpole 1864
H. Walpole, *Memoires of the last ten years of the reign of George the Second, etc.*, London, 1864

Walpole 1888
H. Walpole *Anecdotes of Painting in England*, R. N. Wornum, ed., 3 vols. London; 1762-71

Walpole 1928
H. Walpole, 'Journals of Visits to Country Seats', *Walpole Society*, vol. XVI, 1928

Walpole 1985
H. Walpole, *Memoirs if King George III. 1758-1760*, J. Brooke, ed., New Haven, 1985

Warburton 1851
E. Warburton, *Memoirs of Horace Walpole and His Contemporaries*, 2 vols., London, 1851, vol. II, pp. 358-59

Ward-Jackson 1958
P. Ward-Jackson, *English Furniture Designs of the Eighteenth Century*, London, 1958, 1984 edn

Ware 1731
I. Ware, *Designs of Inigo Jones and Others*, London, 1731

Ware and Ripley 1735
I. Ware and T. Ripley, *The Plans, Elevations and Sections; Chimney-pieces and Ceilings of Houghton in Norfolk...*, London, 1735

Waterhouse 1960
E. K. Waterhouse, 'Poussin et l'Angleterre jusqu'en 1744', *Nicolas Poussin (Actes du Colloque International, Paris, 19-21 Septembre 1958)*, 2 vols., Paris, 1960, vol. 1

Waterhouse 1981
E. Waterhouse, *The Dictionary of British 18th Century Painters in Oils and Crayons*, Woodbridge, 1981

Watson 1940
F. J. B. Watson, 'Thomas Patch (1725-1782); Notes on his Life, Together with a Catalogue of his Known Works', *Walpole Society*, XXVIII, 1940

Watson 1965
F. J. B. Watson, in Cooper 1965

Waywell 1978
G.B. Waywell, *Classical Sculpture in English Country Houses A Hand-Guide*, XI Interrnational Congress of Classical Archaeology, London, 1978

Wazbinski 1985
Z. Wazbinski, '...un [quadro] da camera di Venere e Cupido' di Paris Bordon per il duca Francesco di Lorena', in *Paris Bordon e il suo tempo, Atti del Convegno Internazionale di studi, Treviso, 28-30 ottobre 1985*, Milan, pp. 109-17

Webb 1954
M. Webb, *Michael Rysbrack: Sculptor*, London, 1954

Wegner 1939
M. Wegner, 'Die Herrscherbildnisse in antoninischer Zeit',, in M. Wegner, ed., *Das römische Herrscherbild*, vol. II, 4, Berlin, 1939

Weiner 1910
P. P. Weiner, 'Notizie di Russia', *L'Arte*, anno XIII, 1910, pp. 144-50

Weiner 1916
P. Weiner [Veyner], 'Rozalba Karryera i pasteli Gatchinskogo dvortsa' [Rosalba Carriera and the Pastels at Gatchina Palace], *Starye gody* [Years of Old], October-December 1916, pp. 117-43

Weiner 1923
Meisterwerke der Gemäldesammlung in der Ermitage zu Petrograd von P. P. Weiner, Munich, 1923

Weisbach 1919
W. Weisbach, *Trionfi*, Berlin, 1919

Weisbach 1926
W. Weisbach, *Rembrandt*, Berlin, 1926

Weisbach 1932
W. Weisbach, *Französische Malerei des XVII. Jahrhunderts*, Berlin, 1932

Weizsacker 1936-52
H. Weizsacker, *Adam Elsheimer der Maler von Frankfurt*, 2 vols., Berlin, 1936-52

Wereyke 1949-50
H. van Wereyke, 'Aantenening bij de zogenaamde *Belastingpachters* en Wisselaars van Marinus van Reymerswael', *Gentsche bijdragen tot de Kunstgeschiedenis*, vol. XII, 1949-50, blz. 43-58

Wessely 1886
J. E. Wessely, *Richard Earlom. Verzeichnis seiner Radierungen und Schabkunstblätter*, Hamburg, 1886

Westphal 1931
D. Westphal, *Bonifacio Veronese*, Munich, 1931

Weyerman 1729-69
Jacob Campo Weyerman, *De levens-beschrijvingen der Nederlansche konst-schilders en konst-schilderessen...*, 4 vols; vols 1-3, 's Gravenhage, 1729; vol. 4, Doordrecht, 1769

Wheelock 1981
A. Wheelock, *Jan Vermeer*, New York, 1981

Wheelock 1995
Arthur K. Wheelock, Jr., *Dutch Paintings of the Seventeenth Century, National Gallery of Art, Washington (Systematic Catalogue)*, Washington 1995

White 1868
E. White, *Lord Orford's voyage round the Fens in 1774*, Doncaster, 1868

White, Alexander, D'Oench 1983
C. White, D. Alexander, E. D'Oench, *Rembrandt Harnesz van Rijn. Rembrandt in Eighteenth Century England*, exh. cat., Yale Center for British Art, New Haven, 1983

Whiteley 1928
W. T. Whiteley, *Artists and their Friends in England, 1700-1799*, 2 vols., London-Boston, 1928

Whitley 1915
William T. Whitley, *Thomas Gainsborough*, London, 1915

Wickhoff 1903
F. Wickhoff, 'Aus der Werkstatt Bonifazios', *Jarhbuch der Kunsthistorischen Sammlungen der Allerhöchsten Kaiserhäuses*, vol. XXIV, 1903, pp. 87-104

Wild 1980
W. Wild, *Nicolas Poussin*, 2 vols., Zurich, 1980

Wildenstein 1955
G. Wildenstein, 'Les graveurs de Poussin au XVII-e siècle', *Gazette des Beaux-Arts*, vol. XLVI, September-December 1955 [whole edition]

Wildenstein 1965
G. Wildenstein, 'Les oeuvres de Charles Le Brun d'aprés les gravures de son temps', *Gazette des Beaux-Arts*, July-August 1965

Wilenski 1960
R. H. Wilenski, *Flemish Painters. 1430-1830*, 2 vols., London, 1960

Williams 1980
Robert C. Williams, *Russian Art and American Money, 1900-1940*, London, 1980

Williamson 1904
G. Williamson, 'The Collection of Pictures in the Hermitage Palace at St. Petersburg, *Connoisseur*, IX, no. 33, May 1904, pp. 9-15

Williamson 1995
T. Williamson, *Polite Landscapes: Gardens and Society in Eighteenth-Century England*, London, 1995

Willis 1977
P. Willis, *Charles Bridgeman*, London, 1977

Wilson 1984
M. I. Wilson, *William Kent*, London, 1984

Wilton 1992
A. Wilton, *The Swagger Portrait: Grand Manner Portraiture in Britain from Van Dyck to Augustus John, 1630-1930*, London, 1992

Wilton, Bignamini 1997
A. Wilton, I. Biganmini, eds., *Grand Tour. The lure of Italy in the Eighteenth Century*, London, 1997

Wipper 1962
B. R. Wipper [Vipper], *Ocherki gollandskoy zhivopisi epokhi rastsveta* [Outlines of Dutch Painting During its High Period], Moscow, 1962

Wipper 1966
B. R. Wipper [Vipper], *Problemy realizma v ital'yanskoy zhivopisi 17-18 vekov* [Questions of Realism in Italian 17^th- and 18^th-century Painting], Moscow, 1966

Woodall 1989
J. Woodall, *The Portraiture of Anthonis Mor*, PhD dissertation, London University, Courtauld Institute of Art, 2 vols., 1989 (typescript)

Woodward 1963
J. Woodward, Museum Acquisitions; Paintings By Dolci And Claude For Birmingham.' *Apollo*, March 1963, pp. 250-251

Worsley 1990
G. Worsley, 'Riding on Status', *Country Life*, vol. 184, 27 September 1990, pp. 108-11

Worsley 1993
G. Worsley, 'Houghton Hall, Norfolk', *Country Life*, vol. 187, 4 March 1993, pp. 50-53

Wrangell [1909]
N. Wrangell, *Les chefs d'oeuvre de la galérie de tableaux de l'Ermitage Impérial à St. Petersburg*, Munich [1909]

Wrangell 1908
N. Wrangell [Vrangel'], 'Bytovaya zhivopis' i portrety niderlandskikh khudozhnikov XVII-XVIII vv.' [Genre Painting and Portraits by Netherlandish Artists of the 17th to 18th Centuries], *Staryye gody* [Years of Old], November-December 1908, pp. 675-92

Wrangell 1910
N. Wrangell, 'Les peintres de genres et les portraites néerlandais des XVIIe et XVIIIe siècles', *Les anciennes écoles de Peinture dans les Palais et Collections privées Russes*, Brussels, 1910 [expanded translation of Wrangell 1910]

Wrangell 1913
N. Wrangell [Vrangel'], 'Iskusstvo i gosudar' Nikolay Pavlovich' [Art and the Sovereign Nicholas Pavlovich], *Staryye gody* [Years of Old], June-September 1913, pp. 53-163

Wright 1730
E. Wright, *Some Observations made in travelling through France, Italy, &c., in the years 1720, 1721 and 1722*, London, 1730

Wright 1989
C. Wright, *Poussin Paintings. A Catalogue Raisonné*, London, 1989

Wurm 1984
H. Wurm, *Baldassarre Peruzzi. Architekturzeichnunge*, Tübingen, 1984

Wurzbach 1906-11
A. von Wurzbach, *Niederländisches Künstler-Lexikon*, 3 vols., Vienna-Leipzig, 1906-11

Yakovlev 1926
V. I. Yakovlev, *Kratkiy ukazatel' po Yekaterininskomy dvortsu-muzeyu v Detskom Sele* [Brief Index to the Catherine Palace Museum in Detskoye Selo], Leningrad, 1926

Yaxley 1984
D. Yaxley, ed., *Survey of the Houghton Estate by Joseph Hill, 1800*, Norfolk Record Society, vol. L, Norwich, 1984

Yaxley 1988
D. Yaxley, 'Houghton', in Davison 1988

Yaxley 1994
D. Yaxley, 'The Tower of Houghton St Martin Church', *The Annual Bulletin of the Norfolk Archaeological and Historical Research Group*, no. 3, 1994, pp. 46-50

Yaxley 1996
D. Yaxley, 'The Houghton Gallery', *East Anglian Studies*, ed. A. Longcroft and R. Joby, University of East Anglia, Norwich, 1996

Yegorova 1966
K. S. Yegorova, 'Portrait v tvorchestve Rembrandta 1650-kh godov' [The Portrait in Rembrandt's Work in the 1650s], *Klassicheskoye iskusstvo za rubezhom* [Classical Art Abroad], Moscow, 1966

Yegorova 1996
X. Egorova, 'Flemish Landscapes in Moscow', *Jaarboek van het Koninklijk Museum voor Schone Kunsten*, Antwerp, 1996, pp. 37-57

Yegorova 1998
K. Yegorova, *Gosudarstvennyy muzey izobrazitel'nykh iskusstv imeni A. S. Pushkina. Niderlandy (XV-XVI veka), Flandriya (XVII-XVIII veka), Bel'giya (XIX-XX veka). Sobraniye zhivopisi* [The State Pushkin Museum of Fine Arts. Netherlands (15th-16th Centuries), Flanders (17th-18th Centuries), Belgium (19th-20th Centuries). Collection of Painting], Moscow, 1998

Yerkhova 1971
G. Yerkhova, 'Tekhniko-tekhnologicheskiye issledovaniya pyati kartin Pussena iz sobraniya GMII' [The Technical-Technological Study of Five Paintings by Poussin from the Collection of the Pushkin Museum of Fine Arts], *Soobshcheniya VTsNILKR* [Bulletin of the All-Union Central Scientific Research Laboratory for Conservation and Restoration of Museum and Artistic Valuables], issue 26, 1971

Zanker 1980
P. Zanker, 'Ein hoher Offizier Trajans', in *Eikones. Festschrift Hans Jucker*, Bern, 1980

Zimmerman 1904
'Das Inventar der Prager Schatz und Kunstkammer von 6 Dezember 1621, ed a cura di H. Zimmerman', *Jarhbuch der Kunsthistorischen Sammlungen der Allerhöchsten Kaiserhäuses*, vol. XXV, 1904

Znamerovskaya 1978
T. P. Znamerovskaya, *Neapolitanskaya zhivopis' pervoy poloviny 17 veka* [Neapolitan Painting of the First Half of the 17th Century], Moscow, 1978

Zolotov 1979
Yu. K. Zolotov, 'O khudozhestvennoy sisteme Pussena' [On Poussin's Artistic System], *Iskusstvo* [Art], 1979, no. 1, pp. 47-54

Zolotov 1985
Yu. K. Zolotov, *Nikola Pussen* [Nicolas Poussin], Leningrad, 1985

Zolotov 1986
Yu. K. Zolotov, 'Pussen i antichnost" [Poussin and Antiquity], *Iskusstvo* [Art], 1986, no. 3

Zolotov 1988
Yu. K. Zolotov, *Pussen* [Poussin], Moscow, 1988

Zolotov, Serebriannaia et al 1990
Y. Zolotov, N. Serebriannaia, N. Petroussevitch, M. Maiskaia, I. Kouznetsova, *Nicolas Poussin dans les musées de l'Union Sovietique. Peintures. Dessins*, Leningrad, 1990

Zucchini 1938
F. Zucchini, *Catalogo delle Collezioni Comunali di Bologna*, Bologna, 1938

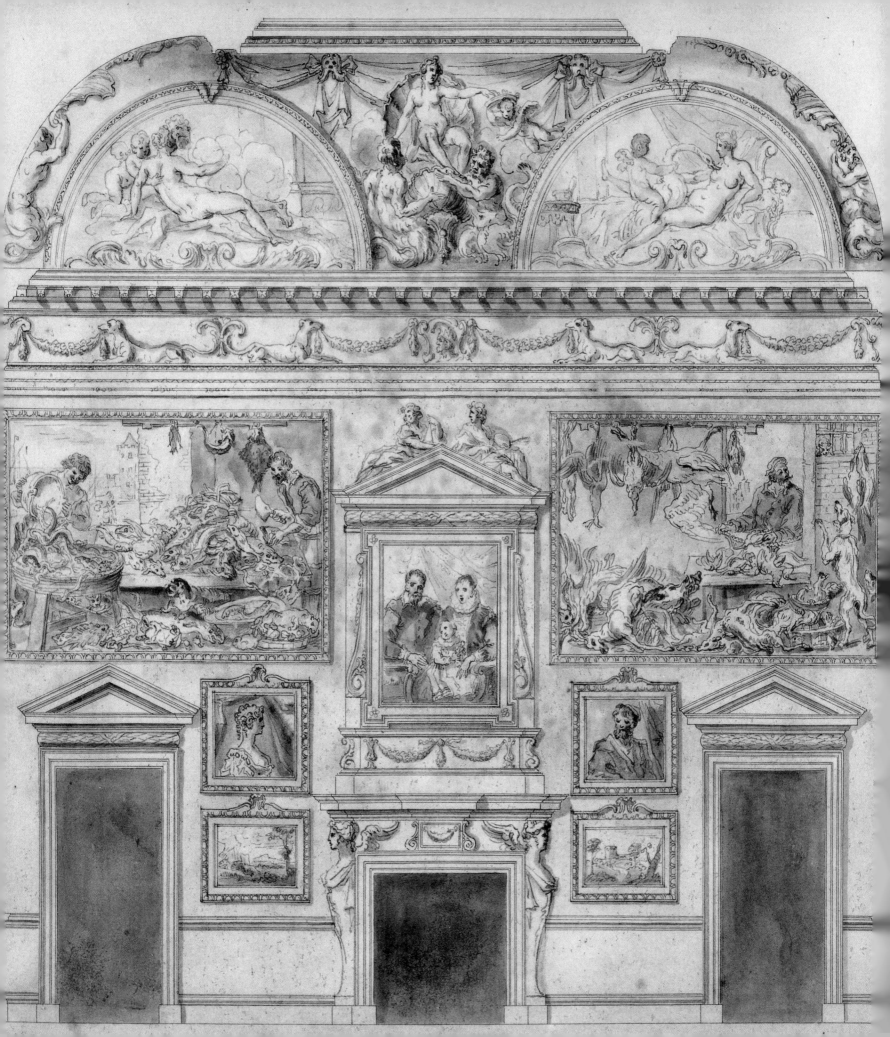